The Dictionary of 20th Century
British Book Illustrators

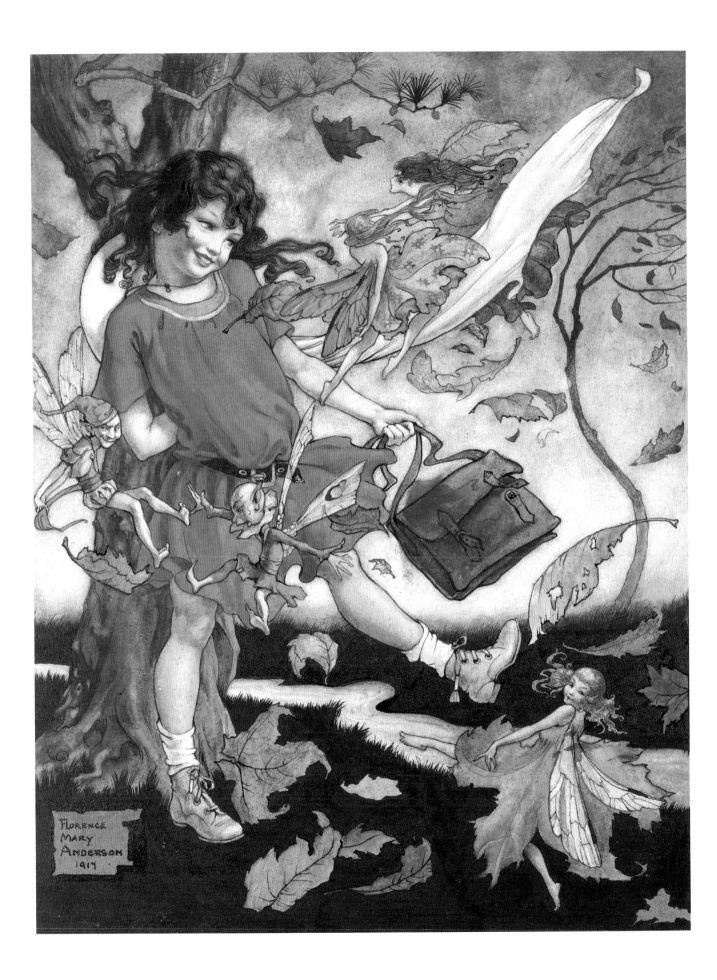

The Dictionary of 20th Century
British Book Illustrators

by Alan Horne

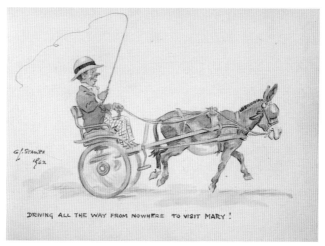

GEORGE LORAINE STAMPA
"Driving all the way from nowhere to visit Mary!"
By permission of Chris Beetles Limited

Frontispiece:
FLORENCE MARY ANDERSON
"A Diller, a Dollar, A Twelve-o'clock
Scholar. What Makes You Come So
Soon?"
By permission of Chris Beetles
Limited

Antique Collectors' Club

ISBN 1 85149 108 2

EDWARD ARDIZZONE
My Uncle Silas by H.E. Bates (Cape, 1939)
By permission of the Estate of the Artist and
Jonathan Cape

British Library Cataloguing-in-Publication Data
A catalogue record for this book is available from the British Library.

Printed in England by Antique Collectors' Club Ltd,
Woodbridge, Suffolk, IP12 1DS
on Consort Royal Satin paper from Donside Mills, Aberdeen, Scotland

THE ANTIQUE COLLECTORS' CLUB

The Antique Collectors' Club was formed in 1966 and now has a five figure membership spread throughout the world. It publishes the only independently run monthly antiques magazine *Antique Collecting* which caters for those collectors who are interested in widening their knowledge of antiques, both by greater awareness of quality and by discussion of the factors which influence the price that is likely to be asked. The Antique Collectors' Club pioneered the provision of information on prices for collectors and the magazine still leads in the provision of detailed articles on a variety of subjects.

It was in response to enormous demand for information on 'what to pay' that the price guide series was introduced in 1968 with the first edition of *The Price Guide to Antique Furniture* (completely revised, 1978 and 1989), and a book which broke new ground by illustrating the more common types of antique furniture, the sort that collectors could buy in shops and at auctions rather than the rare museum pieces which had previously been used (and still to a large extend are used) to make up the limited amount of illustrations in books published by commercial publishers. Many other price guides have followed, all copiously illustrated, and greatly appreciated by collectors for the valuable information they contain, quite apart from prices. The Antique Collectors' Club also publishes other books on antiques, including horology and art reference works, and a full book list is available.

Club membership, which is open to all collectors, costs little. Members receive free of charge *Antique Collecting*, the Club's magazine (published ten times a year), which contains well-illustrated articles dealing with the practical aspects of collecting not normally dealt with by magazines. Prices, features of value, investment potential, fakes and forgeries are all given prominence in the magazine.

Among other facilities available to members are private buying and selling facilities, the longest list of 'For Sales' of any antiques magazine, an annual ceramics conference and the opportunity to meet other collectors at their local antique collectors' clubs. There are over eighty in Britain and more than a dozen overseas. Members may also buy the Club's publications at special pre-publication prices.

As its motto implies, the Club is an amateur organisation designed to help collectors get the most out of their hobby: it is informal and friendly and gives enormous enjoyment to all concerned.

For Collectors – By Collectors – About Collecting

The Antique Collectors' Club, 5 Church Street, Woodbridge, Suffolk

For Bonnie

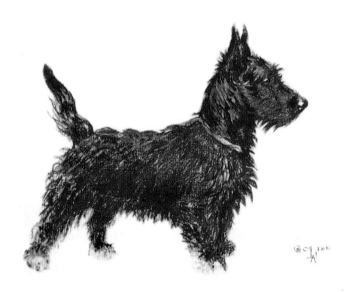

Above
CECIL CHARLES WINDSOR ALDIN
"Scottie"
By permission of Chris Beetles Limited

Opposite
BETTY SWANWICK
"Pearly King and Queen"
By permission of Chris Beetles Limited

CONTENTS

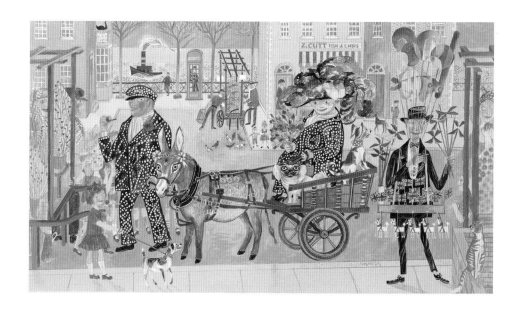

LYNTON LAMB
Can You Forgive Her? by Anthony Trollope
(Oxford University Press, 1948)
By permission of Oxford University Press

FOREWORD

This book had an excellent predecessor in *The Dictionary of British Book Illustrators and Caricaturists 1800-1914* by Simon Houfe (extensively revised under the title of *The Dictionary of 19th Century British Book Illustrators,* Antique Collectors' Club, 1994). Mr. Houfe's scrupulous attention to the details of the lives and careers of hundreds of artists, combined with his ability to see themes and styles and to write about them cogently, were an inspiration for someone whose interests lay in the following period. Given a fascination with the illustrations of the 1920s, 1930s and on into the present, and the example of how such an interest could be translated into a book which might conceivably help others and kindle similar sparks, this writer could not resist the challenge.

No book of this nature can ever be said to be complete; it nevertheless attempts to deal with all the major British book illustrators whose work was published during the period, and includes as many lesser artists as possible. In any work such as this, there is the inevitable challenge of reducing the entries for major figures to a manageable length, aware that other reference sources are plentiful, in order to allow space for the minor but nevertheless important artists about whom little has been written. There is much to support the view that the minor artists need a more extended treatment, and it is hoped that the bibliographies will indicate some further sources of information and stimulate research about many of the neglected illustrators.

For the purpose of this book, book illustration has been defined as any pictorial matter (excluding photographs) which is used in conjunction with a text. Within this definition, technical books dealing with science or architecture are excluded. The majority of the books listed are works of imaginative literature — fiction, poetry, and books for children. Books which are "decorated" rather than "illustrated" are certainly included.

Following the introductory sections, the main part of the book is devoted to an alphabetical listing of the artists. Each entry attempts to outline the major features of the illustrator's life and career, followed by listings of books illustrated; books written and illustrated; books published on subjects relevant to the artist (such as books on art and artistic techniques); journals to which illustrations have been contributed; major exhibitions of the artist's work; locations for major collections of original art; and a bibliography. Where an artist's work is prolific, a shortened list is given with a reference to a fuller bibliography in another reference book or article.

The phrase **See Houfe** refers to entries in Simon Houfe's book. In some cases Houfe's information is sufficient for an illustrator who was already working in the previous period, but in others additional information is required. An asterisk * is used in the dictionary entries to indicate that there is also an entry for the artist whose name is thus marked. A dagger † indicates that a book quoted in an entry will be found in the bibliography for that artist rather than in the bibliography of frequently cited works.

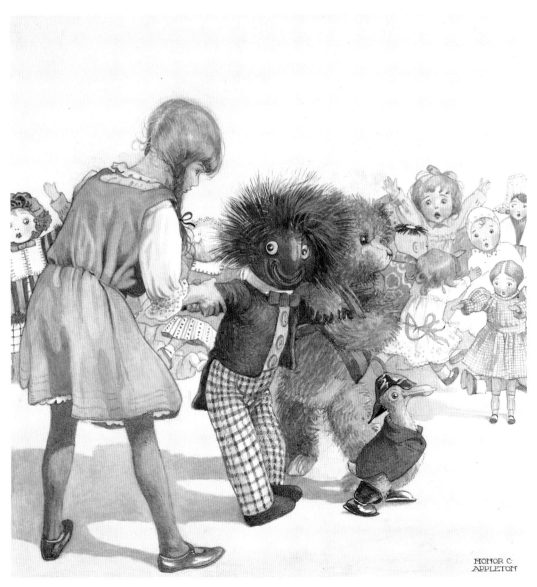

Above
HONOR C. APPLETON
"I promise that Teddy and I will hold him
tight, won't we Teddy?"

Left
CLARENCE LAWSON WOOD
"To the public danger! Scene on the road
from London to Manchester any time
within the next ten years"

Right
HENRY MAYO BATEMAN
"Man versus microbe"

All by permission of Chris Beetles Limited

ACKNOWLEDGEMENTS

Sincere thanks are due to the many illustrators and their families, publishers, and artists' agents who have responded to requests for information and for permission to reproduce examples of their work. It is perhaps invidious to select names from the long list of those who helped significantly, but I must single out for special thanks William Chappell, Helen Craig, David Gentleman, Rigby Graham, Paul Hogarth, Olive Kennedy, Frank Martin, Dodie Masterman (Colour Plate 1), Robert Micklewright, Peter Reddick, Richard Shirley Smith and Charles Stewart; and the Folio Society, the Medici Society, *Punch*, and Thomas Yoseloff of the Golden Cockerel Press. Despite their busy professional lives, more than one hundred artists responded to a request for information, and all willingly provided many details otherwise unavailable. When such information has been used in a dictionary entry, the letters IFA (Information from artist) appear in the bibliography. As well as information, their letters displayed an enormous enthusiasm for the art of illustration, and for their own work and that of fellow artists. Their expressions of interest and support for the project helped the author maintain his momentum through those days when it seemed impossible to complete the task he had set himself.

In addition to the artists themselves, many other people have given assistance,

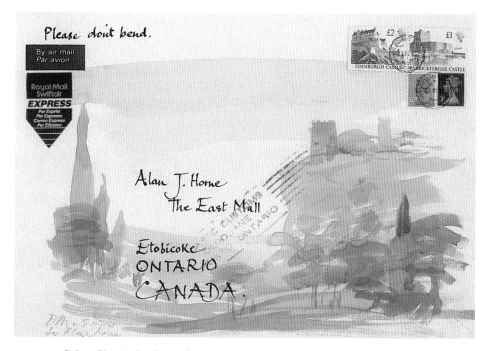

Colour Plate 1. Dodie MASTERMAN Envelope painted by Dodie Masterman

advice and encouragement. Two names must head the list. The first is Bonnie Horne, the author's wife, who provided timely and much needed encouragement and support, read drafts and proofs, made suggestions for change, and took charge of the many chores associated with writing. Without her help and forbearance, the project would never have been completed. The second is Brian Alderson, long-time friend and a notable authority on children's literature, who contributed the preliminary section "Some Notes on Children's Book Illustration 1915-1985" and remedied many inadequacies in the main part of the book. Other names include Hugh Anson-Cartwright, William Blissett, Gayle Garlock, Dennis Hall, Richard Landon, Margaret Crawford Maloney, and Ronald Taylor. Particular thanks go to Chris Beetles who has given continued support and provided many illustrations from his collections of original artwork at the Chris Beetles Gallery in Ryder Street, St. James's, London. The catalogues of exhibitions held at the Chris Beetles Gallery are filled with information and profusely illustrated in colour, and some of the catalogues (such as that on *The Brothers Robinson*, 1992, written by Geoffrey Beare) are important monographs on their subject. Many art agencies supplied information about artists in their "stables"; and the Association of Illustrators was similarly helpful. The admirable pioneer work done by Brigid Peppin and Lucy Micklethwait for their book, *Dictionary of British Book Illustrators: The Twentieth Century* (John Murray, 1983), was invaluable, and frequent references are made to that book.

The collections of several libraries proved invaluable, and their staff without exception readily offered their services and their advice. These libraries include the Robarts Library of the University of Toronto, whose Interlibrary Loan section obtained many "difficult to find" books and articles (Jane Clark, Jane Lynch, Candy Cheung and Shamim Allani), while the Microtexts section searched newspapers for articles and obituaries and supplied innumerable photocopies (Judy Young Chong); the Thomas Fisher Rare Book Library at the University of Toronto (Richard Landon and many others); the Osborne Collection of Early Children's Books, Toronto Public Library (Margaret Crawford Maloney, Dana Tenney and Jill Sheffrin); the National Art Library at the Victoria and Albert Museum; the St. Bride Printing Library; the Centre for the Study of Cartoons and Caricature at the University of Kent, Canterbury (Liz Ottaway, research fellow); and the Art Gallery of Ontario. The illustrations are nearly all reproduced from photographs by Philip Ower, photographer at the University of Toronto Library, or by Chris Beetles, to both of whom I am particularly grateful. Last but not least, thanks go to the Social Sciences and Humanities Research Council of Canada, Ottawa, and to the Research Board of the University of Toronto, for their financial support which enabled the author to spend research time in England.

The illustrators and their publishers have been extremely helpful and generous in granting permission to reproduce illustrations for reference purposes. The illustrations are reproduced with permission of the copyright holder — artist, or publisher, or their successors — wherever they could be traced. When specific wording to indicate copyright permission has been requested, this is given in the caption to the illustrations; otherwise the reader should understand that permission was obtained from the cited artist or publisher. The publisher, Antique Collectors' Club Ltd., 5 Church Street, Woodbridge, Suffolk IP12 1DS, will be pleased to hear from any copyright holders whom it has not been possible to locate.

BRITISH BOOK ILLUSTRATION 1915-1985:
An Overview

The "new century" of British book illustration began in the second decade of the twentieth century. A brief review of Malcolm Salaman's *Modern Book Illustrators and Their Work*, published by The Studio in 1914, reveals that the list of illustrators is filled with the well-known names of the 1890s and the turn of the century — Anning Bell, the Brocks, Harry Clarke, Edmund Dulac, Edmund New, Arthur Rackham, the Robinsons, Edmund Sullivan and Hugh Thomson. This book also revealed an almost complete lack of wood engravings in the 192 pages, apart from two rather dull engravings by Maxwell Armfield which start the illustration section. Wood engravings, so popular in the 1860s, have mostly vanished, supplanted by the photographic process. Line drawings could now be reproduced quickly and easily, in contrast to the relatively slow and tedious business of cutting a design on wood, and then printing from that or from a plate made from it. The new process also allowed and encouraged artists to use colour, which could be copied after a fashion by the half-tone method. The lavishly produced "gift book" was firmly entrenched, and though some were well produced and attractive, many suffered from poor printing, a lack of concern for quality, the fascination with colour at all cost and, above all, from the technical limitations of the "process".

The earlier illustrators included in Salaman's book are appropriately and fully dealt with in Simon Houfe's splendid precursor to the present volume. Many of these artists carried on working after 1914 and continued to produce excellent work which, though important, is often redolent of the styles of the nineteenth century. C.R.W. Nevinson, a leading figure of the pre-1914 *avant-garde* and best known for his fine First World War paintings, in his usual controversial and irreverent style, listed many things which he felt were detrimental to the progress of art at this time, among them

> the pretty-pretty, the commonplace, the soft, the sweet, and mediocre, the sickly revivals of medievalism, . . . Aestheticism, Oscar Wilde, the Pre-Raphaelites . . .[1]

In an essay in the catalogue of an exhibition of English prints held at the Fitzwilliam Museum in 1985, Joseph Darracott writes:

> Who can be sure when a new era has begun? Did the twentieth century effectively start at the death of Queen Victoria? Or should we agree with Virginia Woolf that the year 1910 was a turning-point? However we may answer there is no doubt that British art was on the move in the 1910s.[2]

1. C.R.W. Nevinson: *Paint and Prejudice* (Methuen, 1937): 58-60.
2. Joseph Darracott: "The Great War and After" in *The Print in England 1790-1930* (Cambridge: Fitzwilliam Museum, 1985): 126.

For book illustration, a new era could be said to have started in 1910, when Noel Rooke started teaching wood engraving at the Central School of Arts and Crafts. He was one of the originators of the modern movement of wood engraving, and almost single-handedly reinstated Bewick's white line technique. *The Woodcut of To-day at Home and Abroad*, edited by Salaman and published in 1927, a mere seventeen years after Rooke's pioneer work commenced, lists such artists as Douglas Percy Bliss, Eric Daglish, John Farleigh, Robert Gibbings, Eric Gill, Barbara Greg, Gertrude Hermes, Blair Hughes-Stanton, Clare Leighton, Paul and John Nash, Gwen Raverat, Eric Ravilious, Noel Rooke (of course), Leon Underwood, Clifford Webb and Ethelbert White.

This army of wood engravers, with their concerns for the design of the page, the compatibility of illustration and type, and the appearance of the book as a whole, revitalised book illustration in Britain. By 1931, a whole group of new illustrators had appeared, in addition to the wood engravers. Another Studio book published in that year, *Modern Book-Illustration in Great Britain and America*, with a long introductory essay by F.J. Harvey Darton, includes some of those illustrators in its list — Edward Ardizzone, John Austen, Nicolas Bentley, Barnett Freedman, Stephen Gooden, Norman Hepple, McKnight Kauffer, Lynton Lamb, Albert Rutherston, and Rex Whistler.

Along with the revival of wood engraving, many other factors conspired to make the inter-war years so exciting as far as book production was concerned. There was Harold Curwen's insistence on the importance of quality printing, whether it be for books or the production of an advertising brochure or even an invoice, and his employment and encouragement of many artists. Lithography and autolithography developed rapidly at the hands of such fine craftsmen as Thomas Griffits and in such firms as the Curwen Press, the Baynard Press, Cowells, and Vincent Brooks, Day. This allowed business men like Frank Pick of London Transport and Jack Beddington of Shell to realise the potential of this

Noel ROOKE "The edge of the wood", wood engraving (c.1918)

Gwen RAVERAT "Crossroads": wood engraving from *London Mercury* (October 1936)

new medium for their advertising purposes, and a whole new group of artists evolved as poster artists, producing works of art for purely commercial purposes. The developments in lithography had a considerable effect on the production of all sorts of books, but particularly on books for children, allowing the printing of brilliantly-coloured and gently-modulated picture books.

The beginning of the Second World War dealt a serious blow to the production of fine illustrated books. Many illustrators were "otherwise employed" in the armed forces or, at best, worked as war artists; craftsmen printers were also called up and paper and other supplies were of very poor quality and strictly rationed. The appearance of books, of course, suffered greatly. After the war, although these restrictions were slow to be removed, there was another revival of interest in producing good-looking books. A number of small publishing houses were established (though some did not survive for long), such as Westhouse, Peter Lunn, Lyndsay Drummond, Paul Elek, and John Lehmann, and they employed fine artists to illustrate their books. Though most of the notable private presses no longer existed, the Golden Cockerel Press continued to produce fine books up to 1961, even if the quality was not always what it had been in its "golden" years; and in 1947 the Folio Society was founded "to produce editions of the world's great literature in a format worthy of the contents, at a price within the reach of everyman". Very much a product of the war years and of the resulting social revolution, the Society's rather pompously announced aims were a reaction against the *edition-de-luxe* . . .

> The real challenge was to equate good design with the mass-production techniques of the machine age.[3]

3. Charles Ede in *Folio 21: A Bibliography of the Folio Society 1947-1967* (The Folio Press, 1968): 11.

Charles STEWART *Uncle Silas*
by Sheridan Le Fanu
(Folio Society 1988)

One of the first directors of the Folio Society was Christopher Sandford, then also proprietor of the Golden Cockerel Press. The Folio Society still produces fine books, including the recently published (1980s) complete illustrated edition of Dickens, with magnificent drawings by Charles Keeping.

Following the war, the general economic situation began slowly to improve, and the new optimism seemed to be reflected by the successful Festival of Britain in 1951. During this period, the National Book League's annual exhibitions of British Book Designs continued and acted as a constant reminder to publishers, designers, artists and printers of the necessity of maintaining standards of production. The catalogues of these exhibitions often refer to increasing production costs, and these costs eventually produced some sad events such as the closure of the Curwen Press in 1984. Many publishers looked elsewhere for affordable, fine printing, and found that it could be obtained in such places as Czechoslovakia, Italy and Hong Kong. A large proportion of certain categories of books, such as lithographed chil-

Charles KEEPING "Bill Sikes" from *Oliver Twist* by Charles Dickens (Folio Society, 1984)

dren's picture books, are printed in these countries.

Since 1960, according to the introductions to the National Book League exhibition catalogues, one would believe that book illustration, design and production were in the doldrums. There are however many fine artists working as illustrators, especially in the field of children's books; and some publishers have regularly produced good illustrated books, as Brian Alderson demonstrates in his section "Some Notes on Children's Book Illustration 1915-1985". It is interesting to note also that wood engraving has recently seen another revival of interest. After the 1950s, many of the older engravers had more or less finished working, and by the end of the 1960s the teaching of wood engraving had been dropped from art schools. In the 1980s, there was another renaissance, and in 1984 the Society of Wood Engravers was reactivated under the chairmanship of Simon Brett. It is more than seventy years since Noel Rooke started teaching engraving at the Central School, and a new generation of artists is using the medium in many ways, producing limited edition prints, designs for advertising, and book illustrations.

The following sections deal in more detail with some of the major trends in British book illustration through this period. The bibliographies appended will help readers to find more information about these subjects.

THE REVIVAL OF WOOD ENGRAVING

Woodcuts and wood engravings are certainly not new methods of reproducing designs or illustrations. After the introduction of moveable metal type and the printing press in the mid-fifteenth century, woodcuts became the ideal way of illustrating books because they were compatible with type and could be printed on the same press. In many early illustrated books, such as the *Liber Chronicarum* (Nuremberg: 1493), known as the Nuremberg Chronicle, several blocks were printed more than once in the same book and used to illustrate different things.

These early woodcuts were done so that the black line produced the design, which meant that a great deal of the wood had to be cut away. In the mid-fifteenth century, the copper engraving process was devised to avoid this tiresome procedure, and also to produce a finer line. By the seventeenth century, engraving processes of various kinds had displaced woodcuts as the most common form of book illustration. These engravings, however, had the major disadvantage of using an intaglio process, which was incompatible with the relief printing of the text of the book, so that the text and the illustrations required different presses.

Relief printing of illustrations came back into its own towards the end of the eighteenth century with the introduction of wood engraving. The fine line of

engraving techniques was achieved with wood engraving by cutting the design on the hard end-grain of the wood, normally boxwood, using a graver as for copper engravings but producing a relief block. (Woodcuts are cut with a knife from the flat and softer side of the wood, giving a rougher, coarser look to the finished print; and the design was cut so that it appeared in black line, while the design in wood engravings often appeared in white line.) It took the genius of Thomas Bewick (1753-1828) to perfect the art of wood engraving and show its potential as a method of illustration. He produced hundreds of vignettes as book illustrations, each filled with exceptionally fine detail.

Bewick's work restored the relief block to its pre-eminent position in book illustration, but by the mid-nineteenth century the explosion in the production of books and magazines ensured that artists could not cope with the demand for illustrations. In the 1860s craftsmen turned out thousands of wood blocks to meet the deadlines on the presses, but they were not themselves the originating artists, as Bewick had been. Wood engraving had become a purely reproductive medium, though one of extraordinary skill. Commercial engravers such as the Dalziel Brothers made highly skilled reproductions of drawings by such artists as Holman Hunt, Millais, Rossetti, Du Maurier and Tenniel. These artists apparently knew little of the art and craft of engraving and left it to the hands of artisans to copy their work, even though this process often altered the design, changing it into something quite different, attractive though it might be. This method of illustration was successful while there were major artists and excellent commercial engravers working together.

Throughout the nineteenth century, however, there had been much research and many experiments to find a method of speeding up the production of the printing block, including the use of stereotypes and electrotypes. Steel engravings were used extensively later in the century, and lithography was an enormous discovery which made a huge impact on the printing of illustrations. The real revolution came with the introduction of photography, with its use of light-sensitive coatings on various materials. This heralded the end of the mass of wood engraved illustrations which for many years had filled the pages of books and magazines. These engravings began to be replaced with a less satisfactory but speedier alternative, the "process" print, produced photo-mechanically. Of the many varieties of this, the much used but perhaps least satisfactory was the halftone, in which the image is produced by a series of black dots.

Though photo-mechanical illustration processes brought about a sad degradation of the quality of illustrations, a few artists in the nineteenth century continued to make woodcuts and wood engravings. William Morris, with Burne-Jones, a fine artist and engraver, attempted to revive the traditions of fine printing and design with his Kelmscott Press books. Lucien Pissarro, the son of the French Impressionist painter Camille Pissarro, came to England in 1883, where he met Charles Ricketts and C.H. Shannon and came into contact with the revived interest in wood engravings and the new ideas in book design formulated by Morris. He established another private press, the Eragny Press, and broke new ground in his use of colour woodcuts.

In the 1890s, another artist, Edward Gordon Craig (1872-1966), the actor-director son of the famous English actress, Ellen Terry, and outstanding in many fields, started making woodcuts for the purely practical purpose of reproducing quickly and cheaply the outlines of his theatre designs and direction for distribution to the actors and other people preparing a theatrical production. His work was of immense significance and he produced some superb woodcuts and

Robert GIBBINGS *The Seventh Man* (Golden Cockerel Press, 1930)

Eric GILL *Troilus and Criseyde* by Geoffrey Chaucer (Golden Cockerel Press, 1927)

engravings, the finest of which may be seen in the Cranach *Hamlet*, published by Count Harry Kessler at the Cranach Press in Germany in 1927, for which Craig's illustrations were cut on the plank side of the wood and printed to show the grain in the black areas.

William Nicholson, another such artist, was much influenced by the heavy woodcuts in the chapbooks of Joseph Crawhall. Nicholson's bold and apparently simple designs which appeared in his picture books (published around the turn of the century) were actually made as wood engravings, cut with a graver on the end grain, but they look like woodcuts. The illustrations were then coloured by some lithographic process, and not hand coloured as were Crawhall's.

These artists were exceptions, however, for the majority of illustrations done in the latter part of the nineteenth century and the early years of the twentieth century were produced from a process block. It was not until after Noel Rooke began teaching wood engraving in 1910 that wood engraved illustrations really began to live again. Rooke had been the pupil of the great calligrapher, Edward Johnston, and taught illustration at the Central School of Arts and Crafts in London. He was completely dissatisfied with the way that his drawings were reproduced by photographic methods, and determined to find a way by which his work would be reproduced as he wanted. Wood engraving was the method he chose for this purpose, and from this desire to improve the printed quality of his

own work sprang an amazing revival in wood engraving. Rooke's primary importance was as a teacher, for he illustrated few books and was not a prolific print maker; but as a teacher his influence was far reaching. His pupils included many of those who became wood engravers of great skill — Robert Gibbings, John Farleigh, Clare Leighton and Vivien Gribble may be numbered among the better known. There was a host of others of lesser but not insignificant importance, such as Lady Mabel Annesley, who illustrated a few books and exhibited in Britain and New Zealand, and Margaret Pilkington, who later was responsible for the establishment of the superb collection of wood engravings at the Whitworth Art Gallery, Manchester.

Meanwhile, independent of Rooke and the Central School, other artists had started to take up wood engraving. Paul Nash began experimenting with wood engraving in 1919, and in the 1920s taught wood engraving at the Royal College of Art, where Edward Bawden and Eric Ravilious were two of his students. Nash's "followers" included his brother, John Nash, Claughton Pellew, Eric Daglish the naturalist, and Douglas Percy Bliss, who became the historian of the movement.

Eric Gill, who had been one of Rooke's students, attracted his own group of adherents to the craft. He became the best known wood engraver of the 1920s and 1930s, though he considered himself more a decorator than an illustrator. Gill was also a fine typographer and stone mason; his stone-cut letters and his book designs for the Golden Cockerel Press and others were of immense significance. A Roman Catholic convert in 1913, Gill had fervent religious views as well as strong sexual desires, and much of his work illustrates these two influences. Several engravers worked with Gill in his studio, including David Jones who went to live and work with Gill and his family after he too was received into the Roman Catholic Church in 1921. Jones, the most important artist who worked in Gill's studio, engraved on wood and copper. He also established a major literary reputation with two works, *In Parenthesis* (1937), an epic poem based on the First World War, and *The Anathemata* (1952), which was an exploration of the relationship between Roman Imperialism and Christianity.

The organized development of wood engraving took a major step forward in 1920, when many of these wood engravers joined together to form the Society of Wood Engravers. The founding members, who were Rooke, Pissarro, Craig, Gill, Gibbings, E.M.O'R. Dickey, Philip Hagreen, Sydney Lee, John Nash and Gwendolen Raverat, arranged annual

Philip HAGREEN Woodcut from *The Apple* (1923, 1st quarter) p.34

Dorothea BRABY *The Commandments* (F. Lewis, 1956)

exhibitions which were always remarkably well received in the press. In 1925, however, some artists broke away to form a rival organization, the English Wood Engraving Society (it became defunct in 1932). These included Craig, Claughton Pellew, Ethelbert White, and Leon Underwood and his pupils Mary Groom and Gertrude Hermes. In the same year, Iain Macnab established his Grosvenor School of Modern Art, and his staff included Blair Hughes-Stanton, Graham Sutherland and Claude Flight, the pioneer in Britain of colour linocutting.

The first time that the new wood engravings were used as book illustrations was in 1915, when both *The Devil's Devices* (Hampshire House Workshops), illustrated by Eric Gill, and *Spring Morning* (Poetry Bookshop), illustrated by Gwen Raverat, were published. It was not until 1924, however, when the Golden Cockerel Press was taken over by Robert Gibbings, that the use of wood engravings as illustrations became more common. During the next fifteen years or so, the Press commissioned work from almost all of the better wood engravers of the period, including the two Nashes, Gwenda Morgan, John Buckland Wright, Dorothea Braby, Eric Ravilious and Clifford Webb, to say nothing of Robert Gibbings himself and his friend Eric Gill.

Other private presses played an important role in the development of wood engraving. These included the Boar's Head Press, operated by Christopher Sandford (who later was part-owner of the Golden Cockerel Press): many of his books are illustrated by his wife, Lettice Sandford; and a small press run by F.R. Lewis in Essex, which published a few well-designed and illustrated books, using engravers like Hughes-Stanton and Dorothea Braby. The Gregynog Press, founded in Wales in the 1920s, played a major role, producing its best work in the 1930s, when Blair Hughes-Stanton was the designer. His wood engravings and those of his wife, Gertrude Hermes, and of Agnes Miller Parker are magnificent.

Commercial publishers played their part too in the revival of wood engraving. Many of the engravers who worked for private presses were also commissioned by commercial publishers. Gibbings' "river books" were published by J.M. Dent, while Agnes Miller Parker was particularly well served by Victor Gollancz, who published two of the most successful books illustrated with engravings, books inspired by the English landscape, *Through the Woods* (1936) and *Down the River* (1937). Their success was due, to a considerable extent, to the superb printing job done by the Camelot Press. Natural history and "country matters" have traditionally been popular subjects of certain British literary genres and lend themselves to wood engraving. The work of engravers Joan Hassall, Eric Daglish (a professional naturalist), Charles Tunnicliffe and Barbara Greg appeared mostly in books from commercial publishers, from the 1920s through the 1950s. Clare Leighton's *The Farmer's Year*, printed and published by Collins in 1933, an enormous book measuring more than 11in. tall and 14in. wide, was another splendid commercial production of this period, costing only 10s.6d. on publication. Leighton and Norah Unwin, both particularly effective when using country life and natural history as their major themes, spent most of their productive years in the United States. Unwin died there in 1982 and Leighton not until 1989, in her ninety-first year.

Other engravers at work in this period were George Mackley, Clifford Webb, and Monica Poole, who is primarily a print maker. Poole was taught by Geoffrey Wales and John Farleigh; she recalls her debt to Farleigh:

> John Farleigh was no retiring artist, emerging reluctantly from the seclusion of his studio and I would be surprised if he did not enjoy teaching. He had the qualities of an exceptional teacher; enormous enthusiasm for his subject and his students' work, the ability to assess the potential of each student and to inspire, without subjecting the student to influence from his own work.[1]

Farleigh had been taught by Rooke, and he himself taught wood engraving at the Central School for many years, becoming Head of Book Production there on Rooke's retirement in 1947. He was responsible for one of the huge successes of commercially-published books illustrated with wood engravings when Constable issued his version of Bernard Shaw's *Adventures of the Black Girl in Her Search for God* (1932), which had to be reprinted five times within a few months of its original publication.

By the end of the 1960s, however, the teaching of wood engraving had been dropped from the curricula of art schools; and the Society of Wood Engravers

1. Monica Poole: *The Wood Engravings of John Farleigh* (Gresham Books, 1985): 6.

Agnes Miller PARKER *Down the River* by H.E. Bates (Victor Gollancz, 1937)

Sarah Van NIEKERK *The Curate of Clyro* by Francis Kilvert (Gwasg Gregynog, 1983)

Harry BROCKWAY *The Lad
Philisides* by Sir Philip Sidney
(The Old Stile Press, 1988)

seemed to fade out in the 1970s. In 1984 it took on a new life under engraver
Simon Brett as Chairman, who organized an important exhibition in the late
1980s "Engraving Then and Now: The Retrospective 50th Exhibition of the
Society of Wood Engravers" (1987). The older, established artists were still
engraving, and the work of many younger ones had begun to appear. Especially
notable were Andrew Davidson and Christopher Wormell, who produce
engravings for advertisements in newspapers and magazines as well as for books
and as separate prints.

Private presses, though none now operates in the same way as the Golden
Cockerel Press did earlier in the century, continue to use wood engravings to
illustrate their books. In fact, many of the owners of these small presses are
themselves engravers, like Simon Brett (the Paulinus Press) and Simon King (the
Simon King Press). The Whittington Press, which started in the village of
Whittington in the Cotswolds, and has recently moved to Risbury in Hereford-
shire, is one of the more important private presses of today. Operated by John
and Rosalind Randle, Whittington has published books illustrated with
engravings by Howard Phipps, Miriam Macgregor, John Craig (the grandson of
Edward Gordon Craig) and many other artists. It has also (by 1992) published
eleven issues of its beautiful annual *Matrix*, devoted to the printing arts, and
including articles about and by engravers, and absolutely overflowing with

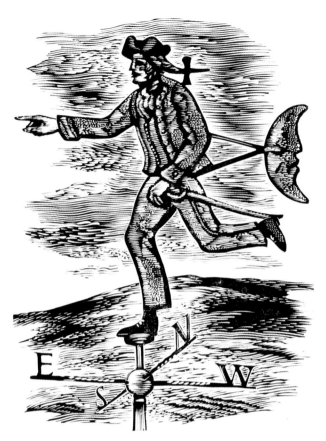

Peter REDDICK *The Trumpet Major* by Thomas Hardy (Folio Society, 1990)

Frank MARTIN *Scarlet and Black* by Stendhal (Folio Society, 1965)

examples of their work.

A new batch of younger engravers, including Sarah Van Niekirk, Colin Paynton and Yvonne Skargon, is working today on a revived Gregynog, Gwasg Gregynog; and many small private presses operating today are helping to keep the art of wood engraving alive. The Folio Society, which has been running for many years, has in a way, replaced the defunct Golden Cockerel Press, and often uses wood engravers to illustrate its books — these include Raymond Hawthorn (*Les Liaisons Dangereuses* 1962), Peter Reddick (the Thomas Hardy novels), Frank Martin (*Scarlet and Black* 1965), Sarah Van Niekirk (the gothic romances of Ann Radcliffe), and younger engravers like Hannah Firmin, Jane Lydbury and the satirist, Peter Forster, who enjoys making coloured engravings.

There is hope that wood engraving as a method of book illustration is here to stay this time. Its revival early in the century was extraordinarily successful, but the Second World War interrupted its progress. As Simon Brett writes:

> It stands at a familiar crossroads: between having been recently saved from extinction by, once again, graphic and illustrational applications and never quite having achieved the independent life which the inter-war period seemed to promise.[2]

2. Simon Brett: *Engravers: A Handbook for the Nineties* (Swavesey, Cambridge: Silent Books, 1987): 8.

Its continued success will depend upon the quality of the artists who use the medium.

Bibliography

Balston, Thomas: *English Wood-Engraving 1900-1950* (Art & Technics, 1951).
— *Wood-Engraving in Modern English Books* (National Book League, 1949).
Bliss, Douglas Percy: *A History of Wood-Engraving* (Dent, 1928).
Brett, Simon: *Engravers: A Handbook for the Nineties* (Swavesey: Silent Books, 1987).
Deane, Yvonne, and Selborne, Joanna: *British Wood Engraving of the 20's and 30's* (Portsmouth City Museum, 1983).
Dodgson, Campbell:*Contemporary English Woodcuts* (Duckworth, 1922).
Farleigh, John: *Graven Image* (Macmillan, 1940).
— *45 Wood-Engravers* (Wakefield: Simon Lawrence, 1982).
Furst, Herbert: *The Modern Woodcut* (John Lane, The Bodley Head, 1924).
— *The Woodcut: An Annual*, four vols. (The Fleuron, 1927-30).
Garrett, Albert: *British Wood Engraving of the 20th Century: A Personal View* (Scolar Press, 1980).
Gascoigne, Bamber: *How to Identify Prints* (Thames and Hudson, 1986).
Leighton, Clare: *Wood Engraving of the 1930s* (The Studio, 1936).
—*Wood-Engravings and Woodcuts* (The Studio, 1932).
Prints in England 1790-1930 (Cambridge: Fitzwilliam Museum, 1985).
Rooke, Noel: *Woodcuts and Wood Engravings* (Print Collectors' Club, 1926).
Salaman, Malcolm C. *The New Woodcut* (The Studio, 1930).
— *The Woodcut of Today at Home and Abroad* (The Studio, 1927).
Sixteen Contemporary Wood Engravers (Newcastle: David Esslemont, 1982).
Sleigh, Bernard: *Wood Engraving Since Eighteen-Ninety* (Pitman, 1932).

COMMERCIAL ART

Commercial art is a term which for some implies the subordination of artistic integrity to the need for financial gain. This is not inevitable, however, for the phrase "accurately expresses the fusion of artistic means and commercial ends into something which, at its best, is neither sell-out nor compromise but a synergy in which a genuine work of art could also be used for a commercial purpose."[1]

1. David Bernstein in *"That's Shell — That Is!" : An Exhibition of Shell Advertising Art*, Catalogue of an Exhibition at the Barbican Art Gallery, 5 July - 4 September 1983 (Barbican Art Gallery and Shell UK, 1983): 8.

Advertising of all kinds has been a good source of steady employment for artists in the twentieth century. When they leave their school or college of art, many artists do not know at this stage of their career if they wish to work as book illustrators; and of those that have chosen book illustration, most do not immediately work in their selected field. A few are fortunate, as was Nicola Bayley, whose final student portfolio was so admired by Tom Maschler of Jonathan Cape that he commissioned her to illustrate a book of nursery rhymes. For many artists, however, "commercial art" provides a living for a few years at least. They help design advertisements in the press and in magazines, posters, leaflets, catalogues, stationery and packaging materials.

The influence of just a handful of companies and their executive officers in charge of advertising on the life and careers of many artists is difficult to exaggerate. The Curwen Press (Harold Curwen and Oliver Simon), the London Passenger Transport Board (Frank Pick), the Empire Marketing Board (Frank Pick again), Shell-Mex (Jack Beddington and Kenneth Rowntree), Ealing Studios (S. John Woods), and Guinness (whose first advertising director was Martin Pick, Frank's brother), are just a few of the organizations on whose advertising policies artists and illustrators depended. Materials produced included posters, newspaper and magazine copy, advertising leaflets, stock blocks, and patterned papers. Not only are the slogans used now part of our "language" — "Guinness Is Good for You", "You Can Be Sure of Shell", "Careless Talk Costs Lives", "Coughs and Sneezes Spread Diseases" — but many of the images also are memorable. Who can fail to recall John Gilroy's toucan and seal for Guinness, the distinctive figures drawn by Fougasse (Cyril Bird) for propaganda posters during the Second World War, Lord Kitcheners's pointing finger in Alfred Leete's 1914 poster, "Your Country Needs You"?

Harold Curwen was one of the few people in the early part of the century to believe that each and every piece of printing was important. In his view, there should be no significant distinction in the attention paid to the design and production between fine printing and jobbing work. He and James Thorpe made an immense difference to the appearance of commercial printing because of this attitude and through their determination to bring a touch of lightheartedness and gaiety to this kind of work. At the Curwen Press they employed such artists as Claud Lovat Fraser (Colour Plate 2), Edward Bawden and Albert Rutherston (Colour Plate 3) to produce a whole range of decorative devices, fleurons, and patterned papers. Artists like these brought a sense of design to an area of printing which had been totally neglected; they added colour and removed solemnity from their designs, and thus made what they produced more interesting and more exciting.

Posters provided much scope for many different artists. Frank Pick (1878-1941) was thirty when he was appointed Traffic Development Officer of a group of transport companies in London which later amalgamated to form the London Passenger Transport Board. He was responsible for the development of the vehicles, buildings and machinery of an enormous organization. Pick combined superb managerial skills with a true understanding of what artists could contribute to business, and it is with lettering and poster art that his name is best remembered. He introduced poster artists like McKnight Kauffer and Austin Cooper to his London public, and was responsible for encouraging Edward Johnston, and later Eric Gill, to produce the first modern sans serif letters, still used today on signs throughout the transport system. The methods of colour printing available in the 1920s and later made it possible for the production of

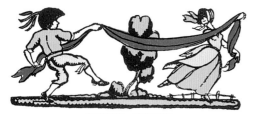

GET THE
SPIRIT OF JOY
INTO YOUR PRINTED THINGS

THE WORLD'S dead tired of drab dullness in Business Life.

GIVE your customers credit for a sense of Humour and some Understanding.

TAKE your courage in both hands and have your printing done

CHEERILY!

I arrange & make
COURAGEOUS PRINTING
At the Curwen Press
Plaistow, London, E.13
Harold Curwen

SPLEEN AND OTHER STORIES
Translated from the French of
PIERRE-VICTOR BARON DE BESENVAL
By H. B. V.
With an Introduction by
HAVELOCK ELLIS

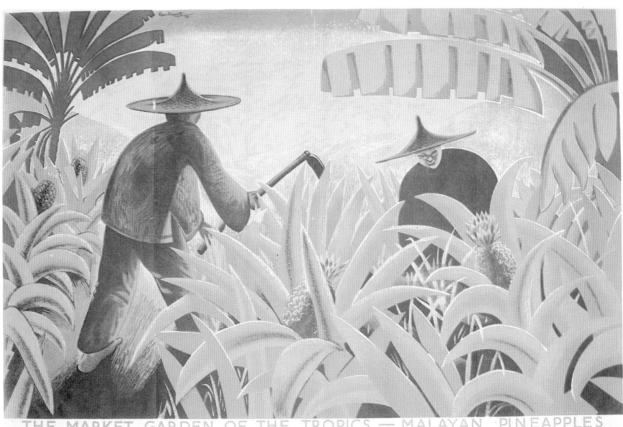

THE MARKET GARDEN OF THE TROPICS — MALAYAN PINEAPPLES

Colour Plate 2. Claud Lovat FRASER "Get the Spirit of Joy" Leaflet by Harold Curwen for the Curwen Press, 1920

Colour Plate 3. Albert RUTHERSTON Curwen patterned paper used for "Eighteenth Century French Romances" edited by Vyvyan Holland (Chapman & Hall, 1926-27); printed by the Curwen Press

Colour Plate 4. Edgar AINSWORTH "The Market Garden of the Tropics — Malayan Pineapples" Poster for the Empire Marketing Board, 1931 (From the Public Record Office CO 956/269)

Colour Plate 5. E. McKnight KAUFFER "London History at the London Museum" Poster for London Transport, 1922 (Courtesy of the London Transport Museum)

Colour Plate 6. James FITTON "Kind Hearts and Coronets" Poster for Ealing Studios, 1949

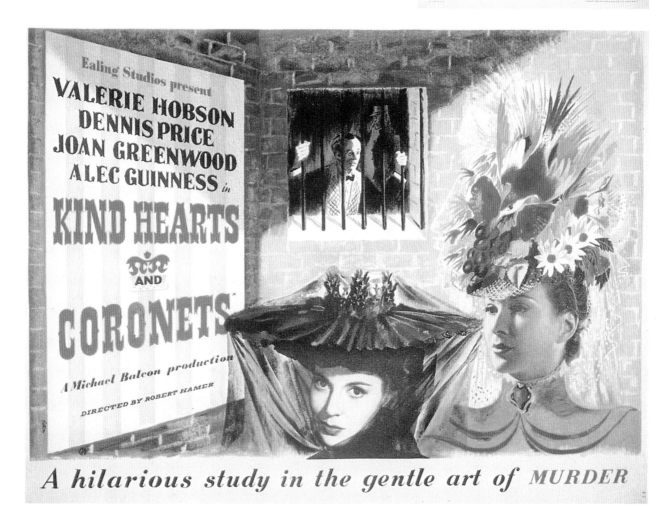

posters that must be called works of art, and for the emergence of poster art as a distinct species. The Curwen Press, the Baynard Press, and Vincent Brooks, Day, were pre-eminent among printers in this area. Thomas E. Griffits, who worked at Vincent Brooks, Day & Son from the turn of the century for thirty-five years, and was Advisory Director and Works Manager from 1919, resigned in 1935 to work at the Baynard Press. He worked there until his death in 1957 at the age of seventy-four, ending as a Director of the Baynard Press, and Chairman of Vincent Brooks, Day, which was absorbed by Baynard in 1951.[2] He was an outstanding lithographic craftsman, who willingly shared his knowledge and expertise with the artists, his patrons and his competitors. He was responsible directly, or indirectly through his influence, for the production of many brilliantly successful posters in the 1920s-1940s. Commercial lithographic processes were used to translate the original artwork, regardless of the medium used — oil, watercolour, engraving, pastel — into mass produced posters.

The artists employed were legion, and included many who were at the time, or subsequently became, painters of the first rank. Paul Nash, John Nash, Graham Sutherland, and Stanley Spencer are some names which should be on that list. Other artists did perhaps their best work on posters, and these should include Edgar Ainsworth (Colour Plate 4), Fred Taylor, G. Spencer Pryse, and Tom Eckersley. Edward McKnight Kauffer, an American citizen who spent many of his productive years in England, is probably the best known of the poster artists who worked for London Transport (Colour Plate 5). He also produced work for Shell and for the Empire Marketing Board, and designed a few war posters while in New York. He was one of those responsible for raising the artistic level of commercial art in England. His posters, as well as his book illustrations, reflect his interest in various movements in the world of "fine" art.

S. John Woods was appointed to the advertising department of Ealing Studios in 1943, working directly under Michael Balcon, the head of production, from 1947 to 1959 when the studios closed. A designer himself, Woods commissioned posters from many remarkable artists, including Edward Bawden, James Boswell, James Fitton (Colour Plate 6), Edward Ardizzone, Ronald Searle, Barnett Freedman and Mervyn Peake. Ealing films were whimsical, funny, very "British" and proud of it. Edward Bawden was a "natural" poster designer for such films as *The Titfield Thunderbolt* (1953). He, like many of the Ealing artists, had also worked for London Transport. The mostly graphic posters made for Ealing Studios sometimes included photographs of the stars in the design, as in John Piper's poster for *Pink String and Sealing Wax* (1945); but after the 1950s, the graphic poster was most often replaced by mainly photographic ones. After Ealing Studios closed in 1959, few graphic posters have been produced for films. It does indeed seem that "the idea that designing a poster as work for an artist is losing ground. The Camera's lens has ousted the artist's eye and hand, and everything is subordinated to commercial impact."[3]

A number of specific advertising campaigns were carried out successfully with posters for Shell ("You Can Be Sure of Shell"; "That's Shell—That Was!"; and the "Conchophiles" campaign — "Artists Prefer Shell", "Photographers

2. Caroline Hawkes: *The Pleasures of Colour Printing: A Bibliography of Thomas Griffits, Craftsman, 1883-1957* (pp., 1977): 24
3. Bevis Hillier: "Introduction", *Projecting Britain: Ealing Studios Film Posters* (British Film Institute, 1982): xiii.

Prefer Shell", and so on); while Guinness also had its series ("Guinness for Strength!"; "Guinness Is Good for You!", "My Goodness, My Guinness!"). Guinness has always had a forward-looking advertising team. Using just four agencies since its advertising began in 1928 — S.H. Benson; J. Walter Thomson; Allen, Brady & Marsh; and Ogilvy and Mather — an incredible number of striking posters and other advertising materials have been produced. Working on these campaigns have been writers like Dorothy L. Sayers, Paul Jennings, and A.P. Herbert; graphic designers like Tom Eckersley (Colour Plate 7) and Abram Games; many artists and illustrators; and virtually every British contemporary cartoonist and humorous artist, including Gerard Hoffnung, H.M. Bateman, Rowland Emett, and Giles.

Both Shell and Guinness were also responsible for publications in book form. From 1933 to 1966, Guinness published a series of complimentary Christmas booklets for family physicians (these have now become expensive collectors' items). These small lighthearted books were somehow supposed to remind the reader of the beneficial powers of drinking Guinness. Five were based on *Alice in Wonderland*, starting with *The Guinness Alice* in 1933, illustrated by John Gilroy, one of the most important artists who worked for Guinness. Other illustrators included Rex Whistler (1936), Edward Ardizzone (1955), John Nash (1957) (Colour Plate 8), Rowland Emett (1958), and the frequently used Anthony Groves-Raines (1937-39, 1950, 1952, 1956 and 1961).

Shell's county guides began appearing in the 1930s and included *The Shell Guide to Dorset*, illustrated by Paul Nash, and *The Shell Guide to the West of Scotland*, illustrated by Stephen Bone. They continued after the war in 1951 with *Shropshire*, written by John Betjeman and illustrated by John Piper, followed by many others into the 1980s, though by then Shell was more of a financial sponsor than a patron of the artist and writer.

Rowland Hilder, in collaboration with Geoffrey Grigson, had completed in 1955 the *Shell Guide to Flowers of the Countryside*, when S.R. Badmin, one of the finest painters of the British landscape, was commissioned to produce the *Shell Guide to Trees and Shrubs*. This book was published by Phoenix House in 1958. Badmin had also done five advertisements for the Shell "Counties" series in the late 1950s and these were gathered together and published in book form in *The Shell and B.P. Guide to Britain* by the Ebury Press in association with George Rainbird in 1964. Also included are five plates by Rowland Hilder, three from Richard Eurich, and two each from Leonard Rosoman, John Nash, David Gentleman, John Trevelyan and John Elwyn. Chris Beetles writes:

> This book really marked the end of a sustained and enlightened art patronage from the oil companies through advertising. It is said that, after a change of management, Shell's advertising was redressed and it was concluded that none of this had ever sold one extra gallon of petrol. Market research is a sophisticated tool and it is in any case useless to argue the point, but it was good while it lasted — even if it did not sell any more petrol, Shell's patronage did represent for a while the acceptable face of naturalism.[4]

Another kind of advertising booklet was that produced with the more obviously direct intention of selling a product or a service. Rex Whistler drew the covers

4. Chris Beetles: *S.R. Badmin and the English Landscape* (Collins, 1985): 36.

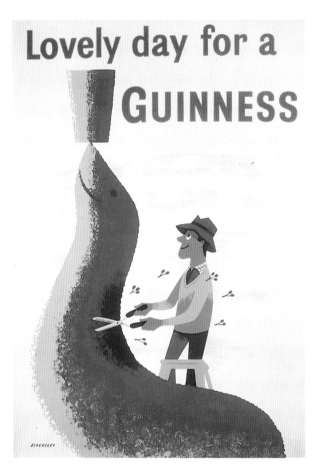

Colour Plate 7. Tom ECKERSLEY Poster for Guinness, 1956 (By permission of Guinness Brewing G.B.)

Colour Plate 8. John NASH— "Happy New Lear", 1957 Guinness Gift Book. (By permission of Guinness Brewing G.B.)

Colour Plate 9. "A Good Jacket Is a Silent Salesman": an advertisement (1926) from the Camelot Press, one of the finer presses of the period whose work includes two books by H.E. Bates, illustrated by Agnes Miller Parker, *Through the Woods* (1936) and *Down the River* (1937), both published by Gollancz

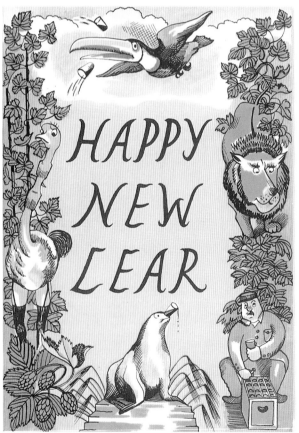

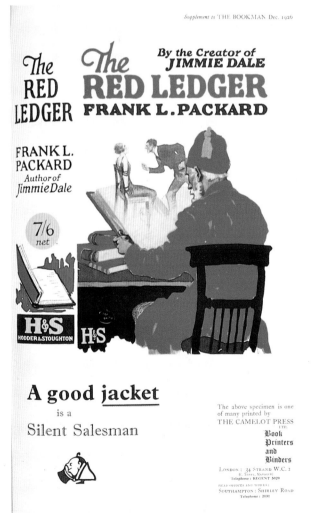

and other decorations for two food catalogues from Fortnum & Mason (London), while Edward Bawden during the 1930s and 1950s designed and illustrated numerous catalogues, menu cards and leaflets for the firm. Bawden's other commercial work included letterhead for Barrows' Stores, Birmingham, promotional leaflets for the Westminster Bank (1920-30s), a map of the air route from Cairo to Capetown for Imperial Airways (1934-5), and a wine list for the Royal Hotel, Scarborough (late 1930s). More for general promotion than for direct sales were the booklets produced by the supreme comic artist, William Heath Robinson, for such different organizations as Moss Brothers (Tailors & Outfitters, London); Ruston-Bucyrus Limited (Crane and Excavator Manufacturers, Lincoln); Connolly Brothers (Curriers, London); and The Port of Manchester Warehouses Limited.

Greeting cards of all sorts, postcards, and calendars are produced by artists and illustrators throughout their career. Some specialize in these forms, such as Rowland Hilder, who established a reputation in the 1930s for his watercolour landscapes, many of which were issued as prints and cards. In two years, 1935-36, he produced fifty-six Christmas cards for the Ward Gallery; he painted a series of landscapes for Whitbread to use in calendars and as posters; and then set up the Heron Press to market and publish his cards and prints. In 1963, the well-established firm of Royle Publishing took over the Heron Press, and Hilder became its consultant art adviser. S.R. Badmin is another artist whose cards are published by Royle. Other artists, such as David Binns, who is primarily a painter of birds and other natural history subjects, produce cards, calendars, and jigsaw puzzles. Binns' "Birds of Yorkshire" shows over two hundred birds on a 40in. circular painting, and has been made into a jigsaw by Waddingtons.

Among the smaller pieces of commercial art, postage stamps must rank high, and many artists have worked on their design. The Head of Royal Mail Stamps commissions three artists at a time to produce stamp designs to commemorate some event or person. The initial designs are submitted to an advisory committee; the chosen ones have an average print run of 75 million and about 200 million for the special Christmas issues. Though Barry Robinson, Head of Design, Royal Mail Stamps, declares there is no such thing as a stamp designer, and every artist receives the same fee, some artists are used more than once.[5] Paul Hogarth's stamp designs were used in 1984, 1985 and 1990, while in 1970 David Gentleman was awarded the ARCA Gold Medal for designing stamps. One of the later sets to be produced, by the Michael Peters design group, was devoted to the "smile"; ten first class stamps, which went on sale in February 1990, each featured a smile from such different characters as Stan Laurel, the Mona Lisa, and the Laughing Policeman!

Bibliography

Barman, Christian: "Frank Pick and His Influence on Design in England", *Graphis* 21 (1948): 70-73.

Cantwell, John D. *Images of War: British Posters 1939-1945* (Public Record Office; HMSO, 1989).

Carrington, Noel: "British Poster Art during the War", *Graphis* 14 (1946): 172-85.

5. "Attractive Stamping Ground for Artists", *The Independent* (9 December 1989).

Constantine, Stephen: *Buy & Build: The Advertising Posters of the Empire Marketing Board* (Public Record Office; HMSO, 1986).

Darracott, Joseph, and Loftus, Belinda: *First World War Posters*, 2nd edition (Imperial War Museum, 1981).

— *Second World War Posters*, 2nd edition (Imperial War Museum, 1981).

Green, Oliver: *Underground Art: London Transport Posters 1908 to the Present* (Studio Vista, 1990).

Holme, Bryan: *Advertising: Reflections of a Century* (NY: Viking Press, 1982).

Hutchison, Harold F. *London Transport Posters* (London Transport Board, 1963).

Levey, Michael F. *London Transport Posters* (Phaidon Press, 1976).

McCullough, Donald H. "Press Advertising in Great Britain", *Graphis* 14 (1946): 238-49.

Projecting Britain: Ealing Studios Film Posters (British Film Institute, 1982).

Rosner, Charles: "British Commercial Art", *Graphis* 31 (1950): 206-49.

Sibley, Brian: *The Book of Guinness Advertising* (Guinness Superlatives, 1985).

Simon, Herbert: *Song and Words: A History of the Curwen Press* (Allen & Unwin, 1973).

Society of Industrial Designers: *Designers in Britain: A Review of Graphic and Industrial Design*, 1- (Allan Wingate/André Deutsch, 1947-).

"That's Shell — That Is!": An Exhibition of Shell Advertising Art (Barbican Art Gallery; Shell UK, 1983).

BOOK JACKETS AND COVERS AND PAPERBACK WRAPPERS

The book jacket is a comparatively recent phenomenon in the history of book production. According to Charles Rosner,[1] the first known British book jacket dates back only to 1832. This jacket, for Heath's *Keepsake*, published by Longmans in 1833, was very plain but had the title and publisher's imprint on the front in a formal frame, and an announcement of another Longmans book on the back. For many years after this, with notable exceptions, book jackets had a mainly utilitarian purpose: to protect the cloth, watered silk or paper boards from dirt and damage before a customer bought the book. Provided by the publisher or the bookseller, the heavy, plain paper for all practical purposes hid the individual identity of the book, and holes were sometimes cut in the jacket's spine to reveal the title and the author's name. By the 1890s, the title and author appeared more frequently on jackets; and by the end of the first decade of the twentieth century, a description of the book or a synopsis of its contents was occasionally given. By the time the First World War began, this was a common practice; but the pictorial jacket did not become firmly established until the 1920s.

1. Rosner, Charles: *The Growth of the Book-Jacket* (Harvard University Press, 1954).

Despite this apparently inevitable development, there has often been controversy about the importance of the jacket. In the Sixth Dent Memorial Lecture, given in 1936, Richard de la Mare, a publisher with the eminent firm of Faber & Faber, decried the expense of the jacket:

> The history of the book-jacket is a strange one. The wretched thing started as a piece of plain paper, wrapped round the book to protect it during its sojourn in the bookseller's shop; but it has become this important, elaborate, not to say costly and embarrassing affair, that we know today, and of which we sometimes deplore the very existence. How much better might this mint of money, that is emptied on these ephemeral wrappers — little works of art though many of them may be — be spent upon improving the quality of the materials that are used in making of the book itself! [2]

It is interesting to note that this little book has its own book jacket, though admittedly a simple, plain thing it is, to protect the lovely Cockerell paper in which the whole series was bound. There were other views, of course, and after A.J. Hoppé read a paper in 1932 on the book jacket to the Society of Bookmen (subsequently printed in the *Publisher and Bookseller*, 5 August 1932), John Carter expressed the hope that it would do something "to stimulate the necessary interest in the historical side of a very significant development of book structure and publishing practice."

Publishers were now employing artists and designers to produce attractive and exciting typographic or illustrated jackets. Some of these artists were already responsible for the illustrations within the book — often an illustration from the book is reprinted on the jacket — while others became "jacket specialists". In 1947 a major exhibition on "The Art of the Book Jacket" was held in London at the Victoria and Albert Museum. In the same year, a Book Jacket Designers Guild was established in New York and it held its first annual exhibition in 1948. Even at this time, the idiosyncratic Sir Max Beerbohm could write in *The Observer*:

> I gather that to the many other arts has now been added the art of the book-jacket, and that there is an exhibition of it in the Victoria and Albert Museum. I doubt whether, if I were in England, I would visit this, for I have in recent years seen many such exhibitions. To stand by any bookstall or to enter any bookshop is to witness a terrific scene of internecine warfare between the innumerable latest volumes, almost all of them vying with one another for one's attention, fiercely striving to outdo the rest in crudity of design and of colour. It is rather like visiting the parrot-house in the Zoological Gardens, save that there one can at least stop one's ears with one's fingers, whereas here one merely wants to shut one's eyes.

Beerbohm's strident objections to the crudity and bright colours may have been a reaction to the sometimes vulgar covers of certain varieties of paperbacks, particularly American editions of crime, horror and science fiction, produced at that period. This kind of cover was represented on only a small percentage of books, and the others were more subdued and often well designed and attractive. As well as protecting the binding, a jacket is intended to advertise the book within, inform the reader what to expect and encourage the hesitant to buy. It

2. De la Mare, Richard: *A Publisher on Book Production (The Sixth Dent Memorial Lecture* (Dent, 1936)

may also advertise books by the same author or the same publisher.

Jackets can be divided into two basic groups — the typographic and the illustrated. The Curwen Press, one of the finest printers and designers of twentieth century England, produced innumerable varieties of typographic book jackets. Under the influence of Harold Curwen, Oliver Simon, James Thorpe and Lovat Fraser, it revolutionized commercial and book printing. Curwen introduced new type faces, modern design, colour and a lack of solemnity into its productions. In the 1920s and 1930s he employed and encouraged a whole contingent of British artists to design patterned paper and typographic decorations. Both of these features were used on jackets, and helped to create a definite style. For example, Curwen used its pattern papers on the boards and jackets of Chapman and Hall's "Eighteenth Century French Romances" series in the 1920s-1930s. In the late 1940s, other Curwen papers were used by Hamish Hamilton for its Novel Library (for the boards of each volume and later the jacket as well). "In the drab surroundings of post-war Britain they provided a startling flash of colour quite unlike any other publisher's series of the kind at this time."[3] The paper is still being used today by many publishers for their jackets or to cover the boards.

A number of designers have used typography to fine effect on jackets, and have produced distinctive designs which clearly identify the publisher. Stanley Morrison devised the famous yellow jackets with the black or purple lettering for books from Victor Gollancz; and Hans Tisdall's distinctive lettering, reproduced on jackets for Jonathan Cape over many years, has the same identifying feature Colour Plate 10). Berthold Wolpe, who died in 1989, has been praised as one of the finest graphic designers of the century. He designed many type faces, including Albertus and Pegasus, and worked for Faber & Faber as a book designer for many years. In this context, he is important as the designer of more than 1,500 book jackets for Faber, many including his distinctive, freely-drawn lettering.

Illustrated jackets and covers, used to decorate and to describe the book, may be reproduced by a great variety of techniques, including line-drawing, wood engraving, scraperboard, and linocut. All of these can be produced by line block, as can photographic half-tones. The use of lithography makes it possible to produce colour drawings and paintings easily and, for long runs, relatively cheaply. Autolithography allows the artist to draw directly on the stone or plate, and is an inexpensive way of making faithful copies of an artist's work. Barnett Freedman (Colour Plate 11), a Curwen artist who gained practical experience from working with Thomas Griffits at the Baynard Press, produced many jackets of distinction using autolithography. His reputation was established by the publication of his illustrated edition of Siegfried Sassoon's *Memoirs of an Infantry Officer* (1931), for which the illustrations, the jacket and the cloth cover were all produced by line blocks combined with lithographic colour. He used bright and varied colour, and he was particularly skilled at producing original lettering.

Many other eminent artists used autolithography for jackets. They include John Piper, best known for his watercolours and prints of landscapes and churches in England and Wales, and his paintings of war-damaged buildings; and

3. McKitterick, David: *A New Specimen Book of Curwen Pattern Papers* (Whittington Press, 1987): 21.

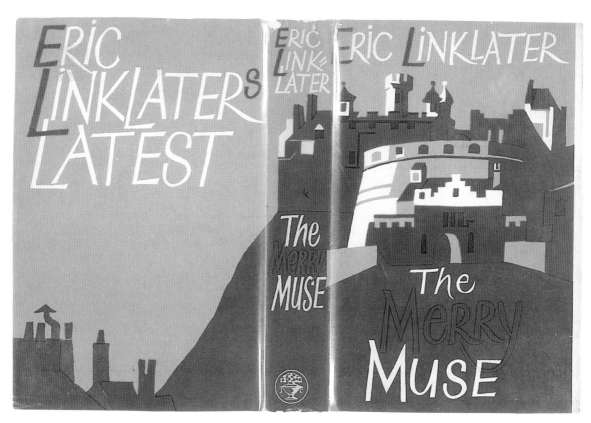

Colour Plate 10. Hans TISDALL Jacket for *The Merry Muse* by Eric Linklater (Jonathan Cape, 1959)

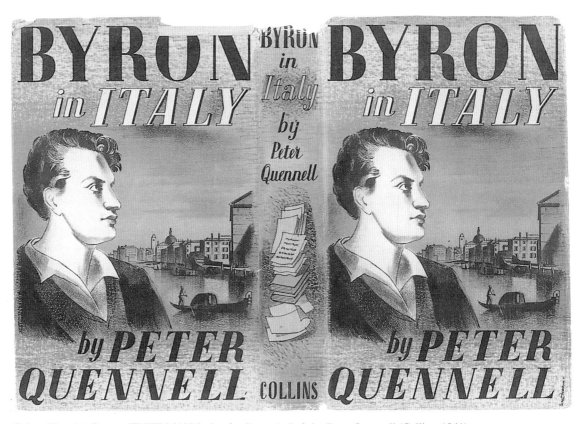

Colour Plate 11. Barnett FREEDMAN Jacket for *Byron in Italy* by Peter Quennell (Collins, 1941)

Michael Ayrton, one of the more cerebral and literary men of the century. Ayrton's work includes a jacket for Phoebe Pool's anthology, *Poems of Death* (Muller, 1945), and several others for the publisher, John Lehmann. Lehmann, whose publishing house survived for less than eight years in the post-Second World War era (1946-54), employed a number of artists to design jackets, including John Minton, Edmund Burra and Lynton Lamb. Keith Vaughan and later Val Biro were in charge of design and production, and also produced jackets themselves. Biro has illustrated some 400 books for different publishers, many of them including his jacket design.

Two of Curwen's artists, Edward Bawden and Eric Ravilious, were fellow students at the Royal College of Art in London in the 1920s. Both were painters, but in the early days of their careers, they designed patterned paper and produced decorative fleurons and other devices for Curwen. Bawden illustrated many jackets, often using linocuts, autolithographs or line drawing. He seems to have shared with Michael Ayrton the responsibility for jackets for the Alfred Duggan novels published by Faber & Faber in the 1950s and 1960s (Colour Plates 12 and 13), and he designed the jackets for the Centaur Series (1930s) and the Collected Edition of Lytton Strachey (1940s), both published by Chatto & Windus. Ravilious was a watercolour artist and a book illustrator. Although he used lithographs on at least one fine book (Richards' *High Street*, published by Country Life in 1938), he first devoted himself to wood engraving, his first book being Martin Armstrong's *Desert* (1926). Other illustrators who used wood engravings for jackets include Gwen Raverat, Robert Gibbings, John Farleigh, C.T. Tunnicliffe (though he also frequently employed the scraperboard technique), and Joan Hassall.

There are two designers whose jackets have a uniquely identifiable style, and the work of both is now very much sought after by collectors. Brian Cook designed more than one hundred and fifty book jackets for Batsford, and introduced revolutionary changes in design and production techniques (Colour Plates 14 to 16). One process employed hand-cut rubber plates and watercolour inks, and the design wrapped right round the book, was "bled off", and was printed in brilliant colours on matt paper. The "Face of Britain" series was printed by photolithography to produce more natural colours. Clifford and Rosemary Ellis collaborated in many projects from the 1930s, producing outstanding posters for London Transport, Shell, and the Empire Marketing Board. From 1945 to 1982, they designed nearly one hundred jackets for Collins' "New Naturalist" series and related monographs. Although the pictorial matter for each title is quite different, the series has a unity through the general design features, including the style and position of the lettering.

One group of artists which requires special mention is the humorists. Sir Osbert Lancaster (1908-86) spent his life writing, designing for the theatre, illustrating books and drawing cartoons. He is well known both for his pocket cartoons which appeared in the *Daily Express* for many years, featuring Maudie Littlehampton, and for his humorous but knowledgeable books on architecture, for each of which he produced a jacket. One of the most prolific artists of our time is Ronald Searle, best known for those fiendish schoolgirls who inhabited St. Trinian's School, and for his innumerable cards about cats and the astrological signs. Though he concentrates now on illustrating his own books, he has also produced many jackets for books by other writers. Other humorous illustrators include Norman Thelwell and Mark Boxer, both frequent contributors of cartoons to *Punch*. Thelwell loves to draw small, indomitable girls battling

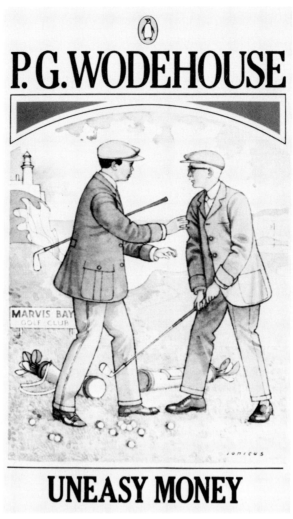

Joshua ARMITAGE ("IONICUS") Cover for *Uneasy Money* by P.G. Wodehouse (Penguin Books)

their almost equally small, shaggy ponies; while Marc (as Mark Boxer was known), using a sparse, free line, most often drew the "upper class".

The concept of the book jacket was easily translated to the wrappers of paperbacks, when they were introduced in Britain in the 1930s. The growth and change of the paperback cover during the period may be demonstrated, using just the publications of Penguin Books. Created by Allen Lane, Penguin Books published its first ten titles in 1935, to appear in bookshops on 30 July of that year. The long print runs meant that the cost of designing the cover was less significant, and the growing number of titles made it necessary for each individual volume to fight harder for attention. The bold coloured stripes of the first covers were designed to enable an easy distinction of the various series — orange for fiction; green for crime and detective fiction; blue for biography; purple for *belles-lettres*. The incredible popularity of the books soon encouraged the publisher to introduce additional series, including the Penguin Illustrated Classics (launched in May 1938 with Robert Gibbings as its art editor); the Penguin Classics; the Penguin Specials; the Penguin Handbooks; and new "birds" in the Penguin aviary, Puffins, Pelicans, and Ptarmigans.

The basic design of these books has changed many times over the years. The

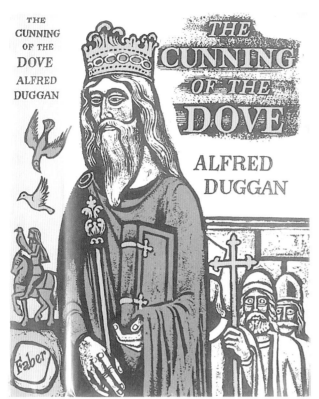

Colour Plate 12. Edward BAWDEN Jacket for *The Cunning of the Dove* by Alfred Duggan (Faber & Faber 1960)

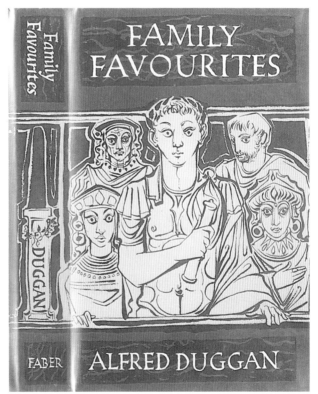

Colour Plate 13. Michael AYRTON Jacket for *Family Favourites* by Alfred Duggan (Faber & Faber 1960)

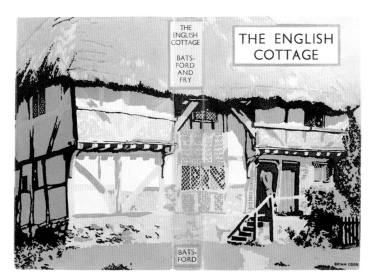

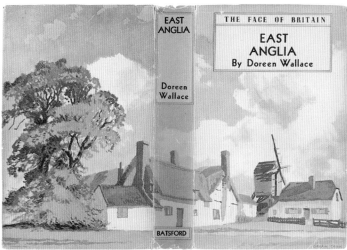

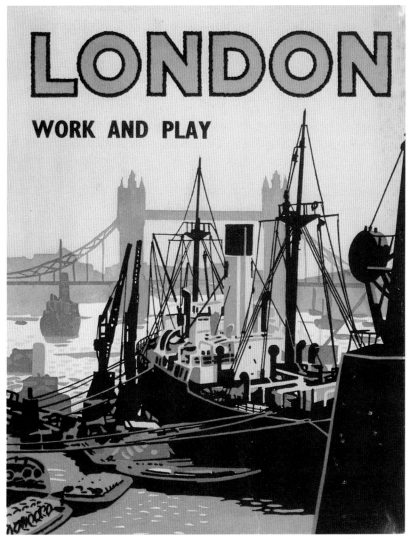

Colour Plates 14, 15 and 16. Brian COOK Jackets for *The English Cottage* (1938); *East Anglia* (1939); and *London: Work and Play* (1950), all published by Batsford

horizontal stripes became two vertical stripes either side of the main white panel with its title and author displayed simply and typographically. Line drawings were then added, and then these became coloured illustrations, some representational of the contents and others impressionistic. Patterned paper designs were used on such series as Penguin Poets and Penguin Scores. Some were deemed successful and had long lives; others did not fare as well, and were quickly discarded in favour of new designs. Though there seems to have been a willingness to experiment with the design of the covers, the basic conservatism of Penguin Books could not withstand the brashness of Alan Aldridge, who was Art Director for only a short time. In 1981 he wrote in *Phantasia* that his covers "with naked tits Sent the sales up but upset the authors. . . Penguin big-wigs hatched plots to roll my head So I left."

Many illustrators have worked on covers for Penguin Books. Gibbings employed members of the Society of Wood Engravers, such as Iain Macnab, Gwendolen Raverat, Ethelbert White and himself, for the Penguin Illustrated Classics, and they illustrated the texts as well as the covers. This series only lasted through ten volumes, all produced in one batch published in May 1938. The intention of this series was to give the reader the quality of illustrated novels available in hardback editions, mostly from private presses, but at the regular Penguin price. Despite the technical skills of the engravers (though one writer declares that the engravings had about them "an outmoded refinement, as if they had been prepared by tired disciples of the old John Lane school of book illustrators",[4] the format was too cramped and the paper quality was much too poor for the series to succeed.

Two Penguin series which were very successful and are now much in demand by collectors are the Puffin Picture Books and the King Penguins. The Puffin Picture Books were the brain child of Noel Carrington, who realized in the late 1930s that there was a real need for attractive, cheap, illustrated books of information for children. Inspired by the Père Castor series from Paris and some of the earlier books for children produced in the Soviet Union, Carrington discovered that initial costs could be kept sufficiently low for the books to retail at sixpence each if autolithography was used to produce the illustrations. This was not a suitable medium for some artists, but of the first 108 titles published, sixty-three were autolithographed. One disadvantage of autolithography was the loss of quality when transferring the image from the master plate to the machine plate, and the further loss, however small, suffered with each impression taken from it. The introduction of Plastocowell, a transparent plastic plate first produced in 1946 by Cowells for commercial use, made it possible to produce more faithful reproductions of the original in long print runs; and Plastocowell was also easier for the artist to work on than the usual zinc plate.

A large proportion of the books in the series were printed by such fine printers as the Curwen Press and Cowells of Ipswich. The first four titles were published in 1940, *War on Land* written and illustrated by James Holland having pride of place as "PP1". Great care was taken to commission artists and writers who were experts in their subject. S.R. Badmin's *Trees in Britain* (PP31, November 1943) has been hailed as "one of the most beautiful books of this century".[5] Other illustrators who collaborated in the early books of the series include James

4. Morpurgo, J.E. Allen Lane: *King Penguin* (Hutchinson, 1979: 143.
5. Thomas, David: "Children's Book Illustration in England", *Penrose Annual* 56 (1962): 70.

Felix KELLY *London* by Ivor Brown (George Newnes, 1960)

Gardner, Enid Marx, Clarke Hutton, Kathleen Hale, and Margaret and Alexander Potter. The Second World War had a direct effect on the series in at least two instances: Eric Ravilious was working on a book on Downland Man when he was lost on a reconnaissance flight near Iceland; and his friend and colleague, Edward Bawden, was not able to do a book until he returned from army service in the Middle East. His illustrations to *The Arabs* (PP61, December 1947), have been highly praised. This book was also one of the few which were issued in a

Colour Plates 17 to 22. Penguin Shakespeare — *Coriolanus* (design first appeared 1937); *Henry VIII* (designed by Jan Tschichold, portrait engraved by Reynolds STONE, 1949); *King John* (C. Walter HODGES 1962); *Henry IV Part 1* (Fritz KREDEL 1970); *Richard III* (David GENTLEMAN 19—); *Henry IV Part 1* (Paul HOGARTH 1987)

special school binding of stiff card covers as well as the usual paper. These bindings, however, raised the cost out of proportion to their apparent value, and only a few received this treatment.

The King Penguin series, launched in November 1939, a few weeks after the start of the Second World War, were adapted from the illustrated volumes in the successful German Insel-Verlag series. The first editor was Elizabeth Senior, who was killed in an air-raid in 1941; Nicholas Pevsner succeeded her, with R.B. Fishenden as technical editor. Their aim was to bring inexpensive illustrated books with an authoritative text to a wide reading public, and in this they surely succeeded. Some of the books were illustrated with drawings from earlier books or by photographs; many had specially created illustrations by a great variety of illustrators; and all had specially designed covers. Edward Bawden drew directly on zinc lithographic plates for his *Life in an English Village* (K51, June 1949); Noel Rooke made drawings in black and white and in colour for *Flowers of Marsh and Stream* (K27, November 1946); for *A Prospect of Wales* (K43, September 1948), Kenneth Rowntree painted a series of watercolours and designed the cover; and William Grimmond designed sixteen of the seventy-six covers.

King Penguins flourished throughout the war and the immediate post-war years, but enormously increasing paper and printing costs forced their demise. This series of short illustrated monographs on a great variety of subjects was a great success, as the continuing interest of collectors indicates. David Hall has written "When some historian of book production or publishing comes to write the history of Penguin Books, the King Penguin series will stand out aesthetically among the much greater body of other series."[6]

Cover design requirements are inevitably affected by mass-promotion and changes in designs are brought about by a number of reasons, not all directly related to production techniques. The books must appeal immediately to the audience at which they are aimed, and public tastes develop and alter continually. It is interesting to compare covers for the same books or in the same series as issued over a number of years. The Penguin Shakespeare (Colour Plates 17 to 22), for example, which began in 1937, has featured the work of several fine illustrators on its covers, including Fritz Kredel, Cyril Walter Hodges, David Gentleman and Paul Hogarth (who is the current incumbent). Sometimes a film or television production will persuade the designer to incorporate a still on the cover, as in the 1984 issue of *Brideshead Revisited*. When a particular artist has helped create a paperback market for the work of a particular writer, for example, Paul Hogarth for Graham Greene, the artist is retained for later issues but with new drawings reproduced in colour.

Jeremy Aynsley writes that

If a conclusion can be drawn on the nature of changes in typography and cover artwork in Penguin's history, it would refer to the context of paperback market requirements. . . the trend of cover artwork and the decisions made in art direction will be partly in response to the changing range of available styles of design and illustration, but will increasingly take into account the requirements of publishing with the film and computer media. Underlying such developments, none the less, is

6. Edwards, Russell, and Hall, David J. "So Much Admired": *Die Insel-Bucherei and the King Penguin Series* (Edinburgh: Salvia Books): 57.

the debate about the quality of the interior and exterior design of books. The debate will continue to raise questions concerning principles of typographic design and the appropriateness of form, as it has done over the last fifty years of Penguin Books. [7]

Bibliography

Biro, B. S: "Techniques of the Book Jacket", *Book Design & Production* 6, no. 3 (1963): 156-59.

Black, Misha: "Dust Wrappers", *Typography* 4 (Autumn 1937): 7-9.

Carrington, Noel: "A Century for Puffin Picture Books", *Penrose Annual* 51 (1957): 62-64.

Curl, Peter: *Designing a Book Jacket*. (Studio Publications, 1956).

Day, Frederick T. "Book Jackets and Their Treatment", *Book Design and Production* 2, no. 2 (1959): 20-24.

Edwards, Russell, and Hall, David J. *"So Much Admired": Die Insel-Bucherei and the King Penguin Series* (Edinburgh: Salvia Books, 1988).

Floud, Peter, and Rosner, Charles: "The Book Jacket Comes of Age", *Graphis* 29 (1950): 14-25.

Green, Evelyn: "Packaged Culture", *The Bookseller* (September 28, 1985): 1322-29.

Harley, Jane: "The King Penguin Series: an Historical Survey", *Matrix* 5 (Winter 1985): 143-50.

Miller, John: "The Book Jacket — Its Later Development and Design", *Antiquarian Book Monthly Review* (December 1988): 452-61.

Fifty Penguin Years (Penguin Books, 1985).

Penguins Progress 1935-1960 (Penguin Books, 1960).

Rosner, Charles: *The Art of the Book Jacket* (HMSO, 1949).

— "The Book Jacket: First Principles", *Penrose Annual* 44 (1950): 44-48.

— "English Book Jackets", *Graphis* no. 14 (1946): 136-44.

— *The Growth of the Book-Jacket* (Harvard University Press, 1954).

Schreuders, Piet: *The Book of Paperbacks* (Virgin Books, 1981).

Vernon, Alfred H. "Layout and Design: the Dual Purpose Jacket", *Print in Britain* 7, no. 8 (December 1959): 235-7.

Weidmann, Kurt: *Book Jackets and Record Sleeves* (Thames & Hudson/André Deutsch, 1969).

Williams, W.E. *The Penguin Story 1935-1956* (Penguin Books, 1956).

7 Aynsley, Jeremy: "Fifty Years of Penguin Design", in *Fifty Penguin Years* (Penguin Books, 1985): 133.

SOME NOTES ON CHILDREN'S BOOK ILLUSTRATION 1915-1985

by Brian Alderson

I: An Anthology for Our Times

During the second half of the 1980s a good deal of fuss about children's books was generated in England through what was known as the Opie Appeal. This was a busy fund-raising campaign, under the patronage of the Prince of Wales, directed towards raising £500,000 so that the superlative collection of children's books assembled by Iona and Peter Opie could be brought to the Bodleian Library at Oxford. Many schemes were devised to forward the Appeal and among them was one of particular aptness, the brainchild of the publisher Sebastian Walker. With Iona Opie's blessing he organised the publication of *Tail Feathers from Mother Goose* ,[1] a collection of lesser-known rhymes, or versions of rhymes, drawn from the Opie archives, and illustrated by sixty contemporary illustrators. Each illustrator was given a double-page spread on which to deploy his or her talents and the book was rounded off with an endpaper design by Janet Ahlberg and a jacket design by Maurice Sendak.

Aside from its charitable function, *Tail Feathers from Mother Goose* was also of consequence as a summary account of the state of picture-book illustration in England in the late twentieth century. True, some of the contributors (like Sendak) were not from Britain, and some ingenious talents (like Pienkowski and Lawrence) were not represented. True also, the chosen nursery rhymes were by no means easy to illustrate. All too often they consisted of gnomic or nonsensical sayings which were sufficient unto themselves and needed no visual interpretation — with the result that some of the select illustrators (Quentin Blake, say, or Helen Oxenbury) were faced with exercises that did not give full play to their characteristic powers. Nevertheless, as a guide to prevailing illustrative fashions and as a glimpse of the artists' attitudes towards illustrating popular texts, *Tail Feathers* makes a handy point of departure.

No one, of course, should look for, or expect to find, a clearly defined common factor in the work of these sixty-two illustrators. What can be said to begin with, however, is that there is a fairly prominent recognition among many contributors that the traditional vigour of nursery verse can most happily be captured through the traditional skills of draughtsmanship. By far the most successful pages in the book are those composed by artists like Helen Craig and Fritz Wegner where the movement of the rhyme is matched by a succession of small, comic pictures — and where, incidentally, the flow of words and images is controlled through the artist's own manuscript writing of the text.

1. *Tail Feathers from Mother Goose: The Opie Rhyme Book* (Walker Books, 1988). Not only did the artists donate their services in aid of the Appeal, but later on they allowed their originals to be auctioned at a Charity Sale at Christie's. The book was a *succès d'estime* in both Britain and America and contributed a healthy sum towards the achievement of the Appeal target well within its allotted time-span.

Such fitness for purpose is found with varying success in several other pictures, whose interpretative span might reasonably be represented by, say, the intense black-and-white cross-hatching, shading and stippling applied by Patrick Benson to his tall-tale verse about a giant's fishing-tackle, or by the swift cartooning of Colin West or Juan Wijngaard, or by the plain and rather static representational pictures of Shirley Hughes and Helen Oxenbury. These all bear witness to continuities in English illustrative art. (For instance, in Colin West's sequence of pictures for "John Wesley" both the costuming and the happy-go-lucky drawing remind one of the more rough-cut engraved picture books that appeared at the start of the nineteenth century.) In so far as there is a "modern" element in such work it stems chiefly from the technical freedoms in design and colour that have been given to the artist by the developments of post-war photolithographic processes for preparing and printing coloured illustrations.

Such processes have also made possible, though, the distinctively eighty-ish illustrations in *Tail Feathers* — the illustrations that will do most to define for later generations the book's "period flavour". For if any factor can be singled out as dominating these tell-tale examples it is surely their artists' self-conscious, not to say self-indulgent, use of sophisticated graphic techniques which could be readily translated into print through computerised colour-separation, camera-work etc.

The most highly-wrought illustrations in this category come from the *émaux et camées* school of practitioners, whose leading figure is probably Nicola Bayley. Hers is one of the talents fostered by the London publisher Tom Maschler, of Jonathan Cape (who nurtured those other nine-day-wonder-books *The Butterfly Ball*, illustrated by Alan Aldridge, and *Masquerade*, the treasure-hunt picture book by Kit Williams). The journalist Barry Fantoni once referred to works like these as "gasp" books, since the reader was called upon to make speechless exclamations when confronted by page upon page of paintings which had not only been executed with great minuteness of effect but were also printed with painstaking exactitude.

In similar vein are those illustrations by such as Reg Cartwright and Anthony Browne who bring to their work painterly skills of a high order but who try to harness their packed designs to dramatic rather than ornamental ends. This doesn't always work, since, in the nature of things, a picture crammed with visual detail does not readily harmonise with the movement of a text — and when the text happens to be a comic rhyme there is a peculiar incongruity about yoking it to an elaborate painting.

For this reason, perhaps, a third group of these quasi "modern" illustrators seeks some kind of return to traditional illustrative values by treating whatever colour media they use (crayon, watercolour, gouache) in a more abandoned manner than the "heavy painters". Thus come about those two sub-schools of artists, who, in *Tail Feathers*, might be seen to specialize in colourful muddle (Anne Dalton, say, or Caroline Anstey) or in a rather modish heavy-handed humour (Joseph Wright, say, or Babette Cole — Colour Plate 26). Cross-reference could easily be made from these to the strip pictures found in English comics, since some of these Mother Goose illustrations look like technicolour blow-ups of one frame from a strip. As such, though, they have outgrown the small frivolity of their genre and thus tend to look merely vulgar.

Colour Plates 23, 24 and 25. The Arden Shakespeare, published by
Methuen & Co., and with covers illustrated by members of the
Brotherhood of Ruralists —*Henry VI Part 3* cover by Ann ARNOLD
(1982); *Timon of Athens* cover by Peter BLAKE (1986); *Romeo and
Juliet* cover by David INSHAW (1986)

Marcia Lane FOSTER *The Golden Journey of Mr Paradyne* by
William J. Locke (John Lane, The Bodley Head, 1924)

II: An Anthology for Times Past

Most salient characteristics of late twentieth century English picture-book art can
be found somewhere in *Tail Feathers from Mother Goose*, and, in eliciting the
broad scope of these characteristics, one is led to consider what Sebastian Walker
might have done with his book if the Opie Appeal had been mounted sixty years
earlier. Who would he have chosen then to respond so enthusiastically to his
project, and how would the result have compared to the present volume?

The answers to those two questions need not depend too heavily upon vague
hypothesis since there were plenty of examples in the 1920s of compendia for
children, and for adults, which used a diversity of illustrations. There were, for
instance, those anthologies (compiled, like *Tail Feathers*, for charitable pur-
poses) in which the good and the great contributed something from the bottom of
their desk-drawers in aid of one good cause or another; and there were the
children's annuals which, at that period, were enjoying a spell of considerable
popularity. They were not confined, as often occurred earlier, to being fancy
bind-ups of the previously published parts of a magazine; nor were they, as now,
tritely edited recyclings of well-known themes from comics or from children's
television programmes. Many of them belonged rather to the genre known as
"bumper books" — fat miscellanies, often printed on thick, so-called "antique"
paper — issued for the Christmas-present-buying public.

In the late 1920s and early 1930s, however, the range of quality in these

bumper books was wide and the pages of even the cheaper publications were open to all manner of illustrators, and provided a base from which careers might be launched — as indeed had been customary since half way through the nineteenth century. (For example, the vellum-bound creations of Arthur Rackham had their origins in a host of humble line-drawings done for such periodicals as *Little Folks*, while the busy working life of Edward Ardizzone saw its beginnings in a couple of drawings done — "for free", so he alleged — in the *1929 Christmas Tree Annual*.)

Looking at these gift-books and annuals *en masse*, I would dare to hazard a contributors' list for a *Tail Feathers* of sixty years ago which may not be definitive but which allows for some instructive comparisons and contrasts to be drawn with the volume of 1988. Perhaps the most striking difference would be the degree of homogeneity that could be seen to pervade the earlier book — although "homogeneity" should not be seen as in any way equivalent to the "sameness" of a stereotyped style. Turning the pages, you might find colour plates by old-stagers from the pre-war heyday: Rackham and Dulac, Aldin and the Brocks, and the ineffable Mabel Lucie Attwell — artists whose style remained fixed to the point of self-quotation. Alongside them might be such contemporaries as W. Heath Robinson, H. R. Millar and William Nicholson, who were by no means so predictable and who retained an alertness to the flexible potential of their skills (Nicholson's *Clever Bill* of 1926 and *The Pirate Twins* of 1929 are not just utterly different from the famous, quasi-portrait albums that he created at the start of his career, they are also — quite simply — the finest and the most fluent picture books of the century).

Many of the illustrators who established themselves in the shadow of these great Edwardians preserved or extended the given graphic language rather than in any way seeking to revolutionise it. They recognised that the foundation of the illustrator's art lay in the illustrator's draughtsmanship and many of the triumphs in the children's books of the *entre deux guerres* were triumphs in the unbluffable craft of drawing. Where Sebastian Walker gave only a couple of page-openings to monochrome, his predecessors would gladly have made open-house for the pen-drawings of such artists as E.H. Shepard and Marcia Lane Foster, Hugh Lofting and Rowland Hilder, while — for contrast — there were the Rackham-y silhouettes of Mary Baker. There were also premonitions, thrumming within the adult private-press boom, of a return to traditions of craftsmanship. Basil Blackwell, the publisher whose *Joy Street* is peerless among the annuals of the period, had taken over the Shakespeare Head Press in 1921, and his experience there without doubt influenced the graceful design of his children's books. Robert Gibbings, the engraver, began his work at the Golden Cockerel Press in 1925 and a few years later was to bring his skills to bear on a few remarkable children's books done for trade publishers.

In so far as any *avant-garde* movement can be discerned alongside these fairly conventional happenings it derives from a quest for individual expression that also lay at the heart of the private-press movement. Thus, early in the 1920s, The Poetry Bookshop put out a number of near-experimental publications which surely drew inspiration, if not style, from the simplifying example of Lovat Fraser, whose early death in 1921 was a tragic loss to the many professions — printing, advertising, textile design, theatre — that were touched by his art. The Bookshop drew upon the services of artists, decorators and engravers of the order of Paul Nash, McKnight Kauffer, Philip Hagreen, for its various series of broadsides, nursery sheets and rhyme sheets, and in the case of two books by

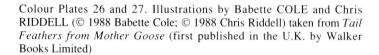

Colour Plates 26 and 27. Illustrations by Babette COLE and Chris RIDDELL (© 1988 Babette Cole; © 1988 Chris Riddell) taken from *Tail Feathers from Mother Goose* (first published in the U.K. by Walker Books Limited)

Colour Plate 28. John LAWRENCE "Then George let off his rifle into the air" from *George: His Elephant and Castle* (Patrick Hardy 1983)

Eleanor Farjeon, *The Country Child's Alphabet* and *The Town Child's Alphabet*, it wedded her verse to designs by Michael Rothenstein and David Jones which had a remarkably forward-looking, near-emblematic intensity.

In similar fashion so persistently pioneering a publisher as the Bodley Head experimented with a curious mixture of revivalist book-design and antiquarian pastiche in a group of books illustrated by Wyndham Payne and bound in quarter cloth with paper boards patterned after themes in the book.[2] And the same publisher was also responsible for books that introduced the wooden world of S.G. Hulme Beaman: *Aladdin* (1924) and *The Seven Voyages of Sinbad* [sic] *the Sailor* (1926). The distinctive elegance of these substantial re-tellings, illustrated in colour and black and white, did not preclude Beaman from taking his original mannerisms to a wider audience. For instance, Nelson's *The Chummy Book* of 1929, a typical bumper-book, had two stories by him: "Bunny's New House" and "The Fire Engine" which contrasted with, but were not disjunct from, the more conventional contributions of such illustrators as Phyllis Chase and Margaret

2. One of these was *Sea Magic* by Cyril W. Beaumont (1928). Beaumont had a private press of his own for which Payne also did illustrations. In 1930 he published the first children's book illustrated by Eileen Mayo: *Toys; an Alphabet*, another fine example of period design which was sold in a plain trade edition and in a superior edition, with pictures coloured by hand, limited to one hundred copies.

Michael ROTHENSTEIN *The Country Child's Alphabet* by Eleanor Farjeon (Poetry Bookshop, 1924)

Tempest. "The Fire Engine", incidentally, was a story of Toy Town, whose local activities were to achieve the widest possible audience by courtesy of the broadcasts on the BBC's Children's Hour.

The capacity for the annuals to absorb a variety of illustrative styles without the degree of incongruity that appears in the Walker *Tail Feathers* bears modest witness to the stability of the norms within which the illustrators of the twenties were working. Obviously the publishing or editorial slant of the annuals guaranteed a certain consistency (the art deco pictures of Joyce Mercer would probably have looked more out of place in *The Chummy Book* than they did in Longman's *Children's Play-Hour Book*, which was, briefly, in competition with *Joy Street*). Over and above this, however, there seems to be a tacit agreement among the illustrators of the time about what was required of the pictures for a children's book.

Through all the illustrations of the annuals, down-market and up, through the illustrations of such diverse landmarks as, say, the Darwins' *Mr Tootleoo*, which the Nonesuch Press published in 1924, or the child drawings which Laurian Jones made for her mother, Enid Bagnold's *Alice and Thomas and Jane* (1930), there runs a touching sense of childhood innocence. This might easily (along with the texts that were illustrated) tip over into the avuncular or the sentimental — how much happier are Milne and Shepard with Winnie-the-Pooh than with Christopher Robin? — but the annuals and the bumper-books, the picture books and the story books were all conceived within a set of attitudes that placed a premium on stability. Root the child's growth in the good-humoured, the comfortable, the known.

III: Moving Out
With the coming of the 1930s the essential stability, the homogeneity, of post-war English children's books was intruded upon by a variety of influences which ineluctably brought change. In the large world, a long way beyond Pooh Corner, there were the dramatic, and by no means comfortable, events of the Depression and political agitation, but even within a much narrower perspective important shifts of emphasis were taking place.

The most immediately obvious of these was the upsurge throughout the 1930s of illustrative influences from abroad. From Russia — but initially via Père Castor in Paris — there came new, stylised forms, making great play with flat, coloured surfaces, both for picture books and story books, and also for a new genre of "concept books". From France, too there came the giant (in all senses) success of Jean de Brunhoff's Babar, whose first adventures were published in England in 1931, and he was the precursor of a heterogeneous assortment of unusual tokens from Continental Europe. Some, like Erich Kästner's *Emil and the Detectives* (1931), with its spare, foregrounded illustrations by Walter Trier, were adapted by English publishers; others, like Lewitt-Him's *The Locomotive* (1939) came with their creators as refugees from the developing European catastrophe.

Alongside this influx of material from across the Channel — and in far greater profusion — came the children's books from America. A mere roll-call of a few significant names must here suffice to indicate the newness and the diversity of what was being discovered: the classic monochrome inventions of Wanda Gàg, the unassuming picture books of Marjorie Flack, the chaste drawing of Helen Sewell, the "product" books of the Petershams, the arrival of Mickey Mouse ...[3] Such transatlantic migrants were important in themselves, but they were also

harbingers of a new professionalism in the making and dissemination of children's books which was to have profound implications both for the working illustrator and his, or her, public.

This professionalism manifested itself in two interconnected developments. On the demand side, as it were, there was the growth in North America of a flourishing body of specialist librarians who saw it as their job to bring to children the best books that they could find. They had made common cause together to this end since 1900, when United States children's librarians founded their own section within the American Library Association, and by 1930 they were adept at promoting professional training, fostering good communications among themselves, and organizing publicity. The first national Children's Book Week was launched in 1919; the Newbery Medal "for the most distinguished contribution to American literature for children" was first awarded in 1922, and this was to be followed by the Caldecott Medal for picture books in 1938.

Such activity was matched on the supply side. In 1919 Louise Seaman was appointed to the first ever specialist post as publisher's editor for children's books by Macmillan, and three years later Doubleday, Page & Co. followed suit by creating a post for May Massee. The making of children's books began to change from being a rather haphazard, back-room process into a professional operation with its own benchmarks and traditions, and in this it was aided not only by the specialist customers in the libraries but also by specialist booksellers and by a growing body of — largely journalistic — discussion. The imposing Bertha Mahony set up her Bookshop for Boys and Girls in Boston in 1916, from which was to stem the bi-monthly journal *The Horn Book* (1924-) and from that time on there built up a steady flow of book-lists, review articles and monographs which expanded both the publicity for and the general interest in contemporary children's books.

All this would eventually have far-reaching results in Britain, since institutional and corporate policies were now being introduced into a field of action where, hitherto, a sometimes cheerful, sometimes aggressive *laissez faire* had prevailed. For the twenty years up to 1950, however, this movement was masked by the coming and going of war and, during that period itself, the most perceptible change in children's book illustration was simply its widening hospitality to new influences and, associated with this, the dynamic effect of an ever more sophisticated printing industry.

During the 1920s most children's book illustration was prepared for

Enid MARX *A Childhood* by F. Allinson (Hogarth Press, 1937)

3. There was also Dr. Seuss. "But you are well off for excellent writers of children's books in the U.S.A.", wrote Beatrix Potter in 1938. "What an amusing book that Mulberry Street by Dr. Seuss — someone sent it to me at Christmas."

printing by letterpress — line drawings were converted photomechanically into line blocks to print with the text, colour was reproduced by three or four-colour half-tone, or by colour line-blocks, all printing from a raised surface. But as the twenties progressed more colour-work was being done on lithographic presses — the Darwins' *Mr Tootleoo* and William Nicholson's picture books are notable examples — and lithography was to play a decisive role in the ramifying developments of the 1930s and 1940s.

What, of course, is "decisive" here is the degree to which photo-offset gave book-designers and illustrators new freedom both in reproducing varied weights and combinations of colours and in organizing flexible combinations of text and image. Part of the greatness of *Clever Bill* and *The Pirate Twins* lies in Nicholson's dramatic control over his hand-written text and its accompanying pictures, and some of the most notable books of the thirties were to adopt this flexibility and employ it on a grand scale: The "Babar" books of Jean de Brunhoff, the "Little Tim" books of Edward Ardizzone, and the "Orlando" books of Kathleen Hale. Most significant of all was Noel Carrington's discovery of photo-lithography applied to cheap, mass-produced children's books in the

Edward ARDIZZONE *Tim's Last Voyage* (Bodley Head, 1972)

Soviet Union, which led him to put up the idea of a similar enterprise to Allen Lane. This resulted in Penguin's entry into children's book publishing with the Puffin Picture Books, which arrived on the market in the unpropitious days of 1940, and carried the graphic treatment of facts for children far beyond anything that Père Castor had dreamed up. (Noel Carrington was a master practitioner where modern lithographic processes are concerned and he was also responsible for editing some of the most remarkable colour books of this period, *ante* Puffin at Country Life, where he commissioned work from the Polish pair Lewitt-Him, and *post* Puffin at his own firm of Transatlantic Arts. Here he harnessed the talents of such experienced designers as Eileen Mayo and Hans Tisdall in developing variations in the presentation of non-fiction to children.)

Tradition sustained itself, however, amidst all these stylistic and technical novelties — often in disconcerting ways. One of the first books of the thirties, for instance, to exhibit a distinctively "modern" appearance was *Jean-Pierre*, written and illustrated by Ursula Moray Williams. The writing turns out to be neatly-turned verses which owe more than a little to A.A. Milne, but these were not set amongst imitation-Shepard line drawings (as happened on a number of occasions at this time). Instead they were set in Gill Sans Bold and edged with repeated line and silhouette designs, while at four points in the text — and on the dust-jacket — there appeared boldly stylised, full-page colour lithographs in which brightly patterned and tinted flat images were superimposed upon a largely matt black background. The effect of the book must have been pretty startling in 1931, but in 1938, when Ursula Moray Williams published her *Adventures of the Little Wooden Horse* (one of the outstanding children's stories of the pre-war years), it was illustrated in an unobtrusive and rather undistinguished manner by Joyce Lankester Brisley, the creator of Milly-Molly-Mandy.

On occasions, too, strange tensions were set up within the covers of a single book. C.F. Tunnicliffe burst upon the scene in 1931 with a set of stunning wood engravings for Henry Williamson's *Tarka the Otter* (and along with such artists as Clifford Webb, Gwen Raverat, and Eric Fitch Daglish, joined Robert Gibbings in reviving the craft of wood engraving in children's books); but in 1934 he turned to fairy tales and illustrated Harcourt Williams' *Tales from Ebony* and managed to combine some finely-drawn and largely traditional head-and-tail pieces with a suite of colour lithographs that varied from a graceful naturalism ("The Ugly Duckling") to a highly-wrought expressionism ("The Three Golden Hairs").

Similar unexpected juxtapositions are found in the work of Harold Jones, who is perhaps the most original children's book illustrator of the period — and who has continued his idiosyncratic career almost to the present time. (His drawings for Naomi Lewis' collection of doll stories *The Silent Playmate* helped to make this one of the most inspired anthologies of the 1980s.) For while it is easy to see how Kathleen Hale in her "Orlando" books, or Lewitt-Him in their semi-surreal picture books may attract the epithet "thoroughly modern", Harold Jones' auto-lithographs for *This Year: Next Year* (1937) gain a far more radical disjunctive-ness simply by appearing not to do so. On the surface — and, indeed, also on the surface of his strange line-drawings for the stories of M.E. Atkinson — there seems to be only a rather stylised, rather wooden, rather traditional pictorialism. But within the hatched, pastel-shaded frames of his pictures there lurks a silent, eerie world — glimpsed or hinted at under the dark arches of the Serpentine bridge, in the eyes of a pensive dog, or behind a half-open door. Walter de la

Mare was called upon to supply verses for these apparently innocent "illustrations" but his forced lilt jars on the resonance in the pictures themselves. What is that eyeless Guy Fawkes staring at? What Petruschka-like scene waits to be enacted with Mr Punch down on the sea-shore?

IV: Towards Confusion

Post-war reconstruction was — unsurprisingly — characterised by post-war uncertainty. Many physical impediments inhibited a free development of the English book trade: shortage of raw materials, deterioration of plant, bureaucratic controls. In consequence, few publishers could be blamed for using slender resources to best effect by feeding a known market with unexceptionable books.

Where children's books were concerned this meant for many firms a preservation of the *status quo ante bellum* both as regards the kinds of books that were commissioned or reprinted and the illustrations with which they were furnished. Indeed, when the *Sunday Times* organised its exhibition of "The One Hundred Best Books for Children" in 1958 the traditional names of English book illustration were still very much to the fore. Kathleen Hale's *Orlando Keeps a Dog* of 1949 was the most unconventional English picture book present — although its lavish piling-up of images made an instructive contrast with the more controlled, and hence more persuasive, colour-work of Edward Ardizzone in *Little Tim and the Brave Sea Captain* (a second edition of 1955) and with the compelling imagery of Harold Jones' pages — alternating colour with monochrome — for Kathleen Lines' nursery rhyme book *Lavender's Blue* (1954). Among the illustrators working chiefly in black and white the emphasis was again on artists whose reputations had been established before the war: Joan Kiddell-Monroe, John and Isobel Morton-Sale, Walter Hodges and the omnipresent Ernest Shepard. The newcomers, with the possible exception of Richard Kennedy in Eilis Dillon's *Island of Horses* (1956), conformed admirably to the disciplines of line-drawing: Pauline Baynes in C.S. Lewis' *The Lion the Witch and the Wardrobe* (1950) and Diana Stanley in Mary Norton's *The Borrowers* (1952). (Intriguingly there was also a guest-appearance by the youthful Maurice Sendak, whose illustrations for Meindert de Jong's *Wheel on the School* appeared in Britain in 1956.)

Such essentially — but by no means stuffily — conservative examples were not entirely representative of the time however. Some new publishing companies were eager to exploit new talent or modern processes: Carrington's Transatlantic Arts, for instance, or the short-lived firm of Peter Lunn, under whose imprint there appeared a series of adventure stories with strikingly dramatic illustrations. Jack Matthew, who had worked during the thirties, did some of his finest illustrations for E.H. Visiak's *The Haunted Island* (1946, with the title-page calling him Matthews), and at the same time Lunn issued some of the earliest work of two illustrators who have maintained prolific careers down to the present — powerful black and white drawings by William Stobbs for Nicholas Cavanagh's *Sister to the Mermaid* (1946) and more astringent work by Robin Jacques for John Keir Cross's *The Angry Planet* (1945). Enterprising publishers from the 1930s, like Faber & Faber, were also preserving a remarkable willingness to make room for new work, while — momentously — Oxford University Press reorganized its children's book publishing department. From being a division largely concerned with the production of painting-books, bumper-books, and the collected works of W.E. Johns, it was converted by a series of editors — Frank Eyre, John Bell (both assisted by Kathleen Lines) and

Robin JACQUES *The Arabian Nights* selected by H. Anderson
(Peter Lunn, 1946)

Mabel George — into an imprint which, during the 1960s at least, was synonymous with publishing excellence.

The rise of Oxford University Press is, in fact, helpfully symbolic of the eventual change in post-war circumstances that was to turn English children's book publishing into the industrial operation that was prefigured in the earlier American experience. With the reorganisation of English education after 1944 a new impetus was given to the activities of what might be called reorganised librarianship. Borough and county libraries not only expanded their services to the public but also began to develop close links with a growing school library movement. The professional training of, and the improved opportunities for, children's librarians claimed attention as never before, and as the energies of the profession developed so they were met by an increasingly energetic and specialised publishing industry. The "new" editorial development at Oxford University Press was only one among many, and as communication and co-operation between professional producers and professional consumers developed, so "children's books" — and hence "children's book illustration" — became subject to normative forces that were governed by experienced, full-time practitioners rather than by the casual, uninstructed buyers and sellers of past times.

Faith JAQUES *A Likely Lad* by Gillian Avery (Collins, 1971)

One result of this institutionalized professionalism was the provision of a secure market for many books that might otherwise have had only a marginal prospect of success (the early, small experimenters like Peter Lunn had missed that boat by a dozen years or so). Publishers' editors with the flair of Grace Hogarth at Constable, Judy Taylor at The Bodley Head, Richard Hough and, later, Julia MacRae at Hamish Hamilton could invest in their own confident knowledge of the market and could encourage new talent alongside the dependability of illustrators schooled in the traditional disciplines of their craft. Edward Ardizzone was *primus inter pares* here, a natural draughtsman who could work as reliably to a commission as in the creation of books which he devised himself, or in sympathetic collaboration with such friendly writers as James Reeves or Eleanor Farjeon.

The very discipline of drawing, of finding the right line to express the nuance of a text, associates Ardizzone with the draughtsmen of earlier times and their simple pleasure in sharing with a child audience "the look of a story". Such an attitude surfaces in traditional draughtsmanship almost willy-nilly and can be seen in the black and white work of a train of artists who are Ardizzone's younger contemporaries or successors: Shirley Hughes, Faith Jaques, Fritz Wegner, John Lawrence (Colour Plate 28), Charlotte Voake ... One of the effects though of the changing nature of the post-war market was to extend and complicate the rationale behind both the writing and illustrating of children's books.

This is most immediately obvious in the making of picture books, and is most dramatically seen in the explosion of activity that followed the publication of Brian Wildsmith's *ABC* in 1962 (one of Mabel George's greatest triumphs at

"You carry on tapping, Master Woodpecker,"
squeaked the mouse. "Owl is always bossing
and chasing us about."

Colour Plate 30. Victor AMBRUS *Mishka* (Oxford University
Press 1975)

Colour Plate 29. Brian WILDSMITH *The Owl and the
Woodpecker* (Oxford University Press 1972)

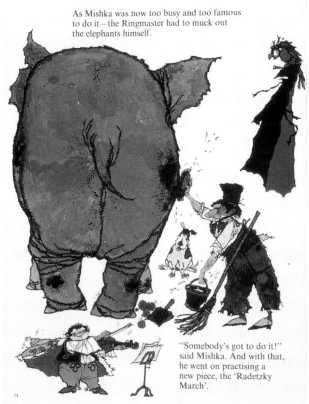

As Mishka was now too busy and too famous
to do it—the Ringmaster had to muck out
the elephants himself.

"Somebody's got to do it!"
said Mishka. And with that,
he went on practising a
new piece, the 'Radetzky
March'.

Peggy FORTNUM From an original drawing for *A Few Fair Days* by
Jane Gardam (Hamish Hamilton, 1971)

Oxford). To Wildsmith, questions of draughtsmanship — or of the didactic status
of alphabet-books — were entirely subordinate to questions of colour. He saw
the alphabet as a line on which to hang brilliant images, and his publisher found
for him a printer and a process which could match his palette. The event was not
so much a rediscovery of the potential of offset (after all Gerald Rose had shown
the way to that in *How St Francis Tamed the Wolf* in 1958); it was rather a public
celebration of a new way of illustrating, blessed by the accolade of critics and
the award of the Library Association's ill-named Kate Greenaway Medal.

From that point on there was no holding the surge of experimentation with
picture books, a movement which has been continuously stimulated by the
economic need for international co-operation in lining up long print-runs, with
its consequent emphasis on the *appearance* of the art-work rather than on the
right blending of words and pictures. In the thirty years since Wildsmith's *ABC*
was conceived and published, picture-book art has been used for a host of

purposes, from the psychological explorations engaged in by Charles Keeping to the political commentaries of Raymond Briggs and the semi-surreal didacticism of Anthony Browne. Stylistic freedom is absolute and the difficulty of formulating any summary account of such protean activity is compounded by the speed with which editions appear and disappear and reconstruct themselves in the (often different) dress of paperbacks.

For the artist, therefore, there is apparently a total liberation. As we have seen with *Tail Feathers from Mother Goose*, any graphic idiom may be acceptable, and no subtle reticulation of colour will defeat the printer — even though there may have been losses elsewhere. (Where now are the splendid cloth bindings, the decorated papers and even the dust-jackets that used to symbolize thought and care in the production of children's books?) And at a more fundamental level, the artist can be shown to have gained liberation at the cost of integrity. For such now is the pressure of the international market and the economics of corporatist publishing that "production" rather than "creation" has become a dominant motive in the making of children's books. As Tessa Chester wisely remarks in a passage from *A History of Children's Book Illustration* (1988), "sophisticated technology and trends are being used for their own sake, when they are not really necessary, and though the eye is dazzled, it is not sustained."

An argument might also be put forward that the artist suffers simply because the market is too big and the succession of new publications too rapid. Whether his work is sustaining or dazzling, or merely trite, it will probably be published in conjunction with dozens of other books and will be rapidly overtaken as publishing season follows publishing season. For the response of even the professional consumers is fragmented and feeble and there is no articulated critical consensus by which the mass of children's book illustration may be judged. Hyper-activity in the way of exhibitions, trade fairs, conferences and book-awards[4] abounds, but the recording, reviewing and principled discussion of children's books is no nearer to maturity than it was in the 1920s.

Paradoxically, the child may well be the ultimate loser. For although the concepts of "quality" that were once fostered by both publishers and librarians are now regarded as paternalistic, although they have been replaced by the apparently democratic notion that the child is the measure of all things — that so long as you don't offend against egalitarian principles, anything goes — the brevity of the child's reading life remains inescapable. The profusion of current publishing supplies more books than most children will be able to read in a lifetime, let alone a childhood, and the flimsy guidance that is offered to them, to their parents and, often, to their teachers ensures that their encounter with great books is something of a bagatelle. For all the expansion and diversification of the market in the last sixty years, progress remains conjectural.

4. Lagging well behind America, the Library Association did not set up its Kate Greenaway Award — for book illustration, not just picture-books — until 1955. After that the award scene went dormant, but from the sixties onwards numerous children's book prizes have been invented, several of them, like the Mother Goose Award and the quaintly-named "Emil", devoted to book illustration. Their criteria, and the judges' application of them, are often wayward and it is depressing to note how little attention, even among the Greenaway judges, is given to the demanding craft of black and white illustration.

"ABBEY" **fl.1919-1925**
Produced a coloured jacket for Mrs. Victor Rickard's *Cathy Rossiter* (Hodder, 1919), and covers for the *Radio Times* for Christmas 1924 and 1925. He also did book jackets for early editions of P.G. Wodehouse's novels for Herbert Jenkins.
Bibl: Driver.

ABBEY, Joseph **b.1889**
Born in Amsterdam, Holland, Abbey came to England when he was three. He became a press artist and illustrator, was Art Editor of *Chums* for some years, illustrating stories in it and in *Tom Merry's Own Annual*. He illustrated many other annuals and books for children.
Books illustrated include: H.J. Massingham: *Birds of the Seashore* (with others; Laurie, 1931); W.E. Johns*: *Biggles in Spain* (with Howard Leigh*; OUP, 1939); E. Blyton: *The Mystery of the Burnt Cottage* (Methuen, 1943), *The Mystery of the Disappearing Cat* (Methuen, 1944), *The Mystery of the Spiteful Letters* (Methuen, 1946), *The Mystery of the Hidden House* (Methuen, 1948); *Arthur Mee's Hero Book* (Hodder, nd).
Books written and illustrated include: *Birds and Their Eggs* (Ward Lock, 1949).
Contrib: *Chums; Tom Merry's Own Annual*.
Exhib: RA.
Bibl: Doyle BWI; Peppin.

ABBOTT, Cynthia **b.1908**
Abbott was born at East Sheen, near London in 1908. She studied drawing and sculpture at the Slade (1927-31) and spent the next year writing a novel. In the 1930s, she travelled to Canada, USA, South Africa and Europe. Worked for an interior decorator and during WW2 drove ambulances and lorries for the Fleet Air Arm. She also spent much time making detailed botanical drawings, and after the war studied painting and drawing at Bromley School of Art, before working for the publishers, Bodley Head, as a commercial artist. She has contributed illustrations to a number of magazines, including an illustrated excerpt from Naipaul's "The Mystic Masseur" in *Motif* No. 2 (1959).
Contrib: *Book Design and Production; Motif*.
Bibl: Ryder.

ABRAHAMS, Hilary Ruth **b.1931**
Born on 11 March 1931 in London, Abrahams studied at the St. Martin's School of Art (1951-55), and at the RA Schools (1955-59). She is a part-time lecturer at Loughborough College of Art. A painter in oils and watercolour, her work has been included in a number of group shows and she had a one-man show in Derby in 1985. A free-lance illustrator since 1962, mostly of children's books, she prefers to draw in black and white.
Books illustrated include: A. Abrahams: *Polonius Penguin Comes to Town* (Dobson, 1963), *Polonius Penguin Learns to Swim* (Dobson, 1963), *Polonius Penguin and the Flying Doctor* (Dobson, 1966); N. Streatfeild: *Enjoying Opera* (Dobson, 1966); L. Tolstoy: *How Varnika Grew Up in a Single Night* (Dobson, 1967); J.G. Hughes: *Queen of the Desert* (Macmillan, 1967), *Invincible Miss— The Adventures of Mary Kingsley* (Macmillan, 1968); J. Harris: *Sam and the Dragon* (Hutchinson, 1968); B. Willard: *Jubilee!* (1973); M. Sharp: *The Children Next Door* (1974); M. Graham-Cunningham: *The Farmer* (Dinosaur Publications, 1975); H. Young: *Magic Balloon, Sleeping Chair* (Deutsch, 1975); E. Ramsbottom and J. Redmayne: *Where Is It From?* (Macmillan, 1978); E. Corney: *Pa's Top Hat* (Deutsch, 1980); J. Cunliffe: *Sara's Giant and the Upside Down House* (Deutsch, 1980); G. Sand: *Wings of Courage* (Kestrel, 1982).
Exhib: Young Contemporaries; RA; St. Michael's Gallery, Derby (one-man show, 1985).
Collns: Durham University.
Bibl: ICB3; ICB4; Peppin; Who.

ACS, Laszlo Bela **b.1931**
Born in Budapest, Hungary, Acs studied graphic design at the Hungarian Academy of Fine Arts, Budapest and, after coming to England, at Hornsey College of Art. He spent three years in advertising before joining Independent Television News for eighteen months as Head of Graphic Design. He then became a full-time free-lance illustrator of children's books, mostly in black and white pen drawings. He designed posters for the *Times*, the Post Office and other clients; and for four years, he was engaged in audiovisual design for foreign language teaching for the Schools Council. He has taught art and graphic design at Exeter College of Art.
Books illustrated include: F. Jackson: *Our Living World* (with Gaynor Chapman*, Weidenfeld, 1964); J. Tate: *Picture Charlie* (1964); P. Farmer: *Emma in Winter* (1966); C.E. Palmer: *The Cloud with the Silver Lining* (Deutsch, 1966); A. Aldous: *Bushfire* (Brockhampton, 1967); N. Coats: *Energy and Power* (Weidenfeld, 1967); L.R. Gribble: *Famous Stories of the Wild West* (Barker, 1967); E. Taylor: *Mossy Trotter* (Chatto, 1967); N. Mitchison: *Don't Look Back* (1969); C.E. Palmer: *A Cow Called Boy* (Deutsch, 1973); J. Muirden: *The Earth's Neighbours* (Hart-Davis, 1975); P. Roberson: *Engines* (with Tom Swimmer; Hart-Davis, 1975); D. Stacey: *Fire in My Bones* (Oxford Religious Educational Press, 1975); P. Appiah: *Ring of Gold* (Deutsch, 1976); G. Avery: *Call of the Valley* (1976); C. Green: *Beetle Bay* (Hamilton, 1976); R.J. Unstead: *Living in Pompeii* (Black, 1976); C.E. Palmer: *Baba and Mr. Big* (Collins, 1976); W. Mayne: *Max's Dream* (Hamilton,

Frank ADAMS *Psammyforshort, Rex. Imp* by Edgar Dickle (Methuen, 1929)

1977); G. Trease: *When the Drum Beats* (Pan, 1979); W. Finlay: *Tales of Sorcery and Witchcraft* (Kaye, 1980); G. de Maupassant: *Une Vie* (Folio Society, 1981); B. Gillham: *My Brother Barry* (Deutsch, 1981); N.W. Hooke: *A Donkey Called Paloma* (Methuen, 1981); D. Rees: *The House That Moved* (Puffin, 1982); A.M. Smith: *The Perfect Hamburger* (Hamilton, 1982); A. Malloy: *The Christmas Rocket* (MacRae, 1983); J. Phipson: *Beryl the Rainmaker* (Hamilton, 1984); B. Willard: *Smiley the Tiger* (MacRae, 1984); A. Ruffell: *The Bowley Boy* (Hamilton, 1985).
Books written and illustrated: *Boys' Choice* (Golden Pleasure Books, 1965).
Exhib: National Gallery, Budapest; Holborn Town Hall and elsewhere in UK; and in Holland and Switzerland.
Bibl: Folio 40; ICB4; Peppin.

ADAMS, Frank **fl.1903-1944**
In addition to painting landscapes, Adams illustrated books for children and for adults in a variety of styles, using pen and ink or colour. Gray's *Elegy* (1931) has rather pale colour plates, while some of his children's books have brightly coloured plates reminiscent of Cecil Aldin* or John Hassall (*see* Houfe) (with whom he collaborated in *The Golden Budget of Nursery Stories*).
Books illustrated include: *The Frog He Would A-Wooing Go* (Blackie, 1904); L. Carroll: *Alice's Adventures in Wonderland* (Blackie, 1912); F. Pitt: *Tommy Wite-Tag the Fox* (Blackie, 1912); J. Pope: *Three Jolly Huntsmen* (Blackie, 1912), *Three Jolly Anglers* (Blackie, 1914); E. Dickle: *Psammyforshort Rex. Imp.* (Methuen, 1929); *The Golden Budget of Nursery Stories* (with John Hassall*; Blackie, c.1929); I. Walton: *The Compleat Angler* (Eyre, 1930); T.

Gray: *Elegy Written in a Country Churchyard* (Medici Society, 1931); P.R. Chalmers: *Rhymes of Flood and Field* (Eyre, 1931); M. Marlowe: *Wotta-Woppa, and Other Stories* (Methuen, 1932); M. Arnold: *The Scholar Gypsy* (Nicholson, 1933); *Nursery Rhymes and Tales* (Blackie, 1938); *Nursery Rhymes, Stories and Pictures* (Blackie, 1938 and 1950); E. Dickle: *The Paper Boat* (Hodder, 1943).
Contrib: *Blackie's Annuals; Cassell's Children's Annuals; Little Folk.*
Bibl: Johnson; Peppin.
Colour Plate 31

ADAMS, Margaret **fl. 1959-1979**
Since the 1950s, Adams has illustrated many of the books and broadsides printed at the Stanbrook Abbey Press, which was founded in 1876. All the printing is done by the enclosed nuns, a small staff under the supervision of Dame Hildelith Cumming, printer since 1955. Adams illustrates in the mediaeval fashion, with initials and decorations hand-drawn on to the printed page. She also produces woodblocks for tailpieces and other illustrations.
Books illustrated include (all published in Worcester at the Stanbrook Abbey Press): *Fret Not Thyself Because of the Ungodly* (broadside; 1959?); St. Leo the Great: *On the Birthday of Our Lord Jesus Christ* (1959); St. Augustine of Hippo and St. Ignatius of Antioch: *Unless the Grain Die* (1961); S. Sassoon: *Something About Myself* (1966); Plotinus: *We Are Like a Company of Singing Dancers* (broadside; 197?); G. von Jacquin: *Genius* (broadside; 197?).
Bibl: Juliet Standing: *The Private Press Today. 17th Kings Lynn Festival* (Leicester: Brewhouse Press, 1967).

ADAMS, Thomas Charles Renwick **fl. 1962-**
Adams was born in Providence, Rhode Island. He came to England and studied at Chelsea School of Art, and then worked as a design consultant and a painter. As an illustrator, he first specialized in natural history themes. He came into prominence with his book jacket for John Fowles' *The Collector*, published in 1962, and since then has done the jackets for several other novels, including Fowles' *The Magus* and *The French Lieutenant's Woman*, for works by Raymond Chandler, and for David Storey's *Saville*. Adams has produced a vast number of covers for Agatha Christie's mystery novels. These were made for the Fontana series from Collins, but new covers with quite different artwork were produced for the US Bantam and Pocket Books editions; and a reissue in the 1980s has again received new covers. There was an exhibition of his cover art in Toronto. Fowles has written that Adams' "secret as cover-illustrator lies, it seems, above all in his capacity for being oblique, yet so presenting this obliquity that it constitutes a lure." (Symons, 1981.†)
Bibl: Amstutz 2; Julian Symons: *Tom Adams' Agatha Christie Cover Story* (Limpsfield: Dragon's World/Paper Tiger, 1981).

ADAMSON, George Worsley **1913-1986?**
Born on 7 February 1913 in New York City, Adamson moved to England and studied at Wigan Mining and Technical College, Wigan School of Art, Liverpool University (Education Department), and Liverpool School of Art. He travelled and taught art in Germany, France and Portugal, before serving in the Royal Air Force during WW2. Having trained as a navigator, he flew Catalina flying boats from bases between Gibraltar and Murmansk, but he also worked as an occasional official war artist for Coastal Command.
After the war, he taught engraving and illustration at Exeter School of Art (1946-53), started contributing to *Punch* again — having first worked for the magazine in 1939 — and made some engravings. In order to be able to support his family (he had married in 1944), Adamson broadened his interests and became a free-lance designer, illustrator and humorist. He has contributed many drawings, including coloured covers, to *Punch*; designed posters, greeting cards and animated films; illustrated about one hundred books of all sorts; and written as well as illustrated several books for children.
Adamson admits to the strong influence of the humorous and political drawings in *Punch*, which "were a regular visual diet. I have always learned from them. Often in their special way they teach the telling shape, the value of a clear created idea and the

importance of a moment." (Adamson, 1984.†) He spends much longer on preparation and planning than on the actual drawing itself.

He was elected ARE.

Books illustrated include (but see Peppin): M. Vasey: *The Day Is Over* (Epworth, 1954); B. Ireson: *Nursery Nonsense* (Faber, 1956); R. Ridout: *Word Perfect* (Ginn, 1957-60); C. Kingsley: *Westward Ho!* (Ginn, 1957); B. Ireson: *The Faber Book of Nursery Verse* (Faber, 1958); W. Hall: *The Royal Astrologer* (Heinemann, 1960); *Singing Together* (BBC, 1960); T. Hughes: *Meet My Folks!* (Faber, 1961), *How the Whale Became* (Faber, 1963); M. Lovett: *Sir Halmanac and the Crimson Star* (Faber, 1965); N. Hunter: *Professor Branestawm* books (BH, 1966-77); T. Hughes: *The Iron Man* (Faber, 1968); J. Aiken: *The Friday Miracle and Other Stories* (Penguin, 1969); G. Barker: *Runes and Rhymes and Tunes and Chimes* (Faber, 1969), *To Aylsham Fair* (Faber, 1970); G. Jackson: *The Oven Bird* (Faber, 1972); M.S. Barry: *Boffy and the Momford Ghosts* (Harrap, 1974); R.L. Green: *Strange Adventures in Time* (Dent, 1974); M. Cockett: *Tufty* (Macmillan, 1978); F. Waters: *The Day the Village Blushed* (Harrap, 1978); R. Ingrams and J. Wells: *The Collected Letters of Dennis Thatcher: Dear Bill* (Private Eye, 1980), *The Other Half* (Private Eye, 1981), *One for the Road* (Private Eye, 1982), *My Round* (1983); P.G. Wodehouse: *Short Stories* (Folio Society, 1983).

Books written and illustrated include: *A Finding Alphabet* (Faber, 1965); *Widdecombe Fair* (Faber, 1966); *Finding 1 to 10* (1968); *Rome Done Lightly* (Chatto, 1972).

Contrib: *British Airports World; Country Fair; Countryman; Daily Telegraph; Harpers; Listener; Nursing Times; Private Eye; Puffin Annual; Punch; Queen; Radio Times; Sketch; Sports Illustrated; Tatler; Time and Tide; Young Elizabethan*.

Exhib: Liverpool; RA; RE; American Inst. of Graphic Arts.

Collns: BM; IWM; Ulster Museum; Exeter Museum.

Bibl: George Adamson: "Eleven Printmakers . . . " *Journal RE*, No.6 (1984), pp.18-19; Folio 40; ICB2; ICB3; ICB4; Peppin; Who.

ADAMSON, Jean **fl. 1962-**

Books about five year-old twins, Topsy and Tim, written by Gareth Adamson and illustrated by Jean Adamson, first appeared in the 1960s. There are now more than sixty of these in the "Handy Books" format, and others in the larger "Activity Books". Published by Blackie, the illustrations give a fair amount of detail but never crowd the page with distractions.

Books illustrated include (all by G. Adamson): *Topsy and Tim's Foggy Day* (Blackie, 1962), *Topsy and Tim at the Football Match* (Blackie, 1963), *Topsy and Tim at the Seaside* (Blackie, 1965), *Through the Year with Topsy and Tim* (Blackie, 1977), *Topsy and Tim's Birthday Party* (Blackie, 1981), *Topsy and Tim's Garden* (Blackie, 1985).

ADCOCK, Fred **fl.1909-1933**

Adcock illustrated several topographical books with line drawings, including a number in the "English Countryside" series, published by Robert Scott in the 1920s.

Books illustrated include: M. Adams: *Some Hampstead Memories* (Priory Press, 1909); A.St.J. Adcock: *Famous Houses and Literary Shrines of London* (Dent, 1912) *The Booklover's London* (Dent, 1913); W.K. Jealous: *Highgate Village* (Baines & Scarsbrook, 1919); A.G. Bradley: *England's Outpost* (Scott, 1921); A.L. Salmon: *The Heart of the West* (Scott, 1922); T.L. Tudor: *The High Peak to Sherwood* (Scott, 1926); F.J. Snell: *The Celtic Borderland* (Scott, 1927); A.St.J. Adcock: *London Memories* (Hodder, 1931).

Books written and illustrated include: *Byways of Old Hampstead* (Baines & Scarsbrook, 1933).

ADLINGTON, Fred **fl. 1920s**

An illustrator in black and white, Adlington produced some illustrations for *The Rubaiyat of Omar Khayyam* which have some similarities to the work of Harry Clark* and John Austen*.

Books illustrated include: C.J. Whitby: *Concerto in A Minor* (Watkins, 1924); *The Rubaiyat of Omar Khayyam* (Sampson Lowe, 1925); A.St.J. Adcock: *A Book of Bohemians* (Sampson Low, 1925); G. Wade: *Tomaso* (Bristol: Horseshoe Publ., 1925).

ADSHEAD, Mary **b.1904**

Born on 15 February 1904 in Bloomsbury, Adshead studied at the Slade (1922-25). A decorative painter as well as a book illustrator, her work has included murals for many restaurants and two churches, postage stamp designs, collages, and at least one poster for London Transport. She married Stephen Bone* in 1929, and they collaborated on some children's books. Two of their books, *The Little Boys and Their Boats* and *The Little Boy and His House* have been praised as "the only completely successful British examples of 'picture-stories with a purpose'" of the period immediately following WW2 (Eyre).

Books illustrated include: E.V. Isaacs: *In the Beginning* (Heinemann, 1926); J. Supervielle: *Souls of the Soulless* (Methuen, 1933); M. Norton: *Bonfires and Broomsticks* (Dent, 1947).

Books written and illustrated include: (all with Stephen Bone): *The Little Boy and His House* (Dent, 1936); *The Silly Snail* (Dent, 1942); *The Little Boys and Their Boats* (Dent, 1953).

Contrib: *Saturday Book*.

Published: *Travelling with a Sketchbook* (Black, 1966).

Exhib: RA; NEAC; SMP; WIAC.

Bibl: Eyre; ICB2; Peppin; Waters; Who.

AHLBERG, Janet **b.1944**

Born in Huddersfield, Ahlberg (née Hall) spent her childhood in Leicester. She trained as a teacher in Sunderland (1963-66) where she was encouraged to paint and draw, and then studied graphic design at the Leicester Polytechnic for three years. She met and married Allan Ahlberg and began to illustrate books for children, her first book being *Night* for Macdonald. Her career took off after Collins accepted the first of the "Brick Street Boys" series for publication in 1975, and since then, she has mostly illustrated books written by her husband. *Here Are the Brick Street Boys* is the first of a series of books about a gang of cheeky boys and the illustrations are as cheerful and comic as the boys themselves. Another series, also by Allan Ahlberg, is "Happy Families", published by Puffin Books. There are some ten titles in that series, though several other illustrators are also used — Joe Wright, Faith Jaques* and André Amstutz. Ahlberg was awarded the Kate Greenaway medal in 1978 for *Each Peach Pear Plum*, which displays a rarely achieved excellence in the relationship of words to illustrations; and *The Jolly Postman* (1986) won the Emil/Kurt Maschler Award, and was described by the reviewer in the *Times Literary Supplement* as "the picture-book of the year — possibly the decade."

Books illustrated include (but see Martin, 1989†): *Night* (Macdonald, 1972); I. Eastwick: *Providence Street* (Blackie, 1972); F. Laws: *Things to Make from Card* (Collins, 1973); all following are by Allan Ahlberg: *Here Are the Brick Street Boys* (Collins, 1975), *A Place to Play* (Collins, 1975), *Sam the Referee* (Collins, 1975), *Fred's Dream* (Collins, 1976), *The Great Marathon Football Match* (Collins, 1976), *The Vanishment of Thomas Tull* (Black, 1977), *Each Peach Pear Plum* (Kestrel, 1978), *Funnybones* (Heinemann, 1980), *Happy Families: Mr. Biff the Boxer* and *Mrs. Wobble the Waitress* (Kestrel, 1980), *Peepo!* (Kestrel, 1981), *The Baby's Catalogue* (Kestrel, 1982), *Daisy Chains* (four titles in series; Heinemann, 1983), *The Jolly Postman* (Heinemann, 1986), *The Clothes Horse* (Kestrel, 1987), *Starting School* (Kestrel, 1988), *Bye Bye Baby* (Heinemann, 1989).

Bibl: Douglas Martin: *The Telling Line: Essays on Fifteen Contemporary Illustrators* (Julia MacRae, 1989); Peppin.

Colour Plate 32

AINSWORTH, Edgar **c.1906-c.1975**

Ainsworth was art editor of the *Picture Post* and a talented draughtsman. He produced some posters in the 1930s, including several for the Empire Marketing Board and at least two for Shell. He later became art editor of the popular family weekly, *Leader*, and though he used mostly photographers to illustrate the articles, he occasionally commissioned drawings. He sent Mervyn Peake* to witness the liberation of the concentration camp complex, Bergen-Belsen, and then to draw the war-torn cities of Germany. Ainsworth himself went to Bergen-Belsen and made powerful illustrations of the horrifying spectacle for *Picture Post*; and in 1948 produced a major account, illustrated in pen and wash, of the last days of the

Edgar AINSWORTH "Officer, arrest that man! He has pinched my buttock!": an illustration for "Youth in Dublin" by Michael Taafe in *The Book of Leisure* edited by John Pudney (Odhams Press, 1957)

British in Palestine. In contrast, he did humorous illustrations for Pudney's *The Book of Leisure* (1957), in black and white and in two colours.

Books illustrated include: J. Pudney: *The Book of Leisure* (with others; Odhams, 1957).
Contrib: *Picture Post*.
Bibl: Paul Hogarth: *The Artist as Reporter* (Fraser, 1986).
Colour Plate 4

ALASTAIR
See Houfe (under Hans Henning VOIGHT)

ALDIN, Cecil Charles Windsor 1870-1935
See Houfe
Aldin was a most prolific artist and illustrator. While living in London, he became friends with the Beggarstaff Brothers (see Houfe under William Nicholson and James Pryde), John Hassall*, Phil May and Dudley Hardy, and their influence on his work was

great. He produced a great number of prints, a select list of which is included with a comprehensive bibliography in Heron's book (Heron, 1981†). He did a great deal of advertising work, including posters, for such companies as Bovril, Colman (manufacturers of starch and mustard), and Cadbury's, and Royal Doulton produced about sixty items with Aldin drawings between 1910 and 1939. Horses, dogs and the English countryside were the major topics of Aldin's illustrations. The obituary in *The Times* asserted that "there never yet has been a painter of dogs fit to hold a candle to him . . . Cecil Aldin can justly be described as one of the leading spirits in the renaissance of British sporting art."
Books illustrated include (but see Heron, 1981†; and Felmingham): J. Masefield: *Right Royal* (Heinemann, 1922); W. Howe-Nurse: *Berkshire Vale* (Blackwell, 1927); P.R. Chalmers: *A Dozen Dogs or So* (Eyre, 1928), *Forty Fine Ladies* (Eyre, 1930); J. Douglas: *The Bunch Book* (Eyre, 1932); J.B. Morton: *Who's Who in the Zoo* (Eyre, 1933); J. Vickerman: *Hotspur the Beagle* (Constable, 1934).
Books written and illustrated: *An Artist's Models* (Witherby, 1930); *Exmoor, the Riding Playground of England* (Witherby, 1935); *Hunting Scenes* (Eyre, 1936).
Bibl: Roy Heron: *Cecil Aldin: The Story of a Sporting Artist* (Webb & Bower, 1981); Felmingham; ICB; Mahoney; Peppin; Titley; Waters.

ALDRIDGE, Alan b.1938
Born in Aylesbury, Buckinghamshire, Aldridge studied at Romford Technical College. He worked as an insurance clerk, repertory actor, and barrow-boy before becoming a free-lance designer and illustrator without having an orthodox artistic education. His highly individualistic brand of fantastic illustration first appeared in 1963 when he was in his early twenties. As well as illustrating books and designing book covers, he did a number of record covers and posters, including one for Warhol's film, *The Chelsea Girls* (for which he was threatened with police prosecution) and for The Great American Disaster, a hamburger restaurant in London. After ten years in the US, Aldridge returned in 1984 to live in Norfolk.
Aldridge led the "pop" movement in British advertising art. He admits to a deeply-felt nostalgia for the early part of the twentieth century, and he is particularly fascinated by old comics. He often first conceives his illustrations as 3-D models and then uses the airbrush technique painstakingly and extensively to execute his design. For a short time, he was Art Director of Penguin Books, but the Board soon found his work unsuited to the innate conservatism of the company — as he wrote in *Phantasia*, "covers with naked tits Sent the sales up but upset the authors. . . Penguin big-wigs hatched plots to roll my head So I left, and set up my own studio Called INK." (Aldridge, 1981.†) Nevertheless he created many covers for the Penguin crime and science fiction series, and others for Penguin and Panther. He is perhaps best known for his record jackets for the Beatles and Elton John, and for the cover and illustrations for *The Beatles' Illustrated Lyrics* (1969), though forty-two other artists collaborated on the book. His success lies in his ability to invent grotesque compositions which have a great popular appeal.
He has produced several outstanding children's books, and in 1974 received the Children's Book of the Year Award for *The Butterfly Ball*. All his work has an element of the visual fairy tale and his strange designs give tangible forms to universal fantasies. They contain much painstaking detail and a certain "darkness", laying the foundations for Raymond Briggs'* even darker work and the intricacies of Kit Williams*.
Books illustrated include: *The Beatles Illustrated Lyrics* (Macdonald, 1969); D. Francis: *Ann in the Moon* (1970); *The Beatles Illustrated Lyrics, 2* (Macdonald, 1971); W. Plomer: *The Butterfly Ball and the Grasshopper's Feast* (Cape, 1973); R. Adams: *The Ship's Cat* (Cape, 1977); G.E. Ryder: *The Peacock Party* (Cape, 1979); Ted Walker: *The Lion's Cavalcade* (Cape, 1980).
Books written and illustrated: *The Penguin Book of Comics* (with George Perry; Penguin Books, 1967); *Bernie Taupin: The One Who Wrote the Words for Elton John* (Cape, 1976); *Phantasia of Dockland, Rockland and Dodos* (Cape, 1981).
Contrib: *Melody Maker; Mirror Magazine; Observer Magazine; Sunday Times Magazine; Daily Telegraph Magazine; Stern; Vogue.*
Exhib: ICA; The Minories, Colchester; Tooth.

Bibl: Alan Aldridge: *"The Beatles' Illustrated Lyrics"*, *Graphis* no.145 (1969/70): 400-409; Alan Aldridge: *Phantasia* (Cape, 1981); Jennifer Manton: "Return of the Native", *Creative Review* 5, no. 2 (February 1985): 19-23; George Perry: "Alan Aldridge", *Graphis* no.145 (1969/70): 392-99; Morgan; Peppin.
Colour Plate 33

ALDRIDGE, John Arthur Malcolm **1905-1983**
Born on 26 July 1905 in Woolwich and educated at Uppingham School and Oxford University, Aldridge was a landscape painter in watercolours and oils; he spent some time in France, Germany, Italy and Spain; and became a member of the 7 & 5 Society. He had his first one-man exhibition at the Leicester Galleries (1933). He settled in Great Bardfield, Essex, the home town of Edward Bawden*, and was associated with him in the design of wallpaper and textiles. He designed at least one book jacket for John Lehmann — De Quincey's *Recollections of the Lake Poets* (1948) — and illustrated at least two books. *The Life of the Dead* contains twelve illustrations designed by Aldridge and cut on to the block by R.J. Beedham.
He served in the Army during WW2 (1941-45); taught at the Slade from 1949; and was elected ARA (1954); RA (1963).
Books illustrated include: L. Riding: *The Life of the Dead* (Barker, 1933); C.H. Warren: *Adam Was a Ploughman* (Eyre, 1947).
Exhib: RA; Leicester Gall; Upper Grosvenor Galleries (1968).
Collns: Tate.
Bibl: *Water-Colours 1931-68; Exhibition Catalogue* (Upper Grosvenor Galleries, 1968); Tate; Waters; Who.

ALLCOCK, Annette **b.1923**
Born on 28 November 1923 in Bromley, Kent, Allcock (née Rookledge) was educated privately and studied at the West of England College of Art (1941-43) and at other art schools as a part-time student. After WW2 she worked as a film animator, mostly for the Ministry of Information, and did advertising for cinemas. She became a free-lance portrait painter, chiefly of children; she was much influenced by Stanley Spencer*, who was a distant relative. After her two children were born, she concentrated on designing greeting cards for various charities, as that work could be done at home. She has illustrated a number of books for young children, published by Methuen in England, and translated into many languages.
Exhib: RA; RWEA; Bath Contemporary Arts Fair.
Bibl: Who; IFA.

ALLDERIDGE, Brian **fl. 1950s**
An illustrator and graphic artist, Allderidge has designed at least one poster for London Transport (1953). The pen drawings he does for illustrations are in a style somewhat similar to Ardizzone's*, but done with a heavier line.
Books illustrated include: Sir Stephen Tallents: *Green Thoughts* (Faber, 1952); N.M.H. Mitchison: *The Land the Ravens Found* (Collins, 1955); A. Petrides: *State Barges on the Thames* (Evelyn, 1959).

ALLDRIDGE, Elizabeth **fl.1930-1950**
Known mainly for her simple black and white illustrations to the "Worzel Gummidge" books.
Books illustrated include: B.E. Todd: *Worzel Gummidge* (Warne, 1936), *Worzel Gummidge Again* (Warne, 1939); R. Morse: *A Book of Common Trees* (OUP, 1942).
Books written and illustrated include: *The Blue Feather Club* (Warne, 1940).
Bibl: Peppin.

ALLEN, Agnes **d.1959**
Allen was born in London, educated at James Allen's Girls' School, Dulwich, and studied art at Redhill School of Art. She was the author and illustrator of several books for children on historical, everyday matters, her first being *The Story of the Village*, published in 1947. *The Story of Your Home*, illustrated jointly with her husband Jack Allen, as were most of her books, won the Carnegie Medal for 1949.
Books written and illustrated include: *The Story of the Village* (Faber, 1947); *The Story of Our Parliament* (Faber, 1949); *The Story of Your Home* (Faber, 1949); *The Story of the Highway* (Faber, 1950); *The Story of the Book* (Faber, 1952); *The Story of Michelangelo* (Faber, 1953); *Living Under the Tudors and the Stuarts* (Johnston, 1955); *Life in Britain Since 1700* (Johnston, 1956); *The Story of Archaeology* (Faber, 1956).
Bibl: Doyle.

ALLEN, Marian **fl.1917-1948**
Allen did most of her work for Blackwell's of Oxford. She was one of the more important and prolific illustrators of the *Joy Street* annuals, illustrating her own work or the writings of others. She used black and white pen drawings and colour plates, and produced seven jackets for the annuals as well. She wrote several books for children and illustrated them herself, as well as illustrating books for such writers as Compton Mackenzie and Laurence Housman. "In common with many of her contemporaries, [she] specialised in mannered drawings of long-legged children" (Peppin).
Books illustrated include: W. Dawson: *A Peep into Nursery Rhyme Land* (Southampton: Buxeys, 1917); R. Fyleman: *Joy Street Poems* (Blackwell, 1927); C. Mackenzie: *The Unpleasant Visitors* (Blackwell, 1928); L. Housman: *Turn Again Tales* (Blackwell, 1930); C. Mackenzie: *Santa Claus in Summer* (Blackwell, 1931); A. Blackwood: *The Fruit Stones* (Blackwell, 193?); L. Housman: *Cotton Woolleena* (Blackwell, 193?).
Books written and illustrated include: *The Wind on the Downs* (Humphreys, 1918); *Ann and Elizabeth at the Zoo* (Blackwell, 1930); *The Wind in the Chimney* (Blackwell, 1931); *Some of Christ's Children* (Faith Press, 1946); *Anemone Pearl* (Faith Press, 1948); *The Hobgoblin of Great Mummers* (Faith Press, 1948).
Contrib: *Joy Street.*
Bibl: Peppin.

Marian ALLEN *Santa Claus in Summer* by Compton Mackenzie (Blackwell, 1931)

ALLINSON, Adrian 1890-1959
See Houfe

"ALPHA"
See FITTON, James

AMBLER, Christopher Gifford b.1886
Born in Bradford, Ambler was educated at Thornton Grammar
School. On leaving school, he designed and modelled pottery for
the Leeds Fireclay Company, and studied at the Leeds School of
Art in evening classes. He went to London in 1910, and did book
illustrations for four years, before travelling to the US and Canada.
He returned to join the Artists Rifles, fighting in France in WWI.
After the war, he resumed his illustrative work, concentrating
mostly on dogs and horses as his subjects. For a short time in 1929
he illustrated the boys' paper, *Nelson Lee*, before Savile Lumley*
took over. He also wrote and illustrated his own stories as well as
doing horse and dog portraits in various mediums.
Books illustrated include: C.R. Acton: *Exmoor River* (Eyre,
1938); J. Gilroy: *Furred and Feathered Heroes of World War II*
(Trafalgar Publications, 1946); W. Cowper: *The Diverting History
of John Gilpin* (P.M. Productions, 1947); J. Chipperfield: *Storm of
Dancerwood* (Hutchinson, 1948), *Greatheart* (Hutchinson, 1950);
D. Clark: *Black Lightning* (Hutchinson, 1951); J. Chipperfield:
Grey Chieftain (Hutchinson, 1952), *Silver Star* (Hutchinson, 1953),
Greeka (Hutchinson, 1953), *Windruff of Links Tor* (Hutchinson,
1954); D. Clark: *Boomer* (Hutchinson, 1954); J. Chipperfield:
Rooloo (Hutchinson, 1955), *Dark Fury* (Hutchinson, 1956), *Ghost
Horse* (Hutchinson, 1959), *Wolf of Badenoch* (Longmans, 1959),
Grasson (Hutchinson, 1960), *Seokoo of the Black Wind*
(Hutchinson, 1961), *Sabre of the Storm Valley* (Hutchinson, 1962),
Checoba (Hutchinson, 1964), *Boru* (Hutchinson, 1965).
Books written and illustrated include: *Maxims of Marquis* (Eyre,
1937), *Smiler* (Hutchinson, 1945), *Working Dogs* (Hutchinson,
1949), *Ten Little Foxhounds* (Hutchinson, 1950), *Zoolyricks*
(Hutchinson, 1950).
Contrib: *Boy's Own Paper; Nelson Lee; Oxford Annual.*
Bibl: Doyle BWI; ICB2; Peppin.

AMBROSE, Katherine Charlotte 1914-1971
Born in Woking, Surrey, Kay Ambrose's main interest was always
ballet. She travelled with Ram Gopal and his company as art-
director, lecturer and dancer; and from 1952-61 was Artistic
Director with the National Ballet of Canada, designing many of the
company's ballets, including Swan Lake, Giselle, Coppelia and The
Nutcracker. She wrote and illustrated many books on ballet; and
illustrated at least one other book, Francis Brett Young's *The
Christmas Box*. During the 1940s, she did some work for the
magazine *Lilliput*, illustrating stories with small black and white
drawings. She died in London in 1971.
Books illustrated include: A. Haskell: *Ballet* (Penguin, 1938);
F.B. Young: *The Christmas Box* (Heinemann, 1938); E.J. Dent:
Opera (Penguin, 1940), *A Theatre for Everybody* (Boardman,
1945).
Books written and illustrated include: *The Balletomane's Sketch-
Book* (Black, 1941); *The Ballet Lover's Pocket-Book* (Black, 1943);
Ballet Impromptu (Golden Galley Press, 1946); *The Ballet Lover's
Companion* (Black, 1949); *Beginners, Please!* (Black, 1953); *The
Story of Ram Gopal* (Dilworth, 1951).
Contrib: *Lilliput.*

AMBRUS, Victor Gyozo Lazlo b.1935
Born on 19 August 1935 in Budapest, Ambrus studied graphic
design, etching and lithography there at the Hungarian Academy of
Fine Art. After the 1956 uprising, he left Budapest and came to
England in the same year, spending a short time at Farnham School
of Art, and then studied at the RCA (1957-60). Even before
graduation, he began illustrating books, and though he is now
dissatisfied with his first published work, his talent was spotted by
Mabel George of Oxford University Press. His first book for OUP
was published the following year, and now he has illustrated more
than 250. Though he has illustrated many books for such writers as
Rosemary Sutcliff and K.M. Peyton, he is perhaps most highly
regarded for his own brilliantly colourful picture-books. The first

Kay AMBROSE *The Christmas Box* by Francis Brett Young
(Heinemann, 1938)

book he wrote and illustrated himself, *The Three Poor Tailors*, was
published in 1965 and won the 1966 Kate Greenaway Medal. *The
Sultan's Bath* was a commended book for the Kate Greenaway
Medal in 1971, and he won the Medal a second time in 1975 for his
picture book, *Mishka*, and for a non-fiction book, *Horses in Battle*.
A number of his stories reflect his Hungarian background. He has
illustrated a number of non-fiction books for children which are not
purely educational nor simply for pleasure reading. These include
two by Peter Dawlish on *The Royal Navy* (1963) and *The Merchant
Navy* (1966), and one by Edward Fitzgerald on *The British Army*
(1964).
Ambrus designs the jackets for his books with as much care as the
other illustrations. The jacket for *A Glimpse of Eden* (1967), for
example, showing an East African landscape in romantic colours,
entices one inside to the black and white drawings. He has also
done some non-book art work, including the design of postage
stamps, and commissions for the *Reader's Digest*.
Ambrus characterizes his work as realistic, decorative and strongly
influenced by his training as an etcher. "My work appears to have
developed in three directions: black and white illustrations for
children's novels which call for fine line work and a strong graphic
quality; full-colour picture books for young children . . . and non-
fiction historical books with dramatic realistic illustrations based on
research." (ICB4.) His wife, Glenys Ambrus (née Chapman), who
was born in London and was a fellow student at the RCA, is also an

illustrator, with one book of her own to her credit (Wynne Jones'
Chair Person, Hamilton 1989), and has collaborated with her
husband on at least three very colourful and decorative picture
books for children. He was elected RE (1973), FRSA (1978).

Books illustrated include (but see Martin, 1989†): A.C. Jenkins:
White Horses and Black Bulls (Blackie, 1960); R. Guillot: *Master
of the Elephants* (OUP, 1961); W. Mayne: *The Changeling* (OUP,
1961); H. Burton: *Castors Away!* (OUP, 1962); K.M. Peyton:
Windfall (OUP, 1962); M. Treadgold: *The Heron Ride* (Cape,
1962); H. Burton: *A Time of Trial* (OUP, 1963); P. Dawlish: *The
Royal Navy* (OUP, 1963); R. Sutcliff: *The Hound of Ulster* (BH,
1963); E. Blishen: *Miscellany One* (OUP, 1964); E. Farjeon and W.
Mayne: *The Hamish Hamilton Book of Kings* (Hamilton, 1964); E.
Fitzgerald: *The British Army* (OUP, 1964); J. Oliver: *Watch for the
Morning* (Macmillan, 1964); K.M. Peyton: *The Maplin Bird* (OUP,
1964); B. Sleigh: *North of Nowhere* (Collins, 1964); R.B. Willson:
Pineapple Palace (Hart-Davis, 1964); M. Dejong: *The Cat That
Walked a Week* (Lutterworth, 1965); F.M. Pilkington: *The Three
Sorrowful Tales of Erin* (BH, 1965); E.M. Almedingen: *Little Katia*
(OUP, 1966); H. Burton: *No Beat of Drum* (OUP, 1966); P.
Dawlish: *The Merchant Navy* (OUP, 1966); I. Serraillier: *The
Challenge of the Green Knight* (OUP, 1966); R. Sutcliff: *The
Chief's Daughter* (Hamilton, 1967); K.M. Peyton: *Flambards*
(OUP, 1967); H. Griffiths: *Stallion of the Sands* (Hutchinson,
1968); I. Serraillier: *Robin in the Greenwood* (OUP, 1967); D.
Defoe: *Robinson Crusoe* (Nonesuch Press, 1968); R. Manning-
Saunders: *The Glass Man and the Golden Bird* (OUP, 1968); K.M.
Peyton: *The Edge of the Cloud* (OUP, 1969), *Flambards in Summer*
(OUP, 1969); I. Serraillier: *Robin and His Merry Men* (OUP,
1969); R.J. Unstead: *The Story of Britain* (Black, 1969); J. Jacobs:
Celtic Fairy Tales (BH, 1970); A. Cordell: *The Traitor Within*
(Brockhampton, 1971); J. Reeves: *How the Moon Began* (Abelard,
1971); R. Sutcliff: *Tristan and Iseult* (BH, 1971), *The Truce of the
Games* (Hamilton, 1971); E. Mitchell: *Silver Brumby Whirlwind*
(Hutchinson, 1973); R. Sutcliff: *The Changeling* (OUP, 1974); F.
Knight: *True Stories of Spying* Benn, 1975); R.L. Green: *The
Hamish Hamilton Book of Other Worlds* (Hamilton, 1976); R.
Welch: *Ensign Carey* (OUP, 1976); R. Swindells: *The Very Special
Baby* (Hodder, 1977); M.A. Wood: *Master Deor's Apprentice*
(Andersen, 1979); J. Riordan: *Tales of King Arthur* (Hamlyn,
1982); R. Selbie: *The Anatomy of Costume* (Bell, 1982); F.
Richards: *Billy Bunter Comes for Christmas* (Quiller, 1982), *Billy
Bunter Does His Best* (Quiller, 1982), *Billy Bunter of Greyfriars
School* (Quiller, 1982); G. Chaucer: *The Canterbury Tales* (OUP,
1984); R.H. Lloyd: *The Legend of the Fourth Wise Man* (Mowbray,
1984); J. Herriot: *James Herriot's Dog Stories* (Joseph, 1986); *An
Illustrated Treasury of Myths and Legends* (Hamlyn, 1987); C.
Collodi: *Pinocchio* (OUP, 1988).
Books illustrated with Glenys Ambrus include: C. Haywood: *A
Christmas Fantasy* (NY: Morrow, 1972; Brockhampton, 1973); *A
Valentine Fantasy* (NY: Morrow, 1976), *Santa Claus Forever!*
(NY: Morrow, 1983; OUP, 1984).
Books written and illustrated include: *The Three Poor Tailors*
(OUP, 1965); *Brave Soldier Janosh* (OUP, 1967); *The Sultan's
Bath* (OUP, 1971); *Horses in Battle* (OUP, 1975); *Mishka* (OUP,
1975); *Dracula* (OUP, 1980); *Dracula's Bedtime Storybook* (OUP,
1981); *Blackbeard* (OUP, 1982); *Grandma, Felix and Mustapha
Biscuit* (NY: Morrow, 1982; OUP, 1984); *Son of Dracula* (OUP,
1986).
Exhib: RA; RE; throughout world.
Collns: Univ. of Southern Mississippi; Library of Congress.
Bibl: Douglas Martin: *The Telling Line: Essays on Fifteen
Contemporary Book Illustrators* (Julia MacRae, 1989); CA;
Carpenter; Eyre; ICB3; ICB4; Klemin; Peppin; Who.
Colour Plates 30 and 34

AMSCHEWITZ, John Henry **1882-1942**
Born in Ramsgate, Kent, Amschewitz studied at the RA Schools.
He was a portrait painter, muralist, illustrator and cartoonist, who
did much of his work in South Africa. He did murals for the
Liverpool Town Hall and the Royal Exchange, and illustrated a few
books. Settled in South Africa in 1939. He was elected RBA in
1914.
Books illustrated include: *Everyman* (Medici Society, 1911); A.S.

Anne ANDERSON *The Cosy Comfy Book* (Collins, 1920)

Rappoport: *Myths and Legends of Ancient Israel* (three vols.,
Gresham, 1928).
Exhib: FAS; RA; RBA; NEAC.
Bibl: Sarah B. Amschewitz: *The Paintings of J.H. Amschewitz*
(Batsford, 1951); Peppin; Waters.

ANDERSON, Anne **1874-1930?**
Anderson was born in Scotland, spent her childhood in Argentina
but later lived in Berkshire. In 1912, she married Alan Wright*
with whom she collaborated in many books for children. Influenced
by both Jessie M. King (see Houfe) and Mabel Lucie Attwell*, she
illustrated over one hundred books for children of which eleven
only were fairy tales. Matthews declares that these "contain all the
qualities which make her so incomparable a children's artist. . .
from the point of view of creating for the child mind she is perhaps
more important than either [Rackham or Charles Robinson]"
(Matthews, 1979†). Anderson was the real breadwinner of the
marriage, but Alan Wright drew the animals and birds needed in her
compositions, and did it so well that it is difficult to distinguish
them from her work. Her success was due in part to the need for her
to work hard and earn a decent income from her illustrations. Her
illustrations in black and white are decorative and lightly drawn,
and the colour plates are delicately coloured. Beside illustrating
books, she was also an etcher, watercolour painter and designer of
greeting cards.
Books illustrated include: E. Underdown: *Aucassin and Nicolette*
(Nelson, 1911), *The Gateway to Chaucer* (Nelson, 1912); H.
Mansion: *Old Nursery Songs* (Harrap, nd), *Old French Nursery*

Songs (Harrap, nd), *The Sleepy Song Book* (Harrap, nd); E.W. Garrett: *Rip* (1919); Mrs. H. Strang: *My Big Picture Book* (with others) (OUP, 1920); E. Talbot: *The Cosy-Comfy Book* (Collins, 1920); E.C. Eliot: *The House Above the Trees* (Thornton Butterworth, 1921); M. Barnes: *Fireside Stories* (Blackie, 1922); A. Herbertson: *Sing Song Stories* (OUP, 1922); N. Joan: *Cosy-Time Tales* (Nelson, 1922); *Grimm's Fairy Tales* (Collins, 1922); H.C. Andersen: *Fairy Tales* (Collins, 1924); E.W. Garrett: *Wanda and the Garden of the Red House* (OUP, 1924); C. Kingsley: *The Water Babies* (Jack, 1924); P. Morrison: *Cosy Chair Stories* (Collins, 1924); J. Spyri: *Heidi* (Harrap, 1924); Mrs. H. Strang: *Little Rhymes for Little Folk* (OUP, 1925); C. Heward: *Mr. Pickles and the Party* (Warne, 1926); *The Old Mother Goose Nursery Rhyme Book* (Nelson, 1926); S. Southwold: *Once Upon a Time Stories* (Collins, 1927); J.R. Crossland and J.M. Parrish: *The Children's Wonder Book* (Odhams, 1933); *My Big New Book* (with others; Blackie, 1938).

Books written and illustrated include: *The Busy Bunny Book* (with A. Wright; Nelson, 1916), *The Naughty Neddy Book* (with A. Wright; Nelson, c.1918), *Two Bold Sportsmen* (with A. Wright; Nelson, 1918); *The Patsy Book* (Nelson, 1918); *The Violet Book for Children* (with A. Wright; OUP, 1920s?); *The Jackie Jackdaw Book* (Nelson, 1920); *The Jacky Horner ABC* (Dean, 1920); *The Anne Anderson Fairy Tale Book* (Nelson, 1923); *The Cuddly Kitty and the Busy Bunny* (with A. Wright; Nelson, 1926); *The Podgy-Puppy* (with A. Wright; Nelson, 1927); *A Series of Fairy Tales* (Nelson, 1928); *The Fairy Tale Omnibus* (Collins, 1929); *Merry Folk* (Collins, 1930); *Playtime ABC* (Collins, 1930); *The Anne Anderson Picture Book* (Collins, 1943); *The Cosy Corner Book* (Collins, 1943); *Little Folk ABC* (Collins, nd).

Contrib: *Blackie's Children's Annual; Cassell's Children's Annual; Mrs. Strang's Annuals; Playbox Annual; Wonder Annual.*

Bibl: Maleen Matthews: "An Illustrator of the 'Nineties", *Book Collector*, 28, No.4 (1979): 530-44; Felmingham; Peppin.

Florence ANDERSON (as Molly McArthur) *Come Christmas* by Eleanor Farjeon (Collins, 1927)

ANDERSON, Florence Mary **fl. 1914-1930**

A watercolour painter and wood engraver, Anderson also illustrated under her maiden name of Molly MacArthur. She wrote a few books but is best known as an illustrator of children's books and annuals, working in black and white and in colour, and occasionally using simple woodcuts, as in Eleanor Farjeon's *Come Christmas*.

Books illustrated include: M. Sackville: *The Dream Pedlar* (Simpkin, Marshall, 1914), *The Travelling Companions* (Simpkin, Marshall, 1915); C. Chaundler: *The Magic Kiss* (Cassell, 1916); Chrysanthème, pseud: *The Black Princess* (Simpkin, Marshall, 1916); E. Howes: *The Cradle Ship* (Cassell, 1916; and a new edition with different illustrations, Cassell, 1930); D. Black: *Adventures in Magic Land* (Harrap, 1917); S.R. Littlewood: *Valentine and Orson, the Twin Knights of France* (Simpkin, 1919); M. Wynne: *The Adventures of Dolly Dingle* (Jarrolds, 1920); T. Blakemore: *China Clay* (Cambridge: Heffer, 1922); H.De G. Simpson: *Mumbudget* (Heinemann, 1928); E. Farjeon: *Come*

Christmas (Collins, 1927); E. Southwart: *The Password to Fairyland* (Simpkin Marshall, 192?).

Books written and illustrated include: *The Rainbow Twins* (Johnson, 1919), *Woodcuts and Verses* (BM: Dept. of Prints, 1922), *Tribute* (Pelican Press, 1925?).

Contrib: *Cassell's Children's Annual; Cassell's Family Magazine; Little Folks; Tiny Tots.*

Bibl: Peppin.

Colour Plate 35

ANDERSON, Wayne **b.1946**

Born in Leicester, Anderson studied at Leicester College of Art. He went to London and worked for two years as a free-lance artist before moving back to a small Leicestershire village in 1970. He has illustrated calendars, greeting cards and record sleeves as well as contributing to magazines and illustrating books. His first book, Christopher Logue's *Ratsmagic*, was published in 1976. He is very fond of animals, which often make an appearance in his illustrations. His work was the subject of a film, *Anderson's Illustrated Extravaganza.*

Books illustrated include: C. Logue: *Ratsmagic* (Cape, 1976); P. Dickinson: *The Flight of Dragons* (New English Library, 1979); C. Logue: *The Magic Circus* (Cape, 1979); H. Seidel: *The Magic Inkstand* (Cape, 1982); N. Lewis: *A Mouse's Tale* (Cape, 1983).

Contrib: *Daily Telegraph; Honey; Nineteen; Sunday Times; Times.*

Bibl: ICB4.

ANDREWS, Douglas Shapus **1885-1944**

Born in Brighton, Andrews studied art at the Royal College of Art and became a painter of landscapes, an illuminator and illustrator. During WWI he served in the Royal Artillery on the Western Front. He was Head of the Bath School of Art, and later Principal of Derby School of Arts and Crafts, Leeds College of Art and Sheffield College of Art.

Books written and illustrated include: *Bath and Wells: A Sketchbook* (Black, 1920); *Cardiff: A Sketchbook* (Black, 1920).

Exhib: RA; RWA; SGA.

Bibl: Waters.

ANGEL, Marie Felicity **b.1923**

Born in London, Angel was educated at Coloma Convent, and studied art at the Croydon School of Arts and Crafts (1940-45) and the RCA Design School (1945-48). She is a free-lance calligrapher and illustrator, who has done much work for US publishers. Her commission from Harvard College Library to produce bestiaries led to invitations to illustrate children's books for various publishers.

Books illustrated include: A. Fisher: *We Went Looking* (New York: Crowell, 1968); *The Twenty-third Psalm* (New York: Crowell, 1970); A. Fisher: *My Cat Has Eyes of Sapphire Blue* (New York: Crowell, 1973); E. Dickinson: *Two Poems*; B. Potter: *The Tale of the Faithful Dove* (Warne, 1971), *The Tale of Tuppenny* (Warne, 1973); J. Dickey: *Tucky the Hunter* (New York: Crown, 1979).

Books written and illustrated include: *The Art of Calligraphy* (Hale, 1978); *Bird, Beast and Flower* (Chatto, 1980); *A Bestiary; A New Bestiary; An Animated Alphabet* (Harvard College Library); *Painting for Calligraphy* (NY: Overlook Press, 1984); *An Alphabet of Garden Flowers* (Pelham Books, 1987).

Exhib: RA; Society of Scribes and Illuminators.

Collns: V & A; Harvard College Library; Hunt Botanical Library, NY.

Bibl: ICB4; Peppin; Who.

ANGRAVE, Bruce **1914-1983**

Born on 6 December 1914 in Leicester, Angrave was educated at grammar schools in Leicester and Ealing. He studied at Ealing School of Art, Central School of Arts and Crafts, and at the Reimann School of Art under Austin Cooper. He joined the London Press Exchange at the age of nineteen; and worked for a large number of advertising agencies. During WW2, he worked for the Ministry of Information, drawing cartoons and producing posters.

He was a free-lance illustrator and industrial artist and designer, with a particular interest in paper sculpture. His posters for London Transport, of which he did at least eight, include one of Sir

Bruce ANGRAVE *The Mechanical Emperor* (Peter Lunn, 1945)

into Paper (Studio, 1957); *CATalogue* (Collins, 1976); *MagnifiCAT* (Collins, 1977); *TripliCAT* (Collins, 1978); *Angrave's Amazing Autos* (Warne, 1980); *Paper into Sculpture* (Warne, 1981).
Contrib: *Aeronautics; Bystander; Lilliput; Punch; Radio Times; Time and Tide; Woman; Woman's Realm.*
Exhib: Foyle's Galleries.
Bibl: Frederick Laws: "Bruce Angrave", *Graphis* no. 14 (1946): 160-71; Peppin; Who.

ANNESLEY, Lady Mabel Marguerite **1881-1959**
Born in London, she studied art at the Frank Calderon School of Animal Painting (1895), and at the Central School of Art and Design (1920-21), under Noel Rooke*. After the death of her husband in WW1, she moved to Ireland and took over the management of her family's estate. She produced a number of wood-engraved prints, and illustrated a few books in the same medium. Later she travelled widely and emigrated to New Zealand in 1945. Elected SWE (1924).
Books illustrated include: R. Rowley: *County Down Songs* (Duckworth, 1924); A.E. Coppard: *Songs from Robert Burns* (GCP, 1925); R. Rowley: *Apollo in Mourne* (Duckworth, 1926).
Books written and illustrated include: *As the Sight Is Bent* (Museum Press, 1964).
Exhib: One-man shows at Batsford Gallery (1933); in Dublin

" . . . doubts whether passengers would survive"

Christopher Wren and St. Paul's Cathedral, produced by photographing an elaborate paper sculpture. He worked as a television designer, winning a British Academy award; and did much work for major exhibitions, such as the Festival of Britain in 1951 and Expo '70 in Japan. Much influenced by poster designers like Tom Eckersley* and Lewitt-Him*, Angrave's book illustrations are usually decorative and humorous and simply executed, in black and white or in colour. His drawings are always meticulously "finished" and combine the elements of design, form and pattern; and out of this comes his sense of gaiety. An exception to his lightheartedness may be seen in the surrealism of his illustrations for John Keir Cross's *The Other Passenger*. In his books for children, he seems to treat machines with a curious combination of suspicion and enthusiasm. In *Lucy Maroon*, the car is presented as almost human, while in *Lord Dragline*, the dragon is in fact an earth-moving machine which terrifies the inhabitants of a small town but which, in turn, is tamed by two small boys who understand its harmless nature. His later books show that he had fallen prey to the fashion for cat books.
Books illustrated include: J.K. Cross: *The Other Passenger* (Westhouse, 1944); S. MacFarlane: *Lucy Maroon* (Lunn, 1944); A. Huxley: *Caught in the Act* (Putnam, 1953); J. Pudney: *The Book of Leisure* (with others; Odhams, 1957); C. Munnion: *Budget and Buy* (Nelson, 1975).
Books written and illustrated include: *Lord Dragline the Dragon* (Lunn, 1944); *The Mechanical Emperor* (Lunn, 1945); *Sculpture*

Bruce ANGRAVE Illustration for "Tunnel Fancier" by Richard Hough in *A Book of Leisure* edited by John Pudney (Odhams Press, 1957)

Lady Mabel ANNESLEY *County Down Songs* by Richard Rowley (Gerald Duckworth, 1924)

(1933); Wellington (1950) and Nelson, New Zealand (1951); Whitworth (1960).
Collns: BM.
Bibl: Mabel M. Annesley: *As the Sight Is Bent* (Museum Press, 1964); Garrett 1; Peppin; *Shall We Join the Ladies?*

ANSON, Peter Frederick **1889-1975**
Born on 22 August 1889 in Portsmouth, Anson was educated at Wixenford, Wokingham, in Berkshire, and first studied architecture at the Architectural Association (1908-10), before studying art under F. L. Griggs*. He later became a Cistercian monk. An artist in watercolour and black and white, he wrote travel books and essays as well as illustrating books. He was interested mostly in fishing boats and ports, being a founder member of the Society of Marine Artists. He exhibited his work in many galleries, and the National Maritime Museum contains over 200 of his drawings and watercolours of British fishing vessels and ports.
Books illustrated include: Sir D. Blair: *A Medley of Memories* (Arnold, 1919), *A Last Medley of Memories* (Arnold, 1936).
Books written and illustrated include: *A Pilgrim's Guide to Franciscan Italy* (Sands, 1927); *Fishing Boats and Fishing Folk* (Dent, 1930); *Mariners of Brittany* (Dent, 1931); *Fishermen and Fishing Ways* Harrap, 1932); *The Quest of Solitude* (Dent, 1932); *The Catholic Church in Modern Scotland* (Burns, 1937); *The Caravan Pilgrim* (Heath Cranton, 1938); *The Benedictines of Caldey* (Burns, 1940); *How To Draw Ships* (Studio, 1941); *Harbour Head: Maritime Memories* (Gifford, 1944); *Churches; Their Plan and Furnishing* (Milwaukee: Bruce, 1948); *The Church and the Sailor* (Gifford, 1948); *Banff and Macduff: An Official Guide* (Aberdeen: Mearns, 1956); *Underground Catholicism in Scotland* (Montrose: Standard Press, 1970); *Building Up the Waste Places* (Faith Press, 1973).
Exhibs: RSA; RHA; Goupil; Liverpool.
Collns: National Maritime Museum, Greenwich.
Bibl: CA; Johnson; Peppin; Who (1950).

"ANTON" **1912-1970**
Born in Brisbane, Australia, the daughter of an English stockbroker, Beryl Antonia Yeoman (née Thompson) came to live in England in 1915. She studied at the RA Schools (1928-30) and under Stephen Spurrier*. From 1932 to 1937, she worked as a free-lance fashion and commercial artist, under the name "Botterill", and then went on to produce cartoons in partnership with her brother, Harold Underwood Thompson, for magazines such as *Punch*, using the name "Anton". As Price writes "They had a very good sense of humour… The drawing was decorative and the massed blacks showed up well on the page…The world of tall men politely inclining forward, of spivs and forgers and waiters and duchesses and wonderful dining-room tables was calmly, courteously mad" (Price, 1957).
After her brother joined the Royal Navy during WW2, she did all the artwork, though he continued to contribute ideas. "Anton" went on to produce a great many cartoons and to illustrate books and book jackets. She became the first female member of the *Punch* Toby Club.
Elected FRSA; FSIA.
Books illustrated include: V. Mollo: *Streamlined Bridge* (David Marlowe, 1947); V. Graham: *Here's How* (Harvill, 1951); J. Grenfell and V. Graham: *Low Life and High Life* (Harvill, 1952); A. Hilton: *This England* (Turnstile Press, 1952); D. Parsons: *Can It Be True?* (Macdonald, 1953); M. Laski: *Apologies* (Harvill, 1955); D. Parsons: *Many a True Word* (Macdonald, 1958); C. Fullerton: *The Man Who Spoke Dog* (Harvill, 1959); P. de Polnay: *Travelling Light* (Hollis, 1959); E. Cleugh: *Without Let or Hindrance* (Cassell, 1960); S. Mead: *How To Live Like a Lord Without Really Trying* (Macdonald, 1964); E. Parr: *Grafters All* (Reinhardt, 1964); D. Briggs: *Entertaining Singlehanded* (Penguin, 1968).
Books written and illustrated include: *Anton's Amusement Arcade* (Collins, 1947).
Contrib: *Daily Telegraph; Evening Standard; Lilliput; London Opinion; Men Only; Night and Day; Punch; Tatler.*
Bibl: Bateman; Peppin; Price.
See illustration on page 74

ANTRIM, Angela Christina, Countess of Antrim **1911-1984**
Born on 6 September 1911 at Sledmere, Yorkshire (née Sykes), she studied art in Brussels (1927-32) and at the British School at Rome. She was a sculptor, book illustrator and cartoonist. RUA.
Books written and illustrated include: *The Antrim McDonnells* (Belfast: Ulster TV, 1977); *Jam Tomorrow* (1978); *The Visitor's Book* (1978); *The Yorkshire Wold Rangers* (Hutton, 1981).
Contrib: *Country Life; Harpers; Queen; Revue Moderne; Sketch; Tatler; Vogue.*
Exhib: RA; RHA; RUA; one-man shows at Beaux Arts Gallery (1937); Belfast (1949, 1977); Hamet (1972).
Bibl: Waters; Who.

APPELBEE, Leonard **b.1914**
Born on 13 November 1914 in Fulham, London, Appelbee studied at Goldsmiths' College School of Art (1931-35) under Clive Gardiner*, and at RCA (1935-38) under Barnett Freedman*. He is a painter in oils, a wood engraver, lithographer and poet. He is married to the artist Frances Macdonald.
Books written and illustrated include: *That Voice* (Hillside, 1980).
Exhib: RA; Leicester Gall; FAS.
Collns: Tate; National Galleries of NSW and Victoria.

APPLETON, Honor Charlotte **1879-1951**
Born on 4 February 1879 in Brighton, one of four children, Appleton painted watercolours while she was still a young girl. She attended the Art branch of the Kensington Schools before going to Frank Calderon's School of Animal Painting and then on to the RA Schools in 1901.
She illustrated her first book, *The Bad Mrs Ginger*, in 1902, while still a student at the RA Schools, and her second, William Blake's *Songs of Innocence* in 1910. Over the next forty years she illustrated more than one hundred and fifty books for children, using delicate watercolours and black and white pen drawings, and occasionally pen and wash, as in her illustrations to Tyrell's books about

"ANTON" *Anton's Amusement Arcade* (Collins, 1947) "Seems quite a good show at the Palladrome — what about printing a couple of tickets?" (originally published in *Punch*)

squirrels. Appleton is probably best known for her illustrations to the "Josephine" books, written by Mrs. Henry Cowper Cradock. The soft colours she used for this series are ideally suited to the gentle stories of a little girl playing with her family of dolls, including a sailor-suited duck called Quackie-Jack who appears in many illustrations. The illustrations are particularly interesting when a floor-level point of view is used, with adults appearing only from the knees down, which seemed to appeal to young children who naturally had the same perspective. Some have criticized her watercolour illustrations for such books as the *Songs of Innocence* and the fairy tales for their "vague and pretty romanticism" and for their lack of definition, and praised her black and white drawings as much stronger (Whalley). Another writer however points out that, compared to many of her contemporaries, Appleton's illustrations

"capture the air of innocence inherent in children without clouding it in sentimentality" (Halpin, 1990†).

Appleton also painted in watercolour, and exhibited at the Royal Academy. In 1952 the Hove Public Library exhibited seventy-two original paintings of her book illustrations, and the exhibition was later displayed in galleries around Britain. The artist unhappily did not see this exhibition, for she died on 30 December 1951 in Brighton where she had lived all her life.

Books illustrated include (but see Halpin, 1990†): *Dumpy Proverbs* (Grant Richards, 1903); W. Blake: *Songs of Innocence* (Herbert and Daniel, 1910); L. and F. Littlewood: *Our Nursery Rhyme Book* (Herbert, 1912); E. Tyrrell: *How I Tamed My Wild Squirrels* (Nelson, 1914); C. Dickens: *A Christmas Carol* (Simpkin Marshall, 1914); E. Tyrrell: *More About Squirrels* (Nelson, 1916);

Honor C. APPLETON "Josephine holds out pieces of paper for Granny to choose" from *Josephine Is Busy* by Mrs H.C. Cradock (Blackie and Sons, 1918) Original pen and ink drawing, signed with initials. By permission of Chris Beetles Limited

H.C. Cradock: *Josephine and Her Dolls* (Blackie, 1916), *Josephine's Happy Family* (Blackie, 1916), *Josephine Is Busy* (Blackie, 1918), *Josephine's Birthday* (Blackie, 1919), *Where the Dolls Lived* (SPCK, 1919); C. Perrault: *Fairy Tales* (Simpkin Marshall, 1919); H. C. Cradock: *Josephine, John and the Puppy* (Blackie, 1920); C. Chaundler: *The Thirteenth Orphan* (Nisbet, 1920), *Snuffles for Short* (Nisbet, 1921); H.C. Cradock: *Josephine Keeps School* (Blackie, 1925); S.C. Bryant: *Epaminondas* (Harrap, 1926); H.C. Cradock: *The Bonny Book of Josephine* (Blackie, 1926), *Josephine Goes Shopping* (Blackie, 1926); M.C. Edgar: *A Treasury of Verse for School and Home* (Harrap, 1926); H.C. Cradock: *Josephine's Christmas Party* (Blackie, 1927), *Josephine Keeps House* (Blackie, 1931); A. Cruse: *The Golden Road to English Literature* (Harrap, 1931); S. Southwold: *The Book of Animal Tales* (Harrap, 1932); *The Children's Sinbad* (Harrap, 1935); *The Children's Don Quixote* (Harrap, 1937); H.C. Cradock: *Josephine's Pantomime* (Blackie, 1939), *Josephine Goes Travelling* (Blackie, 1940); F.H. Lee: *Children's Book of Heroines* (Harrap, 1940); A. Forrester: *The Children's Story of Roland* (Harrap, 1942), *The Children's Book of Irish Legends* (Harrap, 1944); F.H. Lee: *The Children's Tales from Other Lands* (Harrap, 1946).

Books written and illustrated include: *The Bad Mrs. Ginger* (Grant Richards, 1902); *Babies Three* (Nelson, 1921); *Me and My Pussies* (Nelson, 1924); *Towlocks and His Wooden Horse* (Chatto, n.d.); *Mary Was Five and The Black Rock* (Nelson, 1950).

Exhib: RA; Hove Public Library (1951).

Bibl: Fiona Halpin: *Honor C. Appleton (1879-1951)* (Exhibition catalogue, Chris Beetles, 1990); Doyle; Felmingham; Peppin; Whalley.

ARCHER, Janet b.1942

Archer was born in Tynemouth, Northumberland, educated at Tynemouth Grammar School and studied at Newcastle College of Art. She went to London and worked there for fourteen years as a free-lance illustrator; travelled through Europe and Asia; and then returned to the north of England. She used two-colour lithographs for her illustrations to *Pather Panchali* (1971).

Books illustrated include: C. Zolotow: *Summer Is . . .* (Abelard, 1967); B. Banerji: *Pather Panchali* (Folio Society, 1971); F. Stuart: *A Medley of Folk Songs* (Longman, 1971), *Stories of Britain in Song* (Longman, 1972).

Books written and illustrated include: *Puffins for Pleasure* (Puffin, 1976).

Bibl: Folio 40; ICB4.

ARDIZZONE, Edward Jeffrey Irving 1900-1979

Ardizzone was born on 16 October 1900 in Haiphong, Tonkin, but the family returned to England a few years after his birth. He was educated at Clayesmore School, and worked as a clerk at the Eastern Telegraph Company in the City of London while he studied art by evening classes at the Westminster School of Art under Bernard Meninsky (1921-26). He became a free-lance artist in 1927 and his commissions included drawing for many magazines. His drawings frequently appeared in the *Radio Times*, the first in 1932, which included a coloured cover for the Christmas issue. He continued to work for the magazine until well into the 1950s. His first contribution to the *Strand Magazine* was a series of coloured drawings of Londoners (1942); he drew all the coloured covers for the magazine (except one) from October 1946 to December 1947. Ardizzone's best commercial work appeared in periodicals, but he also did book jackets for many publishers; a series of drawings for the whisky firm, Johnny Walker; posters for the London Transport; menus and wine labels and lists; and a birthday greetings telegram.

He was an official war artist, 1940-45; taught illustration at Camberwell School of Art, 1948-52; worked for UNESCO in India, 1952-53; taught at the Royal College of Art, School of Etching, 1953-61.

Ardizzone illustrated his first book in 1929 and, using line drawings and wash, became one of the best loved and most prolific book artists of the period, illustrating well over 170 books. One grudging critic has complained that he "could have done many more wonderful single illustrations and books of them, in black and white as well as in colour, if only he had been less productive and more demanding of himself at all times" (Hodnett, 1988). He held strong

The Public Bar at the George

Edward ARDIZZONE *Back to the Local* by Maurice Gorham (Percival Marshall, 1949)

personal convictions on the illustrator's art and expressed these views both in speech and in writing (see Ardizzone, 1958†). He was strongly opposed to the view that illustration could be merely decoration or graphic embellishment, and believed that illustrators need special skills that many artists, however good, may not possess. For him, the relationship of drawing and words had to be very close, for he felt that the illustrator's task was to create a visual counterpart to the world of the writer. He must be able to read and understand the meaning and implications of the book he is to illustrate; and he must then have the ability to draw from memory, to draw small and to compose with figures and place them together in space. Ardizzone's illustrations are generally concerned with contemporary life untouched by political, religious or ideological conflicts. His approach is not satiric or moralistic but autobiographical, and his drawings are representational and humorous and demonstrate his affection for people.

My Uncle Silas, published in 1939, shows how successful Ardizzone's line drawings were, not only as illustrations to the story but as a decorative, integral part of the design of the page. In contrast, *The Local*, published in the same year, is illustrated with four-colour lithographs, inserted as separate plates. His illustrations for editions of Dickens, Thackeray and Trollope, produced in the period 1947-65, are among his finest work. In particular, his Trollope (*The Warden*, 1952, and *Barchester Towers*, 1953) for Oxford University Press, is outstanding. The modern author with whom many will first associate Ardizzone is Eleanor Farjeon. It has been written of his illustrations for *The Little Bookroom* that "For variety of mood and sensitivity of interpretation, he has not sur-

passed them." His reputation is firmly grounded, however, on the books he wrote and illustrated for children, including *Little Tim and the Brave Sea Captain* (1936), *Tim All Alone* (1956), *Diana and Her Rhinocerous* (1964), and *Tim's Last Voyage* (1972) (see illustration on page 56. He was awarded the Kate Greenaway Medal (1956) for *Tim All Alone* and *Tim's Last Voyage* was selected as one of the *New York Times*' Best Illustrated Children's Books of the Year for 1973. Eleanor Farjeon's *The Little Bookroom*, containing some of his best illustrations, won the Carnegie Medal (1955) and the Hans Christian Andersen Medal (1956).

Ardizzone was elected ARA (1962); RA (1970); and he was made CBE in 1971. He died on 8 November 1979.

Books illustrated include (but see Alderson, 1972): S. Le Fanu: *In a Glass Darkly* (Davies, 1929); G. Crabbe: *The Library* (De La More Press, 1930); P. Bloomfield: *The Mediterranean, an Anthology* (Cassell, 1935); M. Gorham: *The Local* (Percival Marshall, 1939); H.E. Bates: *My Uncle Silas* (Cape, 1939); C. Dickens: *Great Expectations* (New York: Limited Editions Club, 1939); W. de la Mare: *Peacock Pie* (Faber, 1946); *The Poems of François Villon* (Cresset Press, 1946); J. Bunyan: *The Pilgrim's Progress* (Faber, 1947); *Charles Dickens' Birthday Book* (Faber, 1948); M. Gorham: *Showmen and Suckers* (Percival Marshall, 1951) and *Londoners* (Percival Marshall, 1951); J. Reeves: *The Blackbird in the Lilac* (OUP, 1952); A. Trollope: *The Warden* (OUP, 1952), *Barchester Towers* (OUP, 1953); E. Farjeon: *The Little Bookroom* (OUP, 1955); J. Reeves: *Prefabulous Animiles* (Heinemann, 1957); D. Defoe: *Robinson Crusoe* (Nonesuch Press, 1960); C. Gough: *Boyhoods of Great Composers: Book 1* (OUP, 1960) and *Book 2* (OUP, 1963); E. Farjeon: *Eleanor Farjeon's Book* (Penguin, 1960), and *Mrs. Malone* (OUP, 1962); C. Brand: *Naughty Children* (Gollancz, 1962), and *Nurse Matilda* (1964); C. King: *Stig of the Dump* (Puffin, 1963); E. Farjeon: *Old Nurse's Stocking Basket* (OUP, 1965); F.P. Nichols: *The Milldale Riot* (Ginn, 1965); W.J. Lederer: *Timothy's Song* (Lutterworth, 1966); *The Oxford Illustrated Old Testament* (five vols., with others; OUP, 1968-9); G. Greene: *The Little Fire Engine* (BH, 1973); J. Bunyan: *The Land of Beulah* (BH, 1974); *Ardizzone's Kilvert* (Cape, 1976).

Books written and illustrated include: *Little Tim and the Brave Sea Captain* (OUP, 1936); *Lucy Brown and Mr. Grimes* (OUP, 1937; redrawn and reissued by BH, 1970); *Baggage to the Enemy* (Murray, 1941); *Pictures on the Pavement* (Joseph, 1955); *Tim All Alone* (OUP, 1956); *Tim and Lucy Go to Sea* (OUP, 1958); *Diana and Her Rhinoceros* (BH, 1964); *Sarah and Simon and No Red Paint* (Constable, 1965); *Tim and Ginger* (OUP, 1965); *The Young Ardizzone* (Studio Vista, 1970); *Tim's Last Voyage* (OUP, 1972); *The Diary of a War Artist* (BH, 1974).

Contrib: *Radio Times; Punch; Saturday Book; Strand Magazine; London Magazine.*

Exhib: Bloomsbury Gallery; Leger Galleries; Leicester Gall; Mayor Gallery; V & A (retrospective 1973); Middlesborough Art Gallery.

Collns: Tate; IWM; V & A.

Bibl: Brian Alderson: "Edward Ardizzone; a Preliminary Hand-List of His Illustrated Books 1929-1970", *The Private Library*, 2nd series, v.5 no.1, Spring 1972; Edward Ardizzone: "The Born Illustrator", *Motif* 1 (1958): 37-44; Edward Booth-Clibborn: *My Father and Edward Ardizzone* (Patrick Hardy Books, 1983); Charles Hennessy: "Recent Graphic Work by Edward Ardizzone", *Image*, No.6 (Spring 1951): 45-64; *Ardizzone by the Sea* (Exhibition Catalogue, Middlesbrough Museums, 1982); J.M. Richards: "Edward Ardizzone", *Signature*, No.14 (May 1940): 22-28; Gabriel White: *Edward Ardizzone* (Bodley Head, 1979); Carpenter; Driver; Harries; Hodnett; ICB; ICB2; ICB3; ICB4; Jacques; Lewis; Peppin; Ryder; Tate; Usherwood; Waters. See also illustration on page 56

ARIS, Ernest Alfred **1882-1963**
See Houfe
Born 22 April 1883, Aris first studied at Bradford School of Art, and in 1900 went to the Royal College of Art. He began his career as a portrait painter, for a short time taught art at school (1909-12), and did a lot of commercial work. He contributed children's illustrations to the *Graphic* and later became a prolific writer and illustrator of children's books, sometimes using the pseudonym

"Robin A. Hood", mostly dealing with small animals and birds.

Books illustrated include: M.C. Gillington: *The Hole in the Bank* (OUP, 1918); F. Saint Mars: *The Trail of the Wind* (Nisbet, 1923); H. Ould: *New Plays from Old Stories* (1924); M. Collier: *Books for Children* (OUP, 1926); S. Southwold: *Yesterday and Long Ago* (Collins, 1928); H.M. Batten: *Zoo and Animal Friends* (Collins, 1929); R. Bennet: *The Adventures of Spot* (OUP, 1933); L. Wood: *The Smiling Rabbit and Other Stories* (Harrap, 1939), *The Travelling Tree and Other Stories* (Harrap, 1943); J. Thornicroft: *Dawn the Faun* (Ward Lock, 1948).

Books written and illustrated include (but see Peppin): *The Log Books* (Shaw, 1912); *Pirates Three* (Cassell, 1914); *Bunnikins Brighteyes the Indian* (Gale & Polden, 1916); *Rock-a-Bye Stories* (1919); *A Bold Bad Bunny* (Partridge, 1920); *Twinkle Mouse of Cornstalk Cottage* (Partridge, 1933); *Famous Animal Tales* (Harrap, 1935); *The Brambledown Tales* (Ward Lock, 1946); *The Ernest Aris Nature Series*, 4 parts (Fountain Press, 1948).

Contrib: *Blackie's Girl's Annual; Cassell's Children's Annual; Graphic; Little Folks; Playbox Annual; Printer's Pie.*

Published: *The Art of the Pen* (Pen-in-Hand Publishing, 1948).

Exhib: RA; RBA; RI; RWS.

Bibl: Peppin; Waters.

ARKLESS, Lesley Graham **b.1956**
Born on 30 January 1956 in Northumberland, Arkless was educated at the Church High School for Girls, Newcastle-upon-Tyne, and studied at West Surrey College of Art and Design (1974-78).

Books written and illustrated include: *What Stanley Knew* (Andersen Press, 1983).

Bibl: Who.

ARLOTT, Norman Arthur **b.1947**
Born on 15 November 1947 in Reading, Arlott was educated at

Maxwell ARMFIELD *An Artist in Italy* (Methuen, 1926)

Stoneham Boys School, Reading, and had no formal art training. The artists whose work has influenced Arlott include Archibald Thorburn*, C.F. Tunnicliffe*, and Robert Gillmor*. He is a freelance wildlife artist in watercolour and an author. He has illustrated over fifty books, and is one of the team of artists working on a major project, *The Birds of the Palearctic*, to be published in seven volumes by OUP. He was winner of the *British Birds* magazine "Bird Illustrator of the Year" for 1980 and 1981, and was appointed the judge of the competition for 1982. He has also designed postage stamps for many Commonwealth countries, including the Bahamas, Malawi and the British Virgin Islands.

Books illustrated include: *Minsmere – Portrait of a Bird Reserve* (Hutchinson, 1977); J.G. Williams: *A Field Guide to the Birds of East Africa* (Collins, 1980); R. Fitter and A. Fitter: *The Complete Guide to British Wildlife* (Collins, 1981); K. Snow: *A Garden of Birds* (World's Work, 1981); J. Flegg: *Just a Lark!* (Croom Helm, 1984); P. Holden and J. Sharrock: *A First Book of Birds* (Macmillan, 1984); *Threatened Birds of Africa and Related Islands* (ICBP, 1985); *Rare Birds of the World* (Collins, 1988).

Books written and illustrated include: *Norman Arlott's Bird Paintings* (World's Work, 1982).

Contrib: *Bird Life; Bird Study; Birds; British Birds; Connections; Home & Freezer Digest; Natural World.*

Exhib: SWLA; Wildlife Art Gallery, Lavenham; Brotherton Gallery (1982); London Zoological Society (1988).

Bibl: Who; IFA.

ARMFIELD, Maxwell Ashby **1881-1972**
See Houfe
Born in 1881 at Ringwood, Hampshire, Armfield was educated at Leighton Park School and studied at the Birmingham School of Art, under Arthur Gaskin and Joseph Southall*. He started by making small paintings and illustrations mostly in watercolour but with experiments in tempera, in which medium Southall had pioneered a revival. He moved to Paris to study and shared a studio with Norman Wilkinson of Four Oaks* and Keith Henderson*. He returned to London in about 1905 and exhibited his paintings at the Rowley Gallery in that year and at the Carfax Gallery in 1908. He illustrated some books on Italy for Methuen and started contributing drawings to the *Christian Science Monitor*. In 1909 he married Constance Smedley, a novelist and playwright, and in collaboration with her over the next thirty years produced a prodigious amount of work. In addition to book illustration, Armfield also did costume designs, produced plays and did much advertising work.

A regular visitor to the Armfield home was McKnight Kauffer*, whose portrait Armfield painted, and Kauffer much admired Armfield's illustrations in flat colours, which led to Armfield illustrating William Morris' *Life and Death of Jason* and Vernon Lee's *Ballet of the Nations*. Kauffer's enthusiasm for the work of Cézanne and Van Gogh influenced Armfield considerably, as did the arts and crafts of the North American Indian, the influence of which Armfield claimed was of permanent value to his work on book illustrations.

He travelled extensively in the USA and lived there for seven years, finding a better appreciation of his work among artists in that country. He wrote and lectured on art and stage design, and wrote poetry.

The Armfields returned to England and published a series of *Greenleaf Rhythmic Plays* and textbooks, organised the Group of New Forest Painters, and in 1927 opened the Greenleaf Theatre Studio in London. Their pageant play, *The King's Progress*, was performed at the Royal Albert Hall by the English Folk Dance Society.

In 1941 Armfield's wife died, and he embarked on extensive studies covering a vast field of occult and theosophical subjects, and he published books on these subjects, and on design and colour. In 1944 there was a retrospective exhibition of his work at the RWS Galleries. He suffered a heart attack in 1953, but recovered and continued to exhibit at the RA, RWS and the Leicester Galleries. He died on 25 January 1972.

He was elected ARWS (1937), RWS (1941) and Hon. RWS (1961).

Books illustrated include: Augustine: *The Confessions* (Chatto, 1909); E. Hutton: *Rome* (Methuen, 1909); F. Lees: *A Summer in*

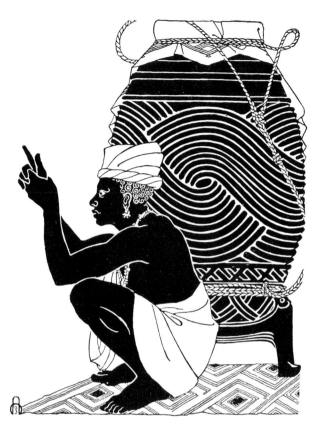

Maxwell ARMFIELD *Tales from Timbuktu* by Constance Smedley (Chatto & Windus, 1923)

Touraine (Methuen, 1909); C. Armfield: *The Flower Book* (Chatto, 1910); *Fairy Tales from Hans Andersen* (Dent, 1910); *Aucassin and Nicolette* (Dent, 1910); C. Armfield: *Sylvia's Travels* (Dent, 1911); H.R. Angeli: *Shelley and His Friends in Italy* (Methuen, 1911); E. Hutton: *Venice and Venitia* (Methuen, 1911); A. Gray: *Cambridge and Its Story* (Methuen, 1912); E. Hutton: *The Cities of Lombardy* (Methuen, 1912); H.C. Andersen: *The Ugly Duckling and Other Tales* (Dent, 1913); D.A. Mackenzie: *Indian Fairy Stories* (Blackie, 1915); V. Lee: *The Ballet of the Nations* (Chatto, 1915); W. Morris: *The Life and Death of Jason* (Headley, 1915); C. Armfield: *Greenleaf Rhythmic Plays* (Duckworth, 1915-22), *Wonder Tales of the World* (Harcourt, Brace & Howe, 1920), *The Armfield's Animal Book* (Duckworth, 1922); W. Shakespeare: *The Winter's Tale* (Dent, 1922); C. Armfield: *Tales from Timbuktu* (Chatto, 1923), *The Blue Bus Route* (OUP, 1927).

Books written and illustrated: *An Artist in America* (Methuen, 1925); *An Artist in Italy* (Methuen, 1926); A Manual of Tempera Painting (Allen & Unwin, 1930); *Tempera Painting Today* (Pentagon Press, 1946).

Published: *The Hanging Garden and Other Verse* (Simpkin, Marshall, 1914); *White Horses* (Blackwell, 1923); *Crown of Gold* (Pentagon Press, 1945); *The Tarot for Today* (Zeus Press, 1963); *The Wonder Beyond* (Regency Press, 1969).

Contrib: *Joy Street.*

Exhib: RA; Rowley Gallery; Carfax Gallery; Leicester Galls; FAS.

Collns: V & A; Tate; BM; NPG; Minerva Gallery, Bath; Medici Galleries, Bournemouth; Derby; Musée de l'Art Moderne, Paris; Metropolitan Museum, New York.

Bibl: *Homage to Maxwell Armfield* (Fine Art Society, 1970); *Maxwell Armfield, 1881-1972* (Southampton Art Gallery, 1972); Felmingham; Peppin; Waters.

John ARMSTRONG *The Week-End Calendar Book* edited by
G. Barry (Geoffrey Bles, 1932)

ARMITAGE, Joshua Charles **b.1913**
Born on 26 September 1913 in Hoylake, Cheshire, Armitage
studied at Liverpool School of Art (1929-36). He taught from 1936
to 1950, with a break while he served in the Royal Navy during
WW2. He is a free-lance artist who has done many illustrations for
magazines such as *Punch* and *Lilliput*, and for many books for
adults and children, including more than fifty Wodehouse titles.
Apparently a keen golfer, many of his watercolour drawings have
golf as their subject, and he has written and illustrated one book on
the subject. Price writes: "The clarity of his method made it well
adapted to drawing buildings. His people had normal skeletons ...
There was space and solidity about his pictures that contrasted
effectively with the odd, private suddenness of his humour." He has
designed covers for Penguin Books since 1968, and his illustrations
were still used on the Penguin covers of their Wodehouse reissues
in the 1980s (see illustration on page 39). He often signs his work
"Ionicus".
Books illustrated include: W. Awdry: *Belinda the Beetle*
(Brockhampton, 1958); R.G.G. Price: *How to Become Headmaster*

(Blond, 1960); G. Sparrow: *How to Become a Millionaire* (Blond,
1960); C. Collodi: *The Adventures of Pinocchio* (Hutchinson,
1960); R.G.G. Price: *Survive with Me* (Blond, 1962); E. Blishen:
Town Story (Blond, 1964); O. Nash: *A Boy and His Room* (Dent,
1964), *The Untold Adventures of Santa Claus* (Dent, 1965); B.
Willard and F. Howell: *Junior Motorist* (Collins, 1969); A.
Lawrence: *Tom Ass* (Macmillan, 1972), *The Half-Brothers*
(Macmillan, 1973); I. Lilius: *Gold Crown Lane* (OUP, 1976), *The
Goldmaker's House* (OUP, 1977); G. Trease: *The Claws of the
Eagle* (Heinemann, 1977); P.G. Wodehouse: *Sunset at Blandings*
(Chatto, 1977) and many other titles; A. Lawrence: *The Good Little
Devil* (Macmillan, 1978); I. Lilius: *Horses of the Night* (OUP,
1979); D. Kossoff: *Sweet Nutcracker* (Robson, 1985).
Books written and illustrated include: *100th Open Championship
at Royal Birkdale*.
Contrib: *Amateur Gardening; Daily Mirror; Dalesman; Evening
Standard; Lilliput; Punch; Tatler*.
Bibl: Peppin; Price; Who.

ARMOUR, George Denholm **1864-1949**
See Houfe
Books illustrated include: J. Masefield: *Reynard the Fox* (Heine-
mann, 1921); R.S. Surtees: *Thoughts on Hunting* (Blackwood,
1925); Lord W. de Broke: *The Sport of Our Ancestors* (Constable,
1925); R. Ball: *Broncho* (Country Life, 1930), *Penny Farthing*
(Country Life, 1931); R.C. Simpson: *Fish – and Find Out* (Black,
1937).
Contrib: *Punch; Tatler*.
Bibl: G. D. Armour: *Bridle and Brush* (Eyre & Spottiswoode,
1937); Peppin; Titley; Waters.

ARMSTRONG, John **1893-1973**
Born on 14 November 1893 at Hastings, Armstrong was educated
at St. John's College, Oxford (1912-13), and studied at St. John's
Wood School of Art (1913-14). He served in the Royal Artillery
during WW1 and then returned to St. John's Wood School. A
painter, muralist, stage and film designer, and book illustrator, he
exhibited at the Leicester Galleries and became a member of Unit
One in 1933. He designed at least two covers for the Hogarth Press
— William Plomer's *Sado* (1931) and *O Providence* (1932); and
designed posters, incuding four for the GPO in 1934-5. His
theatrical work was done for the Old Vic, and Sadler's Wells; and
he worked on films for Sir Alexander Korda. During WW2 he was
an official war artist (1940-45).
Books illustrated include: G. Barry: *The Week End Calendar*
(Bles, 1932).
Exhib: Leicester Galls.
Collns: Tate.
Bibl: Harries; Tate.

ARMSTRONG, Nichola Christina **b.1961**
Born in 1961, Armstrong studied art at the West Surrey College of
Art and Design and at St. Martin's School of Art. Her first
published illustrations appeared in *The Pond* (1985).
Books illustrated include: *The Pond* (1985); G. White: *A Selborne
Year* (Webb & Bower, 1986).

ARNOLD, ANN **b.1936**
Born in Newcastle-on-Tyne, Arnold studied at Epsom School of
Art (1956-59) and worked as an art therapist in Epsom (1959-69).
She became a full-time painter in 1970, and is one of a group of
seven artists, the Brotherhood of Ruralists, who have a particular
concern for English artistic skills and craftsmanship and who see
their work as the celebration of a vital tradition in English art and
its ultimate source, the spirit of the countryside. The leader of the
group was Peter Blake* (see entry for more details); and the other
artists are Graham Arnold*, Jann Howarth, David Inshaw*, Annie
Ovenden*, and Graham Ovenden*. All have illustrated covers to
the paper editions of the "Arden Shakespeare", published by
Methuen in the 1980s. In 1982, Ann Arnold profusely illustrated
Clare's Countryside, a selection of John Clare's poems. She visited
Northamptonshire to paint the scenes and landscapes described by
the poet; her sketches and watercolours are used to illustrate the
book.

She has exhibited widely, including in group shows of the Brotherhood, and has had single-artist exhibitions in Bath (1979) and at the New Grafton Gallery, London (1981).
Books illustrated include: B. Patten, editor: *Clare's Countryside* (Heinemann, 1982).
Exhib: Festival Gallery, Bath; New Grafton Gallery.
Bibl: Nicholas Usherwood: *The Brotherhood of Ruralists* (Lund Humphries, 1981).
Colour Plate 23

ARNOLD, Graham **b.1932**
Born in Beckenham, Arnold studied at Beckenham School of Art (1947-52) and RCA (1955-58). After travelling on a scholarship through Italy, he taught at various art schools from 1961 to 1973. He started painting full-time in 1974, and became a member of the Brotherhood of Ruralists, founded at Peter Blake's house in 1975 (see entry under Blake).
Like other members of the Brotherhood, Arnold has illustrated covers to the new Arden Shakespeare from Methuen, and with other members has illustrated books published by the Redlake Press in Clun. He has exhibited widely, including one-man shows in 1976, 1979 and 1981.
Books illustrated include: E. Machin: *Nine Poems* (with others, Redlake Press, 1987).
Exhib: Brillig Arts Centre (1979); Festival Gallery, Bath (1976, 1981).
Bibl: Nicholas Usherwood: *The Brotherhood of Ruralists* (Lund Humphries, 1981).

ASH, Jutta **fl. 1973-**
Books illustrated include: K. McLeish: *Chicken Licken* (Longman, 1973); N. Benchley: *Feldman Fieldmouse* (Abelard, 1975); M.E. Allen: *Trouble in the Glen* (Abelard, 1976); P. Barton: *A Week Is a Long Time* (Abelard, 1977); N. Lewis: *Jorinda and Joringel* (Andersen Press, 1984), *Wedding Birds* (Andersen Press, 1986).
Books written and illustrated include: *Rapunzel* (Andersen Press, 1982); *The Frog Prince* (Andersen Press, 1983).

ATKINSON, Leslie **fl. 1946-1972**
An illustrator mostly of children's books, who used a sketchy but lively style somewhat reminiscent of E.H. Shepard*. He produced evocative landscape drawings for *This Unknown Island* (1946), a book for adults. Atkinson was probably also the artist responsible for the delicately drawn designs for the front boards and jackets of the Crown Classics series, published by the Grey Walls Press in the late 1940s and early 1950s. There are about six different designs used for the more than thirty small volumes in this series.
Books illustrated include: S.P.B. Mais: *This Unknown Island* (Falcon Press, 1946); C. Knowles: *Hua Ma* (Falcon Press, 1947); L.M. Alcott: *Little Men* (Ingram, 1948); E. Trevor: *Badger's Beech* (Falcon Press, 1948), *The Wizard of the Wood* (Falcon Press, 1948); D. Defoe: *Journal of the Plague Year* (Falcon Press, 1950); E. Trevor: *Mole's Castle* (Falcon Press, 1951), *Sweethollow Valley* (Falcon Press, 1951); G. Trease: *Seven Kings to England* (Heinemann, 1955); E. Trevor: *Badger's Wood* (Heinemann, 1958); R. Ainsworth: *Roly the Railway Mouse* (Heinemann, 1967); G. Trease: *Ship to Rome* (Heinemann, 1972).
Bibl: Roderick Cave: "The Grey Walls Press Crown Classics" *Private Library* 4s., 2 No. 3 (Autumn 1989): 100-17; Peppin.

ATTWELL, Mabel Lucie **1879-1964**
See **Houfe**
Born on 4 June 1879 at Mile End in London, Attwell studied art at Heatherley's School of Art and St. Martin's School of Art, but completed neither course. Her drawings based on imaginary subjects were accepted by such magazines as the *Bystander* and the *Tatler*; and she received commissions from W. & R. Chambers, and illustrated ten books for them (1905-13). In 1906 she designed her first poster, for London Underground, and in 1911 began designing postcards and greeting cards for Valentine's, continuing this sort of commercial art for the rest of her life. (She had married Harold Earnshaw* in 1908.) Her first "gift book" was done for Raphael Tuck in 1910.

Her pictures of chubby, winsome children enjoyed a tremendous vogue in magazines and books for the young; and her annuals, cards, posters, bathroom plaques and all sorts of ephemeral items continued to be incredibly popular through the thirties and into the forties. She was never short of work, and in 1943 she started the black and white strip cartoon for *London Opinion* called "Wot a Life". She moved to Cornwall in 1945 with her son, Peter (her daughter Peggy Wickham became a talented artist and illustrator), and was kept busy by Valentine's with her *Lucie Attwell Annuals*. She died on 5 November, 1964.
Some of her earlier illustrations for books were particularly appealing, but later works have been criticized for providing little variety in concept or technique. "Perhaps the most successful book of her career — the 1910 *Alice* — is the one in which she was able to combine the linear strengths of [John Hassall and the brothers Charles and William Heath Robinson] with her own feeling for child gesture and homely detail, but before long she began to exploit the latter in a way which, while leading to wide commercial success, was at the cost of compositional values and the integrity of illustration and text to be illustrated. In such books as *The Water Babies*, *Peter Pan*, and *Grimm's Fairy Tales* the graphic design was weakened through the introduction of too many extraneous elves and gauzy fairies, while the content of the portraiture in the pictures often ran counter to the intentions of the text" (DNB). Carpenter has written in the same vein — "Such genuine talent as she had was soon submerged in the mediocrity of endless pictures of chubby, dimpled babies and infants, so that her name became synonymous in Britain with the sentimentalization of childhood."
Elected SWA (1925).
Books illustrated include (but see Beetles, 1988†): M. Baldwin: *That Little Lamb* (Chambers, c.1905); K. Burrill: *The Amateur Cook* (Chambers, 1905); M. Quiller-Couch: *Troublesome Ursula* (Chambers, 1905); M. Baldwin: *Dora, a High School Girl* (Chambers, 1906); G. Mar: *The Little Tin Soldier* (Chambers, 1909); Mrs. Molesworth: *The February Boys* (Chambers, 1909), *The Old Pincushion* (Chambers, 1910); L. Carroll: *Alice in Wonderland* (Tuck, 1910); *Nursery Tales* (Nelson, c.1910); *Grimm's Fairy Tales* (Cassell, 1910); *Mother Goose Fairy Tales* (Tuck, nd); R. Jacbern: *Tabitha Smallways, Schoolgirl* (Chambers, 1912); M. Baldwin: *Troublesome Topsy and Her Friends* (Chambers, 1913); H.C. Andersen: *Fairy Tales* (Tuck, 1914); C. Kingsley: *The Water-Babies* (Tuck, 1916); L.T. Meade: *A Band of Mirth* Chambers, 1917); D. Ashley: *Children's Stories from French Fairy Tales* (Tuck, 1917); Mary, Queen of Romania: *Peeping Pansy* (Hodder, 1919); *Puss in Boots and Other Fairy Tales* (Nelson, 1920); A. Marshall: *Wooden* (Collins, 1920); J.M. Barrie: *Peter Pan and Wendy* (Hodder, 1921); *Lucie Attwell's Children's Book* (1930).
Books written and illustrated include: *The Boo Boos Series* (Valentine, 1921-); *Baby's Book* (Tuck, 1922); *Fairy Book* (Partridge, 1932); *The Lucie Attwell Annual* (Partridge, 1922-26; then *Lucie Attwell's Children's Book,* Dean, 1927-32); *Lucie Attwell's Painting Books* (Dean, 1934); *Lucie Attwell's Great Big Midget Book* (Dean, 1935); *Playtime Pictures* (Carlton, 1935); *Story Books* (Dean, 1943-45); *Book of Rhymes* (Dean, 1962).
Contrib: *Cassell's Children's Annual; Father Tuck's Annual; Little Folks; London Opinion; Pearson's Magazine; Printer's Pie; Strand Magazine; Winter's Pie.*
Exhib: Brighton (1979 centenary); Beetles (1984, 1988).
Bibl: Chris Beetles: *Mabel Lucie Attwell* (Pavilion, 1988); Carpenter; DNB; Felmingham; Houfe; Peppin; Waters.
Colour Plate 36

AUGARDE, Stephen André **b.1950**
Augarde was born in Birmingham. He studied art at Yeovil School of Art and Somerset College of Art. After leaving college, he worked as a gardener for the National Trust at Montacute House and then went to Rolle Teacher Training College. He started writing and illustrating books for children, and received an offer of publication for *A Lazy Day* as long as he produced two more to make up a series. He has expressed the view that his early work would have been better unpublished.
Books illustrated include: B. Gilham: *Septimus Fry, FRS* (Deutsch, 1980).

John AUSTEN *The Infernal Marriage* by Benjamin Disraeli (William Jackson, 1929)

Kent. In London, Austen was "the perfect aesthete, precious, even in appearance, to the finger-tips; and a trifle cynical" (Richardson, 1930†). Back in the Kent of his birth, he taught at the Thanet School of Art and combined more simple, country pursuits with his continued illustrative work.

Austen was always more of a book "decorator" than an illustrator. His early illustrations are very reminiscent of Beardsley, and show a tendency to exaggeration in the drawings of figures. His work at this time was very decorative and "stylish", done in pen and ink or flat colours. "He does not attempt to represent in line what the word itself should have conveyed to the thoughtful mind, but . . . he *decorates* it with drawings into which he infuses the spirit of the text. . . Mr. Austen favours the method of flat masses without chiaroscuro, a method which prepares us at once to receive a decoration pure and simple, without any attempt at realism. His line is always graceful, his drawings vivacious and spirited, very skilful in its arrangement of blacks and whites, and his composition rightly balances. . . His colour, too, done expressly for reproduction by line work, is exquisitely adapted to the desired end" (Grimsditch, 1924†). His sense of line and of colour is sure and sensitive, as in the Bodley Head edition of Anatole France's *The Gods Are Athirst* (1927). He later employed wood engraving, as in Cooper's *Poets in Pinafores* (1931), or pencil and wash, for his illustrations.

Books illustrated include: R.H. Keen: *The Little Ape and Other Stories* (Henderson, 1921); H. Fausset: *The Condemned* (Selwyn & Blount, 1922); E.C. Lefroy: *Echoes from Theocritus* (Selwyn & Blount, 1922); C. Perrault: *Tales of Passed Times* (Selwyn & Blount, 1922); W. Shakespeare: *Hamlet* (Selwyn & Blount, 1922); F. Bickley: *The Adventures of Harlequin* (Selwyn & Blount, 1923); E. de Quieroz: *Perfection* (Selwyn & Blount, 1923); T. Moult: *The Best Poems of 1922* (Cape, 1923); J.M. Allison: *The Five Black Cousins and Other Bird Rhymes* (Cape, 1924); J. Austen, comp.: *Rogues in Porcelain* (Chapman & Hall, 1924); B. Disraeli: *Ixion in Heaven* (Cape, 1925); *Everyman and Other Plays* (Chapman & Hall, 1925); Longus: *Daphnis and Chloe* (Bles, 1925); Lord Byron: *Don Juan* (BH, 1926); A. France: *The Gods Are Athirst* (BH, 1927); L. Sterne: *Tristram Shandy* (BH, 1927); G. Flaubert:

Books written and illustrated include: *A Lazy Day* (1974); *The River That Disappeared* (1974); *The Willow Tree* (1974); *Pig* (Deutsch, 1976); *Barnaby Shrew Goes to Sea* (Deutsch, 1978); *Barnaby Shrew, Black Dan and the Mighty Wedgwood* (Deutsch, 1979); *Mr. Mick* (Deutsch, 1980); *January Jo and Friends* (Deutsch, 1981).
Bibl: ICB4; Peppin.

AULT, Norman **1880-1950**
See Houfe
Most of Ault's work was done before 1915. He made a special study of the life and works of Alexander Pope, for which Oxford University gave him an MA in 1941; and he edited two books of poetry, *Elizabethan Lyrics* (Longmans, 1925), and *Seventeenth Century Lyrics* (Longmans, 1928).
Bibl: ICB; Peppin.

AUSTEN, John **1886-1948**
Austen was born in Kent and trained as a carpenter before moving to London in 1906 and studying art. He was much influenced by Aubrey Beardsley and at first his art became very imitative. Richardson† contends that it was not until 1925, in his illustrations for Disraeli's *Ixion in Heaven*, that Austen celebrated his final escape from Beardsley's influence. With the help of Haldane Macfall*, in 1925 he also exhibited at the St. George's Gallery with Harry Clarke* and Alan Odle (see Houfe), for whose art Austen had a high regard — he ranks Odle in his preface to *The ABC of Pen and Ink Rendering* with such artists as Hogarth, Blake, Keene and Beardsley! In the 1920s, following an illness, he returned to

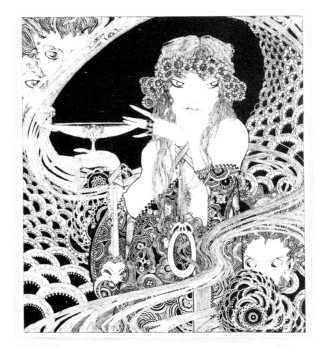

John AUSTEN "The Wine of Circe" from *The Golden Hind* vol.1 no.2 (January 1923)

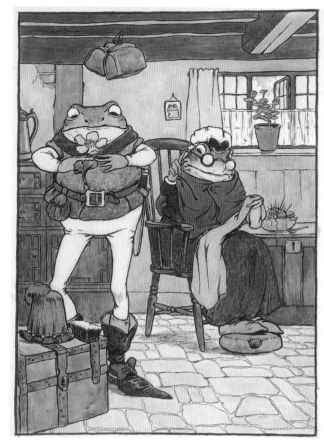

Colour Plate 31. Frank ADAMS "A Frog He Would A-Wooing…" Original drawing in watercolour and pen and ink Illustrated *The Frog Who Would A-Wooing Go* (Blackie & Co., 1904). By permission of Chris Beetles Limited

Colour Plate 32. Janet AHLBERG *Each Peach Pear Plum* by Janet and Allan Ahlberg (Viking Kestrel 1978)

Madame Bovary (BH, 1928); L'Abbé Prévost: *Manon Lescaut* (Bles, 1928); D. Defoe: *Moll Flanders* (BH, 1929); B. Disraeli: *The Infernal Marriage* (William Jackson, 1929); N. Douglas: *South Wind* (two vols., Argus Book Shop, 1929); H.E. Bates: *The Hessian Prisoner* (William Jackson, 1930); V. David: *The Guardsman and Cupid's Daughter* (Cayme Press, 1930); W. Shakespeare: *As You Like It* (William Jackson, 1930); A.B. Cooper: *Poets in Pinafores* (Alston Rivers, 1931); W.M. Thackeray: *Vanity Fair* (NY: Limited Editions Club, 1931); D.U. Ratcliffe: *The Gypsy Dorelia* (BH, 1932); C.C. and D.G: *The English in Love* (Secker, 1933); C. Dickens: *Pickwick Papers* (OUP, 1933); A. France: *The Gods Are Athirst* (BH, 1933); C.C. and D.G.: *A National Gallery, Being a Collection of English Characters* (Secker, 1934); C. Dickens: *David Copperfield* (NY: Heritage, 1935); T.G. Smollett: *Peregrine Pickle* (OUP, 1936); Aristophanes: *The Frogs* (The Hague: Enched, 1937); A.R. Le Sage: *The Adventures of Gil Blas* (OUP, 1937); O. Goldsmith: *Oliver Wakefield* (NY: Heritage, 1939); W. Shakespeare: *Comedy of Errors* (NY: Limited Editions Club, 1939); J. Austen: *Persuasion* (Avalon Press, 1946).

Published: *The ABC of Pen and Ink Rendering* (Pitman, 1937).

Contrib: *Golden Hind*.

Exhib: St. George's Gallery.

Bibl: Herbert B. Grimsditch: "Mr. John Austen and the Art of the Book", *Studio*, 88 (August 1924), 62-7; Dorothy Richardson: *John Austen and the Inseparables* (William Jackson, 1930); Felmingham; Hodnett; Peppin.

AUSTEN, Winifred Marie Louise 1876-1964

Born in Ramsgate, Kent, Austen studied privately, and was a painter, drypoint engraver and etcher of mainly bird and animal subjects. Her first painting hung at the RA was of the head of a lion drawn at the London Zoo. She was commissioned to do illustrations for books and magazines and even postcards. One of the better known books she illustrated was Chalmers' *Birds Ashore and Aforeshore* (1935) which included sixteen plates and sixteen line drawings. Married in 1917 to her agent Oliver O'Donnell Frick, she was widowed six years later and in 1926 moved to a cottage in Suffolk where she lived for the rest of her life. Her work was in demand into the 1940s and '50s — an etching of a wood mouse was exhibited at the RA Summer Exhibition in 1945 and the whole edition of 100 was sold in weeks. She was elected SWA (1905); ARE (1907); RE (1922); RI (1925).

Books illustrated include: E. Nesbit: *A Book of Dogs* (Dent, 1898); A. Cooke: *At the Zoo* (Nelson, 1920); E. Parker: *Field, River and Hill* (P. Allan, 1927); K. Dawson: *Marsh and Mud Flat* (Country Life, 1931), *Just an Ordinary Shoot* (Country Life, 1935); P. Chalmers: *Birds Ashore and Aforeshore* (Collins, 1935).

Exhib: RA; RI; RE.

Bibl: Hammond; Peppin; Who.

AUSTIN, Robert Sargent 1895-1973

Born on 23 June 1895 in Leicester, Austin studied art at the Leicester School of Art (1909-13) and at the RCA (1914, 1919-22) where he was taught engraving by Frank Short. He served in the trenches (Royal Artillery) through WW1. He won a scholarship in engraving at the British School in Rome in 1922, and he lived in Rome, travelling through Italy and Germany (1922-25). He returned to England and began teaching engraving at the Royal College of Art (1926-44), becoming Professor of Graphic Design (1948-55).

Austin became known during the 1920s as an etcher and engraver. The Twenty-One Gallery in London published his first etching in 1920 and continued to publish his plates through the decade. He married Ada Harrison in 1924 and collaborated with her on a number of books, producing pencil landscape illustrations for travel books and humorous drawings for children's books. He illustrated only a few books by other writers. He worked as a war artist on various commissions between 1940 and 1944, and there are thirty-four of his works in the Imperial War Museum.

He was elected ARE (1921); RE (1928); PRE (1962); became a member of the Faculty of Engraving of the British School in Rome in 1926; RWS (1930); PRWS (1956); ARA (1939); RA (1949).

Books illustrated include: J.B. Priestley: *Talking* (Jarrolds, 1926); A. Harrison: *A Majorca Holiday* (Howe, 1927); G.K. Chesterton:

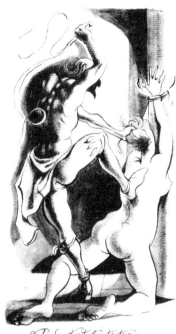

Michael AYRTON *Poems of Death: Verses chosen by Phoebe Pool* (Frederick Muller, 1945)

The Ballad of the White Horse (Methuen, 1928); R. Church: *The Glance Backward* (Dent, 1930); *Grey and Scarlet: Letters from the War Areas by Army Sisters* (Hodder, 1944); J. Austen: *Northanger Abbey* (Avalon Press, 1948).

Books written and illustrated include: *Warwick, Leamington and Kenilworth: A Sketchbook* (Black, 1920); *Surrey: A Sketchbook* (Black, 1922); and all of the following in collaboration with Ada Harrison: *Some Tuscan Cities* (Black, 1924); *Some Umbrian Cities* (Black, 1925); *Examples of San Bernadino of Siena* (Howe, 1926); *Lucy's Village* (OUP, 193?); *The Adventures of Polly Peppermint* (Backus, 1943); *The Tale of Tombo* (Fairston, 1945); *The Doubling Rod* (BH, 1957).

Exhib: RA; RWS; Ashmolean (1980); Douwma (1986).

Collns: Ashmolean; BM; Fitzwilliam; IWM; Tate; V & A.

Bibl: *Robert Austin, 1895-1973: an Exhibition of Etchings, Engravings, Drawings and Watercolours* (Oxford: Ashmolean Museum, 1980); Campbell Dodgson: *A Catalogue of Etchings by Robert Austin 1913-1929* (Twenty-One Gallery, 1930); Campbell Dodgson: "Robert Austin, Etcher and Engraver", *Print Collector's Quarterly* 16 (1929): 327-52; Malcolm Salaman: *Robert Austin R.E. (Masters of Modern Etching)*, (The Studio, 1930); Peppin; Tate; Waters.

AYRTON, Michael 1921-1975

Born on 20 February 1921 in London, the son of Gerald Gould, the poet and critic, and Barbara Ayrton-Gould, suffragette and Labour Party Chairman. He was educated at Abinger Preparatory School but left at the age of fourteen to study art in Paris and Vienna, sharing a studio in Paris during 1939 with John Minton*. He exhibited in England from 1942, and then in Europe and the USA. Ayrton was one of the loosely knit group of young artists — Minton, John Craxton*, Keith Vaughan* and Roderigo Moynihan were others — who met regularly in the early 1940s at the studio of Robert Colquhoun* and Robert MacBryde in Camden Hill. He designed for the theatre, 1942-51, doing the sets and costumes for such productions as Gielgud's *Macbeth* in 1942 and Sadler's Wells

Michael AYRTON *The Unfortunate Traveller* by Thomas Nashe (John Lehmann, 1948)

Ballet's *Le Festin de l'Araignée* in 1944. He taught life drawing and theatre design at the Camberwell School of Art, 1942-44; and was art critic of *The Spectator*, 1944-46. He became a highly successful broadcaster, T.V. art pundit and public personality, known for his urbanity and extraordinary range of knowledge. With Henry Moore* as his mentor, he began working as a sculptor in 1951, and travel in Italy and Greece kindled a particular interest in the myths relating to Icarus and Daedalus.

Ayrton was a "mainstream, almost antiquarian, intellectually elegant and erudite man" (*Word and Image I & II*, 1971†). As well being an artist, he wrote on art and music, and he wrote fiction. He was one of the most cerebral and literary figures ever to have worked in Britain and his performances as writer and artist are of roughly equal stature. In this way, he was like his contemporary, Wyndham Lewis*, and each had a tremendous admiration for the other's work. When Lewis's eyesight began to fail in 1951 — he became totally blind in 1953 — Ayrton designed book jackets and illustrated texts for him. He even completed a missing portion of a damaged drawing of Ezra Pound. Lewis, in his capacity as art critic, had often praised Ayrton, and paid a final tribute to him by writing the introduction to Ayrton's book, *Golden Sections* (1957), which was Lewis' last written work. T.G. Rosenthal in *DNB* claims that "Word and Image", devoted to a comparison of the work of Ayrton and Wyndham Lewis, was Ayrton's most important exhibition. It was held at the National Book League in 1971.

Ayrton's book illustrations developed from his current work as an artist in other media. There is a great variety of techniques in the illustrations, including pen and ink drawings, colour wash and etching. Through Ayrton's involvement with the neo-romantic group of English painters in the 1940s, he was much influenced by John Minton* and Graham Sutherland*. He illustrated several of his own books, and books by others including *The Duchess of Malfi* in 1945, illustrated with pen drawings and autolithographs, and four for the Folio Society. The two volumes of *The Human Age*, by Wyndham Lewis, have only nine drawings but this is because Lewis restricted the number. Two important books illustrated in the

1960s are translations from Greek tragedy, reflecting Ayrton's growing interest in the classical world. In 1972, he produced a number of erotic etchings to illustrate the poems of Verlaine, published as *Femmes/Hombres* by Douglas Cleverdon. Ayrton also produced some fine book covers, one of the most evocative being the design he did for *Poems of Death* (1945), which was lithographed in grey, black, yellow and brown on white cloth.

Peter Tucker writes "A few English artists of the twentieth century — Paul and John Nash, John Piper — have illustrated fine books and have also written perceptively about art. Michael Ayrton did these things well, and moreover, like David Jones and Mervyn Peake, he produced writing which is entirely his own. He was also a sculptor of great strength and very much a creator of images, a Daedalus in inventiveness. He described himself as a narrative artist — something different from a literary artist — and not simply as an illustrator" (Tucker, 1986†).

Ayrton died suddenly in London on 17 November 1975.

Books illustrated include: C. Gray: *Gilles de Rais* (Favil Press, 1945); J. Webster: *The Duchess of Malfi* (Sylvan Press 1945); *Poems of Death: Verses Chosen by Phoebe Pool* (Muller, 1945); J. Arlott: *Clausentum* (Cape, 1946); T. Nashe: *Summer's Last Will and Testament* (OUP, 1946); C. and M. Gray: *The Bed* (Nicholson, 1946); *Poems of John Keats* (Nevill, 1948); T. Nashe: *The Unfortunate Traveller* (Lehmann, 1948); R. Schneider: *Imperial Mission* (NY: Gresham Press, 1948); O. Wilde: *The Picture of Dorian Gray* (Castle Press, 1948); C. Porteus: *Pioneers of Fertility* (Clareville Press for ICI, 1949); E. Linklater: *Trolleri med Gamla Ben (A Spell for Dry Bones)* (Stockholm: Norstedt, 1951); W. Shakespeare: *Macbeth* (Folio Society 1951; 2nd ed. with John Minton, 1964); G. Basile: *The Pentameron* (Kimber, 1952); J. Wentworth Day: *Ghosts and Witches* (Batsford, 1954); L. MacNeice: *The Other Wing (Ariel Poem)* (Faber, 1954); W. Lewis: *The Human Age: Books 2-3, Monstre Gai* and *Malign Fiesta* (Methuen, 1955), *The Human Age: Book 1, The Childermass* (Methuen, 1956); E.A. Poe: *Tales of Mystery and Imagination* (Folio Society, 1957); *A Distraction of Wits Nurtured in Elizabethan Cambridge* (CUP, 1958); Lucius Apuleius: *The Golden Ass* (Folio Society, 1960); R. Church: *North of Rome* (Hutchinson, 1960); Aeschylus: *The Oresteia* (NY: Limited Editions Club, 1961); *The Sonnets of Michelangelo* (Folio Society, 1961); Euripides: *Medea, Hippolytus, The Bacchae* (NY: Limited Editions Club, 1967); P. Verlaine: *Femmes/Hombres* (Douglas Cleverdon, 1972); *The Quest of Gilgamesh* (Cambridge: Rampant Lions Press, 1972); Plato: *The Trial and Execution of Socrates* (Folio Society, 1972); W. Lewis: *The Roaring Queen* (Secker, 1973).

Books written and illustrated include: *Tittivulus* (Reinhardt 1953); *The Testament of Daedalus* (Methuen, 1962); *Berlioz, A Singular Obsession* (B.B.C., 1969); *The Minotaur* (privately published by Genevieve Restaurants, 1970).

Published: *British Drawings* (Collins, 1946); *Golden Sections* (Methuen, 1957); *The Maze Maker* (Longmans, 1967); *The Rudiments of Paradise* (Secker, 1971); *Fabrications* (Secker, 1972).

Contrib: *Countrygoer; Daily Telegraph Colour Magazine; Listener; Penguin New Writing; Radio Times; Strand*.

Exhib: Zwemmer; Redfern; Bruton Gallery, Bruton, Somerset; Wakefield (retrospective 1949); Whitechapel Art Gallery (retrospective 1955); Birmingham (1977).

Collns: BM; Tate; V & A; Christopher Hull Gallery.

Bibl: *Michael Ayrton: Drawings and Sculpture*, 2nd ed. (Cory, Adams & Mackay, 1966); *Paintings by Michael Ayrton* (Grey Walls Press, 1948); Peter Cannon-Brookes: *Michael Ayrton; an Illustrated Commentary* (Birmingham Museums and Art Gallery, 1978); David Mellor: *A Paradise Lost: The Neo- Romantic Imagination in Britain 1935-55* (Barbican Art Gallery/Lund Humphries, 1987); Peter Tucker: "The Book Illustrations of Michael Ayrton", *Private Library*, 3rd s., 9, No.1 (Spring 1986): 2-52; Tucker: "The Book Illustrations of Michael Ayrton: Further Notes", *Private Library* 4s., 1, no. 4 (Winter 1988): 183-91; *Word and Image I & II: Wyndham Lewis and Michael Ayrton* (National Book League, 1971); Malcolm Yorke: *The Spirit of Place: Nine Neo-Romantic Artists and Their Times* (Constable, 1988); DNB; Driver; Folio 40; Hodnett; Peppin; Jacques; Tate; Waters.

Colour Plate 13

Colour Plate 33. Alan ALDRIDGE "The Fakir" from *The Lion's Cavalcade*; poems by Ted Walker (Jonathan Cape 1980)

Colour Plate 34. Victor AMBRUS *Pinocchio* by C. Collodi (Oxford University Press 1988)

Colour Plate 35. Florence Mary ANDERSON "A Diller, a Dollar, A Twelve-o'clock Scholar, What Makes You Come So Soon?" Pen and ink and bodycolour By permission of Chris Beetles Ltd

Colour Plate 36. Mabel Lucie ATTWELL "Just Look at Me, Fido" Signed and inscribed watercolour By permission of Chris Beetles Ltd

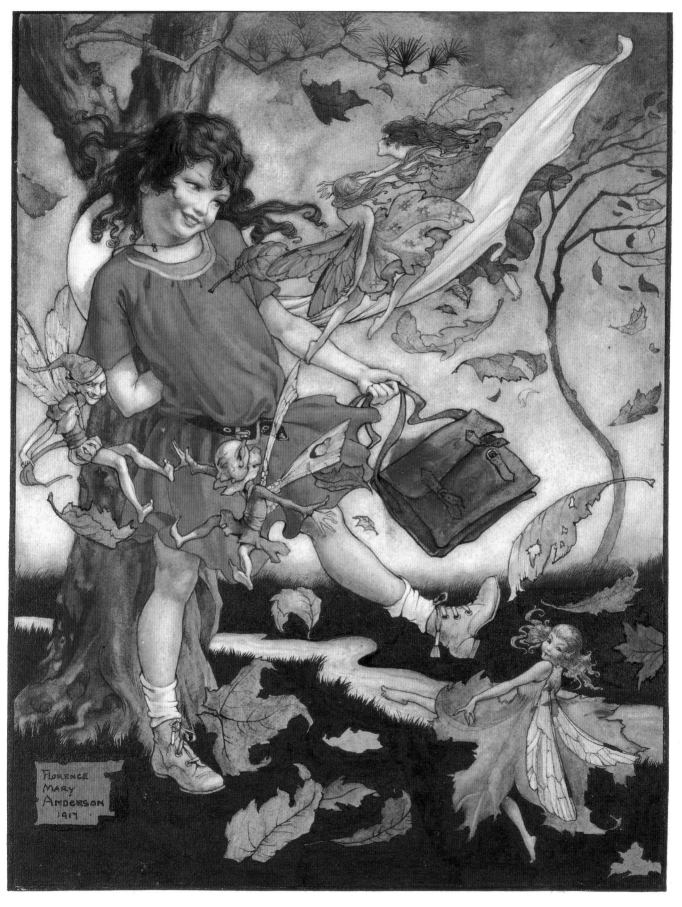

Florence
Mary
Anderson
1917

a master of scraper-board technique, and his book on *Scraperboard Drawing* was published in the Studio Publications "How To Do It" series in 1951. He died on 12 August 1992.

Books illustrated include: E. Teale: *Dune Boy* (Hale 1950); A.E. Williams: *The Adventures of Doctor Barnado* (Allen & Unwin 1949); R. Church: *Essays and Notes* (Hale, 1951); *Voyage Around the World with Captain Cook in HMS Resolution* (1953); M.E. Allen: *Adventure Royal* (Blackie, 1954); *Exploring Britain* (1971).

Contrib: *Lilliput; Listener; Radio Times.*

Published: *Scraperboard Drawing* (Studio, 1951).

Exhib: Folio Society.

Bibl: *Guardian* 29 August 1992 obit; Driver; Usherwood; Who.

BADMIN, Stanley Roy **1906-1989**

Born on 18 April 1906 in Sydenham, Kent, Badmin first studied art at the Camberwell School of Art (1922-24) and then at the RCA, under Randolph Schwabe* and William Rothenstein (1924-28). He was awarded the Diploma of the RCA in 1927 and then did one year of teacher training. He taught at the Richmond Art School (1934), St. John's Wood Art School from 1936 and at the Central School of Art in London from 1954.

Badmin's work has always been associated with the countryside, and with trees in particular. His talent is based on a love for, and a deep experience of, British rural life, and he should be considered as part of the revival of artistic interest in the British pastoral landscape. He has produced etchings and lithographs but works mostly in watercolour or pen and ink.

The first colour reproductions of Badmin's work were published in *The Graphic* in 1927 and *The Tatler* in 1928. In 1928 also he produced a programme cover for the Pavilion Hotel, Scarborough, following a recommendation from the Curwen Press. In 1935, *Fortune* magazine offered him his first major commission, inviting him to do a series of illustrations of various towns in the USA. He has since drawn for many other magazines, notably for the *Radio Times* to which he first contributed in 1951. The detailed and finely drawn cover which he did for the Easter edition in 1954 is typical of his work.

During WW2 Badmin worked for the Ministry of Information, helping with travelling exhibitions and illustrating booklets, until he was "called up" to the RAF in 1942 where he worked on operational model-making. He also worked for the Pilgrim Trust on an enterprise called "The Recording Britain Scheme" with a number of other artists. This project was published in two volumes, as *Recording Britain*, by the Oxford University Press in 1946-47.

Badmin has illustrated many books, his first major project in this field being *The Highways and Byways of Essex*, in which he collaborated with F.L.M. Griggs* (1937). He did three books for the Puffin Picture Book series for Penguin, writing the text of two of these as well as illustrating them, *Village and Town* (1942) and *Trees in Britain* (1943). The latter, produced during the difficult war years by Cowell of Ipswich, with the illustrations drawn directly on the plate by the artist, and costing just a few pence, has been described as "one of the most beautiful illustrated books of this century" (David Thomas, 1962†).

BACON, Cecil W. **1905-1992**

Born on 24 August 1905 in Battle, Sussex, Bacon was educated at Sutton Vallence School and St. Lawrence College, Ramsgate, and studied art at Hastings School of Art (1923-25). He joined a commercial art studio in London (1926-28), and also worked for an advertising agency until 1929. He became a free-lance artist until 1941 when he enlisted in the Royal Air Force. In 1942, he was transferred to the Ministry of Information where he worked until 1946, and then took up his career again as a free-lance artist and a book designer as well as an illustrator.

He has drawn for the *Radio Times* (1935-68) and *The Listener* and for other BBC publications; produced book jackets and posters; and illustrated several books. Bacon's illustrations show him to be

Cecil W. BACON *Dune Boy* by Edwin Way Teale (Robert Hale, 1950)

S.R. BADMIN "Melford Hall, Long Melford, Suffolk" in *Recording Britain* (vol.3, Oxford University Press, 1947)

Throughout his career, he produced a great number of posters and drawings for advertisements, working for such organizations as the London Transport, Horlicks, the Bowater Paper Corporation, the British Travel Authority, the Reader's Digest publications, and Shell. Badmin's greatest project for Shell was the *Shell Guide to the Counties of Britain*, for which he did five counties in four volumes — Yorkshire, Shropshire, Surrey, Middlesex and Hertfordshire, and Northamptonshire. The first four of these counties were included in *The Shell and B.P. Guide to Britain*, published in 1964. Since 1945, he produced work for calendars and Christmas cards for Royle's, the fine art publishers.

He was elected ARE (1931); ARWS (1932); RE(1935); RWS(1939); FSIA.

Books illustrated include: C. Bax: *Highways and Byways in Essex* (with F.L.M. Griggs*; Macmillan, 1937); *Recording Britain* (with others, four vols., OUP, 1946-9); B. Colvin: *Trees for Town and Country* (Lund Humphries, 1947); P. Nicholson: *Country Bouquet* (Murray, 1947); J. Lees-Milne: *National Trust Guide to Buildings* (Batsford, 1949); *The Nature Lover's Companion* (Odhams, 1949); *Nature Through the Seasons in Colour* (Odhams, 1950); *The Children's Wonder Book in Colour* (Odhams, 1950);

The British Countryside in Colour (Odhams, 1951); R.St.B. Baker: *Famous Trees* (Dropmore Press, 1952); R. Wightman: *The Seasons* (Cassell, 1953); G. Stapledon: *Farm Crops in Britain* (Penguin, 1955); G. Grigson: *The Shell Guide to Trees and Shrubs* (Phoenix House, 1958); *Trees of Britain* (Sunday Times, 1960); *The Shell and B.P. Guide to Britain* (with others; Ebury Press, 1964).

Books written and illustrated include: *Village and Town* (Puffin Picture Book; Penguin 1942; *Trees in Britain* (Puffin Picture Book; Penguin, 1943).

Contrib: *Fortune; Graphic; Pictorial Education; Radio Times; Reader's Digest; Tatler.*

Exhib: Twenty One Gallery (1930); RWS (1932-); Fine Art Society (1933, 1937); Leicester Galleries (1955); major retrospective at Chris Beetles Gallery (1985).

Collns: BM; V & A; Chicago; many public collections.

Bibl: Chris Beetles: *S.R. Badmin and the English Landscape* (Collins, 1985); David Thomas: "Children's Book Illustration in England", *Penrose Annual* 56 (1962): 67-74; Driver; ICB; Jacques; Peppin; Waters; Who.

Colour Plate 37

Ronald BALFOUR *Rubaiyat of Omar Khayyam* (Constable, 1920)

BAILEY, Dennis　　　　　　　　　　　　　**b.1931**
Born in Bognor, Sussex, Bailey studied at West Sussex College of Art, Worthing College of Art and RCA. He went to Sicily on a travel scholarship before starting work as a teacher and illustrator in London. He spent 1956 working for the *Graphis* magazine in Zurich, and then was Art Director of *Town* magazine. He taught at the Central School of Arts and Crafts (1957-60) and then at Chelsea School of Art.
A free-lance artist since 1966, his illustrations have been done mostly for magazines; and he has designed postage stamps.
Books illustrated include: *Read to Write: An Anthology for School Children* (Ginn, 1954).
Contrib: *Architectural Review; Economist; Esquire; House and Garden; Nova; Town.*
Bibl: Amstutz 2.

BAIRNSFATHER, Bruce　　　　　　　　　**1888-1959**
See Houfe
Contrib: *Bystander; New Yorker; Passing Show; Tatler.*
Bibl: Bruce Bairnsfather: *Wide Canvas* (John Lang, 1939); Tonie and Valmai Holt: *In Search of a Better Hole: The Life, the Works and the Collectables of Bruce Bairnsfather* (Portsmouth: Milestone Publications, 1985); Bradshaw; DNB; Peppin; Waters.

BAKER, Alan　　　　　　　　　　　　　　**b.1951**
Born in London, Baker studied at Croydon Technical College, Hull University, Croydon College of Art (1972-73) and Brighton College of Art (1972-73). He writes and illustrates children's books, using mostly pen and ink, often with colour added.
Books illustrated include: P. Pearce: *The Battle of Bubble and Squeak* (Deutsch, 1978); E. Bourne: *Heritage of Flowers* (Hutchinson, 1980); D. Headon: *Mythical Beasts* (Hutchinson, 1981).
Books written and illustrated include: *Benjamin and the Box* (Deutsch, 1977); *Benjamin's Dreadful Dream* (Deutsch, 1980).
Bibl: Peppin.

BAKER, Alexandra Clare　　　　　　　　**b.1947**
Baker was born on 26 January 1947 in Southborough, and studied art at Sir John Cass College (1964-65). She is a watercolour artist, mostly dealing with military uniforms and equipment. SGA; FRSA.
Books illustrated include: James: *Before the Echoes Die Away, Gunners at Larkhill.*
Exhib: SGA; Liberty's.
Colln: National Army Museum.
Bibl: Who.

BAKER, Mary　　　　　　　　　　　　　　**b.1897**
Born in Runcorn, Cheshire, Baker was educated at home. After she sold some drawings to magazines, she took a correspondence course from the Press Art School in illustration. She illustrated children's books written by her sister, Margaret, the first of which was *The Black Cats and the Tinker's Wife* (1923). For this book and for many others, she used the silhouette, which was very popular at the time as a method of illustration. She also painted landscapes in watercolour.
Books illustrated include: M. Baker: *The Black Cats and the Tinker's Wife* (Grant Richards, 1923), *Pedlar's Ware* (Duffield, 1925), *The Dog, the Brownie and the Bramble Patch* (Werner Laurie, 1926), *The Lost Merbaby* (Duffield, 1927), *Noddy Goes A Ploughing* (Blackwell, 1930), *Peacock Eggs* (Blackwell, 1931), *Tell Them Again Tales* (ULP, 1933), *Patsy and the Leprechaun* (Blackwell, 1936), *The Margaret and Mary Baker Story Book* (Werner Laurie, 1939), *A Matter of Time* (Blackwell, 193?), *A Wife for Mayor of Buncastle* (Blackwell, 193?), *Polly Who Did As She Was Told* (Blackwell, 194?), *The Nightingale* (Shakespeare Head Press, 1944), *The Book of Happy Tales* (ULP, 1948); *Seven Times Once Upon a Time* (Carwal, 1948).
Bibl: ICB; ICB2; Peppin.

BALFOUR, Ronald Edmund　　　　　　　**1896-1941**
See Houfe
Balfour illustrated at least two books between 1920 and 1930, but there appears to be no information about his life or career. Especially in the black and white illustrations to *The Rubaiyat of Omar Khayyam* (1920), there is a reminder of the decorative quality of Aubrey Beardsley's drawings, but little of that artist's bizarre imagination.
Books illustrated include: E. Fitzgerald: *The Rubaiyat of Omar Khayyam* (Constable, 1920); C. Bridges: *Thin Air* (Brewer & Warren, 1930).
Collns: V & A.
Bibl: Peppin.

BALL, Robert　　　　　　　　　　　　　　**b.1918**
Born on 11 July 1918 in Birmingham, Ball studied art at Birmingham Junior School of Art (1930-33), and at Birmingham College of Art (1933-40), under Harold Smith. An artist in many media, including oils, watercolour and engraving, he has taught at various places but most recently at Gloucester College of Art (1959-81). He is a Cotswold man, and now lives in Gloucestershire. Elected ARE (1943); RE.
Books illustrated include: A. Trollope: *Hunting Sketches* (Hutchinson, 1934); R. Cantwell: *Alexander Wilson, Naturalist and Pioneer* (Lippincott, 1961); W. Scott: *Waverly* (NY: Limited Editions Club, 1961); F. Mansell: *Cotswold Ballads* (Stroud: Richard Courtauld, 1974).
Exhib: RE; RA; RWA; RBA.
Collns: V & A; Ashmolean; Gloucester.
Bibl: Robert Ball: "Eleven Printmakers..." *Journal RE*, No.6 (1984), p.19; Who; Waters.

BANBERY, Frederick E. fl. 1972-
Born in London, Banbery studied at the Central School of Arts and Crafts. For two years just before WW2, he served as staff artist on the *Times of India*, and then was enlisted into the Royal Air Force (1940-46). Since the war, he has worked as a free-lance artist, and is best known as the illustrator of Michael Bond's "Paddington Bear" stories, taking over from Peggy Fortnum* who did the first eleven. He has done much work for US publishers and journals.
Books illustrated include: M. Bond: *Paddington Bear* (Collins, 1972), *Paddington's Garden* (Collins, 1972), *Paddington at the Circus* (Collins, 1973), *Paddington Goes Shopping* (Collins, 1973), *Paddington at the Sea-Side* (Collins, 1975), *Paddington at the Tower* (Collins, 1975), *Paddington's Picture Books* (Collins, 1978), *The Great Paddington Bear Picture Book* (Collins, 1984).
Periodicals: *Atlantic; Colliers; Economist; New Yorker; Sunday Times; Times of India; TV Times; Wall Street Journal*.
Bibl: Peppin.

BANNERMAN, Helen Brodie Cowan Watson 1862-1946
Born in Edinburgh, Bannerman was educated at St. Andrew's University and in Germany and Italy. She married a doctor in the Indian Medical Service and lived with him in India. In 1898, she wrote and illustrated her first book for her two daughters, *Little Black Sambo*, while travelling between Madras and the hill station where her daughters were staying for the summer.It was published in London by Grant Richards in 1899, and was followed by a number of others in the same style and format. Peppin remarks that "her illustrations, though obviously the work of an amateur, were clear and straightforward". The last book published during her lifetime was *Sambo and the Twins*, and *Little White Squibba* was found in manuscript form after her death and published in 1966.In recent years, her books have been attacked for racism, but at least one writer has noted that, though her work "has been much criticized of late as enshrining a crude and paternalistic attitude towards coloured families, . . . there is no escaping that Mrs. Bannerman's little story has an immediacy of appeal which has nothing to do with the names or life-style of its protagonist and everything to do with dramatic shape and unpretentious language" (Alderson, 1973).
Books written and illustrated include: *Little Black Sambo* (Grant Richards, 1899); *Little Black Mingo* (Nisbet, 1901); *Little Black*

Robert BALL *Cotswold Ballads* by Frank Mansell (Richard Courtauld, 1974)

Quibba (Nisbet, 1902); *The Story of Little Degchie-Head* (Nisbet, 1903), *Pat and the Spider* (Nisbet, 1904), *The Story of the Teasing Monkey* (Nisbet, 1906), *The Story of Little Black Quasha* (Nisbet, 1908), *The Story of Little Black Bobtail* (Nisbet, 1909), *Sambo and the Twins* (Nisbet, 1937); *Little White Squibba* (Nisbet, 1966).
Bibl: Elizabeth Hay: *Sambo Sahib: The Story of Helen Bannerman* (Paul Harris, 1981); Alderson; Carpenter; ICB; Peppin.

BANTING, John 1902-1972
Born in Chelsea, Banting studied in London and Paris. He was an artist who made an important contribution to British surrealism, producing blueprints and woodcuts, some of which employed jazz imagery. He was elected to the London Group in 1927, and had established a reputation as a surrealist painter and designer by 1931, when a one-man show of his work was held at the Wertheim Gallery. In that same year, his friend John Lehmann joined the Hogarth Press and Banting was invited to make the visual impact of the Press's books more forceful and innovative. Banting produced eleven designs for the Hogarth Press, including the cover for a new series, "The Hogarth Letters", which design was used in various colour combinations for each of the twelve issues. He also decorated at least one book and designed wrappers and covers for several other publishers, including the Hours Press and Alan Wingate.
After his successes in the 1920s and 1930s, he went through a long period of obscurity before there was a revival of interest in his work. After Banting's death in 1972, a friend wrote that he saw this renewed interest "only in terms of what it might produce to make his life and that of those close to him the more enjoyable in terms of food, drink and fun. The last time I saw him he was dressed as a Marseille gangster with a burnt-cork hairline moustache and toes painted on his shoes. He was swigging vodka and in high spirits. His last letter, when he knew he had not long to go, was as irreverent and self-mocking as ever" (*Times* 9.2.1972). He died on 30 January 1972.
Books illustrated include: L.E. Jones: *A La Carte* (Secker, 1951).
Books written and illustrated include: *A Blue Book of Conversation* (Editions Poetry, 1946).
Contrib: *Horizon*.
Exhib: LG; Seven and Five Society (1929); Wertheim Gallery (1931).
Collns: Tate.
Bibl: Louisa Buck: "John Banting's Designs for the Hogarth Press" *Burlington Magazine* 127 (1985): 91-2; *Times* 2.2.1972; 9.2.1972.

BARKER, Anthony Raine 1880-1963
Born in Harrow, Barker was educated at Framlingham School. He was a painter, etcher, lithographer, watercolorist and illustrator. He received the Soane Medal from the Institute of Architects in 1909. Peppin writes that "his children's books, which were written for his own amusement, were illustrated in a deliberately quaint chap-book style."
Books written and illustrated include: *The Fairyland Express* (1925); *Hidden Gold* (BH, 1926).
Bibl: Peppin; Waters; Who.

BARKER, Carol Mintum b.1938
Born in London, Barker spent the war years in New York, returning to study at Bournemouth College of Art. She later studied painting at the Chelsea Polytechnic and illustration at the Central School of Arts and Crafts under Laurence Scarfe*, Merlyn Evans and Raymond Roberts. She has commented, however, that her father's help and inspiration as a painter and designer were more influential than her art school education.
She became a free-lance illustrator in 1958 and specialized in books for children (she has written and illustrated her own stories). H.E. Bates wrote the story of *Achilles and the Donkey* around Barker's pictures. Her work is very decorative in style and is done mostly in pen and ink and watercolour, though *Achilles and the Twins* (1964) was illustrated in a combination of collage and wax as the basic texture for the illustrations, with ink and watercolour providing the colour. She draws directly from life and prefers streetscapes with figures to landscapes. *King Midas and the Golden*

Cicely M. BARKER *Children's Book of Hymns* (Blackie, 1929)

Touch was commended for the Kate Greenaway Medal in 1972.
Books illustrated include: H.E. Bates: *Achilles the Donkey* (Dobson, 1962); R.L. Green: *Ancient Greece* (1962); N. Wymer: *Gilbert and Sullivan* (Methuen, 1962); H.E. Bates: *Achilles and Diana* (Dobson, 1963); E. Colwell: *Storyteller's Choice* (1963); Fisher: *I Wonder How, I Wonder Why* (Abelard, 1962); J. Rhys: *The Tinsel November* (Hart-Davis, 1963); H.E. Bates: *Achilles and the Twins* (1964); Watts: *The Light Across Piney Valley* (Abelard, 1965); G. Symons: *Morning Glory* (1966); R. Godden: *The Kitchen Madonna* (Viking, 1967); J. McNeill: *It's Snowing Outside* (1968); M. Mahy: *Pillycock's Shop* (1969), *The Princess and the Clown* (1971); H. Hoke: *Dragons, Dragons, Dragons* (Watts, 1972); N. Fisk: *Emma Borrows a Cup of Sugar* (1973); R. Parker: *Lost in a Shop* (Macmillan, 1978); M. Hodgson: *A Touch of Gold: Stories from the Greek Myths* (Methuen, 1983); J. Snelling: *Buddhist Stories* (Wayland, 1986), *The Life of Buddha* (Wayland, 1987).
Books written and illustrated include: *The Boy and the Lion* (Dobson, 1968); *Birds and Beasts* (1968); *King Midas and the Golden Touch* (1972); *An Oba of Benin* (Macdonald, 1976); *A Prince of Islam* (Macdonald, 1976); *Arjun and His Village in India* (OUP, 1979); *Kayod and His Village in Nigeria* (OUP, 1982); *Ananda in Sri Lanka* (Hamilton, 1985); *The United Nations* (Macdonald, 1986).
Bibl: ICB3; ICB4; Ryder; Peppin.

BARKER, Cicely Mary 1895-1973

Barker was born in Croydon, and studied part-time at Croydon School of Art, though she was mainly self-taught. She was a painter in oils, pastels and watercolour, and wrote and illustrated books for children. Her best known illustrations show fairy

children, each dressed to represent a different kind of flower. She could however produce illustrations which showed real life situations, as in *At the Window*. She also designed Christmas cards for the Girls' Friendly Society, and at least one stained glass window.
Books written and illustrated include: *The Book of Flower Fairies* (Blackie, 1922); *Flower Fairies of the Spring* (Blackie, 1923); *The Red Clover Story Book* (Blackie, 1924); *Old Rhymes for All Times* (1928); *The Children's Book of Hymns* (Blackie, 1929); *A Flower Fairy Alphabet* (Blackie, 1934); *A Little Book of Old Rhymes* (Blackie, 1936); *A Little Book of Rhymes Old and New* (Blackie, 1937); *The Lord of Rushie River* (Blackie, 1938); *Flower Fairies of the Garden* (1944); *Groundsel and Necklaces* (1946); *Flower Fairies of the Wayside* (1948); *Fairies of the Flowers and Trees* (Blackie, 1950); *Flower Fairy Picture Book* (1955); *Lively Numbers* (Macmillan, 1957); *Lively Words* (1961); *At the Window* (Blackie, nd).
Contrib: *Little Folks*.
Exhib: RI; SGA; SWA.
Bibl: Carpenter; Peppin; Waters.
Colour Plate 38

BARKER, Kathleen Frances b.1901

As both a writer and an illustrator, Barker appears to have been most interested in depicting animals, especially dogs.
Books illustrated include: M.E. Buckingham: *Phari* (Country Life, 1933); C.M.D. Enriquez: *Khyberie* (Black, 1934); G. Grand: *The Silver Horn* (Country Life, 1934); A. Sewell: *Black Beauty* (Black, 1936); G. Cornwallis-West: *Us Dogs* (Country Life, 1938); C.M.D. Enriquez: *Khyberie in Burma* (Black, 1939).
Books written and illustrated include: *Bellman, the Story of a Beagle* (Black, 1933); *Bellman Carries On* (Black, 1933); *Just Dogs* (Country Life, 1933); *Traveller's Joy* (Country Life, 1934); *Himself* (1935); *Champion: The Story of a Bull Terrier* (1936); *Just Pups* (Country Life, 1937); *Nothing But Dogs* (Black, 1937); *Dog Days* (Heinemann, 1938); *Nothing But Horses* (Black, 1938); *The Rogues' Gallery* (Heinemann, 1939); *The Young Entry: Fox-Hunting, Beagling, and Otter-Hunting for Beginners* (Black, 1939); *The Mole Who Was Different* (Harrap, 1955); *The January Tortoise* (Harrap, 1955); *The Wood By the Water* (Harrap, 1957); *There Are Tigers About* (Harrap, 1958); *Me and My Dog* (Country Life, 1961).
Bibl: Peppin; Titley.

BARKER-MILL, Peter b.1908

Born in Italy, Barker-Mill studied art at the Grosvenor School of

Peter BARKER-MILL *Bligh's Voyage on the Resource* (Golden Cockerel Press, 1937)

Oswald Charles BARRETT ("BATT") "Edward Elgar" from *Radio Times* (27 December 1940)

Art under Iain MacNab* (1931-33), and then worked as a free-lance artist. During WW2 he served in the Civil Defence Camouflage Unit, and since then, he has been a free-lance artist, illustrating books, making animated films, and painting murals, including those for The Red Lion in Wells (1959) and Selwood School, Frome (1960). His book illustrations are mainly black and white wood engravings, though *Topiary* contains thirteen colour engravings. Christopher Sandford, the proprietor of the Golden Cockerel Press, wrote that Barker-Mill, in his illustrations for *A Voyage Round the World*, "produced a collection of engravings which were revolutionary, and a highly successful step forward in the adaptation of the wood-engraving medium to modern art. Blocks like his 'Icebergs with Aurora Australis' fill me with wonder and joy ...".

Books illustrated include: O. Rutter: *Bligh's Voyage in The Resource* (GCP, 1937), *The First Fleet* (GCP, 1937); A. Sparrman: *A Voyage Round the World with Captain James Cook in H.M.S. Resolution* (GCP, 1944); C. Stewart: *Topiary* (GCP, 1954).
Contrib: London Mercury.
Bibl: Peppin; Sandford; Waters; Who.

BARKLEM, Jill b.1951
Born in Epping, Essex, Barklem studied at St. Martin's School of Art. She has been a free-lance artist since 1974, writing and illustrating children's books. Her maiden name was Gillian Gaze and she used this until 1980.
Barklem's *Brambly Hedge Books*, with their Beatrix Potter*-like animals, have become popular, and china and other products have been made based on the illustrations. An enlarged edition of the original four stories were published in 1988. She uses ink and wash for most of her work.
Books illustrated include: A. Turnbull: *The Frightened Forest* (1974); E.M. Clarkson: *Susie's Babies* (Lion, 1976); Janet and John Perkins: *Haffertee Finds a Place of His Own* (Lion, 1977), *Haffertee Hamster's New House* (Lion, 1979); M. Doney: *The Very Worried Sparrow* (Lion, 1978).
Books written and illustrated include: *Everyday Graces* (Lion,

1975); *Prayers for Special Days* (Lion, 1978); *The Brambly Hedge Books* (Collins, 1980); *The Four Seasons of Brambly Hedge* (Collins, 1988).
Bibl: Peppin.

BARNARD, Gwen b.1912
Barnard was educated privately, and studied art at the Chelsea School of Art. Primarily a painter, she has illustrated at least one book.
Books illustrated include: *Shapes of the River* (Gaberbocchus, 1955).
Exhib: Drian Gallery; Camden Arts Centre, etc.
Bibl: Waters; Who.

BARRETT, Angela b.1955
Angela Barrett studied art at Maidstone and at the Royal College of Art. She has illustrated several children's books and books about gardens, with detailed and highly finished coloured illustrations; has contributed to the *Sunday Times Magazine*; and has illustrated paperback covers for Penguin.
Books illustrated include: Y. Menuhin and C. Hope: *The King, the Cat and the Fiddle* (Black, 1983); H. Andersen/N. Lewis: *The Wild Swans* (Benn, 1984); J. Riordan: *The Woman in the Moon and Other Tales of Forgotten Heroines* (Hutchinson, 1984); *Through the Kitchen Window* (1984); C. Hope: *The Dragon Wore Pink* (Black, 1985); *The Sunday Times Gardener's Almanac* (with other illustrators) (1986); S. Hill: *Through the Garden Gate* (Hamilton, 1986?); N. Lewis: *Proud Knight, Fair Lady* (Hutchinson, 1989).
Books written and illustrated include: *Ghostly Towers* (Octopus, 1986).
Contrib: *Sunday Times Magazine*.
Bibl: Parkin.

BARRETT, Oswald Charles ("Batt") 1892-1945
Born in London, Barrett was educated at St. George's School, Ramsgate, and studied at Old Camden School of Art. After WW1, he returned to his studies in 1919 at Heatherley's School of Art and

Goldsmiths' College School of Art. For a while, he shared a studio with Eric Fraser*.

For most of his work, he used the sobriquet "Batt". Barrett's first drawing was published in *The Bystander* in 1911. He illustrated *Current Literature* for two years (1926-28); began contributing to *Radio Times* in 1930, a collaboration which continued for fifteen years; and illustrated a number of books. He is best known for his portraits of musicians; the drawings of composers which he did for the *Radio Times* were so popular that the BBC published special issues for framing. Twenty years after his death, there was an exhibition in 1965 of his "musical work", including all the *Radio Times* portraits, at the Royal Festival Hall in London.

Books illustrated include: W. Holtby: *Astonishing Island* (Lovat Dickson, 1933); H.M. Raleigh: *The Chronicles of Slyme Court* (Bles, 1935); P.A. Scholes: *The Oxford Companion to Music* (OUP, 1938); C.B. Purdom: *How Should We Rebuild London?* (Dent, 1945.)
Contrib: *Bystander; Radio Times; Current Literature.*
Bibl: Driver; Peppin.

BARRETT, Peter **b.1935**
Since 1972, Barrett has concentrated on detailed and beautiful paintings of animals and other natural history subjects for his illustrations. He started this career after working as a free-lance designer and spending ten years in Greece painting colour abstracts.
Books illustrated include: *Animal Families* (Macdonald, 1975); *Porcupines* (Vineyard Books, 1975); B. Halstead: *A Closer Look at Prehistoric Mammals* (with others; Hamilton, 1976); J. Holbrook: *A Closer Look at Elephants* (Hamilton, 1976); N. Duplaix and N. Simon: *World Guide to Mammals* (Octopus Books, 1977); N. Thomson: *A Closer Look at Horses* (Hamilton, 1977); M. Cuisin: *The Wonderful World of Nature* (Octopus Books, 1979); C. Horton: *The Amazing Fact Book of Insects* (Watts, 1979); R. Lenga: *The Amazing Fact Book of Birds* (Watts, 1979); E. and A. Propper: *The Duck* (Macdonald, 1979); A.C. Jenkins: *A Countryman's Year* (Webb & Bower, 1980); R. Lovegrove: *Birdwatcher's Diary* (Hutchinson, 1982); J. Herriot: *Moses the Kitten* (Joseph, 1984), *Only One Woof* (Joseph, 1985); J. Hughes: *Lions and Tigers* (Hamilton, 1985); E. Strachan: *Prehistoric Mammals* (Hamilton, 1985); *Nature Lovers' Library: Animals of Britain* (Reader's Digest, 1985); S. Barrett: *Travels with a Wildlife Artist* (Columbus Books, 1986); K. Grahame: *The Wind in the Willows* (NY: Golden Books, 1986); J. Pope: *Horses* (Hamilton, 1986); G. Durrell: *My Family and Other Animals* (Grafton Books, 1987.)
Contrib: *Sunday Times Magazine.*
Exhib: Drian Gallery; Chris Beetles.
Bibl: *The Illustrators: British Art of Illustration 1800-1989*, exhibition catalogue (Chris Beetles Ltd., 1989); *Images 8/10.*
Colour Plate 39

BARRETT, Roderic Westwood **b.1920**
Born in Colchester, Essex, Barrett studied art at the Central School of Arts and Crafts in London (1936-40), with John Farleigh* as his instructor in wood engraving. He taught for a year at Phillips Exeter Academy, New Hampshire; taught drawing and design at the Central School (1947-68); and was painting and drawing tutor at the RA Schools (1968). Painting is his first preoccupation and he has had many one-artist shows in Britain and the US. Elected SWE (1952).
Books illustrated include: H. Barrett: *Early to Rise* (Faber, 1967).
Exhib: RA; RBA; Minories, Colchester; Cambridge.
Collns: V & A; Univ. of Essex.
Contrib: *Motif.*
Bibl: *Motif 6* (Spring 1961); Garrett; Who; IFA.

BARRINGTON-BROWNE, W.E. **1908-1985**
Educated at Repton School and Pembroke College, Cambridge University, Barrington-Browne studied art in Venice and in Paris. A painter of fishing and sporting subjects, he was art master at Cheltenham College for fourteen years, and during that time illustrated some books.

Books illustrated include: E. Taverner: *The Running of the Salmon* (Bles, 1954), *The Immortal Trout* (Bles, 1955).
Exhib: Tryon Gallery.
Bibl: Waters.

BASE, Graeme **fl.1982-**
Books illustrated include: S. Burke: *The Island Bike Business* (with Betty Greenhatch; OUP, 1982); M. Dann: *Adventures with My Worst Best Friend* (OUP, 1982); L. Carroll: *Jabberwocky* (Hodder, 1989).
Books written and illustrated include: *Creation Stories* (Hodder, 1989).

BATEMAN, Henry Mayo **1887-1970**
See Houfe
The plays for which Bateman produced theatrical posters include *Fanny's First Play* and *John Bull's Other Island* by Bernard Shaw. A few of "The Man Who" series of cartoons which made Bateman famous were drawn around 1911, but most were done in the 1920s and later, in black and white in *Punch* and in colour on the centre pages of the *Tatler*. He also contributed to the *Radio Times*, notably a cover for the Whitsun holiday issue in 1936. There was a memorial exhibition of his work at FAS (1970), a retrospective at the Leicester Galleries (1974), and a centenary exhibition of Bateman's work at the Royal Festival Hall and the National Theatre, London, in 1987.
Contrib: *Comic Life; Chips; The Royal; London Opinion; Tatler; Bystander; Sketch; Windsor; Pearson's Weekly; Printer's Pie; Lady's Realm; Granta; Graphic; Punch; Pan; Life; Radio Times; Winter Pie.*
Exhib: Royal Festival Hall and National Theatre.
Bibl: Anthony Anderson: *The Man Who Was H.M. Bateman* (Exeter: Webb & Bower, 1982; *The Best of H.M. Bateman: The "Tatler" Cartoons 1922-26* (Bodley Head, 1987); DNB; Driver; Feaver; ICB; Peppin; Waters.

BATEMAN, John Yunge **fl. 1946-1959**
Bateman illustrated the last two books that Christopher Sandford designed and published before he sold the Golden Cockerel Press in 1959. His lush, highly-worked drawings were reproduced in collotype. Peppin writes that "he tried to give a cultural veneer to 'page three' titillation".
Books illustrated include: C.N. Buzzard: *The Bumble Bee* (Daily Mail, 1946); *Shining Hours* (Daily Mail, 1946); *The Story of the Ant* (1946); W. Shakespeare: *The Rape of Lucrece* (Winchester Publications, 1948), *Venus and Adonis* (Winchester Publications, 1948); *The Rubaiyat of Omar Khayyam* (GCP, 1958); Ovid: *The Metamorphoses* (GCP, 1959).
Published: *How to Draw on Scraper Board* (Daily Mail, 1947).
Contrib: *Country Life.*
Bibl: Chambers; Peppin.

BATES, Leo **fl. 1920-1965**
As an illustrator chiefly of boys' adventure stories and school stories for girls for Blackie, and of gift books for Hodder, Bates used pencil and pastels, producing both black and white and coloured illustrations. The *Christmas Bookman* for 1924 described *Where the Rainbow Ends* (1921) as "one of the finest art books offered to children".
Books illustrated include: J.M. Barrie: *Mary Rose* (Hodder, 1920); C. Mills: *Where the Rainbow Ends* (Hodder, 1921); A. Cooke: *Stephen Goes to School* (Blackie, 1922), *Planter Dick* (Blackie, 1924), *Ben's Adventure* (Blackie, 1925); R. Kipling: *Songs for Youth* (Hodder, 1926); P.F. Westerman: *A Shanghai Adventure* (Blackie, 1928); J.T. Gorman: *The Lost Crown of Ghorpora* (Blackie, 1935); P.F. Westerman: *At Grips with the Swastika* (Blackie, 1940); J. Lloyd: *Catherine Goes to School* (Blackie, 1945), *Jane Runs Away From School* (Blackie, 1946), *Catherine, Head of the House* (Blackie, 1947), *Audrey, a New Girl* (Blackie, 1948); R.M. Ballantyne: *The Coral Island* (Blackie, 1965).
Bibl: Peppin.
Colour Plate 40

BATSFORD, Sir Brian Cook
See COOK, Brian

"BATT"
See BARRETT, Oswald Charles

BATTEN, John Dickson **1860-1932**
See Houfe (note that Dickson is correct spelling for middle name)

BATTY, Dora M. **d.1966**
A designer and decorative illustrator, Batty was one of the more prolific designers of posters for London Transport in the 1920s amd 1930s. According to Green, she also designed for the Poole Pottery, did publicity work for MacFisheries, and taught in the Textiles Department of the Central School of Arts and Crafts.
Books illustrated include: W.H. Davies: *Secrets: Poems* (Cape, 1924), *A Poet's Alphabet* (Cape, 1925), *The Songs of Love* (Cape, 1926), *A Poet's Calendar* (Cape, 1927).
Books written and illustrated include: *The Giant Without a Heart* (Lund, 1944).
Bibl: Oliver Green: *Underground Art: London Transport Posters 1908 to the Present* (Studio Vista, 1990); Peppin.

BAUMER, Lewis Christopher Edward **1870-1963**
See Houfe
Baumer illustrated many children's books and wrote some in the form of "nonsense verse".
Books illustrated include: I. Hay: *The Lighter Side of School Life* (Foulis, 1915), *The Shallow End* (Hodder, 1924); E. Blyton: *Silver and Gold* (Nelson, 1925); R. Arkell: *Winter Sportings* (Jenkins, 1929); H. Graham: *Happy Families* (Cape, 1934); J.B. Emtage: *Ski Fever* (Methuen, 1936).
Books written and illustrated include: *Bright Young Things* (1928).
Periodicals: Tatler.
Bibl: ICB; Peppin; Waters.

Edward BAWDEN *London Is London* by D.M. Low (Chatto & Windus, 1949). By permission of the Estate of Edward Bawden

Syringa Green, who lived at Sheen—

Lewis BAUMER *Winter Sportings* by Reginald Arkell (Herbert Jenkins, 1929)

BAWDEN, Edward **1903-1989**
Born on 10 March 1903 at Braintree, Essex, Bawden was educated at Braintree High School (1910-13) and the Friends' School in Saffron Walden (1913-19), and studied art at Cambridge School of Art (1919-21) and RCA (1922-25). He worked there under Paul Nash*, and was a contemporary student with Eric Ravilious* and Douglas Percy Bliss*, the three of whom became close friends. Bawden continued to study at the Central School of Arts and Crafts, and then taught at RCA, the RA Schools and Goldsmiths' College. The three exhibited watercolours at the St. George's Gallery (1927); and Bawden's first one-artist show was at the Zwemmer Gallery in 1934.
In 1925, while still at RCA, Bawden was commissioned by Harold Curwen of the Curwen Press to illustrate a booklet called *Pottery Making in Poole*; and around that time, both Bawden and Ravilious were designing patterned paper, borders and fleurons for the Press. In 1928, Bawden illustrated *Popular Song*, a poem by Edith Sitwell published by Faber and printed at the Curwen Press; and Robert Paltock's *The Life and Adventures of Peter Wilkins*, published by Dent, for which seventeen drawings were hand-coloured in France. He illustrated *Adam and Evelyn at Kew* in 1930 with some witty drawings, and *The Review of Reviews*, published the same year, contains a Bawden calendar illustrated with some lovely and typically humorous drawings.
Harold Curwen's encouragement was more than a financial arrangement. He became Bawden's friend, sponsor and teacher. In the 1930s, Curwen was encouraging Bawden to draw directly on the stone, and even as late as the 1940s, Bawden was seeking his advice about which colour to print first. *The Arabs*, illustrated by Bawden for the Puffin Picture Books series, published by Penguin Books in 1947, is the direct result of this consultation.
WW2 interrupted the peaceful life of Bawden and his family at Brick House in Great Bardfield, Essex. Bawden became an official war artist and, after escaping from Dunkirk, was sent on several expeditions to the Middle East and other sectors, where he met and became firm friends with another war artist, Anthony Gross*. He spent five days adrift in a lifeboat after his ship was torpedoed off Lagos, and was then interned for two months just outside Casablanca. He returned to the Middle East and then spent some time in Italy with Edward Ardizzone*. The years that Bawden spent overseas as a war artist deepened his emotional range as an artist, and he claimed that this was the time when he "really learned to draw".
By any standards, Bawden must be considered a master in the art

of illustrating books. He had a remarkable feeling for design, and in his best work, his illustrations decorate the page in a typographical as well as a pictorial way. He had an instinct for picking out essential attributes and recording them with relish. Particular humorous aspects of his subjects appealed to him, and he recorded these in his drawing rather than using a comic formula. A reviewer has written of a recent exhibition of his watercolour paintings at the Fine Arts Society, that "Bawden is…very English in his liking for the frank and unpretentious, for fresh observation, sound draughtsmanship and quiet humour". (Frances Spalding, *TLS*, 24.4.1987.) A most skilful artist in black and white and in colour, he used several techniques in his work, including woodcuts, line drawing, linocutting and auto-lithography.

Besides illustrating many books and book jackets, Bawden made many paintings in watercolour or gouache, painted a number of strikingly successful murals, designed wallpaper and ceramic wall tiles, produced linocut prints and did much commercial work for such companies as Fortnum and Mason, Imperial Airways and the Midland Bank, including poster designs for London Transport and others. All his work showed his enjoyment of life. Bliss wrote that Bawden "saw life like a foreigner at a cricket match, marvelling at its madness." For the greatest part of his life he lived and worked in Essex. He died on 21 November 1989.

Bawden won the Francis Williams Book Illustration Award for 1977 and 1982. He was awarded the CBE in 1946, elected ARA (1947); RA (1956); RDI (1949); Honorary RE (1979); and was appointed a Trustee of the Tate Gallery in 1951.

Books illustrated include (but see Bliss, 1979†): R. Paltock: *The Life and Adventures of Peter Wilkins* (Dent, 1928); E. Sitwell: *Popular Song* (Ariel Poem; Faber, 1928); Ausonius: *Patchwork Quilt* (Fanfrolico Press, 1930); R. Herring: *Adam and Evelyn at Kew* (Matthews & Marrot, 1930); C.B. Cochran: *The Review of Reviews* (Cape, 1930); A. Heath: *Good Food* (Faber, 1932), *Good Food on the Aga* (Faber, 1933); *Kynoch Press Notebook* (Birmingham: Kynoch Press, 1934); C. Bradby: *Well on the Road* (Bell, 1935); A. Heath: *Good Sweets* (Faber, 1937), *Vegetable Dishes & Salads for Every Day of the Year* (Faber, 1938); W. Shakespeare: *Henry the Fourth Part 2* (NY: Limited Editions Club, 1939); M. Joicey: *Cook-Book Note-Book* (Westhouse, 1946); D. Saurat: *Death and the Dreamer* (Westhouse, 1946); M.G. Lloyd Thomas: *Travellers' Verse* (Muller, 1946); R.B. Serjeant: *The Arabs* (Penguin Books, 1947); A. Simon: *Tea and Teacakes* (Wine and Food Society, 1948); J. Swift: *The Voyages of Lemuel Gulliver* (Folio Society, 1948); *Flower of Cities: A Book of London* (with others; Parrish, 1949); N. Carrington: *Life in an English Village* (Penguin Books, 1949); D.M. Low: *London Is London* (Chatto, 1949); J. Metcalf: *London A to Z* (Deutsch, 1953); *The Queen's Beasts* (with Cecil Keeling*; Newman Neame, 1953); W.H. Auden: *Mountains* (Ariel Poem; Faber, 1954); *Historical Ballads of Denmark* (Edinburgh University Press, 1958); Herodotus: *Histories* (NY: Limited Editions Press, 1958); W. Beckford: *Vathek* (Folio Society, 1958); G. Flaubert: *Salammbo* (NY: Limited Editions Club, 1960); C. Roden: *A Book of Middle Eastern Food* (Nelson, 1968); *The Oxford Illustrated Old Testament* (five vols., with others; OUP, 1968-9); T. More: *Utopia* (Folio Society, 1972); W. Blake: *Tyger! Tyger!* (Taurus Press, 1974); S. Johnson: *The History of Rasselas, Prince of Abyssinia* (Folio Society, 1975); T. Hennell: *Lady Filmy Fern* (Hamish Hamilton, 1980); H.M. Prescott: *The Discovery and Conquest of Peru* (Folio Society, 1981); T. Malory: *The Chronicles of King Arthur* (three vols., Folio Society, 1982); T.E. Lawrence: *Revolt in the Desert* (Folio Society, 1986); A. Conan Doyle: *The Hound of the Baskervilles* (Folio Society, 1987).

Books written and illustrated include: *Hold Fast By Your Teeth* (Routledge, 1963); *A Book of Cuts* (Scolar Press, 1979).

Contrib: *Contact Books; Curwen Press Newsletter; Echo (COI); House and Garden; Lilliput; Listener; Signature; Twentieth Century; Vogue.*

Exhib: (but see Howes, 1988†): St. George's; RA; Zwemmer; Leicester Galls; Minories, Colchester (1973); FAS (1968, 1975, 1978, 1987, 1989); Spelman's Bookshop, York (1984); V & A (1989).

Collns: IWM; Tate; V & A; Cecil Higgins Art Gallery, Bedford; Manchester, Newport, Scarborough (and many other provincial galleries); Spelman's Bookshop, York (1984).

Bibl: Douglas Percy Bliss: *Edward Bawden* (Loxhill: Pendomer Press, 1979); Chris Brown: "Edward Bawden", *Illustrators* 48 (1982): 10-12; Noel Carrington: "Edward Bawden", *Graphis* 3, no. 17 (1947): 0-43; Pat Gilmour: *Artists at Curwen* (Tate Gallery, 1977); Robert Harling: *Edward Bawden* (Art and Technics, 1950); Justin Howes: *Edward Bawden: A Retrospective Survey* (Bath: Combined Arts, 1988); Ruari McLean, ed. *Edward Bawden, War Artist, and His Letters Home* (Scolar Press, 1989); Hamish Miles: "The Printed Work of Edward Bawden", *Signature*, no. 3 (July 1936): 23-39; J.M. Richards: *Edward Bawden* (Penguin Modern Painters, Penguin Books, 1946); Denis Saurat: "Edward Bawden's England", *Alphabet and Image* 2 (September 1946): 18-33; Herbert Simon: *Songs and Words; A History of the Curwen Press.* (Allen & Unwin, 1973); Oliver Simon: *Printer's Playground; An Autobiography* (Faber, 1946); *The World of Edward Bawden; An Exhibition . . .* (Colchester: The Minories, 1973); Folio 40; Harries; ICB2; Lewis; Lewis and Brinkley; Morgan; Peppin; Tate; Who; Who's Who.

Colour Plates 12, 41 and 42

BAWDEN, Richard b.1936
Born in Braintree, Essex, the son of Edward Bawden*, Richard Bawden studied at the RCA. He has worked in illustration, poster design, mosaic, murals and printmaking. He has had more than forty one-artist exhibitions, and has shown regularly at the RA Summer Exhibition, selling out complete editions of etchings in 1987 and 1988. He works predominantly in etching, and draws from life. He is Chair of Gainsborough's House Print Workshop in Sudbury, Suffolk, a thriving group of printmakers. He was elected RE, and is a member of the Society of Designer-Craftsmen. He lives and works in Suffolk with his wife Hattie, who is a potter.

Books illustrated include: R. Lister: *Hammer and Hand: An Essay on the Ironwork of Cambridge* (Cambridge: pp., 1969).

Exhib: RA; RE; Saffron Walden.

Bibl: IFA.

BAXTER, Doreen Ethelwyn b.1910
Born in Pietermaritzburg, South Africa, Baxter's books are based on the stories she told to her younger brothers and sisters. The illustrations seen are in pen and ink, some with delicate watercolour added.

Books written and illustrated include: *Fairyland Frolics* (Brockhampton, 1950); *Dreamland Frolics* (Brockhampton, 1951); *Woodland Frolics* (Brockhampton, 1952); *New Fairy Tales* (Dent, 1955); *Wonderland Tales* (Dent, 1958).

Colour Plate 43

BAXTER, Glen b.1944
Born on 4 March 1944 in Leeds, Baxter studied painting and lithography at Leeds College of Art for five years. He lectured at V & A, taught in schools in London and Norwich, and then taught at Goldsmiths' School of Art for about twelve years. His work was first published in the late 1970s, in Holland by a cigar store owner. After an exhibition at the ICA in 1980, several books were published both in England and the US. He claims that his work is based on English children's book illustration from 1930 to 1950, running through to the surrealism of Monty Python. His books consist of zany cartoons in colour and black and white. They appear simply drawn, depicting surreal situations, and are satirical rather than humorous. A reviewer in the *Times Literary Supplement* declares that Baxter "applies techniques of fusing the familiar with the absurd and the improbable, but also a memorably fresh eye and ear, to the task of giving new, surprising and hilarious life to verbal and visual clichés."

Books written and illustrated include: *The Falls Tracer* (Tetrad Press, 1970); *The Impending Gleam* (Cape, 1981); *Atlas* (Cape, 1982); *Glen Baxter — His Life* (T & H, 1983); *Jodhpurs in the Quantocks.*

Exhib: ICA; and in Amsterdam, Belgium and New York.

Contrib: *London; New Yorker; Observer Magazine.*

Bibl: Peter Brookesmith: "Off the Wall", *Graphics World* 77 (March/April 1989): 17-21; *Times Literary Supplement* (6 November 1981); CA.

Richard BAWDEN "The Gate leading from St. John's College to Trinity Piece" from *Hammer and Hand:An Essay on the Ironwork of Cambridge* by Raymond Lister (Cambridge: printed by the University Press, 1969). Reprinted with the permission of Cambridge University Press

BAYLEY, Nicola **b.1949**

Bayley was born in Singapore, and after a teenage ambition to be a fashion designer, studied graphics at the St. Martin's School of Art and illustration at the RCA, where her final portfolio included illustrations for *One Old Oxford Ox*. Tom Maschler of Jonathan Cape saw this and commissioned her first book, *Nicola Bayley's Book of Nursery Rhymes* (1975). Other books followed, including a pop-up book (*Puss-in-Boots*, 1976) and in 1977, *One Old Oxford Ox*. The "Copycats" series, published by Walker Books in 1984, are small books with delicious and delicately coloured illustrations. Her illustrations are beautifully coloured and very detailed, often produced with fine brushes to produce a stippled appearance as if airbrushed.

Bayley must be one of a small number of illustrators whose success was established by work produced while a student. "It is interesting to note that her publisher has approached the sale of Nicola Bayley's books in the overwhelming fashion that, in today's world, now seems necessary: her second book, *The Tyger Voyage* by R. Adams, was created and promoted like a package and its first printing was 100,000 copies. While many librarians argue that her picture books appeal more to adults than to children, the success of Nicola Bayley is phenomenal and her work as an illustrator is superb." (ICB4.)

Books illustrated include: R. Adams: *The Tyger Voyage* (Cape, 1976); C. Logue: *Puss-in-Boots* (Cape, 1976); R. Hoban: *La Corona and the Tin Frog* (Cape, 1979); W. Mayne: *The Patchwork Cat* (Cape, 1981), *The Mouldy* (Cape, 1983).

Books written and illustrated include: *Nicola Bayley's Book of Nursery Rhymes* (Cape, 1975); *One Old Oxford Ox* (Cape, 1977); *Crab Cat; Elephant Cat; Polar Bear Cat; Parrot Cat; Spider Cat* (all Walker Books, 1984); *Bedtime and Moonshine: Lullabies and Nonsense* (Walker Books, 1987).

Bibl: Carpenter; ICB4; Peppin.

Colour Plate 44

BAYLY, Clifford John **b.1927**

Born in London, Bayly studied art at St. Martin's School of Art and the Camberwell School of Art (under Sir William Coldstream.) He is a painter in oils, acrylics and watercolour, and has illustrated many children's educational books and books on painting and drawing techniques. Elected NDD (1950); RWS (1981).

Books illustrated include: W. Shepherd: *Wealth from the Ground* (with Gaynor Chapman*; Weidenfeld, 1962); R. Brown: *Shep the Second* (Abelard, 1975); T. Jupp: *Rich Men, Poor Men* (Heinemann, 1976); P. Rogers: *The Playing Field Horses* (Abelard, 1976); D. Smith and D. Newton: *Collins Children's Dictionary* (Collins, 1978).

Published: *Basic Oil Brushwork* (Search Press, 1982); *Painting Boats and Harbours in Oils* (Search Press, 1982).

Exhib: RA; RWS.

Bibl: Who.

BAYNES, Pauline Diana **b.1922**

Born on 9 September 1922 in Hove, Sussex, Baynes spent her

early childhood in India. She returned to England, where she was educated at Farnborough Convent and Beaufront School, Camberley, and studied art at Farnham School of Art and the Slade (the school had been evacuated to Oxford during WW2, and she had no tuition whatever.) During the war she worked in a camouflage unit in the army, and later for the Admiralty Hydrographic Department, where she drew charts. After the war she became a free-lance designer and illustrator, working on playing cards, greeting cards, tea towels and packaging of various kinds before she did magazine illustration and, finally, book illustration. She married Fritz Gasch in 1961.

Baynes is a painter, designer and illustrator, perhaps best known for her illustrations for several of Tolkien's books, and for C.S. Lewis' 'Narnia' series of books for children. Her illustrations are drawn with a fine line and are very decorative. Her work has been influenced by mediaeval and Persian painting, and she enjoys specializing in historical work, having made a study of costume. She won the Kate Greenaway Medal in 1968 for her illustrations to *A Dictionary of Chivalry*. She has designed hundreds of covers, mostly for Puffin Books, including that for Richard Adams' *Watership Down*; and, early in her career, she contributed illustrations to many magazines.

Books illustrated include: V. Stevenson: *Clover Magic* (Country Life, 1944), *The Magic Footstool* (Country Life, 1946); P. Perry: *Question Mark* (and four others; Perry Colour Books, c. 1949); J.R.R. Tolkien: *Farmer Giles of Ham* (Allen & Unwin, 1949); H. Pourrat: *A Treasury of French Tales* (Allen & Unwin, 1951); *Fairy Tales of the British Isles* (Blackie, 1951); C.S. Lewis: *Chronicles of Narnia*, seven vols. (Macmillan, 1951-56); E.J.S. Lay: *Men and Manners* (Macmillan, 1952); M. Phillips: *Annabel and Bryony* (OUP, 1953); A. Hitchcock: *Great People Through the Ages* (Blackie, 1954); E. Garnett: *The Tudors* (Blackie, 1956); A. Williams-Ellis: *The Arabian Nights* (Phillips, 1957); M. Backway: *Hasan of Basorah* (Blackie, 1958); D. Ensor: *The Adventures of Hakim Tai* (Harrap, 1960); M.C. Borer: *Don Quixote* (Longman, 1960); J.R.R. Tolkien: *The Adventures of Tom Bombadil* (Allen & Unwin, 1962); A. Uttley: *The Little Knife That Did All the Work* (Faber, 1962); K.G. Lethbridge: *The Rout of the Ollafubs* (Faber, 1964); I. and P. Opie: *A Family Book of Nursery Rhymes* (OUP, 1964); A. Uttley: *Recipes from an Old Farmhouse* (Faber, 1966); J.R.R. Tolkien: *Smith of Wootton Major* (Allen & Unwin, 1967); J. Westwood: *Medieval Tales* (Hart-Davis, 1967); G. Uden: *A Dictionary of Chivalry* (Longman, 1968); R.D. Blackmore: *Lorna Doone* (Collins, 1970); N. Mitchison: *Graeme and the Dragon* (CUP, 1970); L. Clark: *All Along Down Along* (Longman, 1971); P. Pearce: *Stories from Hans Andersen* (Collins, 1972); K. Stewart: *The Times Cookery Book* (Collins, 1972); C. Nicolas: *The Roe Deer* (and six others; Chambers, 1974-7); R. Barber: *Companion to World Mythology* (Kestrel, 1979); E. Hunter: *Tales from Way Beyond* (Deutsch, 1979); R. Godden: *The Dragon of Og* (Macmillan, 1981); R. Harris: *The Enchanted Horse* (Kestrel, 1982); M. Norton: *The Borrowers Avenged* (Kestrel, 1982); P. Dickinson: *The Iron Lion* (Blackie, 1983); R. Kipling: *How the Whale Got His Throat* (Macmillan, 1983); A. Sewell: *Black Beauty* (Puffin, 1984); G. Macbeth: *Daniel* (Lutterworth, 1986); B. Potter: *Wag by Wall* (Warne, 1987), *Country Tales* (Warne, 1987); *Noah and the Ark* (Methuen, 1988); R. Harris: *Colm of the Islands* (Walker, 1989), *Love and the Merry-Go-Round* (Hamilton, 1989); J. Koralek: *The Cobweb Curtain* (Methuen, 1989).

Books written and illustrated include: *Victoria and the Golden Bird* (Blackie, 1947); *How Dog Began* (Methuen, 1985); *Good King Wenceslas* (Lutterworth, 1987).
Contrib: *Gas Times; ILN; Nursery World; Sphere; Woman's Journal*.
Bibl: CA; Carpenter; ICB2; ICB3; ICB4; Peppin; Who; IFA.
Colour Plate 45

"BB"
See WATKINS-PITCHFORD, Denys James

BEALES, Joan fl. 1952-
Books illustrated include: E. Hemingway: *The Old Man and the Sea* (Cape, 1952); A. Blackwood: *Where's Charlie?* (Nelson, 1975); R. Hunt: *Chutney and Fossil* and five other titles in the

series (Exeter: Wheaton, 1977); V. Anderson: *The Brownies and the Wedding Day* (Sevenoaks: Knight, 1980); P. Hill: *The Noisiest Class in the School* (Scholastic Publications, 1980); I. Uebe: *Hurrah for Dizzie Lizzy!* (Methuen, 1980); J. Reid and J. Low: *The King Who Wanted To Touch the Moon; and, The Clever Donkey* (with Anne Roger and Sydney Glen; Edinburgh: Holmes McDougall, 1982), *The Lonely Scarecrow; and, The Baby Blackbird* (Edinburgh: Holmes McDougall, 1982).
Books written and illustrated include: *Pip and the Six Cooks* (Blackie, 1964); *Travel By Land* (Blackie, 1966).
Bibl: Lewis.

BEAMAN, Sydney George Hulme 1887-1932
Born in Tottenham, north London, Beaman studied art at Hatherley's School of Art. After WW1, he set up as a toymaker in Golders Green and produced carved wooden figures about 4in. tall, with jointed limbs. He started to draw a comic strip based on these wooden figures, first published in the *Golders Green Gazette* in 1923, and in 1924 his picture book version of *Aladdin* was issued. This book featured these toys, and they continued to appear in all the "Toytown" books he wrote and drew, starting with *The Road to Toytown* in 1925. In 1928, the BBC radio programme for children, "Children's Hour", began to produce "Tales of Toytown" which was a spectacularly successful series due partly to the way in which Derek McCulloch ("Uncle Mac" to a whole generation) played the part of Larry the Lamb. "Toytown" ran for many years, continuing long after Beaman's sudden death in 1932, until the demise of "Children's Hour" in 1964. Larry the Lamb, Dennis the Dachshund and Mr. Mayor are part of the lives of most of us who grew up in that era. These radio adaptations were published in book form, first with Beaman's illustrations, but later with illustrations by other artists or by photographs of the actual toys. In 1947, there was a stage production of "The Cruise of Toytown", and a TV series was produced in the 1950s.

Beaman's illustrations have been compared to Hugh Lofting's* drawings for the "Doctor Doolittle" books. They are very simple line drawings, often made from actual wooden models set up in a toy theatre. His stories are pure farce, usually based on some simple mistake, and his characters similarly simple and gloriously repetitive in phrase. The pomposity of the Mayor, the incompetence of the Inventor, and above all, the well-meaning ineptness of Larry the Lamb, were present in every book and every performance.

Books illustrated include: R.L. Stevenson: *The Strange Case of Dr. Jekyll and Mr. Hyde* (BH, 1930); H.C. Cradock: *The Smith Family* (Nelson, 1931).
Books written and illustrated include: *Aladdin* (BH, 1924); *Illustrated Tales for Children* (OUP, 1925); *The Road to Toytown* (1925); *Trouble in Toyland* (1925); *The Seven Voyages of Sinbad the Sailor* (BH, 1926); *Out of the Ark* (Warne, 1927); *Tales of Toytown* (OUP, 1928); *John Trusty* (Collins, 1929); *Wireless in Toytown* (Collins, 1930); *The Toytown Mystery* (Collins, 1932); *Stories from Toytown* (OUP, 1938); *Larry the Lamb* (Collins, 1946).
Contrib: *Golders Green Gazette; Little Folks; Radio Times; Tiny Tots*.
Bibl: S.G. Hulme Beaman: *The Book of Toytown and Larry the Lamb* (Harrap, 1979); Carpenter; Driver; Peppin.

BEATON, Sir Cecil Walter Hardy 1904-1980
Born on 14 January 1904 in Hampstead, London, Beaton was educated at Harrow and Cambridge University (his first published works were theatrical caricatures which appeared in the University magazine, *Granta*). When he left Cambridge in 1925, he worked in an office for a few months, but by the end of 1926 found he had become a friend of Osbert and Edith Sitwell, and much sought after as a portrait photographer. He worked for *Vogue* as a photographer, illustrator and caricaturist, in both London and New York; and held one-artist exhibitions at the Cooling Gallery in 1927 and 1930. He was a war photographer during WW2, travelling first through Britain and then in the Middle and Far East. A major exhibition of his photographs was held at the NPG in 1968.

His first love was the theatre, and in 1930 he worked on two revues as stage designer. His masterpiece in this category was *My Fair*

Cecil BEATON *The Twilight of the Nymphs* by Pierre Louys (Fortune Press, 1928)

Lady (1956), and when he went to Hollywood to make the film version (1963) he won two Oscars, for costume design and art direction. (He had won his first Oscar for *Gigi* in 1958.) He was also an inveterate diarist and writer and a well-regarded caricaturist. He illustrated a few books and many of the books he wrote contain some drawings and occasionally a drawn title-page and water-colour frontispiece. His first illustrated book was probably Pierre Louys' *The Twilight of the Nymphs* (1928), printed in France at Liège for the Fortune Press, in a limited edition of 1,200 copies on hand-made paper. These decorative illustrations, done in a mixture of ink and wash, are reproduced in black and white. The female characters are tall, slim and willowy, rather like the fashionable people he liked to photograph later in his career. He produced book jackets for his own books and a few for books written by others. He went back to school at the Slade when he was fifty years old because he was dissatisfied with his drawing, but some feel that by doing so his work lost some of its individuality.

He was a flamboyant character, of whom Edward Burra* wrote in a letter dated 9 December, 1929, "Have you seen the December [*Vogue*]? its Cecil Beaton Baba Beaton Annie Beaton Mrs Beaton Father Beaton Lizzie Beaton Beaton Beaton and even one of those amusing drawings of Cecil Beaton impersonating a fragrant old Staffordshire piece representing Apollo." (Chappell, 1985.†) He was an elegant and stylish man. Hugo Vickers writes that "his conversation was witty and penetrating, and while he enjoyed the company of glittering society, above all he valued and sought out talents and individuality." (DNB.)

Beaton was awarded the Legion of Honour (1950); created CBE (1957) and knighted in 1972. He died in Wiltshire on 18 January 1980.

Books illustrated include: P. Louys: *The Twilight of the Nymphs* (Fortune Press, 1928); M. Arlen: *A Young Man Comes to Town* (1932); K.B. Beauman: *Wings on Her Shoulders* (Hutchinson,

1943); H.B. Rattenbury: *Face to Face with China* (Harrap, 1945); R.B. Sheridan: *The School for Scandal* (Folio Society, 1949); Marchioness of Bath: *When the Sunset Fades* (Longleat Estate, 1951); O. Wilde: *The Importance of Being Ernest* (Folio Society, 1960); C.Z. Guest: *First Garden* (NY: Putnams, 1976).

Books published include: *Cecil Beaton's New York* (Batsford, 1938); *Near East* (Batsford, 1943); *British Photographers* (Collins, 1944); *Far East* (Batsford, 1948); *Ballet* (Wingate, 1951); *Ashcombe: The Story of a Fifteen-Year Lease* (Batsford, 1949); *Persona Grata* with Kenneth Tynan (Wingate, 1953); *I Take Great Pleasure* (New York: Day, 1956); and six volumes of diaries from *The Wandering Years* (Weidenfeld, 1961) to *The Parting Years* (Weidenfeld, 1978).

Contrib: *Ballet Magazine; Granta; Vogue.*

Exhib: Cooling Gallery; Redfern; Lefevre; Arts Council, Cambridge; V & A; NPG; Parkin (memorial exhibition, 1983); IWM.

Bibl: Beaton's diaries (listed above); *Beaton's Portraits* (National Portrait Gallery, 1968); *Cecil Beaton: War Photographs, 1939-45* (Imperial War Museum, 1968); William Chappell, ed. *Well, Dearie! The Letters of Edward Burra* (Fraser, 1985); James Danziger: *Beaton* (Secker & Warburg, 1980); David Miller: *Cecil Beaton* (Barbican Art Gallery, 1986); Charles Spencer: *Cecil Beaton — Stage and Film Designs* (Academy Editions, 1975); DNB; Feaver; Peppin.

BEAVEN, Marcus fl.1976-

An artist from Batheaston, he illustrated a compilation of extracts of letters from W.H. Hudson, *Birds of a Feather* (1981) with ten beautifully designed and cut wood engravings.

Books illustrated include: R. Whitlock: *Wildlife in Wessex* (Bradford-on-Avon: Moonraker Press, 1976); W.H. Hudson: *Birds of a Feather* (Bradford-on-Avon: Moonraker Press, 1981).

BECK, Ian b.1947

Beck studied at Brighton College of Art, and works as a free-lance illustrator for magazines and advertising agencies. He has also designed paperback covers, including those for the David Lodge novels for Penguin, and illustrated a few books. His *Pride and Prejudice*, for the Century Edition of Jane Austen, is illustrated with twenty-two colour plates from his paintings.

Books illustrated include: *Round and Round the Garden* (OUP, 1983); J. Austen: *Pride and Prejudice* (Hutchinson, 1985); E. Hemingway: *Short Stories* (Folio Society, 1986); M. Coatts: *Edible Architecture* (Libanus Press, 1987).

Exhib: Francis Kyle; Thumb Gallery.

Bibl: Parkin.

BEDDINGTON, Roy b.1910

Born on 16 June 1910 in London, Beddington was educated at Rugby and went to the Slade for a period in 1928 before reading law at Corpus Christi College, Oxford University (1928-31). After private tuition with Bernard Adams for a year, he returned to the Slade in 1934 to work under Randolph Schwabe*, and then spent some time in Florence and Holland. Apart from the years 1931-32 when he worked as an articled clerk in accountancy, he has been a professional artist, illustrator, writer and poet. During WW2 he served in the Army until he was invalided out, and then as Fisheries Officer in the Ministry of Agriculture and Fisheries.

Early in his career, he exhibited his paintings regularly at NEAC and the Whitechapel Gallery, and at the RA until 1961. His first one-artist show was held at the Old Grafton Gallery, and three at both the Ackermann Gallery and the Walker Gallery. His water-colours have been shown regularly at the Fine Art Society and at the RWS. He has illustrated many books, where his love for natural history, particularly for fish and fishing, is obvious in his choice of subject. His illustrations are often printed in half-tone from water-colours. He has written one novel, a book about fishing, an illustrated edition of his own poems, and a book for children.

Books illustrated include: R.S. Carr: *Alexander and Angling* (Chatto, 1936); S. Gwynn: *The Happy Fisherman* (Country Life, 1936), *River to River* (Country Life, 1937), *Two in a Valley* (Rich & Cowan, 1937); A. Crossley: *The Floating Line for Salmon and Sea Trout* (Methuen, 1939); D. Carruthers: *Beyond the Caspian* (O

Roy BEDDINGTON Painting

& B, 1949); J.W. Walker: *Riverside Reflections* (1955).
Books written and illustrated include: *The Adventures of Thomas Trout* (Methuen, 1939); *To Be a Fisherman* (Bles, 1955); *The Pigeon and the Boy* (Bles, 1957); *Pindar — A Dog to Remember* (Joseph, 1975); *A Countryman's Verse* (Alembic Press, 1981).
Contrib: *Country Fair; Country Life; Field; Game and Gun.*
Exhib: RA; NEAC; RWS; RCamA; FAS; Old Grafton Gallery (1935); Ackermann Gallery; Walker Gallery; Vienna (1988).
Bibl: Peppin; Waters; Who; IFA.

BEDFORD, Francis Donkin **1864-1954**
See Houfe
Bedford was a most prolific illustrator, chiefly of children's books. He trained first as an architect and found this experience useful and relevant to his illustrative work—"I have never regretted an architectural training and my work still includes both pictures and illustrations of English and foreign buildings with an occasional return to architectural design." (ICB.)
Books illustrated include: R. Langbridge: *The Land of the Ever-Young* (SPCK, 1920); G. MacDonald: *At the Back of the North Wind* (Macmillan, 1924), *The Princess and the Goblin* (Macmillan, 1926); F.L. Stephens: *Through Merrie England* (Warne, 1928); Coatsworth: *Knock at the Door* (Macmillan, 1931).
Bibl: Carpenter; ICB; Peppin.

BEE, Joyce
See MANSFIELD, Joyce

BEER, Richard **b.1928**
Born in London, Beer was educated at Ardingly College, Sussex, and studied at the Slade, University College, London, and in Paris. He is a painter and printmaker, and has done other design work, including the designs for the ballet, "The Lady and the Fool" for the Royal Ballet. He has had several one-artist shows, and lectures in printmaking at Chelsea School of Art. He has illustrated at least one book.
Books illustrated include: A. Dumas: *The Pigeon Prize* (Rodale Press, 1955).
Colln: V & A; Metropolitan Museum, NY.
Bibl: ICB3.

BEERBOHM, Sir Henry Maximilian **1872-1956**
See Houfe

BEETLES, Peggy **fl. 1956-1960**
An illustrator of children's books in the 1950s, using line drawings which realistically and accurately portray people and events from life.
Books illustrated include: M. Allan: *The Secret* (1956), *The Runaway* (1957); J. Pudney: *The Grandfather Clock* (Hamilton, 1957); M. Cockett: *Jan the Market Boy* (Brockhampton, 1957), *The Bouncing Ball* (Hamilton, 1958); P. Mansbridge: *The Larks and the Linnets* (Nelson, 1958); M. Allan: *Hide and Seek* (1959), *The Old Pony* (1959), *The Hidden Key* (1960); M. Cockett: *Seven Days with Jan* (Brockhampton, 1960).
Bibl: Peppin.

BEGGARSTAFF BROTHERS
See Houfe under William NICHOLSON and James PRYDE

BELCHER, George Frederick Arthur **1875-1947**
See Houfe

BELL, Steve **fl. 1980s-**
A cartoonist who publishes a strip in the *Guardian*; his books are collections of these strips.
Books written and illustrated include: *Maggie's Farm* (Penguin, 1981); *The If - Chronicles* (Methuen, 1983); *If - Only Again* (Methuen, 1984); *Another Load of If -* (Methuen, 1985); *The Unrepeatable* (Methuen, 1986); *Maggie's Farm: The Last Roundup* (Methuen, 1987).
Contrib: *Guardian.*

BELL, Vanessa **1879-1961**
Bell was born in London, daughter of the Victorian critic and biographer, Sir Leslie Stephen, and sister to Virginia Woolf. She was educated privately and then studied at the Royal Academy Schools (1901-04). She travelled in Italy, Greece, Turkey and France; was profoundly influenced by the work of post-impressionist painters exhibited in London in 1910 and 1912; and produced abstract paintings as well as figurative ones.
She married the art critic, Clive Bell in 1907, and the Bells, together with Virginia and Leonard Woolf, Roger Fry, and Duncan Grant*, were central figures in the Bloomsbury Group. Vanessa Bell was closely associated with Grant as co-directors of the Omega Workshops, and they worked together for more than fifty years, living virtually as man and wife since 1913. Vanessa designed the jackets for all of Virginia Woolf's books published by the Hogarth Press, including *Kew Gardens* (1919), *The Waves* (1931), *Three Guineas* (1938) and *Granite and Rainbow* (1958). She also did the jacket for Henry Green's *Back* (1946) and Dorothy Strachey's *Olivia* (1949). She illustrated some books with woodcuts, and produced cover designs for catalogues from the Hogarth Press.
Books illustrated include: V. Woolf: *Kew Gardens* (Hogarth Press, 1919); C. Bell: *The Legend of Monte Della Sibilla* (with Duncan Grant*; Woolf, 1923); V. Woolf: *Flush* (Hogarth Press, 1933).
Exhib: Anthony d'Offay Gallery; Arts Council memorial exhibition 1961 and 1964.
Collns: Tate Gallery.
Bibl: Isabelle Anscombe: *Omega and After: Bloomsbury and the Decorative Arts* (T &H, 1971); Quentin Bell: *Virginia Woolf, a Biography*, two vols. (1972); Frances Spalding: *Vanessa Bell* (Weidenfeld, 1983); Compton; DNB; Waters.

BELLAMY, Frank **1917-1976**
Born in Kettering, Northants, Bellamy was educated locally. He was a self-taught artist who worked in a local studio until army service in WW2. In 1945, he returned to work in a local design studio and then moved to London, working in a studio on Fleet Street. He began his free-lance career in 1953; his first commission was for *Mickey Mouse Weekly*, but he established his style and reputation with a series of full colour picture strips for the *Eagle* comic, for which he worked from 1957 to 1966. His "Dan Dare" illustrations for *Eagle* are so detailed, and carefully and consistently drawn, that they appear to have been drawn from real life situations. He contributed to other comics and magazines, including the *Sunday Times Magazine*, and did the Garth strip for the *Daily Mirror* (1971-76.) He also produced a great deal of artwork for the *Radio Times* to illustrate the "Dr. Who" programmes (1971-76); and did illustrations for *Lilliput*, including some covers. In 1973, he received the Best Foreign Artist award from the Academy of Comic Book Art, New York.
Books illustrated include: *The Daily Mirror Book of Garth* (Daily Mirror, 1975); *The Second Daily Mirror Book of Garth* (DM, 1976).
Contrib: *BOP; Eagle; Daily Mirror; Home Notes; Lilliput; Men Only; Mickey Mouse Weekly; Radio Times; Sunday Times; Swift; TV Century 21.*
Bibl: Frank Bellamy: *Dr. Who Timeview; the Complete Dr. Who*

Illustrations of Frank Bellamy (Bournemouth: Who Dares Publishing, 1985); *The Best of Eagle* (Ebury Press, 1977); P.R. Garriock: *Masters of Comic Book Art* (Aurum Press, 1977); Driver; Horn.

BELSKY, Margaret **b.1925**
Born in Dorset, Belsky was the daughter of an Australian who went to England during WW1. She studied at RCA and became a cartoonist, contributing to a number of magazines and newspapers, including *Lilliput* and the *Daily Herald*. She married Czech sculptor Franta Belsky, and lived in Holland Park, Kensington.
Contrib: *Daily Herald; Lilliput; Sun.*
Bibl: Bateman.

BENATAR, Molly **fl. 1919-1929**
Benatar produced some fairly competent but ordinary black and white drawings for Molesworth; process plates for Oxenham; and banal illustrations for a girl's school story by Baldwin.
Books illustrated include: *Periwinkle's Island* (1919); Mrs. Molesworth: *The Story of a Spring Morning* (Chambers, 1923), *The Palace in the Garden* (Chambers, 1923); E. Elias: *The Old Treasure House* (Chambers, 1925); E.J. Oxenham: *Patience and Her Problems* (Chambers, 1927); E. Elias: *There's Magic in It* (Chambers, 1928); M. Baldwin: *High Jinks at Priory School* (Chambers, 1929).

BENINGFIELD, Gordon **fl. 1970s-**
Beningfield began his career as an ecclesiastical artist. Since the 1960s, he has built up a reputation as a painter of the countryside, and in recent years his work has reached a wider audience through his appearances on television, starting with the "Look Stranger" programme in 1974.
His paintings have been used as the basis for a number of books, such as *Beningfield's English Landscape*, published in 1985. His illustrations include covers for an edition of Thomas Hardy's novels published by Macmillan in 1985—*The Woodlanders, Far From the Madding Crowd, The Return of the Native, Tess of the D'Urbervilles, The Mayor of Casterbridge* and *The Trumpet-Major*. His commercial work has included postage stamp designs for the Post Office in 1981 and 1985.
Books illustrated include: T. Hardy: *The Darkling Thrush* (1985); B. Wills: *The Downland Shepherds* (Gloucester: Sutton, 1989).
Books written and illustrated include: *Beningfield's Butterflies* (Chatto, 1978); *Beningfield's Countryside* (Chatto, 1980); *Hardy Country* (Chatto, 1983); *Beningfield's English Landscape* (Chatto, 1985).

BENNETT, Harold **fl.1958-1961**
Has illustrated at least two books, using wood engravings.
Books illustrated include: D. de T. Villarroel: *The Remarkable Life of Don Diego* (Folio Society, 1958); J. R. Freile: *The Conquest of New Granada* (Folio Society, 1961).
Bibl: Folio 40.

BENNETT, Jill Crawford **b.1934**
Born in Johannesburg, South Africa, Bennett spent her childhood in Jamaica, and studied in London at the Wimbledon School of Art and the Slade. She illustrates children's books in black and white and in colour. She is quoted as saying "the first consideration for an illustrator is to serve the text and underline its quality — to enrich and, where possible, to delight. I think it is wrong for the artist to seek to force his own vision on a story." (ICB4.) She has designed for the stage and has the National Diploma of Theatre Design.
Books illustrated include: R. Dahl: *Fantastic Mr. Fox* (Allen, 1970), *Danny, the Champion of the World* (Cape, 1975); D. Edwards: *The Magician Who Kept a Pub* (Kestrel, 1975); H. Cresswell: *The Bagthorpe Saga* (seven parts; Faber, 1977-89); R. Harris: *I Want To Be a Fish* (Kestrel, 1977); C. Causley: *Figgie Hobbin* (Puffin, 1979); J. Aitken: *The Cat-Flap and the Apple-Pie and Other Funny Stories* (Allen, 1979); G. Gifford: *Earwig and Beetle* (Gollancz, 1981); L. Salway: *Black Eyes* (Leeds: Pepper, 1981); A. Bull: *The Accidental Twins* (Faber, 1982); S. Corrin: *Once upon a Rhyme* (Faber, 1982); C. Sefton: *The Emma Dilemma*

(Faber, 1982); C. Sloan: *Shakespeare: Theatre Cat* (Macmillan, 1982); C. Storr: *Tales of Polly and the Hungry Wolf* (Puffin, 1982); S. Corrin: *Round the Christmas Tree* (Faber, 1983); D. Edwards: *Mists and Magic* (Lutterworth, 1983); R. King-Smith: *The Queen's Nose* (Gollancz, 1983), *Harry's Mad* (Gollancz, 1984); F. Sampson: *Chris and the Dragon* (Gollancz, 1985); S. Corrin: *Imagine That!* (Faber, 1986); J. Counsel: *A Dragon in Class 4* (Corgi, 1986); M. Elliott: *The Willow Street Kids* (Malin, 1986); F. Sampson: *Josh's Panther* Gollancz, 1986); T. Willis: *A Problem for Mother Christmas* (Gollancz, 1986); V. Chapman: *Miranty and the Alchemist* (Malin, 1987).
Bibl: ICB4; Peppin.

BENSON, Patrick **fl. 1980s-**
Benson won the Mother Goose Award in 1984 for his illustrations to William Mayne's *Hob Stories* (1984). Mayne's funny stories are contained in four small, square books; the illustrations are outlined and textured (rather like cross-hatching) in ink, and then coloured. Hob and the strange creatures he meets are drawn as funny, cartoon-like characters.
Books illustrated include: W. Mayne: *The Hob Stories* (four vols., Walker, 1984); *Tail Feathers from Mother Goose* (with others; Walker, 1988); R. Dahl: *The Minpins* (Cape, 1991).

BENTLEY, Nicolas Clerihew **1907-1978**
Born on 14 June 1907 in Highgate, north London, son of E.C. Bentley, the leader writer for the *Daily Telegraph* and inventor of the four-line verse form named after him as the "clerihew." Nicolas Bentley was educated at University College School, London, and studied art at Heatherley's School of Art. He spent six weeks with a circus and worked for Shell in their publicity department for three years before beginning a career as a free-lance artist, writer and journalist. He also followed a career in publishing, for he was director of André Deutsch Ltd. from 1950; and worked as an editor for Mitchell Beazley Ltd., for Sunday Times Publications (1962-3) and for Thomas Nelson (1963-67).
He established his importance as an illustrator with one of the early books he illustrated, Hilaire Belloc's *New Cautionary Tales* (1930). One of the first of the younger artists to contribute to *Punch* in the early 1930s, he continued to work for the journal for many years. He was one of the comparatively small number of *Punch* artists who succeeded both with the humour of incongruity and the humour of social criticism. His caricatures also appeared in *Punch, Daily Mail,* and the *Sunday Times* during the 1960s, and in *Private Eye* in the 1970s; and he contributed the pocket cartoon each day to the *Daily Mail* from 1958 to 1962.
His black and white drawings, in *Punch* as elsewhere, were stylish, witty and simple. Bentley ranked the artist's observation among the highest of his assets. "Experience has taught me the value of making a minute observation of appearances. Particularly is this true of the comic artist. The study of appearances is of value to an artist only if they are seen and judged in relationship to their surroundings. Only in this relationship does an object acquire an identity of its own. Confronting me, with every new drawing that I begin, is the problem of how to establish that relationship in comic terms. The human species lends itself readily to the more superficial forms of caricature. But comic art extends beyond the strip cartoon. My first and foremost aim is to present not merely a comic interpretation of the human form but of the human mind" (Bentley, 1945†). He was modest about his talents, and is reported as saying "Such talents for illustration as I possess seem partly hereditary. Both my father and grandfather (as well as my godfather, G.K. Chesterton, with whom a great deal of my childhood was spent), drew amusingly and with rather more than amateur skill." (ICB.)
He was elected FSIA (1946), FRSA (1974). He died in Somerset on 14 August 1978.
Books illustrated include: E.C. Bentley: *More Biography* (Methuen, 1929); H. Belloc: *New Cautionary Tales* (Duckworth, 1930); J.B. Morton: *The Beachcomber Omnibus* (Muller, 1931); H. Belloc: *Ladies and Gentlemen* (Duckworth, 1932); H.E. Wright: *There Was a Moon* (BH, 1934); E.T.R. Benson and B.E. Asquith: *Foreigners* (Gollancz, 1935); T. Benson and B. Askwith: *Muddling Through; Or, Britain in a Nutshell* (Gollancz, 1936); L. Russell:

Parody Party (Hutchinson, 1936); D. Runyon: *More Than Somewhat* (Constable, 1937); J. Tickell: *Gentlewomen Aim to Please* (Routledge, 1938); H. Belloc: *Cautionary Verses* (1940); T.S. Eliot: *Old Possum's Book of Practical Cats* (Faber, 1940); B. Hastings: *Lobby Lobster* (Faber, 1943); E. Linklater: *The Wind on the Moon* (Macmillan, 1944); D. Lovell: *Silvanus Goes to Sea* (Faber, 1944); M. Barsley: *This England* (Statesman, 1946); G. Mikes: *How To Be an Alien* (Wingate, 1946), *Wisdom for Others*

Nicolas BENTLEY "You won't let him worry you, will you?" Cartoon from *Lilliput* (December 1937)

Nicolas BENTLEY "Some Eighteenth Century Worthies — Charles James Fox from *Saturday Book* 9 (Hutchinson, 1949)

(Wingate, 1950); L. Durrell: *Stiff Upper Lip* (Faber, 1958); G. Mikes: *How To Be Inimitable* (Deutsch, 1960), *How To Be Decadent* (Deutsch, 1965); J.R. Russell: *The Duke of Bedford's Book of Snobs* (Owen, 1965); K. Amis: *On Drink* (Cape, 1972); A. Waugh: *The Diaries of Auberon Waugh* (Deutsch, 1976); *The Reminiscences of Captain Gronow* (Folio Society, 1977); G. Mikes: *Tsi-Tsa: Biography of a Cat* (Deutsch, 1978); E.M. Delafield: *Diary of a Provincial Lady* (Folio Society, 1979).

Books written and illustrated include: *All Fall Down* (Nicholson & Watson, 1932); *Die? I Thought I'd Laugh* (Methuen, 1936); *Ballet-Hoo* (Cresset Press, 1937); *Le Sport* (Gollancz, 1937); *The Tongue-Tied Canary* (Joseph, 1948); *How Can You Bear To Be Human?* (Deutsch, 1957); *A Version of the Truth* (Deutsch, 1960); *The Victorian Scene* (Weidenfeld, 1968); *Tales From Shakespeare* (Beazley, 1972).

Contrib: *Leader; Lilliput; Radio Times; Daily Mail; Private Eye; Punch; Saturday Book; Sunday Graphic; Sunday Telegraph.*

Bibl: Nicolas Bentley: *A Version of the Truth* (Deutsch 1960); Nicolas Bentley: "Comic Artist" *Saturday Book*, 5 (1945): 86-9; DNB; Driver; Feaver; Folio 40; ICB; Peppin; Price.

BESTALL, Alfred Edmeades **1892-1986**

Born on 14 December 1892 in Mandalay, Burma, Bestall was educated at Rydal School and studied art at Birmingham College of Art (1912-14), and the Central School of Arts and Crafts (1919-22, under A.S. Hatrick and Noel Rooke*). During WW1 he spent three and a half years in Flanders, during which time he contributed cartoons to *Blighty* magazine.

A painter in oils and watercolour, line and wash, Bestall also illustrated more than fifty books, including many educational books, and contributed humorous illustrations to *Punch*, *The Bystander* and other magazines. In 1935 he took over from Mary Tourtel* the Rupert Bear strip published in the *Daily Express* and continued to do this until his retirement in 1965, and after that he continued to draw for the *Rupert* annuals until 1973. Right up to 1982, he still contributed small items. At first, Bestall copied Tourtel's style as closely as possible, but gradually Rupert and his surroundings changed. Bestall's stories were more about real-life adventures, and lack Tourtel's suspense and enchantment, but they are more original. Bestall humanized Rupert and his friends. It was certainly a successful career for an illustrator, for at his death, he left an estate valued at over £193,000.

Bestall was an origami enthusiast, and was responsible for the cut-out, folded paper features in the "Rupert" annuals. At the age of eighty-six he was elected President of the British Origami Society. He died on 15 January 1986 aged ninety-three.

Books illustrated include: E. Blyton: *The Play's the Thing* (Home Library, 1927); *The Myths and Legends of Many Lands* (Nelson, 1934); D. Glass: *The Spanish Goldfish* (Warne, 1934); F. Inchfawn: *Salute to the Village* (Lutterworth, 1943); E. Jones: *Folk Tales of Wales* (Nelson, 1947); A. Dumas: *The Three Musketeers* (1950).

Contrib: *Blackie's Annual; Blighty; Bystander; Daily Express; London Opinion; Passing Show; Punch; Rupert Bear Annuals; Schoolgirl's Own Annual; Tatler.*

Exhib: *RA; RBA.*

Bibl: *Times*, 16 January 1986; Blount; Doyle BWI; Peppin; Waters; Whalley; Who.

BETTINA
See EHRLICH, Bettina

BIANCO, Pamela **b.1906**

Born in London, Bianco's early childhood was spent in France, Italy and England. She was entirely self-taught, and though her drawings were exhibited in Turin when she was eleven, she had her real first one-artist show at the Leicester Galleries in 1919, of drawings which inspired Walter de la Mare to write poems in a book entitled *Flora*. Her mother, Margery Williams Bianco, wrote a number of books about the world of nursery toys, and Pamela illustrated two of these.

Bianco had a second exhibition at the Leicester Galleries in 1920, and the first of many in the US in 1922. She has lived in the US since that date, working for the US Government during WW2, and afterwards returning to writing and illustrating children's books. In 1930 she won a Guggenheim Fellowship and spent a year in Florence and Rome; her book, *Starlit Journey*, was written during that visit.

Books illustrated include: W. de la Mare: *Flora* (Heinemann, 1919); R.A.W. Hughes: *Gipsy Night* (GCP, 1922); M.W. Bianco: *The Little Wooden Doll* (Macmillan, 1925), *The Skin Horse* (1927); W. Blake: *The Land of Dreams* (NY: Macmillan, 1928); O. Wilde: *Birthday of the Infanta* (NY: Macmillan, 1929); J.H. Ewing: *Three Christmas Trees* (NY: Macmillan, 1930); Symonds: *Away to the*

A.E. BESTALL *Salute to the Village* by Fay Inchfawn (Lutterworth Press, 1943)

Moon (NY: Lippincott, 1956).

Books written and illustrated include: *The Starlit Journey* (NY: Macmillan, 1933); *Beginning With A* (OUP, 1947); *Playtime in Cherry Street* (OUP. 1948); *Joy and the Christmas Angel* (NY: OUP, 1949); *Paradise Square* (NY: OUP, 1950); *Little Houses Far Away* (NY: OUP, 1951); *The Look-Inside Easter Egg* (NY: OUP, 1952); *The Doll in the Window* (NY: OUP, 1953); *The Valentine Party* (Philadelphia: Lippincott, 1954).

Exhib: Leicester Galls. (1919).
Bibl: ICB; ICB2.
Colour Plate 46

BIEGEL, Peter **1913-1987**
An equestrian artist, Biegel has illustrated a number of books with paintings and drawings.

Books illustrated include: S.F. Horne: *Bred in the Bone* (Witherby, 1938), *Pat and Her Polo Pony* (Country Life, 1939), *Parachute Silk* (Witherby, 1944); D.W.E. Brock: *Privately Trained* (Witherby, 1946); S.F. Horne: *Mexican Saddle* (Witherby, 1946), *Green Trail* (Witherby, 1947); *Booted and Spurred* (Black, 1949); J. Thorburn: *Hildebrand* (Collins, 1949); D.W.E. Brock: *The Young Fox-Hunter* (Black, 1951); J. I. Lloyd: *Riders of the Heath* (Country Life, 1951); C. Willoughby: *Come and Hunt* (1952); S.F. Horne: *White Poles* (Witherby, 1954); J.T. Foote: *The Look of Eagles* (Allen, 1969); G. Wheeler: *The Year Round* (Gentry, 1971).

Exhib: Tryon Gallery.
Bibl: Titley.

BIGGS, John Reginald **1909-1988**
Born in Hamden Street, Derby, Biggs was educated in Derby and at London University. He studied art at the Derby School of Art (1929-31), where he started to engrave, and at the Central School of Arts and (1931-33), under Noel Rooke* and Bernard Meninsky. He taught engraving at the Chelsea School of Art and the Gravesend School of Art (1933-38); became the first Head of Design at the London School of Printing during WW2 (1939-46); and was Vice-Principal at the Norwich School of Art (1949-53).

John R. BIGGS "Gold Hill" from *Shaftesbury: The "Shaston" of Thomas Hardy* (Shaftesbury: Book in Hand, 1983)

From 1951 to his retirement in 1974 he was Head of the Graphic Design Department at Brighton Polytechnic.

Biggs first became interested in printing while a student in Derby. He set up a small private printing press, the Hamden Press, which issued a small series of books between 1929 and 1945. Only thirteen publications came from the Press, all designed, printed and sometimes written and illustrated by Biggs. The first was a four-page booklet, *One or Two Fragments* (1929), three poems written by Biggs and illustrated with two wood engravings; and the last was *Two Sonnets* by Shakespeare (1945), printed in black and red. His version of Spenser's *Epithalamium* was included in the Fifty Books of the Year Exhibition in 1938.

Biggs was commissioned by James Masters, who operated the High House Press in Shaftesbury, Dorset, to illustrate one of his books and then to make some engravings of the town. He stayed with Masters, drawing and showing Masters how to engrave, and the engravings of both artists are included in *Shaftesbury, The Shaston of Thomas Hardy*, published in 1932. In the 1930s Biggs worked as a free-lance artist for individuals, advertising agencies, and companies such as the Orient Line. He was designer and illustrator for the Baynard Press; and in 1938 he illustrated with wood engravings the Penguin edition of *Robinson Crusoe* and later designed the covers for the first King Penguins. He was Art Editor for SCM Press (1943-49), and production manager at Country Life Books, where he engraved many book jackets. He travelled widely, particularly in Russia, where his engravings were exhibited in Moscow (his last exhibition was held in Moscow in the 1980s), Leningrad and Tashkent; and he wrote some fifteen books on wood engraving, illustration type design, and lettering.

Elected SWE; FRSA.

Books illustrated include: W.J. Ibbett: *One Hundred Facets of Winter and Spring* (High House Press, 1931); J. Masters: *Shaftesbury* (High House Press, 1932; reprinted Shaftesbury: The Book in Hand, 1983); L. Binyon: *Three Poems* (Derby: Hamden Press, 1934); W. Gibson: *A Leaping Flame — A Seal* (Hamden Press, 1935); E. Spenser: *Epithalamium* (Hamden Press, 1938); D. Defoe: *Robinson Crusoe* (two vols., Penguin, 1938); *The Country Mouse and the Town Mouse* (Hamden Press, 1938); H. Read: *A World Within a War* (Hamden Press, 1943).

Books written and illustrated include: *One or Two Fragments* (Hamden Press, 1929); *Three Sonnets* (Hamden Press, 1932); *Sinfin Songs and Other Poems* (Hamden Press, 1932); *Splinters* (Hamden Press, 1939).

Published: *Approach to Type* (Blandford, 1949); *Illustration and Reproduction* (Blandford, 1950); *The Use of Type* (Blandford, 1954); *The Craft of Woodcuts* (Blandford, 1963); *The Craft of Script* (Blandford, 1964); *Basic Typography* (Faber, 1968); *Letterforms and Lettering* (Blandford, 1977); *Lettercraft* (Blandford, 1982.)

Exhib: RA; Redfern; RCamA; SWE.
Collns: Brighton Polytechnic.
Bibl: John R. Biggs: "John R. Biggs", *Journal RE*, no. 9 (1987): 15; John Randle: "John R. Biggs and the Hamden Press", *Matrix* 4 (Winter 1984), pp.129-34; Garrett 1 & 2; Peppin; Who; IFA.

BINCH, Caroline **fl. 1975-**
Binch has illustrated a few books and, since 1975, has done paperback covers for several publishers, including *Vilette* for Pan Books, and *Crown Jewels* by Ralph de Boissières for Picador.

Books illustrated include: E. & A. Propper: *The Hippo* (Macdonald, 1978); R. Guy: *Paris, Pee Wee and Big Dog* (Gollancz, 1984); G. Nichols: *Come Into My Tropical Garden: Poems* (Black, 1988); D. Cate: *Flames* (Gollancz, 1989); O. Wachter: *Close to Home* (Kestrel, 1989).

Bibl: *Images*, 8.

BINDER, Pearl **b.1904**
Born in Fenley, Staffordshire, Binder studied at Manchester School of Art and in Paris studios. She spent 1926 in Paris, drawing for *Le Rire*, returned to London the next year to draw for the *Sketch* and other magazines, and started illustrating books. She studied lithography with James Boswell*, James Holland* and James Fitton* at the Central School of Arts and Crafts, and many of her lithographs of the English social scene were published in *New*

PRIMUS PASSUS

Pearl BINDER *The Tunning of Elynour Rumming* by John Skelton (Fanfrolico Press, 1928)

Pearl BINDER *The Real East End* by Thomas Burke (Constable, 1932)

Masses. She lived in the slums of London's East End for several years, and found there ample subjects to illustrate Thomas Burke's *The Real East End* (1932), for which she produced interesting black and white lithographs. She has written several of her own books, the first being *Odd Jobs* (1933), which she illustrated with drawings and lithos.

She visited Moscow several times in the '30s and an exhibition of her lithographs was held there. Journeys elsewhere in Europe and the Near East were undertaken; she returned to live amongst the miners of South Wales, producing another series of lithographs. She also studied backstage theatre life, doing stage and dress design, and then began to draw for English TV in 1939. During WW2, she worked for the Government information press service.

Books illustrated include: C. Hobson: *Bed and Breakfast* (Bodley Head, 1926); J. Austen: *Persuasion* (Howe, 1928); J. Skelton: *The Tunning of Eleanor Rumming* (Fanfrolico Press, 1928); J. Driberg: *People of the Small Arrow* (Routledge, 1930); T. Burke: *The Real East End* (Constable, 1932); G. de Nerval: *Aurelia* (Chatto, 1932); P. Godfrey: *Back-Stage* (Harrap, 1933); L. Golding: *The Dance Goes On* (Corvinus Press, 1937); B. Malnick: *Everyday Life in Russia* (Harrap, 1938); A. Lomax: *Harriet and Her Harmonium* (Faber, 1955); J. Marquand: *Chi Ming and Tiger Kitten* (Dobson, 1964); J. Gladstone: *Zadig* (London Broadcasting Co., 1976); A. Bland: *Treasure Islands* (Blond, 1977).

Books written and illustrated include: *Odd Jobs* (Harrap, 1935); *Misha and Masha* (Gollancz, 1936); *Russian Families* (Black, 1942); *Misha Learns English* (Puffin Picture Book 25; Penguin, 1942); *Muffs and Morals* (Harrap, 1953); *The Peacock's Tail* (Harrap, 1958); *Look at Clothes* (Hamilton, 1959); *The English Inside Out* (Nicolson, 1961); *Pigeons and People* (with George Ordish) (Dobson, 1967); *Magic Symbols of the World* (Hamlyn, 1972); *The Pearlies* (Jupiter Books, 1975); *Dressing Up and Dressing Down* (Allen & Unwin, 1986).

Periodicals: *Harper's Bazaar; Lilliput; Observer; Le Rire; Sketch; Tatler; Vogue.*

Bibl: ICB; ICB2; Peppin.

BINNS, David b.1935

Born on 30 September 1935 in Sutton-in-Craven, Yorkshire, Binns was educated at Ermysteds Grammar School, Skipton, and studied art at Skipton and Keighley Schools of Art (1952-53) and Leeds College of Art (1954-56). After National Service in the army, he taught art at Aireville Secondary School, Skipton, and was Head of the Art Department at Ermysteds Grammar School. He became a free-lance artist in about 1980, a painter and illustrator of birds, animals and other natural history subjects. He works mostly in watercolour, but also uses linocuts and scraperboard. He has illustrated a few books, produced at least one book jacket (for W.R. Mitchell's *The Year of the Curlew*), contributed many coloured and black and white illustrations to the *Dalesman*, and produced the work which has been turned into circular jigsaws by Waddingtons for the Royal Society for the Protection of Birds. The painting "The Birds of Yorkshire" depicts 237 birds on a 40in. circular painting. His work has been influenced by his father, Daniel Binns, who was an artist and teacher; and by Joseph Crawhall and C.F. Tunnicliffe*. With his wife, Molly, he runs the Brent Gallery in Fenham-Le-Moor, Northumberland, and another in Yorkshire. NDD (1956), SWLA (1968).

Books illustrated include: *Little Animal Books* (5 books; Gibson).

Contrib: *Dalesman.*

Exhib: RI; SWLA; Mall Galleries; Craven Art Centre, Skipton; Acquarius Gallery, Harrogate; Wildfowl Trust, Slimbridge; Wisconsin.

Bibl: Who; IFA.

BINYON, Helen 1904-1979

Helen Binyon was born in Chelsea, London, in 1904, the daughter of the poet and writer Laurence Binyon. She was educated at St. Paul's Girls School and studied art, first at the RCA (1922-26) under E.W. Tristram and Paul Nash*, then in Paris at Académie de la Grande Chaumière Studio, Montparnasse, returning to London to study engraving at the Central School of Art and Design under W.P. Robins. At the RCA, she was a friend and colleague of Edward Bawden*, Douglas Percy Bliss* and Eric Ravilious*; and she maintained a close friendship with Ravilious for the rest of his life. She wrote *Eric Ravilious: Memoir of an Artist* published by the Lutterworth Press in 1983, after her death.

Binyon worked as a part-time teacher from 1931 to 1938 at the Eastbourne College of Art and the North London Collegiate School; and with her twin sister, Margaret, ran a travelling puppet

Helen BINYON *Angelina* by Maria Edgeworth (Swan Press, 1932)

theatre until the start of WW2. With Margaret she also developed the Binyon Books for children, which she illustrated and Margaret wrote. During the war she drew charts for the Hydrographic Department of the Admiralty and then worked for the Ministry of Information, preparing photographic exhibitions, and did am-

bulance service in the evenings. After the war she taught at the Willesden School of Art and at the Bath Academy of Art (1950-65), where she developed her special interest in shadow puppets.

Binyon illustrated books either with wood engravings, including *Pride and Prejudice* for the short-lived Penguin Illustrated Classics series, or, in the books for children, with pen and ink drawings, with colour added on occasion. Deane comments that her "engravings are charmingly domesticated, but though her figures, often in period costume, are sometimes a little stiff and theatrical as in *Brief Candles*, she manages to achieve a sense of drama."

Binyon was elected a member of the SWE in 1946. She also was an accomplished watercolourist and had a solo exhibition at the New Grafton Gallery in the year of her death.

Books illustrated include: M. Edgeworth: *Angelina or L'Amie Inconnue* (Swan Press, 1933); J. Austen: *Pride and Prejudice* (Penguin Books, 1938); L. Binyon: *Brief Candles* (GCP, 1938.)

Books written and illustrated include: The following with Margaret Binyon — *The Birthday Party* (OUP, 1940), *Christmas Eve* (OUP, 1940), *A Country Visit* (OUP, 1940), *A Day at the Sea* (OUP, 1940), *Polly and Jane* (OUP, 1940), *The Picnic* (OUP, 1944), *Polly Goes To School* (OUP, 1944), *The Railway Journey* (OUP, 1949); *The Children Next Door* (1949); *An Every day Alphabet* (1952); *Puppetry Today* (Studio Vista, 1966).

Published: *Eric Ravilious: Memoir of an Artist* (Lutterworth, 1983.)

Exhib: New Grafton Gallery.

Bibl: *Engravings Then and Now: The Retrospective 50th Exhibition of SWE* (SWE, 1987?); Deane; Garrett 1 & 2; Peppin; *Shall We Join the Ladies?*.

BIRD, Cyril Kenneth 1887-1965
See Houfe under FOUGASSE

Born in London on 17 December 1887, Bird was educated at Cheltenham College and King's College, London University. While training to be an engineer at King's College, Bird attended evening classes at the Regent Street Polytechnic and the LCC School of Photo-Engraving and Lithography. He served in the Royal Engineers in WW1, and was seriously wounded. Afterwards, as an artist, he used the sobriquet "Fougasse", a French land mine which might or might not explode, thus implying that there might be a unexpected surprise in his drawings. His first drawings were used by *Punch* in 1916, and he was a regular contributor to that magazine, becoming Art Editor in 1937, and then Editor (1949-52). Houfe writes that "his favourite form was

Helen BINYON
Brief Candles by Laurence Binyon (Golden Cockerel Press, 1938)

C.K. BIRD ("FOUGASSE") "Aha — sketching the weather, eh?!!!" Pen, ink and monochrome watercolour Illustrated *Punch* May 15 1940, p. 539. By permission of Chris Beetles Limited

the strip cartoon in which small outline figures, full of movement, but consisting of only the barest essentials for the story, raced along over the simplest of captions." Best known for his cartoons for *Punch*, and the "Careless Talk Costs Lives" posters he did during WW2, he also wrote and illustrated a number of books and illustrated books by other writers. He died in 1965.

Books illustrated include: H.L. Wilson: *So This Is Golf* (BH, 1923); H.J.C. Graham: *The World's Workers* (Methuen, 1928); E.P.L. Bennett: *Southern Ways and Means* (Southern Railway, 1931); W.D.H. McCullough: *Aces Made Easy* (Methuen, 1934); W.D.H. McCullough: *You Have Been Warned* (Methuen, 1935); G. Reed: *The Little Less* (Min. of Information, 1941); E. Adlard: *Dear Turley* (Muller, 1942); A.W.Bird: *Just a Few Lines* (Methuen, 1943); W.D.H. MacCullough: *Question Mark* (Elek, 1949).

Books written and illustrated include: *A Gallery of Games* (Cape, 1921); *Drawn at a Venture* (Methuen, 1922); *P.T.O.* (Methuen, 1926); *E. and O.E.* (Methuen, 1928); *Fun Fair* (Hutchinson, 1934); *The Luck of the Draw* (Methuen, 1936); *Drawing the Line Somewhere* (Methuen, 1937); *Stop or Go* (Methuen, 1938); *Jotsam* (Methuen, 1939); *And the Gatepost* (Methuen, 1940); *The Changing Face of Britain* (Methuen, 1940); *Running Commentary* (Methuen, 1941); *Sorry — No Rubber* (Methuen, 1942); *Family Group* (Methuen, 1944); *Home Circle* (Methuen, 1945); *A School of Purposes: A Selection of Fougasse Posters* (Methuen, 1946); *You and Me* (Methuen, 1948); *Us* (Methuen, 1951); *The Neighbours* (Methuen, 1954); *Between the Lines* (Methuen, 1958).

Published: "Drawing and Reproduction" *in* R.G.G. Price: *A History of "Punch"*, 1957, pp. 356-69; *The Good-Tempered Pencil* (Reinhardt, 1956).

Bibl: Joseph Darracott and Belinda Loftus: *Second World War Posters*, 2nd ed. (Imperial War Museum, 1981); Bevis Hillier, editor: *Fougasse* (Elm Tree Books, 1977); Bradshaw; DNB; Peppin; Price.

BIRDSALL, Timothy 1936-1963

Birdsall died of leukaemia in 1963 when twenty-seven years old. He had been a professional cartoonist since he was twenty, drawing a cover for *Punch* while still an undergraduate at Cambridge. Immediately after leaving university, he took over the job of doing the little cartoon on page one of the *Sunday Times* and produced about one hundred in two years. In 1962 he was appointed the political cartoonist to *The Spectator* and began to draw for *Private Eye*. He also drew for several television programmes, including "That Was The Week That Was," "Tonight," and "Gallery," immediately achieving TV celebrity status.

Books illustrated include: R. Mander and J. Mitchenson: *The Theatres of London* (Hart-Davis, 1961); M. Frayn: *The Day of the Dog* (Collins, 1962).

Contrib: *Punch; Sunday Times; Spectator; Private Eye.*

Bibl: *Motif*, no.11 (Winter 1963-64); Michael Frayn and Bamber Gascoigne: *The Drawings and Cartoons of Timothy Birdsall* (Joseph, 1964); Feaver.

BIRO, Balint Stephen ("Val") b.1921

Biro was born in Budapest, Hungary, the son of a lawyer attached to the British Legation, and was educated at the School of the Cistercian Monks, Budapest, and studied art at the Jaschnick

Timothy BIRDSALL Cartoon from *The Spectator* (1963)

Val BIRO *No Bombs at All* by C.H. Ward-Jackson (Sylvan Press, 1944)

School of Art, Budapest. In 1939 he was sent by his father to study art at the Central School of Arts and Crafts, London. He joined the Auxiliary Fire Service in 1942 and served until the end of the war. He then worked for publishers and printers — the Sylvan Press as Assistant Production Manager (1945-46); C. & J. Temple as Production Manager and Art Director (1946-48); and John Lehmann, where he was in charge of design and production (1948-53). He designed at least twenty-nine jackets for Lehmann and illustrated one of his books. After this experience, he became a free-lance writer and artist, illustrating some 400 books, mostly for children, and contributed to many other publications. He has produced many illustrated book jackets for his own books and for those by other writers, including at least three for the *Saturday Book*.

Biro admits Rex Whistler* as one of his great heroes and was himself first known as a designer and decorator rather than as an illustrator. He designed many headings and decorations for the *Radio Times*, for which he developed a new technique using white scraperboard. These decorations are mostly pastiches of eighteenth century rococo ornaments. In addition, he illustrated many broadcast operas and drew a number of covers for the journal. He is perhaps best known for his series of children's picture books, the *Gumdrop* series, written and illustrated by Biro and published by Brockhampton Press. These books relate stories about a vintage car, based on the author's own 1926 Austin Healey. The first of these was *Gumdrop: the Adventures of a Vintage Car* (1966).

Biro generally uses pen and watercolour for illustrating children's books; for his book and magazine illustrations intended for adults, he often uses scraperboard and gouache, and occasionally wood engraving. *No Bombs At All* (1944) is decorated with wood engraved

chapter headpieces, a frontispiece, and a full page tailpiece which is also used on the jacket. He is also a watercolour painter of architecture in landscape; has worked for advertising companies; and has designed medallions. FSIA.

Books illustrated include: C. Jackson: *No Bombs At All* (Sylvan Press, 1944); K. Barclay: *The Story of a Carrot* (Sylvan Press, 1944); D. Baker: *Worlds Without End* (Sylvan Press, 1945); R. Parker: *Escape from the Zoo* (Sylvan Press, 1945); Dale: *The Story of Joseph and Pharoah* (Barrie, 1950); F. Dale: *Bon Voyage* (Lehmann, 1950); Rooke: *The South African Twins* (Cape, 1953); E. Bagnold: *Serena Blandish* (Pan, 1951); L. Berg: *Fire Engine by Mistake* (Brockhampton, 1955); D. Thatcher: *Tommy the Tugboat* series (from Brockhampton, 1956); P. Andrieu: *Fine Bouche: A History of the Restaurant in France* (Cassell, 1956); N. Nicholson: *Provincial Pleasures* (Hale, 1959); A. Hope: *The Prisoner of Zenda* (Folio Society, 1961); T. Craig: *The Up- Country Year Book* (Deutsch, 1964); L. Frank Baum: *The Wonderful Wizard of Oz* (Dent, 1965); J. Corneille: *Journal of My Service in India* (Folio Society, 1966); W. Wise: *The Terrible Trumpet* (Hamilton, 1966); T. Humphris: *Garden Glory* (Collins, 1969); J.H.B. Peel: *Country Talk* (Hale, 1970); L. Berg: *Andy's Pit Pony* (Brockhampton, 1973); E.W. Hildick: *The Nose Knows* (Brockhampton, 1974), *Dolls in Danger* (Brockhampton, 1974); B. Nichols: *Down the Kitchen Sink* (1974); D. Thatcher: *Henry on Safari* (Hodder, 1975); H.E. Todd: *George the Fire Engine* (Hodder, 1976); E.W. Hildick: *A Cat Called Amnesia* (Deutsch, 1977); A. Morrison: *The Hole in the Wall* (Folio Society, 1978); H.E. Todd: *The Big Sneeze* (Hodder, 1980), *The Scruffy Scruffy Dog* (Hodder, 1983); K. Grahame: *Tales from The Wind in the Willows* (Bristol: Purnell, 1983).

Books written and illustrated include: *Bumpy's Holiday* (Sylvan Press, 1943); *Gumdrop: The Adventures of a Vintage Car* (Brockhampton, 1966); *Gumdrop Goes To London* (Brockhampton, 1971); *The Gumdrop Annual* (Brockhampton, 1979); *Hungarian Folktales* (OUP, 1980); *Gumdrop Makes a Start* (Brockhampton, 1982); *Fables from Aesop* (Ginn, 1982); *The Long Gumdrop* (Brockhampton, 1983); *Gumdrop for Ever!* (Hodder, 1987); *Gumdrop and the Pirates* (Hodder, 1989).

Colln: V & A.

Contrib: *Radio Times; Saturday Book*.

Bibl: B.S. Biro. "Techniques of the Book Jacket", *Book Design and Production*, 6, 3 (1963), 156-9; *The Penrose Annual*, 56 (1962); CA; Driver; Folio 40; ICB2; ICB3; ICB4; Peppin; Usherwood; Who.

Colour Plate 47

BISSET, Donald b.1910

Born in London, Bisset was an actor with the Royal Shakespeare Company and at the National Theatre. He has written many books for children and illustrated them with rather sketchy, humorous line drawings.

Books illustrated include: Edward Blishen: *Miscellany One* (OUP, 1964).

Books written and illustrated include: *Anytime Stories* (Faber, 1954); *Sometime Stories* (Methuen, 1957); *Talks with a Tiger* (Methuen, 1967); *Tiger Wants More* (Methuen, 1971); *The Adventures of Mandy Duck* (Methuen, 1974); *"Oh Dear," Said the Tiger* (Methuen, 1977); *This Is Ridiculous* (Beaver Books, 1977); *The Adventures of Yak* (Methuen, 1978); *The Hedgehog Who Rolled Uphill* (Methuen 1982); *The Joyous Adventures of Snakey Boo* (Methuen, 1982).

Bibl: Peppin.

BLAKE, Peter b.1932

Born on 25 June, 1932 in Dartford, Kent, Blake studied at Gravesend Technical College & School of Art (1946-51) and, after National Service, at RCA (1953-56). He travelled in Holland, Belgium, France, Italy and Spain on a Leverhulme Research Award to study pop art, and then taught at St. Martin's School of Art (1961-64); Harrow School of Art (1960-63); Walthamstow School of Art (1961-64); and at RCA (1964-76).

Blake and his contemporary, Richard Hamilton, developed independently of each other their own form of Pop Art; their emergence in the late 1950s marks the first phase of British Pop

Art. Blake's painting *On the Balcony* (1957) contains a very wide range of Pop imagery; and after this work, Blake began to make extensive use of collage and assemblage. In 1967 Blake designed the sleeve for the Beatles' record album *Sergeant Pepper's Lonely Hearts Club Band*. He became fascinated by *Alice in Wonderland* and *Through the Looking Glass* and the world of "faeries", and produced a series of marvellous watercolours in 1970-71 dealing with these typically English fantasies. Crucial to Blake's art is his sense of the artist as a kind of editor of the real and the imaginary, of past and present.

In 1969, he left London with his wife Jann Haworth*, and forsook the city for country life. They founded the Brotherhood of Ruralists in 1975, a group of seven artists "who have a passionate concern for English artistic skills and craftsmanship and who see their work as the celebration of a vital tradition in English art and its ultimate source, the spirit of the countryside." (Blurb on cover of the Arden Shakespeare.) The other artists in the group are Ann Arnold*, Graham Arnold*, David Inshaw*, Annie Ovenden* and Graham Ovenden*. These artists share not style but sympathy; their art is not retrograde but reactionary in a non-pejorative sense. All were involved in the imaginative world of the Victorians. It was Blake's influence which ensured that the Brotherhood had something of a public presence as a group. Its first exhibition as a group was in 1976 at the RA Summer Exhibition; in 1977, John Read made a film for BBC TV on the group, *Summer with the Brotherhood*; there was a major group exhibition in Bristol in 1981; and in 1983, by which time the Group had been dissolving slowly, Blake invited them to contribute a series of nudes to his Tate Gallery retrospective.

From time to time, Blake has produced or designed things for mass production, such as *Babe Rainbow*, a silk-screened tin picture sold in Carnaby Street, London; record sleeves; posters, including that for "Live Aid" in 1985; covers for the *Sunday Times Magazine*. He has illustrated at least two books and produced a number of covers/jackets, including those for the Penguin edition of Colin MacInnes's novels and for *Anthony and Cleopatra, Timon of Athens* and *Love's Labours Lost* in Methuen's Arden Shakespeare series.

In 1979, Blake separated from his wife and returned to London.

Blake was elected ARA (1974); RA (1981); and was awarded the CBE in 1983.

Books illustrated include: *The Oxford Illustrated New Testament* (five vols., with others; OUP, 1968-9); R. Longrigg: *The Sun on the Water* (Macmillan, 1969); M. Horovitz: *Midsummer Morning Jog Log* (Madley, Hereford: Five Seasons Press, 1986).

Contrib: *Sunday Times Magazine.*

Exhib: One-artist exhibitions in London and Paris; major retrospectives at The City Art Gallery, Bristol (1969) and Tate (1983); Ramsgate (1987).

Collns: Tate; MOMA; V & A; Bristol Museum and Art Gallery.

Bibl: John Fletcher: "Peter Blake and the Brotherhood of Ruralists", *The Green Book*, no. 10 (Spring-Summer 1983): 4-9; *Peter Blake: Exhibition Catalogue* (Tate Gallery, 1983); Nicholas Usherwood: *The Brotherhood of Ruralists* (Lund Humphries, 1981); Marina Vaizey: *Peter Blake (The Royal Academy Painters and Sculptors)* (Weidenfeld & Nicolson, 1986); Compton; Parry-Cooke; Tate.

Colour Plate 24

BLAKE, Quentin **b.1932**

Born on 16 December 1932 at Sidcup, Kent, Blake was educated at Chislehurst and Sidcup Boys' Grammar School, read English at Downing College, Cambridge (1953-56), and trained as a teacher at the University of London (1956-57). He attended life classes as a part-time student at Chelsea College of Art (under Brian Robb*), and since 1957 has combined teaching with work as an illustrator. He teaches illustration at the RCA (1965-78) and has been Head of the Department since 1978.

He began to draw for *Punch* in 1949 while still at school and has done covers as well as other drawings and cartoons; he has also contributed to *The Spectator*, and this work helped him move from cartooning to general illustration. He began free lancing in 1957, illustrating his first of many children's book in 1960. Most of his work has been done for children, but he has done other sorts of

illustrations, including several books for the Folio Society. In the 1960s, he illustrated book jackets for Penguin Books, including all the Evelyn Waugh and early Kingsley Amis and Malcolm Bradbury.

Russell Hoban's book, *A Near Thing for Captain Najork*, illustrated by Blake, was listed by the *New York Times* as one of the best illustrated children's books of the year (1976); of the books for children which he has written as well as illustrated, his *Mr. Magnolia* won the Kate Greenaway Medal in 1980. In addition to his work for books and periodicals, he has illustrated many editions of the BBC children's television programme, *Jackanory*.

He draws in a cursive style rather like his handwriting, often using pen and ink drawings, over which he applies delicate washes in watercolour. His illustrations, for example, for Russell Hoban's *The Rain Door* (1986), are effective, sketchy lines drawn against vivid colour washes; the rain door itself is brilliantly suggested. Catling writes that his drawings for *Punch* are "loose yet accurate, light yet spiky, [and] in his jackets and illustrations for children's books, his visual fantasy knows no bounds, and children find him very easy to accept, at least until their faculties are dulled by considerations of probability". (Catling, 1965.†) His illustrations are whimsical rather than satirical; they are drawn quickly and appear spontaneous, but the spontaneity is a deliberately drawn artistic device. Blake has said that his selection of the incidents and "confrontations" in the narrative is subjective and largely instinctive; and the incident he illustrates appears not frozen in time, but full of energy and movement.

Blake is a prolific illustrator, having illustrated about 200 books; and he has received the highest professional accolades — RDI (1981); OBE; Senior Fellow RCA (1988).

Books illustrated include (but see Martin, 1989†): P. Campbell: *Come Here Till I Tell You* (Hutchinson, 1960); J. Yeoman: *A Drink of Water, and Other Stories* (Faber, 1960); R. Weir: *Albert the Dragon* (Abelard, 1961); J. Yeoman: *The Boy Who Sprouted Antlers* (Faber, 1961); "Ezo": *My Son-in-Law the Hippopotamus* (Abelard, 1962); P. Campbell: *The P-P-Penguin Patrick Campbell* (Penguin, 1965); N-O. Franzen: *Agaton Sax and the Diamond Thieves* (Deutsch, 1965); J.P. Martin: *Uncle and the Treacle Trouble* (Cape, 1967); E. Bowen: *The Good Tiger* (Cape, 1970); J. Yeoman: *The Bear's Water Picnic* (Blackie, 1970); Aristophanes: *The Birds* (Lion & Unicorn Press, 1971); H. Thompson: *The Witch's Cat* (Blackie, 1971); R. Hoban: *How Tom Beat Captain Najork and His Hired Sportsmen* (Cape, 1974), *A Near Thing for Captain Najork* Cape, 1975); M. Rosen: *Mind Your Own Business* (Collins, 1975); J. Yeoman: *The Puffin Book of Improbable Records* (Penguin, 1975); L. Carroll: *The Hunting of the Snark* (Folio Society, 1976); S. Gibbons: *Cold Comfort Farm* (Folio Society, 1977); R. Dahl: *The Enormous Crocodile* (Cape, 1978); O. Nash: *Custard and Company* (Kestrel, 1979); R. Dahl: *George's Marvellous Medicine* (Cape, 1981); E. Waugh: *Black Mischief* (Folio Society, 1981), *Scoop* (Folio Society, 1982); A.L. Webber: *Joseph and the Amazing Technicolor Dreamcoat* (Pavilion Books, 1982); M. Rosen: *Quick, Let's Get Out of Here* (Deutsch, 1983); R. Kipling: *How the Camel Got His Hump* (Macmillan, 1984); G. Orwell: *Animal Farm* (Folio Society, 1984); R. Hoban: *The Rain Door* (Gollancz, 1986); J. Yeoman: *Our Village* (Walker, 1988); H. Belloc: *Algernon and Other Cautionary Tales* (Cape, 1991); R. Dahl: *The Vicar of Nibbleswicke* (Century, 1991).

Books written and illustrated include: *Patrick* (Cape, 1968); *Jack and Nancy* (Cape, 1969); *Angelo* (Cape, 1970); *Lester at the Seaside* (BBC, 1975); *Mr. Magnolia* (Cape, 1980); *Quentin Blake's Nursery Rhyme Book* (Cape, 1983); *The Story of the Dancing Frog* (Cape, 1984); *Mrs. Armitage on Wheels* (Cape, 1987); *Quentin Blake's ABC* (Cape, 1989).

Contrib: *Listener; New Society; Punch; Reader's Digest; Spectator.*

Exhib: Illustrators Art Gallery; National Theatre (retrospective 1983).

Bibl: Douglas Martin: *The Telling Line: Essays on Fifteen Contemporary Book Illustrators* (Julia MacRae Books, 1989); Patrick Skene Catling: "Quentin Blake" (Punch Artists in Profile) *Punch* 249, (Dec. 15, 1965): 880-1; CA; Carpenter; Folio 40; ICB3; ICB4; Jacques; Peppin; Ryder; Who; IFA.

Colour Plate 48

BLAKELY, Zelma **1927-1978**

Born in London, Blakely was educated in the US and England, and studied art at Kingston School of Art (1939-42) and at the Slade under Randolph Schwabe*, William Coldstream, Norman Janes* and John Buckland Wright* (1945-48). She taught at Heatherley's School of Fine Art in 1970. Blakely was a wood engraver and illustrated books in this medium. She was elected ARE in 1955 and RE in 1966.

Books illustrated include: I. Altamirano: *El Zarco the Bandit* (Folio Society, 1957); A. Simon: *English Fare and French Wines* (Neame, 1958); *Bedside Book of Nature* (Reader's Digest, 1959); S. Bishop: *Geordie's Mermaid* (Methuen, 1961); A. Phillips: *BBC Book of the Countryside* (with others; BBC, 1963); M.M. Reid: *With Angus in the Forest* (Faber, 1963); J. Varney: *Under the Sun* (Constable, 1964); H. Burke: *Kippers to Caviar* (Evans, 1965); Stendhal: *The Charterhouse of Parma* (Folio Society, 1977).

Contrib: *Saturday Book, 32*.

Bibl: Folio 40; Garrett 1 & 2; Peppin; Who.

BLAMPIED, Edmund **1886-1966**
See Houfe

Books illustrated include: J. Farnol: *The Money Moon* (Sampson Low, 1914); W.T. Titterton: *Me As a Model* (Palmer, 1914); J.

Edmund BLAMPIED "Potato planters" from *The Apple* (1920, 4th quarter)

Edmund BLAMPIED "Poverty is not a sin but an inconvenience" from *Hand-Picked Howlers* by Cecil Hunt (Methuen, 1937)

Farnol: *The Chronicle of the Imp* (Sampson Low, 1915); E.M. Dell: *The Way of an Eagle* (Fisher Unwin, 1916); A. Sewell: *Black Beauty* (Jerrold, 1921); M. Fairless: *The Roadmender* (Duckworth, 1924); R.L. Stevenson: *Travels with a Donkey* (BH, 1931); J.B. Priestley: *Albert Goes Through* (Heinemann, 1933); C. Hunt: *Hand-Picked Howlers* (Methuen, 1937), *More Hand-Picked Howlers* (Methuen, 1938); J.M. Barrie: *Peter Pan* (Hodder, 1939); C. Hunt: *Ripe Howlers* (Methuen, 1939), *Hand-Picked Proverbs* (Methuen, 1940).

Contrib: *The Apple; Bystander; Graphic; Men Only; Strand Magazine; Tatler*.

Exhib: RA; Leicester Galls; Guernsey Museum & Art Gallery (1986).

Collns: V & A.

Bibl: B.O. Jones: "Edmund Blampied R.E", *Journal RE*, no. 9 (1987): 13-4; Peppin; Who.

BLANCHE, Leslie **fl.1957**

Blanche illustrated *Songs and Poems of John Dryden*, published by the Golden Cockerel Press in 1957, with pencil drawings and watercolour paintings reproduced in collotype. These watercolours are in the style of Rex Whistler*, who was a fellow student at the RCA. According to Christopher Sandford, for this book she used the pseudonym Lavinia Blythe because she did not wish critics to suppose she had returned to her '30s style, "so different from her trendy latest." (Chambers.)

Books illustrated include: J. Dryden: *Songs and Poems* (GCP, 1957).

Bibl: Chambers.

BLISS, Douglas Percy **1900-1984**

Born on 28 January 1900 in Karachi, Bliss was educated at Watson's College, Edinburgh (1912-18) and at Edinburgh University (1918-22). He studied painting at the RCA under Sir William Rothenstein (1922-25), and became a close friend of Edward Bawden* and Eric Ravilious*. Inspired and encouraged by Paul Nash* who was teaching design at the RCA, he and Ravilious taught themselves wood engraving. From 1932 Bliss was a part-time tutor at the Hornsey School of Art and at the Blackheath School of Art; he served in the Royal Air Force during WW2; and was Director of the Glasgow School of Art (1946-64). In Glasgow he worked to save the magnificent Mackintosh GSA building from destruction, rescued furniture from the famous Glasgow tea rooms, and was tireless in encouraging critical appreciation of the city's environment.

Though he also painted watercolour landscapes, Bliss's major importance is as a wood engraver and a historian of wood engraving. He preferred a clear cut, bolder style than Ravilious, and was happiest when engraving dramatic, even ghoulish, subjects. He selected and illustrated *Border Ballads* in 1925 for Oxford University Press. These ballads gave him scope for his bold engravings which make very effective headpieces. His early work tended to be a little heavy for the type it was set with, but the larger, darker type used for *The Devil in Scotland* (1934) is more sympathetic with his engravings. The difficulty of getting satisfactory results by "dropping" engravings into a page of text persuaded him to try his hand at line drawings, sometimes with stencilled colour. The pen and ink illustrations for Painter's *Palace of Pleasure* (1929), with their visual wit, demonstrate his skill in this medium. In a review of Bliss' exhibit at the Alpine Club Gallery in 1980, John Russell Taylor† wrote "The wood engravings are in general stronger than the paintings . . . and his finest hour seems to have come in the 1980s with the watercolours . . . where he comes nearest in style and technique to his old schoolmates, Bawden and Ravilious."

Bliss was a prolific writer about the history and craft of wood engraving, and his *History of Wood Engraving* (Dent, 1928) is an authoritative survey. His other writings include an introduction to the craft and techniques of wood engraving, articles in *Print Collector's Quarterly* on other engravers, and *Edward Bawden* (Pendomer Press, 1979), an account of the life and work of that respected contemporary artist and illustrator.

He was elected a member of the SWE (1934), and RBA (1939). He died 11 March 1984.

Books illustrated include: S. Johnson: *The History of Rasselas, Prince of Abyssinia* (Dent, 1926); M. de Cervantes: *The Spanish Ladie, and Two Other Stories* (OUP, 1928); W. Painter: *Palace of Pleasure* (Cresset Press, 1929); W.H. Gardner: *Salamander in Spring* (Duckworth, 1933); E.A. Poe: *Some Tales of Mystery and Imagination* (Penguin, 1938); T.J. Hogg: *The Memoirs of Prince Alexy Haimatoff* (Folio Society, 1952).

Books written and illustrated include: *Border Ballads* (OUP, 1925); *The Devil in Scotland* (Maclehose, 1934).

Published: *A History of Wood-Engraving* (Dent, 1928); *Edward Bawden* (Godalming: Pendomer Press, 1979).

Contrib: *The London Mercury; The Sketch; The Woodcut.*

Exhib: Blond (1980); Alpine Club (1980).

Bibl: John Russell Taylor: "How the Modern Classics Confront Their Own Eighties", *Times* (8 July 1980): 13; Balston; Deane; Garrett 1 & 2; Lewis; Peppin; Times obit. (20.3.84).

BLOOMFIELD, Diana **b.1916**
Born in Harrow, Middlesex, Bloomfield (née Wallace) studied art at Harrow School of Art (1933-35). She taught herself to wood engrave; and then taught wood engraving at the City Literary Institute (1966-69), at the Gardner Centre for the Arts, University of Sussex (1971-76), and in the mid-1980s was teaching engraving "to a group from surrounding towns and villages, who have become my friends. I also tutor two painting classes in Eastbourne and Seaford" (Postscript, Burrett, 1985†). She has been most influenced by Thomas Bewick and Reynolds Stone*, whom she regards as the great master of engraved book plates and engraved lettering. Bloomfield has herself engraved many bookplates and illustrated books with engravings and line drawings; from 1962 her books appear to have been published in the US.

Books illustrated include: R. Calder: *Signposts to the Atomic Age* (1958); E. Graham: *A Puffin Quartet of Poets* (Penguin Books, 1958); W. de la Mare: *Come Hither* (Constable, 1960); H. Gregory and M. Zaturenska: *The Crystal Cabinet* (NY: Holt, Rinehart & Winston, 1962); E. Ansell: *Twenty-Five Poems* (Cambridge: Vine Press, 1963); *Poems of William Wordsworth* (NY: Crowell, 1964); E. Thomas: *The Green Roads: Poems* (NY: Crowell, 1965); H. Gregory and M. Zaturenska: *The Silver Swan* (NY: Holt, Rinehart

Douglas Percy BLISS *The Devil in Scotland* (Alexander Maclehose, 1934)

& Winston, 1966).
Contrib: *The Periodical.*
Bibl: Diana Bloomfield: "A Fearful Joy; Transcript of a Talk About Wood-Engraving", *Private Library*, 2nd S., 7, No.1 (Spring 1974): 4-18; Edward Burrett: *Tribute to Diana Bloomfield* (Esher: Penmiel Press, 1985); Garrett; Peppin.

BLYTHE, Lavinia
See BLANCHE, Leslie

BOND, Simon **fl. 1981-**
Bond's funny line drawings for his "anti cat" books may have offended some cat lovers, but his first book, *A Hundred and One Uses for a Dead Cat* (1981) was a great commercial success. He has followed this with books containing similarly funny, but some believe cruel, jokes and drawings.
Books written and illustrated include: *A Hundred and One Uses of a Dead Cat* (Methuen, 1981); *A Hundred and One More Uses of a Dead Cat* (Methuen, 1982); *Odd Visions and Bizarre Sights* (Methuen, 1983); *Unspeakable Acts; Success: and How To Be One* (Methuen, 1984); *Totally U.S.* (Methuen, 1988); *What Shall We Do with the Kids in the Holidays?* (Ashford Press, 1988).

BONE, Sir David Muirhead **1876-1953**
See Houfe

Stephen BONE *Mr Paul* by Gertrude Bone (Jonathan Cape, 1921)

BONE, Freda **fl. 1930s**
A wood engraver, who illustrated a number of books in the '30s. In *Without My Cloak*, her style is similar to Gwendolen Raverat's* though some of the pictures are reminiscent also of Joan Hassall's* "period" engravings.
Books illustrated include: D.W. Bone: *Capstan Bars: Nautical Songs* (Edinburgh: Porpoise Press 1931); K. O'Brien: *Without My Cloak* (Heinemann, 1931); B. Tunstall: *The Shining Night* (Garden City, NY: Doubleday, 1931); A. Bone: *Bowsprit Ashore* (Cape, 1932); M. Holden: *Grace O'Light* (Heath Cranton, 1935).

BONE, Stephen **1904-1958**
Born on 13 November 1904 in Chiswick, Bone was the son of Sir David Muirhead Bone (see Houfe). He was educated at Bedales School (while there he had a watercolour accepted by NEAC), and studied at the Slade (1922-24). After working as a camouflage officer early in WW2, he was appointed an official war artist with the navy, documenting naval life both ashore and at sea, including the invasion of Normandy. After the war, he was art critic for the *Manchester Guardian* and appeared on the BBC show, *The Critics*. Bone's professional career started with wood engravings for book illustrations, for which he won a gold medal at the Paris International Exhibition in 1925. His illustrations included woodcuts and engravings he made for books written by his mother, Gertrude Bone. He was a prolific painter in oils of figures and landscapes, and also worked as a mural painter; he became a member of NEAC in 1932. He married Mary Adshead* in 1929 and they collaborated on a number of children's books. He died in London on 15 September 1958.
Books illustrated include: G. Bone: *The Furrowed Earth* (Chatto, 1921), *Mr. Paul* (Cape, 1921); G. Bourne: *A Farmer's Life* (Cape, 1922); W.H. Davies: *Selected Poems* (Cape, 1923); G. Bone: *Oasis* (Cape, 1924), *Of the Western Isles* (Foulis, 1925), *The Hidden Orchis* (Medici Society, 1928), *The Cope* (Medici Society, 1930); J. Brooke: *The Military Orchid* (BH, 1948).
Books written and illustrated include (all with Mary Adshead): *The Little Boy and His House* (**Dent, 1936**); *The Silly Snail* (**Dent, 1942**); *The Little Boys and Their Boats* (**Dent, 1953**).
Published: *Albion: An Artist's Britain* (Black, 1939).
Exhib: NEAC; RA; Galerie Moderne, Stockholm (1937).
Bibl: Ian Jeffrey: *The British Landscape 1920-1950* (T & H, 1984); *Times* obit. 16 September 1958; DNB; Harries; ICB2; Peppin; Waters.

BOSTOCK, James Edward **b.1917**
Born on 11 June 1917 near Hanley, Staffordshire, Bostock was educated at Borden Grammar School, Sittingbourne. He studied art at the Medway School of Art, Rochester (1933-36) and at the RCA (1936-39), where he was influenced by the work of Paul Nash*, John Nash* and Eric Ravilious*. After army service during WW2, he was appointed senior lecturer at the Ealing School of Art (1946-58); Deputy Principal and Head of Diploma Studies at Stoke-on-Trent College of Art (1962-66); Vice-Principal of the West of England College of Art (1965-70); and Academic Development Officer at Bristol Polytechnic in 1970.
Bostock nearly gave up wood engraving when the sale for prints diminished and he had no commissions for book illustration. He worked as a free-lance artist for advertising from 1949 to the middle 1950s, drawing and engraving, and then went into teaching. He was elected ARE (1947); RE (1961); SWE (1952).
Books illustrated include: *Twenty-Seven Selected Psalms* (Medway College of Art, 1938-39).
Books written and illustrated include: *Roman Lettering for Students* (Studio Publications, 1959).
Exhib: RA; RBA; RE; NEAC; V & A.
Collns: BM; V & A; Hunt Botanical Library, Pittsburgh.
Bibl: Garrett 1 & 2; Who.

BOSTON, Peter **b.1918**
Born in Looe, Cornwall, Boston studied at King's College, Cambridge (1937-40), and Liverpool University School of Architecture (1946-49). A professional architect, he has also illustrated many books by his mother, L.M. Boston, who at the age of sixty started writing a series of books about a house known as "Green Knowe".

Peter BOSTON *Nothing Said* by L.M. Boston (Faber & Faber, 1971)

A child in the stories is modelled on her son and he illustrated the first book, *The Children of Green Knowe* and its sequels. Boston uses a felt pen or the scraperboard technique for his illustrations.

Books illustrated include: L.M. Boston: *The Children of Green Knowe* (Faber, 1954), *The Chimneys of Green Knowe* (Faber, 1958), *A Stranger at Green Knowe* (Faber, 1961), *An Evening at Green Knowe* (Faber, 1964), *The Sea Egg* (Faber, 1967), *The Guardians of the House* (BH, 1974), *The Fossil Snake* (BH, 1975), *The Stones of Green Knowe* (BH, 1976).
Bibl: Carpenter; Doyle; Eyre; Peppin.

BOSWELL, Hilda **1903-1976**
Born in London, Boswell studied at Hornsey School of Art and the Regent Street Polytechnic. As an illustrator, she preferred water-colour as her medium, and she wrote and edited books for children.
Books illustrated include: R.L. Stevenson: *A Child's Garden of Verses* (Collins, 1963).
Books written and illustrated include: *Jenny's Fairy Years* (1945), *The Little Birthday Horse* (1950), *Treasury of Fairy Tales* (Collins, 1959), *Treasury of Poetry* (Collins, 1968), *Omnibus* (Collins, 1972).
Bibl: Peppin.

BOSWELL, James **1906-1971**
Born in Westport, New Zealand, Boswell studied at the Elam School of Art, Auckland, before moving to England in 1925 where he continued his studies at the RCA (1925-29). He exhibited with the LG in 1927, but in 1932 he temporarily gave up painting for graphic art. In the same year, he joined the Communist Party, his politics having been shaped by the early years of the Depression. In 1933 he became a founder member of the Artists International Association, an organization established to promote left-wing and anti-militarist art. He attended James Fitton's* evening classes in lithography at the Central School along with Pearl Binder* and James Holland*.

After army service in WW2 (some of his drawings of army life are in the IWM and V & A), he became an art director for Shell and art editor of *Lilliput* magazine (1947-50). Under his direction (and that of Kaye Webb, his predecessor), *Lilliput* published fine work of such typically English artists as Edward Ardizzone*, Edward Bawden*, John Minton* and Ronald Searle*. Boswell himself was a regular contributor, and as an outstanding draughtsman of the '30s and '40s, continued to exercise a considerable influence on the illustration scene of the period. After painting a large mural for the Festival of Britain in 1951, he once again concentrated on painting (much of his work now became wholly abstract), though he also worked as a graphic artist and journalist.

He was a deeply committed political artist, a relatively rare thing in Britain. His harsh vision of the realities of life can be seen in many of his illustrations, even in some of the lighter pieces in *Lilliput*. His illustrations to his own brief article on "Face to Face: Nine Interviews with a Mirror" (*Lilliput*, October 1949) are like Grosz in style and similarly satiric. At the V & A, a pen and ink drawing of Rowton House in Lambeth, done around 1950, captures the grim austerity of the city just after the war, showing a bomb-ruined site of a public house and a pathetic assemblage of second-hand goods for sale in the street, at a time when nearly everything was severely rationed.

Boswell did work for other magazines, such as *Left Review* (for which, with James Holland* and James Fitton*, he produced some incisive caricatures), *Punch,* and *The Radio Times,* and illustrated a number of books. He also produced a number of posters, including some for Ealing Studios in the 1950s.

Boswell died in May 1971. A collection of his drawings of London, with a commentary by William Feaver, was published in 1978.

Books illustrated include: M. Hayman: *The Adventures of the Little White Girl in Her Search for Knowledge* (Cranley & Day, 1934); R. Swingler: *The Years of Anger* (Meridien Books, 1946); J. Pudney: *Low Life* (BH, 1947); *Flower of Cities: A Book of London* (with others; Parrish, 1949); M. Richardson: *The Exploits of Engelbrecht* (Phoenix House, 1951); W. Mankovitz: *A Kid for Two Farthings* (Deutsch, 1953); L. Rolt: *Railway Adventure* (Constable, 1953); L. Benedict: *The Paper Chase* (Deutsch, 1954); D. Malcolm: *The Winning Art* (Parish, 1958); M. Reynolds: *Prisoner At the Bar* (Phoenix House, 1958); B. Holt: *All This and the Family Too* (Hamilton, NZ: Paul, 1960); F. de Roberte: *The Viceroys* (MacGibbon & Kee, 1962); J. Symonds: *Dapplegray* (Harrap, 1962); C. MacKenzie: *Little Cat Lost* (Barrie, 1965); A.S. Jasper: *A Hoxton Childhood* (Barrie, 1969); J. Symonds: *Conversations with Gerald* (Duckworth, 1974).
Books written and illustrated include: *The Artist's Dilemma* (BH, 1947).
Published: "Recent Trends in English Illustration", *Graphis* 2, no. 14 (1946): 186-99; "English Book Illustration Today", *Graphis* 7, no. 34 (1951): 42-57.
Contrib: *Compleat Imbiber; Daily Worker; Left Review; Observer; Our Time; Punch; Radio Times; Lilliput.*
Collns: V & A; Tate; IWM.
Exhib: RA; AIA; Commonwealth Art Gallery (1967).
Bibl: William Feaver: *Boswell's London* (Wildwood House, 1978); Paul Hogarth: *The Artist As Reporter* (Studio Vista, 1967; and Fraser, 1986); *Times* obit. 17 May 1971; Peppin; Price; Jacques; Usherwood.
Colour Plate 49 and illustrations on page 112

BOTTERILL, Beryl Antonia
See "ANTON"

BOULTON, Reg **b.1923**
Boulton trained as a teacher after service in the RAF, and taught art at Huntingdon Grammar School for ten years; he then taught at colleges of education in Yorkshire and Hereford for a further eighteen years. He had engraved illustrations for the Vine Press while teaching, and after taking early retirement he returned to printmaking and engraving. He is also a slate letter cutter, and his skill in this art may be seen in the bookplates he has engraved. In 1981, his wholly engraved book, *Protest,* a poem by D.M. Thomas,

James BOSWELL Illustration for "Iron Curtain" by V.S. Pritchett in *Lilliput* (November 1948) p.39

was published. For *The Sculptures of Kilpeck,* Boulton made ninety-three vinyl engraved illustrations of the sculptures at Kilpeck Church, and tinted them with watercolour to reproduce the old, red sandstone. He also wrote, designed, printed and published the book. Elected SWE.

Books illustrated include: H. Read: *The Parliament of Women* (Vine Press, 1960); D.M. Thomas: *Protest* (1981).

Books written and illustrated include: *The Sculptures of Kilpeck* (Hereford: Barton Press, 1987).

Exhib: SWE.

Bibl: *Engraving Then and Now: The Retrospective 50th Exhibition of the SWE (SWE, 1987?)*; Brett.

BOWMAN, Peter **b.1957**

Born in Yorkshire, Bowman studied at Norwich School of Art, completing a degree in graphic design and illustration. After working exclusively with pencil, he later began to experiment with watercolour. In 1984, he illustrated Rudyard Kipling's *Just So Stories*, and has since illustrated other books.

Books illustrated include: R. Kipling: *Just So Stories* (Octopus Books, 1984); L. Zirkel: *Amazing Maisy's Family Tree* (OUP, 1986), *Cats Are —* (Hutchinson, 1989), *Dogs Are —* Hutchinson, 1989).

Bibl: *The Illustrators: The British Art of Illustration 1800-1987* (Chris Beetles Ltd., 1987).

BOXER, Charles Mark Edward ("Marc") **1931-1988**

Born on 19 May 1931, Boxer was educated at Berkhamsted School and King's College, Cambridge. In his last year at Cambridge, he was editor of the undergraduate magazine, *Granta*, and was sent down for blasphemy. He worked briefly on the *Sunday Express* before joining *Ambassador*, a fashion magazine, and then started to draw for *Tatler*. Though he had no formal art training, he became art editor of *Queen* in 1957, was first editor of the *Sunday Times* colour supplement (1962), and then became editor of *Tatler* in 1983. He resigned in 1987 to be editor-in-chief of *Vogue*.

Besides his skills as magazine editor, Boxer's permanent legacy lies in his cartoons and other drawings which for thirty years he

James BOSWELL "So good of you to come, Your Grace" from *Lilliput* (October 1949)

Mark BOXER ("MARC") *Antrobus Complete* by Lawrence Durrell (Faber & Faber, 1985)

contributed to a number of magazines, newspapers and books, normally signing his work as "Marc". He started as a fashion artist, but for *Punch* he did some decorative headings and small illustrations. Since then, his work appeared in many magazines, including *Tatler* and *New Statesman*. His pocket cartoon (featuring that dreadful couple, the Stringalongs) appeared in *The Times* from 1969 to 1983, the natural successor to Osbert Lancaster's* work. As Philip Howard commented in *The Times* (21 July 1988), "He was the abstract and brief chronicler of our generation. It is going to be harder to recognize the way we live in Britain tomorrow, and to laugh at our funny little ways, without his daily commentary." Boxer illustrated a few books and did the illustrations for many book covers, such as the "Bumbo" books by Andrew Sinclair for Faber, and Anthony Powell's novels for Penguin. With an elegant and economical line, sometimes with a colour wash added, his drawings are usually gentle, satirical comments on the social scene, and in particular on the "establishment". He died from a brain tumour on 20 July 1988.

Books illustrated include: C. James: *The Fate of Felicity Fark in the Land of the Media* (Cape, 1975); *Britannia's Bright Bewilderment in the Wilderness of Westminster* (Cape, 1976); *Charles Charming's Challenges on the Pathway to the Throne* (Cape, 1981); L. Durrell: *Antrobus Complete* (Faber, 1985).

Books written and illustrated include: *The Trendy Ape* (Hodder, 1968); *"Private Eye's" Book of Pseuds* (Private Eye, 1973); *The Times We Live In* (Cape, 1978); *Marc Time* (Hodder, 1984); *People Like Me* (Hodder, 1986).

Contrib: *Compleat Imbiber; Daily Telegraph; Guardian; New Yorker; New Statesman; Observer; Punch; Tatler; Times.*

Collns: V &A.

Bibl: *Times* (21 July 1988); Feaver; Price.

BOYD, Alexander Stuart **1854-1930**
See Houfe

BOYD HARTE, Glynn
See HARTE, Glynn Boyd

BOYER, Trevor **b.1948**
Born on 11 November 1948 in Castleford, Yorkshire, Boyer left school at fourteen to attend Wakefield College of Art (1963-67), where he specialized in graphic art. He worked as a commercial artist in various studios in Leeds for nine years, before becoming a free-lance artist in 1976. Since then, he has concentrated on birds as his subject matter, illustrating books, magazine covers, and exhibiting in Leeds and London. An admirer of the work of Archibald Thorburn* and David Reid-Henry*, his illustrations are finely painted and in full colour.

Books illustrated include: *Usborne's Spotter's Guide to Birds* (Usborne, 1978); *Penguins* (BH, 1978); *Birds of Britain* (Reader's Digest, 1981); *Vanishing Eagles* (1981); *The Illustrated Guide to Britain's Coast* (Automobile Association, 1984); *Ducks of the Northern Hemisphere* (Dragon's World, 1986); *Save the Birds* (Cambridge: International Council for Bird Preservation, 1987); *Complete Book of British Birds* (RSPB, 1988); *Birds of Prey of the World* (Dragon's World, 1989).

Exhib: Leeds (1963); King Street Galleries (1986; 1989).

Bibl: *The Dalesman* (August 1987); IFA.

Colour Plate 50

BRABY, Dorothea Paul **1909-1987**
Born on 17 October 1909 in London, Braby studied at the Central School of Art and Design under John Farleigh* (1926) and Noel

Dorothea BRABY *Gilgamesh* (Golden Cockerel Press, 1946)

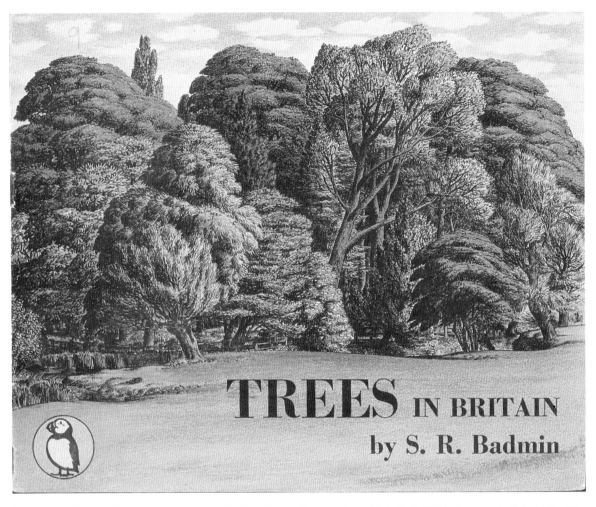

Colour Plate 37. S.R. BADMIN *Trees in Britain* (Puffin Picture Book No. 31; Penguin Books 1943)

Colour Plate 38. Cicely M. BARKER Cover design for *The Snowdrop Story Book* (Blackie & Sons) Original watercolour with body colour, pen and ink By permission of Chris Beetles Limited

Colour Plate 39. Peter BARRETT "Badger's House" Original watercolour Illustrated *Wind in the Willows* by Kenneth Grahame (New York: Golden Books 1986) By permission of Chris Beetles Limited

(Opposite) Colour Plate 40. Leo BATES "Saint George! For Merrie England!" from *Where the Rainbow Ends* by Clifford Mills (Hodder & Stoughton 1921)

R.A. BRANDT *The Devil's Heir and Other Stories* (John Westhouse, 1945)

Rooke* (1931), and later in Florence, Paris and at Heatherley School of Fine Art (1928-30).

Braby worked as a portrait painter and as a commercial artist, but it is as a book illustrator that she is best known. Working mostly in black and white, her illustrations are produced by wood engraving, pen and ink, or occasionally by scraperboard. She produced illustrations for a number of journals, notably the *Radio Times*, but her best work was done for private presses, particularly the Golden Cockerel Press. She spent eighteen months working on the *Mabinogion* (1948), reading and researching so that her illustrations would reflect not only her own ideas but the perceptions of traditional Celtic art. The illustrations for *The Saga of Llywarch the Old* (1955) are colour engravings, using just brown and green. The frontispiece is suggestive of brasswork but the others look like mediaeval carved ivory tablets.

Braby was elected SWE and exhibited widely. In 1953 Studio published her *The Way of Wood Engraving* in their "How To Do It Series." She stopped working as a professional artist about 1959, and worked full-time for the elderly; even after retirement from this, she voluntarily worked three days a week for the last twelve years of her life. She did her last engraving in 1980.

Books illustrated include: C. Whitfield: *Mr. Chambers and Persephone* (GCP, 1937); *The Ninety-First Psalm* (GCP, 1944); V.G. Calderon: *The Lottery Ticket* (GCP, 1945); *The Mabinogion* (GCP, 1948); F.L. Lucas: *Gilgamesh* (GCP, 1948); J. Keats: *Poems*

(Folio Society, 1950); *Sir Gawain and the Green Knight* (GCP, 1952); N. Streatfeild: *The Fearless Treasure* (Joseph, 1953); O. Wilde: *Lord Savile's Crime* (Folio Society, 1954); E. Eden: *The Semi-Attached Couple* (Folio Society, 1955); G. Jones: *The Saga of Llywarch the Old* (GCP, 1955.)

Books written and illustrated include: *The Commandments* (Lewis, 1946); *The Way of Wood Engraving* (Studio, 1953).

Contrib: *ICI Magazine; Radio Times; Observer; TLS.*

Exhib: SWA; NBL; SWE; Studio One, Oxford.

Bibl: *Engraving Then and Now: The Retrospective 50th Exhibition of the SWE* (SWE, 1987?); Folio 40; Garrett 1 & 2; Peppin; Sandford; *Shall We Join The Ladies?*; Who.

See also illustration on page 21

BRADLEY, Maureen fl. 1978-

Books illustrated include: B. Ball: *Jackson and the Magpies* (Hamilton, 1978); E. Blyton: *The Enid Blyton Goodnight Story Book* (Hodder, 1980); J. Holiday: *Merman in Maids Moreton* (Hodder, 1980); J. Escott: *Alarm Bells* (Hamilton, 1981); G. Trease: *The Running of the Deer* (Hamilton, 1982); J. Escott: *Bell Rescue* (Hamilton, 1983); *Bell Puzzle* (Hamilton, 1984); P. Sykes: *Left-Handed Magic* (Hodder, 1985); E. Lallemand: *The Seven on the Screen* (Knight, 1986); J. Escott: *Radio Trap* (Hamilton, 1987); E. Colwell: *Highdays and Holidays* (Kestrel, 1988); J. Curry: *Through the Pink Wall* (Hamilton, 1988); B. Ball: *Stone Age Magic* (Hamilton, 1989); J. Nimmo: *The Red Secret* (Hamilton, 1989).

BRANDT, Rolf A. 1906-1986

Born a British subject in Hamburg, Germany, Brandt settled in England in 1933. He studied art briefly at the Amédée Ozenfant School in London (1936-37) and later in Paris. He illustrated books for Peter Lunn and John Westhouse (1942-46); but after the publishers went bankrupt, he did little illustrating and taught at the London College of Printing during the '50s-'70s, and at the Byam Shaw School of Art.

Brandt won the News Chronicle Award for a New Illustrator in 1942 for his illustrations for Stephen MacFarlane's *The Story of a Tree* (1946). He was close to his brother, photographer Bill Brandt, and the distorted perspective and images in *Rabelais and Gargantua* (1946) can be seen as a reflection of his brother's work. Though he used bright gouache colours for *The Story of a Tree* and *The Fisherman's Son*, his book illustrations were mostly pencil drawings, which often have a strong macabre feeling about them. John Keir Cross† wrote, however, that "His figures are not haunting figures from neurotic nightmare: they are the inventions of a free imagination that sees the world with a lofty, detached penetration and records, without comment, human character and experience. . . in short, he is Rabelaisian."

Books illustrated include: *Fairy Tales by the Brothers Grimm* (Lunn, 1944); *The Fisherman's Son* (Lunn, 1944); *Russian Anthology* (Westhouse, 1945); H. de Balzac: *Les Contes Drolatiques* (Westhouse, 1945); *Come Not, Lucifer! A Romantic Anthology* (Westhouse, 1945); Rabelais: *Gargantua and Pantagruel* (Westhouse, 1946); S. Macfarlane: *The Story of a Tree* (Lunn, 1946); *Russian Stories: Pushkin to Gorky* (Westhouse, 1946); *Russian Stories: Leskov to Andreyev* (Westhouse, 1946); *Why the Sea Is Salt* (Lunn, 1946); T. Hughes: *The Earth Owl and Other Moon People* (Faber, 1983).

Books written and illustrated include: *The Man with the Red Umbrella* (1946).

Exhib: Galleria Pater, Milan (1958); Paris Gallery, London (1961); ICA (1965); Royal Festival Hall (1988).

Bibl: *Apparitions: [A Catalogue of] An Exhibition of Drawings and Illustrations by Rolf Brandt* (Royal Festival Hall, 1988); John Keir Cross: "The Book Illustrations of R. A. Brandt", *Graphis*, 15 (1946), pp.374-9; Peppin.

BRANGWYN, Sir Frank 1867-1956
See Houfe

Brangwyn was a most versatile and prolific artist, working in many mediums including oils, watercolours, etchings and woodcuts. He was a muralist, printmaker, interior designer, jewellery designer; he produced posters and bookplates; and he did magazine illustrations and illustrated some forty books, his subjects

embracing classical and contemporary themes. He made sixteen coloured woodcuts for Hayter Preston's *Windmills* and seventy-two illustrations for Walter Shaw-Sparrow's *A Book of Bridges*.

Books illustrated include: *The Rubaiyat of Omar Khayyam* (Foulis, 1910; a second version was published in 1919); W. Shaw-Sparrow: *A Book of Bridges* (BH, 1915); E. Phillpotts: *The Girl and the Faun* (Palmer and Hayward, 1916); H. Stokes: *Belgium* (Paul, 1916); E. Hutton: *A Pageant of Venice* (BH, 1922); H. Preston: *Windmills* (BH, 1923); C. Barman: *The Bridge* (BH, 1926).

Bibl: Rodney Brangwyn: *Brangwyn* (Kimber, 1978); William de Belleroche: *Brangwyn's Pilgrimage* (Chapman & Hall, 1948); Philip Macer-Wright: *Brangwyn: A Study of Genius at Close Quarters* (Hutchinson, 1940); G.S. Sandilands: *Frank Brangwyn (Famous Water-Colour Painters)* (The Studio, 1928); Johnson FDIB; Peppin.

BRATBY, John Randall 1928-1992

Bratby was born on 19 July 1928 in Wimbledon, educated at Tiffin Boys' School, Kingston, and studied at Kingston School of Art (1948-50) and RCA (1950-54). He taught painting in Carlisle and at RCA (1957-58). A member of the London Group, his paintings depict the domestic trivia of the so-called "Kitchen Sink" realists. His first one-man exhibition was held at the Beaux Arts Gallery in 1954; in 1957-58, he designed sets for the film, *The Horse's Mouth* (and he illustrated the book in 1969). His well-received novels, starting with *Breakdown*, written in the 1960s, were illustrated with heavy black pen drawings, and the same style is used for the later

Horace BRAY *The Plays of Euripides* (Gregynog Press, 1931). By permission of the National Library of Wales, Aberystwyth

books which he illustrated. He wrote in *The Oxford Illustrated Old Testament*, of which he illustrated Job, Amos, Obadiah and 1 Maccabees, "The work of illustrating parts of the Bible was a gift because I have always enjoyed illustration but not had enough of it to do."

Elected ARA (1959), RA (1971). Died 20 July 1992 in Hastings, Sussex.

Books illustrated include: *The Oxford Illustrated Old Testament* (five vol., with others; OUP, 1968-9); J. Cary: *The Horse's Mouth* (Folio Society, 1969); R. Duncan: *Tale of Tails* (St. German, Cornwall: Elephant Press, 1975); E. Lowbury: *Masada; Byzantium; Celle: Poems* (Bristol: Sceptre Press, 1985); A. Huxley: *The Devils of Loudun* (Folio Society, 1986).

Books written and illustrated include: *Breakdown* (Hutchinson, 1960); *Breakfast and Elevenses* (Hutchinson, 1961); *Brake Pedal Down* (Hutchinson, 1962); *Break 50 Kill* (Hutchinson, 1963).

Exhib: Beaux-Arts Gallery (1954-9); RA; Zwemmer (1956-9); Furneax Gallery (1970); Thackeray Gallery (1971-7); National Theatre; Venice Biennale.

Collns: Tate; V & A; Ashmolean; Arts Council; National galleries of Canada, New Zealand, NSW, and Victoria.

Bibl: *The Forgotten Fifties* (Sheffield City Art Galleries, 1984); Compton; Folio 40; Parry-Cooke; Peppin; Tate; *Times* obit. 22 July 1992; Who.

BRAY, Horace Walter 1887-1963

Born in West Ham, London, Bray was apprenticed as a scenic artist when he was fourteen, and studied later at the Westminster School of Art, under Walter Sickert. In 1924, his friend R.A. Maynard* invited him to join him at the Gregynog Press, and they were responsible for illustrating most of the books produced there before 1930. Before moving to Gregynog, Bray had no knowledge of wood engraving, but he quickly learned the technique from Maynard. The last two volumes which were produced at Gregynog before they left for London were Charles Lamb's *Elia* and *The Last Essays of Elia*. These two volumes are illustrated entirely by Bray

John BRATBY *Breakdown* (Hutchinson, 1960)

Colour Plate 41. Edward BAWDEN *Adam and Evelyn at Kew* by Robert Herring (Matthews & Marrot 1930). By permission of Estate of Edward Bawden

Colour Plate 42. Edward BAWDEN *Travellers' Verse* edited by M.G. Lloyd Thomas (Frederick Muller 1946). By permission of Estate of Edward Bawden

Colour Plate 43. Doreen BAXTER "They were great friends with the forest creatures" Original drawing in pen and ink and watercolour with body colour Illustrated *Wonderland Tales* (Dent 1958). By permission of Chris Beetles Limited

Colour Plate 44. Nicola BAYLEY *One Old Oxford Ox* (Jonathan Cape 1977)

Simon BRETT "Restoratives" from *Hobbes's Whale* by John Gohorry (Paulinus Press, 1988)

with twenty-seven wood engravings of great charm and delicacy.

Bray and Maynard left in September 1930 to set up their own press, The Raven Press, in Harrow Weald. Four books were produced there and then the production of greeting cards was added to the Press's activities for financial reasons. Following a disagreement over profit-sharing in 1934, Bray had a breakdown and left, and the partnership was formally dissolved in December.

Bray returned to scene painting until his retirement in 1958 and never produced another wood engraving. He looked back on his involvement with the Raven Press with bitterness and burned most of his unsold copies of its books.

Books illustrated include: H. Vaughan: *Poems* (with Maynard, Gregynog Press, 1924); *Caneuon Ceiriog Detholiad* (with Maynard, Gregynog Press, 1925); E. Thomas: *Chosen Essays* (with Maynard, Gregynog Press, 1926); *The Life of Saint David* (with Maynard, Gregynog Press, 1927); *The Autobiography of Edward Lord Herbert of Cherbury* (Gregynog Press, 1928); T.L. Peacock: *The Misfortunes of Elphin* (Gregynog Press, 1928); C. Lamb: *Elia* and *The Last Essays of Elia*, two vols. (Gregynog Press, 1931); Euripides: *Plays* (with Maynard, Gregynog Press, 1931); W. Shakespeare: *Venus and Adonis* (Raven Press, 1931); *The Book of Tobit* (Raven Press, 1931); D. Cecil: *Sir Walter Scott* (Raven Press, 1933); H.F. Waddell: *The Abbé Prévost* (Raven Press, 1933).F

Bibl: James A. Dearden: "The Raven Press", *Private Library*, 2nd S., 6, No. 4 (Winter 1973): 158-91; Dearden: "Horace Walter Bray at the Raven Press", *Private Library*, 2nd S., 7, No. 3 (Autumn 1974): 122-3; Dorothy A. Harrop: *A History of the Gregynog Press* (Private Libraries Association, 1980); Cave; Peppin.

BRECK, G. William **fl. 1919**

Illustrated, in firmly drawn black and white, a series of books by

Edward Streeter about a character called "Bill", a genuinely humorous creation.

Books illustrated include: E. Streeter: *Dere Mabel* (Jarrolds, 1919), *As You Were, Bill!* (Pearson, 1920).

BRENNAN, Nicholas Stephen **b.1948**

Brennan was born in Coventry and studied at Coventry College of Art. In his final year as a student, he produced his first book, *Jasper and the Giant*. Brennan's picture book, *Olaf's Incredible Machine*, is a somewhat disconcerting book, for its message about how man is destroying the earth ecologically is more suitable for teenagers and adults.

Books illustrated include: Kay Webb and Treld Bicknell, eds: *Puffin's Pleasure* (Puffin, 1976); Ruth Jennings: *In the Bin* (Kestrel, 1979).

Books written and illustrated include: *Jasper and the Giant* (Kestrel, 1970); *Olaf's Incredible Machine* (Kestrel, 1973); *The Blundle's Bad Day* (Kestrel, 1974); *The Magic Jacket* (Kestrel, 1976).

Bibl: ICB4; Peppin.

BRETT, Bernard **b.1925**

Born in Birmingham, Brett was educated at Hove Grammar School and Todmorden Grammar School, and studied art at Brighton College of Art. He taught at Wolverhampton College of Art (1951-57) and was Vice-Principal at East Surrey College of Art (1967-75).

He has been writer, editor, design consultant, director of a fine art studio producing artists' lithographs, and illustrator. He uses a variety of different media, and produces work that has much textural and tonal richness.

Books illustrated include: A. Williams: *Between the Lights* (Dent, 1952); J. Clark: *Crab Village* (Dent, 1954); S.F. Woolley: *The Romans* (ULP, 1972); N. Ingman: *Story of Music* (Ward Lock, 1972), *Gifted Children of Music* (Ward Lock, 1978).

Books written and illustrated include: *Captain Cook* (Collins, 1970); *The Travels of Marco Polo* (Collins, 1971); *Bernard Brett's Book of Explorers* (Longman, 1973); *Ships* (Hamlyn, 1979); *A Young Person's Book Guide to Witchcraft* (1981).

Contrib: *American Traveller*.

Bibl: ICB4; Peppin.

BRETT, Mary Elizabeth **fl. 1936-**

Works as Molly Brett. Born in Croydon, she studied illustration by correspondence, and since 1934 has worked as a free-lance illustrator, writing and illustrating children's books and producing greeting cards and gift wrap. Her work is very popular among young children, and there are twenty-one of her books listed in the Medici Society's 1988 catalogue. She uses watercolour and pen and pencil.

Books illustrated include: N.M. Nimmo: *The Bed That Learned To Fly* (Warne, 1963), *Through the Magic Mirror* (Warne, 1963).

Books written and illustrated include (but see Peppin): *The Little Garden* (Warne, 1936); *The Story of a Toy Car* (Warne, 1938); *Drummer Boy Duckling* (Muller, 1945); *Follow Me Round the Farm* (Tuck, 1947); *Mr. Turkey Runs Away* (Brockhampton, 1947); *Master Bunny, the Baker's Boy* (Brockhampton, 1950); *The Japanese Garden* (Warne, 1959); *Robin Finds Christmas* (Medici Society, 1961); *Tom Tit Moves House* (Medici Society, 1962); *A Surprise for Dumpy* (Medici Society, 1965); *The Untidy Little Hedgehog* (Medici Society, 1966); *Paddy Gets Into Mischief* (Medici Society, 1972); *The Hare in a Hurry* (Medici Society, 1975); *Goodnight Time Tales* (Medici Society, 1982); *The Run-Away Fairy* (Medici Society, 1982); *Plush and Tatty on the Beach* (Medici Society, 1987); *The Magic Spectacles and Other Tales* (Medici Society, 1987).

Contrib: *Puck; Tiny Tots*.

Bibl: CA; Peppin; Who.

BRETT, Simon **b.1943**

Born on 27 May 1943 in Windsor, Berkshire, and educated at Ampleforth College (1955-60), Brett studied art at St. Martin's School of Art (1960-64), where he was taught wood engraving by Clifford Webb*. He was awarded the Helene Worlitzer Foundation

Simon BRETT "Epistle to the Romans for *The Reader's Digest Illustrated Bible* (not published)

grant to study in New Mexico (1965-67), and worked in Denmark and London before going to Les Arcs in Provence (1969-70); and then for almost twenty years he taught part-time in the art department of Marlborough College (1971-1989). In 1974 he married painter Juliet Wood.

Until 1970, engraving was of secondary concern to painting in Brett's career. For the next ten years, he worked on a lot of ephemeral material, but also included book illustration for private presses. In 1981, he established the Paulinus Press, first in Llandovery, and later in Marlborough, where he now lives; and in 1986 he was elected both ARE and Chairman of the SWE. He began work on *Engravers, A Handbook for the Nineties*, and organized the SWE's 50th anniversary exhibition, "Engraving Then and Now", which toured major museums in Britain (1987-89).

Brett has illustrated a number of books with powerful but complex and contemplative wood engravings which "combine an ambitious imagination with brilliance of execution" (Saunders, 1987†). He won a Francis Williams Illustration Award for *The Animals of Saint Gregory* (1981). Brett is obviously a Christian and a man for whom religion is important, but he is disconcerted at being described as "heir to the Christian tradition of Gill and Jones" (Saunders.) As an artist, he claims to have been influenced by Clifford Webb*, and by the work of William Hogarth, Eugene Delacroix, Gwen Raverat* and Gertrude Hermes*.

Books illustrated include: T. Gunn: *The Missed Beat* (Gruffyground Press, 1976); J. Finzi: *Twelve Months of the Year* (Libanus Press, 1981); B. O'Malley: *The Animals of Saint Gregory* (Paulinus Press, 1981); M.J. Davis: *The Way to the Tree of Life* (Old Stile Press, 1983); P. Levi: *Music of Dark Tones* (1983); A. Thwaite: *Telling Tales* (Gruffyground Press, 1983); M.J. Davis: *To*

the Cross (Paulinus Press, 1984); W. Shewring: *Translations and Poems* (Paulinus Press, 1984); B. O'Malley: *A Pilgrim's Manual* (Paulinus Press, 1985); N. Perry-Gore: *Coherence Through the Eyes of Mary* (Paulinus Press, 1985); N. Braybrooke: *Four Poems for Christmas* (Paulinus Press, 1986); J.C. Bretherton: *The Road to Advent* (Paulinus Press, 1986); L. Saunders and K. Spencer, editors: *"Seven Years On"; The Green Book Poets 1979-1986* (with others; Bath: Green Book Press, 1987); J. Gohorry: *Hobbes's Whale* (Paulinus Press, 1988); W. Shakespeare: *Hamlet; Antony and Cleopatra* (Folio Society, 1988), *Shakespeare's Sonnets* (Folio Society, 1989).

Published: *Engravers: A Handbook for the Nineties* (Swavesey: Silent Books, 1987).

Contrib: *Green Book*.

Exhib: RE; SWE; one-artist shows — Mission Gallery, Taos, New Mexico (1967); University of Exeter (1974); Katharine House Gallery, Marlborough (1982); Radley College, Oxford (1984); St. Botolph's Church, Aldgate, London (1986).

Bibl: Brian North Lee: *The Ex Libris of Simon Brett* (Frederikshavn, 1982); Linda Saunders: "Letting in Light and Maintaining Darkness", *The Green Book*, 2, No. 5 (1987), 30-35; Brett; Garrett 1 & 2; Who; IFA.

BRICKDALE, Eleanor Fortescue　　　　　　　**1871-1945**
See Houfe

BRIERLEY, Louise　　　　　　　　　　　　　**b.1958**
Born on 15 February 1958 at Glossop, Brierley was educated at Manchester Polytechnic (1976-80), where she was awarded a BA in illustration, and then received an MA from RCA (1980-83). She has already written and illustrated two books for children and illus-

Colour Plate 45. Pauline BAYNES *A Dictionary of Chivalry* by Grant Uden (Longman 1968)

Colour Plate 46. Pamela BIANCO "Angel and child" from *Flora* by Walter de la Mare (William Heinemann 1919)

'Of course you do!' cried Mr Oldcastle, realising the truth at last. 'And what's more, so do I!'

He must have been mad to think that he could ever part with Gumdrop. The very thought of it made him shudder now. 'Hop in, children, and I'll take you back to Gumdrop now!'

(Opposite) Colour Plate 47.
Val BIRO *Gumdrop for Ever!*
(Hodder & Stoughton 1987)

Colour Plate 48. Quentin BLAKE *The Story of the Dancing Frog*
(Jonathan Cape 1984)

Colour Plate 49. James BOSWELL, *Lilliput* cover, November 1949

trated a few books for other writers. She has designed covers for Penguin Books (including one for Iris Murdoch's *The Good Apprentice*) and other publishers; and contributed to a number of magazines. Her *Twelve Days of Christmas* (1986) won a Distinguished Mention in the W.H. Smith Illustration Awards for 1987.

Books illustrated include: R. Kipling: *The Elephant's Child*; *The Twelve Days of Christmas* (Walker Books, 1986); W. de la Mare: *Peacock Pie* (Faber, 1989).

Books written and illustrated include: *The Singing, Ringing Tree* (Walker Books, 1988); *King Lion and His Cooks*; *The Fisherwoman* (Walker, 1989).

Contrib: *Cosmopolitan; Observer; Sunday Times.*
Bibl: IFA.
Colour Plate 51

BRIGGS, Raymond Redvers **b.1934**
Born on 18 January 1934 in Wimbledon Park, London, the son of a Cooperative Dairies milkman, Briggs studied at Wimbledon School of Art (1949-53) and at the Slade (1955-57). He has been a full-time illustrator and writer since 1957, and a part-time lecturer in illustration at Brighton Polytechnic since 1961.

often inappropriate draughtsmanship . . . and harsh, coarsely printed colours" (Alderson). Elsewhere his *Mother Goose Treasury* has been claimed as the finest modern illustrated collection from traditional sources, and it won the Kate Greenaway Medal in 1966. Briggs is perhaps best known for his "comic-strip" style of illustration, first used for his hilarious *Father Christmas* in 1973, which also won the Greenaway Medal. In this book, which was a great public success, Briggs' central character is given a very grumpy surface nature, fed up with the weather and his job, but beneath he is clearly shown to be kind and warm. Another prize winner was *The Snowman* (1978), which won the Francis Williams Illustration Award for 1977-82. *When the Wind Blows* (1982), a savage satire on nuclear war, was produced for adults in comic-strip style. Versions of its round faced, bald-headed central character had appeared in earlier books, and seem to be Briggs' "man in the street" image, based perhaps on his father. The book was a popular success, and has been adapted for radio (winning the Broadcasting Press Guild's award for the most outstanding radio programme of 1983) and for theatre.

Books illustrated include (but see Martin†): R. Manning-Sanders: *Peter and the Piskies: Cornish Folk and Fairy Tales* (OUP, 1958);

Raymond BRIGGS *Gentleman Jim* (Hamish Hamilton, 1980)

Early in his career, Briggs is quoted as saying that "the whole point of illustration is that it is literary. If it is not, it remains a drawing only . . . Something must be 'going on' in the illustration. The people must be thinking and feeling and not just forms in a composition" (Ryder). Before Briggs had developed and refined his characteristic visual and verbal style, he wrote and illustrated three adventure stories of a very conventional kind — *Midnight Adventure* (1961), *The Strange House* (1961), and *Sledges to the Rescue* (1963). His "picture books" began with a collection of nursery rhymes, *Ring-a-Ring o'Roses*, published in 1962. One critic at least is unhappy about the way that Briggs' style moved from the warmth of that book to the sharpness of *The Mother Goose Treasury* (1966). "Briggs's three earlier and smaller collections, despite their evolving manner, all acknowledged the distinctive humour or feeling of their contributory rhymes and were very much unified wholes. The *Treasury*, on the other hand, has sacrificed a single standpoint . . . in favour of a kind of graphic opportunism. It is at its best in some of the smaller jokes and riddles, but for much of the book it manifests itself in crude and

A. Ross: *The Onion Man* (Hamilton, 1959); A. Duggan. *Look at Castles* (Hamilton, 1960), *Look at Churches* (Hamilton, 1961); M. Trevor: *William's Wild Day Out* (Hamilton, 1963); W. Mayne: *Whistling Rufus* (Hamilton, 1964); R. Manning-Sanders: *The Hamish Hamilton Book of Magical Beasts* (Hamilton, 1965); J. Aldridge: *The Flying 19* (Hamilton, 1966); B. Carter: *Jimmy Murphy and the Duesenberg* (Hamilton, 1968); W. Mayne: *The Hamish Hamilton Book of Giants* (Hamilton, 1968); J. Reeves: *The Christmas Book* (Heinemann, 1968); E. Vipont: *The Elephant and the Bad Baby* (Hamilton, 1969); I. Serraillier: *The Tale of Three Landlubbers* (Hamilton, 1970); V. Haviland: *The Fairy Tale Treasury* (Hamilton, 1972); J. Reves: *The Forbidden Forest* (Heinemann, 1973); M. Anno: *All in a Day* (Hamilton, 1986).

Books written and illustrated include: *Midnight Adventure* (Hamilton, 1961); *The Strange House* (Hamilton, 1961); *Ring-a-Ring o'Roses* (Hamilton, 1962); *Sledges to the Rescue* (Hamilton, 1963); *The White Land* (Hamilton, 1963); *Fee-fi-fo-fum* (Hamilton, 1964); *The Mother Goose Treasury* (Hamilton, 1966); *Jim and the Beanstalk* (Hamilton, 1970); *Father Christmas* (Hamilton, 1973);

Father Christmas Goes on Holiday (Hamilton, 1975); *Fungus the Bogeyman* (Hamilton, 1977); *The Snowman* (Hamilton, 1978); *Gentleman Jim* (Hamilton, 1980); *When the Wind Blows* (Hamilton, 1982); *The Tinpot Foreign General and the Old Iron Woman* (Hamilton, 1984); *Unlucky Wally* (Hamilton, 1987).

Bibl: Richard Kilborn: *The Multi-Media Melting Pot: Marketing "When the Wind Blows"* (Comedia, 1986); Douglas Martin: *The Telling Line: Essays on Fifteen Contemporary Book Illustrators* (Julia MacRae, 1989); Alderson; Carpenter; Doyle; ICB3; ICB4; Peppin; Ryder.

BRIGHTON, Catherine b.1943
Born in London, Brighton is the daughter of an artist and a writer. She studied illustration at the St. Martin's School of Art in the early 1960s and then at the RCA. She became a free-lance illustrator, working for newspapers, television and educational publishers, and in the late 1970s started to specialize in children's books, writing as well as illustrating them. In the 1980s, she produced three books for Faber. For *The Voice* (1986), which is a sequence of poems by Walter de la Mare, she wrote that she wanted "to see if I could interpret (rather than just illustrate) some of his verse. But in order to make it mine as well I had to create my own Walter de la Mare-like world. . . this is partly done by the choice of poems and by using the same characters throughout the book and imposing on it my own loose narrative." Jane Doonan in *TLS* (20-26 November, 1987), writes that Brighton's pictorial style "owes much to the seventeenth century Dutch art of describing. . . With wit and intelligence Brighton breaks the earlier pictorial conventions for her own expressive purpose by introducing bold changes of eye-level, scale and viewpoint, which give the art of the past the immediacy of the present."

Books illustrated include: S. Victory: *Two Little Nurses* (Faber, 1983).

Books written and illustrated include: *Cathy's Story* (Evans); *Emily's a Guzzleguts* (Evans); *I Was Only Trying to Help* (Faber, 1984); *Maria* (Faber, 1984); *The Picture* (Faber, 1985); *The Voice* (Faber, 1986); *Five Secrets in a Box* (Methuen, 1987); *Hope's Gift* (Faber, 1988); *Nijinsky* (Methuen, 1989).

Bibl: Information from Faber (1986).

BRIGHTWELL, Leonard Robert b.1889
See Houfe
Born in London, Brightwell studied at the Lambeth School of Art and at the Zoological Gardens. He served in the army in WW1 and as an Air Raid Warden in WW2.

Mostly interested in drawing and painting animals, he sold his first drawing to *The Boy's Own Paper* and contributed to many comic magazines including *Punch*. His illustrations appear in several issues of *Chums* annual and in *Joy Street* from 1931 to 1935, a few in colour. He was seriously interested in animals and in fish in particular, having been a Fellow of the Zoological Society of London since 1906 and a member of the Marine Biological Association since 1922. His work for museums included the creation of extinct animals; and he produced animated cartoons, both humorous and educational. He joined many scientific and commercial trawling expeditions and produced clear and accurate scientific drawings. His other illustrations tend to be sketchy, but the pictures he produced for Olwen Bowen's stories were done in clear colours and outlines. The animals are neither dressed nor is their anatomy humanized, but their antics are human without any suggestion of cartoon.

Books illustrated include: E.H. Barker: *A British Dog in France* (Chatto, 1913); E. Davies: *Our Friends at the Farm* (Harrap, 1920); C. Evans: *Reynard the Fox* (Evans, 1921); L. Mainland: *Zoo Saints and Sinners* (Partridge, 1925); E.G. Boulenger: *A Naturalist at the Zoo* (Duckworth, 1926); O. Bowen: *Hepzibah Hen* (Benn, 1927); H. Chesterman: *The Odd Spot* (Blackwell, 1928); M. Swannell: *Animal Geography* (Evans, 1930); O. Bowen: *Taddy Tadpole and the Pond Folk* (Nelson, 1933); G. Davidson: *Standard Stories from the Operas* (Laurie, 1935-40); Sister Margaret: *Zoo Guy'd* (Burns, Oates, 1935); E. Andrade: *More Simple Science* (Harper, 1936); F. Buckland: *Buckland's Curiosities of Natural History* (Batchworth, 1948); O. Bowen: *Dog's Delight* (Nelson, 1949).

Books written and illustrated include: *A Cartoonist Among Animals* (Hurst, 1921); *The Tiger in Town* (C & H, 1930); *On the Seashore* (Nelson, 1934); *Zoo Calendar* (Hutchinson, 1934); *The Zoo You Knew* (Blackwell, 1936); *Neptune's Garden* (Pitman, 1937); *The Dawn of Life* (Odhams, 1938); *The Garden Naturalist* (Medici Society, 1941); *Rabbit Rearing* (Medici Society, 1944); *Sea-Shore Life in Britain* (Batsford, 1947); *Pond People* (Wells, Gardner, 1949); *The Story Book of Fish, Fishermen and the Home* (Wells, Gardner, 1951); *The Story Book of Pets and How To Keep Them* (Wells, Gardner, 1951); *The Story Book of Animals and the Home* (Wells, Gardner, 1952); *The Story Book of Jungle to Home* (Wells, Gardner, 1952); *The Zoo Story* (Museum Press, 1952); *Down to the Sea* (Pitman, 1954); *Trimmer, the Tale of a Trawler Tyke* (Muller, 1956).

Contrib: *BOP; Bystander; Captain; Chums; Humorist; Joy Street; London Opinion; Punch; Quiver.*

Bibl: *Blount; Doyle BWI; ICB; ICB4; Peppin.*

BRISLEY, Joyce Lankester 1896-1978
With her sister, Nina Brisley*, attended Lambeth School of Art; and both, with another sister, Ethel, exhibited at the RA. Joyce became well known for her Milly-Molly-Mandy stories, the first of which was published in 1928 and the last in 1967. The stories are simple, with a feeling of cosiness which appeals to young children, relying on the repetition of phrases to provide a gentle humour. These books first were issued in instalments in the *Christian Science Monitor*, before Harrap published them.

Books illustrated include: H.C. Cradock: *Adventures of a Teddy Bear* (Harrap, 1934), *Teddy Bear's Farm* (Harrap, 1941); U.M. Williams: *Adventures of a Little Wooden Horse* (Harrap, 1938); E. Wetherell: *The Wide Wide World* (ULP, 1950).

Books written and illustrated include: *Milly-Molly-Mandy Stories* (Harrap, 1928); *Marigold in Grandmother's House* (Harrap, 1934); *Adventures of Purl and Plain* (Harrap, 1941); *Milly-Molly-Mandy and Co* (Harrap, 1955); *Children of Bible Days* (Harrap, 1970); *The Joyce Lankester Brisley Book* (Harrap, 1981).

Contrib: *Blackie's Children's Annual; Christian Science Monitor; Home Chat; Watkin's Annual.*

Exhib: RA.

Bibl: Carpenter; Peppin.

BRISLEY, Nina Kennard d.1978
With her sister, Joyce Brisley*, she attended Lambeth School of Art and exhibited at the RA. She illustrated many books for children, including a long series on girls' school life at the Châlet School in the Austrian Tyrol, written by Elinor Brent-Dyer. Elizabeth Clark and Elsie Oxenham were other favorite authors for whom she illustrated many books. Apparently she also designed posters.

Books illustrated include: M.M. Hayes: *The Book of Games* (with Margaret Tarrant*; 1920); E. Brent-Dyer: *A Head Girl's Difficulties* (Chambers, 1923), *The Maids of La Rochelle* (Chambers, 1924); E. Oxenham: *The School Without a Name* (Chambers, 1924), *Ven at Gregory's* (Chambers, 1925); E. Brent-Dyer: *The School at the Châlet* (Chambers, 1925), *Jo of the Châlet School* (Chambers, 1926), *The Princess of the Châlet School* (Chambers, 1927), *The Head Girl of the Châlet School* (Chambers, 1928), E. Clark: *More Stories and How To Tell Them* (ULP, 1928), *The Tale That Had No Ending* (ULP, 1929); E. Oxenham: *Deb at School* (Chambers, 1929), *Dorothy's Dilemma* (Chambers, 1930), *Deb of Sea House* (Chambers, 1931); E. Brent-Dyer: *The Châlet School and Jo* (Chambers, 1931), *The Exploits of the Châlet Girls* (Chambers, 1933); E. Clark: *Tales for Jack and Jane* (ULP, 1936), *Story Books* (ULP, 1936), *Tell Me a Tale* (ULP, 1938), *A Little Book of Bible Stories* (ULP, 1938); E. Brent-Dyer: *The New Châlet School* (Chambers, 1938); E. Clark: *Twilight and Fireside* (ULP, 1942), *Sunshine Tales for Rainy Days* (ULP, 1948); D. Norman: *The Secret of "The Beeches"* (ULP, 1950); *SPCK Giant Picture Books* (with E. A. Wood; SPCK, 1950).

Contrib: *Wilfred's Annual; Wonder Books.*

Exhib: RA.

Bibl: Peppin.

T.BOYER

(*Opposite*) Colour Plate 50. Trevor BOYER Original painting for *Birds of Prey of the World* (Dragon's World 1989)

Colour Plate 51. Louise BRIERLEY Original painting for *Peacock Pie* by Walter de la Mare (Faber & Faber 1989)

Colour Plate 52. Anthony BROWNE. Copyright illustration © from *Gorilla* (Julia MacRae Books, London and Alfred A. Knopf Inc, New York, 1983)

Colour Plate 53. Violet BRUNTON *Ecclesiasticus* (John Lane, The Bodley Head 1927)

Colour Plate 54. John BURNINGHAM *Mr Gumpy's Outing* (Jonathan Cape 1970)

BROCK, Charles Edmond **fl.1928**

This Brock is no relation to the better known "Cambridge" Brocks; his watercolour illustrations are totally different from their precise and clean style.

Books illustrated include: The Marchioness of Londonderry: *The Magic Ink-Pot* (Macmillan, 1928).

Bibl: Ian Rogerson: *The Brocks: A Cambridge Family of Illustrators* (Skilton, 1975).

BROCK, Charles Edmund **1870-1938**
See Houfe

Charles, Henry and Richard Brock (see Houfe) were the sons of Edmund Brock, a Cambridge scholar and reader to the University Press, and Mary Pegram, one of a London family of some artistic distinction. After WW1, the three brothers became heavily involved in illustration for children, both for magazines and annuals, and for adventure and school stories. They produced coloured illustrations, printed as plates, and line drawings in the text. Rogerson asserts that of the brothers, "Harry was both the most prolific and versatile, Charles possibly the most sensitive and Dick the most pedestrian, at least in book illustration" (Rogerson, 1985†).

Bibl: C.M. Kelly: *The Brocks: A Family of Cambridge Artists and Illustrators* (Skilton, 1975); Ian Rogerson: *The Brocks: A Cambridge Family of Illustrators; an Exhibition of Their Work* (Manchester Polytechnic Library, 1985); Peppin.

BROCK, Henry Matthew **1875-1960**
See Houfe

BROCK, Richard Henry **fl. 1901-1937**
See Houfe

Russell BROCKBANK Cartoon from *Lilliput* (April 1947)

BROCKBANK, Russell P. **1913-1979**

Brockbank was a Canadian, who had served in the Royal Navy and worked in industry. He became an important *Punch* artist and in 1949 was appointed Art Editor under Kenneth Bird*. His main interest was in cars and aeroplanes, and though the non-motorist could enjoy his jokes, the expert could appreciate the drawn details of individual models. "His drawing was better with things than with people, who tended to be rather repetitively horrified or eager or ferocious or terrified . . . As a colourist he was bold and decorative and did some striking covers" (Price).

Books written and illustrated include: *The Penguin Brockbank*

(Penguin, 1963); *Motoring Through Punch* (D & C, 1970); *The Best of Brockbank* (D & C, 1975).

Contrib: *Lilliput; Punch*.
Bibl: Price.

BROCKWAY, Harry John **b.1958**

Born on 26 August 1958 in Newport, South Wales, Brockway was educated in Newport and at the United World College of the

Harry BROCKWAY *The Lad Philisides* by Sir Philip Sidney (The Old Stile Press, 1988)

Atlantic, South Wales (1974-76). He studied at Newport School of Art (1977-78), and then specialized in sculpture, first at Kingston Polytechnic (1978-81) and then at the RA Schools (1981-84), where he won a travelling prize and the British Institute prize for sculpture. He taught at Christ's Hospital School, Horsham in 1984-85, and was adult education tutor in sculpture at Chelsea/Westminster in 19858-6. After working as a stone mason in Wells, Somerset, at the Wells Cathedral works in 1987, he became a self-employed stone carver in 1988.

Brockway had learned wood engraving from Sarah Van Niekirk* while at the RA Schools. He has illustrated a few books with wood engravings, including contributions to the Folio Society's *Shakespeare*. His wood engravings for *The Lad Philisides* are beautifully and finely cut, and the whole book, from the Old Stile Press, is a fine example of what good work little presses can produce (see also illustration on page 24).

Books illustrated include: W. Shakespeare: *All's Well That Ends Well, The Merchant of Venice* (Folio Society, 1988); Sir P. Sidney: *The Lad Philisides; Being a Selection from the Countess of Pembroke's Arcadia* (Old Stile Press, 1988); W. Shakespeare: *Sonnets* (Folio Society, 1989).
Exhib: RA; SWE; IKON Gallery, Birmingham (1988-9); Winchester (1989).
Bibl: Brett; IFA.

BROMHALL, Winifred fl. 1923-1967
Born in Walsall, Bromhall studied at Queen's Mary College, Birmingham University and Walsall School of Art. She emigrated to the US in 1924, and much of her illustrative work was done for American publishers.
Books illustrated include: W. de la Mare: *A Child's Day* (NY: Holt, 1923); E.M. de Chesnez: *Lady Green Satin and Her Maid Rosette* (Macmillan, 1923); C. Perry: *The Island of Enchantment* (Hutchinson, 1926); B. Thompson: *Silver Pennies* (NY: Knopf, 1930); K. Morse: *The Pig That Danced a Jig* (NY: Dutton, 1938); K. Avery: *Wee Willow Whistle* (NY: Knopf, 1947); M. Watts: *Patchwork Kilt* (Aladdin, 1954).
Books written and illustrated include: *Johanna Arrives* (NY: Knopf, 1941); *Belinda's New Shoes* (NY: Knopf, 1945); *Mrs. Polly's Party* (NY: Knopf, 1949); *The Chipmunk That Went to Church* (NY: Knopf, 1952); *Circus Surprise* (NY: Knopf, 1954); *The Princess and the Woodcutter's Daughter* (NY: Knopf, 1955); *Bridget's Growing Day* (NY: Knopf, 1957); *Middle Matilda* (NY: Knopf, 1962); *Peter's Three Friends* (NY: Knopf, 1964); *Mary Ann's Duck* (NY: Knopf, 1967).
Bibl: ICB; ICB2; Peppin.

BROOK, Judy fl. 1966-
An illustrator of children's books, Brook writes mostly for young children. Her illustrations for the "Tim Mouse" series are amusing and spirited, and set against a background of the English countryside.
Books illustrated include: M. Sharp: *The Rescuers* (Collins, 1976).
Books written and illustrated include: *Tim Mouse* (World's Work, 1966); *Tim Mouse Goes Down the Stream* (World's Work, 1966); *Tim Mouse and the Major* (World's Work, 1967); *Tim Mouse Visits the Farm* (World's Work, 1968); *The Friendly Letter-Box* (World's Work, 1975); *Belinda* (World's Work, 1976); *Mrs. Noah and the Animals* (World's Work, 1977); *Belinda and Father Christmas* (World's Work, 1978); *Around the Clock* (World's Work, 1980); *Charlie Clown* (Kingfisher Books, 1986).

BROOKE, Iris b.1908
Following her studies at the RCA (1926-29), Brooke's main interest was in the history of costume. Her first book was *English Children's Costume* (1930) and she subsequently wrote and illustrated several others in the same field. She has also illustrated several books by other authors with her drawings.
Books illustrated include: J. Laver: Costume of the Nineteenth Century (Black, 1929), *English Costume of the Eighteenth Century* (Black, 1931); M. and C.E. Carrington: *A Pageant of Kings and Queens* (CUP, 1937); S. Knowles: *Arpies and Sirens* (Harrap, 1942).

Books written and illustrated include: *English Children's Costume Since 1775* (Black, 1930); *English Costume in the Age of Elizabeth* (Black, 1933); *English Costume of the Seventeenth Century* (Black, 1934); *English Costume of the Early Middle Ages* (Black, 1936); *A History of English Costume* (Methuen, 1937); *English Costume 1900-1950* (Methuen, 1951); *Four Walls Adorned: Interior Decoration 1485-1820* (Methuen, 1952); *Pleasures of the Past* (Odhams, 1955); *English Costume of the Later Middle Ages* (Black, 1956); *Dress and Undress* (Methuen, 1958); *English Children's Costume Since 1775* (Black, 1958); *Costume in Greek Classic Drama* (Methuen, 1962); *Western European Costume and Its Relation to the Theatre* (NY: Theatre Arts Books, 1963); *Medieval Theatre Costume* (Black, 1967).
Bibl: Peppin.

BROOKE, Leonard Leslie 1863-1940
See Houfe
Brooke wrote many books for children, the first, *Johnny Crow's Garden,* being published in 1903 by Warne. Warne published all his books, and most of those he illustrated.
Books illustrated include: E. Everett-Green: *Miriam's Ambition* (Blackie, 1889); Mrs. Molesworth: *Nurse Heatherdale's Story* (Warne, 1891), *The Girls and I* (Warne, 1892), *My New Home* (Warne, 1894), *Miss Mouse and Her Boys* (Warne, 1897); R. Browning: *Pippa Passes* (Duckworth, 1898); E. Lear: *The Jumblies and Other Nonsense Verses* (Warne, 1900), *Nonsense Songs* (Warne, 1900), *The Pelican Chorus and Other Nonsense Songs (Warne, 1900); The Golden Goose Book* (Warne, 1905); Brothers Grimm: *The House in the Wood* (Warne, 1909); G.F. Hill: *The Truth About Old King Cole* (Warne, 1910); A. Trollope: *Barchester Towers* (Blackie, 1924); R.H. Charles: *A Roundabout Turn* (Warne, 1930).
Books written and illustrated include: *Johnny Crow's Garden* (Warne, 1903); *The History Of Tom Thumb* (Warne, 1904); *The Man in the Moon* (Warne, 1913); *This Little Pig Went to Market* (Warne, 1922); *Johnny Crow's New Garden* (Warne, 1935).
Bibl: Henry Brooke: *Leslie Brooke and Johnny Crow* (Warne, 1982); Johnson FIDB; Peppin.

BROOKER, Christopher fl.1955-
An illustrator of children's books, using pen and ink in a rather sketchy style.
Books illustrated include: P. Lynch: *Brogeen and the Princess of Sheen* (Burke, 1955), *Cobbler's Luck* (Burke, 1957); A.S. Tring: *Pictures for Sale* (Hamilton, 1958); E. Dillon: *Aunt Bedelia's Cats* (Hamilton, 1958); A. Scott-Moncrieff: *Auntie Robbo* (Constable, 1959); P. Lynch: *The Stone House at Kilgobbin* (Burke, 1959), *The Lost Fisherman of Carrigmor* (Burke, 1960); W. Mayne: *The Rolling Season* (OUP, 1960); A.C. Stewart: *The Boat in the Reeds* (Blackie, 1960).
Bibl: Peppin.

BROOKES, Peter b.1943
Brookes was born in Liverpool. After failing to finish a three-year pilot's course for the Royal Air Force at Cranwell, he took an extra-mural degree (1964.) He went on to study art at the Manchester School of Art (1965), and in 1966 moved to the Graphic Design department of the Central School of Arts and Crafts in London. He taught at the Central School (1977-78), and at the RCA from 1978. He became a free-lance artist in the early 1970s, and was a regular contributor to the *Radio Times* and *The Listener* and to other English, French, German and US magazines. He has done paper-back covers for Penguin and Fontana, and has illustrated books for a number of publishers, including Hutchinson and the Folio Society. There is a fantastic, ironic and almost surrealist element to many of Brookes' illustrations, yet some — such as his coloured covers for special issues of the *Radio Times* ("Summer Music" 1978, "Spring to Life" 1977) — are charming and gentle.
Books illustrated include: M. Palin: *The Brand New Monty Python Book* (Methuen, 1973); J. Pool: *Lid off a Daffodil* (Hutchinson, 1982); J. Verne: *Around the World in Eighty Days* (Folio Society, 1982); A.G. Macdonald: *England, Their England* (Folio Society, 1986).
Contrib: *Architectural Design; Cosmopolitan; L'Expansion;*

Peter BROOKES *England, Their England* by A.G. Macdonald (Folio Society, 1986)

Listener; Marie Claire; New Society; New Statesman; Radio Times; Time Out; Times; TLS.
Exhib: *Mel Calman Workshop Gallery; Association of Illustrators.*
Bibl: *Design*, #296 (August 1973); Driver; Folio 40.

BROOKSHAW, Percy Drake b.1907
Born in Southwark, London, Brookshaw was a graphic artist, who drew for the *Radio Times*, using line and wash, designed at least three posters for London Transport in the late 1920s, and illustrated a few books.
Books illustrated include: J. Pudney: *The Book of Leisure* (with others; Odhams, 1957); I. Evans: *Inventors of the World* (Warne, 1962), *Engineers of the World* (Warne, 1963).
Contrib: *Radio Times.*
Bibl: Usherwood.

BROOMFIELD, Robert b.1903
Born near Brighton, Sussex, Broomfield studied at Brighton College of Arts and Crafts. He worked for an advertising agency in London (1955-57) before turning free lance. He has used a variety of techniques, including watercolour, coloured inks and woodcuts. Besides illustrating books for children, he has designed cards and posters, drawn for BBC TV and produced cartoons. He has produced a number of his own picture books for children.

Books illustrated include: D. Parsons: *What's Where in London* (Kenneth Mason, 1961); D. Clewes: *The Purple Mountain* (Collins, 1962); *Dame Wiggins of Lee and Her Seven Wonderful Cats* (BH, 1963); A. Hewitt: *Mrs Mopple's Washing Line* (BH, 1966), *Mr Faksimily and the Tiger* (BH, 1967); E. Barnes and D. Smith: *"Blue Peter" Special Assignment, Hong Kong and Malta* (BBC, 1975); D. Smith: *The Rainbow Story of St. Francis of Assisi* (McCrimons, 1987).
Books written and illustrated include: *The Baby Animal ABC* (BH, 1964); *The Toy ABC* (BH, 1964); *The Twelve Days of Christmas* (BH, 1965); *Animal Babies* (BH, 1973); *Toys* (BH, 1974).
Bibl: ICB3; ICB4; Peppin.

BROWN, Christopher S. b.1953
Born on 17 September 1953 in London, Brown was educated at Emmanuel School (1964-72), and studied art at Hornsey College of Art (1972-73), graphic design at Middlesex Polytechnic (1973-76), and illustration at the RCA (1977-80). Brown has contributed illustrations to many magazines, illustrated a book for the Folio Society and several by James Lees Milne for Faber, produced book jackets and paperback covers for several publishers (including the R.K. Narayan Penguin series), and designed ties for Yves Saint Laurent. He states that he has been influenced by the work of many artists, from the School of Siena to David Hockney*, but has been most inspired by Jean Cocteau and Edward Bawden*. He has taught various illustration, graphic textile and fashion courses.
Books illustrated include: S. Maugham: *Short Stories* (Folio Society, 1985); J.L. Milne: *Caves of Ice; Ancestral Voices; Another Self; Proffering Peace; Midway on the Waves* (Faber).
Contrib: *Cosmopolitan; Esquire; Financial Times; GQ; Listener; New Scientist; Radio Times; Sunday Express Magazine; Sunday Telegraph; Sunday Times Magazine.*
Bibl: Folio 40; Parkin; IFA.

Chris BROWN Design for card

BROWN, Denise Lebreton **b.1910?**

Brown was born in London, educated in Germany at the Lyzeum Nonnenwerth/Rhein, and studied at the RCA under Malcolm Osborne and Robert Austin*. She is an engraver and a painter, and has illustrated many children's books and gardening books. She was elected ARWA (1935); RE (1959).

Books illustrated include: *Christmas: The Story of the Nativity* (Sheed & Ward, 1946).

Exhib: RA; RWA; RE.

Collns: RWA; BM; V & A; Ashmolean.

Bibl: Who.

BROWNE, Anthony **b.1946**

Born in Sheffield, Browne studied at Leeds College of Art (1963-67), but found the design course too advertising-oriented for his liking. He worked for more than two years at Manchester Royal Infirmary, drawing in the operating theatres and the mortuary; and then designed greeting cards for Gordon Fraser. He was introduced to Julia MacRae at Hamish Hamilton and began writing and illustrating picture books for children. His highly finished colour illustrations often seem to reflect his interest in surrealism, and there is a feeling of foreboding and melancholy in much of his work. In 1983 *Gorilla* won both the Kate Greenaway award and the "Emil" award, and was listed by the New York Times as one of the ten Best Illustrated Books of 1985. Kate Flint, writing in *TLS* (20-26 November, 1987), described *Kirsty Knows Best* as "imaginatively anarchic" and "immaculately executed" and claimed that it was "an excellent example of how the extraordinary may be brought into the everyday, and subvert, rather than reinforce, its values." His freshly-imagined illustrations for *Alice's Adventures in Wonderland* (1988) show the influence of Magritte perhaps too clearly and are loaded with details which serve to distract the reader from the text. Browne was however awarded the "Emil" again in 1988 for these illustrations.

Books illustrated include: Grimm: *Hansel and Gretel* (MacRae, 1981); A. McAfee: *The Visitors Who Came To Stay* (Hamilton, 1984); S. Grindley: *Knock, Knock, Who's There?* (Hamilton, 1985); A. McAfee: *Kirsty Knows Best* (MacRae, 1987); L. Carroll: *Alice's Adventures in Wonderland* (MacRae, 1988).

Books written and illustrated include: *Through the Magic Mirror* (Hamilton, 1976); *A Walk in the Park* (Hamilton, 1977); *Bear Hunt* (Hamilton, 1979); *Look What I've Got!* (MacRae, 1980); *Bear Goes to Town* (Hamilton, 1982); *Gorilla* (MacRae, 1983); *Willy the Wimp* (MacRae, 1984); *Willy the Champ* (MacRae, 1985); *Piggybook* (MacRae, 1986); *I Like Books* (MacRae, 1989); *Things I Like* (MacRae, 1989); *The Tunnel* (MacRae, 1989).

Exhib: Barbican (1988).

Bibl: Douglas Martin: *The Telling Line: Essays on Fifteen Contemporary Illustrators* (Julia MacRae, 1989).

Colour Plate 52

BROWNFIELD, Mick **b.1947**

After studying at Hornsey College of Art, Brownfield has worked as a successful free-lance illustrator in many fields, especially advertising. He has done work for the Guinness and Heineken campaigns, and has also produced covers for paperbacks and contributed to the *Radio Times* and the *Observer Magazine*.

Contrib: *Marie France; New Scientist; Observer Magazine; Radio Times; Time Out; World Medicine Magazine*.

Bibl: Parkin.

BRUNSKILL, Ann **b.1923**

Born on 5 July 1923 in London, Brunskill was educated at Langford Grove School, and studied art at Central School of Arts and Crafts and the Chelsea College of Art (1960-65). She works as a printmaker, doing mostly etchings, and in 1971 started the World's End Press in Egerton, near Ashford, Kent, which she describes as "an artist's press. The words and images are equal partners. Books are produced in the intervals between painting and making prints…The illustrations are etchings or woodcuts coloured by hand." Her first portfolio, *Aphrodite*, which includes eight etchings in indigo and scarlet, was in fact printed by Circle Press and Studio Prints, but later works have been printed entirely in her

Ann BRUNSKILL "Queen with the apple" from *The Girl in the Apple* translated by Helena Attlee (World's End Press)

studio. Her work shows the influence of the French "livre d'artiste" published before 1939, with illustrations by Picasso, Matisse and Dérain. She was elected ARE (1969).

Books illustrated include: *Aphrodite* (World's End Press, 1970); *Aesop's Fables* (World's End Press, 1972); G. Chaucer and G. de Lorris: *The Romaunt of the Rose* (World's End Press, 1974); T. Traherne: *A Glimpse* (World's End Press, 1979); H. Attlee: *The Girl in the Apple: A Tuscan Folktale* (World's End Press, 1984).

Exhib: V & A; Stanhope Institute (1979); Ulster Museum (1980); Bertram Rota (1985); Drew Gallery, Canterbury (1985); St. John's, Smith Square (1987).

Collns: V & A; Bibliothèque Nationale; LC.

Bibl: Ann Brunskill: "World's End Press", *Journal RE*, no. 6 (1984): 31; Who; IFA.

BRUNTON, Violet **1878-1951**

Born on 28 October 1878 in Brighouse, Yorkshire, Brunton studied at Southport School of Art, Liverpool School of Art and RCA. She was primarily a painter of miniatures and a sculptor, but she produced decorative book illustrations, some of which show a whimsical sense of humour. Her book illustrations for *Green Magic* are very reminiscent of the early William Heath Robinson*. The decorative line drawings are more successful than the coloured, some of which suffer from poor printing. Many of the full page black and white drawings are unusually composed, with the centre of interest not in the centre of the illustration; or when they do feature the main interest centrally, telling the "story" in a most interesting way. For "He threw down the spoons and stamped on them", Brunton shows only the spoons and the stamping feet. The sixteen flat, coloured plates in *Ecclesiasticus*, described in the introduction as "decoratively modern", depict rather grotesque characters; the book also contains a few black and white endpieces done in chalk.

Brunton was elected RMS (1925); she died on 18 September 1951.

Violet BRUNTON *Green Magic: Fairy Tales* by R. Wilson (Jonathan Cape, 1928)

Books illustrated include: *Ecclesiasticus* (Bodley Head, 1927); R. Wilson: *Green Magic: Fairy Tales* (Cape, 1928), *Silver Magic* (Cape, 1929).
Exhib: RMS; RA; Arlington Gallery.
Bibl: Johnson; Peppin; Waters.
Colour Plate 53

BRUNTON, Winifred Mabel **1880-1959**
After studying in South Africa and at the Slade, Brunton became a watercolour painter of landscapes, portraits and miniatures, and she also illustrated a few books. Married to an Egyptologist, she painted Egyptian subjects and published *Kings and Queens of Ancient Egypt* in 1925. RBA (1912); ARMS (1912); RMS (1916); she died on 28 January 1959.
Books illustrated include: *The Kings and Queens of Ancient Egypt* (Hodder, 1925); *The Great Ones of Ancient Egypt* (Hodder, 1929).
Exhib: RA; RBA; RMS; Walker.
Bibl: Johnson; Waters.

BUCHANAN, Lilian L. **fl.1954-**
An illustrator of children's books.
Books illustrated include: H.E. Todd: *Bobby Brewster* series (1954-); E. Blyton: *The Mystery of the Missing Man* (1956), *The Mystery of the Strange Message* (1957), *The Mystery of Banshee Towers* (1966); M. Saville: *Four and Twenty Blackbirds* (1959); J. Blathwayt: *The Mushroom Girl* (Warne, 1960); *Popular Book for Girls* (with others, nd); *Warne's Happy Book for Girls* (with others, Warne, nd).
Bibl: Peppin.

BUCKELS, Alec **fl. 1923-1945**
Buckels was a painter, etcher and wood engraver, who wrote and illustrated children's books. He used woodcuts, line drawings and full colour for his illustrations. He made some finely detailed illustrations to poems, and energetic sketches for stories for boys; but his work varied in quality. His colour wrappers and plates for *Joy Street* are simple, bright and show a sense of humour. He was a major illustrator of Blackwell's magazine, *Merry-Go-Round*. Elected ARE (1924).
Books illustrated include: W. de la Mare: *Before Dawn* (Selwyn & Blount, 1924), *Miss Jemima* (Oxford: Blackwell, 1925), *Come Hither* (Constable, 1927); R. Fyleman: *Joy Street Poems* (Blackwell, 192-?); L. Housman: *Turn Again Tales* (Blackwell, 1930); A. Uttley: *The Adventures of No Ordinary Rabbit* (Faber, 1937), *Six Tales of the Four Pigs* (Faber, 1941), *Six Tales of Brock the Badger* (with F. Gower; Faber, 1941), *Six Tales of Sam Pig* (with F. Gower; Faber, 1941), *Six Tales of the Four Pigs* (Faber, 1941), *Ten Tales of Tim Rabbit* (with F. Gower; Faber, 1941).
Books written and illustrated include: *Adventures of Bunny Buffin* (Faber, 1933); *Billy Bobtail* (Faber, 1933); *Plays for Little Players* (Evans, 1935); *Three Little Ducklings* (Faber, 1936); *Stories of Bunny Buffin* (Faber, 1945); *The Little Scissors Men* (Macmillan, 1959).
Contrib: *Joy Street; Merry-Go-Round*.
Exhib: RE.
Bibl: ICB2; Peppin; Waters.

BUCKLAND WRIGHT, John **1897-1954**
Born on 3 December 1897 in Dunedin, New Zealand, Buckland Wright was educated at a preparatory school in Switzerland and,

John BUCKLAND WRIGHT *Mademoiselle de Maupin* by Theophile Gautier (Golden Cockerel Press, 1938)

after moving to England, at Clifton and Rugby. He served in a Scottish ambulance unit during WW1 and won the Croix de Guerre; after the war he went to Oxford University to study history but transferred to architecture. Finally he determined to be an artist, and after travelling in Europe (through the luxury of a small inheritance) in 1926 settled in Brussels.

Buckland Wright was almost entirely self-taught as an artist. He painted in watercolour and oil, but started to learn the technique of wood engraving, exhibiting with the Xylographes Belges and the Gravure Originale Belge in 1927. The Dutch publisher, A.A.M. Stols, saw his work and commissioned illustrations for several books, of which *The Collected Sonnets of John Keats* (1930) was the first.

Buckland Wright had married Mary Anderson in 1929 and lived in Paris from 1930 to 1939. There he met Stanley Hayter and started to work at Hayter's studio, Atélier 17, where he learned many different engraving techniques, and became highly proficient in copper engraving. His work was becoming well known, and although most of his first twenty books were published in Holland, he began to receive commissions from England and the US, as well as from private collectors; and in 1935-36, under the imprint "J.B.W. Editions", he produced two books, *Cupid's Pastime* and *The Marriage of Cupid and Psyche*. Both of these books are set in classical Greece, and like much of his work, demonstrate the artist's fascination with the female form and feature nude or scarcely-dressed figures in amorous poses.

At this point in his career, Buckland Wright received an important commission from the Golden Cockerel Press in England, to produce fifteen woodcuts for *Love Night* (1936). Thus began an association which lasted for eighteen years, ending only with the artist's death. He produced more than 200 illustrations for seventeen books from the Press, some of which are considered examples of its best work. Often accepted as the artist's masterpiece, *Endymion* (1947) contains fifty-eight wood engravings which took more than four years to produce. The artist's vision "approaches that of Keats as closely as possible for any artist working in our generation. While there is more than a hint of classicism in his admirable figures, their groupings and settings are romantic. . . He constructs his designs on an underlying abstract rhythm." (Sandford.) Hodnett considered Buckland Wright one of the most accomplished and productive interpretive illustrators of the twentieth century. Of *Endymion* he wrote, "He treated with great richness of texture foliage, rocks, water, shells, and human forms and irradiated every design with white. And these illustrations, apart from their beauty, are welcome because they are positioned in the book in just the right places to make concrete what the apostrophic couplets are saying. The Romanticism of Keats's verse captivated Buckland-Wright, and he found ways to captivate us." (Hodnett.)

At the start of WW2, the Buckland Wrights fled from Paris and moved to London. The artist joined a camouflage unit but soon became the Censor in Charge of Reuters, which post he held until the end of the war. During these years, he continued to work on wood and copper engravings, with the Golden Cockerel Press as his major patron, though he worked for other publishers, including the Folio Society. During and since WW2, he spent much time extra-illustrating a few books, notably *Daphnis and Chloe*, for which he produced nearly two hundred major illustrations (one for every page) in pen and wash. This work, by its nature, could not be published. Other work undertaken during this period included book plates, book jackets, Christmas cards and an assortment of other commercial art. He also provided a large collection of designs to the binding company of Sangorski & Sutcliffe, to be used by them in making tools and stamps.

In 1947, Buckland Wright began to use the scraperboard technique for his work for journals and produced illustrations for about forty articles; and in 1953, The Studio published his definitive work, *Etching and Engraving*. He taught at the Camberwell School of Art (1948-52), transferring to the Slade in 1952 to teach engraving. He died on 27 September 1954.

SWE (1940); RE; SIA.

Books illustrated include (but see Reid, 1968†): J. Keats: *Collected Sonnets* (Maastricht: Stols, 1930); A. Rimbaud: *Les Oevres Complètes* (Maastricht: Halcyon Press, 1931); Goethe: *Die*

John BUCKLAND WRIGHT *Endymion* by John Keats (Golden Cockerel Press, 1947)

Lieden des Jungen Werthers (Maastricht: Halcyon Press, 1931); A. Rimbaud: *Deux Poèmes* (Maastricht: pp., 1932); E.A. Poe: *The Masque of the Red Death and Other Tales* (Maastricht: Halcyon Press, 1932); A.R. Holst: *Tusschen Vuur en Maan* (Maastricht: Halcyon Press, 1932); J. Ishill: *Free Vistas* (Berkeley Heights, NJ: Oriole Press, 1933); J.E. Barlas: *Yew-Leaf and Lotus-Petal: Sonnets* (Berkeley Heights, NJ: Oriole Press, 1935); *Cupid's Pastime* (Maastricht: JBW Editions, 1935); *The Marriage of Cupid and Psyche* (Haarlem: JBW Editions, 1936); P. Mathers: *Love Night* (GCP, 1936); J. Ishill: *Free Vistas: Volume II* (Berkeley Heights, NJ: Oriole Press, 1937); T. Gautier: *Mademoiselle de Maupin* (GCP, 1938); *The Rubaiyat of Omar Khayyam* (GCP, 1938); C. von Dansdorf: *Heart's Desire* (Paris: pp., 1939); G. Reavey: *Quixotic Perquisitions* (Europa Press, 1939); *Pervigilium Veneris* (GCP, 1939); A.C. Swinburne: *Hymn to Proserpine* (GCP, 1944); *Kwatrijnen Omar Khayyam* (Amsterdam: Busy Bee Press, 1944); *Napoleon's Memoirs* (GCP, 1945); Dobblemans: *A*

L'Ombre et au Soleil (pp., 1946); *Matthew Flinders' Narrative of His Voyage in the Schooner Francis: 1798* (GCP, 1946); L. Andreyev: *The Seven Who Were Hanged* (Drummond, 1947); J. Keats: *Endymion* (GCP, 1947); A.C. Swinburne: *Laus Veneris* (GCP, 1948); R. Brooke: *Poems* (Folio Society, 1948); Homer: *The Odyssey* (Folio Society, 1948); C.G. Campbell: *Tales from the Arab Tribes* (Drummond, 1949); J.B. Cabell: *Jurgen* (GCP, 1949); P.B. Shelley: *Poems* (Folio Society, 1949); Musaeus: *Hero and Leander* (GCP, 1949); *Vertellingen uit de Duizend en een Nacht* (Amsterdam, Uitgeverij Contact, 1950); A.C. Swinburne: *Pasiphaë* (GCP, 1950); Homer: *The Iliad* (Folio Society, 1950); M. Bonaparte: *Flyda of the Seas* (Imago, 1950); G. Pavis: *Pour et Contre la Femme* (The Hague: Boucher, 1951); *Salmacis and Hermaphrodtus* (GCP, 1951); P. Hartnoll: *The Grecian Enchanted* (GCP, 1952); M. Waddington: *Cassell's Picture Dictionary* (Cassell, 1952); Hui-Lan-Ki: *The Story of the Circle of Chalk* (Rodale Press, 1953); Boccaccio: *The Decameron* vols; Folio Society, 1954-5); A. Bury: *Syon House* (Dropmore Press, 1955); G. Pavis: *So Sind die Frauen* (Stuttgart: Asmus, 1955); S. Mallarm : *L'Après Midi d'un Faune* (The Hague: JBW Editions, 1956), *L'Après Midi d'un Faune* (GCP, 1956).
Published: *Etching and Engraving* (Studio, 1953).
Contrib: *London Mystery Magazine; Message; Studio.*
Exhib: Xylographes Belges; Gravure Originale Belge; Paris; SWE; Folio Society (1956); Blond Fine Art (1981, 1986); Wellington, NZ (1982); Ashmolean (retrospective 1990).
Collns: BM; Tate; V & A; Hornby Art Library, Liverpool (book plates); Bibliothèque Royale, Brussels; Rijksmuseum, Amsterdam; Bibliothèque Nationale, Paris.
Bibl: Christopher Buckland Wright, *ed. The Engravings of John Buckland Wright* (Scolar Press, 1990); Roderick Cave, *ed.* "'A Restrained but Full-Blooded Eroticism': Letters from John Buckland Wright to Christopher Sandford, 1937-1939", *Matrix* 9 (Winter 1988): 55-75; Richard Gainsborough: "The Wood-Engravings of John Buckland-Wright", Image No. 4 (Spring 1950): 49-62; Anthony Reid: A Check-List of the Book Illustrations of John Buckland Wright (Pinner: Private Libraries Association, 1968); George Sims: "John Buckland Wright", *Antiquarian Book Monthly Review* (April 1988): 128-32; Folio 40; Garrett 1 & 2; Hodnett; Peppin; Sandford; Waters.

BUCKMASTER, Ann Devereux **b.1924**
Born on 27 March 1924 in London, Buckmaster was educated at Bromley High School and studied at Beckenham School of Art and Bromley School of Art. She is a free-lance artist using pen for illustrations and fashion drawing for magazines and advertising. Married to Anthony Gilbert*.
Books illustrated include: *An Old Fashioned Girl* (Contact Publications); *Vogue Beauty Book* (c. 1950).
Contrib: *Contact; Lilliput.*
Bibl: Who.

BUDAY, George **b.1907**
Born in Kolozvár, Transylvania, Buday studied in Hungary, graduating with a doctorate from the University of Szeged in 1934, after first travelling to England and producing his first wood engravings in 1928-29. After discovering the work of the University Settlements in the East End of London, he became one of the founders of the Agrarian Settlement Movement in Hungary. He began teaching graphic arts at the Franz Joseph University in 1934, won the Rome Scholarship in 1936, and in 1937 began living and working in London. During WW2, he worked for the BBC and then the Foreign Office, and was director of the Hungarian Cultural Institute in London (1948-49).
Though Buday did most of his work in England, he is certainly a "European" artist. Of the Expressionist school, he has made a memorable contribution to the British school of wood engraving. "Buday's style of expression is virtually the opposite of the archetypal Eric Gill. . . Buday uses freely and eloquently both the white-and black-line principles, the bold juxtapositions of solid blacks against white, the cut and thrust of the very long against the very short line, including the use of the single burin contracted with the multiple tool." (Garrett 1.)
Buday was elected ARE (1938); RE (1953); and SWE (1954).

George BUDAY *The Vigil of Venus* done into English by Lewis Gielgud (Frederick Muller, 1952)

Books illustrated include: K. Berezeli and A.A Bkása: *Poems: The Fall of Adam* (Szeged University, 1931); L. Magyar: *The Land in Revolt* (Szeged: Hungarian Theka, 1933); I. Madach: *The Tragedy of Man* (Stockholm University, 1936); F. Mauriac: *The Life of Jesus* (Budapest: Atheneum, 1937); *Great Stories from Austria* (Pallas, 1938); W. Shakespeare: *Timon of Athens* (NY: Limited Editions Club, 1940); L. Aragon: *Aurelien, a Novel* (Pilot Press, 1946); B. Naughton: *Pony Boy* (Pilot Press, 1946); W. Shakespeare: *Plays* (Odhams, 1946); *The Rubaiyat of Omar Khayyam* (Muller, 1947); J.C. Fennessy: *The Siege of Elsinor* (Sidgwick, 1948); *The Vigil of Venus* (Muller, 1952); D. Garnett: *The Essential T.E. Lawrence* (Penguin, 1956); C.M. Doughty: *Arabia Deserta* (Penguin, 1956); F. Kabraji: *The Cold Flame* (Fortune Press, 1956); J. Moxon: *Mechanick Exercises* (OUP, 1962); A. Pushkin: *The Queen of Spades and Other Stories* (1962); A. Pope: *Poetical Works* (1967); A. Alvarez: *Hungarian Short Stories* (OUP, 1968); A. Shah: *Arabian Fairy Tales* (Muller, 1969); A.W. West: *Candlemas: The Benewick Book of Candle-Ends* (West, 1972); E. Moberly: *Marian Trilogy* (1977); A. Koestler: *Darkness at Noon* (Folio Society, 1980).
Books written and illustrated include: *Pilgrimage of the Holy Virgin* (Szeged: College of Art, 1931); *Book of Ballads* (Szeged: College of Art, 1934); *Little Book: Hungarian Folktales* (Favil Press, 1943), *Second Little Book* (pp. 1944); *Third Little Book: A Christmas Keepsake* (Westminster Press, 1945), and at least nine others, to *Twelfth Little Book: Proverbial Cats and Kittens* (pp. 1955); *Multiple Portraiture* (1980).
Contrib: *John O'London Weekly; Lilliput; London Mercury; TLS.*
Exhib: RA; RSA; RE; UA; and in Europe.
Published: *The History of the Christmas Card* (Odhams, 1951).
Bibl: G. Ortutay: *George Buday's Wood Engravings* (Budapest: Magyar Helikon, 1970); Folio 40; Garrett 1 & 2; Peppin; Waters; Who.

BULL, René **1870?-1942**
See Houfe
Books illustrated include: *Hans Andersen Fairy Tales* (nd); Rose Fyleman: *A Garland of Roses* (Methuen, 1928).

Bibl: Pat Hodgson: *The War Illustrators* (Osprey, 1977); ICB; Peppin.

BULLEN, Anne **b.1914**
Bullen studied at the Académie Julian in Paris and Chelsea School of Art. She wrote and illustrated books about horses, using crayon and pen and ink for the illustrations.
Books illustrated include: J. Cannan: *A Pony for Jean* (BH, 1936); G. Bullivant: *Fortune's Foal* (Country Life, 1939); R. Manning-Sanders: *Mystery at Penmarth* (Collins, 1940); J. Cannan: *Hamish* (Puffin Picture Book 13; Penguin, 1944); D.P. Thompson: *I Wanted a Pony* (Collins, 1946); M. Edwards: *No Mistaking Corker* (Collins, 1947), *A Wish for a Pony* (Collins, 1947), *Summer of the Great Secret* (Collins, 1948), *The Midnight Horse* (Collins, 1949); J.P. Thompson: *For Want of a Saddle* (1960).
Books written and illustrated include: *Darkie, the Life Story of a Pony* (with Rosamund Oldfield; Country Life, 1950); *Ponycraft* (Blandford, 1956); *Showing Ponies* (Allen, 1964).
Bibl: Peppin.

BURLEIGH, Averil Mary **d.1949**
See Houfe
Books illustrated include: J. Keats: *Poems* (C & H, 1911); W. Shakespeare: *Macbeth* (Kegan Paul, 1914?), *The Merchant of Venice* (Kegan Paul, 1914?); L. Everett: *Thistledown* (BH, 1927).

BURNINGHAM, John Mackintosh **b.1936**
Born in Farnham, Surrey, Burningham was educated in Suffolk before studying at the Central School of Arts and Crafts (1956-59). He won the Kate Greenaway Medal for his first picture book, *Borka, the Adventures of a Goose Without Feathers* (1963), but his distinctive style did not develop until his *Mr. Gumpy's Outing* (1970). This book, which won both the Greenaway Medal again for Burningham and the *Boston Globe* Horn Book Award for illustration in 1972, is a perfect picture-book story. "The gradual pile-up of creatures in Mr. Gumpy's boat, the inevitable disaster and the concluding tea-party have a naturalness in both the telling and the illustration which goes a long way to support the claim that perfection in picture books is not to be sought in the predominance of one element over another but in the easy interlocking of all the parts." (Alderson.)
Come Away from the Water, Shirley (1978) was equally successful, with Burningham illustrating Shirley's wild fantasies which are her response to the ordinary cautions of her parents. It was listed in the *New York Times* choice of the best illustrated children's books of the year for 1977 (as *Mr. Gumpy's Outing* was similarly listed in 1971). Burningham has also produced wall friezes and books for young children just beginning to read. He draws in a deliberately naïve style but he uses a wide variety of media, including pen and ink, gouache and pastels.
Books illustrated include: I. Fleming: *Chitty-Chitty-Bang-Bang* (Cape, 1964); L. Schatz: *The Extraordinary Tug of War* (BH, 1969); K. Grahame: *The Wind in the Willows* (Kestrel, 1983).
Books written and illustrated include: *Borka, the Adventures of a Goose without Feathers* (Cape, 1963); *Trubloff, the Mouse Who Wanted To Play the Balalaika* (Cape, 1964); *John Burningham's ABC* (Cape, 1964); *Humbert, Mr. Firkin and the Lord Mayor* (Cape, 1965); *Harquin* (Cape, 1967); *Seasons* (Cape, 1969); *Mr. Gumpy's Outing* (Cape, 1970); *Mr. Gumpy's Motor Car* (Cape, 1973); *Come Away From the Water, Shirley* (Cape, 1978); *Time to Get Out of the Bath, Shirley* (Cape, 1979); *Avocado Baby* (Cape, 1982); *Granpa* (Cape, 1984); *Oi! Get Off the Train* (Cape, 1989).
Bibl: Douglas Martin: *The Telling Line: Essays on Fifteen Contemporary Book Illustrators* (Julia MacRae, 1989); Alderson; Carpenter; ICB3; ICB4; Peppin; Whalley.
Colour Plate 54

BURNS, Robert **1869-1941**
See Houfe
After 1920 Burns concentrated on interior decorative schemes and on book illustration. Forrest† writes that "this later work shows no waning of Burns' prowess and, indeed, the art deco emphasis which can be seen in the exemplary murals he carried out for *The*

Chinese Tearoom in Crawford's Restaurant in 1925, shows Burns' continuing interest in the development of decorative art."
Books illustrated include: *The House that Jack Built* (Moray Press, 1937); *Scots Ballads* (Seeley Service, 1939).
Bibl: Martin Andrew Forrest: "Art Nouveau and symbolism in the work of Robert Burns 1869-1941", *The Green Book*, 9 (Winter 1983), pp.10-12; Waters.

BURRA, Edward John **1905-1976**
Born on 29 March 1905 in South Kensington, London, Burra attended preparatory school but had to be withdrawn because of illness. After private art classes in Rye, he studied life drawing, illustration and architectural drawing at Chelsea Polytechnic (1921-23) and then spent two years at the RCA (1923-25), where his drawing tutors were Randolph Schwabe* and Raymond Coxon. During the next two years, he spent some time travelling in France and Italy before settling in Rye. His early work, especially his sardonic drawings of the people he met on his travels, shows how much he was influenced by the work of George Grosz. At Rye, he became very friendly with Paul Nash* who lived nearby and learned wood engraving from him. Burra had his first one-artist exhibition at the Leicester Galleries in 1929, and exhibited with Nash and other Surrealists in the 1930s. In 1933-34 he made the first of several trips to North America and his paintings show how

Edward BURRA *The Adventures of Huckleberry Finn* by Mark Twain (Paul Elek, 1948)

much he was influenced by the popular culture of Mexico and the night life of Harlem. The Spanish Civil War and WW2 affected Burra considerably, and his paintings show images of brutish soldiers and predatory monsters in bird-like masks. Later, he concentrated more on landscapes and everyday objects but his figurative style changed little.

Besides paintings, Burra also designed scenery and costumes for ballets, including "Barabau" and "Miracle in the Gorbals" performed by the Sadlers Wells Company in 1938 and 1944; and "Don Juan" and "Don Quixote" for the Royal Ballet at Covent Garden in 1948 and 1950. He also did the decor and costumes for the opera "Carmen" at Covent Garden in 1947. He was a close friend of William Chappell*, a ballet dancer and designer, painter and illustrator, who edited two books on Burra.

Burra illustrated only a handful of books. Nash proposed to Cassells in 1931 that Burra illustrate a *de luxe* edition of Conrad Aitken's recently published poem *John Deth*, but the proposal was not accepted. His first book was *ABC of the Theatre*, a collaboration with the poet Humbert Wolfe. In 1948 he did endpapers, a frontispiece and fourteen full-page illustrations for *The Adventures of Huckleberry Finn*, which has been described as "the masterpiece of Burra's work as an illustrator and one of the outstanding examples of English Neo-Romantic book illustration. Burra was a natural storyteller in pictures and his absorption can be felt as the story unfolds." (Hayward Gallery, 1985.†)

He declined membership of the RA in 1963 after being elected; and was created CBE (1971). After breaking his hip in 1974, he never fully recovered, and died on 22 October 1976.

Books illustrated include: H. Wolfe: *ABC of the Theatre* (Cresset Press, 1932); C.F. Ramuz: *The Triumph of Death* (Routledge, 1946); M. Twain: *The Adventures of Huckleberry Finn* (Elek, 1948); L. Lee: *The Voyage of Magellan, a Dramatic Chronicle for Radio* (Lehmann, 1948); *The Oxford Illustrated Old Testament* (five vols., with others, OUP, 1968-9).

Exhib: One-artist shows at the Leicester Galleries (1929, 1932, 1949); the Redfern Gallery (1942); Lefevre Gallery; and in Boston, Providence R.I. Retrospectives at the Magdalene Sothmann Gallery, Amsterdam (1955), Tate (1973), Hayward Gallery (1985), Rye Art Gallery (1989).

Colln: Tate; Rye Art Gallery.

Bibl: William Chappell, ed. *Edward Burra; a Painter Remembered by His Friends* (Deutsch, 1982); William Chappell, ed. *Well, Dearie! The Letters of Edward Burra* (Fraser, 1985); Hayward Gallery: *Edward Burra* (Arts Council, 1985); John Rothenstein: *Edward Burra* (Penguin Modern Painters, 1945); John Rothenstein: *Edward Burra* (Tate Gallery, 1973); Compton; DNB; Peppin; Rothenstein; Tate; Waters.

BURROUGHES, Dorothy Mary L. d.1963
Born in London, Burroughes studied at the Slade, Heatherley's School of Art and in Germany. A painter of animals and figure studies, she also produced posters and wrote and illustrated children's books. *The Story of a Red-Deer* (1936), for which Burroughes produced eleven illustrations as head-pieces, contained the only illustrations printed in colour at Gregynog, and was the last book produced at the Gregynog Press while Lloyd Haberly was controller. Burroughes was elected RBA (1925); SWA; and she died on 6 October 1963.

Books illustrated include: G. Davidson: *Queer Beasts at the Zoo* (Allen & Unwin, 1927), *Queer Birds at the Zoo* (Allen & Unwin, 1927); *The Animal Lovers' Calendar* (Jenkins, 1930); R. Fyleman: *Fifty-One New Nursery Rhymes* (Methuen, 1931); N.C. James: *Tinkle the Cat* (Dent, 1932); M. Pallister: *Gardener's Frenzy* (Methuen, 1933); J.W. Fortescue: *The Story of a Red-Deer* (Gregynog Press, 1936).

Books written and illustrated include: *Amazing Adventures of Little Brown Bear* (Methuen, 1930); *Jack Rabbit, Detective* (Methuen, 1931); *Journeyings of Selina Squirrel and Her Friends* (Methuen, 1931); *The Odd Little Girl* (Methuen, 1932); *Captain Seal's Treasure Hunt* (BH, 1933); *Harris the Hare and His Own True Love* (BH, 1933); *More Adventures of the Odd Little Girl* (BH, 1933); *The Strange Adventures of Mary Jane Stubbs* (BH, 1933); *The House the Moles Built* (Hutchinson, 1939); *Niggs, the Little Black Rabbit* (Hutchinson, 1940); *Teddy, the Little Refugee*

Doris BURTON *Slumber Songs and Carols* by Sir Harold Boulton (Philip Allan, 1927)

Mouse (Hutchinson, 1942); *The Little Pigs Who Sailed Away* (Hutchinson, 1944); *The Magic Herb* (Hutchinson, 1945); *The Conceited Frog* (Hutchinson, 1949); *The Little White Elephant* (Hutchinson, 1953).

Bibl: Dorothy A. Harrop: *A History of the Gregynog Press* (Private Libraries Association, 1980); Peppin; Waters; Who.

BURTON, Doris fl. 1920s-1930s
Produced decorative black and white and full colour illustrations.

Books illustrated include: H.E. Boulton: *The Huntress Hag of the Blackwater* (Philip Allan, 1926), *Slumber Songs and Carols* (Philip Allan, 1927); B. Rhys: *A Book of Ballads* (Cape, 1929); H.C. Cradock: *Elizabeth* (Nelson, 1930), *Barbara and Peter* (Nelson, 1931).

Bibl: Peppin.

BUSBY, John b.1928
Born in Bradford, Busby moved with his family to rural Wharfedale in 1935. After National Service in the RAF, he studied at Leeds College of Art and Edinburgh College of Art, where he is now a lecturer in drawing and painting. The first artists who influenced him greatly were Talbot Kelly* and Eric Ennion*. Busby was impressed by the way that Kelly made the birds in his illustrations seem to be individuals and by Ennion's ability to transmit a feeling of movement and his all-round knowledge of natural history. Busby has written a book on "how to" draw birds and an assessment of Ennion's work, and has illustrated several ornithological monographs.

Books illustrated include: J.B. Nelson: *Azraq — Desert Oasis* (BH, 1973); *The Gannet* (Berkhamsted: Poyser, 1978), *Sulidae: Gannets and Boobies* (OUP, 1978); H. Miles: *The Track of the Wild Otter* (Elm Tree, 1984); T. Soper: *Discovering Animals* (BBC, 1985); R. Furners: *The Skuas* (Poyser, 1987).

Published: *The Living Birds of Eric Ennion* (Gollancz, 1982); *Drawing Birds* (RSPB, 1986); T. Soper & R. Lovegrove: *Birds in Your Garden* (Webb & Bower, 1989).

Bibl: Hammond.

CABLE, W. Lindsay **fl. 1927-1951**
An illustrator of children's books, mainly girls' school stories.
Though some of her work is simple black and white line drawing,
Peppin notes that it had developed by the 1940s to employ a good
range of textures and shading.
Books illustrated include: G. Trease: *Running Deer* (Harrap,
1941); E. Blyton: *The Second Form at St. Clare's* (Methuen, 1944),
Fifth Formers at St.Clare's (Methuen, 1946), *The Naughtiest Girl
in the School* (Newnes, 1951); A. Brazil: *The School on the Loch*
(Blackie, 1946), *Monitress Merle* (Blackie, 1947).
Contrib: *Blackie's Children's Annual; The Girls' Budget; Little
Folks.*
Bibl: Peppin.

CAINE, William **fl.1916**
An artist, a gifted sentimental writer, and a born humorist who
never studied art except through the eyes of his friend, H.M.
Bateman*. Published after his death, *The Glutton's Mirror* (1925) is
a collection of "burlesque" drawings. Caine wrote a number of
novels, such as *The Strangeness of Noel Carton* and *Lady Sheba's
Last Stunt*, but was perhaps better known for his stories in magazines.
Books written and illustrated include: *Bildad the Quill-Driver*
(BH, 1916); *The Glutton's Mirror* (Fisher Unwin, 1925).

CALDWELL, Edmund **1852-1930**
See Houfe

CALMAN, Mel **b.1931**
Born on 19 May 1931 in London, Calman studied at St. Martin's
School of Art, obtaining the National Diploma in Design, and the
Art Teacher's Diploma. He joined the *Daily Express* in 1957 as a
cartoonist; 1963-64 he worked as a cartoonist for the BBC, the
Sunday Telegraph and the *Observer*. He has been a regular
cartoonist for the *Sunday Times* since 1965.His work is character-
ized by humour and economy of line.
Calman is a writer and journalist as well as a cartoonist; and he has
done covers for Penguin Books.
Books illustrated include: J. de Manio: *To Auntie with Love*

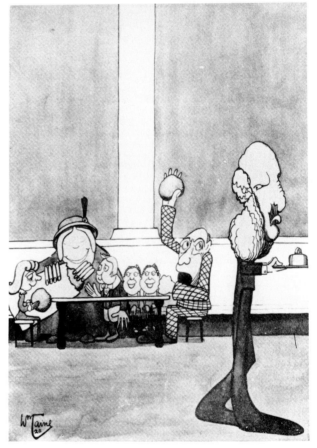

William CAINE *The Glutton's Mirror* (T. Fisher Unwin, 1925)

(Hutchinson, 1967); K. Whitehorn: *Whitehorn's Social Survival*
(Methuen, 1968); *How To Survive Abroad* (Methuen, 1971); *Worse
Verse* (Times, 1971); *How To Lie with Statistics* (Penguin, 1973);
M. Ewan: *The Director's and Company Secretary's Handbook of
Draft Letters* (Business Books, 1975); B. James: *1001 Money
Saving Tips* (Luscombe, 1976); M. Linehan: *Asserting Yourself*
(Wiley, 1983); D. Meichenbaum: *Coping with Stress* (Wiley,
1983); J. Roden: *Controlling Your Weight* (Wiley, 1983); J. Rush:
Beating Depression (Wiley, 1983).
Books written and illustrated include: *Bed-Sit* (Cape, 1963);
Boxes (Cape, 1964); *For Such as Are of Riper Years* (Lane, 1965);

Calman and Women (Cape, 1967); *The Penguin Mel Calman* (Penguin, 1968); *My God* (Souvenir Press, 1970); *Couples* (The Workshop, 1972); *This Pestered Isle* (Times, 1973); *The New Penguin Calman* (Penguin, 1977); *Dr. Calman's Dictionary of Psychoanalysis* (Allen, 1979); *But It's My Turn To Leave You* (Eyre Methuen, 1980); *How About a Little Quarrel Before Bed?* (Eyre Methuen, 1981); *The Big Novel* (Methuen, 1983); *Calman Revisited* (Methuen, 1983); *Help! And Other Ruminations* (Methuen, 1983); *It's Only You That's Incompatible!* (Methuen, 1984); *What Else Do You Do? Some Sketches from a Cartoonist's Life* (Methuen, 1986).
Contrib: *Daily Express; Observer; Sunday Telegraph; Sunday Times.*
Exhib: Cartoon Gallery.
Bibl: Amstutz 2.

CALTHROP, Dion Clayton 1878-1937
See Houfe

CAMERON, Sir David Young 1865-1945
See Houfe
Books illustrated include: R.B. Cunningham-Graham: *District of Monteith* (1930); Seton P. Gordon: *Highways and Byways in the Central Highlands* (1948).
Bibl: *The Etchings and Drypoints of Sir D.Y. Cameron* (Print Collectors Club, 1947); Arthur M. Hind: *The Etchings of D.Y. Cameron* (Halton & Truscott Smith, 1924); Frank Rinder: *D.Y. Cameron* (Jackson Wylie, 1932); DNB; Peppin; Waters.

CAMERON, Katharine 1874-1965
See Houfe

CAMPBELL, Barbara Mary b.1913
Campbell studied at Clapham School of Art, St. Martin's School of Art and the Central School of Arts and Crafts. During WW2, she worked in the Land Army, and in the long evenings, with nothing else to occupy her, she wrote and illustrated her first book, using the pseudonym "Cam". Later she turned from illustration to making models for exhibitions at such places as the Imperial Institute and the Science Museum in London.
Books illustrated include: K. Jaeger: *The Bull That Was Terrifico* (Putnam, 1956).
Books written and illustrated include: *The Story of the Buttercup Fairy* (BH, 1945); *The Story of Margaret Field-Mouse* (BH, 1946); *The Story of Timothy Tibbycat* (BH, 1947); *The Story of Belinda Bear* (BH, 1949); *The Story of Bill Frog* (BH, 1950); *Bill Frog to the Rescue* (BH, 1951); *Barbara Lamb* (BH, 1951); *The Three Jolly Clowns* (Collins, 1952); *The Three Jolly Fishermen* (Collins, 1952); *The Three Jolly Mountaineers* (Collins, 1954).
Bibl: ICB2.

CAMPBELL, Jennifer fl.1973-
Books illustrated include: E.M. Forster: *Howard's End* (Folio Society, 1973); Alexandre Dumas: (*La Dame aux Camélias* (Folio Society, 1975);(Katherine Mansfield: *Twelve Stories* (Folio Society, 1978); R. Adams: *The Iron Wolf* (Lane, 1980).
Bibl: Folio 40.

CAMPBELL, John F. fl. 1909-1930
Illustrated boys' adventure stories in watercolour paintings, reproduced in colour or black and white half-tones.
Books illustrated include: E. Gilliatt: *Heroes of Modern Crusades* (with others; Seeley, 1909), *Heroes of the Elizabethan Age* (with others; Seeley, 1911); P.F. Westerman: *Under King Henry's Banners* (Pilgrim Press, 1914); R.L. Stevenson: *The Black Arrow* (Cassell, 1915); E. Gilliatt: *Heroes of the Indian Mutiny* (Seeley, 1918).
Bibl: Peppin.

CAMPBELL, Peter fl.1973
Books illustrated include: R. Hague: *The Death of Hector* (Skelton, 1973).

CANEY, Eric b.1908
Born in London, Caney was an architectural illustrator in water-colour, ink and pencil.
Exhib: RA; RI; RBA; NS.
Bibl: Waters.

CANZIANI, Estella Louisa Michaela 1887-1964
See Houfe
While travelling in Italy, she became fascinated by folklore and costume, which led to her writing and illustrating her first book, *Costumes, Traditions and Songs of Savoy* (Chatto, 1911).
Bibl: ICB; Peppin.

CARLINE, Sydney William 1888-1929
Born in London, Carline was educated at Repton and studied at the Slade (1907-10) and in Paris. He was a fighter pilot during WW1 and was shot down over the Somme before his brother Richard, who had been entrusted with the task of deciding the scope and direction of RAF art, "rescued" him from further active service and had him posted as official war artist with the Royal Air Force (1918-19). Only four of his paintings were accepted but the many sketches he and his brother made in the Middle East were exhibited at the Goupil Gallery in March 1920 and brought considerable public recognition. After the war he became Ruskin Master of Drawing, Oxford (1921-29). He painted landscapes and portraits and exhibited with the London Group.
Books illustrated include: T.E. Lawrence: *Revolt in the Desert* (1926).
Exhib: Goupil Gallery; IWM (1973).
Collns: IWM.
Bibl: Harries; Waters.

CARRICK, Edward
See CRAIG, Edward Anthony

CARSE, A. Duncan d.1938
Carse lived in London, Knebworth (Hertfordshire) and Crowthorne (Berkshire). As a painter in oils and tempera, his subject matter being mostly figures and mural decoration, he exhibited at nine annual RA shows from 1922 to 1938, and twice at the FAS. He exhibited fans at the FAS in 1911. He illustrated at least two books of fairy tales. He died in October 1938.
Books illustrated include: H.C. Andersen: *Andersen's Fairy Tales* (Black, 1912); L.M. Scott: *Dewdrops from Fairyland* (Warne, 1912).
Exhib: FAS; London Salon; RA; Walker.
Bibl: Waters.

CARSTAIRS, Helen fl.1938
Produced colour plates and other colour decorations for *Looking Round London*.
Books written and illustrated include: *Looking Round London* (Blackie, c.1938).

CARTER, Frederick 1885-1967
See Houfe
Carter trained as a civil engineer and surveyor, but gave this up for art; he learned etching at the RCA from Sir Frank Short and later himself taught etching at the Liverpool School of Art (1922-27). He was a friend of fellow symbolist Austin Osman Spare* and helped to develop Spare's theories on automatic drawing. He published a number of books, including various essays on art and symbolism such as *The Dragon and the Alchemists* (1926), and a critique of Wyndham Lewis*. He gained three successive gold medals in the South Kensington National Competition for book illustration.
Books illustrated include: Lord Byron: *Manfred* (Fanfrolico Press, 1929); *The Works of Cyril Tourneur* (Fanfrolico Press, 1930); H. Heine: *Florentine Nights* (Howe, 1933); T. Burke: *"Will Someone Lead Me To a Pub?"* (Routledge, 1936); J. Gawsworth: *The Flesh of Cypris* (Samuel, 1936); W.J. Tarling: *Café Royal Cocktail Book* (Pall Mall, 1937).
Books written and illustrated include: *London At Night; a Sketchbook* (Black, 1914); *The Dragon of the Alchemists* (Elkin

Frederick CARTER "Waterloo steps": etching from *The Apple* (1920, 4th quarter) p. 233

Mathews, 1926); *Gold Like Glass* (Twyn Barlwm Press, 1932).
Contrib: *The Apple*.
Bibl: Victor Arwas: *Alastair: Illustrator of Decadence* (T & H, 1979); "Earlier Members of the R.E. Recalled: Frederick Carter." *Journal RE*, No.6 (1984), pp.32-33; Herbert Furst: "Frederick Carter", *Print Collector's Quarterly*, 20 (1933): 346-61; Peppin; Waters.

CARTWRIGHT, Reginald Ainsley **b.1938**
Born in Leicester and educated at Gateway Boys' School, Cartwright is self-taught. He worked in various studios as a commercial artist and art director for thirteen years, doing work for such companies as TDK Audio Tapes, and began painting in oils in 1969. In 1974 he became a full-time painter and illustrator and was in the same year awarded MSIA for illustrations and graphics. In addition to illustrating several children's books, Cartwright has produced book covers and posters, and exhibited his paintings in galleries in London and elsewhere. His first book, *Mr. Potter's Pigeon*, was featured on BBC's "Jackanory" (1982) and he did the graphics for the opening titles of the "Mapp and Lucia" series on Channel 4 (1985).

Books illustrated include: D. Bradman: *Cricket* (Leicester: Knight Books, 1977); P. Kinmonth: *Mr. Potter's Pigeon* (Hutchinson, 1979); A. Cartwright: *Norah's Ark* (Hutchinson, 1983), *The Proud and Fearless Lion* (Hutchinson, 1986); S. Hastings: *Peter and the Wolf* (Walker Books, 1987); J. Taylor: *My Cat* (Walker Books, 1987), *My Dog* (Walker Books, 1987); S. Hastings: *The Man Who Wanted To Live Forever* (Walker Books, 1988); G. Chaucer: *The Canterbury Tales: A Selection* (Walker Books, 1988); A. Cartwright: *Hedgehog* (Hutchinson, 1989), *The Last Dodo* (Hutchinson, 1989), *The Winter Hedgehog* (Hutchinson, 1989).
Contrib: *Observer*.
Exhib: Portal Gallery; Gadsby Gallery; Leicestershire Museum & Art Gallery; Royal Festival Hall.
Bibl: IFA.
Colour Plate 55

CASSON, Sir Hugh (Maxwell) **b.1910**
Born on 23 May 1910 in London, Casson was educated at Eastbourne College and St. John's College, Cambridge, and was Craven Scholar at the British School in Athens (1933). In private practice as an architect since 1937, he served as camouflage officer in the Air Ministry during WW2 (1940-44). He was Director of Architecture, Festival of Britain (1948-51); and associated with RCA in various capacities — Professor of Environmental Design (1953-75), Provost (1980-86); on the Faculty, RDI (1969-71); and member of various Boards and Commissions — Royal Fine Art Commission (1960-83), British Museum (Natural History) (1976-86), NPG (1976-), National Trust Executive Council, and British Rail Environment Panel.
Casson has been a prolific watercolour painter, and he designed three operas for Glyndebourne and three musicals in London. He has written several books on architecture and interior design, and has illustrated a few books with delicate watercolours in pale, evocative colours. He draws as an architectural draughtsman and his *Diary*, a record of his life during one year while he was President RA, is delightfully illustrated with black and white and watercolour sketches.
RDI (1951); RA (1970); Pres. RA (1976-84); knighted 1952; KCVO (1978); CH (1985).
Books illustrated include: J. Grenfell: *Nanny Says* (Dobson, 1972); HRH Prince Charles: *The Old Man of Lochnagar* (Hamilton, 1980); S. Gaul: *Pushkin the Polar Bear* (Quartet Books, 1983); D. Avebury: *Zelda and the Corgis* (Piccadilly Press, 1984); J. Betjeman: *The Illustrated Summoned By Bells* (Murray, 1989).
Books written and illustrated include: *Diary* (Methuen, 1981); *Hugh Casson's London* (Dent, 1983); *Hugh Casson's Oxford* (Phaidon, 1988).
Contrib: *Architectural Review; Contact; Country Life; Housewife; Leader; Saturday Book 8; Vogue*.
Bibl: Anthony Hippisley-Coxe: "Hugh Casson: An Architectural Draughtsman", *Alphabet and Image* no. 6 (January 1948): 41-54; Who; Who's Who.
Colour Plate 56

CHADWICK, Enid M. **b.1902**
Born on 26 October 1902 in Basingstoke, Chadwick was educated at St. Michael's School, Oxford, and studied art privately in Exeter and Brighton. She painted murals in churches, did screen decoration and altar panels, and illustrated books for children.
Books illustrated include: *My Book of the Church Year; Come and Worship; The Seven Sacraments*.
Bibl: Who.

CHADWICK, Paxton **1903-1961**
Born in Fallowfield, Lancashire, Chadwick was educated at Manchester Grammar School and studied at Manchester College of Art. In the 1920s, he worked in Manchester as an artist, cartoonist and designer, then moved first to London and then to Suffolk. He developed into an artist of mainly natural history, exhibiting widely in Britain and overseas, and illustrated many nature books. He used autolithography for many of his book illustrations. He illustrated *The Memoirs of Josiah Sage* (1951) with seven headpiece drawings of early trade unionism, and the binding contains a full-spread drawing.

Paxton CHADWICK *Wild Flowers* (Puffin Picture Books; Penguin Books, 1949)

Books illustrated include: *The Memoirs of Josiah Sage* (Lawrence and Wishart, 1951); J. Gorvett: *Pond Life* (Puffin Picture Books 93; Penguin, 1953).
Books written and illustrated include: *Wild Flowers* (Puffin Picture Book 81; Penguin,1949); *Flowers of the Seashore* (Cassell, 1960); *Naturescope Books* (five vols., Cassell, 1960-62).
Bibl: Waters.

CHAMBERLAIN, Christopher **1918-1984**
Born in Worthing, Sussex, Chamberlain studied painting at the Clapham School of Art (1934-38); and went on to the Royal College of Art in 1938, where his training was broken by six years army service during the war. He returned to the RCA (1946-48) and taught at Camberwell School of Art and Bromley. Other painters teaching at Camberwell included William Coldstream and Victor Pasmore — the "Euston Road School" — but they soon moved to the Slade. Chamberlain was certainly influenced by them and studied their methods.
He became a free-lance illustrator, with commissions from Hodder & Stoughton, Phoenix House, André Deutsch and others; and contributed to the *Radio Times* and other journals. He is married to Heather Copley* and usually collaborates with her in illustrating books for children. Their styles are virtually indistinguishable; and they seem able to make their illustrations suit the subject matter.
Books illustrated include (all with Heather Copley): J. Ryder: *Printing for Pleasure* (BH, 1955); R.L. Green: *Heroes of Greece and Rome* (BH, 1960), *Tales of Ancient Egypt* (BH, 1967); E. de Maré: *London's River* (BH, 1964.)
Contrib: *Radio Times; Cockaigne; Motif 2*.
Exhib: Trafford Gallery; RA.
Bibl: *Motif* 2 (1959); ICB3; Peppin; Ryder; Usherwood; Waters.

CHAMBERS, Basil **b.1920**
Chambers studied at schools of art in Chelsea, Hornsey and Beckenham. He was an artist in watercolour, and advertising designer and an illustrator.
Bibl: Who.

CHANDLER, Cynthia Ann **b.1937**
Born in Isleworth, Middlesex, Chandler was educated at Hampton High School and studied at Twickenham Schoolof Art. She became a free-lance illustrator and portrait painter.
Collns: Nuneaton Art Gallery.
Bibl: Who.

CHAPMAN, Charles Henry **1879-1969?**
See Houfe
Born in Thetford, Norfolk, Chapman drew for the Billy Bunter stories which appeared in *Magnet* from 1911 until the comic ceased publication in 1939. He shared these *Magnet* illustrations with Leonard Shields*. When the publisher, Charles Skilton, started to produce Bunter stories in book form after WW2, the first seventeen volumes were illustrated by R.J. Macdonald*, who had done the St. Jim's illustrations in *Gem*, but on Macdonald's death in 1955, Chapman took over, working on them until 1965, doing the illustrations and producing coloured jackets.
Chapman did many illustrations for children's annuals and children's magazines and comics, but is best known for his illustrations of Billy Bunter and the rest of the characters who inhabited Greyfriars School, building up what were to become the traditional images of the boys and their environment. He gave Bunter his owl-like, larger-than-life appearance, and was the first artist to portray Bessie Bunter. He is generally regarded as the best of the illustrators who worked on Frank Richards' stories. ("Richards" is a pseudonymn for Charles Hamilton (1876-1961), an astonishingly prolific writer of boys' stories.)
Books illustrated include: F. Richards: *Backing Up Billy Bunter* (Cassell, 1955), and some eighteen more until *Bunter's Last Fling* (Cassell, 1965).
Books written and illustrated include: *The Billy Bunter Picture Book* (Maidstone: Charles Hamilton Museum, 1967).
Contrib: *Boy's Own Paper; Chums; Comic Cuts; Magnet; Marvel;* etc.
Bibl: Mary Cadogan: *Frank Richards: The Chap Behind the Chums* (Viking, 1988); W.O.G. Lofts and D.J. Adley: *The World of Frank Richards* (Baker, 1975); Frank Richards: *The Autobiography of Frank Richards*, 2nd ed. (Skilton, 1962); Carpenter; Doyle BWI; Horn; Peppin.
Colour Plate 57

Dorothy CHAPMAN *1, 2, 3* (Baby Puffin; Penguin Books, 1943)

CHAPMAN, Dorothy **fl.1943-1946**
Chapman drew her illustrations directly on the lithographic plate for the Baby Puffin series and for Transatlantic Arts.
Books written and illustrated include: *A B C* (Baby Puffin; Penguin, 1943); *1 2 3* (Baby Puffin; Penguin, 1943); *The Land of the Sun* (Transatlantic Arts, 1944); *Stories for Paul* (Transatlantic Arts, 1945); *Stories for Jean* (Transatlantic Arts, 194-); *The Land of Snow* (Transatlantic Arts, 1944).
Bibl: Noel Carrington: "Illustrated Books for Young Children", *Graphis* 14 (1946): 220-37.

CHAPMAN, Gaynor **b.1935**

Born in London, Chapman studied at Epsom School of Art (1951-52), Kingston School of Art (1952-55) and RCA (1955-58). After working for Thames and Hudson for two years, she became a freelance artist in 1960, doing much graphic design work for such companies as London Transport, Shell, also the COI and American Express. She has illustrated several books, including Grimm's *The Luck Child* (1968), which was runner-up for the Kate Greenaway Medal, and *Aesop's Fables* (1971), where each fable is illustrated by a page-opening in bright colours.

Books illustrated include: M. Burton and W. Shepherd: *The Wonder Book of Our Earth* (Ward, Lock, 1960); E. Vipont: *The Story of Christianity in Britain* (1960); S. Piggott: *The Dawn of Civilization* (with others; 1961); A. Brown: *Treasure in Devil's Bay* (Blackie, 1962); W. Shepherd: *Wealth from the Ground* (with Clifford Bayly*; Weidenfeld, 1962); E. Bacon: *Vanished Civilizations* (1963); K. Rowland: *Our Living World* (1964); E. Blishen: *Miscellany Two* (OUP, 1965); M. Ishii: *The Dolls' Day for Yoshiko* (OUP, 1965); M. Skipper: *The Fooling of King Alexander* (Hamilton, 1967); Brothers Grimm: *The Luck Child* (Hamilton, 1968); E. Dillon: *The Wise Man on the Mountain* (Hamilton, 1969); *Aesop's Fables* (Hamilton, 1971); H.C. Andersen: *The Jumping Match* (Hamilton, 1973); D. Swann: *Around the Piano with Donald Swann* (BH, 1979).

Books written and illustrated include: *The Building Site* (Walker, 1988); *Road Works* (Walker, 1988).

Contrib: *Aerial; Director; Esso Magazine; Family Magazine; Homes and Gardens; Living; Radio Times.*

Bibl: Peppin.

CHAPPELL, William Evelyn **b.1907**

Born on 27 September 1907 in theatrical lodgings in Wolverhampton, Chappell was educated first by nuns and then at grammar school. When he was thirteen, he entered Chelsea School of Art

William CHAPPELL *Studies in Ballet* (John Lehmann, 1948)

and studied there for three years (he met and made friends with Edward Burra* at Chelsea). He became a pupil of Marie Rambert and, as a ballet dancer, spent a year in a company formed by Nijinska (Nijinsky's sister). He was a member of the corps-de-ballet there with Frederick Ashton, and then appeared with many of the major ballerinas in British and Russian companies. He was also a prolific designer of scenery and costumes for ballets, including those for Ashton's "Les Patineurs" and "Les Rendezvous". The year before Ashton died, Chappell resuscitated his "Apparitions", designed by Cecil Beaton*, for Fonteyn and Nureyev. In the late

1950s and through the 1960s he was a successful director of plays and reviews, once having three of his productions in the West End of London at the same time. He illustrated three books by Doris Langley Moore, wrote and illustrated books on ballet, designed several book jackets for John Lehmann, and edited two books on Burra.

Books illustrated include: D.L. Moore: *The Pleasure of Your Company* (Howe, 1933), *The Technique of the Love Affair* (Rich & Cowan, 1936), *They Knew Her When . . .* (Rich & Cowan, 1938).

Books written and illustrated include: *Studies in Ballet* (Lehmann, 1948); *Fonteyn: Impressions of a Ballerina* (Rockliff, 1951).

Contrib: *Penguin New Writing.*

Bibl: Francis Gadan and Robert Maillard: *A Dictionary of Modern Ballet* (Methuen, 1959); G B.L. Wilson: *A Dictionary of Ballet.* (rev. ed., Black, 1974); IFA.

George CHARLTON *Mr Weston's Good Wine* by T.F. Powys (Chatto & Windus, 1927)

CHARLTON, George **b.1899**

Born in London, Charlton studied at the Slade and taught there (1919-62) and at Willesden School of Art (1949-59). He was a landscape painter and illustrator.

Books illustrated include: E. Wolff: *Anatomy for Artists* (H.K. Lewis, 1925); T.F. Powys: *Mr. Weston's Good Wine* (Chatto, 1927); R. Hughes: *The Spider's Palace* (Chatto, 1960).

Exhib: NEAC.

Bibl: Waters.

CHARLTON, Michael Alan **b.1923**

Born in Poole, Dorset, Charlton studied at Poole School of Art and Edinburgh College of Art. He admits to being influenced by the illustrations of William Heath Robinson* and Edmund Dulac (see Houfe). An illustrator mostly of children's books in both black and white and full colour, he is particularly fond of animals as his subject.

Books illustrated include: K. Fidler: *The Desperate Journey* (Lutterworth, 1964); D. Skirrow: *The Case of the Silver Egg* (BH, 1966); R.Sutcliff: *The High Deeds of Finn MacCool* (BH, 1967); J. Westwood: *Gilgamesh and Other Babylonian Tales* (BH, 1968); M. Holden: *The Unfinished Feud* (Brockhampton, 1970); E.M. Almedingen: *The Land of Muscovy: The History of Early Russia* (Longmans, 1971); J. London: *White Fang* (Collins, 1971); S. Lapsley: *I Am Adopted* (BH, 1974); E. Fanshawe: *Rachel* (BH, 1975); H.W. Longfellow: *The Song of Hiawatha* (Cobham: Starfish Books, 1975); F. Bloom: *The Boy Who Couldn't Hear* (BH, 1977); M. Hynds: *Frog Paper* (Blackie, 1977), *The House of the Future* (Blackie, 1977), *The Mint Market* (Blackie, 1977) *Oliver's Photo* (Blackie, 1977); G. Waldman: *I Went to School One Morning* (BH,

Melvina CHEEK Illustration to "The Snow Line" by H.E. Bates in *Saturday Book* no. 11 (Hutchinson, 1951)

1978); V. Shennan: *Ben* (BH, 1980); V. Boyle: *Toby, Peetie, Harry and Fred Were Here* Macmillan, 1981); D. Hill: *The Golden Bicycle* (Hamilton, 1982); A. Coles: *Mandy and the Hospital* (and others in the "Mandy and Michael" series; Hodder, 1984); M. Wadhams: *Anna* (BH, 1987); R. Hunt: *The Boy and the Tiger* (OUP, 1987), *Kate and the Crocodile* (OUP, 1987); J. Allen: *County Rovers for Charlie* (Hamilton, 1988).
Books written and illustrated include: *Wheezy* (BH, 1988).
Bibl: ICB4; Peppin.

CHATTERTON, George Edward **b.1911**
Born on 15 July 1911 in Kidderminster, Chatterton was educated in Toronto and studied at Kidderminster School of Art and the Farnborough School of Photography. He was an artist, cartoonist and photographer, with the RAF as artist/photographer (1938-50), and contributed to many magazines and newspapers in Reading, London and Dundee since 1932. He is perhaps best known as the creator (1938) of "Chad", a WW2 cartoon character who appeared in "Wot, No —?" sketches.
Contrib: *Blighty; Boy's Own Paper; Daily Mirror; Daily Sketch; Everybody's; Leader; London Opinion; Picturegoer; Weekend Mail*.
Bibl: Who.

CHEEK, Melvina **fl. 1940s-1950s**
Cheek illustrated with drawings and watercolours two books in Paul Elek's series of books on the English scene, "Vision of England", and contributed some atmospheric pen and ink illustrations to several issues of the *Saturday Book*. She was elected MSIA.

Books illustrated include: W. Allen: *The Black Country* (Elek, 1946); N. Kirkham: *Derbyshire* (Elek, 1947).
Contrib: *Future; Saturday Book* 10,11.

CHEESE, Chloe **b.1952**
Cheese has illustrated at least two books, produced posters, and designed book jackets. Her impressionistic cover for the Faber edition of Lee Zacharias' *Lessons* is done in a mixture of coloured inks and pencil and watercolour.
Books illustrated include: R. Kipling: *How the Alphabet Was Made* (Macmillan, 1983); N. Scott: *The Hot Drinks Book* (Bath Street Press, 1988).

CHESTERMAN, Hugh **1884-1941**
Chesterman was educated at Cambridge University and was a friend of both Walter de la Mare and Basil Blackwell. He edited the children's annual, *Merry-Go-Round* 1924-30, and wrote plays, books of poetry, and textbooks, including a "Teaching of English" series for Nelson. He also illustrated several books and contributed to a number of annuals.
Books illustrated include: G. Chaucer: *Canterbury Tales* (Oxford: Blackwell); E. Fleming: *Gammon and Spinach* (Collins, 1927); E. Farjeon: *Mighty Men: From Achilles to Harold* (Blackwell, 1928); E. Fleming: *The "Creepie-Stool"* (Nelson, 1931); S.G. Buchan: *The Freedom of the Garden* (OUP, 1932); E. Fleming: *The Lucky Pedlar* (Nelson, 1933); E.D. Hancock: *Father Time's Tales* (Nelson, nd).
Books written and illustrated include: *Proud Sir Pim and Other Verses* (Oxford: Blackwell, 1926); *Kings and Other Things* (Methuen, 1930); *The First Boy in the World* (Nelson, 1933); *The*

Muse Amuses (Nelson, 1933); *Playing with History* (Nelson, 1936); *Seven for a Secret* (Blackwell, 193?); *Crusaders* (Oxford: Blackwell, 1946).
Contrib: *Joy Street; Manchester Guardian; Merry-Go-Round; Punch; Saturday Review.*

CHESTERTON, Gilbert Keith **1874-1936**
See Houfe
Chesterton was primarily an essayist, critic and novelist — his Father Brown detective stories remain his most popular work. As Houfe states, he was a competent amateur artist who illustrated several books written by his friend, Hilaire Belloc. An anthology of Chesterton's work, *The Coloured Lands*, which contains a selection of his drawings, was published posthumously in 1938. Unfortunately most of the stock of this book was destroyed during the Blitz.
Books illustrated include: H. Belloc: *The Great Inquiry* (Duckworth, 1903); E.C. Bentley: *Biography for Beginners* (Werner Laurie, 1905); H.Belloc: *The Green Overcoat* (Arrowsmith, 1912), *The Haunted House* (Arrowsmith, 1926), *The Man Who Made Gold* (Arrowsmith, 1930), *The Hedge and the Hose* (1936).
Books written and illustrated include: *Greybeards at Play* (Brimley Johnson, 1900), *The Coloured Lands* (Sheed & Ward, 1938).
Bibl: Dudley Barker: *G.K. Chesterton: A Biography* (Constable, 1973); John Sullivan: *G.K. Chesterton 1874-1974* (National Book League, 1974); John Sullivan: *G.K. Chesterton: A Centenary Appraisal* (Elek, 1974); Maise Ward: *Gilbert Keith Chesterton* (Sheed & Ward, 1944); Peppin.

Hugh CHESTERMAN *Crusaders* (Basil Blackwell, 1946)

CHEVINS, Hugh Terry **b.1931**
Born on 2 July 1931 in Retford, Chevins was educated at Gunnersbury Grammar School, and studied at Twickenham School of Art, RA Schools and in Paris. He has done commercial work for companies such as ICI, Shell, Reed Paper and John Laing. He is a muralist, portrait painter and book illustrator. MSIA.
Books illustrated include: R.P.A. Edwards: *Opposites* (Burke, 1967), *Wild Animals* (Burke, 1967), *School* (Burke, 1968), *Counting and Measuring* (Burke, 1970); A.H. Dunhill: *The Gentle Art of Smoking* (3rd ed., Reinhardt, 1981).
Books written and illustrated include: *Perspective* (Studio-Vista, 1966).
Exhib: RA; RBA; Glasgow Academy; Piccadilly Gallery; Brighton; Bournemouth.
Collns: Science Museum; Rijksmuseum, Amsterdam.
Bibl: Who.

CHIANG YEE **b.1903**
Born in Kiu-kiang, China, Chiang was educated at the Third Middle School of the Kiangsi Province and the National South-Eastern University, Nanking, where he studied chemistry. After being local governor of four districts in succession, he moved to England in 1933. There he lectured in Chinese language and literature at the School of Oriental and African Studies, University of London. He also took charge of the Chinese section of the Wellcome Historical Medical Museum, London.
Since 1942, he has been a free-lance writer and painter. He had several one-artist exhibitions in London; and designed the sets and costumes for the Sadler's Wells Ballet, "The Birds". He went to the US in 1955 to teach at Columbia University, and settled there. He was elected a Fellow of the American Academy of Arts and Sciences in 1956.
He has written several children's books; at least eleven *Silent Traveller* books about his travels; and several books on Chinese art. All his illustrations show his background in Chinese painting and culture.
Books written and illustrated include: *The Silent Traveller in Lakeland* (1937); *The Silent Traveller in London* (Country Life, 1938); *Chin-pao and the Giant Pandas* (Country Life, 1939); *Chin-pao at the Zoo* (Methuen, 1941); *Lo Cheng: The Boy Who Wouldn't Keep Still* (Puffin Picture Books; Penguin, 1941); *The Silent Traveller in the Yorkshire Dales* (Methuen, 1944); *The Silent Traveller in Oxford* (Methuen, 1944); *Yebbib* (Methuen, 1947); *The Silent Traveller in Edinburgh* (Methuen, 1948); *The Silent Traveller in New York* (Methuen, 1950); *The Silent Traveller in Dublin* (Methuen, 1953); *The Silent Traveller in Paris* (Methuen, 1956); *The Silent Traveller in San Francisco* (1964); *China Revisited after Forty-Two Years* (NY: Norton, 1977).
Bibl: Chiang Yee: *A Chinese Childhood* (Methuen, 1940); ICB; ICB2; Peppin.

CHOPPING, Richard **fl.1939-1946**
Chopping was an artist who illustrated natural history and other books for children, these interests being combined in his *Butterflies in Britain*, published by Penguin Books for the Puffin Picture Books series in 1943. The illustrations were done by autolithography, being drawn directly on the plate by the artist. Peppin describes his illustrations for the Bantam Picture Book series (published by Transatlantic Arts) as "lively and humorous but slightly grotesque." Unlike his other work, the book jackets for Ian Fleming's "Bond" novels are surrealist; and he produced at least one jacket for the *Saturday Book*. In the 1950s Chopping and his companion, artist Denis Wirth-Muller, were introduced to John Minton* by the two Roberts, Colquhoun* and MacBryde, and they became close and lasting friends.
Books illustrated include: D. Wirth-Miller: *Heads, Bodies and Legs* (Baby Puffin Books; Penguin, 1946).
Books written and illustrated include: *Butterflies in Britain* (Puffin Picture Books; Penguin, 1943); *A Book of Birds* (1944); *The Old Woman and the Pedlar* (Transantlantic Arts, 1944); *The Tailor and the Mouse* (Transatlantic Arts, 1944); *Wild Flowers* (Transatlantic Arts, 1944); *Mr. Postlethwaite's Reindeer* (Transatlantic Arts, 1945).
Bibl: Peppin.

Ralph CHUBB "Brothers" from *Woodcuts* (Andrew Block, 1928)

and then hand-lithographed on the paper. In some books there are elaborate illustrations on every page and every book took years to complete. An edition of these books never amounted to more than three dozen copies, of which six would be set aside for hand colouring. With each succeeding work his mysticism deepened and this was echoed by the hand-painted pictures in the major works, which shine from the page like jewels." (Bellamy,† p.36.) His masterpieces are *The Child of Dawn* (1948) and *Flames of Sunrise* (1953). *The Child of Dawn* took nine years to make, composed of ornamented calligraphy, with full-page plates of coloured lithographs and hand-painted pictures. The message of the book and its successor is perplexing and offensive to some, declaring homosexuality and pederasty to be an inextricable part of a new religion. Even the binding Chubb declared to be "phallic for tactile pleasure."

Books written and illustrated include: *Manhood* (Curridge: pp., 1924); *The Sacrifice of Youth* (Curridge: pp., 1924); *A Fable of Love & War* (Curridge: pp., 1925); *The Cloud & the Voice* (Newbury: pp., 1927); *The Book of God's Madness* (Cambridge: p.p. 1928); *Woodcuts* (Andrew Block, 1928); *Songs of Mankind* (Newbury: pp., 1930); *The Sun Spirit: A Visionary Phantasy* (Newbury: pp., 1931); *The Heavenly Cupid* (Kingsclere: pp., 1934); *Songs Pastoral and Paradisal* (Brockweir: Tintern Press, 1935); *Water Cherubs* (Kingsclere: pp., 1936); *The Secret Country* (Kingsclere: pp., 1939); *The Child of Dawn* (Ashford Hill: pp., 1948); *Flames of Sunrise* (Ashford Hill: pp., 1953); *Treasure Trove* (Newbury: pp., 1957); *The Golden City* (Newbury: pp., 1958-60).

Ralph CHUBB "Contemplation" from *Woodcuts* (Andrew Block, 1928)

CHUBB, Ralph Nicholas 1892-1960

Born at Harpenden, Hertfordshire, in 1892, Chubb was educated at St. Albans Grammar School and Selwyn College, Cambridge, and then enlisted in the army for the duration of WW1. He studied art at the Slade (1919-22) and became a close friend of Leon Underwood* who was responsible for Chubb's work being exhibited. He exhibited paintings at the RA and elsewhere, with one-artist shows at Chenil's in 1922 and 1924 and at the Goupil Gallery in 1929. He was a part-time art teacher at Bradfield College (1924-27), but had to resign for sexual indiscretions. He taught life-drawing at St. Martin's School of Art (1930-33).

Early on, he seemed destined to have a fairly conventional artistic career but he painted pictures which shocked and wrote books which no-one would publish. In the early 1920s he set up a private press and turned to printing. He was a poet as well as an artist and his first books, printed letterpress and illustrated with engravings and woodcuts, were of his own poetry. These early books were printed on a home-made press built by Chubb's brother; but by 1930, influenced greatly by William Blake whom he admired and tried to imitate, he bought a lithographic press and produced eight lithographed volumes. "His method of production was extremely painstaking and the labour involved beyond the reach of most artists. Every word was written by hand, transferred to the stone

Contrib: *Island*.
Exhib: RA; NEAC; Alpine Club; Goupil Gallery.
Collns: The Chubb Archive and Memorial Collection (see *Private Library*, 2nd S., 3, No.4, Winter 1970: 194); British Library; Bodleian Library.
Bibl: Roderick Cave: "Blake's Mantle; a Memoir of Ralph Chubb", *Book Design and Production*, 3, No.2 (1960): 24-28; B.E. Bellamy: *Private Presses & Publishing in England Since 1945* (Bingley, 1980); Anthony Reid: "Ralph Chubb, the Unknown. Part 1: His Life", *The Private Library*, 2nd S., 3, No.3 (Autumn 1970): 141-156; Anthony Reid: "Ralph Chubb, the Unknown. Part 2: His Work", *The Private Library*, 2nd S., 3, No.4 (Winter 1970): 193-213; Garrett 1 & 2; Peppin; Waters.

CLARK, Dorothy fl. 1960-
Books illustrated include: O. Dehn: *The Caretakers* (Burke, 1960), *The Caretakers and the Poacher* (Burke, 1961), *The Caretakers and the Gypsy* (Burke, 1962), *The Caretakers to the Rescue* (Burke, 1964), *The Caretakers of Wilmhurst* (Burke, 1967); I. Chilton: *The Lamb* (Macmillan, 1973).
Books written and illustrated include: *Baa Sheep* (Epworth, 1961); *Black One* (Epworth, 1961); *Polly Piglet* (Epworth, 1961); *Tufty Rabbit* (Epworth, 1961); *Jo-Jo's Day Out* (Collins, 1965); *Shepherd's Pie* (MacRae, 1982).

CLARK, Emma Chichester fl. 1981-
Chichester Clark did book covers for Picador Books in 1981 while

Emma Chichester CLARK *The Despot and the Slave* by Benjamin Constant (Folio Society, 1986)

still a student at RCA. She has since illustrated a few books, winning the Mother Goose 1987 award for her *The Story of Horrible Hilda*.
Books illustrated include: B. Constant: *The Despot and the Slave* (Folio Society, 1986); L. Cecil: *Listen to This!* (BH, 1987), *Catch That Hat!* (BH, 1988), *Stuff and Nonsense* (BH, 1989).
Books written and illustrated include: *The Story of Horrible Hilda and Henry* (BH, 1988); *Myrtle, Tertle and Gertle* (BH, 1989); *Tea with Aunt Augusta* (Methuen, 1991).
Bibl: Folio 40.

CLARK, James 1858-1943
Clark studied in Hartlepool, at RCA and in Paris at the École des Beaux Arts. He was a painter in oils and watercolour, a book illustrator, and a designer of stained glass, spending most of his career in London.
Exhib: RI; ROI; RBC; NEAC.
Bibl: Waters.

CLARK, Laurie fl. 1983-
In *By Footpath and Stile*, Laurie Clark has brought together a collection of pen and ink drawings drawn from her walks in the woods and fields around her home in the Cotswolds. They are beautifully produced and loosely bound in a folio. She has also illustrated some of her husband's poems.
Books written and illustrated include: *By Footpath and Stile* (Nailsworth, Glos: Moschatel Press, 1983?).

CLARKE, Graham Arthur b.1941
Born in an Oxfordshire village where his mother had been evacuated from the family home in Hayes, Kent, Clarke was educated at Beckenham and Penge Grammar School. He studied at Beckenham Art School (1958-60) under Wolf Cohen and Susan Einzig* who taught illustration there for one year, and in 1961 went to the RCA to do postgraduate work. He admits to being much influenced by the work of Samuel Palmer, who even makes an appearance in one of Clarke's etchings.
Clarke began to teach at Canterbury College of Art and in 1965, was given the first of several commissions by Editions Alecto. To produce a set of twelve prints of Shoreham landscapes, Clarke set up his Ebenezer Press in 1966, and made the prints with his apprentice, David Birtwhistle. Then, using the wood of a single apple tree, he cut the pages of text and the illustrations for a limited edition of *Balyn and Balan*, based on a part of Roger L. Green's *King Arthur and His Knights of the Round Table*, and published as a *livre d'artiste* in 1969 by his Ebenezer Press.
Meanwhile, Clarke also produced posters for London Transport (1967-73) and for Shell, and did cartoon drawings for architectural magazines. Then in 1968, Wolf Cohen gave Clarke some rudimentary instructions in the art of etching, and he used that medium to illustrate his next handprinted book, *Vision of Wat Tyler* (1972?), a long narrative poem commissioned from John Birtwhistle. This collaboration later inspired Clarke to prepare his own book of illustrated poems, published as *The Goose Man*, for which he devised his own typeface, "Rural Pen".
An etching exhibited at the RA in 1973 featured the distinctive "arched top" of many of Clarke's prints. This was so popular and so appealing that a business arrangement was made with Christie's Contemporary Art, and Clarke has become one of their best-selling printmakers. Since 1977 the etchings have been accompanied by a humorous, unconventional guide, or *Notes for the Interested*, and these have been produced in booklet form. All his work, in fact, exhibits this light-hearted sense of humour, reflecting his escapist attitude.
Books illustrated include: R.L. Green: *Balyn and Balan* (Ebenezer Press, 1969); J. Birtwhistle: *Vision of Wat Tyler* (Ebenezer Press, 1972); M. Morpurgo: *Miss Wirtle's Revenge* (Kaye, 1981).
Books written and illustrated include: *The Goose Man* (Ebenezer Press, 1974); *History of England* (Phaidon Press, 1987).
Exhib: National Theatre; RA.
Bibl: Clare Sydney: *Graham Clarke* (Oxford: Phaidon, 1985).

Harry CLARKE *The Fairy Tales of Hans Christian Andersen* (George Harrap, 1929)

CLARKE, Henry Patrick ("Harry") **1889-1931**
See Houfe

Although Clarke illustrated only a few books, his graphic output was considerable. He was commissioned to illustrate Coleridge's *Rime of the Ancient Mariner* by the Dublin publishing firm of Maunsel and Co., which was announced for publication in 1916, but had to be abandoned when all but the eight full-page illustrations were destroyed by fire. For his patron, Laurence Ambrose Waldron, Clarke made six pen and ink drawings in 1913 to illustrate Pope's *Rape of the Lock*. These drawings, apparently never intended for publication, illustrate the same scenes as Beardsley and are highly derivative in style. His work was definitely in the Beardsley tradition, but he was not unique in this regard, for several of his artist friends — John Austen* and Alan Odle (see Houfe) — and other contemporary illustrators, such as Kay Nielsen*, Alastair (see Houfe under Hans Henning Voight) and Sidney Sime* exhibited a similar fascination with a decadent sexuality and tales of horror, producing highly decorated and textured work. He was elected member of the Royal Irish Academy in 1922.
Books illustrated: No evidence has been found to confirm his illustration of an edition of Synge's *The Playboy of the Western World*. However, he did make a stained glass panel which depicted a scene from the play.
Contrib: *Dublin Magazine; Eve; Golden Hind; Good Housekeeping; Irish Review.*

Exhib: RA; RBA; RHA; ROI; RWA.
Colln: Nat. Gallery Ireland.
Bibl: Thomas Bodkin: "The Art of Mr. Harry Clarke", *Studio*, 78, 320 (November 1919), 45-51; Nicola Gordon Bowe: *Harry Clarke: His Graphic Art* (Mountrath: Dolmen Press, 1983); John Russell Taylor: "Clarke's Subtle Taste for the Perfumed Sinner", *The Times*, January 15, 1980; Johnson FDIB; Peppin; Waters.

CLARKE, Richard Cambridge **b.1909**
Born in Ilford, Essex, Clarke was educated at Bishop's Stortford College (1921-26), and studied at Regent Street Polytechnic, London (1937-38) as a part-time student. He was a watercolour artist who illustrated a number of books for Heinemann, Longman and Nelson.
Bibl: Who.

CLAYTON, Frances
See RICHARDS, Frances

CLEAVER, James **b.1911**
Cleaver was educated at Southwark County School, and studied at Camberwell School of Art (1930-34) and RCA (1934-38). As a painter, he exhibited in London and the provinces; he also contributed to magazines such as *Radio Times*, and illustrated a number of books. ARCA (1937); MSIA.
Books written and illustrated include: *The Theatre Through the Ages* (Harrap, 1946); *The Theatre at Work* (Puffin Picture Book: Penguin, 1947).
Contrib: *Observer; Radio Times.*
Published: *A History of Graphic Art* (Owen, 1963).
Exhib: RA.
Bibl: Waters; Who.
Colour Plate 58

CLEAVER, Ralph **fl. 1893-1932**
See Houfe

CLEAVER, Reginald Thomas **d.1954**
See Houfe
Books illustrated include: Rudyard Kipling: *Humorous Tales* (Macmillan, 1931).
Books written and illustrated include: *A Winter Sport Book* (Black, 1911); *Included in the Trip* (Bale, 1921).

CLOKE, René **fl. 1932-**
Born in Plymouth, Cloke worked as a greeting card designer, and as an illustrator and writer of books for young children. His work is done in either black and white or in full colour. Some of his books are printed using the "Initial Teaching Alphabet".
Books illustrated include: A. Macdonald: *Jill's Curmudgeon* (Chambers, 1932); A. Turnbull: *Mr. Never-Lost Goes On* (Chambers, 1934); B. Royle: *Red Riding Hood Goes to the Teddy-Bear's Picnic* (Crowther, 1943); L. Carroll: *Alice in Wonderland* (Gawthorn, 1944); H.C. Andersen *The Nightingale* (Ward, 1945), *Fairy Tales* (Ward, 1947); *The Sleeping Beauty* (1947); E. Blyton: *Mister Meddle's Muddles* (Dean, 1950); M. Sedwick: *A Tale for Pebblings Village* (1960); *Little Folk's First Book* (1964); E. Blyton: *Enid Blyton's Everyday Book* series (four books; Dean, 1975); *My Best Book of Enid Blyton Stories* (1980).
Books written and illustrated include: *Mr. Podge of Oaktree Lodge* (Crowther, 1943); *Chickweed* (Ward, 1947); *Joy Bells Picture and Story Book* (Juvenile Productions, 1949); *Little Boy Blue Nursery Rhymes* (Juvenile Productions, 1949); *Before We Go to Bed* (Juvenile Productions, 1953); *The Little Roundabout Horse* (Blackie, 1954); *Tippety Is Snowed Up* (Blackie, 1954); *Barnaby's Cuckoo Clock* (Wheaton, 1958); *Dumpling Wants a House* (1958); *Paul Piglet Keeps Shop* (Blackie, 1960); *Popkyn the Pedlar* (Blackie, 1960); *Snowy for Sale* (Blackie, 1961); *Adventure in Acorn Wood* (Blackie, 1962); *The Dragonfly* series (eight books; Exeter: Wheaton, 1966); *Fairyland Favourites* series (six books; Award, 1975-6); *Rene Cloke's Bedtime Book* (Award, 1978); *My Big Book of Brer Rabbit Stories* (Award, 1983); *Town Mouse and Country Mouse, and Other Stories* (Award, 1983).

Bibl: Peppin.
Colour Plate 59

COBB, Gerald **fl.1942-**
Books illustrated include: H.B. Pereira: *The Colour of Chivalry* (ICI, 1950).
Books written and illustrated include: *The Old Churches of London* (Batsford, 1942); *London City Churches* (1951); *Our Heritage in London's City Churches* (Ecclesiological Society, 1966); *English Cathedrals* (T & H, 1980).

COBB, Ruth **fl. 1902-1953**
See Houfe
A figure artist, most of whose book illustrations were done for children's books, of which she wrote a number herself. She contributed to a number of magazines, including *Punch*.
Books illustrated include: R. Hunter: *Dollies* (Richards, 1902), *More Dollies* (Richards, 1903); E. Shirley: *Sea and Sand* (Nelson, 1904), *The Wonder-Voyage* (Nelson, 1906), *Sinbad the Sailor* (Nelson, 1908), *Tommy's Adventures in Fairyland* (Nelson, 1908), *A Trip to Fairyland* (Nelson, 1908); S. Morrison: *Manx Fairy Tales* (Nutt, 1911); L.A.G. Strong: *Patricia Comes Home* (Blackwell, 1929), *The Old Argo* (Blackwell, 1931); R. Hunter: *Somewhere Street* (Burns, Oates, 1933); *The Golden Book for Girls* (1936); C.S. Goodsman: *This Happy Home* (Crowther, 1944).
Books written and illustrated by Cobb include: *Baby Ballads* (Blackie, 1911); *This Way to London* (Pitman, 1936); *The Golden Thread* (Pitman, 1937); *This Way to the Castle* (Pitman, 1937); *Brown, Jones and Robinson* (Pitman, 1937); *Adventures at Dial House* (Pitman, 1938); *Village Story* (Crowther, 1945); *Country Town Story* (Crowther, 1946); *A Sussex Highway* (Epworth, 1946); *Travellers to the Town* (Epworth, 1953).
Contrib: *Chatterbox; Collins Children's Annual; Merry-Go-Round; Playtime Annual; Punch; Wonderland Annual*.
Bibl: Peppin.

COBER, Alan E. **fl.1973-**
An American artist and illustrator, Cober has provided striking illustrations for a number of children's books published in Britain. For Susan Cooper's *The Dark Is Rising*, he made three double-page spreads in black and white and a book jacket, all of which reflect the mysterious quest and the conflict between good and evil with which the book is concerned.
Books illustrated include: S. Cooper: *The Dark Is Rising* (Chatto, 1973); P. Dickinson: *Giant Cold* (Gollancz, 1984).
Books written and illustrated include: *Forgotten Society* (Constable, 1975).

COLBERT, Anthony William **b.1934**
Born in Newport, Isle of Wight, Colbert went to the West Sussex College of Arts and Crafts in Worthing in 1949. After combining his National Service with studies at Farnham Art School, he worked for advertising agencies, illustrated a few books, and spent eight years on the staff at the *Guardian*. He contributed to many other magazines such as *New Society, Drum* and *Times Educational Supplement*, and to the *Observer*. His concern for social matters led him to a trip to South Vietnam in 1967 commissioned by the Save the Children Fund. The drawings, paintings and woodcuts he produced showed graphically and horrifically the fate of the children in that country, and the exhibition of his work caused a sensation, with the Press comparing his pictures to those of Goya.
A free-lance illustrator since 1968, he has taught illustration at Camberwell School of Arts and Crafts, and written a few books for young children. He uses a variety of techniques including linocuts, line drawing, gouache, and two-colour lithographs, though he seems happier working in black and white. His linocuts for *Round About and Long Ago* are refreshingly naïve and humorous, and show a clear, simple line. The "Amanda" books for children are illustrated with black and white drawings.
Books illustrated include: A. Hitchcock: *Haunted Houseful* (Reinhardt, 1962); C. Brontë: *Jane Eyre* (Folio Society, 1965); T. Parker: *Five Women* (Hutchinson, 1965); J. Peters: *Growing Up in the World* (Longmans, 1966); T. Parker: *People of the Streets* (Cape, 1968); A. Brontë: *The Tenant of Wildfell Hall* (Heron

Books, 1969); G. Eliot: *Adam Bede* (Heron, 1969); M. Gorky: *The Spy* (Heron, 1969); D.H. Lawrence: *The Lost Girl* (Heron, 1969); V. Smith: *Moon in the River* (Longman, 1969); H.G. Wells: *The Research Magnificent* (Heron, 1969); *Books, Plays, Poems* (BBC, 1971); E. Colwell: *Round About and Long Ago* (Longmans, 1972); *My England* (Heinemann, 1973); R. Furneaux: *On Buried and Sunken Treasure* (Longman, 1973), *Volcanoes* (1974); E. Hyams: *The Changing Face of England* (Kestrel, 1974); E. Colwell: *Tales from the Islands* (Kestrel, 1975); V. Netchayev: *Petya and His Dog* (Kestrel, 1975); J. Bowie: *Penny Boss* (Constable, 1976); N. Grant: *Stagecoaches* (Kestrel, 1977); N. Beechcroft: *A Farthing for the Fair* (Heinemann, 1978); J. Riordan: *Tales from Tartary* (Kestrel, 1978); A. Chambers: *Animal Fair* (Chambers, 1979); M. West: *The Greek Heroes* (Longman, 1980).
Books written and illustrated include: *Amanda Has a Surprise* (Macmillan, 1971); *Amanda Goes Dancing* (Macmillan, 1972).
Contrib: *Drum; New Society; Observer; Radio Times; Spectator*.
Bibl: Curt Visel: "Der Engelische Illustrator Anthony Colbert", *Illustration 63* 12 (1975): 25-27; CA; Folio 40; ICB4; Jacques; Peppin.

COLE, Babette **fl.1975-**
Books illustrated include: J. Tate: *Your Dog* (Pelham, 1975); J. Butterworth: *Daisy* (Kaye, 1976); A. Farjeon: *The Unicorn Drum* (Kaye, 1976); J. Aiken: *Mice and Mendelson* (Cape, 1978); O. Postgate: *A Flying Bird* (Kaye, 1978), *The Marrow Boat* (Kaye, 1978); J. Slater: *Grasshopper and the UNwise Owl* (Granada, 1979), *Grasshopper and the Pickle Factory* (Granada, 1980); W. Hall: *The Last Vampire* (BH, 1982), *The Inflatable Shop* (BH, 1984).
Books written and illustrated include: *Basil Brush of the Yard* (Purnell, 1977); *Nungu and the Hippopotamus* (Macdonald, 1978); *Nungu and the Elephant* (Macdonald, 1980); *Beware of the Vet* (Hamilton, 1982); *The Trouble with Mum* (Kaye, 1983); *The Hairy Book* (Cape, 1984); *The Trouble with Dad* (Heinemann, 1985); *Princess Smartypants* (Hamilton, 1986); *Prince Cinders* (Hamilton, 1987); *King Change-a-Lot* (Hamilton, 1988); *Three Cheers for Errol!* (Heinemann, 1988); *Promise Solves the Problem* (Heinemann, 1989).
Colour Plate 26

COLE, Herbert **1867-1930**
See Houfe

COLLARD, Derek **b.1936**
Born in London, Collard studied at South East Essex School of Art. He did his National Service (1958-60), lectured for four years and has been free-lancing since 1969. A painter and printmaker, he illustrates his own books for children and books by other writers.
Books illustrated include: R. Nye: *Poor Pumpkin* (Macmillan, 1971); P. Pearce: *The Squirrel Wife* (Kestrel, 1971); F. Law: *Topics* (Collins, 1975); H. Sargeant: *Danny on the Motorway* (Abelard, 1975); E. Beresford: *The Wombles Gift Book* (Benn, 1975); J. Manton: *The Flying Horses* (Methuen, 1977); A. Jungman: *The Dragon Becomes a Pet* (Arnold, 1978), *The Dragon Joins the Army* (Arnold, 1978), and two others in series; S. McCullagh: *The Island of Solomon Dee* (Arnold, 1980), *The Silver Ship* (Arnold, 1980), and five others in series; J. Bailey: *Gods and Men* (with others, OUP, 1981); K. Hersom: *The Spitting Image* (Macmillan, 1982).
Books written and illustrated include: *At the Zoo* (Macdonald, 1977), *In the Park* (Macdonald, 1977), and two others in series; *Opposites* (Hamlyn, 1981).
Bibl: ICB4; Peppin.

COLLINS, [James Henry] Cecil **1908-1989**
Born on 23 March 1908 in Plymouth, Collins studied at Plymouth School of Art (1923) and the RCA (1927-31). He became a painter of mystical and visionary works. His first one-artist exhibition was held at the Bloomsbury Gallery in 1935, and he contributed to the International Surrealist Exhibition in London in 1936. Through the American artist, Mark Tobey, he became interested in Eastern art and philosophy. He painted and taught at Dartington Hall (1939-43), producing a celebrated series of paintings and drawings known as the Cycle of the Fool. His book, *The Vision of the Fool*, was

published by Grey Walls Press in 1947. He moved to Cambridge and taught at the Central School of Arts and Crafts from 1956. His first retrospective exhibition was held at the Whitechapel Gallery in 1959.

A Neo-Romantic, his "universe was a textual one, constituted by traces of Vaughan, Herbert and Donne's mystical, metaphysical poetry. It was also made up from the endlessly rewritten Arthurian legend from Malory to Eliot, and from Shakespeare too." (Mellor.†) Collins illustrated a few books, including providing a frontispiece to Kathleen Raine's *Six Dreams and Other Poems* (1968), designed tapestries and wrote poetry. His *In the Solitude of This Land* was published in an edition of 100 copies, each containing a signed lithograph. He died in 1989 while his major retrospective exhibition was being held at the Tate.

Books illustrated include: W. Gardiner: *The Gates of Silence* (Grey Walls Press, 1944); K. Raine: *Six Dreams and Other Poems* (Enithamon Press, 1968); *The Oxford Illustrated Old Testament* (five vols., with others; OUP, 1968-9).

Books written and illustrated include: *In the Solitude of This Land: Poems 1940-81* (Ipswich: Golgonooza Press, c. 1981).

Contrib: *Counterpoint; Temenos.*

Exhib: Anthony d'Offay Gallery; Bloomsbury Gallery; Whitechapel Art Gallery (retrospective 1959); Tate (retrospective 1989).

Collns: Dartington Hall Trust; Tate.

Bibl: William Anderson: *Cecil Collins: The Quest for the Great Happiness* (Barrie & Jenkins, 1988); Judith Collins: *Cecil Collins: A Retrospective Exhibition* (Tate Gallery, 1989); Anthony d'Offay: *The Music of Dawn: Recent Paintings by Cecil Collins* (Anthony d'Offay, 1988); David Mellor, ed. *A Paradise Lost: The Neo-Romantic Imagination in Britain 1935-55* (Lund Humphries/Barbican Art Gallery, 1987); Tate.

COLLINS, George Edward 1880-1968
Born in Dorking, Collins studied at Epsom School of Art and Lambeth School of Art. A watercolorist and etcher, his black and white illustrations and his colour work are naturalistic and quiet, and his subject matter is usually natural history. RBA (1905); RCamA (1941).

Books illustrated include: G. White: *The Natural History of Selborne* (Macmillan, 1911); P. Chalmers: *Green Fields and Fantasy* (Methuen, 1934); R. Jeffries: *Wild Life in a Southern County* (Nelson, 1937).

Exhib: RA; RBA; ROI.

Bibl: Peppin; Waters.

COLQUHOUN, Robert 1914-1962
Born on 20 December 1914 in Kilmarnock, Ayrshire, Colquhoun was educated at Kilmarnock Academy Secondary School, and studied at Glasgow School of Art, where he first met Robert MacBryde. Colquhoun and MacBryde, inseparable from that time, became known as the Two Roberts. They travelled to France and Italy in 1938; then, after Colquhoun had served with the RAMC in WW2 (before being invalided out in 1941), for a period they shared a studio in London with John Minton*.

A painter, lithographer and theatrical designer, Colquhoun was much influenced by the work of Wyndham Lewis* and a Polish refugee painter, Jankel Adler. His first one-artist exhibition was at the Lefevre Gallery (1943); he designed the scenery and costumes for a ballet at Covent Garden and *King Lear* at Stratford; and he illustrated one book. The sixteen lithographs he did for *Poems of Sleep and Dream* show strange images, several of which appear to have been completed in a hurry, and seem to have nothing to do with the text. After a lengthy period, during which their art was out of fashion and Colquhoun and MacBryde were more or less homeless and spending what money they had on drink, Colquhoun had a retrospective exhibition in Whitechapel in 1958. He died of a heart attack in London on 20 September 1962.

Books illustrated include: W.J. Turner and S. Shannon: *Poems of Sleep and Dream* (Muller, 1947).

Exhib: Lefevre Gallery (1943); Whitechapel Art Gallery (retrospective 1958).

Collns: Tate.

Bibl: David Mellor: *A Paradise Lost: The Neo-Romantic Imagination in Britain 1935-55* (Lund Humphries/Barbican Art Gallery,

1987); Malcolm Yorke: *The Spirit of Place: Nine Neo-Romantic Artists and Their Times* (Viking, 1988); Tate.

CONNARD, Philip 1875-1958
See Houfe

COOK, Alice May 1876-1960
Cook (née Barnett) studied at St. John's Wood Art School and RA Schools; she lived in London and exhibited there and overseas. She was a miniature painter and illustrator of children's books in colour and in black and white. There are fifteen colour plates and more than sixty black and white illustrations in *Peggy's Travels*.

Books illustrated include: W. Cook: *Busy Little People All Over the World* (Blackie, 1911), *Peggy's Travels* (Blackie, c.1915).

Exhib: RA; RSA.

Bibl: Waters.

COOK, Beryl b.1926
Cook started to exhibit her paintings in England in 1975. She has been a typist, show dancer, hotel cook, book keeper, and used to run her home as a boarding house. Now a successful and popular painter, she has produced a number of books of her lighthearted portrayals of people and cities, and done book jackets and covers for several publishers, including Macmillan, Penguin Books and Abacus. She has lived in Plymouth for over twenty years.

Books illustrated include: C. O'Hare: *Seven Years and a Day* (Collins, 1980); E. Lucie-Smith: *Bertie and the Big Red Ball* (Murray, 1982); H.E. Bates: *A Breath of French Air* (Penguin Books, 1983).

Books written and illustrated include: *The Works* (Murray, 1978); *Private View* (Murray, 1980); *My Grannie Was a Dreadful Bore* (Collins, 1983); *Beryl Cook's New York* (Murray, 1985); *Beryl Cook's London* (Murray, 1988).

Exhibit: Portal Gallery; Plymouth Arts Centre (1975).

Bibl: Plymouth Arts Centre. *On the Town* (Plymouth: Devon Books, 1988).

Colour Plate 60

COOK, Brian 1910-1991
Cook was born in Gerrards Cross, Buckinghamshire, and in 1946 he assumed his mother's maiden name of Batsford in order to ensure the retention of that name in the family publishing business. Cook was educated at Repton, and in 1928 entered the Batsford publishing business, attending on a part-time basis the Central School of Arts and Crafts under John Farleigh* and Noel Rooke*.

For the firm of Batsford, through the 1930s, he contributed numerous pen and ink drawings for their *English Life* series, and designed over 150 book jackets, for which he introduced revolutionary changes in design and production techniques. For the *English Life* series and the *British Heritage* series, the Jean Berty printing process was used, which employed hand-cut rubber plates and watercolour inks. The design of these jackets wrapped right round the book, was "bled off", and was printed in brilliant colours on matt paper. The design of the jackets for the *Face of Britain* series was similar, but it was decided to print them by photolithography in order to produce more natural colours. These were the main series of books for which he did jackets, but there were many other titles from Batsford that were given his jackets, and he worked for other publishers as well. For several years, he also did the complete design of Batsford's books, collaborating from time to time with Cecil Beaton* and Oliver Messel.

Cook designed posters for the LNER, the British Tourist Board, and for Thomas Cook. One-artist shows of his paintings have been held in London and Cornwall.

After WW2, as Brian Batsford, he was Chairman of Batsford (1952-74) and followed a Parliamentary career — he was Member of Parliament for Ealing South (1958-74), and was knighted in 1974. He also served as Chairman of the Royal Society of Arts, and on the Post Office Advisory Committee. He was elected SGA in 1933; received a diploma at the Paris Exhibition of 1935; SIA (1936), FSIA (1970).

Books illustrated include: A.K. Wickham: *The Villages of England* (Batsford, 1932); C.B. Ford: *The Landscape of England* (Batsford, 1933); H. Batsford and C. Fry: *The Face of Scotland*

(Batsford, 1933), *The Cathedrals of England* (Batsford, 1934); G. Blake: *The Heart of Scotland* (Batsford, 1934); A.E. Richardson: *The Old Inns of England* (Batsford, 1934).
Exhib: Michael Parkin Gallery.
Bibl: *Landscape in Britain 1850-1950* (Arts Council, 1983); Brian Cook Batsford: *The Britain of Brian Cook* (Batsford, 1987); Ian Jeffrey: *The British Landscape 1920-1950* (Thames and Hudson, 1984).
Colour Plates 14, 15 and 16

COOK, Jennifer **b.1947**
Born on 5 July 1947 in Eastbourne, Cook was educated at Chichester High School for Girls and studied at West Sussex College of Art and Design in Worthing (1958-64) and Central School of Arts and Crafts (1966-69). She teaches art and designs textiles, and has illustrated at least two books.
Books illustrated include: M. Cockett: *Benny's Bazaar* (O & B, 1964); S. Clarke: *Children's Book of Poetry*.
Bibl: Who.

COOK, J. Kingsley **b.1911**
Cook studied at RA Schools where he won a gold medal and a travelling scholarship, and in Paris and Rome. He was an instructor in Book Production and Typography at Edinburgh College of Art. He painted figure subjects in oil but used wood engravings for the illustrations for *Teamsmen*. During WW2 he served in the Merchant Navy, was shipwrecked off North Africa and was held there as a prisoner-of-war. *Aftermath* is a collection of seven poems with wood engravings from drawings made in London and Bristol after air raids during WW2. The engravings, started soon after the war and completed in 1980, with "The Greening" added as a postscript in 1984, are large and dark.
Books illustrated include: C. Porteous: *Teamsmen* (Harrap, 1939).
Books written and illustrated include: *Aftermath* (Centaur Press, 1986).
Exhib: RSA; RWA.
Bibl: Waters.

COOKE, William Cubitt **1866-1951**
See Houfe

COOMBS, Charles John Franklin **fl.1978-**
Born in Bristol, Coombs was educated at Clifton College and Trinity Hall, Cambridge. He is a retired family doctor and paints in oils, acrylic and gouache. He has illustrated a number of books. SWLA.
Books illustrated include: *The Birds of the Western Palaearctic* (OUP).
Books written and illustrated include: *The Crows* (Batsford, 1978).
Exhib: SWLA; ROM.
Bibl: Who.

COOPER, John **fl.1957**
Cooper contributed black and white drawings and two-colour illustrations to one story in Pudney's *The Book of Leisure*, as well as a colour book jacket.
Books illustrated include: J. Pudney: *The Book of Leisure* (with others, Odhams, 1957).

COPLEY, [Diana] Heather **b.1918**
Born in Brewood, Staffordshire, Copley studied drawing and painting at Clapham School of Art and then went to the RCA in 1939. She married Christopher Chamberlain* in 1940. During WW2 she served in the Civil Defence and returned to the RCA after the war. She taught at St. Martin's School of Art and regularly exhibited paintings at the RA. As well as illustrating for magazines and other commercial work (including coloured drawings for an engagement book for Tinlings of Liverpool), she illustrates books, mostly in collaboration with her husband. Their styles are very similar, so their illustrations form a cohesive whole. She is quoted as saying that "I prefer to be thought of as a painter who draws rather than an illustrator". (ICB3.)
Books illustrated include: L. Clark: *Drums and Trumpets* (BH,

1962); (The following all with Christopher Chamberlain) J. Ryder: *Printing for Pleasure* (BH, 1955); R.L. Green: *Heroes of Greece and Rome* (BH, 1960), *Tales of Ancient Egypt* (BH, 1967); E. de Maré: *London's River* (BH, 1964).
Contrib: *Book Design and Production*.
Exhib: RA.
Bibl: ICB3; Peppin; Ryder.

COPPING, Harold **1863-1932**
See Houfe
Books illustrated include (but see Peppin): J. Bunyan: *The Pilgrim's Progress* (RTS, 190?); J. Finnemore: *Three School Chums* (Chambers, 190?); F. Harrison: *Wynport College* (Blackie, 1900); J.M. Callwell: *A Little Irish Girl* (Blackie, 1902); E.F. Heddle: *Strangers in the Land* (Blackie, 1904); L.M. Alcott: *Little Women* (RTS, 1912), *Good Wives* (RTS, 1913); E. Turner: *The Cub* (Ward Lock, 1915), *St. Tom and the Dragon* (Ward Lock, 1918); C. Dickens: *A Christmas Carol* (1920); L.T. Meade: *Peter the Pilgrim* (Chambers, 1921); E. Thurner: *King Anne* (Ward Lock, 1921), *Nicola Silver* (Ward Lock, 1924); C. Dickens: *Character Sketches from Boz* (Tuck, 1924); E. Helme: *The Perfect Friend* (RTS, 1929).
Bibl: Doyle BWI; Peppin; Waters.

CORBETT, Jennie **fl.1960-**
Illustrates mostly "nature" books for children; has written some books for children.
Books illustrated include: A. Hewitt: *The Pebble Nest* (1965); A. Uttley: *The Mouse, the Rabbit and the Little White Hen* (Heinemann, 1966), *Enchantment* (Heinemann, 1966), *The Little Red Fox and the Big, Big Tree* (Heinemann, 1968); D. Ross: *Blackbird* (1968); L. Clark: *Four Seasons* (Dobson, 1975).
Books written and illustrated include: *How-Do-You-Do Cookery* (Nelson, 1965); *How-Do-You-Do Dogs and Cats* (Nelson, 1966); *How-Do-You-Do Gardening* (Nelson, 1966); *How-Do-You-Do Indoor Plants* (Nelson, 1966); *How-Do-You-Do Sewing* (Nelson, 1966); *How-Do-You-Do Garden Birds* (Nelson, 1967).
Bibl: Peppin.

CORNFORD, Christopher **fl. 1953-1960**
Illustrated *On a Calm Shore* with a series of full- and half-page three-colour lithographs. The poet writes in the Preface "The coloured designs are not intended to be direct illustrations of the text. Partly they are there as invitations to the reader to pause between one short poem and the next...but more essentially they are a sort of *obbligato* of imagery evoked by my verses in the imagination of an artist of another generation." In the 1950s Cornford also provided decorations for book jackets for three books by Edith Wharton, for the publisher John Lehmann.
Books illustrated include: F. Cornford: *On a Calm Shore* (Cresset Press, 1960).
Bibl: A.T. Tolley, editor: *John Lehman: A Tribute* (Ottawa: Carleton University Press, 1987).

CORSELLIS, Elizabeth **fl.1937**
The artist's twelve etchings "did not seem to us quite to capture the fertile paganism of the text." (Sandford.)
Books illustrated include: L. Powys: *The Book of Days* (GCP, 1937).
Bibl: Sandford.

COSMAN, Milein **b.1921**
Born and educated in Düsseldorf, Cosman studied at the International School in Geneva, and then came to England and attended the Slade. She paints portraits and landscapes, and does etchings. As an illustrator, she has been mostly concerned with drawing portraits of composers and other musical personalities. Her first drawing for the *Radio Times* (1946) was of Constant Lambert and she illustrated Neville Cardus' *A Composer's Eleven*. She has exhibited in London, Paris and New York.
Books illustrated include: N. Streatfeild: *White Boots* (Collins, 1951); *Musical Sketchbook* (Faber, 1957); J. Pudney: *The Book of Leisure* (with others, Odhams, 1957); *Stravinsky at Rehearsal* (Dobson, 1962); Neville Cardus: *A Composer's Eleven* (Cape,

E.A. COX "The House of the Keeper of the Bridge": lithograph from *Golden Hind* vol.1 no.3 (April 1923)

1975); H. Keller: *Stravinsky at Rehearsal* (Oxford: Cassirer, 1962); *Stravinsky Seen and Heard* (Toccata Press, 1982).
Contrib: *Penguin Music Magazine; Radio Times.*
Exhib: Berkeley Galleries; Camden Arts Centre; City of London Festival.
Collns: NPG; RCM; British Academy.
Bibl: Driver; Usherwood; Who.

COVERLEY-PRICE, Victor **b.1901**
Born on 31 January 1901 in Winchester, Coverley-Price was educated at Harrow and Pembroke College, Cambridge. He served overseas as a member of the Diplomatic Service (1925-46), but he states in his book *An Artist Among Mountains* that "painting has been my principal hobby, walking and climbing in mountain regions my favourite recreation." A self-taught artist in oils and watercolour, he exhibited quite widely, and wrote and illustrated a few school books for children published by OUP. He was a member of the Alpine Club.
Books illustrated include: J. Bourdillon: *The Sherpas of Nepal* (OUP, 1959); H.V.H. Elwin: *The Hill People of North-East India* (OUP, 1959); D. Beattie: *Adventures of Joan, Billy, Willy and Bobby* (Gloucester: Thornhill, 1975); T. McHugh: *An Astronaut Leprechaun* (Thornhill, 1975).
Books written and illustrated include: *The Amazon* (OUP, 1960); *A Banana Plantation in Guatemala* (OUP, 1961); *A Coffee Plantation in Brazil* (OUP, 1961); *A Japanese Village* (OUP, 1961).
Exhib: RA; RBA; RI; RP.
Bibl: Victor Coverley-Price: *An Artist Among Mountains* (Hale, 1957); Who.

COWHAM, Hilda **1873-1964**
See Houfe

COWLES, Hookway **fl. 1948-1965**
An illustrator of the classic adventure story. Peppin describes his work as "in the sketchy style typical of the period, using vigorous shading to create dramatic tonal contrasts."
Books illustrated include (published by Macdonald unless otherwise indicated): C. Kingsley: *Westward Ho!* (1948); H. Rider Haggard: *Allan Quatermain* (1949); A. Dumas: *The Three Musketeers* (1950); H. Rider Haggard: *The Brethren* (1952); G.A. Henty: *The Cornet of Horse* (Latimer House, 1953); W. Scott: *Kenilworth* (1953); H. Rider Haggard: *Heart of the World* (1954), *King Solomon's Mines* (1956), *Ayesha* (1956), *Cleopatra* (1958), *She* (1958), *Marie* (1959); H. Treece: *Wickham and the Armada* (Hulton, 1959); H. Rider Haggard: *Finished* (1962), *Maiwa's Revenge* (1965), *Benita* (1965).
Bibl: Peppin.

COX, Elijah Albert **1876-1955**
Born in Islington, London, Cox studied at Whitechapel People's Palace and at Bolt Court. He first worked as a designer for a manufacturing chemist and later assisted Sir Frank Brangwyn*. He was a mural painter and poster artist, and in his book illustrations he liked to portray historic and heroic adventures. *Westward Ho!* contains sixteen colour plates and black and white decorations in the text. Elected RA (1915); RI (1921); ROI (1923).
Books illustrated include: C. Kingsley: *Westward Ho!* (Dent, 1923); T.B. Macaulay: *The Lays of Ancient Rome* (OUP, 1926); P.F. Westerman: *A Mystery of the Broads* (Blackie, 1930); *The Rubaiyat of Omar Khayyam* (1944); C.F. Smith: *Thames Side Yesterdays* (Leigh-on-Sea: Lewis, 1945); Confucius: *The Sayings of Confucius* (Lewis, 1946); Jami: *Salaman and Absal* (Lewis, 1946); *Aucassin and Nicolette* (Lewis, 1947); C.F. Smith: *Country Days and Country Ways* (Lewis, 1947).
Contrib: *Golden Hind.*
Exhib: RA; RBA; RI; ROI; SGA.
Bibl: ICB; Peppin; Waters.

COX, Morris **fl. 1957-**
After his first book of poetry was issued by Routledge in 1954, Cox turned to printing his work privately. *Yule Gammon* was printed on a home-made block printing press in 1957, with a handcoloured linocut frontispiece, but Cox was dissatisfied with the result and withdrew the edition. In 1958 he started again, founding the Gogmagog Press in order to produce books which could display his own artistic and literary vision, creating complete books in the William Blake tradition, and never issuing more than a few dozen of each. All the books listed were illustrated by Cox in various media including linocuts and holochromes, and employ a combination of direct and offset printing.
Books illustrated include: A.R. Philpott: *Chimneypots* (Gogmagog Press, 1961).
Books written and illustrated include (all Gogmagog Press except the first): *Yule Gammon* (pp., 1957); *Nine Poems from Nature* (1959); *The Slumbering Virgin* (1958); *The Curtain* (1960); *War in a Cock's Egg* (1960); *Conversation Pieces* (1962); *Mummer's Fool* (1965); *An Impression of Winter* (1965); *An Impression of Summer* (1966); *The Warrior and the Maiden* (1967); *Poems 1970-1971* (1972); *Intimidations of Mortality* (1977); *Winter Trees* (1977); *Studio Book* (1980).
Bibl: Bellamy.

COX, Paul **b.1957**
Born in London, Cox was educated at Stanbridge Earls School, Hampshire, and studied illustration at Camberwell School of Art (under Linda Kitson*, 1975-79) and the RCA (1979-82). He won second prize in the Folio Society's annual competition, for illustra-

Paul COX *Three Men in a Boat* by Jerome K. Jerome, illustrated by Paul Cox (Pavilion Books London, 1989)

tions to *Lucky Jim* (not published), and was commissioned to illustrate the Chilingirian Quartet at the Guildhall for the *Sunday Times*. This was the start of Cox's illustrative journalism (or "reportage"), and he now spends half his time in travel or reportage, and the rest on illustrating books, brochures and posters. His collaboration with writer Tim Heald has been particularly successful. After first working together on a book about cricket, they formed a reporting team for the *Daily Telegraph*; and now have a weekly assignment for *Punch*. He believes that reportage illustration is "illustration with an intellectual content, because you're manipulating the world to suit yourself. The more you are able to juggle with it, the better the work is." (*Graphics World*, 1988).

Cox has illustrated several books, using ink and sometimes pale watercolour for his sketch-like, light-hearted illustrations and many book covers. His major books include *The Outing* (1985), *Three Men in a Boat* (1989), and two for the Folio Society.

Books illustrated include: P. Richards: *Learning Medicine* (BMA, 1983); E. Bishop-Potter: *Dear Popsy* (Penguin, 1984); J. Cooper: *The Common Years* (Methuen, 1984); U. Marks: *A Varied Life* (Keynes Press, 1984); E. Somerville and M. Ross: *Experiences of an Irish R.M.* (Folio Society, 1984); *The Dirty Weekend Book* (Quartet, 1984); D. Brock: *Cuckoo Marans in the Tap Room* (Murray, 1985); L. Salway: *The Vain Teddy* (Piccadilly Press, 1985); D. Thomas: *The Outing* (Dent, 1985); T. Heald: *The Character of Cricket* (Pavilion Books, 1986); C. Irving: *The House*

of Commons Cookery Book (Hutchinson, 1987); G. Alington: *Evacuee* (Walker Books, 1988); G. Rose: *The Romantic Gardens* (1988); P. Terson: *The Offcuts Voyage* (OUP, 1988); Lord Chesterfield: *Dear Boy* (Bantam Press, 1989); A. Gurr: *Rebuilding the Globe* (Weidenfeld, 1989); J.K. Jerome: *Three Men in a Boat* (Pavilion, 1989); P.G. Wodehouse: *Leave It to Psmith* (Folio Society, 1989).

Contrib: *Blueprint Magazine; Daily Telegraph; Independent; Listener; Marketing Week; Observer; Punch; Radio Times; Spectator; Sunday Times; Times*.

Exhib: Cartoon Gallery (1984); Assoc. of Illustrators (1985); Beetles (1989).

Bibl: "Life on the Road", *Graphics World* 72 (June 1988): 37-41; Folio 40; IFA.

CRADDOCK, Kenneth Julius Holt **1910-1989**

For *Voices on the Green*, Craddock did the coloured jacket and several small, wood engraved tailpieces. Unfortunately the book was produced just after WW2 and is badly printed on poor paper which does not do justice to any of the engravings.

Books illustrated include: A.R.J. Wise and R.A. Smith: *Voices on the Green* (with others; Joseph, 1945).

CRAIG, Edward Anthony **b.1905**

Worked as Edward Carrick. Born on 3 January 1905 in London,

K.J.H. CRADDOCK *Voices on the Green* edited by A.R.J. Wise and Reginald A. Smith (Michael Joseph, 1945)

Edward Anthony Craig was the son of Edward Gordon Craig* and Elena Meo. He lived with his father in Italy from 1908 to 1927, and there studied art, the theatre, and photography. He spent some time in England during WW1 and acted with Ellen Terry, his grandmother, just as his father had done before him. With his father's encouragement, he began to make wood engravings in addition to helping generally with the journal *The Mask*.

He returned to England in 1927 and worked as an art director and designer for films, a painter and a wood engraver, illustrating several books. The engravings he made for *The Voyage to the Island of the Articoles* (1928) are somewhat static, but those for *The Georgics* (1931) are decorative and delightful, as are those he made for the four poems on the seasons, published in the same year. He also did some decorated initial letters for *The Review of Revues* edited by C.B. Cochrane (1930). Later he concentrated on film and theatre design, and worked on many notable productions, including *Macbeth* at the Old Vic in 1932. In 1938, he founded the first film school in Britain, and during WW2 he became art director to the Ministry of Information's famous Crown Film Unit, helping to produce such films as *Target for Tonight* and *Western Approaches*. He moved to the Rank organization, and in the 1940s and 1950s was a leading art director in films. He was elected FRSA, and was a member of the Architectural Association, and Vice-Chairman of the Guild of Film Art Directors.

Books illustrated include: A. Maurois: *A Voyage to the Islands of the Articoles* (Cape, 1928); Virgil: *The Georgics* (George W. Jones, 1931); E. Blunden: *In Summer* (pp.,1931); W.H. Davies: *In Winter* (pp., 1931); J. Gawsworth: *Above the River* (Ulysses Bookshop, 1931), *Fifteen Poems: Three Friends* (Twyn Barlwm Press, 1931); H. Palmer: *In Autumn* (pp., 1931); E. Sitwell: *In Spring* (pp., 1931); E. Selsey: *So Far So Glad* (Duckworth, 1934).

Published: *Designing for Moving Pictures* (Studio); *Gordon Craig: The Story of His Life* (Gollancz, 1968); "Gordon Craig Prints *The Mask* in Italy", *Matrix* no. 1 (1981): 7-11; *Edward Gordon Craig: The Last Eight Years, 1958-1966* (Andoversford: Whittington Press, 1983).

Exhib: St. George's Gallery; Redfern Gallery.

Collns: BM; V & A; Berlin; Metropolitan Museum, NY.

Bibl: Edward Anthony Craig: *Gordon Craig* (Gollancz, 1968); Peppin; Waters; IFA.

Edward Anthony CRAIG ("Edward CARRICK") *The Georgics* by Virgil (G. W. Jones, 1931)

CRAIG, Edward Gordon　　　　　　　　　　**1872-1966**
See Houfe

Born on 16 January 1872 in Stevenage, Hertfordshire, Craig was the son of the great British actress, Ellen Terry, and the brilliant but erratic William Godwin, architect, scene designer and critic. When she was only sixteen, Terry married the artist, George Frederick Watts, but the marriage lasted only a short time. She married twice later but her only children were by Godwin. Craig and his sister, Edith, decided to take the name Craig after a boat trip in Scotland to the island of Ailsa Craig.

Craig became both an important theatre designer and an incredibly influential woodcutter. After having been expelled from school in 1889, Craig began a theatrical career as an actor at the age of seventeen, in Henry Irving's famous Lyceum Theatre in London. Ellen Terry was Irving's leading lady, and Craig acted both with his mother and with Irving. Craig was an actor for eight years, playing Hamlet for five different companies between 1890 and 1897. In that year, shortly before his marriage, he ended his acting career in order to devote himself to the execution of his own visionary ideas of a "new" theatre.

In 1898, Craig began publishing *The Page*, a magazine devoted to

31 West Hill. N.6

Edward Gordon CRAIG "Ellen Terry as Ophelia", woodcut, 1898

interior white lines to indicate clothes and limbs. Some of the blocks were printed grey with some black superimposed. The Cranach *Hamlet* is one of the most striking and imaginative works of the twentieth century. He also produced many fine engravings for an edition of *Robinson Crusoe* which was finally published in 1979. He produced a large number of woodcut bookplates and designed books, on the covers of which his woodcuts were also used.

Craig died on 29 July 1966 in Vence, France.

Books illustrated include (but see Fletcher and Rood, 1967†): T.E. Pemberton: *Ellen Terry and Her Sisters* (Pearson, 1902); Haldane Macfall: *Sir Henry Irving* (with others; Foulis, 1906); Hugo von Hofmannsthal: *Der Weisse Facher* (Leipzig: Insel Verlag, 1907); W.B. Yeats: *Plays for an Irish Theatre* (Bullen, 1911); Haldane Macfall: *The Splendid Wayfaring* (with others; Simpkin, Marshall, 1913); William Shakespeare: *Die Tragische Geschichte von Hamlet* (Weimar: Cranach Presse, 1928; English edition, Cranach Press, 1930); William Shakespeare: *Macbeth* (New York: Limited Editions Club, 1939); D. Defoe: *Robinson Crusoe* (Basilisk Press, 1979).

Books written and illustrated include (but see Fletcher and Rood, 1967†): *A Book of Portraits* (Chicago: Stone, 1899); *The Art of the Theatre* (Foulis, 1905); *On the Art of the Theatre* (Heinemann, 1911); *Towards a New Theatre* (Dent, 1913); *A Living Theatre* (Florence: School for the Art of the Theatre, 1913); *Scene* (OUP, 1923); *Woodcuts and Some Words* (Dent, 1924); *Nothing; or, The Bookplate* (Chatto, 1925); *Henry Irving* (Dent, 1930); *Ellen Terry and Her Secret Self* (Sampson, Low, 1931); *Index to the Story of My Days* (Hulton Press, 1957).

Contrib: *The Chapbook; The Dome; The Mask; The Page.*

Exhib: Glasgow; RHA; V & A; National Gallery, Ottawa.

Collns: BM; V & A.

Bibl: Edward Anthony Craig: *Gordon Craig* (Gollancz, 1968); Edward Anthony Craig *and* John Craig: *Edward Gordon Craig: the Last Eight Years* (Andoversford: Whittington Press, 1983); Edward Gordon Craig: *Ellen Terry and Her Secret Self* (Sampson, Low, 1931); Edward Gordon Craig: *Index to the Story of My Days* (Hulton Press, 1957); I.K. Fletcher and A. Rood: *Edward Gordon Craig: A Bibliography* (Society for Theatre Research, 1967); Colin Franklin: *Fond of Printing; Gordon Craig as a Typographer and Illustrator* (San Francisco: Book Club of California, 1980); Janet Leeper: *Edward Gordon Craig* (Penguin Books, 1948); Haldane Macfall: "Concerning the Woodcuts of Gordon Craig", *Print Collector's Quarterly* 9, no. 4 (December 1922): 406-32; George Nash: *Edward Gordon Craig 1872-1966* (V & A Large Picture Book; HMSO, 1967); *Edward Gordon Craig and Hamlet: Towards a New Theatre* (Ottawa: National Gallery, 1975); L.M. Newman: "Artist and Printer: A Problem of the Cranach Press 'Hamlet' Resolved", *Matrix*, 4 (1984), pp.1-12; Enid Rose: *Gordon Craig and the Theatre* (Sampson Low, nd); Ellen Terry: *The Story of My Life* (Hutchinson, 1908); DNB; Garrett 1 & 2; Hodnett; Peppin; Waters.

Colour Plate 61

CRAIG, Helen **b.1934**

Born on 30 August 1934 in London, Helen Craig is a member of the immensely talented Craig family — grand-daughter of Edward Gordon Craig*, daughter of Edward Anthony Craig* and sister of John Craig*. She was educated at a village school in Essex during WW2, before going in 1943 to King Alfred's School, first in Hertfordshire and then in London. She had no full-time formal art training, although she attended life classes as a part-time student at the Central School (under Mervyn Peake*) and Hornsey School of Art. She was apprenticed to a commercial photographers in London (1950-56), and then ran her own photographic studio in Hampstead (1956-63), doing portraits of actors, writers and musicians, and some still-life and experimental work. Feeling in need of a change, she went to Spain with Till Norland, a painter, and lived there for three years, and started drawing and ceramic sculpture.

She returned to England with a small son in 1967, and worked at various jobs including being a photographer in a large advertising agency. During this period, she had commissions from Macmillan to illustrate three children's books. In 1975 she left London to live in a cottage in Buckinghamshire, continuing to work as a photo-

the arts, and started to produce, design and direct for the theatre, his first production being Henry Purcell's *Dido and Aeneas* in London in 1900. He left England in 1904 to produce in Germany and then went to Italy where he had a passionate affair with the dancer, Isadora Duncan. For most of his life after this he lived in Europe, directing plays and writing about the theatre.

As well as making a great contribution to the development of the theatre, Craig was also an important figure in the development of book illustration. Towards the end of the nineteenth century he had met The Beggarstaff Brothers, James Pryde and William Nicholson (see Houfe), who were doing simple but powerful woodcuts. Craig was inspired to start woodcutting himself, and produced some bold woodcut character studies, in a style very similar to that of Nicholson, of Irving and Ellen Terry; and he used the medium as a means of making copies of his production ideas available for his designers, actors and stagemanagers. He used cuts also for the production of posters and programmes. In addition he became obsessed with the idea of the book as a complete work of art — he considered all aspects of it important, including the paper, the page design and the binding.

Craig illustrated only a few books, the outstanding example of which is the Cranach Press *Hamlet*, produced by Count Harry Kessler in Germany in 1927. The illustrations created powerful and startling images, using solid black silhouetted figures with a few

John CRAIG "Heyford Common" from *The Locks of the Oxford Canal* (Whittington Press, 1984)

grapher, but also making pottery and working on a children's book project, the *Mouse ABC* concertina book. After studying etching at the Ruskin School in Oxford in 1976, her book project was accepted by Aurum Press, and by 1978 she was devoting all her time to book illustration. She works mostly for other writers, including several books for Katharine Holabird — their *Angelina Ballerina* (1983) won the Bluegrass Award in Kentucky, which is voted for by the children of that State, and in 1987 she travelled around the United States to promote the fifth "Angelina" book, *Angelina on Stage*. Her etchings for *The Yellow House* by Blake Morrison (1987) have been highly praised. A reviewer in the *Times Literary Supplement* declared that her illustrations "exemplify the mystery of the child's experience by using colour, not to decorate, but to heighten the expression, and by two different ways of depicting space. On the plates, Craig uses geometric perspective to give the illusion of reality. On the text pages she overlaps images, and by placing the girl in front of the framed words (which we perceive as lying on the picture plane) and placing the boy behind, she emphasizes his elusive otherness."

Craig is now a full-time illustrator, and she has written and illustrated some books for children, including a number of imaginative folding books. However, she took three months off in 1984 to work for an exhibition at the Camden Centre in 1985, and hopes to spend more time in future on etching and sculpture.

Books illustrated include: R. Nye: *Wishing Gold* (Macmillan, 1970); T. Lee: *Animal Castle* (Macmillan, 1972), *Princess Hynchatti* (Macmillan, 1972); K. Holabird: *Angelina Ballerina* (Aurum, 1983), *Angelina and the Princess* (Aurum Press, 1984), *Angelina Goes to the Fair* (Aurum Press, 1985), *Angelina's Christmas* (Aurum Press, 1985); M. Mahy: *Jam* (Dent, 1985); J.

Corbalis: *The Wrestling Princess and Other Stories* (Deutsch, 1986); S. Hayes: *This Is the Bear* (Walker Books, 1986); K. Holabird: *Angelina on Stage* (Aurum Press, 1986); N. Gray: *The One and Only Robin Hood* (Walker, 1987); K. Holabird: *Angelina and Alice* (Aurum, 1987); B. Morrison: *The Yellow House* (Walker, 1987); J. Corbalis: *Porcellus, the Flying Pig* (Cape, 1988); S. Hayes: *This Is the Bear and the Picnic Lunch* (Walker, 1988); K. Holabird: *Alexander and the Dragon* (Aurum, 1988), *Angelina's Birthday* (Aurum Books, 1989); S. Hayes: *Crumbling Castle* (Walker, 1989).

Books written and illustrated include: *ABC (Mouse House* (Aurum Press, 1978); *A Number of Mice* (Aurum, 1978); *123 (Mouse House)* (Aurum, 1980); *Months of the Year* (Aurum, 1981); *The Days of the Week* (Aurum, 1982); *The Mouse Birthday Book* (Aurum, 1982); *Susie and Alfred in The Knight, the Princess and the Dragon* (Walker, 1985); *Susie and Alfred in The Night of the Paper Bag Monsters* (Walker, 1985); *Susie and Alfred in A Busy Day in Town* (Walker, 1986); *Susie and Alfred in A Welcome for Annie* (Walker, 1986).

Exhib: Museum of Modern Art, Oxford (1983, 1984); Camden Arts Centre (1985); Royal Free Hospital, Hampstead (1985); Master Eagle Gallery, NY (1985, 1986).

Bibl: IFA.

Colour Plate 62

CRAIG, John Edward **b.1931**

Born on 15 August 1931 in London, John Craig is the son of Edward Anthony Craig*, and grandson of Edward Gordon Craig*; his sister is the illustrator of children's books, Helen Craig*. He was educated at a local village school in Essex and an independent

Colour Plate 58. *The Theatre at Work*, written and illustrated by James CLEAVER (Puffin Picture Book No. 75, 1947)

Colour Plate 59. René CLOKE Original drawing in pen and ink and watercolour. By permission of Chris Beetles Limited

Colour Plate 60. Beryl COOK Cover illustration for *A Breath of French Air* by H.E. Bates (Penguin Books 1983)

Colour Plate 61. Edward Gordon CRAIG Coloured wood engraving from cover of the Palace Theatre programme for April 23 1929 for a matinée in aid of the Ellen Terry Memorial

Colour Plate 62. Helen CRAIG Illustration from *The Yellow House*. Text © Blake Morrison 1987. Illustration © Helen Craig 1987 (Walker Books Limited 1987)

Colour Plate 63. Peter CROSS "Zzzzzz" Original drawing in pen and ink and watercolour Illustrated *Dudley* by J. Taylor (Walker Books 1986). By permission of Chris Beetles Limited

John CRAIG "Somerton Deep Lock" from *The Locks of the Oxford Canal* (Whittington Press, 1984)

school (King Alfred's) until he was fifteen years old. He started work in films as a junior draughtsman, and after National Service in the RAF as a topographical model maker, returned to films and theatrical design for theatres and ice shows. He has also worked in advertising, was a partner in an architectural practice, and is now a free-lance illustrator, bookbinder and "jack of all trades".

Although he has had no formal art school training, Craig is carrying on the family tradition of wood engraving. He had two lessons from his father, but otherwise is self-taught. He believes his work has been influenced by Gordon Craig*, Eric Ravilious*, John O'Connor* and James Dolby. His finely-cut engravings have all been commissioned work for books or bookplates; but his first book illustrations, for Gogol's *Overcoat*, were two-colour scraperboard drawings. Elected SWE.

Books illustrated include: Gogol: *The Overcoat* (Merlin Press, 1956); *E.G. Craig: The Last Eight Years 1958-1966* (Andoversford: Whittington Press, 1983).

Books written and illustrated include: *The Locks of the Oxford Canal* (Andoversford: Whittington Press, 1984).

Contrib: *Matrix*.

Exhib: SWE; Halifax House, Oxford (1987); Fiery Beacon Gallery, Painswick (1989).

Collns: Ashmolean.

Bibl: *Engraving Then and Now* (SWE, 1987?); IFA.

CRAIGIE, Dorothy M. **b.1908**

Born in London, Craigie was a theatre designer in London and Paris before 1941, since when she has written and illustrated her own stories, mostly for young children. She has also illustrated books by other writes, notably the children's stories by Graham Greene.

Books illustrated include: G. Greene: *The Little Train* (Parrish, 1946); M.E. Atkinson: *Chimney Cottage* (BH, 1947); G. Greene: *The Little Fire Engine* (Parrish, 1950); R. Ainsworth: *Rufty Tufty the Golliwog* (Heinemann, 1952); G. Greene: *The Little Horse Bus* (Parrish, 1952), *The Little Steamroller* (Hale, 1955); R. Ainsworth: *Rufty Tufty Goes Camping* (Heinemann, 1956), *Rufty Tufty Runs Away* (Heinemann, 1957).

Books written and illustrated include: *Summersalts Circus* (E & S, 1947); *The Little Balloon* (Parrish, 1953); *Akoo and the Crocodile Who Cried* (Parrish, 1954); *Akoo and the Sad Small Elephant* (Parrish, 1954); *The Little Parrot Who Thought He Was a Pirate* (Parrish, 1954); *The Saucy Cockle* (Parrish, 1955); *Captain Flint* series (Parrish, 1957-60); *Tim Hooley's Hero* (Parrish, 1957); *Tim Hooley's Haunting* (Parrish, 1958); *Nick and Nigger and the Pirate* (Parrish, 1960); *Nick and Nigger Join the Circus* (Parrish, 1960).

Contrib: *Sphere; Tatler*.

Bibl: ICB2; Peppin.

CRAXTON, John **b.1922**

Craxton was born on 3 October 1922 in St. John's Wood, London; his father was a distinguished musicologist, and his sister is renowned oboist Janet Craxton. He was educated at various private schools and studied at Central School of Arts and Crafts (1940),

John CRAXTON *Mani* by Patrick L. Fermor (John Murray, 1958)

Goldsmiths' College School of Art (1942), and Académie Julian in Paris. He is primarily a painter; his first one-artist show was held at the Leicester Galleries in 1944. He shared a home and studio with Lucien Freud*, and was much influenced by Graham Sutherland* and the Surrealists who shaped his interpretation of nature. His desire to create a timeless, mysterious space was a recurrent feature of the neo-romantics. He was an indefatigable traveller, first visiting Greece in 1946 and adopting Xania in Crete as his home for many years. "He is bright, supremely decorative, figurative, unambiguous and optimistic . . . By now he is an English painter only in the literal passport sense." (Yorke, 1988.†)

Though first a painter, he also designed sets and costumes for the Royal Ballet's productions of *Daphnis and Chloe* (1951) and *Apollo* (1966). He illustrated a few books and designed a number of book jackets. For Patrick Leigh Fermor's *Mani* (1958), he did a colour jacket and a black and white frontispiece. Much of Craxton's work, including his first major drawing, "Poet in a Landscape" (1941), and the lithographs and drawings he did for *The Poet's Eye* (one title in Muller's pronouncedly neo-romantic "New Excursions into English Poetry"), show how much he was influenced by Samuel Palmer.

Books illustrated include: G. Grigson: *The Poet's Eye: An Anthology Chosen by Geoffrey Grigson* (Muller, 1947); P.L. Fermor: *A Time to Keep Silence* (Queen Anne Press, 1953), *Mani: Travels in the Southern Peloponnese* (Murray, 1958).
Exhib: Leicester Galls; London Gallery; Whitechapel Art Gallery (retrospective 1967).
Collns: Tate; V & A; City Art Gallery; Bristol; Birmingham; Manchester; Christopher Hull Gallery.
Bibl: Rigby Graham: *Romantic Book Illustration in England 1943-55* (Pinner: Private Libraries Association, 1965); Geoffrey Grigson: *John Craxton* (Horizon, 1948); David Mellor: *A Paradise Lost: The Neo-Romantic Imagination in Britain 1935-55* (Lund Humphries/Barbican Art Gallery, 1987); Malcolm Yorke: *The Spirit of Place: Nine Neo-Romantic Artists and Their Times* (Viking, 1988); Tate; Waters; Who.

CROCKER, Barbara
See WHELPTON, Barbara Fanny

CROMBIE, Charles E. **fl. 1904-1932**
See Houfe
Books illustrated include: J.H.L. Sherratt: *The Goblin Gobblers* (Warne, 1910); W.M. Thackeray: *Vanity Fair* (Dent, 1924); Allan: *The Canny Scot* (Valentine, 1932).
Books written and illustrated include: *Laws of Cricket* (Kegan Paul, 1906); *Motoritis* (Simpkin Marshall, 1906); *Simple Simon and His Friends* (Greening, 1906).

CROSBIE, William **b.1911**
Born in China, Crosbie studied at Glasgow School of Art and in Rome and Paris. He was primarily a painter of portraits, flowers and birds. ARSA.
Books illustrated include: S. Maclean: *Dain do Eimhir* (Glasgow: McLellan, 1943).
Exhib: RSA; GI.
Colln: Glasgow Art Gallery.
Bibl: Waters.

CROSS, Peter **b.1951**
Born in Guildford, Cross was educated at Parkside, East Horsley, and at Ewell Castle. While working as a trainee draughtsman for Hawker Siddeley, Cross qualified as a botanical artist. He began to illustrate children's books, and in 1986 illustrated a series of books about Dudley, a dormouse, which have become bestsellers. His illustrations show his sense of fantasy and a quirky humour, and this is also present in his eccentric cabinets and his advertising work. He has recently produced two books of more interest to adults, the artwork for which was exhibited at the Beetles Gallery. Some of these illustrations, particularly the endpapers, show contraptions very similar to those drawn by William Heath Robinson*.
Books illustrated include: P. Dallas-Smith: *Trouble for Trumpets* (Benn, 1982), *Trumpet in Trumpetland* (Black, 1984); D. Lloyd: *Breakfast* (Walker, 1985), *Early Morning* (Walker, 1985) and two

other in "Dinosaur Days" series; J. Taylor: *Dudley* (Walker, 1986), *Dudley Bakes a Cake* (Walker, 1988) and at least four other titles in series.
Books written and illustrated include: *1588 and All This* (Pavilion, 1988); *The Boys' Own Battle of Britain* (Pavilion, 1989).
Exhib: Beetles (1988, 1990).
Bibl: *The Illustrators: The British Art of Illustration: Catalogue* (Chris Beetles, 1987, 1991).
Colour Plate 63

CROW, Barbara Joan **b.1942**
Born on 20 January 1942 in Liverpool, Crow (née Warmsley) was educated at the Merchant Taylors' School for Girls, Liverpool, and studied at the Slade (1959-62) under Sir William Coldstream. She later did post-graduate printmaking at Bristol Polytechnic (1982-84), and gained an MA in Visual Arts from the University of Wales at Aberystwyth (1984-47). She worked as a teacher in primary and secondary schools, and is currently lecturing part-time in the Art Education Department of Gwent College of Higher Education. She writes that her own art work "has been a steady trickle — originally painting, then using textiles, but not engraving until 1984." She now does some book illustration and produces limited editions of prints. The artists who have been a source of inspiration to her include William Blake, Eric Gill*, Stanley Spencer*, Eduard Munch, and David Jones*. She was elected SWE.
Books written and illustrated include: *The Acrobatic Alphabet* (Andoversford: Whittington Press, 1986); W. Shakespeare: *Macbeth; The Two Noble Kinsmen* (Folio Society, 1988); *The Young Dragon Book of Verse* (with others; OUP, 1988).
Exhib: RWA; RCA; SWE; Catherine Lewis Gallery, Aberystwyth (1986); Wenninger Gallery, Boston (1987).
Bibl: Who; IFA.

CROWE, Jocelyn **b.1906**
Born in Yelverton, South Devon, Crowe was educated at Wycombe Abbey School and Leeds University. She studied at the Central School of Arts and Crafts, under Noel Rooke*. Growing up near Dartmoor, she loved to draw the local ponies around the house. Rooke fostered her already keen interest in illustration, and under his influence she "developed the theories on which [her] work is based, that is, that an illustration should be an integral part of book production, enhancing the printed page, not just a pretty picture stuck between leaves." (ICB.) *The Painted Princess* was an experiment in what could be done with line-blocks alone.
Books illustrated include: M. Boyd: *The Painted Princess* (Constable, 1936); W. de la Mare: *Peacock Pie* (Constable, 1936).
Bibl: ICB.

CRUM, Paul
See PETTIWARD, Roger

CULLEN, Gordon **b.1914**
Born in Bradford, Cullen is the son of a Scottish minister (his mother was a native of the Shetland Isles). In 1931 his father's ministry took him to London, and Cullen was sent to the Central School of Arts and Crafts. However, he was advised to study architecture as a more financially secure field, and was accepted at the School of Architecture, Regent Street Polytechnic (1930-32). He worked as an architectural assistant (1933-36), before going into private practice (1936-40) as an architectural illustrator and exhibition designer. After WW2, he was an architect and planner for the Colonial Office in Barbados; and from 1946 to 1956 was assistant editor, writer and draughtsman on the *Architectural Review*. He returned to private practice in 1959, and worked on many town planning projects including the replanning of the city of New Delhi, and the townscapes of Liverpool, Peterborough and Telford.

Cullen is primarily an architect and town planner, but his architectural drawings just as much as his delicate drawings of plants, paintings and sketches, full-scale murals, and illustrations for book jackets, are all works of art. He draws with a fine, continuous line in ink, pencil and pastel, and uses soft, clear colours to tint the drawings. His illustrations are often reproduced by the letterpress line-block process, and he sometimes does his own colour separa-

Colour Plate 64. Anne DALTON "Then one evening the old man looked out of the window and there in the sky was their star" Original drawing in pen and ink, watercolour and body colour Illustrated *Prince Star* (Kaye & Ward Ltd. 1985). By permission of Chris Beetles Limited

Colour Plate 65. Elinor DARWIN *Mr Tootleoo and Co.* by Bernard Darwin (Faber & Faber 1935)

Colour Plate 66. Andrew DAVIDSON *The Iron Man* by Ted Hughes (Faber & Faber 1985)

Gordon CULLEN Design for a new pub on the City riverfront from *The City of London* (Architectural Press, 1951)

tions, remaining virtually in full control of his work until it is handed over to the machine-minder.
He was elected Hon. FRIBA (1970); awarded CBE (1976); RDI (1977).
Books illustrated include: M. Gorham: *Inside the Pub* (Architectural Press, 1950); *The City of London: A Record of Destruction and Survival* (Architectural Press, 1951); I. Nairn: *Outrage* (Architectural Press, 1955); J. Charlton: *Chiswick House* (HMSO, 1958).
Books written and illustrated include: *Townscape* (Architectural Press, 1961).
Contrib: *Architectural Review; Compleat Imbiber; Penrose Annual 44.*
Exhib: RA; Paris Salon; Building Centre.
Bibl: Gordon Cullen: "Colour Line", *Penrose Annual* 44 (1950): 57; Raymond Philip: "The Architectural Drawings of Gordon Cullen", *Image* no. 8 (Summer 1952): 31-47; IFA.

CUMMINGS, Michael **b.1919**
Born in Leeds, Cummings was educated at The Hall, Hampstead, and Gresham's School in Holt, Norfolk. He studied at Chelsea School of Art for three years, though his studies were interrupted by WW2. He became a cartoonist, and though he subsequently worked for primarily Conservative papers, his first cartoons were

done for the *Tribune*, and he later contributed drawings for the paper's book pages.
Cummings' father was the political editor of the *News Chronicle*, and he suggested that his son try for a job as a political cartoonist with Lord Beaverbrook. He started work for the *Daily Express* in 1948 and has worked for the *Express* papers ever since, drawing with a heavy black line.
Contrib: *L'Aurore; Daily Express; Paris Match; Punch; Sunday Express; Tribune.*
Collns: University of Kent.
Bibl: *Beaverbrook's England 1940-1965: An Exhibition of Cartoon Originals . . .* (Centre for the Study of Cartoons and Caricature, University of Kent, 1981); *Getting Them in Line: An Exhibition* (Centre for the Study of Cartoons and Caricature, University of Kent, 1975); Bateman; Feaver; Price.

CUNEO, Nell Marion
See TENISON, Nell Marion

CUNEO, Terence Tenison **b.1907**
Born on 1 November 1907, in Shepherd's Bush, London, Cuneo is the son of Cyrus Cuneo (see Houfe) and Nell Tenison*. He was educated at various preparatory schools and then at Sutton Valence School in Kent, and studied at Chelsea School of Art and the Slade. During the 1920s and 1930s he contributed to children's annuals and to many magazines, especially *Wide World Magazine* and *Illustrated London News*, and illustrated several books. During WW2 he was special artist to *ILN* and, like his father, did some remarkably graphic war illustrations.
By the late 1940s Cuneo's work as an illustrator had virtually ended. He produced posters for each region of British Rail and did commercial work for several companies. He became a highly successful painter, especially of such ceremonial occasions as the Coronation (1953) and the consecration of the new Coventry Cathedral (1962). He was renowned for his paintings of military and engineering subjects, especially steam locomotives, but he also did many official portraits, paintings of wild animals in Africa, and fantasy paintings of anthropomorphised mice. His first one-artist show was at the Grand Central Art Gallery, New York (1956), and others were held at RWS and the Sladmore Gallery.
Books illustrated include: H. Strang: *On London's River* (OUP, 1929); Scott: *The Treasure Trail* (1931); P.F. Westerman: *Tales of the Sea* (Tuck, 1934); M. England: *Warne's Happy Book for Girls* (with others; Warne, c.1938); P.F. Westerman: *Alan Carr in Command* (Blackie, 1944), *Secret Convoy* (Blackie, 1944), *Squadron Leader* (Blackie, 1946); *The Blue Book for Boys* (Hodder, nd).
Books written and illustrated include: *Sheer Nerve* (Warne, 1939); *Tanks and How to Draw Them* (Studio, 1943).
Contrib: *Autocar; Blackie's Annual; BOP; Champion Annual; Christian Herald; Chums; Good Housekeeping; ILN; Little Folks; Magnet; Motor; Nash's Magazine; Oxford Annual; Picture Post; Strand; Tuck's Annual; War Weekly; Wide World Magazine; Windsor Magazine.*
Exhib: RA; ROI; RP; RWS; Sladmore Gallery; in New York and Paris.
Published: *Tanks and How To Draw Them* (Studio).
Collns: IWM.
Bibl: Terence Cuneo: *The Mouse and His Master* (New Cavendish Books, 1977); Doyle BWI; Peppin; Titley; Waters; Who.

CURTIS, Cécile **fl. 1964-**
An American-born artist, naturalised British, who works mostly in scraperboard. Her illustrations for *Woody's Wonderful World* (1964) and *He Looks This Way* (1965) have been highly praised as animal art.
Books illustrated include: R. Curtis: *East End Passport* (Macdonald, 1969), *Thames Passport* (Macdonald, 1970).
Books written and illustrated include: *Samantha and the Swan* (Hodder, 1964); *Woody's Wonderful World* (Hodder, 1964); *He Looks This Way* (Warne, 1965); *Panda* (Warne, 1976).
Published: *The Art of Scraperboard Engraving* (Batsford, 1988).

D'ACHILLE, Gino fl. 1974-

D'Achille did black and white illustrations for each chapter heading and a coloured book jacket for *Ludo and the Star Horse*.

Books illustrated include: M. Stewart: *Ludo and the Star Horse* (Brockhampton, 1974); J. Verne: *20,000 Leagues Under the Sea* (NY: Random House, 1983); D. Kossoff: *Bible Stories* (Collins, 1984).

DADD, Frank 1851-1929
See Houfe

Eric Fitch DAGLISH "The Red Deer" from *Animals in Black and White: vol.1 The Larger Beasts* (J.M. Dent, 1928)

DAGLISH, Eric Fitch 1894-1966

Born on 29 August 1894 in London, Daglish studied at Hereford County College and received a scientific education at universities in London and Bonn. He served in the army in France during WW1 and from 1918 to 1922 was an army education officer; he was in the RAF during WW2 (1940-48). He became a professional naturalist, lecturing on zoology at Toynbee Hall, and was President of the Natural History Society there (1924-26). He soon left London and retired to the country, living as a field naturalist, writing and engraving, painting in watercolour, and giving nature talks for the BBC.

He became a friend of Paul Nash* in 1919 and learned wood engraving from him. Daglish exhibited three wood engravings in the opening exhibition of the Society of Wood Engravers (1920) and in 1922 both artists were invited to become members of the Society. Daglish was a fine draughtsman and engraver, and illustrated many books on natural history (mostly of birds and animals). Usually the illustrations were done by wood engraving (though he occasionally used pen and ink) and his engravings are accurate and decorative renderings of his subject though they often lack the artistic interpretation of more imaginative illustrators. He wrote and illustrated a number of books for children, the most successful as an illustrator perhaps being the *Animals in Black and White* series which contains effective solid black engravings with a few white-line details. The *Daily News*, reviewing this series, stated that "Mr. Daglish has quickly established himself as the Bewick of our times, with his exquisite woodcuts of birds and fishes and wild life. He has done nothing more charming than his series of six animal books. Such delicate craftsmanship, of both pen and the engraver's knife, is wholly delightful." He also illustrated some of the classics of English literature. FZS.

Books illustrated include: J.H.C. Fabre: *Animal Life in Field and Garden* (Butterworth, 1926); E.M. Nicholson: *Birds in England* (C & H, 1926); H.D. Thoreau: *Walden* (C & H, 1927); I. Walton: *The Compleat Angler* (Butterworth, 1927); D. Dewar: *Game Birds* (C & H, 1928); G. White: *The Natural History of Selborne* (Butterworth, 1929); Lord Falloden: *Fly Fishing* (Dent, 1930); W.H. Hudson: *Far Away and Long Ago* (Dent, 1931); H.T. Massingham: *Birds of the Sea-Shore* (1931); E. Thomas: *The South Country* (Dent, 1932), *The Heart of England* (Dent, 1932); I. Turgenev: *A Sportsman's Sketches* (Dent, 1932); H. Thoreau: *A Week on the Concord and Merrimac Rivers* (Dent, 1932); W. Cobbett: *Rural Rides* (Dent, 1932); W.H. Hudson: *Nature in Downland, and An Old Thorn* (Dent, 1933).

Books written and illustrated include: *Marvels in Plant Life* (Butterworth, 1924); *Woodcuts of British Birds* (Benn, 1925); *The Book of Garden Animals* (C & H, 1928); *Animals in Black and White* (six vols., Dent, 1928-9); *Life Story of Birds* (Dent, 1930); *Life Story of Beasts* (Dent, 1931); *A Nature Calendar* (Dent, 1932); *The Children's Nature Series* (six vols., Dent, 1932-34); *The Dog Owner's Guide* (Dent, 1933); *The Junior Bird Watcher* (Routledge, 1936); *The Book of the Dachshund* (Manchester: Our Dogs, 1937); *Birds of the British Isles* (Dent, 1948); *The Dog Breeder's Manual* (Dent, 1951); *Enjoying the Country* (Faber, 1952); *The Seaside*

Eric Fitch DAGLISH "A Rookery in March" from *A Nature Calendar* (J.M. Dent, 1932)

Claire DALBY *Even the Flowers* by Freda Downie (Gruffyground Press, 1989)

Nature Book (Dent, 1954); *The Pet-Keeper's Manual* (Dent, 1958); *The Beagle* (1961); *Dog Breeding* (Foyle, 1961); *The Basset Hound* (Foyle, 1964).
Contrib: *Form; Saturday Book 12; The Woodcut.*
Exhib: SWE; NEAC.
Collns: V & A; BM; and many other public collections.
Bibl: Douglas Percy Bliss: "The Wood-Engravings of Eric Fitch Daglish", *Print Collector's Quarterly* 17: 279-98; Deane; Garrett 1; ICB; ICB2; Peppin; Waters.

DALBY, Clarence Reginald b.1904
Born in Leicester, Dalby studied at Leicester College of Art (1917-21), and soon became a free-lance artist. He served in the RAF during WW2, and returned to illustration after the war. He was the first illustrator of the popular series of books for young children by the Reverend Wilbert Awdry, on Thomas the Tank Engine and other locomotives (which started as stories told to his three-year old son while suffering from measles). The last books in the series were illustrated by Peter Edwards*.
Books illustrated include (all published by Ward): W. Awdry: *The Three Railway Engines* (1945), *Thomas the Tank Engine* (1946), *James the Red Engine* (1948), *Tank Engine Thomas Again* (1949), *Troublesome Engines* (1950), *Henry the Green Engine* (1951), *Toby the Tram Engine* (1952), *Gordon the Big Engine* (1953), *Edward the Blue Engine* (1954), *Four Little Engines* (1955), *Percy the Small Engine* (1956).
Books written and illustrated include: *Tales of Flitterwick Harbour* (Ward, 1955).
Bibl: Carpenter; Peppin.

DALBY, [Joy] Claire [Allison] b.1944
Born in St. Andrews, Dalby was educated at Haberdashers' Aske's School, Acton (1955-63), and studied at the City and Guilds School (1964-67), where she specialized in engraving and lettering. She is a watercolour painter, wood engraver, calligrapher, and illustrator of mostly botanical subjects. Her published work includes black and white and colour illustrations for *The Observer's Book of Lichens* and two wall charts on that subject for the British Museum (Natural History). She has also engraved a frontispiece for Freda Downie's *Even the Flowers*. She confesses to being influenced by Joan Hassall* and Thomas Bewick as a wood engraver, and by past and present members of the Royal Society of Painters in Water-colour as a watercolourist. She was elected ARWS (1973); RWS (1977); ARE (1978); RE (1982); SWE.
Books illustrated include: K.L. Alvin: *The Observer's Book of Lichens* (Warne, 1977); H. Angel and P. Wolseley: *The Family Water Naturalist* (Joseph, 1982); F. Downie: *Even the Flowers* (Gruffyground Press, 1989).
Exhib: SWE; RA; RWS; RE; Clarges Gallery (1968; 1972; 1977); one-artist shows at Consort Gallery, Imperial College (1981, 1988), BM (NH) (1982), Shetland Museum, Lerwick (1988).
Collns: BM (NH); V & A; National Library of Wales; Science Museum; Shetland Museum.
Bibl: *Claire Dalby's Picture Book* (Kettering: Carr, 1989); Brett; Jaffé; Who; IFA.

DALTON, Anne b.1948
Born on 5 December 1948 in London, Dalton studied at Camberwell School of Art and Hornsey College of Art. After her marriage

in 1974, she has combined illustrating mainly children's books with working as a part-time teacher at a school in South London. She normally uses line or very detailed watercolour; for *The King's Toothache* (1987), she produced coloured crayon drawings which have some similarity to Sendak's work. *Tournaments* (1978) by Richard Barber won the Times Education Award.

Books illustrated include: P. Lively: *Boy Without a Name* (Heinemann, 1975); J. Reeves: *The Shadow of the Hawk* (Collins, 1975); H. Seton: *The Stonemason's Boy* (Heinemann, 1975); R. Barber: *Tournaments* (Kestrel, 1978); M. Baring: *The Blue Rose* (Kaye, 1982); C. West: *The King of Kennelwick Castle* (Walker, 1986), *The King's Toothache* (Walker, 1987).

Books written and illustrated include: *Prince Star* (Kaye, 1985).

Bibl: *The Illustrators: The British Art of Illustration 1800-1987* (Chris Beetles Ltd., 1987); ICB4; Peppin.

Colour Plate 64

Biddy DARLOW *The Year Returns* by Elizabeth Hamilton (Michael Joseph, 1952)

DARLOW, Biddy **b.1910**

Born in Maidenhead, Darlow studied at RCA, Académie Ranson in Paris, Chelsea School of Art and the City and Guilds School of Art. A painter, printmaker and book illustrator, she has taught at the Ruskin School of Drawing, Oxford, at Dartington Hall, and at Bath Academy. Cave notes that *Fifteen Old Nursery Rhymes*, illustrated with hand-coloured linocuts, was selected as one of the "Fifty books of the year in 1935."

Books illustrated include: E. Hamilton: *The Year Returns* (Joseph, 1952).

Books written and illustrated include: *Fifteen Old Nursery Rhymes* (Perpetua Press, 1935); *Shakespeare's Lady of the Sonnets* (Oxford: Haslam, 1974).

Bibl: Cave; Peppin.

DARWIN, Elinor May Monsell **d.1954**

Born in County Limerick, Ireland, Darwin was educated at home and at University College, London. In 1906 she married Bernard Darwin, grandson of Charles Darwin, and taught her sister-in-law, Gwendolen Darwin (later Raverat*), the rudiments of wood engraving. She made woodcuts, painted portraits of children and illustrated children's books, for which she made line drawings, using wood engravings only on her first book. The "Tootleoo" books, written by her husband, are illustrated with simple, childlike drawings which work very well with the stories. *Mr Tootleoo and Co.* was printed by the Curwen Press, and the coloured pictures are thus beautifully reproduced. She reported being influenced by the drawings of Charles Keene in *Punch* and by Randolph Caldecott's children's books. The covers of the publications of the Irish Literary Society were designed by her.

Books illustrated include: A.M.C. Smith: *Tom Tug and Others* (1898); W. de la Mare: *The Three Mullar Mulgars* (1910); B. Darwin: *The Tale of Mr. Tootleoo* (Nonesuch Press, 1925), *Tootleoo Two* (Nonesuch Press, 1927); E. Eckersley: *Stories Barry Told Me* (Longman, 1927); B. Darwin: *Mr. Tootleoo and Co.* (Faber, 1935), *Oboli, Boboli and Little Joboli* (Country Life, 1938), *Ishybushy and Topknot* (Country Life, 1946); R.E. Ingpen: *Nursery Rhymes for Certain Times* (Faber, 1946); B. Darwin: *Every Idle Dream* (1948).

Bibl: ICB; ICB2; Peppin (under "Monsell").

Colour Plate 65

DAVIDSON, Andrew **b.1958**

Davidson studied at the RCA, where he was introduced to wood engraving by Fred Dubery, Yvonne Skargon* and John Lawrence*. After graduating in Graphic Design in 1982, he became a free-lance illustrator, working on commercial packaging and large scale advertising campaigns, as well as contributing to the *Sunday Times*. He won the 1985 Emil/Kurt Maschler Award for an illustrated children's book for Ted Hughes' *The Iron Man*, reissued in 1985 by Faber (first illustrated by George Adamson* in 1968). Davidson's wood engravings "match the strength, energy and pathos of the text quite startlingly, and ensure that *The Iron Man* will continue to be recognized as a children's classic that challenges us all." (A judge's comment reported in *Bookseller*, November 1985.) Elected SWE.

Books illustrated include: T. Hughes: *The Iron Man* (Faber, 1985), *Tales of the Early World* (Faber, 1988).

Books written and illustrated include: *From the Sea to the Land* (Lion & Unicorn Press, 1982).

Bibl: Brett.

Colour Plate 66

DAVIDSON, Ulla R.B. **fl. 1940-1957**

Using the pseudonym "Victoria", Davidson contributed humorous drawings to a number of magazines including *Lilliput* in the '40s and '50s, using ink to produce a silhouette impression. She illustrated at least one book, and also produced commercial drawings for advertising for companies such as Guinness. MSIA.

Books illustrated include: J. Pudney: *The Book of Leisure* (with others, Odhams, 1957).

Contrib: *Leader; Lilliput; Neue Auslese; Sketch*.

Bibl: Brian Sibley: *The Book of Guinness Advertising* (Guinness Superlatives, 1985).

Gulliver Tackles a Fence

U. DAVIDSON ("VICTORIA") Decoration in *Lilliput* (October 1949)

DAVIE, Howard **fl.1914-1935**
Biographical information does not appear to be available about this artist who worked for the publisher, Raphael Tuck, producing colour plates and black and white drawings.
Books illustrated include: E. Nesbit and D. Ashley: *Children's Stories from English History* (with others, Tuck, 1914); L. Romano: *Children's Stories from Italian Fairy Tales and Legends* (Tuck, 1921); R.Y. Woolf: *The Seven Champions of Christendom* (Tuck, 1921); C. Kingsley: *The Heroes of Greek Fairy Tales* (Tuck, 1924); A. Miles: *Brave Deeds by Brave Men* (Tuck, 1935).
Bibl: Peppin.

DAVIS, Brian
See "FFOLKES", Michael

DAVIS, Jon **b.1928**
Born on 14 April 1928, Davis spent several years in the Merchant Navy before studying at Walthamstow College of Art and Dagenham School of Graphic Illustration. He began his artistic career by contributing romantic illustrations to women's magazines, before concentrating on illustrations for children. He has worked as a strip cartoonist, and is the latest illustrator of "Rupert".
Bibl: *The Illustrators: Catalogue* (Chris Beetles Ltd., 1991).

DAWSON, Gladys **b.1909**
Born at Castleton, Rochdale, Dawson was educated at private schools, and studied at Heatherley's (1936-39). A painter in oils, watercolour and pastel, she was also a writer and illustrator of children's books, and contributed illustrations to magazines. She was President of the Society of Women Artists (1982-85); and was elected ARCamA (1943); RCamA (1946); ASWA (1953); SWA (1955); FRSA (1952).
Exhib: RI; RCamA; SWA; RWA; RCA.
Collns: Birkenhead; Anglesey.
Bibl: Waters; Who.

DAWSON, Muriel **fl.1920-1962**
Dawson studied at RCA, and became a painter of figure studies in watercolour. She also illustrated children's books.
Books illustrated include: C. Kingsley: *The Water Babies* (Black, 1920); A. Latham: *Wonderful Days* (Palmer, 1929); *The Rose Fyleman Birthday Book* (with Margaret Tarrant*; Medici Society, 1932).
Books written and illustrated include: *My Book of Nursery Rhymes* (Tuck, 1944); *Another Lovely Book of Nursery Rhymes* (Tuck, 1945); *Happy Days* (1945); *The Childhood of Jesus* (with Clare Dawson; Medici Society, 1962).
Bibl: Peppin; Waters.

DEAKINS, Cyril Edward **b.1916**
Born on 5 October 1916 at Bearwood, Birmingham, Deakins was educated at Christ's College, Finchley, and studied art at Hornsey School of Art under Norman Janes*. He is a landscape painter in oil, tempera and watercolour; and an etcher, wood engraver and book illustrator. He has worked mainly in East Anglia, and now lives in Great Dunmow, Essex. Elected ARE (1948).
Books illustrated include: J.R. Milsome: *Olaudah Equiano* (with Sylvia Deakins, Longman, 1969); P. Moore: *The A-Z of Astronomy* (Fontana, 1976).
Exhib: RA; RE; NEAC; RBA; RI.
Bibl: Mackenzie; Waters; Who.

DE BOSSCHÈRE, Jean **1878-1953**
De Bosschère was born in Uccle, Belgium, the son of a botanist, but little is known of his early years. He had worked in Brussels and Paris as a writer and artist, and in 1909 he achieved a Continental reputation as a poet, novelist and painter with the publication in Paris of his first book, *Béâle-Gryne*, which he had illustrated with his own "images" which is how he liked to refer to his illustrations. In 1915 he sought asylum in England and, needing to earn a living, taught French and Latin at a school in Greenwich. He was soon moving in artistic avant-garde circles, counting T.S. Eliot and Ezra Pound among his friends. He returned to the Continent probably in 1920 and lived in Italy and then France,

becoming a French citizen in 1951.
As an artist, De Bosschère believed that the role of writer and illustrator should be indissolubly welded together, the text and the illustrations forming a complete whole, one being complementary to the other. He felt this could only be achieved when woodcuts or line blocks were used. He began to illustrate the works of others while he lived in England, but he found this generally unsatisfactory. In the introduction to Putnam's *The World of Jean de Bosschère* (1932), he wrote "I never wrote or published a book of my own which did not contain both text and images. I say 'images' and not illustrations for the reason that the latter would seem to give a secondary place to my drawings, whereas the text and the drawings have exactly the same weight of expression...But what I did never amounted to anything more than gratuitous solitary experiments. . . One of my experiments had unhappy consequences; that is, when commercialized publishers began to exploit my aptitude for drawings. The result was a series of books from the classics illustrated by means of mechanical reproduction. . . I would ask to be judged by those of my books which contain images, and by those to which I have added woodcuts and etchings. It would be unjust to judge me by books which have been sold commercially at difficult times of my life."
The illustrations to his own writings are sometimes abstract, containing echoes of symbolism, Dadaism and surrealism. Most of his illustrations for the books by other writers were done in black and white, and with his occasional delight in the macabre and Satanism it is natural that his name should often be linked with that of Aubrey Beardsley. De Bosschère's work is, however, more lively and full of Rabelaisian fun rather than decadent. Early in his career, he had design objection to colour illustrations unless framed as in a mediaeval manuscript, but later he abandoned this concept and produced some delightful colour pictures. He thought that he had been most successful with *Job le Pauvre* (1923), where the line blocks were printed on coloured paper scattered throughout the book.
Books illustrated include: *Christmas Tales of Flanders* (Heinemann, 1917); J. Swift: *Gulliver's Travels* (Heinemann, 1920); M. de Cervantes: *The History of Don Quixote de la Mancha* (Constable, 1922); E. and J. Anthony: *The Fairies Up-to-Date* (Butterworth, 1925); M. Sinclair: *Uncanny Stories* (Hutchinson, 1923); *The Golden Asse of Lucius Apuleius* (BH, 1923); G. Flaubert: *The First Temptation of Saint Anthony* (BH, 1924); *The Love Books of Ovid* (BH, 1925); H. de Balzac: *Ten Droll Tales* (BH, 1926); O. Wilde: *Poems* (NY: Boni & Liveright, 1927); C. Baudelaire: *Little Poems in Prose* (Paris: Titus, 1928); Aristophanes: *Plays* (two vols., NY: Boni & Liveright, 1928); H. de Balzac: *Droll Tales: The Second Decade* (NY: Covici, Friede, 1929); G. Boccaccio: *Decameron* (two vols., NY: Putnam's, 1930); *Strato's Boyish Muse* (Fortune Press, 1932); Plato: *Symposium* (Fortune Press, 1932); P. Louys: *The Songs of Bilitis* (Fortune Press, 1933); Petronius: *The Satyricon* (Fortune Press, 1933?); W.B. Pickard: *The Adventures of Alcassim* (Cape, 1936); M. Aymé: *The Green Mare* (Fortune Press, 1938).
Books written and illustrated include: *Béâle-Gryne* (Paris: L'Occident, 1909;) *Dolorines et les Ombres* (Paris: L'Occident, 1911); *Métiers Divins* (Paris: L'Occident, 1911); *Twelve Occupations* (Elkin Mathews, 1916); *The Closed Door* (BH, 1917); *Beasts and Men* (Heinemann, 1918); *The City Curious* (Heinemann, 1920); *Weird Islands* (C & H, 1921); *Job le Pauvre* (BH, 1923); *Marthe and the Madman* (NY: Covici, Friede, 1928); *The House of Forsaken Hope* (Fortune Press, 1942).
Contrib: *Little Review; Monthly Chapbook; New Coterie; Reveille.*
Bibl: Samuel Putnam: *The World of Jean de Bosschère* (Fortune Press, 1932); William Ridler: "Jean de Bosschère: A Brief Appraisal and a Check-List of Books in English with His Illustrations", *Private Library* 4, no. 3 (Autumn 1971): 103-112; May Sinclair: "Introduction" to J. de Bosschère: *The Closed Door* (Bodley Head, 1917); Peppin.

D'EGVILLE, Alan Hervey **1891-1951**
Born on 21 May 1891, D'Egville was educated at Berkhamsted, and in France, Germany and Spain. He served in the army during WW1 and then studied at St. John's Wood Art School. He started drawing political caricatures for the *Bystander* and later contributed

to other magazines. He worked for two years in the US. He died 15 May 1951.

Books illustrated include: D. Rooke: *Call Me Mister* (Heinemann, 1946), *A Touch of the Sun* (Heinemann, 1947), *Rude Health* (Heinemann, 1948), *Let's Be Broad-Minded* (Blakes Norfolk Broads Holidays, 1964).

Books written and illustrated include: *Modern Skiing* (Arnold, 1927); *Slalom* (Arnold, 1934); *Darts with the Lid Off* (Cassell, 1938); *The Game of Ski-ing* (Arnold, 1938); *Calling All Fly-Fishers* (Cassell, 1946); *Money for Jam; or, How To Be a Magnate* (Cassell, 1947); *Calling All Coarse-Fishers* (Cassell, 1949); *Calling All Sea-Fishers* (Cassell, 1950).

Contrib: *Bystander*.

Bibl: Waters.

Len DEIGHTON *My Husband Cartwright* by Olivia Manning (William Heinemann, 1956)

DEIGHTON, Leonard Cyril **b.1929**

Born on 18 February 1929 in Marylebone, London, Deighton studied at St. Martin's School of Art and the RCA. His art work includes a cookery strip for the *Observer*, the cover for at least one issue of the College magazine, *Ark*, a poster for London Transport ("Village Life", 1957), and some book jackets, including those for R.P. Lister's *The Idle Demon* (1958) and for *Fred Bason's Third Diary* (1955). He illustrated Olivia Manning's *My Husband Cartwright* with some thirty-five competently made ink drawings, and designed the boards and the jacket.

Although he was earning a good living, working in a variety of jobs including that of a flight attendant for British Overseas Airways Corporation, a pastry cook and a waiter, as well being an illustrator, he turned to writing novels — *The Ipcress File* (1962) was the first. His espionage novels have become incredibly successful, some having been transformed into films and television serials. He said in an interview that he "wasn't completely happy as an illustrator...In some ways there is more satisfaction to be gained from completing a picture than from writing a book. But some of the people you have to work for make life extremely depressing...when you're a commercial artist, almost all of your instructions come from people who are unable to draw." (Milward-Oliver.†)

Books illustrated include: O. Manning: *My Husband Cartwright* (Heinemann, 1956).

Books written and illustrated include: *Len Deighton's Cookstrip Cook Book* (Bernard Geis, 1966).

Contrib: *Observer*.

Bibl: Christopher Frayling: *The Royal College of Art; One Hundred and Fifty Years of Art and Design* (Barrie & Jenkins, 1987); E. Milward-Oliver: *The Len Deighton Companion* (Grafton Books, 1987); CA.

DE LA BERE, Stephen Baghot **1877-1927**
See Houfe

Born in Leicestershire, De La Bere studied art in Leicester and then attended Westminster School of Art. He illustrated some books, but worked mostly for magazines.

Contrib: Bystander; ILN.

Bibl: *The Illustrators: Catalogue* (Chris Beetles Ltd., 1991)

DE LACEY, Charles John **fl.1885-1925**
See Houfe

DENVIR, Catherine **b.1953**

Born in Bethersden, Kent, Denvir was educated at Foundation Kingsdale Comprehensive School, South London, and studied at Chelsea School of Art for three years. She is a young artist with a most distinctive, angular style, who has done advertising work, including a poster for London Transport, and contributed a number of covers to magazines, including one for *Listener* (February 1985) and for the *Bookseller* (September 1987). She has also illustrated various book jackets and paperback covers, including the cover for a Faber paperback, *The Way-Paver* by Anne Devlin and *All About H. Hatter* by G.V. Desani for Penguin.

Contrib: *Bookseller; GQ; Harpers; Honey; Listener; Mademoiselle; New Scientist; Queen; Sunday Times; Vogue*.

Exhib: Association of Illustrators; Cooper Hewitt Museum, NY; elsewhere in Britain, France, USA.

Bibl: IFA.

Colour Plate 67

DENVIR, Joan **b.1925**

Joan Denvir was born in India and came to England in 1939. She studied at the Slade in 1943, then was evacuated to Oxford where she continued her studies under Randolph Schwabe*, Barnett Freedman*, Albert Rutherston* and Vladimir Polunin. Her drawings have been published in a number of journals, including the *Sunday Times* and *The Observer*. She has also worked for Associated-Rediffusion.

Contrib: *Daily Telegraph; Observer; Sunday Times; Times Educational Supplement*.

Bibl: Ryder.

DERRICK, Thomas C. **1885-1954**
See Houfe

Born in Bristol, Derrick was educated at Didcot and studied at the RCA, where he later taught decorative painting. During WW1, Derrick was an art adviser at Wellington House, as the Foreign Propaganda Department was known before it was incorporated into the Department of Information. His work there included offering Eric Kennington* a commission for six lithograph portraits of soldiers, and arranging a travelling exhibition of lithographs from the front line which was shown simultaneously in Paris, New York and Los Angeles. He did at least one painting, of "American Troops at Southampton Embarking for France" (1918).

Thomas DERRICK *Cautionary Catches* by Cyril Alington (Basil Blackwell, 1931)

An artist in stained glass, a muralist, and an illustrator, Derrick taught for five years at the RCA under Sir William Rothenstein. He became best known as a cartoonist of literary and social characters and events, contributing to *Punch*, *Time and Tide*, and other magazines. His book illustrations are often humorous, as are the racy thumb-nail sketches he drew for Richard Dark's amusing travesty of English literary history, *Shakespeare and That Crush* (1931). He also made woodcuts which have strength and simplicity; for *The Decameron* (1920) the woodcuts were printed in five colours; and his *Life of Christ* contains no text. He contributed black and white drawings for *Joy Street*, published by Blackwell, and provided the last four jackets (1933-36).

Books illustrated include: J. de la Fontaine: *Les Fables* (Siegle, Hill, 1910); A. Tooth: *Here Begynneth ye Storie of ye Palmerman* (Fisher Unwin, 1914); G. Boccaccio: *The Decameron* (Chatto, 1920); R. Hakluyt: *The Principal Navigations* (Dent, 1927); *Everyman* (Dent, 1927); E. Farjeon: *The ABC of the BBC* (Collins, 1928); A. Bierce: *Battle Sketches* (First Editions Club, 1930); V. McNabb: *God's Book and Other Poems* (St. Dominic's Press, 1930); G.K. Chesterton: *The Turkey and the Turk* (St. Dominic's Press, 1930); C. Alington: *Cautionary Catches* (Blackwell, 1931); H. Belloc: *Nine Nines* (Blackwell, 1931); R. Dark: *Shakespeare— and That Crush* (Blackwell, 1931), *The Hilarious Universe* (Blackwell, 1932); F.S. Thacker: *Kennet Country* (Blackwell, 1932); G. Bullett: *The Bubble* (Dent, 1934); R. Dark: *Jobs for Jane* (Blackwell, 1934); S.L. Robertson: *The Shropshire Racket* (Sheed & Ward, 1937); C.E.M. Joad: *The Untutored Townsman's Invasion of the Country* (Faber, 1946).

Books written and illustrated include: *The Prodigal Son and Other Parables* (Blackwell, 1931); *The Muses* (Blackwell, 1933).

Contrib: *Bookman; Everyman; G.K.'s Weekly; Joy Street; London Mercury; Punch; Sunday Express; Time and Tide.*

Exhib: RE; RI; NEAC; FAS; Glasgow.

Bibl: H.R. Westwood: *Modern Caricaturists* (Lovat Dickson, 1932); Harries; ICB; Peppin; Price; Waters.

DETMOLD, Edward Julius **1883-1957**
See Houfe
Bibl: C. Dodgson: "Maurice and Edward Detmold", *Print Collector's Quarterly*, 9, no. 4 (December 1922); David Larkin: *The Fantastic Creatures of Edward Julius Detmold* (Pan Books, 1976); Johnson FDIB; Peppin.

DICKENS, Frank **b.1932**
Born in Hornsey and educated at the Stationers' School, Dickens had no formal art training. After leaving school at sixteen, he worked in his father's office, sold vacuum cleaners and sewing machines, and did his National Service in the Air-Sea Rescue service. His first cartoon was done for *Paris Match*, and he then had cartoons accepted by the *Evening Standard* and other London newspapers. He started the "Bristow" strip in 1962. He wrote a children's book, *Fly Away Peter* (Dobson, 1964), which is illustrated by Ralph Steadman*, one of Dickens' idols.

Contrib: *Daily Mirror; Daily Sketch; Evening Standard; Paris Match; Punch.*

Bibl: Bateman.

DINAN, Carolyn **fl.1969-**
An illustrator of mostly children's books, who has started writing and illustrating her own stories.

Books illustrated include: J. McNeill: *Umbrella Thursday* (1969); C. Storr: *Puss and Cat* (Faber, 1969); P. Oldfield: *Melanie Brown Climbs a Tree* (Faber, 1972); H. Cresswell: *At the Stroke of Midnight* (Fontana, 1973); G. Kaye: *Tim and the Red Indian Headdress* (1973); G. Kemp: *Tamworth Pig Saves the Trees* (Faber, 1973); J. Tate: *Jock and the Rock Cakes* (1973); R. Weir: *Uncle Barny and the Sleep-Destroyer* (1974); J. Allen: *Boots for Charlie* (Hamilton, 1975); J. Gard: *Handysides Shall Not Fall* (1975); G. Kemp: *Tamworth Pig and the Litter* (Faber, 1975); A. Schmidt: *Bob and Jilly* (Methuen, 1976); R. Weir: *Uncle Barny and the Sleep-Drink* (1977); G. Kemp: *Ducks and Dragons* (Puffin, 1980), *Dog Days and Cat Naps* (Faber, 1980); R. Stemp: *Guy and the Flowering Plum Tree* (Faber, 1980); H. Cresswell: *A Kingdom of Riches* (Fontana, 1981); G. Kemp: *The Clock Tower Ghost* (Faber,

1981); C. Cookson: *Nancy Nutall and the Mongrel* (Macdonald, 1982); J. Counsel: *But Martin!* (Faber, 1984); D. Edwards: *Robert Goes to Fetch a Sister* (Methuen, 1986); M. Waddell: *Owl and Billy* (Methuen, 1986); S. Spencer: *The Witch's Shopping Spree* (Hamilton, 1987).

Books written and illustrated include: *The Lunch Box Monster* (Faber, 1983); *Skipper and Sam* (Faber, 1984); *Say Cheese!* (Faber, 1985); *Ben's Brand-New Glasses* (Faber, 1987); *Born Lucky* (Hamilton, 1987).

Bibl: Peppin.

DINSDALE, Mary **b.1920**
Dinsdale was born in Guildford, Surrey, and studied at the Guildford School of Art (1936-39). She did not begin to draw seriously until 1945 although she did some engineering drawing during WW2. Her first published work was for the journal *Lilliput* which was followed by illustrations for the *Radio Times* and *Strand Magazine* and for advertising. Her drawings and programme borders for the *Radio Times* show that she has skills as a decorator as well as an illustrator. She has illustrated numerous books, mostly for children.

Books illustrated include: L. Cooper: *Bob-a-Job* (1963); E. Lyon: *Echo Valley* (Brockhampton, 1966); M. Cockett: *Strange Valley* (Oliver & Boyd, 1967), *Frankie's Country Day* (1968), *The Lost Money* (Macmillan, 1968); J. Tate: *The Ball and the Tree House* (Macmillan, 1969); U.M. Williams: *Man on a Steeple* (1971); M. Cockett: *The Marvellous Stick* (1972); M. de Jong: *The Easter Cat* (Lutterworth, 1972); J. Edwards: *Mandy* (1972); W. Mayne: *Robin's Real Engine* (1972); N. Streatfeild: *Ballet Shoes for Anna* (Collins, 1972); J.P. Walsh: *The Dawnstone* (Hamilton, 1973); G. Kaye: *Joanna All Alone* (1974); J. Elliot: *Living in Hospital* (King Edward's Hospital Fund for London, 1975); K. Fidler: *Turk the Border Collie* (Lutterworth, 1975); P. Rogers: *Sometimes Stumps* (Hamilton, 1975); M. Darke: *Kipper's Turn* (Blackie, 1976); G. Kilner: *Jet: A Gift to a Family* (Kestrel, 1976); A. Knowles: *Flag* (Blackie, 1976); S. McCullagh: *Princess Ugly-Face* (Longman, 1976); M. Mahy: *The Pirate Uncle* (Dent, 1977); J. Phipson: *Hide Till Daytime* (1977); M. Cockett: *The Balloon That Brought Luck* (Kaye, 1978), *The Wedding Tea* (Macmillan, 1978), *Monster on the River* (Exeter: Wheaton, 1979.)

Contrib: *Argosy; Economist; Good Housekeeping; Lilliput; Radio Times; Strand Magazine.*

Bibl: ICB4; Peppin; Ryder; Usherwood.
See illustration on page 168

DIXON, Arthur A. **fl.1893-1920**
Dixon was a genre and historical painter in oils, and a book illustrator. Most of his illustrations are conventional and unexceptional, and were done for books mostly produced before 1915. He also contributed to several magazines.

Books illustrated include (but see Peppin for earlier works): S. Pulman: *Children's Stories from Russian Fairy Tales and Legends* (Tuck, 1917); A. Brazil: *The Fortunes of Philippa* (Blackie, 192?); H.R. Haweis: *A Child's Life of Christ* (Tuck, 192?); W. Irving: *Tales of the Alhambra* (with H.M. Brock; Tuck, 1924); C.M.D. Jones: *The Candle of the North* (Mowbray, 1924); *Pictures from the New Testament* (Blackie, 1953); *Pictures from the Old Testament* (Blackie, 1953).

Contrib: *Collins Children's Annual; Pearson's; Tuck's Annual.*

Exhib: RA; RBA.

Bibl: Peppin; Waters.

DODDS, Andrew **b.1927**
Born on 5 May 1927 in Gullane, Scotland, Dodds was educated in England and studied art at the Junior Art Department, North-East Essex Technical College, Colchester (1941-43), and at Colchester School of Art (1943-45). He served in the Royal Navy from 1945 to 1947, and on his release went to the Central School of Arts and Crafts (1947-50) where he studied under Bernard Meninsky, Keith Vaughan* and John Minton*. He taught at St. Martin's School of Art (1953-72), was appointed lecturer at Ipswich School of Art in 1972, and since 1980 has been Principal Lecturer and Deputy Head at Suffolk College, School of Art and Design.
Dodds' first job was with the Hulton Press (1950), illustrating the

Mary DINSDALE *Strangers at the Door* by Elinor Lyon (Brockhampton Press, 1967)

Eagle, but in 1951 he became a full-time free-lance ilustrator, his first commissions including illustrations for the *Farmer's Weekly*, *Lilliput* and the *Radio Times*; then over three decades he recorded London scenes for the *Eastern Daily Press*. Dodds is a countryman by upbringing and by nature, so it seems appropriate that his first illustration for the *Radio Times* should be for the Archers series (using his mother as model for Doris Archer).

He contributed more than 300 illustrations to the *Radio Times* (1951-70), and three "reportage" drawings each week for the *Eastern Daily Press* (1953-85). He has had commissions from many sources including the BBC, Lloyds of London and British Railways. He has illustrated a number of books, including three books for children, and book jackets for many of these; and he has exhibited paintings and drawings in the south and east of England. His illustrations, done in pen and ink, are usually factual rather than imaginative, though they are very successfully evocative of place and time.

Books illustrated include: C. Benham: *Essex Ballads* (Benham, 1960); R. Armstrong: *Island Odyssey* (Dent, 1963); "Miss Read": *Country Bunch* (Joseph, 1963); R. Armstrong: *The Big Sea* (Dent, 1964); E. Allen: *Smitty and the Plural of Cactus* (Nelson, 1965); J. Morgan: *The Casebook of Capability Morgan* (Macdonald, 1965); "Miss Read": *Hob and the Horse Bat* (Joseph, 1965); E. Allen: *Smitty and the Egyptian Cat* (Nelson, 1966); B. Naughton: *A Roof Over Your Head* (Blackie, 1967); W. Vaughan-Thomas: *Madly in All Directions* (Longman, 1967); C. Hibbert: *London* (with others, Longman, 1969); P. Reder: *Epitaphs* (Joseph, 1969); E. Nendick: *Silver Bells and Cockle Shells* (Joseph, 1971); M. Ward: *The Blessed Trade* (Joseph, 1971); *The Hospice Book of Poems* (St. Helena Hospice, 1989).

Andrew DODDS "Aldeburgh" from *East Anglia Drawn* (Jardine Press, 1987)

Books written and illustrated include: *East Anglia Drawn* (Stoke by Nayland: Jardine Press, 1987).
Contrib: *Daily Telegraph; Eagle; Eastern Daily Press; Farmer & Stockbreeder; Farmer's Weekly; Guardian; Homes and Gardens; Lilliput; Motor; Observer; Radio Times; Reader's Digest; Sunday Telegraph*.
Exhib: Studio Club (1961); Assembly House, Norwich (1963); Minories, Colchester (1968; 1970; 1983); Mermaid Theatre (1975); Aldeburgh Festival (1989).
Bibl: Driver; Peppin; Ryder; Usherwood; Who; IFA.

DODDS, James **fl. 1984-**
Dodds illustrates with linocuts and vinyl engravings.
Books illustrated include (all published by Jardine Press): G. Crabbe: *Peter Grimes* (1984); K. Crossley-Holland: *The Wanderer* (1986), *East Anglian Poems* (1988); R. Kipling: *The Shipwright's Trade* (1988).

DORN, Marion **1899-1964**
Born in San Francisco, Dorn studied graphic art at Stanford University and became an interior designer, specializing in textiles — carpets and curtains. She met illustrator and poster artist Edward McKnight Kauffer* first in New York in 1921 and again in Paris in 1923. They returned to London and lived together until Kauffer's death in 1954, being married in New York in 1950. Kauffer and Dorn held a joint exhibition of rugs made to their designs at Arthur Tooth Gallery (1929) and worked together on various projects such as designing a study for Arnold Bennett and doing the interior design for the *Orion* and *Orcades*, ships in the Orient Line. Dorn founded her own company in 1934, and after moving back to New York in 1940, continued to be successful with important commissions for an airport in Los Angeles and for a carpet for the White House.
There is only one recorded instance of book illustration by Dorn, for Beckford's *Vathek* (1929). These semi-abstract pictures were

the first autolithographs done at the Curwen Press, preceding Kauffer's own work. She died in Tangier in 1964.
Books illustrated include: W. Beckford: *Vathek* (Nonesuch Press, 1929).
Exhib: Tooth.
Bibl: Mark Haworth-Booth: *E. McKnight Kauffer: A Designer and His Public* (Fraser, 1979); Simon Jervis: *The Penguin Dictionary of Design and Designers* (Lane, 1984); Gilmour.
Colour Plate 68

DOWD, James H. **1884-1956**
See Houfe
Apart from his contributions to *Punch*, Dowd was well known for his rather sentimental pencil drawings of children and babies for the books by Brenda Spender. See illustration on page 170
Books illustrated include: B.E. Spender: *Important People* (Country Life, 1930), *People of Importance* (Country Life, 1934), *Serious Business* (Country Life, 1937); J. Drinkwater: *Robinson of England* (Methuen, 1937).
Books written and illustrated include: *The Doings of Donovan in and out of Hospital* (Country Life, 1918).
Bibl: Feaver; Peppin; Waters.

DRAPER, Richard **b.1949**
Born in London, Draper studied at the Hornsey College of Art and the East Ham Technical College and School of Art. He worked on the staff of the *Radio Times* as an art assistant for three years from 1969, and has also worked for the Central Office of Information. He began his free-lance career working with Nigel Holmes*. His illustrations for the *Radio Times* in the 1970s are diagrammatic and instructional rather than imaginative.
Contrib: *Radio Times*.
Bibl: Driver.

Bag & baggage.

J.H. DOWD *People of Importance* by J.H. Dowd and Brenda E. Spender (Country Life, 1934)

DREW, Simon Brooksby b.1952

Born on 9 October 1952 in Reading, Drew was educated at Bradfield College in Berkshire (1965-70). He had no formal art training, and studied zoology at Exeter University (1971-74), and then trained as a teacher at Reading University (1974-75). He taught for five years in Sussex, drawing only in his spare time, before moving to Dartmouth in 1981 to set up a gallery for the sale of his illustrations and paintings, and the work of studio potters. His book illustrations, done mostly in pen, ink and crayon, are humorous and deal with animals and birds in strange situations created by his puns, slightly mixed phrases and verses, such as "When Did You Last See Your Farmer?" (from *Still Warthogs Run Deep*). He has exhibited in Britain and the US, and his work, on cards and prints, sells well in many countries where English is the language.

Books written and illustrated include (all published by Antique Collectors' Club): *A Book of Bestial Nonsense* (1986); *Nonsense in Flight* (1987); *Still Warthogs Run Deep* (1988); *The Puffin's Advice* (1989); *Cat with Piano Tuna* (1990); *Camp David* (1992).

Exhib: Birdsey Gallery, Cape Cod (one-man show); Beetles; Lymington, Hants.; Coventry; Simon Drew Gallery, Dartmouth.

Bibl: *The Illustrators* (exhibition catalogue October 1988; Chris Beetles Ltd., London); *Western Morning News*, 18 November 1989; IFA.

Colour Plate 69

DRISCOLL, Barry fl.1960-

Born in England, Driscoll has illustrated mostly animals, using a wash technique.

Books illustrated include: R. Guillot: *Mokokambo, the Lost Land* (1961), *King of the Cats* (Collins, 1962); W. Swinton: *Digging for Dinosaurs* (BH, 1962); R. Guillot: *Mountain with a Secret* (Collins, 1963); G. Vevers: *Life in the Sea* (BH, 1963); D. Morris: *Apes and Monkeys* (1964); H. Williamson: *Tarka the Otter* (Nonesuch Press, 1964); D. Morris: *The Big Cats* (BH, 1965); J. Chipperfield: *Lone Stands the Glen* (1966).

Bibl: ICB3; Peppin.

DRUMMOND, Violet Hilda b.1911

Born on 30 July 1911 in London, Drummond was educated at home, in Eastbourne and in Paris before studying at St. Martin's School of Art. During WW2 she did some work for the First Aid

V.H. DRUMMOND *Mrs Easter and the Storks* (Faber & Faber, 1957)

Nursing Yeomanry (later the Auxiliary Territorial Service). A painter and lithographer, mostly of London scenes, she is also the author and illustrator of children's picture books which she started to produce for her son Julian. The first of these was *Phewtus the Squirrel* (1939). This book and some ten others were re-issued in the 1960s in a larger format and with new illustrations. She is probably best known for her *Little Laura* series for young children, and she produced eighteen new cartoon films based on them for the BBC. She won the Kate Greenaway Award for *Mrs. Easter and the Storks* (1957). Peppin writes that "she cheerfully abandons spatial and anatomical conventions in a spontaneous style which is both expressive and witty". After a successful exhibition of her paintings in 1968 (which has since been followed by seven other exhibitions), she determined to concentrate more on that aspect of her art, although she did produce new books for her new grandchildren.
Books illustrated include: J.K. Stanford: *The Twelfth* (Faber, 1944); T.A. Powell: *Here and There a Lusty Trout* (Faber, 1947); G. Bles: *The Title's My Own* (Faber, 1952); A. Silcock: *Verse and Worse* (Faber, 1952); E. Partridge: *The Shaggy Dog Story* (Faber, 1953); E. Dillon: *Wild Little Horse* (1955); B. Sleigh: *Carbonel King of the Cats* (1955); L. Durrell: *Esprit de Corps* (Faber, 1957); A. Jean: *The Kingdom of the Winds* (Parrish, 1957); B. Ireson: *Liza and the Helicopter* (1958); H. Cresswell: *The Piemakers* (Faber, 1967); A. Miller: *The Quest of the Catnip Mouse* (Faber, 1967).
Books written and illustrated include: *Phewtus the Squirrel* (OUP, 1939); *Mrs. Easter's Parasol* (Faber, 1944); *Miss Anna Truly* (Faber, 1945); *Lady Talavera* (Faber, 1946); *The Charming Taxicab* (Faber, 1947); *The Mountain That Laughed* (Grey Walls Press, 1947); *Tidgie's Innings* (Faber, 1947); *The Flying Postman* (Longman, 1948); *Mrs. Finch's Pet Shop* (Faber, 1953); *Mrs. Easter and the Storks* (Faber, 1957); *Little Laura on the River* (Faber, 1960); *Little Laura's Cat* (Faber, 1960); *Little Laura and Her Best Friend* (1963); *Little Laura and the Thief* (1963); *Miss Anna Truly and the Christmas Lights* (Longman, 1968); *Mrs. Easter and the Golden Bounder* (Faber, 1970); *Mrs. Easter's Christmas Flight* (Faber, 1972); *I'll Never Be Asked Again* (Debrett, 1979).
Exhib: Chenil Gallery; Upper Grosvenor Gallery; Oliver Swann Gallery.
Bibl: CA; Carpenter; ICB2; ICB3; ICB4; Peppin; Waters; Who; IFA.

DU CANE, Ella fl.1890-1930
Du Cane was a painter of watercolour landscapes which she also used to illustrate books. Most of the books she illustrated were published before 1915. She exhibited three times at the Fine Arts Society.
Books illustrated include: R. Bagot: *The Italian Lakes* (Black, 1905); J. Finnemore: *Japan* (1907); F. Du Cane: *The Flowers and Gardens of Japan* (Black, 1908), *The Flowers and Gardens of Madeira* (Black, 1909), *The Canary Islands* (Black, 1911); J.A. Todd: *The Banks of the Nile* (Black, 1913).
Books written and illustrated include: *The Nile Water-Colours* (1931).
Exhib: FAS.
Bibl: Peppin.

DUCHESNE, Janet b.1930
Born on 11 May 1930 in London, Duchesne studied at Bromley College of Art and the RA Schools. She painted landscapes and portraits, but after her marriage could find time only for doing illustrations. She illustrates mostly children's books, using pen and ink with occasional watercolour washes; and has written and illustrated a few books of her own. Ryder quotes her as saying that she has found her training as a painter most valuable in drawing for illustration. "Illustration, a work of collaboration, is less solitary and rewarding in a different way from the achievement of a painting."
Books illustrated include (published by Hamilton unless noted): J. MacGibbon: *Peter's Private Army* (1960), *Red Sail, White Sail* (1961); W. Mayne: *The Glass Ball* (1961); M. O'Donnell: *The Lorry Thieves* (1961); J. Hope-Simpson: *Danger on the Line* (1962); J. MacGibbon: *The Red Sledge* (1962), *The View-Finder* (1963); W. Mayne: *Plot Night* (1963); J. Hope-Simpson: *The*

Ninepenny (1964), *The Witch's Cave* (1964); M. Shemin: *The Little Riders* (1964); W. Mayne: *The Big Wheel and the Little Wheel* (1965); M. Ray: *The Eastern Beacon* (Cape, 1965); E. Vipont: *The Offcomers* (1965); J. Phipson: *The Crew of the "Merlin"* (1966); K.S. Allen: *The Story of London Town* (Odhams, 1967); J. MacGibbon: *Sandy in Hollow Tree House* (1967), *The Tall Ship* (1967), *The Great-Great Rescuers* (1967); M. Ray: *Standing Lions* (Faber, 1968), *Spring Tide* (Faber, 1969); P. Rogers: *All Change* (1974); S. Watson: *Venus Pool* (1975); J. Smith: *Pilgrim's Way* (1976), *November and the Truffle Pig* (1977); D. Huddy: *Creaky Knees* (1978); P. Oldfield: *Children of the Plague* (1979); D. Starkey: *Monsters, Dragons and Sea-Serpents* (Kaye, 1979); J. Allen: *Stitches for Charlie* (1980); E. Davies: *Cam* (1980); B. Ashley: *Dinner Ladies Don't Count* (MacRae, 1981); R. Dennant: *The Video Affair* (1981); B. Ashley: *Linda's Lie* (MacRae, 1982); J. Stinton: *Tom's Tale* (MacRae, 1983); D. Hendry: *Midnight Pirate* (MacRae, 1984); J. Stinton: *The Apple-Tree Man* (MacRae, 1985); L. Kingman: *The Best Christmas* (MacRae, 1086); J. Allen: *Computer for Charlie* (1987); M. Cockett: *Kate of Candlewick* (Hodder, 1987).
Books written and illustrated include: *Two to Five Books* (1963); *Richard Goes Sailing* (Constable, 1966); *Peach Pudding* (Hamilton, 1978).
Bibl: Peppin; Ryder; ICB3; ICB4.

DUFFIN, Emma S. fl. 1927-1935
She wrote and illustrated a few books for children, and illustrated those by others with rather banal pen drawings.
Books illustrated include: D. Russell: *The Secret Chest* (Nelson, 1927).
Books written and illustrated include: *The Magic Watch* (Nelson, 1927); *The Nursery Book* (Nelson, 1927); *The Tale of Li-Po and Su-Su* (Nelson, 1927); *The Adventures of Prince Jan* (Nelson, 1928); *The Magic Glasses* (Belfast: Quota Press, 1935).
Bibl: Peppin.

DULAC, Edmund 1882-1953
See Houfe

DUNBAR, Evelyn Mary 1906-1960
Born on 18 December 1906 in Reading, Dunbar studied at Rochester and Chelsea Schools of Art, then at RCA (1929-33). A painter, muralist and book illustrator, she did murals at Brockley County School (1933-36) and Bletchley Training College (1958-60). During WW2 she was an official war artist (1940-45), recording the activities of the Women's Voluntary Services and the Women's Land Army; from 1950 she was a visiting lecturer at Ruskin School, Oxford. Dunbar moved to Kent in 1952, and painted mostly portraits. She was a member of the NEAC and the SMP.
She illustrated at least two books, the first in 1937 when she wrote and illustrated with Cyril Mahoney *Gardener's Choice*.
Books illustrated include: M. Greenhill: *A Book of Farmcraft* (Longmans, 1942).
Books written and illustrated include: (with Cyril Mahoney) *Gardener's Choice* (Routledge, 1937).
Exhib: NEAC.
Collns: IWM; Tate.
Bibl: *Landscape in Britain 1850-1950* (Arts Council, 1983); Ian Jeffrey: *The British Landscape 1920-1950* (T & H, 1984); Harries; Waters.

DUNCAN, John 1866-1945
See Houfe
Duncan became the chief painter of the Celtic revival, and was the Director of the new School of Art in Edinburgh. He also contributed illustrations to books and magazines, and received commissions for altar pieces, church murals and stained glass.
Bibl: *The Illustrators: Catalogue* (Chris Beetles Ltd., 1991).

DUNKLEY, Jack b.1906
Dunkley was born in Holloway, north London, and educated at Sir Hugh Middleton Secondary School. When he was sixteen years old, he got a job doing the subtitles for advertising films at a film studio

in Wardour Street, London, and worked there until 1930. During that time, he studied at the Central School of Arts and Crafts and started as a free-lance artist when he left the film studio. His first commissions were for *The Daily Mirror* and the *Radio Times* in 1932.

Dunkley is really a cartoonist; he confesssed that "I have always specialized in humour and sport." For thirty years he produced all the sporting drawings for the *Radio Times*, including a number of covers, but he was not entirely restricted to sporting subjects for he also illustrated play scripts, variety programmes and drew caricature portraits. Most of his work is done in black and white, using a pen or brush.

Contrib: *Daily Mirror; Daily Express; Daily Sketch; News Chronicle; Radio Times.*
Bibl: Driver.

DUNLOP, Gilbert **fl.1949-1966**
An illustrator of children's books, using mostly line drawings and occasionally full colour.
Books illustrated include: E. Blyton: *The Rockingdown Mystery* (1949), *The Rubadub Mystery* (1952); P. Mansbridge: *Family Adventure* (Nelson, 1953), *Riverside Adventure* (Nelson, 1954), *The Children in the Square* (Nelson, 1955), *A House for Five* (Nelson, 1956); M. Gervaise: *Golden Path Pets* (1957); P. Mansbridge: *Holiday in London* (Nelson, 1960), *The Creek Street Jumble* (Nelson, 1961); E. Blyton: *The Mystery That Never Was* (Collins, 1961); P. Mansbridge: *Battle Tunes at Bindleton* (Nelson, 1964); E. Blyton: *The Rilloby Fair* (1965), *Ring O'Bells Mystery* (1965), *The Ragamuffin Mystery* (1966).
Books written and illustrated include: *The Baby Elephant* (1948).
Bibl: Peppin.

DYKE, John **b.1935**
Born in Alcester, Warwickshire, Dyke studied at Birmingham College of Art (1959-62) after seven years in the Royal Navy. He has lectured at Folkestone School of Art and Amersham College of Further Education. According to Peppin, he has also worked as a painter, designed animated films, and made puppets. Some of his illustrations were for educational books.
Books illustrated include: A-C. Vestly: *The Eight Children Series* (Methuen, 1973-79); E. Ramsbottom and J. Redmayne: *Secret Island* (Macmillan, 1975); A. Thwaite: *Rose in the River* (1975); D.

Edwards: *Dad's New Car* (Methuen, 1976); I. McGee: *Oliver the Famous Birdman* (1976); N. Tucker: *In the Picture* (Longman, 1976); M. Green: *The Magician Who Lived in the Mountain* (Hodder, 1977); E. Ramsbottom and J. Redmayne: *In the Air* (Macmillan, 1977); F. Hunia: *The Elves and the Shoemaker* (Ladybird, 1978), *The Sly Fox and Red Hen* (Ladybird, 1978); S. Parker and A. Ward: *Sciencewise* (Nelson, 1978); G. Clemens: *Shapes and Words* (Macmillan, 1980); R. Impey: *The Ladybird Book of Fairy Tales* (with others, Ladybird, 1980); P. Edwards: *Jimmy James* (Longman, 1987).
Books written and illustrated include: *Peter and the Pier* (Dobson, 1967); *Magic Colour* (1974); *Columbus Mouse* (1975); *Pigwig* (Methuen, 1978); *Pigwig and the Pirates* (Methuen, 1979); *Pigwig and the Crusty Diamonds* (Methuen, 1982); *Barrington the Circus Mouse* (Methuen, 1984).
Bibl: Peppin.

DYKE, John C.A. **b.1923**
Born on 16 May 1923 in Rossett, East Denbighshire, Dyke was educated at Holly Bank, Chester, and studied at the Chester School of Art. Formerly a resident of Lundy Island, where he edited and illustrated the island's *The Illustrated Lundy News*, and designed the island's local stamps, he is illustrator to the National Trust. He has received the Westminster Gold Medal and the Randolph Caldecott Memorial Prize for book illustration (1937-41).
Bibl: Who.

DYSON, William Henry **1880-1938**
See Houfe
Books illustrated include: E. Patand and E. Pouget: *Syndicalism and the Co-operative Commonwealth* (1913); G. Gould: *Lady Adela* (1920); *The Martyrs of Tolpuddle* (1934).
Books written and illustrated include: *Kultur Cartoons* (Paul, 1915); *War Cartoons* (Hodder, 1916); *Australia at War* (1918); *Artist Among the Bankers* (1933).
Contrib: *Daily Herald; London Mercury; Melbourne Herald; Sydney Bulletin.*
Collns: University of Canterbury.
Bibl: H.R. Westwood: *Modern Caricaturists* (Lovat Dickson, 1932); R. McMullin: *Will Dyson: Cartoonist, Etcher and Australia's Finest War Artist* (Angus & Robertson, 1984); Peppin; Waters.

EARNSHAW, Anthony fl.1968-

Earnshaw illustrated at least two books of adult fiction written by Eric Thacker. *Musrum* (1968) received much praise and attention at the time of publication and won a Francis Williams Bequest prize in 1972 for one of the best illustrated books published 1967-1971.

Books illustrated include: E. Thacker: *Musrum* (Cape, 1968), *Wintersol* (Cape, 1971).

Books written and illustrated include: *Seven Secret Alphabets* (Cape, 1972); *An Eighth Secret Alphabet* (Hanborough Parrot Books, 1988).

EARNSHAW, Harold C. d.1937
See Houfe

A painter and illustrator, Earnshaw studied art in London. He met Mabel Lucie Attwell* at St. Martin's School of Art and married her in 1908. In the same year, Earnshaw joined the London Sketch Club, where he met many artists and illustrators, including John Hassall (see Houfe), Harry Rountree*, William Nicholson and James Pryde (see Houfe). During WW1 he was seriously wounded, losing his right arm, but he learned to draw with his left hand and illustrated several books for children and contributed to a number of annuals. His work is similar in its boldness and use of colour to that of John Hassall. He died in 1937 after a prolonged illness which may have been a result of his war injuries.

Books illustrated include: K. Carr: *Rivals and Chums* (Chambers, 1908); C. Greig: *The Rebel Cadets* (1908); T.B. Reed: *The Willoughby Captains* (Hodder, 1910); *Princess Mary's Gift Book* (with others; Hodder, 1914); E. Oxenham: *Girls of the Hamlet Club* (Chambers, 1914), *At School with the Roundheads* (Chambers, 1915), *The School of Ups and Downs* (Chambers, 1918), *A Go-Ahead Schoolgirl* (Chambers, 1919); C. Asquith: *The Flying Carpet* (with others., Partridge, 1926); W. Scott: *Ivanhoe* (Odhams, 1930); *The Golden Budget of Nursery Stories* (nd).

Contrib: *BOA; Captain; Cassell's Children's Annual; Chums; Graphics; The Jolly Book; Little Folks; Playbox Annual; Punch.*

Bibl: Doyle BWI; Peppin

ECKERSLEY, Thomas C. b.1914

Born on 30 July 1914 in Newton Willows, Lancashire, Eckersley was educated at Lords College, Bolton, and studied at Salford School of Art (1930-34). He became particularly interested in graphic design, inspired both by an exhibition of *avant-garde* Continental artists, including the great French poster designer, A.M. Cassandre, and by the dramatic posters by E. McKnight Kauffer* for London Transport. With fellow student, Eric Lombers, in 1934 he moved to London, where they produced posters and other graphic work for such customers as London Transport, Shell and the GPO. This partnership was forced to break up when they were separated during WW2. Eckersley taught poster design at Westminster School of Art (1937-39) and during WW2 did cartographical drawings for the RAF and posters for the RAF, the GPO and the Royal Society for the Prevention of Accidents. Since 1945, he has worked as a free-lance artist and was Head of Design, London School of Printing (1957-77).

Though most of Eckersley's finest work was done for posters, he has also designed murals, including for Heathrow Airport underground station, and illustrated a few books. He was awarded the OBE in 1948 for poster design; RDI (1963).

Books illustrated include: E.A. Cabrelly: *Animals on Parade* (Conrad, 1947); D. Eckersley: *Cat O'Nine Lives* (Lunn, 1947).

Published: *Poster Design* (Studio, 1954).

Exhib: London Transport Museum (1984).

Collns: V & A; MOMA; IWM.

Bibl: Joseph Darracott and B. Loftus: *Second World War Posters*, 2nd ed. (IWM, 1981); René Elvin: "Tom Eckersley", *Graphis* 10, no. 56 (1954): 468-73; Amstutz 2.

Colour Plate 7

EDE, Janina b.1937

Born in Southampton, Ede studied illustration, engraving, lithography and typographic design at Winchester School of Art (1953-57). In her final year she was commissioned by the Hampshire County Council to make three murals in a school near Portsmouth. She was awarded a travelling scholarship for illustration and went to France, Switzerland and Italy. On her return, Ede became a free-lance artist. Her first commission was for book covers for Penguin Books; her drawing for Colette's *Gigi* persuaded Secker & Warburg to ask her to do jacket designs. Her illustrative work — apart from jackets and covers — started with a French text for John Murray but since then has been mostly for children's books. She uses many different techniques for her illustrations, including pen and ink, gouache, scraperboard, and spatter, and has printed from leaves and fabric to obtain a variety of textures.

Books illustrated include (but see Peppin): Colquhoun and Guergady: *Sur les Routes de France* (Murray, 1959); F. Collins: *The Pack Mascot* (Brockhampton, 1962); P. Duggan: *The Travelling Boy* (Heinemann, 1965); M. Gayler: *It's the New Sound* (Macdonald, 1965); Y. Mitchell: *Cathy Away* (Heinemann, 1964), *Cathy At Home* (Heinemann, 1964); M. Stuart: *Marassa and Midnight* (Heinemann, 1966); A. Winn: *Helter Skelter* (Brockhampton, 1966); M.J. Miller: *Mousetails* (1967); M. Gayler:

Operation Hotel (1968); M.J. Miller: *Willow and Albert* (1968); G. Rae: *Mostly Mary* (1968), *All Mary* (1968); P. Sykes: *Air Day for the Brownies* (Brockhampton, 1968); H. Cresswell: *A Gift from Winklesea* (Brockhampton, 1969); G. Rae: *Mary Plain on Holiday* (1969); M. Sedgwick: *Matilda's Special Plate* (1969); Septima and "Margett": *Child's Play* (Dent, 1969); P. Sykes: *The Brownies at the Zoo* (Brockhampton, 1969); G. Rae: *Mary Plain and the Twins* (1970), *Mary Plain's Big Adventure* (1970), *Mary Plain V.I.P.* (1970); Septima and "Margett": *More Child's Play* (Dent, 1970); A. Uttley: *Lavender Shoes, Eight Tales of Enchantment* (Faber, 1970); G. Rae: *Mary Plain Goes to America* (1971); B. Riha: *Johnny's Journey* (Dent, 1970); M. Storey: *The Mollyday Holiday* (Faber, 1971), *The Sleeping Witch* (Faber, 1971); Colette: *My Apprenticeships* (1972), *Music Hall Sidelights* (1972); G. Rae: *Mary Plain in Trouble* (1972); R.L. Stevenson: *Travels with a Donkey* (1972); P. Sykes: *The Brownies on Television* (Brockhampton, 1972); G. Rae: *Mary Plain's Whodunnit* (1973); A. Chekhov: *Stories* (1974); "Margett": *It's Sunny Outside* (1974), *Hard and Soft* (1974); R.L. Stevenson: *An Amateur Emigrant* (1974); P. Sykes: *The Brownies in Hospital* (Brockhampton, 1974); S Maugham: *Theatre* (1975); N. Shute: *The Rainbow and the Rose* (1975); L. Garfield: *Adventures of the Boy and the Monkey* (Puffin, 1976); C. Maxwell-Hudson: *The Natural Beauty Book* (Macdonald, 1976); M. Storey: *A War of Wizards* (Faber, 1976); P. Sykes: *The Brownies Throw a Party* (Hodder, 1976); W.M. Thackeray: *The History of Henry Esmond* (1976); D. George: *Einar and the Seal* (Winchester: Hambleside, 1977); M.J. Miller: *The Big Brown Teapot* (Hodder, 1979); J. Holiday: *Biddy's Talking Pineapple* (Hodder, 1980); M.J. Miller: *The Mad Muddle* (Hodder, 1982).
Contrib: *Homes and Gardens; Vogue.*
Bibl: Peppin; Ryder.

EDWARDS, Gunvor **fl. 1958-**
Born in Uppsala, Sweden, Edwards (née Övden) studied in Sweden and at Regent Street Polytechnic under Stuart Tresilian*. An illustrator of educational books and books for children. She married Peter Edwards* in 1957.
Books illustrated include (but see Peppin): M.H. Bell: *Whistle Down the Wind* (Boardman, 1958); J. Hawthorne: *The Mystery of the Blue Tomatoes* (Harrap, 1958); J.C. Jones: *James and Susan in the Country* (Hutchinson, 1959); E. Colwell: *Tell Me Another Story* (1964); K. Mackenzie: *Garden Railway* (Methuen, 1966); J.B. Olsen: *Stray Dog* (Constable, 1966); B. Softly: *Magic People* (O & B, 1966); D. Thomson: *Danny Fox* (Puffin, 1966); U.M. Williams: *Cruise of the "Happy-Go-Gay"* (Hamilton, 1967); G. Bell: *The Smallest King in the World* (O & B, 1968); D. Thomson: *Danny Fox at the Palace* (Puffin, 1968), *Danny Fox Meets a Stranger* (Puffin, 1968); B. Softly: *More Magic People* (Chatto, 1969); F. Law: *Something To Make* (Collins, 1971), *Bad Boys* (1972); U.M. Williams: *Tiger-Nanny* (Brockhampton, 1973); F. Grice: *Tales and Beliefs* (1974); M.C. Ibbetson: *Daniel's Shed* (1974); B. Sleigh: *Ninety-Nine Dragons* (Brockhampton, 1974); A-C. Vestly: *Aurora and the Little Blue Car* (Longman, 1974); L.M. Alcott: *Little Women* (OUP, 1975); E. Beresford: *Snuffle to the Rescue* (Kestrel, 1975); E.M. Matterson: *Play with a Purpose for the Under Sevens* (Penguin, 1975); A-C. Vestly: *Aurora and Socrates* (Kestrel, 1975); F. Lindsay: *Mr. Bits and Pieces* (Hodder, 1976); H. Thomas: *A Book of Children's Parties* (Penguin, 1976); A-C. Vestly: *Aurora in Holland* (Kestrel, 1976); R.B. Wilson: *Musical Merry-Go-Round* (Heinemann, 1977); M.S. Barry: *Maggie Gumption* (Hutchinson, 1979); S. Weimar: *Norway Is Like This* (Kaye, 1979); F. Law: *Going To School* (Octopus, 1980); M.S. Barry: *Maggie Gumption Flies High* (Hutchinson, 1981); J. Smith: *Grandmother's Donkey* (MacRae, 1982).
Books written and illustrated include: *Cat Samson* (Abelard, 1978).
Contrib: *The Egg; Puffin Post.*
Bibl: ICB4; Peppin.

EDWARDS, Lionel Dalhousie Robertson **1878-1966**
See Houfe
Books illustrated include: P. Gwynne: *The Guadalquiver* (Constable, 1912); E.A.H. Alderson: *Pink and Scarlet; or Hunting As a School for Soldiering* (Hodder, 1913); C. Tower: *The Moselle* (Con-

stable, 1913); S. Galtrey: *The Horse and the War* (Country Life, 1918); J. MacKillop: *Letters to a Young Huntsman on Hunting, Angling and Shooting* (Country Life, 1920); W.H. Ogilvie: *Galloping Shoes* (Constable, 1922), *Scattered Scarlet* (Constable, 1923); G.A.B. Dewar: *The Pageant of English Landscape* (Classic Press, 1924); G.J.W. Melville: *Songs and Verses* (Constable, 1924); M.F. MacTaggart: *Mount and Man* (Country Life, 1925); W.H. Ogilvie: *Over the Grass* (Constable, 1925); R.G. Verney: *Hunting the Fox* (Constable, 1925); R.E.E. Warburton: *Hunting Songs* (Constable, 1925); Crascredo: *Horse Sense and Sensibility* (Country Life, 1926); Sabretache: *Shires and Provinces* (Eyre, 1926); S.G. Goldschmidt: *Bridle Wise* (Country Life, 1927); A.L. Gordon: *Sporting Verse* (Constable, 1927); Crascredo: *Country Sense and Common Sense* (Country Life, 1928); W.H. Ogilvie: *A Handful of Leather* (Constable, 1928); Sabretache: *More Shires and Provinces* (Eyre, 1928); Golden Gorse: *Moorland Mousie* (Country Life, 1929); A.H. Higginson: *Letters from an Old Sportsman to a Young One* (NY: Doubleday, 1929); E. Roberts: *Somewhere in England* (Constable, 1929); M. Charlton: *Tally Ho* (Putnam, 1930); Rancher: *Forrard—On!* (Country Life, 1930); R. Ball: *Hounds Will Meet* (Country Life, 1931); Rancher: *Tally Ho Back!* (Country Life, 1931); Golden Gorse: *Older Mousie* (Country Life, 1932); W.H. Ogilvie: *Collected Sporting Verse* (Constable, 1932); H.F. Wallace: *A Highland Gathering* (Eyre, 1932); H.M. Budgett: *Hunting By Scent* (Eyre, 1933); R. Kipling: *The Fox Meditates* (Medici, 1933); W. Fawcett: *Thoroughbred and Hunter* (Medici, 1934); R.C. Lyle: *Brown Jack* (Putnam, 1934); H.F. Wallace: *A Stuart Sketchbook* (Eyre, 1934); E.E. Helme: *Mayfly* (Eyre, 1935); A.G. Street: *Country Calendar* (Eyre, 1935); Lady Apsley: *Bridleways Through History* (Hutchinson, 1936); L. Dawson: *Sport in War* (Collins, 1936); R. Kipling: *The Maltese Cat* (Macmillan, 1936); E. MacDermot: *The Devon and Somerset Staghounds* (Collins, 1936); A.G. Street: *Moonraking* (Eyre, 1936); P.R. Chalmers: *The Horn* (Collins, 1937); J.M. Vivian: *Riding with Reka* (Eyre, 1937); M. Flint: *Grig the Greyhound* (Country Life, 1938); R.C. Lyle: *The Aga Khan's Horses* (Putnam, 1938); S.P.B. Mais: *Light Over Lundy* (Eyre, 1938); E. Bannisdale: *Riders of the Hills* (Eyre, 1939); M. Charlton: *Echoing Horn* (Putnam, 1939); E. Bannisdale: *Back to the Hills* (Eyre, 1940); F. Pitt: *Betty* (Country Life, 1943); G. Roderick: *Gimcrack* (Eyre, 1944); B. Holden: *They're Away* (Collins, 1945); R.C. Lyle: *Royal Newmarket* (Putnam, 1945); P. Cumming: *The Great Horses* (Dent, 1946); E.E. Helme: *Shank's Pony* (Eyre, 1946); A. Sewell: *Black Beauty* (Lunn, 1946); B. Vesey-Fitzgerald: *The Book of the Horse* (Nicholson, 1946); P.M. Morris: *Topper* (Carrington, 1947); "Golden Goose": *My First Horse* (Lunn, 1947); M. Charlton: *Pendellion* (Methuen, 1948); "Golden Goose": *The Young Rider's Picture Book* (Country Life, 1948); R. Greaves: *Dainty — A Foxhound* (Black, 1948); N. Kalishnikov: *Jumper* (Lunn, 1948); K.M. Peyton: *Sabre, the Horse from the Sea* (Black, 1948); *Mandrake* (Black, 1949); Lady Apsley: *The Foxhunter's Bedside Book* (Eyre, 1949); P.M. MacGregor: *Lucky Purchase* (1949), *Exmoor Ben* (1950); E.E. Helme: *Dear Busybody* (Eyre, 1950); A.G. Street: *In His Own Country* (Eyre, 1950); R.D. Blackmore: *Lorna Doone* (Dent, 1951); B.W.R. Curling: *British Racecourses* (Witherby, 1951); A. Trollope: *Hunting Sketches* (Benn, 1952); A. Sewell: *Black Beauty* (Ward Lock, 1954); M. Bowen: *Irish Hunting* (Tralee, 1955); F. Marryat: *The Children of the New Forest* (Dent, 1955); R.L. Stevenson: *Black Arrow* (Dent, 1957).
Books written and illustrated include: *Hunting and Stalking Deer* (1927); *The Passing Seasons* (Country Life, 1927); *My Hunting Sketch Book* (two vols., Eyre, 1928-30); *Huntsmen Past and Present* (Eyre, 1929); *My Scottish Sketchbook* (Country Life, 1929); *Famous Foxhunters* (Eyre, 1932); *The Wiles of the Fox* (Medici, 1932); *Sketches in Stable and Kennel* (Putnam, 1933); *A Leicestershire Sketchbook* (Eyre, 1935); *Seen from the Saddle* (Eyre, 1937); *A Sportsman's Bag* (Country Life, 1937); *Horses and Ponies* (Country Life, 1938); *My Irish Sketchbook* (Collins, 1938); *The Lighter Side of Sport* (Methuen, 1940); *Scarlet and Corduroy* (Eyre, 1941); *Our Food from Farm to Table* (Methuen, 1943); *Our Horses* (Puffin Picture Book, 1945); *Reminiscences of a Sporting Artist* (Putnam, 1947); *Getting to Know Your Pony* (Collins, 1948); *Horses and Riders* (1948); *Our Cattle* (Puffin Picture Book, 1948); *The Fox* (Collins, 1949); *Beasts of the Chase* (Putnam, 1950); *Thy*

Beresford EGAN "Marilyn" Pen and ink drawing Illustrated *Marilyn* book 1, Chapter 5. By permission of Chris Beetles Limited

Servant the Horse (Country Life, 1952); *A Sportsman's Sketchbook* (Putnam, 1953).
Contrib: *Bystander; Country Life; Field; Graphic; Foxhunter's Yearbook; Holly Leaves; Illustrated Sporting and Dramatic; Pearson's Magazine; Printer's Pie; Punch; Strand; Tatler.*
Exhib: RA; RI; RCA; Liverpool; Tryon Gallery; Alpine Gallery (1986).
Bibl: *Lionel Edwards 1878-1966 [Catalogue of an Exhibition at the Alpine Club, 1986] (British Sporting Art Trust, 1986);* Marjorie Edwards: *Figures in a Landscape: Lionel Edwards, R.I., R.C.A.: A Sporting Artist and His Family* (Regency Press, 1986); Lionel Edwards: *Reminiscences of a Sporting Artist* (Putnam, 1947); J.N.P. Watson: *Lionel Edwards: Master of the Sporting Scene* (Sportsman's Press, 1986); ICB2; Peppin; Titley.

EDWARDS, Peter William **b.1934**
Born on 4 February 1934 in London, Edwards spent his childhood

in London but was evacuated during WW2 to Devon and later North Wales. He studied at Regent Street Polytechnic (1950-1954), where he first met the Swedish artist, Gunvor Övden (Gunvor Edwards*) whom he later married. After National Service, he worked as an illustrator in Sweden (1956-8), returning to London in 1958. Working mostly on books for children, he illustrated the last nine titles in the "Railway Engine" series for young children, written by the Reverend Wilbert Awdry, the first titles of which were illustrated by C. Reginald Dalby*. Edwards is quoted in ICB4 as saying "England is a splendid place for illustrators, but my wife and I suffer from the disease of meticulous elaboration."
Books illustrated include: D. Clewes: *Wilberforce and the Slaves* (Hutchinson, 1961); W. Collins: *The Moonstone* (Blackie, 1961); H.L. Davies: *Honey in the Horn* (1961); D. Clewes: *Skyraker and the Iron Imp* (Hutchinson, 1962); E. Vipont: *Search for a Song* (OUP, 1962); W. Awdrey: *Railway Series* (last nine titles Ward, 1963-72); K. Rudge: *Man Builds Houses* (Hamilton, 1963); C. Memling: *Seals for Sale* (Abelard, 1964); J. Wyndham: *The Chrysalids* (Hutchinson, 1964); H. Mills: *Prudence and the Pill* (Triton, 1965); D.R. Sherman: *Old Mali and the Boy* (Heinemann, 1966); J. Wyndham: *The Trouble with Lichen* (Hutchinson, 1966); E. Berridge: *That Surprising Summer* (Kaye, 1971); J.O.E. Clark: *Chemistry* (Hamlyn, 1971); M. Dickens: *The Great Escape* (Kaye, 1971); L. Meynell: *Tony Trotter and the Kitten* (1971); M. Holt and R. Ridout: *The First Big Book of Puzzles* (Longman, 1972); and two others; C. Mackenzie: *The Dining Room Battle* (Kaye, 1972); A. Chambers: *Great Ghost Stories of the World* (Pan, 1974); M. Coles and B. Lord: *Access to English* (four books, OUP, 1975-80); J. Denton: *The Colour Factory* (Kestrel, 1976); D. Edwards: *A Look, See and Touch Book* (Methuen, 1976); S. Marshall: *Nicholas and Finnegan* (Puffin, 1977); S. Buckland: *English on Line* (1980-82); M. Holt: *Puma Puzzles* (1980); J. Goodwin and M. Jacklin: *Growing Things in School* (Ward Lock, 1982); H. Morgan: *Grandad at Large* (BBC, 1983); *Rentaghost Enterprises* (BBC, 1984); W. Rowlinson: *Kapiert!* (OUP, 1984).
Books written and illustrated include: *Simply Salt* (Macmillan, 1978); *Simply Sell* (Macmillan, 1978); and four other titles in series.
Bibl: ICB4; Peppin.

EGAN, Beresford **b.1906?**
Born in England, Egan was educated in South Africa. After working as a bank clerk, he became sports cartoonist on the *Rand Daily Mail* in Johannesburg. By the time he returned to England in 1926, his satirical bent was well established. In London, he first became known as a draughtsman and also made his name as a writer. He used many media including oil, watercolour, chalk, scraperboard, gouache and pencil, but mostly used a brush or pen. As his skill increased, he used solid blacks instead of cross-hatching — he wrote in *Epitaph* (1943) that he used "Black and white with no linear half-tones to confuse the issue, no photographic realism to frustrate the design."
Egan's work has often been compared to that of Aubrey Beardsley, but in Egan's case, the feeling of decadence is a reflection of his disgust — he wrote that "What I do is in revulsion — to shock by the power of satire!"
He aimed his satiric attacks at such persons as the Home Secretary, Sir William Joynson-Hicks, as the representative of the censorship of art and literature (in *Policeman of the Lord*). He satirized Radclyffe Hall's *Well of Loneliness* in *The Sink of Solitude*; and he made erotic drawings for his *De Sade* and other books. However, he also wrote about the theatre for *Courier* in the 1950s, wrote and illustrated for *Man About Town* in the same period, and even did commercial work for such companies as High Duty Alloys and Floris Bakeries.
Books illustrated include: P. Loüys: *Aphrodite* (Fortune Press, 1927); P.R. Stephensen: *Policeman of the Lord* (Sophistocles Press, 1928), *The Sink of Solitude* (Hermes Press, 1928); C. Baudelaire: *Les Fleurs du Mal* (Sophistocles Press/Werner Laurie, 1929); P. Loüys: *The Adventure of King Pausole* (Fortune Press, 1930); N. Balchin: *Income and Outcome* (Hamilton, 1936).
Books written and illustrated include: *Pollen: A Novel in Black and White* (Dennis Archer, 1933); *No Sense in Form* (Archer, 1933); *But the Sinners Triumph* (Fortune Press, 1934); *Epitaph: A Double-Bedside Book for Singular People* (Fortune Press, 1943);

Susan EINZIG *Tom's Midnight Garden* by Philippa Pearce
(Oxford University Press, 1958)

respected and prolific illustrator. She has contributed to *Radio Times, Picture Post, House and Garden* and to many other magazines, and illustrated many books. Her first book was Noel Carrington's *Mary Belinda and the Ten Aunts*, published in 1946; she worked on this book at night while doing war work in a factory from six in the morning to eight in the evening. When she was invalided out of war work in 1946, she met Robert Harling who gave her the first regular free-lance commission. Her illustrations for Philippa Pearce's *Tom's Midnight Garden* (1958) brought her recognition, and the book was awarded the Carnegie Medal. She was elected MSIA.

Books illustrated include: N. Carrington: *Mary Belinda and the Ten Aunts* (1946); E. Mörike: *Mozart on the Way to Prague* (Westhouse, 1946); E. Brontë: *Wuthering Heights* (Weidenfeld, 1949); A. Daudet: *Sappho* (Folio Society, 1954); R. Warner: *The Vengeance of the Gods* (MacGibbon, 1954); P. Pearce: *Tom's Midnight Garden* (OUP, 1958); B. Sleigh: *The Seven Days* (Parrish, 1958); H. Burton: *Her First Ball* (OUP, 1959); G. Avery: *In the Window Seat* (OUP, 1960); M. Love: *An Explorer for an Aunt* (Blackie, 1960); E. Spence: *Lillypilly Hill* (OUP, 1960); C. Brontë: *Jane Eyre* (Collins, 1961); E. Poston: *The Children's Song Book* (BH, 1961); E. Nesbit: *The Bastables* (Nonesuch Press, 1965).

Contrib: *Collins Magazine; Compleat Imbiber; Contact; Good Housekeeping; Homes and Gardens; House and Garden; Lilliput; Our Time; Picture Post; Radio Times; Saturday Book; She; Strand; Tatler; Vogue;* and the house magazines of ICI, British Petroleum, Yardleys, Watneys and Whitbreads.

Exhib: Mel Calman Workshop Gallery, London (one-woman show 1975); RA; Leicester Galls.

Bibl: Driver; ICB3; Jacques; Parkin; Peppin; Usherwood.

Epilogue: A Potpourri of Prose, Verse and Drawings (Fortune Press, 1943).

Contrib: *Courier; London Mystery Magazine; London Opinion; Man About Town; Rand Daily Mail; Time & Tide.*

Bibl: C. Bower Alcock: "A Satirist Amongst Us", *Arts & Crafts* 2, no. 2 (December 1928); Paul Allen: *Beresford Egan: An Introduction to His Work* (Lowestoft: Scorpion Press, 1966); Peppin.

EHRLICH, Bettina **b.1903**
Born in Vienna, Ehrlich (née Bauer) studied there at the Academy of Applied Arts, and then moved to London. She is a painter, with a strong interest in children as her subject, and she writes and illustrates her own books for children. Works under the name "Bettina".

Books illustrated include: G.S. Cèrère: *Poiuwayu and the Rainbow* (1958); V. Haviland: *Favorite Fairy Tales Told in England* (Boston: Little, Brown, 1959; BH, 1969); J. Hosier: *The Sorcerer's Apprentice* (OUP, 1960).

Books written and illustrated include: *Poo-Tsee the Water Tortoise* (Chatto, 1943); *Show Me Yours* (Chatto, 1943); *Carmello* (Chatto, 1945); *Cocolo* (Chatto, 1945); *A Horse for the Island* (Hamilton, 1952); *Angela and Rosaline* (Collins, 1957); *Pantaloni* (OUP, 1959); *Trovato* (OUP, 1960); *Paolo and Panetto* (OUP, 1960); *For the Leg of a Chicken* (Collins, 1962); *Francesco and Francesca* (OUP, 1962); *Dolls* (OUP, 1962); *Of Uncles and Aunts* (OUP, 1963); *The Goat Boy* (OUP, 1965); *Sardines and the Angel* (1967); *Neretto* (OUP, 1969); *A Day in Venice* (OUP, 1973).

Bibl: Peppin.

EINZIG, Susan **b.1922**
Einzig was born in Berlin and educated there. In 1939 she went to London, and studied at the Central School of Arts and Crafts (1939-42). She became a part-time lecturer at the Camberwell School of Art (1946-51) where both John Minton* and Keith Vaughan* were also teaching, St. Martin's School of Art (1948-51), Beckenham School of Art (1959-60), and the Chelsea School of Art (1959-65). Einzig began her free-lance career in 1945 and has become a highly

Mildred E. ELDRIDGE "Baptism in the River Ceiriog" from *Recording Britain* vol.1 (Oxford University Press, 1946)

Clifford ELLIS "Priory Place, Lyncombe Hill, Bath" from *Recording Britain* vol.4 (Oxford University Press, 1949)

ELCOCK, Howard K. **fl. 1910-1923**
See Houfe

ELDRIDGE, Mildred E. **b.1909**
Born on 1 August 1909 in London, Eldridge spent much of her
childhood in Scotland. She studied art at Wimbledon School of
Art, at the RCA, where she won a travelling scholarship in painting.
She went to Italy and studied at the British School in Rome, and to
Austria. She won the Prix de Rome (1934); and then painted
several murals including those at South Kensington, Brockley High
School and at a hospital in Oswestry, Shropshire. Some of her
illustrations, including those done for the *Recording Britain* project
in the 1940s and *The Three Royal Monkeys* (1946), seem rather
uninspired, though the reproduction of the former may be at fault.
The drawings she did for Henry Williamson's *Star-Born* (1948),
first illustrated by C.F. Tunnicliffe* in 1933 with wood-engravings,
are crisp and incisive; and the colour illustrations for the two little
children's books from the Medici Society are delightful. Elected
RWS; and member of the Society of American Mural Painters.
Books illustrated include: W. de la Mare: *The Three Royal

Monkeys (Faber, 1946); H. Leyel: *Compassionate Herbs* (Faber,
1946); T. Richards: *South Wales* (Vision of England series, Elek,
194-); *Recording Britain* (with others, four vols., OUP, 1946-9); H.
Williamson: *The Star-Born* (Faber, 1948).
Books written and illustrated include: *Gwenno the Goat* (Hart-
Davis, 1957); *In My Garden* (Medici Society); *The Sea-Shore*
(Medici, 1986).
Exhib: RA; RSA; RWS; RHA; RCamA.
Collns: V & A.
Bibl: ICB2; Peppin; Waters; Who.

ELLIS, Clifford **1907-1985**
 and Rosemary **b.1910**
Two artists who married in 1931 and collaborated, from the 1930s
on many projects including murals, posters and book jackets. They
produced some outstanding posters for London Transport, the
Empire Marketing Board, the GPO, and Shell — their "Antiquaries
Prefer Shell" initiated the "Professions" series in 1934; and murals
included those done for the British Pavilion in the Paris
International Exhibition (1937) and the entrance to the "Britain Can

Colour Plate 67. Catherine DENVIR Jacket for *The Bodysurfers* by Robert Drewe (Faber & Faber 1988)

Colour Plate 68. Marion DORN *Vathek* by William Beckford (The Nonesuch Press 1929)

Colour Plate 70. Clifford and Rosemary ELLIS Cover for *Dartmoor* by L.A. Harvey and D.St. Leger-Gordon ("New Naturalist" series, Collins)

Colour Plate 69. Simon DREW "Parrot eyes lost . . . Parrot eyes regained" Original drawing in pen and ink, watercolour and crayon. By permission of Chris Beetles Limited

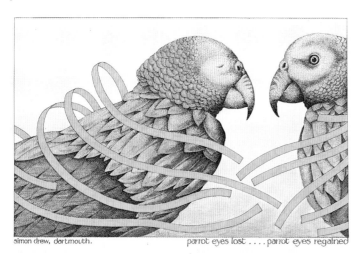

Colour Plate 71. Ronald FERNS — "Alice Versary", 1959 Guinness Gift Book. (By permission of Guinness Brewing G.B.)

Colour Plate 72. Barbara FIRTH Illustration from *We Love Them*. Text © 1990 Martin Waddell. Illustrations © 1990 Barbara Firth (first published by Walker Books Limited in the UK)

Make It" exhibition at V & A (1946). From 1945 to 1982, the Ellises designed nearly 100 jackets for Collins's "New Naturalist" series and related monographs. This work in watercolour and gouache is very distinctive and, together with the Batsford books of Brian Cook*, filled bookshops and libraries with a mass of well-designed examples of the art of the book jacket. Clifford Ellis contributed three paintings of Bath to the *Recording Britain* project in the 1940s. For twenty years from 1946, they concentrated their energies on the Bath Academy of Art which was established for the education of art teachers.

Books illustrated include: *Recording Britain* (with others, four vols., OUP, 1946-9).
Published: *Modelling for Amateurs* (Studio, 1939).
Bibl: *Landscape in Britain 1850-1950* (Arts Council, 1983); Ian Jeffrey: *The British Landscape 1920-1950* (T&H, 1984).
Colour Plate 70

ELLIS, Edwina N. b.1946
Born on 14 May 1946 in Sydney, Australia, Ellis was educated at Manly Girls School, Sydney, and trained and practised in Australia as a designer-jeweller before coming to England and settling in London in 1972. She studied at Sir John Cass College, continuing to work in metal, before she took two summer courses on wood engraving under Simon Brett*. Since 1982, she has concentrated on wood engraving and most recently has specialized in coloured engravings; she published a boxed set of five prints from *The Maxims of the Duc de la Rochefoucauld* in 1986; and in 1987, produced *Garden Prigs* as cards, posters, a concentina-fold book, and a limited edition set of prints. She designed six book jackets for Faber in 1985. Elected SWE.

Books illustrated include: *Batrachomyomachia; or, The Battle of the Frogs and Mice* (Libanus Press, 1985?); *The Maxims of the Duc de la Rochefoucauld* (1986).
Books written and illustrated include: *Animal Alphabet* (Libanus Press, 1982); *Picture Book of E.N. Ellis* (Carr, 1985); *Garden Prigs* (Barbican Editions, 1987).
Contrib: *Matrix.*
Exhib: RA; RE; SWE.
Bibl: Edwina Ellis: "A Morroccan Diary", *Matrix* 7 (1987): 16-18; *Engraving Then and Now* (SWE, 1987?); Brett; Who.

ELLIS, Lionel b.1903
Born on 7 February 1903 in Plymouth, Ellis studied at Plymouth School of Art (1918-22), at RCA under Sir William Rothenstein (1922-25), and in Paris, Florence and Rome. He exhibited at the RA, NEAC, and NS (and was elected to the NS in 1930). He was a lecturer in painting at Wimbledon School of Art (1937-68).
He illustrated a few books, mostly for the Fanfrolico Press of Jack Lindsay. His best work in this field may be the ten collotype plates (printed at the Curwen Press) of warm and soft nude figures, a mixture of Rubens and Henry Moore, which illustrate *Delighted Earth*, a selection from Herrick's "Hesperides". He used woodcuts for *Theocritus* and *Daphnis and Chloe*, in which book his large figures show an unrefined, peasant antiquity.

Books illustrated include: R. Herrick *Delighted Earth* (Fanfrolico Press, 1927); Theocritus: *Complete Poems* (Fanfrolico Press, 1929); *The Complete Poetry of Catullus* (Fanfrolico Press, 1929); Longus: *Daphnis and Chloe* (Daimon Press, 1948).
Contrib: *London Aphrodite.*
Exhib: RA; NEAC; NS.
Bibl: Jack Lindsay: *Fanfrolico and After* (Bodley Head, 1962); Peppin; Waters; Who.

ELLISON, Pauline b.1946
Pauline Ellison was born in Keighley, Yorkshire, and educated at Keighley Grammar School. She studied art at Bradford and at the Cambridge Art School. In 1967 she came to London and began a free-lance career. She has contributed to *Radio Times* and many other magazines, and illustrated a few books.
Books illustrated include: *Trial* (Heron Books); *A Love of Flowers*; R. Carlyon: *The Dark Lord of Pengersick* (Deutsch, 1976); *Grimm's Fairy Tales* (Routledge, 1981)
Contrib: *Good Housekeeping; Harpers; Nova; Observer; Radio Times; Sunday Times; Times Saturday Review; Welcome Aboard Magazine—BOAC.*
Bibl: Driver.

ELLSWORTH, Roy b.1940?
Born in Australia, Ellsworth was educated at Brighton Grammar School, Melbourne. He worked first as a sign writer, and then joined *Home Beautiful* to do architectural studies and general illustration. He went to live in London in 1964, and worked at a general art studio until 1969. He married, lived in Greece for six months, and then in Amsterdam (1972-74) where he started working as a free-lance artist. He has designed covers for Penguin Books and contributed illustrations to a number of magazines, including a cover for the *Economist* (1976), which depicts Kissinger as the Statue of Liberty.
Contrib: *Economist; Observer Magazine; Penthouse; Der Spiegel; Stern; Sunday Times Magazine.*
Bibl: Fred Metcalf: ["Roy Ellsworth"] *Novum Gebrauchsgraphik* (1981, No. 11): 28-35.

ELVERY, Beatrice Moss (Lady Glenavy) (1883-1970)
See Houfe

EMETT, Rowland 1906-1990
Born on 22 October 1906 in London, Emett showed his father's enthusiasm as an inventor and registered his first patent when he was thirteen. He also wanted to be a landscape painter, and studied at the Birmingham School of Arts and Crafts, and then in the 1930s worked for a process engraver's studio in Birmingham. He started contributing to *Punch* in 1939, first with realistic drawings of subjects directly related to the early days of WW2, but soon developed his own special style which marked "the return of the decorative tradition and [expressing] some of the wartime nostalgia for fantasy and detail and the past. His derelict railway stations, pleasure

Rowland EMETT "None of my guests have ever actually asked me to prove the statement, but . . ." Pen and ink drawing with bodycolour. By permission of Chris Beetles Limited

steamers in Cornish coves and gipsies by gnarled copses had a passion behind them that gave them wide appeal." (Price.) However, he began to be pressured, by the very popularity of his drawings of railway engines and stations, to restrict his work to that one subject, and he struggled to avoid this, refusing to draw a train for *Punch* for more than a year.

He started making three-dimensional, "Gothick-Kinetic" (as he calls them in *Who's Who*) working models of elaborate and fanciful inventions. His design for the railway at the Battersea Pleasure Gardens for the Festival of Britain in 1951 made him world famous — there was magazine and newspaper coverage in fifty-eight countries. In 1953, Emett and his wife travelled throughout the United States for *Life* magazine, and produced twelve pages of colour illustrations and the front cover for the 5 July 1954 edition.

The incredible success of the Far Tottering and Oyster Creek Railway in 1951 led to a succession of increasingly complex inventions which have been exhibited all over the world. This trend continued with the models he built for the film *Chitty-Chitty Bang-Bang* in 1968 (the contraptions were not made at United Artists studios but at a 200 year-old blacksmith's forge which was operated by Emett and fifteen local craftsmen); and with a number of permanent constructions, the first of which was "The Rhythmical Time Fountain" for the City of Nottingham. His models have been compared to the contrivances illustrated by W. Heath Robinson*, but Emett's work is much more delicate and elegant and Edwardian. The *South African Financial Times*, in an article published during the Emetts' tour in 1975, commented "The joy of Emett's THINGS is that they are utterly non-functional. Baroque, glittering and moving in time to music, their curliques and wheels gracefully parody the real world of functional engineering."

Emett worked in other fields also, designing murals and advertisements, painting and making lithographs, and illustrating books and book jackets. Though some of Emett's early book illustrations in de la Mare's *Bells and Grass* (1941) have the charm and whimsy of John Nash*, normally the world he draws is fantastic, "centred nearly always on some mechanical freak, ... a recognisable world in which the wildest devices can be seen to work, and in which his spindled-shanked characters, quiet but self-important people, are clearly figures spilled over from the Edwardian period and remembered with affection from his boyhood." (Keown, 1952.†) FSIAD; awarded OBE in 1978. Emett died on 13 November 1990.

Books illustrated include: W. de la Mare: *Peacock Pie* (Faber, 1941), *Bells and Grass* (Faber, 1941); *Hobby Horses* (Guinness, 1958); *Make Your Own Scotch Whisky* (Glasgow: Teacher, 1981).

Books written and illustrated include: *Engines, Aunties and Others* (Faber, 1943); *Sidings and Suchlike* (Faber, 1946); *Home Rails Preferred* (Faber, 1947); *Saturday Slow* (Faber, 1948); *Buffer's End* (Faber, 1949); *Far Twittering* (Faber, 1949); *High Tea, Infused by Emett* (Faber, 1950); *The Forgotten Tramcar* (Faber, 1952); *Nellie Come Home* (Faber, 1952); *New World for Nellie* (NY: Harcourt, Brace, 1952); *The Early Morning Milk Train* (Murray, 1976); *Alarms and Excursions* (Murray, 1977); *Emett's Ministry of Transport* (Penguin, 1981).

Contrib: *Cosmopolitan; Holiday; Life; Mademoiselle; Punch; This Week.*

Exhib: RA; NEAC; Beetles (1988); Smithsonian Museum (1991).

Collns: V & A; Tate; "contraptions" at Ontario Science Centre, Toronto; Chicago Museum of Science and Industry; Smithsonian Museum of Air and Space, Washington.

Bibl: Jacqui Grossart: *Rowland Emett: From "Punch" to "Chitty-Chitty-Bang-Bang" and Beyond* (Chris Beetles, 1988); Eric Keown: "Emett", *Graphis* 8, no. 42 (1952): 292-301; Amstutz 2; ICB; Peppin; Price; Who; Who's Who.

"EMMWOOD", John Musgrave-Wood b.1915

John Musgrave-Wood, who always signed his work "Emmwood", was born in Leeds. He was educated at Leeds Modern School, and studied at Leeds College of Art. He became a ship's steward and then took part in the Burma campaign during WW2. After the war he studied at Goldsmiths' College at the same time as he was making a reputation as a cartoonist on the *Tatler*. He joined the *Daily Mail* in 1957, for a short time as the editor of the *Junior Express*, and became the paper's political cartoonist. He was also a regular contributor to *Punch*, illustrating Bernard Hollowood's television

and radio column. He retired in 1975, and took up painting in oils.

Contrib: *Daily Mail; Evening Standard; Punch; Sunday Dispatch; Tatler.*

Collns: University of Kent, Canterbury.

Bibl: *The Illustrators: Catalogue* (Chris Beetles Ltd., 1991); *Getting Them in Line: An Exhibition [of Cartoons]* (Centre for the Study of Cartoons and Caricature, University of Kent, 1975); Bateman; Price.

ENGLEFIELD, Cicely b.1893

Born on 29 June 1893 in London, Englefield was educated at Maidstone Grammar School and Blackheath High School before studying art at St. Martin's School of Art and the Central School of Arts and Crafts. Mostly interested in natural history subjects, she started illustrating stories in children's annuals, and later concentrated on illustrating her own books and stories. Her favourite medium was wood engraving but she also used pen and ink, watercolour and lithography.

Books written and illustrated include: *George and Angela* (Murray, 1932); *Katie the Caterpillar* (Murray, 1933); *Billy Winks* (Murray, 1934); *The Tale of a Guinea Pig* (Murray, 1935); *A House for a Mouse* (Murray, 1936); *Squishy Apples* (Murray, 1937); *Bennie Black Lamb* (Murray, 1938); *Connie the Cow* (Murray, 1939); *Jeremy Jack, the Lazy Hare* (Murray, 1940); *Burt the Sparrow* (Muller, 1941); *Monty the Frog* (Murray, 1941); *Feather the Foal* (Murray, 1942); *The Tale of a Tadpole* (Murray, 1945); *In Field and Hedgerow* (Hollis & Carter, 1948); *Scruffy the Little Black Hen* (Murray, 1948); *Stories of an Old Grey Wall* (Evans, 1958).

Bibl: ICB; Peppin.

ENNION, Eric Arnold Roberts 1900-1981

Born 7 June 1900 in Ketteringham, Norfolk, Ennion was educated privately and then at Perse School, Cambridge, and Epsom College (1914-18). He studied medicine at Caius College, Cambridge and St. Mary's Hospital, Paddington (1918-26), and in 1926 joined his father's practice in Burwell, Cambridgeshire. He began studying birds seriously and drawing them, though he had no formal art training and his style of painting developed from his observations of nature. In 1945 he left practising as a doctor and became the first Warden of Flatford Mill Field Study Centre in Suffolk, and from then on devoted his life to the study of nature and to art, with water birds his particular interest. After five years he moved to Monks' House at Seahouses on the Northumberland coast where he ran his own field study courses. His last move was in 1961 when he went to Shalbourne in Wiltshire, helped to run his son's watercress farm and continued his courses until his death.

Ennion was very much a part of the post-WW2 revival of interest in nature, was a pioneer in bird observatory work, wrote many books and articles on natural history and broadcast regularly on nature programmes for the BBC. He was the first chairman of the executive committee of the Society of Wildlife Artists.

Books illustrated include: R. Morse: *Life in Pond and Stream* (OUP, 1945); E.A. Armstrong: *Bird Life* (Drummond, 1949); B. Vesey-Fitzgerald: *British Bats* (Methuen, 1949); J.R. Garrood: *Archaeological Remains* (Methuen, 1949); M. Sisson: *Country Cottages* (Methuen, 1949); J. Fisher: *The Shell Bird Book* (Joseph, 1966); G. Allen and J. Denslow: *Birds* (OUP, 1968); J. Craster: *Naturalist in Northumberland* (Hale, 1969); N. Tinbergen and H. Falkus: *Signals for Survival* (OUP, 1970).

Books written and illustrated include: *The Animal World. Its Attack and Defence* (Tuck, c.1941); *Adventurers Fen* (Methuen, 1942); *The British Bird* (OUP, 1943); *The Story of Migration* (Harrap, 1947); *Life on the Sea Shore* (OUP, 1948); *The Lapwing* (Methuen, 1949); *Cambridgeshire, Huntingdonshire and the Isle of Ely* (Hale, 1951); *Bird Study in a Garden* (Puffin Picture Book, 1958); *The House on the Shore* (Routledge, 1960); *Birdwatching* (Pelham Books, 1963); *Tracks* (with N. Tinbergen, OUP, 1967).

Contrib: *Birds; East Anglian Magazine; Farm and Country; Field.*

Exhib: Greatorex Galleries (1937); Ackermann Galleries (1945, 1959); SWA; Sladmore Gallery (1972); Marler Gallery, Ludlow (1977-8).

Bibl: John Busby: *The Living Birds of Eric Ennion* (Gollancz, 1982); Hammond.

EPSTEIN, Sir Jacob **1880-1959**

Born 10 November 1880 in New York, Epstein began drawing in childhood. He studied at the Art Students League in the late 1890s and, on the proceeds made from illustrating *The Spirit of the Ghetto* (1902), went to Paris where he spent six months at l'Ecole des Beaux-Arts, and afterwards studied at the Académie Julian. He settled in London in 1905, becoming a British citizen in 1911. Though he did some painting and illustrating, his claim to fame is as a controversial monumental and portrait sculptor, his first commission being to carve eighteen figures for the headquarters of the British Medical Association in London (1907-8) which provoked an intense attack on their nudity. The sculptor was even required to appear before an enquiry by the BMA, which the DNB says was "reminiscent of the appearance of Veronese before the Inquisition in 1573." His later sculptures also drew attacks, one of his main critics being Roger Fry. He was rejected as a candidate for membership of the Royal Society of British Sculptors (c.1910) and later by the RA when proposed by Sir John Lavery. However, after his sculpture of Lazarus was bought by New College, Oxford, in 1952, he received more commissions for large sculptures than he could execute.

He was a founder-member of the London Group in 1913, the same year as his first one-man exhibition at the Twenty-One Gallery, Adelphi. He made many public sculptures, including "Night" and "Day" for St. James's Underground Station (1928-29); held many exhibitions at the Leicester Galleries. He was a painter as well as a sculptor, and most of his exhibitions sold out. He illustrated a few books only, but his drawings for the *Old Testament* and for Baudelaire's *Les Fleurs du Mal* were not well received.

He received an honorary LLD from Aberdeen University (1938), and hon. DCL at Oxford in 1953; and was knighted in 1954. He died in London on 19 August 1959.

Books illustrated include: H. Hapgood: *The Spirit of the Ghetto* (Funk & Wagnalls, 1902); *The Old Testament* (1929-31); M. Oyved: *The Book of Affinity* (Heinemann, 1933); C. Baudelaire: *The Flowers of Evil* (NY: Limited Editions Club, 1940).

Contrib: *Blast.*

Exhib: LG; Twenty-One Gallery (1913); Leicester Galls; Temple Newsam, Leeds (retrospective 1942); Tate (retrospective 1952, 1961); Edinburgh Festival (retrospective 1961); Whitechapel (1987).

Collns: Tate.

Bibl: Robert Black: *The Art of Jacob Epstein* (Cleveland: 1942); Richard Buckle: *Jacob Epstein: Sculptor* (Faber, 1963); Jacob Epstein: *An Autobiography* (Hulton Press, 1955); Compton; DNB; Peppin; Tate.

EVANS, Powys **fl. 1920s-1930s**

Evans studied at the Slade, under Richard Sickert and Sylvia Gosse, before serving in the Welsh Guards during WW1. He drew caricatures of his regimental comrades and, after the war, exhibited in 1922 a series of pen and ink caricatures of the actors in a revival of *The Beggar's Opera*, and published them in a portfolio. A review in the *Christmas Bookman* for 1922 declared that "here is sure draughtsmanship, a delicate sense of line and balance, ... a caricaturist of rare humour and sensibility and a true artist." His work also appeared in *The Golden Hind* in 1923, and he produced a whole series of caricature portraits for the *Saturday Review*, which were collected and published in book form in 1926. Simultaneously he was drawing whole page portraits, not caricatures, for the *London Mercury*, a series which lasted for nine years. Evans also painted landscapes and portraits, and exhibited in various London galleries.

Books illustrated include: John Gay: *The Beggar's Opera* (Palmer, 1922).

Books written and illustrated include: *Eighty-Eight Cartoons* (Cayme Press, 1926); *Fifty Heads* (Sheed & Ward, 1928).

Contrib: *Bookman; Everyman; G.K.'s Weekly; Golden Hind; John O'London; London Mercury; Saturday Review; Time and Tide.*

Exhib: NEAC; Bumpus (1931); Cooling Gallery; Goupil Gallery.

Bibl: H.R. Westwood: *Modern Caricaturists* (Lovat Dickson, 1932).

EVANS, Treyer Meredith **b.1889**

Born in Chichester, Evans worked as a commercial illustrator for Pearson and Hulton (1909-10). "He was a bright, stylish illustrator

Powys EVANS Caricature from *Golden Hind* vol.1 no.2 (January 1923) p.29

who worked in pen and ink or pencil, often with broad expanses of shading." (Peppin.)

Books illustrated include: A. Brazil: *Loyal to the School* (Blackie, nd), *A Fortunate Term* (Blackie, 1921), *Monitress Merle* (Blackie, 1922); F. Inchfawn: *Will You Come As Well?* (Ward Lock, 1931), *The Verse Book of a Garden* (Ward Lock, 1932); E. Blyton: *The Christmas Book* (Macmillan, 1944); A. Armstrong: *England Our England* (Dakers, 1948); G. Trease: *The Hills of Varna* (Macmillan, 1948); E. Blyton: *The Mystery of the Strange Bundle* (Methuen, 1952), *The Mystery of Holly Lane* (Methuen, 1953), *The Mystery of Tally-Ho Cottage* (Methuen, 1954); M.E. Procter: *Three Wise Men* (Blandford Press, 1958).

Contrib: *Girls' Realm; The Humorist; Little Folks; London Magazine; Punch; Scout; Sketch; Strand; Tatler.*

Bibl: Peppin.

EVE, Esmé Frances Olive **b.1920**

Born on 13 September 1920 in Sydenham, Eve was educated at Wallington County School, and studied at Croydon School of Art (1937-41) and RCA (1941-44). She was a part-time lecturer in colleges of art, and a free-lance book illustrator, and a textile and general designer. She has contributed illustrations to several magazines and annuals, designed book jackets, produced greeting cards for the Medici Society, J. Arthur Dixon, and various charities, and designed fabrics for Simpson & Godlee, the Cotton Board, and others. She has been influenced by the work of Edward Bawden*, Eric Ravilious* and Eric Fraser*.

Books illustrated include: *Little Red Steamer* (Methuen, 1941);

Stumpy Sings on Wednesdays Too (Nelson, 1949); *Cross River Tales* (two vols., Nelson, 1949); *Caterpillar Capers* (Nelson, 1950); *The Disobedient Cuckoo Clock* (Nelson, 1950); *The Drum* (Longman, 1957); *Mother Goose Nursery Rhymes* (Blackie, 1957); *Cookery for Schools* (Blackie, 1961); *The Flower Lover's Miscellany* (Warne, 1961); *Merry Are the Bells* (Blackie, 1961); *The Mystery Garden* (ULP, 1963); *366 Goodnight Stories* (with others; Hamlyn, 1963); *Poetry Panorama* (four vols., Odhams, 1964); *Thumberlina* (Nelson, 1964); *First Book of Bible Stories* (Nelson, 1966); *First Book of Hans Andersen Stories* (Nelson, 1966); *The Toy House* (O & B, 1966); *Wolf Baby* (O & B, 1966); M. Burton: *The Animal World* (NY, Watts, 1968); *More Animals* (OUP, 1968); B.H. Steinberg: *The Magic Millstones* (OUP, 1969); P. Osborne: *Macdonald Starters-Farms, Trees, Cats, Rivers, Eggs, Birds* (Macdonald, 1971-2); J. Vaughan: *Sea and River Animals* (Macdonald, 1973); S. Swallow: *Insects and Reptiles* (Macdonald, 1974), *Tame Animals* (Macdonald, 1974); A. Jack: *Witches and Witchcraft* (NY: Watts, 1980).

Books written and illustrated include: *We Are Here* (Hamlyn, 1962); *I Can See You* (Hamlyn, 1963); *Weatherwise* (Hamlyn, 1964); *The Christmas Book* (Chatto, 1970).

Contrib: *Animal Annual; Britannia & Eve; Collins Annual; Daily Sketch Modern Girl Annual; Pussy Cat William Annual; Streatfeild's Ballet Annual; Zoo Time Annual.*

Bibl: Who (1950); IFA.

EVERETT, Ethel Fanny fl. 1900-1939
See Houfe
Books illustrated include: C. Kingsley: *The Water Babies* (1910); M. Dowson: *Elizabeth Ann's Delight* (1922); E. Blyton: *Silver and Gold* (1927); *Old Fairy Tales* (1927); *Old Nursery Rhymes* (1927); L.G. Eady: *Elizabeth's Book* (1928); R. Fyleman: *Old-Fashioned Girls* (1928).

Contrib: *Aunt Judy's Magazine; The Jolly Book.*
Bibl: Peppin.

EXELL, Fred R. fl. 1954-
Excell's style of illustration has the precision of an engraving, particularly in his earlier work. His subject matter is often historical.
Books illustrated include: D. Suddaby: *Village Fanfare* (OUP, 1954); J.M. Falkner: *Moonfleet* (Arnold, 1954; Puffin, 1962); J. Chipperfield: *A Dog Against Darkness* (Heinemann, 1963); R.L. Stevenson: *Kidnapped* (Ginn, 1964); G. Symons: *The Rose Window* (Heinemann, 1964); *The Quarantine Child* (Heinemann, 1966); K. Fidler: *Flodden Field September 9, 1513* (Lutterworth, 1971), *The '45 and Culloden* (Lutterworth, 1973).

Contrib: *Radio Times; Saturday Book.*
Bibl: Peppin; Usherwood.

EYLES, D.C. d.1975
An illustrator of books and annuals for boys.
Books illustrated include: J.R. Crossland: *The Children's Wonder Book* (with others, Odhams, 1934); *The Golden Wonder Book* (with others, Odhams, 1934); *The Big Christmas Wonder Book* (with

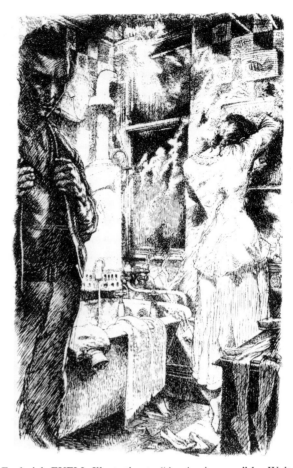

Frederick EXELL Illustration to "An Anniversary" by Walter de la Mare in *Saturday Book* 12 (Hutchinson, 1952)

others, Odhams, 1936); P. Westerman: *The Mystery of Nix Hall* (1950); J. Rowan: *Rufus the New Forest Pony* (Warne, 1967); *Selfridge's Schoolboys' Story Book* (with others; nd); *Thrilling Air Stories* (with others; nd).

Contrib: *Big Budget; Boys; Blackie's Boys Annual; Champion Annual; Chums; Holiday Annual; Little Folks; Scout.*
Bibl: Doyle BWI; Peppin.

FALCONER, Pearl

fl.1945-

Born in Dundee, Falconer studied art at St. Martin's School of Art and then painting under Bernard Meninsky at the Central School of Arts and Crafts. She began her career doing fashion drawings, her first commissions being for newspapers — *New York Times, New York Herald Tribune* and later for the British dailies. She became interested in illustrating stories in magazines; in murals — three pavilions at the Festival of Britain in 1951 contained her work; and then in book illustration, mostly for children. Her style is somewhat reminiscent of Osbert Lancaster*, particularly in her black and white line drawings with their solid blacks and a humorous undertone. FSIA.

Books illustrated include: H. Phillips: *Ask Me Another* (Ptarmigan Book; Penguin, 1945); H. Phillips: *Meet William Shakespeare* (Cornleaf Press, 1949); *The Hubert Phillips Annual* (Hamilton, 1951); B.W. Aldiss: *The Brightfount Diaries* (Faber, 1955); N.S. Carson: *The Happy Orpheline* (Blackie, 1960); P. Farmer: *The China People* (Hutchinson, 1960); M. Treadgold: *The Winter Princess* (Brockhampton, 1962); N.S. Carson: *The Orphelines in the Enchanted Castle* (Blackie, 1963), *A Pet for the Orphelines* (Blackie, 1963).

Contrib: *Harpers; Housewife; Listener; New York Herald Tribune; New York Times; Radio Times; Saturday Book.*

Bibl: ICB3; Jacques; Peppin; Ryder; Usherwood.

FANTONI, Barry

b.1940

Born in East London of an Italian father and a Jewish mother, Fantoni studied at Camberwell School of Art (1953-58). A pop painter rather than a cartoonist, he collaborated with William Rushton* on a painting which showed a bishop, a judge and a general reading a "girlie" magazine. It was entered under a false name, and accepted, for the RA show. His illustrations for *Private Eye* are satirical pop portraits and he contributed to the *Radio Times* in the 1970s. He wrote for the satirical TV revue "That Was the Week That Was" in 1963; and now concentrates on writing, his detective story, *Mike Dime*, being published in 1980.

Books illustrated include: R. Ingrams: *The Bible for Motorists* (Walton-on-Thames: Hobbs, 1970); G. Melly: *The Media Mob* (Collins, 1980).

Pearl FALCONER Illustration to "The Spring" by Alison Uttley in *Saturday Book* 8 (Hutchinson, 1948)

Books written and ilustrated include: *100 Best Jokes of Barry Fantoni* (Deutsch, 1975); *Book of Cartoons* (Deutsch, 1977); *The Times Diary Cartoons* (Blond, 1984); *Barry Fantoni's Chinese Horoscopes* (Sphere, 1985).

Contrib: *Cosmopolitan; Listener; Observer; Private Eye; Radio Times; Times.*

Exhib: RA.

Bibl: Bateman; Driver; Feaver.

FARJEON, Joan Jefferson **b.1913**

Born on 26 May 1913 in London, Farjeon was educated at Lindores School, Bexhill, and studied at Westminster School of Art. She was a professional stage designer and scene painter for many years, first at the Westminster Theatre in London and then for repertory theatre with touring companies. During WW2 she worked on the land and then returned to the West End theatre, designing many productions, including *Song of Norway* and *Dear Miss Phoebe*. The first book she illustrated was one by her cousin, Eleanor Farjeon, the well-known writer for children. With her friend, Nicholas Gray, she founded the London Children's Theatre in 1950. For over twenty years, she designed the sets and costumes for the plays written by Gray, and illustrated his books and plays for children.

Books illustrated include: E. Farjeon: *Grannie Grey* (Dent, 1939); N.S. Gray: *Beauty and the Beast* (OUP, 1951), *The Tinder-Box* (OUP, 1951), *The Princess and the Swineherd* (OUP, 1952), *The Hunters and the Henwife* (OUP, 1954), *The Marvellous Story of Puss in Boots* (OUP, 1955), *The Imperial Nightingale* (OUP, 1957), *New Clothes for the Emperor* (OUP, 1957), *The Other Cinderella* (OUP, 1958), *The Seventh Swan* (Dobson, 1958), *The Stone Cage* (Dobson, 1963), *New Lamps for Old* (Dobson, 1968).

Bibl: ICB2; Peppin.

FARLEIGH, John **1900-1965**

Born on 16 June 1900 in London (and christened Frederick William Charles — he used John after 1927), Farleigh was educated at St. Mary Abbots, Kensington. In 1914 he was apprenticed for five years to the Artists Illustrators Agency in Balham. He started evening study at the Bolt Court School Life Classes, and after war service and completing his apprenticeship studied at the Central School of Arts and Crafts under Bernard Meninsky and Noel Rooke* (1919-22). From 1922 to 1925 he was an art teacher at Rugby School, and from 1925 taught at the Central School, becoming Head of the Book Production Department in 1947. During the 1940s he was director of the Sylvan Press; Chairman of the Arts and Crafts Exhibition Society (1940-46); and Chairman of the Crafts Centre of Great Britain (1950-64).

Best known as a book illustrator, Farleigh painted landscapes and figure studies and murals, designed postage stamps and a number of posters for London Transport, and did a great deal of textile design. He exhibited at the RA from 1937 and held a number of one-man shows at the Leicester and Lefevre galleries. He produced a large number of book jackets and did some magazine illustration, including several covers for *The Listener*. In his autobiographical text-book, *Graven Image* (1940), Farleigh wrote that he had "no original intention of becoming a book illustrator myself, and [do] not even to this day [consider] myself a professional". In the same book he wrote that he "stumbled on wrappers partly by accident." Nevertheless, he did much illustrative work for publishers, and many wrappers. He worked for many publishers, including private presses like the Golden Cockerel Press and the Shakespeare Head Press, and for commercial publishers such as Dent, Constable and Faber.

Wood engraving became Farleigh's favourite illustrative technique, although he did work in other media. Noel Rooke was largely responsible for the revival of wood engraving in the twentieth century, and John Farleigh had been one of his early and significant students. Farleigh made his reputation with the widely acclaimed wood engravings for Bernard Shaw's *The Adventures of the Black Girl in Her Search for God*, published by Constable in 1932. The book was an example of fine printing and design from a general publisher. It was very popular and the first printing was soon exhausted, so that five further reprints followed over the next few months. Despite the popularity of this work, Farleigh admits in *Graven Image* that he was hampered somewhat by having to keep the final engravings close to the original drawings in order to satisfy Shaw.

The Man Who Died by D.H. Lawrence appeared with Farleigh's illustrations in 1935. Monica Poole writes that "working on this book was probably one of the most satisfactory experiences of John Farleigh's life as an illustrator." (Poole, 1985.†) He worked closely with the typographer, J.H. Mason, and the result was a fine piece of book production. Farleigh worked in lithography to make the illustrations for Sacheverell Sitwell's *Old Fashioned Flowers* (1939),

and used pen drawings for several books, including Christina Hole's *Haunted England* (1940.) Some of his later work shows his attempts to combine contemporary trends towards abstraction and surrealism with the more realistic, illustrative tradition, attempts which were not always successful.

In addition to *Graven Image*, Farleigh wrote or edited a number of books on wood engraving and other arts and crafts. These include *Fifteen Craftsmen on Their Crafts* (Sylvan Press, 1945); *It Never Dies; A Collection of Notes and Essays* (Sylvan Press, 1946); *Engraving on Wood* (Dryad Press, 1954); and *Design for Applied Decoration in the Crafts* (Bell, 1959.)

Farleigh was elected SWE (1925); ARE (1927), and RE (1948). He was also a member of RBA, LG and SMP. He was awarded two diplomas for his designs for Green Line posters by the International Poster Exhibition in Vienna. For his work in founding the Crafts Centre of Great Britain, he received the CBE in 1949. He died on 30 March 1965.

Books illustrated include: J. Swift: *Selected Essays* (only vol. 1 publ., GCP, 1925); *Odes of Pindar* (two vols., Oxford: Blackwell, 1928-30); Bede: *History of the Church of England* (Oxford: Blackwell, 1930); *The Whole Works of Homer* (five vols., Shakespeare Head Press, 1930-31); G.B. Shaw: *Adventures of the*

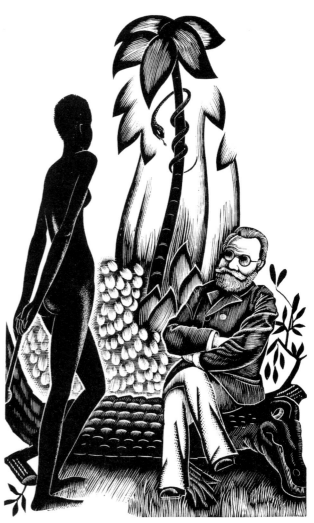

John FARLEIGH *The Adventures of the Black Girl in Her Search for God* by George Bernard Shaw (Constable, 1932)

Wally FAWKES ("TROG") Cartoon from *Punch* 24 November 1976

Black Girl in Her Search for God (Constable, 1932); C. Hamilton: *Little Arthur's History of the 20th Century* (Dent, 1933); W. de la Mare: *Stories from the Bible* (Faber, 1933); S. Butler: *The Way of All Flesh* (Collins, 1934); C. Houghton: *Three Fantastic Tales* (Joiner & Steele, 1934); H. Martinsson: *Cape Farewell* (Cresset Press, 1934); C. Owen: *Before Bethlehem* (Athenaeum Press, 1934); G.B. Shaw: *Short Stories, Scraps and Shavings* (Constable, 1934), *Prefaces* (Constable, 1934); *The Story of David* (Black, 1934); D.H. Lawrence: *The Man Who Died* (Heinemann, 1935); J. Lindsay: *Storm at Sea* (GCP, 1935); E. Armitage: *A Country Garden* (Country Life, 1936); W.J. Brown: *The Gods Had Wings* (Constable, 1936); M. Goldsmith: *John the Baptist: A Modern Interpretation* (Barker, 1936); E. Pargeter: *Hortensius, Friend of Nero* (Dickson, 1936); H.H. Marks: *Pax Obbligato* (Cresset Press, 1937); A.N. Tucker: *The Disappointed Lion* (Country Life, 1937); *This Is the Way* (Dent, 1937); G.B. Shaw: *Back to Methuselah* (NY: Limited Editions Club, 1939); S. Sitwell: *Old Fashioned Flowers* (Country Life, 1939); C. Hole: *Haunted England* (Batsford, 1940); R. Turnor: *The Spotted Dog; A Book of English Inn Signs* (Sylvan Press, 1948); G. Daniell: *God's Blanket* (Batchworth Press, 1953); W. Shakespeare: *The Histories* (NY: Heritage Press, 1958); Aeschylus: *Prometheus Bound* and P.B. Shelley: *Prometheus Unbound* (NY: Limited Editions Club, 1965; NY: Heritage Press, 1966).
Contrib: *Listener; London Mercury; Strand Magazine; Time and Tide.*
Exhib: Leicester Galls; Lefevre Gallery; Batsford Gallery; Ashmolean (1986).
Bibl: *John Farleigh: Wood Engravings.* (Ashmolean Museum, 1986); John Farleigh: *Graven Image* (Macmillan, 1940); Monica

Poole: *The Wood Engravings of John Farleigh* (Gresham Books, 1985); Deane; Garrett 1 & 2; Peppin; Waters; Who Was Who.

FARRAR, Mildred fl.1937
The only illustrations which Farrar appears to have produced are coloured linocuts for a Nonesuch edition of Milton's *The Mask of Comus* (1937). As Meynell wrote, the linocuts have "much of the richness of a Jacobean tapestry". Farrar is believed to have died during WW2.
Books illustrated include: J. Milton: *The Mask of Comus* (Nonesuch Press, 1937).
Bibl: John Dreyfus: *A History of the Nonesuch Press* (Nonesuch Press, 1981).

FAWKES, Wally ["TROG"] b.1924
Born in Vancouver, Fawkes came to England in 1931 with his family. He studied at Sidcup School of Art (1938-39) but had to abandon his studies for financial reasons and worked in a camouflage factory during WW2 until it was bombed. He then worked for the Coal Commission in Victoria and won an art competition for employees, judged by the distinguished cartoonist, Leslie Illingworth*, who later arranged for Fawkes to be employed by the *Daily Mail* as a graphic artist. He almost immediately adopted the pen name "Trog" which he took from a jazz band with which he played the clarinet, known as "The Troglodytes". He is an outstanding jazz musician, playing with Humphrey Littleton's band from 1948 to 1956, before giving up because of shyness and claustrophobia.
"During Trog's early days at the *Daily Mail* Illingworth was . . . an inspiration . . . He taught Trog about techniques and materials and communicated an enthusiasm for craftsmanship for its own sake." (Whitford, 1987.†) Other artists influenced Hawkes, including John Minton* who taught him as a part-time student at Camberwell College of Art (1947). At the *Daily Mail*, his work soon extended to producing a daily comic strip before becoming the paper's chief political cartoonist. The main character of the strip, Flook, was a strange but loveable creature with a trunk, large ears and round eyes and a tightly-curled coat. The strip was incredibly popular and ran for thirty-five years from 1949 to 1984; and even now it continues to appear if only as a two-frame political cartoon in the *Sunday Mirror*. Over the years, other artists had been involved in the story writing and the drawing for the strip, including Fawkes' jazz friends, Humphrey Littleton and George Melly. Jacques wrote in 1963 that the "Flook" strip "has been consistently brilliantly drawn for fifteen years. His incisive line and unfailing wit have weathered a decade of deadlines and a multiplicity of script-writers and still shows no signs of flagging."
After "Flook" had been running for some ten years, Fawkes was invited to contribute political cartoons to the *Spectator*, *Observer* and other papers. His work also appeared occasionally in *Private Eye* and, on Illingworth's retirement, Fawkes became the *Mail*'s senior political cartoonist. In the early 1970s, Fawkes left the *Mail*, returned to the *Observer* and also for a few years drew the full-page weekly political cartoon for *Punch*.
Fawkes has been producing cartoons for more than forty years, but he is more than one of the best political cartoonists in the world, for he is a versatile artist who work has extended into other areas.
Books illustrated include: G. Melly: *Owning-Up* (Weidenfeld, 1965); B. Took: *The Max Miller Blue Book* (Robson, 1975).
Books written and illustrated include: *The Amazing Adventures of Rufus and Flook*; *Rufus and Flook v. Moses Maggot* (Daily Mail, 1950); *Rufus and Flook at School*; *Flook by Trog*; *I Flook* (Macmillan, 1962); *A Flook's-Eye View of the Sixties* (Sidgwick, 1970); *Flook and the Peasants' Revolt* (Robson, 1975); *The World of Trog* (Robson, 1977).
Contrib: *Daily Mail; London Daily News; New Statesman; Observer; Private Eye; Punch; Spectator.*
Exhib: Cartoon Gallery; Kettle's Yard, Cambridge (1980).
Collns: University of Kent at Canterbury.
Bibl: *Flook at Thirty* (University of Kent at Canterbury, 1980); Frank Whitford: *Trog: Forty Graphic Years: The Art of Wally Fawkes* (Fourth Estate, 1987); Bateman; Feaver; Jacques.

FEARON, Percy Hutton 1874-1948
Born on 6 September 1874 in Shanghai, Fearon studied at the Art

Students' League in New York, then came to England and studied at Herkomer's School, Bushey. He lived in London and contributed cartoons to the *Evening Standard* from 1913. He died on 5 November 1948.

Contrib: *Evening Standard*.
Bibl: Waters.

FELMINGHAM, Michael **fl.1950s**
Felmingham, a painter, writer and illustrator, is senior lecturer in the Faculty of Art and Design at Coventry Polytechnic. He has exhibited at the RA, Business Arts Gallery and the New Academy Gallery. During the 1960s he ran his own private press and with Rigby Graham* he is the author of *Ruins: A Personal Anthology*. He contributed many illustrations to a number of the *Saturday Book*, including the half-titles throughout issue 16 (1956), and decorated initials for "An Architect's Alphabet" in issue 18 (1958). His figure sketches have a similarity to Ardizzone's* work.
Contrib: *Saturday Book*.
Published: (with R. Graham) *Ruins: A Personal Anthology* (Country Life, 1972); *The Illustrated Gift Book 1880-1930* (Scolar Press, 1988).
Exhib: RA; Business Arts Gallery; New Academy Gallery.

FELTS, Shirley **fl. 1975-**
Felts is a prolific, traditional but talented illustrator of mostly books for children, using black and white for illustrations and colour for jackets.
Books illustrated include: B. Cunliffe: *Rome and the Barbarians* (BH, 1975); P. Harbison: *The Archaeology of Ireland* (BH, 1976);

Ronald FERNS Illustration to "One Man's Mate Is Another Man's Poison" by Geoffrey Gorer in *Lilliput* (April 1950) p. 83

Shirley FELTS *The Dead Moon* by Kevin Crossley-Holland (André Deutsch, 1982)

R. Sutcliff: *Sun Horse, Moon Horse* (BH, 1977); C. Causley: *The Gift of a Lamb* (Robson, 1978); R. Sutcliff: *The Light Beyond the Forest* (BH, 1979); R. Jones: *The Mouse That Roared* (Heinemann, 1979); A. Lawrence: *The Hawk of May* (Macmillan, 1980); R. Sutcliff: *The Road to Camlann* (BH, 1981), *The Sword and the Circle* (BH, 1981); C. Curley: *The Wood Within the Wall* (Macmillan, 1982); H. Cresswell: *The Secret World of Polly Flint* (Faber, 1982); K. Crossley-Holland: *The Dead Moon* (Deutsch, 1982); A. Uttley: *Foxglove Tales* (Faber, 1984); M.R. Mitford: *Our Village* (Sidgwick, 1986); *Witch Words* (Faber, 1987).
Books written and illustrated include: *Naturescapes* (Macmillan, 1988).

FERNS, Ronald **b.1925**
Born on 14 October 1925 in London, Ferns studied at St. Martin's School of Art, and then worked for a publisher and as a scene

LILLIPUT

"FFOLKES" "Her references said: 'Unorthodox but does the work of two people'": cartoon from *Lilliput* (October 1949)

painter before becoming a free-lance artist. He designed carpets (for the Time-Life Building in London), sets and costumes for a ballet, and painted a mural for the Festival of Britain Exhibition (1951). He illustrated a children's feature in *Good Housekeeping* for twenty years, and in the 1940s and 1950s contributed many drawings to *Lilliput*. His drawings are usually decorative, frivolous, witty, and fantastic in the English tradition. This style, which with time developed in complexity and invention, was admirably suited to the Guinness Christmas books which were produced for doctors, and he illustrated three of these — *Album Victorianum* (1951), *Untopical Songs* (1953) and *Alice Versary* (1959).
Books illustrated include: G. Williams: *Semolina Silkpaws Comes to Town* (Methuen, 1962); L. Cooper: *Garibaldi* (Methuen, 1964); G. Williams: *Fireworks for Semolina Silkpaws* (Methuen, 1964), *Semolina Silkpaws' Motor-Car* (Methuen, 1968); R. Batten: *Under the Golden Throne* (Lion, 1984); G. Ewart: *The Learned Hippopotamus* (Hutchinson, 1986).
Books written and illustrated include: *Osbert and Lucy* (Hutchinson, 1988).
Contrib: *Compleat Imbiber; Country Fair; Good Housekeeping; Housewife; Lilliput; Listener; Scope; Vogue.*
Bibl: Brian Sibley: *The Book of Guinness Advertising* (Guinness Books, 1985); ICB3; Peppin.
Colour Plate 71

FERRIER, Arthur **1891-1973**
Born in Scotland, Ferrier began his working life in the pharma-

ceutical trade in Glasgow, but gave this up and moved to London to pursue an artistic career. He became a theatrical cartoonist and portrait painter, and contributed drawings to many magazines, including the *Radio Times* in the 1920s, and the *News of the World* from 1923 to 1959. His subjects were most often treated humorously and the illustrations usually contained a pretty woman with long, slender legs — Driver states that he "created the 'dolly bird' and the mini skirt before their time." He died in May 1973.
Contrib: *Blighty; Everybody's; News of the World; Radio Times.*
Bibl: *Times* obit. 29 May 1973; Driver.

"FFOLKES", Michael Brian Davis **1925-1988**
Born on 6 June 1925, ffolkes, as Brian Davis was known as an artist, was educated at Leigh Hall College, Essex, and studied at St. Martin's School of Art under John Farleigh* (1943), and Chelsea School of Art, under Ceri Richards* and Robert Medley* (1946-9). Ffolkes was primarily a cartoonist or, as Bateman puts it, "a right-wing satirist", with a very wide range of subject matter, whose humour was light, fantastic and sometimes Rabelaisian. His drawings are often very decorative, reminding one of Paul Crum (see Pettiward, Roger) and Rowland Emett*. After trying unsuccessfully for fourteen years, his first drawings appeared in 1946 in *Punch* and in *Lilliput*, and he was a regular contributor to many magazines since then. MSIA.
Books illustrated include: M. Bradbury: *All Dressed Up and Nowhere to Go* (Parrish, 1962); S. Oram: *Holland* (Macdonald, 1973); J. Vaughan: *Egypt* (Macdonald, 1973); H. Franks: *"I'm Sorry to Have to Tell You"* (Carcanet Press, 1974); J. Millington-Ward: *Practice in the Use of English* (Longman, 1974); M. Green: *Squire Haggard's Journal* (Hutchinson, 1975); P. Simple: *A Choice of Peter Simple* (Daily Telegraph, 1975); S. Raven: *The Fortunes of Fingel* (Blond, 1976); J. Gathorne-Hardy: *The Terrible Kidnapping of Cyril Bonhomy* (Evans, 1978); N. Rees: *"Quote-Unquote"* (Allen & Unwin, 1978); J. Ebdon: *Ebdon's Odyssey* (Davies, 1979); A. Gill: *How To Be Oxbridge* (Grafton, 1985); A. Loos: *Gentlemen Prefer Blondes* (Folio Society, 1985).
Books written and illustrated include: *I'm Out of Pink* (1972); *Mini Art* (Duckworth, 1968); *The Jokes of ffolkes* (Deutsch, 1976); *ffolkes' ffauna* (Harrap, 1977); *ffolkes' Cartoon Companion to Classical Mythology* (David & Charles, 1978); *Amazing Times* (Allen & Unwin, 1982); *ffolkes' Companion to Sex.*
Contrib: *Daily Telegraph; Lilliput; New Yorker; Playboy; Private Eye; Punch; Reader's Digest.*
Exhib: Leicester Galls; Arthur Jeffress Gallery.
Bibl: Bateman; Jacques; Price; Who.

FIELDING, Lola **b.1930**
Born in London, Fielding studied illustration, typography and some fashion drawing at Twickenham School of Art. She draws mostly for advertising and for magazines [1960!]. She contributed to *Radio Times* and did a series of colour illustrations for a children's story by Rumer Godden, published in *Homes and Gardens*. She seemed fascinated by dolls, fair grounds and the atmosphere of fairy tales.
Contrib: *Homes and Gardens; Radio Times.*
Bibl: Ryder; Usherwood.

FIENNES, Celia Mary Twisleton-Wykeham- **fl. 1926-30**
A wood engraver, about whom little is known. She illustrated at least two books with engravings, and produced a coloured drawing for one of the Ariel poems. For the Cresset Press edition of Stevenson's 1661 *The Twelve Moneths* (1929), she produced twelve wood engravings, one to illustrate each month. The book was beautifully printed by the Alcuin Press of Chipping Camden on good paper and bound in cloth with an art deco pattern of coloured zig-zag lines in green, mauve and blue. Her engravings are attractively stylized, being decorative rather than naturalistic. She married Noel Rooke* in 1932.
Books illustrated include: *The Fables of Aesop* (GCP, 1926); M. Stevenson: *The Twelve Moneths (1661) Together with a Diary for 1929* (Cresset Press, 1929); G.K. Chesterton: *The Grave of Arthur* (Ariel Poem No. 25; Faber, 1930).

FINNEMORE, Joseph **1860-1939**
See Houfe

188

Books illustrated include: G. Allen: *The White Man's Foot* (1888); G.A. Henty: *When London Burned* (Blackie, 1895); Mrs. Molesworth: *Philippa* (Chambers, 1896); W. Shakespeare: *The Merry Wives of Windsor* (Tuck, 1897); J. Wyss: *Swiss Family Robinson* (Newnes, 1897); W.G. Stables: *Kidnapped by Cannibals* (Blackie, 1900); H. Gilbert: *The Book of Pirates* (Harrap, 1916); J. Glass: *Chats over a Pipe* (Simpkin, Marshall, 1922); C. Kingsley: *Westward Ho!* (RTS, 1925); D. Defoe: *Robinson Crusoe* (n.d.)
Books written and illustrated include: *The Animal's Circus* (1915).
Bibl: Doyle BWI; Peppin; Waters.

FIRMIN, Charlotte **b.1954**
Born on 2 May 1954 in London, the daughter of illustrator Peter Firmin*, Charlotte Firmin was educated at Simon Langton Grammar School, Canterbury. She studied art at Hornsey School of Art (1972-73) and Brighton Polytechnic (1973-76), where she was awarded a B.A. in graphic design. She illustrates books for children in pen and ink and in watercolour, and has written and illustrated a few books.
Books illustrated include: A. Farjeon: *The Cock of Round Hill* (Kaye, 1977); T. Deary: *The Custard Kid* (Black, 1978); H. Rice: *The Remarkable Feat of King Caboodle* (Black, 1978); B. Alton: *The Magic of Ah* (Kaye, 1980); T. Deary: *Calamity Kate* (Black,

1980); M. Dickinson: *Alex's Bed* (Deutsch, 1980), *Alex and Roy* (Deutsch, 1981); T. Deary: *The Lambton Worm* (Black, 1981); M. Dickinson: *Alex and the Baby* (Deutsch, 1982); T. Deary: *The Wishing Well Ghost* (Black, 1983), *The Windmill of Nowhere* (Black, 1984); M. Dickinson: *New Clothes for Alex* (Deutsch, 1984); M. Jones: *I'm Going on a Dragon Hunt* (Deutsch, 1987), *I'm Going on a Gorilla Hunt* (Deutsch, 1988); E. de Jong: *Isn't She Clever* (Deutsch, 1988), *Aren't They Wonderful* (Deutsch, 1990).
Books written and illustrated include: *Hannah's Great Decision* (Macmillan, 1978); *Claire's Secret Ambition* (Macmillan, 1979); *Eggbert's Balloon* (Collins, 1979); *The Eggham Pot of Gold* (Collins, 1979); *Egglantine's Party* (Collins, 1979); *The Giant Egg Plant* (Collins, 1979); *Weird Windows* (Deutsch, 1989).
Contrib: *The Egg*.
Bibl: CA; Peppin; IFA.

FIRMIN, Hannah May **b.1956**
Born on 24 March 1956 in Battersea, London. Firmin is one of six daughters of the illustrator, Peter Firmin* (two are illustrators, she and Charlotte Firmin*). She moved to Kent with her family when she was two years old, and was educated in Canterbury. She studied at Chelsea School of Art (1974-78), followed by postgraduate work in illustration at RCA (1978-81). Between 1981 and 1984 she taught at various schools of art, including the City and Guilds, Chelsea, and the Ulster Polytechnic, Belfast. Since 1984 she has "worked" part-time in order to have time with her two young sons.
She has worked continuously since 1981 as a free-lance illustrator for books, magazines, newspapers and design groups. Her bold illustrations are done using woodcuts, linocuts, and collage. Her designs for the cover of *Axe-Age, Wolf-Age* and the 1986 Faber edition of *Folk Tales* are printed very effectively in colour. She has designed some paperback covers, including *Weather Forecasting the Country Way* for Penguin.
Books illustrated include: K. Crossley-Holland: *Axe-Age, Wolf-Age* (Deutsch, 1985), *Folk Tales of the British Isles* (Folio Society,

Hannah FIRMIN *Folk Tales of the British Isles* by Kevin Crossley-Holland (Folio Society, 1985)

Celia FIENNES *The Twelve Moneths* by Matthew Stevenson (The Cresset Press, 1928)

1985); G. Chaucer: *The Canterbury Tales* (with others; Folio Society, 1986); K. Crossley-Holland: *Anglo-Saxon Elegies* (Folio Society).
Contrib: *Cosmopolitan; Guardian; Harpers: Listener; Radio Times; Sunday Times; Vogue*.
Exhib: RA; Cartoon Gallery; Illustrators Gallery; Smiths Gallery.
Bibl: Folio 40; IFA.

FIRMIN, Peter **b.1928**
Born on 11 December 1928 at Harwich, Firmin studied at

Colour Plate 73. James FITTON, *Lilliput* cover, July 1950

Colour Plate 75. Peter FORSTER *The Rape of the Lock* by Alexander Pope (Folio Society 1989)

Colour Plate 74. Michael FOREMAN "The Goose-Girl" in "The Goose-Girl and the Curdie" from *The Brothers Grimm Popular Folk Tales* newly translated by Brian Alderson (Victor Gollancz 1978)

Colour Plate 76. Claud Lovat FRASER *Peacock Pie* by Walter de la Mare (Constable 1924)

Colour Plate 77. Barnett FREEDMAN *Lavengro* by George Borrow (New York: Limited Editions Club 1936)

Colour Plate 78. Annie FRENCH "Reverie" Original drawing in pen and ink and watercolour. By permission of Chris Beetles Limited

Colchester School of Art (1944-47) and the Central School of Arts and Crafts (1949-52) where he learned wood- and lino-cutting from Gertrude Hermes*. *The Land and the Garden* (1989) contains sixty specially commissioned wood engravings; but Firmin normally uses pen and ink or wash for his illustrations. He has worked with the writer Oliver Postgate since 1958 on television programmes for children and books about Noggin the Nog, and other creations. The first book in this series was *Noggin the King*, published in 1965. He also created a much-loved television puppet for children, the fox Basil Brush, whose antics continue to amuse children. The boisterous fox is featured in a great many stories published by Kaye & Ward. A later creation has been Bramwell the Rat, first featured in *The Winter Diary of a Country Rat* (1981). Two of his six daughters, Charlotte Firmin* and Hannah Firmin*, are illustrators.

Books illustrated include: O. Postgate: *Noggin the King* (Ward, 1965), *Noggin and the Whale* (Ward, 1965), and more than ten other titles in the series; O. Postgate: *Bagpuss in the Sun* (Collins, 1974), *Bagpuss on a Rainy Day* (Collins, 1974); B. Baxter: *The "Blue Peter" Book of Limericks* (Pan Books, 1976), *The "Blue Peter" Book of Odd Odes* (BBC, 1976); O. Postgate: *Mr Rumbletum's Gumboot* (Carousel, 1977), *Silly Old Uncle Feedle* (Carousel, 1977), *The Song of Pongo* (Carousel, 1977), *Ivor the Engine* (Fontana, 1977) and at least five more in series; P. Meteyard: *Stanley: The Tale of a Lizard* (Deutsch, 1979); E. Nesbit: *The Last of the Dragons* (Macdonald, 1980), *Mélisande* (Macdonald, 1981); H.F Amery: *Day and Night* (Usborne, 1985), *Summer and Winter, Spring and Autumn* (Usborne, 1985), *Then and Now* (Usborne, 1985); V. Sackville-West: *The Land and the Garden* (Webb & Bower, 1989).

Books written and illustrated include: *Basil Brush Goes Flying* (Kaye, 1969); *Basil Brush Goes Boating* (Kaye, 1969) and at least eleven other "Basil Brush" titles; *The Winter Diary of a Country Rat* (Kaye, 1981); *Chicken Stew* (Pelham, 1982); *Tricks and Tales* (Kaye, 1982); *The Midsummer Notebook of a Country Rat* (Kaye, 1983); *Pinny and the Bird* (and four other titles in series; Deutsch, 1985-7).

Contrib: *Country Fair; Good Eating, New Scientist, Radio Times.*
Bibl: CA; Peppin.

FIRTH, Barbara　　　　　　　　　　　　　**fl. 1984-**
Firth was drawing plants and animals from the age of three; later she became interested in design and studied pattern cutting at the London College of Fashion. She worked for *Vogue*, where her work included producing the step-by-step illustrations of knitting, crocheting and dressmaking. She became a free-lance artist in 1971, and worked on the crafts magazine *Golden Hands*. She was able to return to her favourite field in illustrations when she began illustrating books for Walker Books in 1984 with a series for young children, and has gone on to produce a number of award-winning books. *Can't You Sleep, Little Bear?* by Martin Waddell won the 1988 Smarties Grand Prize, the 1988 Kate Greenaway Award, and the Belgian Le Prix des Critiques de Livres pour Enfants in 1989. A second book by Waddell, *The Park in the Dark*, won the 1989 Emil/Kurt Maschler Award.

Books illustrated include: *Jack the Dog, Mot the Mouse* and four other titles in the Great Escapes series (Walker, 1984-5); *"Quack" Said the Billy-Goat* (Walker, 1986); *The Munros' New House* (1987); *Barnabas Walks* (Walker, 1987); *Leapfrog* (Walker, 1987); M. Waddell: *Can't You Sleep, Little Bear?* (Walker, 1988), *The Park in the Dark* (Walker, 1989); *We Love Them* (Walker, 1990); *The Grumpalump* (Walker, 1990).

Bibl: Inf. from Walker Books.
Colour Plate 72

FISH, Anne Harriet　　　　　　　　　　　　**d.1964**
See Houfe
Books illustrated include: "Fowl": *The New Eve* (BH, 1917), *The Third Eve Book* (BH, 1919); G. Frankau: *One of Us* (Chatto, 1917); R. Holmes: *The Clock and the Cockatoo* (Blackwell, 1922); S. Tremayne: *Tatlings* (BH, 1922); *The Rubaiyat of Omar Khayyam* (BH, 1922); H. Graham: *The World We Laugh In* (Methuen, 1924); K. Vincent: *Lipstick* (BH, 1925), *Sugar and Spice* (BH, 1926), *Gin and Ginger* (BH, 1927); H. Graham: *The World We Laugh In: More Departmental Ditties* (Methuen, 1928).

Anne FISH *Tatlings; Epigrams* by Sydney Tremayne (Bodley Head, 1922)

Books written and illustrated include: *High Society* (Putnam, 1920); *Awful Weekends and Guests* (Methuen, 1938); *All's Well That Ends Swell* (Methuen, 1939).
Bibl: Peppin; Waters.

FISHER, Alfred Hugh　　　　　　　　　　　**1867-1945**
See Houfe

FISHER, Thomas Henry　　　　　　　　　　　**1879-1962**
See Houfe under Thomas HENRY
Born at Eastwood, Nottinghamshire, Fisher studied at Nottingham School of Art. He was apprenticed as a lithographer in Nottingham; one of his first jobs was to work on the original colour production of the famous "Sailor" trademark for Players cigarettes. Later he turned to illustrations for magazines for boys like *Chums* and *Captain*; he drew most of the covers for *Happy* magazine and in one year contributed forty-five cartoons to *Punch*.

Thomas Henry (which is the name Fisher used as an illustrator) is best known for his sketchy, light-hearted illustrations, done in pen and ink, for Richmal Crompton's "Just William" books. In 1919 he had been asked to contribute illustrations for a "William" story in *Home Magazine*, after the interpretation of L. Hocknell, who had illustrated Crompton's pre-William stories in the magazine, had been rejected. Though Henry did not meet Crompton until 1954, his work was much appreciated by the author, and he illustrated every "William" book published before his death in 1962, thirty-three titles in all. *William and the Witch* (1964) includes illustrations by him and some by Henry Ford*, the most successful "William" illustrator of the 1960s. Henry died on 15 October 1962.

Books illustrated include: R. Crompton: *Just William* (Newnes, 1922) and thirty-three other titles in the series.
Contrib: *BOP; Captain; Chums; Crusoe; Happy; Home Magazine;*

Humorist; London Opinion; Punch; Tatler; Windsor Magazine.
Bibl: Mary Cadogan: *Richmal Crompton: The Woman Behind William* (Allen & Unwin, 1986); Kay Williams: *Just - Richmal: The Life and Work of Richmal Crompton Lamburn* (Guildford: Genesis Publications, 1986); Doyle BWI; Peppin.

FISK, Nicholas **b.1923**
Born 14 October 1923 in London, Fisk was educated privately in Sussex. After service in the Royal Air Force during WW2, he worked as an actor, publisher and musician. He was head of the creative group at the publishers, Lund Humphries, and now is a writer and illustrator of children's books. Since the early 1970s he has concentrated on writing rather than illustration, and has produced many science fiction short stories and some books; he also writes for television.
Books illustrated include: P. Joubert: *Look at Aircraft* (Hamilton, 1960); L.U. Cooper: *The Bear Who Was Too Big* (Parrish, 1963); G. Morgan: *Tea with Mr. Timothy* (Parrish, 1964), *The Small Wish* (Parrish, 1965); W. Mayne: *Skiffy* (Hamilton, 1972).
Books written and illustrated include: *Look at Cars* (Hamilton, 1959); *Cars* (Parrish, 1963); *The Bouncers* (Hamilton, 1964).
Bibl: CA; Peppin.

FITTON, James **1899-1982**
Born on 11 February 1899 in Oldham, Lancashire, the second son of working-class Methodist parents, Fitton was educated at the Watersheddings Board School, Oldham (1904-13). He became a part-time student at Manchester School of Art (1914-21), first while working as an apprentice to a free-lance calico designer, then briefly as an office boy for the *Daily Citizen* in Manchester, the first labour newspaper. For six years (1915-21) he worked for a textile merchant in Manchester before the family moved to Dulwich, South London. There he worked for a printer and then painted scenery for a film company, while in 1925 once again he started as a part-time student, this time at the Central School of Art and Crafts, under A.S. Hartrick (see Houfe). He later taught lithography at the Central School. He married in 1928, exhibited for the first time at the RA Summer Exhibition (1929), and became a free-lance illustrator for a number of magazines, and a poster designer. He became a member of NEAC, was appointed Art Director of an advertising agency and, using the pseudonym "Alpha", began supplying the *Daily Worker* with cartoons.
His fellow students at the Central School included James Boswell*, James Holland* and Pearl Binder*: all four were resolutely opposed to fascism, and looked to the satirists such as Hogarth and George Grosz for their inspiration. The three "Jameses" acted as the Three Musketeers of the graphic Left, contributing cartoons exposing

hypocrisy, profiteering, greed and dereliction each month to the *Left Review*, while Fitton continued to send cartoons to the *Daily Worker*. In 1933 he became a founder member of the Artists' International Association, producing publications which supported the Association's efforts to use art as an agent for social improvement.
For the whole of his life as a working artist, Fitton continued to paint, taking part in many group shows and exhibiting at least one painting in almost every RA Summer Exhibition from 1929 to 1982. He contributed to a number of magazines, illustrated a few books, designed book jackets, and produced posters for London Transport, the Empire Marketing Board, the Ministry of Information, the Ministry of Food, and for Ealing Studios (including one for the film, *Kind Hearts and Coronets* in 1949). The work Fitton did for *Lilliput* in the 1940s-1950s is much softer, to suit the nature of the magazine. It includes paintings of the interiors of public houses (reproduced in colour), illustrations in black and white of articles, a cartoon-like article on "Are You a Sport?", and a coloured cover.
Fitton was a kind of "Renaissance" man in the graphic arts from the late 1930s through the 1960s, creatively active in many fields. He taught, painted, made prints and posters, and played an important role as political and social critic. His cartoons for the *Left Review* in the 1930s, together with the work of Boswell and Holland, "maintained in incisive mordant imagery, an onslaught against such reaction and intolerance which stylistically was to dominate British caricature for the next quarter of a century." (Denvir, 1986.†)
Despite his left-wing leanings — maybe because of them — he took an active part in certain conservative organizations. He was elected ARA (1944) and RA (1954), and narrowly missed being elected President some years later (he tried unsuccessfully three times for election as PRA), much to the relief of Sir Alfred Munnings who described him to the *Daily Mail* as "That creature Fitton!". He was a trustee of the BM and a member of the Arts Council; and became a TV personality. He died on 2 May 1982.
Books illustrated include: H.F. Hutchinson: *The First Six Months Are the Worst* (Davies, 1939); S.M. Pearce: *Hyacinth Pink* (Wingate, 1947).
Contrib: *Daily Worker; Leader; Left Review; Lilliput; Time and Tide; Woman and Beauty.*
Exhibs: RA; LG; NEAC; Tooth (1933); Oldham (retrospective 1983); Dulwich (retrospective 1986).
Collns: Oldham; Dulwich; IWM; Tate; V & A; BM; National Museum of Wales.
Bibl: Bernard Denvir: "The Man from Oldham", *Art and Artists*, November 1986, pp. 13-15; Sidney C. Hutchinson: *The History of the Royal Academy 1768-1986* (Royce, 1986); Ian Jeffrey: *The British Landscape 1920-1950* (T & H, 1984); John Sheeran: *James Fitton, R.A. 1899-1982* (Dulwich Picture Gallery, 1986); Feaver; Tate; Waters; Who's Who.
Colour Plates 6 and 73

FLANDERS, Dennis **b.1915**
Born on 2 July 1915, Flanders was educated at Merchant Taylor's School in London and studied at the Regent Street Polytechnic, St. Martin's School of Art and Central School of Arts and Crafts. He was a painter of watercolour landscapes and townscapes, an etcher and an illustrator. He contributed to a number of magazines, notably the *Illustrated London News* (1956-64). His book, *Dennis Flanders' Britannia*, published in 1984, contains over two hundred drawings, half in colour, done over forty years.
ARWS (1970); RBA (1970); RWS (1976).
Books illustrated include: G. Wade: *Yorkshire Sketchbook* (with others, 1947); J.R. Walbran: *A Visit to Bolton Priory* (1948); A.M. Dunnett: *Land of Scotch* (with others, Edinburgh: Scotch Whisky Assoc., 1953); R. Edmonds: *Chelsea: From the Five Fields to the World's End* (Phene Press, 1956); C.V. Hancock: *East and West of Severn* (with J.P. Wood, Faber, 1956); M. Brander: *Soho for East Anglia* (Bles, 1963); J. Raynor: *A Westminster Childhood* (Cassell, 1973).
Books written and illustrated include: *The Great Livery Companies of the City of London* (Skilton, 1974); *Dennis Flanders' Britannia* (Oriel Press, 1984).
Contrib: *Birmingham Post; Builder; Daily Telegraph; Field; ILN; Radio Times; Sphere; Sunday Times; Yorkshire Post.*

James FITTON Illustration to "Ping-Pong, Kittle and Boom!" by Samuel Selvon in *Lilliput* (July 1950) p.59

Exhib: RA; Colnaghi (one-artist show 1947).
Bibl: Peppin; Waters; Who.

FLEMING, John Baxter **b.1912**

Born in Dumbarton, Fleming was educated at Dumbarton Academy and studied at Glasgow School of Art (1930-35). An artist in water-colour and pen and ink, he illustrated a number of books. Elected RSW (1960); MSIAD (1956).

Books illustrated include: P. Glasier: *As the Falcon Her Bells* (Heinemann, 1963); I. Niall: *A Galloway Shepherd* (County Book Club, 1970); J.M.A. Lenihan: *Science in Focus* (Blackie, 1975), *Science in Action* (Bristol: Institute of Physics, 1979); *Pioneers of Science*; *Human Engineering*.
Exhib: RSW; RSA; RGI.
Bibl: Who.

FLETCHER, Hanslip **1874-1955**
See Houfe

FLIGHT, W. Claude **1881-1955**

Born on 16 February 1881 in London, Flight began to study art at Heatherley's Art School in 1912 (where he met C.R. Nevinson*) when he was in his thirties, after he had tried various jobs as an engineer, librarian and bee-keeper. His art studies were interrupted by three and a half years' service in France during WW1. After the war, much aware of the experiments taking place around him among the Cubists, Futurists and Vorticists, he was invited (1912) to join the *7 and 5* group of progressive painters which included Paul Nash*, Christopher Wood and John Piper*, who were turning towards abstraction, though he was later dropped. Concerned with notions of speed and movement, and the simplification of forms, Flight has been described as Britain's only real futurist.

He popularised the use of the linocut while teaching at Iain Macnab's* Grosvenor School of Modern Art, influenced perhaps by his exposure to Russian artists who exhibited in Paris in 1925. He found that the linocut, a relatively unrecognised art form, was the perfect medium for his gifts as artist, teacher and propagandist; and he organised the "First Exhibition of British Lino-Cuts" at the Redfern Gallery in 1929, and each of the annual exhibitions until 1937.

In 1920, he met former Slade student Edith Lawrence (1890-1973) and they soon became close friends and collaborators on exhibitions and writing and illustrating books with linocuts. In 1927, they went into business together as interior decorators. His *Animal, Vegetable or Mineral* is a delightful book for children illustrated throughout the text with linocuts printed in black. In 1941 many of his paintings and all of his colour blocks were destroyed in the Blitz during WW2.

He was elected RBA (1923); died 10 October 1955.

Books written and illustrated include: *Lino-Cuts* (BH, 1927); *Tinker, Tailor* (Besant, 1929); *Animal, Vegetable or Mineral* (OUP, 1931); *The Art and Craft of Lino Cutting and Printing* (Batsford, 1934); and, with Edith Lawrence, *Christmas and Other Feasts and Festivals* (Routledge, 1936).
Exhib: Redfern Gallery; Michael Parkin.
Collns: BM; V & A.
Bibl: *Claude Flight and His Circle: Exhibition Catalogue* (Michael Parkin Fine Art, 1975); Mackenzie; Peppin; Waters; Who Was Who.

FLINT, Sir William Russell **1880-1969**
See Houfe

Books written and illustrated include: *Drawings* (Collins, 1950); *Models of Propriety* (Joseph, 1951); *Minxes Admonished* (GCP, 1955); *Pictures from the Artist's Studio* (Royal Academy, 1962); *Shadows in Arcady* (Skilton, 1965); *Breakfast at Périgord* (Medici Society, 1968).
Bibl: W.R. Flint: *In Pursuit: An Autobiography* (Medici Society, 1970); Peppin; Waters.

FLOYD, Gareth **b.1940**

Born on 11 December 1940 in Whiston, Lancashire, Floyd was educated at Sir John Leman Grammar School, Beccles, Suffolk, and studied art at Lowestoft School of Art, Guildford School of Art and Brighton College of Art. He started teaching in 1963 and was lec-

Gareth FLOYD *The Signposters* by Helen Cresswell (Faber & Faber, 1968)

turer in illustration at Leicester College of Art (1964-67). He became a free-lance illustrator in 1967 and has illustrated more than one hundred books, mostly for children. He has also produced book jackets, contributed to magazines and been a regular artist on the BBC TV programme "Jackanory". His art work has been combined with an active interest in politics and local government.

Books illustrated include (but see Peppin): R. Parker: *Second-Hand Family* (Brockhampton, 1965); S. Porter: *The Knockers* (OUP, 1965); M. Ballard: *Bristol* (Constable, 1966); G. Kaye: *The Raffle Pony* (1966); M. Ballard: *The Emir's Son* (Constable, 1967); R. Welch: *The Hawk* (Abelard, 1967); B. Willard: *The Grove of Green Holly* (Longman, 1967); H. Burton: *Otmoor for Ever* (Hamilton, 1968); H. Cresswell: *The Signposters* (Faber, 1968); I. Serraillier: *Havelock the Warrior* (Hamilton, 1968); H. Cresswell: *The Night-Watchmen* (Faber, 1969), *The Game of Catch* (Chatto, 1969); H. Burton: *Through the Fire* (Hamilton, 1969); R.P.A. Edwards: *The Tower Block* (Burke, 1969), *The By-Pass* (Burke, 1969); B. Byars: *The Midnight Fox* (Faber, 1970); H. Cresswell: *The Wilkses* (Faber, 1970); M. Hunter: *The Walking Stones* (Methuen, 1970); H. Cresswell: *Up the Pier* (Faber, 1971); M. Baker: *The Sand Bird* (Methuen, 1973), *Lock, Stock and Barrel* (1974); J. Reeves: *Two Greedy Bears* (1974); C.B. Hicks: *Alvin Fernald, Mayor for a Day* (Macdonald, 1975); C. Maiden: *Castle Dangerous* (Pelham, 1975); M. Polland: *Prince of the Double Axe*

(Abelard, 1976); B. Willard: *The Miller's Boy* (Kestrel, 1976); J. de Hamel: *Take the Long Path* (Lutterworth, 1978); A. Chambers: *Ghosts That Haunt You* (Kestrel, 1980); M. Greaves: *The Snake Whistle* (BBC, 1980); R. Grunsell: *Stan the Stammer* (Macmillan, 1980); C. Storr: *February Yowler* (Macmillan, 1982); M. Morpurgo: *Little Foxes* (Kaye, 1983); G. Cross: *Swimathon!* (Methuen, 1986); R. Swindells: *A Candle in the Dark* (Knight, 1983); A. Farjeon: *The Lucky Ones* (Kaye, 1984); J. Butterworth: *The House in the Woods* (Kaye, 1984); G. Gerlings: *Spangler's Gang* (Hodder, 1985); A. Saddler: *The Relay Race* (1986); K. Lillington: *The Halloween Cat* (Faber, 1987); K. Crossley-Holland: *Wulf* (Faber, 1988).
Contrib: *Car; Cricket; Sunday Telegraph.*
Bibl: ICB4; Peppin.

FOLKARD, Charles James **1878-1963**
See Houfe

FORD, Henry **fl. 1947-**
An artist known chiefly for his illustrations for Richmal Crompton's "William" stories. He took over the "William" strip in *Woman's Own* (which ran from 1947 to 1969); and after Thomas Henry Fisher's* death in 1962, became the most successful of the artists who portrayed William in editions published in the 1960s.
Books illustrated include: R. Crompton: *William and the Witch* (with Fisher*; Newnes, 1964), *William and the Pop Singers* (Newnes, 1965), *William and the Masked Ranger* (Newnes, 1966), *William the Spaceman* (Newnes, 1968), *William the Lawless* (Newnes, 1970).
Contrib: *Woman's Own.*
Bibl: Mary Cadogan: *Richmal Crompton: The Woman Behind William* (Allen & Unwin, 1986); Kay Williams: *Just - Richmal: The Life and Work of Richmal Crompton Lamburn* (Guildford: Genesis Publications, 1986).

FORD, Henry Justice **1860-1941**
See Houfe

FORD, Noel **fl. 1980-**
Ford is a cartoonist for *Punch*.
Books illustrated include: J. Rothman: *The Cannibal Cookbook* (Guildford: But Is It Art? 1982).
Books written and illustrated include: *Deadly Humorous* (Nuneaton: Grainbon, 1984); *Golf Widows: A Survival Course* (A & R, 1988); *Cricket Widows* (A & R, 1989).
Contrib: *Punch.*

FOREMAN, Michael **b.1938**
Born on 21 March 1938 near Lowestoft, Suffolk, in Pakefield, a fishing village where his mother kept the village shop, Foreman studied painting at Lowestoft School of Art (1954-58). He then studied commercial art at St. Martin's School of Art (1958-59), before going to the RCA to study graphics under Edward Bawden* (1960-63). At RCA he found painting more attractive, particularly because of the presence at the College of such luminaries as David Hockney* and Allen Jones. He won a silver medal and a travelling scholarship to the US, which enabled him to make the first of many visits. He has travelled widely since then, working in Chicago as art director for *Playboy* magazine for four months in 1966, and doing books and articles as a travel illustrator. He has taught at various art schools in London (St. Martin's School, 1963-66; London College of Printing, 1966-68; RCA, 1968-70 and intermittently to 1981; Central School, 1972), and since 1961 has written and illustrated books as a free-lance artist. He has made at least six animated films for BBC and Scandinavian TV.
Foreman's first illustrated book, *The General*, was published in 1961 and received good reviews. Other illustrating commissions did not come, however, and Foreman became a general illustrator, working for magazines like *Playboy, King, Nova* and the colour supplements. 1967 marked his return to book illustration with two picture books written and illustrated by himself, *The Perfect Present* and *The Two Giants*. He uses watercolour and line drawing, often putting full colour over pencil drawings. Many of his illustrations "rest on the page, sharing a common reading plane with the typography, and in this way the poetry of the illustrations unfolds in pace

with the text." (Martin, 1989.†) Foreman was a very prolific illustrator through the 1980s and into the 1990s, and many of the books are lavishly as well as imaginatively illustrated (for example, the two anthologies published in 1991 to celebrate the fiftieth anniversary of Puffin Books). His illustrations are humorous and decorative, but are also occasionally threatening.
Though better known for his children's books, Foreman has illustrated many books and articles for adults. Having grown up in a house with no books at all, he is often reading them for the first time when he is asked to illustrate the classics, and is not influenced by earlier illustrators, which he believes is a help to him. He is a great traveller, and in the 1970s and 1980s he went on several travel assignments for *Pegasus*, the house journal of Mobil Oil, one of the notable results of which was a portfolio published as a twelve-page fold-out in 1970, illustrating a three-week train journey through Russia. His watercolour paintings of California which illustrate Michael Moorcock's *Letters from Hollywood* (1986) have the same "feeling" for place as Paul Hogarth's* *Graham Green Country*, also published in 1986. The sketches he brings back from his travels often become the backgrounds for many of his children's books: trips to India and Australia, for example, provided him with background information for Madhur Jaffrey's *Seasons of Splendour* and Foreman's own *Panda and the Bushfire*. He won the Francis Williams Book Illustration Award in 1972 (for *Horatio* and *The Great Sleigh Robbery*) and 1977, and was awarded a Distinguished Mention in the W.H. Smith Illustration Award for 1987 (*A Child's Garden of Verses*). He also won L'Aigle d'Argent prize (Paris, 1972), and the Emil/Kurt Maschler Award in 1982 and the Kate Greenaway Medal in 1982 and 1989.
Books illustrated include (but see Martin, 1989†): J. Charters: *The General* (Routledge, 1961); C. Hughes: *The King Who Lived on Jelly* (Routledge, 1961); E. Partridge: *Comic Alphabets* (Routledge, 1961); D. Cooper: *The Bad Food Guide* (Routledge, 1966); D. Davie: *Essex Poems* (Routledge, 1969); J. Elliott: *The Birthday Unicorn* (Gollancz, 1970); W. Fagg: *Living Arts of Nigeria* (Studio Vista, 1971); B. Adachi: *Living Treasures of Japan* (Wildwood, 1973); S. Burnford: *Noah and the Second Flood* (Gollancz, 1973); G. McHargue: *Private Zoo* (Collins, 1975); H.C. Andersen: *Classic Fairy Tales* (Gollancz, 1976); Grimm: *Popular Folk Tales* (Gollancz, 1978); O. Wilde: *The Selfish Giant* (Kaye & Ward, 1978); A. Garner: *The Girl of the Golden Gate* (Collins, 1979), *The Golden Brothers* (Collins, 1979), *The Princess and the Golden Mane* (Collins, 1979), *The Three Golden Heads of the Well* (Collins, 1979); A. Allen: *The Pig Plantaganet* (Hutchinson, 1980); P. Dickinson: *Tales from the Old Testament* (Gollancz, 1980); A. Huxley: *After Many a Summer* (Folio Society, 1980); A. Paul: *The Tiger Who Lost His Stripes* (Andersen Press, 1980); T. Jones: *Fairy Tales* (Pavilion, 1981); A. Carter: *The Sleeping Beauty and Other Favourite Fairy Tales* (Gollancz, 1982); R. McCrum: *The Magic Mouse and the Millionaire* (Hamilton, 1982); H. Piers: *Longneck and Thunderfoot* (Kestrel, 1982); C. Dickens: *A Christmas Carol* (Gollancz, 1983); R. McCrum: *The Brontosaurus Birthday Cake* (Hamilton, 1983); T. Jones: *The Saga of Erik the Viking* (Pavilion, 1983); N. Newman: *A Cat and Mouse Love Story* (Heinemann, 1984); R. Dahl: *Charlie and the Great Glass Elevator* (Allen & Unwin, 1985); L. Garfield: *Shakespeare Stories* (Gollancz, 1985); M. Jaffrey: *Seasons of Splendour* (Pavilion, 1985); T. Jones: *Nicobobinus* (Pavilion, 1985); R. McCrum: *Brontosaurus Superstar* (Hamilton, 1985); W. McGonagall: *Poetic Gems* (Folio Society, 1985); C. Causley: *Early in the Morning* (Kestrel, 1986); E. O'Brien: *Tales for the Telling* (Pavilion, 1986); R.L. Stevenson: *A Child's Garden of Verses* (Gollancz, 1986); R. Kipling: *The Jungle Book* (Viking, 1987), *Just So Stories* (Viking, 1987); J. Mark: *Fun* (Gollancz, 1987); J.M. Barrie: *Peter Pan and Wendy* (Pavilion, 1988); T. Jones: *The Curse of the Vampire's Socks* (Pavilion, 1988); M. Bax: *Edmond Went Far Away* (Walker, 1989); A. Turnbull: *The Sand Horse* (Andersen, 1989); C. Causley: *The Young Man of Cury* (Macmillan, 1991); J. Elkin: *The Puffin Book of Twentieth-Century Children's Stories* (Viking, 1991); B. Patten: *The Puffin Book of Twentieth-Century Children's Verse* (Viking, 1991).
Books written and illustrated include: *The Perfect Present* (Hamilton, 1967); *The Two Giants* (Brockhampton, 1967); *The Great Sleigh Robbery* (Hamilton, 1968); *Horatio* (Hamilton, 1969); *Moose* (Hamilton, 1971); *War and Peas* (Hamilton, 1974); *Panda's*

Puzzle and His Voyage of Discovery (Hamilton, 1977); *Panda and the Odd Lion* (Hamilton, 1980); *Trick a Tracker* (Gollancz, 1981); *Land of Dreams* (Andersen, 1982); *Cat and Canary* (Andersen, 1984); *Panda and the Bunyips* (Hamilton, 1984); *Panda and the Bushfire* (Hamilton, 1985); *Ben's Box* (Hodder, 1986); *Letters from Hollywood* (Harrap, 1986); *Ben's Baby* (Andersen, 1987); *The Angel and the Wild Animal* (Andersen, 1988); *Michael Foreman's World of Fairy Tales* (Pavilion Books, 1990).

Contrib: *Ambit; King; Nova; Pegasus*.

Exhib: Queenswood Gallery; Perrins Gallery; Graffiti Gallery; Neal St. Gallery; Beetles (1990).

Collns: V & A.

Bibl: Derek Birdsall: "Michael Foreman", *Graphis* 187 (1977); Douglas Martin: *The Telling Line: Essays on Fifteen Contemporary Book Illustrators* (Julia MacRae Books, 1989); Amstutz 2; CA; Folio 40; ICB4; Parkin; Peppin.

Colour Plate 74

FORREST, Archibald Stevenson **1869-1963**
See Houfe
Books illustrated include: S.L. Bensusan: *Morocco* (Black, 1904), *Picturesque Normandy* (London Brighton & South Coast . . . Railways, 1905); F.T. Bullen: *Back to Sunny Seas* (Smith, Elder, 1905); J. Henderson: *The West Indies* (Black, 1905); H.E. Marshall: *Stories of Robin Hood* (Jack, 1905); J. Henderson: *Jamaica* (Black, 1906); M.A.S. Hume: *Through Portugal* (Grant Richards, 1907); J. Finnemore: *Morocco* (Black, 1908); H.E. Marshall: *Our Island Story* (Jack, 1909); C. Kingsley: *Westward Ho!* (Nelson, 1920); M. Merrythought: *Martin Merrythought's Child's Guide to London* (A. & E.W., 1922); G. Eliot: *Adam Bede* (Nelson, 1933); P.F. Westerman: *Trapped in the Jungle* (Blackie, 1947).

Books written and illustrated include: *Pictures for Little Englanders* (Dean, 1900); *A Tour through Old Provence* (Paul, 1911); *A Tour Through South America* (Paul, 1913); *Switzerland Revisited* (with H. Bagge; Griffiths, 1915).

Peter FORSTER "Socrates and the romantic novel" from *Plato's Symposium* (Libanus Press)

FORSTER, Peter **b.1934**
Forster writes that he is London-born and country-bred and describes himself as a wood engraver, satirist and watercolourist. He studied wood engraving at Luton Art School and the Ruskin School of Art, Oxford, and then taught art at Bedford Modern School for one year. For a few years in the 1960s he was a freelance illustrator, but in 1963 he started working as an illustrator and reconstruction artist in the Department of the Environment (Ancient Monuments & Historic Buildings). On 1 May 1985, Forster resigned from this department to become a full-time wood engraver, and set up the Malaprop Press to print his own engravings and

books. He has also illustrated a number of books for other publishers, and contributed to the *Observer*.

Forster is a miniaturist and describes his subject matter as "satire, caricature and parody." A member of SWE and editor of its journal, *Multiples*, he has exhibited there and at RE and RA.

Books illustrated include: J. Harland: *Adventure Acre* (Constable, 1965); D. Huddy: *Blackbird's Barn* (Constable, 1965); G. Chaucer: *Canterbury Tales* (with others, Folio Society, 1986); Plato: *Symposium* (Marlborough: Libanus Press, 1986); W. Shakespeare: *A Midsummer Night's Dream* (Folio Society, 1988), *Troilus and Cressida* (Folio Society, 1988); A. Pope: *The Rape of the Lock* (Folio Society, 1989).

Books written and illustrated include: *Britannic Majesty* (Malaprop Press, 1984); *The Whitehall Venus* (Malaprop Press, 1984?); *Mrs. Bluetit's Diary; or, The Twelve Days of Christmas* (Malaprop Press, 1985); *The Abdication, a Quinquagenarian Retrospection* (Malaprop Press, 1986); *A Publicity Vignette* (Malaprop Press, 1986); *A Study of Dinosaurs* (Whittington Press, 1986); *Election Lights* (Malaprop Press, 1987); *Diamond Jubilee* (Malaprop Press, nd).

Contrib: *Observer*.

Exhib: RA; RE; SWE; Printmaker's Council; one-artist shows — Hampstead; Marlborough (1983); Westminster (1985); Harrogate (1987).

Bibl: Peter Forster: "Portrait of the Wood-engraver in Middle Age", *Matrix* 6 (1986): 72-5; Forster: *A Publicity Vignette* (Malaprop Press, 1986); Brett; IFA.

Colour Plate 75

FORTNUM, Peggy [Margaret Emily Noel] **b.1919**
Born on 23 December 1919 in Harrow, Middlesex, Fortnum was encouraged as a child by W. Heath Robinson* and by Sir Frank Brangwyn* who awarded her a prize at a Young Artists exhibition of paintings. She was educated at St. Margaret's School, Harrow, studied at Tunbridge Wells School of Arts and Crafts (1936-39), and then served as a signals operator in the Auxiliary Territorial Service during WW2. She was invalided out of the army because of an accident and attended the Central School of Arts and Crafts (1944-45). There she met John Farleigh*, who was editor of Sylvan Books, and through him got her first commission to illustrate a children's book.

She has illustrated some eighty children's books, mostly with line drawings delightfully evocative of the situations and feelings which she is portraying. She has worked for many publishers, including Oxford, Dent, and Bodley Head. For Collins she created Paddington Bear for Michael Bond's successful series of books, illustrating them from 1958 to 1974. She has also done some book jackets for the World Classics series from OUP, has drawn for the television programmes for children, "Jackanory" and "Playschool", and from 1947-50, worked as a textile designer. *Running Wild* (1975) is an account of her childhood as the youngest member of a large family, and is illustrated with her fine ink drawings, which look very spontaneous.

She was married to Ralph Nuttall-Smith (since deceased), a sculptor-painter who taught at the Slade; and has two stepsons. She lives in West Mersea, near Colchester, Essex.

Books illustrated include: M.F. Moore: *Dorcas the Wooden Doll* (Sylvan Press, 1944); R. Fyleman: *Adventures with Benghazi* (Eyre, 1946); S. Mead: *Before the Cock Crowed* (Sylvan Press, 1947); U. Hourihane: *Pedlar Pete's Enchanted Toys* (Muller, 1948), *Christine and the Apple Woman* (Muller, 1950); B. Nichols: *The Mountain of Magic* (Cape, 1950); M. Dunn: *Mountain Mystery* (Lutterworth, 1951); D. Ross: *The Enormous Apple Pie* (Lutterworth, 1951); M.J. Baker: *Four Farthings and a Thimble* (BH, 1952); P. Lynch: *Brogeen Follows the Magic Tune* (Burke, 1952), *Brogeen and the Green Shoes* (Burke, 1953); A. Waterhouse: *The Goose That Loved a Doctor* (Brockhampton, 1953); L. Berg: *Trust Chunky* (Brockhampton, 1954); E. Kyle: *The House of the Pelican* (Nelson, 1954); C.F. Smith: *Seldom Seen* (1954); M. Fitt: *Pomeroy's Postscript* (Nelson, 1955); M. Jowett: *Candidate for Fame* (OUP, 1955); E. Farjeon: *Grannie Gray* (OUP, 1956); P. Lynch: *The Bookshop on the Quay* (Dent, 1956); E. Farjeon: *The Children's Bells* (OUP, 1957); G. Vacher: *The Shoemaker's Daughter* (Blackie, 1957); M. Bond: *A Bear Called Paddington* and at least eleven other titles in

Peggy FORTNUM *When Marnie Was There* by Joan G. Robinson (Collins, 1967)

series (Collins, 1958-74) ; P. Lynch: *The Old Black Sea Chest* (Dent, 1958); H. May: *The Swan: The Story of Pavlova* (Nelson, 1958); K. Grahame: *The Reluctant Dragon* (BH, 1959); P. Lynch: *Jinny the Changeling* (1959); U.M. Williams: *The Adventures of a Little Wooden Horse* (Puffin, 1959); M. Hooper: *The Goose Girl* (Faber, 1960); G. Kaye: *The Boy Who Wanted to Go Fishing* (Methuen, 1960); E. Beresford: *Two Gold Dolphins* (Constable, 1961); I. Eastwick: *A Camel for Saida* (Collins, 1961); A. Winn: *Round About* (Brockhampton, 1961); C. Storr: *The Freedom of the Seas* (Faber, 1962), *Robin* (Faber, 1962); M. Mackay: *Dolphin Boy* (Harrap, 1963); E.J. Hodges: *The Three Princes of Serendip* (Constable, 1965); M.M. Reid: *The Tinkers' Summer* (Faber, 1965); H. Cresswell: *Where the Wind Blows* (Faber, 1966); G. Kaye: *Chik and the Bottle House* (Nelson, 1966); J.G. Robinson: *When Marnie Was There* (Collins, 1967); O. Wilde: *The Happy Prince and Other Stories* (Dent, 1968); C. Storr: *Rufus* (Faber, 1969); N. Streatfeild: *Thursday's Child* (Collins, 1970); J. Gardam: *A Few Fair Days* (Hamilton, 1971).
Books written and illustrated include: *Running Wild* (Chatto, 1975).
Contrib: *Blue Peter; BBC Children's Hour Annual; Child Education; Church Times; Elizabethan; Loisirs.*

Exhib: BM; ICA; Mersea Island Museum; Minories, Colchester; V & A.
Bibl: Eyre; ICB2; ICB3; ICB4; Peppin; Ryder; Who; IFA.
See also illustration on page 62

FOSTER, Marcia Lane b.1897
See Houfe

Born on 27 August 1897 at Seaton, Devon, Foster studied at St. John's Wood Art School, the RA Schools and the Central School of Arts and Crafts (under Noel Rooke*). A wood engraver and illustrator, she did much work in advertising, and illustrated more than forty books for children. For *The Golden Journey of Mr. Paradyne* (1924), she produced eight illustrations superbly reproduced by five-colour line blocks (see illustration on page 50). She exhibited widely and was elected ARE in 1959.
Books illustrated include: K. Grahame: *The Headswoman* (BH, 1921); C. Macmillan: *Canadian Fairy Tales* (BH, 1922); A. France: *The Merrie Tales of Jacques Tournebroche* (BH, 1923); W.L. Locke: *The Golden Journey of Mr. Paradyne* (BH, 1924); A. France: *Little Sea Dogs* (Dodd, 1925); N. Streatfeild: *The Children in Primrose Lane* (Collins, 1947); K. Barne: *Dusty's Windmill* (Dent, 1949); J. Kinross: *Blackfoot Lagoon* (Gryphon Books, 1950); K. Barne: *Barbie* (Dent, 1952); M. Saville: *The Ambermere Treasure* (1953); M. Baker: *Lions in the Potting Shed* (Brockhampton, 1954); V. Bayley: *Paris Adventure* (Dent, 1954), *Lebanon Adventure* (Dent, 1955); M. Baker: *Acorns and Aerials* (Brockhampton, 1956); K. Barne: *Rosina and Son* (Evans, 1956); V. Bayley: *Kashmir Adventure* (Dent, 1956); P. Whitlock: *The Open Book* (Collins, 1956); V. Bayley: *Turkish Adventure* (Dent, 1957); M.C. Carey: *Nicky Goes Ashore* (Dent, 1957); V. Bayley: *The Shadow on the Wall* (Dent, 1958); W. Mayne: *Underground Alley* (OUP, 1958); V. Bayley: *Swedish Adventure* (Dent, 1959); E. Spence: *The Summer in Between* (OUP, 1959); V. Bayley: *Mission on the Moor* (Dent, 1960); L. Hill: *The Vicarage Children* (Evans, 1961); V. Bayley: *London Adventure* (Dent, 1962); G. Plummer: *My Bible Stories* (Longman, 1963); V. Bayley: *Italian Adventure* (Dent, 1964), *Scottish Adventure* (Dent, 1965), *Welsh Adventure* (Dent, 1966), *Austrian Adventure* (Dent, 1968).
Books written and illustrated include: *Let's Do It* (nd).
Exhib: NEAC; RA; RE; SWA; Paris Salon.
Collns: BM.
Bibl: ICB; ICB2; Peppin; Waters; Who.

FOTHERGILL, George Algernon 1868-1945
See Houfe

Books written and illustrated include: *A Riding Retrospect* (Edinburgh: Waterston, 1895); *An Old Raby Hunt Club Album, 1786-1899* (Waterston, 1899); *A North Country Album* (Darlington: Dresser, 1901); *Notes from the Diary of a Doctor, Artist and Sportsman* (York: Sampson, 1901); *Sketch Books* (Darlington: Dodds, 1903-); *Stories and Curiosities of Edinburgh and Neighbourhood* (Edinburgh: Orr, 1910); *British Fire-Marks from 1680* (William Green, 1911); *A Gift to the State: The National Stud* (Edinburgh: p.p. 1916); *An Artist's Thoughts in Verse and Design* (Edinburgh: p.p. 1919); *Hunting, Racing, Coaching and Boxing Ballads* (Heath Cranton, 1926).
Bibl: Peppin; Titley; Waters.

FOUGASSE, see BIRD, Cyril Kenneth

FOXWELL, H.S. fl.1915-1940?

Best known for his humorous animal drawings and comic strips, Foxwell took over "Tiger Tim" and the Bruin Boys from the original creator, J. S. Baker, less than a year after Baker first drew them. He also drew the female counter-part for the new *Playbox* comic, the "Hippo Girls"; and did the Teddy Tail strip in the *Daily Mail* for some years after it was first created by C. Folkard (see Houfe). Foxwell died during WW2.
Contrib: *Daily Mail; Playbox; Puck; Rainbow; Tiger Tim's Weekly.*
Bibl: Doyle BWI.

FRASER, Claud Lovat **1890-1921**
See Houfe

Fraser was persuaded by James Thorp, consultant for the Curwen Press, to join the Design and Industries Association where he met Harold Curwen. Fraser became an enthusiast for Curwen's bold and imaginative ideas on printing, while Curwen was captivated by Fraser's personality and artistic skills. In a remarkably short time, Curwen had acquired dozens of Fraser's bright and cheerful drawings and began using them in the Press's publications. The first advertising booklet on the Press itself, *Apropos the Unicorn*, was written by Thorp and most elegantly printed in 1920; its cover paper was designed by Fraser who also drew the unicorn on the title page. Besides illustrating several books which the Press printed, Fraser produced patterned paper, borders and other items for the Curwen Press. The designs Fraser drew to illustrate A.E. Housman's *A Shropshire Lad* were inexplicably rejected by the poet, but Harold Curwen used them as stock blocks for much of his commercial printing.

Books illustrated include: *Flying Fame: Broadsides*, 1st Series (1913) — 1. R. Hodgson: *A Song*; 2. R. Hodgson: *February*; 3. R. Honeywood (i.e. C.L. Fraser): *The Robin's Song*; 4. C.L. Fraser: *A Parable*; 5. *Captain Macheath*; 6. C.L. Fraser: *The Lonely House*. *Flying Fame: Chapbooks*, 1st Series (1913) — 1. R. Hodgson: *Eve and Other Poems*; 2. H. Jackson: *Town: An Essay*; 3. R. Honeywood: *The Two Wizards and Other Poems*; 4. R. Honeywood: *Six Essays in the XVIIIth Century*; 5. R. Honeywood: *The Almondsbury Garland*. *Flying Fame: Broadsides*, 2nd Series [1913] — 1. W. de la Mare: *The Old Men*; 2. C.L. Fraser: *Summer*; 3. R. Hodgson: *The Gipsy Girl*; 4. O. Davies: *Staffordshire*; 5. R. Hodgson: *The Beggar*; 6. C.L. Fraser: *The Wind*; 7. R. Hodgson: *Playmates*; 8. R. Hodgson: *The Late, Last Book*; 9. R. Hodgson: *The Birdcatcher*; 10. *The Blind Fiddler's Dog. Flying Fame: Chapbooks*, 2nd Series (1913) — 1. R. Hodgson: *The Bull*; 2. R. Hodgson: *Song of Honour*; 3. R. Hodgson: *The Mystery and Other Poems*; 4. J. Stephens: *Five New Poems*; 5. C.L. Fraser: *A Garland of New Songs*; 6. *A Garland of Portraitures*. Poetry Bookshop publications — 20 *Rhyme Sheets* including some items reprinted from Flying Fame publications (1915-17); *Nursery Sheets*; three *Songs from The Beggar's Opera* (1920); five *Monthly Chapbooks* (of some thirty published, 1919-22); *Nurse Lovechild's Legacy* (1916); C. Cotton: *Poems* (1922). Other books — H. Beerbohm Tree: *Thoughts and After-Thoughts* (Cassell, 1913); H. Macfall: *The Splendid Wayfaring* (with others; Simpkin, Marshall, 1913); *Pirates* (Simpkin, Marshall, 1915); R. Corbet: *The Fairies' Farewell* (pp., 1916); K. Hare: *Three Poems* (pp., 1916); *Nursery Rhymes* (Jack, 1919); T. Burke: *The Song Book of Quong Lee of Limehouse* (Allen & Unwin, 1920); *The Lute of Love* (Selwyn & Blount, 1920); Felix Folio (i.e. W. Maas): *Helion Hill* (Selwyn & Blount, 1921); J. Gay: *The Beggar's Opera* (Heinemann, 1921); C. Nodier: *The Luck of the Bean-Rows* (O'Connor, 1921), *The Woodcutter's Dog* (O'Connor, 1921); C. Goldoni: *The Liar* (Selwyn & Blount, 1922); H. Preston: *The House of Vanities* (BH, 1922); *Sixty-Three Unpublished Designs* (First Editions Club, 1924); W. de la Mare: *Peacock Pie* (Constable, 1924).

Contrib: *Apple; Change; Chapbook; Form; Imprint; Onlooker; Pan.*
Exhib: Leicester Galleries 1921; University of Hull 1968; V & A, 1969; Philadelphia, Rosenbach Foundation 1971-2; Manchester Polytechnic Library 1984.
Collns: Tate; V & A; Bryn Mawr College, Pa.
Bibl: J. Drinkwater and A. Rutherston: *Lovat Fraser* (Heinemann, 1923); Clive E. Driver: *The Art of Claud Lovat Fraser: Book Illustrator, Theatrical Designer and Commercial Artist: An Exhibition* (Philadelphia: Rosenbach Foundation, 1971); Grace Lovat Fraser: *Claud Lovat Fraser* (V & A, 1969); Grace Lovat Fraser and Malcolm Easton: *Claud Lovat Fraser: The Printed Work; Catalogue of an Exhibition* (University of Hull, 1968); Gerard Hopkins: *"The Sketchbooks of Claude Lovat Fraser", Alphabet & Image 7* (May 1948): 14-25; Haldane Macfall: *The Book of Lovat* (Dent, 1923); Ian Rogerson: *Claud Lovat Fraser: An Exhibition of His Illustrations* (Manchester Polytechnic Library, 1984); Gilmour; Peppin.
Colour Plate 2

Eric FRASER *The Castle of Fratta* by Ippolito Nievo (Folio Society, 1954)

FRASER, Eric George **1902-1983**

Born on 11 June 1902 in London, Fraser was educated at Westminster City School and studied art first at Westminster School of Art (under Walter Sickert) as an evening student while still a schoolboy, and then at Goldsmiths' College (1919-24 under E. J. Sullivan (see Houfe) and Clive Gardiner*). He taught figure composition and commercial design at Camberwell School of Art (1928-40). During WW2 he was a full-time member of the civil defence force.

His first published drawings were for the Christmas catalogue of Barkers of Kensington in 1923, and from 1929 to 1933 he provided fashion drawings and illustrations to short stories and articles for *Harper's Bazaar*. He contributed drawings and scraperboard illustrations to many other magazines including *Lilliput*, the *Listener*, and the *Radio Times*. His work for *Radio Times* was superb: as Pat Hodgson writes in the introduction to the British Gas exhibition catalogue, "His illustrations, seldom forgotten by those who saw them at the time, revive memories of 60 years of social life in Britain as seen through the pages of *Radio Times*."

He illustrated many books, including several for the Folio Society, the Golden Cockerel Press, and Limited Editions club; and he pro-

duced illustrations for a number of book jackets for Dent's "Everyman Library" and for other publishers. The illustrations are nearly all done in black and white, using pen or brush and ink, or scraperboard. There is a great richness of detail and of texture in his work; the blacks are really black, but he also achieves an incredible textural variety. "Fraser's formidable talents as an illustrator are crowned by a powerful gift for graphic organization. In this department his mastery is complete. His dramatic handling of large areas of full black played off against the delicacy of his linear drawing is unique in contemporary illustration." (Jacques.)

Fraser also painted, his work having been exhibited at the RA, the Brussels exhibition (1958), and elsewhere. He did a number of murals including those for the Festival of Britain (1951) and for Babcock House (1957). He also did a great deal of work for advertising agencies for many companies including the Gas, Light & Coke Company, for whom he drew his "Mr. Therm" which increased his prestige immensely. He designed posters for London Transport, Shell, the GPO and Guinness (including a splendid one in 1951, "Guinness and Alice Go to the Festival of Britain") and trade-marks, church windows and pub signs and postage stamps. SIA (1945).

Books illustrated include: H. Bett: *English Legends* (Batsford, 1950); W. Shakespeare: *Complete Works* (Collins, 1951); Tacitus: *The Reign of Nero* (Folio Society, 1952); Baker: *Realms of Gold* (Univ. of London Press, 1954); I. Nievo: *The Castle of Fratta* (Folio Society, 1954); Xenophon: *The Ephesian Story* (GCP, 1957); *The Book of the Thousand Nights and One Night* (Vols. 1 & 3; Folio Society, 1958); J. Reeves: *Sir William and the Wolf* (Dent, 1959); B. Picard: *Tales of the British People* (1961); M. Sotomayer: *A Shameful Revenge and Other Stories* (Folio Society, 1963); N. Sullivan: *Pioneers Against Germs* (Harrap, 1962), *Pioneers in Astronomy* (Harrap, 1964); *The Golden Fleece* (Blackie, 1965); A. Manzoni: *The Betrothed* (Folio Society, 1969); Ovid: *The Art of Love* (NY: Limited Editions Club, 1971); *Folklore, Myths and Legends of Britain* (Reader's Digest, 1973); Homer: *The Voyage of Odysseus* (Blackie, 1973); P. Hill: *Joan of Arc* (OUP, 1974); R. Wagner: *The Ring* (Dawson, 1976); W. Barclay: *A Life of Christ* (Darton Longman, 1977); H. Mitchnik: *Egyptian and Sudanese Folk-Tales* (OUP, 1978); J. R.R. Tolkien: *Lord of the Rings* (Folio Society, 1977), *The Hobbit* (Folio Society, 1979); N. Sustins: *The Scent of Freedom* (CIO, 1982); R. Cavendish: *Legends of the World* (1983).

Contrib: *Art and Industry; Britannia and Eve; Bystander; Harper's Bazaar; Leader; Lilliput; London Mystery Magazine; London Opinion; Listener; Nash's; Night and Day; Radio Times; Reader's Digest; Studio; Vogue.*

Exhib: RA; SSA; RCA ("British Gas" Travelling Exhibition, 1991). **Bibl**: *Eric Fraser: An Illustrator of Our Time* (British Gas, 1991); Alec Davis: *Eric Fraser* (Uffculme Press, 1974); Brian Sibley: *The Book of Guinness Advertising* (Guinness Superlatives, 1985); Amstutz 2; Driver; Folio 40; Hodnett; ICB2; Jacques; Peppin; Sandford; Usherwood; Waters.

FRASER, Peter b.1888
See Houfe

Born on 6 November 1888 in the Shetland Isles, Fraser studied at the Central School of Arts and Crafts. He contributed to *Punch* and other magazines, specializing in humorous animal drawings. He wrote and illustrated a number of books for young children.

Books illustrated include: W.H. Harrison: *Humour in the East End* (1933); E. Fraser: *Chuffy* (Leicester: Ward, 1942), *Duckling to Dunce* (Burrow, 1944), *Floppity-Hop* (Ward, 1944), *Helping Mrs. Wigglenose* (Wheeler, 1944), *Jock and Jack's Great Discovery* (Partridge, 1944), *Billy Bobtail Goes to School* (Glasgow: Art & Education, 1945), *Bunky the Bear Cub* (Art & Education, 1945), *Camping Out* (Pocket Editions, 1945), *The New Recruit* (Burrow, 1945); S. Rye: *The Blackberry Picnic* (Pictorial Arts, 1946), *Bevis and the Giant* (Partridge, 1948); E. Fraser: *John & Ann* (Children's Press, 1949).

Books written and illustrated include: *Funny Animals* (Nelson, 1921); *Tufty Tales* (Warne, 1932); *Moving Day* (Pocket Editions, 1945).

Contrib: *Punch; Sketch; Tatler.*
Bibl: Peppin; Waters.

FREEDMAN, Barnett 1901-1958

Born on 19 May 1901 in Stepney, East London, Freedman was the son of poor Jewish immigrants from Russia. He spent four years as a child between the ages of nine and thirteen in hospital, where he learned to read, write, and play the violin, and started to draw. In 1916 he started work as a draughtsman for a firm of monumental masons and spent his evening for five years studying at St. Martin's School of Art. An unsuccessful LCC scholarship applicant on three occasions, he appealed to Sir William Rothenstein, then Principal of RCA, who succeeded in having the adjudicator's decision reversed. Freedman then studied at RCA (1922-25), and in 1928 became an instructor in still life at RCA and then began to teach at the Ruskin School of Art, Oxford, under Albert Rutherston*. He married Claudia Guercio* in 1930.

The years following his studies at RCA were described by Freedman as years of starvation, but the quality of his work was beginning to be recognised and he had a first exhibition of his work in 1929. His second exhibition at the Zwemmer Gallery in 1931, which included his lithographic illustrations to Sassoon's *Memoirs of an Infantry Officer* (Faber, 1931), attracted more attention. He had met Oliver Simon of the Curwen Press while still at RCA, and he received his first commission from the Press when asked to illustrate *Wonder Night* by Lawrence Binyon for the Ariel Poems series, published by Faber. He later illustrated two more in the series; but it was the Faber *Memoirs of an Infantry Officer* which established his reputation. For this book, his drawings were made into line blocks but teamed with lithographic colour; in this venture, and not for the last time, Freedman was helped by Thomas Griffits, one of the great technicians of modern lithography, who worked for the printers, Vincent Brooks Day, and later for the Baynard Press. In 1936 Freedman illustrated a two volume edition of Borrow's *Lavengro*, printed at the Curwen Press. The colour pages are very subtle, employing to great effect rose-pink, tan, gold, blue and green in landscapes and character sketches. One of the techniques which Freedman developed with Harold Curwen's help was a way of drawing with chalk for a black and white line block so that the resulting illustration looked like a lithograph. In *Lavengro*, the result was that the black and white endpieces match the lithographic nature of the main illustrations and are equally successful. Two years later he did a five volume set of *War and Peace*, this time with Griffits again. During this period, and throughout his career, Freedman was designing and executing a great number of lithographic book jackets, mostly for Faber; the best known of his jackets is perhaps the one he did for Walter de la Mare's *Love* in 1943. He also produced a large number of posters for London Transport, Shell, Ealing Studios, and other organizations; designed a decorative alphabet of initial letters for the Baynard Press; greeting cards and calendars; and other commercial work.

Freedman's career was interrupted by WW2: he was soon appointed an official war artist to the War Office but was released after he exasperated the authorities with what they felt were unreasonable demands and complaints about the quality of the reproductions of his work. In July 1941, he joined HMS *Repulse* where he did a series of portraits before being transferred to a submarine, HMS *Tribune*, where he did another even more successful series. He went to Normandy with the Navy for the invasion, but he became ill and was sent back to England.

During his war service, Freedman managed to illustrate three books, including *Love*, for which he provided a colour lithographed jacket and twenty-two black and white drawings. He produced more jackets and illustrated a few books after the war but suffered from prolonged ill health and died on 4 January 1958. CBE (1946); RDI (1949).

Books illustrated include: L. Binyon: *The Wonder Night* (Ariel Poem series; Faber, 1927); W. de la Mare: *News* (Ariel Poem series; Faber, 1930); R. Campbell: *Choosing a Mast* (Ariel Poem series; Faber, 1931); S. Sassoon: *Memoirs of an Infantry Officer* (Faber, 1931); S. Sitwell: *Liszt* (Faber, 1935); G. Borrow: *Lavengro* (two vols., NY: Limited Editions Club, 1936); L. Tolstoy: *War and Peace* (five vols., NY: Limited Editions Club, 1938); C. Dickens: *Oliver Twist* (NY: Heritage Club, 1939); W. Shakespeare: *Henry IV, Part 1* (NY: Limited Editions Club, 1939); E. Brontë: *Wuthering Heights* (NY: Heritage Club, 1941); C. Brontë: *Jane Eyre* (NY: Heritage Club, 1942; Collins, 1955); W. de la Mare:

Love (Faber, 1943); L. Tolstoy: *Anna Karenina* (two vols., NY: Limited Editions Club, 1951); E. Williams: *Readings from Dickens* (Folio Society, 1953); W. de la Mare: *Ghost Stories* (Folio Society, 1956).
Contrib: *Leader*.
Published: "Lithography: A Painter's Excursion", *Signature* no. 2 (March 1936): 1-14.
Exhib: Zwemmer; Arts Council (retrospective, 1978); Manchester Polytechnic Library (1990).
Collns: Manchester Polytechnic Library; IWM; National Maritime Museum; Tate; V & A.; Bryn Mawr College, Pa.
Bibl: *Barnett Freedman 1901-1958* (Arts Council, 1958); Pat Gilmour: *Artists at Curwen* (Tate Gallery, 1977); Ian Jeffrey: *The British Landscape 1920-1950* (T & H, 1984); Jonathan Mayne: *Barnett Freedman* (Arts & Technics, 1948); Herbert Simon: *Song and Words: A History of the Curwen Press* (Allen & Unwin, 1973); Folio 40; Harries; ICB; ICB2; Lewis and Brinkley; Peppin; Ross; Waters.
Colour Plates 11 and 77

FREEDMAN, Claudia
See GUERCIO, Beatrice Claudia

FREEMAN, Barbara Constance **b.1906**
Born on 29 November 1906 in Ealing, Middlesex, Freeman studied at Kingston-upon-Thames School of Art. Working first as a painter in the studios of a wallpaper company in London, she became a free-lance illustrator of children's books in 1928; and her first self-illustrated book was published in 1961.
Books illustrated include: *Stories from Hans Andersen* (1949); *Stories from Grimm* (1949); E. Blyton: *The Treasure Hunters* (Collins, 1950); A. Ridge: *Jan and His Clogs* (Faber, 1951), *Jan Klaassen Cures the King* (Faber, 1952), *Puppet Plays for Children* (Faber, 1953); C. Perrault: *The Sleeping Beauty and Other Tales* (Blackie, 1954); A. Ridge: *Never Run from the Lion* (Faber, 1958); F. Browne: *Granny's Wonderful Chair* (nd).
Books written and illustrated include: *Two-Thumb Thomas* (Faber, 1961); *Timi* (Faber, 1961); *A Book by Georgina* (Faber, 1962); *Broom Adelaide* (Faber, 1963); *The Name on the Glass* (Faber, 1964); *Lucinda* (Faber, 1965); *The Forgotten Theatre* (Faber, 1967); *Tobias* (Faber, 1967); *The Other Face* (Macmillan, 1975); *A Haunting Air* (Macmillan, 1976); *A Pocket of Silence* (Macmillan, 1977); *The Summer Travellers* (Macmillan, 1978); *Snow in Maze* (Macmillan, 1979); *Clemency in the Moonlight* (Macmillan, 1981).
Bibl: CA; Peppin.

FREEMAN, Terence Reginald **b.1909**
Born on 27 February 1909 in London, Freeman was brought up as a Christian Scientist. As a boy, he was devoted to the illustrations in *Punch*. He studied art at Clapham School of Art and the RCA, spending three years on the study of mural painting. He worked for an advertising agency and in films, and held various teaching posts. As a free-lance illustrator in the 1950s and 1960s, he drew mostly in pen and ink for numerous children's books, taking over from A. H. Watson* as illustrator of Fidler's "Brydons" books.
Books illustrated include (but see Peppin): E. Vipont: *The Lark in the Morn* (OUP, 1948); A.S. Tring: *Penny Dreadful* (and five other titles in series., OUP, 1949-57); M. Allen: *Chiltern Adventure* (1950); K. Fidler: *The Brydons Look for Trouble* (Lutterworth, 1950), *The Brydons in a Pickle* (Lutterworth, 1950), and at least thirteen more titles in series; R. Welch: *The Gauntlet* (OUP, 1951); M.J. Baker: *Treasure Trove* (Brockhampton, 1952), *The Young Musicians* (Brockhampton, 1954); Martin: *Joey of Jasmine Street* (Nelson, 1954); E. Vipont: *The Family at Dowbiggins* (Lutterworth, 1955), *The Spring of the Year* (OUP, 1957); M.J. Baker: *Tip and Run* (Brockhampton, 1958), *Homer Goes on Stratford* (Brockhampton, 1958); M. Curry: *London* (Longman, 1958); E. Vipont: *More About Dowbiggins* (Lutterworth, 1958), *Changes at Dowbiggins* (Lutterworth, 1960); P. Mansbridge: *The Larchwood Mystery* (Nelson, 1960); M.J. Baker: *Homer in Orbit* (Brockhampton, 1961), *Into the Castle* (Brockhampton, 1962); M.

Saville: *Treasure at Amorys* (Newnes, 1964); M.J. Baker: *Homer Goes West* (Brockhampton, 1965).
Bibl: ICB2; Peppin.

FRENCH, Annie **1873-1965**
See Houfe
Born in Glasgow, French studied at the Glasgow School of Art, and in 1909 returned there to take up the teaching position formerly held by Jessie M. King (see Houfe). She remained there until 1914 when she married the painter and author George W. Rhead (see Houfe). Like King, French was a designer, decorator and illustrator, and both artists were described by Philippe Jullian, in his *Dreamers of Decadence*, as "those charming lace-makers." She illustrated many children's books in watercolour and pen and ink, often using the "massed dot" technique, reflecting the work of Beardsley and King, which helps to create the feeling of an insubstantial world.
Contrib: *ILN*.
Exhib: RA; RI; RWA; GI.
Collns: V & A.
Bibl: Johnson FDIB; Waters.
Colour Plate 78

Cecil FRENCH "The Captive Queen": lithograph from *Golden Hind* vol.1 no.3 (April 1923)

FRENCH, Cecil **fl.1920s**
French's first book, *Between Sun and Moon*, was a collection of his poems and woodcuts.
Books written and illustrated include: *Between Sun and Moon* (Favil Press, 1922).
Contrib: *The Apple; Golden Hind*.

FRENCH, Fiona **b.1944**
Born on 27 June 1944 in Bath, French was educated at a convent school in England while her family was in the Middle East, and

"When I am king," said the
pomegranate-tree, lazily,
"it will always be
summer. The garden
will be green all
the year."

Colour Plate 79. Fiona FRENCH *King Tree*
(Oxford University Press 1973)

Colour Plate 80. Brian FROUD Title-page for
Are All the Giants Dead? by Mary Norton (J. M.
Dent 1975)

studied at Croydon College of Art (1961-66), obtaining the NDD in 1966. She started working as a free-lance illustrator in 1967 though for two years she also taught art therapy at a hospital in Epsom, Surrey. She taught design at Wimbledon School of Art (1970-71), and at Leicester and Brighton Polytechnics (1973-74). She was encouraged as an illustrator by Mabel George, one-time editor of children's books at OUP, and until 1976, worked entirely for that publisher. She illustrates mostly her own books, using different media to produce bright picture books. Her interest in collecting blue and white china was reflected in her book, *Blue Bird*, which won the Children's Book Showcase award in 1973. *King Tree* was commended for the Kate Greenaway Prize in 1973.

Books illustrated include: M. Mayo: *The Book of Magical Birds* (1977); C. Crowther: *Clowns and Clowning* (with others; Macdonald, 1978); R. Blythe: *Fabulous Beasts* (Macdonald, 1978); O. Wilde: *The Star Child* (Evans, 1979); J. Karavasil: *Hidden Animals* (Cambridge: Dinosaur, 1982); J. Westwood: *Fat Cat* (Abelard, 1984), *Going to Squintum's* (Blackie, 1985).

Books written and illustrated include: *Jack of Hearts* (OUP, 1970); *Huni* (OUP, 1971); *The Blue Bird* (OUP, 1972); *King Tree* OUP, 1973); *City of Gold* (OUP, 1974); *Aio the Rainmaker* (OUP, 1975); *Matteo* (OUP, 1976); *Hunt the Thimble* (OUP, 1978); *The Princess and the Magician* (Evans, 1981); *John Barleycorn* (Abelard, 1982); *Future Story* (OUP, 1983); *Maid of the Woods* (OUP, 1985); *Snow White in New York* (OUP, 1986); *The Song of the Nightingale* (Blackie, 1986).

Bibl: CA; ICB4; Peppin.
Colour Plate 79

FREUD, Lucian Michael **b.1922**
Born on 8 December 1922 in Berlin, the son of Ernst Freud, the architect, and grandson of Sigmund Freud, Freud came to England in 1932 (he became a naturalized British subject in 1939) and went to school at Dartington Hall. He studied at the Central School of Arts and Crafts and at Goldsmiths' College and for a short period at the art school run by Cedric Morris and Lett Haines at Dedham in Suffolk. He served for six months in the Merchant Navy during WW2, before being invalided out. After the war, he painted in France and Greece.

An important British post-war artist who has achieved an international reputation, Freud had his first exhibition at the Lefevre Gallery in 1944. Like Francis Bacon, he was one of the "School of London" painters, a group which has been largely unaffected by successive "movements". His paintings are mostly portraits, though he has done interiors and still-lifes. He exhibited at the Venice Biennale in 1954, and frequently at the Marlborough Gallery. A retrospective exhibition was arranged by the Arts Council at the Hayward Gallery in 1974.

He has illustrated two books and produced a number of typographical book jackets, including those for Nicholas Moore's *The Glass Tower* (1944) and Nigel Dennis' *Cards of Identity* (1955).

Freud won the Arts Council Prize, Festival of Britain (1951), and was Visitor at the Slade (1953-4); created CH (1983).

Books illustrated include: N. Moore: *The Glass Tower* (Nicholson and Watson, 1944); W. Sansom: *The Equilibriad* (Hogarth Press, 1948).

Exhib: Lefevre Gallery; Marlborough Gallery; Hayward Gallery (retrospective 1974, 1988); British Council/Tate (retrospective 1991).

Collns: Tate; many other galleries.
Bibl: *Lucian Freud*. (Arts Council, 1974); Lawrence Gowing: *Lucian Freud* (T & H, 1982); *Lucien Freud: Works on Paper* (T & H, 1988); Compton; Rothenstein; Tate; Waters.

FRIERS, Rowel Boyd **b.1920**
Born on 13 April 1920 in Belfast, Friers studied at Belfast College of Art (1935-42) and during the first five years was apprenticed to a lithographer. He is a painter in oils of landscapes and figures, a cartoonist, stage designer, poster and greeting card designer, and illustrator. He has written and illustrated a number of books, and contributed to many periodicals, including cartoons for the *Irish Times*, the *Dublin Opinion* and the *Belfast Telegraph*. His illustrations to two autobiographical accounts of rural Ireland by Florence McDowell are light-hearted pen drawings, including small thumb-

Rowel FRIERS *Other Days Around Me* by Florence Mary McDowell (Belfast: Blackstaff Press, 1966)

nail sketches. He was elected RUA (1953); UWS (1977); and awarded the MBE.

Books illustrated include: J.C. Cooper: *Ulster Folklore* (Belfast: Carter, 1951); J. McNeill: *My Friend Specs McCann* (Faber, 1955), *A Pinch of Salt* (Faber, 1956), *A Light Dozen* (Faber, 1957); J. Pudney: *The Book of Leisure* (with others; Odhams, 1957); J. McNeill: *Specs Fortissimo* (Faber, 1958), *Special Occasions* (Faber, 1958), *This Happy Morning* (Faber, 1959); R. Harbinson: *Tattoo Lily* (Faber, 1961); J. McNeill: *Various Specs* (Faber, 1961), *Try These for Size* (Faber, 1963); G. Palmer and N. Lloyd: *A Brew of Witchcraft* (Odhams, 1964); W. White: *The Beedy Book* (Odhams, 1965); F.M. McDowell: *Other Days Around Me* (Belfast: Blackstaff Press, 1966; repr. 1972); G. Palmer and N. Lloyd: *Journey by Broomstick* (Odhams, 1966), *Moonshine and Magic* (Odhams, 1967), *The Obstinate Ghost* (1968), *Starlight and Spells* (1969); J. McNeill: *Best Specs* (Faber, 1970); F.M. McDowell: *Roses and Rainbows* (Belfast: Blackstaff Press, 1972); T. Bonner: *Don't Shoot I'm Not Well* (1974); C. Cusack: *The Humour Is on Me* (Belfast: Appletree, 1980).

Books written and illustrated include: *Wholly Friers* (Lisburn: McMurray, 1948); *Mainly Spanish* (Belfast: Carter, 1951); *Riotous Living* (Blackstaff, 1971); *Pig in the Parlour* (1972); *The Book of Friers* (1973); *The Revolting Irish* (1974); *On the Borderline* (Blackstaff, 1982).

Dame Elisabeth FRINK *The Odes of Horace* (Folio Society, 1987)

Contrib: *Belfast Telegraph; Daily Express; Dublin Opinion; Economist; Irish Times; London Opinion; Punch; Radio Times; Sunday Independent.*
Exhib: RHA; RUA.
Bibl: ICB2; Peppin; Waters; Who.

FRINK, Dame Elisabeth 1930-1993
Born in Suffolk on 14 November 1930, Frink was educated at the Convent of the Holy Family, Exmouth, and studied at Guildford School of Art under Henry Moore's assistant, Bernard Meadows (1947-49) and the Chelsea School of Art (1949-53). She taught at Chelsea and St. Martin's School of Art (1954-62) and was visiting instructor at RCA (1965-67), after which she lived in France until 1973.
An eminent British sculptor, she was a member of the post-war school of expressionist British sculptors which attracted special commendation at the 1952 Venice Biennale. In that same year, the Tate bought its first work by her. She exhibited regularly at the Waddington Galleries and is represented in many collections worldwide. Her *Canterbury Tales* contains nineteen etchings drawn directly on to copper plates and etched by Frink, and the "book" was issued in three limited editions. Her illustrations have been both excessively praised as "amongst the most successful illustrations of the century, encompassing the mood of the text in concise delin-

eations and disarmingly ribald humour" (Sarah Kent, as quoted by Hogben, 1985†), and discounted as "unwieldy" (Tom Phillips in the *Times Literary Supplement* 26 May 1985). She has illustrated a few other, more modest, books with coloured lithographs or drawings.
She was on the Board of Trustees, British Museum, from 1976, and was a member of the Royal Fine Art Commission (1976-81). CBE (1969), DBE (1982), ARA (1971), RA (1977). She died on 18 April 1993.
Books illustrated include: G. Chaucer: *The Canterbury Tales* (Waddington Gallery, 1972); Homer: *The Odyssey* (Folio Society, 1974), *The Iliad* (Folio Society, 1975); K. McLeish: *Children of the Gods* (Longman, 1983); Horace: *Odes* (Folio Society, 1987); R.M. Rilke: *The Duino Elegies* (Carcanet, 1989).
Exhib: Beaux Arts Gallery (1952); St. George's Gallery (1955); RA (1985); Waddington Galleries.
Collns: Tate; V & A.; NPG; MOMA; National Gallery, Australia.
Bibl: Carol Hogben and Rowan Watson: *From Manet to Hockney: Modern Artists' Illustrated Books* (V & A, 1985); Laurie Lee: "Elisabeth Frink", *Motif* 1 (1958): 61-68; Parry-Cooke; Who; Who's Who.

FRONT, Charles b.1930
Born on 10 March 1939 in London, Front grew up in the East End of London until he was evacuated during WW2 to Northampton. He

Colour Plate 81. Robert GEARY Unpublished drawing (1981) instrumental in persuading authors and publisher to produce a children's picturebook, *The Elephant Man* (1983)

St John, Smith Square and Lord North Street

Colour Plate 82. David GENTLEMAN "St John, Smith Square" from *David Gentleman's London* (Weidenfeld & Nicolson 1985)

Colour Plate 83. Anthony GILBERT, *Lilliput* cover, April 1950

Colour Plate 84. John GOODALL *Paddy Goes Travelling* (Macmillan 1982)

studied at the Northampton School of Art, the South-East Essex School of Art, the Slade (under Edward Ardizzone* and Lynton Lamb*), and University College, London. After two years' National Service in the 1950s, he worked for twelve years in advertising; then, with encouragement from his wife, he became an illustrator of children's books.

Books illustrated include: S. Front: *Raffan and Jeremy* (BH, 1969); S. Steen: *A Child's Bible* (1969); Parker: *Not a Home* (Macmillan, 1972); S. Front: *The Three Sillies* (Abelard, 1974); M. MacPherson: *The Boy on the Roof* (1974); P. Binns: *Flavio and the Cats of Rome* (Abelard, 1976); M. Darke: *The Big Brass Band* (Kestrel, 1976); N. Chambers: *Stickleback, Stickleback* (Kestrel, 1977); S. Front: *The Golden Goose* (Benn, 1977); F.E. and F.J. Schonell: *Essential Read-Spell* (v.3; Macmillan, 1979); F. Law: *Tudor Palace 1587* (Pepper Press, 1981); E. Farjeon: *The Little Dressmaker* (MacRae, 1984); S. Front: *The Scary Book* (Deutsch, 1985); A. Morgan: *Staples for Amos* (MacRae, 1986).
Bibl: ICB4; Peppin.

FROUD, Brian b.1948
Born in Winchester, Froud studied at Maidstone College of Art. He worked for a graphic art agency for about three years before becoming a free-lance illustrator. He works in pen and pencil, and often in full colour applied by airbrush, though many of his illustrations are done in similar tones, resulting in a subdued, sombre effect. His illustrations of other worlds and creatures — trolls, goblins, fairies and ghosts — often vividly recall the work of Arthur Rackham; other influences on his work are Edmund Dulac, the Robinson* brothers, and of course the legends of Britain and Germany. The publication with Alan Lee* of *Faeries* in 1978 was an enormous success, with more than 600,000 copies in nine languages sold by 1984.
Books illustrated include: M. Mahy: *The Man Whose Mother Was a Pirate* (1972), *The Railway Engine and the Hairy Brigands* (1973), *The Ultra-Violet Catastrophe* (1975); M. Norton: *Are All the Giants Dead?* (Dent, 1975); M. Mahy: *The Wind Between the Stars* (Dent, 1976); J.J. Llewellyn: *The World of the Dark Crystal* (Mitchell Beazley, 1983); T. Jones: *Goblins of the Labyrinth* (Pavilion, 1986).
Books written and illustrated include: *Faeries* (with Alan Lee*; Souvenir Press, 1978); *Goblins* (Blackie, 1983).
Contrib: *Men Only*.
Bibl: David Larkin. *The Land of Froud*. (Pan, 1977); Peppin.
Colour Plate 80

FRY, Rosalie Kingsmill b.1911
Born on 22 April 1911 on Vancouver Island, British Columbia, Fry came to England with her parents when she was four. She was educated in Swansea and studied at Central School of Arts and Crafts (1929-34), concentrating mainly on book illustration. During WW2 she served in the Women's Royal Naval Service (1939-45). She writes and illustrates books for children, using pen and ink and colour washes, though several of her books written since 1965 are illustrated by other artists such as Margery Gill* and Robin Jacques*. Some of her books were published first in the USA.
Books illustrated include: M. Knight: *The Land of Lost Handkerchiefs* (1954); M. Sidgwick: *Jan Perry Stories* (1955); C. Kingsley: *The Water Babies* (1957); M. Sidgwick: *More Jan Perry Stories* (1957), *New Jan Perry Stories* (1959).
Books written and illustrated include: *Bumblebuzz* (NY: Dutton,

1938); *Ladybug! Ladybug!* (NY: Dutton, 1940); *Bandy Boy's Treasure Island* (NY: Dutton, 1941); *Baby's Progress Book* (W.H. Smith, 1944); *Adventure Downstream* (Hutchinson, 1946); *In a Rock Pool* (Hutchinson, 1946); *Cherrywinkle* (Hutchinson, 1951); *The Little Gipsy* (Hutchinson, 1951); *Pipkin the Woodmouse* (Dent, 1953); *Deep in the Forest* (Hutchinson, 1955); *Wind Call* (Dent, 1955); *Lucinda and the Painted Bell* (Dent, 1956); *Child of the Western Isles* (Dent, 1957); *Secret of the Forest* (Hutchinson, 1958); *Lucinda and the Sailor Kitten* (Dent, 1958); *Fly Home Colombina* (Dent, 1960); *The Mountain Door* (Dent, 1960); *Princess in the Forest* (Hutchinson, 1961); *The Echo Song* (Dent, 1962); *Secrets* (Dent, 1973).
Contrib: *Collins' Children's Annual; Country Life; Countryman; Lady; Parents*.
Bibl: CA; ICB2; Peppin.

FURNISS, Harry 1854-1925
See Houfe
Books illustrated include: W.M. Thackeray: *Ballads and the Rose and the Ring* (with others., Smith, Elder, 1879); L. Sterne: *Tristram Shandy* (1883); H. Lennard: *Romps at the Seaside* (Routledge, 1885), *Romps in Town* (Routledge, 1885); E.J. Millikan: *Romps All the Year Round* (Routledge, 1886); C.M. Norris: *Hugh's Sacrifice* (1886); G.A.A'Beckett: *The Comic Blackstone* (1887); F.C. Burnand: *The Incompleat Angler* (1887); L.T. Courtney: *Travels in the Interior* (1887); E. Hamilton: *The Moderate Man* (1888); L. Carroll: *Sylvie and Bruno* (Macmillan, 1889), *Sylvie and Bruno Concluded* (Macmillan, 1889); *The Works of Charles Burton Barber* (1890); J. Davidson: *Fleet Street Eclogues* (1890); W.H. Lucy: *A Diary of the Salisbury Parliament* (1892); N. Chester: *Olga's Dream* (1892); G.E. Farrow: *The Wallypug of Why* (1895), *The Missing Prince* (1896); *How's That?* (1896); E. Adams: *Miss Secretary Ethel* (1898); H.E.A. Cowen: *Financial Philosophy* (1902); C. Dickens: *The Uncommercial Traveller* (OUP, 1902); H.E. Cowan: *Financial Philosophy* (1902); R. Marshall: *The Haunted Major* (1902); M.H. Spielmann: *Littledom Castle and Other Tales* (1903); B.L. Farjeon: *Shadows on the Snow* (1904); G.E. Farrow: *The Wallypug Book* (1905); E.A. Parry: *A Gamble with Gold* (1907); F. Wicks: *My Undiscovered Crimes* (1909); M. Browne: *Wanted, A King* (1910); *Charles Dickens Library* (1910); W. Thackeray: *Works* (1911); H. de F. Cox: *Yarns Without Yawns* (1923).
Books written and illustrated include: *Pictures At Play* (1881); *A River Holiday* (1883); *Parliamentary Views* (Bradbury & Agnew, 1885); *The Story of Harry Furniss's Royal Academy* (Nimmo, 1888); *M.P.s in Session* (Bradbury & Agnew, 1889); *Royal Academy Antics* (Cassell, 1890); *The Grand Old Mystery Unravelled* (Simpkin, Marshall, 1894); *Pen and Pencil in Parliament* (Sampson Low, 1897); *Australian Sketches Made on Tour* (Ward Lock, 1899); *America in a Hurry* (1900); *Harry Furniss at Home* (Fisher Unwin, 1904); *Friends Without Faces* (1905); *Poverty Bay* (Chapman & Hall, 1905); *Our Lady Cinema* (Arrowsmith, 1914); *Publications for Peace in War* (Salvation Army War Work Fund, 1917); *The By Ways and Queer Ways of Boxing* (Harrison, 1919); *My Bohemian Days* (Hurst & Blackett, 1919); *Stiggins* (1920); *Some Victorian Women* (BH, 1923); *Some Victorian Men* (BH, 1924); *The Two Pins Club* (Murray, 1925).
Exhib: NPG (1983).
Bibl: Alison Opyrchal: *Harry Furniss 1854-1925: Confessions of a Caricaturist* (NPG, 1983); Peppin; Waters.

GAASTRA, John fl. 1940s-1950s

Gaastra illustrated at least two books with wood engravings. For the Folio Society edition of Oscar Wilde's fairy tales, the illustrations are bright, three-colour engravings.

Books illustrated include: R.B. Lockhart: *My Rod, My Comfort* (Dropmore Press, 1949); O. Wilde: *The Young King and Other Stories* (Folio Society, 1953).
Bibl: Folio 40.

GABAIN, Ethel Leontine 1883-1950

Born at Le Havre, Gabain studied at the Slade, the Central School of Arts and Crafts, and in Paris. A portrait and figure painter, etcher and lithographer, Gabain illustrated only a few books. She won the De Laszlo silver medal in 1933 for a portrait of the actress, Flora Robson; and she was elected RBA (1932); ROI (1933). She was an official war artist during WW2; died on 30 January 1950. She was married to John Copley.
Books illustrated include: C. Brontë: *Jane Eyre* (Paris: Imprimerie Nationale, 1923); A. Trollope: *The Warden* (Mathews & Marrot, 1926).
Exhib: RA; ROI; GI.
Collns: IWM.
Bibl: Harold Wright: *The Lithographs of John Copley and Ethel Gabain* (Chicago: Albert Roullier Art Galleries, 1924); Harries; Peppin; Waters.

GAGE, Edward Arthur b.1925

Born on 28 March 1925 in Gullane, Scotland, Gage was educated at The Royal High School, Edinburgh (1933-41). He studied art at Edinburgh College of Art (1941-42) before serving in the army during WW2, and then returned to College (1947-52). In 1951-52 he spent a travelling scholarship in Majorca. He was art master at Fettes College (1952-68) and was appointed art critic to *The Scotsman* in 1966. He became Senior Lecturer in the Design Department of Napier College in 1968.

He started drawing for the *Radio Times* in 1953, and contributed work for other BBC publications, using first scraperboard before turning to pen and ink. He has had illustration commissions from several publishers, including Bodley Head, Cassell and Michael Joseph.

Gage is primarily a painter in oils and watercolour. He has had several one-man shows and his work is in the permanent collections of galleries in Scotland. In the 1950s he was also a stage set designer. He was President of the Scottish Society of Artists (1960-64); RSW (1963).
Contrib: *Radio Times.*
Published: *The Eye in the Wind; Scottish Painting Since 1945* (Collins, 1977).
Exhib: French Institute, Edinburgh; Scottish Gallery; RSA; RSW; Royal Glasgow Inst.
Collns: Glasgow; Edinburgh; Aberdeen Univ; Edinburgh Univ.
Bibl: Driver; Usherwood; Waters; Who.

GALSWORTHY, Gay John b.1932

Born in Portugal, Galsworthy studied at Hammersmith School of Art and at the South-West Essex Technical College. He first taught at a secondary school before working for a commercial art studio. Since 1960 he has been a free-lance illustrator, mostly for children's books and works on folklore.
Books illustrated include (but see Peppin): B.L. Picard: *Hero-Tales from the British Isles* (Ward, 1963), *Celtic Tales* (Ward, 1964); G. Kaye: *Kassim and the Sea Monkey* (1967); E. Porter: *The Folklore of East Anglia* (Batsford, 1974); T. Deane and T. Shaw: *The Folklore of Cornwall* (Batsford, 1975); C. Ekwensi: *The Rainbow-Tinted Scarf* (Evans, 1975); C. Hole: *English Traditional Customs* (Batsford, 1975); R. Palmer: *The Folklore of Warwickshire* (Batsford, 1976); J. Tate: *Crow and the Brown Boy* (Cassell, 1976), *Polly and the Barrow Boy* (Cassell, 1976); V. Canning: *The Runaways* (1977); R. Whitlock: *The Folklore of Wiltshire* (Batsford, 1976), *The Folklore of Devon* (Batsford, 1977); J. Milne: *The Long Tunnel* (Heinemann, 1980); R. Ramharacksingh: *Caribbean Primary Agriculture* (Cassell, 1982); K. Thear: *Part Time Farming* (Ward Lock, 1982); *Primary English for the Gambia* (Longman, 1984).
Contrib: *Housewife.*
Bibl: Peppin.

GAMMON, Reginald William b.1894
See Houfe

Born on 8 January 1894 in Petersfield, Hampshire, Gammon was educated at Churchers College, Petersfield. He was first apprenticed to a village builder (1908) but after an illness started to work for Frank Patterson, a black and white artist. After army service during WW1, he began work as a free-lance artist for several magazines, including the *Scout, Motor* and *Motor Cycling*. For sixty years (1924-84) he wrote and illustrated a country feature for the *Cyclists' Touring Club Gazette*. In 1930 he was invited by the *News Chronicle* to collaborate with Stanley Baron to illustrate the latter's weekly cycling feature, and to write and illustrate his own weekly feature, "The Week in the Country". In the 1930s he illustrated six books based on the popular BBC radio series "Romany" for chil-

Colour Plate 85. Philip GOUGH Jacket for *The Greater English Church of the Middle Ages* by Harry Batsford and Charles Fry (Batsford 1940)

Colour Plate 86. Rigby GRAHAM "Aylestone factories" from *Graham's Leicestershire* (Gadsby Gallery + Sycamore Press 1980)

Reg GAMMON *One Man's Furrow* (first published in Great Britain by Webb & Bower (Publishers) Ltd., 1990)

dren. Early during WW2 he moved to Wales, and in 1942 bought a hill sheep farm in the Llanthony Valley, Abergavenny; he retired from farming in 1962 and moved to Somerset.

Gammon has been painting in watercolour since 1918, and has exhibited widely. He had a retrospective exhibition at the RWA in 1985 to honour his record of fifty unbroken years of exhibiting, and has had two one-artist shows at the New Grafton Gallery in London during the 1980s which received very favourable reviews in the *Times*. His autobiographical account, *One Man's Furrow: Ninety Years of Country Living* (1990), consisting almost entirely of illustrated articles published between 1918 and 1972, contains thirty-two colour illustrations and more than 150 in black and white. He was elected RWA and ROI in 1966.

Books illustrated include: H. Rand: *A Book of Petersfield* (Petersfield: Childs, 1927); S.R. Baron: *Westward Ho! From Cumbria to Cornwall* (Jarrolds, 1934); G.B. Evans: *Romany, Muriel and Doris* (1939), *Out with Romany by the Sea* (ULP, 1941).
Books written and illustrated include: *One Man's Furrow* (Webb & Bower, 1990).
Contrib: *Cyclist's Touring Club Gazette; Light Car; Morris Owner; Motor; Motor Cycling; News Chronicle; Punch; Scout.*
Exhib: NEAC; RA; RBA; RI; ROI; RWA (retrospective 1985); New Grafton Gallery (one-artist shows 1986, 1988).
Bibl: Reg Gammon: *One Man's Furrow* (Webb & Bower, 1990); Peppin; Waters; Who.

GARDINER, Alfred Clive 1891-1960
Born in Blackburn, the son of writer and newspaper editor A.G. Gardiner, he was educated at University College, London, and studied art at the Slade (1909-12) and the RA Schools (1913-14). He taught at Goldsmiths' College School of Art, becoming Principal in 1952. He painted in oils, produced posters in the Cubist style for the Empire Marketing Board and for London Transport, some of which recall the work of McKnight Kauffer*, and illustrated a few books, including several written by his father.
Books illustrated include: A.G. Gardiner: *The War Lords* (Dent, 1915); W.L. Courtney: *Pillars of Empire* (Jarrolds, 1918); A.G. Gardiner: *Leaves in the Wind* (Dent, 1921), *Many Furrows* (Dent,

1924); J.L. Campbell: *Miracle of Peille* (Collins, 1930).
Exhib: RA; RP.
Collns: Tate.
Bibl: Stephen Constantine: *Buy & Build: The Advertsing Posters of the Empire Marketing Board* (HMSO, 1986); Peppin; Waters.

GARDNER, James b.1907
Born on 29 December 1907, Gardner studied at Chiswick and Westminster Schools of Art. He became a jewellery designer for Cartier (1924-31), and then produced advertising material. In 1940 he wrote and illustrated two of the earliest Puffin Picture Books; and he served in the army during WW2 from 1939, including an appointment as Chief Deception Officer in the camouflage section (1941-46). After the war he concentrated as a designer for permanent and temporary exhibitions, his work including the design of the Festival Gardens, Battersea, for the Festival of Britain (1951); the British Pavilion at Expo '67 in Montreal; the Commonwealth Institute, Kensington; the Geological Museum, South Kensington; and the visual design of the QE2. His work overseas has included the Evoluon Museum, Eindhoven, Netherlands, and the National Museum of Natural Science, Taiwan. An internationally renowned industrial designer and consultant, his honours include RDI (1947), CBE (1959), Senior Fellow, RCA (1987).
Books illustrated include: D. Garnett: *The Battle of Britain* (Puffin Picture Books 21; Penguin, 1941).
Books written and illustrated include: *War in the Air* (Puffin Picture Books 3; Penguin, 1940); *On the Farm* (Puffin Picture Books 4; Penguin, 1940).
Published: *Drawing for Advertising* (1938); *Elephants in the Attic* (1983).
Bibl: Mary Banham and Bevis Hillier: *A Tonic to the Nation* (T & H, 1976); Peppin; Who's Who.
See illustration on page 210

GARDNER, Phyllis b.1890
Born on 6 October 1890 in Cambridge, Gardner studied at the Slade and at Frank Calderon's School of Animal Painting. A painter in watercolour and tempera, she also did wood carving and illustrated books with wood engravings.
Books illustrated include: M. Gardner: *Plain Themes* (1913); S. Casson: *Rupert Brooke and Skyros* (1921); M.W. Cannan: *The House of Hope* (1923); A. Cippico: *Carme Umanistico* (1923); M. Gardner: *Songs of the Broads* (1924); W. Scott: *The Irish Wolfhound* (with Delphis Gardner; 1931), *Alice Brand* (with Delphis Gardner; 1932); D. Gardner: *The Latin Writings of Saint Patrick* (1932), *The Tale of Troy* (1924-5).
Exhib: NEAC; RMS; SWA; WIAC.
Bibl: Peppin; Waters.

GARFIT, William b.1944
Born on 9 October 1944 in Cambridge, Garfit was educated at Bradfield College and studied art at Cambridge School of Art (1963-64), Byam Shaw (1964-67) and the RA Schools (1967-70). An artist in oils, he concentrated on East Anglian landscapes (1965-79), before specializing in painting water and river scenes and illustrating books and magazines. His illustrative work is concerned mostly with country sports and other rural matters, and is done with pen and wash. He has also produced three book jackets, for Collins and Deutsch. Elected RBA.
Books illustrated include: C. Willock: *Dudley, the Worst Dog in the World* (Deutsch, 1977); A. Coats: *Amateur Keeper* (Deutsch, 1978); C. Willock: *Town Gun II* (Deutsch, 1981); B. Bishop: *Cley Marsh and Its Birds* (Boydell, 1983); I. McCall: *Your Shoot* (Black, 1985); R. Page: *The Fox and the Orchid* (Quiller Press, 1987); M. Barnes: *The Game Shot* (Crowood Press, 1988); P. Coats: *Prue's Country Kitchen* (WPA, 1988); R. Page: *How the Heron Got Long Legs* (Bird Farm Books, 1989).
Contrib: *Country Sport; Field; Shooting Times.*
Exhib: Waterhouse Galleries; Mall Galleries; Tryon Gallery (1981, 1983, 1985, 1988).
Bibl: Who.

GARLAND, Nicholas b.1935
Born in London, Garland spent his childhood in New Zealand, but

Threshing the Grain

nto piles, called

nces the square

abbits and mice

xcited dogs and

ricks until it is

James GARDNER *On the Farm* (Puffin Picture Book 4; Penguin Books, 1940)

in 1954 returned to England to study at the Slade. He first worked in the theatre, but started to draw cartoons in 1964. In 1966, he was appointed political cartoonist for the *Daily Telegraph*, and has also contributed to a number of weekly magazines. With Barry Humphries, he created the strip "Barrie Mackenzie" for *Private Eye*.
Books illustrated include: B. Humphries: *The Wonderful World of Barrie McKenzie* (Macdonald, 1968), *Bazza Pulls It Off* (Australia: Sun Books, 1971; Private Eye, 1972); T.B. Macaulay: *Horatius* (Duckworth, 1977); A. McPherson and A. Macfarlane: *Mum — I Feel Funny!* (Chatto, 1982).
Books written and illustrated include: *Buy Back the Dawn* (NY: Marek, 1980; Fontana, 1981); *An Indian Journal* (Edinburgh: Salamander Press, 1983); *Cartoons by Garland* (Salamander Press, 1984); *Travels with My Sketch Book* (Harrap, 1987).
Contrib: *Daily Telegraph; New Statesman; Private Eye; Spectator*.
Bibl: Feaver.

GARNETT, Eve C.R. fl.1927-
Born in Worcestershire, Garnett spent her childhood there and in Devon. She was educated privately and in various schools in Devon, before studying at Chelsea School of Art and the RA Schools. While at RA, she won prizes for landscape painting; and also received a commission from John Lane to illustrate Evelyn Sharp's *The London Child*. While doing research for this book, Garnett was so moved by the living conditions of the poor that she determined to exhibit this situation in her later work. The 40ft. mural she completed for The Children's House, Bow, and some of her books, particularly *The Family from One End Street* (1937), for which she was awarded the Carnegie Gold Medal in 1938) and *"Is It Well with the Child?"* (1938), resulted from this commitment. All critics are not in agreement on the value of *The Family from One*

End Street, for Eyre declares it a "basically unreal, snobbish, unsatisfying book" whose "shadow hangs over much contemporary realistic writing for children." Garnett was also a landscape painter and exhibited at NEAC from 1938, at the Tate, and elsewhere.
Books illustrated include: E. Sharp: *The London Child* (BH, 1927); N. Hunter: *The Bad Barons of Crashbania* (Blackwell, 1932); R.L. Stevenson: *A Child's Garden of Verse* (Penguin, 1948); J. Reeves: *A Golden Land* (with others; Constable, 1958).
Books written and illustrated include: *The Family from One End Street* (Muller, 1937); *"Is It Well with the Child?"* (Muller, 1938); *In & Out & Roundabout* (Muller, 1948); *A Book of the Seasons* (OUP, 1952); *Further Adventures of the Family from One End Street* (Heinemann, 1956); *Holiday at the Dew Drop Inn* (Heinemann, 1962); *To Greenland's Icy Mountains* (Heinemann, 1968); *Lost and Found: Four Stories* (Muller, 1974).
Exhib: Tate; NEAC; Goupil Gallery; Lefevre Gallery.
Bibl: Eve Garnett: *First Affections: Some Autobiograhical Chapters of Early Childhood* (Muller, 1982); Doyle; Eyre; ICB; ICB2; Peppin; Waters; Who.

GARNETT, Rachel Alice 1891-1940
Born on 22 May 1891 in London, Rachel Alice Marshall became "Ray" Garnett, the first wife of David Garnett, a "Bloomsbury" writer. She was one of Noel Rooke's* early pupils of book illustration at the Central School of Arts and Crafts, after he had started to teach wood engraving. In 1910 she drew a few political cartoons for *The Common Cause*; and she wrote and illustrated at least two books for children. Apart from these and a few other early illustrations, which were mostly coloured line drawings and done as Rachel Marshall, she used woodcuts to illustrate books by her husband and by T.F. Powys. One late book, *The Book of the Bear*

R.A. GARNETT *The Grasshoppers Come* by David Garnett (Chatto & Windus, 1931)

(1926), contains eight coloured illustrations.
Books illustrated include (but see Mitchell†): A. and J. Taylor: *The Vulgar Little Lady* (Central School, 1913); C. Loundsberry: *The Happy Testament* (Chatto, 1913); O. Chandler: *The Imp of Mischief* (Chatto, 1920); D. Garnett: *Lady into Fox* (Chatto, 1922); T.F. Powys: *Black Bryony* (Chatto, 1923); D. Garnett: *A Man in the Zoo* (Chatto, 1924); J. Harrison and H. Mirrlees: *The Book of the Bear* (Nonesuch Press, 1926); M. Hodder: *Pax, the Adventurous Horse* (Faber, 1928); T.F. Powys: *The Key of the Field* (William Jackson, 1930); D. Garnett: *The Grasshoppers Come* (Chatto, 1931), *A Rabbit in the Air* (Chatto, 1932).
Books written and illustrated include: *Archibald* (Central School, 1915); *A Ride on a Rocking-Horse* (Chatto,1917).
Contrib: *The Common Cause*.
Bibl: J. Lawrence Mitchell: "Ray Garnett as Illustrator", *Powys Review* 10 (Spring 1982): 9-28; Garrett 1; Peppin.

GARWOOD, Tirzah 1908-1951
Born Eileen Lucy (the third child, thus "tertia" or Tirzah) in April, 1908, Garwood was educated at West Hill School and studied at Eastbourne School of Art under Reeve Fowkes and Eric Ravilious*, from whom she learned wood engraving. Some of her college work was exhibited at the SWE annual show at the Redfern Gallery in 1927 and in 1928. Ravilious introduced her to Oliver Simon at the Curwen Press and to the BBC. She did engravings for the BBC in 1928, designed a new version of its crest, and did many line drawings for the *Listener*. Her engravings were also reproduced in *The New Woodcut*, published by the *Studio* (1930), and in the *London Mercury*. She moved to London in 1929 to study at the Central School and married Ravilious in 1930. The Raviliouses moved to Great Bardfield in Essex and for a while shared a house with

Edward Bawden* and his wife Charlotte. Garwood designed four borders for the Kynoch Press in 1931 and borders for *Heartsease and Honesty*, published by the Golden Cockerel Press in 1935. She worked with her husband on murals for a hotel in Morecambe, and with Charlotte Bawden she designed and produced marbled paper, but with the birth of three children (the first in 1935) and the onset of WW2, her artistic career seemed to have ended. Ravilious died in 1942 on a mission to Iceland as an official war artist, and Garwood learned that she had cancer. She nevertheless began to paint again and produced paper collages. She married Henry Swanzy in 1946 and continued to paint, despite the onset of secondary cancer, and died on 27 March 1951.
Books illustrated include: L.A.G. Strong: *The Big Man* (Joiner & Steele, 1931).
Contrib: *Listener; London Mercury; The Woodcut*.
Exhib: SWE; Towner Art Gallery, Eastbourne (retrospectives 1952, 1987); Arts Council (retrospective).
Collns: V & A.
Bibl: Olive Cook: "The Art of Tirzah Garwood", *Matrix* 10 (Winter 1990): 3-10; Anne Ullmann: *The Wood-Engravings of Tirzah Ravilious* (Fraser, 1987); Anne Ullmann: "Tirzah Garwood", *Private Library*, 3s. 10, no. 3 (Autumn 1987): 100-107.

GAUNT, William 1900-1980
Born on 5 July 1900 in Hull, Gaunt was educated at Hull Grammar School and Worcester College, Oxford, and studied at Westminster School of Art (1924-25) under Walter Bayes and Bernard Meninsky. A painter of landscapes and townscapes, he had several one-man shows and exhibited at the RA. He was art critic of the *Evening Standard* and *Punch*; and published extensively on social history and nineteenth century art.

William GAUNT *London Promenade* (Studio, 1930)

Books written and illustrated include: *London Promenade* (Studio, 1930).
Published: *The Pre-Raphaelite Tragedy* (Cape, 1942); *The Aesthetic Adventure* (Cape, 1945); *Victorian Olympus* (Cape, 1952).
Bibl: Waters.

GAZE, Gillian
See BARKLEM, Jill

GEARY, Robert John **b.1931**
Born on 15 January 1931 in Battersea, London, Geary was educated in elementary schools in South London, and privately, and studied art at Hammersmith School of Arts and Crafts (1945-48). He later studied typographic design at the London College of Printing (1968-69) as a part-time student. He was a graphics officer at the Geological Museum in South Kensington, working from 1971 to 1985 as part of a team of designers and illustrators. He has been a free-lance book illustrator since the early 1960s, working in pen and ink and watercolour, though that was done only on a part-time basis until 1985. He claims to have been influenced by the economy of line of Phil May; by Edward Ardizzone*; and by an exhibition of the work of children's book illustrators at the RBA Gallery in the early 1960s, which led him to become a children's book illustrator himself.
Geary was commissioned by *Punch* during the late 1970s to illustrate humorous short stories by such writers as Richard Gordon, Caryl Brahms and Ludovic Kennedy. Another major undertaking was the illustration of a picture book, based on the story of the "elephant man", a book he instigated by producing a number of location drawings in Whitechapel Road, and adding Victorian figures from imagination. Since 1985 he has worked for many publishers, and illustrated several books for children; produced a set of postage stamps for Guernsey Post Office, commemorating the visit of John Wesley to the Channel Islands; and produced sixteen black and white illustrations for Trollope's *Ayala's Angel* for the Folio Society. He was elected MSIA (1967); FCSD (1980); SGA (1969); FRSA (1981).
Books illustrated include: M. Treadgold: *The Weather Boy* (Brockhampton, 1964); J.P. Rutland: *A First Look at Bread* (Watts, 1972); R. Kerrod: *Tools* (Watts, 1977); C. Kingsley: *The Water Babies* (Collins, 1978); R.W. Lane: *Let the Hurricane Roar* (Puffin, 1982); M. Howell and P. Ford: *The Elephant Man* (Alison & Busby, 1983); H. Khattab: *Stories from the Muslim World* (Macdonald, 1987); S. Sheridan: *Stories from the Jewish World* (Macdonald, 1987); A. Trollope: *Ayala's Angel* (Folio Society, 1989).
Contrib: *Good Housekeeping; Punch; Radio Times*.
Exhib: SGA.
Bibl: Who; IFA.
Colour Plate 81

GEDDES, Elisabeth **fl. 1937-**
Geddes' small book, *Animal Antics*, which she illustrated with twenty-five wood engravings, is described by Sandford as "a Christmas frivolity." She later wrote and illustrated two books on embroidery.
Books written and illustrated include: *Animal Antics* (GCP, 1937); *Design for Flower Embroidery* (Mills & Boon, 1961); *Blackwork Embroidery* (with M. MacNeill; Mills & Boon, 1965).
Bibl: Sandford.

GELDART, William **b.1936**
Born on 21 March 1936 at Marple, Cheshire, Geldart was educated at Hyde Grammar School and studied art at Regional College, Manchester (1956-57). He works as an illustrator in pencil, pen and ink, scraperboard and gouache; some of his work has been published in France by Editions Gallimard.
Books illustrated include: J. Stranger: *The Fox at Drummer's Darkness* (Dent, 1976), *Kym* (Joseph, 1976); B. Reson: *Ghostly Laughter* (Beaver); J. Gardam: *Kit* (Macrae, 1983); Z. & I. Woodward: *Witches' Brew* (Hutchinson, 1984); L.R. Banks: *The Fairy Rebel* (Dent, 1985); Z. and I. Woodward: *Poems That Go Bump in the Night* (Beaver, 1985); L.R. Banks: *Return of the Indian* (Dent, 1986); J. Gardam: *Kit in Boots* (MacRae, 1986); *Words on Water: An Anthology of Poems* (Kestrel, 1987).

Books written and illustrated include: *Geldart's Cheshire* (Whitethorn Press).
Exhib: RA; Manchester Fine Arts.
Bibl: Who.

GELL, Kathleen **b.1913**
Gell illustrated several books by Enid Blyton and other books for young children published mostly by Blackwell.
Books illustrated include: O. Dehn: *Come In* (Shakespeare Head Press, 1946); E. Blyton: *A Second Book of Naughty Children* (Methuen, 1947), *The Yellow Story Book* (Methuen, 1950); J.G. Hughes: *A King in the Oak Tree* (1956); A.S. Tring: *Penny and the Pageant* (Blackwell, 1959), *Penny Says Goodbye* (Blackwell, 1961).
Books written and illustrated include: *An Alphabet* (Blackwell, 1956).
Bibl: Peppin.

GENTLEMAN, David **b.1930**
Born on 11 March 1930 in London, Gentleman was educated at Hertford Grammar School and studied at St. Albans School of Art (1947-48) and the RCA (1950-53) under John Nash* and Reynolds Stone*. He taught at the RCA for two years immediately after graduating and travelled for short periods in Europe, India and the US. In 1955 he became a free-lance artist working in many areas and different media, painting and drawing, designing postage stamps and posters, doing murals, textiles, wallpapers and book jackets (including some fine jackets and paperback covers for reissues of Durrell's *Alexandria Quartet* for Faber and for Durrell's later books), and producing many fine book illustrations.
Gentleman's first commission from a publisher was for wood engravings to illustrate *What About Wine?* for Newman Neame (1953), while still at RCA. In the same year he produced some colour engravings for *The Tale of Two Swannes*. For *The Swiss*

David GENTLEMAN "September" from *The Shepherd's Calendar* by John Clare (Oxford University Press, 1964)

Family Robinson (1963), the engravings are balanced by the addition of a drawn coloured background. His first commission from Penguin Books was for *Plats du Jour* (1957) which he illustrated with pen and ink drawings; and he produced bold woodcuts, coloured using overlays of coloured plastic film, for the new edition of the Penguin Shakespeare (1967-77). He produced many drawn illustrations for four books about rural England by George Evans, his father-in-law; and Gentleman's *Bridges on the Backs* (1961), with its drawings and hinged overlays, is one of the finest "Christmas Books" from CUP.

Gentleman has illustrated more than fifty books, and written and illustrated a few books for children. He uses wood engravings, pen and ink, and watercolour for his illustrations; most recently he has produced three books of watercolour drawings about England which have become very popular. The watercolour originals are scanned by the printer instead of using autolithography, resulting in good quality reproductions at a reasonable cost; and the advantage for the artist is that it allows him to paint in front of the subject rather than in a studio.

Gentleman was awarded the ARCA Gold Medal for designing stamps (1970); RDI; FRCA; SWE.

Books illustrated include (but see Tucker, 1988†): A.L. Simon: *What About Wine?* (Neame, 1953); W. Vallans: *A Tale of Two Swannes* (Lion and Unicorn Press, 1953); P. Gray and P. Boyd: *Plats du Jour* (Penguin, 1957); F. Stockton: *The Griffin and the Minor Cannon* (BH, 1960); E. Kendall: *House into Home* (Dent, 1962); J. and E. Brooke: *Suffolk Prospect* (Faber, 1963); L. Notestein: *Hill Towns of Italy* (Hutchinson, 1963); J.R. Wyss: *The Swiss Family Robinson* (NY: Limited Editions Club, 1963); G. Grigson: *The Shell Book of Roads* (Ebury Press, 1964); J. Clare: *The Shepherd's Calendar* (OUP, 1964); J. Hornby: *Gypsies* (Oliver & Boyd, 1965); J.L. Styan: *The Dramatic Experience* (CUP, 1965); G.E. Evans: *Pattern under the Plough* (Faber, 1966); J. Keats: *Poems* (NY: Limited Editions Club, 1966); R. Kipling: *The Jungle Book* (NY: Limited Editions Club, 1968); C.D. Lewis: *The Midnight Skaters* (BH, 1968); R.E. Moreau: *The Departed Village* (OUP, 1968); G.E. Evans: *Where Beards Wag All* (Faber, 1970); H. Rider Haggard: *King Solomon's Mines* (Barre, Mass: Imprint Society, 1970); W. Wordsworth: *The Solitary Song* (BH, 1970); *St. George and the Dragon* (NY: Atheneum, 1973); F.A. Steel: *Tales of the Punjab* (BH, 1973); Francine: *Vogue French Cookery* (Collins, 1976); *The Ballads of Robin Hood* (NY: Limited Editions Club, 1977); R. Hoban: *The Dancing Tigers* (Cape, 1978); J. Stallworthy: *A Familiar Tree* (Chatto, 1978); J.R. Brown: *Shakespeare and His Theatre* (Kestrel, 1982); G.E. Evans: *The Strength of the Hills* (Faber, 1983), *Spoken History* (Faber, 1987).

Books written and illustrated include: *Bridges on the Backs* (CUP, 1961); *Fenella in Greece* (Cape, 1967); *Fenella in Ireland* (Cape, 1967); *Fenella in the South of France* (Cape, 1967); *Fenella in Spain* (Cape, 1967); *A Cross for Queen Eleanor* (London Transport, 1979); *David Gentleman's Britain* (Weidenfeld, 1982); *David Gentleman's London* (Weidenfeld, 1985); *A Special Relationship* (Faber, 1987); *Westminster Abbey* (with E. Carpenter; Weidenfeld, 1987); *David Gentleman's Coastline* (Weidenfeld, 1988).

Published: *Design in Miniature* (Studio Vista, 1972).

Contrib: *Ark; Compleat Imbiber; Saturday Book* 17 (1957).

Exhib: SWE; National Postal Museum (1968).

Bibl: Peter Tucker: "David Gentleman as Book-Illustrator", *Private Library* 4 s., 1, no. 2 (Summer 1988): 50-100; CA; Garrett 1 & 2; Hodnett; Jacques; Lewis; Peppin; Ryder.

Colour Plates 21 and 82

GEORGE, Adrian b.1944

Born in Cirencester, George studied at the Harrow School of Art and at the RCA (1964-67). Since 1967 he has participated in many group exhibitions in Britain and overseas, and has had a number of one-man shows, two being held at the Francis Kyle Gallery. He has contributed free-lance work to several magazines and newspapers, including *Radio Times, The Times,* and *New York Magazine.*

Contrib: *New York Times, New York Magazine, Nova, Queen, Radio Times, Sunday Times, Times.*

Exhib: Francis Kyle Gallery.

Bibl: Driver; Parkin.

GERRARD, Roy b.1935

Born in 1935 in Atherton, Lancashire, Gerrard studied art at the Salford School of Art, and then taught in school for twenty years which eclipsed his interest in painting. While immobilized as the result of a rock-climbing accident, he began to paint watercolours. In 1981, with his wife, he wrote a book for children, *Matilda Jane,* which he illustrated with elaborate pictures. His second book, *The Favershams,* was chosen by the *New York Times* in 1982 as one of the top illustrated books of the year, and *Sir Cedric* was similarly

distinguished in 1983. He exhibits at the RA summer exhibitions and at the Seen Gallery in London.

Books written and illustrated include: *Matilda Jane* (with Jean Gerrard; Gollancx, 1981); *The Favershams* (Gollancz, 1982); *Sir Cedric* (Gollancz, 1984); *Sir Cedric Rides Again* (Gollancz, 1986).

GERVIS, Ruth S. b.1894

Born in Frant, Sussex, the eldest of six children of the Bishop of Lewes, Gervis (née Streatfeild — Noel Streatfeild, the well-known author of books for children, was her sister) was in poor health as a child and spent much of her time at home, drawing. She studied art during WW1 at various schools of art in the south of England, and then started teaching and illustrating. In 1928 she married, and gave up most of her teaching responsibilites to concentrate on illustrating books for children. During WW2 she taught art at Sherborne School in Dorset.

Books illustrated include: K. Barne: *Young Adventurers* (Nelson, 1936); N. Streatfeild: *Ballet Shoes* (Dent, 1936); K. Barne: *She Shall Have Music* (Dent, 1938), *Family Footlights* (Dent, 1939), *Visitors from London* (Dent, 1941), *In the Same Boat* (Dent, 1945); M. Treadgold: *No Ponies* (Cape, 1946); K. Barne: *Musical Honours* (Dent, 1947); E. Blyton: *The Saucy Jane Family* (Lutterworth, 1947), *The Seaside Family* (Lutterworth, 1950), *The Pole Star Family* (Lutterworth, 1950), *The Buttercup Farm Family* (Lutterworth, 1951), *The Very Big Secret* (Lutterworth, 1952), *The Caravan Family* (Lutterworth, 1953).

Bibl: ICB; Peppin; Who.

GHILCHIK, David L. 1892-1972

Born in Romania, Ghilchik studied at Manchester School of Art, the Slade (under Tonks and McEvoy) and in Paris. A landscape and figure painter, he exhibited widely in London; was a founder member of SWE (1920), a member of the London Sketch Club (President 1942), and was elected ROI. He illustrated a few books, contributed humorous drawings to *Punch*, mostly from 1920 to 1939, and drew political cartoons for London papers during WW2.

Books illustrated include: J.A. Hammerton: *The Rubaiyat of a Golfer* (Country Life, 1946).

Books written and illustrated include: *Children* (Studio, 1961).

Contrib: *Christmas Pie; Punch.*

Exhib: RA; ROI; RI; RBA; NEAC; SWE.

Bibl: David Cuppleditch: *The London Sketch Club* (Dilke Press, 1978); Peppin; Price; Waters.

GIBBINGS, Robert John 1889-1958

Born on 23 March 1889 in Cork, Ireland, Gibbings was educated at local day and boarding schools and studied medicine for two years at University College, Cork. He went to London in 1911 and studied for two years at the Slade. While working three days a week at the Slade he started attending the Central School of Arts and Crafts where he studied illustration and wood engraving under Noel Rooke*. In August 1914 he was commissioned in the Royal Munster Fusiliers, fought at Gallipoli where he was shot in the throat, and was finally invalided out in March 1918 with the rank of captain.

Gibbings started engraving again, first working on colour prints, about which Malcolm Salaman produced a long article in the January 1919 issue of the *Studio.* Dissatisfied with colour work, Gibbings then produced some black and white engravings and soon established himself as a leader of the movement. With nine other engravers, representing both the traditional black line illustrators, such as Gordon Craig*, Eric Gill* and Philip Hagreen*, and the exponents of the modern white line technique, who included himself, John Nash*, Noel Rooke* and Gwen Raverat*, he helped to found the Society of Wood Engravers, becoming its first secretary. He contributed twelve prints to the Society's first exhibition (1920) and as a result was commissioned to produce engravings for advertising purposes.

In 1921 the Baynard Press printed 125 copies of his *Twelve Wood Engravings*; and though he exhibited a number of prints in the SWE's next three shows, the sale of prints and the few commissions for book jackets and other work were hardly enough to support him. In 1923, Cape commissioned him to make thirty-eight head- and tail-pieces for a new edition of *Erewhon*; and Harold Taylor, the

Robert GIBBINGS *The Glory of Life* by Llewelyn Powys (Golden Cockerel Press, 1934)

greater emphsasis on graduation of texture. The eight 'river books', containing altogether nearly 500 engravings, all closely integrated with his own text, represent a remarkable combination of the talents of author, illustrator, and book designer." (DNB.)

Books illustrated include (but see Kirkus†): S. Butler: *Erewhon* (Cape, 1923); Brantôme: *The Lives of the Gallant Ladies* (GCP, 1924); H. Carey: *Songs and Poems* (GCP, 1924); H. Thoreau: *Where I Lived and What I Lived For* (GCP, 1924); *Miscellaneous Writing of Henry the Eighth* (GCP, 1924); *Samson and Delilah* (GCP, 1925); E.P. Mathers: *Red Wise* (GCP, 1926); Lord Grey: *Falloden Papers* (Constable, 1926); A.E. Coppard: *Pelagea and Other Poems* (GCP, 1926); Lord Grey: *The Charm of Birds* (Hodder, 1927); *The True Historie of Lucian* (GCP, 1927); A.E. Coppard: *Count Stefan* (GCP, 1928); J. Swift: *Miscellaneous Poems* (GCP, 1928); E. Forbes: *A Mirror of Witches* (Houghton Mifflin, 1928); J. Keats: *Lamia and Other Poems* (GCP, 1928); E.P. Mathers: *A Circle of the Seasons* (GCP, 1929); A.E. Coppard: *The Man from Kilsheelan* (Jackson, 1930), *The Hundreth Story* (GCP, 1931); G. Flaubert: *Salambo* (GCP, 1931); J.H. Driberg: *Initiation* (GCP, 1932); A.E. Coppard: *Crotty Shinkwin and the Beauty Spot* (GCP, 1932); Lord Dunsany: *Lord Adrian* (GCP, 1933); H.E. Palmer: *The Roving Angler* (Dent, 1933); L. Powys: *The Glory of Life* (GCP, 1934); O. Rutter: *The Voyage of the Bounty's Launch* (GCP, 1934), *The Journal of James Morrison* (GCP, 1934); H. Waddell: *Beasts and Saints* (Constable, 1934); O. Rutter: *Mr. Glasspoole and the Chinese Pirates* (GCP, 1935); G.P. Harrison: *A Bird Diary* (Dent, 1936); E. Doorly: *The Insect Man* (Cambridge: Heffer, 1936); Sir T. Malory: *Le Morte d'Arthur* (NY: Limited Editions Club, 1936); Pushkin: *The Tale of the Golden Cockerel* (GCP, 1936); L. Powys: *The Twelve Months* (BH, 1937); G. Scott-

founder of the Golden Cockerel Press, asked him to make ten blocks for the *Lives of Gallant Ladies* (1924). When he learned that Taylor was about to give up the Press for health reasons, with the financial support of a friend, he moved to Waltham St. Lawrence, bought the Press and was Director from 1924 to 1933, when he sold out to Christopher Sandford and others. Under his leadership the Press became one of the most popular in the history of the private press. Most of the books produced during these years were illustrated with wood engravings, and he introduced many fine engravers to a narrow but discerning public. Among the engravers he employed, many for their first book, were John Nash*, Eric Ravilious*, Blair Hughes-Stanton*, Eric Gill*, John Farleigh* and Agnes Miller Parker*, though the bulk of the work was done by Gibbings himself. In 1929, Gibbings visited Tahiti and a number of books sprang from his interest in this area; in 1930, he started to work as a sculptor. He wrote and illustrated a number of books of memoirs and travel which were published by Dent. *Sweet Thames Run Softly* (1940) was the first of a series which combined personal anecdotes and descriptions of natural history, beautifully illustrated with the author's engravings which often matched the type even better than was the case with his Golden Cockerel books. He travelled in Britain, Europe and the South Pacific, continuing to produce books, engravings and paintings, returning to England to finish his last book, *Till I End My Song* (1957). He died in Oxford on 19 January 1958 after a period of increasing ill health.

Gibbings was a prolific engraver and illustrator. There are over one thousand engravings published in books and, in addition, more than one hundred separately issued prints, to say nothing of the work he did for commerce. There are some who find his work lacking in depth and sensitivity — "Had Robert Gibbings limited himself to one-tenth of his output, he might have been a much better wood engraver, but there is little reason to believe that he might have been a sensitive interpretive illustrator." (Hodnett.) That critic does however agree that "his enthusiasm for fine illustrations harmoniously associated with fine typography had far-reaching influence." Gibbings was a countryman, a Fellow of both the Royal Geographical Society and the Zoological Society, and had a great love of and knowledge of birds and animals, landscapes and seascapes, buildings and implements, so that his subjects seemed endless. He was one of the founders of the modern revival of wood engraving, and possessed great technical skills as an engraver. J.C.H. Hadfield writes that "his own work was at first characterized by bold contrasts and organization of masses, with a skilful use of the 'vanishing line'. Later his technique became more subtle, with

Robert GIBBINGS *Trumpets from Montparnasse* (J.M. Dent, 1955)

Moncrieff: *A Book of Uncommon Prayer* (Methuen, 1937); H. Melville: *Typee* (Penguin, 1938); J.M. Fabre: *Marvels of the Insect World* (NY: Appleton, 1938); E. Doorly: *The Microbe Man* (Cambridge: Heffer, 1938), *The Radium Woman* (Heinemann, 1939); W. Shakespeare: *Othello* (NY: Limited Editions Club, 1939); O. Warner: *The Discovery of Tahiti* (Folio Society, 1955); C. Darwin: *The Voyage of HMS Beagle* (NY: Limited Editions Club, 1956).

Books written and illustrated include (but see Kirkus†): *The Seventh Man* (GCP, 1930); *Fourteen Engravings on Wood* (Orient Lines, 1932); *Iorana!* (NY: Houghton Mifflin; Duckworth, 1932); *Rummy* (with A.E. Coppard; GCP, 1932); *The Wreck of the Whaleship Essex* (GCP, 1935); *A True Tale of Love in Tonga* (Faber, 1935); *Coconut Island* (Faber, 1936); *John Graham, Convict* (Faber, 1937); *Blue Angels and Whales* (Penguin, 1938); *Sweet Thames Run Softly* (Dent, 1940); *Coming Down the Wye* (Dent, 1942); *Lovely Is the Lee* (Dent, 1945); *Over the Reefs* (Dent, 1948); *Sweet Cork of Thee* (Dent, 1951); *Coming Down the Seine*

Robert Gibbings: A Bibliography (Dent, 1962); Fiona MacCarthy: "Gibbings and Gill: Arcady in Berkshire", *Matrix* 9 (Winter 1989): 27-36; Malcolm Salaman: "The Woodcuts and Colour Prints of Captain Robert Gibbings", *Studio* 76 (1919): 3-8; DNB; Deane; Garrett 1 & 2; Hodnett; ICB; ICB2; Peppin; Sandford; Waters. See also illustration on page 19

GILBERT, Anthony Allen **b.1916**
Born on 31 March 1916 at Leamington Spa, Gilbert studied at Goldsmiths' College of Art, and started to make a living as an illustrator at the age of eighteen. He worked for an advertising agency and, as well drawing for a large number of magazines including *Lilliput* and the *Radio Times*, he produced posters for London Transport, murals for the Festival of Britain in 1951 and has worked with stained glass. Married to Ann Buckmaster*.

His illustrations are mostly black and white line drawings, though he has used colour for covers, and four paintings were reproduced in *Lilliput* in October 1949. Some of his drawings have a "Bawden-

LILLIPUT

Anthony GILBERT Illustration to "Bloods on the Box" by S.P. Kernahan in *Lilliput* (July 1950) p.43

(Dent, 1953); *Trumpets from Montparnasse* (Dent, 1955); *Till I End My Song* (Dent, 1957).
Contrib: *Apple; Beacon; Chance; Golden Hind; Listener; Saturday Book 10, 12, 16, 17; Woodcut.*
Exhib: SWE; St. George's Gallery (1927); V & A (1960); Whitworth (1960).
Collns: Bodleian; V & A; Reading Public Library; Reading University Library.
Bibl: Thomas Balston: "The River Books of Robert Gibbings", *Alphabet & Image* 8 (December 1948): 39-49; Balston: *Wood-Engraving in Modern English Books: The Catalogue of an Exhibition* (National Book League, 1949); Balston: *The Wood-Engravings of Robert Gibbings* (Art and Technics, 1949); John Dreyfus, editor: "Some Correspondence between Robert Gibbings and Thomas Balston", *Matrix* 9 (Winter 1989): 37-54; Patricia Empson: *The Wood Engravings of Robert Gibbins* (Dent, 1959); A. Mary Kirkus:

esque" quality. MSIA (1951).
Books illustrated include: L. Gamlin: *Don't Be Afreud!* (Methuen, 1946).
Contrib: *Good Housekeeping; Lilliput; Radio Times; Saturday Book 9, 12; Strand; Vogue; Vogue Beauty Book.*
Collns: V & A; Leeds Museum.
Bibl: Jacques; Usherwood; Who.
Colour Plate 83

GILES, Carl Ronald **b.1916**
Born on 29 September 1916 in Islington, North London, Giles had no formal art training. He was employed in film offices in Wardour Street, London, and as a cartoonist in various commercial studios in London (1930-35) and then worked for Alexander Korda before joining *Reynolds News* where he was cartoonist for almost seven years. During WW2, Giles was war correspondent and cartoonist

"I wouldn't fancy our striking postmistress's chances of having her trespasses forgiven
if Vicar's pools don't reach their destination on time."

GILES Cartoon in *Sunday Express* (17 January 1971)

with the 2nd Army in Europe. On his return to Europe, he was appointed cartoonist to the *Daily Express* in 1942 and has produced regular work for it and the *Sunday Express* since that time. Lord Beaverbrook described him as "a man of genius . . . who takes the solemnity out of the grand occasion and helps the world to keep sane by laughing at its soaring moments. Giles has a sardonic humour that appeals because he always keeps close to the life of the street and the farm." (Amstutz 2.) His regular, hilarious cartoons in the *Express* newspapers, which feature a working class family with many small children and an independent-minded and sometimes ferocious and anarchic "Grandma", have been collected in a series of annual volumes since 1945. He was awarded the OBE in 1959.

Books illustrated include: *Selected Cartoons* (Series 1-, Daily Express, 1945-).

Contrib: *Daily Express; Reynolds News; Sunday Express.*

Exhib: NPG (1970).

Bibl: Joseph Darracott and B. Loftus: *Second World War Posters* 2nd ed. (IWM, 1981); Peter Tory: *Giles: A Life in Cartoons* (Headline, 1992); Amstutz 2; Bateman.

GILI, Phillida b.1944

Born in Newbury, Berkshire, the daughter of Reynolds Stone*, Gili studied at the Ruskin School of Drawing (1961-64), the Central School of Arts and Crafts (1964-65), and St. Martin's School of Art (1965-68). She married Jonathan Gili, and with him runs the publishing company of Warren Editions. She is also a free-lance illustrator, using various media, and writes children's books.

Books illustrated include: M. Schroeder: *My Horse Says* (Chatto, 1963); R. Pope: *One's Pool* (1969); M. Baker: *Juby* (1970); H.

Mott: *The Year of the Fire* (1974); E. Gili: *Apple Recipes from A-Z* (1975); H.S.V. Hodge: *Five Overs and Two Wides* (1975); H. Belloc: *A Remaining Christmas* (1976); A. Dumas: *The Nutcracker* (1976); E. Dunlop: *A Flute on Mayferry Street* (OUP, 1976); A. Pearson: *Memories of My Childhood* (1976); J. Betjeman: *Archie and the Strict Baptists* (Murray, 1977); B. Willard: *Spell Me a Witch* (1979); C. Matthew: *Loosely Engaged* (1980); K. Ansden: *Up the Crossing* (1981); N. Bawden: *Prince Alice* (Deutsch, 1985); S. Leacock: *Hoodoo McFiggin's Christmas* (Skelton, 1985); S. Butler: *Quis Desiderio?* (Libanus Press, 1987).

Books written and illustrated include: *The Lost Ears* (1970); *Dottie* (1973); *ABC* (1974); *Demon Daisy's Dreadful Week* (MacRae, 1980); *Fanny and Charles* (1983); *The Trick That Went Wrong* (MacRae, 1983).

Bibl: Peppin.

GILL, Arthur Eric Rowton 1882-1940

Born on 22 February 1882 at Brighton, the second of thirteen children, Eric Gill was educated at Arnold House, Brighton. The family moved to Chichester in 1897, and he spent one year at Chichester Theological College before studying at the Technical and Art School, Chichester (1898-99). He went to London to be articled at an architect's offices and joined Edward Johnston's lettering class at the Central School of Arts and Design (1899), where a fellow-student was Noel Rooke*. By 1903 he had given up architecture for letter-cutting (his first commissioned stone-cut inscription was completed while he was a student at the Central School). He taught the use of gold leaf at the Central School (1904) and lettering for stonemasons at the LCC Paddington Institute

Eric GILL *The Four Gospels* (Golden Cockerel Press, 1931)

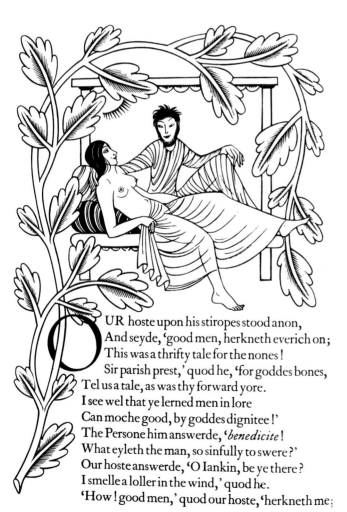

OUR hoste upon his stiropes stood anon,
And seyde, 'good men, herkneth everich on;
This was a thrifty tale for the nones!
Sir parish prest,' quod he, 'for goddes bones,
Tel us a tale, as was thy forward yore.
I see wel that ye lerned men in lore
Can moche good, by goddes dignitee!'
The Persone him answerde, '*benedicite*!
What eyleth the man, so sinfully to swere?'
Our hoste answerde, 'O Iankin, be ye there?
I smelle a loller in the wind,' quod he.
'How! good men,' quod our hoste, 'herkneth me;

(1905). He maried Ethel ("Mary") Moore in 1904, and began wood engraving around this time (as did Rooke), because of his interest in book illustration and the compatability of engraving with type. In 1907 he moved to Ditchling, Sussex, where he continued lettering in all its forms, and in 1909 began to sculpt figures in stone. At Ditchling, Gill and his family formed the nucleus of an artistic community in which he combined the roles of master-craftsman, social prophet, and sexual experimenter.

Gill had his first exhibition in 1911 at the Chenil Gallery. By now he believed that a strong religion was a necessity for the world, and in 1913 was received into the Roman Catholic Church. He continued to work with stone, and the "Stations of the Cross", fourteen 5ft. panels to be carved in bas-relief for Westminster Cathedral, dominated his life as a sculptor from 1913 to 1918. He was also becoming more involved with Douglas Pepler and his St. Dominic's Press, making his first illustrations — woodcuts and wood engravings — for *The Devil's Devices*, produced by Pepler at the Hampshire House Workshops in 1915. As MacCarthy writes: "This was the beginning of the flowering of Gill's talents as a wood engraver and typographer. Ditchling saw the development of his work in graphics, his most individual and enduring achievements: his mastery of linear communication, his gift for the disposal of the image on the page." In 1920, he was a founder-member of the SWE (with Robert Gibbings*, Gordon Craig*, John Nash*, Noel Rooke* and others). In the same year David Jones* visited Ditchling and stayed with the community there; in 1921, members of that community formed themselves into the Guild of St. Joseph and St. Dominic.

Eric GILL *The Canterbury Tales* by Geoffrey Chaucer (Golden Cockerel Press, 1929-31)

In 1924, Gill left Ditchling for Capel-y-ffin in the Black Mountains in Wales. There he designed the first two of his type faces, Perpetua and Gill Sans; completed many wood-engravings for the Golden Cockerel Press, including *The Song of Songs* (1925) and *Troilus and Criseyde* (1927) (see illustration on page 19); and did some sculpture. Walter Shewring in DNB writes "His sculpture, mainly in low relief, but also in the round, was in the forefront of modern work . . . His drawings were of great purity and precision, and his illustrations reveal an unequalled sense of the nature of a book and the proper sympathy between engravings and type."

In 1928 Gill moved again, to "Piggotts" in High Wycombe, where he wrote and published some important books, including *Art-Nonsense* in 1929; and completed his most ambitious and successful illustrations, for *The Canterbury Tales* (1929-30) and *The Four Gospels* (1931). In 1930, he visited Count Harry Kessler of the Cranach Press in Weimar, illustrated his *Canticum Canticorum* (1931), and collaborated with him and Gordon Craig* on the magnificent Cranach *Hamlet*. He went to Jerusalem to carve ten panels on the Palestine Museum (1934); created the relief sculpture of "The Creation of Adam" for the League of Nations council hall, Geneva (1935-38); and achieved many public honours in Britain — RDI, 1936; ARA, 1937; ARIBA, 1935; Hon. LL.D, Edinburgh University, 1938. He continued to work, writing, lecturing, and carving, but illness forced him into hospital, and he died of lung cancer on 17 November 1940 at Uxbridge.

Gill was an influential figure in many aspects of his art, but particularly for his stone-carved lettering and for his type faces. As a wood engraver, he was not a technical innovator, favouring "black line" engraving as being more compatible with type than the lighter and more modern "white line" engravings of Gwen Raverat*, John Nash* and Robert Gibbings*. Nevertheless his *Devil's Devices*, published in 1915, and Raverat's *Spring Morning* (1915 also), are viewed as books containing the first examples of modern wood engravings. More of a decorator than a book illustrator, his engravings for *The Four Gospels* (Golden Cockerel Press, 1931), and his own Cockerel type, combine perfectly to produce a magnificent example of collaboration between artist (Gill) and typographer/printer (Gibbings). A profoundly religious man, Gill was also a highly sexual and sensual person. He was fascinated by the female form, and many of his illustrations show the female nude in sensual and erotic poses. He produced a few small volumes of drawn and engraved nudes, as well as a number of erotic bookplates.

Books illustrated include (but see Evan Gill, 1953†): D. Pepler: *The Devil's Devices* (Hampshire House Workshops, 1915), *The Way of the Cross* (Ditchling Press, 1917); *Adeste Fideles* (St. Dominic's Press, 1919); H. Pepler: *God and the Dragon* (St. Dominic's Press, 1917); *The Way of the Cross* (St. Dominic's Press, 1917); F. Cornford: *Autumn Midnight* (Poetry Bookshop, 1923); E. Clay: *Sonnets and Verses* (GCP, 1925); *The Song of Songs* (GCP, 1925); *The Passion of the Lord Jesus Christ* (GCP, 1926); E.P. Mathers: *Procreant Hymn* (GCP, 1926); G. Chaucer: *Troilus and Criseyde* (GCP, 1927), *The Canterbury Tales* (four vols., GCP, 1929-31); *The Four Gospels* (GCP, 1931); *Canticum Canticorum* (Weimar: Cranach Press, 1931); W. Shakespeare: *Hamlet* (NY: Limited Editions Club, 1933); E. Clay: *The Constant Mistress* (GCP, 1934); W. Shakespeare: *Complete Works* (Dent, 1934-5); P. Miller: *The Green Ship* (GCP, 1936); *The New Testament* (Dent, 1936); W. Shakespeare: *Henry the Eighth* (NY: Limited Editions Club, 1937); J. De Brébeuf: *The Travels and Sufferings of Father Jean de Brébeuf Among the Hurons of Canada* (GCP, 1938); *Glue and Lacquer* (GCP, 1941).

Books written and illustrated include (but see Evan Gill, 1953†): *Dress* (St. Dominic's Press, 1921); *War Memorial* (St. Dominic's Press, 1923); *Wood-Engravings* (St. Dominic's Press, 1924); *Art and Prudence* (GCP, 1928); *Art-Nonsense and Other Essays* (Cassell, 1929); *Clothes* (CUP, 1931); *Clothing Without Cloth* (GCP, 1931); *Typography* (Sheed and Ward, 1931); *Sculpture and the Living Model* (Sheed and Ward, 1932); *Engravings 1928-1933* (Faber, 1934); *The Lord's Song* (GCP, 1934); *Twenty-Five Nudes* (Dent, 1938); *Drawings from Life* (Hague & Gill, 1940).

Contrib: *Change; Fleuron; The Game; Woodcut*.

Exhib: Chenil Gallery; Goupil Gallery; SWE; V & A; Ditchling Museum ("Eric Gill in Ditchling"; 1989); Fisher Library, University

of Toronto (1991).

Collns: V & A; Tate.

Bibl: Elizabeth Brady: *Eric Gill: Twentieth Century Book Designer* (rev. ed., Metuchen, NJ: Scarecrow Press, 1974); *The Engravings of Eric Gill* (Wellingborough: Christopher Skelton, 1983); Eric Gill: *Autobiography* (Cape, 1940); Evan Gill: *A Bibliography of Eric Gill* (Cassell, 1953); David Kindersley: *Eric Gill: Further Thoughts by an Apprentice* (Wynkyn De Worde Society, 1982); Fiona MacCarthy: *Eric Gill* (Faber, 1988); J.F. Physick: *The Engraved Work of Eric Gill* (V & A; HMSO, 1963); Physick: *The Engraved Work of Eric Gill* (Large Picture Book 17; V & A; HMSO, 1963); Walter Shewring: *Letters of Eric Gill* (Cape, 1947); Robert Speight: *The Life of Eric Gill* (Methuen, 1966); *Eric Gill: His Life and Art.* (University of Toronto, 1991); Malcolm Yorke: *Eric Gill: Man of Flesh and Spirit* (Constable, 1981); Compton; DNB; Garrett 1 & 2; Peppin; Sandford; Tate; Waters.

GILL, Macdonald **1884-1947**

Born on 6 October 1884 in Brighton, one of Eric Gill's* many siblings, Gill was educated at the Royal Naval Academy, Bognor, and studied art at Chichester School of Art and the Central School of Arts and Crafts. He was articled to an architect (1901-03), and worked as assistant to Sir Charles Nicholson. He also did some work for the Curwen Press, producing drawings and other decorations, including a Curwen unicorn for the booklet, *Apropos the Unicorn* (1918); and painted murals. He also produced at least two hoarding posters for the Empire Marketing Board which were displayed in 1927 and 1931 respectively. He died in London on 14 January 1947.

Books illustrated include: E. Farjeon: *Nursery Rhymes of London Town* (Duckworth, 1916), *More Nursery Rhymes of London Town* (Duckworth, 1917).

Bibl: Stephen Constantine: *Buy & Build: The Advertising Posters of the Empire Marketing Board* (HMSO, 1986); Waters.

GILL, Margery Jean **b.1925**

Born on 5 April 1925 in Coatbridge, Scotland, Gill studied at Harrow School of Art and RCA (1945-48), where she concentrated on etching and engraving. She married in 1946 while still a student at RCA, and had two children. Deciding to be a home mother, but needing to earn money, she started illustrating books for children, and has become a respected and prolific illustrator. Her work is done mostly with pen and ink, producing simple but lively sketch-like drawings. In 1955 she started teaching at Maidstone College of Art.

Books illustrated include (but see Peppin): R.L. Stevenson: *A Child's Garden of Verses* (OUP, 1946); Pertwee: *Islanders* (OUP, 1950); Tarn: *Treasure of the Isle of Mist* (OUP, 1950); Pertwee: *Rough Water* (OUP, 1951); R.L. Green: *Mystery at Mycenae* (BH, 1957); R. Guillot: *The Blue Day* (BH, 1958); E. Hamilton: *The Heavenly Carthorse* (BH, 1958); N. Streatfeild: *Bertram* (Hamilton, 1959); M. Kornitzer: *Mr Fairweather and His Friends* (BH, 1960); F.H. Burnett: *A Little Princess* (Penguin, 1961); N. Streatfeild: *Apple Bough* (Collins, 1962); R. Arthur: *Dragon Summer* (Hutchinson, 1962); B. Bingley: *The Story of a Tit-Be and His Friend* (Abelard, 1962); A. Lang: *Fifty Favourite Fairy Tales* (Nonesuch Press, 1963); J. Craig: *What Did You Dream?* (Abelard, 1964); W. Mayne: *Sand* (Hamilton, 1964), *A Day without Wind* (Hamilton, 1964); E. Beresford: *The Hidden Mill* (Benn, 1965); L. Boston: *The Castle of Yew* (BH, 1965); A. Barrett: *Midway* (1967); M. Cockett: *Twelve Gold Chairs* (1967), *The Wild Place* (1968); C. Rossetti: *Doves and Pomegranates* (BH, 1969); R.M. Arthur: *The Autumn Ghosts* (Gollancz, 1973), *Candlemas Mystery* (Gollancz, 1974); M. Mahy: *The Bus Under the Leaves* (Dent, 1974); N. Streatfeild: *When the Siren Wailed* (Collins, 1974); H. Cresswell: *The Butterfly Chase* (Kestrel, 1975); C. Cookson: *Mrs Flanagan's Trumpet* (Macdonald, 1976); M. Crompton: *The House Where Jack Lives* (BH, 1978); J. Denton: *Catch* (Macmillan, 1980), *Short Cut* (Macmillan, 1980); E. Chapman: *Suzy* (BH, 1982); A. Thwaite: *Pennies for the Dog* (Deutsch, 1985).

Bibl: ICB3; Ryder; Peppin.

GILLETT, Edward Frank **1874-1927**
See Houfe

GILLIAM, Terry fl.1978-

Gilliam was a member of the Monty Python group of actors and comedians which made a large number of programmes for BBC TV, "The Monty Python Show." He was responsible for the strange animation scenes which appeared in the programmes and in several films; and has directed a number of full-length feature films, two critically successful titles being *Brazil* (1984) and the 1989 release, *The Adventures of Baron Munchausen*.

Books written and illustrated include: *Animations of Mortality* (Eyre Methuen, 1978).

GILLMOR, Robert Allen Fitzwilliam b.1936

Born on 6 July 1936 at Reading, Gillmor was educated at Leighton Park School, Reading, and studied in the Fine Art Department of Reading University (1954-59) that had been established by his grandfather, Allen W. Seaby. In 1959 Gillmor returned to Leighton Park as Director of Arts and Crafts, where he remained until 1965, when he became a free-lance artist.

An illustrator, designer and painter, Gillmor claims to have been influenced by the work of his grandfather, Allen Seaby, and by others including Eric Ennion*, Robert Hainard, and C.F. Tunnicliffe*. His first work to be published was his cover design for the Reading Ornithological Club's annual report (1949), and he has contributed many covers and other illustrations to several other magazines. He uses several media for his illustrations, including watercolour and linocut. His linocut designs for book jackets and magazines are distinctive, with strong colours and bold patterns. Two of his covers for *Birds* are linocuts, and his jacket design of a roe deer running

Margery GILL *Midway* by Anne Barrett (Collins, 1967)

through a wood for *The Handbook of British Mammals* (1964) is memorable. Other jackets include those for *Evolution Illustrated by Wildfowl* (1974), *Rare Birds in Britain and Ireland* (1976), and for the Collins' "New Naturalist" series, which he took over from Clifford and Rosemary Ellis* — his first was *British Warblers* in 1985. He has illustrated more than a hundred books and many magazine articles; Christmas cards for the British Trust for Ornithology (1959); other greeting cards and calendars; and in the 1960s illustrations for use on gift items produced by the Royal Society for the Protection of Birds. He has been involved in many ornithological and conservation organizations, and in 1964 was co-founder of the Society of Wildlife Artists, of which he has been President since 1984. President of the Reading Guild of Artists (1969-86). NDD (1958).

Books illustrated include: *A Study of Blackbirds* (Allen & Unwin, 1958); *The Handbook of British Mammals* (Blackwell, 1964); *The Bird Table Book* (David & Charles, 1965); *The Life of the Robin* (Witherby, 1965); *Longmans Birds* (Longman, 1966); *Animal Life in the Antarctic* (BH, 1969); *Owls* (David & Charles, 1970); *The Wind Birds* (Viking, 1973); *Evolution Illustrated by Waterfowl* (Blackwell, 1974); *Seal Woman* (Rex Collings, 1974); *Crows of the World* (BMNH, 1976); *The Birds of the Western Palearctic* (seven vols., OUP, 1977-); J. Hancock and H. Elliott: *Herons of the World* (London Editions, 1978); *A Natural History of Britain and Ireland* (Dent, 1979); *Bird of the Week* (BBC, 1981); *John Clare's Birds* (OUP, 1982); *A Natural History of British Birds* (Dent, 1983).

Contrib: *Birds; Bird Life; British Birds; Countryman; Country Fair; Country Life; Living Bird (US); International Wildlife (US); Radio Times; Wildlife Observer; Wildfowl*.

Exhib: SWLA (1964-); Reading Guild of Artists (1959-); Reading (1971); Washburn Gallery, Boston (1969).

Collns: Reading Museum; Ulster Museum.

Bibl: "Robert Gillmor", *British Birds* 70 (1977): 294-6; Nicholas Hammond: *Twentieth Century Wildlife Artists* (Croom Helm, 1986); Frank Lewis: *A Dictionary of British Bird Painters* (F. Lewis, 1974); Hammond; Who; IFA.

GILMOUR, J. L.
See GOVEY, Lillian Amy

GILROY, John T. Young 1898-1985

Born in Newcastle, Gilroy was educated at Heaton Park School, Newcastle. He studied at the King Edward VII School of Art, Newcastle, and after WW1 at RCA (1919). He was a British Institute scholar in 1921 and won an RCA travelling scholarship in 1922. He later taught at Camberwell School of Art.

He created posters and advertisements for Guinness for many years (1925-68), producing much loved and well-remembered images for the "Guinness for Strength" and "My Goodness! My Guinness!" campaigns, and illustrated the first three Guinness Christmas booklets. He first contributed to the *Radio Times* in 1932, producing at least two covers, including the delightful laughing cat image for the "Humour Number", October 9, 1936. He illustrated a few books, but since the end of WW2 he concentrated on portrait painting.

Books illustrated include: H. Maclennan: *McGill: The Story of a University* (Allen & Unwin, 1960); *Rough Island Story*.

Contrib: *Radio Times*.

Exhib: RA; RP; ROI; RBA; NEAC; Grosvenor Galleries.

Bibl: Brian Sibley: *The Book of Guinness Advertising* (Guinness Books, 1985); Driver; Waters.

GINGER, Phyllis Ethel b.1907

Born on 19 October 1907 in London, Ginger was educated at Tiffin's Girls School, Kingston-on-Thames, and studied for a short time by evening class at Kingston School of Art and then at Richmond School of Art, under S.R. Badmin*. She became interested in etching and attended evening classes at the Central School of Arts and Crafts under W.P. Robins before winning a scholarship to become a full-time student (1937-39), under John Farleigh* and Clarke Hutton*. Her first ambition was to become an illustrator, but her interest in etching and portraiture was also encouraged by Robins, and a portrait of her father was exhibited at the RA in 1939. During and after WW2 she did some lithographic illustrations for *Country Life* and Penguin Books, following commissions from Noel

Phyllis GINGER "The Paragon, Clifton" from *Recording Britain* vol.1 (Oxford University Press, 1946)

Carrington, watercolour drawings for *Recording Britain*, and illustrations and a number of book jackets for Mrs. Henrey's books for Dent.

She was elected ARWS (1952), RWS (1958) and returned to etching after her young family grew up, exhibiting at RE and RA in the 1970s.

Books illustrated include: R. Henrey: *A Farm in Normandy* (Davies, 1941), *The King of Brentford* (Davies, 1946), *The Return to the Farm* (Davies, 1947); *Recording Britain* (with others, four vols., OUP, 1946-9).

Books written and illustrated include: *Alexander the Circus Pony* (Puffin Picture Books, 24; Penguin, 1943).

Contrib: *Country Life*.

Exhib: RA; RE; RWS.

Collns: V & A; London Museum; South London Art Gallery; Washington State Library.

Bibl: Charles Bartlett: "Phyllis Ginger", *Journal RE*, no. 8 (1986): 17; Waters; Who; IFA.

GLASHAN, John **b.1934**
Born in Glasgow, the son of Archie McGlashan, a Scottish Royal Academician, Glashan (as he is known) was educated at Woodside School, and studied at Glasgow School of Art. His work was first published in *Lilliput* and *Queen*; and though his cartoons have appeared in *Punch*, his success had nothing to do with that magazine. Bateman calls him "quite the most original cartoonist of our times". He is a social cartoonist, and his work often tells a longish story in several drawings, with his hero, a bearded man, having problems with "The System."

Contrib: *Lilliput; Punch; Queen*.

Bibl: Bateman.

GOBLE, Warwick **1862-1943**
See Houfe
Born in London, Goble was educated at the City of London School and studied art at the Westminster School of Art. For several years he worked for a printing firm specializing in chromolithography. He contributed to many magazines and joined the staff of the *Pall Mall Gazette* and later the *Westminster Gazette* as artist. Among his earliest illustrations are those for H.G. Wells' "War of the Worlds" in *Pearson's Magazine*. Strongly influenced by Oriental art, Goble's colour washes are extremely subtle. During his life he earned a reputation as a watercolour painter, exhibiting widely, including at the RA from 1893. He also illustrated books of fairy and adventure stories and he is best known today for the charm of these illustrations, most of which were reproduced as colour plates

in gift books. His work has been criticized as being "bland", but Johnson writes that "Although at times overly precious and somewhat derivative in his designs, Goble's skill as a colorist compensates for his lack of intensity as an illustrator." (Johnson FIDB.) He died on 22 January 1943.

Books illustrated include: S.R. Crockett: *Lad's Love* (Bliss Sands, 1897); H.G. Wells: *The War of the Worlds* (Heinemann, 1898); M. Molesworth: *The Grim House* (Nisbet, 1899); A. Van Millingen: *Constantinople* (Black, 1906); F.A. Gasquet: *The Greater Abbeys of England* (Chatto, 1908); J. Barlow: *Irish Ways* (Allen, 1909); C. Kingsley: *The Water Babies* (Macmillan, 1909); G. James: *Green Willow and Other Japanese Fairy Tales* (Macmillan, 1910); G.B. Basile: *Stories from the Pentamerone* (Macmillan, 1911); *The Modern Reader's Chaucer* (Macmillan, 1912); L. B. Day: *Folk Tales of Bengal* (Macmillan, 1912); D.M.M. Craik: *The Fairy Book* (Macmillan, 1913); D.A. Mackenzie: *Indian Myth and Legend* (Gresham, 1913); D.M.M. Craik: *John Halifax, Gentleman* (OUP, 1914); C. Sourabji: *Indian Tales of the Great Ones* (1916); J.S. Fletcher: *The Cistercians in Yorkshire* (SPCK, 1919); W.G. Stables: *Young Peggy McQueen* (Collins, 191-?); D. Owen: *The Book of Fairy Poetry* (Longmans, 1920); R.L. Stevenson: *Treasure Island* (Macmillan, 1923), *Kidnapped* (Macmillan, 1925); W. Irving: *The Alhambra* (Macmillan, 1926); E. Whitney: *Tod of the Fens* (Macmillan, 1928).

Contrib: *BOP; Captain; ILN; Little Folks; The Minister; Pall Mall Gazette; Westminster Gazette; Windsor Magazine; World Wide Magazine.*

Exhib: RA; FAS (1909, 1910, 1911); Liverpool; Brook Street Art Gallery.

Bibl: *The Illustrators: The British Art of Illustration 1800-1989* exhibition catalogue (Chris Beetles Ltd., 1989); Doyle BWI; ICB; Johnson FIDB; Peppin; Waters.

GOFFE, Toni fl.1975-

Goffe started as an illustrator by working on educational books, including "flash cards" for pre-reading children (e.g. Boyce's *Introductory Teaching Pictures*) and illustrations for foreign language texts. Now a prolific illustrator of books for children, Goffe has become the latest in a series of "Paddington Bear" illustrators.

Books illustrated include: B. Root: *The Little Red Hen* (Macdonald, 1975); A. Topping: *Formidable* (Arnold, 1975); S. Connell: *A Fourth Book of Sounds* (Macdonald, 1976); J. Hindley: *The Time Traveller's Book of Knights and Castles* (Usborne, 1976); B. Read: *The Wonder Why Book of Building a House* (Transworld, 1977); E.R. Boyce: *Introductory Teaching Pictures* (Macmillan, 1979); J. Strong: *Lightning Lucy* (Black, 1982); M. Clarke: *Six Witches* (Collins, 1984); M. Bond: *Paddington at the Airport* (A Paddington Bear Slot Book; Hutchinson, 1986) and three other titles; C. Storr: *A Fast Move* (Macdonald, 1987), *Find the Specs* (Macdonald, 1987), *Gran Builds a House* (Macdonald, 1987); M. Waddell: *The Tall Story of Wilbur Small* (Blackie, 1987); F. Walker: *The School with the Troll* (Hodder, 1987); M. Joy: *The Little Explorer* (Kestrel, 1989); H. Sharpe: *Adelaide's Naughty Granny* (Methuen, 1989).

Books written and illustrated include: *Kipper the Kitten* (Macdonald, 1977); *The Wonder Why Book of the XYZ of Sport* (Transworld, 1977); *The Wonder Why Book of the XYZ of Dogs* (Transworld, 1979); *This Is France* (Transworld, 1981); *This Is the USA* (Transworld, 1981); *Toby's Animal Rescue Service* (Hamilton, 1981).

GOODALL, John Strickland b.1908

Born on 7 June 1908 in Heacham, Norfolk, the son of a famous heart specialist, Goodall was educated at Harrow (1922-26), and studied art privately under Sir Arthur Cope (1923) and Watson Nicol and Harold Speed (1924), and at the RA Schools (1925-29). He contributed illustrations to magazines from 1929 and in the 1930s began working for the *Radio Times*, supplying one drawing each week until WW2, during which he served in the army. He has illustrated a number of books, mostly for children, and after producing two children's books in 1954, in 1968 he wrote *The Adventures of Paddy Pork*, which won the Boston Globe-Horn Book award in 1969, and thereafter concentrated on writing and illustrating his own children's stories. His *The Surprise Picnic* (1977) was listed in the New York Times choice of the best illus-

trated children's books of the year, and *Paddy Goes Travelling* was similarly chosen in 1982. He uses black and white and full colour for his illustrations, his cross-hatching technique and fine line being particularly suitable for the "period" subjects he draws.

He was elected RI and RBA.

Books illustrated include: C.W. Cooper: *Town and Country* (1937); E. Nesbit: *Five Children and It* (Benn, 1948), *The Phoenix and the Carpet* (Benn, 1948), *The Story of the Amulet* (Benn, 1949); White: *Dream Pony* (Country Life, 1951); K. Jarvis : *A Nightingale in the Sycamore* (Mowbray, 1953); F. Knight: *The Golden Monkey* (Macmillan, 1953); L.W. Meynell: *The Bridge Under the Water* (Phoenix House, 1954); R. Arkell: *Trumpets Over Merriford* (Joseph, 1955); S. Heaven: *The Puritaine* (Blackie, 1955); "Miss Read": *Village School* (Joseph, 1955); S. Blow: *Through Stage Doors* (Chambers, 1958); R.L. Green: *The Land of the Lord High Tiger* (Bell, 1958); K. Jarvis: *Diary of a Parson's Wife* (Mowbray, 1958); S. Dewes: *Suffolk Childhood* (Hutchinson, 1959); "Miss Read": *Thrush Green* (Joseph, 1959); G. Trease: *Thunder of Valmy* (Macmillan, 1960); M. Dale: *Mrs. Dale's Friendship Book* (Arlington Books, 1961); "Miss Read": *Winter in Thrush Green* (Joseph, 1961); F. Swinnerton: *Reflections from a Village* (Hutchinson, 1969); "Miss Read": *Battle at Thrush Green* (Joseph, 1975); *No Holly for Miss Quinn* (Joseph, 1976).

Books written and illustrated include: *Dr. Owl's Party* (Blackie, 1954); *Field-Mouse House* (Blackie, 1954); (all published by Macmillan 1968-82)*The Adventures of Paddy Pork* (1968); *Shrewbettina's Birthday* (1970); *Jacko* (1971); *Paddy's Evening Out* (1973); *Creepy Castle* (1975); *An Edwardian Summer* (1976); *Paddy Pork's Holiday* (1976); *The Surprise Picnic* (1977); *An Edwardian Christmas* (1977); *An Edwardian Diary for 1979* (1978); *The Story of an English Village* (1978); *An Edwardian Holiday* (1978); *An Edwardian Season* (1979); *Paddy's New Hat* (1980); *Escapade* (1980); *Victorians Abroad* (1980); *Lavinia's Cottage* (1981); *Before the War* (1981); *Shrewbettina Goes to Work* (1981); *Paddy Finds a Job* (1981); *Paddy Goes Travelling* (1982); *Naughty Nancy Goes to School* (Deutsch, 1985); *Paddy Pork to the Rescue* (Deutsch, 1985); *The Story of a High Street* (Deutsch, 1985); *Little Red Riding Hood* (Deutsch, 1988); *The Story of a Farm* (Deutsch, 1989).

Contrib: *Radio Times.*

Exhib: RA; RI; RBA; Paris Salon; New Zealand.

Bibl: CA; Driver; ICB2; Peppin; Waters; Who.

Colour Plate 84

GOODEN, Stephen Frederick 1892-1955

Born on 9 October 1892 in Tulse Hill, London, Gooden was educated at Rugby School and studied at the Slade (1909-13), before serving in the 19th Hussars and the Royal Engineers during WW1. As an artist, he produced a few etchings before turning to engravings in 1923, using mostly copper. He first exhibited at RA in 1935 with a line engraving of "St. George".

Most of Gooden's work however was done for book illustration and decoration, including some for the Nonesuch Press, notably the *Odes* of Anacreon (1923) and *The Nonesuch Bible* (1924). The Anacreon was the first illustrated book from the Press, and it was Gooden's first effort at book illustration. An extra problem was that the copperplates had to be printed on a different kind of press from that used for the letterpress text. The book was a great success and Gooden went on to illustrate twice as many Nonesuch books as any other artist. He was a "literary" artist, being sensitive not only to the form of the book but appreciating the possibilities of its page for decoration, and he also seemed to appreciate the quality of the books he illustrated. If not a particularly expressive draughtsman, he did have an imaginative grasp of the subject matter, and his witty and elegant illustrations are finely engraved and inventive in design. He also produced bookplates, including those for the Royal Library at Windsor. He was elected ARA (1937); RA (1946); ARE (1931); RE (1933); RMS (1925); and created CBE in 1942. He died on 21 September 1955.

Books illustrated include: Anacreon: *Odes* (Nonesuch Press, 1923); G.R. Hamilton: *The Latin Portrait* (1923); *The Nonesuch Bible* (five vols., Nonesuch Press, 1924-7); *Songs of Gardas* (1925); Pindar: *The Pythian Odes* (Nonesuch Press, 1928); G. Moore: *The Brook Kerith* (Heinemann, 1929); *La Fontaine's Fables*

Stephen GOODEN *Odes of Anacreon* done into English by Alexander Crowley (Nonesuch Press, 1923)

(Heinemann, 1933); *Peronnik the Fool* (Harrap, 1933); S. Sassoon: *Vigils* (1934); *Aesop's Fables* (Harrap, 1936); G. Moore: *Ulick and Soracha* (Nonesuch Press, 1936); O. Henry: *The Gift of the Magi* (Harrap, 1939); *The Rubaiyat of Omar Khayyam* (Harrap, 1940); M. Gooden: *The Poet's Cat* (Harrap, 1946); C. Singer: *The Earliest Chemical Industry* (1946).

Collns: BM; V & A; Ashmolean; Fitzwilliam.
Bibl: Campbell Dodgson: "The engravings of Stephen Gooden", *Print Collector's Quarterly* 28 (1941): 140-63, 292-321, 478-95; Dodgson: *An Iconography of the Engravings of Stephen Gooden* (Mathews, 1944); John Dreyfus: *A History of the Nonesuch Press* (Nonesuch Press, 1981); James Laver: "The Line-Engravings of Stephen Gooden", *Colophon* 2 (1930): np; F. Reid: *"The Line Engravings of Stephen Gooden"*, *Print Collector's Quarterly* 19 (January 1932); *Times* (22 September 1955); DNB; Hodnett; Mackenzie; Peppim; Waters.

GORDON, Cora Josephine **d.1950**
 and Godfrey Jervis **1882-1944**
See Houfe
Cora Gordon (née Turner) studied at the Slade and became a painter of landscapes and figure studies, and an illustrator. She married Godfrey ("Jan") Gordon, lived in Paris and travelled through Europe, and later settled in London. She wrote and illustrated several travel books with her husband. She was elected RBA; SWA; WIAC. Jan Gordon died on 2 February 1944 and Cora died on 1 July 1950.
Books written and illustrated by Cora and Jan Gordon include: *Poor Folk in Spain* (BH, 1922); *Misadventures with a Donkey in Spain* (Blackwood, 1924); *Two Vagabonds in the Balkans* (BH, 1925); *Two Vagabonds in Languedoc* (BH, 1925); *Two Vagabonds in Sweden and Lapland* (BH, 1926); *On Wandering Wheels* (BH, 1929); *Star-Dust in Hollywood* (Harrap, 1930); *Three Lands on Three Wheels* (Harrap, 1932); *The London Roundabout* (Harrap, 1933); *Portuguese Somersault* (Harrap, 1934).
Books written and illustrated by Jan Gordon: *A Balkan Free-Booter* (Smith, Elder, 1916); *On a Paris Roundabout* (BH, 1927).
Published: *A Step-Ladder to Painting* (by Jan Gordon; Faber, 1934).
Contrib: *Coterie; Apple.*
Bibl: Peppin; Waters.

GORDON, Margaret Anna **b.1939**
Born on 19 May 1939 in London, Gordon studied at St. Martin's School of Art, Camberwell School of Arts and Crafts, and the Central School of Arts and Crafts. She taught part-time for five years after she left art school in 1960; then started as a free-lance illustrator of children's books. She uses ink and gouache to make colour illustrations — for example, George Macbeth's *Noah's Journey* (1966) contains twelve page-openings in full colour. She has recently produced some attractive picture books of her own, about a bear called "Wilberforce".
Books illustrated include: E. Smith: *Emily's Voyage* (Macmillan, 1966); K. Crossley-Holland: *The Green Children* (Macmillan, 1966); G. Macbeth: *Noah's Journey* (Macmillan, 1966); E. Beresford: *The Wombles* (Benn, 1968) and at least twelve other titles; K. Crossley-Holland: *The Callow Pit Coffer* (1968); H. Cresswell: *A House for Jones* (Benn, 1969); A. Jezard: *Albert in Scotland* (Gollancz, 1969), *Albert's Christmas* (Gollancz, 1970) and at least three other titles; G. Macbeth: *Jonah and the Lord* (Macmillan, 1970); K. Crossley-Holland: *The Pedlar of Swaffham* (Macmillan, 1971); P.J. Stephens: *Lillapig* (Benn, 1972); H. Cresswell: *My Aunt Polly* (Wheaton, 1979), *Aunt Polly By the Sea* (Wheaton, 1980).
Books written and illustrated include: *Wilberforce Goes on a Picnic* (Kestrel, 1982); *Wilberforce Goes Shopping* (Kestrel, 1983); *The Supermarket Mice* (Kestrel, 1984); *Wilberforce Goes to a Party* (Kestrel, 1985).
Bibl: ICB3; ICB4; Peppin.

GOSSOP, Robert Percy **fl.1901-1925**
See Houfe

GOUGH, Philip **b.1908**
Born on 11 June 1908 in Warrington, Lancashire, Gough studied at Liverpool School of Art, and Chelsea School of Art. He trained as a stage designer at Liverpool, his first production being *A Midsummer Night's Dream* in 1928, and in 1929 he designed the original production of *Toad of Toad Hall*. He moved to London, working in a commercial art studio for two years, and then designed some twenty-five theatrical productions in London.
Since WW2, Gough has concentrated on illustrating books and designing book jackets. He has a great interest in late 18th century, early 19th century architecture, furniture and decoration. He admirably evokes the Regency atmosphere of the Jane Austen novels which he illustrated with a number of colour plates in each volume. These illustrations show a similarity in style and interest to the work of Rex Whistler* and John Austen*. His many book jackets include at least five for the *Saturday Book*; and he contributed many illustrations to the annual. He has also illustrated a number of books for children.

Books illustrated include: E. Farjeon: *The New Book of Days* (with M.W. Hawes; OUP, 1941); H.C. Andersen: *Fairy Tales* (Puffin, 1946); J. Austen: *Emma* (Macdonald, 1948); E. Farjeon: *The Old Nurse's Shopping Basket* (University of London Press, 1949); B.L. Picard: *The Mermaid and the Simpleton* (OUP, 1949); C. Asquith: *The Children's Ship* (Barrie, 1950); W.B. Thomas: *A Year in the Country* (Wingate, 1950); J. Austen: *Pride and Prejudice* (Macdonald, 1951); M.M. Johnson: *A Bunch of Blue Ribbons* (Skeffington, 1951); M. Clive: *Christmas with the Savages* (Macmillan, 1955); J. Austen: *Mansfield Park* (Macdonald, 1957); J. Pudney: *The Book of Leisure* (with others., Odhams, 1957); J. Austen: *Sense and Sensibility* (Macdonald, 1958), *Persuasion* (Macdonald, 1961), *Northanger Abbey* (Macdonald, 1961); P.W. Turner: *Colonel Sheperton's Clock* (OUP, 1964); J. Blathwayt: *On the Run for Home* (Macdonald, 1965); P. Rush: *Frost Fair* (Collins, 1965); R.K. Fry: *Gypsy Princess* (Dent, 1969); G. Cooper: *An Hour in the Morning* (OUP, 1971); R.L. Green: *Ten Tales of Adventure* (Dent, 1972); B.L. Picard: *Three Ancient Kings* (OUP, 1972); I. Serraillier: *The Franklin's Tale* (Kaye, 1972); J.R. Townsend: *A Wish for Wings* (OUP, 1972); L. Carroll: *Alice in Wonderland* (nd); N. Lewis: *Hans Andersen's Fairy Tales* (Puffin, 1981).
Contrib: *Saturday Book* 7, 12, 15, 16.
Bibl: Hodnett; ICB2; ICB4; Parkin; Peppin.
Colour Plate 85

GOVEY, Lilian Amy **1886-1974**
A writer and illustrator of books for children, Govey also contributed illustrations to a number of children's annuals.
Books illustrated include: Mrs. H. Strang: *The Rose Fairy Book* (1912); *Dean's Happy Common Series* (Dean, 1920); *The Dolly Book* (OUP, 1920); A.G. Herbertson: *The Book of Happy Gnomes* (OUP, 1924); C. Heward: *Grandpa and the Tiger* (Harrap, 1924); *Old Fairy Tales* (Nelson, 1936).
Books written and illustrated included: *Nursery Rhymes from Animal Land* (OUP, 1934).
Contrib: *Little Folks; Mrs Strang's Annual*.
Bibl: Peppin.

GRAHAM, Alex **b.1918**
Born in Glasgow, Graham was educated at Dumfries Academy and studied at the Glasgow School of Art. First a portrait painter, he served in the Argyll and Sutherland Highlanders during WW2, and at the end of the war contributed his "Wee Hughie" strip to a Scottish paper. His cartoon, "Briggs the Butler," ran for seventeen years in *Tatler*, and "Fred the Basset Hound" started in the *Daily Mail* in 1964. His "Fred" strip is about the people who own him, with the dog acting as an eavesdropper. He also contributes drawings to *Punch* and *Golfing*.
Contrib: *Daily Mail; Golfing; Punch; Tatler*.
Bibl: Bateman.

GRAHAM, Rigby **b.1931**
Born on 2 February 1931 in Stretford, Lancashire, Graham was educated at Wyggeston School, Leicester (1943-49), and studied at Leicester College of Art (1949-54). He then taught at a boys' school in Leicester (1954-56) and from 1956 lectured at Leicester College of Art before becoming Principal Lecturer in Art at Leicester Polytechnic.
He has illustrated well over three hundred books, many for a number of private presses, some of which were his own. The first press that he was associated with was the Orpheus Press which foundered after the printer disappeared. The empty shed seemed rather like a Pandora's box — thus the next press was named the Pandora Press. Printing was done in the most casual way. The Press had no fixed abode — first in an attic of the old rectory at Aylestone, then at Abbey Magna, near Rugby, then at Walton Street, Leicester. Pandora was the pastime of a triumvirate of dilettanti — Patricia Green, compositor and editor; Tom Savage, printer, pressman and business manager; and Graham, illustrator and interleaver. Then came the Brewhouse Press which Graham ran with Terry Hickman for twenty-one years (1963-83) and produced sixty-three books or pamphlets in that time. The Press became a showcase for his work and many publications were illustrated by him, those volumes of his typographical drawings being perhaps the most successful books

from the Press. He uses a great variety of techniques for his illustrations, including pen drawings, woodcuts, watercolours, and lithographs.
Graham is a theoretician as well as a practitioner of illustration, and has written many articles on printing, illustration and bookbinding, several of which have been published in *Private Library*. He is of course much more than a book illustrator. John Piper*, with whom Graham has much in common as neo-Romantic, has written that "he is also a landscape and topographical painter of real merit, using bold colour and striking contrasts: notably well seen in a book devoted to "Leicestershire" and published in 1980 by the Gadsby Gallery, Leicester." (Goldmark Gallery, 1987†.) His illustrative work has always carried the vision of the artist complementing and enhancing the text and book production, unlike so many of his contemporaries. His own work as a printmaker, painter and illustrator reflects his interest in romanticism, and he acknowledges a debt to such artists as John Minton* and Graham Sutherland*. "He enjoys illustration because it gives him scope for flights of fancy and he prefers ethereal, unearthly subjects . . . The quality of his drawing is wiry, spidery, nervous . . . He feels that an illustration should tie in closely with the atmosphere of the subject matter and should either balance the printed matter or contrast heavily with it . . . A large number of his illustrations are line blocks and here he feels that they should reflect the mood of the writing rather than becoming a literal translation of the text . . . He has a leaning towards the decorative and a rich decorative sense." (Garulfi, 1962.†)
Books illustrated include: J. Mason: *Papermaking as an Artistic Craft* (Faber, 1959), *More Twelve By Eight Papers* (Maggs, 1959); R.M. Rilke: *Die Sonnette an Orpheus* (Munich: Orpheus Press,

Rigby GRAHAM *Venice* (Cog Press, 1986)

1959); C. Tichbourne: *My Prime of Youth But a Frost of Cares* (Orpheus Press, 1959); J. Best: *Poems and Drawings in Mud Time* (Orpheus Press, 1959); D. Martin: *Kirby Hall* (Orpheus Press, 1960); J. Clare: *Lines Written in Northampton County Asylum* (Orpheus Press, 1960); T. Churchyard: *Lovesong to an Inconstant Lady* (Orpheus Press, 1961); J. Mason: *J.H. Mason RDI* (Twelve by Eight Press, 1961); P.B. Shelley: *Lines Written Among the Euganean Hills* (Pandora Press, 1961); O. Wilde: *The Nightingale and the Rose* (Percival & Graham, 1961); A. Swinburne: *The Garden of Proserpine* (Pandora Press, 1961); J. Gascoigne and D. Goodwin: *The Living Theatre* (Pandora Press, 1962); F.G. Lorca: *Llauto por Ignacio Sanches Mejias* (St. Anthony Press, 1962); T. Scott: *Fingal's Cave* (Pandora Press, 1962); A. Swinburne: *A Match* (Pandora Press, 1962); P. Holt: *A Sicilian Memory* (Pandora Press, 1963); I. Perkins: *In Favour of Bundling* (Twelve By Eight, 1963); O. Baylden: *The Papermaker's Craft* (Twelve By Eight, 1964); J. Best: *Nine Gnats* (Pandora Press, 1964); S.J. de Medina: *El Icaro* (Cog Press, 1965); P. Hoy: *Silence at Midnight* (Brewhouse Press, 1967); S. Milligan: *Values* (Offcut Press, 1968); R.H. Mottram: *Twelve Poems* (Daedalus Press, 1968); D. Tew: *The Oakham Canal* (Brewhouse Press, 1968); P. Holt and E. Thorpe: *Gold and Books* (Brewhouse Press, 1969); R. Shaw: *Private Time, Public Time* (Poet and Printer Press, 1969); A. Stramm: *Twenty-Two Poems* (Brewhouse Press, 1969); P. Graham: *The Brewhouse at Wymondham* (Brewhouse Press, 1974); F. Lissauer: *The Lost Shepherd* (New Broom Press, 1974), *A Visit to Ireland* (Cog Press, 1975); D. Roger: *The Peddars Way* (Brewhouse Press, 1975); C. Baudelaire: *Sleen de Paris* (Saint Bernard's Press, 1977); P. de Vos: *De Lof van de Bottermarket* (Holland: Bonnefant Press, 1980); *Murphy's Select Bar* (Bonnefant Press, 1985); P. Scupham: *Under the Barrage* (Bonnefant Press, 1988); A. Tucker: *Rigby Graham: Sketchbook Drawings* (Hanborough Books, 1989).

Books written and illustrated include: *Vale* (St. Bernard's Press, 1961); *The Pickworth Fragment* (Brewhouse Press, 1966); *Slieve Bingian* (Cog Press, 1968); *An Alderney Afternoon* (Brewhouse Press, 1970); *Rocks, Boulders and Ruins* (with M. McCord; Cog Press, 1969); *Tower Houses and Ten Pound Castles* (with M. McCord, Belfast: Grannoy Press, 1970); *Abbeys and Churches* (with M. McCord; Grannoy Press, 1971); *The Casquets* (Brewhouse Press, 1972); *Edmund Spenser's Kilcolman* (1975); *James Joyce's Tower, Sandycore* (Brewhouse Press, 1975); *Patterned Paper* (1978); *Seriatim: Paintings, Places and Asides* (1979); *Venice* (Cog Press, 1986).

Published: *Romantic Book Illustration in England 1943-55* (Private Libraries Association, 1965).

Contrib: *Enigma; Latitudes (US); Littack; Priapus; Private Library; Wymondham-Edmondsthorpe Journal; Yorkshire Review.*

Exhib: one-artist shows include Gadsby Gallery, Leicester (1963, 1969, 1974); Wymondham Art Gallery (1979, 1984); Goldmark Gallery, Uppingham (1987, 1989); David Holmes Gallery, Peterborough (1988-92).

Bibl: Christine Battye: *The Brewhouse Private Press 1963-1983* (Wymondham: Sycamore Press, 1984); Alessandra Garulfi: "Rigby Graham: Illustrator", *Private Library*, 4, no.4 (October 1962): 57-62; *Rigby Graham at the Goldmark Gallery* (Uppingham: Goldmark Gallery, 1987); Rigby Graham: "The Pandora Press", *P.L.*, 7, no.1 (Spring 1966): 5-12; Anne Greer: *Rigby Graham* (Newcastle: Brian Mills, 1981); Bellamy; Hodnett; Peppin; information from Mark Goldmark; IFA.

Colour Plate 86

GRAHAME-JOHNSTONE, Janet and Anne fl.1950-

Illustrators of children's books, mostly for Dean, often using brightly-coloured, sentimental pictures. Some of their own books recall the old-fashioned and unsatisfactory nursery rhyme and fairy tale books of the earlier years of the century; but their illustrations for other authors can be quite delightful line drawings. They usually work as a team, but Anne Grahame-Johnstone has produced some books on her own, including a recent series of pop-up books for Dean (1982-3).

Books illustrated include (but see Peppin): H. Hoffman: *Struwwelpeter* (Gifford, 1950); D. Smith: *The Hundred and One Dalmatians* (Heinemann, 1956); J. Pudney: *Crossing the Road* (1958); R.L. Green: *Tales of the Greeks and Trojans* (1964), *Folk Tales of the World* (1966); P. Gallico: *Miracle in the Wilderness* (Heinemann, 1975).

Books written and illustrated include (but see Peppin): *Dean's Gold Medal Book of Fairy Tales* (Dean, 1964); *A Child's Book of Prayers* (Dean, 1968); *An Enchanting Book of Nursery Rhymes* (Dean, 1972); *Dean's Gift Book of Hans Christian Andersen Fairy Tales* (Dean, 1975); *Dean's Gold Star Book of Cowboys* (Dean, 1976); *Dean's Gold Star Book of Indians* (Dean, 1977); *A Book of Children's Rhymes* (Dean, 1978); *The Wonderful Story of Cinderella* (Dean, 1979).

Books written and illustrated by Anne Grahame-Johnstone include: *Santa Claus Is Coming to Town* (Dean, 1980); *Santa's Toyshop* (Dean, 1980).

Bibl: Peppin.

GRANT, Alistair b.1925

Born in London, Grant first intended to study veterinary surgery at Glasgow University, but instead studied painting at Birmingham School of Art and the RCA. After service in the Middle East with the RAF during WW2, he returned to England in 1947 and taught at various art schools, including the RCA. A painter and lithographer, he has exhibited at a number of London galleries, including Zwemmer, and illustrated a few books with lithographs.

Books illustrated include: G. de Maupassant: *Bel-Ami* (Folio Society, 1955); A. de Musset: *A Door Must Be Either Open or Shut* (Rodale Press, 1955); *The Oxford Illustrated Old Testament* (five vols., with others., OUP, 1968-9).

Bibl: Folio 40; Parkin; Ryder.

GRANT, Duncan James Corrowr 1885-1978

Born on 21 January 1885 in Rothiemurchus, Inverness-shire, Grant spent his early years in Burma and India, where his father was posted in the army. He was educated in England at St. Paul's School, and studied at Westminster School of Art, at "La Palette" in Paris, and at the Slade. He lived in Paris for two years (1907-09), and visited Greece (1910), Sicily and Tunisia (1911). He was introduced to the Bloomsbury Circle by his cousin, Lytton Strachey, and, as a painter, was much influenced by the 1910 London exhibition, "Manet and the Post-Impressionists", organized by Roger Fry, which encouraged him to experiment briefly with abstraction. He exhibited with the Camden Town Group (1911) and with others, worked with Fry on two panels for the dining hall of Borough Polytechnic. In 1913 he designed costumes and sets for a production of *Twelfth Night* in Paris, and with Fry and Vanessa Bell* founded the Omega workshops. Bell, the sister of Virginia Woolf, was a painter also and she and Grant began a long personal association, living virtually as man and wife for fifty years.

During WW1 Grant was a conscientious objector. After the war his landscape paintings became more representational and in the 1920s and 1930s he and Bell spent much time painting in France. He exhibited with the London Group in 1919, and had his first one-artist show at the Carfax Gallery in 1920. Between the wars his reputation as a painter increased and he and Bell continued to decorate town and country houses. He designed sets and costumes for a number of ballets and plays in London and, with Bell, completed many other decorative commissions. Grant designed some book jackets for the Hogarth Press, including the jacket for Julia Strachey's *Cheerful Weather for the Wedding* (1932), did catalogue covers for the bookshop started by David Garnett in 1921 and for *Fanfare*, a small magazine which started in 1922 and ran for only a few months. Most of his jackets and book illustrations however date from after WW2. In the 1940s Grant, Bell and friends decorated a small church at Berwick in Sussex; and in the 1950s Grant and Bell were involved in decorating Lincoln Cathedral. Grant did the scenery and costumes for "Venus and Adonis" at the Aldeburgh Festival in 1956. After Bell's death in 1961, Grant continued to paint, decorate pottery and travel. He died on 8 May 1978, aged ninety-three.

Books illustrated include: B. Grant: *The Receipt Book of Elizabeth Raper* (Nonesuch Press, 1924); D. Garnett: *A Terrible Day* (Joyner & Steele, 1932); S.T. Coleridge: *The Rime of the Ancient Mariner* (Lane, 1945); Wu Ch'eng-en: *Monkey* (Folio Society, 1968); D. Rhodes: *In an Eighteenth Century Kitchen* (Woolf, 1968).

Contrib: *Fanfare.*

Colour Plate 87. William GRIMMOND Cover for *Tulipomania* (King Penguin 44, 1950)

Colour Plate 88. Brian GRIMWOOD Cover for *New Scientist*

Colour Plate 89. Anthony GROSS *The Forsyte Saga* by John Galsworthy (William Heinemann 1949)

Roland GREEN *Birds and Their Young* (A & C Black, 1929)

(RSPB, 1945); K. Lloyd: *The Children's Book of British Birds and Verses* (Foy Publications, 1946); W. Willett: *British Birds* (Black, 1948).

Books written and illustrated include: *Wing-Tips* Black, 1947); *Sketching Birds* (RSPB, 1948); *How I Draw Birds* (Black, 1951).

Exhib: Ackermann Galleries.

Bibl: Waters.

GREENWOOD, John Frederic **1885-1954**

Born on 13 June 1885 in Rochdale, Greenwood studied at Shipley and Bradford Schools of Art (1904-08) and at RCA (1908-11). He taught at Batley School of Art (1911-12), Battersea Polytechnic (1912-27), Bradford School of Art (1927-37), and was Head of the Design School at Leeds College of Art until 1948. His first engraving was exhibited at SWE in 1921; though mainly an engraver and printmaker, he illustrated a few books. He was elected ARE (1922); RE (1939); RBA (1940). He died on 28 April 1954.

Books illustrated include: S. Evans: *A Short History of Elÿ Cathedral* (CUP, 1927); R.L. Hine: *A Short History of St. Mary's, Hitchin* (Paternoster & Males, 1930).

Exhib: Paul Guillaume Gallery; Tate (retrospective, 1959); Scottish National Gallery of Modern Art (90th birthday, 1975); Bluecoat Gallery, Liverpool (1980).

Collns: Tate.

Bibl: Isabelle Anscombe: *Omega and After: Bloomsbury and the Decorative Arts* (T & H, 1981); *Landscape in Britain 1850-1950* (Arts Council, 1983); *Duncan Grant: A Retrospective Exhibition.* (Tate, 1959); Ian Jeffrey: *The British Landscape 1920-1950* (T&H, 1984); Raymond Mortimer: *Duncan Grant* (Penguin Books, 1948); Compton; Tate; Waters.

GRAVE, Charles **b.1886**

See Houfe

GRAY, Millicent Ethelreda **b.1873**

See Houfe

GREEN, Roland **1896-1972**

Born on 9 January 1896 in Rainham, Kent, Green studied at Rochester School of Art and the Regent Street Polytechnic. He painted birds and other wild-life, did etchings, and illustrated books. He held many one-man shows in London, especially at the Ackermann Galleries. Elected FZS. He lived alone for many years at Hickling Broad, Norfolk; and died on 18 December 1972.

Books illustrated include: T. Wood: *Birds One Should Know* (Gay & Hancock, 1921); W.P. Pycraft: *Birds in Flight* (Gay & Hancock, 1922); T.A. Coward: *Birds and Their Young* (Black, 1922); E. Blyton: *The Bird Book* (Newnes, 1926); W. Willett: *British Birds* (Ruskin Studios, 1935-9); T.L. Bartlett: *How To Look at Birds*

John GREENWOOD "Jesus College" from *Twenty-Four Woodcuts of Cambridge* (John Lane, The Bodley Head, 1926)

Books written and illustrated include: *Scarborough and Whitby: A Sketch-Book* (Black, 1920); *Twenty-Four Woodcuts of Cambridge* (BH, 1926); *The Dales Are Mine* (Skeffington, 1952).
Contrib: *London Mercury*.
Bibl: John F. Greenwood: *The Dales Are Mine* (Skeffington, 1952); Deane; Garrett 1 & 2; Peppin; Waters.

GREER, Terence **b.1929**
Born in Surbiton, Surrey, Greer was educated at private schools in Kew and Richmond. He studied art for a year at Twickenham School of Art, and after two and a half years' National Service in the Royal Air Force continued his studies at the St. Martin's School of Art and returned to study painting at Twickenham for three years, and later at the RA Schools.
After finishing his education, he turned free lance and joined the Saxon Artists agency. His work includes book illustration, covers for Penguin Books and others, drawings for magazines such as the *Radio Times,* the *Economist* and the *New Statesman*, and advertising. Greer's drawings for the *Radio Times* were always done in pen and ink, with a lot of solid black tones. He had been much influenced in his youth by Hollywood films, and this no doubt helped him when asked to illustrate such plays as *High Noon* for the BBC and perhaps accounts for the brashness and immediacy of his drawings. In the 1970s, Greer changed career from illustrator to playwright.
Contrib: *Economist; New Society; New Statesman; Radio Times*.
Exhib: Whitechapel Gallery; Redfern Gallery.
Bibl: Driver; Jacques; Ryder; Usherwood.

GREG, Barbara **1900-1984?**
Born on 30 April 1900 in Styal, Cheshire, Greg was educated at Bedales School. She studied art at the Slade (1919-23) under Norman Janes* (whom she subsequently married), at the Central School of Arts and Crafts (1921-23), and at the Westminster School of Art (1926-27). She was probably taught wood engraving by W.T. Smith at the Central School. Her grandfather, H.T. Greg, had a collection of Bewick's work which profoundly influenced her choice of technique and subject matter.
Greg exhibited her first wood engraving, "The Warping Room", in 1924 at the Society of Wood Engravers, and continued exhibiting prints regularly until 1976, latterly working in coloured linocut. Among her first work was the production of book endpapers from designs cut in lino or wood. She and her husband then started producing engravings for decorating piano rolls from 1926 to 1930, and for many years contributed an illustration for the calendars of R. Greg & Company, her father's cotton spinning business. She illustrated six books with wood engravings and her subjects were invariably nature and the countryside. Her illustrations are accurate, but tend to be stylistically and technically uninteresting.
Greg was elected a member of the Manchester Academy of Fine Art in 1925; ARE (1940), RE (1946); SWE (1952).
Books illustrated include: G.L. Ashley Dodd: *A Fisherman's Log* (Constable, 1929); E.L. Grant Watson: *Enigmas of Natural History* (Cresset Press, 1936), *More Enigmas of Natural History* (Cresset Press, 1937); I. Niall: *The Poacher's Handbook* (Heinemann, 1951), *Fresh Woods* (Heinemann, 1951), *Pastures New* (Heinemann, 1952); M. Bruxner: *Letters to a Musical Boy* (OUP, 1958).
Contrib: *Country Fair; Countrygoer; Country Life*.
Exhib: RA; RE; NEAC; SWE.
Bibl: Marian Janes: "Barbara Greg, R.E.", *Journal RE* no.6 (1984): 31; Deane; Garrett 1 & 2; Peppin; Waters.

GREGORY, Margaret
See Houfe

GREGORY, Peter Ronald **b.1947**
Born on 13 October 1947 in Ilford, Essex, Gregory was educated at Leyton Grammar School, and studied at Walthamstow School of Art. A free-lance illustrator of mostly non-fiction for children, he uses ink drawings with some colour washes added.
Books illustrated include: R. Thomson: *Henry Ford* (Macdonald, 1973); J. Dyson: *Know Your Car* (ITV, 1975); E. Hyams: *Working for Man* (Kestrel, 1975); J. Denton: *On the Railway* (Puffin, 1976); J. London: *The Call of the Wild* (Beaver, 1976); G. Uden: *High*

Barbara GREG *Fresh Woods* by Ian Niall (William Heinemann, 1951)

Horses (Kestrel, 1976); J. Denton: *On the Road* (Puffin, 1977); F. Bell: *Shen Stories — The Lioness* (Longman, 1979), *Shen Stories — Trapped* (Longman, 1979); H. Hossent: *The Beaver Book of Bikes* (Beaver, 1980); J. Ross: *Lord Mountbatten* (Hamilton, 1981), *Thomas Edison* (Hamilton, 1982); H. Sutton: *Museum Puzzle-Picture Books* (three vols., Heritage, 1982).
Bibl: ICB4; Peppin.

GRIBBLE, Vivien Massie **1888-1932**
Born in London, the third daughter of a wealthy merchant father and a mother from the aristocratic Royds family who had herself studied at the Slade, Gribble studied art in Munich and then at the Slade and later at the Central School of Arts and Crafts. There she learned wood engraving from Noel Rooke* which he started teaching in 1912, the same year that she was asked to do the illustrations for *Three Psalms*, a book which J.H. Mason produced and printed at the School. A second book was undertaken by the same team of Mason and Gribble, *Cupid & Psyche*, the engravings being cut in 1916 although the book was not published until 1935, after

Colour Plate 90. Mark HARRISON Original painting for cover of *A Story of the Stone* (Bantum Doubleday Dell)

Colour Plate 91. Rowland HILDER Jacket for *The Countryside and How To Enjoy It* (Odhams Press 1948)

Colour Plate 92. Rowland HILDER *The Shell Guide to the Flowers of the Countryside* by Geoffrey Grigson (Phoenix House 1955)

Vivien GRIBBLE *Odes* by John Keats (Gerald Duckworth, 1923)

Gribble's death.

During WW1 Gribble joined the Women's Land Army and won a prize for drawing in its journal, *The Landswoman*. A year after the war ended Gribble married Douglas Doyle Jones, a barrister; from 1921 to 1925 she contributed engravings to the annual exhibitions of the SWE, though she was never invited to become a member. She illustrated three books for Duckworth and in 1924 did at least two jackets, *When the Bough Breaks* for Cape and *Spanish Farm* for Chatto & Windus. In 1922, Campbell Dodgson, Keeper of Prints and Drawings at the British Museum, edited a volume of *Contemporary English Woodcuts*, which contained two of Gribble's engravings and had a cover designed by her. Perhaps her finest work was done for an edition of Hardy's *Tess of the D'Urbervilles*, published by Macmillan in 1926 and containing forty-one exquisite wood engravings. Gribble's engravings were always formal and simple, "classical" in style but not static. The Hardy engravings show the same powerful simplicity, but, as J.C. Squire commented in the *London Mercury*, July 1927, "Her line has become finer and is more under comand than in her earlier engravings. . . She now uses the white line as well as the black. In her use of either there is a wonderful economy: every line, every space is dramatic." *Tess* was Gribble's last major work, for she soon became seriously ill and died of cancer on 6 February 1932.

Books illustrated include: *Three Psalms* (Central School, 1912); Theocritus: *Sixe Idillia* (Duckworth, 1922); J. Keats: *Odes* (Duckworth, 1923); A. Tennyson: *Songs from the Princess* (Duckworth,

1924); T. Hardy: *Tess of the D'Urbervilles* (Macmillan, 1926); Apuleius: *Cupid & Psyche* (pp., 1935).
Contrib: *Change; Country Life; Golden Hind; London Mercury*.
Exhib: SWE.
Bibl: Judith Butler: "Vivien Gribble, 1888-1932: An Under-Rated Illustrator", *Private Library* 3s., 5 (Autumn 1982): 119-135; Peppin; Waters.

GRIEVE, Averil Mackenzie
See MACKENZIE-GRIEVE, Averil

GRIGGS, Frederick Landseer Maur **1876-1938**
See Houfe
Books illustrated include: *Ernest Gimson; His Life and Works* (Shakespeare Head Press, 1924).
Bibl: R.A. Alexander. *The Engraved Work of F.L. Griggs: Etchings and Dry-Points 1912-28* (Shakespeare Head Press, 1928); Francis MacGill: "F.L. Griggs, master etcher", *The Green Book*, 1, No. 4 (Winter 1980): 10-12; Ian Jeffrey: *The British Landscape, 1920-1950* (T & H, 1984); Peppin; Waters.

GRIMBLE, Rosemary Ann **b.1932**
Born in the South Pacific, the daughter of colonial administrator and author, Sir Arthur Grimble, Rosemary Grimble was educated in France. A painter and designer, she is also an illustrator of books and magazines, using mostly pen and ink drawings.
Books illustrated include (but see Peppin): A. Grimble: *Return to the Islands* (Murray, 1957); R.L. Stevenson: *Treasure Island* (1959); L.E. Snelgrove: *From Coracles to Cunarders* (Longmans, 1962); N. Mitchison: *Alexander the Great* (Longmans, 1964); E.J. Sheppard: *Ancient Athens* (Longmans, 1967); P. Fox: *How Many Miles to Babylon?* (1972); A. Grimble: *Migrations, Myth and Magic from the Gilbert Islands* (Routledge, 1972); I. Grimble: *Scottish Clans and Tartans* (Hamlyn, 1973); J. Innes: *The Pauper's Homemaking Book* (Penguin, 1976).
Books written and illustrated include: *Jonothon and Large* (Deutsch, 1965); *The Thief Catcher and Other Stories from Ethiopia* (1972).
Contrib: *Field; Go; Guardian; Harpers; House and Garden; Observer; Radio Times; Sunday Times; Vogue*.
Bibl: Peppin; Usherwood.

GRIMES, Leslie **fl.1920s**
Grimes' first school was an orphanage, but he later went to an art school. He served in the army and air force during WW1, and after the war, worked in an advertising agency before joining the *Evening Star*. Grimes followed Low* as political cartoonist on the *Star*, but after a few years began to produce "All My Own Work" for the paper, dealing with the humorous situations in which ordinary people found themselves. He mostly used soft pencil and chalk for his cartoons.
Contrib: *Evening Star*.
Bibl: Bradshaw.

GRIMMOND, William **b.1884**
Born on 1 September 1884 in Manchester, Grimmond studied at Manchester School of Art. A painter, illustrator and poster designer, he designed sixteen covers for the King Penguin series, ranging from K8 (*Elizabethan Miniatures*, 1943) to K64 (*Magic Books from Mexico*, 1953).
Exhib: RA; RI; RBA; NEAC.
Bibl: Russell Edwards and David J. Hall: *"So Much Admired": Die Insel-Bucherei and the King Penguin Series* (Edinburgh: Salvia Books, 1988); Waters.
Colour Plate 87

GRIMWOOD, Brian **fl.1980s-**
A London-based artist who works in pen and ink and gouache. He does illustrations for advertising and for magazines, designs posters and works for television.
Contrib: *Listener; New Society; Observer Colour Magazine*.
Bibl: *Images* 7-11.
Colour Plate 88

GROOM, Mary Elizabeth **fl.1920-1939**
Groom studied at Leon Underwood's Art School from 1921, and
was one of a number of students who started wood engraving —
others included Blair Hughes-Stanton*, Gertrude Hermes*, Agnes
Miller Parker* and Underwood* himself. She helped reintroduce
the multiple graver from France. Her own work is mostly in white
line with minimal contrast and little textual interest; Sandford, while
claiming the illustrations to the Golden Cockerel's *Paradise Lost*
(1937) are "extremely interesting and refreshingly original",
describes her work as unsuited to Milton's sophistication and unsuc-
cessful in achieving a unity of text and illustration on the page.
Books illustrated include: J. Milton: *Paradise Lost* (GCP, 1937);
Roses of Sharon (GCP, 1937).
Contrib: *The Island.*
Bibl: Peppin; Sandford.

GROSS, Imre Anthony Sander **1905-1984**
Born on 19 March 1905 in Dulwich, London, the son of Alexander
Gross, the map publisher, a naturalized British subject of Hungarian
origin, Gross was educated at Repton School. In 1923 he studied at
the Slade and took evening classes in etching at the Central School
of Arts and Crafts under W.P. Robins. He then studied in Paris and
Madrid and travelled widely in Europe, settling in France in 1926.
He painted and produced etchings and then became interested in
animated cartoons, producing *The Fox Hunt* in colour for
Alexander Korda in 1934-36. Commissioned by the French biblio-
phile society, Les Cents Unes, he illustrated Cocteau's *Les Enfants
Terribles* in 1936 with etchings and drawings.
Gross returned to England at the beginning of WW2 and was
appointed an official war artist (1941-46), working in Egypt, India
and Burma, and then in Europe. He worked on the spot and his
drawings and paintings have an immediacy and tension as a result.
He recorded what he saw and his work, though it makes no pro-
found comment on war, has a considerable value as documentation.
The landscapes he did during the war, with their scratchy strokes
and pale washes of colour, have been compared to Lear's because
of the their elegance and economy. There was an exhibition of
some of these works at the National Gallery in 1943. He was able to
make use of his memory of the time he spent in the Middle East and
the sketches he made there for his illustrations to *The Oxford
Illustrated Old Testament* (1968-69).
In 1946, he was elected RA; in the same year, he illustrated
Wuthering Heights and in 1948, *The Forsyte Saga*, with drawings
and colour lithographs. The latter was his masterpiece in this
medium — the illustrations have an ethereal quality, the freely
applied lithographic colouring giving the effect of light washes
contrasting with areas of textural interest. The elegant tail-pieces
and chapter headings were originally working sketches. He started
drawing illustrations for the *Radio Times* in 1951 and continued to
do so for some years.
He taught at the Central School (1948-54) and taught etching and
engraving at the Slade (1955-71). In 1955, Gross bought a house in
Le Boulvé, France, and often went there to paint. He produced a
series of etchings, *Le Boulvé Suite*, for the St. Georges Gallery, and
in 1960 the BBC made a television film, *Anthony Gross — the
Artist Speaks*, shot in Le Boulvé, London and at the Slade. In 1980
Will and Sebastian Carter designed and printed at the Rampant
Lions Press in Oxford Gross' *The Very Rich Hours of Le Boulvé*.
This celebrated the French village with twenty-six etchings and
engravings, printed in black and white, and Gross' own commentary
on his village's history and way of life.
Gross was primarily a painter and an etcher. During an interview,
recorded in Driver's book, Gross said "To me the most important
thing is painting, and I must not allow myself to be diverted from it
— plus, of course, my etching and engraving. Illustration I've
always done as little as possible because it becomes a profession
very quickly." His first one-man show was held at the Abbey
Gallery in London in 1925; he won prizes at the Biennale in
Lugano, Ljubljana and Carrara; and had a retrospective exhibition
of his etchings at the Victoria and Albert Museum in 1968. He was
elected ARA in 1979 and RA in 1980. He was a founder member of
La Jeune Gravure Contemporaine and elected Hon. RE (1979); and
awarded CBE (1982). He died in France on 8 September 1984.
Books illustrated include: J. Cocteau: *Les Enfants Terribles* (Paris:

Les Cent Unes, 1937); E. Brontë: *Wuthering Heights* (Elek, 1946);
J. Galsworthy: *The Forsyte Saga* (Heinemann, 1949); H. James:
English Hours (Heinemann, 1960); *The Oxford Illustrated Old
Testament* (five vols., with others., OUP, 1968-9); Theocritus: *Sixe
Idyllia* (New York: Clover Hill Editions, 1971); W. Steode: *Old
Christmasses* (Samson, Low).
Books written and illustrated include: *The Very Rich Hours of Le
Boulvé* (Oxford, Rampant Lions Press, 1980).
Published: *Etching, Engraving, and Intaglio Printing* (OUP, 1970).
Contrib: *Radio Times; Strand Magazine.*
Exhib: RA; BM; National Gallery (1943); V & A (retrospective
1968); Abbey Gallery; Leicester Galls; Oxford Gallery; Blond Fine
Art; and in Paris and New York.
Collns: BM; V & A; IWM; Tate; MOMA; Bibliothèque Nationale.
Bibl: Michael Blaker: "The Anthony Gross Evening at the R.E.",
Journal RE no.5 (1983): 9-11, 27; *Anthony Gross, RA; Etchings
1950-1980* (Blond Fine Art, 1981); Peter and Mary Gross, eds:
Anthony Gross (Scolar Press, 1992); Jonathan Mayne: "The Graphic
Work of Anthony Gross", *Image*, no. 4 (Spring 1950): 31-48;
Graham Reynolds: *The Etchings of Anthony Gross* (V & A
Museum, 1968); *Times* obit. 12 September 1984; Amstutz 1; Driver;
Harries; Hodnett; Peppin; Ross; Tate; Usherwood; Waters.
Colour Plate 89

GROVES-RAINES, [Ralph Gore] Anthony **b.1928**
Born in County Down, Ireland, Groves-Raines was educated at
Tonbridge School and at Christ's College, Cambridge, and studied
in Europe, intending to follow a career in the diplomatic service.
Instead he became a painter and illustrator. He did a lot of adver-
tising work for Guinness, including coloured press advertisements
and eight funny and colourful Christmas booklets —*A Guinness
Scrapbook* (1937), *Alice Aforethought* (1938), *Prodigies and
Prodigals* (1939), *Sportfolio* (1950), *Alice Where Art Thou?* (1952),
What Will They Think of Next? (1954), *Can This Be Beeton?* (1956)
and *My Goodness! My Gilbert and Sullivan!* (1961). Sibley writes
that "Groves-Raines's early work comprised delicate line illustra-
tions reminiscent of Rex Whistler*, but his style later matured and
developed into richly detailed pictures that stand as classic exam-
ples of *trompe-l'oeil* art. In order to achieve this astonishing three-
dimensional quality to his work, Groves-Raines first created plas-
ticine models of every scene to be depicted, using real flowers,
properties and drapes." (Sibley, 1985.†) His illustrations for *Lays of
Courtly Love* are black and white line drawings, while those for *On
Christmas Day in the Morning!* are done in watercolour.
Books illustrated include: H.A.: *The Golden String* (Lunn, 1947);
J. Langstaff: *On Christmas Day in the Morning!* (World's Work,
1963); *Lays of Courtly Love* (1963).
Books written and illustrated include: *The Tidy Hen* (World's
Work, 1963).
Bibl: Brian Sibley: *The Book of Guinness Advertising* (Guinness
Superlatives, 1985); ICB3; Klemin; Peppin.

GUERCIO, Beatrice Claudia **b.1904**
Born in Formby, Lancashire, of Sicilian stock, Claudia Guercio
studied at Liverpool School of Art and at the RCA. She married

Claudia GUERCIO Decoration from *Review of Revues* edited
by C.B. Cochrane (Jonathan Cape, 1930)

Colour Plate 93. Paul HOGARTH *Graham Greene Country* (Pavilion/Michael Joseph 1987)

Colour Plate 94. Shirley HUGHES *Dogger* (Bodley Head 1977)

Colour Plate 95. Clarke HUTTON Illustrations and cover for *Popular English Art* (King Penguin 21, 1945)

There was a Fancy Dress Parade.

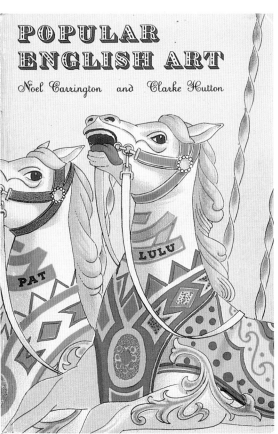

Barnett Freedman* in 1930, and was one of the many artists encouraged by Oliver Simon of the Curwen Press. For Curwen, she designed many vignettes, including flower-laden baskets and huge vases. She was a painter and illustrator, and as an illustrator worked mostly in pen and ink. In 1935 her husband designed a decorative alphabet for the Baynard Press, named Baynard Claudia after her.

Books illustrated include: *German Tales and Legends* (1925); W. de la Mare: *A Snowdrop* (Ariel Poem; Faber, 1929); C.B. Cochrane: *Review of Revues* (Cape, 1930); E. Graham: *The Puffin Book of Verse* (Penguin, 1953).

Books written and illustrated include: (by Claudia Freedman) *My Toy Cupboard* (nd.)

Contrib: *Housewife*.

Exhib: RA.

Bibl: Jonathan Mayne: *Barnett Freedman* (Art & Technics, 1948); Herbert Simon: *Song and Words: A History of the Curwen Press* (Allen & Unwin, 1973); Peppin; Waters; Who.

GURNEY, Nancy Bankart **fl.1930**
Illustrated Coppard's *Pink Furniture* (1930) with naïve but rather funny pen drawings.

Books illustrated include: A.E. Coppard: *Pink Furniture* (Cape, 1930).

GUTHRIE, James Joshua **1874-1952**
See Houfe
Born on 11 April 1874 in Glasgow, Guthrie was a poet, printer, bookplate designer, painter and essayist, who was independent and self-sufficient and despised the orthodox. Printed at the Pear Tree Press, his plate books (as he called them) were probably his most important printed items. The blocks for each print were hand coloured so that each copy of the print was different and each book, made up of these prints, was different. Colin Franklin writes that "his series of poems, *Frescoes from Buried Temples* (1928), is an extraordinary production from poet and artist alike . . . [the book] strikes me as among the three or four monumental achievements of private presses in the twentieth century; and by its originality of concept and content, the highest." (Franklin, 1976.†) He died on 25 October 1952.

Books illustrated include: C. Blatherwick: *Peter Stonnor* (with A.

S. Boyd; 1884); A.F.S. de Passemere: *Wedding Bells* (1895); F.H. Low: *Little Men in Scarlet* (Jarrold, 1896); H. Beardsell: *Pillow Fancies* (Pear Tree Press, 1901); E.A. Poe: *Some Poems* (Pear Tree Press, 1901-1908); Mrs. Williams: *The Floweret* (Pear Tree Press, 1902); D.G. Rossetti: *The Blessed Damozel and Hand and Soul* (Old Bourne Press, 1903); H. Beardsell: *Garden Fancies* (Pear Tree Press, 1904); J. Milton: *Hymn on the Morning of Christ's Nativity* (Old Bourne Press, 1904); G. Bottomley: *Midsummer Eve* (Pear Tree Press, 1905); *The Beatitudes from the Sermon on the Mount* (Pear Tree Press, 1905); J.D.B.: *Echoes of Poetry* (Pear Tree Press, 1908); G. Bottomley: *The Riding to Lithend* (Pear Tree Press, 1909); V. Ellis: *Epode* (Pear Tree Press, 1915); H. Munro: *Trees* (Poetry Bookshop, 1915); G. Bottomley: *Frescoes from Buried Temples* (Pear Tree Press, 1928), *The Viking's Barrow at Littleholme* (Pear Tree Press, 1930); W. Collins: *Ode to Evening* Pear Tree Press, 1937); W. Blake: *Songs of Innocence* (Pear Tree Press, 1939).

Books written and illustrated include: *An Album of Drawings* (Shorne: White Cottage, 1900); *My House in the World* (Heath Cranton, 1919).

Bibl: Colin Franklin. "James Guthrie", *Private Library* 2nd s., 9, no. 1 (Spring 1976): 2-17; Bellamy; Peppin; Waters.

GWYNNE, Jessica **b.1944**
Gwynne studied at Chelsea School of Art and at the Slade. A painter, printmaker, and theatrical designer, she has illustrated a few books.

Books illustrated include: H. Williams: *Love Life* (Deutsch, 1979).
Bibl: Parkin.

GWYNNE-JONES, Emily **b.1948**
Born on 7 July 1948, Gwynne-Jones studied at RA Schools (1966-70), North-East London Polytechnic (textiles), and Central School of Arts and Crafts (etching, 1977-8). She has exhibited at various galleries and illustrated at least one book.

Books illustrated include: H.R. Williamson: *Pavane for a Dead Infanta*.

Exhib: RA; NEAC; Mayor Gallery; New Grafton Gallery; Parkin Gallery (one-man show, 1977).

Collns: Nuffield Trust, Eton College.

Bibl: Who.

H

HAGREEN, Philip **1890-1988**

Born into a family of artists, it seemed inevitable that Hagreen should follow in that tradition. He studied at Goldsmiths' College, and was a founder member of SWE — the first meeting took place in Hagreen's studio in 1920, with Robert Gibbings*, Lucien Pissarro (see Houfe), Noel Rooke*, Sydney Lee, and E.M.O'R. Dickey. They invited others, including John Nash*, Eric Gill*, Gwen Raverat*, and Gordon Craig*. Hagreen was an exponent of the black line technique, but these founding members included both black and white line craftsmen. He worked with Eric Gill and shared a studio with David Jones*. During WW1, he converted to Roman Catholicism and after the war joined Gill's group of artists at Ditchling. In 1923 he moved with Gill to Capel-y-ffin, then lived in France from about 1925 to 1932, when he rejoined the Ditchling group and settled permanently in Sussex.

Hagreen taught for a time at Brighton College of Art, and did some advertising work for ICI. He also did ivory carvings, for which he designed and made his own tools. He was however principally a wood engraver though some of his book illustrations are done in ink drawings. Throughout his life he made many fine book plates (168 are described in Lee's book†), which demonstrate his particular skill in lettering.

Hagreen died on 5 February 1988, at the age of ninety-seven.

Books illustrated include: J.M. Strachey: *Nursery Lyrics* (Chatto, 1922); T. Moult: *The Best Poems of 1922* and *1923*, *1924* (Constable, 1923-25); L. Apuleius: *The Golden Ass* (Navarre Society, 1924); A.R. Le Sage: *The Devil on Two Sticks* (Navarre Society, 1927); T. Kempis: *Meditations on Our Lady*) (St. Dominic's Press, 1929); R. Crashaw: *Musicks Duell* (Walters, 1935).

Contrib: *The Apple; Change; Chapbook.*

Bibl: Brian North Lee: *The Ex-Libris of Philip Hagreen* (Bookplate Society, 1987); *Times* obit. 10 February 1988; Brett; Deane; Garrett 1; Peppin; Waters.

See illustration on page 20

Kathleen HALE *Orlando the Marmalade Cat: A Camping Holiday* (Country Life, 1938)

HAILSTONE, Harold William **b.1897**

Born on 14 July 1897 in London, Hailstone studied at Goldsmiths' College School of Art (1919-22). Illustrator and cartoonist, he visited North America in 1928. He began contributing to *Punch* in 1931 and during WW2 he served as an official war artist in the Royal Air Force, making records of RAF operations with the partisans in Yugoslavia, and of the recapture of the Channel Islands. After the

war he continued as illustrator and staff cartoonist for the *Daily Mirror*.
Contrib: *Daily Mirror; ILN; Punch*.
Collns: IWM.
Bibl: Harries; Waters.

HALE, Kathleen b.1898
Born on 24 May 1898 at Broughton, Biggar, Peebleshire, Hale was educated at Manchester High School for Girls, and studied art at Manchester School of Art, and Reading University (under A.W. Seaby*, 1915-17). She moved to London from Reading in 1917 and worked in a market gardener's nursery for the Ministry of Food. After WW1 she did various jobs, including caring for children and collecting debts for a window cleaner, and began designing book jackets and illustrating some books for children. After her marriage in 1926, Hale lived in the countryside, studied at the Central School of Arts and Crafts (1928-30), and also studied under Cedric Morris at the East Anglian School of Painting and Drawing in 1938. In that same year, she started writing and illustrating the "Orlando the Marmalade Cat" books for her two sons. These books became extremely popular (she wrote nineteen of them, the last being published in 1972), mostly because of their richly detailed and brightly coloured lithographic illustrations.
Hale was elected SIAD, and was awarded the OBE in 1976.
Books illustrated include: M.R. Harrower: *"I Don't Mix Much with Fairies"* (Eyre, 1928); E. Waugh: *Basil Seal Rides Again* (C & H, 1963).
Books written and illustrated include: *Orlando the Marmalade Cat: A Camping Holiday* (Country Life, 1938); *Orlando: A Trip Abroad* (Country Life, 1939); *Orlando's Evening Out* (Puffin Picture Books 14; Penguin, 1941); *Orlando Buys a Farm* (Country Life, 1942); *Orlando's Home Life* (Puffin Picture Books 26; Penguin, 1942); *Henrietta the Faithful Hen* (Transatlantic Arts, 1943); *Orlando Becomes a Doctor* (Country Life, 1944); *Orlando's Invisible Pyjamas* (Transatlantic Arts, 1947; new illus., Murray, 1964); *Orlando Keeps a Dog* (Country Life, 1949); *Puss-in-Boots: A Peep Show Book* (1951); *Manda* (Murray, 1952); *Orlando's Zoo* (Murray, 1954); *Orlando's Magic Carpet* (Murray, 1958); *Orlando the Marmalade Cat Buys a Cottage* (Country Life, 1963); *Orlando and the Three Graces* (Murray, 1965); *Orlando the Marmalade Cat and the Water Cats* (Cape, 1972); *Henrietta's Magic Egg* (Allen & Unwin, 1973).
Exhib: NEAC; LG; Grosvenor Galleries; Leicester Galls.
Bibl: CA; ICB2; Peppin; Waters.

HALES, Robert fl.1967-
An illustrator of children's books.
Books illustrated include: D. Clewes: *A Bit of Magic* (Hamilton, 1967); R. Ottley: *Rain Comes to Yamboorah* (1967); M. Cockett: *Something Big* (1968); E. Mitchell: *Moon Filly* (Hutchinson, 1968); R. Weir: *The Foxwood Flyer* (1968); J. Chipperfield: *Rex of Larkbarrow* (1969); D. Clewes: *Peter and the Jumble* (1969), *Library Lady* (1970); P. Dickinson: *Heartsease* (Gollancz, 1969), *The Devil's Children* (Gollancz, 1970); U.M. Williams: *Traffic Jam* (1971); J. Chipperfield: *Banner* (Hutchinson, 1972), *Lobo* (Hutchinson, 1974); L. Garfield: *Baker's Dozen* (Ward Lock, 1973); P. Breinburg: *Brinsley's Dream* (Burke, 1976); T. Hopkins: *Nobody Pushes Me Around* (Macmillan, 1980).
Bibl: Peppin.

HALL, Arthur Henderson 1906-1982
Born on 25 June 1906 in County Durham, Hall studied at Accrington and Coventry Schools of Art, and at RCA. He won the Prix de Rome for engraving in 1931 and studied at the British School in Rome. On his return in 1932, he became a part-time teacher of drawing at Kingston School of Art, and also taught at the Central School of Arts and Crafts (1932-41). After service in the RAF during WW2 in its photo-interpretation section, he returned to the Central School, and in the 1950s was appointed Lecturer in Charge of Graphic Design at Kingston, becoming Head in 1963.
He was a painter in watercolour, an engraver and print maker, and a glass designer. He also illustrated a few books, mostly for children or on gardening. Most of his books were published by Penguin, either in the Puffin Story Books series or the Penguin Handbook

series.
He was elected ARWS (1958); RWS (1970); ARE (1956); RE (1961).
Books illustrated include: *The Children's Guide to Knowledge* (Odhams, 1949); M. Twain: *The Adventures of Tom Sawyer* (Penguin, 1950); E.R. Janes: *The Flower Garden* (Penguin, 1952); M. Twain: *The Adventures of Huckleberry Finn* (1953); E.R. Janes: *The Vegetable Garden* (Penguin, 1954); M. Dallow: *Heir of Charlecote* (Penguin, 1955); R.L. Green: *The Adventures of Robin Hood* (Penguin, 1956); E.R. Janes: *Growing Vegetables for Show* (Penguin, 1956), *Flower-Growing for Shows* (Penguin, 1959); *Library of the Garden* (three vols., Reader's Digest, 1963); R. Ainsworth: *Bedtime Book* (1974); S. McCullagh: *Jacca and the Talking Dog* (1978); B. Sherman: *George Moves House* (1978); *History of England* (Odhams, nd).
Exhib: RA; RE; RWS; LG.
Bibl: Wilfred Fairclough: "Arthur Henderson Hall, RE, 1906-1982", *Journal RE* 4 (1983): 24-5; Peppin; Waters.

HALL, Douglas b.1931
Born in Doncaster, Hall studied at Doncaster School of Art (1947-48), Leeds College of Art (1948-50) and RCA (1953-6). Since leaving RCA, Hall has been a free-lance artist, illustrating books (mostly for children) and designing book jackets.
Books illustrated include: R.L. Green: *The Land Beyond the North* (BH, 1958); L. Beckwith: *The Hills Is Lonely* (Hutchinson, 1959), *The Sea for Breakfast* (1961); L. Carroll: *Alice in Wonderland* (1960); D. Rybot: *My Kingdom for a Donkey* (Hutchinson, 1963); B. Willard: *The Battle of Wednesday Week* (Constable, 1963); L. Beckwith: *The Loud Halo* (Hutchinson, 1964); B. Willard: *Three and One to Carry* (Constable, 1964), *Charity at Home* (Constable, 1965); Bell: *The Rebels of Journey's End* (Hutchinson, 1966); D. Huddy: *How Edward Saved St. George* (with Dorothy Hall, Constable, 1966); M. Macpherson: *The Rough Road* (Collins, 1966); L. Beckwith: *Rope in Case* (Hutchinson, 1968); J.R. Townsend: *Pirate's Island* (OUP, 1968); M. Wiggin: *A Cottage Idyll* (Nelson, 1969); J.D. White: *The Fursedown Comet* (Hutchinson, 1970); L. Beckwith: *About My Father's Business* (Hutchinson, 1971), *Lightly Poached* (Hutchinson, 1973), *Beautiful Just!* (Hutchinson, 1975), *Hebridean Cookbook* (Hutchinson, 1976); J. McNeill: *Just Turn the Key* (Hamilton, 1976); E. Prentis: *A Nurse in Time* (Arrow, 1977) and several other titles; L. Beckwith: *Bruach Blend* (1978); G. Macbeth: *The Rectory Mice* (Hutchinson, 1982); S. Sheringham: *The Lonely House* (Hamlyn, 1982), *Splodge Pig* (Hamlyn, 1983); *More Stories from Listen with Mother* (Hutchinson, 1983); *Animal Tales from Listen with Mother* (Hutchinson, 1984); E. Chapman: *Marmaduke Goes to Scotland* (Hodder, 1986); F. Lindsay: *The Circus Treat* (Hodder, 1986), *The Clever Clue* (Hodder, 1986), *The Treasure Hunt* (Hodder, 1986).
Books written and illustrated include: *Douglas Hall's Nursery Rhymes* (Hamlyn, 1979); *Douglas Hall's Animal Nursery Rhymes* (Hamlyn, 1979); *Daisy the Naughty Kitten* (Dean, 1985); *Sophie the Busy Bunny* (Dean, 1985); *An Adventure for Hannah Hippo* (Dean, 1986).
Bibl: ICB3; ICB4; Peppin.

HALLWARD, Adelaide fl. 1888-1922
See Houfe under HALLWARD, Mrs. Reginald

HALLWARD, Reginald 1858-1948
See Houfe

HAMMOND, Aubrey 1894-1940
Born in Folkestone, Hammond studied at the Byam Shaw School of Art and the Académie Julian, Paris, and later taught at the Westminster School of Art. He drew mostly in pen and ink, designed for the theatre, produced posters, including several for London Transport, and did caricatures.
Books illustrated include: L. Melville: *The London Scene* (Faber, 1926); P. Traill: *Under the Cherry Tree* (Faber, 1926); D. Greville: *The Diary of Mr. Niggs* (Nicholson, 1932).
Contrib: *Nash's Magazine*.
Bibl: Peppin.

HAMMOND, Gertrude E. Demain 1862-1953
See Houfe

HAMNETT, Nina 1890-1956
See Houfe
Born on 14 February 1890 at Tenby in South Wales, Hamnett was educated in Westgate-on-Sea and at the Royal School, Bath. She studied art first at Portsmouth School of Art (1903) and then at Pelham School of Art (under Sir Arthur Cope), and at the London School of Art (under Sir Frank Brangwyn* and William Nicholson — see Houfe). She taught at Westminster Technical Institute (1917-18).

Hamnett led a genuinely Bohemian life as an artist — often desperately poor, painting, writing, drinking, taking many lovers. She was a portrait and landscape painter, a friend of Modigliani and Gaudier-Brzeska. She lived and painted in Paris and London and wrote two autobiographical books about her life as an artist. She illustrated a few books in pen and ink.

She fell forty feet from the window of her room in London and died on 16 December 1956.

Books illustrated include: S. Leslie: *The Silent Queen* (Cape, 1927); O. Sitwell: *The People's Album of London Statues* (Duckworth, 1928).

Books written and illustrated include: *Laughing Torso* (Constable, 1932); *Is She a Lady?* (Wingate, 1955).

Contrib: *The Gypsy; New Coterie; Radio Times; Vogue.*

Exhib: NEAC; LG; Eldar Gallery (1918); Tooth Gallery (1928); Parkin Gallery (1986); in France.

Bibl: Denise Hooker: *Nina Hamnett: Queen of Bohemia* (Constable, 1986); Peppin; Waters.

HAMPSON, Frank 1918-1985
Born on 21 December 1918 in Audenshaw, near Manchester, Hampson was educated in local primary schools and the King George V Grammar School in Southport. While just thirteen, he entered some comic drawings in an art competition run by *Meccano Magazine*, was given a prize and contributed work over the next two years. After school he delivered telegrams for the Post Office and in 1935 started work as a counter clerk for the GPO. In the same year, he started contributing cartoons to *Post*, the GPO's official magazine. After part-time studies at art school, he enrolled full-time at the Victoria College of Arts and Science in 1938, where he struck up a friendship with another artist, Harold Johns. During WW2 both served in the army and in 1946 both enrolled at the Southport School of Arts and Crafts, and soon both were doing freelance work.

In 1948 Marcus Morris, a Lancashire vicar, invited Hampson to contribute illustrations to his parish magazine, *Anvil*, which was designed to look like *Lilliput* and soon gained a wide circulation. After a public movement complaining of the violence of imported American comics, Morris and the Hulton Press started a new British comic, *Eagle* with Hampson creating the incredibly successful Dan Dare front page colour strip (1950-60). A studio was established for the production of the comic drawings and a long line of "Dan Dare" merchandise, with Johns and other artists working together on the projects. When Odhams took over the Hulton Press, Hampson resigned, feeling he no longer had control of the Dan Dare operation, and the cartoon was taken on by Frank Bellamy*.

From 1961 to 1964 Hampson did some advertising work and contributed illustrations to *Reveille* and *Radio Times*. He illustrated seven Ladybird books (1964-71) though the last, on Winston Churchill, was not published because of Hampson's ill health. In 1975 he was awarded a special award at the Lucca World Comics Convention as the "prestigioso maestro" and acknowledged as the best writer and illustrator of strip cartoons since WW2. In the late 1970s and early 1980s, several episodes from *Eagle* were reprinted in book form; and in 1976, a new Hampson strip appeared in *Ally Sloper*, about Dawn O'Dare, but there was only one episode. The *Eagle* comic was finally revived in March 1982, but Hampson was not involved. In that same year Hampson suffered a massive stroke and he died on 8 July 1985.

Books illustrated include: *First Ladybird Book of Nursery Rhymes; Madame Curie; Food Through the Ages; Transport Through the Ages; Kings and Queens; Out in the Sun* (all Ladybird, 1964-71).

Books written and illustrated include: *Man from Nowhere* (1979); *Rogue Planet* (1980); *Dan Dare: Pilot of the Future* (Hamlyn, 1981); *Road of Courage* (1981).

Contrib: *Anvil; Eagle; Eagle Annual; Meccano Magazine; Post; Radio Times; Reveille; TV21.*

Bibl: Bethnal Green Museum of Childhood: *Penny Dreadfuls and Comics: A Loan Exhibition from the Library of Oldenburg University, West Germany* (V & A, 1983); Alastair Crompton: *The Man Who Drew Tomorrow* (Bournemouth: Who Dares Publishing, 1985); Marcus Morris: *The Best of Eagle* (Joseph, 1977); Horn; Peppin.

HAMPTON, F. Michael b.1937
Born on 29 May 1937 at Croydon, Hampton studied at Croydon School of Art (1952-59). He worked in advertising from 1954 to 1978, and since then has been a wildlife artist in watercolour, scraperboard, ink and acrylic. He has done covers for magazines on birds, and has exhibited his paintings widely. He is a member of the SWLA and the Croydon Art Society.

Contrib: *Birds; British Birds.*

Exhib: RSPB; Swann Gallery; Bourne Gallery, Reigate; Craftsman's Gallery, Woodstock; Mall Gallery (1989).

Bibl: Who; IFA.

HANCOCK, John ("Jack") fl.1915
Described as a "painting Shelley", after a childhood of great promise, Jack Hancock was struck down by Bright's disease and died by drowning in his early twenties. *"Come Unto These Yellow Sands"*, a book for children, was the first book Hancock illustrated. It contains sixteen colour plates and decorations throughout.

Books illustrated include: M. Woods: *"Come Unto These Yellow Sands"* (BH, 1915).

HARBOUR, Jennie fl. 1920s
Books illustrated include: E. Vredenburg: *My Book of Favourite Fairy Tales* (with others, Tuck, 1921), *My Book of Mother Goose Nursery Rhymes* (Tuck, 1927).

HARDY, M. Dorothy fl. 1891-1925
See Houfe
A children's illustrator, in whose work animals feature largely. She lived in Long Eaton, Derbyshire, contributed to the *Strand Magazine* in 1891, and illustrated works by Lillian Gask.

Books illustrated include: L. Gask: *In Nature's School* (1908).

Contrib: *Strand.*

Bibl: *The Illustrators: Catalogue* (Chris Beetles Ltd., 1991).

HARGRAVE, John Gordon b.1894
See Houfe
Books written and illustrated include: *At Suvla Bay* (Constable, 1916); *The Totem Talks* (Pearson, 1918); *The Boy's Book of Signs and Symbols* (Pearson, 1920); *Young Winkle* (Duckworth, 1925); *The Imitation Man* (Gollancz, 1931); *Words Win Wars* (Wells Gardner, 1940).

HARGROVE, Ethel Craven d.1932
Born in York, Hargrove studied at the Lambeth School of Art. A book illustrator and designer, she wrote and illustrated a number of books on the Isle of Wight and on European countries.

Books illustrated include: A. Wahlenberg: *'Twas Long Ago* (Nutt, 1912).

Books written and illustrated include: *The Charm of Copenhagen* (Methuen, 1911); *Silhouettes of Sweden* (Methuen, 1913); *Wandering in the Isle of Wight* (Melrose, 1913); *Progressive Portugal* (Werner Laurie, 1914); *The Garden of Desire: A Story of the Isle of Wight* (Grafton, 1916); *England's Garden Island* (Newport, I of W: County Press, 1925).

Exhib: SWA.

Bibl: Waters.

HARNETT, Cynthia Mary 1893-1981
Born on 22 June 1893 in London, Harnett spent her childhood in Kensington. She was educated at a private school in Eastbourne,

and studied at Chelsea School of Art and at the studio of her cousin, G. Vernon Stokes, who was an animal painter. She collaborated with him on stories for children, both contributing to the writing and the illustrations. Her book, *The Wool-Pack*, won the Carnegie Medal in 1951. She also wrote a number of books illustrated by other artists, such as *Monasteries and Monks* (Batsford, 1963, illustrated by Edward Osmond*), and *The Writing on the Hearth* (Methuen, 1971, illustrated by Gareth Floyd*).

Books written and illustrated include: (with G.V. Stokes) *The Pennymakers* (Eyre, 1937); *David's New World* (Country Life, 1937); *Junk, The Puppy* (Blackie, 1937); *Banjo, The Puppy* (Blackie, 1938); *To Be A Farmer's Boy* (Blackie, 1940); *Mudlarks* (Collins, 1940); *Mountaineers* (Collins, 1941); *Ducks and Drakes* (Collins, 1942); *Bob-Tail Pup* (Collins, 1944); *Sand Hoppers* (Collins, 1946); *Two and a Bit* (Collins, 1948); *Follow My Leader* (Collins, 1949); *Pets Limited* (Collins, 1950); the following without Stokes — *The Great House* (Methuen, 1949); *The Wool-Pack* (Methuen, 1951); *Ring Out, Bow Bells!* (Methuen, 1953); *The Green Popinjay* (Blackwell, 1955); *Stars of Fortune* (Methuen, 1956); *The Load of Unicorn* (Methuen, 1959); *A Fifteenth Century Wool Merchant* (OUP, 1962).

Bibl: CA; ICB2; Peppin.

Derrick HARRIS Wood engraving for cover of *Listener* (Spring issue, 1957)

HARRIS, Derrick 1919-1960

Born in Chislehurst, Kent, Harris spent his childhood in Sussex. He was educated at Worthing High School and first studied architecture at Worthing School of Art, before working on the land and for London Civil Defence Service during WW2. He managed to study at St. Martin's School of Art during the war, and when John Farleigh* and Noel Rooke* returned to London with the Central School of Arts and Crafts, Harris went there. He worked as a hospital porter at the end of the war and then became a free-lance artist, concentrating on engraving since 1950. He did commercial

work for such companies as Whitbread, Colman's Mustard and the Richardson Printing Ink Company, for whom he illustrated a twentieth-century chapbook, *The Sales Conference*, written by Ellic Howe; and produced wood engravings to illustrate the covers of the Penguin edition of Evelyn Waugh. He started teaching at Kingston School of Art in 1947 and at Reigate School of Art in 1955. He was Chairman of the Illustrators' Group of the SIAD; member of SWE and RE.

Harris claimed to have been much influenced by Bewick and Eric Ravilious* as well as by his teachers, and learned a great deal from the decorative qualities of John Buckland Wright's* engravings. Harris' work is bold and humorous and obviously was inspired by the woodcuts in broadsheets and chapbooks of the eighteenth and nineteenth centuries.

Books illustrated include: *Word for Word: An Encyclopaedia of Beer* (Whitbread & Co., 1953); H. Fielding: *Joseph Andrews* (Folio Society, 1953); J. Barclay: *Euphormio's Satyricon* (GCP, 1954); T. Smollett: *Humphry Clinker* (Folio Society, 1955); H. Fielding: *Tom Jones* (Folio Society, 1959; repr. 1973).

Contrib: *Listener; Radio Times.*

Exhib: RA; SWE.

Bibl: Muriel Harris: "Fine Art or Commercial? A Profile of Derrick Harris", *Book Design & Production* 1, no. 2 (Summer 1958): 34-41; Folio 40; Jacques; Peppin; Usherwood.

HARRIS, Robin b.1949

Born in London, Harris was educated at St. Clement Dane's Grammar School and studied at Hammersmith College of Art (1967-68), Liverpool College of Art (1968-71) and RCA (1971-74). He began as a free-lance artist after travelling abroad, working for such magazines as *Radio Times, New Scientist* and *Esquire*. He also has done book illustrations, record covers and has had a one-artist show of his paintings in Leeds.

Contrib: *Esquire; Manage (Hamburg); Management Today; Mimms Magazine; New Scientist; Radio Times; Times Saturday Review.*

Exhib: Park Square Gallery, Leeds.

Bibl: Driver.

HARRISON, Charles d.1943
See Houfe

Books illustrated include: S.H. Hamer: *Master Charlie* (Cassell, 1899); R. Andom: *Troddles and Us and Others* (Jarrold, 1901); P.G. Wodehouse: *The Swoop; Or, How Clarence Saved England* (Alston Rivers, 1909); H. Rowan: *London Japanned* ("Black & White", 1910); F.F. McCabe: *A Living Machine* (Grant Richards, 1921).

Books written and illustrated include: *Grandma's Nursery Rhymes* (Dean, 1883); *The Prince and the Penny* (Dean, 1883); *Rhymes and Jingles* (Dean, 1883); *Accidents Will Happen* (with W.K. Haselden; Nutt, 1907); *A Humorous History of England* (Warwick & Bird, 1920).

HARRISON, [Emma] Florence fl. 1877-1925
See Houfe

Books illustrated include (all published by Blackie): C. Rossetti: *Poems* (1910); A. Tennyson: *Guinevere* (1911); W. Morris: *Early Poems* (1914); A.G. Herbertson: *Tinkler Johnny* (1916); N. Syrett: *Godmother's Garden* (1918); *My Fairy Tale Book* (1919); *"Beautiful Poems" Series* (four parts, 1923).

Books written and illustrated include (all published by Blackie): *Rhymes and Reason* (1905); *The Rhyme of a Faun* (1907); *In the Fairy Ring* (1908); *Elfin Song* (1912); *Tales in Rhyme and Colour* (1916); *The Man in the Moon* (1918); *The Pixy Book* (1918).

HARRISON, Mark Stephen James b.1951

Born on 27 February 1951 in Leicester, Harrison was educated at Loughborough Grammar School, and Keene Technical College. After an art foundation course at Loughborough College of Art, he studied graphic design at Trent Polytechnic, Nottingham (1970-73), and illustration at Wimbledon College of Art (1973-74). He painted his first cover art for Penguin Books while at college, but worked as a temporary clerk (1979-81) before painting a new portfolio and changing agents (to John Martin and Artists in 1981). He got many

A.S. HARTRICK "Strand-on-the-Green" from *Recording Britain* vol.2 (Oxford University Press, 1946

commissions, mostly for publishers, and went free lance in 1987. He has now painted more than 150 book jackets and paperback covers, mostly for crime, fantasy, and serious fiction, including covers for Penguin, Pan and Abacus books. He has done the latest 1980s edition of the crime novels by P.D. James, jackets for Michael Moorcock's novels for Harrap and is currently painting an increasing amount of fantasy covers for Bantam Doubleday Dell in the US.
Books illustrated include: M. Edwards and R. Holdstock: *Realms of Fantasy* (with others, Dragon's World, 1983); *Lost Realms* (with others, Dragon's World); *Nature Hide and Seek: Oceans* (Methuen).
Contrib: *Images* 10, 11.
Exhib: Association of Illustrators (1986).
Bibl: IFA.
Colour Plate 90

HARRISON, Stephanie Miriam **b.1939**
Born on 10 December 1939 in King's Lynn, Harrison was educated at Chapter Secondary School, Rochester, and studied illustration and typography at Medway College of Art (1955-60). She is a painter, illustrator and graphic artist. She worked for the Reed Paper Group (1960-65) in package design, and then moved to the Science Museum, South Kensington, where she did illustration and graphics, painting and exhibition design. Since 1970 she has free-lanced as a painter and illustrator, except for 1974-79 when she worked at the British Museum (Natural History). Her illustration work includes a few publications for the museums where she worked. *The Private Life of a Country House* includes some finely drawn, neat ink illustrations of interiors and details. NDD; ARMS; RBA.
Books illustrated include: *Finding and Identifying Mammals in Britain* (BMNH, 1975); *Handbook of British Mammals* (Blackwell, 1976); *Marine Life* (Leventhal, 1977); *Wild Flowers of Britain* (Reader's Digest, 1979); L. Lewis: *Private Life of a Country House 1912-39* (D & C, 1980).
Contrib: *Country Life; Edenbridge Courier; Fine Art.*
Exhib: RI; RMS; RBA; Mall Galleries; Gallery 19 (1979).
Bibl: Who; IFA.

HART, Dick **b.1920**
Born on 3 April 1920 on the Isle of Sheppey, Kent, Hart studied at Rochester School of Art, RA Schools and, after service with the RAF during WW2, at the RCA and in Paris. Since 1946 he has taught at various art schools, including Polytechnic School of Art, Regent Street, since 1956, and worked as a painter, graphic designer and illustrator. SIAD.
Books illustrated include: R. Blythe: *Danger Ahead* (1951); N. Streatfeild: *Day Before Yesterday* (Collins, 1956); G. Avery: *The Warden's Niece* (Collins, 1957), *Trespassers at Charlcote* (Collins, 1958); J. Aiken: *The Kingdom and the Cave* (Abelard, 1960); A. Hewett: *Piccolo* (BH, 1960); E.F. Stucley: *Magnolia Buildings* (BH, 1960); C. Storr: *Lucy* (BH, 1961); J.R. Townsend: *Grumble's Yard* (Hutchinson, 1961); J. Verne: *Journey to the Centre of the Earth* (Hutchinson, 1961); A. Hewett: *Piccolo and Maria* (BH, 1962); C. Storr: *Lucy Runs Away* (BH, 1962); R.B. Maddock: *The Widgeon Gang* (Nelson, 1964); J. Reeves: *The Pillar-Box Thieves* (Nelson, 1965).
Bibl: ICB2; Peppin; Ryder.

HART, Frank **1878-1959**
See Houfe

HARTE, Glynn Boyd **b.1948**
Harte was born in Lancashire and studied at the RCA (-1973). A painter and illustrator, he has travelled extensively and had several one-artist exhibitions; his lithographs have featured on the BBC series, "Artists in Print." His work often features paintings made during his travels. His book illustrations are colourful lithographs: *Liberty Prints* were a set of six issued in a loose-leaf folder (1984), while *Les Sardines à l'Huile* (1985) were printed at the Curwen Studio and published by Warren Editions. He lives in London with his wife and two children.
Books illustrated include: J. Betjeman: *Metroland* (Warren Editions, 1978); *Murderer's Cottages* (Warren Editions, 1979); R. Stamp: *Temples of Power* (Cygnet Press, 1979); C. Clifton and M. Nicolls: *Edible Gifts* (BH, 1982); C. Clifton: *Edible Flowers* (BH,

1983); *Les Sardines à l'Huile* (Warren Editions, 1985); T. and A. Waugh: *The Entertaining Book* (Hamilton, 1986); F.S. Fitzgerald: *Tender Is the Night* (Folio Society, 1987).
Books writen and illustrated include: *A Weekend in Dieppe* (Warren Editions, 1981); *Venice* (Hamilton, 1988).
Contrib: *Times*.
Exhib: Francis Kyle Gallery.
Bibl: Folio 40; Parkin.

HARTLEY, Marie fl.1953-
Hartley has illustrated a number of books about Yorkshire, using competent but unremarkable strong ink drawings, occasionally using colour.
Books writen and illustrated include: (all with J. Ingilby) *Yorkshire Village* (Dent, 1953); *Life and Tradition in the Yorkshire Dales* (Dent,1968); *Yorkshire Heritage* (Dent, 1950); *The Wonders of Yorkshire* (Dent, 1959); *Life in the Moorlands of North-East Yorkshire* (Dent, 1972); (and all with E. Pontefract) *Swaledale*; *Wensleydale*; *Wharfedale*; *Yorkshire Tour*; *Yorkshire Cottage*.

HARTRICK, Archibald Standish 1864-1950
See Houfe

HARWOOD, John Hammond 1904-1980
Born on 3 December 1904 in Darwen, Lancashire, Harwood was educated at Ripon School, and studied at Harrogate School of Art (1921-24) and the RCA (1924-28). A painter in both oil and water-colour, he wrote and illustrated a number of books for children, including several for the various Puffin series in the 1940s and 1950s. He became Principal of Gloucester School of Art (1939-45) and then Sheffield School of Art (1945-64).
Books illustrated include: H.C. White: *Bible Picture Books* (Bible Reading Fellowship, 1945-); B.E. Todd: *Worzel Gummidge and Saucy Nancy* (Puffin Story Books; Penguin, 1947); R. Parker: *A Moor of Spain* (Puffin Story Books; Penguin, 1953).
Books writen and illustrated include: *Puffin Rhymes* (Baby Puffin Books 3; Penguin, 1944); *The Old Woman and Her Pig* (Baby Puffin Books 4; Penguin, 1944); *A Christmas Manger* (Puffin Picture Books 103; Penguin, 1954); *The Yuletide Cottage* (Puffin Picture Books 107, 1955).
Exhib: LG; NEAC; RA.
Bibl: Peppin; Waters.

HASELDEN, William Kerridge 1872-1953
See Houfe

HASSALL, Joan 1906-1988
Born on 3 March 1906 in Notting Hill, London, the daughter of John Hassall (see Houfe), she first studied to be a teacher at the Froebel Training College and helped run her father's London School of Art (1925-27). Determined to be an artist, she attended RA Schools (1928-33) and the LCC School of Photo-Engraving (1931-34) under R.J. Beedham. She was introduced to the work of Thomas Bewick and, as McLean† writes, "from then on, Bewick was an intoxicating and vital influence." Like him, she found that she had a particular affinity for creating small head and tail pieces. She taught book production at Edinburgh College of Art (1940-47); and was elected SWE (1947), ARE (1938), RE (1948), and to the Art Workers' Guild (1964).
As an illustrator, her first commission was to engrave the title-page of her brother Christopher's book of poems, *Devil's Dyke* (1936), which persuaded the publishers to commission her to illustrate Francis Brett Young's *Portrait of a Village*. In addition to three full-page engravings, for this book Hassall also produced her first vignettes. By the mid-1940s she was receiving regular commissions for book illustration; in addition, she was gaining a reputation for her beautifully engraved bookplates. In 1951 she began to suffer from arthritis in her hands and had to turn to scraperboard for a while, using this media for a number of books, including Margaret Lane's *The Bronte Story* (1953) and *The Oxford Book of Nursery Rhymes* (1955).
She is perhaps best known for her illustrations to the Folio Society's editions of Jane Austen which appeared in the late 1950s and early 1960s. A later edition of the Folio Society's Jane Austen includes

Joan HASSALL *Sealskin Trousers* by Eric Linklater (Hart-Davis, 1947)

additional illustrations done by scraperboard; and the latest edition, published in 1984, reproduces both the wood engravings and scraperboard illustrations by offset lithography.
Her attention to detail and historical accuracy are clearly demon-strated in her book illustrations, and helped to make her reputation. "Joan Hassall's imagination makes her a true illustrator, and her craftsmanship and skill make her an outstanding one. In the field of story-illustration she is probably better at interpreting and con-veying atmosphere than character, for there is much of the poet in her; and work that she has done shows her to have a special gift for capturing the mysterious, the romantic, and the sinister." (McLean, 1960.†) Hodnett considers her work too dark and insufficiently animated, and believes that she was miscast as an interpreter of the feminine and domestic worlds of Mitford, Austen and Gaskell. In contrast, he praises her engravings for Bernard Gooch's *The Strange World of Nature* (1950) as her best work.
She made perhaps 1,500 engravings, many of which were printed in books of bad quality paper or by printers who did not take sufficient care. "She remains, nevertheless, one of the finest illustrators of her

time: sensitive to text, intelligent, incisive but tender, and with an eye to the niceties of period depiction to satisfy the purist." (Lee, 1986.†)

In 1972 Hassall was made Master of the Art Workers' Guild; was awarded a medal of the Paris Salon (1973); OBE (1987). She died on 6 March 1988.

Books illustrated include (but see Chambers, 1985†): C. Hassall: *Devil's Dyke* (Heinemann, 1936); F.B. Young: *Portrait of a Village* (Heinemann, 1937); C. Hassall: *Penthesperon* (Heinemann, 1938); Mrs. Gaskell: *Cranford* (Harrap, 1940); *Saltire Chapbooks* (1-6, 1943-6; 8-10, 1947-50; 12, 1951; Edinburgh: Saltire Society); J. Fergussen: *The Green Garden* (O & B, 1946); M.R. Mitford: *Our Village* (Harrap, 1946); M. Webb: *Fifty-One Poems* (Cape, 1946);

Press, 1975); E. Bowen: *The Collected Stories* (Cape, 1980); M. Lane: *The Drug-Like Bronte Dream* (Murray, 1980).
Contrib: *Housewife; London Mystery Magazine; Masque; The Periodical; Saturday Book.*
Exhib: RA; RSA; RHA; NEAC; SWE.
Bibl: David Chambers: *Joan Hassall: Engravings and Drawings* (Pinner: Private Libraries Association, 1985); Basil Gray: "Joan Hassall", *Signature* NS, 1 (July 1946): 36-43; Joan Hassall: "My Engraved Work", *Private Library* 2nd s., 7, No. 4 (1974): 139-64; Brian Lee: "The Wood Engravings of Joan Hassall", *Green Book* 2, no. 2 (1986): 36-39; Ruari McLean: *The Wood Engravings of Joan Hassall* (OUP, 1960); Deane; Garrett 1 & 2; Hodnett; ICB2; Peppin; Waters; Who.

Irene HAWKINS "Lodge, Thirkleby Park, Yorkshire" from *Recording Britain* vol.3 (Oxford University Press, 1947)

R.L. Stevenson: *A Child's Garden of Verses* (Hopetoun Press, 1947); E. Linklater: *Sealskin Trousers* (Hart-Davis, 1947); *The Missal in Latin and English* (Burns Oates and Washbourne, 1949); A. Trollope: *The Parson's Daughter* (Folio Society, 1949); B. Gooch: *The Strange World of Nature* (Lutterworth, 1950); A. Young: *Collected Poems* (Cape, 1950); J.R. Allan: *Lowlands of Scotland* (About Britain 11; Collins, 1951); L.A.G. Strong: *Sixteen Portraits* (Naldrett Press, 1951); A. Trollope: *Mary Gresley and Other Stories* (Folio Society, 1951); W.C. Dickinson: *The Sweet Singers* (O & B, 1953); M. Lane: *The Bronte Story* (Heinemann, 1953); P. Whitlock: *All Day Long* (OUP, 1954); H.C. Dent: *Books in Your Schools* National Book League, 1955); I. and P. Opie: *The Oxford Nursery Rhyme Book* (OUP, 1955); J. Austen: *Pride and Prejudice* (Folio Society, 1957; new edition, 1975); R. Church: *Small Moments* (Hutchinson, 1957); J. Austen: *Sense & Sensibility* (Folio Society, 1958; new edition, 1975), *Mansfield Park* (Folio Society, 1959; new edition, 1975); A. Young: *Quiet as Moss* (Hart-Davis, 1959); J. Austen: *Northanger Abbey* (Folio Society, 1960), *Persuasion* (Folio Society, 1961), *Emma* (Folio Society, 1962; new edition, 1975), *Shorter Works* (Folio Society, 1963); R. Burns: *Poems* (NY: Limited Editions Club, 1965); A. Young: *Burning as Light* (Hart-Davis, 1967); D. Burnett: *The True Vine* (Hedgehog

HASSALL, John **1868-1948**
See Houfe

HATHERELL, William **1855-1928**
See Houfe

HAWKINS, Irene Beatrice **b.1906**
Born 2 May 1906 in York, Hawkins was educated at the Queen Anne School for Girls, York, and studied art first by evening class and then as a full-time student at York School of Art and at the RCA (1929-33) under Sir William Rothenstein. After college, she worked as a student apprentice for one year at the Curwen Press with Harold Curwen, gaining knowledge of book production methods, including auto-lithography. Hawkins did a number of jacket designs, some of which were for books by Sacheverell Sitwell, including *Edinburgh* (1938), *Primitive Scenes and Festivals* (1942), *Splendours and Miseries* (1943), *The Hunters and the Hunted* (1947), *Cupid and the Jacaranda* (1952), and *Selected Works* (1954). These jackets were drawn directly on the stone at the Curwen Press. Hawkins also illustrated a number of books for children, including several by Alison Uttley, and books about flowers and herbs. She contributed to *Robin*, an educational journal for chil-

dren. She taught drawing and painting at York School of Art and during WW2 she was commissioned by the Pilgrim Trust to make drawings for *Recording Britain*. In later years, her main occupation was painting and making gouache drawings.

Books illustrated include: R.J. Macgregor: *Chi-Lo the Admiral* (Faber, 1940); D.A. Lovell: *The Strange Adventures of Emma* (Faber, 1941); W. de la Mare: *The Old Lion and Other Stories* (Faber, 1942); A. Uttley: *Nine Starlight Tales* (Faber, 1942); W. de la Mare: *The Magic Jacket* (Faber, 1943); E. Ramal: *Timothy* (Faber, 1943); A. Uttley: *Cuckoo Cherry-Tree* (Faber, 1943), *The Spice Woman's Basket* (Faber, 1944); D.A. Lovell: *Lolly Popkin* (Faber, 1944); D. Clewes: *The Cottage in the Wild Wood* (Faber, 1945); W. de la Mare: *The Scarecrow* (Faber, 1945); *Recording Britain* (four vols., OUP, 1946-9); W. de la Mare: *The Dutch Cheese* (1946), *Collected Stories for Children* (Faber, 1947); D. Clewes: *The Stream in the Wild Wood* (Faber, 1946); A. Uttley: *The Washerwoman's Child* (Faber, 1946); D. Clewes: *The Treasure in the Wild Wood* (Faber, 1947); J. Gilmour: *Wild Flowers of the Chalk* (Penguin, 1947); W. de la Mare: *Stories from the Bible* (Faber, 1947); D. Clewes: *The Fair in the Wild Wood* (Faber, 1949); A. Uttley: *The Cobbler's Shop* (Faber, 1950); D. Ross: *The Tooter and Other Nursery Tales* (Faber, 1951); F. Lingstrom and M. Bird: *Andy Pandy, the Baby Clown* (Faber, 1953).

Exhib: NEAC; Brighton; Ditchling Gallery; Southover Gallery, Lewes.

Collns: V & A.

Bibl: Sacheverell Sitwell: *A Note for Bibliophiles* (pp., 1975); ICB2; Peppin.

HAWKINS, Sheila **b.1905**
Born on 20 August 1905 in Kalgoorlie, Western Australia, Hawkins spent her childhood in Australia and New Zealand. She had little professional art training, and after leaving Toorak College, Victoria, she became a commercial artist (work she did not enjoy) and painted as a "weekend painter". She came to England in 1931, worked for Shell-Mex Advertising, and started writing and illustrating children's books. Her first book, *Black Tuppeny*, was published in 1932. Many of her illustrations are of animals, done in pen and ink or pastel.

Books illustrated include: G. Elliot: *The Long Grass of Whispers* (Routledge, 1949), *Where the Leopard Passes* (Routledge, 1949), *The Hunter's Cave* (Routledge, 1951); M. Skipper: *The Meeting Pool* (Penguin, 1954); P. Lynch: *Long Ears* (Penguin, 1954); G. Elliot: *The Singing Chameleon* (Routledge, 1957); A. Judah: *Tommy with the Hole in His Shoe* (Faber, 1957), *Tales of Teddy Bear* (Faber, 1958), *The Adventures of Henrietta Hen* (Faber, 1958); W.C. Strode: *Three Men and a Girl* (Heinemann, 1958), *Top off the Milk* (Heinemann, 1959); A. Judah: *Miss Hare and Mr. Tortoise* (Faber, 1959), *Basil Chimpy Isn't Bright* (Faber, 1959), *Henrietta in the Snow* (Faber, 1960), *Basil Chimpy's Comic Light* (Faber, 1960), *Henrietta in Love* (Faber, 1961); J. Stagg: *Bran of the Moors* (Dent, 1961); A. Judah: *The Elf's New House* (Faber, 1962); D. Lord: *Kiwi Jane* (Odhams, 1962); G. Kaye: *Kofi and the Eagle* (Methuen, 1963); A. Judah: *The Careless Cuckoo* (Faber, 1963); A. Wills: *Boy of the Mohawks* (Odhams, 1963); R. Park: *Airlift for Grandee* (Macmillan, 1964); A. Judah: *On the Feast of Stephen* (Faber, 1965); R. Nye: *March Has Horse's Ears* (Faber, 1966), *Taliesen* (Faber, 1966).

Books written and illustrated include: *Black Tuppeny* (1932); *Ena-Mina-Mina-Mo* (Warne, 1935); *Appleby John* (Hamilton, 1938); *Pepito* (Hamilton, 1938); *The Panda and the Piccaninny* (1939); *The Bear Brothers* (OUP, 1941); *The Bear Brothers' Holiday* (OUP, 1942); *The Bear Brothers' Shop* (OUP, 1942); *A Book of Fables* (Puffin Picture Books 22; Penguin, 1942); *Animals of Australia* (Puffin Picture Books 45; Penguin, 1947); *Homes and Families — Africa* (Edinburgh House, 1955); *Ena-Meena-Mina-Mo and Benjamin* (Warne, 1960); *Australian Animals and Birds* (A & R, 1962).

Contrib: *Farmer's Weekly; Nursery World.*

Bibl: ICB; Peppin.

HAWORTH, Jann **b.1942**
Born in Hollywood, California, Haworth studied at UCLA (1959-61) and the Slade (1962-63). A painter, she was married to Peter

Blake* and with him founded the Brotherhood of Ruralists. She has exhibited widely with the Brotherhood and elsewhere, and had a number of one-artist shows. She has illustrated covers for the new Arden Shakespeare from Methuen.

Exhib: RA; one-man shows at Fraser Gallery (1966,1969); Jarvis Gallery, NY (1971); Arnolfini Gallery, Bristol (1972); Waddington Galleries (1973); Festival Gallery, Bath (1974).

Bibl: Nicholas Usherwood: *The Brotherhood of Ruralists* (Lund Humphries, 1981).

HAWTHORN, Raymond Humphrey Millis **b.1917**
Born on 18 March 1917 in Poole, Dorset, Hawthorn was educated at Bablake School, Coventry (1927-34). He studied art at Coventry School of Art (1935-39) and engraving and the history of engraving at Hornsey School of Art and Crafts (1939-40) under Norman Janes* and Douglas Bliss*. After service in the army during WW2, he taught part-time at Coventry School of Art (1946) and was a full-time lecturer at the Medway School of Art (1946-47), before going to the Laird School of Art (subsequently the Wirral School of Art, Design and Adult Studies), Birkenhead (1947-78). He was elected ARE (1960); RE (1975); SWE (1985).

Hawthorn is a printmaker and illustrator. Many of his engravings are abstract, for his art "arises from a world of symbols all of which

Raymond HAWTHORN *The Rise and Fall of Athens* by Plutarch (Folio Society, 1967)

Keith HENDERSON *Green Mansions* by W.H. Hudson (Gerald Duckworth, 1926)

are given a visual image whether or not they possess such an identity." (Garrett, 1.) He was influenced by the work of Gertrude Hermes*, Blair Hughes-Stanton* and Agnes Miller Parker*. All of his book illustrations have been made for editions published by the Folio Society, though he has made engravings for the cover decoration of paperback editions of "The New Testament Commentaries" for SCM/Penguin.

Books illustrated include: K. Fenwick: *The Third Crusade* (Folio Society, 1958); Herodotus: *The Struggle for Greece* (Folio Society, 1959); P.C. de Laclos: *Les Liaisons Dangereuses* (Folio Society, 1962; rep. 1979); Suetonius: *The Twelve Caesars* (Folio Society, 1964); Plutarch: *The Rise and Fall of Athens* (Folio Society, 1967); Flavius Arrianus: *The Life of Alexander the Great* (Folio Society, 1970); *Abelard and Heloise* (Folio Society, 1977); *G. Chaucer: The Squire's Tale, and The Tale of Melibee* for *The Canterbury Tales* (with others, three vols., Folio Society, 1986); W. Shakespeare: *Julius Caesar; Coriolanus* (Folio Society, 1988).

Exhib: RE; SWF; Mall Prints (1972); Southport (1972); one-artist shows at Folio Gallery (1959), Birkenhead (1980).

Collns: Atkinson Art Gallery, Southport; Williamson Art Gallery, Birkenhead.

Bibl: Folio 40; Garrett 1 & 2; Peppin; Waters; Who; IFA.

HEATH, George 1900-1968
Born in Tonbridge, Kent, Heath studied at Goldsmiths' College and trained as an art teacher at the Regent Street Polytechnic. He taught at Teddington School of Art until it closed in the early 1930s, when

he started as a commercial artist. He soon became a leading artist for adventure comic strips, including Westerns and those which featured film stars like Clark Gable in *Radio Fun*. His best remembered character may be The Falcon, a detective who appeared in *Radio Fun* from 1947 to 1960.

He did not sign any of his work, and his son, Michael Heath*, has said that his father disliked his job. He died in Brighton in 1968.

Contrib: *Radio Fun*.
Bibl: Horn.

HEATH, Michael b.1935
The son of George Heath*, Michael Heath was one of the first of several *Punch* cartoonists to contribute to *Private Eye*.

Books illustrated include: C. and A. Russell-Taylor: *All Gourmets Great and Small* (Headline, 1989).

Books written and illustrated include: *Book of Bores* (Private Eye/Deutsch, 1976); *Michael Heath's Automata* (Rushton, 1976); *The Punch Cartoons of Heath* (Harrap, 1976); *Love All? Michael Heath's Cartoons from the Guardian* (Blond & Briggs, 1982); *Private Eye's Bores 3* (Private Eye, 1983); *The Best of Heath* (D & C, 1984).

Contrib: *Guardian; Private Eye; Punch; Spectator*.

HEDDERWICK, Mairi b.1939
Born on 2 May 1939 in Renfrewshire, Scotland, Hedderwick studied at Edinburgh College of Art. After college, she married and went to live on a Hebridean island where she did much sketching. After nine years, she returned to the mainland to run an art printing shop, doing book illustrations as an escape from the stresses of business. In 1983, she illustrated two books written in Gaelic by L. Storey, and published in Inverness.

Books illustrated include: R. Godden: *The Old Woman Who Lived in a Vinegar Bottle* (Macmillan, 1972); J. Duncan: *Brave Janet Reachfar* (Macmillan, 1975), *Herself and Janet Reachfar* (Macmillan, 1975), *Janet Reachfar and the Kelpie* (Macmillan, 1976), *Janet Reachfar and Chickabird* (Macmillan, 1978); W. Body: *A Cat Called Rover; A Dog Called Smith* (Longman, 1981); M. Miller: *Hamish and the Wee Witch* (Methuen, 1986); A. Wood and A. Pilling: *Our Best Stories* (Hodder, 1986).

Books written and illustrated include: *Mairi Hedderwick's Views of Scotland* (Gartocharn: Famedrum, 1981); *Katie Morag Delivers the Mail* (BH, 1984); *Katie Morag and the Big Boy Cousins* (BH, 1987).

Bibl: ICB4.

HEMMANT, Margaret Lynette b.1938
Born in London, Hemmant studied at St. Martin's School of Art (1952-58), and as Lynette Hemmant has worked as a free-lance illustrator of mostly children's books since 1958.

Books illustrated include (but see Peppin): B. Willard: *The Suddenly Gang* (Hamilton, 1963); M. Cockett: *Acrobat Hamster* (Hamilton, 1965); R. Manning-Sanders: *The Crow's Nest* (Hamilton, 1965); J. Seed: *Small House, Big Garden* (Hamilton, 1965); M. Cockett: *Sunflower Giant* (Hamilton, 1966); J. Hope-Simpson: *The High Toby* (Hamilton, 1966); R.J. Manning: *Boney Was a Warrior* (Hamilton, 1966); M. Treadgold: *Elegant Patty* (Hamilton, 1967); G. Trease: *The Dutch Are Coming* (Hamilton, 1967); H. Cresswell: *The Barge Children* (Brockhampton, 1968); B.E. Todd: *The Box in the Attic* (World's Work, 1970); D. Edwards: *The Read-To-Me Story Book* (Methuen, 1974); M. Hynds: *The Wishing Bottle* (Blackie, 1975); G.F. Lamb: *More Good Stories* (Wheaton, 1975); R.H. Barham: *The Jackdaw of Rheims* (World's Work, 1976); I. Byers: *Tiptoes Wins Through* (Hodder, 1976); C. Dickens: *A Christmas Carol* (World's Work, 1978); R. Field: *Poems for Children* (World's Work, 1978); *The Rubaiyat of Omar Khayyam* (World's Work, 1979); J. Austen: *Pride and Prejudice* (World's Work, 1980); J. Taylor and T. Ingleby: *Messy Malcolm's Dream* (World's Work, 1981).

Bibl: Peppin.

HENDERSON, Keith 1883-1982
See Houfe
Born on 17 April 1883 in Scotland, Henderson was brought up in Aberdeenshire and London, where his father worked as a lawyer.

Thomas HENNELL "The Kitchen of Bangrave Farm" from *Country Relics* by H. J. Massingham (Cambridge University Press, 1939) Reprinted with the permission of Cambridge University Press

He was educated at Orme Square School, London, and Marlborough College, and studied at the Slade (where Noel Rooke* was a fellow student) and in Paris at L'Académie de la Grande Chaumière. In Paris he shared a studio with fellow students Maxwell Armfield* and Norman Wilkinson*, and met Edmund Dulac (see Houfe). He served on the Western Front in WW1 and in WW2 was an official war artist in the RAF.

After leaving Paris, his first commissions were for portraits but he also painted landscapes and did murals, using various media, including watercolour, oils and pastels. He exhibited many times at such places as RA, RWS and ROI. He did some advertising work, producing posters for London Transport and the Empire Marketing Board, and was sent to Cyprus by the Board for more than a year to paint. Although his first book illustrations were based on paintings, notably the watercolours he painted for the *Romaunt of the Rose*, most of his illustrations were done in scraperboard or pen and ink. These black and white illustrations are very strong and decorative, some spread over two pages. His illustrations for the two-volume *Conquest of Mexico* (1922) might be his greatest achievement though some of the artist's favourite work was done for *Burns — By Himself* (1938). For more than twenty years he worked on a final book as artist and author, *Creatures and Personages*, a book of Assyrian, Egyptian and Greek mythology, for which he engraved more than sixty illustrations and which has yet to be published. With his artistic work he combined a talent for literature, and published volumes of poetry, plays and memoirs.

Henderson died in South Africa on 24 February 1982, in his 99th year. Malcolm Fry wrote in his obituary in *The Times*, 27 February 1982, that "His passing is a great loss to the art world . . . He was perhaps the last of the great Victorian painters of his generation. . . He was a fine artist, a great gentleman. His lively wit and sense of humour, his humanity and friendliness will be hard to replace. . ."

He was elected RP (1912), ARWS (1930), RWS (1937), ROI (1934), and awarded the OBE.

Books illustrated include: G. Chaucer: *The Romaunt of the Rose* (with Norman Wilkinson*; Chatto, 1908); T. Hardy: *Under the Greenwood Tree* (Chatto, 1913); E.R. Eddison: *The Worm Ouroboros* (Cape, 1922); W.H. Prescott: *The Conquest of Mexico* (two vols., Chatto, 1922); E.R. Eddison: *Styrbiorn the Strong* (Cape, 1926); W.H. Hudson: *Green Mansions* (Duckworth, 1926), *The Purple Land* (Duckworth, 1929); J. Beith: *No Second Spring* (Hodder, 1933); E. Cunningham: *Buckaroo* (Hodder, 1934); E.R. Eddison: *Mistress of Mistresses* (Faber, 1935); J. Beith: *Sand Castle* (Hodder, 1936); A. Fleming: *Christina Strang* (Hodder, 1936); R. Burns: *Burns by Himself* (Methuen, 1938); N.M. Gunn: *Highland Pack* (Faber, 1949); *Recording Scotland* (with others, O & B, 1952); E.R. Eddison: *The Mezentian Gate* (pp., 1958); S. Piggott: *Scotland Before History* (Nelson, 1958).

Books written and illustrated include: *A Book of Whimsies* (with G. Whitworth; Dent, 1909); *Letters to Helen* (Chatto, 1917); *Palm-groves and Humming Birds* (Benn, 1924); *Prehistoric Man* (Chatto, 1927); *Pastels* (Studio, 1952); *Till 21* (Regency Press, 1970).

Exhib: RA; ROI; RSA; RWS; NEAC; FAS (1914,1917).

Collns: V & A; Manchester; Preston; Birmingham.

Bibl: Stephen Constantine: *Buy & Build: The Advertising Posters of the Empire Marketing Board* (HMSO, 1986); Keith Henderson: *Till 21* (Regency Press, 1970); Keith Nicholson: "The Artist and the Book — Conversations with Keith Henderson", *Antiquarian Book Monthly Review* 2, no.11 (1975): 18-28; *Times* obit. 27 February 1982; Harries; ICB; Peppin; Waters.

HENNELL, Thomas Barclay **1903-1945**
Born on 16 April 1903 in Ridley, Kent, and brought up in his father's rectory, Hennell was educated at Bradfield College, Berkshire, and studied art at the Regent Street Polytechnic (1921-25). He taught art in schools in Bath and Bruton in the late 1920s but left

teaching in 1929 to devote more time to writing and painting.

From 1931, Hennell became a friend of Edward Bawden* and Eric Ravilious* and often visited them at Brick House in Great Bardfield, Essex, while he was preparing his book, *Change on the Farm* (1934). He suffered from a mental illness (1932-35), returning to painting in 1936, and moved back to Ridley in the same year. His experience of schizophrenia is described in *The Witnesses* (1938).

Hennell was a painter of landscapes, mostly in watercolour, a poet of distinction and an illustrator. His knowledge of the countryside and expertise on farm practices is revealed in all his work. He wrote, in the preface to *Change on the Farm*, "all the country's history, and not only a chronicle of small-beer, is written out in the carpentry of broken carts and waggons, on the knots and joints of old orchard-trees, among the tattered ribs of decaying barns, and in the buried ancestral furrows and courses which can still be traced under the turf when the sun falls slantwise across the fields in long autumn afternoons."

Hennell illustrated mostly his own works and those by the country writer, H.J. Massingham. He had received early encouragement as an artist from A.S. Hartrick (see Houfe) and both worked on the Pilgrim Trust/Oxford University Press project, *Recording Britain* in the 1940s, in which eleven of Hennell's paintings are reproduced. He became an official war artist and in 1943 was sent to Iceland, replacing his friend Ravilious who had been reported missing, presumed dead, on an air patrol off the coast of Iceland in 1942. Hennell was later posted to the Far East and in November 1945 was reported missing, presumed killed by Indonesian nationalists.

Maurice De Sausmarez wrote that "with many painter-illustrators there is a clear difference between the two divisions of their work, and although there is almost invariably the imprint of identity, book illustration imposes a set of limitations which evokes a new manner or, as sometimes happens, a mannerism. The fact that Hennell only worked on books that were bound up with his own interests meant that he was never called on to compromise and his work demonstrates this integrity. . . Hennell was successful as an illustrator of books dealing with the countryside, largely because he allowed no aspect of his subject to go unstudied." (De Sausmarez, 1947.†)

Hennell was elected ARWS (1938); RWS (1943); NEAC (1943).

Books illustrated include: H.J. Massingham: *A Countryman's Journal* (C & H, 1939), *Country Relics* (CUP, 1939), *Chiltern Country* (Batsford, 1940); Sir J. Russell: *English Farming* (Collins, 1943); C.H. Warren: *The Land Is Yours* (E & S, 1943); C.S. Orwin: *Farms and Fields* (OUP, 1944); C.H. Warren: *Miles from Anywhere* (E & S, 1944); H.J. Massingham: *The Natural Order* (Dent, 1945); *Recording Britain* (with others, four vols., OUP, 1946-9); R. Wailes: *The English Windmill* (Routledge, 1954).

Books written and illustrated include: *Change in the Farm* (CUP, 1934); *The Witnesses* (Davies, 1938); *British Craftsmen* (Collins, 1943); *The Countryman at Work* (Architectural Press, 1947).

Contrib: *Architectural Review; Countryman; Geographical Magazine; Newcomen Society Transactions.*

Exhib: RWS; NEAC; IWM (1956); Leicester (1955).

Collns (but see MacLeod, 1988†): IWM; RAF Museum; V & A; Tate; National Maritime Museum; Wye College, University of London.

Bibl: Maurice De Sausmarez: "The Pen Drawings of Thomas Hennell", *Alphabet and Image*, 4 (April 1947): 61-74; Hennell: *The Witnesses* (Peter Davies, 1938), *The Countryman at Work*. (Architectural Press, 1947), and *Lady Filmy Fern* (Hamish Hamilton, 1980); Ian Jeffrey: *The British Landscape, 1920-1950* (T &H, 1984); Michael MacLeod: *Thomas Hennell: Countryman, Artist and Writer* (CUP, 1988); Robin Stemp: "Thomas Hennell (War Artists 2)", *The Artist* (May 1987): 16-9; Harries; Peppin; Ross; Waters.

HENRY, David Reid
See REID-HENRY, David

HENRY, Thomas
See FISHER, Thomas Henry

HEPPLE, Robert Norman **b.1908**
Born on 18 May 1908 in London, Hepple was educated at Colfe's Grammar School, Blackheath, studied at Goldsmiths' School of Art

and the RA Schools. During the 1930s he was best known as an illustrator, primarily of the novels of the Shropshire writer, Mary Webb. His illustrations are in black and white with some colour plates. Some of the full-page pen drawings have a characteristic drawn frame around them, and the boldly drawn, sketchlike smaller pieces recall those of Lovat Fraser*.

He served as an official war artist (1941-44) and since that time has made a considerable reputation as a portrait painter, sculptor and engraver. NEAC (1947); RP (1948); ARA (1954); RA (1961); Pres. RP (1979).

Books illustrated include: M. Webb: *The Golden Arrow* (Cape, 1930), *Gone to Earth* (Cape, 1930), *The House in Dormer Forest* (Cape, 1931), *Seven for a Secret* (Cape, 1932); M. Fairless: *The Roadmender* (Collins, 1933); J. Buchan: *English Literature* (1934); A.M. Huntington: *The Ladies of Vallbona* (Collins, 1934); M. Webb: *The Spring of Joy* (Cape, 1937); P. Dawson: *Peg-Leg and the Fur Pirates* (1939); E. Vipont: *Blow the Man Down* (OUP, 1939).

Contrib: *Britannia; Nash's Magazine.*

Bibl: Ian Jeffrey: *The British Landscape 1920-1950* (T & H, 1984); Peppin; Waters; Who.

HEPWORTH, Dame Barbara **1903-1975**
Born on 10 January 1903 in Wakefield, Hepworth studied art at Leeds College of Art (1920) and was a fellow student of Henry Moore*; and at the RCA (1921-24), where she won a travelling scholarship to visit Italy (1924-25). She married John Skeaping in 1924 and exhibited with him on a number of occasions; Ben Nicholson became her second husband (the marriage was dissolved in 1951). She moved to St. Ives in 1935, where she died in a fire at her studio in 1975. The Barbara Hepworth Museum was opened in St. Ives in 1976.

Hepworth was primarily a sculptor who attained an international reputation, developing her style in the 1930s after contact with the

Norman HEPPLE *Gone to Earth* by Mary Webb (Jonathan Cape, 1930)

Stanley HERBERT Illustration from *News Chronicle* reproduced in *Scraperboard Drawing* by C.W. Bacon (Studio Publications, 1951)

HERBERT, Stanley fl.1930s-1950s

Herbert came to art after apprenticing to an engineering firm. He studied drawing in Denmark and later worked for an advertising agency in London, did a number of attractive coloured covers for *Radio Times* in the 1930s, produced some illustrations for *Lilliput* in the 1930s and 1940s, and illustrated at least three books. He often used the scraperboard technique.

Books illustrated include: F. Pitt: *Meet Us in the Garden* (Lutterworth, 1946), *The Year in the Countryside* (Lutterworth, 1947); H. Ballan: *The Story of a Thread of Cotton* (Puffin Picture Books 99; Penguin, 1952).
Contrib: *Lilliput; News Chronicle; Radio Times.*
Bibl: C.W. Bacon: *Scraperboard Drawing* (Studio, 1951); *Lilliput*, Dec. 1937; Driver.

HERMAN, E.R. fl.1890-1930

No biographical information seems available. He was apparently influenced by the art nouveau illustrations of Beardsley, Selwyn Image and Arthur Mackmurdo.
Books illustrated include: R.L. Stevenson: *Fables* (Longmans, 1914).
Bibl: Johnson FIDB.

HERMES, Gertrude Anna Bertha 1901-1983

Born on 18 August 1901 in Bromley, Kent, and educated at Belmont Private School, Bickley, Kent, Hermes studied at the Beckenham School of Art (1919-21) and at the Leon Underwood School of Painting and Drawing (1921-25). In 1922 she made her

work of contemporary European artists, specifically Brancusi, Gabo and Arp. Her work shows a great sensitivity to materials and a love of abstract or biomorphic shapes. She illustrated at least one book, Kathleen Raine's first book of poems, *Stone and Flower*, contributing a coloured frontispiece and several drawings.

Hepworth had many one-person exhibitions and her work was included in numerous group exhibitions. She won the major award of the San Paulo Bienal in 1959; and was created DBE in 1965. She was a Trustee of the Tate Gallery 1965-72.
Books illustrated include: K. Raine: *Stone and Flower; Poems 1935-43* (Poetry London, 1943).
Exhib: Tate (retrospective 1968); Whitechapel Art Gallery (retrospective (1954, 1962); Lefevre Gallery; Gimpel Gallery.
Collns: Tate.
Bibl: J.D. Hodin: *Barbara Hepworth; Life and Work* (Lund Humphries, 1952); A.M. Hammacher: *Barbara Hepworth.* (T & H, 1959); *St. Ives 1939-64; Twenty-Five Years of Painting, Sculpture and Pottery* (Tate Gallery, 1985); Compton; Tate.

HEPWORTH, Philip fl. 1947-1950

An illustrator in black and white.
Books illustrated include: R.J. MacGregor: *Chi-Lo the General* (Faber, 1947); A. Uttley: *John Barleycorn: Twelve Tales of Fairy and Magic* (Faber, 1948); M. Trevor: *The Forest and the Kingdom* (Faber, 1949), *Hunt the King, Hide the Fox* (Faber, 1950).
Bibl: Peppin.

Gertrude HERMES *The Pilgrim's Progress* by John Bunyan (The Cresset Press, 1928)

first wood engraving. She was married to Blair Hughes-Stanton*
from 1926 to 1932, and worked with him on engravings for the
Cresset Press edition of *The Pilgrim's Progress* (1928).

Hermes moved with her husband to Gregynog in 1930. She worked
on illustrations for an edition of White's *Natural History of
Selborne*, but this came to nought and the project was finally
dropped by Gregynog because Hermes completed only the frontis-
piece and two other engravings. Harrop writes that "her creative
ability, at that time, was virtually anaesthetized by personal misery .
. . she had left her husband and had taken a flat in London where
she proposed continuing her work for the Press." (Harrop, 1980.†)
In 1933, she was asked to redesign parts of *The Lovers' Song-Book*,
a version of which done earlier by Hughes-Stanton and William
McCance had been rejected. Hermes asked permission to start the
book from scratch but this was rejected, and she refused the com-
mission. "So ended Gertrude Hermes's tenuous and unhappy asso-
ciation with the Press. Looking back on her long and highly suc-
cessful career as wood engraver and sculptor, one cannot but regret
that Gregynog never succeeded in making use of her very consider-
able talent." (Harrop, 1980.†)

In the 1920s and 1930s, Hermes was working as a painter, sculptor,
and a decorator at international exhibitions, as well doing wood
engravings and illustrating books. She produced murals for the Paris
World Fair (1928) and sculpted glass panels for the British Pavilion,
Paris (1937) and the World Fair, New York (1939). Her decorative
architectural work included the mosaic floor and carved stone foun-
tain in the foyer of the Shakespeare Memorial Theatre, Stratford.
She illustrated two books in Penguin's "Illustrated Classics" series
in 1938 and 1939 and in 1939 was selected as one of the seven
wood engravers to represent Britain at the Venice Biennale
International Exhibition. She was appointed visiting teacher of life
drawing at the Westminster School of Art, taught wood engraving
at the St. Martin's School of Art and life drawing at the Camberwell
School of Art. During WW2 she took her young children to Canada,
and worked as a precision draughtsman for shipbuilders, and then
returned to England and resumed teaching in London in 1945.
Though devoting her own artistic energies mostly to sculpture, she
taught wood engraving at Camberwell and later at the Central
School of Arts and Crafts (1945-66), and at the RA Schools from
1966. She had a stroke in 1968 and never drew, engraved or sculpt-
ed again. She died on 9 May 1983 in Bristol.

Hermes is regarded as one of the most versatile and accomplished
of twentieth century wood engravers. Her book illustrations, which
like all her work show a fine feeling for design and composition,
were done both for private presses and commercial publishers.
Many honours and awards were bestowed upon Hermes during her
career. In 1925 she was awarded the Prix de Rome for engraving; in
1961, the first prize in the Giles Bequest competition; and in 1967
the Jean Masson Davidson Medal for sculpture by the Society of
Portrait Sculptors. She was elected a member of the SWE (1932); a
member of the London Group (1935); RE (1951); ARA (1963), RA
(1971); and was appointed O.B.E.

Books illustrated include: T.E. Lawrence: *The Seven Pillars of
Wisdom* (with others; pp., 1926); J. Bunyan: *The Pilgrim's Progress*
(with Blair Hughes-Stanton*; Cresset Press, 1928); *The Apocrypha*
(with Hughes-Stanton; Cresset Press, 1929); I. Gosse: *A Florilege*
(Swan Press, 1931); R.H. Mottram: *Strawberry Time* (GCP, 1934);
F. Toussaint: *The Garden of Caresses* (GCP, 1934); R. Jefferies:
The Story of My Heart (Penguin Books, 1938); I. Walton: *The
Compleat Angler* (Penguin Books, 1938); N. Mitchison: *The Alban
Goes Out* (Raven Press, 1939); P.L. Travers: *I Go By Sea, I Go By
Land* (Harpers, 1941); *Waves* (Faber, 1971); *Wood Engravings . . .
Being Illustrations to "Selborne"* (Gwasg Gregynog, 1988).

Exhib: RA (retrospective 1981); RE; SWE; Whitechapel Art
Gallery (1967); Print Makers Council (1973).

Collns: BM; V & A; Portsmouth City Museum and Art Gallery.

Bibl: *Landscape in Britain 1850-1950* (Arts Council, 1983); John
Gould Fletcher: "Gertrude Hermes and Blair Hughes-Stanton",
Print Collector's Quarterly 16 (1929): 182-98; Dorothy A. Harrop:
A History of the Gregynog Press (Private Libraries Association,
1980); Ian Jeffrey: *The British Landscape 1920-1950.* (T & H,
1984); Times obit. 11 May 1983; Sarah Van Niekirk: "Gertrude
Hermes", Journal RE, no.6 (1984): 11, 40; Deane; Garrett 1 & 2;
Peppin; Shall We Join the Ladies?; Waters.

William HEWISON "Daniel Day-Lewis and Michael Bryant in
'Hamlet'": illustration from *Punch* (1989)

HEWISON, William Coltman b.1925

Born on 15 May 1925 at South Shields, Hewison was educated at
South Shields High School (1936-41), and studied at South Shields
School of Art (1941-43). After army service in the Royal Tank
Regiment (1943-47), he studied painting at Regent Street Poly-
technic (1947-49), and obtained an Art Teacher's Diploma from the
University of London (1949-50). He was part-time art master at
Latymer Upper School in Hammersmith (1950-56), while at the
same time he developed free-lance illustration for magazines and
advertising, including contributions to *Punch*. He joined the
editorial staff of *Punch* in 1957 as Deputy Art Editor, and was
appointed Art Editor in 1960, resigning after twenty-four years in
1984, though he still contributes. His work for the magazine is
wide-ranging, including cartoons, caricatures, political cartoons,
"serious" short story illustrations, parodies of other illustrators,
colour work (including covers), posters and layout. He now does a
weekly caricature drawing for the drama review page. Price writes
of his work for *Punch* that "His humour might be wild but his
drawing was realistic, or rather, of reality with its comic aspects
heightened. Like ffolkes*, he was an accomplished drawer of
decorative initials and headings."

Hewison has contributed drawings to many other magazines, has
illustrated a number of books, including some by Basil Boothroyd
and Patrick Skene Catling, and has had three one-artist shows of his
theatre caricatures at the National Theatre. He cites as influences on
his work Ronald Searle* and Leslie Illingworth*.

Books illustrated include: R. Lewis: *What We Did to Father*
(Hutchinson, 1960); H.F. Ellis: *Mediatrics* (Bles, 1961), *A.J.
Wentworth BA (Retd.)* (Bles, 1962); *Germany; Mexico; Israel* (three
titles in "Places" series; Macdonald, 1972-3); K. Amis: *Lucky Jim*
(Geneva: Edito-Service, 1974); B. Took and M. Feldman: *Round
the Horne* (Woburn Press, 1974); M. Becket: *Economic Alphabet*

(Flame Books, 1976); D. Rogg: *No Turn Unstoned* (Elm Tree Books, 1982); N. Lebrecht: *Hush! — Handel's in a Passion* (Deutsch, 1985); P.G. Wodehouse: *The Great Sermon Handicap* (NY: Heinemann, 1989).
Books written and illustrated include: *Types Behind the Print* (Museum Press, 1964); *The Cartoon Connection* (Elm Tree Books, 1977); *How To Draw and Sell Cartoons* (with Ross Thomson; Quarto Publishing, 1985).
Contrib: *Architect's Journal; Classical Music; Country Life; Ford Magazine; House Beautiful; In Britain; Lilliput; Listener; Punch; Reader's Digest; Saturday Review; Sunday Times.*
Exhib: Whitechapel Art Gallery; National Theatre (1981, 1985, 1990); NPG.
Collns: V & A.
Bibl: Feaver; Price; IFA.

HICKLING, P.B. **fl. 1895-1960**
See Houfe
Books illustrated include: J.F. Fraser: *Life's Contrasts* (with others; 1908); *The Three Clerks* (1908); C.F. Parsons: *"All Change Here!"* (with Mary Stevens; 1916); N. Barr: *The Inquisitive Harvest Mouse* (Ladybird Books, 1949) and nine others.
Bibl: Peppin.

HIGGINS, Don **b.1928**
Born in Ilford, Essex, Higgins' childhood was plagued by long periods in hospital, but eventually he was able to start his art studies at Wimbledon School of Art, and then in 1947 entered RCA. Recurring ill-health interrupted his studies, though he did exhibit at the RA during this period, and he returned to RCA in 1952, studying under John Minton* and Edward Ardizzone*. He became a graphic designer for the BBC Television Design Department in 1955, but also worked as a free-lance illustrator, using mostly pen and ink. Since 1963, he has concentrated mostly on film work.
Books illustrated include: *The Life of John Wilkes, Gentleman* (Lion & Unicorn Press, 1955); J. Buchan: *The Thiry-Nine Steps* (1959); C.S. Forester: *Brown on Resolution* (1959), *Death to the French* (1959), *The Gun* (1959), *Payment Deferred* (1959); R. Guillot: *Elephant Road* (BH, 1959); O. Hall: *Warlock* (BH, 1959); R. Hardy: *Lost Sentinel* (Laurie, 1960); J. Ryder: *Six on the Black Art* (with others, Wynkyn de Worde Society, 1961); D. Stephen: *Rory the Roebuck* (BH, 1961); E.R. Braithwaite: *Paid Servant* (BH, 1962); M. Cervantes: *Don Quixote* (1962); J. Laborde: *Falcon and the Dove* (BH, 1962).
Contrib: *Radio Times.*
Bibl: Jacques; Peppin; Ryder; Usherwood.

HILDER, Rowland **b.1905**
Born of British parents on 28 June 1905 at Great Neck, Long Island, NY, Hilder was educated in Morristown, New Jersey, and came to England in 1915 with his family. He studied etching and drawing at Goldsmiths' College (1921-24); he won a travelling scholarship in 1924 and visited the Low Countries. In the same year he worked two days each week in a printer's shop; and from 1924-27 he studied etching and illustration under E.J. Sullivan (see Houfe). As a painter, he specialized in landscapes and seascapes, and his work is very much in the English tradition of Constable and Samuel Palmer. Contemporaries for whom he has a high regard are John and Paul Nash* and Hilder's close friend, Douglas Percy Bliss*.
In 1925 he began to illustrate books, including Masefield's *Midnight Folk* (1927), and *Precious Bane* by Mary Webb (1929). His illustrations to Stevenson's *Treasure Island* (1929) and *Kidnapped* (1930) demonstrated a real talent, focusing attention on the characters and producing tension with his strong line and dramatic composition. Between 1925 and 1935 he illustrated at least nine books of adventure stories by Percy F. Westerman. In the late 1920s he also started to do work for Shell, including illustrating some of their booklets such as *Then and Now* (1929) and *In Defence of British Rivers* (1932). He designed Christmas cards and posters, and contributed drawings to the *Sphere*.
By 1935, when he moved to Blackheath, Hilder was establishing a reputation for his watercolour landscapes of Britain, many of which were issued as prints and used on greeting cards. In 1939 he designed posters for a National Savings campaign, but during WW2

Rowland HILDER *Precious Bane* by Mary Webb (Jonathan Cape, 1929)

he was a camouflage officer, and illustrated the *Army Manual on Camouflage* (1941), and then worked for the COI until the end of the war, doing posters, illustrations and drawings for press advertisements. After the war he devoted more and more time to painting, initially doing pictures for Whitbread's advertising. He set up the Heron Press to market his prints and Christmas cards, and by 1951 he was the most popular landscape artist of the time. With his wife he worked on the *Shell Guide to Flowers of the Countryside*, published in 1955, and in 1958 produced paintings for the *Shell Guide to Kent*, the first in the series. In 1960 the printing and publishing company of Royle took over the stock of the Heron Press and acted as distributor of its cards, and Hilder continued to produce many paintings which were used as prints or on greeting cards. In 1963, Royle took over the Heron Press, and Hilder became its consultant art adviser. His career as a commercial illustrator virtually ended and he devoted his time to painting for painting's sake; the fact that much of his work was reproduced was almost incidental. He was elected RI (1938); President RI (1964-74); and was awarded OBE (1986).
Books illustrated include: P.F. Westerman: *The Riddle of the Air* (Blackie, 1925), *East in the "Golden Grain"* (Blackie, 1925), *The Luck of the "Golden Dawn"* (Blackie, 1926); H. Melville: *Moby Dick* (Cape, 1926); J. Lesterman: *The Adventures of a Trafalgar Lad* (Cape, 1926); P.F. Westerman: *The Junior Cadet* (Blackie, 1927), *The Chums of the "Golden Vanity"* (Blackie, 1927); J. Lesterman: *A Sailor of Napoleon* (Cape, 1927), *A Pair of Rovers* (with Richard Southern; Cape, 1928), *The Second Mate of the Myradale* (Cape, 1929); M. Webb: *Precious Bane* (Cape, 1929); R.L. Stevenson: *Treasure Island* (OUP, 1929), *Kidnapped* (OUP,

1930); H.A. Manhood: *Little Peter the Great* (Jackson, 1931); J. Masefield: *The Midnight Folk* (Heinemann, 1931); P.F. Westerman: *The Senior Cadet* (Blackie, 1931), *All Hands to the Boats* (Blackie, 1932); C. Fox-Smith: *True Tales of the Sea* (OUP, 1932); H. Avery: *No Surrender* (1933); P.F. Westerman: *The Black Hawk* (Blackie, 1934), *The Red Pirate* (Blackie, 1935); W.M.W. Watt: *Fire Down Below* (Muller, 1935); M. Redlich: *Five Farthings* (1939); L.A.G. Strong: *They Went to the Island* (Dent, 1940); *The Bible for Today* (with other artists; OUP, 1941); *Recording Britain* (with others; four vols., OUP, 1946-9); G. Grigson: *The Shell Guide to Flowers of the Countryside* (with Edith Hilder; Phoenix House, 1955); J.M. Fisher: *Birds and Beasts* (with Maurice Wilson*, Phoenix House, 1956).

Books written and illustrated include: *Horse Play* (Golden Gallery Press, 1946); *Starting with Watercolour* (Studio Vista, 1966); *Painting Landscapes in Watercolour* (Collins, 1983).
Contrib: *Envoy; Good Housekeeping; Nash's Magazine; Radio Times; Sphere.*
Exhib: RI; RA; Fine Art Society; Furneaux Gallery (1968); Hayward Gallery (1983); Everard Read Gallery, Johannesburg.
Bibl: *Landscape in Britain 1850-1950* (Arts Council, 1983); Rowland Hilder: *Rowland Hilder's England* (Herbert Press, 1986); Ian Jeffrey: *The British Landscape 1920-1950* (T & H, 1984); John Lewis: *Rowland Hilder: Painter and Illustrator*, 2nd ed. (Woodbridge: Antique Collectors' Club, 1987); Peppin; Waters; Who; Who's Who.
Colour Plates 91 and 92

HILKEN, Annie Kathleen **b.1902**
Born on 10 July 1902 in Walthamstow, Hilken was educated at Walthamstow High School for Girls and then went to Bedford College (1923). She trained as a teacher at Oxford Training College, and taught in Sunderland and Walthamstow before going to Canada for five years. She taught in Saskatchewan and then studied art at the Ontario College of Art, Toronto, returning to England for a year at the Slade, and four years at Central School for Arts and Crafts. Her career continued to change as she then started to nurse in 1939, becoming a state registered nurse in 1944; the one book which she is found to have illustrated came from this period. From 1950 she was art therapist at a hospital in Highgate.
Books illustrated include: Newell: *Fly-By-Nights* (Blackie, 1947).
Bibl: ICB2.

HILL, Vernon **1887-1953**
See Houfe

HILLIER, Jack **b.1912**
Born in Fulham, South London, Hillier was educated at Childerley Street Secondary School in London but left when he was fifteen to work for the British General Insurance Company. During the 1920s he studied art at the Central School of Arts and Crafts and was taught wood engraving by Noel Rooke*. He continued in the insurance business until his early retirement at the age of fifty-five.
Hillier became fascinated by Japanese prints and books, having found a portfolio of Japanese prints at the Farringdon Road book market in 1947. He studied Japanese art enthusiastically, and he is now an acknowledged expert in the field. He has published numerous books, catalogues and articles on various aspects of woodblock printing throughout the world, and has formed a large and varied collection of Japanese illustrated books which is now housed in the British Museum. His latest book (he says his last) is a splendid two-volume work on *The Art of the Japanese Book* (Sotheby's, 1989). Hillier is also a watercolourist and wood engraver. In 1951 he produced a book on Surrey watermills, illustrated with his sketches.
Books written and illustrated include: *Old Surrey Watermills* (Skeffington, 1951).
Bibl: Matthi Forer: *Essays on Japanese Art, Presented to Jack Hillier* (Robert G. Sawers, 1982.)

HIM, George **1900-1982**
Born in Lodz, Poland, Him was educated in Moscow and at the University of Bonn, where he was awarded a Ph.D., and studied at Leipzig School of Art for four years. He and Jan Lewitt* started their years of collaboration as design artists in Warsaw in 1933 (the partnership broke up in 1954), and moved to London after exhibiting there in 1937. They worked together, designing advertising material for companies such as Schweppes, Guinness, Shell and Ford; painted murals; designed posters and greeting cards; contributed illustrations to magazines (including covers to the *New Middle East*); and illustrated books for children. As a design team, it is impossible to distinguish the work of the two artists; and after the partnership was dissolved, Him's illustrations continued to show friendliness and wit, with no touch of malice. He won the Francis Williams Book Illustration Award in 1977.
Him taught at Leicester Polytechnic (1969-77), and designed animated films. He was elected SIAD, and appointed RDI (1978). He died in 1982.
Books illustrated include: J. Tuwim: *Locomotive* (with Jan Lewitt, Minerva Press, 1939); D. Ross: *The Little Red Engine Gets a Name* (with Lewitt, Faber, 1942); A. Lewitt: *Blue Peter* (with J. Lewitt, Faber, 1943), *Five Silly Cats* (with J. Lewitt, Minerva, 1944); M. Beerbohm: *Zuleika Dobson* (NY: Limited Editions Club, 1960); F. Herrmann: *The Giant Alexander* (Methuen, 1964), *The Giant Alexander and the Circus* (Methuen, 1966); S. Potter: *Squawky* (1964); L. Berg: *Folk Tales* (Brockhampton, 1966); A. Thwaite: *The Day with the Duke* (1969); L. Berg: *Little Nippers* (1975); L. Reid-Banks: *Adventures of King Midas* (Dent, 1976); J. Rogerson: *King Wilbur the Third* and four others in series (Dent, 1976); M. Cervantes: *Don Quixote* (Methuen, 1980).
Books written and illustrated include: *The Football's Revolt* (with Jan Lewitt, Country Life, 1939); *Israel, the Story of a Nation* (HMSO, 1958); *Twenty-Five Years of the Youth Aliyah* (1961).
Contrib: *Collins Magazine; New Middle East; Punch.*
Bibl: Manuel Gasser: "Lewitt-Him", *Graphis* 14 (1946): 200-211; Charles Rosner: "George Him", *Graphis* 94 (1961): 146-55; C.G. Tomrley: "Lewitt-Him", *Graphis* 48 (1953): 268-75; Amstutz 2; ICB3; Peppin.

HOCKNEY, David **b.1937**
Born 9 July 1937 in Bradford, Hockney was educated at Bradford Grammar School (1948-53), and studied at Bradford College of Art (1953-57). As a conscientious objector, he then served his national service in hospitals before attending RCA (1959-61). One of the "Pop" artists who was acclaimed by the media and turned into a kind of cult hero, Hockney exhibited at the 1960 and 1962 "Young Contemporaries" shows. After the success of his series of etchings, "A Rake's Progress" — published by Editions Alecto in 1963, all fifty sets were sold within a year, producing £5,000 for Hockney — he moved to California, his paintings became clearer and more specific, and his work grew progressively more naturalistic.
Hockney has been a very important influence in the development of British art. His "openness, his spontaneity, his total freedom from pedantry, his indifference to received dogma, has done much to liberate the opinions of his generation . . ." (Rothenstein 3.) He is a brilliant draughtsman and an experimentalist who is prepared to venture into new areas. In addition to his paintings and etchings, Hockney's theatre designs, particularly those for Glyndebourne productions of Stravinsky's *Rake's Progress* and Mozart's *The Magic Flute*, and *Parade* for the Metropolitan Opera, New York, have been extremely influential. It has been suggested that his work for the theatre may have been responsible for the shift from naturalism and an acknowledgement of artifice in his paintings in the late 1970s and 1980s.
His book illustrations are normally a series of etchings published separately as well as in book form. The Grimm *Six Fairy Tales*, published in 1970, contain thirty-four etchings; and *The Blue Guitar*, inspired by a Wallace Stevens poem, are etchings printed in one of a number of colours. For *Hockney's Alphabet*, the reviewer in the *TLS* (November 22, 1991) wrote that Hockney "has drawn a range of mostly bright and cheery letters. Each one is an object, often seen in a room or landscape, and the emphasis is on its singularity on the page . . . rather than its potential to combine and make words."
Elected ARA (1985).
Books illustrated include: C.P. Cavafy: *14 Poems* (Editions Alecto, 1967); *The Oxford Illustrated Bible: The Book of Nehemiah* (OUP, 1968); Brothers Grimm: *Six Tales* (1970); W. Stevens: *The*

Walter HODGES *The Namesake* (George Bell, 1964)

Man with the Blue Guitar (Petersburg Press, 1977); T. Seidler: *The Dulcimer Boy* (NY: Viking, 1979; Cape, 1981); *Hockney's Alphabet* (Faber, 1991).

Books written and illustrated include: *Travels with Pen, Pencil and Ink* (Petersburg Press, 1978); (with Stephen Spender) *China Diary* (T & H, 1982).

Exhib: One-artist shows in New York, Los Angeles, Amsterdam, Berlin, Paris, Munich, Lisbon; Waddington Galleries (1988); RA; Hayward; Whitechapel (retrospective 1970); Tate (retrospective 1988).

Collns: Tate.

Bibl: *David Hockney: Paintings, Prints and Drawings 1960-1970* (Whitechapel Art Gallery, 1970); *David Hockney: A Retrospective* (Tate Gallery, 1988); Martin Friedman: *Hockney Paints the Stage* (T & H, 1983); Marco Livingstone: *Hockney: Etchings and Lithographs* (T & H, 1988); Compton; Parry-Cooke; Peppin; Rothenstein 3; Who's Who.

HODGES, Cyril Walter **b.1909**

Born on 18 March 1909 in Beckenham, Kent, Hodges was educated at Mount Pleasant School, Southbourne, and at Dulwich College. He studied at Goldsmiths' College of Art (1925-28) under E.J. Sullivan (see Houfe) and was first interested in designing for the theatre. He designed costume and scenery for the Everyman Theatre (1928-30), and in 1934 he designed and painted a mural for the Museum of the Chartered Insurance Institute, London. He moved to an advertising agency but soon became a free-lance illustrator of magazine articles and books. His first commission was for the *Radio Times* in 1931, and he continued to contribute to the magazine for nearly forty years. He asserts that those who most influenced his work were the other contributors "whose excellence I tried so hard — & rather despairingly — to emulate."

After serving in the army during WW2, he re-established his career as a free-lance illustrator and lectured at the Brighton Polytechnic School of Art (1959-69). He has become one of the leading authorities on the Elizabethan stage. He became a designer for the Mermaid Theatre in 1951, in 1979 he was made an Honorary Doctor of Literature, Sussex University, and he has been involved with the project at Wayne State University in Michigan to build a replica of the Globe Theatre. In 1989 he started making reconstruction drawings of the Rose and Globe theatres in Southwark for the Museum of London.

He has illustrated some one hundred books, mostly for children, using pen and ink or watercolour. As well as illustrating the books of others, he writes and illustrates his own, one of which, *Shakespeare's Theatre* (1964), was awarded the Greenaway Medal for its illustrations. "He is a distinguished example . . . of the value of scholarship and the advantages of familiarity with the everyday things of the period in which a story is set." (Usherwood.) Hodges himself wrote "Many of the books that most attracted me and my friends when I was young were not specifically written as 'children's books'; therefore today, though I write mostly for children, I do not bother extremely to make my books only suitable for them at their age. I like to make them also suitable for me at mine. Besides, I am quite sure that children of any age ought not to be given children's books that are not suitable for adults to read." (Segar, 1980.†)

Books illustrated include (but see Peppin): L.A.G. Strong: *King Richard's Land* (1933), *Mr. Sheridan's Umbrella* (1935); G.B. Harrison: *New Tales from Shakespeare* (1938), *New Tales from Malory* (1939); E. Goudge: *Sister of the Angels* (1939), *Smoky-House* (1940); G.B. Harrison: *New Tales from Troy* (1940); I. Serraillier: *They Raced for Treasure* (1946); E. Nesbit: *The Story of the Treasure-Seekers* (Benn, 1947), *The New Treasure Seekers* (Benn, 1948), *The Would-Be-Goods* (Benn, 1948); J.D. Wyss: *The Swiss Family Robinson* (OUP, 1949); R. Sutcliff: *The Chronicles of*

Robin Hood (OUP, 1950), *The Armourer's House* (OUP, 1951), *Brother Dusty-Feet* (OUP, 1952); G. Trease: *Crown of Violet* (1952); M. Twain: *The Adventures of Huckleberry Finn* (Dent, 1955), *The Adventures of Tom Sawyer* (Dent, 1955); R. Manning-Sanders: *Red Indian Folk and Fairy Tales* (OUP, 1960); A. Duggan: *Growing Up in the 13th Century* (Faber, 1962); M. Baker: *The Shoe Shop Bears* (Harrap, 1963); M. Renault: *The Lion in the Gateway* (Longman, 1964); M. Baker: *Hannibal and the Bears* (Harrap, 1965); A. Duggan: *Growing Up with the Norman Conquest* (Faber, 1965); B. Willard: *The Richleighs of Tantamount* (Constable, 1966); R. Browning: *The Pied Piper of Hamelin* (Chatto, 1971); S.T. Coleridge: *The Rime of the Ancient Mariner* (Chatto, 1971).

Books written and illustrated include: *Columbus Sails* (Bell, 1939); *The Flying House* (Bell, 1947); *Shakespeare and the Players* (Bell, 1948); *The Globe Restored* (Benn, 1953; 2 ed., OUP, 1968); *The Namesake* (Bell, 1964); *Shakespeare's Theatre* (OUP, 1964); *The Norman Conquest* (OUP, 1966); *The Marsh King* (Bell, 1967); *The Spanish Armada* (OUP, 1967); *The Overland Launch* (Bell, 1970); *The English Civil War* (OUP, 1972); *Shakespeare's Second Globe* (OUP, 1973); *Playhouse Tales* (Bell, 1974); *The Emperor's Elephant* (OUP, 1975); *Plain Lane Christmas* (Dent, 1978); *The Battlement Garden* (Deutsch, 1979).

Contrib: *Radio Times*.
Exhib: Folger Shakespeare Library, Washington (1988).
Collns: Folger Shakespeare Library, Washington.
Bibl: Rufus Segar: "C. Walter Hodges: A Celebration", *Illustrators* No. 36 (1980): 10-15; Carpenter; Driver; ICB; ICB2; ICB3; Jacques; Peppin; Usherwood; Who; IFA.
Colour Plate 19

HODGSON, Edward S. **fl. 1908-1936**
See Houfe
A landscape painter who exhibited at RA, Hodgson illustrated ad-

venture stories for boys (particularly those by Percy F. Westerman) and travel books.
Books illustrated include (all published by Blackie except where noted): H. Collingwood: *A Middy in Command* (1908); P.F. Westerman: *A Lad of Grit* (1908), *The Sea Monarch* (Black, 1912), *Rounding Up the Raider* (1916), *Winning His Wings* (1919), *The Salving of the "Fusi Yama"* (1920), *The Third Officer* (1921), *Clipped Wings* (1923), *Unconquered Wings* (1924); D.A. Edwards: *My Native Land* (Benn, 1928); P.F. Westerman: *Captain Fosdyke's Gold* (1932), *Captain Flick* (1936).
Contrib: *Captain; Chums; Girls' Realm; Herbert Strang's Annual; Quiver*.
Exhib: RA.
Bibl: Peppin.

HODGSON, Robert **fl. 1955-1968**
An illustrator of children's books, with sketch-like drawings done in pen and ink.
Books illustrated include: E. Kyle: *Caroline House* (Nelson, 1955); R.B. Maddock: *Corrigan and the White Cobra* (and nine other titles in series, Nelson, 1956-63); E. Kyle: *Queen of Scots* (Nelson, 1957), *Maid of Orleans* (Nelson, 1957); R.B. Maddock: *Rocky and the Lions* (Nelson, 1957); B. Willard: *The Horse without Roots* (Constable, 1959); R.B. Maddock: *The Time Maze* (Nelson, 1960), *The Tall Man from the Sea* (Nelson, 1962), *Rocky and the Elephant* (Nelson, 1962); M. Twain: *The Prince and the Pauper* (1968).
Bibl: Peppin.

HOFFNUNG, Gerard **1925-1959**
Born on 22 March 1925 in Berlin, Hoffnung came to London in 1938, was educated at Highgate School and studied at Hornsey and Harrow Schools of Art. He was art teacher at Stamford School (1944) and at Harrow (1945-50), and staff artist at the *Evening*

Gerard HOFFNUNG "The Burglar": original drawing in pen, ink and wash. By permission of Chris Beetles Limited

News. He became a cartoonist, illustrator, musicologist, broadcaster, and a celebrated wit and raconteur. He organized and conducted a series of Hoffnung Festival Concerts; contributed to many magazines; appeared on BBC radio and television; spoke regularly at the Oxford and Cambridge Unions; and was the staff artist on the London *Evening News* and *Flair* in New York. He was particularly renowned for his black and white cartoons of musicians and their instruments.

Hoffnung was a serious musician and it is impossible to disassociate his art from his love of music, which did not stop him from satirizing music and musicians. He was a splendid draughtsman and a fine caricaturist, with an odd, gentle and, strangely, very English sense of humour, and his cartoons and other drawings show his love of music and his skills as a listener. He contributed to a number of journals, illustrated a few books by others, and produced a number of little books of his drawings.

Hoffnung was commissioned in 1959 to illustrate a Guinness book on cats and dogs; though he died before the project could be completed, it was published in 1960. He died suddenly on 28 September 1959; there was a memorial concert at the Royal Festival Hall in 1960.

Books illustrated include: J. Broughton: *The Right Playmate* (Hart-Davis, 1952); E. Pakenham: *Points for Parents* (1954); P. Cudlipp: *Bouverie Ballads* (Eyre, 1955); J. Symonds: *The Isle of Cats* (Werner Laurie, 1955); S. Penn: *Reigning Cats and Dogs; A Guinness Book of Pets* (Guinness, 1960); Colette: *The Boy and the Magic* (Dobson, 1964).

Books written and illustrated include: *The Maestro* (1953); *The Hoffnung Symphony Orchestra* (1955); *The Hoffnung Music Festival* (1956); *The Hoffnung Companion to Music* (1957); *Hoffnung's Musical Chairs* (1958); *Ho Ho Hoffnung* (Putnam, 1959); *Birds, Bees and Storks* (1960); *Hoffnung's Little Ones* (1961); *Hoffnung's Acoustics*; *Hoffnung's Encore* (1968); *Hoffnung's Harlequinade* (1979).

Exhib: Little Gallery (1949); Royal Festival Hall (1951, 1956); Edinburgh Festival (1968).

Contrib: *Daily Express; Evening News; Flair; Housewife; Lilliput; Punch; Radio Times; Strand Magazine; Tatler.*

Bibl: Annetta Hoffnung: *Gerard Hoffnung: His Biography* (Fraser, 1988); *O Rare Hoffnung: A Memorial Garland* (Putnam, 1960); Urban Roedl: "Gerard Hoffnung", *Graphis* 8, no. 40 (1952): 118-22; Brian Sibley: *The Book of Guinness Advertising* (Guinness Superlatives, 1985); Amstutz 1; Feaver; Peppin; Waters.

HOGARTH, [Arthur] Paul **b.1917**
Born on 4 October 1917 in Kendal, Westmorland, Hogarth was educated at St. Agnes School, Rusholme, South Manchester (1922-33), and studied at Manchester College of Art (1933-37) and at St. Martin's School of Art (1938-39). He lectured in illustration at the Central School of Arts and Crafts (1951-56), at the Cambridge School of Art (1959-61) and at the RCA (1964-71), where he continued as visiting lecturer (1971-85). He was staff illustrator and graphic designer for Shell International (1946-48) and then art editor of various periodicals, becoming a free-lance painter and illustrator in 1950.

Hogarth has established a reputation principally as a graphic reporter; he is widely travelled and draws a portrait of the country he visits and its peoples. He was the first British artist to set foot in China after WW2, and wrote and illustrated *Looking at China* as a record of that visit. In 1959 he travelled to Ireland with the playwright Brendan Behan to illustrate *Brendan Behan's Ireland* (1962), which led to a second collaboration on *Brendan Behan's New York* (1964). The greatly enlarged and revised second edition of his *The Artist as a Reporter* (1986) discusses the history and techniques of graphic reporting from the introduction of the illustrated newspaper in the nineteenth century, and introduces the reader to many artists who reported events which they witnessed. This book received the *Yorkshire Post* award as the best art book of 1986.

Best known for his own books, including illustrated "Walking Tours" of Philadelphia, Boston and Washington, he has also illustrated a number by other writers, including such classics as *The Diary of a Nobody* (1984), and has done many covers for Penguin Books, including those for the Graham Greene and Shakespeare

Paul HOGARTH "Tower Hill: Bill and his mate 'working a flush'" from *London à la Mode* by Malcolm Muggeridge (Studio Vista, 1966)

series. His recent work includes two collections of bright watercolours which are sensuously evocative of the settings of works by two writers, Graham Greene and Lawrence Durrell. He won the Francis Williams Book Illustration Award in 1982 for his illustrations of Robert Graves' *Poems*, and *Graham Greene Country* won a "distinguished mention" in the W.H. Smith Illustration Award, 1987.

Hogarth is also a prolific printmaker. A portfolio of lithographs entitled *Deya*, with handwritten poems by Robert Graves, appeared in 1978, and in 1981 he was commissioned by the Imperial War Museum to do a series of watercolour paintings of the Berlin Wall to mark its 20th anniversary. Christie's Contemporary Art regularly publish his lithographs in their Royal Academy Graphics series.

The artists who influenced Hogarth's style were the painter-illustrators of the Pre-Raphaelite Brotherhood — Ford Madox Brown, Millais and Arthur Boyd Houghton (on whom Hogarth produced an illustrated monograph in 1981) — James Boswell*(with whom Hogarth worked as his assistant), Degas, and Miklos Vadasz, a Hungarian draughtsman and illustrator.

He was elected ARA (1974); RA (1984); RDI (1979); awarded OBE (1989).

Books illustrated include: C. Brontë: *Jane Eyre* (Prague: Mlada Fronta, 1954); C. Dickens: *Pickwick Papers* (Prague: SNDK, 1956); J. Walsh: *My Life* (Prague: Mlada Fronta, 1956); D. Lessing: *Going Home* (Joseph, 1957); A.C. Doyle: *The Adventures of Sherlock Holmes* (Folio Society, 1958); A.R. Haggard: *King Solomon's Mines* (Penguin, 1958); P. Knight: *Gold of the Snow Goose* (Nelson, 1958); E. Sheppard-Jones: *Welsh Legendary Tales* (Nelson, 1958); O. Henry: *Short Stories* (Folio Society, 1960); O. Schreiner: *The Story of an African Farm* (NY: Limited Editions

Paul HOGARTH "'Finch's', Goodge Street" from *London à la Mode* by Malcolm Muggeridge (Studio Vista, 1966)

Club, 1960); C.H. Rolph: *The Trial of Lady Chatterley* (Penguin, 1961); B. Behan: *Brendan Behan's Ireland* (Hutchinson, 1962); E. Sheppard-Jones: *Scottish Legendary Tales* (Nelson, 1962); L.M. Alcott: *Little Men* (1963); *Use Your Russian* (BBC, 1963); V.S. Pritchett: *The Key to My Heart* (Chatto, 1963); B. Behan: *Brendan Behan's New York* (Hutchinson, 1964); R. Graves: *Majorca Observed* (Cassell, 1965); M. Muggeridge: *London à la Mode* (Studio Vista, 1966); P. Sherrard: *Byzantium* (The Great Ages of Man series; NY: Time-Life Books, 1966); J. Atwater and R.E. Ruiz: *Out from Under* (NY: Doubleday, 1969); A. Jacob: *A Russian Journey* (Cassell, 1969); D. Whitman: *The Hand of Apollo* (Chicago: Follett, 1969); *The Smithsonian Experience* (Washington: Smithsonian Institution, 1977); *Visiting Our Past* (Washington: National Geographic Society, 1977); J. Joyce: *Ulysses* (Philadelphia: Franklin Library, 1978); S. Sassoon: *Memoirs of a Fox-Hunting Man* (NY: Limited Editions Club, 1978); N. Buxton: *America* (Cassell, 1979); S. Spender: *America Observed* (NY: Clarkson Potter, 1979); R. Graves: *Poems* (NY: Limited Editions Club, 1980); S. Sassoon: *Memoirs of an Infantry Officer* (NY: Limited Editions Club, 1981); H. Johnson: *Hugh Johnson's Wine Companion* (Mitchell Beazley, 1983); A. & M. Roux: *New Classic Cuisine* (Macdonald, 1983); J. Conrad: *Nostromo* (Folio Society, 1984); G. & W. Grossmith: *The Diary of a Nobody* (Hamilton, 1984); W. Trevor: *Nights at the Alexandria* (Hutchinson, 1987).
Books written and illustrated include: *Defiant People: Drawings of Greece Today* (Lawrence & Wishart, 1953); *Drawings of Poland* (Warsaw: Wydawnictwo Artystczno-Graficzne, 1954); *Looking at China* (Lawrence & Wishart, 1955); *People Like Us: Drawings of South Africa and Rhodesia* (Dobson, 1958); *Creative Pencil Drawing* (Studio Vista, 1964); *London à la Mode* (Studio Vista, 1966); *Creative Ink Drawing* (Studio Vista, 1968); *Drawing People* (NY: Watson-Guptill, 1971); *Drawing Architecture* (NY: Watson-Guptill, 1973); *Paul Hogarth's American Album: Drawings 1962-65* (Lion & Unicorn Press, 1974); *Paul Hogarth's Walking Tours of Old Philadelphia* (NY: Barre, 1976); *Paul Hogarth's Walking Tours of Old Boston* (NY: Dutton, 1978); *Walking Tours of Old Washington and Alexandria* (Washington: EPM, 1985); *Graham Greene Country* (Pavilion, 1986); *The Mediterranean Shore: Travels in Lawrence Durrell Country* (Pavilion, 1988).

Published: *Artists on Horseback: The Old West in Illustrated Journalism 1857-1900* (NY: Watson-Guptill, 1972); *Arthur Boyd Houghton* (Fraser, 1981); *The Artist as Reporter* (2nd edition; Fraser, 1986).
Contrib: *Coal; East Anglian Magazine; Echo (COI); Fortune; ILN; Life; Lilliput; Sports Illustrated; Weekend Telegraph.*
Exhib: Architectural Association (1953); Leicester (1955); ACA Gallery, NY. (1962, 1965); RCA (1970); Fitzwilliam (1977); Francis Kyle (1980, 1983, 1985, 1986, 1988); IWM (1981); Shakespeare Centre, Stratford (1988); Norwich Gallery (1989).
Collns: Fitzwilliam; IWM; Tate; Whitworth; V & A; Boston Public Library; Library of Congress.
Bibl: Charles Rosner: "Paul Hogarth: From His China Sketchbook", *Graphis* 14, no. 79 (1958): 448-50; Charles Rosner: "Paul Hogarth", *Graphis* 18, no. 103 (Sept/Oct 1962): 508-15; Amstutz 2; Peppin; Waters; Who; IFA.
Colour Plates 22 and 93

HOLDEN, Edith Blackwell **1871-1920**
Born on 28 September 1871 in Kings Norton, near Birmingham, Holden was the fourth of seven children, two of her sisters also becoming artists. She commenced her studies at Birmingham School of Art in 1884 when she was thirteen, and her fellow students included A.J. Gaskin, Charles Gere and others who became well-known book illustrators. She painted plants and animals in oils and watercolour, and illustrated a few books for children before 1915. She is included here only because of the highly successful publication of her *The Country Diary of an Edwardian Lady* in 1977, nearly sixty years after her death.
Books written and illustrated include: *The Country Diary of an Edwardian Lady* (Joseph, 1977).
Bibl: Ina Taylor: *The Edwardian Lady: The Story of Edith Holden* (Webb & Bower, 1980); Peppin.

HOLIDAY, Charles Gilbert Joseph **1879-1937**
See Houfe under HOLIDAY, Gilbert
Born in London, the son of Sir Frederick Holiday and nephew of painter Henry Holiday, Holiday was educated at Westminster School and studied at RA Schools. He contributed to a number of

magazines, including *Graphic* and *Punch*, and later became interested mostly in horses as his subject, painting and illustrating books. Paget writes that Holiday was probably the most successful artist to tackle polo. "He was a master in depicting speed — no-one better — but his technique and knowledge just failed to put him in the top class." (Paget, 1945.†) He died on 8 January 1937.

Books illustrated include: W.E. Lyon: *In My Opinion* (Constable, 1928); E.G. Roberts: *Hunter's Moon, and Other Hunting Verses* (1930); H.B.C. Pollard: *Hard Up on Pegasus* (Eyre, 1931); M. Charlton: *The Midnight Steeplechase* (Methuen, 1932); F. Watson: *In the Pink; Or, The Little Muchley Run* (Witherby, 1932); M. Charlton: *Three White Stockings* (Putnam's, 1933); W. Jelf: *Sport in Silhouette* (Country Life, 1933); "D. Fife": *A Mixed Bag: A Book of Sporting and Open-Air Verses* (1934); C.J. Cutliffe-Hyne: *Ben Watson* (Country Life, 1936); R.S. Summerhays: *It's a Good Life with Horses* (Country Life, 1951).

Books written and illustrated include: *We'll All Go A'Hunting Today* (Medici Society, 1933); *Horses and Soldiers: A Collection of Pictures by the Late Gilbert Holiday* (Gale & Polden, 1938).

Contrib: *Graphic; ILN; Punch; Tatler.*

Exhib: RA; RI; PS; Tryon Gallery.

Bibl: Guy Paget: *Sporting Pictures of England* (Collins, 1945); Titley; Waters.

Contrib: *Left Review; Lilliput.*

Exhib: LG; NEAC.

Bibl: *Lilliput*, (October 1947); Waters.

HOLMES, Nigel **b.1942**

Born in Yorkshire, Holmes was educated at Charterhouse and studied at Hull Art School and RCA (1962). While at college he did some free-lance work and then travelled to the US on a scholarship after graduating. He contributed to a number of magazines including some "factual" illustrations for *Radio Times* for which he sometimes collaborated with Peter Brookes*. In 1967 he worked for the Cornmarket Press and now works for *Time* magazine in the US.

Contrib: *New Society; Observer; Radio Times; Woman's Mirror.*

Bibl: Driver.

HONEYSETT, Martin **b.1923**

Honeysett studied briefly at Croydon Art School, and works as a cartoonist. Richard Ingram describes him as representing the spirit of the seventies in *Private Eye*, and writes of his cartoon characters that they "all look distinctly scruffy and seedy, suggesting that everything, not only the furniture, is falling apart." (Ingrams, 1983.†)

Contrib: *Private Eye.*

James HOLLAND Illustration for "The Carter" by Bill Naughton in *Lilliput* (November 1948) p.103

HOLLAND, James Sylvester **b.1905**

Born on 19 September 1905 in Gillingham, Kent, Holland studied at Rochester School of Art and at the RCA, and with James Boswell* and Pearl Binder* attended James Fitton's* lithography classes at the Central School. The three "Jameses" were resolutely opposed to fascism and contributed cartoons each month to the *Left Review*, graphically exposing corruption, greed and hypocrisy. During WW1, he worked at the Ministry of Information, and later was chief designer at the Central Office of Information. He drew directly on the plate for the lithographs he made for the Puffin Picture Books series; he also did book jackets for Bodley Head. He married artist Diana John, who was a fellow illustrator for *Lilliput*, to which Holland contributed some small drawings and four realistic paintings which depict "A Miner's Day" (October 1947).

Books illustrated include: R. James: *A Book of Insects* (Puffin Picture Books 5; Penguin Books, 1940); E. Welty: *The Robber Bridegroom* (BH, 1944); *El Periquillo Sarniento* (BH).

Books written and illustrated include: *War on Land* (Puffin Picture Books 1; Penguin Books, 1940); *War at Sea* (Puffin Picture Books 2; Penguin Books, 1940).

Bibl: Richard Ingrams: *The Penguin Book of Private Eye Cartoons* (Penguin, 1983).

HORRABIN, James Francis **1884-1962**

Born on 1 November 1884 in Peterborough, Horrabin was educated at Stamford Grammar School, and studied at Sheffield School of Art. He did design work for his father's silver-plate works in Sheffield while attending evening classes and in 1906 he took a job in the Art Department of the *Sheffield Telegraph* (1906-09), and in 1909 became Art Editor on the *Yorkshire Telegraph and Star* (1909-11). After moving to London in 1911, he was Art Editor of the *Daily News* (which later became the *News Chronicle*), and began to lecture in geography at the Central Labour College in Earl's Court, London. He edited the National Council of Labour College's monthly, *The Plebs*, and drew cartoons for it.

After army service during WW1, he returned to the *Daily News* where he contributed drawings of peace treaty maps. H.G. Wells invited Horrabin to produce the maps and other illustrations for his *Outline of History* (1920). In 1919, Horrabin had started a Children's Corner in the paper, the "Adventures of the Noah

Family, including Japhet", and his daily drawings for that appeared for many years. After Happy the Bear appeared, the strip soon was called "Japhet and Happy". When the *Daily News* combined with the *Daily Chronicle* in 1930, the strip continued in the *News Chronicle* and ran right through WW2.

In 1922, he started another comic strip, "Dot and Carrie", which featured two office girls, for the *Star*, celebrated on 11 February 1939 by that paper when the "Star Man's Diary" was entirely devoted to a tribute to Horrabin, whose strip had appeared daily for seventeen years. *The Star* was absorbed by the *Evening News* but "Dot and Carrie" continued to appear until Horrabin's death. The final strip of 2 March 1962 bore the serial number 11,735!

Horrabin was elected Labour Member of Parliament for Peterborough in 1929, but continued to produce his comic strips and also did caricatures of his fellow-members for the "Star Man's Diary". He lost his seat in 1931, but as a committed socialist collaborated in the foundation of the Fabian Colonial Bureau, becoming Chairman from 1945 to 1950. After he lost his parliamentary seat, Horrabin returned to drawing maps for many books, including *An Atlas of Current Affairs* (1934) and *Atlas of Empire* (1937), and started regular map-talks for television in 1938. During WW2 he worked for M. O. I., doing maps for films.

Books illustrated include: H.G. Wells: *The Outline of History* (Macmillan, 1920); L. Hogben: *Mathematics for the Millions* (Allen & Unwin, 1936), *Science for the Citizen* (Allen & Unwin, 1938); J. Nehru: *Glimpses of World History* (1939); L. Hogben: *Principles of Animal Biology* (Allen & Unwin, 1940).

Books written and illustrated include: *Some Adventures of the Noah Family* (Cassell, 1920); *The Noahs on Holiday* (Cassell, 1921); *Japhet and Fido* (1922); *Mr. Noah* (1922); *More About the Noahs — and Tom Tosset* (Cassell, 1922); *Dot and Carrie* (Daily News, 1923); *Dot and Carrie [and Adolphus]* (Daily News, 1924); *The Japhet Book* (Daily News, 1924); *Dot and Carrie [not Forgetting Adolphus]* (Daily News, 1925); *About Japhet and the Rest of the Noah Family* (Fleetgate, 1926); *Japhet & Co.* (Fleetgate, 1927); *Japhet and the Arkubs* (Daily News, 1927); *Japhet and the Arkubs at Sea* (Daily News, 1929); *Japhet & Co. on Arkub Island* (News Chronicle, 1930); *An Atlas of Current Affairs* (Gollancz, 1934); *An Atlas of European History* (Gollancz, 1935); *An Atlas of Empire* (Gollancz, 1937); *An Atlas History of the Second Great War* (ten vols., Nelson, 1940-46); *An Atlas of Africa* (Gollancz, 1960).

Contrib: *Daily News (News Chronicle); Japhet and Happy Annual; Plebs; Star (Evening News)*.

Bibl: Bradshaw; DNB; Doyle BWI; Gifford; Horn; Waters.

HOUGH, [Helen] Charlotte　　　　　　　　　**b.1924**
Born on 24 May 1924 in Brockenhurst, Hampshire, Hough (née Constantine) was educated at Frensham Heights School in Surrey. During WW2, she served in the WRNS (1942-43); married Richard Hough (1943), a writer and editor (divorced 1977). She started to illustrate books for children, the first being published in 1950, and then began to write and illustrate her own books (though she had no formal art training), her first being *Jim Tiger* (1956). She has travelled widely, and writes travel articles and detective stories for adults.

Books illustrated include (but see Peppin): M.E. Atkinson: *The House on the Moor* (1948), *Steeple Folly* (BH, 1950), *Castaway Camp* (BH, 1951); M. Oliver: *Land of Ponies* (Country Life, 1951); A.S. Tring: *Barry Books* (OUP, 1951-54); M.G. Aym : *The Wonderful Farm* (BH, 1952); L. Lewis: *Mystery at Winton's Park* (Heinemann, 1952); L. Meynell: *Smokey Joe Books* (BH, 1952-56); M.E. Atkinson: *Hunter's Moon* (BH, 1953); B. Carter: *Peril on the Iron Road* (Transworld, 1953); E. Fearon: *The Sheepdog Adventure* (Lutterworth, 1953); A. Jaffé: *The Enchanted Horse* (Hutchinson, 1953); L. Lewis: *Hotel Doorway* (OUP, 1953); A. Stafford: *Five Proud Riders* (Penguin, 1953); A. Sewell: *Black Beauty* (Penguin, 1954); B. Carter: *Gunpowder Tunnel* (Hamilton, 1955); A. Hewett: *Elephant Big and Elephant Little* (BH, 1955); B.E. Todd: *The Boy with the Green Thumb* (Hamilton, 1956); R. Hough: *The Enchanted Islands* (Dent, 1975).

Books written and illustrated include: *Jim Tiger* (Faber, 1956); *The Homemakers* (Hamilton, 1957); *Morton's Pony* (Faber, 1957); *The Story of Mr. Pinks* (Faber, 1958); *The Hampshire Pig* (Hamilton, 1958); *The Animal Game* (Faber, 1959); *The Trackers*

(Hamilton, 1960); *Algernon* (Faber, 1961); *Annie and Minnie* (Faber, 1962); *Three Little Funny Ones* (Hamilton, 1962); *The Owl in the Barn* (Faber, 1964); *More Funny Ones* (Hamilton, 1965); *Red Biddy* (Faber, 1966); *Sir Frog* (Faber, 1968); *Educating Flora* (Faber, 1968); *My Aunt's Alphabet* (Hamilton, 1969); *A Bad Child's Book of Moral Verse* (Faber, 1970); *Abdul the Awful* (McCall, 1970); *Queer Customer* (Heinemann, 1972); *Bad Cat* (Heinemann, 1975); *Charlotte Hough's Holiday Book* (Heinemann, 1975); *Pink Pig* (Heinemann, 1975); *Wonky Donkey* (Heinemann, 1975); *The Mixture As Before* (Heinemann, 1976); *Verse and Various* (Dent, 1979).

Bibl: CA; ICB2; Peppin; IFA.

HOUSMAN, Laurence　　　　　　　　　　**1865-1959**
See Houfe

HOWARD, Alan　　　　　　　　　　　　**b.1922**
Born on 1 February 1922, Howard was educated at Nottingham High School, Caius College, Cambridge (where he read chemistry), and the School of Oriental and African Studies, University of London. He studied art at Nottingham College of Arts and Crafts. He has designed and illustrated books and book jackets since about 1952. "He is particularly successful at capturing the element of magic in folk or fairy tales, and his work combines humour with a strong decorative sense." (Peppin.)

Books illustrated include: Prokofiev: *Peter and the Wolf* (1951); E. Hutchinson: *Roof-Top World* (Faber, 1956); D. Walker: *The Fat Cat Pimpernel* (1958); W. de la Mare: *Tales Told Again* (Faber, 1959); K. Lines: *The Faber Story Book* (Faber, 1961); R. Coe: *Crocodile* (1964); J. Tomlinson: *The Bus That Went to Church* (Faber, 1965); K. Lines: *Tales of Magic and Enchantment* (1966); R. Browning: *The Pied Piper of Hamelin* (1967); *The Faber Book of Nursery Songs* (Faber, 1968); *David and Goliath* (Faber, 1970); A. Thwaite: *Allsorts 5* (Macmillan, 1972); R.D. Jones: *Hwiangerddi Gwreiddiol* (1973); K. Crossley-Holland: *The Faber Book of Northern Legends* (Faber, 1977), *The Faber Book of Northern Folk-Tales* (Faber, 1980).

Bibl: ICB2, ICB3; Peppin.

HOYLAND, Rosemary Jean　　　　　　　**b.1929**
Born on 16 November 1929 in London, Hoyland (Mrs. Kitson) was educated at Sydenham High School and studied book illustration at St. Martin's School of Art. She became secretary to a firm of architects (during which time her first two "Ethelbert" books were written) until her marriage in 1956. She spent two years in Canada with her husband.

Books written and illustrated include: *Ethelbert* (Collins, 1954); *Ethelbert Visits the Moon* (Collins, 1955).

Bibl: ICB2.

HUDSON, Gwynedd M.　　　　　　　　**fl. 1910-1935**
See Houfe
Hudson studied at Brighton School of Art, and became a painter of figure studies, an illustrator and a poster artist. Some of her drawings for *Peter Pan and Wendy* are full-page and some are head or tail pieces. Her illustrations, which have some similarities to those of Lovat Fraser*, decorate rather than illustrate the book.

Books illustrated include: L. Carroll: *Alice's Adventures in Wonderland* (1922); J.M. Barrie: *Peter Pan and Wendy* (Hodder, 1931).

Exhib: RA.

Bibl: Peppin; Waters.

HUGHES, Pamela　　　　　　　　　　　**b.1918**
Born on 2 November 1918, Hughes studied stage design at the Central School of Arts and Crafts (1938-39), Regent Street Polytechnic (1950-53, where James Osborne was her tutor in wood engraving), and at Cambridge College of Art (1956-60). During WW2, she served in the WRNS, correcting charts and routeing convoys along the East Coast. A painter and printmaker, she has exhibited widely throughout Britain, including many times at the RA since 1964, and since 1972 at RE. She has lived for many years at Cambridge (where her husband was a geologist at the University until retirement), and she has been a member of the Cambridge Drawing

Society since 1954 (Secretary 1967-73; President 1973-9). She has illustrated a few books, including scientific papers for her husband and others. Her wood engravings have been included in *Forty-Five Wood Engravers* (Simon Lawrence, 1982) and *Cat Cuts* (Silent Books, 1989).

Books illustrated include: H. Nockolds: *Linton; an Intimate Portrait of a Cambridgeshire Village* (Royston: Golden Head Press, 1954); J. Dyer: *Grongar Hill* (Golden Head Press, 1963); *Epitaphs* (Cambridge: Heffers).
Exhib: RA; RE; SWE; one-artist shows at Arts Theatre, Cambridge; Homerton College, Cambridge; Old Fire Engine House Gallery, Ely; Art Centre, Corn Exchange, Saffron Walden.
Bibl: IFA.

HUGHES, Shirley b.1927
Born on 16 July 1927 in Hoylake, near Liverpool, Hughes was educated at West Kirby High School and studied drawing and costume design at Liverpool School of Art, and then went to Ruskin School, Oxford. Her time at Oxford was most influential to her later career, for there she was encouraged by Jack Townend* to do work on the picture book format and to make lithographic illustrations. Barnett Freedman* was a visiting lecturer and he gave encouragement and letters of introduction to a number of editors. A commission from Collins followed and her ability to draw children in a convincing way was recognized. She moved to London, became a free-lance artist, and married John Vulliamy, an architect and etcher.

Hughes is an interpretative illustrator of the Edward Ardizzone* school of thought, and a fine line artist who does work in full colour, though she admits that the change to that medium was difficult for her. Her illustrations show a naturalistic, graphic style which appears undemanding but is highly effective in communicating with her young readers. She has illustrated about 200 titles since 1950, and written about thirty of those. For the child who cannot yet read, she has developed a "comic strip" format with no words, or with words in balloons. Her delightful *Up and Up* (1979) contains no words and the shape and size of each strip varies. Some of her work has been criticized as quaint and sentimental, but in 1984 she received the Eleanor Farjeon Award for distinguished services to children and books, and she won the Kate Greenaway Medal in 1977 for *Dogger*. Her illustrations to Leonard Clark's *Flutes and Cymbals* were commended for the Greenaway Award in 1968, and *Helpers* won the Other Award in 1976.

Books illustrated include (but see Martin, 1989†): O. FitzRoy: *The Hill War* (Collins, 1950); J. Hale: *Fourwinds Island* (Faber, 1951); N. Chauncy: *World's End Was Home* (OUP, 1952); W. Mayne: *Follow the Footprints* (OUP, 1953), *The World Upside Down* (OUP, 1954); D. Rust: *The Animals at Number Eleven* (Faber, 1956); M. Storey: *The Smallest Doll* (Faber, 1956); D. Ross: *William and the Lorry* (Faber, 1956); D. Clewes: *Adventures on Rainbow Island* (Collins, 1957); D. Pullein-Thompson: *The Boy and the Donkey* (Collins, 1958); N. Streatfeild: *New Town* (Collins, 1960); B. Softly: *Plain Jane* (Macmillan, 1961), *Place Mill* (Macmillan, 1962); M. McPherson: *The Shinty Boys* (Collins, 1963); H. Morgan: *Meet Mary Kate* (1963); R. Sawyer: *Roller Skates* (BH, 1964); A. Uttley: *Tim Rabbit's Dozen* (Faber, 1964); H. Morgan: *A Dream of Dragons* (Faber, 1965); A. Bull: *Wayland's Keep* (Collins, 1966); B. Ireson: *The Faber Book of Nursery Stories* (Faber, 1966); M.E. Allan: *The Wood Street Secret* (Methuen, 1968), L. Clark: *Flutes and Cymbals* (BH, 1968); M.E. Allan: *The Wood Street Group* (Methuen, 1970); M. Stewart: *The Little Broomstick* (Brockhampton, 1971); M. Mahy: *The First Margaret Mahy Story Book* (Dent, 1972); R. Ainsworth: *The Phantom Fisherboy* (Deutsch, 1974); D. Bisset: *Hazy Mountain* (Puffin, 1975); A. Abel: *Make Hay While the Sun Shines* (Faber, 1977); K. Lines: *From Spring to Spring* (Faber, 1978); M. Welfare: *Witchdust* (Murray, 1980); H. de Balzac: *Cousin Pons* (Folio Society, 1984); M. Mahy: *The Horrible Story* (Dent, 1987); F.H. Burnett: *The Secret Garden* (Gollancz, 1988).
Books written and illustrated include: *Lucy and Tom's Day* (Gollancz, 1960); *The Trouble with Jack* (BH, 1970); *Lucy and Tom Go to School* (Gollancz, 1973); *Sally's Secret* (BH, 1973); *Clothes* (BH, 1974); *Helpers* (BH, 1975); *It's Too Frightening for Me!* (Hodder, 1976); *Lucy and Tom at the Seaside* (Gollancz, 1976); *Dogger* (BH, 1977); *Moving Molly* (BH, 1978); *Up and Up* (BH,

1978); *Here Comes Charlie Moon* (BH, 1980); *Over the Moon* (Faber, 1980); *Lucy and Tom's Christmas* (Gollancz, 1981); *Alfie Gets in First* (BH, 1981); *Alfie's Feet* (BH, 1982); *Charlie Moon and the Big Bonanza Bust-Up* (BH, 1982); *Sally's Secret* (BH, 1983); *Lucy and Tom's ABC* (Gollancz, 1984); *Bathwater's Hot* (Walker, 1985); *Chips and Jessie* (BH, 1985); *Noisy* (Walker, 1985); *When We Went to the Park* (Walker, 1985); *All Shapes and Sizes* (Walker, 1986); *Another Helping of Chips* (BH, 1986); *Colours* (Walker, 1986); *Two Shoes, New Shoes* (Walker, 1986); *Lucy and Tom's 123* (Gollancz, 1987); *Out and About* (Walker, 1988).
Contrib: *Children's Book Review; Cricket.*
Bibl: Douglas Martin: *The Telling Line: Essays on Fifteen Contemporary Book Illustrators* (Julia MacRae, 1989); Carpenter; ICB3, ICB4; Peppin.
Colour Plate 94

HUGHES-STANTON, Blair Rowlands 1902-1981
Blair Hughes-Stanton was born on 22 February 1902 in London, the son of painter Sir Herbert Hughes-Stanton (né Hughes), RA,

Blair HUGHES-STANTON *Revelations of St. John the Divine* (Gregynog Press, 1932). By permission of the National Library of Wales, Aberystwyth

255

Blair HUGHES-STANTON *The Lamentations of Jeremiah* (Gregynog Press, 1933). By permission of the National Library of Wales, Aberystwyth

PRWS. He was educated at Colet Court and on HMS *Conway*. Having decided against a career in the Merchant Navy, he studied art at the Byam Shaw School (1919-22), the RA Schools (1922-23), and Leon Underwood's* School (1921-25) where he first started wood engraving. He was one of an illustrious group of students which included Henry Moore*, his first wife-to-be Gertrude Hermes*, Vivian Pitchforth, Agnes Miller Parker*, Nora Unwin* and Mary Groom*. Another student, Marion Mitchell, was responsible for the introduction of the multiple engraver to England from France, and her enthusiasm for the medium of wood engraving played an important part in persuading both Hughes-Stanton and Hermes to try their hands at it.

From 1929 to 1932 Hughes-Stanton was a designer and wood engraver at the Gregynog Press. Then with his second wife, Ida Graves, he set up his own press, the Gemini Press. He taught drawing at the Westminster School of Art (1934-39), and drawing and wood engraving at the Colchester School of Art (1945-47) and St. Martin's School of Art (1947-48). He lectured on drawing and printmaking at the Central School of Arts and Crafts from 1948 to 1979.

Hughes-Stanton became one of the most distinguished wood engravers Britain has ever produced. He worked mostly for private presses which could produce his engravings satisfactorily, for his fine line made much of his work impossible to reproduce effectively by photomechanical methods. William McCance wrote that "he worked at great speed leaving a trail of textures like that of a comet beyond the actual forms and shapes associated with the subject. He was an expressionist. But to find an expressionist who is able to take an intractable medium like wood-engraving and make it a flexible instrument for his fancy and sensuous flights is unique." (Lewis, 1951.†) The imagery of his early work tended to be anthropomorphic but later it became more abstract. One of the outstanding features of his work is the depth of blackness, the extremely fine white lines cutting through it, and the areas of solid white — Fletcher calls it "the velvety black intensity" (Fletcher, 1929†).

The first book he illustrated was Lawrence's *The Seven Pillars of Wisdom* (1926), though he was but one of several illustrators, including Eric Kennington*, William Roberts*, Edward Wadsworth*, and his wife Gertrude Hermes* with whom Hughes-Stanton collaborated on a number of books. Many other commissions followed the publication of this book, including D.H. Lawrence's *Birds, Beasts and Flowers* (1930) on which the writer and illustrator collaborated directly during production. The 1930s were incredibly productive years for Hughes-Stanton. The three years spent at the Gregynog Press in Wales (1929-32) were very important, not only for the number of engravings which he completed but also because he was involved in every stage of book production there, including the design of typography and innovative book-bindings. Hughes-Stanton's technical virtuosity may be seen in the fine lines of the diaphanous drapery and sinuous bodies in the engravings in *The Revelations of St. John The Divine* (1932), so skilfully printed by William McCance at the Gregynog Press. After leaving Gregynog, he illustrated books for other presses as well as for his own Gemini Press. During this pre-war period, Hughes-Stanton also produced many individual engravings, and was awarded the International Prize at the Venice Biennale in 1938.

During WW2 he served in the Army and was shot while a prisoner of war. This injury affected his eyesight and afterwards made it difficult for him to engrave. He illustrated some nine more books, a few with wood engravings and others in other media; and he continued to paint and draw. Following an accident, he died suddenly on 6 June 1981.

Hughes-Stanton was a member of SWE (1932) and of the London Group; a founder-member of the International Society of Wood Engravers (1953); an Honorary Fellow of L'Academia Florentina Delle Arti des Pisegro (1962); and an Honorary Fellow of the Society of Designer Bookbinders (1980).

Books illustrated include (but see Penelope Hughes-Stanton†): T.E. Lawrence: *The Seven Pillars of Wisdom* (with others; pp., 1926); W. de la Mare: *Alone* (Ariel Poems 4; Faber, 1927), *Self* (Ariel Poems 11; Faber, 1928); J. Bunyan: *Pilgrim's Progress* (with Gertrude Hermes*) (Cresset Press, 1928); *The Apocrypha* (with Gertrude Hermes*) (Cresset Press, 1929); V. Pilcher: *The Searcher* (Heinemann, 1929); S. Gantillon: *Maya* (GCP, 1930); D.H. Lawrence: *Birds, Beasts and Flowers* (Cresset Press, 1930); J. Milton: *Comus* (Gregynog Press, 1931); W.J. Gruffyd: *Caniadau* (Gregynog Press, 1932); *The Revelation of St. John The Divine* (Gregynog Press, 1932); S. Butler: *Erewhon* (Gregynog Press, 1933); C. Marlowe: *The Tragical History of Doctor Faustus* (Golden Hours Press, 1932); *The Lamentations of Jeremiah* (Gregynog Press, 1933); J. Milton: *Four Poems* (Gregynog Press, 1933); D.H. Lawrence: *The Ship of Death and Other Poems* (Secker, 1933); I. Graves: *Epithalamion* (Gemini Press, 1934); A. Calder-Marshall: *A Crime Against Cania* (GCP, 1934); J. Mavrogordata: *Elegies and Songs* (Cobden-Sanderson, 1934); *The Book of Ecclesiastes* (GCP, 1934); C. Sandford: *Primaeval Gods* (Boars Head Press, 1934); J. Collier: *The Devil and All* (Nonesuch Press, 1934); T.O. Hubbard: *Tomorrow Is a New Day* (Lincoln Williams, 1934); H.H.M.: *Pastoral* (Gemini Press, 1935); Y. Lane: *African Folk Tales* (Lunn, 1946); T. de Quincy: *Confessions of an English Opium Eater* (Folio Society, 1948); J. Austen: *Sense and Sensibility* (Avalon Press, 1949); A. Trollope: *The Eustace Diamonds* (two vols., OUP, 1950); C. Dickens and W. Collins: *The Wreck of the Golden Mary* (Kentfield, California: Allen Press, 1959); J. Conrad: *Youth* (Allen Press, 1959); H. James: *The Beast in the Jungle* (Allen Press, 1963); J. Mason: *More Papers Hand Made by John Mason* (Twelve By Eight Press, 1967); *Genesis* (Allen Press, 1970); J. Conrad: *The Lagoon* (Allen Press, 1973).

Contrib: *Theatre Arts Monthly; The Woodcut.*

Exhib: SWE; Studio One Gallery, Oxford (1982); The Minories, Colchester (1984).

Collns: BM; Portsmouth City Art Gallery and Museum; V & A; Whitworth.

Bibl: Paul Collet: "Blair Hughes-Stanton on Wood-engraving", *Matrix* 2 (1982): 44-50; John Gould Fletcher: "Gertrude Hermes and Blair Hughes-Stanton", *Print Collector's Quarterly* 16 (1929): 182-98; J.G. Fletcher: "Blair Hughes-Stanton", *Print Collector's Quarterly* 21 (1934): 353-372; Dorothy Harrop: *A History of the Gregynog Press* (Private Libraries Association, 1980); Penelope Hughes-Stanton: *The Wood-Engravings of Blair Hughes-Stanton* (Private Libraries Association, 1991); John Lewis: "The Wood-Engravings of Blair Hughes-Stanton", *Image* no. 6 (Spring 1951): 26-44; *Blair Hughes-Stanton (1902-1981); Engravings* (Oxford: Studio One Gallery, 1982); Deane; Garrett 1 & 2; Peppin; Waters.

HULME BEAMAN, Sydney George
See BEAMAN, Sydney George Hulme

HUMPHREYS, Graham b.1945

Born on 30 October 1945 in Solihull, Humphreys spent his child-hood in Sutton Coldfield. He studied at Sutton Coldfield School of Art, and Leicester College of Art. When he left college in 1967, he became a free-lance illustrator, teaching part-time for a few years in a London grammar school, and then lecturing in the Department of Visual Communication, Birmingham Polytechnic. The subject mat-ter of his illustrations is usually historical, and he has a special interest in sailing ships and in reconstructing townscapes.

Books illustrated include: J.R. Townsend: *The Intruder* (1969); P. Turner: *Wig-Wig and Homer* (1969); R. Armstrong: *The Albatross* (1970); C. Bibby: *The Mirrored Shield* (Longman, 1970); R.B. Maddock: *Northmen's Fury* (Macdonald, 1970); B. Willard: *Chichester and Lewes* (1970); I. Serraillier: *Heracles the Strong* (Hamilton, 1971); Anderson: *The Discovery of America* (Kestrel, 1973); J. Seed: *The Sly Green Lizard* (Hamilton, 1973); Sherriff: *The Siege of Swayne Castle* (Gollancz, 1973); Anderson: *The Vikings* (Kestrel, 1974); B. Lee: *The Frog Report* (1974); M. Brown: *Sailing Ships* (Hamilton, 1975); K. Rudge: *The Mud Scene* (Macmillan, 1975); J.H. Crockatt: *The Battle of Marston Moor* (Lutterworth, 1976); P. Rogers: *Little Stick and Big Who* (Hamilton, 1976); A.C. Jenkins: *The Winter-Sleeper* (Hamilton, 1977); N. Grant: *Smugglers* (Kestrel, 1978); N. Blundell: *The Absolute End* (Piccolo, 1983).
Bibl: ICB4; Peppin.

HUNT, James b.1908

No biographical information can be found about Hunt, who illus-trated books for children in the 1960s and 1970s, using both black and white and colour

Books illustrated include: R. Brown: *A Saturday in Pudney* (Abelard, 1966), *The Battle against Fire* (Abelard, 1966), *The Via-duct* (Abelard, 1967); P. Lynch: *The Kerry Caravan* (Dent, 1967); R. Brown: *The Day of the Pigeons* (Abelard, 1968), *The Wapping Warrior* (1969), *The River* (1970), *The Battle of Saint Street* (1971); A. Cox: *Two in a Boat* (Longman, 1971); E. Beresford: *The Secret Railway* (1973); J.E. Clemson: *Let's Be Friends* (and three others, Nelson, 1975); R. Brown: *The Big Test* (Andersen Press, 1976); H. Spiers: *Freddy Is a Monster* (Methuen, 1976), *What Size Am I?* (Methuen, 1976); R. Clare: *Islands* (four vols., Nelson, 1977); J. Beaton: *A Day at the Sea* (Nelson, 1978), *A Day on the Farm* (Nelson, 1978); S. Johnson: *The Fountains* (Harmsworth, 1978).
Bibl: Peppin.

HUTCHINS, Pat b.1942

Born on 18 June 1942 in Catterick Camp, Yorkshire, Hutchins stud-ied at Darlington School of Art and Leeds College of Art. She worked in an advertising agency for a short time, then married and accompanied her husband to New York, where she wrote and illus-trated her first book, *Rosie's Walk* (1968). Now a free-lance illustra-tor who apparently illustrates only the books she writes (though her husband has illustrated at least three of the books she has written), she lives in London, but visits New York regularly, and her books are published in both countries. She won the Kate Greenaway Medal in 1974 for *The Wind Blew*.

Books written and illustrated include (all published in UK by BH): *Rosie's Walk* (NY: 1968; BH, 1970); *Tom and Sam* (1969); *The Surprise Party* (1970); *Clocks and More Clocks* (1970); *Changes, Changes* (1971); *Titch* (1972); *Goodnight, Owl!* (1973); *The Silver Christmas Tree* (1974); *The Wind Blew* (1974); *Don't Forget the Bacon* (1976); *Happy Birthday Sam* (1978); *One-Eyed Jake* (1979); *The Best Train Set Ever* (1979); *The Tale of Thomas Mead* (1980); *I Hunter* (1982); *King Henry's Palace* (1983); *You'll* *Soon Grow Into Them Titch* (1983); *The Very Worst Monster* (1985).
Bibl: ICB4; Peppin.

HUTTON, Clarke 1898-1984

Born in London, Hutton studied art at the Central School of Arts and Crafts (1927-30) after he had worked since 1915 as assistant to William Pitcher, the designer of many ballets at the old Empire Theatre in Leicester Square. He travelled to Italy in 1926, and this inspired him to turn his attention to painting and the graphic arts. A.S. Hartrick encouraged him to start making lithographic prints, and Hutton replaced him at the Central School as Instructor in Lithography (1930-68).

Hutton started book illustration around 1930, using lithography in bright colours. His *Pilgrim's Progress* (1947), which contains sev-enteen full-page lithographs and a similar number of smaller ones, is better than much of his later work for children, where the plates are more ostentatious and overpowering. In the autolithographic plates in the Puffin Picture Books, and in the later OUP history books, he bleeds the illustrations. He has done work for many pub-lishers, but is probably best known for the Oxford University Press "Picture History" series, illustrated in four-colour autolithographs.

Books illustrated include (but see Peppin): T. Gray: *Elegy Written in a Country Churchyard* (BH, 1928); D. Byng: *More Byng Ballads* (BH, 1935); N. Streatfeild: *Harlequinade* (Chatto, 1943); N. Carrington: *Popular English Art* (King Penguin 21; Penguin, 1945); W.E. Williams: *The Tale of Noah and the Flood* (Puffin Picture Books 54; Penguin, 1946); J. Bunyan: *Pilgrim's Progress* (SCM, 1947); A. Skibulits: *The Story of Tea* (Puffin Picture Books 72; Penguin, 1948); N. Streatfeild: *The Circus Is Coming* (Dent, 1948); R. Church: *Cave* (Dent, 1950); W.M. Thackeray: *The History of Henry Esmond* (Folio Society, 1950); H. Commager: *A Picture History of the United States* (OUP, 1958); R.L. Stevenson: *The Beach at Falesa* (Folio Society, 1959); T.L. Jarman: *A Picture History of Italy* (OUP, 1961); J. Conrad: *Altmayer's Folly* (Folio Society, 1962); R.M. Crawford: *A Picture History of Australia* (OUP, 1962); M.E. Von Almedingen: *A Picture History of Russia* (OUP, 1964); J. Hampden: *A Picture History of India* (OUP, 1965); M. Twain: *The Prince and the Pauper* (NY: Heritage, 1965); W. Scott: *Kenilworth* (NY: Limited Editions Club, 1966); C. Brontë: *Villette* (Folio Society, 1967); A.S. Pushkin:*The Queen of Spades* (Folio Society, 1970); J. Austen: *Northanger Abbey* (NY: Limited Editions Club, 1971); G.B. Shaw: *Pygmalion; Candida* (NY: Limited Editions Club, 1974); P.M. Taylor: *Confessions of a Thug* (Folio Society, 1974); R.L. Stevenson: *New Arabian Nights* (NY: Limited Editions Club, 1976); J. Millican: *Rivers in the Desert* (Penmiel Press, 1982).
Books written and illustrated include: *The Hare and the Tortoise* (1939); *A Country ABC* (OUP, 1940); *Nursery Rhymes* (Puffin Picture Books 17; Penguin, 1941); *Punch and Judy* (Puffin Picture Books 27; Penguin, 1942); *A Picture History of France* (OUP, 1951).
Bibl: Folio 40; Hodnett; ICB; ICB2; ICB3; ICB4; Peppin; Waters.
Colour Plate 95

HUTTON, Dorothy fl.1920s

Hutton was a calligrapher who ran the Three Shields Gallery in London during the 1920s. She designed the cover illustration for *Merry-Go-Round*.
Books illustrated include: M. Marlowe: *Toffee Boy* (with L. Housman: *The Open Door*; Blackwell, 192-?).
Contrib: *Joy Street*; *Merry-Go-Round*.

ILLINGWORTH, Leslie Gilbert 1902-1979

Born on 2 September 1902 in Barry, South Wales, Illingworth was educated at a church school in Barry and then attended Cardiff Art School, sharing his time with the Lithographic Department of the *Western Mail*. He went on a scholarship to the RCA and the Slade, but in 1920 returned as cartoonist for the *Western Mail*. For the next few years, he was flooded with commissions for drawings for many humorous journals, including *Punch* (from 1927), and other magazines.

From 1939 to 1968 Illingworth was the editorial cartoonist on the *Daily Mail*, and in 1945 he took over from Bernard Partridge as senior cartoonist for *Punch*. After Malcolm Muggeridge became editor, Illingworth's drawings were more bitingly satirical. Price declares that "Illingworth was a superb draughtsman in a job that needed one. His joke drawings had always had a clarity and an authority of line that made them stand out; they were both decorative and representational. . . he was often savage in the *Daily Mail* and has shown no embarrassment when given savage subjects in *Punch*." He drew in ink or used the scraperboard technique. He was a superb artist who selflessly encouraged young cartoonists, including Ralph Steadman* and Wally Fawkes* ("Trog"), for whom Illingworth arranged a position on the *Daily Mail*.

Contrib: *Daily Mail; Good Housekeeping; Life; Nash's; Passing Show; New of the World; Punch; Sun; Western Mail*.

Collns: University of Kent.

Bibl: Frank Whitford: *Trog: Forty Graphic Years: The Art of Wally Fawkes* (Fourth Estate, 1987); Bateman; Bradshaw; Feaver; Price; Waters.

INGPEN, Robert fl. 1985-

Ingpen won the Hans Christian Andersen Award for his illustrations to *Encyclopaedia of Things That Never Were* (1986).

Books illustrated include: M. Page: *Encyclopaedia of Things That Never Were* (Dragon's World, 1985); C. Dickens: *A Christmas Tree* (Dragon's World, 1988); M. Saxby: *The Great Deeds of Superheroes* (Dragon's World, 1989); K. Scholes: *Peacetimes* (Dragon's World, 1989).

Books written and illustrated include: *The Idle Bear* (Blackie, 1986).

INSHAW, David b.1943

Born on 21 March 1943 at Wednesfield in Staffordshire, Inshaw studied at Beckenham School of Art (1959-63) and the RA Schools (1963-66). He left London for Bristol in 1967 and taught at the West of England College of Art, Bristol (1966-75). He was appointed a painting Fellow of Trinity College, Cambridge (1975-

77), which allowed him to paint, free of teaching commitments and financial worries, for two years.

A painter whose subject is mostly the English landscape, he formed a close association with Graham Arnold* and Ann Arnold* in 1972, known as the Broad Heath Brotherhood, and in 1973 first met Peter Blake*. Inshaw has taken part in many one-artist shows and joint exhibitions, including "Peter Blake's Choice" at the Festival Gallery, Bath (1974). In that year, the BBC film on his work, "Private Landscapes", was shown. In 1975, the first meeting of the Brotherhood of Ruralists was held, organized by Peter Blake, and Inshaw became a member and exhibited with the group several times.

Inshaw has produced covers for the Methuen Arden Shakespeare series; and his painting, "The Badminton Game", now at the Tate Gallery, was used for the cover of *The Penguin Book of Modern British Short Stories* (1988), and also on the poster for the Shaw Festival in Niagara-on-the-Lake, Ontario, in 1987.

Exhib: RA; Arnolfini Gallery, Bristol (1969, 1972); Waddington Galleries (1975, 1980); Wren Library, Trinity College, Cambridge (1977); Brighton (retrospective, 1978).

Bibl: *David Inshaw* (Academy Editions, 1978); Nicholas Usherwood: *The Brotherhood of Ruralists* (Lund Humphries, 1981); Parry-Cooke.

Colour Plate 25

IONICUS
See ARMITAGE, Joshua Charles

IRVING, Beryl fl. 1926-1959

Irving illustrated a few books in black and white and occasionally in colour.

Books illustrated include: E.S. Rohde and E. Parker: *The Gardener's Week End Book* (with Anne Bullen*; Seeley Service, 1939); E. Parker: *The Shooting Weekend Book* (Seeley Service, 1942), *The Countryman's Week End Book* (Seeley Service, 1946).

Books written and illustrated include: *The Dawnchild* (Faber, 1926).

Bibl: Peppin.

IRVING, Laurence Henry Foster b.1897

Born on 11 April 1897 in London, Irving studied at the Byam Shaw School of Art and the RA Schools. He was a painter of landscapes and seascapes, a stage designer, writer and illustrator. He worked as Art Director for Douglas Fairbanks (1928-29) on the films *The Iron Mask* and *The Taming of the Shrew*.

Books illustrated include: R. Hakluyt: *A Selection of the Principal Voyages* (1926); F.V. Morley: *River Thames* (1926); G.W. Bullett: *The Spanish Caravel* (1927); J. Masefield: *Philip the King* (Heinemann, 1927); H. Reckitt: *The Adventure of Ann and the White Seals* (1930); J. Conrad: *The Mirror of the Seas* (1935); W. Bligh: *Bligh and the Bounty* (1936); E. Woolridge: *The Wreck of the Maid of Athens* (1952); R. Church: *Dog Toby* (1953); A. de Saint-Exupéry: *The Flight to Arras* (1955); M.F.E. Stewart: *The Wind off the Small Isles* (1968).

Books written and illustrated include: *Windmills and Waterways* (1927); *Henry Irving* (1951).

Exhib: RA; FAS (1924, 1927, 1936, 1950).

Bibl: Peppin; Waters.

J

JACKSON, Albert Edward 1873-1952
Born in London, Jackson studied at Camden School of Art. As a painter in watercolour and oil, he exhibited at the RA and in the provinces; as an illustrator, he worked for Amalgamated Press from 1893 to 1947, and illustrated books for children and contributed to several annuals. He used black and white and full colour for his illustrations, which are generally not distinguished, or distinguishable from other illustrators of the period. He died on 3 April 1952.
Books illustrated include: B.S. Woolf: *The Twins in Ceylon* (1913); L. Carroll: *Alice's Adventures in Wonderland* (1915); C. Lamb: *Tales from Shakespeare* (1918); C. Kingsley: *The Water Babies* (1920); *Tales from the Arabian Nights* (Ward Lock, 1920); F. Marryat: *The Children of the New Forest* (1934); D. Defoe: *Robinson Crusoe* (nd).
Contrib: *Cassell's Children's Annual; Little Folks; London Magazine; Playbox Annual; Pearson's Magazine; Royal; Strand.*
Bibl: Peppin; Waters.

JACKSON, Michael fl. 1972-
Jackson is an illustrator of children's books, using mostly pen and pencil.
Books illustrated include: U.M. Williams: *The Kidnapping of my Grandmother* (1972); M. Darke: *Ride the Iron Horse* (1973); D.P. Makhanlall: *The Best of Brer Anansi* (Blackie, 1973); R. Parker: *One Green Bottle* (1973); M. Darke: *The Star Trap* (1974); R. Leeson: *Maroon Boy* (1974); G. Avery: *Book of the Strange and Odd* (1975); T. Brading: *Pirates* (1976); A. Harper: *Ella Climbs a Mountain* (1977); A. Green: *The Ghostly Army* (1980).
Bibl: Peppin.

JACKSON, Raymond Allen b.1927
Born in London on 11 March 1927, Jackson was a schoolboy during the London Blitz. He was educated at Lyulph Stanley Central School, studied at Willesden School of Art and, after National Service in the army, worked for a publishing house on a naturist magazine. He started as an illustrator on the *Evening Standard* before being appointed its regular cartoonist (since 1952), using the sobriquet "Jak". The first *Annual* of his cartoons was published in 1969.
Contrib: *Evening Standard.*
Bibl: Bateman.

JACKSON, Sheila fl. 1940s
Ballet in England, printed by the Curwen Press and, in appearance, very similar to the contemporary Puffin Picture Books, was illustrated with ten autolithographs in colour and eight in black and white, with an additional two in colour on the jacket. The thirty lithographs in *A First Book of Nursery Rhymes* are quite reminiscent of Kathleen Hale's* work.
Books illustrated include: *Ballet in England* (Transatlantic Arts, 1945); P. Hemelryk: *Music Time* (Puffin Picture Books 80; Penguin, 1947); *A First Book of Nursery Rhymes* (National Magazine Co., 1947); O. Wilde: *The Importance of Being Ernest* (Falcon Press, c.1948).
Colour Plate 96

JACOBS, Helen Mary 1888-1970
Born in Ilford, Essex, the sister of writer W.W. Jacobs, Helen Jacobs studied art at West Ham Municipal College. She illustrated children's books in pen and ink, and in watercolour, towards the end of her career specializing in drawing for educational books. *The Open Road Pictures*, done as an oblong folio with H.M.B. Brown and published by Nisbet in 1952, included word-matching cards and jigsaw puzzles. She exhibited at the RA and elsewhere.
Books illustrated include: E.L. MacPherson: *Native Fairy Tales of South Africa* (Harrap, 1919); N. Syrett: *Magic London* (Thornton Butterworth, 1922); H.M.B. Brown: *The Friendly Road* (with A.H. Watson*; Nisbet, 1939); M.H. Higham: *Let's Paint Pictures of China* (with Joyce Burton, Zenith Press, 1947); M.E. Allan: *The Exciting River* (Nelson, 1951); H.M.B. Brown: *The Open Road Pictures* (Nisbet, 1952).
Contrib: *Cassell's Children's Annual; Little Folks; Playbox Annual; Wonder Annual.*
Exhib: RA; RI.
Bibl: Peppin; Waters.

JACQUES, Robin b.1920
Born on 27 March 1920 in Chelsea, London, Jacques was educated at the Royal Masonic Schools, Bushey, Hertfordshire, but he left school at fifteen to work for an advertising agency. He had no formal art training, but when he was invalided out of the army in 1945 after service during WW2, he became a free-lance illustrator, and was art editor of the *Strand Magazine* (1948-51) and later for the Central Office of Information. He taught at various art schools — Brighton (1947-48), Harrow (1977-79) and Canterbury (1979); lived in Mexico (1953) and France (1964-72).
He contributed to many magazines, including *Radio Times* (his cover illustrating Shakespeare's *The Tempest* is an example of his finest work) and *Lilliput*. He has illustrated many books, including about twenty written for children by Ruth Manning-Sanders. His illustrations are notable for the detailed and meticulous quality of his draughtsmanship, yet they are romantic in feeling. They are usually done with a fine pen, often using a pointilliste technique, occasionally with a colour wash added; sometimes they look much like wood engravings. All his drawings are very distinctively his work. His illustrations of period themes include fine drawings of costumes and furnishings; the people he draws are all individuals rather than caricatures; and in some of his illustrated versions of the modern classics he succeeds in doing "what illustrators rarely manage to do: increasing the reader's knowledge of the characters and what happens to them." (Hodnett.) Even his single drawings

Robin JACQUES *The Man in the Moonlight* by John Keir Cross (Westhouse, 1947)

done for the *Radio Times* to illustrate a performance brilliantly indicate not only the characters involved as individuals but also seem to conjure up the atmosphere.

Books illustrated include: J.K. Cross: *The Angry Planet* (Lunn, 1945), *The Owl and the Pussycat* (Lunn, 1946); C. Dickens: *Doctor Marigold* (Westhouse, 1945); P. de Heriz: *Fairy Tales with a Twist* (Lunn, 1946); W. Irving: *Alhambra Tales* (Lunn, 1946); L. Whistler: *The English Festivals* (Heinemann); H. Anderson: *Selected Tales from the Arabian Nights* (Lunn, 1946); M. de Cervantes: *Don Quixote* (Lunn, 1947); H. Bell: *Youth* (Westhouse, 1947); J.K. Cross: *The Man in Moonlight* (Westhouse, 1947), *Blackadder* (Muller, 1950); J. Swift: *Gulliver's Travels* (OUP, 1955); J. Joyce: *Portrait of the Artist As a Young Man* (Cape, 1956); A. Thwaite: *The House in Turner Square* (1960); R. Kipling: *Kim* (NY: Limited Editions Club, 1962); R. Manning-Sanders: *A Book of Giants* (Methuen, 1962); C.V. Jamieson: *Lady Jane* (Hart-Davis, 1963); W.M. Thackeray: *Vanity Fair* (Folio Society, 1963); H. Cresswell: *The White Sea Horse* (1964); R. Manning-Sanders: *A Book of Dragons* (Methuen, 1964), *A Book of Dwarves* (Methuen,

1964); O. Wilde: *Three Short Stories* (Macmillan, 1964); A. Norton: *Steel Magic* (1965); R. Manning-Sanders: *A Book of Wizards* (Methuen, 1966); H. Cresswell: *A Tide for the Captain* (1967); J. Joyce: *Dubliners* (Cape, 1967); H. Cresswell: *The Sea Pipe* (1968); R. Manning-Sanders: *A Book of Ghosts and Goblins* (Methuen, 1968); W.B. Yeats: *Poems* (NY: Limited Editions Club, 1970); B. Nichols: *The Wickedest Witch in the World* (1971); R. Manning-Sanders: *A Choice of Magic* (Methuen, 1971); G. Eliot: *Middlemarch* (Folio Society, 1972); G. Cooper: *A Time in a City* (1972), *A Second Springtime* (1973); R. Manning-Sanders: *A Book of Sorcerers and Spells* (Methuen, 1973); S. Porter: *The Hospital* (1973); *Folklore, Myths and Legends of Britain* (Reader's Digest, 1973); G. Cooper: *Hester's Summer* (1974), *A Certain Courage* (1975); R. Manning-Sanders: *A Book of Monsters* (Methuen, 1975); R. Tomalin: *A Stranger Thing* (1975); L.R. Banks: *The Indian in the Cupboard* (1980); H. James: *The Europeans* (Folio Society, 1982); E. Farjeon: *Kings and Queens* (1983); E.O. Parnott: *Limericks* (1983).
Contrib: *Leader; Lilliput; Listener; Observer; Punch; Radio Times; Saturday Book; Strand; Sunday Times; Vogue.*
Published: *Illustrators at Work* (Studio, 1963).
Exhib: Calman; Arts Council.
Bibl: John Keir Cross: "An Author Writes About His Illustrator", *Alphabet & Image* 7 (May 1948): 33-45; Driver; Hodnett; Peppin; Ryder; Usherwood.
See also illustration on page 59

"JACQUIER"
See SKINNER, Ivy

JAK
See JACKSON, Raymond

JAMES, Gilbert fl.1895-1926
See Houfe
Books illustrated include: J. Spence: *The Myths of Mexico and Peru* (with others, 1913); V.M. Petrovic: *Hero Tales and Legends of the Serbians* (with others, 1914); E. Holland: *The Story of Buddha* (1916); M.R. James: *The Five Jars* (Arnold, 1922); R.W. Trine: *In Tune with the Infinite* (1926).

JANES, Norman Thomas 1892-1980
Born on 19 May 1892 at Egham, Surrey, Janes studied commercial art at the Regent Street Polytechnic (1909-14). His studies were interrupted by WW1 and he volunteered in 1914 and served as an infantryman in the London Irish Rifles, being wounded at Cambrai in 1917. After the war he went to the Slade (1919-22) to study drawing and then to the Central School of Arts and Crafts and the RCA (1923-24) for etching and engraving under Sir Frank Short. At the Slade he met a fellow student, Barbara Greg*, and they married in 1925. Their meagre living from teaching and illustrating books was augmented by money earned for producing woodcuts used to illuminate piano rolls published by the Aeolian Company until business fell off during the Depression. During the 1920s and '30s he designed music covers and book jackets for various publishers.
Janes' best work as an etcher and engraver was done during the years between the wars, but after service in the RAF during WW2 his talent as a watercolour painter blossomed. He returned to teaching at Hornsey College of Art after WW2 and also taught at the Slade. The subjects for his works covered landscapes, city scenes and river and dock scenes, with London's riverside as a particular interest. He was a member of the Royal Society of Marine Artists; elected ARE (1922), RE (1938), ARWS (1957) and RWS (1966). He was Honorary Secretary of RE (1945-62), and elected SWE (1952).
Books illustrated include: W. Partington: *Smoke Rings and Roundelays* (John Castle, 1924); L. Merrick: *Four Stories* (1925); C. Williams: *Heroes and Kings* (Sylvan Press, 1930); *Recording Britain* (with others, four vols., OUP, 1946-9).
Exhib: NEAC; RA; RE; SWE; Beaux Arts Gallery; Highgate Gallery; Lott & Gerrish.
Bibl: "Norman Janes", *Journal RE* no. 7 (1985): 26-7, 40; Garrett 1 & 2; Peppin.

JAQUES, Faith b.1923

Born on 13 December 1923 in Leicester, Jaques was educated at
Wyggeston School for Girls, but she is quoted as saying that she
"went to a perfectly good school, but truly believe that I was
educated by Penguin Books, public libraries and the BBC."
(Martin, 1989.†) She left school when she was fifteen to study at
Leicester School of Art (1941-42). While serving with the WRNS
during WW2, she continued her studies at Oxford School of Art
(under William Roberts* and Bernard Meninsky), and in 1946
resumed her full-time studies at the Central School of Arts and
Crafts (under John Farleigh*, Laurence Scarfe* and John Minton*).
She taught at Guildford School of Art (1949-53) and Hornsey
School of Art (1960-68).

Jaques had commissions to contribute illustrations to several
magazines while still at college and on leaving became a free-lance
illustrator. She was a regular contributor to *Radio Times* (1949-73),
producing over 500 drawings to illustrate plays and books, gen-
erally eighteenth and nineteenth century classics. Her work for
Radio Times was based on meticulous research which often took
more time than the actual drawing. She designed many book
jackets, including two full colour jackets for the *Saturday Book* (13,
1953; 14, 1954), and also drew half-titles and illustrations for the
annual. She drew decorative rules, ornaments and borders for Folio
Society books in 1949, designed postage stamps, greeting cards,

Faith JAQUES *Moss and Blister* by Leon Garfield (William
Heinemann, 1976)

and accepted other non-book commissions. She found her niche in
the illustration of children's books, working intensively during the
1960s and early 1970s as a black and white illustrator for many of
the finer writers of books for children. Edward Bawden* and Eric
Fraser* were strong influences on her early work, and later she fell
under the spell of Edward Ardizzone*, with whose attitude to illus-
tration she generally agreed. Her illustrations are not decorations
but make up a visual interpretation of what the writer has created.
With the explosion into full colour of children's books in the late
1960s, Jaques began to receive commissions for full colour work.
She also became an author, her first book, *Tilly's House*, being pub-
lished in 1979. The success of this led to her best-selling cut-out
picture books, *Little Grey Rabbit's House* and *Our Village Shop*.
She has been a most prolific book illustrator, and well over one
hundred titles are listed in Martin (1989†).

Books illustrated include (but see Martin, 1989†): *Cinderella*
(with record, Adprint, c.1950); *Goldilocks* (with record, Adprint,
c.1950); L. Alcott: *Little Women* (Contact Publications, 1950); G.
Buckett: *The Circus Book* (Adprint, c.1952); D. Wellesley: *Rhymes
for Middle Years* (Barrie, 1954); *Bambi* (pop-up book, Adprint,
1956); J. Manton: *A Portrait of Bach* (Methuen, 1957); Sir W.
Scott: *Ivanhoe* (Ginn, 1958); J. Reeves: *A Golden Land* (Constable,
1958); R. Guillot: *The White Shadow* (OUP, 1959); A. Konttinen:
Kirsti Comes Home (Methuen, 1961); J. Kamm: *The Story of Mrs.
Pankhurst* (Methuen, 1961); *The Hugh Evelyn History of Costume*
(four vols., Evelyn, 1966-70); H. Treece: *The Windswept City*
(Hamilton, 1967); R.L. Stevenson: *Treasure Island* (Heron Books,
1967); I. Turgenev: *Torrents of Spring* (Folio Society, 1967); R.
Dahl: *Charlie and the Chocolate Factory* (Allen & Unwin, 1968);
M. Treadgold: *The Humbugs* (Hamilton, 1968); G. Infield: *A
Seasoning of Menus* (Heinemann, 1969); M. Dickens: *The Great
Fire* (Kaye, 1970); G. Avery: *A Likely Lad* (Collins, 1971); J.
Cunliffe: *The Giant Who Stole the World* (Deutsch, 1971), *The
Giant Who Swallowed the Wind* (Deutsch, 1972); P. Pearce: *What
the Neighbours Did and Other Stories* (Longmans, 1972); R. Dahl:
Charlie and the Great Glass Elevator (Allen & Unwin, 1973); K.
Lines: *The Faber Book of Greek Legends* (Faber, 1973); H.
Cresswell: *Lizzie Dripping Again* (BBC, 1974); H. Seton: *A Lion in
the Garden* (Heinemann, 1974); M. Sharp: *The Magical Cockatoo*
(Heinemann, 1974); B. Willard: *Field and Forest* (Kestrel, 1975);
L. Garfield: *The Apprentices* (ten books, Heinemann, 1976-78); A.
Lang: *The Red Fairy Book* (Kestrel, 1976); G. Avery: *Mouldy's
Orphan* (Collins, 1978); M.M. Kaye: *The Ordinary Princess*
(Kestrel, 1980); A. Uttley: *Tales of Little Grey Rabbit* (Heinemann,
1980); E. Nesbit: *The Railway Children* (Puffin, 1982); J.
Masefield: *The Box of Delights* (Heinemann, 1984); A. Uttley:
Tales of Little Brown Mouse (Heinemann, 1984); P. Thompson:
Good Girl Grannie (Gollancz, 1987); A. Ahlberg: *Miss Dose the
Doctor's Daughter* (Kestrel, 1988).

Books written and illustrated include: *A Peck of Pepper* (Chatto,
1974); *Tilly's House* (Heinemann, 1979); *Tilly's Rescue* (Heine-
mann, 1980); *Kidnap in Willowbank Wood* (Heinemann, 1982);
Our Village Shop (cut-out model; Heinemann, 1983); *The Christ-
mas Party* (cut-out model; Orchard, 1986).

Published: *Drawing in Pen and Ink* (Studio Vista, 1964).

Contrib: *Cricket (US); House and Garden; Housewife; Leader;
Lilliput; Our Time; Radio Times; Saturday Book; Strand; World
Review*.

Exhib: Calman Gallery; David Paul Gallery, Chichester; New
Ashgate Gallery, Surrey.

Collns: Osborne Collection.

Bibl: Douglas Martin: "The Book Illustrations of Faith Jaques",
Private Library 3s. 7, no. 4 (Winter 1984): 150-70; Martin: *The
Telling Line: Essays on Fifteen Contemporary Book Illustrators*
(Julia MacRae, 1989); Driver; Peppin; Usherwood.
See also illustration on page 60

JENSEN, John b.1930

Born in Sydney, Australia, Jensen established a reputation as a
cartoonist in Australia before emigrating to England in the early
1950s. He was the political cartoonist of the *Sunday Telegraph*
(from 1961-79), and has contributed social cartoons to the *Spec-
tator* and theatre caricatures to the *Tatler*. He is perhaps best known
for his vivid caricatures of sporting and theatrical personalities.

John JENSEN "Soft-Talking Carter, Hard-Talking Reagan" published in *Now!* 13.2.1981 Pen, ink and watercolour (By permission of Chris Beetles Gallery Ltd.)

Contrib: *Birmingham Gazette; Books and Bookmen; Daily Express; Evening News; Glasgow Bulletin; Highlife; King; Lilliput; New Statesman; Now; Punch; Spectator; Sunday Telegraph; Tatler.*
Collns: University of Kent.
Exhib: Beetles (1990).
Bibl: *The Illustrators: Catalogue* (Chris Beetles Ltd., 1991); Feaver.

JERROLD, Daphne B. **fl.1927-1932**
Peppin states that Jerrold was a flower painter; she illustrated a few books in black and white.
Books illustrated include: C. Asquith: *Sails of Gold* (with others, 1927), *The Children's Cargo* (with others, 1930); R.H. Heaton: *Mr. Manners* (with others, 1932), *The Perfect Christmas* (1932).
Bibl: Peppin.

JOBSON, Patrick Arthur **b.1919**
Born on 5 September 1919 at Ilford, Essex, Jobson is the fourth consecutive generation of artists in his family. He was educated at Sir George Monoux Grammar School, Walthamstow (1930-36), and attended life classes at the Tottenham Polytechnic in North London and a course of architectural study at the Northern Polytechnic in Holloway, North London (1936-39). During the whole period 1924-39, he was strongly influenced by the work of Frank Brangwyn*, and from 1934 to 1953 went to him regularly for advice and criticism. From 1924 until about 1935, Jobson had early art training from his father, Francis Mears Jobson, and this continued as constructive criticism until his death in 1976.
A marine and landscape painter, he was a founder member of the Society of Marine Artists (1946), and in the same year was a founder member of the Wapping Group of Artists (President 1977-82), the Artists Society & Langham Sketching Club (President 1971-72), the Society of Graphic Artists, and the Pastel Society. He has exhibited widely since 1946, with one-artist shows in Hitchin, Kettering and Croydon; and from 1947 until the present day he has designed and painted a great many pub signs for various brewers in Britain, Europe and the US. From 1946 to 1961, he illustrated many books for children, mostly dealing with the sea. He continues to paint, exhibit and teach, including demonstrations to art societies.
Books illustrated include: P. Dawlish: *Dauntless Finds Her Crew* (OUP, 1947), *The First Tripper* (OUP, 1947), *Dauntless Sails Again* (OUP, 1948), *Dauntless and the Mary Baines* (OUP, 1949), *Peg-Leg and the Fur Pirates* (OUP, 1949), *North Sea Adventure*

(OUP, 1949), *Captain Peg-Leg's War* (OUP, 1949), *Dauntless Takes Recruits* (OUP, 1950); J. Carruthers: *The Forest Is My Kingdom* (OUP, 1951); P. Dawlish: *Aztec Gold* (OUP, 1951); J. Lindsay: *The Dons Sight Devon* (Blackie, 1951); P. Dawlish: *Dauntless Sails In* (OUP, 1952); L. Houghton: *Haunted Creek* (OUP, 1953); P. Dawlish: *The Bagoda Episode* (OUP, 1953), *Dauntless in Danger* (OUP, 1954); P.F. Westerman: *A Midshipman of the Fleet* (Harrap, 1954), *Daventry's Quest* (Harrap, 1955); P. Dawlish: *He Went with Drake* (OUP, 1955); F. Knight: *Voyage to Bengal* (Macmillan, 1954), *Clippers to China* (Macmillan, 1955), *Mudlarks and Mysteries* (Macmillan, 1955), *The Bluenose Pirate* (Macmillan, 1956), *Please Keep off the Mud* (Macmillan, 1957); P. Rush: *He Went with Dampier* (Harrap, 1957); F. Knight: *The Partick Steam Boat* (Macmillan, 1958), *He Sailed with Blackbeard* (Macmillan, 1958); M. Sankey: *Unwilling Stowaway* (Harrap, 1959); F. Knight: *Shadows on the Mud* (Macmillan, 1960), *The Slaver's Apprentice* (Macmillan, 1961), *The Golden Monkey* (Macmillan, 1961).
Exhib: SMA; RI; SGA; PS; one-artist shows in Hitchin, Kettering, and Croydon.
Bibl: Peppin; Waters; Who; IFA.

JOHNS, Jimmy **b.1936**
Born in Poplar, East London, he was educated at local schools, including Bow Secondary School for Boys which he left in 1951. He worked in a variety of jobs in factories, offices and parks for the next thirteen years, becoming art editor for *Elam*, an East London magazine. He created all the illustrations himself as well as doing other editorial work.
Contrib: *Elam.*
Bibl: Wayne Mockett: "Jimmy Johns: Illustrator", *East London Papers* 12, no.2 (Summer 1969): 66-73.

JOHNS, William Earl **1893-1968**
Born on 5 February 1893 in Bengeo, a suburb of Hertford, Johns was educated at Hertford Grammar School. When he left school, though he wanted to have a career in the army, his father articled him to the county municipal surveyor for four years. During this time, he studied part-time at the local art school. In October 1913, he joined the Territorial Army, and fought during WW1 with the Norfolk Yeomanry until his transfer to the Royal Flying Corps in 1917. He was shot down over Germany in 1918 and imprisoned until the armistice was signed. He held a commission in the RAF until October 1927, and started to write books on aviation; the first "Biggles" story appeared in *Popular Flying* in 1932, and the first collection published as a book appeared in 1934. In all, he wrote more than 100 "Biggles" books, and some seventy-five other titles.
Though he is best known as a writer, Johns produced a number of aviation illustrations during the early 1920s, many of them being reproduced in the *Illustrated London News* and in *The Modern Boy*, a weekly magazine for boys. He also illustrated many of the books on aviation published by a recently established company, John Hamilton, including the first "Biggles" book, *The Camels Are Coming* (1932).
Books illustrated include: C. Clark: *Desert Night* (Hamilton, 1935).
Books written and illustrated include: (with H.M. Schofield) *The Pictorial Flying Course* (Hamilton, 1932); *The Camels Are Coming* (Hamilton, 1932).
Contrib: *ILN; Modern Boy; Popular Flying.*
Bibl: Peter B. Ellis and Piers Williams: *By Jove, Biggles!* (W.H. Allen, 1981); Carpenter; Doyle.

JOHNSON, Jane **b.1951**
Born in London, Johnson's formal art training did not extend beyond work in high school, but after University she joined Cape as a designer of children's books. In her spare time, she illustrated *A Russian Gentleman* by Aksakov and started writing and illustrating her own stories for children. Her first book, *Sybil and the Blue Rabbit*, won the "Owl Prize" in Japan and was runner-up for the Mother Goose Award in 1980. The influence of her mother's nostalgic stories of her own Edwardian childhood can be seen in the illustrations, so delightfully evocative of that period, for *Bertie on the Beach* (1981). She turned free-lance, writing and illustrating

books, contributing to magazines and producing greeting cards. Books planned for 1989 include a book for children on gardens which she is writing and illustrating — *Our Garden Year* — and illustrations for Penelope Lively's book of short stories.
Books illustrated include: S. Aksakov: *A Russian Gentleman* (197?); D. Lloyd: *Explorers, Pirates, Dragon Catchers*.
Books written and illustrated include: *Sybil and the Blue Rabbit* (NY: Doubleday, 1979); *Bertie on the Beach* (Benn, 1981); *A Book of Nursery Riddles* (Black, 1984); *Today I Thought I'd Run Away*; *The Children's Book*; *My Bedtime Rhyme* (1987).
Exhib: Beetles (1986).
Bibl: *The Illustrators: The British Art of Illustration 1800-1987* (Chris Beetles Ltd., 1987).
Colour Plate 97

JOHNSON, W.R.H.
Johnson illustrated *Legends of the Flowers* with woodcuts, some full-page, others head and tail pieces.
Books illustrated include: J. Hepworth: *Legends of the Flowers* (Blackie, nd).

JON
See JONES, William John Philpin

JONES, Barbara d.1978
Born in Croydon, Jones studied at the RCA. A landscape painter, muralist and illustrator, she painted murals for the Festival of

Barbara JONES *Flower of Cities: A Book of London* (Max Parrish, 1949)

W.R.H. JOHNSON *Legends of the Flowers* by Janet Hepworth (Blackie, nd)

Britain and for several liners in the 1940s, '50s and '60s. Jones contributed thirty-one paintings to the *Recording Britain* project during WW2, but used black and white for the illustrations in *Flower of Cities* (1949), adding a three-colour jacket. She did a number of other book jackets, including one for David Cecil's *Two Quiet Lives* (Constable, 1948). She was particularly good at drawing buildings, whose character she seemed able to portray so well either in pen and ink or in paint. For the *About Britain* series published by Collins for the Festival of Britain office in 1951, she contributed several painted title-pages. She also wrote several books, including a rather macabre discussion of death and all the customs and artifacts which surround it. She died on 28 August 1978.
Books illustrated include: H. Casson and others: *Bombed Churches* (with others, Architectural Press, 1945); *Recording Britain* (with others, four vols., OUP, 1946-9); A. De Selincourt: *Dorset* (Vision of England series; Elek, 1947); W. Gooden: *This or That?* (1947); R. Turnor: *Sussex* (Vision of England series; Elek, 1947); C. Williams-Ellis: *On Trust for the Nation* (Elek, 1947); G.S. Fraser: *Visions of Scotland* (Elek, 1948); *Flower of Cities: A Book of London* (with others., Parrish, 1949); R.H. Mottram: *East Anglia* (About Britain #4; Collins, 1951); W. Addison: *English Fairs and Markets* (1953); E.L. Mascall: *Pi in the High* (Faith Press, 1959); G. Peele: *Twice So Fair* (Leicester: Offcut Press, 1970).
Books written and illustrated include: *The Isle of Wight* (King Penguin; Penguin, 1950); *The Unsophisticated Arts* (1951); *Follies*

and Grottoes (Constable, 1953); *English Furniture At a Glance* (1954); *Design for Death* (1963).
Contrib: *Architectural Review; Contact.*
Exhib: SMP.
Collns: V & A.
Bibl: Jacques; Peppin; Waters.
Colour Plate 98

JONES, Cordelia **b.1936**
Born in Oxford, Jones studied at the Slade (1954-57) and Girton College, Cambridge (1962-64). Through contact with Patricia Jaffé at Cambridge, she was introduced to wood engraving, which became her favourite medium. She taught at Norwich School of Art (1964-68) and wrote a number of books for older children, the first of which appeared in 1964 and which she did not illustrate. Dissatisfied with the printing of her engravings, she acquired an Arab press in 1977 to specialize in the production of cards, letterheads, bookplates and other ephemera. In 1989 she contributed illustrations to two books published by Silent Books, *Engraved Gardens* and *Cat Cuts*.
Books illustrated include: K. Briggs: *Hobberdy Dick* (Japan: Iwanami, 1987), *Kate Crackernuts* (Japan: Iwanami, 1987).
Books written and illustrated include: *A Cat Called Camouflage* (Deutsch, 1970); *The View from the Window* (Deutsch, 1978).
Exhib: "The Artist at Work", Norwich Castle Museum (1984).
Bibl: Brett; IFA.

JONES, David Michael **1895-1974**
Born on 1 November 1895 at Brockley, Kent, of Welsh and English stock, Jones showed remarkable talent in drawing as a small child and was encouraged by his parents. He studied (1910-14) at the Camberwell School of Art under A.S. Hartrick (see Houfe). After serving with the Royal Welch Fusiliers for four years during WW1, he returned to his studies at the Westminster School of Art under Walter Bayes and Bernard Meninsky (1919-21).
Jones met Eric Gill* in 1921 and, after being received into the Roman Catholic Church that same year, went to live with Gill and his family, joining the community founded by Hilary Pepler at Ditchling. Jones learned wood engraving, joined Gill's Guild of St. Joseph and St. Dominic, and illustrated various publications for St. Dominic's Press (1923-24). When Gill moved to Capel-y-ffin, near Abergavenny, and subsequently to Piggotts, a house in Buckinghamshire, Jones paid many long visits. In 1924 he became engaged to Gill's daughter, Petra, but the engagement was broken off in 1927 and he never married. Gill wrote an essay on Jones, and Jones wrote one on Gill. The influence of Gill is strong in the early wood engravings but not apparent in the copper engravings or the watercolours or the lettering.
He joined SWE in 1927 and illustrated several books for the Golden Cockerel Press with wood engravings, including *Gulliver's Travels* (1925), *The Book of Jonah* (1926) and *The Chester Play of the Deluge* (1927), the latter two being reprinted in the 1970s by the Rampant Lions Press for Clover Hill Editions, to remedy the effect of the inadequate printing achieved at the Golden Cockerel Press on first publication. He began to engrave on copper in 1925, and in 1929 a young Bristol bookseller, Douglas Cleverdon, published an edition of Coleridge's *The Rime of the Ancient Mariner*, illustrated with ten copper engravings. In 1981, Cleverdon produced a survey — *The Engravings of David Jones* (Clover Hill Editions, printed by the Rampant Lions Press) — which describes Jones's engraved work in detail and lists engravings and books and ephemera which contain engravings. The bulk of the ninety-six plates are printed from the original blocks.
Eye trouble forced him to give up engraving in 1930, and in 1933 he suffered a nervous breakdown and made no more prints. "In the short space of time that he was engraving, he produced a remarkable amount of work, of great variety; some witty, some mystical; some boldly cut, some delicately shaded; some simple to print, some virtually impossible. Although he never attained, particularly in wood, the greatest technical mastery in the conventional sense, his prints are nearly always distinguished by their excellence of design, personal commitment and absolute individuality. At their peak, in the *Deluge* and *Ancient Mariner* sets, they are major achievements of book illustration." (*The Rampant Lions Press,*

David JONES *The Book of Jonah* (Golden Cockerel Press, 1926)

1982, p.80.†)
Concurrently with his engravings and book illustrations but continuing into his later years, Jones was a prolific and highly acclaimed watercolourist, producing many English and Welsh landscapes, still-lifes, and complex drawings of religious and mythical subjects. In 1928 he joined the 7 & 5 Society, with which he exhibited until 1933; he had a joint exhibition with Gill at the Goupil Gallery in 1929, and after that his work was shown frequently elsewhere in Britain and overseas. Two large shows of his work have been exhibited at the Tate Gallery, in 1954-55 and 1981. He began making inscriptions fairly late in his career, either for himself, as gifts for friends, or as illustrations to his own books. He always chose the text himself and his intention was to give a visible, abstract form to the meaning for him of the text.
Often likened to William Blake because of his achievement in two arts and the religious vision that pervades all his works, Jones began writing in the late 1920s. His *In Parenthesis* (1937) has been recognized one of the literary masterpieces of the Great War, and *The Anathemata* (1952) was hailed by W.H. Auden as "very probably the finest long poem written in English this century." A book of shorter poems or "fragments", *The Sleeping Lord*, was published in the last year of his life (1974) and a further collection, *The Roman Quarry*, in 1981; and there are two books of criticism, including essays on the "Welsh thing" — *Epoch and Artist* (1959) and the posthumous *The Dying Gaul* (1978).
Jones was elected a member of SWE (1927); awarded the C.B.E. (1955); Hon. D. Litt., University of Wales (1960); FRSL (1961); CH (1974). He died 28 October 1974.
Books illustrated include: E. Gill and H. Pepler: *In Petra; Being a Sequel of Nisi Dominus* (Ditchling: St. Dominic's Press, 1923); H. Pepler: *Libellus Lapidum* (Ditchling: St. Dominic's Press, 1924); E. Farjeon: *The Town Child's Alphabet* (Poetry Bookshop, 1924); J. Swift: *Gulliver's Travels* (GCP, 1925); *The Book of Jonah* (GCP, 1926; reprinted, Clover Hill Editions, 1979); F. Coventry: *The History of Pompey the Little* (GCP, 1926); H. Pepler: *Pertinent and Impertinent* (Ditchling: St. Dominic's Press, 1926); *Llyfr y Pregeth-Wr (Ecclesiastes)* (Gregynog Press, 1927); *The Chester Play of the Deluge* (GCP, 1927; reprinted, Clover Hill Press, 1977); H. Munro: *The Winter Solstice* (Ariel Poem; Faber and Gwyer, 1928); S.T. Coleridge: *The Rime of the Ancient Mariner* (Cleverdon, 1929); R. Campbell: *The Gum Trees* (Ariel Poem 30; Faber, 1930); W.H. Shewring: *Hermia and Some Other Poems* (Ditchling: St. Dominic's Press, 1930); T.S. Eliot: *The Cultivation of Christmas Trees* (Ariel Poem; Faber, 1954); K. Raine: *Solitary Perfectionist* (Golgoncoza Press, 1974).
Books written and illustrated include: *In Parenthesis* (Faber,

1937); *The Anathemata* (Faber, 1952).
Contrib: *The Game* (St. Dominic's Press); *The Woodcut*; and many others.
Exhib: Goupil Gallery; Redfern Gallery; a retrospective held by the Welsh Committee of the Arts Council 1954-55 and shown at the National Library of Wales, the Tate Gallery, and elsewhere; Tate Gallery 1981.
Colln: National Museum of Wales; Tate; Kettles Yard, Cambridge; Fitzwilliam;.
Bibl: *Agenda* 5 nos. 1-3 (1967), *and* 11 no. 4/12 no. 1 (1973-4) — David Jones special issues; William Blissett: *The Long Conversation: A Memoir of David Jones* (OUP, 1981); Nicolete Gray: "David Jones", *Signature* n.s. no. 8 (1949): 46-56; Nicolete Gray: *The Painted Inscriptions of David Jones* (Fraser, 1981); René Hague, ed. *Dai Greatcoat: A Self-Portrait of David Jones in His Letters* (Faber, 1980); Paul Hills: *David Jones* (Tate Gallery, 1981); Robin Ironside: *David Jones* (Penguin Modern Painters, 1949); Ian Jeffrey: *The British Landscape 1920-1950* (T & H, 1984); *The Rampant Lions Press; a Printing Workshop Through Five Decades. Catalogue of an exhibition at the Fitzwilliam Museum* (Cambridge: Rampant Lions Press, 1982); *Text and Image; English Woodblock Illustration, Thomas Bewick to Eric Gill* (Cambridge: Fitzwilliam Museum, 1985); DNB; Garrett 1 & 2; Peppin; Rothenstein 2; Spalding; Waters.

JONES, Harold 1904-1992
Born on 22 February 1904 in Romford, Essex, Jones was educated at St. Dunstan's College, Catford, and worked on a farm, before studying at Goldsmiths' College School of Art (1921) under E.J. Sullivan (see Houfe), and then at RCA (1924-28) under William Rothenstein and Randolph Schwabe*. He taught in Bermondsey in the 1930s and was Visiting Lecturer at the Ruskin School of Drawing, Oxford, where Albert Rutherston* was Master. During WW2, he served in the Royal Engineers in the map section and from 1945-58 he lectured on a part-time basis at Chelsea College of Art.
A painter, wood engraver and printmaker, he started book illustration in the 1930s, using pen and ink, often with colour washes delicately applied. His lithographs for de la Mare's *This Year: Next Year* (1937) marked the emergence of a fresh talent in book illustration; and the flat colours strike the eye as something quite new. *Lavender's Blue* (1954), illustrated by Jones with muted colours and shadows and texture created with cross-hatching, was included in the Hans Christian Andersen Award honours list and received the American Library Association Award in the US. Brian Alderson, in his introductory essay to this volume, describes Jones as "the most original illustrator of the period." He is a book designer as well as illustrator, and he has also produced book jackets for a number of publishers. Jones died on 10 June 1992.
Books illustrated include: M.E. Atkinson: *August Adventure* (Cape, 1936), *Mystery Manor* (BH, 1937); W. de la Mare: *This Year: Next Year* (1937); C. Brooks: *The First Hundred Years* (1947); J. Pudney: *Elegy for Tom Roding* (BH, 1947); K. Lines: *Four to Fourteen* (OUP, 1950), *Lavender's Blue* (OUP, 1954), *Once in Royal David's City* (1956); D. Suddaby: *Prisoners of Saturn* (BH, 1957); W. Blake: *Songs of Innocence* (Faber, 1958); K. Lines: *Noah and the Ark* (OUP, 1961); C. Kingsley: *The Water Babies* (Gollancz, 1961); W. Shakespeare: *It Was a Lover and His Lass* (Faber, 1961); R. Browning: *The Pied Piper of Hamelin* (OUP, 1962); L. Carroll: *The Hunting of the Snark* (Whittington Press, 1975); O. Wilde: *The Fairy Stories of Oscar Wilde* (Gollancz, 1976); R. Manning-Sanders: *The Town Mouse and the Country Mouse* (A & R, 1977); P. Lively: *Voyage of the QV66*

(1978); N. Lewis: *The Silent Playmate* (Gollancz, 1979).
Books written and illustrated include: *The Visit to the Farm* (Faber, 1939); *The Enchanted Night* (1947); *The Childhood of Jesus* (Gollancz, 1964); *There and Back Again* (OUP, 1977); *Silver Bells and Cockle Shells* (OUP, 1979); *Tales from Aesop* (MacRae, 1981); *A Happy Christmas* (Deutsch, 1983); *Tales to Tell* (MacRae, 1984).
Exhib: RA; NEAC; Leicester Galls.
Collns: Tate; V & A.; Osborne Collection.
Bibl: Ian Jeffrey: *The British Landscape 1920-1950* (T & H, 1984); *Guardian* obit. 16 June 1992; Parkin; Peppin; Tate; Waters; Who.
Colour Plate 99

JONES, William John Philpin fl.1930s-
Born in Llandrindod Wells, Wales, "Jon" (the name he uses as an artist) studied at Birmingham School of Art and the RCA. He started as a cartoonist on the *Western Mail* and worked in an advertising agency, before serving as a Guards officer during WW2 and creating the "Two Types" cartoon for an army newspaper. After the war, he worked on the *Sunday Pictorial*, and other papers before he settled with the *Daily Mail*.
Books written and illustrated include: *The Two Types* (Benn, 1960); *"I'm the Greatest" : The Wit and Humour of Muhammad Ali* (with Roy Ullyett*, Frewin, 1975).
Contrib: *Daily Mail; News Chronicle; Sunday Graphic; Sunday Pictorial; Western Mail*.
Collns: University of Kent.
Bibl: Bateman.

JOPE, Anne b.1945
Born on 31 January 1945 in Corfe Mullen, Dorset, Jope studied art at Ealing College of Art (1966-67), and at the Central School of Arts and Crafts (1967-70, 1980-81), and learned wood engraving from Blair Hughes-Stanton* and Ian Mortimer. A painter in watercolour and oil, engraver and printmaker, she has exhibited widely in Britain, and illustrated a few books with engravings. Elected ARE (1979); RE (1984); SWE (1984).
Books illustrated include: W. Shakespeare: *King John* (Folio Society), *Much Ado About Nothing* (Folio Society); L. Norris: *Ransoms* (Gregynog Poets; Gregynog Press, 1989).
Exhib: NEAC; RA; RBA; RE; SWE; Camden Arts Centre.
Collns: Ashmolean; BM.
Bibl: Brett; Jaffé; Who.

JULLIAN, Philippe b.1921?
A French etcher and art critic, illustrator and novelist, who has divided his time between London and Paris. He is a prolific writer on literary and artistic subjects, and his books include *Dreamers of Decadence* (1971) and *The Symbolists* (1973). He has illustrated a number of books and contributed to *Lilliput* and the *Saturday Book* (fashion sketches).
Books illustrated include: M. Proust: *Remembrance of Things Past* (1949); V. Sackville-West: *Nursery Rhymes* (Joseph, 1950); H. Nicolson: *Some People* (Folio Society, 1951); A. Wilson: *For Whom the Cloche Tolls* (1953); Colette: *Chéri* (Folio Society, 1963); C. Dickens: *Great Expectations*; H. James: *The Turn of the Screw*; Tolstoy: *Crime and Punishment*.
Books written and illustrated include: *Ann of Oxford Street* (Chatto, 1948); *Gilberte Regained* (Hamilton, 1957); *The Collectors* (Sidgwick, 1967).
Contrib: *Lilliput; Saturday Book 21*.
Bibl: *Lilliput* (December 1940).

Colour Plate 96. Sheila JACKSON "Hamlet" from *Ballet in England* (Transatlantic Arts 1945)

Colour Plate 97. Jane JOHNSON "The Circus Ring" Original drawing in watercolour and body colour with pen and ink Illustrated *Bertie on the Beach* by Jane Johnson (Ernest Benn 1981). By permission of Chris Beetles Limited

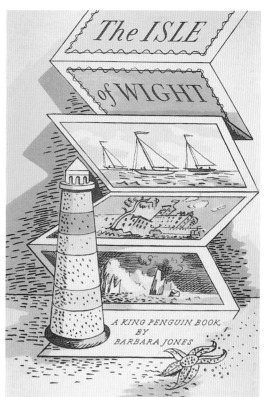

Colour Plate 98. Barbara JONES *The Isle of Wight*, cover by Clifford BARRY (King Penguin 52, 1950)

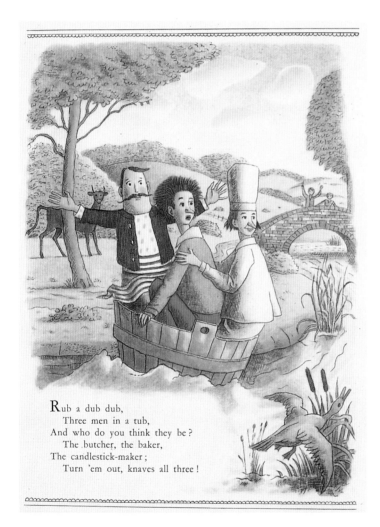

Rub a dub dub,
Three men in a tub,
And who do you think they be?
The butcher, the baker,
The candlestick-maker;
Turn 'em out, knaves all three!

Colour Plate 99. Harold JONES *Lavender's Blue: A Book of Nursery Rhymes* edited by Kathleen Lines (Oxford University Press 1954)

KAPP, Edmond Xavier 1890-1978
See Houfe

KAPP, Helen b.1901
Born in London, Kapp studied at the Slade, Central School of Arts and Crafts, and in Paris. She was a painter in watercolour and oils, a wood engraver and a book illustrator. Her small engravings used as tail-pieces for an edition of John Aubrey (1931) appear simple and rough, and are ideal for the book. She became director of the City

Helen KAPP *The Scandal and Credulities of John Aubrey* (Peter Davies, 1931)

Helen KAPP *The Scandal and Credulities of John Aubrey* (Peter Davies, 1931)

Art Gallery in Wakefield (1951-61) and of the Abbott Hall Gallery in Kendal.
Books illustrated include: G. Bullett: *Seed of Israel: Tales from the English Bible* (Howe, 1927); J. Aubrey: *The Scandal and Credulities of John Aubrey* (Davies, 1931); H. Morland: *Fables and*

Satires (Routledge, 1945); J. Laver: *Toying with a Fancy* (Hale, 1948).
Books written and illustrated include: *Take Forty Eggs* (with B. Collier, Gollancz, 1938).
Exhib: RA; LG; SWA; SWE.
Bibl: Peppin; Waters.

KAUFFER, Edward McKnight 1890-1954
See Houfe
Born in Great Falls, Montana, USA, on 14 December 1890, Kauffer was educated in the US. When his parents' marriage ended in divorce, Kauffer spent two years in an orphanage before his mother remarried and Kauffer returned to the family home in Evansville. Although his step-father encouraged his artistic aspirations, it was not until Kauffer met Joseph McKnight, a professor at the University of Utah, in 1912, that he could afford to follow an artistic career. McKnight became his patron and, in gratitude, Kauffer took his name as part of his own. He studied at the Art Institute of Chicago (1912-13) while working as a scene painter, and then spent six months in Munich and a year in Paris, where he met and married Grace Ehrlich, a gifted American concert pianist. They settled in

England in 1914, first in Durham and then London, where he worked as an advertising artist, producing among other things some brilliantly coloured lithographed labels for use on cotton bales (between 1916 and 1928 he designed thirty-six such labels for the Manchester company Steinthal & Co. for its exports to South America). He achieved lasting fame as a poster designer for many customers, but especially for the posters he produced for London Transport and Shell. As well as designing posters, he did all sorts of other commercial art work — theatre and exhibition design, designs for textiles and furnishings, brochures, and book jackets and illustrations. He went to New York in 1921, expecting to establish himself there as a designer, but was practically unknown there and left to return to England where he was almost a national figure. He maintained his American citizenship and at the beginning of WW2 he returned again to the US, where he continued to work, designing actively for Pan American and American Airlines (1948-54). Depressed and disillusioned with the New York advertising scene, however, he started drinking heavily and died on 22 October 1954.

Kauffer had visited Paris in 1923 where he renewed an acquaintanceship with Marion Dorn*, an interior designer from California. They returned to London and lived together until Kauffer's death in 1954. They worked together on various design projects and had a joint exhibition of rugs made to their designs at the Arthur Tooth Gallery in 1929. Dorn established her own company in 1934; and in 1929, she illustrated Beckford's *Vathek* for the Nonesuch Press, apparently her only book illustration.

Kauffer brilliantly illustrated a number of books, including several for the Nonesuch Press, Cassell and other publishers, most of which were printed by the Curwen Press, using the pochoir stencilling method. Kauffer used watercolour or gouache for these illustrations, and the results are amazingly bright and fresh. The illustrations for Arnold Bennett's *Elsie and the Child* (1929) are perhaps his best, though Desmond Flower, quoted in Haworth-Booth, states that the frontispiece to Melville's *Benito Cereno* (1926) is "one of the most brilliant designs [Kauffer] ever conceived; with pen and two tints — grey and mauve — he built up a shimmering design of a ship becalmed at last light which has an intricate beauty of which the eye can never tire." (Haworth-Booth, 1979.†)

Kauffer formed Group X in 1919 with Wyndham Lewis* to give focus to London's avant-garde. It provided another place for exhibitions of modern works of art, though only one was held (1920). Kauffer's posters and his book illustrations reflect his interest in such movements as cubism, vorticism and surrealism. He was a fine artist, attuned to the art world around him, who was responsible more than anyone else for raising the artistic level of commercial art in Britain. His posters, in particular, can be appreciated as works of art; and his finest book illustrations, produced over just five or six years, were outstanding.

Books illustrated include: R. Burton: *The Anatomy of Melancholy* (Nonesuch Press, 1925); H. Melville: *Benito Cereno* (Nonesuch Press, 1926); T.S. Eliot: *Journey of the Magi* (Ariel Poem no. 8; Faber & Gwyer, 1927), *A Song for Simeon* (Ariel Poem no. 16; Faber & Gwyer, 1928); D. Defoe: *Robinson Crusoe* (Etchells & Macdonald, 1929); A. Bennett: *Elsie and the Child* (Cassell, 1929); M. de Cervantes: *Don Quixote* (Nonesuch Press, 1930); Earl of Birkenhead: *The World in 2030 AD* (Hodder, 1930); T.S. Eliot: *Marina* (Ariel Poem no. 29; Faber & Gwyer, 1930); A. Bennett: *Venus Rising from the Sea* (Cassell, 1931); T.S. Eliot: *Triumphal March* (Faber, 1931); C. Isherwood: *Lions and Shadows* (Hogarth Press, 1938); L. Hughes: *Shakespeare in Harlem* (NY: Knopf, 1942); W.H. Hudson: *Green Mansions* (NY: Random House, 1944); E.A. Poe: *The Complete Poems and Stories* (NY: Knopf, 1946).

Contrib: *The Apple; Fortune; Radio Times.*

Exhib: NEA; Hampshire House, Hammersmith; Ashmolean; Tooth; V & A; MOMA (retrospective 1937); Cooper-Hewitt.

Collns: V & A.; London Transport; Cooper-Hewitt; MOMA.

Bibl: *Landscape in Britain 1850-1950* (Arts Council, 1983); *Catalogue to the Memorial Exhibition of E. McKnight Kauffer* (V & A, 1955); Mark Haworth-Booth: *E. McKnight Kauffer: A Designer and His Public* (Fraser, 1979); Charles Rosner: "In Memoriam: E. McKnight Kauffer", *Graphis* 11, no. 57 (1955): 10-19; Driver; Gilmour; Peppin; Waters.

Colour Plates 5 and 100

Cecil KEELING *Zastrozzi* by P.B. Shelley (Golden Cockerel Press, 1955)

KEELING, Cecil **1912-1976**

Born in Teddington, Keeling studied at Putney (1930-34) and Chelsea Schools of Art (1934-36), while he worked in a printing shop. He demonstrated a great versatility and imagination, possessed a mastery of many illustrative techniques and had an impeccable taste in typography. He worked in scraperboard, lithography, linocuts and wood engraving. Of his splendid engravings for the Golden Cockerel *Zastrozzi* (1955), Sandford wrote in *Cock-A-Hoop* that "Keeling cut eight sinister full-page engravings to match Shelley's eerie tale, and I managed with great difficulty to find some Japanese vellum for this book, so as to get the maximum effect in printing the blocks. The specials were bound in black morocco blocked in gold with skull and serpent designs by Keeling, with French marbled endpapers suggestive of the flames of hell." (Chambers.)

In 1937, he became a designer for the BBC, and after war service during WW2 he rejoined the Corporation. He drew for the *Radio Times* and the *Listener*, and did publicity for the BBC transcription service for overseas. He described his war service in two books, *A Modicum of Leave* (1943), which he illustrated with a four-colour autolithographed frontispiece and forty humorous drawings, and *Pictures from Persia* (1947), which contains thirty coloured lithographs.

He was a member of RE, SWE (1953), the Art Workers' Guild (1945), and FSIA (1956).

Books illustrated include: *A History of British Music* (BBC); P. Harben: *What's Cooking* (BBC); *World Theatre* (BBC); *The Queen's Beasts* (Neame for Shell Petroleum, 1951); P.B. Shelley: *Zastrozzi* (GCP, 1955); R. Bage: *Hermsprong; Or, Man as He Is Not* (Folio Society, 1960); O. Goldsmith: *The Citizen of the World* (Folio Society, 1969).

Colour Plate 100.
E. McKnight KAUFFER
Elsie and the Child
by Arnold Bennett (Cassell 1929)

Colour Plate 101.
Charles KEEPING
Through the Window
(Oxford University Press 1970)

But what's that noise?
Why are those pigeons flying up into the air?

Colour Plate 103.
John KETTELWELL
"The Grand Vizier" (1928)
Original drawing in pen and ink
with watercolour and gold.
By permission of Chris Beetles
Limited

Colour Plate 104.
Reginald KNOWLES
Norse Fairy Tales
(Freemantle 1910)

Colour Plate 102.
Chloe Talbot KELLY
Original painting

Henry KEEN "The Dwarf": drawing from *Golden Hind* vol.1 no.3 (April 1923)

Books written and illustrated include: *A Modicum of Leave* (Hale, 1943); *Pictures from Persia* (Hale, 1947).
Contrib: *Listener; Radio Times*.
Collns: V & A; IWM.
Bibl: Charles Rosner: "Cecil Keeling", *Graphis* 11, no. 62 (1955): 512-17; Amstutz 1; Chambers; Garrett 1 & 2; Folio 40; Jacques; Peppin; Usherwood.

KEEN, Henry Weston 1899-1935
Little biographical information available. Keen was primarily a printmaker and illustrator. He exhibited lithographs at the Senefelder Club in London and did book illustrations for John Lane, the Bodley Head. Some of his vivid and imaginative drawings are quite bizarre and show the influence of Sidney Sime* and Beardsley. He died in Switzerland in 1935, in which year a memorial exhibition of his work was held at the Twenty-One Gallery, London.
Books illustrated include: R. Garnett: *The Twilight of the Gods* (BH, 1924); O. Wilde: *The Picture of Dorian Gray* (BH, 1925); Voltaire: *Zadig and Other Romances* (BH, 1926); J. Webster: *The Duchess of Malfi; and The White Devil* (BH, 1930).
Contrib: *Golden Hind*.
Exhib: Twenty-One Gallery.
Bibl: Johnson FIDB; Peppin.

KEEPING, Charles William James 1924-1988
Born on 22 September 1924 in Lambeth, East London, and educated at the Frank Bryant School, Kennington, Keeping left school when he was fourteen and became an apprentice to a printer. He served in the Royal Navy during WW2 and studied art at the Regent Street Polytechnic (1946-52), where he met Renate Meyer*, whom he later married. He later was lecturer at several schools of art,

including the Regent Street Polytechnic, Croydon and Camberwell (from 1979).
He had various jobs before he started illustrating books, including a time as cartoonist on the *Daily Herald*. In 1956 he was commissioned by OUP to illustrate stories for children by Rosemary Sutcliff, and with the encouragement of Mabel George, the Press's children's books editor, launched on a career which made him one of the best known and most prolific illustrators of the 1960s to the 1980s, much of his work being done for children's books.
His upbringing in the working-class district of Lambeth, where his house was next door to a stable for cart-horses, had a great influence on his work. When he was working his way through art school, he was a gas meter man in poor areas of London, Paddington and North Kensington, and discovered people living in conditions which were practically Dickensian. He made use of this experience later when illustrating Dickens for the Folio Society, and he used his memories of cart-horses in several children's books. His illustrations are usually dramatic and often sinister, as may be seen in those he did for Kevin Crossley-Holland's prose version of *Beowulf*. He won the Kate Greenaway award for *Charley, Charlotte and the Golden Canary* (1967), and again for *The Highwayman* (1981); was a prize winner in the Francis Williams Award for *Tinker, Tailor* (1968), and for Kevin Crossley-Holland's *The Wildman* (1976); and won the Emil Award for 1987 for *Jack the Treacle Eater*.
For his black and white illustrations, Keeping used mainly India ink with steel-nibbed pens or a bamboo pen, and sometimes a Chinese brush. Along with Brian Wildsmith* and John Burningham*, he made brilliant use of colour and the new printing techniques in his books for children, with many double-page spreads, using a mixture of gouache, tempera, watercolour and inks. He was an early enthusiast for "Plastocowell", the grained plastic sheets designed by the printers, Cowells of Ipswich, for lithographic illustrations. His theory of illustration was that, in his books, the illustrations were as

important as the words; they did not merely reiterate what the text said, but were the response of the artist to the story. In 1970, Keeping said "I'm sick to death of the illustration that just shows an incident. It bores me doing it. I would much sooner make a drawing that has an evocative mood." (Keeping, 1970.†) There has been some criticism that his illustrations and his stories are too sophisticated for the children for which they are intended; but, as Martin declares, "even those who dislike much of his work must concede his immense influence in shaping attitudes to children's books over the past three decades and for the future." (Martin, 1989.†)

A project of immense size and importance was his commitment to illustrate the complete Dickens for the Folio Society (see also illustration on page 16). Happily this project, the first full edition to be illustrated by a single illustrator, was completed just before his death.

Keeping died on 16 May 1988. In an obituary in *The Independent*, Leon Garfield wrote "He was a sturdy Cockney, intensely proud of his origins in the Old Kent Road; and, at the same time, he was a fastidious artist possessed of a wonderfully keen and critical mind. Whatever he did was thoughtful; and we, who were fortunate enough to have written books that he illustrated, were always flattered by the care, integrity and beauty of his work. And the humour, too."

Books illustrated include (but see Martin, 1989†): R. Sutcliff: *The Silver Branch* (OUP, 1957), *The Lantern Bearers* (OUP, 1959), *Beowulf* (BH, 1961); E. Brontë: *Wuthering Heights* (Folio Society, 1964); K. Crossley-Holland: *King Horn* (Macmillan, 1964); E.M. Remarque: *All Quiet on the Western Front* (Folio Society, 1966); G. Trease: *The Red Towers of Granada* (Macmillan, 1966); H. Treece: *The Dream-Time* (Brockhampton, 1967); L. Garfield and E. Blishen: *The God Beneath the Sea* (Longman, 1970); F. Dostoyevsky: *The Idiot* (Folio Society, 1971); L. Garfield and E. Blishen: *The Golden Shadow* (Longman, 1973); M.R. James: *Ghost Stories* (Folio Society, 1973); R. Newman: *The Twelve Labours of Hercules* (Hutchinson, 1973); B. Ashley: *Terry on the Fence* (OUP, 1975); K. Crossley-Holland: *The Wildman* (Deutsch, 1976); V. Hugo: *Les Misérables* (Folio Society, 1976); H. Walpole: *The Castle of Otranto* (Folio Society, 1976); C. Dickens: *The Pickwick Papers* and thirteen other vols. (Folio Society, 1981-8) A. Noyes: *The Highwayman* (OUP, 1981); K. Crossley-Holland: *Beowulf* (OUP, 1982); L. Garfield: *The Wedding Ghost* (OUP, 1985); C. Causley: *Jack the Treacle Eater* (Macmillan, 1987); N. Philip: *The Tale of Sir Gawain* (Lutterworth, 1987); A. Sewell: *Black Beauty* (Gollancz, 1988); M. Shelley: *Frankenstein* (Blackie, 1988).

Books written and illustrated include: *Black Dolly* (Brockhampton, 1966); *Shaun and the Carthorse* (OUP, 1966); *Charley, Charlotte, and the Golden Canary* (OUP, 1967); *Alfie and the Ferry Boat* (1968); *Tinker, Tailor: Folk Songs* (Brockhampton, 1968); *Joseph's Yard* (OUP, 1969); *Through the Window* (OUP, 1970); *The Garden Shed* (OUP, 1971); *The Spider's Web* (OUP, 1972); *Richard* (OUP, 1973); *The Nanny Goat and the Fierce Dog* (Abelard, 1973); *The Railway Passage* (OUP, 1974); *Cockney Ding Dong* (Kestrel, 1975); *Wasteground Circus* (OUP, 1975); *Inter-City* (OUP, 1977); *Miss Emily and the Bird of Make-Believe* (Hutchinson, 1978); *River* (OUP, 1978); *Willie's Fire Engine* (OUP, 1980); *Sammy Streetsinger* (OUP, 1984); *Classic Tales of the Macabre* (Blackie, 1987); *Adam and Paradise Island* (OUP, 1989).

Contrib: *Daily Herald; Radio Times*.
Collns: V & A.
Bibl: Edward Blishen: "Charles Keeping", *Times Educational Supplement* 27 May 1988: B3; Leon Garfield: [Obit.] *Independent* 18 May 1988; Charles Keeping: "Illustration in Children's Books", *Children's Literature in Education* 1 (March 1970): 41-54; Douglas Martin: *The Telling Line: Essays on Fifteen Contemporary Book Illustrators* (Julia MacRae Books, 1989); *Times* obit. 20 May 1988; CA; Carpenter; Folio 40; ICB3; ICB4; Peppin; Ryder; Usherwood; Who's Who.
Colour Plate 101

KELLY, Chloe Elizabeth Talbot **b.1927**
Born on 15 July 1927 in Hampstead, North London, Kelly was educated privately and at St. George's School for Girls and the Convent

of the Sacred Heart. She had no formal art training, but received help and advice from her artist father, R.B. Talbot Kelly*, whose decision it was that she should work in the "bird room" at the British Museum (Natural History Museum) in London. Her first job was to draw two small plates for David Lack's *Darwin's Finches*; and then she started making black and white drawings for the *African Handbook of Birds*, working on this for over twenty-one years (1952-73). She travelled to Sierra Leone and New Zealand, continuing her work on the *AHB*, and after the breakdown of her first marriage in 1960 returned to the "bird room". (She remarried in 1963, and now runs a small picture framing business with her son.) She has illustrated, or contributed illustrations to, many books on birds; designed book jackets; contributed frontispieces to *Avicultural Magazine*; painted panels for the Warwick County Museum and the London Zoological Gardens; and has produced paintings of birds.

Despite her efforts to the contrary, her father has obviously been an important influence on her life and work as an artist, though less so as an illustrator. She received much help from David Reid-Henry* while working with him on *Eagles, Hawks, Falcons* (1968). She was a founder member of the Society of Wildlife Artists (1964), and was elected SIA (1968).

Books illustrated include: D. Lack: *Life of the Robin* (with others; Penguin, 1953); Smithies: *Birds of the Bechuanaland Protectorate* (National Museum of Southern Rhodesia, 1964); L. Thompson: *New Dictionary of Birds* (with others, Nelson, 1964); *Field Guide to Birds of New Zealand* (Collins, 1966); Brown and Amadon: *Eagles, Hawks and Falcons of the World* (with others, Country Life, 1968); D.A. Bannerman: *Birds of Cyprus* (O & B, 1971); *Field Guide to Birds of the Seychelles* (Collins, 1974); Mackworth-Praed and C.H.B. Grant: *African Handbook of Birds* (with others, Longman); D.A. Bannerman: *Birds of Malta* (Valetta: Museums Department, 1976); *Birds of Fiji, Tonga and Samoa* (Wellington, NZ: Millward Press, 1982).
Exhib: SWLA; "Animals in Art" (ROM, 1975).
Bibl: Who; IFA.
Colour Plate 102

KELLY, Felix **b.1916**
Born in Auckland, New Zealand, Kelly came to England in about 1937 and served in the RAF during WW2. He was a painter in oil and gouache, who exhibited at the Lefevre Gallery and had a one-man show in Scotland. He did some cartoons for *Lilliput*, working as "Fix" or "Fix Kelly", and illustrated a few books in fine pen and ink, pencil, or romantic colour, for Longman, Hutchinson, Macmillan, Chatto and other publishers. His fine pen drawings for Rosenberg's *The Desperate Art* (1955) are among his best illustrations. For both Cecil Roberts' *And So To Rome* (Hodder, 1950), and Ivor Brown's *London* (1960), he produced romantic watercolour book jackets. He also worked as a theatrical designer in London, for the Haymarket, Phoenix, Sadlers Wells, and Old Vic theatres.

Books illustrated include: H.E. Read: *The Green Child* (Grey Walls Press, 1945); E.J. Holmyard: *Ancestors of Industry* (with others, ICI, 1950); J. Rosenberg: *The Desperate Art* (Longmans, 1955); E. Burton: *The Elizabethans at Home* (1958); I. Brown: *London* (Newnes, 1960); E. Burton: *The Georgians at Home* (1967), *The Jacobeans at Home* (1967), *The Early Victorians at Home* (1972).
Contributed: *Lilliput*.
Exhib: Lefevre Gallery (1943/44/46); Leicester Galls. (1950/52); Tooth (1965/68/71); Partridge Fine Arts (1978/81).
Bibl: *Paintings by Felix Kelly* (Falcon Press, 1946); *Lilliput* 123 (Sept. 1947): 262; Peppin; Waters; Who.
See illustration on page 43

KELLY, Richard Barrett Talbot **1896-1971**
Son of artist and illustrator Robert George Talbot Kelly (see Houfe), Kelly was born in Birkenhead, 20 August 1896. He moved with his family to London a few years after his birth but spent his childhood holidays in Scotland where he became interested in natural history. He was educated at The Hall, Hampstead, at Rottingdean, and at Rugby School, and after leaving school in 1914, he entered the Royal Military Academy at Woolwich. He served in

the Royal Artillery (1915-29), and fought in France until he was wounded in 1917, after which he became a camouflage instructor. After the war, when he was posted to India (1919-22), he began to paint seriously and his interest in birds started. He exhibited regularly at the Royal Society of Painters in Water Colours and was elected RWS in 1923. In 1929 he resigned his commission, and became Director of Art at Rugby School where he remained, with a break during WW2 in which he served as Chief Instructor in camouflage, until his retirement in 1966.

After his retirement, he taught children and adults for the RSPB and Leicester University. In the 1950s, he produced paper model birds for RSPB and Puffin Books, and wrote and illustrated at least two Puffin Picture Books. He also made three-dimensional models, mobiles and dioramas, and was the Design Consultant for the Pavilion of Natural Science at the Festival of Britain in 1951. Kelly was influenced both by Egyptian and Chinese artists; and in England by the work of Joseph Crawhall, whose approach to bird painting Kelly felt worthy of study by all beginners in bird art. His one book not connected to his passion for birds seems to be *A Subaltern's Odyssey* (1980), an account of his experiences during service in France during WW1. The book is illustrated with line and wash illustrations, which are sometimes quite humorous.

Kelly won the MC during WW1, and was awarded the MBE for services during WW2; elected RI (1923). He died on 30 March 1971.

Books illustrated include: R.M. Lockley: *Birds of the Sea* (King Penguin; Penguin, 1945).

Books written and illustrated include: *The Way of Birds* (Collins, 1937); *Mountain and Moorland Birds* (Puffin Picture Books 65; Penguin Books, 1947); *Paper Birds* (Puffin Picture Book 52; Penguin, 1947); *Bird Life and the Painter* (Studio, 1955); *A Subaltern's Odyssey: A Memoir of the Great War 1915-1917* (Kimber, 1980).

Exhib: RWS; RA; RI; FAS; Paris Salon.

Bibl: *Sea-Birds, Wild-Fowl and Other Birds: Watercolours by R.B. Talbot Kelly* (FAS, 1947); Hammond; Waters.

KEMP-WELCH, Lucy Elizabeth **1869-1958**
See Houfe

KENNEDY, A.E. **d.1963**
An illustrator of children's books, mostly about animals. He was one of the few illustrators of whom Alison Uttley approved both his work and his personality.

Books illustrated include: E. Talbot: *Baby Animals* (Nelson, 1928); L. Kennedy: *For the Tinies* (Nelson, 1930), *For the Toddlers* (1931), *Holiday Friends* (Nelson, 1932); C. Wickham: *The Teddy Bear Book* (Collins, 1937), *Countryside Folk* (Collins, 1938); C. Egan: *Epaminondas and the Lettuces* (Collins, 1940); *The Gollywog Book* (Collins, 1940); A. Uttley: *Sam Pig Goes to Market* (Faber, 1941), *Sam Pig and Sally* (Faber, 1942), *Sam Pig at the Circus* (Faber, 1943), *The Adventures of Tim Rabbit* (Faber, 1945); R.J. McGregor: *The Adventures of Grump* (Faber, 1946); A. Ridge: *The Handy Elephant* (Faber, 1946), *Rom-Bom-Bom* (Faber, 1946), *Endless and Co* (Faber, 1948); A. Uttley: *Sam Pig in Trouble* (Faber, 1948); A. Ridge: *Galloping Fred* (Faber, 1950); A. Uttley: *Macduff* (Faber, 1950), *Yours Ever, Sam Pig* (Faber, 1951), *Sam Pig and the Singing Gate* (Faber, 1955), *Tim Rabbit and Company* (Faber, 1959), *Sam Pig Goes to the Seaside* (Faber, 1960); D. Stephen: *Timothy's Book of Farming* (Collins, 1963); A. Groom: *Farmyard Friends* (Parnell, 1965).

Books written and illustrated include: *The Big Coloured Picture Book* (with others, Blackie, 1924); *Gay Gambols* (Blackie, 1925).

Bibl: Denis Judd: *Alison Uttley: The Life of a Country Child* (Joseph, 1986); Peppin.

KENNEDY, Richard Pitt **1910-1989**
Born on 4 September 1910 in Cambridge, Kennedy was educated at Marlborough College, though he failed to progress past the Lower School and left when he was sixteen. He joined the Hogarth Press in 1926 and worked for two years with Leonard and Virginia Woolf. In 1972 he published an illustrated acount of his time there (*A Boy at the Hogarth Press*) in the form of a journal he might have kept. He was next employed by a silkscreen printer, and illustrated jokes

Richard KENNEDY *A Parcel of Time* (Whittington Press, 1977)

for *Strang's Weekly News*. He took a course in journalism at University College, London, and studied art at the Regent Street Polytechnic (1932-33), continuing as an evening student at the Central School of Arts and Crafts (1934-36). He worked for an advertising agency (1936-37), became a free-lance artist again, married in 1937, and began oil painting.

During WW2 he served in the RAF (1941-46), but during this period started on his career as a book illustrator, his first commission being to illustrate *Snowbird* by his cousin Virginia Pye. He set up the family home in Marlow, Buckinghamshire (1947), and then moved to Maidenhead in 1955 where he lived for the next forty-four years. During this period he travelled to Italy and other European countries, to India and to California. He made watercolours of Indian scenes, and in the late 1970s started etching. In the 1980s, right up to the time of his death, he continued to paint and to produce illustrations. He died on 11 February 1989.

For forty years Kennedy was a prolific illustrator of more than 200 books for children and adults. His versatility may be understood by the great variety of different kinds of books he illustrated. He did children's books for Brockhampton, Bodley Head, and Faber; he had a long collaboration with Kaye Webb in the design of Puffin Books for Penguin; he illustrated his own autobiographical accounts, and the classics of fiction. His drawings show a sketchy but fluid, expressive line, somewhat similar in style to the work of the Morton-Sales*. Kennedy claimed that the sculptor, Gaudier-Brzeska, was the greatest inspiration of his artistic life.

Books illustrated include: V. Pye: *Snowbird* (Faber, 1941), *Primrose Polly* (Faber, 1942), *Half-Term Holiday* (Faber, 1943); I. Mitchell: *The Beginning Was a Dutchman* (Faber, 1944); M.M. Atwater: *Ski Patrol* (Faber, 1945); J.E. Clapton: *Up, Down and Sideways* (Faber, 1946); B. Nichols: *The Stream That Stood Still* (Cape, 1948); P. Young: *Music Is for You* (Lutterworth, 1948); E. Leyland: *Fire Over London* (Muller, 1949); M. Byrom: *Jockey Silks* (Witherby, 1950); G. Trease: *Under Black Banner* (Heinemann, 1951); E. Dillon: *The Lost Island* (Faber, 1952); E. Farjeon: *Martin Pippin and the Apple Orchard* (OUP, 1952); E. Dillon: *The San Sebastian* (Faber, 1953); R. Sutcliff: *Simon* (OUP, 1953); M.M.

Reid: *Carrigmore Castle* (1954); G. Trease: *Black Banner Abroad* (Heinemann, 1954); H. Treece: *Desperate Journey* (Faber, 1954); M. Fitt: *Annabelle Takes a Plunge* (Nelson, 1955); A. Lindgren: *Pippi Longstocking* (OUP, 1955); E. Dillon: *The Island of Horses* (Faber, 1956); K.M. Gadd: *Summer-Tenting* (Ginn, 1955); M.M. Reid: *Tiffany and the Swallow Rhyme* (Faber, 1956); A. Casserley: *About Barney* (Faber, 1957); B. Edwards: *Midnight on Barrowmead Hill* (Brockhampton, 1957); N. Streatfeild: *Wintle's Wonders* (Collins, 1957); D. Ford: *Dr. Barnado* (Black, 1958); R. Martin: *Gangster Pie* (Hutchinson, 1958); A. Judah: *God and Mr. Sourpuss* (Faber, 1959); A. Casserley: *Michael and His Friends* (Faber, 1960); R. Guillot: *The Fantastic Brother* (Methuen, 1961); W. Irving: *Stories of the Alhambra* (Heinemann, 1962); M.J. Baker: *Castaway Christmas* (Methuen, 1963), *Cut Off from Crumpets* (Methuen, 1964); E. Dillon: *The Sea Wall* (Faber, 1965); A. Pullen: *The Man in the Train* (Benn, 1965); M. Kennedy: *Susan's Cottage* (Chatto, 1966); A. Trollope: *Dr. Thorne* (Heron, 1968); E. Goudge: *I Saw Three Ships* (Brockhampton, 1969); H. Cresswell: *Bluebirds Over Pit Row* (Benn, 1972); R. Southall: *Head in the Clouds* (A & R, 1972); M. Armitage: *A Long Way to Go* (Faber, 1973); E. Dillon: *Living in Imperial Rome* (Faber, 1974); *Song of Songs* (Whittington Press, 1976); E. Kempson and G.W. Murray: *Marlborough, Town and Countryside* (Whittington Press, 1978); I. Azmi: *The Garden of Night* (Whittington Press, 1979); R. Wheeler: *Irish Folk Tales* (Nelson, 1980); E. Dillon: *Down in the World* (Hodder, 1983); I. Azmi: *The Mirror and the Eye* (Whittington Press, 1984); *Letters from a Portuguese Nun* (Whittington Press, 1986); D. Kennedy: *Beyond the Pyramids* (Unwin, 1988); T.E. Lawrence: *Letters to E.T. Leeds* (Whittington Press, 1988).
Books written and illustrated include: *A Boy at the Hogarth Press* (Whittington Press, 1972); *A Parcel of Time* (Whittington Press, 1977).
Contrib: *Elizabethan; Farmer's Weekly; Matrix; Puffin Post; School Journal (NZ); Strang's Weekly News.*
Exhib: Dublin (1940); Reading (1962); San Diego (1980); Century Galleries, Henley (1981, 1982); Illustrators Art (1981); Sally Hunter Fine Art (1987).
Bibl: *Guardian* obit. 14 February 1989; *Independent* obit. 14 February 1989; *Times* obit. 14 February 1989; ICB2; ICB3; ICB4; Peppin; Ryder; Who; IFA.

KENNEY, John Theodore Eardley **1911-1972**
Kenney was an equestrian artist, but he also illustrated some children's books, including the historical series of the *Ladybird* books, the *Hunter Hawk Series* and Books 12-17 of the *Railway Series* (1957-62) by W. Awdry.
Books illustrated include: E.B. Wade: *There Is an Honour Likewise: The Story of 154 (Leicestershire Yeomanry Field Regiment, RA)* (with Edward Seago*, 1948); E. Pochin: *Over My Shoulder and Beyond* (1954); R.S. Summerhays: *The Young Rider's Guide to the Horse World* (Nicholas Kaye, 1960); J.F. Kelly: *Dealing with Horses* (Paul, 1961); R.H. Smythe: *The Mind of the Horse* (Country Life, 1965).
Books written and illustrated include: *The Grey Pony* (Ward, 1954); *The Shetland Pony* (Ward, 1955).
Exhib: Gadsby Gallery, Leicester (1963, 1980); in New York and Chicago.
Bibl: Titley.

KENNINGTON, Eric Henri **1888-1960**
Born on 12 March 1888 in Chelsea, the son of painter T.B. Kennington, he studied at Lambeth School of Art (1905-07) and the City and Guilds School. He started to exhibit at the RA in 1908, but enlisted in the 13th London Regiment, the Kensingtons, and fought France and Flanders during WW1 until he was invalided out in 1915. He was an official war artist (1916-19), mostly making pastel portraits of soldiers. The first exhibition at the Goupil Gallery (1916) of "The Kensingtons at Laventie", an emotionally powerful painting of a group of exhausted soldiers, caused a sensation. He later had a successful one-artist show at the Leicester Galleries in 1918, "The British Soldier", which focused on the courage and self-sacrifice of the individual soldiers. He also had his own issue of *British Artists at the Front*, containing fifteen colour plates. In 1920 he had another exhibition of war pictures at the Alpine Club

Gallery, and met T.E. Lawrence, who subsequently invited him to be art editor of the first edition of *The Seven Pillars of Wisdom*. For this book, Kennington visited the Near East and produced some fine drawings of Arab fighters. Between the wars, he worked as a sculptor and a painter. During WW2, he served in the Home Guard and was once again a war artist (1940-43), painting portraits of airmen. He also designed a series of posters for London Transport on "Seeing It Through", based on portraits of actual members of London Transport staff.
Elected ARA (1951); RA (1959). He died on 13 April 1960 in Reading.
Books illustrated include: C. Dodgson and C.E. Montague: *British Artists at the Front* (vol. 4, Country Life, 1918); *The Legion Book* (with others, 1925); T.E. Lawrence: *The Seven Pillars of Wisdom* (1926), *Revolt in the Desert* (with others, Cape, 1927); B.L. Bowhay: *Caspar* (1930); N. Mitchison: *The Powers of Light* (Pharos, 1932); J. Brophy: *Britain's Home Guard* (Harrap, 1945).
Books written and illustrated include: *Drawing the R.A.F.* (OUP, 1942); *Tanks and Tank Folk* (1943).
Exhib: RA; Goupil Gallery; Leicester Galls.
Collns: IWM; Tate.
Bibl: DNB; Harries; Peppin; Tate; Waters.

KENSINGTON, Sarah **b.1949**
Born on 26 December 1949 in Pinner, Middlesex, Kensington was educated at Northwood College. After seven months at the Triangle Secretarial College in London, she left to go to Harrow School of Art. Since leaving art school, she has worked as a free-lance illustrator. She was married in 1975 and lives near Richmond in Surrey.
Books illustrated include: D. McKay: *Helping* (1973); M.E. Patchett: *The Brumby* (Longman, 1974); H. Gautier and G. Braughton: *Let's Go* (Longman, 1975); R. Mabey: *Street Flowers* (Kestrel, 1976); G. Smith: *Sure and Simple Gardening* (Mills & Boon, 1976); P. Hughes: *Kelligant Pig and Other Stories* (Sackett & Marshall, 1979).
Bibl: ICB4; Peppin.

KENWARD, James Macara **b.1908**
Born on 1 January 1908 in New Eltham, Kent, Kenward studied at Brighton College of Art. He started working at Lloyd's of London when he was seventeen, but in 1928 became a full-time writer and illustrator. He has written several novels and books for children.
Books written and illustrated include: *The Roof-Tree: A History of English Domestic Architecture* (OUP, 1938); *Prince Foamytail* (Comyns, 1946); *The Market Train Mystery* (Nisbet, 1959); *The Story of the Poor Author* (Nisbet, 1959).
Bibl: CA; Peppin.

KENYON, Ley **b.1913**
Born on 28 January 1913 in London, Kenyon was educated at Marylebone Grammar School, and studied at Central School of Arts and Crafts (1929-34) under Bernard Meninsky and William Roberts*. He was a free-lance illustrator and graphic designer (1934-9), and served in the Royal Canadian Air Force as a gunnery leader of a night bomber squadron during WW2. He taught life drawing, painting and illustration at various art schools (1945-65), and then became a free-lance artist, doing illustrations and book jackets for many publishers, including Hutchinson, Faber and Bodley Head. In recent years, he has concentrated on portrait and landscape painting, and has exhibited widely.
Books illustrated include: P. Brickhill and C. Norton: *Escape to Danger* (Faber, 1946); J. Pudney: *Saturday Adventure* (and five other vols., BH/Evans, 1950-55).
Books written and illustrated include: *Collins Pocket Guide to the Undersea World* (Collins, 1956); *Discovering the Undersea World* (ULP, 1962).
Contrib: *ILN; Tatler.*
Exhib: RA; RI; ROI.
Collns: RAF Museum, Hendon.
Bibl: Who; IFA.

KERMODE, William **fl. 1930s**
Kermode studied at the Grosvenor School of Art under Iain Macnab*, and then worked as a commercial artist and illustrator. He

William KERMODE *A Moral Ending, and Other Stories* by Sylvia T. Warner (William Jackson, 1931)

used a variety of techniques to produce heavy black line illustrations, including woodcuts, linocuts and scraperboard. For *Tomorrow* he used linocuts to produce small headpieces and an attractive illustration for the title page.
Books illustrated include: F.B. Austin: *Tomorrow* (E & S, 1930); C. Sale: *The Specialist* (Putnams, 1930); H. Williamson: *The Patriot's Progress* (Bles, 1930); H.F.G. Heard: *The Emergence of Man* (Cape, 1931); M. Il'in: *Moscow Has a Plan* (Cape, 1931); S.T. Warner: *A Moral Ending and Other Stories* (William Jackson, 1931).
Contrib: *Evening Standard; London Mercury; Observer; Radio Times.*
Published: *Drawing on Scraperboard for Beginners* (Routledge, 1936).
Bibl: Peppin.

KESSELL, Mary M. b.1914
Born on 13 November 1914 in London, Kessell studied at Clapham School of Art (1935-37) and the Central School of Arts and Crafts (1937-39). She was an official war artist in Germany in 1945. A painter, muralist and illustrator, she exhibited at a one-artist show at the Leicester Galleries in London in 1950. Her book illustrations are done in line or wash; those for *Best Poems of 1937* are small impressionistic pen drawings.

Books illustrated include: O. Sitwell: *Mrs Kimber* (Macmillan, 1937); T. Moult: *Best Poems of 1937* (Cape, 1938); I. Turgenev: *A Sportsman's Notebook* (1959).
Books written and illustrated include: *A Visit to India for Oxfam* (pp., 1969).
Bibl: Peppin; Waters.

KETTELWELL, John fl.1916-1930
Some of Kettelwell's fantastic drawings recall the style of John Austen* and Harry Clarke*; others are quite dissimilar, using simple outlines and flat colours. He used the pseudonym "M. Watson-Williams" for some of his work.
Books illustrated include: S. Pepys, jnr: *A Diary of the Great War* (BH, 1916), *A Second Diary of the Great War* (BH, 1917), *A Last Diary of the Great War* (BH, 1919); S. Leacock: *Nonsense Novels* (BH, 1921); J.E. Miles: *The Oxford Circus* (BH, 1922); R. Burton: *The Kasidah* (Philip Allan, 1925); Sa'di: *Tales from the Gulistan* (Allan, 1928); W. Congreve: *The Way of the World* (BH, 1929).
Books written and illustrated include: *Beaver: An Alphabet of Beards* (Werner Laurie, 1922); *The Story of Aladdin and the Wonderful Lamp* (Knopf, 1928).
Colour Plate 103

KIDDELL-MONROE, Joan 1908-1972
Born on 9 August 1908 in Clacton, Essex, Kiddell-Monroe studied at Willesden and Chelsea Schools of Art. She started work in an advertising studio, but left to become a free-lance artist. She married Webster Murray, a Canadian illustrator and portrait painter, in the late 1930s, and then travelled in Africa. She worked for the WVS in England during WW2, leaving to have a son in 1944. Her husband died in 1957, and she toured Africa again with her son, and then settled in Majorca where she continued to illustrate though she did no more writing.
Most of her book illustrations were done after 1940. Her work often deals with animals and life in Africa and other countries overseas. Four of her own stories for children (*In His Little Black Waistcoat* series) feature a panda as the hero. She was a prolific illustrator in the 1940s, '50s and '60s, using various media, including scraperboard, wash, and pen and ink. Her work shows a remarkable use of white space and a fine line. For her version of *Arabian Nights*, published by Dent in 1951, she used a formal decorative treatment, while the *Aesop's Fables*, published by Blackwell in 1972, was illustrated in vivid, flat colours. The work she did as series illustrator for the OUP series on folk tales of the world is particularly successful.
Books illustrated include (but see CA): T.W. Bagshawe: *Pompey Was a Penguin* (OUP, 1940); D. Severn: *Rick Afire!* (BH, 1942); P. Lynch: *Longears* (Dent, 1943); H. Gardner: *Beyond the Marble Mountains* (OUP, 1948); E. Dixon: *Fairy Tales from the Arabian Nights* (Dent, 1951); R. Forbes-Watson: *Ambari!* (OUP, 1952); R. Guillot: *Sama* (OUP, 1952); B. Picard: *Odyssey of Homer* (OUP, 1952); J. Reeves: *English Fables and Fairy Stories* (OUP, 1954); B.K. Wilson: *Scottish Folk-Tales and Legends* (OUP, 1954); G. Jones: *Welsh Legends and Folk-Tales* (OUP, 1955); B.L. Picard: *French Legends, Tales and Fairy Stories* (OUP, 1955); R. Guillot: *Animal Kingdom* (OUP, 1957); B. Picard: *The Iliad of Homer* (OUP, 1959); *Aesop's Fables* (Dent, 1961); R. Graves: *Myths of Ancient Greece* (Cassell, 1961); J.E.B. Gray: *Indian Tales and Legends* (OUP, 1961); K. Arnott: *African Myths and Legends* (OUP, 1962); I. Southall: *The Curse of Cain* (A & R, 1968), *The Sword of Esau* (A & R, 1968); H. Burton: *The Great Gale* (OUP, 1969); L. Wood: *Hags by Starlight* (Dent, 1970).
Books written and illustrated include: *In His Little Black Waistcoat* (Longman, 1939); *In His Little Black Waistcoat to China* (Longman, 1940); *Little Skunk* (Nicholson, 1942); *Ingulabi* (Nicholson, 1943); *Wau-Wau the Ape* (Methuen, 1947); *The Irresponsible Goat* (Methuen, 1948); *In His Little Black Waistcoat to India* (Longman, 1948); *In His Little Black Waistcoat to Tibet* (Longman, 1949).
Contrib: *Daily Mail Annual.*
Bibl: CA; ICB2; ICB3; Peppin.

KIDSTON, Annabel b.1896
Born at Hillhead, Glasgow, Kidston studied at Glasgow School of

Annabel KIDSTON *The Forsaken Mermaid* by Matthew Arnold (Bodley Head, 1927)

KING, Jessie Marion 1876-1949
See Houfe

KING, Simon John Forrester b.1951
Born on 28 July 1951 in Markyate, Hertfordshire, King studied art at Luton School of Art (1969-71) and painting and printmaking at the Central School of Art and Design (1971-75), under Blair Hughes-Stanton* and Ian Mortimer. After a year (1978) working free-lance for Editions Alecto in London, he was etching technician at the Central School where he also did some part-time teaching (1978-81). In 1981, he moved to Beetham, Cumbria, and set up a studio to print his own linocuts and wood engravings, and embarked on typography, printing his own limited edition books. He was one of four engravers who started work on illustrating, with wood engravings, the *Reader's Digest Bible*, though the project was later terminated. Elected SWE.
Books illustrated include (all published by Simon King Press): J. Swift: *Baucis and Philemon* (1983); R. Browning: *Home Thoughts from Abroad* (1984); J. Keats: *To Autumn* (1985); R. Bridges: *London Snow* (1988); *The Garden of Proserpine* (1990).
Exhib: RA; SWE; Collingwood College, Durham (1984); Gateway Centre Gallery, Windermere (one-man show, 1985).
Bibl: Brett; IFA.

Art (1918-21) under Maurice Greiffenhergen and Forester Wilson, and then in France (1922). After teaching art in Laurel Bank School, Glasgow, for three years, she went to London to study painting and engraving at the Slade (1926). During WW2 she was instructor of drawing and wood engraving for the Committee for Education for the Forces. There were two other engravers in the north-east of Scotland during the war period — Alison and Winifred McKenzie* — and together they formed the St. Andrews group. With Winifred Mackenzie, Kidston started wood engraving classes for the Forces at St. Andrews University. After the war, Kidston taught painting at Duncan of Jordanstone School of Art, Dundee (1947-50) and in 1972 was elected President of the Art Committee of St. Andrews.
Books illustrated include: M. Arnold: *The Forsaken Mermaid, and The Scholar Gipsy* (BH, 1927).
Bibl: Garrett 1 & 2; Jaffé; *Shall We Join the Ladies?*.

KING, Eric Meade 1911-1987
An equestrian painter who illustrated a few books, contributed paintings to magazines and covers to *Field* and *Foxhunting Illustrated*, and some good two-colour engravings of farm life for the seventh issue of the *Saturday Book* (1947).
Books illustrated include: C.R. Acton: *Sport and Sportsmen of the New Forest* (Heath Cranton, 1936), *Hunting for All* (Witherby, 1937); R. Crottet: *The Enchanted Forest and Other Tales* (Richards Press, 1949); R.P.G. Orde: *The Household Cavalry at War* (Gale & Polden, 1953).
Books written and illustrated include: *The Silent Horn* (Collins, 1938).
Contrib: *Field; Fox-Hunting Illustrated; Illustrated Sporting and Dramatic News; Saturday Book 7*.
Exhib: Greatorex Galleries (1938, 1939); Three Counties Show, Malvern (1958-).
Bibl: Titley.

Simon KING *To Autumn* by John Keats (privately printed, Simon King, 1985)

David KNIGHT *Flower of Cities: A Book of London* (Max Parrish, 1949)

KITSON, Linda Frances **b.1945**
Born on 17 February 1945 in London, Kitson was educated at Tortington Park, near Arundel, Sussex, and studied at St. Martin's School of Art (1964-67) and RCA (1967-70). She was appointed an official war artist to cover the Falkland Islands war, the first woman to accompany troops into battle.
Books illustrated include: J. Norman: *Picnic.*
Books written and illustrated include: *The Falklands War, a Visual Diary* (Beazley/Imperial War Museum, 1982).
Exhib: IWM; Illustrators Art Gallery; Workshop Gallery; National Theatre.
Collns: IWM.
Bibl: Who.

KNEEBONE, Peter **fl.1952-**
An artist who contributed humorous illustrations to the *Radio Times*, and has illustrated a few educational books in a similar vein. Usherwood claims that "his work owes its quality to the concentration and lucidity of his thought."
Books illustrated include: J. Trim: *English Pronunciation Illustrated* (CUP, 1965); C. Mortimer: *Stress Time* (CUP, 1976); D.M. Davey and P. McDonnell: *How To Interview* (British Inst. of Management, 1975), *How To Be Interviewed* (British Inst. of Management, 1980).
Books written and illustrated include: *Look before You Elope* (Longman, 1952); *Sexes and Sevens* (CUP, 1953).
Contrib: *Radio Times; Town Crier.*
Bibl: Usherwood.

KNIGHT, Anne **b.1946**
Born on 7 August 1946 in Sussex, Knight studied at Brighton College of Art and St. Martin's School of Art. A landscape painter and illustrator of children's books, she is particularly concerned that her drawings not only fit together with the text to produce good-looking pages, but also suit the feeling of the writing.
Books illustrated include: J. Counsel: *Mostly Timothy* (Longman, 1971); E.C. Ellis: *Mr and Mrs Vinegar* (Blackie, 1971); H. Cresswell: *The Beetle Hunt* (Longman, 1973); S. Dickinson: *Stories for Bedtime* (Collins, 1975); M. Hynds: *The Fire Bell* (Blackie, 1975); F. Law: *Red* (Collins, 1976); B. Lee: *Late Home* (Kestrel, 1976); V. Pitt: *Coffee* (Watts, 1982), *Sugar* (Watts, 1982), *Tea* (Watts, 1982).
Bibl: ICB4; Peppin.

KNIGHT, David **1923-1982**
Born in Coulsdon, Surrey, Knight's studies at Wimbledon School of Art were interrupted by service in the army during WW2. After working as an art editor of a magazine for just three months, he became a free-lance illustrator. His first commissions were for magazine illustrations, including the *Radio Times*. He decorated or illustrated many books, including children's books and educational publications for schools, using black and white drawings. He had a particular facility in depicting architecture and townscapes with fine pen and ink drawings.
Books illustrated include: *Flower of Cities: A Book of London* (with others; Parrish, 1949); E. Farjeon: *Mrs Malone* (Joseph, 1950); P. Elek: *This Other London* (Elek, 1951); P. Gallico: *The Small Miracle* (Joseph, 1951); J. Pudney: *The Smallest Room* (Joseph, 1954); A. Barrett: *Songbird's Grove* (Collins, 1957); J. Pudney: *The Book of Leisure* (with others; Odhams, 1957); L.W. Meynell: *The Young Architect* (OUP, 1958); R. Vailland: *The Law* (OUP, 1958); S. Potter: *The Magic Number* (Reinhardt, 1959); S.

Churchill: *A Thread in the Tapestry* (Deutsch, 1960); C. Dalton: *Malay Boy* (Brockhampton, 1961); C. Roberts: *Wide Is the Horizon* (Hodder, 1962); L. Lafitte: *Eau Trouble* (CUP, 1962); R.W. Pilkington: *Boats Overland* (Macmillan, 1962), *Small Boat to Bavaria* (Macmillan, 1962); H.F. Collins: *Point de Départ* (Macmillan, 1964); R. Guillot: *Balloon Journey* (Collins, 1964); M. Sarton: *Joanna and Ulysses* (Murray, 1964); H. Walpole: *Mr. Perrin and Mr. Traill* (1964); C. Dalton: *Malay Treasure* (Brockhampton, 1967); O.S. Manders: *Mrs Manders' Cookbook* (Macmillan, 1968); A.P. Herbert: *The Singing Swan* (1970); J. Rice: *Mortimer* (1970); P. Rush: *That Fool of a Priest* (1970); E. Macdonald: *The Incredible Magic Plant* (World's Work, 1976); J. Rice: *The Day the Queen Was Crowned* (World's Work, 1977); E. Macdonald: *The Little Weather House* (World's Work, 1978); S. Cunningham-Brown: *Crowded Hour* (1980); *Whizz Kids Crazy Crossword Book* (Macdonald, 1982).
Contrib: *Contact; Good Housekeeping; Leader; Radio Times.*
Bibl: Jacques; Ryder; Peppin; Usherwood.

KNOWLES, Horace John 1884-1954
See Houfe
Born on 22 July 1884 in Poplar, East London, Horace was the fifth child of Ebenezer and Emma Knowles, and the brother of Reginald Knowles*. He was educated at George Green's School in Poplar, and designed the cover for the first issue of the school magazine, November 1911. With his brothers Reginald and Charles, he attended evening classes at the Craft School in Aldgate, East London, while still at school. Although he wanted to be an artist like his brothers, he was apprenticed as an engineering draughtsman, but managed in the evenings to produce illustrations with his brother Reginald for *Legends from Fairyland* (1907) and *Norse Fairy Tales*

Horace KNOWLES *Countryside Treasures* (Francis James Publishing, 1946)

Horace KNOWLES Page opening: *Countryside Treasures* (Francis James Publishing, 1946)

Reginald KNOWLES Title-page opening from *The Early Romances of William Morris* ("Everyman Library"; J.M. Dent, 1907)

Reginald KNOWLES *My River* by Wilfred G. Brown (Frederick Muller, 1947)

(1910). He became a full-time free-lance artist some time later, his first commissions being to produce illuminated addresses on vellum, before he illustrated several church magazines and many books. He also took part in amateur dramatics, acting as well as designing costumes and producing plays. The last major task of his career, which he worked on for five years, was to produce some five hundred illustrations and maps for the Bible published to commemorate the third jubilee of the British and Foreign Bible Society in 1954. For most of his book illustrations, Knowles worked in black and white, and produced very decorative, delicate drawings, often of scenes of the countryside.

Horace Knowles died on 21 August 1954 at Norbury.

Books illustrated include: H. Lee: *Legends from Fairyland* (with Reginald Knowles*; Freemantle, 1907); G.W. Dasent, trans.: *Norse Fairy Tales* (with R. Knowles*; Freemantle, 1910); C.D. Cole: *Cowslips and Kingcups* (Methuen, 1920); A. Latham: *Among the Innocent* (Methuen, 1920); *Berni, the Story of a German* (Harrap, nd); M. Pedley: *The Land of Goodness Knows Where* (Newnes, 1923); S. Lagerlof: *Christ Legends* (Elkin Mathews, 1930); A.M. Buckton: *Eager Heart* (Elkin Mathews, 1931); B. Buxton: *My First Book of Prayers* (Atheneum Press, 1932); *A Book of Thoughts on Courage* (Elkin Mathews, 1932); *A Book of Thoughts on Hope*

(Elkin Mathews, 1932); *A Book of Thoughts on Friendship* (Elkin Mathews, 1932); J. Stirling: *For a Child Like Me* (Mathews, 1934); *The Sermon on the Mount* (Nicholson, 1936); C. D. Cole: *Cowslips and Kingcups* (Methuen, n.d.); E. Blyton: *The Land of Far Beyond* (Methuen, 1942); H. McKay: *This Duck and That Duck* (Francis James, 1944); A.L. Hetherington: *Three Asiatic Legends* (Francis James, 1945); L. Rivett: *Through the Hole in the Wall* (Francis James, 1946); A.G. Ghant: *Legend of Glastonbury* (Epworth Press, 1948); E. Blyton: *The Enid Blyton Book of Fairies* (Newnes, 1954); *The Jubilee Bible* (British & Foreign Bible Society, 1954).

Books written and illustrated include: *Peeps into Fairyland* (Thornton & Butterworth, 1924); *Countryside Treasure* (Francis James Publishing, 1946).

Contrib: *Cassell's Children's Annual; Merry Moments Annual*.

Bibl: A.J.L. Hellicar: "Charles, Reginald and Horace Knowles, Artists", *East London Papers* 2, no. 2 (October 1959): 83-93; mss. at Central Library, London Borough of Tower Hamlets; Peppin.

KNOWLES, Reginald Lionel　　　　　　　**1879-1950**
See Houfe
Reginald Knowles was born at Poplar in east London, the second son of Ebenezer Caleb Knowles and Emma Dece Scutt. Along with his brothers, Charles and Horace*, Reginald attended the Craft School in Aldgate, and when he left school, probably shortly before 1900, he became an artist for the publishing house of J.M. Dent.
Knowles' most easily recognized and regularly appreciated work is the decoration of the *Everyman's Library*, the first fifty volumes of which were published in 1906. The endpapers of each volume, printed in pale grey-green, show the draped figure of Good Deeds, the sister of Knowledge, facing a scroll of the latter's address to Everyman — "Everyman, I will go with thee and be thy guide, In thy most need to go by thy side" — and the pages are filled with swirling floral decorations in the art nouveau style. The title-pages and frontispieces have elaborate floral borders, designs which are clearly derived from the work of William Morris and Laurence Housman (see Houfe), and the flat spines are decorated with a trellis of winding flowers and have hand drawn titles. Knowles' designs were used for thirty years until 1935, when the hand-drawn lettering on the title-pages was replaced by typeset titling in Eric Gill's*

Perpetua Roman face, and the elaborate decorations were removed in favour of a series of small abstract designs by Eric Ravilious*.
Apart from his work for the *Everyman's Library*, Knowles drew not only lettering for the spines of a great many of Dent's general publications but also the title-pages and other decorations. He designed bindings for several publishers as well as for Dent (including commissions from George Newnes, Jarrolds, Cassell, and George Allen), recognizable by their sumptuous gold-blocked, highly decorated front boards. At the time of his death in 1950 he was working on a design for a series of books to be published by Frederick Muller.
In addition to the huge number of books which he designed and decorated, Knowles also worked as an illustrator, sometimes in colour but mostly in black and white. Many of his illustrations are too static and, though some are quite effective, such as those he did for *My River* (1947), they are often too derivative to be really successful. His *Old-World Love Stories* (1913) has many coloured plates and other decorations, a typical "Knowles" binding design, and is a splendid production.
Knowles was an important figure in the second rank of book designers and made a considerable contribution to the concept of producing good-looking, carefully made books for a mass audience.
Books illustrated include: H. Lee: *Legends from Fairyland* (with Horace Knowles*) (Freemantle, 1907); G.W. Dasent, trans.: *Norse Fairy Tales* (with Horace Knowles*) (Freemantle, 1910); Marie de France: *Old-World Love Stories* (Dent, 1913); E. Sutton: *The Happy Isles* (Dent, 1938); P. Strong: *The Round of the World* (Muller, 1945); W. Brown: *My River* (Muller, 1947), *Angler's Almanac* (Muller, 1949).

Contrib: *Ecclesia*.

Bibl: Joseph Malaby Dent: *The House of Dent* (Dent, 1938); A.J.L. Hellicar: "Charles, Reginald and Horace Knowles, Artists", *East London Papers* 2, no. 2 (October 1959): 83-93; A.J. Hoppé: *The Reader's Guide to the Everyman's Library*. 4th ed. (Dent, 1976); Alan Horne: "Reginald Knowles", *The Devil's Artisan* (Toronto), no. 10 (1983): 16-24; John Russell Taylor: *The Art Nouveau Book in Britain* (Methuen, 1966); mss. at Central Library, London Borough of Tower Hamlets; Peppin.
Colour Plate 104

LA DELL, Edwin 1914-1970

Born on 7 January 1914, La Dell studied at RCA. A painter and lithographer, he illustrated *The Moonstone* with colour lithographs. He was senior tutor at RCA from 1948; elected RBA (1950), ARA (1969). He died on 27 June 1970.

Books illustrated include: W. Collins: *The Moonstone* (Folio Society, 1951).
Published: *Your Book of Landscape Drawing* (Faber, 1964).
Exhib: RA.
Bibl: Folio 40; Waters.

LAIDLER, Gavin Graham ("Pont") 1908-1940

Born in Jesmond, Newcastle Upon Tyne, Laidler was educated at Trinity College, Glenalmond, near Perth, and in 1926 went to the London School of Architecture. Unable to practise architecture because of poor health (though he was responsible for the restoration of the Old Bull Inn at Dorchester), he began to draw professionally, contributing first of all to *Woman's Pictorial* in 1930, using the *nom de plume* "Pont". Laidler started contributing drawings to *Punch* in 1932, with his popular series, "The British Character", which dealt with the English laughing at themselves, beginning in 1936. His work had become so important to *Punch* by this time that, in an extraordinary gesture, he was given a contract which stipulated that he should offer none of his work to any other British magazine, and he published over 450 cartoons in that magazine over an eight year period. Laidler died of poliomyelitis on 23 November 1940 at the age of thirty-two. J.B. Priestley wrote of him in *The Times* that he had become "one of the few English comic artists who have been thoroughly appreciated in America. He was, too, a genuine comic artist and not merely a draughtsman who illustrated jokes."

Books written and illustrated include: *The British Character* (Collins, 1938); *The British at Home* (Collins, 1939); *The British Carry On* (Collins, 1940); *Most of Us Are Absurd* (Collins, 1946).
Contrib: *Punch; Scribner's Magazine; Woman's Pictorial*.
Bibl: "Fougasse": *Pont* (Collins, 1942); Bernard Hollowood: *Pont: An Account of the Life and Work of Graham Laidler (1908-1940)* (Collins, 1969); *Most of Us Are Absurd* (1946); Price.

LAMB, Lynton Harold 1907-1977

Born in Nizamabad, India, on 15 April 1907, Lamb spent his childhood in London, and was educated at Kingswood School, Bath. His father's death forced him to leave school, and he worked in an estate agent's office for a year, studying life drawing in the evenings at Camberwell School of Art under Randolph Schwabe*.

Edwin LA DELL *The Moonstone* by Wilkie Collins (Folio Society, 1951)

Graham LAIDLER ("PONT")
"The importance of news"
from *Punch* (16 February
1938)

He then became a full-time student at Central School of Arts and Crafts (under Noel Rooke*, B. Meninsky, J.H. Mason and A.S. Hartrick — see Houfe). During WW2 he served as Camouflage Staff Officer (1940-45).

Lamb had a most diverse career. He was a painter — his first exhibition was at the Storran Gallery in 1936 and he became a member of the London Group in 1939; he was Production Adviser to the Oxford University Press; prepared architectural decorations for the Orient Liners (1935-50); was head of lithography at the Slade (1950-71), where Sarah Van Niekerk* was a pupil, and at RCA (1956-70); was President SIAD (1951-53); designed the binding of the Coronation Bible (1953); designed postage stamps.

Above all, he was an important and influential book illustrator. He used a variety of techniques for his illustrations — wood engraving, as for *The Log of the Bounty* (1937); pen and ink drawing, as for his *County Town* (1950); chalk drawn directly on lithographic stones,

Lynton LAMB *County Town* (Eyre & Spottiswoode, 1950)

as for Trollope's *Can You Forgive Her?* (1948) and Eliot's *Silas Marner* (1953); and chalk on zinc plates, as for Collins' *The Woman in White* (1956). He also designed many book jackets, and is particularly remembered for those he did for the World's Classics.

Lamb wrote and talked a great deal about the art and theory of book illustration. He believed that a work of imagination did not need illustrations to explain it, for the author creates his own moods and reaches his own climaxes unaided. Good illustrations should provide a parallel interpretation of the text; and they must be well drawn — they must exist as drawings in their own right. He insisted that good illustrations had to be accurate reflections of real life, and he spent much time in detailed and accurate research for any book he illustrated. In this view, he was in direct opposition to Edward Ardizzone*, who believed in "the born illustrator" who drew from memory. Lamb did commend Ardizzone for making "no change whatsoever in his 'style' whether he is illustrating a nursery rhyme or *Manon Lescaut*. And this is as it should be." The only necessary common denominator of all good children's book illustrators was to have "the ability to enter and open with some key or other the mind of a child. . .the touch and technique of each one of them is as varied here as in any other kind of art." (Lamb, 1962.†)

SWE; FSIA (1948); FRSA (1953); RDI (1975).

Books illustrated include (but see Mackie, 1978†): G. Chaucer: *Works* vol.7 (Shakespeare Head Press, 1929); Plato: *Lysis: A Dialogue* (Fulcrum Press, 1930); H.E. Bates: *A German Idyll* (GCP, 1932); H. Walpole: *The Apple Trees* (GCP, 1932); *The Log of the "Bounty"* (GCP, 1937); A. Trollope: *Can You Forgive Her?* (OUP, 1948); I. Walton: *The Compleat Angler* (Folio Society, 1949); L. Avilov: *Chekov in My Life: A Love Story* (Lehmann, 1950); I. Brown: *Winter in London* (Folio Society, 1951); T. Hardy: *Our Exploits at West Poley* (OUP, 1952); D.P. Jones: *Welsh Country Characters* (Batsford, 1952); G. Eliot: *Silas Marner* (Limited Editions, 1953); W. Collins: *The Woman in White* (Folio Society, 1956); W. Mayne: *The Member for the Marsh* (OUP, 1956), *A Grass Rope* (OUP, 1957); E. Nesbit: *The Railway Children* (Benn, 1957); D. Severn: *Foxy Boy* (BH, 1959); H.G. Wells: *Tono- Bungay* (Limited Editions Club, 1960); I. Gundy: *Staying with the Aunts* (Harvill Press, 1963); H. James: *Washington Square* (Folio Society, 1963); A. Bull: *Friend with a Secret* (Collins, 1965); T. Holme: *The*

Carlyles at Home (OUP, 1965); R. Herrick: *The Music of the Feast* (BH, 1968); *The Oxford Illustrated Old Testament* (five vols., with others, OUP, 1968-9); J. Reeves: *The Strange Light* (Heinemann, 1969); S. Sassoon: *Memoirs of a Fox-Hunting Man* (Folio Society, 1971), *Memoirs of an Infantry Officer* (Folio Society, 1974).
Books written and illustrated include: *County Town* (OUP, 1950); *Cat's Tales* (Faber, 1959).
Published: *The Purpose of Painting* (OUP, 1936); *Preparation for Painting* (OUP, 1954); *Drawing for Illustration* (OUP, 1962).
Contrib: *Chambers Journal; Field; Motif; Radio Times; Saturday Book 24; Signature.*
Exhib: RA; RBA; LG; Storran Gallery.
Collns: V & A.
Bibl: Lynton Lamb: "Predicaments of Illustration", *Signature* N.S. 4 (1947): 16-27; Lamb: "The True Illustrator", *Motif* 2 (1959): 70-6; Lamb: "The Art of Book Illustration", *Book Design & Production* 5, no. 2 (1962): 95-105; John Lewis: "The Drawings and Book Decorations of Lynton Lamb", *Alphabet & Image* 5 (1947): 57-74; George Mackie: *Lynton Lamb, Illustrator* (Scolar Press, 1978); DNB; Driver; Folio 40; Garrett 1 & 2; Hodnett; ICB2; ICB3; Jacques; Peppin; Ryder; Sandford; Usherwood; Waters; Who Was Who.
Colour Plate 105

LAMBERT, Agnes **fl. 1920s**
Agnes Lambert (Mrs. Pinder-Davis) was the sister of Richard Stanton Lambert, who established the Stanton Press in 1921 with his wife, Elinor Lambert*. She was a talented artist who illustrated two books for the Press with line-drawings.
Books illustrated include: Roswitha the Nun of Gandersheim: *Abraham: A Play* (Stanton Press, 1922), *Callimachus* (Stanton Press, 1923).

LAMBERT, Elinor **fl. 1920s**
Lambert was a wood engraver who illustrated a number of books printed at the Stanton Press, set up by her husband Richard Stanton Lambert at Wembley Hill in 1921. It operated until 1924. Richard Stanton, sometime editor of the *Listener* and author of books on the occult and psychical phenomena, retired to Victoria, British Columbia, where he died in the early 1980s.
Books illustrated include: M.J. Vida: *The Game of Chess* (Stanton Press, 1921); Sir J. Davies: *Orchestra; or, A Poeme of Dauncing* (Stanton Press, 1922); Statius: *Ode to Sleep* (Stanton Press, 1923); *The History of Susanna, Taken out of the Apocrypha* (Stanton Press, 1923); W. Strabo: *Hortulus; or, The Little Garden* (Stanton Press, 1924); L. Binyon: *The Sirens: An Ode* (Stanton Press, 1924).
Bibl: Colin Franklin: *The Private Presses* (Studio Vista, 1969).

LAMBERT, H.G.C. Marsh **fl. 1920s**
An illustrator and writer for young children, who worked for Blackie, Ward Lock, and Allday, and contributed to some annuals. Her illustrations are as simple as the words, and are usually done in ink with added colour. Peppin lists some fifty titles.
Contrib: *Cassell's Annual; Playbox Annual.*
Bibl: Peppin.

LAMBOURNE, Nigel **1919-1988**
Born on 30 May 1919 in Croydon, Lambourne was educated at Selhurst Grammar School, and studied art at the Regent Street Polytechnic, and etching by evening study at the Central School of Arts and Crafts (1934-37). From there he went to the at RCA (1937-39) under R.S. Austin*, John Nash* and Malcolm Osborne. He served in the army for six years during WW2, married Barbara Standen in 1943, and after the war, returned to the RCA to complete his degree course. His first published illustrations appeared in 1947 in *Lilliput* and *Leader*, and he did some work for an advertising agency. He started teaching engraving and illustration at the Regent Street Polytechnic and St. Martin School of Art in 1948, and in 1950 joined the a team at the Central Office of Information which included James Holland* and F.H.K. Henrion. An artist and printmaker, his first one-artist show of drawings was held at the Kensington Gallery in 1949, and he spent much of the 1950s producing material for exhibitions. By the end of that decade, he had become disenchanted with the art establishment, and he changed the

Nigel LAMBOURNE *The Informer* by Liam O'Flaherty (Folio Society, 1961)

direction of his career. He taught graphics and printmaking at Guildford College of Art (1950-56), while free lancing with art agencies. In 1959 he and his wife went to Leicester College of Art to teach, and they worked there until his resignation in 1972 and her retirement in 1984.

Lambourne's reputation as an illustrator rests upon his illustrations for the ten titles commissioned by the Folio Society. He used a variety of techniques for this work, from the coloured autolithographs done on Plastocowell (his *A Sentimental Journey* was the first to use these sheets of grained plastic for illustrations), to the black drawings for *The Brothers Karamazov* (1964) and the soft-ground etchings for *The Georgics* (1969). He was a friend of Charles Ede, Director of the Folio Society, and worked closely with him and later with Brian Rawson, editorial director, producing one book every three or four years. He left unpublished a number of illustrations prepared for books which were never produced, including drawings for a Folio Society *Ulysses*, and lithographic proofs for an edition of *Dr. Faustus* from the Leipziger Presse in Germany. He has been claimed as one of the supreme draughtsmen of our time (Martin, 1989†); Hodnett however complains that his illustrations all tend to look the same, and notes a lack of detail or context, which makes the drawings less interesting.
Elected RBA (1947); RE.

Books illustrated include: L. Sterne: *A Sentimental Journey* (Folio Society, 1949); D. Defoe: *Moll Flanders* (Folio Society, 1954); G. de Maupassant: *Short Stories* (Folio Society, 1959); L. O'Flaherty: *The Informer* (Folio Society, 1961); P. Knight: *The Boreas Adventure* (Nelson, 1963); L. Derwent: *Braeside: A Scottish Farm* (and three other titles for N.Z. Dept. of Education, 1963-4); F. Dostoyevsky: *The Brothers Karamazov* (Folio Society, 1964); E. Gray: *I Will Adventure* (O & B, 1964); G. Furnell: *Left Hand Wood* (O & B, 1967); F. Kafka: *The Trial* (Folio Society, 1967); Virgil: *Georgics* (Folio Society, 1969); W. Owen: *10 War Poems* (with P.P. Piech; Taurus Press, 1972); A. Chekov: *Short Stories* (Folio Society, 1974); J. Tucker: *Ralph Rashleigh* (Folio Society, 1977); B. Disraeli: *Sybil* (Folio Society, 1983).
Books written and illustrated include: *People in Action* **(Studio, 1961).**
Contrib: *Leader; Lilliput; Our Time.*
Exhib: RA; RBA; RE; NEAC; Kensington Gallery (1949); Wilton Gallery (1951, 1952); Zwemmer (1954, 1956, 1959).
Bibl: Douglas Martin: "Nigel Lambourne", *Private Library* 3rd S., 5, No. 1 (1982): 2-24; Martin: *The Telling Line: Essays on Fifteen Contemporary Book Illustrators* (Julia MacRae, 1989); Folio 40; Hodnett; Peppin; Waters.

LANCASTER, Sir Osbert **1908-1986**
Born on 4 August 1908 in Notting Hill, London, Lancaster grew up in his middle class family in West London. His years at Charterhouse, where Max Beerbohm (see Houfe) a guiding presence through Lancaster's life, had been a student before him, were very unhappy. He then went to Lincoln College, Oxford (1926-30), which he enjoyed much more, and there took on his adult persona, adopting the outward style of Beerbohm. He sat the Bar exams before going on to study art at the Byam Shaw School (1925-26), the Ruskin School of Drawing, Oxford (1929-30), and the Slade (1931-32). He worked for the *Architectural Review*, designed book jackets and posters, and did murals for a house in Blandford. During WW2 he worked in the News Department of the Foreign Office and then was attached to the British Embassy in Athens (1944-46). After the war he lectured on art at Liverpool University and was adviser to the Greater London Council Historic Buildings Board.
Like two artists who seem to have influenced his work, Edward Bawden* and Eric Ravilious*, he engaged in a wide range of activities including working for two of the most enlightened patrons of the time, the Curwen Press and London Transport. Lancaster spent his life writing and illustrating, designing for the theatre, painting murals, producing posters, and drawing cartoons. He worked as a cartoonist for the *Daily Express* since 1939, and is well known for his "pocket cartoons" of the irrepressible Maudie Littlehampton and her friends, but he had started writing and illustrating his knowledgeable but humorous books on architecture in 1936. He was an architectural connoisseur with an extensive knowledge of buildings and design, and the nostalgic love of an earlier age. In addition, he had the ability to depict the mores of his own time with clarity and wit. "Many people love Osbert's work for its elegance, its wit, its good humour, its lack of pretension, its 'bubbling sense of fun'. . . It is only just to point out, however, that he possessed a didactic talent of the first order, which was the mainspring of many of his activities." (Lucie-Smith, 1988.†) This can be seen in several of his books, from *Pillar to Post* (1938), a solid introduction to European architecture, to *Sailing to Byzantium* (1969), a beautifully clear exposition of Byzantine architectural style. He wrote and illustrated two autobiographical volumes, *All Done from Memory* (1953), which has been described as "perhaps the most vivid of all accounts of the Wind-in-the-Willows England that perished in the First World War" (Boston, 1989†), and *With an Eye to the Future* (1967). In addition to his own books, he illustrated those of others, including the Folio Society's edition of *All's Well That Ends Well* (1963), illustrated with his designs for the 1953 Old Vic production, and *The Pleasure Garden* written by his second wife, Anne Scott-James, a distinguished journalist, writer, and authority on gardens. He designed book jackets for others, including P.G. Wodehouse, Evelyn Waugh and Anthony Powell.
Lancaster worked with John Piper* on the 250-yard main vista of the Festival Pleasure Gardens, done for the Festival of Britain

(1951). Following that collaboration, Piper suggested Lancaster as the designer for the ballet *Pineapple Poll* for the Sadler's Wells Ballet (1951), which was a great success. For the next twenty years, Lancaster received many invitations to work for the stage. He produced costumes and sets for plays, opera and ballet, and his successes include *Bonne Bouche* (1952), *The Rake's Progress* (1953), *High Spirits* (1953), *Don Pasquale* (1954), *Candide* (1959), *La Fille Mal Gardée* (1960) and *The Sorcerer* (1971). His flat colour paintings, with a sense of time and motion wittily suspended, a technique which he used in many book illustrations, were ideally suited to his theatre work. He also painted the mural "The Progress of Transport" for the foyer of the theatre of the Shell Centre on London's South Bank (1963).
Hon. FRIBA; CBE (1953); Kt. (1975); RDI (1979). He died in Chelsea on 27 July 1986.
Books illustrated include: N. Quennell: *The Epicure's Anthology* (1936); D. Villiers: *A Winter Firework* (GCP, 1936); V. Graham: *Say Please* (Harvill Press, 1951); S. Lambert: *London Night and Day* (1951); R. McKenney and R. Bransten: *Here's England* (Hart-Davis, 1951); C.N. Parkinson: *Parkinson's Law for the Pursuit of Progress* (1958), *Inlaws and Outlaws* (1962); N. Mitford: *The Water Beetle* (1962); W. Shakespeare: *All's Well That Ends Well* (Folio Society, 1963); C.N. Parkinson: *The Law and the Profits* (Murray, 1965); N. Dennis: *An Essay on Malta* (1972); N. Mitford: *Noblesse Oblige* (1973); M. Beerbohm: *Zuleika Dobson* (Shakespeare Head Press, 1975); Saki: *Short Stories* (Folio Society, 1976); A. Scott-James: *The Pleasure Garden* (Murray, 1977); Saki: *The Unbearable Bassington* (Folio Society, 1978); J. Betjeman: *An Oxford University Chest* (OUP, 1979); C.N. Parkinson: *The Law; or, Still in Progress* (Murray, 1979).
Books written and illustrated include (but see Lucie-Smith, 1988†): *Progress at Pelvis Bay* (Murray, 1936); *Our Sovereigns* (Murray, 1938); *Pillar to Post* (Murray, 1938); *Homes Sweet Homes* (Murray, 1938); *Pocket Cartoons* (1940-3); *Classical Landscape with Figures* (Murray, 1947); *More and More Productions* (Gryphon, 1948); *A Pocketful of Cartoons* (Gryphon, 1949); *Draynflete Revealed* (Murray, 1949); *Façades and Faces*

Osbert LANCASTER *Here, of All Places* (John Murray, 1959)

David LANGDON "Delivering a protest from Beijing over the Battle of Trafalgar Square" from *Punch* (13 April 1990)

(1950); *All Done from Memory* (Murray, 1953); Tableaux Vivants (Gryphon, 1955); *Private Views* (Gryphon, 1956); *Here of All Places* (Murray, 1959); *Graffiti* (Murray, 1964); *Fasten Your Safety Belts* (Murray, 1966); *With an Eye to the Future* (Murray, 1967); *Sailing to Byzantium* (Murray, 1969); *Liquid Assets* (1975); *A Cartoon History of Architecture* (1975); *Scene Changes* (Murray, 1978); *The Life and Times of Maudie Littlehampton* (Penguin, 1982).
Contrib: *The Ambassador; Architectural Review; Daily Express; Isis; Scottish Country Life; The Weekend Review.*
Exhib: Hanover Gallery; NPG (1973); Redfern Gallery (retrospective 1980).
Collns: V & A; Tate.
Bibl: Richard Boston: *Osbert: A Portrait of Osbert Lancaster* (Collins, 1989); Osbert Lancaster: *All Done from Memory* (Murray, 1963), *With an Eye to the Future* (Murray, 1967); Edward Lucie-Smith: *The Essential Osbert Lancaster* (Barrie & Jenkins, 1988); *Times* obit. (29/7/86); Amstutz 2; Bateman; Feaver; ICB2; Peppin; Tate; Waters; Who's Who.

LANGDON, David **b.1914**
Langdon was born in London on 24 February 1914 and educated at Davenant Grammar School and the London School of Economics, never studying art or design. He was first employed in an administrative position on the London County Council and published

some sketches in its staff journal. After a cartoon was accepted by *Time and Tide*, a number of sports cartoons produced for the *Sunday Referee*, and an advertising idea accepted by Shell, his career as an artist was launched.
He has drawn for many magazines and newspapers, and since 1937 has been a regular contributor to *Punch*, his cartoons usually based on a one-line joke. He uses mainly brush and ink for his cartoons, and line and gouache for his caricatures; he claimed to have invented the open mouth for cartoon characters. Langdon is not a great draughtsman but his drawing and his ideas are funny and have a long-lasting and almost universal appeal.
During WW2, Langdon served in the Royal Air Force and began to publish humorous books, such as *Home Front Lines* (1941). Since 1948 he has worked for the *Sunday Mirror* and contributed to the *New Yorker* since 1957. He was awarded the OBE in 1988.
Books illustrated include: C.H.W. Jackson: *It's a Piece of Cake* (1943); G. Mikes: *Little Cabbages* (1955), *The Best of Mikes* (with N. Bentley*; 1962); D. Rooke: *Let's Be Broad-Based* (Habe's Norfolk Broads Holidays, 1964), *Camper Beware!* (Hale, 1965); F. Trueman: *You Nearly Had Him That Time* (1968); B. Boothroyd: *Let's Move House* (1977); *You and Your Rights* (Reader's Digest, 1980).
Books written and illustrated include: *Home Front Lines* (Methuen, 1941).
Contrib: *Lilliput; New Yorker; Punch; Radio Times; Sunday Mirror; Time and Tide.*
Collns: University of Kent.
Bibl: Bradshaw; Peppin; Price.

David LANGDON "I thought it was tomorrow night you were on plain-clothes duty" from *Lilliput* (October 1939)

LANGLEY, Jonathan b.1952

Born in Lancaster, Langley studied at Lancaster College of Arts and Crafts (1970-71) and Liverpool College of Art (1971-74). He went on to take an M.A. in Graphic Design at the Central School of Art and Design and studied bookbinding at Camberwell School of Art. Since 1974 he has worked as a free-lance illustrator. His recent work includes illustrations for three Kipling "Just So" stories for Methuen.

Books illustrated include: F. Maschler: *Cooking Is a Way Round the World* (Kestrel, 1978); K. Grahame: *The Wind in the Willows* (Octopus Books, 1984); F. Baum: *The Wizard of Oz* (Octopus Books).

Exhib: Beetles.

Bibl: *The Illustrators: The British Art of Illustration 1800-1987* (Chris Beetles, 1987).

"LARRY"
See PARKES, Terence

LAWRENCE, John b.1933

Born on 15 September 1933 in Hastings, Sussex, Lawrence was educated in Oxford and studied art at Hastings School of Art (1951-53) and, after National Service in West Africa, at the Central School of Arts and Crafts (1955-57), where he learned wood engraving from Gertrude Hermes*. He taught part-time at Maidstone College of Art (1958-60), Brighton College of Art (1960-68) and at Camberwell School of Art since 1960.

Garrett declares that Lawrence has an "easily identifiable personality. [His] engravings are very busy and his wit and humour are essentially English. In some respects he is the Rowlandson of the twentieth-century engraving school. His engravings are tightly packed, highly charged and with the exact number of burin thrusts to make a salient form." (Garrett 1.) His first book illustrated by wood engravings, Defoe's *Colonel Jack* (1967), won a Francis Williams award for illustration. The twelve full-page illustrations are printed in two colours, and show an imaginative use of unusual perspective. For his own *Rabbit and Pork, Rhyming Talk* (1975), he used wood engravings with watercolour washes added. In a number of books, Lawrence engraves a large, full-page block, and then uses details from this to produce many small illustrations and decorations — *The Road to Canterbury* by Ian Serraillier (1979) is one of these.

One of Britain's most prolific illustrators, he uses many media. These may be separated into two groups, one of engravings on wood, vinyl or lino, and the other of autographic techniques, including pen and ink, watercolour and gouache. His pen and ink illustrations to *The Blue Fairy Book* (1975), though they lost some detail and delicacy in the printing, are nevertheless superb and add a new and enlightening commentary on the text. The delightfully funny and beautifully illustrated *George: His Elephant and Castle* (1983), which Lawrence wrote for children, is done in pen and wash, and well printed. A recent book, *Sketchbook Drawings* (1991), is filled not only with his delightful ink sketches done on various trips in Britain, Europe and the United States, but also with his comments on illustration and illustrators. Those artists he believes influenced him a great deal include John Minton*, Ardizzone* and Eric Ravilious*; but he also clearly admires artists such as Mervyn Peake*, Anthony Gross* and Charles Keeping*.

"Among his generation John Lawrence has achieved eminence in wood-engraving and book illustration; he is no less gifted — though less known — as a watercolour painter. He combines with this graphic talent a sensitivity to the written word and a historical perspective which enables him convincingly to set a text in its time and place. . . it is from the English countryside that he draws inspiration and renews his vitality and it is to the English tradition in illustration that he belongs." (Guy, 1983†).

Books illustrated include (but see Martin, 1989†): H. Burton: *A Book of Modern Short Stories* (OUP, 1959); *Black's Children's Encyclopaedia* (Black, 1961); A. McCarthy: *The Little Store on the Corner* (Abelard, 1962); J. Redmayne: *Redcoat Spy* (Macdonald, 1964); R. Sutcliff: *Redcoat Spy* (OUP, 1965); G. Butler: *South of the Zambesi* (Abelard, 1966); J. Onslow: *The Stumpfs* (Cape, 1966); D. Defoe: *Colonel Jack* (Folio Society, 1967); E. Vipont: *A Child of the Chapel Royal* (OUP, 1967); G. and W. Grossmith: *The Diary of*

John LAWRENCE *The Magic Apple Tree: A Country Year* by Susan Hill (Hamish Hamilton, 1982)

a Nobody (Folio Society, 1969); N. Freeling: *Kitchen Book* (Hamilton, 1970); L. Sterne: *Tristram Shandy* (Folio Society, 1970); J. Reeves: *Maildun the Voyager* (Hamilton, 1971); G. Avery: *Jemima and the Welsh Rabbit* (Hamilton, 1972); D. Defoe: *Robinson Crusoe* (Folio Society, 1972); A.F. Kinnet: *Rogues, Vagabonds and Sturdy Beggars* (Imprint Society, 1973); L. Garfield: *The Sound of Coaches* (Kestrel, 1974); A. Lang, ed. B.W. Alderson: *The Blue Fairy Book* (Kestrel, 1975); S. Sassoon: *Sherston's Progress* (Folio Society, 1975); R. Adams: *Watership Down* (Kestrel, 1976); M. Davidson: *Dragons and More* (Chatto, 1976); F. Nunez de Pinada y Bascunan: *The Happy Captive* (Folio Society, 1977); J. Clare: *The Shepherd's Calendar* (Paradine, 1978); T. Hardy: *Our Exploits at West Poley* (OUP, 1978); P. Theroux: *A Christmas Card* (Hamilton, 1978); I. Serraillier: *The Road to Canterbury* (Kestrel, 1979); P. Theroux: *London Snow* (limited ed., Russell, 1979; Hamilton, 1980); A. Ahlberg: *A Pair of Sinners* (Granada, 1980); Mrs. H. de la Pasture: *The Unlucky Family* (Folio Society, 1980); S. Marshall: *Everyman's Book of English Folk Tales* (Dent, 1981); S. Hill: *The Magic Apple Tree* (Hamilton, 1982); M. Berthoud: *Precisely Pig* (Collins, 1982); E. Robinson: *The Autobiographical Writings of John Clare* (OUP, 1983); G.M. Brown: *Christmas Poems* (Perpetua Press, 1984); A. Mitchell: *Nothingmas Day* (Allison & Busby, 1984); R. Adams: *A Nature Diary* (Viking, 1975); G.M. Brown: *Christmas Stories* (Perpetua, 1985); G. Chaucer: *The Canterbury Tales* (with others; Folio Society, 1986); J. B. Simpson: *Awful Annie and Perfect Percy* (MacRae, 1986); R. Edwards: *Whispers from a Wardrobe* (Lutterworth, 1987); P. Pearce: *Emily's Own Elephant* (MacRae,

1987); G.M. Brown: *Songs for St. Magnus Day* (Perpetua, 1988); W. Shakespeare: *The Merry Wives of Windsor; Twelfth Night* (Folio Society, 1988); D. Hendry: *Christmas in Exeter Street* (MacRae, 1989); J.B. Simpson: *Awful Annie and the Squeaking Chop* (MacRae, 1989); N. Philip: *A New Treasury of Poetry* (Blackie, 1990); R.L. Stevenson: *Treasure Island* (Guild Publishing, 1990); E. Waugh: *The Sword of Honour Trilogy* (Folio Society, 1990); *Memoir of Luke Hansard* (Fleece Press, 1990).

Books written and illustrated include: *The Giant of Grabbist* (Hamilton, 1968); *Pope Leo's Elephant* (Hamilton, 1969); *The King of the Peacocks* (Hamilton, 1970); *Rabbit and Pork: Rhyming Talk* (Hamilton, 1975); *Tongue Twisters* (Hamilton, 1976); *George, His Elephant and Castle* (Hardy, 1983); *Good Babies, Bad Babies* (Whittington Press, 1986; MacRae, 1987); *Sketchbook Drawings* (Previous Parrot Press, 1991).

Exhib: RE; SWE.

Collns: Ashmolean; Nat. Museum of Wales.

Bibl: Peter Guy: "The Wood-Engravings of John Lawrence", *Matrix* 3 (1983): 21-41; John Lawrence: *Sketchbook Drawings* (Previous Parrot Press, 1991); Douglas Martin: *The Telling Line: Essays on Fifteen Contemporary Book Illustrators* (MacRae, 1989); Folio 40; Garrett 1 & 2; Hodnett; ICB4; Peppin; Who; IFA.

Colour Plate 28

LAWSON, Carol Antell b.1946

Born on 23 February 1946 in Giggleswick, Yorkshire, Lawson studied at Harrogate College of Art, and at Brighton College of Art where she concentrated on illustration only in her last two terms. In 1969 she married illustrator Chris McEwan, and then spent two years in Paris, working mostly in advertising. On their return to England in 1971, Lawson continued as an illustrator and also taught illustration at Brighton College of Art. Her work as an illustrator seems to have ended in 1978.

Books illustrated include: C. Rush: *The Scarecrow* (Macmillan, 1968); J. Woodberry: *Little Black Swan* (Hamilton, 1970); G. Gifford: *Jenny and the Sheep Thieves* (Gollancz, 1975); T. Brading: *Pirates* (with others; Macdonald, 1976); D. Manley: *The Piccolo Holiday Book* (Pan, 1976); P. Street: *Colour in Animals* (Kestrel, 1977), *Poison in Animals* (Kestrel, 1978).

Bibl: ICB4; Peppin.

LAWSON, Frederick 1888-1963

Born on 9 October 1888 in Yeadon, near Leeds, Lawson studied at

Fred LAWSON "In a York street" from *Lapwings and Laverocks* by D. U. Ratcliffe (Country Life, 1934)

Leeds School of Art. A landscape painter, etcher and engraver, he exhibited in London and Glasgow. He illustrated books on Yorkshire with pen and ink drawings (*Folk Tales of Yorkshire*), watercolours (*Dale Dramas*) or in other media. *Lapwings and Laverocks* is a nice production, though the paintings are not reproduced as well as the black and white sketches, which are most attractive. He lived in Yorkshire all his life.

Books illustrated include: D.U. Ratcliffe: *Dale Dramas* (BH, 1923), *The Shoeing of Jerry-Go-Nimble* (BH, 1926), *Dale Folk* (BH, 1927), *Fairings* (BH, 1928), *Lillilows* (BH, 1931), *Lapwings and Laverocks* (Country Life, 1934), *Under T'Hawthorn* (Muller, 1946); H.L. Gee: *Folk Tales of Yorkshire* (Nelson, 1952).

Exhib: RA; RI; IS; GI.

Bibl: Peppin; Waters.

LEATHAM, Moyra b.1928

Born on 21 October 1928 in London, Leatham spent her childhood in Godalming, Surrey, and was educated at a boarding school in Wiltshire. She studied at Guildford School of Art, and had a particular interest in Oriental art. She has illustrated at least two books for children.

Books illustrated include: Fanchiotti: *Bow in the Cloud* (OUP, 1953); R. Guillot: *397th White Elephant* (OUP, 1954).

Bibl: ICB2.

LE CAIN, Errol John 1941-1989

Born on 5 March 1941 in Singapore, Le Cain was educated there, but had no formal art training. He travelled extensively through the Far East, living in India for five years; and his time there made him a committed member of a Buddhist organization in Britain. He moved to England and worked in advertising and film studios from 1956 (after Pearl and Dean had been impressed with his first animated film made with a borrowed camera when he was just fifteen), producing animation sequences for television and motion pictures, and became a free-lance designer in 1969. He designed sets for BBC television shows, and won awards for cartoons and graphics in drama.

In 1968 Le Cain published his first picture book, *King Arthur's Sword*, and he started on a new career as an illustrator. He is quoted in ICB4 as saying that his first book "made me aware of the scope and possibilities of children's book illustration, and now I am convinced this is the medium for me." He continued "The first task of an illustrator is to be in full sympathy with the writer. No matter how splendid and exciting the drawings may be, if they work against the story the picture book is a failure." He wrote and illustrated three books for children, but was apparently uncomfortable as an author, and most of his work was done for other writers. His most characteristic work may be found in the illustrations he made for traditional stories such as *Cinderella* (1972) and *The Twelve Dancing Princesses* (1978). His illustrations usually have much detail, and the colour is brilliant, with each page-opening showing his natural feeling for page design. He sometimes employed a decorative border which is reminiscent of the work of Kay Nielsen* and Edmund Dulac (see Houfe). After being runner-up twice for the Kate Greenaway Medal with *The Cabbage Princess* (1969) and *The Thorn Rose* (1975), he won with *Hiawatha's Childhood* in 1985. Le Cain died on 3 January 1989 after a long illness.

Books illustrated include: A. Davies: *Sir Orfeo* (Faber, 1970); W. de la Mare: *Rhymes and Verses* (Faber, 1970); *The Faber Book of Songs for Children* (Faber, 1970); R. Harris: *The Child in the Bamboo Grove* (Faber, 1971); *Cinderella* (Faber, 1971); H. Cresswell: *The Beachcombers* (Faber, 1971); R. Harris: *The King's White Elephant* (Faber, 1973); W. Golding: *Wigger* (Faber, 1974); R. Harris: *The Lotus and the Grail* (Faber, 1974), *The Flying Ship* (Faber, 1975); Brothers Grimm: *Thorn Rose* (Faber, 1975); W. Pater: *Cupid and Psyche* (Faber, 1977); B. Patten: *The Sly Cormorant* (Kestrel, 1977); *The Twelve Dancing Princesses* (Faber, 1978); R. Harris: *The Beauty and the Beast* (Faber, 1979); J. Riordan: *The Three Magic Gifts* (Kaye, 1980); A. Lang: *Aladdin* (Faber, 1981); W. de la Mare: *Molly Whuppie* (Faber, 1983); H.W. Longfellow: *Hiawatha's Childhood* (Faber, 1985); T.S. Eliot: *Growltiger's Last Stand* (Faber, 1986); R. Browning: *The Pied Piper of Hamelin* (Faber, 1988).

Books written and illustrated include: *King Arthur's Sword*

(Faber, 1968); *The Cabbage Princess* (Faber, 1969); *The White Cat* (Faber, 1973).
Bibl: *Times* obit., 6 January 1989; CA; ICB4; Peppin; Whalley.
Colour Plate 106

LEE, Alan **b.1947**
Born at Harrow, Middlesex, Lee studied at Ealing School of Art (1966-69), where he became interested in Celtic and Norse mythology. He has worked as a free-lance illustrator since 1970, achieving a great success with publication (with Brian Froud*) of *Faeries* (1978). By 1984 that book had sold 600,000 copies in nine languages, and its success allowed him to concentrate on illustrating *The Mabinogion* (1982). In 1982 he also illustrated the covers of the new Penguin edition of Mervyn Peake's* *Gormenghast* trilogy. He created the conceptual design for the film version of Terry Jones' *Eric the Viking*, and produced fifty illustrations for the Tolkien centenary edition of *The Lord of the Rings* (1991). He has had exhibitions of his work in San Francisco, Boston and London.
Books illustrated include: *The Mabinogion* (1982); D. Day: *Castles* (1984); M. Palin and R. Seymour: *The Mirrorstone* (Cape, 1986); P. Dickinson: *Merlin Dreams* (Gollancz, 1988); J.R.R. Tolkien: *The Lord of the Rings* (Grafton, 1991).
Books written and illustrated include: *Faeries* (with Brian Froud*; Souvenir Press, 1978).
Bibl: *The Illustrators: Catalogue* (Chris Beetles Ltd., 1991).

LEE, Joseph **fl.1930s-1950s**
Lee was born in Leeds and studied at Leeds College of Art and in 1919 by correspondence from Percy Bradshaw. He moved to London and worked in an advertising agency. Later he deputized for Strube* on the *Daily Express* and then became a general utility artist on the *Daily Mail*. For the *Mail* he invented "Pin-Money Myrtle", a comic strip which ran for several years, and did some political cartoons, sketching in the House of Commons. For many years he produced one cartoon a day for the *Evening News* and another for its allied group of newspapers which were published in the provinces.
Contrib: *Daily Express; Daily Mail; Evening News*.
Collns: University of Kent
Bibl: Bradshaw.

LEETE, Alfred Chew **1882-1933**
See Houfe
Born on 28 August 1882 in Thorpe Achurch, Northampton, the son of a farmer, Leete was educated at Weston-super-Mare Grammar School, and started work in printing when he was fifteen. He became a humorous illustrator and poster designer. A regular contributor to *Punch* from 1905 to his death in 1933, he also illustrated at least two books. He designed a few posters for the Underground Electric Railways, but he is best known for his recruiting poster design, "Your Country Needs You", with its pointing finger of Lord Kitchener. This started as the cover design for the 5 September 1914 issue of *London Opinion*, and Leete presented this design to the Imperial War Museum. The Parliamentary Recruiting Committee changed the words to read "Britons [Kitchener] wants you; join your country's army! God save the King" and issued it later in September 1914. It is still the best known war poster, and has been pirated for many uses totally unrelated to war. Leete died in London on 17 June 1933.
Books illustrated include: R. Arkell: *All the Rumours* (Duckworth, 1916), *The Bosch Book* (Duckworth, 1916).
Books written and illustrated include: *Schmidt the Spy* (Duckworth, 1916); *A Book of Dragons* (Illustrated Newspapers, 1931).
Contrib: *London Opinion; Pall Mall Gazette; Passing Show; Punch*.
Bibl: Joseph Darracott and Belinda Loftus: *First World War Posters* (Imperial War Museum, 1972); Bevis Hillier: *Posters* (Weidenfeld and Nicolson, 1969); Waters.

LEIGH, Stanley Howard **1909-1942**
Born on 16 July 1909, Leigh is best remembered as one of the earliest illustrators of the books for boys written by W.E. Johns*. Johns had separated from his wife in the early 1920s, and when he met Doris Leigh in 1924 soon set up house with her, and lived with her

for the rest of his life. S. Howard Leigh, her younger brother, made a name for himself early in his artistic career as an aviation illustrator. By the 1930s he was contributing covers to magazines like *Modern Boy* and in 1931 illustrated, with others, *The Modern Boys' Book of Aircraft*. Johns was an illustrator himself, but when he started writing adventure stories for boys — he wrote more than 150 books about "Biggles" and other characters — he used Leigh as his illustrator. Leigh continued in this capacity until his early death, of cancer, on 6 February 1942. He provided attractive and accurate colour frontispieces for many of the early Biggles books (often with Alfred Sindall* as a collaborating artist, making line drawings in the text).
Books illustrated include: W.E. Johns: *Fighting Planes and Aces* (John Hamilton, 1932), *The Spy Flyers* (Hamilton, 1933), *The Cruise of the Condor* (Hamilton, 1933), *Biggles of the Camel Squadron* (Hamilton, 1934) and at least sixteen more "Biggles" titles, some with Alfred Sindall*, *The Passing Show: A Garden Diary* (Newnes, 1937).
Contrib: *Modern Boy; Popular Flying*.
Bibl: Peter B. Ellis and Piers Williams: *By Jove, Biggles!* (W.H. Allen, 1981).

LEIGH-PEMBERTON, John **b.1911**
Born on 18 October 1911 in London, Leigh-Pemberton was educated at Eton and studied in London (1928-31). During WW2 he served as a flying instructor in the RAF and was awarded the AFC in 1945. He has done much advertising work for Shell, completed a series of paintings of natural history subjects for the Midland Bank, and decorated a number of ships. He has written and illustrated many books on natural history, mostly for children. His detailed coloured paintings are very similar to those done by Rowland Hilder* for the *Shell Guide to Flowers*.
Books illustrated include J. Moore: *Whitbread Craftsmen* (Whitbread, 1948); J. Laver: *Royal Progress* (Collins, 1953); G. Grigson: *The Shell Guide to Wild Life* (Phoenix House, 1959); S.A. Manning: *A Ladybird Book of Butterflies, Moths and Other Insects* (Wills & Hepworth, 1965); R. Fitter: *Britain's Wild-Life* (Kaye, 1966).
Books written and illustrated include: *The Ladybird Book of Sea and Estuary Birds* (Wills & Hepworth, 1967); *Big Animals* (Ladybird, 1975); *The Ladybird Colouring Book of Birds* (Ladybird, 1978); *The Ladybird Colouring Book of World Wild Life* (with B.H. Robinson; Ladybird, 1978); *Bears and Pandas* (Ladybird, 1979); *Hedges* (Ladybird, 1979).
Exhib: RA; ROI; NS.
Collns: National Maritime Museum; IWM.
Bibl: Who; Who's Who.
Colour Plate 107

LEIGHTON, Clare Veronica Hope **1899-1989**
Born in London, Leighton was the daughter of two popular writers. She was educated privately, and studied art at Brighton School of Art, at the Slade, and at the Central School, where she learned wood engraving from Noel Rooke*. A wood engraver, stained glass designer and writer, Leighton was elected SWE (1928); ARE (1932); and RE (1934); and a Fellow of the National Academy of Design (US). She moved to the United States with her parents in 1939, becoming a US citizen in 1945. In 1951 she went to live in New England, and won the New England Society of New York award for the greatest contribution to New England culture. She has won many prizes and awards in England and the US.
Although she has illustrated books with pencil and ink drawings, the large majority of her illustrations are wood engravings. Her subject is usually rural, often with figures prominently displayed and sometimes reminiscent of the engravers of the 1860s. Her books were done mostly for commercial presses, but many had the good fortune to be very well printed. The oblong folio volume, *The Farmer's Year*, written and illustrated by Leighton, published by Collins in 1933, contain probably her most ambitious wood engravings, with their intense blacks and fine white lines. In addition to book illustration, Leighton designed posters for the Empire Marketing Board and London Transport; has made many prints; has produced stained glass windows, including those done for St. Paul's Cathedral, Worcester, Massachusetts; and has engraved glassware

Lynton Lamb

Colour Plate 105. Lynton LAMB "The owl and the pussycat" Original drawing in pen and ink and watercolour Illustrated *Other Travellers* (Orion Line). By permission of Chris Beetles Limited

Colour Plate 106. Errol LE CAIN *Growltiger's Last Stand* by T. S. Eliot (Faber & Faber 1986)

Colour Plate 107. John LEIGH-PEMBERTON *Shell Guide to Wild Life* by Geoffrey Grigson (Phoenix House 1959)

Colour Plate 108. LEWITT-HIM *The Little Red Engine Gets a Name* by D. Ross (Faber & Faber 1942)

Colour Plate 109. John LORD — "A Visit to Bedsyde Manor", 1965 Guinness Gift Book. (By permission of Guinness Brewing G.B.)

Clare LEIGHTON *The Bridge of San Luis Rey* by Thornton Wilder (Longmans, Green, 1929)

for Steuben. Her manual on *Wood-Engraving and Woodcuts* (1932) is an excellent introduction to the subject and to the revival of wood engraving during the 1920s and 1930s. She died on 3 November 1989.

Books illustrated include (but see Leighton: *Growing New Roots* 1976†): M.F.B. Connor: *The Girl of Yellow Diamonds* (Pearson, 1920); W. Holtby: *Anderby Wold* (BH, 1923), *The Crowded Street* (BH, 1924); A.M. Mackenzie: *The Half Loaf* (Heinemann, 1925); I. Felix-Jones: *The Walking Voice* (Duckworth, 1926); T. Wilder: *The Angel That Troubled the Waters* (Longmans, 1927); A. Mulgan: *Home: A New Zealander's Adventure* (Longmans, 1927); R. Nathan: *The Fiddler in the Barley* (Heinemann, 1927); J. Auslander: *Letters to Women* (Harper, 1929); T. Hardy: *The Return of the Native* (Macmillan, 1929); T. Wilder: *The Bridge of San Luis Rey* (Longmans, 1929); H.C. Tomlinson: *The Sea and the Jungle* (Duckworth, 1930); E. Brontë: *Wuthering Heights* (Duckworth, 1931); E. Farjeon: *Perkin the Pedlar (Faber, 1932), Pannychis* (Shaftesbury: High House Press, 1933); C. Holme: *The Trumpet in the Dust* (Nicholson, 1934); T. Hardy: *Under the Greenwood Tree* (Macmillan, 1940); E. Symington: *By Light of Sun* (NY: Putnam's, 1941); B. Damon: *A Sense of Humus* (NY: Simon & Schuster, 1943); G. White: *Selborne* (Penguin Illustrated Classics; Penguin, 1941); E.M. Roberts: *The Time of Man* (NY: Viking, 1945); M. Campbell: *Folks Do Get Born* (NY: Rinehart, 1946); *The Book of Psalms* (NY: Doubleday, 1952); H. Plotz: *Imagination's Other Place* (NY: Crowell, 1955), *Untune the Sky* (NY: Crowell, 1957); M. Campbell: *Tales from the Cloud Walking Country* (Bloomington: Indiana University Press, 1958); E. Parker: *I Was Just Thinking*

(NY: Crowell, 1959); H. Thoreau: *Works* (four vols., NY: Crowell, 1961); E. Parker: *The Singing and the Gold* (NY: Crowell, 1962); H.R. Williamson: *The Flowering Hawthorn* (NY: Hawthorn Books, 1962); H. Plotz: *The Earth Is the Lord's* (NY: Crowell, 1965); T. Hardy: *The Pinnacled Tower* (NY: Macmillan, 1975).

Books written and illustrated include: *Woodcuts: Examples of the Work of Clare Leighton* (Longmans, 1930); *Wood-Engraving and Woodcuts* (Studio, 1932); *The Musical Box* (Gollancz, 1932); *The Wood That Came Back* (Nicholson, 1934); *Four Hedges* (Gollancz, 1935); *Country Matters* (Gollancz, 1937); *Sometime Never* (Gollancz, 1939); *Southern Harvest* (Gollancz, 1943); *Give Us This Day* (NY: Reynal & Hitchcock, 1943); *Tempestuous Petticoat* (Gollancz, 1948); *Where Land Meets Sea* (NY: Rinehart, 1954); *Growing New Roots* (San Francisco: Book Club of California, 1976).

Contrib: *London Mercury*.

Exhib: Boston Public Library.

Collns: BM; V & A; Baltimore Museum; Boston Museum of Fine Arts.

Bibl: Thomas Balston: *Wood-Engraving in Modern English Books* (National Book League, 1949); Martin Hardie: "The Wood-Engravings of Clare Leighton", *Print Collector's Quarterly* 22; Clare Leighton: *Growing New Roots: An Essay with Fourteen Wood Engravings* (San Francisco: Book Club of California, 1976); Garrett 1 & 2; Hodnett; ICB2; ICB3; ICB4; Jaffé; Peppin; *Shall We Join the Ladies?*; Who's Who.

LE MAIR, Henrietta Willebeek **1889-1966**
See Houfe

LEMAN, Martin **b.1934**
Born in London, Leman is a self-taught artist. His subject matter is almost entirely cats, which he depicts in full colour, highly-finished paintings.

Books illustrated include: A. Carter: *Comic and Curious Cats* (Gollancz, 1979); C. Pearson: *Book of Beasts* (Gollancz, 1980); J. Leman: *Martin Leman's Lovely Ladies* (Pelham, 1984).

Books written and illustrated include: *Martin Leman's Starcats* (Pelham, 1980); *Ten Cats and Their Tales* (Pelham, 1981); *Twelve Cats for Christmas* (Pelham, 1982); *The Perfect Cat Anthology* (with J. Leman; Pelham, 1983); *Cat's Companion* (with J. Leman; Pelham, 1986).

Published: *A World of Their Own: Twentieth-Century British Naïve Painters* (with J. Leman; Pelham, 1985).

LENDON, Warwick William **b.1883**
Born on 30 April 1883, Lendon was a painter and etcher of portraits and landscapes. Elected SGA (1925).

Contrib: *Punch; Sketch; Tatler*.

Books illustrated include: W.J. Locke: *A Christmas Mystery* (BH, 1922); G. West: *Jogging Round Majorca* (Alston Rivers, 1929).

Exhib: ROI; RP; NEAC; SGA.

Bibl: Waters.

LESLIE, Cecil Mary **1900-1980**
Born on 23 March 1900 in Wimbledon, Leslie studied at Heatherley's (1919), the London School of Photolithography and Engraving, and at the Central School of Arts and Crafts. She was a painter, sculptor, etcher and illustrator of children's books. Her illustrations are usually done in pen and ink, sometimes with colour added. She was particularly careful to depict periods and places as accurately as possible, and very conscious of the responsibility of the illustrator to reflect the author's plot and feeling.

Books illustrated include: R. Fyleman: *Jeremy Quince* (Cape, 1933), *The Princess Dances* (Dent, 1933); P. Clarke: *The Pekinese Princess* (Cape, 1948), *The Great Can* (Faber, 1952); H. Clare: *Five Dolls in a House* (and four other titles in series; BH, 1953-63), *Merlin's Magic* (BH, 1953); P. Clarke: *Smith's Hoard* (Faber, 1955), *Sandy the Sailor* (Hamilton, 1956), *The Boy with the Erpingham Hood* (Faber, 1956); J. Spyri: *Heidi* (Puffin, 1956); P. Clarke: *James the Policeman* (and three other titles in series; Hamilton, 1957); R. Garland: *The Country Bus* (Hamilton, 1958); E. Nesbit: *The Story of the Treasure Seekers* (Puffin, 1958), *The Would-Be-Goods* (Puffin, 1958); E. Kyle: *The Money Cat*

(Hamilton, 1958); R. Garland: *The Little Forest* (Hamilton, 1959); P. Clarke: *The Lord of the Castle* (Hamilton, 1960), *The Robin Hooders* (Faber, 1960), *Keep the Pot Boiling* (Faber, 1961), *The Twelve and the Genii* (Faber, 1962), *Crowds of Creatures* (Faber, 1964); E. Nesbit: *The Enchanted Castle* (Dent, 1964); A. Uttley: *The Sam Pig Story Book* (Faber, 1965); P. Clarke: *The Bonfire Party* (Hamilton, 1966).
Exhib: RA; RSA; RCamA; GI.
Bibl: Peppin; Waters.

LESLIE, Russell **fl. 1940s**
In the foreword to *Alpines I Have Grown*, Robert Gibbings* wrote "I know the work of all the leading wood-engravers in England today, and I believe that not one of them can engrave flowers like Russell Leslie." For the books by Sparrow, Leslie made four-colour autolithographed plates and book jackets (printed by W.S. Cowell), and black and white drawings in the text.
Books illustrated include: K. Sparrow: *Nature Rambles in Spring* (Evans, 1947), *Nature Rambles in Summer* (Evans, 1948).
Books written and illustrated include: *Alpines I Have Grown* (Drummond, 1940).

LEWIS, Percy Wyndham **1882-1957**
Born on 18 November 1882 on his father's yacht, near Amherst, Nova Scotia, Lewis was educated at Rugby School for two years only (1897-98), leaving to study at the Slade (1898-1901). For several years, he travelled in Europe, living mostly in Paris, and became a friend of Augustus John. He returned to England in 1909, became a professional painter, and was closely associated with various art movements. He exhibited in the Second Post-Impressionist Exhibition (1912); was an original member of the London Group (1913); formed the Rebel Art Centre with Wadsworth*, Etchells, and later William Roberts*. In 1914, he founded the Vorticist Movement, and edited its paper *Blast*. Meanwhile he was writing, his first stories having appeared in the *English Review* in 1909. During WW1 he first served with the Royal Artillery (1915-17) and then became an official war artist to the Canadian Corps Headquarters (1917-19). After the war, he exhibited widely, organized the Group X exhibition in 1920, and continued to write. He spent WW2 in North America; and then had two major retrospective exhibitions in England. He began to lose his sight in 1951, was totally blind by 1953, and died in London on 7 March 1957.
In his autobiographical study, Lewis describes himself as "a novelist, painter, sculptor, philosopher, draughtsman, critic, politician, journalist, essayist, pamphleteer, all rolled into one . . ." (Lewis, 1937.†) He was certainly one of the more important figures in the British art scene during the first half of the twentieth century. His work was strong and harsh, and his style abstract. His book illustrations started in 1914, when he produced a folio containing twenty remarkable drawings for *Timon of Athens*. He contributed drawings to the magazine *Blast*, and illustrated some of his own works. When his eyesight began to fail, his friend Michael Ayrton* designed book jackets and illustrated texts for him, including his *Human Age* (1955-56).
Books illustrated include: W. Shakespeare: *Timon of Athens* (Cube Press, 1914); N.M. Mitchison: *Beyond This Limit* (Cape, 1935).
Books written and illustrated include: *The Apes of God* (Arthur Press, 1930); *The Enemy of the Stars* (Harmsworth, 1932); *Thirty Personalities and a Self-Portrait* (Harmsworth, 1932); *Blasting and Bombardiering* (E & S, 1937).
Contrib: *Apple; Blast; Chapbook; Enemy; Tyro.*
Exhib: Retrospectives at Redfern Gallery (1949); Tate (1956); Manchester (1980).
Collns: Tate.
Bibl: Jane Farrington: *Wyndham Lewis: Catalogue of Exhibition at Manchester City Art Gallery* (Lund Humphries, 1980); Charles Handley-Read: *The Art of Wyndham Lewis* (Faber, 1951); Wyndham Lewis: *Blasting and Bombardiering* (Eyre & Spottiswoode, 1937); Jeffrey Meyers: *The Enemy: A Biography of Wyndham Lewis* (Routledge, 1980); *Word and Image I & II* (NBL, 1971); Compton; DNB; Harries; Peppin; Ross; Rothenstein; Tate.

LEWITT, Jan **b.1907**
Lewitt was born on 3 April 1907 in Czestochowa, Poland, and spent

his childhood there. He is a self-taught artist, achieved while working on a great variety of jobs. In 1933 he met George Him* in Warsaw when both had returned to Poland after years overseas, and they started working together. The Lewitt-Him collaboration continued after they both moved to London in 1937, and they designed posters (including some for the General Post Office and for Kia-Ora fruit drinks in the 1940s and 1950s), designed exhibitions, and illustrated books. Their greatest success is in the picture books for children which they produced. *The Football's Revolt* (1939) can be considered a landmark in illustration for children. It is remarkably inventive, with no pretence at realism, but the figures are vigorously drawn and the colour bright and attractive. Whalley notes various influences on their work, particularly surrealism and cubism, which is demonstrated in their illustrations by the flat, two-dimensional abstract shapes, often seen from a strange perspective. Lewitt only illustrated one book without Him, *The Vegetabull* (1956), which also shows the influence of cubism on his work. This book began "life" in 1943 as a poster designed by Lewitt-Him for the Ministry of Food, to encourage the British public during WW2 to substitute a vegetable meal for meat dishes.
Lewitt was a painter and graphic artist as well as an illustrator, and he exhibited widely in Europe and the US. The partnership with George Him was dissolved in the mid-1950s because Lewitt wished to concentrate on his painting. He has also designed costumes and scenery for Sadler's Wells Ballet, and produced tapestries, and worked in glass, becoming an honorary member of the Centro Internazionale delle Arti nel Vitro, Venice.
Books illustrated include (all with George Him*): J. Tuwim: *The Locomotive* (Faber, 1939); D. Ross: *The Little Red Engine Gets a Name* (Faber, 1942); A. Lewitt: *Blue Peter* (Faber, 1943), *Five Silly Cats* (Minerva, 1944).
Books written and illustrated include: *The Football's Revolt* (with Him; Country Life, 1939); *The Vegetabull* (Collins, 1956).
Bibl: Manuel Gasser: "Lewitt-Him", *Graphis* 14 (1946): 200-211; C.G. Tomrley: "Lewitt-Him", *Graphis* 48 (1953): 268-75; Amstutz 2; ICB; ICB2; Peppin; Whalley.
Colour Plate 108

LINDLEY, Kenneth Arthur **1928-1986**
Born on 28 June 1928 in Shepherds Bush, London, Lindley was educated at St. Clement Dane's Grammar School (1938-43). He studied art at Ealing School of Art under James Bostock* (1943-49) and then at Hornsey School of Art and Crafts under Arthur S. Mills and Norman Janes* (1949-50). He was appointed art lecturer at Loughborough College of Art (1950-57), and then at Swindon School of Art (1957-65). He was Head of Wakefield School of Art (1965-71) and since then was Principal of Herefordshire College of Art.
Lindley used a variety of processes for book illustration, including wood engraving, linocut, etching and his own photographs. He illustrated the writings of others but usually wrote and illustrated the books himself. Apart from his study of *The Woodblock Engravers* (David & Charles, 1970), he produced two types of book. The first type is based on his enjoyment of places and things, produced by commercial publishers for the general public and occasionally with a particular educational intent. These books include titles like *Urns and Angels*, *Chapels and Meetinghouses* and *Seaside Architecture*, and they are lavishly illustrated with his own drawings, engravings and photographs. The second kind of book is a production of his own Pointing Finger Press, written in verse or prose and printed with engravings or other relief prints on a small proofing press in his own home.
Lindley was elected MSIA (1950); ARE (1959); RE; SWE (1960).
Books illustrated include: M. Kantor: *Wicked Water* (Falcon Press, 1950), *But Look in the Morn* (Falcon Press, 1950); H.E. Carey: *One River* (Falcon Press, 1952); G.M. Hopkins: *Selected Poems* (Nonesuch Press, 1954); W. Nathan: *Gone Fishing* (Heinemann, 1960); J. Marshall: *Preparing for Marriage* (Darton, Longman and Todd, 1962); D. Burnett: *Shimabara Poem* (Hereford, Pointing Finger Press, 1970); G. Storhaug: *The Kilpeck Anthology* (1981); C. Milne: *The Windfall* (Methuen, 1985).
Books written and illustrated include (published by Pointing Finger Press unless indicated): *How To Explore Churches* (Educational Supply Assoc., 1953); *How To Explore Abbeys and Monas-*

teries (ESA, 1961); *A Sequence of Downs* (1962); *Town, Time and People* (Phoenix Press, 1962); *Urns and Angels* (1965); *Of Graves and Epitaphs* (Hutchinson, 1965); *Coastline* (Hutchinson, 1967); *Figures in a Landscape* (1967); *Black Riding* (1968); *Chapels and Meeting Houses* (Baker, 1969); *What It Looks Like* (Pergamon, 1969); *Nostalgia* (1970); *Coastwise* (1970); *Landscape and Buildings* (Pergamon, 1972); *Graves and Graveyards* (Routledge, 1972); *Seaside Architecture* (Hugh Evelyn, 1973); *The Flower and the Skull* (Hugh Evelyn, 1974); *Seamarks* (1974-75); *Seaside and the Seacoast* (Routledge, 1975); *Herefordshire Late Autumn* (1977); *A Hereford Window* (1979); *Border Incidents* (1983).

Contrib: *Architectural Review; Country Life; The Green Book.*

Published: *The Woodblock Engravers* (David & Charles, 1970).

Bibl: Reg Boulton: "A Delight of Places; the Wood-Engravings of Kenneth Lindley", *The Green Book* 1, 12 (1984), 9-11; Ray Hedger and Dennis Hall: "Kenneth Lindley and the Pointing Finger Press", *Matrix* 10 (Winter 1990): 8pp. after 180; CA; Garrett 1 & 2; Peppin; Who.

Kathleen LINDSLEY "February 1965" from *A Lakeland Diary* by Enid Wilson (Fleece Press, 1985)

LINDSLEY, Kathleen M. **b.1951**

Born in Gibraltar, Lindsley was educated in Australia, Singapore and England. She studied decorative arts, furniture and porcelain at Leeds Art School; and graduated in fine art from Newcastle where she started engraving with Leo Wyatt in 1975. At the same time, she learned printing with the Columbian press and wrote her dissertation on Edward Calvert. In 1978 she established the Struan Craft Workshop on the Isle of Skye, producing landscape watercolours as well as engravings. During the winter months, she prints her engravings at the Mill House Gallery, Edinburgh.

In 1982, Lindsley was commissioned by the Yorkshire brewers, Samuel Webster, to produce 250 wood engravings, to be enlarged into signs for their pubs. She had complete freedom in creating the designs as long as they were suggestive of the pubs' names. Some forty of these engravings were produced in book form in 1983 by the Whittington Press. Another book illustrated with her engravings appeared in 1985, also printed by the Whittington Press, but published by the Fleece Press in Wakefield — *A Lakeland Diary* by Enid Wilson, illustrated with ten engravings each from Lindsley and Edward Stamp.

Books illustrated include: *Seeing Oxford* (Oxford Books, 1982);

Pub Signs for Samuel Webster (Whittington Press, 1983); E. Wilson: *A Lakeland Diary* (with Edward Stamp; Fleece Press, 1985); *Adventures of John McAlpine* (Greenock: Black Pennell Press, 1985); *In the Highlands and Islands* (Faber, 1986); *Magnus' Saga* (Perpetua Press, 1987).

Bibl: Kathleen Lindsley: "Pub Signs for Samuel Webster", *Matrix*, no. 3 (Winter 1983): 105-12; Linda Saunders: "Kathleen M. Lindsley, Wood Engraver", *The Green Book*, 8 (Summer 1982): 4-5; Brett.

LISTER, Raymond George **b.1919**

Born on 28 March 1919 in Cambridge, Lister was educated at Cambridge High School, and at St. John's College, Cambridge. He studied illuminating privately under Albert Cousins, and oil painting at Cambridge School of Art. He entered the family firm of architectural metalworkers, becoming a director in 1940.

In the 1930s, Lister began to collect fine books, and after WW2 (during which he worked in munitions) he founded the Golden Head Press and experimented in producing well-made books on subjects of limited interest. A number of these books are illustrated by Lister, using a variety of media, including wood engraving and line drawing. The last book published under the Golden Head imprint was *Ardna Gashel* by Olive Cook, illustrated with engravings by Edwin Smith (1970), but Lister continued to produce very limited editions with his own illustrations under the Windmill House Press imprint.

A Fellow of Wolfson College, Cambridge (1975), and syndic of the Fitzwilliam Museum since 1980, Lister is a miniature painter, a wrought iron designer, and a writer of scholarly works on British artists. He has published monographs on British miniatures, silhouettes, decorative British ironwork, and on artists Edward Calvert, Samuel Palmer, William Blake and George Romney. He was elected ARMS (1946); RMS (1948); and was President RMS (1970-80).

Books illustrated include: *Virgil's Second Eclogue* (Golden Head Press, 1958); T. Moore: *The Song of Fionnuala and Nine Other Songs* (GHP, 1960); F. Warner: *Perennia* (GHP, 1962).

Books written and illustrated include: *The First Book of Theodosius* (Golden Head Press, 1962); *The Song of Theodosius* (GHP, 1963); *Gabha* (GHP, 1964); *Tao* (GHP, 1965); *Inrey* (GHP, 1967); *The Emblems of Theodosius* (GHP, 1969); *A Title to Phoebe* (Windmill House Press, 1972); *Apollo's Bird* (WHP, 1974); *For Love of Leda* (WHP, 1976); *Bergomask* (1982); *There Was a Star Danced* (1983).

Exhib: RMS; RCamA; RSA.

Bibl: Simon Lissim: *The Art of Raymond Lister* (Cambridge: John P. Gray, 1958); Raymond Lister: "The Golden Head Press", *Private Library* 5, no. 4 (October 1964): 62-69; Cynthia M. Morris: "Checklist of Golden Head Press Books 1964-70", *Private Library* 3rd s., 2, no. 4 (Winter 1979): 138-142; CA; Peppin; Waters; Who.

LLOYD, Errol **b.1943**

Born on 19 April 1943 in Jamaica, Lloyd was educated there at Munro College, before going to London in 1964 to study law at the University of London and the Council of Legal Education in London. He had however been interested in art as a boy, and gradually he became more involved in this area and became a professional painter. He started as an illustrator, working in full colour, when he was approached by Bodley Head to illustrate a series of books on West Indian children living in Britain. His first book, *My Brother Sean*, was highly commended for the Kate Greenaway Medal in 1973. He is one of the first illustrators to depict black children and black communities in a positive, un-stereotyped manner.

Books illustrated include: P. Breinburg: *My Brother Sean* (BH, 1973), *Doctor Sean* (BH, 1974), *Sean's Red Bike* (BH, 1975); H. Sherlock and D. Craig: *New Caribbean Readers* (Ginn, 1978); A. Walmsley & N. Caistor: *Facing the Sea* (Heinemann, 1986).

Books written and illustrated include: *Nini at Carnival* (BH, 1978); *Nini on Time* (BH, 1981); *Nandy's Bedtime* (BH, 1982).

Bibl: ICB4; Peppin; Whalley.

LODGE, Grace **fl. 1921-1961**

A rather uninspiring illustrator of children's books (including many written by Enid Blyton), Lodge began writing and illustrating her

own stories in the 1940s. She also contributed to several annuals, decorating with black and white drawings *Father Tuck's Annual* from 1922.

Books illustrated include: Mrs. H. Strang: *The Golden Wonder Book* (with others, 1921); E. Blyton: *Just Time for a Story* (1948), *Brer Rabbit Books* (eight vols., 1948-58), and at least eleven other titles; A. Adams: *The Boy Next Door* (1952).

Books written and illustrated include: *Three Friends and Chip* (Crowther, 1944); *Lucy's Adventures* (Hutchinson, 1945); *The Tiny Prince* (Hutchinson, 1946); *The Little Men of the Mountains* (Hutchinson, 1947); *Puddledock Farm* (Hutchinson, 1947); *The Hole in the Hedge* (Hutchinson, 1948); *Spring, Summer, Autumn, Winter* (RA Publishing, 1948); *The Marsh Princess* (Hutchinson, 1949); *Misty and the Magic Necklace* (Hutchinson, 1954); *My Picture Book of Animals* (Dean, 1961).
Contrib: *Father Tuck's Annual; Little People's Annual; Mrs. Strang's Annual for Children.*
Bibl: Peppin.

LOFTING, Hugh John **1886-1947**
Born on 14 January 1886 in Maidenhead, Berkshire, Lofting trained as an engineer, going to the US in 1904 to study at the Massachusetts Institute of Technology, finishing his studies at the London Polytechnic. He worked as a civil engineer in West Africa and South America, but he found this work incompatible and started to write stories and plays. In 1912 he settled in the US, and began to contribute humorous pieces to magazines. During WW1 Lofting joined the British army to fight in Flanders, and his letters home to his children told of a doctor who loved animals so much that he learned to talk with them. These letters developed into the "Doctor Dolittle" stories, the first of which was first published in the US in 1920 and later in England, where the books have remained extremely popular. His simple and undecorated black and white drawings illustrate the stories beautifully. *The Voyages of Doctor Dolittle* won the Newberry Medal in 1923.

A film titled *Doctor Dolittle* was produced in 1968, starring Rex Harrison, and to coincide with the interest this stimulated, *Dr. Dolittle: A Treasury* was published in the same year. This was a selection of episodes from the entire series and contained many pre-viously unpublished Lofting illustrations. He wrote and illustrated a number of other books besides the Dolittle series, some of which are picture books for small children. Towards the end of his life, he moved to California, where he died on 26 September 1947.

Books illustrated include: C. Asquith: *Sails of Gold* (with others, Jarrolds, 192?).
Books written and illustrated include (all published in England by Cape): *The Story of Doctor Dolittle* (1922); *The Voyages of Doctor Dolittle* (1923); *Doctor Dolittle's Post Office* (1924); *The Story of Mrs Tubbs* (1924); *Dr. Dolittle's Circus* (1925); *Porridge Poetry* (1925); *Dr. Dolittle's Zoo* (1926); *Dr. Dolittle's Caravan* (1927); *Dr. Dolittle's Garden* (1928); *Dr. Dolittle in the Moon* (1929); *Noisy Nora* (1929); *Gub Gub's Book* (1932); *Dr. Dolittle's Return* (1933); *Tommy, Tilly and Mrs. Tubbs* (1937); *Dr. Dolittle and the Secret Lake* (1949); *Doctor Dolittle and the Green Canary* (1951).
Bibl: Carpenter; Doyle; ICB; Peppin; Whalley.

LORD, Elyse **fl. 1920s**
A painter and etcher of figures and flowers, sometimes painting on silk. She illustrated a few books. Elected RI.
Books illustrated include: *The Arabian Nights.*
Exhib: RA; RSA.
Bibl: *Elyse Lord* (Masters of the Colour Print; Studio, 1927); Waters.

LORD, John Vernon **b.1939**
Born on 9 April 1939 in Glossop, Derbyshire, the son of a baker and a ship's hairdresser, Lord was educated at Rydal School, Colwyn Bay, North Wales (1948-56), and studied at Salford School of Art (1956-60), and at the Central School of Arts and Crafts (1960-61). He worked at various jobs, including being a postman and a factory worker, but since 1961 has been a free-lance book illustrator, accepting comissions covering a wide spectrum of work for books, magazines and advertising. Since the early 1970s he has devoted most of his illustration time to children's books, having collaborated with a number of established writers and having written and illustrated some of his own books. Throughout the 1980s he has worked exclusively in black and white, having completed more than 700 published drawings in pen and ink during the decade. *The Nonsense Verse of Edward Lear* (1984) and *Aesop's Fables* (1989) contain many detailed and imaginative pen illustrations. Other artists who influenced his work include André François, Gerard Hoffnung*, Paul Klee, Ronald Searle*, Saul Steinberg, and the Victorian engravers.

Since 1970 he has also had a full-time career in education at Brighton Polytechnic where he was Head of the Department of Visual Communication (1974-81), and was appointed Professor of Illustration in 1986. He was chairman of the Graphic Design Board of the Council for National Academic Awards (1978-81) and has been external examiner for many courses within Britain and Hong Kong.

He is married to Lorna Trevelyan and they have three daughters. Their home is in Ditchling, a village which lies below the northern slopes of the South Downs in Sussex.

Books illustrated include: S. Penn: *A Visit to Bedsyde Manor* (Guinness, 1965); J.K. Brierley: *Biology and the Social Crisis* (Heinemann, 1967); G. Barnard: *Success with English* (Penguin, 1968); L.F. Hurlong: *Adventures of Jaboti on the Amazon* (Abelard, 1968); R. Brown: *Reynard the Fox* (Abelard, 1969); J.K. Brierley: *A Natural History of Man* (Heinemann, 1970); J. Burroway: *The Truck on the Track* (Cape, 1970); A. Coates: *Dinosaurs Don't Die* (Longman, 1970); J.C. Harris: *The Adventures of Brer Rabbit* (BBC, 1972); R. Sutcliff: *Sword at Sunset* (Heron Books, 1975); C. Aiken: *Who's Zoo* (Cape, 1977); E. Lear: *The Nonsense Verse of Edward Lear* (Methuen, 1984); *Aesop's Fables* Cape, 1989); R. Craft: *The Song That Sings the Bird: Poems for Young Children* Collins, 1989).
Books written and illustrated include: *The Giant Jam Sandwich* (with J. Burroway; Cape, 1972); *The Runaway Rollerskate* (Cape, 1973); *Mr. Mead and His Garden* (Cape, 1974); *Miserable Aunt Bertha* (with Fay Maschler; Cape, 1980); *The Doodles and Diaries of John Lord* (Camberwell Press, 1986).
Exhib: British Drawing of the 20th Century, ICA (1966); NBL;

Hugh LOFTING "Why don't you drop in again soon? said the white mouse" from *Doctor Dolittle's Zoo* (Jonathan Cape, 1926)

John Vernon LORD *The Nonsense Verse of Edward Lear* (Jonathan Cape, 1984)

Minories, Colchester (1978); Museum of Modern Art, Oxford (1984); one man shows Gardner Arts Centre, Brighton (1971), and Brighton Festival (1985); jt. exhibition with Ralph Steadman* at Brighton Festival (1976).

Contrib: *Listener; Observer; New Society; Punch; Radio Times; Sunday Times.*
Bibl: CA; Peppin; IFA.
Colour Plate 109

LOW, Sir David Alexander Cecil **1891-1963**
See Houfe
Born on 7 April 1891 in Dunedin, New Zealand, Low was educated briefly at Christchurch Boys' High School and attended a local art school for a short period only. As a boy, English comics attracted him to caricature, and then old copies of *Punch* introduced him to Phil May and other artists, and encouraged him to try his hand at cartoons. He became the political cartoonist on the Christchurch *Spectator* and then in 1902 on the *Canterbury Times*. Following several years as the resident cartoonist on the Sydney *Bulletin* (1911-), where he was strongly influenced by such cartoonists as Will Dyson* and Norman Lindsay, he came to England in 1919 at the invitation of the London *Star* for which he worked from 1919 to 1927. He then joined the *Evening Standard* and began attacking Hitler in his cartoons as early as 1933. From 1950 to 1953 he worked for the *Daily Herald*, and for the *Manchester Guardian*

from 1953 to his death on 19 September 1963. He was knighted in 1962.

He had a strong interest in politics and a fierce belief in democracy. He produced his best work during WW2, and probably helped to form public opinion while reporting on events of the war. The stream of cartoons he produced made their own propaganda, but in addition he produced leaflets to be dropped over Germany and a few posters. Between 1941 and 1944 he broadcast monthly talks, many of which were reprinted in the *Listener*, and also wrote for the *New York Times*. In the 1930s he had invented the pompous and reactionary "Colonel Blimp", who became a national figure. During WW2 Blimp became a synonym for those who were responsible for military administrative incompetence and unthinking patriotism. Low thought that he had created merely a comic figure, but in his *Autobiography* (1956) he states that Blimp was "an object lesson in what can happen to a symbol." Later he produced the "Muzzler", a combination of Hitler and Mussolini.

Low also did portrait caricatures, drawing them for the *Leader*, fifty of which were published in his *Low's Company* (1952); and he contributed them occasionally to the *Guardian*.

Low was a brilliant draughtsman and possessed a subtle, analytical humour, which combined to produce a great number of splendid cartoons and caricatures. For his mature work, he used mostly pencil and wash.

Books illustrated include: G. Taylor: *With Scott — The Silver*

Lining (Smith Elder, 1916); J. Adderley: *Old Seed on New Ground* (Putnam, 1920); F.W. Thomas: *Low and I: A Cooked Tour in London* (Methuen, 1923), *The Low and I Holiday Book* (Daily News, 1925); 'Lynx' i.e. (R. West): *Lions and Lambs* (Cape, 1928); D.J. Hopkins: *Hop of the Bulletin* (Sydney: A & R, 1929); H.G. Wells: *The Autocracy of Mr. Parham* (Heinemann, 1930); R. Strauss: *A Whip for the Woman* (C & H, 1931); K. Martin: *Low's Russian Sketchbook* (Gollancz, 1932); H. Thorogood: *Low and Terry* (Hutchinson, 1934); R. West: *The Modern Rake's Progress* (Hutchinson, 1934); Q. Howe: *A Cartoon History of Our Time* (NY: Simon & Schuster, 1939); P. Fleming: *The Flying Visit* (Cape, 1940).

Books written and illustrated include: *Low's Annual* (1908); *Caricatures* (Sydney: Tyrrell, 1915); *The Billy Book* (Sydney: Bookstall, 1918); *Lloyd George & Co.* (Allen & Unwin, 1921); *Man, the Lord of Creation* (Putnam, 1921); *Sketches by Low* (New Statesman, 1926); *The Best of Low* (Cape, 1930); *Caricatures by Low* (New Statesman, 1933); *Ye Madde Designer* (Studio, 1935); *Low's Political Parade* (Cresset Press, 1936); *This England* (New Statesman, 1937); *Low Again* (Cresset Press, 1938); *This England* (New Statesman, 1940); *Europe Since Versailles* (Penguin, 1940); *Europe at War* (Penguin, 1941); *Low on the War: A Cartoon Commentary of the Years 1939-41)* (New York: Simon & Schuster, 1941); *Low's War Cartoons* (Cresset Press, 1941); *The World at War* (Penguin, 1941); *C'Est la Guerre* (New Europe Publishing, 1945); *Valka Zacalka Mnichovem* (New Europe Publishing, 1945); *13 Jahre Weltgeschehen* (Zurich: Atlantis, 1946); *Lows Kleine Weltgeschichte* (Rowohlt, 1949); *Years of Wrath: A Cartoon History of 1932-45* (Gollancz, 1949); *Low's Company* (Methuen, 1952); *Low's Visibility: A Cartoon History 1945-53* (Collins, 1953); *Low's Autobiography* (Joseph, 1956); *The Fearful Fifties: A History of a Decade* (BH, 1960).

Published: *British Cartoonist, Caricaturists and Comic Artists* (Britain in Pictures; Collins, 1942).

Contrib: *Canterbury Times; Daily Herald; Evening Standard; Leader; Listener; Manchester Guardian; New Statesman; Punch; Saturday Book; Spectator (NZ); Star; Sydney Bulletin.*

Exhib: NPG.

Collns: Alexander Turnbull Library (NZ); Australian National Library; NPG; New Zealand High Commission, London; State Library NSW; University of Kent.

Bibl: *Beaverbrook's England 1940-1965: An Exhibition of Cartoon Originals* (Centre for the Study of Cartoons and Caricature, University of Kent, 1981); David Low: *Low's Autobiography*

(Joseph, 1956); Peter Mellini: "Colonel Blimp's England", *History Today* 34 (October 1984): 30-37; Colin Seymour-Ure and Jim Schoff: *David Low* (Secker & Warburg, 1985); Lawrence H. Streicher: "David Low and the Sociology of Caricature", *Comparative Studies in Society and History* 8 (1965-66): 1-15; H.R. Westwood: *Modern Caricaturists* (Lovat Dickson, 1932); Bradshaw; DNB; Feaver; Peppin; Waters.

LOWINSKY, Thomas Edmond **1892-1947**
See Houfe

Born on 2 March 1892 in India, Lowinsky returned to England with his family while still a small child. He was educated at Eton College (1906-09) and read English for one year at Trinity College, Oxford (1911). He studied at the Slade (1912-14) where he met his wife-to-be, Ruth Hirsch, and then served in the army in France and Germany during WW1. He painted scenes from history and myth which show the influence of both surrealism and romanticism; and

Thomas LOWINSKY *Paradise Regained* by John Milton (The Fleuron, 1924)

"NOW LET US SEE YOU UNLOCK IT"

David LOW *The Fearful Fifties* (Bodley Head, 1960)

he designed for the theatre. As a portrait and figure painter, he exhibited with the NEAC, and had his first one-artist show (held jointly with Albert Rutherston*) at the Leicester Galleries in 1926. With Harold Curwen, Oliver Simon, Joseph Thorpe, Paul Nash*, and Albert Rutherston*, Lowinsky was a founder-member of the Double Crown Club, established in 1924 partly to provide a forum for discussion of the art of the book. He produced at least two pattern papers for the Curwen Press in 1928, though they were not pro-

duced until after WW2; and he illustrated or decorated a few books, including four commissions from the Shakespeare Head Press and the Nonesuch Press. Francis Meynell wrote that "Lowinsky had what one might call a proud subordination. He was completely convinced that 'the book's the thing'; and he rejoiced in the discipline of making his line suit exactly the 'colour' of the type with which it was to be associated, and of making his shapes suit the page." (Dreyfus, 1981.†) His illustrations were done in pen and ink, with cross-hatching, and sometimes by coloured woodcuts. Probably his best work was the line drawings he did for *Paradise Regained* (Fleuron, 1924), for which he produced three imaginative illustrations in addition to his usual decorations; and the fourteen fashion plates he did for *Modern Nymphs* in 1930.
Elected NEAC (1926). He died in London on 24 April 1947.
Books illustrated include: W. Shakespeare: *The Merchant of Venice* (Benn, 1923); J. Milton: *Paradise Regained* (Fleuron, 1924); M. Drayton: *Ballad of Agincourt* (Shakespeare Head Press, 1926); W. Meinhold: *Sidonia the Sorceress* (Benn, 1926); *The Rubaiyat of Omar Khayyam* (Shakespeare Head Press, 1926); E. Sitwell: *Elegy on Dead Fashion* (Duckworth, 1926); S. Sitwell: *Dr. Donne and Gargantua* (1926), *Exalt the Eglantine* (Fleuron, 1926); F. de Voltaire: *The Princess of Babylon* (Nonesuch Press, 1928); *Plutarch's Lives* (Blackwell, 1928); R. Mortimer: *Modern Nymphs* (Etchells, 1930); R.B. Sheridan: *The School for Scandal* (Blackwell, 1930); R. Lowinsky: *Lovely Food* (Nonesuch Press, 1931); J. Laver: *Ladies' Mistakes* (Nonesuch Press, 1933); R. Lowinsky: *More Lovely Food* (Nonesuch Press, 1935), *What's Cooking?* (Secker, 1945).
Exhib: RA; NEAC; Glasgow; Leicester Galls. (1926); Graves Art Gallery, Sheffield (retrospective 1981); Tate (retrospective 1990).
Collns: Fitzwilliam; Tate; V & A.
Bibl: Monica Bohm-Duche: *Thomas Lowinsky* (Tate, 1990); John Dreyfus: *A History of the Nonesuch Press* (Nonesuch Press, 1981); Hodnett; Peppin; Waters.

LUBBOCK, Joe G. **fl. 1967-**
J.G. Lubbock took an engineering degree at Cambridge and worked on the development of the Spitfire fighter airplane and then, with Barnes Wallis, on the Wellington bomber. During WW2 he served in the Royal Engineers and after the war studied at Heatherley's and St Martin's School of Art. He returned to industry, working on computers and guided missiles, before retiring to produce limited edition books filled with his hand-coloured prints. The artist has described his technique in producing the prints as follows: "The prints are hand-made . . . from copper plates worked by engraving, etching, aquatint and soft-ground etching. The colours are applied from intaglio and relief, and additional colours are added by hand to some pages after printing."
Lubbock prints the plates himself; the texts are printed by the Rampant Lions Press in Cambridge, apart from the first book, *Art and the Spiritual Life* (1967), which was printed at the Stellar Press. Colin Franklin has declared that "His are extraordinary and visionary books. Nobody has steered his course in taking on the universe — for that is the theme, nothing less." (Franklin, 1979.†)
Books written and illustrated include: *Art and the Spiritual Life* (Leicester: Twelve by Eight Press, 1967); *Aspects of Art and Science* (Leicester: Twelve by Eight Press, 1969); *Reflections from the Sea* (1971); *Light and the Mind's Eye* (Rota, 1974); *Perceptions of the Earth* (Rota, 1977); *From Garden to Galaxy* (1980); *The Sphere of Rocks and Water* (Rota, 1983); *From the Snows to the Seas* (Rota, 1986); *Love for the Earth* (Rota, 1990).
Bibl: David Chambers: *Private Library*, 3rd series, 7, (Summer 1984): 50; Colin Franklin: *Fine Print* 3 (1979); *The Rampant Lions Press* (Cambridge: Rampant Lions Press, 1982).

LUMLEY, Savile **fl. 1910-1950**
An illustrator of children's books in black and white, and a prolific contributor to magazines and annuals, for which he produced line drawings, halftones and colour plates. He is best known, however, for his WW1 recruitment poster, "Daddy, What Did YOU Do in the War?"
Books illustrated include: E. Everett-Green: *A Disputed Heritage* (1911); C. Heward: *Chappie and Others* (Warne, 1926); R.L. Stevenson: *The Black Arrow* (1949); M. England: *Warne's Happy*

Book for Girls (Warne, nd); H. Strang: *The Big Book for Boys* (with others; nd); *Selfridge's Schoolboys' Story Book* (with others; nd).
Contrib: BOP; Champion Annual; Chatterbox; Chums; Little Folk; Nelson Lee; Printer's Pie' Scout; Schoolfriend Annual; Schoolgirl's Own Annual; Young England.
Bibl: Bevis Hillier: *Posters* (Weidenfeld and Nicolson, 1969); Doyle BWI; Peppin.

Jane LYDBURY *The Norse Myths* retold by Kevin Crossley-Holland (Folio Society, 1989)

LYDBURY, Jane Sarah **b.1953**
Born in London, Lydbury was educated at Newnham College, Cambridge (1972-75), and studied graphic design at Camberwell School of Arts and Crafts (1979-81), where she was taught wood engraving by John Lawrence*. She has been a free-lance illustrator and printmaker since 1982, doing a year of postgraduate studies at the Camberwell Press. Lawrence has been a lasting influence, and her career has been actively supported by Eileen Hogan, a painter and the Dean of the Camberwell School. Other sources of inspiration are medieval art, especially book illumination, and 17th century literature. Her illustrations are frequently wood engravings or vinyl engravings. She has illustrated a number of book jackets. Member of the Greenwich Printmakers Association, and SWE.
Books illustrated include: M. Doney: *Goodnight Stories* (Piccolo

Books, 1982); *The Oxford Book of Christmas Poems* (with others, OUP, 1983); V. Alcock: *Ghostly Companions* (Methuen, 1984); *A Light in the Dark* (BBC, 1984); E. Heslewood: *Earth, Air, Fire & Water* (OUP, 1985); J. Donne: *Mud Walls* (Wakefield: Fleece Press, 1986); *The Shorter Mrs. Beeton* (with others; Ward Lock, 1987); D. Swann: *Puddings and Desserts* (Guinness Superlatives, 1987), *Soups and Starters* (Guinness, 1987); R. Blanc: *Recipes from Le Manoir aux Quat' Saisons* (with others, Macdonald, 1988); E. Poston and M. Williamson: *A Book of Christmas Carols (Simon & Schuster, 1988); K. Crossley-Holland: The Norse Myths (Folio Society, 1989); W. Shakespeare: The Sonnets; A Lover's Complaint (Folio Society, 1989).*

Books written and illustrated include: *This Solid Globe* (Camberwell Press, 1984).

Exhib: SWE; Greenwich Printmakers Gallery.

Bibl: IFA.

LYNE, (Charles Edward) Michael　　　　　　**1912-1989**

Born on 12 September 1912 at Upton Bishop, Herefordshire, Lyne studied at Cheltenham School of Art. An artist in oils and watercolour, he has illustrated some forty books on horses.

Books illustrated include (but see Titley): H. Baron: *Martin Claims Damages* (Country Life, 1937); S. Lynch: *Rhymes of an Irish Huntsman* (Country Life, 1937); F. Pitt: *Hounds, Horses and Hunting* (Country Life, 1948); H. Wynmalen: *Riding for Children* (Puffin Picture Book #82; Penguin, 1949); G.T. Burrows: *Gentleman Charles: A History of Foxhunting* (Vinton, 1951); M.C. Self: *A Treasury of Horse Stories* (Hutchinson, 1953), *A Second Treasury of Horse Stories* (Hutchinson, 1954); H. Wynmalen: *The Horse in Action* (Burke, 1954); C. Heber-Percy: *Hym: The Life Story of a Famous Fox* (Faber, 1959), *While Others Sleep* (Faber, 1962), *Us Four* (Faber, 1963); H.M. Peel: *Easter the Showjumper* (Harrap, 1965); R.S. Summerhays and S. Walker: *The Controversial Horse* (1966); D. Moore: *In Nimrod's Footsteps* (1974); D. Williams: *Lost* (1974); J.K. Stanford: *The Horsemasters* (1975); R. Grant-Rennick: *Coursing* (with others; Standfast Press, 1976); S.A. Walker: *Enamoured of an Ass: A Donkey Anthology* (A & R, 1977); T. Bishop: *Horses, Hounds and the Odd Stag* (with Brian Rowling; Standfast Press, 1979); S. Newsham: *The Hunting Diaries of Stanley Barker* (Standfast Press, 1981).

Books written and illustrated include: *Horses, Hounds and Country* (E & S, 1938); *From Litter to Later On* (Standfast Press, 1973); *A Parson's Son: Sporting Artist* (1974); *The Michael Lyne Sketchbook* (Standfast Press, 1979).

Contrib: *Country Life; Horse & Hound*.

Exhib: Frost and Reed's Gallery; Christopher Wade Gallery; National Museum of Sport, NY.

Bibl: Titley; Waters; Who.

MACARTHUR, Molly
See ANDERSON, Florence Mary

MACAULAY, David Alexander b.1946
Born on 2 December 1946 in Burton-on-Trent, Macaulay spent the first ten years of his life in England, and then moved to the US, and studied at Rhode Island School of Design. As an illustrator, he is best known for his detailed drawings of buildings and other constructions with pencil and pen. His first book, *Cathedral* (1973 US), a superbly illustrated story of the planning and construction in the Middle Ages which became a bestseller worldwide, won many honours, including a listing in the *New York Times* Best Illustrated Books of the Year (1973), and was a Caldecott Honor Book in 1974. *The Way Things Work* (1988), with his funny but practical drawings which feature a woolly mammoth to explain his subjects, was a huge success. He has illustrated a few books by other writers, and has written a number of books for younger children, including *Why the Chicken Crossed the Road*, which is a funny foray into cause and effect.

His books are normally published first in the US, or published simultaneously in Britain and the US. He is quoted thus "I use pictures to communicate my subject matter because pictures do it best. I rely on words only to tie it all together. This doesn't mean that I automatically, or even intentionally, create books for children." (ICB4)
Books illustrated include: *Amazing Brain*; *Baaa*.
Books written and illustrated include: *Cathedral* (Collins, 1974); *City: A Story of Roman Planning and Construction* (Collins, 1975); *Pyramid* (Collins, 1975); *Underground (Collins, 1978)*; *Unbuilding*; *Mill (Collins, 1984)*; *Motel of Mysteries*; *Great Moments in Architecture*; *The Way Things Work* (Dorling Kindersley, 1988); *Why the Chicken Crossed the Road (Harper Collins, 1991)*.
Bibl: ICB4.

MCCONNELL, Jeanie fl. 1920s
McConnell produced some delicately coloured illustrations for several books for children by Daisy Sewell.

Haldane MACFALL *The Splendid Wayfaring* (Simpkin, Marshall, 1913)

Books illustrated include: D. Sewell: *Visions in Fairyland* (Allinson, 1927), *About Fairies and Other Important People* (Allinson, 1928), *A Pilgrimage in Fairyland* (Allinson, 1928).

MACDONALD, Alister K. fl. 1898-1947
See Houfe
Best known as an illustrator in the *Tatler*, Macdonald contributed pen or pencil drawings to a number of other magazines. He also illustrated some collections of stories and poems for children with bright colour plates.
Books illustrated include: C. Asquith: *The Silver Ship* (with others; Putnams, 1926), *The Treasure Ship* (with others; 1926), *Sails of Gold* (with others; 1927), *The Children's Cargo* (with others; 1930); A. Armstrong: *The Naughty Princess* (1945).
Contrib: *Cassell's Magazine; Holly Leaves; ILN; Longbow; Nash's Magazine; Pearsons; Printers' Pie; Sketch; Strand; Tatler*.
Colour Plate 110

MACDONALD, R.J. d.1955
Macdonald started illustrating stories in comics such as *Marvel, Pluck* and *Magnet* from the 1890s. In 1909, he did his first illustration for Frank Richards' "St. Jim's" stories in *Gem*; and took over as the major illustrator after the death of Warwick Reynolds*.

He was the longest running artist on *Gem*, working continuously on the paper until it ceased publication in 1939, except for his years of service during WW1 (1916-19). He illustrated the first seventeen books by Richards about "Billy Bunter and the Greyfriars School" when they were published as books, first by Charles Skilton and from 1952 by Cassell. After his death in 1955, C.H. Chapman*, the regular illustrator of "Bunter" in the *Magnet*, took over as the book illustrator.

Books illustrated include: F. Richards: *Billy Bunter of Greyfriars School* (Skilton, 1947), and sixteen others, ending with *Billy Bunter's Double* (Cassell, 1955).

Contrib: *Gem; Magnet; Marvel; Nelson Lee; Pluck; Wonderland Annual*.

Bibl: Mary Cadogan: *Frank Richards: The Chap Behind the Chums* (Viking, 1988); Doyle BWI; Peppin.

Haldane MACFALL "Mermaid" from *The Apple* (1920 4th quarter) p.265

MACFALL, [Chambers] Haldane [Cooke] 1860-1928
See Houfe
Books illustrated include: E.E. Fisk: *Persuasions to Joy: An Anthology of Elizabethan Love Lyrics* (NY: Doran, 1926).
Books written and illustrated include: *The Splendid Wayfaring* (with C.L. Fraser*, Gaudier-Brzeska, E.G. Craig*; Simpkin, 1913); (by Ford O. Bludde, pseud.) *The Perfect Lady* (Southampton: Camelot Press; Simpkin Marshall, 1926); *Songs of the Immortals* (Jack, 1927); *Songs of Honour and Marching Lilts* (Jack, 1927).
Published: *The Book of Lovat* (Dent, 1923); *Some Thoughts on the Art of Eileen Soper* (Dickens, 1924); *Aubrey Beardsley* (BH, 1928).

MCGILL, Donald Fraser Gould 1875-1962
A forebear of McGill had founded McGill University in Montreal, Canada, and McGill's grandfather had held senior positions in the university, was president of the Bank of Montreal and Mayor of Montreal (1840-42). McGill's father was born in Montreal, served for a while in the Indian Army, and then returned to live in Blackheath. Donald McGill was born in Blackheath on 28 January 1875 and was educated at Blackheath Preparatory School. He intended to make his career in sports, but this was made impossible because, when he was just seventeen, his left foot had to be amputated. He started work as a draughtsman in a naval architect's

office, and while there (in 1900) married Florence Hurley, his superior in height, who was the daughter of a music-hall proprietor. He began producing comic drawings for his own enjoyment which were seen by a German, Joseph Asher, who recognized their commercial possibilities and arranged their production in Germany as postcards (1905). McGill is now renowned for his cheeky postcards, many featuring seaside "scenes", which include short pieces of dialogue invariably laced with *double entendre*. Tens of millions of these postcards were sold during his lifetime, and the originals are now energetically sought after by collectors. Despite this success, when he died on 13 October 1962, McGill left only a modest amount of money (though the *Evening Standard* reported that he "had made his own arrangements with his grandchildren").
Bibl: *The Illustrators: Catalogue* (Chris Beetles Ltd., 1991); Arthur Calder-Marshall: *Wish You Were Here: The Art of Donald McGill* (Hutchinson, 1966); Richard Carline: *Pictures in the Post* (Fraser, 1959); George Orwell: "The Art of Donald McGill", *Horizon* (September 1941).

MCGLASHAN, JOHN
SEE GLASHAN, JOHN

MACGREGOR, Miriam b.1935
Born in Shillong, Assam, India, Macgregor came to England in 1945 and was educated at a boarding school on the Isle of Wight. She studied at Hastings School of Art (1951) — where John Lawrence*, a fellow student, encouraged Macgregor in wood engraving — and Guildford School of Art (1952-56). She worked for an advertising agency as a typographer, and then went to work for the publishers, B.T. Batsford, where she ran the art department, being responsible for typography, book jackets and advertising display. She was with Batsford from 1957 to 1969, with a year out when she travelled to Southern Rhodesia and Kenya, and a short time in 1966 when she worked for Hutchinsons.
After leaving Batsford, she free lanced for them for a few years and started wood engraving. Some of her earlier work was done with pen and ink, such as the illustrations for *London Pubs* (1962). In 1977, she began to work as part-time compositor, layout artist and printer for the Whittington Press, in Andoversford, Gloucestershire. Since then, Macgregor has written and illustrated books with wood engravings, prepared marbled paper, and continues to help with the actual printing. John Randle, the joint owner of the Whittington Press (with his wife, Rosalind) has been an important influence on the life and work of Macgregor. The Press has produced some magnificent and important books, and has been of considerable significance in arousing and maintaining interest in wood engraving in Britain in the 1970s and 1980s. Macgregor was elected SWE.
Books illustrated include: A. Reeve-Jones: *London Pubs* (Batsford, 1962), *Sussex Pubs*; J. Turner: *Cotswold Days* (Whittington Press, 1977); N. Petrova: *Russian Cookery* (Batsford, 1979); K. Thomas: *West Country Cookery* (Batsford, 1979); J. Turner: *Other Days* (Whittington, 1979); O. Goldsmith: *The Deserted Village* (Rampant Lions Press, 1980); P.J. Kavanagh: *Real Sky* (Whittington, 1980); L. Clark: *An Intimate Landscape* (Nottingham Court Press, 1981); J. Turner: *Lost Days* (Whittington, 1981); B. Mawdesley: *Song of the Scythe* (Whittington, 1983); R.P. Lister: *Allotments* (Whittington, 1985).
Books written and illustrated include: *Heads, Bodies and Legs: A Book of Country Chaos* (Whittington, 1980); *Weeds in My Garden* (Whittington, 1986).
Exhib: SWE; King Street Gallery; Parade Gallery, Cheltenham.
Bibl: Jaffé; Brett; IFA.
See illustration on page 304

MCGUINNESS, Norah 1901-1980
Born in Derry, Northern Ireland, McGuinness studied at Dublin Metropolitan School of Art, the Chelsea Polytechnic, and in Paris. A figurative painter in oil and gouache, she also designed for the theatre in Dublin, and illustrated a few books in black and white.
Books illustrated include: L. Sterne: *A Sentimental Journey* (Macmillan, 1926); W.B. Yeats: *Stories of Red Hanrahan* (Macmillan, 1927); M. Edgeworth: *The Most Unfortunate Day of My Life* (1931); E. O'Faolain: *Miss Pennyfeather and the Pooka* (Clonskeagh: Browne & Nolan, 1944); E. Bowen: *The Shelbourne* (1951);

Colour Plate 110. A.K. MACDONALD *The Silver Ship* edited by Cynthia Asquith (Putnams 1926)

Colour Plates 111 to 113. James MARSH Covers for *The Boarding House* (1983); *The Love Department* (1981); *Other People's Worlds* (1982) all by William Trevor (Penguin Books)

Colour Plate 114. Enid MARX Cover for *Early British Railways* (King Penguin 56, 1950)

KING PENGUIN

THE LOVE
DEPARTMENT
William Trevor

KING PENGUIN

OTHER PEOPLE'S
WORLDS
William Trevor

KING PENGUIN

THE
BOARDING HOUSE
William Trevor

*Early
British Railways*

A KING PENGUIN BOOK

WIGAN BRANCH
RAILWAY.
1830

Miriam MACGREGOR *Song of the Scythe* by
Bruce Mawdesley (Whittington Press, 1983)

Norah MCGUINNESS *The Stories of Red Hanrahan and the
Secret Rose* by W.B. Yeats (Macmillan, 1927)

E. Hamilton: *An Irish Childhood* (Chatto, 1963).
Contrib: *Golden Hind*.
Bibl: Peppin; Waters.

MCKEE, David **b.1943**
Born in Italy, McKee received no formal art training. He is a most
prolific illustrator and author of books for children, his humorous
illustrations drawn in outline and coloured. He created a number of
characters who reappear in many books, for example, King Rollo
and the Magician. He is also the chosen illustrator for the latest
series of Michael Bond's "Paddington Bear" books.
"Like Michael Foreman*, McKee can use humour and his con-
siderable talents as an artist to make young people think of current
issues. [In *Tusk Tusk*] militant black and white elephants gun for
each other with their trunks — while peaceable black and white ele-
phants go deep into the jungle, their progeny emerging grey."
(Elaine Moss in *Times Literary Supplement*, 29 September 1978.)
Books illustrated include: S. Paulden: *Yan and the Gold Mountain
Robbers* (Abelard, 1974); A. Schwartz: *A Twister of Twists*
(Deutsch, 1974); K. Baumann: *Joachim the Policeman* (Black,
1975); C. Nostlinger: *Fiery Frederica* (Abelard, 1975); B. Harrop:
Okki-Tokki-Unga (Black, 1976); S. Paulden: *Yan and the
Firemonsters* (Abelard, 1976); K. Wales: *A Book of Elephants*
(Kaye, 1977); G. Snell: *The King of Quizzical Island* (Black, 1978);
R. Weir: *Albert's World Tour* (Abelard, 1978); F. Wilson: *Super
Gran* (Andersen Press, 1978); R. Debnam: *A Book of Pig Tales*
(Kaye, 1979); D. Mackay: *What in the World* (Longman, 1979); D.
Gadsby: *Harlequin* (Black, 1981); U.M. Williams: *Jeffy, the
Burglar's Cat* (Andersen Press, 1981); F. Wilson: *Super Gran Rules
O.K.!* (Puffin, 1981); L.F. Baum: *The Wizard of Oz* (Puffin, 1982);
R. Debnam: *A Book of Bears* (Kaye, 1982); R.A. Smith: *Blue Bell
Hill Games* (Kestrel, 1982); H. Townson: *The Speckled Panic*
(Andersen Press, 1982); R. Debnam: *A Book of Cats* (Kaye, 1983);
M. Bond: *Paddington and the Knicker-Bocker Rainbow* (Collins,
1984), and at least five other titles; F. Wilson: *More Television
Adventures of Super Gran* (Puffin, 1984); H. Townson: *The
Choking Peril* (Andersen Press, 1985); U.M. Williams: *Spid*
(Andersen Press, 1985); S. Isherwood: *Something New for a Bear
To Do* (Hutchinson, 1986); B. Mathias: *Pudmuddle Jump In: Poems*
(Methuen, 1987); F. Wilson: *Super Gran on Holiday* (Puffin, 1987).
Books written and illustrated include (but see Peppin): *Bronto's*

Wings (Dobson, 1964); *Two Can Toucan* (Abelard, 1964); *Mr. Benn, Red Knight* (Dobson, 1967), and others in series; *Elmer* (Dobson, 1968); *The Magician Who Lost His Magic* (1970), and at least six others; *The Day the Tide Went Out . . . and Out* (Abelard, 1975); *Elmer Again and Again* (Dobson, 1975); *Tusk Tusk* (Andersen Press, 1978); *King Rollo and the Bread* (Andersen Press, 1979), and at least ten other titles; *Not Now Bernard* (Andersen Press, 1980); *The Hill and the Rock* (Andersen Press, 1984); *Two Monsters* (Andersen Press, 1985); *The Sad Story of Veronica* (Andersen Press, 1987).
Contrib: *Punch; Times; TES*.
Bibl: Peppin.

MCKENZIE, Alison 1907-1982
Born on 30 August 1907 in Bombay of Scottish parents, McKenzie was educated at Prior's Field School (1921-25), studied art at Glasgow School of Art (1925-29), and later studied wood engraving at the Grosvenor School of Modern Art under Iain Macnab* (1932-23). She was very close to her sister, Winifred, who was also a wood engraver, and they studied wood engraving together. During WW2 they moved to St. Andrews and, with Annabel Kidston*, started a drawing and engraving class for the troops stationed there. Alison painted in oil and gouache, taught life drawing at Dundee College of Art (1946-58), made many prints, and illustrated at least one book. She was elected RSW (1952); NS.
She died in 1982.
Books illustrated include: J. Milton: *On the Morning of Christ's Nativity* (Gregynog Press, 1937).
Exhib: RSA; RSW; ROI; NS; SSA.
Bibl: Linda Saunders: "Two Women Wood-Engravers in Fife", *Green Book* 2, no. 4 (1986): 37-43; Garrett 1 & 2; *Shall We Join the Ladies?*; Waters.

MACKENZIE, Thomas Blakeley 1887-1944
Born in Bradford, Yorkshire, Mackenzie studied at the Bradford College of Art and then at the Slade. When he finished his studies, he was commissioned by the publisher James Nisbet to illustrate in watercolour an edition of *Arthur and His Knights*. Most of his illustrative work shows the influence of Beardsley, Harry Clarke* and colour plate illustrators like Kay Nielsen*. *The Crock of Gold*, for example, is illustrated with twelve colour plates and black and white decorative headings and tailpieces. He was also an etcher and engraver and contributed to the *Sketch* and other journals. He had hoped to make his name as a painter and he spent some time in France. He did not achieve success and on his return to England, concentrated on producing topographical etchings and cheap jewellery.
Books illustrated include: *Ali Baba and Aladdin* (1919); A.M. Ransome: *Aladdin and His Wonderful Lamp* (Nisbet, 1920); C. Chaundler: *Arthur and His Knights* (Nisbet, 1920); E. Southwart: *Brontë Moors and Villages* (BH, 1923); J.E. Flecker: *Hassan* (Heinemann, 1924); J. Stephen: *The Crock of Gold* (Macmillan, 1926).
Contrib: *Sketch*.
Bibl: Johnson FDIB; Peppin.

MACKENZIE-GRIEVE, Averil b.1903
Educated privately in Sussex and Devon, Mackenzie-Grieve (Mrs Le Gros Clark) studied art in Florence and cultivated her passion for illuminated manuscripts. She returned to England, and lived with her mother in St. Ives, where she worked at wood engraving, exhibiting in that medium, and determined to become a scribe and book-decorator. She married an administrator in the Colonial Office and went with him to Sarawak, spending eleven years there. She returned to Europe in 1937, reaching London in 1938 where she met Owen Rutter and Christopher Sandford of the Golden Cockerel Press, and started writing, engraving, and designing book jackets. During WW2 she worked for the government Censorship Office and for the BBC. She divorced her husband (who was later killed in a prisoner-of-war camp), married again in 1946 and settled in East Sussex. She travelled in Europe again until she was struck down with Parkinson's Disease, though some of its symptoms were alleviated by a brain operation, and she was able to continue her travels.
She is the author or translator of some twelve books, including her

Averil MACKENZIE-GRIEVE *John Fryer of the Bounty* (Golden Cockerel Press, 1937)

autobiography, *Time and Chance* (1970). A wood engraver, she has illustrated a few books, including the poems of Su Tung P'o translated by her husband. She wrote the scholarly introduction to *The New London Letter-Writer* (1948) as well as editing it and illustrating it with fourteen delicate wood engravings in period style.
Books illustrated include: M.A. Fryer: *John Fryer of the Bounty* (GCP, 1939); S. Johnson: *The New London Letter-Writer* (GCP, 1948).
Contrib: *Saturday Book 11*.
Bibl: A. Mackenzie-Grieve: *Time and Chance: An Autobiography* (Bles, 1970); Sandford; *Shall We Join the Ladies?*.

MACKEY, Haydn Reynolds b.1883
Born on 9 December 1883, Mackey studied at the Slade. During WW1 he was an official war artist; after the war he illustrated a few books in various media.
Books illustrated include: G. Flaubert: *Salammbo* (Mandrake Press, 1930); T. Nash: *The Unfortunate Traveller* (Verona Society, 1930).
Books written and illustrated include: *La Grande Ducasse Drolatique* (Romney Press, 1922).
Contrib: *Golden Hind*.
Exhib: RA; ROI; RI; RHA; Paris Salon.
Bibl: Peppin; Waters.

George MACKLEY Illustration for "Low Country Landscape" in *Saturday Book* 25 (Hutchinson, 1965)

MACKIE, George **b.1920**

Mackie spent three years at Dundee College of Art, and after six years in the RAF during WW2 he went to Edinburgh College of Art for two years. He became a free-lance artist, and taught part-time before becoming Head of Design at Gray's School of Art, Aberdeen. He illustrated a few books and contributed drawings to the *Radio Times*, and wrote an excellent monograph on Lynton Lamb*.

Books illustrated include: A. Gray: *Historical Ballads of Denmark* (with Edward Bawden*; Edinburgh UP, 1958); A. Keith: *Aberdeen University Press* (1963).

Contrib: *Radio Times*.

Published: *Lynton Lamb, Illustrator* (Scolar Press, 1978).

Bibl: Jacques.

MACKLEY, George **1900-1983**

Born on 13 May 1900 in Tonbridge, Kent, Mackley was educated at the Judd School, Tonbridge. He trained as a teacher at the Goldsmiths' College, London (1918-21), specializing particularly in etching. He spent his life as a teacher, including sixteen years from 1927 teaching art at the Roke Central School in Purley. Then he became Headmaster of Thames Ditton Primary School, and from there moved to Sutton East School where he set up a special art course for talented children from the whole country.

It was a chance meeting with Noel Rooke* in the 1930s which converted Mackley to a fervent admirer of wood engraving. After some basic instruction from Rooke, Mackley taught himself to engrave, having studied the work of other engravers minutely. He was much influenced by Bewick and by contemporary artists such as Agnes Miller Parker*, Blair Hughes Stanton*, Robert Gibbings* and Joan Hassall*. He became a superb craftsman, finding the medium capable of a precision which suited the subjects he preferred — boats,

bridges, architecture, plants. In 1948 he was commissioned to write a book on wood engraving for the National Magazine Company. He illustrated only a few books, being more interested in print-making, though he wrote several articles for the *Saturday Book*, illustrating them with many superb wood engravings. In 1969, after a stroke made it impossible for him to engrave, he regained enough control to draw, and went on to produce some fine watercolours.

Mackley was elected ARE (1950), RE (1961). He became a member of SWE in 1948 and of the Art Workers Guild in 1959; and was awarded the M.B.E. in 1983.

Books illustrated include: A.M-T. Colt: *Weeds and Wild Flowers* (Printed at the Rampant Lions Press, for Two-Horse Press, 1965).

Books written and illustrated include: *Wood Engraving* (National Magazine Company, 1948); *Confessions of a Woodpecker* (Gresham Press, 1981).

Contrib: *The Saturday Book 20/25/28/30.*

Exhibs: Ashmolean; Fitzwilliam; SWE; University of Exeter.

Collns: Ashmolean; Fitzwilliam.

Bibl: Thomas Balston: "The Wood-Engravings of George Mackley", *Image*, 8 (Summer 1952): 17-30; Lewis H. Green: *George Mackley, Wood Engraver* (Old Woking: Gresham Books, 1981); Monica Poole: "George Mackley, M.B.E., R.E.; tribute to a woodpecker", *The Green Book*, 10 (Spring/Summer, 1983): 10-11; Garrett 1 & 2; Peppin; Waters.

MCLACHLAN, Edward Rolland **b.1940**

Born in Leicester, McLachlan studied at Leicester College of Art (1956-58). He has had a varied career, working as a film writer and designer, a cartoonist, a book illustrator, and a commercial artist for several agencies. As a free-lance artist since 1965, he was political cartoonist to the *Sunday Mirror* (1967-70) and *Punch* (1969-71). He

has written and illustrated books for children, using mostly pen and brightly coloured inks. He won the Illustrator of the Year Award in 1980 for a poster he designed for London Transport.

Books illustrated include: A. Hewitt: *Fire Engine Speedy* (1966); J. English: *Tippy the Tipper Wagon* (BBC, 1969); P. Groves: *Bangers and Mash* series (1975-9); S. Webb: *Chess for Tigers* (1978), *The Changing of Claude* (1979); R. Kilroy: *Graffiti 1-3* (1979-81), *Limericks* (1981).

Books written and illustrated include: *Simon Books* (1969-74); *The Dragon That Only Blew Smoke* (1971).

Contrib: *Playboy; Private Eye; Punch; Radio Times; Reader's Digest; Sunday Mirror; Sunday Telegraph; Times.*

Bibl: Peppin.

MCLAREN, William 1923-1987?

McLaren studied at the Edinburgh College of Art (1940-46) under Joan Hassall*. A free-lance artist since that time, he took over as the illustrator of Beverley Nichols' books after the death of Rex Whistler*. His style is very similar to Whistler's, with highly decorative black and white drawings. He also used scraperboard, and full colour for book jackets (including two for the *Saturday Book*) and endpapers. He engraved a few bookplates; and painted murals, portraits and landscapes.

Books illustrated include: W. Wankowicz: *Sunshine and Storm* (Broomsleigh Press, 1948); B. Nichols: *Merry Hall* (Cape), *Laughter on the Stairs* (Cape, 1953); E. Parker: *Surrey Gardens* (Batsford, 1954); B. Nichols: *Sunlight on the Lawn* (Cape, 1956); D. Macleod: *Oasis of the North* (Hutchinson, 1958); H.L.V. Fletcher: *The Rose Anthology* (Newnes, 1963); B. Nichols: *Garden Open Today* (Cape, 1963), *The Art of Flower Arrangement* (Collins,

William MCLAREN *Sunlight on the Lawn* by Beverley Nichols (Jonathan Cape, 1956)

1967), *Garden Open Tomorrow* (Heinemann, 1968), *The Gift of a Home* (Allen, 1972); C.D. Sansom: *Aurora's Glade* (Castle Cary Press, 1973).

Bibl: Brian North Lee: *British Bookplates: A Pictorial History* (D & C, 1979).

MACNAB, Iain 1890-1967

Born on 21 October 1890 in Iloilo in the Philippines, Macnab moved back to Scotland as a child. He was educated at Merchiston Castle School, Edinburgh, and first intended to be an accountant. He volunteered for the army and was commissioned to the Argyll and Sutherland Highlanders during WW1. After being invalided out of the army in 1916 and spending two years in hospital, he studied art at the Glasgow School of Art (1917) and at Heatherley's School of Art in London (1918). A year studying in Paris was followed by his appointment in 1919 as Joint Principal of Heatherley's School, which he left in 1925 to found his own school in London, the Grosvenor School of Modern Art, remaining its Principal until it was forced to close in 1940. Macnab joined the Royal Air Force in 1941 and was finally invalided out in 1945. He regained possession of the premises formerly occupied by his Grosvenor School and in 1946 rented them out to Heatherley's School and became its Director of Art Studies (1946-53). He died on 24 December 1967.

Macnab was an artist and a printmaker, who illustrated only a few books. He is important in twentieth century British art because he was one of the guiding influences in British wood engraving, found-

Edward R. MCLACHLAN "Well, if it's not another sign of the greenhouse effect, what is it?" from *Punch* (6 April 1990)

Iain MACNAB *Nicht at Eenie*
(Samson Press, 1932)

ing the famous Grosvenor School of Art and teaching wood engraving there to many students, including Peter Barker-Mill*, Gwenda Morgan*, and Averil Mackenzie-Grieve*. Of his own engravings, Garrett writes in his *A History of British Wood Engraving* that "Macnab was the pure engraver as were Eric Gill, David Jones and John Buckland-Wright; the fundamental discipline of Palaeolithic art and engraving engaged his lifelong interest . . . He regarded the style of engraving which evolved from the nineteenth century book illustration as contamination of the arts of design because the designing of books was dealt with as an applied art." He continued to engrave until well after WW2.

Macnab's first illustrated book was *Nicht at Eenie: The Bairn's Parnassus* (1932), the first of three he did for the Samson Press. His finest work as a book illustrator may be the engravings he produced for *The Sculptured Garland* (1948), also published by the Samson Press. Some of the engravings are full page illustrations and the rest are headpieces. All his illustrative work consists of wood engravings, apart from the drawings he did for his *Figure Drawing* (1936) and *Introduction to Woodstock* (1951).

Macnab was elected ARE (1923) and RE (1932); SWE (1932). He took an active part in the foundation of the Federation of British Artists, becoming a governor in 1959. From 1949 until his death, he was President of the Royal Institute of Oil Painters and was elected Chairman of the Imperial Arts League in 1962.

Books illustrated include: *Nicht at Eenie: The Bairn's Parnassus* (Samson Press, 1932); R. Burns: *Tam O'Shanter* (Samson Press, 1934); J.H. Whyte: *Towards a New Scotland* (1935); R. Browning: *Selected Poems* (Penguin, 1938); W.S. Landor: *The Sculptured Garland* (Samson Press, 1948).

Books written and illustrated include: *Figure Drawing* (Studio, 1936); *The Student's Book of Wood Engraving* (Pitman, 1938); *Introduction to Woodstock* (Samson Press, 1951).

Exhib: Federation of British Artists Galleries (memorial exhibition, 1969).

Collns: Whitworth; Portsmouth City Museum and Art Gallery; Ashmolean; V & A.

Bibl: Albert Garrett: *Wood Engravings and Drawings of Iain Macnab of Barachastlain* (Midas Books, 1973); Deane; Garrett 1 & 2; Peppin; Waters.

MCNAUGHTON, Colin b.1951
Born on 18 May 1951 in Wallsend, Northumberland, McNaughton moved to London in 1970 to study graphic design at the Central School of Arts and Crafts, and illustration at RCA. After illustrating

his first children's book for Benn while in his second year at RCA, he became a free-lance illustrator in 1975, concentrating on books for children. which he illustrates in pen or pencil, with watercolour washes added.

In the 1970s he was illustrating some five or six books each year, some in colour and some in black and white. His picture book, *Football Crazy* (1980), became a minor classic and was still in print ten years later, explained partly because McNaughton retains the same kind of humour that his young readers have, and this is present in most of his books. *King Nonn the Wiser* and *Fat Pig* (which was turned into a rock n' roll musical for children and has played in Paris, Vienna, Germany, Sweden and the United States) were both published in the same year, establishing his reputation. For *The Pink Fairy Book* (1982), he made many black and white illustrations, which exhibit great ability and inventiveness. He loves working in black and white but finds it very time-consuming and not financially rewarding — so most of his books are now picture books in full colour.

Although he is happy about parts of these books, he believes that his career took a turn for the better when he started working for Walker Books in 1981. He has said that *There's an Awful Lot of Weirdos in Our Neighbourhood* (1987) was his "first book really. I finally thought I was getting somewhere, doing what I wanted to with books." (Steedman, 1989.†) He writes most of his own books now, though his collaboration with Allan Ahlberg in a number of series, especially the little "Red Nose Readers", has been a great success. He teaches at Cambridge School of Art as a part-time lecturer.

Books illustrated include: J. Reeves: *The Springtime Book* (Heinemann, 1976), *The Autumn Book* (Heinemann, 1977); E. Attenborough: *Walk, Rabbit, Walk* (Heinemann, 1977); H. Burton: *A Grenville Goes to Sea* (Heinemann, 1977); J. Reeves: *Eggtime Stories* (Blackie, 1978); M. McCaffrey: *The Mighty Muddle* (Eel Pie, 1979); J. Hawkesworth: *A Handbook of Family Monsters* (Dent, 1980); E. Pacholek: *A Ship to Sail the Seven Seas* (Kestrel, 1980); W. Wood: *The Silver Chaunter: Traditional Scottish Tales and Legends* (Chatto, 1980); A. Ahlberg: *Miss Brick the Builder's Baby* (Kestrel, 1981), *Mr. and Mrs. Hay the Horse* (Kestrel, 1981); R. Hoban: *The Great Fruit Gum Robbery* (Walker, 1981), *They Came from Aargh!* (Walker, 1981); A. Lang, ed. B.W. Alderson: *The Pink Fairy Book* (Kestrel, 1982); A. Ahlberg: *Foldaways* series (Granada, 1984), *Red Nose Readers* (16 books; Walker, 1985-6), *Mrs. Joll's Joke Shop* (Viking, 1988).

Books written and illustrated include: *ABC and Things* (Benn,

Colin MCNAUGHTON "The Snow Man" in *The Pink Fairy Book* collected by Andrew Lang and edited by Brian Alderson (Kestrel Books, 1982)

1976); *123 and Things* (Benn, 1976); *The Great Zoo Escape* (Heinemann, 1978); *The Rat Race* (Benn, 1978); *The Pirates* (Benn, 1979); *Football Crazy* (Heinemann, 1980); *Fat Pig* (Benn, 1981); *If Dinosaurs Were Cats and Dogs* (Benn, 1981); *King Nonn the Wiser* (Heinemann, 1981); *Opposites* (five board books; Walker, 1982);

Seasons (four board books; Walker, 1983); *There's an Awful Lot of Weirdos in Our Neighbourhood* (Walker, 1987); *Jolly Roger and the Pirates of Abdul the Skinhead* (Walker, 1988); *Santa Claus Is Superman* (Walker, 1988).
Bibl: *Books for Keeps* 37 (March 1986): 12-3; Scott Steedman: "Jolly Colin", *Inprint* (April 1989); CA; Peppin; IFA.

MACNEILL, Alyson **b.1961?**
Alyson MacNeill studied printmaking and illustration at the Duncan of Jordanstone College of Art, Dundee, where she was awarded the Josef Sekalski memorial prize. She then went to the Glasgow College of Art for a postgraduate year in design.
MacNeill works in various media, including wood engraving, linocuts, watercolour, gouache and etching. She has illustrated a number of books, including a children's book of poetry and *The Mill on the Floss*, which contains some forty illustrations.
Books illustrated include: G. Eliot: *The Mill on the Floss* (Folio Society, 1986); C. Mackay: *The Song of the Forest* (Edinburgh: Canongate, 1986); *Twenty-Three Wood engravings from Colin Mackay's "The Song of the Forest"* (Old Stile Press, 1987); *Benedicite Omnia Opera* (Old Stile Press, 1987); *A Second Book of Scottish Poetry* (OUP).
Bibl: Linda Saunders: "Two Women Wood-Engravers in Fife; Winifred McKenzie and Alyson MacNeill", *The Green Book*, 2, No.4 (1986): 37-43; Folio 40.

MACPHERSON, Douglas **b.1871**
See Houfe

MAHOOD, Kenneth **b.1930**
Born on 4 February 1930 in Belfast, where he spent his childhood, Mahood had no formal art training and painted and drew cartoons as a hobby after he left school. He was working for a lithographic designer when he started contributing to *Punch* in 1948, and has continued drawing for that magazine and several others. He was art editor of *Punch* (1960-65), and political cartoonist for the *Times* (1966-69). He has also illustrated a number of books for children, and written and illustrated some himself. He has an apparently simple style of drawing, but as Fougasse† comments, his "half-formal half-childlike style might easily be a handicap, but never seems to be."

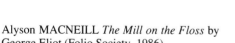

Alyson MACNEILL *The Mill on the Floss* by George Eliot (Folio Society, 1986)

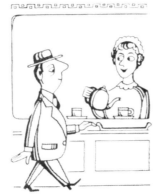

Kenneth MAHOOD Cartoon in *Lilliput* (April 1950) p.41

Locke: *The Runaway Settlers* (Cape, 1966); R. Weir: *The Loner* (Constable, 1966); L. Garfield: *Smith* (Kestrel, 1967), *Black Jack* (Longman, 1968); B. Willard: *To London! To London!* (1968); S. Dickinson: *The Restless Ghost* (Collins, 1970); P. Lively: *Astercote* (Heinemann, 1970); R. Ainsworth: *The Phantom Cyclist* (Deutsch, 1971); L. Garfield: *The Ghost Downstairs* (Longman, 1972); M.W. Bianco: *Poor Cecco* (Deutsch, 1975); R. Ainsworth: *The Bear Who Liked Hugging People* (Heinemann, 1976); A. Lang, ed. B. Alderson: *The Green Fairy Book* (1978); L. Garfield: *John Diamond* (1980); E. Farjeon: *Invitation to a Mouse* (Pelham Books, 1981).
Books written and illustrated include: *The Secret of the Shed* (Constable, 1962); *Ben Goes to the City* (Longman, 1964); *James and the Roman Silver* (Constable, 1965); *Idle Jack* (1977).
Bibl: CA; ICB3; ICB4; Peppin.

MANSBRIDGE, Norman b.1911
Born on 22 July 1911, Mansbridge was educated at Forest School in Essex, and studied art at Heatherley's. He first worked as a commercial artist in advertising, but became a free-lance artist in the late 1930s and began to contribute cartoons to *Punch*. During WW2, while he was in the Merchant Navy, he produced marine car-

Books illustrated include: A.B. Hollowood: *Tory Story* (Hammond, 1964); R. Benedictus: *Fifty Million Sausages* (Deutsch, 1975); D. Bailey and E. Cooper: *Italy* (Macdonald, 1985).
Books written and illustrated include: *Not a Word to a Soul* (Hammond, 1958); *Fore! Forty Drawings by Mahood* (Hammond, 1959); *The Laughing Dragon* (Collins, 1970); *Why Are There More Questions Than Answers, Grandad?* (Macmillan, 1974); *Losing Willy* (Macmillan, 1977); *Name Droppings* (Columbus, 1986).
Contrib: *Financial Times; New Yorker; Punch; Times.*
Bibl: Fougasse: *The Good-Tempered Pencil* (Reinhardt, 1956); ICB4; Peppin; Price.

MAITLAND, Anthony Jasper b.1932
Born on 17 June 1932 in Andover, Hampshire, Maitland studied at the West of England College of Art, Bristol, and then spent a year studying in Europe. He is a free-lance artist, who concentrates on illustrating books for children, though he also paints, designs, and does murals and graphic work for exhibitions. His book illustrations are usually a combination of line and wash, but he also uses black and white or full colour. His illustrations for Philippa Pearce's *Mrs. Cockle's Cat* (his first book) won the Kate Greenaway medal for 1961; and *The Ghost Downstairs* was commended in 1972.
Books illustrated include (but see CA): P. Pearce: *Mrs. Cockle's Cat* (Constable, 1961), *A Dog So Small* (Constable, 1962); R. Ainsworth: *Ten Tales of Shellover* (1963); J. Clarke: *The Happy Planet* (1963); K. Fidler: *The Little Ship Dog* (1963); A. Molloy: *A Proper Place for Chip* (Constable, 1963); E. Smith: *Out of Hand* (Macmillan, 1963); L. Garfield: *Jack Holborn* (Constable, 1964); E.

Anthony MAITLAND "The Story of the Three Little Pigs" in *Green Fairy Book* collected by Andrew Lang and edited by Brian Alderson (Kestrel Books, 1978)

Anthony MAITLAND *Smith* by Leon Garfield (Constable Young Books, 1967)

has become the "indispensable illustrator" for Joan Aiken's picaresque stories.

Books illustrated include: I. Serraillier: *Belinda and the Swans* (Cape, 1952); J. Aiken: *All You've Ever Wanted* (Cape, 1953), *More Than You Ever Bargained For* (Cape, 1955); N. Streatfeild: *The Grey Family* (Hamilton, 1956); A. de Céspedes: *Between Then and Now* (Cape, 1959); J. Hope-Simpson: *The Great Fire* (Hamilton, 1961); J. Aiken: *The Wolves of Willoughby Chase* (Cape, 1962), *Black Hearts in Battersea* (Cape, 1963); J. Hope-Simpson: *The Ice Fair* (Hamilton, 1963); T. Colson: *Rinkin of Dragon's Wood* (Cape, 1965); E. Vipont: *Larry Lopkins* (Hamilton, 1965); J. Aiken: *The Whispering Mountain* (Cape, 1968); M. Treadgold: *The Polly Harris* (Hamilton, 1968); J. Aiken: *A Small Pinch of Weather* (Cape, 1969), *Night Birds on Nantucket* (Penguin, 1969); J. Clarke: *Foxon's Hole* (1969); E. Vipont: *Michael and the Dogs* (Hamilton, 1969); C. Causley: *Figgie Hobbin* (Macmillan, 1970); J. Aiken: *The Cuckoo Tree* (Cape, 1971); A. Schlee: *Two Strangers* (Macmillan, 1971); J. Aiken: *A Harp of Fishbones* (Cape, 1972), *Midnight Is a Place* (Cape, 1974); C. Baxter: *The Stolen Telesm* (Cape, 1975); U.M. Williams: *No Ponies for Miss Pobjoy* (Chatto, 1975); G. Hogarth: *A Sister for Helen* (Deutsch, 1976); J. Aiken: *The Faithless Lollybird* (Cape, 1977); R. Anderson: *Between Then an*

toons and later political cartoons. He became senior cartoonist on *Punch* from the mid-1950s to 1968. He has also worked for several newspapers; illustrated his own books; and exhibited oil paintings at the RA.

Books written and illustrated include: *The Modern Mariner* (1946); *The Pale Artist* (1947).
Contrib: *Punch*.
Exhib: RA; Beetles.
Bibl: *The Illustrators: Catalogue* (Chris Beetles Ltd., 1991).

MANSFIELD, Joyce **b.1920**
Born in Newbury, Berkshire, Mansfield attended Loughborough College of Art and Nottingham University. She worked as a bank clerk and secretary, but developed a love for the world of nature and began to draw what she saw. In 1966, she was encouraged to put her knowledge to a practical use and began to make natural history illustrations for children's books under the pseudonym Joyce Bee. Her drawings are scientifically accurate, but also attractive and lively.
Books illustrated include: Burton: *The Oxford Book of Insects* (OUP, 1968); J.L. Cloudsley-Thompson: *Spiders and Scorpions* (BH, 1973), *Bees and Wasps* BH, 1974).
Bibl: ICB4.

MARC
See BOXER, Charles Mark Edward

MARRIOTT, Patricia **b.1920**
Born on 16 May 1920 in Cheshire, Marriott studied at Westminster School of Art and Chelsea School of Art. She has illustrated many books for children, mostly with carefully controlled black pen drawings, which might at first glance appear mere sketches. Some of these show the liveliness and humour of Edward Ardizzone*. She

Patricia MARRIOTT *The Cuckoo Time* by Joan Aitken (Jonathan Cape, 1971)

Francis MARSHALL Illustration to "Seven Ways of Living" in *The Book of Leisure* edited by John Pudney (Odhams Press, 1957)

Now (Cape, 1978); J. Aiken: *Go Saddle the Sea* (Cape, 1978); R. Fuller: *Pilgrim* (Deutsch, 1980); W. Price: *Arctic Adventure* (Cape, 1980); K. Moore: *The Little Stolen Sweep* (Allison & Busby, 1982); J. Aiken: *Up the Chimney Down* (Cape, 1984), *Dido and Pa* (Cape, 1986).
Bibl: ICB3; ICB4; Peppin.

MARSH, James **b.1946**
Born in Morley, Yorkshire, Marsh studied graphic design at Batley College of Art and Design. He first worked for agencies and studios, designing and illustrating record sleeves, and worked with Alan Aldridge* (1968-69) before establishing his own studio under the name "Head Office" in 1969. In 1975 he became a free-lance artist working from his own home, painting oils and acrylics and illustrating books and magazines.
His work first appeared in the British "girlie" magazines, *Penthouse* and *Men Only*, which provided a major source of patronage for imaginative illustrations, and were an important medium for Marsh at a critical moment in his career. Marsh is primarily a "graphic artist", producing first-rate art for business and commerce, rather than an illustrator, but he is also well known as the illustrator of book jackets and covers for many publishers and magazines (covers for the William Trevor novels for Penguin Books, for example). His

work is very imaginative and inventive, decorative and extremely colourful.
Books illustrated include: D. Larkin: *Once Upon a Time* (1976); I. Shah: *World Tales* (Harcourt Brace, 1979); *Monkeys* (1980), *Eggs* (1980), *Cat Tales* (1980); M. Gallant: *The Cow Book* (1981).
Contrib: *Connoisseur; Daily Telegraph Sunday Magazine; Graphis; Honey; Men Only; Penthouse; Radio Times; Sunday Times Magazine; Time; Women's Own.*
Bibl: Ken Baynes: "James Marsh", *Graphis* 34, no. 199 (1978/79): 384-391; Amstutz 2.
Colour Plates 111 to 113

MARSHALL, Constance Kay **b.1918**
Born on 17 February 1918 in Waterford, Ireland, Marshall came to England when she was two and grew up in Cheshire. She was educated at Brownhills High School, Staffordshire, and studied at Burslem School of Art and RCA. She married in 1939 and started doing illustrations as they could be done at home between household chores. In 1952, she joined an art studio, doing advertisements and other illustrations. She was particularly fond of drawing animals; later in her career, she concentrated on educational books.
Books illustrated include: Clarke: *Drowsy and the Beanstalk* (OUP, 1952), *Drowsy Goes to School* (OUP, 1952); M.E. Allan: *At School in Skye* (Blackie, 1957); R. Manning: *Green Smoke* (Constable, 1957), *Dragon in Danger* (Constable, 1959); N. Streatfeild: *Look at the Circus* (1960); B. Willard: *The Pram Race* (1961); L. Berg: *A Newt for Roddy* (1965); R. Manning-Sanders: *Slippery Shiney* (1965); B. Carter: *The Gannet's Nest* (1966); D. Ross: *Nothing to Do* (1966); R. Brown: *Little Brown Mouse* (1967); E. Vipont: *The China Dog* (1967); M. Hynds: *The Television Castle* (Blackie, 1975).
Bibl: ICB2; ICB4; Peppin.

MARSHALL, Francis **1901-1980**
Marshall was educated on HMS Worcester and at University College, London. He studied at the Slade, and became an illustrator in black and white and watercolour, specializing in fashion drawing, and developing a very distinctive "svelte" style to match his subjects. He contributed to *Vogue* and other magazines and illustrated a few books. During WW2 he served as a camouflage officer at the Admiralty.
Books illustrated include: J. Pudney: *The Book of Leisure* (with others, Odhams, 1957).
Books written and illustrated include: *London West* (Studio, 1944); *An Englishman in New York* (GB Publications, 1949); *The London Book* (Seeley Service, 1951); *The Londoner's Weekend Book* (Seeley Service, 1953).
Published: *Fashion Drawing* (Studio, 1941); *Sketching the Ballet* (Studio, 1950); *Magazine Illustration* (Studio, 1959); *Drawing the Female Figure* (Studio, 1957).
Contrib: *Daily Mail; Daily Sketch; Harper's Bazaar; Saturday Book; Vogue; Woman's Journal.*
Exhib: Walker Gallery.
Bibl: Parkin; Who.

MARTIN, Frank Vernon **b.1921**
Born on 14 January 1921 in Dulwich, London, Martin was educated at Uppingham School and Hertford College, Oxford. After serving in the Royal Artillery during WW2, he studied at St. Martin's School of Art (1946-49), learning wood engraving from Gertrude Hermes*, for whom he worked as studio assistant for colour printing in 1947. In 1949, he became a free-lance wood engraver and illustrator, and taught etching, engraving and graphic design at Camberwell School of Art (1953-80), finishing as Head of the Department of Graphic Arts (1976-80).
He has illustrated many books with wood engravings, some in two colours, mostly for the Folio Society. Hodnett judged his illustrations for Stendhal's *Scarlet and Black* (1965) to be among his better work (see illustration on page 25), and declares them "one of the best series of English illustrations of the postwar period." After 1966, Martin concentrated on printmaking, many of his subjects relating to the world of the cinema and theatre, producing etchings of such artists as Tallulah Bankhead, Jean Harlow and Montgomery Clift. He has illustrated a few books in the 1980s and over the last

Frank MARTIN *Titus Andronicus* by William Shakespeare
(Folio Society, 1988)

thirty years has engraved a few bookplates. He has had many one-artist shows in Britain and the US since 1956.

He was elected SWE (1952), and served as Honorary Secretary (1952-9); MSIA (1959); ARE (1955); RE (1961); Hon. Academician of the Accademia delle Arti del Disegno, Florence (1965).

Books illustrated include: V. Bayley: *The Dark Lantern* (Dent, 1951); N. Goodland: *My Father Before Me* (Hutchinson, 1953); T. Balston: *The Housekeeping Book of Susanna Whatman 1776-1800* (Bles, 1956); T. Wilder: *The Bridge of San Luis Rey* (Folio Society, 1956); U. Bloom: *The Elegant Edwardian* (Hutchinson, 1957); M. Sisson: *The Cave* (Vine Press, 1957); O. Wilde: *Salome* (Folio Society, 1957); *The Book of the Thousand Nights and One Night* (vols. 2 and 4; Folio Society, 1958); *The Bedside Book of the Art of Living* (Readers' Digest, 1959); U. Bloom: *Youth at the Gate* (Hutchinson, 1959); T. Smollett: *The Adventures of Roderick Random* (Folio Society, 1961); *The Manual of Catholic Prayer* (Burns & Oates, 1962); N. Goodland: *Old Stan's Diary* (Hutchinson, 1963); C. Lamb: *Essays* (Folio Society, 1963); W. Hazlitt: *Essays* (Folio Society, 1964); S. Stendhal: *Scarlet and Black* (Folio Society, 1965); *The New Small Missal* (Burns & Oates, 1965); H. Fielding: *The Life of Jonathan Wild* Folio Society, 1966); M. King-Hall: *The Diary of a Young Lady of Fashion* (Folio Society, 1982); G. Chaucer: *The Canterbury Tales* (with others, three vols., Folio Society, 1986); W. Shakespeare: *Titus Andronicus* (Folio Society, 1988); D. Burnett: *Kantharos* (Tragara Press, 1989),

Pharos (Tragara Press, 1989), *Lesbos* (Tragara Press, 1990).
Published: "Some Recollections of the Society of Wood Engravers During the 1950s" in *A Cross Section — The Society of Wood Engravers in 1987* (Wakefield: Fleece Press, 1988).
Exhib: Folio Society (1956, 1961); London Graphic Arts Gallery (1968); National Film Theatre (1971); Editions Graphiques (1972, 1989); Leeds International Film Festival (1988); and in Europe and US.
Bibl: Victor Arwas and John Kobal: *Frank Martin: Hollywood - Continental* (Academy Editions, 1988); Brian Lee: *British Bookplates* (D & C, 1979); Brett; Folio 40; Garrett 1 & 2; Hodnett; Peppin.

MARX, Enid Crystal Dorothy **b.1902**
Born on 20 October 1902 in London, Marx was educated at Roedean School. She studied painting, drawing, ceramics and printed textile design at the Central School of Arts and Crafts (1920-21), and at the RCA (1922-25), under Paul Nash*, Leon Underwood* and Bernard Adeney. At the RCA, she was a fellow student of Eric Ravilious*, who helped to teach her wood engraving, and Edward Bawden*. The three became enthusiasts for English traditional art, and it was then that Marx became interested in the simplicity and strength of early chapbooks.

She worked at a textile studio in London (1925-26), before establishing her own studio to design and print hand-blocked textiles (1927-39). One of her more important commissions at this time was for upholstery fabric for London Transport during the 1930s. A free-lance graphic and textile designer since 1939, she has done a great variety of work including wood engraving and autolitho-

Enid MARX *A Childhood* by F. Allinson (Hogarth Press, 1937)

graphy for pattern papers; book jackets; illustrations for children's books; decorations and trade marks; designs for wallpapers, ceramics and fabrics; advertising posters for London Transport and Shell; and postage stamps. Her most outstanding achievement in fabric design were the furnishing fabrics she designed for the wartime Utility Scheme. She designed pattern paper for the Curwen Press, and in the post-war period designed and illustrated books for Chatto and Windus and for Penguin Books. She designed fifteen covers for the Zodiac Books from Chatto, and five for Penguin's King Penguin series.

Marx taught wood engraving at Ruskin School of Art, Oxford (1931-33), and then was an instructor in design at Bromley School of Art and Maidstone School of Art. From 1960 to 1965 she was Head of the Department of Dress, Textiles and Ceramics at the

Croydon College of Art; and lectured on the history of textiles at various colleges (1965-74). A retrospective exhibition of her work was held at the Camden Arts Centre in 1979.

Marx was appointed RDI (1944), SIA (1946), SWE (1955), Honorary FRCA (1982).

Books illustrated include: F. Allinson: *A Childhood* (Hogarth Press, 1937); N. Douglas: *An Almanac* (Chatto, 1945); *The Butterfly's Ball* (Bantam series; Transatlantic Arts, 1946); *Tom Thumb* (Bantam series; Transatlantic Arts, 1946).

Books written and illustrated include: *A Book of Nursery Rhymes* (Chatto, 1939); *Bulgy the Barrage Balloon* (OUP, 1941); *Nelson the Kite of the King's Navy* (Chatto, 1942); *The Pigeon Ace* (Faber, 1943); *A Book of Rigamaroles, or Jingle Rhymes* (Puffin Picture Book; Penguin, 1945); *A Quiz* (Faber, 1945); *English Popular and Traditional Art* with Margaret Lambert (Collins, 1946); *The Little White Bear* (Faber, 1946); *Slithery Sam* (Wingate, 1947); *English Popular Art* with Margaret Lambert (Batsford, 1951); *Sam and 'Arry, or Thereby Hangs Two Tails* (1972); *An ABC of Birds & Beasts* (Douglas Cleverdon, Clover Hill Editions, 1985).

Exhib: RA; Geffrye Museum (*Utility Furniture and Fashion 1941-51*, 1974); Hayward Gallery (*Thirties: British Art and Design Before the War*, 1979); Camden Arts Centre (1979); British Craft Council Gallery (*The Makers Eye*, 1981).

Collections: V & A; Sheffield.

Bibl: Christian Barnard: "Enid Marx", *Signature* 4 (November 1936); *Enid Marx: Exhibition Catalogue* (Camden Arts Centre, 1979); *Thirties; British Art and Design before the War* (Hayward Gallery, 1979); Michael Taylor: "Enid Marx, Designer and Wood-engraver", *Matrix* 7 (1987): 98-102; C.G. Tomrley: "Enid Marx", *Graphis* 10, no. 54 (1954): 302-5; Garrett 1 & 2; Morgan; Peppin; *Shall We Join the Ladies?*; Waters; Who; IFA.

See also illustration on page 55

Colour Plate 114

MASEFIELD, Isobel Judith Yates b.1904
Judith Masefield was the daughter of author John Masefield, and illustrated his *Box of Delights* with small black and white head- and tail-pieces. The endpapers and jacket have small coloured illustrations.

Books illustrated include: John Masefield: *The Box of Delights* (Heinemann, 1935).

Colln: Osborne Collection.

MASON, Frank Henry 1876-1965
See Houfe
Born in Seaton Carew, County Durham, Mason was educated at private schools and on HMS Conway. He went to sea, and then worked in engineering, including shipbuilding in Leeds and Hartlepool. He served in the RNVR in Egypt and the North Sea area during WW1.

He travelled widely, painted marine and coastal subjects, and designed posters. He exhibited at the RA from 1900; elected RBA (1904), RI (1929). He illustrated many books on ships and other engineering subjects, and wrote and illustrated a few himself.

Books written and illustrated include: *The Book of British Ships* (Hodder, 1910); *Ship Model Making* (Studio, 1935); *Our Trains* (Tuck, 1946).

Contrib: *Graphic.*

Exhib: Birmingham; Glasgow; Liverpool; RA; RBA; RHA; RI.

Bibl: Waters.

MASTERMAN, Dodie b.1918
Born Rhoda Helen Glass on 8 November 1918 in Brixham, Devon, Masterman as a child was always drawing. When she was about eleven or twelve she produced her own little magazine, "The Wing Sting Journal", and included in it stories she wrote and illustrated. She lived for a while in St. John's Wood, London, with an aunt who had been at the London School of Art in John Hassall's (see Houfe) day, and also got to know Bloomsbury well. She was educated at Minerva College, a boarding school in Leicestershire, and while there also studied at Leicester School of Art. At the age of sixteen she went to the Slade (1934-39), where her natural love of the kind of illustration done in England and France in the 19th century was strengthened, and where she was trained in stage design by

Vladimir Polunin, Diaghilev's scene painter. At the Slade she also came into contact with the Euston Road Group, and thus the Bloomsbury scene: Victor Pasmore painted her ("The Striped Dress, or Painting Lesson") in Duncan Grant's* studio in Fitzroy Street in 1939. Her husband, Standish Masterman, whom she married in 1940, was a relative of artist Archibald Standish Hartrick (see Houfe), and both had lived in Fitzroy Street in Bloomsbury.

During WW2 she did voluntary work and exhibited paintings in various galleries, including a one-artist show of watercolour drawings at the Leger Galleries in 1945. This successful show of 19th century "scenes", which were inspired by her love of Rowlandson and the 19th century illustrators, was one event which encouraged her to start illustrating books. She then combined teaching illustration at Camberwell School of Art (1945-65) with the actual illustrating of books.

Her passion for eighteenth and nineteenth century illustrations has influenced much of her own work. Like Ardizzone*, whom she knew well and whose illustrations she "adores", she believes that good illustrations show a relationship between people and "something going on." Many illustrations have been done for her own enjoyment and not actually for publication, and she loves to use a variety of materials in her work, including pen and ink, chalk, aquatints, monotypes, autolithography, and occasionally adhesive tints added to line drawings. The illustrations for *A Hero of Our Time* (1980) are black drawings or paintings done on transparent plastic material; and she produced a large set of glass paintings to illustrate Tennyson's "Maud" for exhibition at the Usher Art Gallery in Lincoln. She is fascinated by toy theatres and recently she created the sets and characters for a toy theatre production in Denmark. Some of her books for children show her love of old cuts and prints while many other of her book illustrations show how much her work is influenced by modern French painters.

Masterman has done many book jackets, including those for Dent's "Everyman" 1960s edition of Jane Austen's novels; and has exhibited widely in London and outside.

Books illustrated include: Barbey D'Aurevilly: *Les Diaboliques* (Elek, 1947); H. de Balzac: *Eugénie Grandet* (Folio Society, 1953); D.H. Lawrence: *The Virgin and the Gypsy* (Folio Society, 1955); M. Barker: *Jane and Peter* series (1956); L.W. Bellhouse: *The Helicopter Children* (1956); L. de Vilmorin: *Les Belles Amours* (1956); E. Farjeon: *Perkin the Pedlar* (OUP, 1956); L.W. Bellhouse: *Carolina's Holiday* (1957); L. de Vilmorin: *Love Story* (1957); E.G. Thorpe: *Sad Little Star* (1958); L. de Vilmorin: *The Letter in a Taxi* (1960); H. Murger: *Vie de Bohème* (Folio Society, 1960); N. de Buron: *Feed the Brute* (1961), *Say I'm in Conference* (1961); J. Wayne: *The Day the Ceiling Fell Down* (1961); B. Cavanna: *The Scarlet Sail* (1962); J. Wayne: *The Night the Rain Came In* (1963); J. Joyce: *A Portrait of the Artist as a Young Man* (Folio Society, 1965); L.M. Alcott: *Little Women* (Folio Society, 1966); W.S. Maugham: *Cakes and Ale* (Folio Society, 1970); Calisto: *The Spanish Bawd* (Folio Society, 1973); L. Tolstoy: *Anna Karenina* (Folio Society, 1975); M. Lermontov: *A Hero of Our Time* (Folio Society, 1980); A. Scott: *A Murmur of Bees* (1980); M. Franklin: *My Brilliant Career* (Folio Society, 1983); F. Hodgson: *The Secret Garden* (Folio Society, 1986).

Contrib: *Envoy; Radio Times; Vogue.*

Exhib: Leger Galls. (1945); Usher Gallery, Lincoln; Midhurst; York.

Bibl: Folio 40; ICB2; Jacques; Peppin; Usherwood; IFA.

Colour Plate 1

MATTHEW, Jack b.1911
Born on 8 January 1911, Matthew grew up in Oldham, Lancashire. He studied at Oldham School of Art and Goldsmiths' College School of Art (under Stanley Anderson, Clive Gardiner and Rowland Hilder*), concentrating on wood engraving, lithography and illustration. The books he illustrated were usually adventure stories; his illustrations to Stevenson's *Catriona* (1947) show Hilder's influence. He illustrated two books for Peter Lunn (*The Haunted Island* and *Spanish Galleon*) with textured pencil drawings, the full-page illustrations printed black over various colours. They are very well drawn and full of action.

Books illustrated include: M. Redlich: *Jam Tomorrow* (Nelson, 1937); M. Sankey: *Chuckwaggon* (1939); U.M. Williams: *Peter and*

Donald MAXWELL "Wouldham, on the Medway" from *More Adventures Among Churches* (Faith Press, 1929)

the Wanderlust (Harrap, 1939); T. Watkins: *Spanish Galleon* (Lunn, 1945); E.H. Visiak: *The Haunted Island* (Lunn, 1946); R.L. Stevenson: *Catriona* (OUP, 1947); L.E. Cheesman: *Marooned in Du-Bu Cove* (Bell, 1949); R.M. Ballantyne: *Coral Island* (Blackie, 1952); K. Fidler: *Tales of the North Country* (1952); P.F. Westerman: *Round the World in the "Golden Gleaner"* (1952), *Bob Strickland's Log* (1953); D. Suddaby: *Merry Jack Jugg, Highwayman* (1954); Robertson: *Blue Wagon* (OUP, 1955).
Contrib: *Radio Times*.
Bibl: ICB2; Peppin.

MATTHEWS, Rodney Clive **b.1945**
Born on 6 July 1945 in Paulton, Somerset, Matthews studied at The West of England College of Art, Bristol (1961-62). After working for an advertising agency in Bristol (1963-70), he formed a partnership, called "Plastic Dog Graphics", specializing in art for record sleeves and posters. In 1976 he became a free-lance illustrator of fantasy and science fiction. His work usually consists of highly-worked, detailed and imaginative colour paintings, done in coloured inks, gouache, and often using the airbrush technique. Besides illustrating a number of books (including four picture books for children without words, *The Blue Planet Series*), he has produced book jackets and many paperback covers, record sleeves, posters and calendars; and he is working (1992) on "Lavender Castle", a television series to be shown on BBC TV in 1993. He writes that he has been influenced by the work of Walt Disney, Arthur Rackham and Edmund Dulac, "and most of all by the British countryside." (IFA.)
Books illustrated include: G. Smith: *Yendor: The Journey of a Junior Adventurer* (Big O Publishing, 1978); *Greek Myths and Legends* (Usborne, 1986); *Norse Myths and Legends* (Usborne, 1986); M. Moorcock: *Elric at the End of Time* (Paper Tiger/ Dragon's World, 1987).
Books written and illustrated include: *The Blue Planet Series* (four vols., Childs Play International, 1975); *In Search of Forever* (Paper Tiger, 1985); *Last Ship Home* (Paper Tiger, 1989).
Contrib: *Great Writers; Imagine; Orbit (Holland); Vortex.*
Exhib: Langton Gallery (1985); Festival International de la Bande Dessinée, Switzerland (1986); Conspiracy 87, Brighton (1987).
Bibl: Rodney Matthews: *In Search of Forever* (Paper Tiger, 1985); Matthews: *Last Ship Home* (Paper Tiger, 1989); IFA.
Colour Plate 115

MAXWELL, Donald **1877-1936**
See Houfe
Books illustrated include: H.W. Longfellow: *The Building of the Ship* (1904); W. Watson: *Wordsworth's Grave* (1904); W. Wordsworth: *Lines Composed a Few Miles Above Tintern Abbey* (1904), *Resolution and Independence* (1904); A. Herbert: *The Isle of Man* (1909); J. Baker: *Austria* (1913); G.S. Maxwell: *The Motor Launch Patrol* (1920), *The Naval Front* (1920), *The Fringe of London* (1925); R. Kipling: *Sea and Sussex* (Macmillan, 1926); H. Belloc: *Hills and the Sea* (1927); R. Kipling: *Songs of the Sea* (1927); G.S. Maxwell: *The Road to France* (1928); J. Milne: *Travels in Hope* (Hodder, 1928); R. Kipling: *East of Suez* (Macmillan, 1931); C.B. Mortlock: *Famous London Churches* (1934).
Books writen and illustrated include: *The Log of the Griffin* (with C.W. Taylor; 1905); *A Cruise Across Europe* (with C.W. Taylor; 1907); *Adventures with a Sketch Book* (BH, 1914); *A Dweller in*

R.A. MAYNARD *Poems of George Herbert* (Gregynog Press, 1923). By permission of the National Library of Wales, Aberystwyth

Mesopotamia (1920); *Unknown Kent* (and seven other titles in series; 1921-35); *The New Lights o'London* (1926); *History with a Sketch Book* (1926); *The Book of the Clyde* (1927); *The Enchanted Road* (1927); *Excursions in Colour* (Cassell, 1927); *Adventures Among Churches* (Faith Press, 1928); *The Landscape of Thomas Hardy* (Cassell, 1928); *A Detective in Kent* (and three others in series; BH, 1929-33); *More Adventures Among Churches* (Faith Press, 1929); *Colour Sketching in Chalk* (1934).
Bibl: Peppin; Waters.

MAYNARD, Robert Ashwin　　　　　　　　**1888-1966**
Trained originally as an architect at the London Polytechnic School of Architecture, Maynard soon turned to painting. Before serving in the London Scottish Regiment during WW1, Maynard earned his living as a theatrical scene painter. Invited to be the organiser of crafts at Gregynog, Maynard took up his appointment as Controller in February 1921, but spent the next eighteen months learning about printing and wood engraving. The first book printed at Gregynog, *The Poems of George Herbert* (1923), contains one wood engraving and engraved capital letters by Maynard. In 1924, Maynard invited his friend Horace Bray* to join him at Gregynog, and they were jointly responsible for most of the illustrations in the books produced there before 1930.
As more publications came from the Press, Maynard's administrative duties grew also and by 1928 he had become dissatisfied for he was no longer able to devote as much time as he wanted to his creative work. In 1931 both he and Bray resigned and established their own Raven Press in Harrow Weald, and Blair Hughes-Stanton* took over as Director of the Gregynog Press. Bray left the Raven Press in 1934 after a disagreement about profit-sharing, but Maynard continued, producing mainly high quality greeting cards.
Maynard and Bray made an outstanding contribution to the production of eighteen books which were published by the Gregynog Press in the years 1923-31. "Their style was so similar that where they worked jointly on illustrations for a book, it is not easy to discern which artist was responsible for a particular engraving unless the block is actually signed. This factor contributed significantly to the unity of the books produced in this first period. . . When one remembers that Maynard had received no formal training in typography and book design, the standard he achieved is no less than amazing." (Harrop, 1980.†)
Books illustrated include (published by Gregynog Press unless otherwise indicated): G. Herbert: *Poems* (1923); H. Vaughan: *Poems* (with H.W. Bray, 1924); *Caneuon Ceiriog Detholiad* (with H.W. Bray, 1925); T.G. Jones: *Detholiad o Ganiadau* (1926); E. Thomas: *Chosen Essays* (with H.W. Bray, 1926); *The Life of Saint David* (with H.W. Bray, 1927); *Penillion Omar Khayyam* (1928); E. L. Jones: *Arnold House . . .* (pp., Gregynog Press, 1929); C. Rossetti: *Poems* (1930); *The Stealing of the Mare* (1930); Euripides: *Plays* (with H.W. Bray, 1931); J. Milton: *Samson Agonistes* (Raven Press, 1931).
Bibl: Dorothy A. Harrop: *A History of the Gregynog Press* (Private Libraries Association, 1980); Peppin.

MAYO, Eileen b.1906

Mayo was educated in Yorkshire and Bristol, and studied at the Slade (1924-25) and at the Central School of Arts and Crafts as a part-time student, under Noel Rooke* and John Farleigh*. She later attended the Chelsea Polytechnic (1936) and the Académie Montmartre in Paris, under Fernand Léger (1948-49). She was instructed in linocutting techniques by Claude Flight*; and was well known as Dame Laura Knight's favourite model. She taught in various art schools in London, Sydney (Australia) and New Zealand, where she lived from 1962. She is a painter, printmaker, poster designer and illustrator. Elected SWE.

Books illustrated include: E.C. Blunden: *Japanese Garland* (Beaumont Press, 1928); *Serge Lifar* (Beaumont Press, 1928); C.W. Beaumont: *Toys* (Beaumont Press, 1930); *The Poems of Amriolkais* (High House Press, 1930); C. Flight: *Lino Cutting and Printing* (with others, Batsford, 1934); S. Carrigher: *One Day on Beetle Rock* (Pleiades Books, 1946).

Books written and illustrated include: *Nature's ABC* (Pleiades Books, 1944); *Shells and How They Live* (Pleiades Books, 1944); *The Story of Living Things and Their Evolution* (Gawthorn, 1944); *Little Animals of the Countryside* (Pleiades Books, 1945); *Larger Animals of the Countryside* (Pleiades Books, 1949); *Animals on the Farm* (Puffin Picture Book; Penguin, 1951).

Bibl: Parkin; Peppin.

MAYS, Douglas Lionel b.1900

Born on 4 August 1900, Mays was educated at Tiffins School, Kingston-on-Thames, and studied art at Goldsmiths' College School of Art (1920-23), under Harold Speed and E.J. Sullivan (see Houfe). A painter in oil and watercolour, Mays illustrated school stories and adventure stories for children, using pen, pencil and wash. He exhibited at the RA and elsewhere, and contributed drawings to a number of magazines, including *Punch*, where, after years of illustrating jokes about children or fashionable women "in the tradition of du Maurier" (Price), he most successfully illustrated the weekly features which reported on world events.

Books illustrated include: P.F. Westerman: *The Disappearing Dhow* (1933), *Andy-All-Alone* (1934) and four other titles to *Cadet Alan Car* (1938); *The New Green Book for Girls* (with others, 1934); N. Streatfeild: *Tennis Shoes* (1937), *The House in Cornwall* (1940), *Curtain Up!* (1944); N. Breary: *Junior Captain* (1946), *Rachel Changes Schools* (1948); A. Buckeridge: *Take Jennings for Instance* (Collins, 1958), *Jennings As Usual* (Collins, 1959) and nine other titles in series to *The Jennings Report* (Collins, 1970).

Contrib: *Big Budget; Holiday Annual; John Bull; Punch; Tatler.*

Exhib: RA; RBA; SGA.

Bibl: Peppin; Price; Waters; Who.

MEDLEY, Charles Robert Owen b.1905

Born on 19 December 1905 in Chelsea, London, Robert Medley was educated at Gresham's School, Norfolk, (where he met W.H. Auden, the beginning of a long friendship) and studied at the Byam Shaw (1923-24), the RA Schools for two months, the Slade (1924-26) and in Paris (1926-28). He has had several teaching appointments, including the Chelsea School of Art in the 1930s and 1940s; he was in the Theatre Design Departmant at the Slade (1949-58); and Head of the Department of Fine Art at Camberwell School of Art and Crafts (1958-65). During WW2 he was first an official war artist for the ARP and then enlisted in the Royal Engineers.

Painter, designer and draughtsman, Medley had his first one-artist exhibition at the Goupil Galleries in 1930. He exhibited with the London Group from 1929 and was elected a member in 1937. He was also much involved in the theatre: he was chief designer of the left-wing Group Theatre (he designed sets and costumes), and later did sets and costumes for Sadler's Wells and painted the safety curtain for the Old Vic in 1939. He contributed four ink drawings and a full-page colour lithograph to the second issue of the magazine *The Arts* (c.1945), to illustrate poems by Kathleen Raine; and he illustrated at least two books, and one of these, *Samson Agonistes*, he regarded as "one of the best things I have done". (Medley 1983.†) He had made representational paintings on the theme in 1949, and in 1978 exhibited a trial run of sixteen large-format screenprints illustrating the poem. As this was a success, in 1980 he published the book (printed at Norwich School of Art) in a limited edition,

with twenty-four screen-printed images. He also produced book jackets for Lehmann, including that for Saul Bellow's *Dangling Man* (1946).

Books illustrated include: R. Fuller: *Savage Gold — a Story of Adventure* (Lehmann, 1946); J. Milton: *Samson Agonistes* (pp., 1980). He was elected RA (1985); and awarded the CBE.

Contrib: *Arts 2; Penguin New Writing.*

Exhib: LG; Goupil Galleries; Hanover Gallery; Lefevre Gallery; Leicester Galls; Whitechapel Art Gallery (retrospective, 1963); Museum of Modern Art, Oxford.

Collns: Tate.

Bibl: Robert Medley: *Drawn from the Life: A Memoir* (Faber, 1983); *Robert Medley; Paintings 1928 to 1984* (Oxford: Museum of Modern Art, 1984); Tate; Waters.

Colour Plate 116

MELDRUM, Roy fl. 1927-1936

Meldrum wrote novels, books on rowing, and studies of Latin elegiac verse, as well as writing and illustrating a number of books for children, all of which were published by Basil Blackwell.

Books illustrated include: L. Housman: *Turn Again Tales* (with others, 1930).

Books written and illustrated include: *Col & Joy* (Blackwell, 1927); *The Silver Ship* (Blackwell, 1927); *Zed* (Blackwell, 1930); *The Happy Cobbler* (Blackwell, 1932); *Robin the Monk* (Blackwell, 1934); *Susanna; also The Duckling* (Blackwell, 1936).

Contrib: *Joy Street.*

Bibl: Peppin.

MERCER, Amy Joyce 1896-1965

Born in Sheffield, Mercer studied at Sheffield School of Art and Chelsea School of Art. She became a book illustrator and postcard designer, and contributed cartoons to several magazines, including *Punch*. Her illustrations are done in ink or in full colour, and are flat, two-dimensional.

Books illustrated include: *Grimm's Fairy Tales* (1934); H.C. Andersen: *Andersen's Fairy Tales* (1935); *The Favourite Wonder Book* (Odhams, 1938); E. Blyton: *Mister Meddle's Mischief* (and two others, with Rosalind M. Turvey, 1940-54).

Contrib: *Bystander; Collins' Toddlers' Annual; Girl's Own Paper; ILN; London Opinion; Prize; Punch; Sketch.*

Bibl: Peppin.

MEREDITH, Norman b.1909

Born in Liverpool, Meredith studied at Liverpool College of Art, the RCA and in Italy, France and Germany. He lectured at University College, Aberystwyth, and at the St Martin's College of Art (1947-74).

He contributed humorous illustrations to a large number of magazines, including *Punch*, and a strip cartoon to the *Evening Standard*. At the end of WW2, he was asked to illustrate Enid Blyton's stories, and since then he has illustrated more than one hundred books, mostly in pen and ink. The success of this venture resulted in designs for textiles, tin boxes, greeting cards and gift wrap. Since 1974, he has concentrated on producing humorous, full-colour paintings of anthropomorphised animals. He had his first exhibition at Beetles Gallery in London in 1984 (and sold all the twenty-two pictures available), and his first one-artist show there in 1985.

Books illustrated include: *The Modern Gift Book for Children* (1948); G. Trease: *Fortune, My Foe* (1949); G. Brandon: *Sangler's Circus* (1948); E. Blyton: *Rubbalong Tales* (1950), *Feefo, Tuppenny and Jinks* (1951); G. Brandon: *Sangler's Sawdust Ring* (1951), *Sangler's Rising Star* (1952); E. Blyton: *The Queer Adventure* (1952); E. Graham: *The Story of Charles Dickens* (1952); G. Brandon: *Sangler Comes to Town* (1953), *Sangler Buys Babette* (1954); V.S. Petheram: *Racing Car Mystery* (1960), *The Moon Rocket* (1960), *The Sea-Devil Divers* (1960), *Sam Spanner Detective* (1960); I. Byers: *Sea Sprite Adventure* (1960), *The Twins' Good Turn* (1961); P. Symonds: *Let's Speak French* (1963); A.E. Smith: *Mr. Tarr's Tale* (1966); C.A. Burland: *Montezuma, Lord of the Aztecs* (1967); P. Titley: *Look and Remember History Series*, six books (Mills & Boon, 1969-77), *Look and Remember People and Events Series*, four books (Mills & Boon, 1975-76).

Contrib: *Bystander; Evening Standard; Punch; Sketch; Tatler.*

Exhib: Beetles (1985).
Bibl: *The World of Norman Meredith* (Exhibition catalogue, Beetles, 1985); *The Illustrators* (Exhibition catalogues, Beetles, 1986-); Peppin; Who.
Colour Plate 117

MEYER, Renate **b.1930**
Born on 5 March 1930 in Berlin, Meyer studied at the Regent Street Polytechnic, where she met Charles Keeping* and later married him. She wrote and illustrated a few books for children between 1968 and 1972, but since that time she has been working mainly in creative textiles. She has had several exhibitions. For the last seven years, she has been creating a family tree in frieze form, in a combination of paint, fabric and stitch, and by the end of 1989 had reached the year 1960.
Books illustrated include: H. Cresswell: *The Bird Fancier* (Benn, 1971).
Books written and illustrated include: *Vicki: A Picture Book* (BH, 1968); *Hide-and-Seek: A Picture Book* (BH, 1969); *Let's Play Mums and Dads: A Picture Book* (BH, 1970); *The Story of Little Knittle and Threadle: A Picture Book* (BH, 1971); *Mr. Knitted and the Family Tree* (BH, 1972); *Susie's Dolls Pram* (BH, 1973).
Bibl: IFA.

MICHAEL, Arthur C. **fl. 1903-1928**
See Houfe

MICKLEWRIGHT, Robert Flavell **b.1923**
Born on 1 May 1923 in West Bromwich, Staffordshire,

Robert MICKLEWRIGHT *The Witch's Brat* by Rosemary Sutcliffe (Oxford University Press, 1970) From the original drawing

Robert MICKLEWRIGHT Illustration for "The Windsor of George IV" in *Radio Times* (22 December 1966) From the original drawing

Micklewright was educated in Balham, South London, and studied at Croydon School of Art (1939), and at Wimbledon College of Art (1940-42). After war service with the Northumberland Fusiliers in North Africa and Europe, he returned to Wimbledon School of Art (1947-49) and the Slade and the Bartlett School of Architecture (1949-52), where the Euston School exerted a strong influence.
After leaving school he became a free-lance painter, designer and illustrator, doing posters for London Transport, stamp books for the Post Office, and various design assignments for such companies as Gulf Oil and Shell. He started contributing to *Radio Times* in 1954; has illustrated many books, especially for the Oxford University Press; and designed many book jackets. In recent years, he has worked mainly as a watercolour painter. Elected MSIA (1955); FSIA (1966, resigned 1979); ARE (1961); RE (1976); RWS.
Books illustrated include: M-A. Boudray: *Mick and the Motorbike* (BH, 1961); R.L. Stevenson: *Treasure Island* (Nonesuch Press, 1963); H. Agg: *A Cypress in Sicily* (Blackwood, 1967); A.C. Clarke: *A Fall of Moondust* (1967); S. Rathnamal: *Beyond the Jungle* (1968); R.L. Stevenson: *The Black Arrow* (1968); H.E. Brimsmead: *Listen to the Wind* (OUP, 1970); R. Sutcliff: *Witches Brat* (OUP, 1970); E.L. Almedingen: *Ellen* (OUP, 1971); K. Hudson: *The Story of Elizabethan Boy Actors* (OUP, 1971); M. Saville: *See How It Grows* (OUP, 1971); E.L. Almedingen: *Anna* (OUP, 1972); A.C. Clarke: *The Song Tree* (1972); N. Shelley: *Family at the Lookout* (Hamilton, 1972); J.R. Townsend: *Summer People* (OUP, 1972); *The Case of the Vanishing Spinster & Other Stories* (Collins, 1972); K. Hudson: *Chaucer in His Time* (OUP, 1973); J. Wills: *The Sawdust Secret* (Hamilton, 1973); H.M. Dobinson: *Bird Count* (with Roy Wiltshire, Penguin, 1976); J. Escott: *Oddments Corner* (Hamilton, 1976); D. Edwards: *A Strong and Willing Girl* (Methuen, 1980); M. Saville: *The Seashore Quiz* (Carousel, 1981); *Geoffrey Grigson's Countryside* (Ebury Press, 1982).

Contrib: *Farmer & Stockbreeder; Listener; New Society; Punch; Radio Times; Reader's Digest; Sunday Times; Times; TV Times.*
Exhib: RA; RWS.
Collns: V & A; Sheffield; Southend.
Bibl: Driver; ICB4; Jacques; Peppin; Ryder; Usherwood; Waters; Who; IFA.

MIDDA, Sara **b.1951**
Born on 8 November 1951, Midda studied at Eastbourne College of Art, Goldsmiths' College and the St. Martin's School of Art. She became a free-lance illustrator, contributing to magazines and designing book jackets and greeting cards, before she produced her first book in 1982. As an illustrator, Midda is best known for *In and Out the Garden*, which she both wrote and illustrated and for which she was awarded the Francis Williams prize for the best illustrated book of 1982. She has recently worked as designer for a Japanese department store.
Books written and illustrated include: *In and Out the Garden* (1982); *A Sketchbook of Southern France* (Sidgwick).
Contrib: *Cosmopolitan.*
Bibl: *The Illustrators: Catalogue* (Chris Beetles Ltd., 1991); Parkin.

MIDDLEHURST, Frederick **1918-1982**
Born on 6 January 1918 in Great Harwood, near Blackburn, Lancashire, Middlehurst studied art at the Blackburn School of Art (1932-39), gaining a scholarship to the RCA, where he studied engraving under Malcolm Osborne and Robert Austin* (1942-45). A painter in watercolour and gouache, he gained a reputation in the post-war years as a designer and illustrator, producing work for a variety of publishers and studios. He taught in many London art schools, including Camberwell, Hammersmith, Kingston and for more than twenty years at the London College of Printing. As an artist, he produced watercolours, wood engravings, lino cuts and etchings. He was elected ARE (1945); RE.
Exhib: RA; RE; Preston.
Bibl: Les Duxbury: "Fred Middlehurst, R.E.", *Journal RSP-EE*, No.6 (1984): 37; Waters.

MILLAR, Harold Robert **1869-c. 1940**
See Houfe

MILLER, Hilda T. **1876-1939**
Miller studied at Birmingham School of Art, at the Slade, and then at St. Albans Art School. She worked for Liberty, the London store (1910-18) as a commercial artist, and later illustrated a few books in a decorative style. The illustrations, in both black and white and full colour, which she did for *The Rose Fyleman Fairy Book*, a gift book with a splendid gold-blocked cover and the text printed in blue and black, are typical of her best work.
Books illustrated include: J.A. Bentham: *Shoes* (Duckworth, 1920); P. Saunders: *The Flame Flower* (Butterworth, 1922); *The Rose Fyleman Fairy Book* (Methuen, 1923); W. de la Mare: *Lucy* (1927); *The Butterflies' Day* (nd); *The Pageant of Flowers* (nd).
Contrib: *Joy Street.*
Exhib: RSA.
Bibl: Peppin; Waters.

MILLER-PARKER, Agnes
See PARKER, Agnes Miller

MILLS, Dorothy **fl.1920s?**
No information about this artist is available. She provided attractive black and white line drawings for at least one book.
Books illustrated include: S. Strowska: *Ten Polish Folk Tales* (Burns, Oates & Washbourne, 1929).

MINTON, Francis John **1917-1957**
Born on 25 December 1917 in Cambridgeshire, Minton was educated in Bognor Regis and Reading, and studied at St. John's Wood Art School (1935-38). He then spent eight months in France with Michael Ayrton* and Michael Middleton, returning to London just before WW2 where he registered as a conscientious objector. He began to paint a series of London street scenes and in 1941, with Ayrton, designed the costumes and decor of Gielgud's *Macbeth*. He

Dorothy MILLS *Ten Polish Folk Tales* by Suzanne Strowska (Burns, Oates & Washbourne, 1929)

then withdrew his conscientious objection and served in the army for two years before being released in 1943. He taught illustration at Camberwell School of Art (1943-46), then at Central School before becoming a Tutor in painting at RCA (1948-56). His many friends in London included Dylan Thomas, John Craxton*, Richard Chopping*, Susan Einzig*, and Keith Vaughan* with whom he shared a studio for six years (1946-52).

Minton was a painter, draughtsman, theatre designer, poster artist and book illustrator, and had a passion for travel, which his inherited fortune allowed him to satisfy. He held many one-artist exhibitions, the first in 1945; and was elected a member of the London Group in 1949. He was a lyrical, neo-romantic artist of great personal charm. He made friends easily, and seemed full of nervous energy which often exhibited itself in his exuberant clowning. He made many intense homosexual relationships, acted in a generous but reckless way, and suffered from alcoholism. The popular press sometimes described him as a member of the "beat" generation, but beneath his frivolity was a seriousness towards his art, and beneath it also lurked despair and a preoccupation with death. One of the last pictures he painted was "Composition: The Death of James Dean", which now is in the Tate Gallery. Minton died of an overdose of drugs on 20 January 1957.

Minton strongly held the view that illustrations must complement the literary idea and interpret what has been said in words. He also believed that a successful illustrator must know a great deal about the different methods of reproduction and understand typography and book design so that the illustrations would fit into the book as a whole. In 1947 he illustrated his first book, *The Wanderer* by Alain Fournier, which some believe contain his finest illustrations, inter-

John MINTON *Time Was Away* by Alan Ross (John Lehmann, 1948)

preting the author's mood sympathetically. Alan Ross' *Time Was Away* (1948), has been called one of the key modern British artists books. Not only did it bring together two of the finest post-war talents in Ross and Minton, but it was designed by Keith Vaughan* in his capacity as graphic artist for John Lehmann. Minton illustrated four other books for Lehmann, designed a number of jackets for his books and did designs to be incorporated in typographic jackets. Other books he illustrated include two country books for Michael Joseph and three cookery books. He contributed illustrations to many popular and literary magazines, and to house journals for such companies as Unilever and the Imperial Smelting Corporation. His illustrations for an article on glassmaking for the magazine *Future* in 1948 make up an outstanding portfolio in the English romantic tradition. Rigby Graham* writes of his illustrative work that "because his vision and his drawing had a literary slant, he was able to produce illustrations which were relevant to, and which complemented the printed page, and yet retained the immediacy, the flow and the uninterrupted vitality of a sketch and it is this which made them exceptional." (Graham, 1968.†)

Books illustrated include: A. Fournier: *The Wanderer* (Elek, 1947); O. Cross: *The Snail That Climbed the Eiffel Tower* (Lehmann, 1947); R.L. Stevenson: *Treasure Island* (Elek, 1947); D.L. Toye: *Vogue's Contemporary Cookery* (with Denton Welch*, Condé-Nast, 1947); A. Ross: *Time Was Away* (Lehmann, 1948); H.E. Bates: *The Country Heart* (Joseph, 1949); *Flower of Cities* (with others, Parrish, 1949); R. Arkell: *Old Herbaceous* (Joseph, 1950); E. David: *A Book of Mediterranean Food* (Lehmann, 1950), and *French Country Cooking* (Lehmann, 1951); H.L. Hunter and C. Whiley: *Leaves of Gold* (George Whiley, 1951); W. Shakespeare: *The Tragedy of Macbeth* 2nd ed. (with Michael Ayrton*, Folio Society, 1964).

Contrib: *Ark; Circus; Coal; Complete Imbiber; Future; Lilliput;*

Listener; London Magazine; Opera; Orpheus; Penguin New Writing; Picture Post; Radio Times; Vogue.

Exhib: Roland, Browse & Delbanco; Lefevre; Leicester Galls; RA; Arts Council (1958); Reading (1974).

Collns: Fitzwilliam; Tate; V & A; and many provincial galleries.

Bibl: *John Minton, 1917-1957: An Exhibition of Paintings, Drawings and Illustrations* (Arts Council, 1958); Rigby Graham: "John Minton as a Book Illustrator", *Private Library* 2nd.s., 1, 1 (Spring 1968): 7-36; Rigby Graham: *Romantic Book Illustration in England 1943-55* (Pinner: Private Libraries Association, 1965); John Lewis: "Book Illustrations by John Minton", *Image* 1 (Summer 1949): 51-62; David Mellor: *A Paradise Lost: The Neo-Romantic Imagination in Britain 1935-55* (Lund Humphries/Barbican Art Gallery, 1987); *John Minton 1917-1957: Paintings, Drawings, Illustrations and Stage Designs* (Reading Museum & Art Gallery, 1974); Frances Spalding: *Dance Till the Stars Come Down: A Biography of John Minton* (Hodder, 1991); Malcolm Yorke: *The Spirit of Place: Nine Neo-Romantic Artists and Their Times* (Constable, 1988); Driver; Jacques; Peppin; Tate; Usherwood.

MONSELL, Elinor May
See DARWIN, Elinor May Monsell

MONSELL, John Robert **b.1877**
See Houfe
Born on 15 August 1877 in Cahirciveen, County Kerry, Ireland, Monsell grew up in County Limerick. He was educated at St. Columba's College, Rathfarnham, Dublin, and moved to London when his sister, Elinor Monsell (see Darwin, Elinor), won a scholarship to the Slade. Monsell started illustrating, though he had no formal training, when he told a group of children his story *The Pink Knight*, and drew the illustrations in his sketchbook. The success of this book on publication persuaded Monsell to continue with illustration. He contributed to a number of magazines, such as *London Magazine* and *Little Folks*, and illustrated several books, some of which he wrote. He claims to have been influenced by Walter Crane and Randolph Caldecott, and later by Caran d'Ache. Besides his illustrations, helped by his early love of heraldry, he designed the book jackets for the historical novels written by his wife, Margaret Irwin.

Books illustrated include: T.W.H. Crosland: *The Old Man's Bag* (Grant Richards, 1903); M.C. Hime: *Fanny Haire Her Dream* (Simpkin Marshall, 1904), *The Unlucky Golfer* (Simpkin Marshall, 1904); A.E. Bonser: *The Buccaneers* (Duckworth, 1908); Grimm: *Grimm's Fairy Tales* (Cassell, 1908); W. Pulitzer: *My Motor Book* (Kegan Paul, 1911); W.M. Thackeray: *The Rose and the Ring* (Kegan Paul, 1911); C. Mackenzie: *Kensington Rhymes* (Secker, 1912); B.R.M. Darwin: *Elves and Princes* (Duckworth, 1913); O.C. Williams: *Three Naughty Children* (Duckworth, 1922); L. Housman: *What-O'Clock Tales* (Blackwell, 1932).

Books written and illustrated include: *The Pink Knight* (Chatto, 1901); *Funny Foreigners* (Cassell, 1905); *The Jingle Book* (Nister, 1905); *Notable Nations* (Cassell, 1905); *The Hooded Crow* (Blackwell, 1926); *Polichinelle* (OUP, 1928); *Balderdash Ballads* (Windmill Press, 1934); *Un-Natural History* (Macmillan, 1936).

Contrib: *Cassell's Magazine; Joy Street; Little Folks; London Magazine; My Magazine.*

Bibl: ICB; Peppin.

MONTGOMERIE, Norah Mary **b.1913**
Born on 6 April 1913 in London, Montgomerie was educated in Dulwich and Folkestone, and studied at Putney School of Art. She travelled in Europe before working as a free-lance artist in London. After marrying (1934) William Montgomerie, a poet and authority on Scottish folk-songs, she moved to Scotland and worked as an illustrator for a Scottish publishing company. After her son and daughter were born, Montgomerie made many sketches of them, and these led to commissions to paint portraits, nursery murals, and illustrations for children's books. She and her husband compiled and edited a number of collections of Scottish nursery rhymes, most of which she illustrated.

Books written and illustrated include: *Sandy Candy, and Other Scottish Nursery Rhymes* (Hogarth Press, 1948); *Well at the World's End* (Hogarth Press, 1956); with Kathleen Lines *Poems and*

Mona MOORE "Penclawdd, Gower" in *Recording Britain* vol.1 (Oxford University Press, 1946)

Pictures (Abelard, 1959); *Twenty-Five Fables* (Abelard, 1961); *The Merry Little Fox, and Other Animal Stories* (Abelard, 1964); *One, Two, Three: A Little Book of Counting Rhymes* (Abelard, 1968).
Contrib: *Scottish Educational Journal.*
Bibl: CA; ICB2; ICB3; Peppin.

MONTGOMERY, Elizabeth **fl.1920-1940**
According to Peppin, Montgomery was a member of the Chelsea Illustrators Club, and a founder member of the firm of Motley, which did stage design, and later, couture. She illustrated at least three issues of the "Best Poems" edited by Thomas Moult, decorating them with a frontispiece and small line drawings.
Books illustrated include: T. Moult: *Best Poems of 1930* (and of *1932* and *1940*; Cape, 1931, 1932, 1940).
Bibl: Peppin.

MOORE, Henry Spencer **1898-1986**
Born on 30 July 1898 in Castleford, Yorkshire, Moore served in the army during WW1 (1917-19) and then studied at Leeds College of Art (1919-21), RCA (1921-14) and in France and Italy. A draughtsman and sculptor of international repute, his first one-artist show was held at the Warren Gallery in 1928. He was a member of the London Group, the 7 & 5 Society and Unit One, and exhibited at the International Surrealists Exhibitions in 1936 and 1938. He taught at the RCA (1925-32), and at the Chelsea School of Art (1932-39). During WW2 he was an official war artist, and made many drawings of life in London underground shelters during the Blitz. He is best known for his much larger than life-size sculptures

of human forms, in rounded, abstract shapes, many of reclining figures. Apart from his books of drawings, he illustrated a few books. Hodnett finds no merit with any of the illustrations, referring to the lithographs for the Auden poems as "a pretentious piece of commercialism." He was created CH (1955), and OM (1963).
Books illustrated include: E. Sackville-West: *The Rescue* (Secker, 1945); J.W. Goethe: *Prométhée* (Paris: Jonquières, 1952); W.H. Auden: *Selections from Poems* (1974).
Books written and illustrated include: *Shelter Sketch Book* (Editions Poetry, 1940).
Exhib: Tate (retrospectives 1951, 1968); Bradford (1978).
Collns: Tate; AGO.
Bibl: *The Drawings of Henry Moore* (Tate Gallery; AGO, 1977); Compton; Hodnett; Rothenstein; Tate.

MOORE, Mona **b.1917**
Born on 20 March 1917 in London, Moore was educated at St. Martin's-in-the-Fields, and studied art at St. Martin's School of Art and the Central School of Arts and Crafts (1931-39). A painter in watercolour and gouache, mainly of street scenes and landscapes, she illustrated at least one book (*Sea Poems* in Muller's important "New Excursions in English Poetry" series, contributing sixteen original colour lithographs and a lithographed cloth cover) and contributed eight paintings to the "Recording Britain" project. During WW2 she worked as a war artist, painting scenes of women at work.
Books illustrated include: M. Piper: *Sea Poems* (Muller, 1944); *Recording Britain* (four vols., OUP, 1946-9).

Colour Plate 115. Rodney MATTHEWS Original painting

Colour Plate 116. Robert MEDLEY "Saraband for Dead Lovers" Poster for Ealing Studios, 1948

Colour Plate 117. Norman MEREDITH "Out at Last" Watercolour and bodycolour By permission of Chris Beetles Ltd.

Gwenda MORGAN *Goat Green* by T.F. Powys (Golden Cockerel Press, 1937)

Contrib: *Good Housekeeping; Listener; Radio Times.*
Exhib: Leger Gallery; Leicester Galls; NG; Tate; Whitechapel.
Collns: V & A; National Museum of Wales.
Bibl: Harries; Waters; Who.

MOORE, Thomas Sturge **1870-1944**
See Houfe

MORE, David **b.1954**
Born on 16 September 1954 in Dingwall, Ross & Cromarty, Scotland, More was educated in Sidcup, Kent, at primary school (1959-65) and secondary modern (1965-70). He has had no formal art training, but since 1978 has worked as an illustrator specializing in trees as his subject matter. He has illustrated a number of books; and produced a poster for the Countryside Commission, and at least one book cover for Collins/Fontana.
Books illustrated include: Rushforth: *Trees* (Beazley, 1979); A. Fitter: *Gem Guide to Trees* (Collins, 1980); T.J. Jennings: *Trees* (OUP, 1981); *The Country Life Pocket Guide to Trees* (Hamlyn, 1985); A. Mitchell: *The Complete Guide to Trees of Britain and Northern Europe* (Dragon's World, 1985); *The Guide to Trees of Canada and North America* (Dragon's World, 1987); *Tree* (Dorking Kindersley, 1988).
Bibl: IFA.

MORGAN, Gwenda **1908-1991**
Born on 1 February 1908 in Petworth, Sussex, Morgan was educated at Brighton and Hove High School (1921-26), and studied art at

Goldsmiths' College School of Art (1926-29), leaving to learn wood engraving from Iain Macnab* at the Grosvenor School of Modern Art (1930-36). He recommended her to Christopher Sandford at the Golden Cockerel Press, put her name forward for membership to the SWE and the RE, and introduced her to Joan Shelmerdine who ran the Samson Press with her friend Flora Grierson.

Morgan's first book, *Pictures and Rhymes*, was commissioned by the Samson Press and published in 1936. She illustrated relatively few books, preferring to produce prints and do other work, such as greeting cards for the Samson Press. She did four books for the Golden Cockerel Press, including *Gray's Elegy* (1946), which contains some of her best work and may be regarded as her masterpiece. Christopher Sandford commented that Morgan had produced for this book a set of engravings "which, though entirely in the modern vein, proved a perfect complement to the eighteenth century text. Technically dexterous, they were also delightfully interpretative of village life in England and the unchanging face of the land."

Though occasionally Morgan used scraperboard — for example, *The Course of Nature* (1948) includes five full-page coloured scraperboard illustrations — most of her illustrative work was done as wood engravings. John Randle† has written that "the two wood-engravers whose work Gwenda Morgan most admires are Eric Ravilious* and Douglas Percy Bliss*, and like them she engraves with conviction and clarity. Her blocks are beautifully clean and deeply cut, the antithesis of the very fine line technique beloved of some engravers which can make the printer's job such a difficult one." She stopped engraving in 1970. She was elected a member of NS (1935); SWE (1950); ARE (1952); RE (1961).

Books illustrated include: D.G. Bunting: *Pictures and Rhymes* (Samson Press, 1936); M. Duley: *The Eyes of the Gull* (Barker, 1937); T.F. Powys: *Goat Green* (GCP, 1937); A.E. Coppard: *Tapster's Tapestry* (GCP, 1938); M.H. Tiltman: *A Little Place in the Country* (Hodder, 1944); C. Helmericks: *We Live in Alaska* (Hodder, 1945); T. Gray: *Gray's Elegy* (GCP, 1946); W.K. Robinson: *The Course of Nature* (Hodder, 1948); M.H. Tiltman: *The Birds Began To Sing* (Hodder, 1952); *Grimms' Other Tales* (GCP, 1957); *Nursery Rhymes* (Lorson's Books and Prints, 1985); *Country Calendar* (Lorson's Books and Prints, 1985).
Collns: V & A; Brighton; Ashmolean (incl. proofs and sketchbooks); Herefordshire Museum; Whittington Press (blocks).
Bibl: *Independent* obit. 12 January 1991; John Randle: "Gwenda Morgan, 1908-991", *Matrix* 11 (Winter 1991): 169-71; Randle, ed: *The Wood-Engravings of Gwenda Morgan* (Andoversford: Whittington Press, 1985); Garrett 1 & 2; Hodnett; Sandford; *Shall We Join the Ladies?*; Waters; Who.

MORGAN, Roy **1928-1990**
Born on 21 October 1928 in Wales, Morgan spent his childhood in Aberystwyth. He was educated at Ardwyn Grammar School; after leaving school, he joined the Royal Navy and, on his release, studied at Cardiff College of Art and RCA under Edward Bawden* (1952-56). He illustrated several books while still a student at RCA. He has used wood engravings (including coloured woodcuts) and lithographs for his illustrations; and the subject matter of his books that have been seen is concerned with medieval or contemporary romantic legend. For *Sir Gawain*, published in 1956 by the RCA's own press, he produced twelve lithographs in up to four colours. He died in December 1990 after a house fire.
Books illustrated include: B.L. Picard: *Stories of King Arthur and His Knights* (OUP, 1955); *Sir Gawain and the Green Knight* (Lion & Unicorn Press, 1956).
Bibl: *Guardian* obit. 17 December 1990; ICB2.

MORRIS, Anthony **b.1938**
Born on 2 August 1938 in Headington Quarry, near Oxford, Morris studied painting and pottery at Oxford School of Art (1954-58). He won a scholarship to the RA Schools, and studied under Peter Greenham (1958-61), becoming increasingly interested in portrait painting. He set up a studio in Oxford, painting portraits (his first commission was to paint the retiring Librarian of the Bodleian Library, Professor Myers) and doing pottery. He exhibited landscapes and portraits regularly at the RA and the Royal Society of

Portrait Painters; his first one-artist exhibition was held at the Medici Gallery in 1981.

In 1980 he started doing illustrations for children's books and for television.His subjects include the figurative and historical, and wildlife. He was a major contributor to the "Puddle Lane" reading series from Ladybird, and to the Oxford Junior History. Married in 1970, he moved to Wales in 1989 to avoid advancing urbanization, and find wild and unspoilt country. He was elected RP (1971).

Books illustrated include: *World Atlas of Birds* (Mitchell Beazley).

Exhib: RA; RP; Medici Gallery (1981).

Bibl: Who; IFA.

MORROW, Albert George　　　　　　　　　　**1863-1927**
See Houfe

MORROW, George　　　　　　　　　　　　　**1869-1955**
See Houfe
Books illustrated include: C.L. Graves: *Musical Monstrosities* (Pitman, 1909); E.V. Lucas: *In Gentlest Germany* (BH, 1915); N. Ross: *The House-Party Manual* (Cassell, 1917); A.P. Herbert: *Light Articles Only* (Methuen, 1921); E.A.W. Smith: *Some Pirates and Marmaduke* (BH, 1921); E.V. Lucas: *You Know What People Are* (Methuen, 1922); G.C. Faber: *Elnovia* (Faber, 1925); A.P. Herbert: *Laughing Ann* (Fisher Unwin, 1925); M.L. Gower: *Chuckles*

John MORTON-SALE *Good Afternoon, Children* by "Columbus" (Hodder & Stoughton, 1932)

(Methuen, 1927); E.A.W. Smith: *The Marvellous Land of Snergs* (Benn, 1927); F.G. Evans: *Puffin, Puma and Co* (Macmillan, 1929), *Here Be Dragons* (Macmillan, 1930); A.G. Herbertson: *Hurrah for O-Pom-Pom* (Nelson, 1931); D.M. Large: *Irish Airs* (Constable, 1932); A. Marshall: *The Birdikin Family* (Dent, 1932); J.B. Morton: *The Death of the Dragon* (Eyre, 1934).

Books written and illustrated include: *George Morrow: His Book* (Methuen, 1920); *More Morrow* (Methuen, 1921); *Podgy and I* Nelson, 1926); *Some More* (Methuen, 1928).

Contrib: *Bystander; Idler; London Mercury; Pall Mall; Pearsons; Punch; Radio Times; Strand; Tatler.*

MORTELMANS, Edward Eugene Louis　　　　　　**b.1915**
Born on 18 April 1915 in London, Mortelmans was educated at Carlingford College. When he left school, he worked as a sales clerk in a menswear shop, and attended evening art classes at Upper Hornsey Road Evening Art Institute and the Central School of Arts and Crafts. After losing his job in 1938, he worked as a builder's labourer while attending the Slade as a part-time student (under Randolph Schwabe*). He served in the Red Cross in 1939 and the army (1940-45) during WW2, returning to the Slade after the war (1945-48). He became a free-lance artist, painting murals and doing commercial and book illustrations, which are mostly straight-forward drawings in pen and ink or in full colour.

Books illustrated include: K. Fidler: *The Boy with the Bronze Axe* (O & B, 1968); A. Catherall: *Antlers of the King Moose* (Dent, 1970); R. Dallas: *A Dob Called Wig* (Methuen, 1970); R. Garrett: *Great Sea Mysteries* (Pan Books, 1971); G. Durrell: *Catch Me a Colobus* (Collins, 1972); J. Gilbert: *Buccaneers and Pirates* (Ham!yn, 1975); E. Abranson: *Ships of the High Seas* (Lowe, 1976); H.G. Castle: *Spion Kop* (Almark, 1976); J. Gilbert: *Prehistoric Man* (Macdonald, 1979); E. Blyton: *Robin Hood and His Merry Men* (Windward, 1980); E. Abranson: *Stories of the Sea* (Hodder, 1983); E. Nesbit: *The Story of the Treasure Seekers* (Purnell, 1983); A. Prince: *Night Landings* (Methuen, 1983); J. Ross: *Alexander Fleming* (Hamilton, 1984); N. Richardson: *Edith Cavell* (Hamilton, 1985); A. Bull: *Marie Curie* (Hamilton, 1986); N. Hunter: *A Medieval Monk* (Wayland, 1987).

Bibl: ICB4; Peppin.

MORTON-SALE, John　　　　　　　　　　　**b.1901**
MORTON-SALE, Isobel　　　　　　　　　　　**b.1904**
Born on 29 January 1901 in Kensington, London, Morton-Sale studied at Putney School of Art and at the Central School of Arts and Crafts, under A.S. Hartrick (see Houfe) and G. S. Pryse*. Even as a child, he was interested in illustration, for he painted dust covers for his books, and illustrated a magazine produced by his brother. Also while a child, he met his future wife at the local church, and later they were fellow students at the Central School. His wife, Isobel, was born on 15 May 1904 in Chelsea, and grew up there and in Kew. She studied at Ramsgate School of Art and at the Central School, under Hartrick, Pryse, and Noel Rooke*.

At first, Isobel was primarily a painter of children's portraits, while John concentrated on landscapes. During WW2 John Morton-Sale produced a system of camouflage which was adopted for use. They founded and directed the Parnassus Gallery, which for many years published reproductions of their own paintings and the works of established masters. As illustrators, they worked together on books for children, using a variety of techniques, including pen, pencil, crayon, and watercolour. Sometimes they combined marginal sketches, full-page drawings and colour plates in the same book, such as in *Good Afternoon, Children* (1932), which was a collection of stories and plays first heard in the BBC's "Children's Hour". Introduced to Eleanor Farjeon by the publisher, Robert Lusty, their drawings of children's games inspired the writer to produce a number of books which combined verse and pictures — *Cherrystones, The Mulberry Bush* and *The Starry Floor* (later reissued in one volume as *Then There Were Three*, 1958). The work of the two illustrators is hard to distinguish, and the drawings are not signed. Doyle asserts that together they.produced "some of the loveliest drawings of children in all their moods ever to appear in books", and he considers *Something Particular* (1955) one of their finest.

Books illustrated (by both John and Isobel unless otherwise indicated) include: W.H. Ogilvie: *A Clean Wind Blowing* (Constable,

Colour Plate 118. Charles MOZLEY Cover for *Country Fair: The Country Fair Annual for 1938* (Country Life 1938)

Colour Plate 119. Paul NASH *Urne Burialle* by Sir Thomas Browne (Cassell 1932)

Colour Plate 120. John O'CONNOR "Apple growing" from *An Essex Dozen* (Benham 1953)

Colour Plate 121. Jan ORMEROD *Moonlight* (Kestrel Books 1982)

Colour Plate 122. Helen OXENBURY *The Quangle Wangle's Hat* by Edward Lear (William Heinemann 1969)

And the small Olympian bear

Irene MOUNTFORT Illustration from *Number Eleven Joy Street* (Basil Blackwell, 1933)

1930); "Columbus": *Good Afternoon, Children* (Hodder, 1932); L. Carroll: *Alice in Wonderland; and Through the Looking Glass* (John; 1933); M. Grigs: *The Yellow Cat* (OUP, 1936); E. Farjeon: *Martin Pippin in the Daisy Field* (OUP, 1938), *Sing for Your Supper* (1938); J. Buchan: *The Long Traverse* (Hodder, 1941); E. Farjeon: *Cherrystones* (Joseph, 1942); Lynch: *Fiddler's Quest* (Isobel; Dent, 1943); E. Farjeon: *The Mulberry Bush* (Joseph, 1945); B. Nichols: *The Tree That Sat Down* (Cape, 1945); E. Farjeon: *The Starry Floor* (Joseph, 1949); Knight: *Anne-Marie and the Pale Pink Frock* (Isobel; Dent, 1953); A. Driver and R. Ramirez: *Something Particular* (Hodder, 1955); E. Farjeon: *Then There Were Three* (Joseph, 1958); W.C. Dickinson: *Borrobil* (John; Penguin, 1964).
Contrib: *Good Housekeeping; Leisure; Strand; Woman's Journal.*
Bibl: Doyle; ICB; ICB2; Peppin.

MOUNTFORT, Irene **fl. 1934-1939**
Little is known of Mountfort, who illustrated children's books with ink drawings, occasionally coloured with watercolour washes.
Books illustrated include: E. Farjeon: *Jim at the Corner* (Blackwell, 1934), *The Clumber Pup, And I Dance My Own Child* (1935); R. Fyleman: *Here We Come A'Piping Again* (1936), *A'Piping Again* (1938), *Pipe and Drum* (1939); L. Carroll: *Alice in Wonderland* (1939).
Contrib: *Joy Street.*
Bibl: Peppin.

MOZLEY, Charles **b.1915**
Born on 29 May 1915 in Sheffield, Mozley studied painting and drawing at Sheffield School of Art and RCA. Before serving in the army during WW2, he taught at Camberwell School of Art (1938-39). A free-lance artist since 1937, his commissions have included autolithographic posters for the Lyric Theatre, Hammersmith, film

posters, murals for the Festival of Britain (1951), drawings for TV commercials, and press advertising for firms such as Shell and BEA, and interior decoration. He is a prolific illustrator, often using pen, pencil, wash, pastel or crayon; occasionally he draws directly on the plate to produce autolithographs. He has also produced many illustrated book jackets. His lithographs and line drawings for *The Man of Property* (1964) show that he is a true illustrator, able to create characters, scenes and atmosphere.
Books illustrated include (but see Peppin): P. Galdos: *Torment* (Weidenfeld, 1952); P.M. Shand: *Building* (Token Construction, 1954); A. Trollope: *The Duke's Children* (OUP, 1954); R. Guillot: *Nicolette and the Mill* (BH, 1960); O. Wilde: *Complete Fairy Tales of Oscar Wilde* (BH, 1960); *Pacala and Tandala* (Methuen, 1960); M. Rouff: *The Passionate Epicure* (Faber, 1961); P.H. Andrews: *Ginger Over the Wall* (Lutterworth, 1962); D. Defoe: *Moll Flanders* (Chatto, 1962); G.B. Shaw: *Man and Superman* (NY: Limited Editions Club, 1962); N. Streatfeild: *A Vicarage Family* (Collins, 1962); G. Macdonald: *At the Back of the North Wind* (Nonesuch, 1963); E. Spenser: *An Hymne of Heavenly Beautie* (1963); G. de Maupassant: *Tellier House* (Cassell, 1964); J. Galsworthy: *The Man of Property* (NY: Limited Editions Club, 1964); E. Kyle: *Girl with a Song* (Evans, 1964); J. Spyri: *Heidi* (1967); H.G. Wells: *The Invisible Man* (NY: Limited Editions Club, 1967); M. Mahy: *The Procession* (1969); E. Childers: *The Riddle of the Sands* (1970); S. Crane: *The Red Badge of Courage* (Dent, 1971); A. Pushkin: *The Captain's Daughter and Other Stories* (NY: Limited Editions Club, 1971); D. Diderot: *The Nun* (Folio Society, 1972); B. Naughton: *A Dog Called Nelson* (1976); C. Ray: *Lickerish Limericks* (1979).
Books written and illustrated include: *The First Book of Ancient Egypt* (1960); *Wolperiana* (Merrion Press, 1960).
Contrib: *Book Design and Production; Motif 1.*
Exhib: RA; NEAC; AIA; Savage Gallery (1960).
Collns: V & A; IWM.
Bibl: Amstutz 1; Hodnett; ICB3; Peppin; Ryder.
Colour Plate 118

MUCKLEY, A. Fairfax **fl. 1892-1944**
The artist who illustrated the books listed seems to have been concerned mostly with books for children which feature animals in the Beatrix Potter* tradition. There is some uncertainty about his identification, as two painters are noted in other reference sources, Angelo Fairfax Muckley and Arthur Fairfax Muckley.
Books illustrated include: A.E. Bonser: *Cassell's Natural History for Young People* (Cassell, 1905); G.E.S. Boulger: *Familiar Trees* (Cassell, 1906-07).
Books written and illustrated include: *Widow Grizzles* (Collins, 1920); *Sly Bill and Squeak Shrew* (Collins, 1943); *Sly Bill Again* (Collins, 1943); *Mr and Mrs Fuzzmops* (Collins, 1944); *Sammy Sharpnose* (Collins, 1944); *The Story of Bunnikins* (Collins, 1944); *The Story of Teddy Toad* (Collins, 1944).
Bibl: Peppin.

MUNGAPEN, Shirley **b.1933**
Born on 9 December 1933 in Boston, Lincolnshire, Mungapen was educated at Kesteven and Grantham Girls Grammar School (1944-50) and studied at Nottingham College of Art (1950-54). After nursing at Peterborough Memorial Hospital and qualifying as an SRN, she went to Portsmouth College of Art and Design, and learned wood engraving from Gerry Tucker. A painter, engraver and writer, she has worked as an art therapist for some years, and became a lay pastor in 1983. Elected SWE (1974).
She much admires the work of two engravers, Eric Ravilious* and George Buday*; and has been influenced by the work of such disparate painters as Paul Klee, William Blake, Goya and Fra Angelica. Most of Mungapen's engraved work is in the form of separate prints, but she has illustrated a few books, and been represented in several collections of engravers, such as *Forty-Five Wood Engravers* (Simon Lawrence, 1982). She has exhibited frequently in Britain, France and Russia.
Books illustrated include: G. Turton: *The Moon Dies* (Leopard's Head Press, 1982); W. Shakespeare: *The Tempest* (Folio Society, 1988), *Timon of Athens* (Folio Society, 1988).
Exhib: SWE; RE; Mall Gallery.
Bibl: Brett; Garrett 1 & 2; *Shall We Join the Ladies?*; IFA.

Shirley MUNGAPEN *The Moon Dies* by Godfrey Turton
(Leopard's Head Press, 1982)

MUSGRAVE-WOOD, John
See EMMWOOD, John

MYNOTT, Gerald P. b.1957
Born in London, Mynott is a brother of Katherine Mynott* and
Lawrence Mynott*, and son of Derek and Patricia Mynott*, all of
whom are artists. Gerald studied at Reigate College of Art, the
College of Arms (London), and in Vienna. He is a topographical
artist and printmaker, who has done work for several publishers,
including Penguin and Weidenfeld and Nicolson.
Contrib: *Field; Observer; Radio Times; Tatler; Times.*
Exhib: Francis Kyle Gallery (1980-); Bath Festival (1983); Arts
Club (1987).
Collns: Tate; V & A.
Bibl: Who.

MYNOTT, Katherine b.1962
Born in London, Katherine Mynott has two artist brothers, Gerald
Mynott* and Lawrence Mynott*, and is the daughter of Derek and
Patricia Mynott*. She studied at Heatherleys, the Central School of
Arts and Crafts, and St. Martin's School of Art. A printmaker and
illustrator, she has contributed to many magazines.
Contrib: *Cosmopolitan; Daily Telegraph; Economist; Harpers;
Listener; New Scientist; Observer; Over 21; Queen; Tatler; Time
Out; Vogue.*

Bibl: Who.

MYNOTT, Lawrence b.1954
Born in London, Lawrence Mynott is brother to Gerald Mynott*
and Katherine Mynott*, and the son of Derek and Patricia Mynott*,
all of whom are artists. He studied at Chelsea School of Art (1972-
76) and the RCA (1976-79). A portrait painter, lecturer and writer,
he has also worked for various publishers, including designing
covers for Penguin Books. He has contributed illustrations to a
number of magazines, including a series on "Great Interior Decora-
tors of SW1" for *Tatler* in 1984.
Contrib: *Harpers; Observer; Queen; Radio Times; Tatler; Vogue.*
Exhib: RA; Folio Society; Cale Art, Chelsea.
Collns: NPG.
Bibl: Parkin; Who.

MYNOTT, Patricia b.1927
Born in London, Patricia and Derek Mynott are the parents of three
artists, Lawrence*, Gerald* and Katherine*. Patricia was educated
at the Dominican Convent, Chingford, and studied at the South-
West Essex School of Art. She is a film designer, illustrator and nat-
ural history artist.
Books illustrated include: J. Pope: *Beachcombing and Beachcraft*
(Hamlyn, 1975).
Bibl: Who.

NACHSHEN, Donia b.1903

Born in Ghitomir, Russia, Nachshen came to England and studied at the Slade. She used scraperboard for her illustrations to the Russian stories, published by Lindsay Drummond in the 1940s (producing strong, dramatic illustrations which have the appearance of Eastern European woodcuts), and for *The Way of All Flesh* (1936). The pen drawings for Anatole France's *The Red Lily* and Irina Odoevtzeva's *Out of Childhood* are lighter, more like John Austen's* work. According to Peppin, she was also a portrait painter who lived in London.

Books illustrated include: A. France: *The Works of Anatole France* (BH, 1925); V. Bartlett: *Topsy Turvy* (1927); A. Schnitzler: *Rhapsody* (Constable, 1928), *Fraulein Else* (Constable, 1929); A. France: *The Red Lily* (BH, 1930); *The Haggadah* (1934); S. Butler: *The Way of All Flesh* (Cape, 1936); E. Blyton: *Nature Lover's Book* (with Noel Hopking; Evans, 1944); G. Trease: *Black Night, Red Morning* (1944); N. Gogol: *Diary of a Madman; Nevski Prospect* (Drummond, 1945); F. Dostoyevsky: *Three Tales* (Drummond, 1945); A. Blok: *The Spirit of Music* (Drummond, 1946); A. Pushkin: *Tales of Bielkin* (Drummond, 1947); *Pushkin, Lermontov, Tyutchev: Poems* (Drummond, 1947); I. Odoevtzeva: *Out of Childhood* (Constable); I. Turgenev: *Poems in Prose* (Drummond).
Bibl: Peppin.

NASH, John Northcote 1893-1977
See Houfe

Born in Kensington, London on 11 April 1893, the younger brother of Paul Nash*, John Nash was educated at Wellington College. He had no formal art training, but was encouraged by his brother, and started painting in oils in 1914. He joined the Artists' Rifles in 1916 and served in France (1916-18) as an official war artist; and during WW2 once again he served in the same capacity for the Admiralty. He taught at the Ruskin School of Art, Oxford (1922-27), and at RCA (1934-40, 1945-57).

A landscape and still-life painter in oils and watercolour, he exhibi-

Donia NACHSHEN *Three Tales* by Feodor Dostoyevsky (Lindsay Drummond, 1945)

ted first with his brother at Dorien Leigh Gallery in 1913, and had his first one-artist show at the Goupil Gallery in 1921. He was a founder member of the London Group (1914), exhibited at the first exhibition of the Camden Town Group (1915), and became a member of NEAC. He also was a wood engraver of distinction, and was

a founder member of the Society of Wood Engravers (1920).

Although he regarded book illustration of secondary importance, he became an excellent and prolific illustrator in various media. His career in this field really started after WW1 when his woodcuts and wood engravings were published in art and literary periodicals. The revival of wood engraving coincided with the emergence of a number of private presses, such as the Blackmore Press, the Cresset Press and the Golden Cockerel Press, which produced limited, well-printed editions of books ideally suited to the reproduction of wood engravings. Nash's work was in demand by these publishers; and he also worked for the Curwen Press, doing colour autolithographs for such books as *Men and Fields* (1939). When the demand for wood engraving decreased, he was able to turn to line drawing which had the real advantage for an illustrator of being much faster.

Not only was he able to adapt to changing circumstances, but he approached each job with an open mind, realizing the responsibility of the illustrator to interpret the author's narrative. He wrote "The illustrator is concerned with the highest form of book decoration apart from the typography not merely to make picture books but to convey by his illustrations an enhanced sense of the book and its impact on the artist. For this he must be a good artist and a good craftsman receptive to the ideas offered by his subject, and able to carry them out in several 'media'." (Nash 1950.†)

Nash covered many subjects in his illustrations. As a plant illustrator, he liked to work from actual specimens, and used various media, including wood engraving, line drawing and watercolour. Some believe that his engravings of plants are the equal of anything done on wood during the years between the wars, and even Hodnett understood why these had "so stimulating an effect on illustrators who followed him away from the tight restraints of the post-Bewick tradition of wood engraving." He also enjoyed comic work, using

John NASH Illustration for "A Ballade of Vain Delight" from *One Hundred & One Ballads* (Cobden-Sanderson, 1931)

John NASH *Flowers and Faces* by H.E. Bates (Golden Cockerel Press, 1935)

pen and ink drawings for such books as *Dressing Gowns and Glue*, his first book (1919), and *One Hundred & One Ballads* (1931), and wood engravings for *Directions to Servants* (1925), and many think these illustrations are his best work. He illustrated Gilbert White's *Natural History of Selborne* twice, with line drawings for the Lutterworth Press (1951), and with line drawings and whole-page colour lithographs for the Limited Editions Club (1972). These illustrations show how well he could combine humour, botanical exactness, and landscape drawing. Despite Hodnett's carping criticism that "Nash never made the most of his opportunities as an illustrator" and that he "persisted in illustrating and decorating books by pen and ink, a medium that he never mastered", Nash is doubtless one of the more important illustrators of the period.

Nash was elected SWE (1921); ARA (1940); RA (1951); and awarded CBE (1964). He died 23 September 1977.

Books illustrated include (but see Colvin†): L.de G. Sieveking: *Dressing Gowns and Glue* (Palmer & Hayward, 1919); B. Blinders

(pseud. of D. Coke): *The Nouveau Poor* (C & H, 1921); J. Swift: *Directions to Servants* (GCP, 1925); Ovid: *Elegies* (Etchells and Macdonald, 1925); L. de G. Sieveking: *Bats in the Belfry* (Routledge, 1926); A.W. Hill: *Poisonous Plants* (Etchells and Macdonald, 1927); W. Gibson: *The Early Whistler* (Ariel Poem 6; Faber, 1927); *The Apocrypha* (with others; Cresset Press, 1929); S. Hudson: *Celeste and Other Sketches* (Blackmore Press, 1930); E. Spenser: *The Shepheards Calendar* (Cresset Press, 1930); W. Cobbett: *Rural Rides* (Davies, 1930); T.F. Powys: *When Thou Wast Naked* (GCP, 1931); W. de la Mare: *Seven Short Stories* (Faber, 1931); *One Hundred and One Ballads* (Cobden Sanderson, 1931); J. Hill: *The Curious Gardener* (Faber, 1932); H. E. Bates: *Flowers and Faces* (GCP, 1935); R. Gathorne-Hardy: *Wild Flowers in Britain* (Batsford, 1938); P. Synge: *Plants with Personality* (Lindsay Drummond, 1938); A. Bell: *Men and Fields* (Batsford, 1939); J. Hill: *The Contemplative Gardener* (Faber, 1940); J. Pudney: *Almanack of Hope* (Lane, 1944); G. White: *The Natural History of Selborne* (Lutterworth,1951); Earl of Cranbrook: *Parnassian Molehill* (Cowell, 1953); S. Penn: *Happy New Lear* (Guinness, 1957); R. Gathorne-Hardy: *The Tranquil Gardener* (Nelson, 1958); R. Nett: *Thorntree Meadows* (Nelson, 1960); R. Gathorne-Hardy: *The Native Garden* (Nelson, 1961); A. Phillips: *The B.B.C. Book of the Countryside* (with others; BBC, 1963); T. Housby: *The Art of Angling* (Evans, 1965); F.J. Bingley and S.M. Walters: *Wicken Sedge Fen* (National Trust, 1966); G. White: *The Natural History of Selborne* (Limited Editions Club, 1972).

Books written and illustrated include: *Bucks Shell Guide* (Batsford, 1937); *English Garden Flowers* (Duckworth, 1948); *Flower Drawings* (Warren Editions, 1969); *The Artist Plantsman* (Anthony d'Offay, 1976).

Contrib: *Apple; Art and Letters; By the Way; Chapbook; Countryman; Curwen Press News-Letter (14); Far and Wide; Form; Gardening Illustrated; Golden Hind; ILN; Land; Land and Water; Listener; London Mercury; Saturday Book 7, 13; Woodcut.*

Collns: Tate; V & A; IWM; Liverpool; Manchester; and many others.

Exhib: RA (retrospective 1967); LG; SWE; Goupil (1921; 1930); Leicester Galls. (retrospective 1954).

Bibl: Clare Colvin: *John Nash Book Designs* (Colchester: The Minories, 1986); John Lewis: *John Nash: The Painter As Illustrator* (Pendomer Press, 1978); John Nash: "Book Illustration", *Ark* 1 (October 1950): 21-2; John Rothenstein: *John Nash* (Macdonald, 1983); Frances Sarzano: "The Engravings and Book Decorations of John Nash", *Alphabet and Image* 3 (December 1946): 20-36; Garrett 1 & 2; Gilmour; Harries; Hodnett; Peppin; Ross; Rothenstein; Tate; Waters; Who Was Who.

Colour Plate 8

Paul NASH *Abd-er-Rhaman in Paradise* by Jules Tellier (Golden Cockerel Press, 1928)

NASH, Paul 1889-1946
See Houfe

Born 11 May 1889 in Kensington, London, elder brother of John Nash*, Nash was educated at St. Paul's School and studied at Chelsea Polytechnic (1906-07), Bolt Court (1908-10) and the Slade (1910-11). He worked under Roger Fry at the Omega Workshops, assisting in the restoration of the Mantegna cartoons at Hampton Court Palace in 1914. He served with the Artists' Rifles and the Hampshire Regiment (1914-17), was wounded at Ypres in 1917, and was appointed an official war artist on the Western Front (1917). He taught at Oxford (1920-23) and RCA (1924-25; and 1938-40); and at the outbreak of WW2 he organized the Arts Bureau in Oxford for War Service, and then was an official war artist to the Air Ministry (1940) and at MOI (1941). He was a member of LG (1914), NEAC (1919), and SWE (1922); was represented at the Venice Biennale in 1926, 1932 and 1938; and exhibited at International Surrealists Exhibitions in 1936 and 1938. During the last ten years of his life he took many photographs which he often used in the place of sketches for his paintings. He died on 11 July 1946 at Boscombe, Hampshire.

One of the more important and influential painters in Britain in the 20th century, he exhibited widely, his first exhibition being at the Carfax Gallery and his last in 1945 in Cheltenham. His early romanticism was changed by his experiences in France during WW1. Of the scene there he wrote "It is unspeakable, godless, hopeless. I am no longer an artist interested and curious. I am a messenger who will bring back word from the men who are fighting to those who want the war to go on for ever. Feeble, inarticulate will be my message, but it will have a bitter truth and may it burn their lousy souls." (Eates, 1948.†) Out of the horrors of war he produced harsh but powerful landscapes; and later, after experimenting with abstraction, he remained a landscape artist though he remoulded nature in his paintings. He was concerned that the meaning of his works should reside in the forms as well as in what they represented. In 1937 he contributed to *The Painter's Object*, edited by Myfanwy Piper, which upheld surrealism and objective abstraction but which also heralded a return to the British landscape tradition. Spalding writes that "Nash's heightened sense of atmosphere and feeling for place, his love of strange juxtapositions, his ability to perceive presences in natural objects and to uncover symbolic or associated meanings in landscape all contributed to the rise of neo-romanticism." (Spalding, 1986†).

In addition to painting, Nash illustrated nearly twenty books and contributed illustrations to many journals. This work forms an important part of his artistic output and it includes some of his finest work in any media. *Urne Buriall* has been praised as one of the most beautiful books of the twentieth century, and Bertram, Nash's biographer, called it "the crisis of his artistic life" (Bertram, 1955†). Hodnett does not agree and prefers Nash's illustrations to Richard Aldington's poems of WW1, *Images of War* (1919), finding that the crude drawings and violent colour complements the poet's poems of death, heroism and horror so well that an enduring illustrated work

is created. Nash wrote on a variety of subjects, including *Room and Book*, an essay on decoration (1932). He wrote also on patterned papers, on the stencil process and modern methods of illustration; he designed theatre sets, book plates, book bindings and book jackets; he produced posters for London Transport; and he cut blocks for patterned papers for the Curwen Press. He was an important participant in the revival of wood engraving in England and was instrumental in encouraging a number of young artists to take up the craft, including Edward Bawden* and Eric Ravilious*.

Books illustrated include: J. Drinkwater: *Loyalties* (Beaumont Press, 1918); R. Aldington: *Images of War* (Beaumont Press, 1919); J. Drinkwater: *Cotswold Characters* (OUP, 1921); F.M. Ford: *Mister Bosphorus and the Muses* (Duckworth, 1923); *Genesis* (Nonesuch Press, 1924); W. Shakespeare: *A Midsommer Nights Dreame* (Benn, 1924); L.A. Leroy: *Wagner's Music Drama of the Ring* (Douglas, 1925); R. Graves: *Welchman's Hose* (The Fleuron, 1926); T.E. Lawrence: *Seven Pillars of Wisdom* (Cape, 1926); W. Shakespeare: *The Tragedie of King Lear* (Benn, 1927); M. Armstrong: *Saint Hercules and Other Stories* (The Fleuron, 1927); S. Sassoon: *Nativity* (Ariel Poems; Faber and Gwyer, 1927); J. Tellier: *Abd-er-Rhaman in Paradise* (Golden Cockerel Press, 1928); A.E. (George Russell): *Dark Weeping* (Ariel Poems; Faber and Gwyer, 1929); M.Y. Lermontov: *A Song about Tsar Ivan Vasilyevitch* (Aquila Press, 1929); Sir T. Browne: *Urne Buriall and The Garden of Cyrus* (Cassell, 1932); M.P. Rivers: *Dorset Shell Guide* (Architectural Press, 1935).

Books written and illustrated include: *The Sun Calendar* (with John Nash; 1920); *Places* (Heinemann, 1922); *A Shell Guide to Dorset* (1935).

Published: *Monster Field* (illus. with photographs; Oxford: Counterpoint, 1946); *Aerial Flowers* (illus. with photographs; Oxford: Counterpoint, 1947).

Contrib: *Apple; Chapbook; Curwen Press Newsletter; Form; Listener; Radio Times; Woodcut*.

Exhib: Carfax Gallery (1912); Colnaghi (1973); Curwen Press (1937); Leicester Galls; Minories (1982); Redfern (1928, 1961); Oxford Arts Club (1931); Cheltenham (1945); Tate (1948, 1975); V & A (1975).

Collns: IWM; Tate; V & A.

Bibl: Anthony Bertram: *Paul Nash: Portrait of an Artist* (Faber, 1955); Andrew Causey: *Paul Nash* (Oxford: Clarendon Press, 1980); Causey: *Paul Nash's Photographs* (Tate Gallery, 1973); Clare Colvin: *Paul Nash: Book Designs* (Colchester: Minories, 1982); Margot Eates: *Paul Nash: Paintings, Drawings and Illustrations* (Lund Humphries, 1948); Eates: *Paul Nash: The Master of the Image 1889-1946* (Murray, 1973); Rigby Graham: *A Note on the Book Illustrations of Paul Nash* (Wymondham: Brewhouse Press, 1965); James King: *Interior Landscapes; A Life of Paul Nash* (Weidenfeld and Nicolson, 1987); Susan Lambert: *Paul Nash As a Designer* (V & A, 1975); Paul Nash: *Fertile Image* (Faber, 1951); Paul Nash: *Outline: An Autobiography* (Faber, 1949); Alexander Postan: *The Complete Graphic Work of Paul Nash* (Secker, 1973); Herbert Read: *Paul Nash* (Penguin Modern Painters; Penguin, 1944); Frances Spalding: *British Art Since 1900* (T &H, 1986); Malcolm Yorke: *The Spirit of Place: Nine Neo-Romantic Artists and Their Times* (Constable, 1988); Compton; DNB; Driver; Garrett 1 & 2; Harries; Hodnett; Peppin; Ross; Rothenstein; Tate; Waters.

Colour Pate 119

NEVINSON, Christopher Richard Wynne 1889-1946

Born in Hampstead on 13 August 1889, Nevinson was educated at Uppingham School (1904-07) and studied painting at St. John's Wood School of Art (1907-08) and at the Slade (1908-12). After the Slade he went to Paris and shared a studio with Modigliani, met Picasso and became acquainted with Cubist techniques. Nevinson was closely associated with the Futurist movement and in 1914 was co-author of *A Futurist Manifesto: Vital English Art*. He was a founder member of the London Group, exhibited in the Vorticist Exhibition (1915), and contributed an illustration to Wyndham Lewis'* *Blast No. II*.

Although he was declared unfit for service (he suffered ill health throughout his life), Nevinson served in France during WW1 in the Red Cross and as an ambulance driver in the RAMC (1914-16)

before being invalided out. His war pictures received much attention when exhibited in 1916 and in 1917 he was made an official war artist. His paintings are grim, showing the war without its popular aura of glory, for he had probably experienced the horrors of war more fully than any other war artist. Seventeen of his paintings were published in 1918 in the first issue of *British Artists at the Front*. After the war Nevinson painted town and river scenes, landscapes, portraits and genre pieces, mostly realistically but with a touch of Cubism. During WW2 his subjects included scenes of bombed London and views from aeroplanes.

Nevinson was a member of many artistic groups and belonged to no particular artistic coterie. Stemp† declares that he loved to look and play the part of an artist. He certainly courted publicity, for in the Tate Gallery there are fourteen volumes of press cuttings he collected throughout his life. He was a member of RBA (1932); ROI; NS; NEAC; appointed Chevalier Légion d'Honneur (1938); and elected ARA (1939). He died following a stroke on 7 October 1946.

Contrib: *Blast*.

Collns: IWM; Tate; BM; Fitzwilliam; MM, New York; and elsewhere.

Exhib: NEAC (1915-); Leicester Galleries (1916,1918; memorial exhibition, 1947); Kettles Yard, Cambridge (retrospective, 1989).

Bibl: P.G. Konody: *Modern War: Paintings by C.R.W. Nevinson* (1917); C.R.W. Nevinson: *Paint and Prejudice* (1937); M.C. Salaman: *C.R.W. Nevinson* (Masters of Etching; 1932); Osbert Sitwell: *C.R.W. Nevinson* (1925); Robin Stemp: "Artists in War and Peace: C.R.W. Nevinson 1889-1946", *The Artist* (February 1989): 18-20; Tate; DNB; Harries; Ross; Rothenstein.

NEW, Edmund Hort 1871-1931
See Houfe

NEWMAN, Leo b.1908?

Born in Birmingham, Newman studied at Birmingham Central School of Art and then came to London and became a free-lance artist. He contributed some illustrations to *Lilliput* in the late 1930s.

Contrib: *Lilliput*.

Bibl: *Lilliput*, December 1938.

NEWNHAM, Annie fl.1983-

Newnham illustrates with a free-flowing pen or pencil line, and apparently works only for Dennis Hall's presses, first the Inky Parrot Press which was established within the Design Department of the Oxford Polytechnic, and later for his Hanborough Parrot press.

Books illustrated include (all published by Inky Parrot Press): O. Henry: *Four Stories* (1983); C.H. Sisson: *Night Thoughts and Other Poems* (1983); A. Stevenson: *Black Grate Poems* (1984); J. Fothergill: *An Innkeeper's Diary* (1987).

Books written and illustrated include: *What's in a Name!* (Hanborough Parrot Pieces, 1988).

NICHOLSON, Sir William Newzam Prior 1872-1949
See Houfe

NICKLESS, Will b.1902

Born in Essex, Nickless started work when he was fourteen and was drawing for an agency by the time he was eighteen. He joined the staff of the magazine *Motor* in 1920 to do technical drawings and, later, general figure work. He left to be a free-lance artist, began illustrating books and writing his own books. He started his own press, printing limited illustrated editions of his own poems and made a series of anti-war etchings, reproduced in the *New Leader* in 1939. He also made models and musical instruments.

Books illustrated include: B.E. Todd: *Worzel Gummidge and Saucy Nancy* (1947); *The Children's Wonder Book* (Odhams, 1948); H.C. Andersen: *The Ugly Duckling* (Porpoise Books, Penguin, 1948); B.E. Todd: *Worzel Gummidge Takes a Holiday* (1949); P.F. Westerman: *Missing Believed Lost* (1949); M.W. Jennings: *The Story of the Golden Fleece* (1954); H. Treece: *The Return of Robinson Crusoe* (1958); F. Knight: *Stories of Famous Ships* (O & B, 1963), *Stories of Famous Sea Fights* (O & B, 1963), *Stories of Famous Explorers by Sea* (O & B, 1964), *Stories of Famous Explorers by Land* (O & B, 1965), *Stories of Famous Sea*

Adventures (O & B, 1966), *Stories of Famous Adventurers* (O & B, 1966).

Books written and illustrated include: *A Guide to the Tower* (1947); *Aesop's Fables* (Warne, 1962); *Owlglass* (1964); *Dotted Lines* (1968).

Contrib: *New Leader*.

Bibl: ICB3; Peppin.

NIELSEN, Kay Rasmus **1886-1957**
See Houfe

Though Nielsen did illustrations for several writers when he was studying in Paris, and some of his books were republished in the US, none of his books was first published outside England.

NIGHTINGALE, Charles Thrupp **b.1878**
Born in Kingston-on-Thames, Nightingale was a wood engraver and illustrator; his woodcuts for *Boggarty Ballads* are strong and detailed, somewhat similar to those done by Lucien Pissaro. He used full colour for some books, including *Tony-o'-Dreams* (1919).

Books illustrated include: M. Nightingale: *The Babe's Book of Verse* (1918), *Verses Wise and Otherwise* (1918), *Nursery Lays of Nursery Days* (1919), *Tony-o'-Dreams* (Blackwell, 1919), *Farmyard Ditties* (Blackwell, 1920), *Tinker, Tailor* (Blackwell, 1920), *Ring a Ring o'Fairies* (1921), *Benedicamus Domino* (1922), *Adeste Fideles* (1922), *Boggarty Ballads* (1923), *Mostly Moonshine* (1924); W. de la Mare: *Old Joe* (Blackwell, 1927); M. Nightingale: *Roundabout Tabitha* (1927), *Poems* (1927); W. de la Mare: *Readings* (1928); M. Nightingale: *The Magic Snuff Box* (1936).

Contrib: *Joy Street*.

Bibl: Bernard Sleigh: *Wood Engraving Since 1890* (Pitman, 1932); Peppin.

NISBET, Noel Laura **1887-1956**
Born on 30 December 1887 in Harrow, Nisbet was educated at Notre Dame Convent in Clapham, London, and studied art at South Kensington, winning three gold medals and the Princess of Wales Scholarship. A figure, landscape and flower painter in oils and watercolour, she also illustrated a few books. She exhibited at the RA and RI, and was elected RI in 1926. She married artist Harry Bush in 1910; and died on 16 May 1956.

Books illustrated include: Polevoi: *Russian Fairy Tales* (Harrap, 1915); *Cossack Fairy Tales*.

Exhib: RA; RI.

Bibl: ICB; Waters.

NIXON, Kathleen Irene **1894-1988**
Born in London at Woodside Park, Nixon studied at the Camden School of Art, receiving a teacher's certificate in 1911. She moved to Birmingham in 1913 to study book illustration at the School of Art there. For fifteen years she worked as a commercial illustrator, with animals as her favourite subject, including the illustrations and covers she produced for books by Enid Blyton. She lived in India from 1928 to 1952, where she worked as a graphic artist for the *Times of India* and designed animal posters for the Indian State Railway. On her return to England she wrote and illustrated a number of whimsical stories for children, some based upon her own pets, a Siamese kitten and a Dachshund, "Pushti" and "Pindi Poo". These stories show "her draughtsmanship and her use of water-

colour were clear and unpretentious, preserving into the post-war decades a style of illustration that was closely related to that of such Victorian artists as Cecil Aldin* and Harry Rountree*." (*Times* 6 October 1988.) Nixon also was an easel painter, painting animals and birds in India and England, and was awarded many medals. Elected SWA. She died in England in 1988 at the age of ninety-three.

Books illustrated include: *Nature Stories* (Harrap, 1922); E. Blyton: *Sunny Stories* series (Newnes, 1924-7); *Bird Studies in India* (OUP, 1928); M. Batten: *Sentinels of the Wild* (1938), *Whispers in the Wilderness* (1960); Foran: *Animal Mothers and Babies* (1960); M. Burton: *Bird Families* (1962).

Books written and illustrated include: *Pushti* (Warne, 1955); *Pindi Poo* (Warne, 1957); *Poo and Pushti* (Warne, 1959); *The Bushy Tail Family* (Warne, 1963); *Animal Legends* (Warne, 1966); *Strange Animal Friendships* (Warne, 1967); *Animals and Birds in Folklore* (Warne, 1969).

Contrib: *Times of India*.

Bibl: *Times* obit. 6 October 1988; Peppin.

NOBLE, John Edwin **1876-1941**
See Houfe

NOCKOLDS, Roy Anthony **1911-1979**
Born on 24 January 1911 in London, Nockolds had no formal art training apart from private lessons in figure drawing. He began sketching motoring subjects in the 1920s, and contributed to several motor magazines. During WW2 he worked for the Ministry of Information, served in the RAF, and was an official war artist. He produced at least one wartime propaganda poster ("Back Them Up! The RAF's Intensive Bombing . . ." 1943), exhibited widely, and was the Chairman of the Guild of Aviation Artists in 1975.

Contrib: *Autocar; Motor; Motor Sport*.

Exhib: RA; RP; ROI; RSMA; SWLA; Society of Aviation Artists; Guild of Aviation Artists; Kensington Art Gallery (one-man show 1953).

Bibl: Waters.

NORFIELD, Edgar George **d.1977**
Norfield was a painter and humorous illustrator. He contributed to *Punch* and illustrated a few books, mostly with brush drawings.

Books illustrated include: L. Dutton: *Rags, M.D.* (1933); J. Gibbons: *Roll, on, Next War!* (1935); C. R. Benstead: *Alma Mater* (1944), *Mother of Parliaments* (1948); P. Gallico: *The Small Miracle* (1951).

Contrib: *Punch*.

Bibl: Peppin; Who.

NORMAN, Michael Radford **b.1933**
Born on 20 August 1933 in Ipswich, Norman was educated at Woodbridge School, and studied at Bournemouth School of Art. An artist in pen and ink and watercolour, often of river and coastal scenes, Norman has illustrated at least one book. He was elected RSMA (1975).

Books illustrated include: J. Salmon: *The Suffolk-Essex Border*.

Exhib: RI; RSMA.

Bibl: Who.

John O'CONNOR *A Pattern of People* (Hutchinson, 1959)

OAKLEY, Graham b.1929

Born on 27 August 1929 in Shrewsbury, Oakley studied at Warrington School of Art (1950). He worked first as a theatrical designer in repertory theatre (1950-55) and as a designer's assistant at the Royal Opera House, Covent Garden (1955-57), and then worked for an advertising agency (1960-62). He was a set designer for BBC Television (1962-77), before becoming a free-lance artist, his "Church Mice" series of picture books bringing instant success. *The Church Mice Adrift* (1976) was nominated for the Kate Greenaway Medal and was selected as one of the year's best illustrated children's books by the *New York Times* in 1977.

Books illustrated include: J. Ruskin: *The King of the Golden River* (Hutchinson, 1958); H. Popham: *Monsters and Marlinspikes* (Hart-Davis, 1958); R.L. Stevenson: *Kidnapped* (1960); C. Kevern: *White Horizons* (ULP, 1962); M. Clarke: *The Three Feathers* (Hart-Davis, 1963); R. Garnett: *The White Dragon* (Hart-Davis, 1963), *Jack of Dover* (1966); B. Read: *The Water Wheel* (World's Work, 1970); T. Lee: *Dragon Hoard* (1971); E. MacDonald: *The Two Sisters* (World's Work, 1975).

Books written and illustrated include (all published by Macmillan): *The Church Mouse* (1972); *The Church Mice Spread Their Wings* (1975); *The Church Mice Adrift* (1976); *The Church Mice at Bay* (1978); *The Church Mice and the Moon* (1979); *Magical Changes* (1979); *The Church Mice at Christmas* (1980); *Hetty and Harriet* (1981); *The Church Mice in Action* (1982).

Bibl: CA; ICB4; Peppin.

O'CONNOR, John Scorror b.1913

Born on 11 August 1913 in Leicester, O'Connor was educated at Wyggeston School, and studied at Leicester College of Art (1930-33) and at the RCA (under Eric Ravilious*, John Nash*, and Robert Austin*, 1933-37). He went with a few other students to the Central School of Art and Design to study printing and typography, and there exhibited his first four engravings, of Irish stories. He visited the Raviliouses, and Eric recommended him to Christopher Sandford as a possible illustrator of *Here's Flowers* for the Golden Cockerel Press. In the autumn of 1937 O'Connor started teaching at Birmingham College of Art and about this time he was elected to the Society of Wood Engravers. In 1938 he started teaching at the West of England College of Art in Bristol.

He served in the RAF during WW2, but managed to continue engraving. After his release he taught at Hastings School of Art and received more commissions for illustrations, including books for the Dropmore Press and advertising work for *Harper's Bazaar*, the Zinc Development Association, and other companies. In 1947 John O'Connor and his wife (he had married in 1945) moved to Essex, and he became Head of the Colchester School of Art. From this period came three important books, his own *Canals, Barges and People* and two for Benhams of Colchester, *Essex Pie* and *Essex Dozen*. *A Pattern of People* followed in 1959, based on his essays about people and their environment and illustrated with many engravings, some in two colours. He resigned from his full-time job in Colchester in 1964 to concentrate more on his own work, and then for ten years taught part-time at St. Martin's School of Art.

More book illustrations and prints followed; he also began to exhibit paintings, and wrote two books on the techniques of wood engraving and printing.

The O'Connors moved to Scotland in 1975. There was a retrospective exhibition of his work in Glasgow; he taught a few hours each week at the Glasgow School of Art for a few years; and the Foulis Archive Press (the School's press) published two books illustrated with his engravings.

O'Connor is a prolific and exciting artist in many media. His book illustrations are done mostly by wood engravings, though he has used linocuts, line drawings and lithography. His engravings are distinctive through their intricacy and decorativeness, and use of two colours; and some are more impressionistic than representational. O'Connor is a fine decorative illustrator, and a skilful craftsman.

Books illustrated include: J. Rutter: *Here's Flowers* (GCP, 1937); C. Whitfield: *Together and Alone* (GCP, 1945); O. Rutter: *We Happy Few* (GCP, 1946); B. Darwin: *The Golfer's Manual* (Dropmore Press, 1947); C. Sandeman: *Thyme and Bergamot* (Dropmore Press, 1947); *The Funeral Oration of Pericles* (Dropmore Press, 1948); *The Young Cricketer's Tutor* (Dropmore Press, 1948); E.L.G. Watson: *Departures* (Pleiades Books, 1948); *The Kynoch Press Notebook* (Kynoch Press, 1948); T.M. Hope: *Essex Pie* (Benham, 1952); *An Essex Dozen* (Benham, 1953); T. Gray: *Elegy Written in a Country Churchyard* (Rodale Press, 1955); J. Clare: *The Wood Is Sweet* (BH, 1966); W. Wordsworth: *Poems* (NY: Limited Editions Club, 1973); F. Kilvert: *A View of Kilvert* (Foulis Archive Press, 1979); R. Ingrams: *England* (Collins, 1989).

Books written and illustrated include: *Canals, Barges and People* (Art and Technics, 1950); *A Pattern of People* (Hutchinson, 1959); *The Boy and Heron* (Foulis Archive Press, 1977); *Duke's Village* (Florin Press, 1988).

Published: *The Technique of Wood-Engraving* (Batsford, 1971); *Introducing Relief Printing* (Batsford, 1973).

Contrib: *Harper's Bazaar; House and Garden; Radio Times; Saturday Book.*

Exhib: RA; RE; RWS; SWE; Mackintosh Gallery, Glasgow; one-artist shows — Zwemmer (1955-68); New Grafton Gallery (1970-78).

Bibl: Roderick Cave: "A Collaboration: Letters Between John O'Connor and Christopher Sandford, 1940-44", *Matrix* 6 (1986): 149-64; Cave: "Fanfares, Amazons and Narrow-Boats: Correspondence Between John O'Connor and Christopher Sandford, 1944-47." *Matrix* 7 (1987): 128-46; Jeannie O'Connor: *The Wood-engravings of John O'Connor* (Whittington Press, 1989); Stuart Rose: "The Engravings of John O'Connor", *Image* 1 (Summer 1949): 27-39; Garrett 1 & 2; Jacques; Peppin; Usherwood; Waters; Who.

Colour Plate 120

ODLE, Alan Elsden **1888-1948**
See Houfe

OGLE, Richard Bertram **fl. 1920-1962**
A portrait painter, Ogle also illustrated books for children and wrote a few himself. His favourite subjects were animals; he illustrated with pen drawings, and sometimes produced full colour plates.

Books illustrated include: P.F. Westerman: *Clinton's Quest* (1925); *Stories from the Arabian Nights* (1928); *King Arthur and His Knights* (1929); *Old English Fairy Stories* (1930); *Wild Life of the World* (1944); P. Rush: *He Sailed with Dampier* (1947); C. Kingsley: *Hereward the Wake* (1948); A. Miles: *Brave Deeds by Brave Men* (nd).

Books written and illustrated include: *The Secret* (1936); *Seal Cove* (1943); *Albert the Ant* (1946); *Silent Terror* (1947); *Mystery of the Migrants* (1947); *Animals Strange and Rare* (1951); *Sailors of the Queen* (1954); *People of the Sun* (1955); *Pets and Their Care* (1955); *Animals in the Service of Man* (1957); *Animals and Their Camouflage* (1958); *Animals of the Past* (1962).

Contrib: *BOP; Graphic; Merry-Go-Round; Printer's Pie.*
Bibl: Peppin.

OLDHAM, Claire **fl. 1940s**
A wood engraver who has illustrated a few books.

Jack ORR *Nursery Rhymes* (T.C. and E.C. Jack, 1924)

Books illustrated include: R. Lynd: *Things One Hears* (Dent, 1945); V.E. Walker: *A Rhyme Book of Christian Verse* (SCM, 1946); G. White: *The Natural History of Selborne* (Cresset Press, 1947); W.R. Philipson: *Birds of a Valley* (Longmans, 1948).
Books written and illustrated include: *The Backwood Book* (Dent, 1948).

OPENSHAW, Olive F. **fl. 1942-1953**
There seems to be no biographical information available about Openshaw. She produced the original illustrations for Enid Blyton's series of stories about Mary Mouse, first published during the war years and immediate post-war years by Brockhampton Press.
Books illustrated include E. Blyton: *Mary Mouse and the Doll's House* (1942), and eleven other titles ending with Mary Mouse and the Noah's Ark (1953).
Bibl: Peppin.

ORMEROD, Jan **fl.1981-**
Born in Western Australia, Ormerod was a secondary school art teacher and lecturer in art education; she now lives in England. Her own picture books are for the very young. *Sunshine* and *Moonlight* tells the story of a little girl's life in the morning and in the evening as she prepares for bed. Her straightforward, almost "documentary"-like illustrations are painted in flat, subdued colours, and the whole book is more effective than the individual illustrations appear to be. *Sunshine* won the Mother Goose Award in 1982, presented to "the most exciting newcomer to British children's books illustration." Her series of books for babies are small and square, and tell about the ordinary things which happen during the day, such as reading and sleeping.
Books illustrated include: J. Mark: *Hairs in the Palms of My Hand* (Kestrel, 1981); K. Lorentzen: *Lanky Longlegs* (Dent, 1982); M.

Mahy: *The Chewing-Gum Rescue* (Dent, 1982); S. Hayes: *Happy Christmas* Walker, 1986); J.M. Barrie: *Peter Pan* (Viking Kestrel, 1988); S. Hayes: *Eat Up, Gemma* (Walker, 1988).
Books written and illustrated include: *Sunshine* (Kestrel, 1981); *Moonlight* (Kestrel, 1982); *Be Brave Billy* (Dent, 1983); *101 Things To Do with a Baby* (Kestrel, 1984); *Jan Ormerod's Baby Books* (four books; Walker, 1985); *Jan Ormerod's Little Ones* (four books; Walker, 1986); *The Story of Chicken Licken* (Walker, 1986).
Colour Plate 121

ORMROD, Frank **1896-1988**
Ormrod taught at the Slade, and then lectured in design at Reading School of Art (1934-64). He produced at least one poster for London Transport, and illustrated *Life on the Land* with fine wood engravings.
Books illustrated include: F. Kitchen: *Life on the Land* (Dent, 1941).

ORR, Jack **fl. 1904-1944**
One of three Orr brothers, all illustrators who lived in Glasgow, according to Peppin. Jack Orr's illustrative work seems to have been mostly devoted to books of nursery rhymes, for which he produced pleasing but fairly ordinary colour plates and black and white drawings.
Books illustrated include: L. Chisholm: *Nursery Rhymes Told to Children* (with S.R. Praeger, 1904); E.F. Sellar: *The Story of Lord Roberts* (1909); *The Nursery Book* (Nelson, 1924); *Nursery Rhymes* (Jack, 1924); *The Travels of Perrywinkle* (1944).
Bibl: Peppin.

ORR, Monro Scott **b.1874**
See Houfe

ORR, Stewart **1872-1945**
See Houfe

OSMOND, Edward **b.1900**
Born on 6 May 1900 in Orford, Suffolk, Osmond was educated privately and studied at the Regent Street Polytechnic (1917-24). He taught part-time at Hastings College of Technology, Sussex, and at Hornsey College of Art. An artist in oils, wash and line, he became a free-lance illustrator in 1928, working in colour and black and white, and concentrating on books for children. He both designed and wrote children's books, and he won the Carnegie Medal in 1924 for *A Valley Grows Up*. He was MSIA and a member of the Society of Authors.
Books illustrated include: R. Armstrong: *The Lost Ship* (1956); P.F. Westerman: *Held in the Frozen North* (1956); H. Griffiths: *Horse in the Clouds* (1957); A. Catherall: *Tenderfoot Trappers* (1958); H. Griffiths: *Wild and Free* (1958); P.F. Westerman: *Jack Craddock's Commission* (1958); H. Griffiths: *Moonlight* (1959); C. Harnett: *Monasteries and Monks* (1963); A. Catherall: *Lone Seal Pup* (1964), *A Zebra Came to Drink* (1967); M.J. Robson: *Children of Africa* (Longman, 1970); A.S. Playfair: *Modern First Aid* (Hamlyn, 1973); W. Boorer: *Dog Care* (1979).
Books written and illustrated include: *A Valley Grows Up* (OUP, 1953); *Animals of the World* series (OUP, 1953-6); *Houses* (Batsford, 1956); *Villages* (Batsford, 1957); *Towns* (Batsford, 1958); *Animals of Britain* series (OUP, 1959-62); *From Drumbeat to Tickertape* (Hutchinson, 1960); *The Artist in Britain* (Studio, 1961); *People of the Desert* and five other titles in series (Odhams, 1963-5); *Animals of Central Asia* (Abelard, 1967); *Exploring Fashions and Fabrics* (Odhams, 1967).
Bibl: CA; ICB2; ICB4; Peppin; Who.

OUTHWAITE, Ida Rentoul **1888-1960**
Born in Melbourne, Australia, on 9 June 1888, Outhwaite was educated there at the Presbyterian Ladies' College. Her sister Annie wrote many fairy stories which Outhwaite illustrated and contributed to the magazine *The New Era* (1903-). The sisters then combined to produce a book, printed by chromolithography, *The Story of the Pantomime Humpty Dumpty* (1907), to accompany a production at Her Majesty's Theatre, Melbourne. Outhwaite married, exhibited at the Fine Art Society, Melbourne (1916), and then

travelled to England in 1920. She exhibited there and illustrated a series of colour-plate books for A. & C. Black.
Her pen and ink illustrations are very decorative, and seem to be in a style which recalls both John Austen* and W.H. Robinson*. A reviewer writing in the *Christmas Bookman* for 1930 remarks of *The Little Fairy Sister* that it is "the prettiest of any of the Christmas gift-books I have seen this year."
Books illustrated include: A. Outhwaite: *Mollie and the Bunyip* (Melbourne, 1904), *Australian Songs for Young and Old* (Melbourne, 1907), *The Story of the Pantomime Humpty Dumpty* (Melbourne, 1907), *Peter Pan* (Melbourne, 1908); G. Outhwaite: *The Little Fairy Sister* (Black, 1923).
Books written and illustrated include: *Blossom* (Black, 1928); *Bunny and Brownie* (Black, 1930).
Contrib: *New Era*.
Bibl: *The Illustrators: Catalogue* (Chris Beetles Ltd., 1991); *Christmas Bookman* 1923; 1928; 1930.

OVENDEN, Annie **b.1945**
Born in Amersham, Buckinghamshire, Ovenden studied at High Wycombe School of Art (1961-65). She worked as a graphic designer (1966-69) before painting full-time since 1975. Married to Graham Ovenden*, they became members of the Brotherhood of Ruralists, founded by Peter Blake* in 1975, and exhibited with the group. Like the other members, she has illustrated covers of the new Arden Shakespeare, published by Methuen.
Bibl: Nicholas Usherwood: *The Brotherhood of Ruralists* (Lund Humphries, 1981).

OVENDEN, Graham **b.1943**
Born in Alresford, Hampshire, Ovenden studied at Southampton School of Art (1960-64) and RCA (1965-68). He is a painter whose

I.R. OUTHWAITE *The Little Fairy Sister* by G. and I.R. Outhwaite (A. & C. Black, 1923)

subject matter consists mostly of young girls and the English landscape, and his work is distinctly erotic. He explains that "My work is the celebration of youth and spring — the fecundity of nature and our relationship to it. This is why the subject-matter of my work tends towards the girl child (more often than not at the point of budding forth) and the English landscape in all its richness and mystery." (Parry-Cooke.)

He has had several one-artist exhibitions at the Piccadilly Gallery and the Waddington Galleries. His interest in the idea of "Alice" showed in his joint exhibition with Peter Blake* in 1970; he subsequently edited *Illustrators of Alice* for Academy Editions (1971). In 1975 he had a one-artist show, "Lolita — Drawings and Prints" at the Waddington Galleries, and in the same year co-founded the Brotherhood of Ruralists with Blake, exhibiting with the Brotherhood in various cities throughout Britain over the next few years. Each member of the Brotherhood has illustrated covers for the new Arden Shakespeare from Methuen (see Blake, Peter).

Ovenden has edited a number of books on photography; and written and illustrated books.

Books illustrated include: E. Brontë: *Sturmhöhe* (Gütersloh: Bertelsmann, 1981).

Books written and illustrated include: *Aspects of Lolita* (Academy Editions, 1976); *Nymphets and Fairies* (Academy Editions, 1977).

Published: *Illustrators of Alice* (Academy Editions, 1971); *Pre-Raphaelite Photography* (Academy Editions, 1972); *Victorian Erotic Photography* (Academy Editions, 1973); *Alphonse Mucha Photographs* (Academy Editions, 1974); *A Victorian Album* (with Lord David Cecil, Secker, 1976); *Lewis Carroll* (Macdonald, 1984).

Exhib: Piccadilly Galleries (1970, 1972, 1977, 1979); Waddington Galleries (1973, 1975); RA.

Bibl: Victor Arwas and others: *Graham Ovenden: Essays* (Academy Editions, 1987); Nicholas Usherwood: *The Brotherhood of Ruralists* (Lund Humphries, 1981); Parry-Cooke.

OWEN, Will **1869-1957**
See Houfe

OXENBURY, Helen **b.1938**
Born on 2 June 1938 in Ipswich, Suffolk, Oxenbury studied at Ipswich School of Art and the Central School of Arts and Crafts, where she specialized in theatrical design. Before she started work as an illustrator of children's books, she designed for the Colchester repertory company, and then spent three years in Israel working in the theatre and on films. On her return to England she did some work in television studios and on film sets, and designed greeting cards for Jan Pienkowski* and his Gallery Five.

Her first book was published in 1967, and she soon established a reputation as an illustrator, winning the Kate Greenaway Medal with her version of Edward Lear, *The Quangle-Wangle's Hat*, and Lewis Carroll's *The Hunting of the Snark*, in 1970. Rosen's *We're Going on a Bear Hunt*, with Oxenbury's illustrations, won the Smarties Book Prize (1989), and was short-listed for the Emil/Kurt Maschler Award (1989). Martin reports that she found it an initial advantage not having studied illustration at art school and thus not being influenced by particular artists, though she confesses that Ernest Shepard* and Edward Ardizzone* are favourite illustrators. She married the illustrator, John Burningham*, and though some of her early pen and ink line drawings, coloured with watercolour, are reminiscent of his work, her style is generally quite distinct. She started doing board books for very young children in 1980 when Walker Books was starting as a publisher.

Books illustrated include (but see Martin†): L. Tolstoi: *The Great Big Enormous Turnip* (Heinemann, 1968); E. Lear: *The Quangle-Wangle's Hat* (Heinemann, 1969); M. Mahy: *The Dragon of an Ordinary Family* (Heinemann, 1969); M. Kempadoo: *Letters of Thanks* (Collins, 1969); L. Carroll: *The Hunting of the Snark* (Heinemann, 1970); I. Cutler: *Meal One* (Heinemann, 1971); B. Alderson: *Cakes and Custard* (Heinemann, 1974); I. Cutler: *Balooky Klujypoop* (Heinemann, 1975); *The Animal House* (1976); F. Maschler: *A Child's Book of Manners* (Cape, 1978); J. Bennett: *Tiny Tim: Verses for Children* (Heinemann, 1981); M. Rosen: *We're Going on a Bear Hunt* (Walker, 1989); M. Waddell: *Farmer Duck* (Walker, 1991).

Books written and illustrated include: *Numbers of Things* (Heinemann, 1967); *ABC of Things* (Heinemann, 1971); *Pig Tale* (Heinemann, 1973); *The Queen and Rosie Randall* (Heinemann, 1978); *Heads, Bodies, and Legs* (Methuen, 1980); *Baby Board Books* (five titles; Walker, 1981); *Bill and Stanley* (Benn, 1981); *Board Books* (nine titles; Metheun, 1982-6); *First Picture Books* (nine titles; Walker, 1983-4); *The Helen Oxenbury Nursery Story Book* (Heinemann, 1985); *The Helen Oxenbury Nursery Rhyme Book* (Heinemann, 1986); *Big Board Books* (four titles; Walker, 1987); *Pippo* (eight titles; Walker, 1988-9).

Bibl: Douglas Martin: *The Telling Line: Essays on Fifteen Contemporary Book Illustrators* (Julia MacRae, 1989); ICB4; Peppin.
Colour Plate 122

PACKER, Neil **b.1962**
Born in Sutton Coldfield, Warwickshire, Packer travelled exten-
sively as a child before finally settling in Chelmsford. He studied
fine art and graphic design at Colchester College of Art, and then
worked as a junior with a London design consultant. He is now a
free-lance artist doing design work and illustration.
Books illustrated include: *The Rest of Your Day Is Your Own*
(Methuen, 1985).

PAGRAM, Edward **fl. 1960s**
Books illustrated include: *A View of London* (Hamilton, 1963); A.
Burgess: *The Eve of Saint Venus* (Sidgwick, 1964); M.B. Jones:
Nothing in the City (Sidgwick, 1965).
Books written and illustrated include: *Never Had It So Good*
(Heinemann, 1968).

PAIGE, John **b.1927**
Paige was educated at Rugby School and came under the influence
of the art master, Denys Watkins-Pitchford*. He went to Cambridge
University to read law but did not graduate, and then spent fifteen
years as an officer in the Royal Armoured Corps. In his mid-thirties
Paige went to Birmingham College of Art to study graphic design,
and has continued to use a variety of media in his art, including col-
lage, silkscreen painting, watercolours and oils. His subject matter
is similarly diverse, including wildlife, landscapes and portraits. He
has produced friezes of steam trains for children, illustrated books
for children, painted a mural and designed a Silver Jubilee mug.
Bibl: Hammond.

PAILTHORPE, Doris **fl.1920s-1930s**
Books illustrated include: E. Farjeon: *The Wonderful Knight*
(Blackwell, 1927); *The Story of Tobit* (Sidgwick, 1930).
Books written and illustrated include: *A Was an Archer* (Harrap,
1920).
Contrib: *Joy Street; Merry-Go-Round*.

PALMER, Doris **fl. 1920s-1930s**
Palmer illustrated *The Rubaiyat* with colourful, simply designed
illustrations, a decorative title-page and ornamental borders; but for
her book for children, *The House with the Twisting Passage*, the
illustrations are outline drawings in black and white.
Books illustrated include: *The Rubaiyat of Omar Khayyam*
(Leopold Hill, 1921); M.St.J. Webb: *The House with the Twisting
Passage* (Harrap, 1922); I. Dall: *Noah's Wife* (Blackwell, 1925).
Books written and illustrated include: *Tell Me a Story* (Cecil
Palmer, 1931).
Bibl: *Christmas Bookman* 1921; 1922.

PALMER, Garrick Salisbury **b.1933**
Born in Portsmouth, Palmer studied at Portsmouth College of Art
and Design (1951-55) and at the RA Schools (1955-59). He taught
at the Winchester School of Art since 1958, for the first four years
part-time, becoming Head of the Foundation Department. He
retired from teaching in 1986 to work as a full-time free-lance
illustrator, engraver, and photographer. He has exhibited widely,
paintings and engravings since 1961 (Wildenstein Gallery), and
photography since 1980 (Peter Seymonds College, Winchester).
Palmer has illustrated a number of books with forceful, dramatic
wood engravings, with scenes often depicted from an unusual point
of view. He is a genuinely interpretative illustrator, and his art
seems ideally suited to the mystery and horror of Melville's stories,
and to boats and the sea. In addition he has been fortunate that his
publishers have selected such fine printers so that his work is
beautifully reproduced. The illustrations to *The Destruction of the
Jews* are printed in two colours.
Hodnett considers Palmer one of the best wood engravers of his
generation to engage in book illustration. Palmer however admits to
a love-hate relationship with wood engraving, having a tendency to
give it up every other year. A new edition of *The Ancient Mariner*
is just about complete after almost three years of work and two
other books are in the pipeline (May 1990.) He was elected ARE
(1963); RE (1970); SWE.
Books illustrated include: H. Melville: *Three Stories* (Folio
Society, 1967); H.M. Tomlinson: *The Sea and the Jungle* (Barre,
Ma: Imprint Society, 1971); F. Josephus: *The Destruction of the
Jews* (Folio Society, 1971); H. Melville: *Benito Cereno* (Barre, Ma:
Imprint Society, 1972), *Moby Dick* (Folio Society, 1974); J. Fuller:
The Ship of Sounds (Didcot: Gruffyground Press, 1981); W.
Shakespeare: *Pericles; The Winter's Tale* (Folio Society, 1988).
Contrib: *Motif 12; Washington Times*.
Exhib: RE; SWE; Wildenstein Gallery (1961); Reading (1964);
Portsmouth (retrospective 1973); Xylon 8 (Switzerland, 1979);
Bristol (1979); Winchester (photographs, 1983); Portsmouth
(photographs, 1987); Southern Arts Exhibition (1989).
Bibl: Brett; Folio 40; Garrett 1 & 2; Hodnett; Peppin; IFA.
See illustrations on page 340

PALMER, Harold Sutton **1854-1933**
Palmer was born in Plymouth, educated at Camden Town High
School, and studied at the South Kensington Schools. He painted

Garrick PALMER *Benito Cereno* by Herman Melville (Barre, Ma: The Imprint Society, 1974)

Garrick PALMER *The Sea and the Jungle* by H.M. Tomlinson (Barre, Ma; The Imprint Society, 1971)

still lifes and landscapes, exhibiting at the RA from 1870. He was commissioned by A. & C. Black to produce colour plates for their series of illustrated books. Elected RBA (1892), RI (1920).

Books illustrated include: A.R.H. Moncrieff: *Bonnie Scotland* (Black, 1904); M. Austin: *California* (Black, 1914); G.E. Mitton: *Buckinghamshire and Berkshire* (Black, 1920).

Exhib: RA; RBA; RI.

Bibl: *The Illustrators: Catalogue* (Chris Beetles Ltd., 1991).

PALMER, Juliette **b.1930**

Born on 18 May 1930 in Romford, Essex, Palmer was educated at Brentwood County High School, studied illustration and book production at S.E. Essex School of Art (1946-50 under William Stobbs*), and trained to be a teacher at the Institute of Education, University of London (1950-51). She taught in three Essex secondary modern schools (1952-57), before working as a commercial artist for two years. In 1959 she became a free-lance artist, mostly for children's stories and educational material, and has illustrated about sixty books for children. Nearly all of the jackets are produced from her artwork or feature one of her illustrations. She has also written and illustrated for Macmillan six children's books which were influenced in format and text by Jenny Williams' *The Silver Wood* and Dylan Thomas' *Under Milk Wood*. She admires many contemporary illustrators, such as Edward Bawden*, John Minton*, John Ward* and Eric Fraser*; and as a teenager she was influenced by the Studio "How To Draw" books on children, horses and cats. Working concurrently as a watercolour painter, she has exhibited widely, having single-artist shows in England, Australia and Japan.

Books illustrated include: R. Garland: *The Canary Shop* (Hamilton, 1960); J. Hatcher: *The Gasworks Alley Gang* (Burke, 1960); C. Knowles: *Hippo, a Welsh Cob* (Evans, 1960); E. Kyle: *Eagle's Nest* (Nelson, 1961); L.N. Baker: *Torkel's Winter Friend* (Abelard, 1961); B. Wilkinson: *Hambro the Elephant* (Hamilton, 1961); B. Willard: *The Penny Pony* (Hamilton, 1961); E. Coatsworth: *Cricket and the Emperor's Son* (World's Work, 1962);

I Spy Churches (Dickens Press, 1962); B. Brims: *Runaway Riders* (World's Work, 1963); D. Clewes: *The Branch Line* (Hamilton, 1963); D. Williams: *Wendy at Wembley* (Burke, 1963); B. Brims: *Red Rosette* (World's Work, 1965); J. Packer: *Pepper Leads the String* (Jenkins, 1965); W. Horsburgh: *Puppies to the Rescue* (Methuen, 1966); P. Mansbridge: *No Clues for Caroline* (Dent, 1966); E. Farjeon: *Jim and the Pirates* (Kaye, 1967; first illustrated by Richard Naish*, 1936); C. Mackenzie: *The Stairs That Kept Going Down* (Kaye, 1967); J. Paton-Walsh: *The Butty Boy* (Macmillan, 1975); D. Edwards: *Once, Twice, Thrice Upon a Time* (Lutterworth, 1976), *Once, Twice, Thrice, and Then Again* (Lutterworth, 1976); I. Chilton: *The Witch* (Macmillan, 1979).

Books written and illustrated include (all published by Macmillan): *Cockles and Shrimps* (1973); *Mountain Wool* (1974); *Swan Upping* (1974); *Stow Horse Fair* (1976); *Barley Sow, Barley Grow* (1978); *Barley Ripe, Barley Reap* (1979).

Contrib: *Country Fair; Elizabethan; London Mystery Magazine; Sunday Telegraph.*

Exhib: RA; NEAC; ROI; RWS; RI; single-artist shows at Bodkin Gallery, Chipping Norton; Crane Gallery, Chichester; Norwood, S. Australia.

Bibl: Peppin; Who; IFA.

PALMER, Margaret b.1922

Born on 10 September 1922 in London, Palmer studied at Hornsey School of Art (1938-39), Salisbury School of Art (1939-41) and Bournemouth School of Art (1941-42). A portrait painter, animal and genre painter, Palmer also illustrated a number of books, and wrote and illustrated at least one.

Books illustrated include: H. Townson: *Looking for Lossie* (Brockhampton Press, 1975), *The Barley Sugar Ghosts* (Hodder, 1976); J. Wayne: *Sprout and the Conjuror* (Heinemann, 1976).

Books written and illustrated include: *Honeypot and Buzz.*

Exhib: RP; ROI.

Bibl: Who.

PAPAS, William b.1927

Born on 15 July 1927 in Ermelo, South Africa, of a Greek father and German mother, Papas joined the South African Air Force at the age of fifteen and a half. After WW2 he came to England and studied at Beckenham School of Art, travelled in Europe, and returned to South Africa in 1961 to work on the *Cape Times* as staff artist. He then started a timber trucking business with his brother, but after two years returned to England and started working on the *Guardian* as a cartoonist. He later did strip and political cartoons for the *Sunday Times.*

His book illustrations are mostly done in pen and ink, and his people are drawn almost as caricatures. He has also done some attractive work in colour, for example for Peter Walsh's *Freddy the Fell Engine* (1966), and for his own *No Mules* (1967). He is quoted thus in ICB3: "I prefer writing and illustrating children's books especially on social and political themes. It is a form of elongated cartooning."

Books illustrated include (all published by OUP unless otherwise stated): P.H. Nortje: *The Green Ally* (1963); E. Blishen: *Miscellany One* (1964); C. Downing: *Tales of the Hodja* (1964); F. Grice: *A Severnside Story* (1964); P.H. Nortje: *Wild Goose Summer* (1964); R. Manning-Sanders: *Damien and the Dragon* (1965); P.H. Nortje: *Dark Waters* (1965); T. Papas: *The Story of Mr. Nero* (1965); P. Turner: *The Grange at High Force* (1965); N. Shrapnel: *Parliament* (1966); J. Stone: *The Law* (1966); H. F. Brinsmead: *Beat of the City* (1968); C. Downing: *Armenian Folk Tales* (1972); W.H. Nelson: *The Londoners* (Hutchinson, 1975); M. Muggeridge: *In a Valley of This Restless Mind* (Collins, 1978); C.S. Lewis: *The Screwtape Letters* (Collins, 1979); A. Oz: *Soumchi* (Chatto, 1980).

Books written and illustrated include: *Under the Tablecloth* (Capetown: Miller, 1952); *The Press* (OUP, 1964); *Tasso* (1966); *No Mules* (OUP, 1967); *A Letter from India* (OUP, 1968); *A Letter from Israel* (OUP, 1968); *Taresh the Tea Planter* (OUP, 1968); *People of Old Jerusalem* (Collins, 1980).

Contrib: *Cape Times; Guardian; Punch; Sunday Times.*

Collns: University of Kent.

Bibl: Bateman; ICB3; Peppin.

Juliette PALMER *The Butty Boy* by J. Paton-Walsh (Macmillan, 1975) From the original drawing

William PAPAS *The Press* (Oxford University Press, 1964)

PAPÉ , Frank Cheyne **1878-1972**
See Houfe

There is little biographical information available. Papé was a prolific illustrator, whose best work was perhaps done for the books by the American writer James Branch Cabell, and for the French writer Anatole France, which were published in illustrated editions in the 1920s. His finely-drawn illustrations combine elements of the grotesque, the humorous, the horrific and the fantastic. Often charming and containing striking images, his work brings to mind that of Sidney Sime*. Peppin reports that "Papé married Agnes Stringer, a former Slade student whose illustrations to *Little Folks* (c.1910) are in her husband's early manner, and who did much of the colouring of his pictures."

Books illustrated include: E.F. Buckley: *Children of the Dawn* (1908); J. Bunyan: *Pilgrim's Progress* (Dent, 1910); *Hans Andersen's Fairy Tales* (Nister, 1910); G. Macdonald: *At the Back of the North Wind* (Blackie, 1911); G. Sand: *The Wings of Courage* (1911); F.W. Carové: *The Story Without an End* (1912); A. Clark: *As It Is in Heaven* (1912); M.M. Stawell: *The Fairy of Old Spain* (1912); *The Gateway to Spenser* (Nelson, 1912); *Siegfried and Kriemhild* (1912); *Stories from Spenser* (1912); *The Book of Psalms* (1913); R. Wilson: *The Indian Story Book* (Macmillan, 1914), *The Russian Story Book* (Macmillan, 1916); J.B. Cabell: *Jurgen* (BH, 1921); R.H. Foster: *Two Romances in Verse* (1922); A. France: *At the Sign of the Reine Pedauque* (BH, 1922); J.B. Cabell: *The High Place* (NY: McBride, 1923); G. Hodges: *When the King Comes* (1923); A. France: *The Revolt of the Angels* (BH, 1924), *Penguin Island* (BH, 1925), *Thais* (BH, 1925); J.B. Cabell: *Figures of Earth* (BH, 1925), *The Cream of the Jest* (BH, 1927); F. Rabelais: *Complete Works* (BH, 1927); J.B. Cabell: *The Silver Stallion* (BH, 1928); A. France: *The Well of St. Clare* (BH, 1928), *Mother of Pearl* (BH, 1929); J.B. Cabell: *Something About Eve* (BH, 1929), *The Way of Ecben* (BH, 1929), *Domnei* (BH, 1930); R. Davies: *The Stars, the World and the Women* (William Jackson, 1930); *Suetonius's Lives of the Twelve Caesars* (Chicago: Argus Press, 1930); A. Daudet: *Tartarin de Tarascon* (Nelson, 1932); D. Defoe: *Picture Story of Robinson Crusoe* (1933); D. Wheatley: *Old Rowley* (Hutchinson, 1933); *Tales from the Arabian Nights* (1934); B. Falk: *The Naked Lady* (Hutchinson, 1934), *Rachel the Immortal* (Hutchinson, 1935); R.D.K. Storer: *Hercules* (OUP, 1962).

Contrib: *Boy's Herald; Cassell's Magazine; Pall Mall Magazine.*
Bibl: Johnson; Peppin.

"It is a matter to take into account if one marries a widow"

Frank PAPE *Mother of Pearl* by Anatole France (John Lane, The Bodley Head, 1929)

PARKER, Agnes Miller **1895-1980**

Born on 25 March 1895 in Irvine, Ayrshire, Parker was educated at Whitehill Higher Grade School, Glasgow, and studied at Glasgow School of Art (1914-18). She taught there for two years, and then taught at schools in England (1920-30). She studied wood engraving under Gertrude Hermes* and Blair Hughes-Stanton*, then travelled to France and Italy. She married William McCance, artist and typographer; and taught and engraved at the Gregynog Press (1930-33). She illustrated two books by H.E. Bates, and books for the Golden Cockerel Press and the Limited Editions Club of New York. After WW2 she moved to the Isle of Arran, Scotland, and in later years became more and more of a recluse. She was elected SWE; ARE (1939).

Essentially an illustrator, her first book, *How It Happened*, was illustrated with a delightful series of bold linocuts of animals. In the following books, her illustrations are wood engravings of the highest quality. They are quite distinctive, being filled with fine cross-hatching and stippled dots, which give her work their subtle tones. She worked at the Gregynog Press in 1930s with her husband, Hughes-Stanton and Hermes, together producing a series of splendidly illustrated books. *The Fables of Esope*, published in April 1932 despite the date of 1931 on the book itself, was the first Gregynog book illustrated by Parker and contained thirty-seven large wood engravings. The second, and last, book Parker did for Gregynog was *XXI Welsh Gypsy Tales*, published in 1933 with eight wood engravings. Soon after this, Parker and McCance left Gregynog, and Parker started to illustrate a number of books for other publishers, notably two books for Gollancz (printed by the Camelot Press), for the Golden Cockerel Press and for the Limited Editions Club of New York, all with engravings similarly finely cut. Gray's *Elegy Written in a Country Churchyard* (Limited Editions Club, 1938) is one of her finest works. Simon Brett writes in *Engraving Then and Now†* that her engravings are "designed with weighty and fully realised forms imbued with a springing lightness of action"; and Hodnett claims that few engravers are her equal when she was at the top of her form. Two commercially produced books, praised by critics and the bookbuying public both in Britain and in North America, were H.E. Bates' *Through the Woods* (1936) and *Down the River* (1937), published by Victor Gollancz and printed by the Camelot Press (see also illustration on page 23). They were the "perfect vehicle for her microscopic observation of country things". (Hodnett.)

Books illustrated include: R. Power: *How It Happened* (CUP, 1930); *The Fables of Esope* (Gregynog Press, 1932); R. Davies: *Daisy Matthews and Three Other Tales* (GCP, 1932); J. Sampson: *XXI Welsh Gypsy Tales* (Gregynog Press, 1933); H.E. Bates: *The House with the Apricot* (GCP, 1933); A. Le Corbeau: *The Forest Giant* (Cape, 1935); H.E. Bates: *Through the Woods* (Gollancz, 1936), *Down the River* (Gollancz, 1937); T. Gray: *Elegy Written in a Country Churchyard* (NY: Limited Editions Club, 1938); A.E. Housman: *A Shropshire Lad* (Harrap, 1940); W. Shakespeare: *Richard II* (NY: Limited Editions Club, 1940); T. Hardy: *The return of the Native* (NY: Limited Editions Club, 1942); H. Furst: *Essays in Russet* (Muller, 1944); R. Jefferies: *Spring of the Year* (Lutterworth, 1946), *Life of the Fields* (Lutterworth, 1947), *The Old House at Coats* (Lutterworth, 1948), *Field and Hedgerow* (Lutterworth, 1948), *The Open Air* (Lutterworth, 1948); A. McCormick: *The Gold Torque* (Glasgow: McLellan, 1951); A. Roche: *Animals under the Rainbow* (Welwyn: Broad Water Press, 1952); E. Spenser: *The Faerie Queene* (NY: Limited Editions Club, 1953); E. Lewis: *Honey Pots and Brandy Bottles* (Country Life, 1954); J.C. Powys: *Lucifer* (Macdonald, 1956); T. Hardy: *Tess of the D'Urbervilles* (NY: Limited Editions Club, 1956), *Far from the Madding Crowds* (NY: Limited Editions Club, 1958); W. Shakespeare: *The Tragedies* (NY: Heritage Press, 1959); T. Hardy: *The Mayor of Casterbridge* (NY: Limited Editions Club, 1964); W. Shakespeare: *Poems* (NY: Limited Editions Club, 1967); T. Hardy: *Jude the Obscure* (NY: Limited Editions Club, 1969).

Contrib: *Saturday Book 1.*

Exhib: LG; RE; SWE.

Collns: V & A; Whitworth.

Bibl: *Engraving Then and Now: 50th Exhibition of the Society of Wood Engravers* (SWE, 1987?); Dorothy A. Harrop: *A History of the Gregynog Press* (Private Libraries Association, 1980); Patricia

Agnes Miller PARKER *Through the Woods* by H.E. Bates (Victor Gollancz, 1936)

Jaffé: *Women Engravers* (Virago, 1988); Ian Rogerson and John Dreyfus: *Agnes Miller Parker: Wood-Engraver and Book Illustrator* (Fleece Press, 1990); Deane; Garrett 1 & 2; Hodnett; Peppin; Sandford; *Shall We Join the Ladies?*; Waters.

PARKES, Terence **b.1927**

Born in Birmingham, the son of a welder, Parkes was educated at Handsworth Grammar School and studied at Birmingham College of Art. He served with the Royal Artillery, taught in Peterborough, and worked in a factory, drawing cartoons in his spare time before he was able to draw full-time. Using the pseudonym "Larry", he has been contributing cartoons to *Punch* since 1954, then to the *Daily Express*, and since the mid-1960s to *Private Eye*. His "Man in Apron" series for *Punch* made his name.

Books illustrated include: B. Fantoni: *Private Eye's Cannonballs* (Private Eye, 1982), *Private Eye's Cannonballs 2* (Private Eye, 1984); J. Robertson: *Any Fool Can Keep a Secret* (Headline, 1989).

Contrib: *Daily Express; Private Eye; Punch.*

Collns: University of Kent.

Bibl: Bateman.

PARRY, Nicholas **fl.1973-**

The Tern Press, which Nicholas Parry and his wife Mary operate, is named after the River Tern which runs through the end of their garden near Market Drayton. The Press was established in 1973 with

the prize money from a Welsh Arts Council open painting competition. Most of the illustrations are wood engravings or linocuts, often printed in more than one colour. Each part of the production of the books is done by the Parrys, including the printing, illustrations and the binding.

Books illustrated include (all published by the Tern Press): *Winter* (1974); J. Shelton: *A First Selection* (with Mary Parry, 1974); *Eighteen Poems of Dante Alighieri* (1975); R. Ellis: *Disasters of War* (1975); R.G. Jones: *Bardsey* (1976); *Llywarch Hen* (1976); R.G. Jones: *Guto'r Glyn* (1976); R. Jefferies: *Meadow Thoughts* (1977); J. Porter: *The Ruin* (1977); M. Radnoti: *The Witness* (1977); *The Riddles from the Exeter Book* (1978); P. Abbs: *For Man and Islands* (1978); T. Orszag-Land: *Prince Bluebeard's Castle* (1978); A. Conran: *Metamorphoses* (1979); P. Abbs: *Songs of a New Taliesin* (1979); *Aelfric's Colloquy* (1980); D. Grubb: *The Mind and Dying of Mister Punch* (1980); T. Orszag-Land: *The Seasons* (1980); *The Gospel According to Saint Mark* (1980); *Sir Orfeo* (1980); B. Griffiths: *The Nine Herbs Charm* (illus. M. Parry, 1981); D. Grubb: *Return to the Abode of Love* (1981); R. Sheale: *The Hountying of the Chivyat* (1981); *In Valleys of Springs of Rivers* (1981); R. Jefferies: *The Water Colley* (1982); T. Orszag-Land: *Antarctic Testimony* (1982); J. Dowland: *A Little Collection of Verse* (1983); D. Grubb: *Three Meeting Houses* (illus. M. Parry); J. Stevenson: *The Romantic Hills of Hawkstone* (1983); D. Thomas: *Poem on His Birthday* (1983); *Verses from the Psalms* (1983); G. Miller: *A Prospect of Whitby* (1984); *Beowulf* (1984); *Dafydd ap Gwilym* (1984); Anacreon: *Five Odes* (1985); R. Jefferies: *The Birth of a Naturalist* (1985); G. Miller: *The Burial* (1985); M. Webb: *The Prize* (1985); J. Clare: *The Primrose Bank* (1986); Froissart: *From the Chronicles* (1986); D. Grubb: *Eight Village Poems* (1986).
Bibl: Nicholas Parry: "A Painter's Approach to Fine Printing", *Matrix* 5 (Winter 1985): 87-93.

PARSONS, Jacynth **1911-1992**
Born on 8 January 1911 in Northwood, Middlesex, Parsons was the daughter of Karl Parsons, a designer and maker of stained glass. She received no formal art training but from her earliest childhood must have absorbed the visual language of the late Pre-Raphaelites from her father. In 1927 the Medici Society in London mounted an exhibition of her "pictures from the age of 3 to 16" which met with considerable success. In the same year Blake's *Songs of Innocence* was published and received a similar acclaim and, because of that, the Medici Society commissioned drawings for a book of poetry by W.H. Davies, followed by watercolours for a Masefield volume. She then illustrated a book of her father's poems for children, and in the early 1930s produced some charming drawings for Gladys Forbes' *The Enchanted Forest*.
Parsons married architect Dennis Clough and after the birth of a son and daughter gave up her artistic career, except for illustrations to a series of school "readers" published by E.J. Arnold. Later in life she retired to north Cornwall and died on 21 September 1992.
Books illustrated include: W. Blake: *Songs of Innocence* (Medici Society, 1927); W.H. Davies: *Forty-Nine Poems* (Medici Society, 1928); J.E. Masefield: *South and East* (Medici Society, 1929); K. Parsons: *Ann's Book* (Medici Society, 1929); G.M. Forbes: *The Enchanted Forest*.
Exhib: Medici Galleries (1927).
Bibl: *Independent* obit. Sept. 1992; ICB; Peppin.
Colour Plate 123

PARSONS, John **fl. 1944-**
Parsons was a graphic artist who did commercial advertising work and illustrated a few books and book jackets. He was art editor of *House and Garden* and *Vogue* in the 1950s. FSIA.
Books illustrated include: A. Armstrong: *The Pack of Pieces* (Joseph, 1944); J.K. Cross: *Jack Robinson* (Lunn, 1945); *Vogue Cookery Book* (1948?).
Books written and illustrated include: *Innocence Is No Protection: An Alphabet of Proverbs* (Sylvan Press, 1949).
Bibl: Noel Carrington: "Illustrated Books for Young Children", *Graphis* no. 14 (1946): 220-37.

PARSONS, Marjorie Tulip **b.1902**
Born in Natal, South Africa, Parsons was the daughter of an architect. She studied at the Slade and, working as Trekkie Ritchie, she illustrated books with colour lithographs and wrote many books for children.
Books illustrated include: N. and W. Montgomerie: *Scottish Nursery Rhymes* (Hogarth Press, 1946); M.A. Gibbs: *Living Things* (1957); L. Healing: *Cooking for Mother* (Chatto, 1958); N. and W. Montgomerie: *The Hogarth Book of Scottish Nursery Rhymes* (Hogarth Press, 1964).
Books written and illustrated include: *Midget Books* (thirty-six titles, Chatto, 1942-); *Bells Across the Sand* (Chatto, 1944); *Treasures of Li-Po* (Hogarth Press, 1948); *A Junior Course in Nature Study* (four vols., Chatto, 1950-61); *England Under Four Queens* (Chatto, 1953).
Bibl: ICB2; Peppin; Waters.

PATERSON, George William Lennox **b.1915**
Born on 7 January 1915, Paterson studied at Glasgow School of Art. A portrait painter and engraver, he became Deputy Director of the Glasgow School; and was elected ARE in 1947. He illustrated a few books with engravings and scraperboard drawings, and published two manuals.
Books illustrated include: M. Fairless: *The Roadmender* (Collins, 1950); A.M. Dunnett: *Land of Scotch* (1953); R. Burns: *Poetical Works* (Chambers, 1958); N. Mitchison: *A Fishing Village on the Clyde* (OUP, 1960).
Published: *Scraperboard* (Dryad, 1960); *Making a Colour Linocut* (Dryad, 1963).
Contrib: *Woodcut* 4.
Exhib: RSA; RE; GI.
Bibl: Peppin; Waters.

A. Wyndham PAYNE *Sea Magic* by Cyril Beaumont (John Lane, The Bodley Head, 1928)

PATON, Jane Elizabeth **b.1934**
Born on 16 May 1934 in London, Paton studied at St. Martin's
School of Art and at the RCA (graphic design under Edward
Ardizzone*). In her last year at RCA, she was commissioned to
illustrate her first children's book, *The Twins of Ceylon* (1958). She
works in black and white and full colour, and her illustrations have
charm and a wistful appeal. While she was living with her sister and
brother-in-law and their three children, she illustrated *Mr. Crankle's
Taxi*, and modelled her characters on the family.
Books illustrated include: H. Williams: *The Twins of Ceylon*
(Cape, 1958); G. MacDonald: *The Princess and the Goblin*
(Blackie, 1960); J. Reeves: *Ragged Robin* (Heinemann, 1961); R.
Guillot: *Three Girls and a Secret* (Harrap, 1963); N. Mitchison: *The
Fairy Who Couldn't Tell a Lie* (Collins, 1963); D. Clewes: *Boys
and Girls Come Out to Play* (Hamilton, 1964); B. Willard: *A Dog
and a Half* (Hamilton, 1964); U.M. Williams: *Beware of This
Animal* (Hamilton, 1964); C. Cenac: *Four Poems into Adventure*
(Harrap, 1965); E. Vipont: *Rescue for Mittens* (Hamilton, 1965); E.
Farjeon: *Mr. Garden* (Hamilton, 1966); B. Willard: *Surprise Island*
(Hamilton, 1966); J. MacNeill: *I Didn't Invite You to My Party*
(Hamilton, 1967); B. Rongen: *Anna of the Bears* (Methuen, 1967);
H. Arundel: *The Amazing Mr. Prothero* (1968); E. Farjeon: *Around
the Seasons* (1969); M. Cockett: *Farthing Bundles* (1970); J.
MacNeill: *A Helping Hand* (1971); E. Davies: *Little Bear's Father*
(Hamilton, 1972), *Little Bear the Brave* (Hamilton, 1976); N. Rock:
Race Against the Wolves (Hamilton, 1976); B. Willard: *The
Bridesmaid* (Hamilton, 1976); E. Davies: *The Little Foxes*
(Hamilton, 1977); A. Bull: *The Bicycle Parcel* (Hamilton, 1980); C.
M. White: *A Present from 2B* (Hamilton, 1982).
Bibl: ICB3; Peppin.

PAUL, Evelyn **fl. 1906-1928**
See Houfe
Books illustrated include: W. Morris: *Stories from the Earthly
Paradise* (Harrap, 1906); S. Cannington: *Stories from Dante* (1910);
M. Gaskell: *Cranford* (1910); E. Ross: *The Birth of England* (1910);
W.D. Munro: *Stories of Indian Gods and Heroes* (1911); E. Ross:
From Conquest to Charter (1911); F.H. Davis: *Myths and Legends
of Japan* (Harrap, 1912); M.P. West: *Clair de Lune* (1913); E.M.
Wilmot-Buxton: *Britain Long Ago* (Harrap, 1914); J.L.T.C. Spence:
Myths and Legends of Ancient Egypt (Harrap, 1915), *Myths and
Legends of Babylonia and Assyria* (Harrap, 1916); *The Romance of
Tristram of Lyones and La Belle Isoude* (Hodder, 1921); C. Reade:
The Cloister and the Hearth (1922); W.J. Gordon: *Warne's
Pleasure Book for Girls* (1928).

PAYNE, A. Wyndham **fl. 1920-1930**
Payne was a book decorator and illustrator, who worked mostly for
Cyril Beaumont in the latter's capacity as either an author or pub-
lisher. He made woodcuts, hand-coloured line drawings, and
designed jackets and endpapers.
Books illustrated include: C.W. Beaumont: *A Burmese Fire at
Wembley* (Beaumont, 1924), *The Mysterious Toyshop* (Beaumont,
1924); A. Taylor: *Meddlesome Matty* (BH, 1925); C.W. Beaumont:
The Strange Adventures of a Toy Soldier (Beaumont, 1926); *Peter
Piper's Practical Principles* (BH, 1926); A. Symons: *Parisian
Nights* (Beaumont, 1926); C.W. Beaumont: *The Wonderful Journey*
(Beaumont, 1927); K. Grahame: *The Wind in the Willows* (Methuen,
1927); C.W. Beaumont: *Sea Magic* (BH, 1928); Basildon: *A
Handful of Sovereigns* (Medici, 1930).
Books written and illustrated include: *Town and Country* (Beau-
mont, 1927).
Bibl: Cyril W. Beaumont: *The First Score* (Beaumont Press, 1927);
B.T. Jackson: "The Beaumont Press 1917-1931", *Private Library*
2s, 8, no. 1 (Spring 1975): 4-37; Eva White: *An Introduction to the
Beaumont Press* (V & A, 1986); ICB; Peppin.

PAYNE, Charles Johnson ["Snaffles"] **1884-1967**
A sporting illustrator who usually went under the sobriquet
"Snaffles". He used watercolour, pen and ink or crayon, and his
work often is humorous.
Books illustrated include: G.F.H. Brooke: *Horse Lovers* (Con-
stable, 1927); M.J. Farrell: *Red Letter Days* (Collins, 1933); G. S.
Hurst: *The P.V.H. (Peshawar Vale Hunt)* (with Maurice Tulloch;

Gale & Polden, 1934); J.K. Stanford: *Mixed Bagmen* (Jenkins,
1949).
Books written and illustrated include: *My Sketchbook in the
Shiny* (Gale & Polden, 1930); *'Osses and Obstacles* (Collins, 1935);
More Bandobast (Collins, 1936); *A Half Century of Memories*
(Collins, 1949); *Four-Legged Friends and Acquaintances* (Collins,
1951); *"I've Heard the Revelly"* (Gale & Polden, 1953).
Exhib: McDonald Booth Gallery (1973); Alpine Club Gallery
(1981); Malcolm Innes Gallery (1984).
Bibl: Mark Flower and Donald Crawford: *Snaffles: Charles
Johnson Payne (1884-1967): A Selection of His Hunting and
Racing Prints* (1983); Peppin; Titley.

Hilary PAYNTER *Bwyta'n Te* by Bobi Jones (Gwasg
Gregynog, 1988)

PAYNTER, Hilary **b.1943**
Born in Dunfermline, Paynter lived in China and Malta as a child,
and studied art at the Portsmouth College of Art (1959-64). She
then attended the Tavistock Institute, University of London (1964-
65) and was awarded a diploma in the education of maladjusted
children. Her studies continued at the University of London where
she obtained an MA in Psychology in 1982, and at the North-East
London Polytechnic (MSc in Educational Psychology, 1988). She
has taught art in various establishments, including the Hammer-
smith Remand Home. She is a wood engraver, and exhibits regu-
larly in group shows of prints, and has illustrated a few books with
her engravings. She was elected SWE (1972), and became Honor-
ary Secretary in 1983; RE and Council Member (1984); FRSA
(1984).
Books illustrated include: B. Weatherhead: *The Imprisoned Heart*
(Gryphon Press, 1979); *Astrologer's Pocket Almanac* (Mitchell
Beazley, 1980); *Alternative Holidays* (Pan, 1981); *Hilary Paynter's*

Colin PAYNTON *Yr Alarch* by Euros Bowen (Gwasg Gregynog, 1988)

Picture Book (Kettering: Carr, 1984); B. Jones: *Bwyta'n Te* (Gregynog Poets; Gregynog Press, 1989); W. Shakespeare: *King Lear; Richard II* (Folio Society, 1989).
Collns: Ashmolean; Fitzwilliam; V & A.
Exhib: RA; RE; SWE.
Bibl: *Hilary Paynter: Wood Engravings* (SWE, 1991?); Brett; Garrett 1 & 2; Jaffé; IFA.

PAYNTON, Colin **b.1946**
Born in Bedford, Paynton began his studies at Northampton School of Art in 1963. He is a painter, printmaker and self-taught wood engraver. He lives in Wales and has illustrated books not only for the Gregynog Press but also for the Gruffyground Press and for the Barbarian Press in Canada. He belongs to various associations of wildlife artists, birds and animals being common subjects for him. *Engraving Then and Now* notes that the combination of his exact observation of the subject, and the formality of his approach to wood engraving often results in work of "an almost oriental splendour." He has been elected ARCamA (1982); ARE (1983); RE (1986); SWE (1984); SWLA (1986).
Books illustrated include: *Honeydew on the Wormwood* (Gregynog Press, 1984); *The Chimes* (Barbarian Press, 1985); *The Ladies of Gregynog, 1985*); *Hymn to the Virgin* (Gregynog Press, 1986); J. Mole: *Learning the Ropes* (Gruffyground Press, 1986); E. Bowen: *Yr Alarch* (Gregynog Press, 1987); *The Book of Jonah* (Gregynog Press, 1988); *Lieder* (Gregynog Press, 1989); Giraldus Cambrensis: *Itinerary Through Wales* (Gregynog Press, 1989); *Old Men or Boys Love . . .* (Gruffyground Press, 1989).
Exhib: RA; RWS; SWE; SWLA; RE; RCamA.
Collns: National Library of Wales; Ashmolean.

Bibl: *Engraving Then and Now: The Retrospective 50th Exhibition of SWE* (SWE, 1987?); Colin Paynton: "Colin Paynton", *Journal RE*, no. 7 (1985): 21; Brett; Who; IFA.

PEAKE, Mervyn Lawrence **1911-1968**
Born on 9 July 1911 in Kuling, central China, Peake was educated in Tientsin Grammar School (1917-22), after which he came to England with his family and attended Eltham College, Kent (1922-27). He then studied at Croydon School of Art (1928) and RA Schools (1929-32). In 1931 he exhibited for the first, and last, time at the RA, and went to Sark, Channel Islands, where he wrote and painted. He exhibited there and later in London at the Cooling Galleries with the Sark group of painters. He taught at Westminster School of Art (1935-38), where he met Maeve Gilmore whom he married in 1937. He served in the army in WW2 but was found to be "quite unsuited to soldiering" and was soon left largely to his own devices, so that he managed to devote enough time to writing *Titus Groan* that he finished it during his period of service and supplemented his army pay with the proceeds from book illustrating. He was invalided out in 1942.
Besides painting and designing for the theatre, Peake illustrated several books and wrote plays, poetry and fiction, winning the Heinemann Award for Literature in 1951 for *Gormenghast* and *The Glassblowers*. Peake gained a cult following on both sides of the Atlantic with his modern gothic novels, the "Titus" trilogy — *Titus Groan; Gormenghast; Titus Alone*. It was his ambition to publish illustrated editions of these, but a combination of ill health and indifference from publishers meant that the original editions have only book jackets and frontispieces illustrations by the author. Later editions include some of the many sketches which accompanied his manuscript.
Peake suffered cruelly from Parkinson's disease for some twelve years. The disease caused incredible difficulties for him when producing illustrations for *Droll Stories* (1961) and *The Rhyme of the Flying Bomb* (1962), and it was only through his perseverance and his wife's dedicated help that they were completed. He died on 17 November 1968 after spending the last four years of his life in hospital.
Peake's illustrations interpret very successfully his favourite themes and scenes of fantasy, with their feeling of the macabre and the grotesque, yet they also contain a sense of humour. His faces often remind one of the grotesque characters drawn by Heath Robinson* for his edition of Rabelais (1904). Peake used chiefly indian ink and watercolour, and most of his illustrations are in black and white. The first book he was commissioned to illustrate, *Ride a Cock-Horse* (1940), does however have detailed coloured illustrations. Watney declares that the seven magnificent illustrations in *The Rime of the Ancient Mariner* (1943) "represent, perhaps, his highest achievement as an illustrator. . . Here was that rarity in an illustrator: a man who could add a new dimension to the work he was illustrating. From this date, Peake was openly spoken of as 'the greatest living illustrator of the day.'" (Watney, 1976.†)
Books illustrated include: L. Carroll: *The Hunting of the Snark* (Chatto, 1941); Q. Crisp: *All This and Bevin Too* (Nicholson & Watson, 1943); C.E.M. Joad: *The Adventures of the Young Soldier in Search of a Better World* (Faber, 1943); S.T. Coleridge: *The Rime of the Ancient Mariner* (Chatto, 1943); A.M. Laing: *Prayers and Graces* (Gollancz, 1944); C. Hole: *Witchcraft in England* (Batsford, 1945); *Grimm's Household Tales* (Eyre, 1946); M. Collis: *Quest for Sita* (Faber, 1946); R.L. Stevenson: *Dr. Jekyll and Mr. Hyde* (Folio Society, 1948); R.L. Stevenson: *Treasure Island* (Eyre, 1949); D.K. Haynes: *Thou Shalt Not Suffer a Witch* (Methuen, 1949); J.D. Wyss: *Swiss Family Robinson* (Heirloom Library, 1950); H.B. Drake: *The Book of Lyonne* (Falcon Press, 1952); E.C. Palmer: *The Young Blackbird* (Wingate, 1953); L. Carroll: *Alice's Adventures in Wonderland and Through the Looking Glass* (Wingate, 1954); P.B. Austin: *The Wonderful World of Tom Thumb* (two vols., Radio Sweden, 1954-5); A. Sander: *Men: A Dialogue Between Women* (Cresset Press, 1955); A.M. Laing: *More Prayers and Graces* (Gollancz, 1957); H. B. Drake: *Oxford English Course for Secondary Schools, Book 1* (OUP, 1958); A. Judah: *The Pot of Gold and Two Other Tales* (Faber, 1959); H. de Balzac: *Droll Stories* (Folio Society, 1961).
Books written and illustrated include: *Captain Slaughterboard*

Mervyn PEAKE *Prayers and Graces* by A.M. Laing (Victor Gollancz, 1944)

Drops Anchor (Country Life, 1939); *Ride a Cock Horse, and Other Nursery Rhymes* (Chatto, 1940); *Rhymes Without Reason* (Eyre, 1944); *Titus Groan* (Eyre, 1946); *The Craft of the Lead Pencil* (Wingate, 1946); *Letters from a Lost Uncle from Polar Regions* (Eyre, 1948); *The Drawings of Mervyn Peake* (Grey Walls Press, 1949); *Gormenghast* (Eyre, 1950); *Mr. Pye* (Heinemann, 1953); *Figures of Speech* (Gollancz, 1954); *Titus Alone* (Eyre, 1959); *The Rhyme of the Flying Bomb* (Dent, 1962); *Poems and Drawings* (Keepsake Press, 1965); *A Book of Nonsense* (Owen, 1972).
Contrib: *Leader; Lilliput; London Mercury; Radio Times; Satire; World Review.*
Exhib: RA; Sark; Cooling Galleries; RBA; Leger; Calman; Leicester Galleries; Waddington; Collectors Gallery, Portobello Road; Guernsey Museum & Art Gallery (1987); Rye Art Gallery (1990).
Collns: Imp. War Mus.
Bibl: Maeve Gilmore: *Peake's Progress* (with an introduction by John Watney; Allen Lane, 1978); Maeve Gilmore: *A World Away* (Gollancz, 1970); Maeve Gilmore and Shelagh Johnson: *Mervyn Peake: Writings & Drawings* (Academy Editions, 1974); *Word and Image 3: Mervyn Peake 1911-1968* (National Book League, 1972); Sebastian Peake: *A Child of Bliss: Growing Up with Mervyn Peake* (Lennard Publ., 1989); Frances Sarzano: "The Book Illustrations of Mervyn Peake", *Alphabet and Image* 1 (Spring 1946): 19-37; Gordon Smith: *Mervyn Peake: A Personal Memory* (Gollancz, 1984); John Watney: *Mervyn Peake* (Joseph, 1976); Driver; Harries; ICB; Jacques; Peppin; Waters.

PEARS, Charles **1873-1958**
See Houfe

PEARSE, Alfred **1856-1933**
See Houfe

PEARSE, Susan Beatrice **1878-1980**
See Houfe
Born in Fair Oak, Hampshire, Pearse studied at the RCA. She painted in watercolour, and exhibited at a number of London galleries. She was a major contributor to the *Children's Encyclopaedia*, designed posters in the 1930s, including one for "Start-Rite Shoes", and illustrated a number of books for small children. Almost all of her illustrations were devoted to the "Ameliaranne" series of books, written by different authors, about little girls and their dolls. They were simply illustrated in pleasant colours, and recall the books of Mabel Lucie Attwell* and Honor Appleton*. She died on 3 January 1980, just eighteen days before her 102nd birthday; she was married to the late W.E. Webster, a portrait painter.
Books illustrated include (but see Felmingham): E.M. Jameson: *The Pendleton Twins* (Hodder, 1909); C. Dickens: *The Magic Fishbone* (Nisbet, 1911), *The Trial of William Tinkling* (Constable, 1912); C. Heward: *Ameliaranne and the Green Umberella* (Harrap, 1920), *The Twins and Tabiffa* (Harrap, 1923); C. Dickens: *Captain Boldheart and the Latin Grammar Master* (Macmillan, 1927); C. Heward: *Ameliaranne Keeps Shop* (Harrap, 1928); N. Joan: *Ameliaranne in Town* (Harrap, 1930); M. Gilmour: *Ameliaranne at the Circus* (Harrap, 1931); E. Farjeon: *Ameliaranne's Prize Packet* (Harrap, 1933); K.L. Thompson: *Ameliaranne at the Zoo* (Harrap, 1936); C. Heward: *Ameliaranne Keeps School* (Harrap, 1940).
Exhib: RA; RI.
Bibl: *Times* obit. 15 January 1980; Felmingham; ICB; Peppin.

PEARSON, Bruce **b.1950**
Born in Newmarket, Suffolk, Pearson studied at Great Yarmouth College of Art and at Leicester College of Art where he received a B.A. (Fine Arts). He became interested in linking photographic work with paintings, and in 1973 started working for eighteen months as trainee production assistant with the RSPB film unit. Painting in his spare time, he mounted an exhibition of his work on East Anglian wildlife at the Assembly Rooms, Norwich, and some illustrations were used in *Bird Life*. He went to the Antarctic in 1975 and film he shot there was shown on BBC Television. Pearson has continued to travel and has produced illustrations for magazines and books.
Books illustrated include: *Gem Guide to Wild Animals* (Collins, 1980); B. Jackman: *The Countryside in Winter* (Century Hutchinson, 1985).
Contrib: *Bird Life; Birds; Wildlife.*
Exhib: Norwich; Scott Polar Institute, Cambridge; SWLA.
Bibl: Hammond.

PELLEW, Claughton **1890-1966**
Born on 11 April 1890 in Redruth, Cornwall, the eldest son of William Pellew-Harvey, a mining engineer, Pellew later dropped "Harvey" from his name. He spent his early childhood with his family in Vancouver, Canada, returning to England around 1900, first to Greenwich and later Blackheath. He was educated at Merchant Taylor's School, Northwood, Middlesex (1902-06), and studied at the Slade (1907-11), where his fellow students included Paul Nash*, Stanley Spencer*, Ben Nicholson and William Roberts*. Paul Nash stayed with the Pellew family in 1910, and in 1912 both Paul and John Nash* spent holidays in Norfolk with Pellew. John Nash and Pellew became close friends. Having become a Roman Catholic in 1914, Pellew was a conscientious objector during WW1 and was confined in work centres until 1918. He married fellow artist Emma-Marie (Kechie) Tennent in 1919 and they moved to Norfolk, where they lived until he died in 1966.
He exhibited at NEAC in 1921 (his wife's first exhibition was held at the Goupil Gallery in 1927), and in 1923 began wood engraving, exhibiting with the SWE. He continued to engrave until 1943, painted and produced etchings and exhibited widely. A few of his engravings were published in books, and he contributed at least one cover to the *Radio Times*. For Elizabeth Goudge's *The Reward of*

Gladys PETO *Gladys Peto's Children's Annual* (Sampson Low, 1923)

Faith and Other Stories he did eight full page pen and ink drawings, eight tail-pieces, and a book jacket.

Books illustrated include: *H. Ould: Episode* (Berlin: Wilmersdorf, 1923); *The New Leader Book* (New Leader, 1925); E. Goudge: *The Reward of Faith and Other Stories* (Duckworth, 1950).

Contrib: *Radio Times*.

Exhib: NEAC; SWE; English Wood Engraving Society; Society of Artist Printers; Ashmolean (1987).

Collns: Ashmolean; V & A.

Bibl: *Claughton Pellew: Wood Engravings* (Ashmolean Museum, 1987); Anne Stevens: *Claughton Pellew: Five Wood Engravings... with a Biographical Note* (Fleece Press, 1987).

PENNELL, Betty **b.1930**

Pennell studied at RCA (1949-52), where she learned wood engraving from John Nash* and Edward Bawden*. She taught at Birmingham College of Art (1959-64), and since then has worked as a free-lance painter and engraver in Herefordshire.

Books illustrated include: W. Shakespeare: *As You Like It, The Comedy of Errors* (Folio Society, 1988).

Bibl: Brett.

PEPPÉ, Rodney **b.1934**

Born in Eastbourne, Peppé studied at Eastbourne School of Art (1951-53). After National Service in Malaya, he returned to finish his studies at Eastbourne (1955-57) and the Central School of Arts

and Crafts (1957-59). He worked in advertising and television before becoming a free-lance graphic artist in 1965. He has written and illustrated children's books since 1968, using a great variety of techniques, including at least one pop-up book (*Run Rabbit Run!*).

Books illustrated include: R. & J. Marchant: *The Little Painter* (1971).

Books written and illustrated include (but see Peppin): *The Alphabet Book* (1968); *Circus Numbers* (1969); *The House That Jack Built* (Longman, 1970); *Cat and Mouse* (Longman, 1973); *Henry's Present* (Methuen, 1975); *Picture Stories* (Kestrel, 1976); *Humphrey the Number Horse* (Methuen, 1978); *My Surprise Pull-Out Wordbook, Indoors* (Methuen, 1980); *Rodney Peppé's Moving Toys* (Evans, 1980); *The Mice Who Lived in a Shoe* (Kestrel, 1981); *Run Rabbit Run! A Pop-Up Book* (Methuen, 1982); *The Kettleship Pirates* (Kestrel, 1983); *Hello Henry* (Methuen, 1984); *Tell the Time with Mortimer* (Methuen, 1986).

Contrib: *Homes and Gardens; Observer; Radio Times*.

Bibl: CA; ICB4; Peppin.

PEPPER, Reginald **fl. 1985**

Pepper's illustrations to *Pepper and Jam* are brilliant and appear naïve. The different pictures are painted in various styles — a 1940s bedroom as by a St. Ives painter, and linoleum which looks like a Vuillard pattern, for example.

Books illustrated include: "Longbody": *Pepper and Jam* (Cape, 1985).

PETHERICK, Rosa C. **d.1931**
See Houfe
Books illustrated include: *Mother Hubbard's Cupboard of
Nursery Rhymes* (1903); L. Gask: *Little Folks of Many Lands* (with
K. Fricero; Cassell, 1910); *Stories from Wales* (SPCK, 1920); E.
Oxenham: *The Abbey Girls in Town* (Collins, 1925); *Simple Com-
position Steps* (1930).
Contrib: *Little Folks.*

PETO, Gladys Emma **1890-1977**
See Houfe
Born in Maidenhead, Peto studied at Maidenhead School of Art and
at the London School of Art. She was an illustrator and painter,
working both in black and white and in colour. She wrote and illus-
trated books for children, and contributed illustrations to a number
of magazines, including a satirical illustrated diary, which appeared
weekly in the *Sketch* from 1915 to 1926. She also designed pottery,
textiles, posters and costumes; and in the 1920s and early '30s, as
The Times reports, it was the "in" thing to wear a Gladys Peto dress.
Her book illustrations have been compared to those of Aubrey
Beardsley, particularly for their use of solid blacks and for their
decorative quality. Some of her colour work, however, such as illus-
trations in the *Gladys Peto's Annual* for 1923, remind one more of
Jessie King (see Houfe); while in Enid Hunt's *A Fine Lady upon a
White Horse* (1929), she used flat, bright, poster-like colours.
She was married to Colonel C.L. Emmerson and moved to Northern
Ireland in 1939, where she had a number of exhibitions of water-
colours of Irish landscapes. Though hampered by a stroke which
forced her to use her left hand, she continued to draw the flowers
she cultivated for sale. She died in 1977 at the age of eighty-six.
Books illustrated include: L.M. Alcott: *The Works* (1914); E.L.
Hunt: *A Fine Lady upon a White Horse* (Sampson Low, 1929); S.
Stokes: *The China Cow* (Sampson Low, 1929).
Books written and illustrated include: *Books for Children* (four
vols., Sampson Low, 1924-5); *Malta and Cyprus* (Dent, 1928); *The
Egypt of the Sojourner* (Dent, 1928); *Bedtime Stories* (Shaw, 1931);
Twilight Stories (Shaw, 1932); *Girl's Own Stories* (Shaw, 1933);
The Four-Leaved Clover and Other Stories (Juvenile Productions,
1937); *Sunshine Tales* (Shaw, 1935); *The Peto Picture Book*
(Sampson Low, 193?).
Contrib: *Bystander; Gladys Peto's Children's Annual; Pearsons;
Printer's Pie; Sketch.*
Bibl: *Times* obit. 7 June 1977; Peppin; Waters; Who.

PETTIWARD, Roger **1906-1942**
Born on 25 November 1906 in Suffolk, Pettiward was the second of
four children of a well-to-do father who was an amateur illustrator
and caricaturist. He was educated at Eton and Christ Church,
Oxford, where he became captain of the college boat club and drew
for *Isis*. He first studied agriculture but then turned to art, studying
in Vienna, at the Slade and in Paris. He travelled widely and in
1932 accompanied Peter Fleming in an expedition to Brazil to look
for the missing explorer, Colonel Fawxett, an expedition described
in Fleming's *Brazilian Adventure.*
Using the sobriquet "Paul Crum", Pettiward contributed humorous
drawings in line or line and wash to a number of magazines, notably
to *Punch* and the short-lived *Night and Day*. He did some colour
illustrations for both these publications and for a booklet published
by Austin Reed, *London Holiday*. His drawings, though they appear
at first sight sometimes to be "scribbles", are accurately and eco-
nomically made, often having the characteristic feeling of carica-
tures. Price declares that he influenced many *Punch* artists, estab-
lishing "a bleak, fantastic humour, in which drawing and joke
formed a unity. He created a world of precise insanity." Ruari
McLean, in the introduction to the collection of Pettiward's draw-
ings, *The Last Cream Bun* (1984), compares Pettiward to Nicolas
Bentley*, declaring that both artists felt everything in humorous
drawings should be funny and that both were highly successful in
portraits and costume drawing. Unfortunately, Pettiward was able to
produce drawings for only some five years, for he was killed while
leading a commando raid on Dieppe during WW2 in 1942.
Books illustrated include: D. Pettiward: *Truly Rural* (Dent, 1939).
Contrib: *Bystander; Isis; London Week; Night and Day; Punch;
Sunday Express.*

John PETTS *Against Women* (Golden Cockerel Press, 1953)

Bibl: Roger Pettiward: *The Last Cream Bun* (Chatto & Windus,
1984); Price.

PETTS, John **b.1914**
Born in Hornsey, North London, Petts studied at Hornsey College
of Arts and Crafts (1930-33), where he learned to engrave from
Norman Janes*, and then at RA Schools (1933-35), while he
worked on engraving with W.F. Robins at the Central School
(1934). From 1935, he worked as a free-lance artist, engraving,
sculpting and working in stained glass. He ran his own Caseg Press
in Wales from 1938 to 1951, apart from the years 1943-47 when he
served in the Middle East and Greece during WW2. He was
Assistant Director for Wales, Arts Council (1951-56), and taught at
the Dyfed College of Art (1958-61).
Petts illustrated a number of books, including some for the Golden

Cockerel Press. He made all the engravings for *The Green Island* (1946) in a tent in the desert, while he was serving as a parachutist in the army. His engravings for *Against Women* and *In Defence of Women* were done in four colours and black, and were printed from five blocks. Sandford wrote in *Cock-A-Hoop* that Petts conceived of these illustrations in terms of stained glass, "a medium which he, like Rouault, practised most expertly." (Chambers.)

Petts was elected SWE (1953); ARE (1957). He was awarded the Churchill Fellowship in 1967 and travelled to the US and Mexico. He has lived in Wales for most of his adult life, and now lives and works in Abergavenny.

Books illustrated include: E.C. Davies: *Storiau am Annibynwyr* (Undeb yr Annibynwyr, 1939), *Y. Morwr a'r Merthyr* (Livingstone Press, 1940); *The Caseg Broadsheets* (Caseg Press, 1942); A. Lewis: *Raider's Dawn* (Allen & Unwin, 1942); G. Jones: *The Green Island* (GCP, 1946); A. Lewis: *In the Green Tree* (1948); C. Hughes: *A Wanderer in North Wales* (Phoenix House, 1949); *Susanna and the Elders* (Caseg Press, 1949); J. Bramwell: *Sauna* (Caseg Press, 1949); *Against Women* (GCP, 1953); *In Defence of Women* (GCP, 1960); J. Dyer: *Grongar Hill* (1977).
Contrib: *Listener; Welsh Review.*
Exhib: RA; RE; SWE; Glynn Vivian Gallery, Swansea (1975).
Bibl: Chambers; Garrett 1 & 2; Peppin; Waters; Who; IFA.

PEYTON, Kathleen Wendy b.1929

Peyton (née Herald) was born in Birmingham and educated at Wimbledon High School. She studied at Manchester Art School and took an art teacher's diploma. With her husband, Michael, she began writing short stories, and when three of these were published in book form, *North to Adventure* (1958), the publisher Collins did not want two authors on the title page. They were stated to be by "K.M.Peyton", and Kathleen continued to use this name for her later books. Her first solo book was *Windfall*, published in 1962, and in 1967 she struck out in a new direction with *Flambards*, the first of a trilogy set in Essex before and during WW1. The second of these, *The Edge of the Cloud* (1969), won the Carnegie Medal. This series, and some of her earlier books, were illustrated by Victor Ambrus*, but she illustrated her next series about a schoolboy named Pennington.

Peyton is much better known as a writer than an illustrator. Townsend† writes that with her first book she "took an immediate place in the front rank of contemporary children's writers", and Carpenter declares that her novels "have played a large part in establishing the genre of teenage novels in Britain. . . She is a master at plot-construction and at holding her readers' attention."
Books written and illustrated (all published by OUP): *Pennington's Seventeenth Summer* (1970); *The Beethoven Medal* (1971); *A Pattern of Roses* (1972); *Pennington's Heir* (1973); *Dear Fred* (1981); *Going Home* (1982).
Published (by OUP): *Windfall* (1962); *The Maplin Bird* (1964); *Flambards* (1967); *The Edge of the Cloud* (1969); *Flambards in Summer* (1969).
Bibl: John Rowe Townsend: *25 Years of British Children's Books* (National Book League, 1977); Carpenter; Eyre.

PHILLIPS, Douglas b.1926

Born in Dundee, Phillips had no formal art training. After office work and service with the army in India and Sri Lanka (1945-48), he worked for an art agency in Dundee, illustrating stories in comics and magazines for boys. He became a free-lance artist in 1966, and illustrates fiction and non-fiction for children.
Books illustrated include (but see Peppin): R. Ottley: *Brumbie Dust* (1969); J. Williams: *Gallipoli* (1969); A. Catherall: *Big Tusker* (1970); M.C. Borer: *The Boer War* (1971); M. Patchet: *Roar of the Lion* (1973); J. Tate: *The Runners* (1974); G. Cook: *Sea Adventures* (1974); M. Hynds: *Dolphin Boy* (Blackie, 1975); K. Sibley: *Adam and the FA Cup* (Dobson, 1975); M. Hynds: *Mumbo Jumbo* (Blackie, 1976); K. Sibley: *Adam and the Football Mystery* (Dobson, 1979); J. Furminger: *Bobbie Takes the Reins* (Hodder, 1981), *Bobbie's Sponsored Ride* (Hodder, 1982); J. Stranger: *The Honeywell Badger* (Severn House, 1986).
Contrib: *Adventure; Reader's Digest; Rover; Scottish Field; Wizard.*
Bibl: Peppin.

Howard PHIPPS "Interior with wicker chair" from *Interiors* (Whittington Press, 1985)

PHIPPS, Howard b.1954

Born on 2 January 1954 in Colwyn Bay, North Wales, Phipps grew up in Gloucestershire and studied painting and printmaking at Gloucestershire College of Art, Cheltenham (1971-75), followed by another year at Brighton Polytechnic. He has taught art at Burgate Comprehensive School in Hampshire. Although he is best known as a wood engraver, he is largely self-taught in that discipline, and still spends much time working at large drawings and paintings, which often form the basis of his wood engravings. His first commission was from John Randle of the Whittington Press to illustrate a book of poems by Roland Gant, *Stubble Burning* (1982); and he then produced *Interiors* (1985), also for Whittington, which consists of fifteen wood engravings printed in two or three colours and no text at all. In 1985 he won the Christie's Contemporary Print Award for a colour print. He has exhibited widely, including one-artist shows at Salisbury, joint exhibitions with Sarah Van Niekerk* (1986) and Kathleen Lindsley* (1987), and regularly at RA and RE. He has lived in Salisbury since 1980. He was elected member of the Royal West of England Academy (1979); SWE.
Books illustrated include: R. Gant: *Stubble Burning* (Andoversford: Whittington Press, 1982); G. Chaucer: *The Prologue to the Canterbury Tales* (Salisbury: Perdix Press, 1984); R. Gant: *Mountains in the Mind* (Andoversford: Whittington Press, 1987); W. Shakespeare: *Henry V, Henry VIII* (Folio Society, 1988); I. Walton: *Life of George Herbert* (Perdix Press, 1988); J. Lydgate: *Table Manners for Children* (Perdix Press, 1989); M. Osler: *A Gentle Plea for Chaos* (Bloomsbury, 1989); R. Verey: *A Countrywoman's Notes* (Gryffon Publications, 1989).
Books by Phipps include: *Interiors* (Andoversford: Whittington Press, 1985).
Contrib: *Matrix.*
Bibl: Howard Phipps: "A Painter's Approach to Wood-Engraving", *Matrix* 9 (Winter 1988): 8pp. between 80-81; Linda Saunders: "Why Not Just a Drawing; the Wood Engravings of Howard Phipps", *The Green Book*, 2, no.3 (1986): 26-29; Brett; IFA.

Howard PHIPPS Wood engraving: "Old Sarum in Winter"

PIENKOWSKI, Jan Michel **b.1936**

Born in Warsaw, Pienkowski lived in the countryside in Poland, Bavaria and Italy for the first ten years of his life. He came to England in 1946 and studied classics and English literature at King's College, Cambridge. After he left university he worked for a while in advertising and in 1961 founded Gallery Five to produce cards, posters and other paper products.

His first illustration commission was for book jackets for Cape (1960-61), and his first illustrated book was also done for Cape, *Annie, Bridget and Charlie* (1967). He became involved in television at this time, doing graphics and cartoons for the BBC children's programme, "Watch!" His own first picture book, which he wrote with Helen Nicoll, was published in 1972 (*Meg and Mog*), and at least eleven other titles in the series have been produced. These are small books for very young children, with bright colours filling in areas outlined in heavy, black lines, rather like stained glass. The "Concept Books" and "Nursery Books" are done in much the same way. Pienkowski is very concerned about the production quality of his books, and has experimented with many different methods of producing illustrations, including torn paper, marbling, black silhouettes, and a bronze-powder technique for gold printing. He strongly dislikes the commonly used three-colour separation process which often is detrimental to the appearance of the printed illustration. He has won the Kate Greenaway Medal twice, for his illustrations to Joan Aiken's *The Kingdom Under the Sea* (1971), and for his own pop-up book, *Haunted House* (1979).

In the 1980s Pienkowski continued with children's books, but also did two books based on the Christian themes of Christmas and Easter, using texts from the King James version of the Bible. He did some designing for the theatre, including "Beauty and the Beast" for the Royal Opera House, Covent Garden (1986), and "Anything for a Quiet Life" for the Théâtre de Complicité (1988). That year saw exhibitions of his stage designs at the Lyric Theatre, Hammersmith, and "Works in Cut Paper, Wood and Metal" at the Oxford Gallery.

Books illustrated include (but see Martin, 1989†): J.G. Townsend: *Annie, Bridget and Charlie* (Cape, 1967); J. Aiken: *A Necklace of Raindrops* (Cape, 1968); E. Brill: *The Golden Bird* (Dent, 1970); J. and N. Langstaff: *Jim along Josie* (OUP, 1970); J. Aiken: *The Kingdom under the Sea* (Cape, 1971); A. Szudek: *The Amber Mountain* (Hutchinson, 1976); D. Starkey: *Ghosts and Bogles* (Good Reading, 1978); J. Aiken: *Tale of a One-Way Street* (Cape, 1978), *Past Eight O'Clock* (Cape, 1986), *A Foot in the Grave* (Cape, 1989).

Books written and illustrated include: (with Helen Nicoll) *Meg and Mog* (and eleven other titles in series; Heinemann, 1972-87); *Quest for Gloop* (Heinemann, 1975); *Fairy Tale Library* (Heinemann, 1977); *Concept Books* (four titles, Heinemann, 1979-80); *Haunted House* (Heinemann, 1979); *Dinner Time* (Gallery Five, 1981); *Gossip* (Gallery Five, 1983); *Christmas* (Heinemann, 1984); *Nursery Books* (four titles, Heinemann, 1985-6); *Little Monsters* (Orchard, 1986); *Easter* (Heinemann, 1989).

Exhib: Oxford Gallery (1988); Lyric Theatre Hammersmith (1988).

Bibl: Douglas Martin: *The Telling Line: Essays on Fifteen Contemporary Book Illustrators* (Julia MacRae, 1989); Peppin.

Colour Plate 124

PILKINGTON, Margaret **1891-1974**

Born on 25 November, 1891 in Salford, Lancashire, Pilkington was educated at Croham Hurst School, Croydon. She studied art at the Slade and wood engraving at the Central School of Art and Design under Lucien Pissarro and Noel Rooke* (1914). A wood engraver who has illustrated a few books, Pilkington became Secretary of SWE in 1924 and Chairman in 1952. She was elected Governor of the Whitworth Art Gallery, Manchester, in 1925, becoming Honorary Director (1935-59), and it was largely through her efforts that the Gallery acquired its fine collection of wood engravings by purchasing from the annual exhibitions of SWE.

Most of her work deals with townscapes and landscapes. "Her approach to engraving is akin to the simplicity of Gwendolen Raverat*. [Her] style is linear in emphasis, her lines are dominantly

John PIPER *Church Poems* by John Betjeman (John Murray, 1981)

parallel and a little coarse in texture, which give her prints their distinctive crisp quality." (Garrett 1.)

She was elected a member of the Art Workers' Guild (1965); SWE (1922); OBE (1954). She died on 2 August 1974.

Books illustrated include: L. Pilkington: *An Alpine Valley and Other Poems* (Cloister Press, 1924), *Tattlefold* (Warne, 1926); K.C. Chorley: *Hills and Highways* (Dent, 1928); L. Pilkington: *The Chimneys of Tattleton* (Warne, 1928).

Bibl: Garrett 1 & 2; Peppin; *Shall We Join the Ladies?*; Who Was Who.

PIPER, John Egerton Christmas **b.1903**

Born on 13 December 1903 in Epsom, Surrey, the son of a City solicitor who was also an amateur artist interested in architectural drawing, Piper was educated at Epsom College (1917-21). He was an unwilling articled clerk in his father's firm (1921-26), and when his father died in 1926 he left law and attended Richmond School of Art and then RCA (1927-29). He started making topographical notebooks of English architecture from the 1920s, had a couple of books of poetry published also in the 1920s, illustrated his father's autobiography (1925) and had his first exhibition (of wood engravings) at the Arlington Galleries (1927).

Piper had left RCA early to marry Eileen Holding, a fellow student at Richmond, and spent his time painting, making stained glass, writing art and theatre criticism for *Listener* and *New Statesman*. He became a good friend of Ivon Hitchens and met Myfanwy Evans (who in 1937 became his second wife) while visiting Hitchens at his home in Suffolk. He was elected a member of the London Group (1933) and the 7 & 5 Society (1934), worked on "constructions" through 1934, did his first abstract oil painting (1935) and adver-

tisements for Imperial Airways, and joined the Group Theatre as a designer with Robert Medley* (1937). In that year he was commissioned by John Betjeman to write the *Shell Guide to Oxfordshire* (which Piper illustrated with photographs), in 1939 published his *Brighton Aquatints*, and in 1940 was commissioned by the War Artists' Advisory Committee. He painted bombed churches and other buildings during WW2, and when he was appointed an official war artist in 1944, painted shipping and agricultural subjects for the Ministry of War Transport.

After WW2 Piper's remarkably varied artistic life continued. He painted; did murals and stained glass, including windows in Eton College Chapel and Coventry Cathedral; produced fabric designs; designed scenery and costumes for plays, operas and ballets; designed tapestries for Chichester Cathedral and the Civic Hall, Newcastle; published screen prints and lithographs; and illustrated books.

Piper is perhaps best known for his watercolours and prints of landscapes and buildings in England, Wales, France and Italy. He called for a return to the landscape tradition in an article he wrote for *The Painter's Object* (1937), edited by Myfanwy Evans, and his own *British Romantic Artists* (Collins, 1942) traces the Romantic impulse in British art; and he worked on the *Recording Britain* project during WW2, contributing twelve paintings. He is widely recognised as one of the leading neo-romantic painters of the postwar period in Britain; and his illustrations have the same moody, picturesque and dramatic feeling as his paintings. A theatrical painter who chooses his vantage point to provide the greatest dramatic effect, Piper may be a romantic artist, but as described by Robert Medley* in an article in the *Penguin New Writing*, he is also "equipped with the disciplines of an abstract painter . . . His eye notes the proportions of the confronting masonry, translates them to terms of abstract relationships, dramatises them with colour, then comes the texture . . ."

Piper was a Trustee of the Tate Gallery 1946-52 and 1954-61, and member of the Arts Council Panel 1952-7. He was made a Companion of Honour in 1972.

Books illustrated include: C.A. Piper: *Sixty-three Not Out* (pp., 1925); J. Betjeman and G. Taylor: *English, Scottish and Welsh Landscape 1700-c.1860* (Muller, 1944); F. Kilvert: *Kilvert's Diary 1870-1879* (Cape, 1944); O. Sitwell: *Left Hand, Right Hand* (five vols., Macmillan, 1945-50); W. de la Mare: *The Traveller* (Faber, 1946); J.M. Richards: *The Castles on the Ground* (Architectural Press, 1946); *Recording Britain* (four vols., OUP, 1946-9); G.R. Sitwell: *On the Making of Gardens* (Dropmore Press, 1949); W. Wordsworth: *A Guide through the District of the Lakes in the North of England* (Hart-Davis, 1951); J. Betjeman: *First and Last Loves* (Murray, 1952), *Poems in the Porch* (SPCK, 1954); E. Muir: *Prometheus* (Ariel Poem; Faber, 1954); J. Stone: *Edward Sydney Woods* (Gollancz, 1954); J. Hadfield: *Elizabethan Love Songs* (Barham Manor, Suffolk: Cupid Press, 1955); J. Betjeman: *Collins' Guide to English Parish Churches* (Collins, 1958); B. Russell: *The Wisdom of the West* (Macdonald, 1959); R.F.H. Duncan: *Judas* (Blond, 1960); G. White: *The Natural History of Selborne* (Folio Society, 1962); J. and K. Lindley: *Urns and Angels* (Swindon: Pointing Finger Press, 1965); K. Lindley: *Of Graves and Epitaphs* (Hutchinson, 1965); A. Stokes: *Venice* (Lion and Unicorn Press, 1965); R.S. Thomas: *The Mountains* (NY: Chilmark Press, 1968?); A. Ridler: *The Jesse Tree* (Lyrebird Press, 1972); *India Love Poems* (Paradine, 1977); J. Betjeman: *Church Poems* (Murray, 1981); R. Blythe: *Places: An Anthology of Britain* (OUP, 1981); J. Dyer: *Grongar Hill* (Stourton Press, 1982); R. Ingrams: *Piper's Places* (Chatto, 1983); D. Thomas: *Deaths and Entrances* (Gwasg Gregynog, 1984).

Books written and illustrated include: *Wind in the Trees* (Bristol: Horseshoe Publishing, 1921); *The Gaudy Saint* (Bristol: Horseshoe Publishing, 1924); *Shell Guide to Oxfordshire* (Batsford, 1938); *Brighton Aquatints* (Duckworth, 1939); *Buildings and Prospects* (Architectural Press, 1948); *Romney Marsh* (Penguin, 1950).

Contrib: *Ambassador; Architect and Building News; Architectural Review; Britain Today; Cornhill Magazine; Fortune; Horizon; Listener; London Mercury; New Leader; Penrose Annual; Poetry London; Quarto; Saturday Book 16; Signature.*

Exhib: Arlington Gallery; Zwemmer; London Gallery; Leicester Galls; V & A; Arts Council (Cambridge and Cardiff); Arthur

Jeffries Gallery; Marlborough Fine Art; Aldeburgh Festival; Hamet Gallery; Glynn Vivian Art Gallery, Swansea; and in Belfast, New York, Cologne, Osaka, Johannesburg; retrospective exhibs. at Marlborough New London Gallery (1964); Arts Centre, Folkestone (1970); Museum of Modern Art, Oxford (1979); Gallery (1983).
Collns: Tate; V & A; Kettle's Yard, Cambridge.
Bibl: John Betjeman: *John Piper*, The Penguin Modern Painters (Penguin Books, 1948); Richard Ingrams and John Piper: *Piper's Places: John Piper in England and Wales* (Chatto, 1983); David Mellor: *A Paradise Lost: The Neo-Romantic Imagination in Britain 1935-55* (Lund Humphries/Barbican Art Gallery, 1987); *John Piper* (Tate Gallery, 1983); S. John Woods: "John Piper as a Topographical Illustrator", *Image*, no. 2 (Autumn 1949): 3-18; Malcolm Yorke: The Spirit of Place: Nine Neo-Romantic Artists and Their Times (Constable, 1988); Compton; Harries; Peppin; Ross; Tate; Waters; Who; Who's Who.
Colour Plate 125

PIPPET, Gabriel **b.1880**
Born on 19 March 1880 in Solihull, Warwickshire, Pippet studied at Birmingham School of Art. After school he worked with his father, who was also an artist, before working with an artist in stained glass. In his spare time he started making illustrations for children's stories, then turned his attention to woodcarving. After

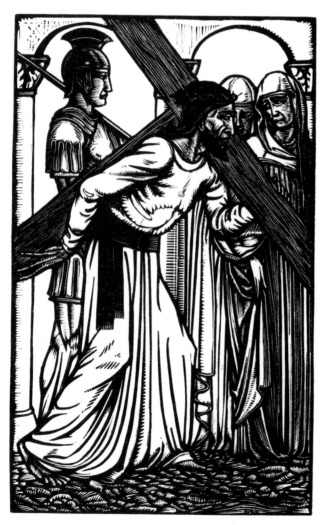

Gabriel PIPPET *XV Roses*, verses by E. Hamilton Moore (Basil Blackwell, 1926)

WW1 he studied mosaics in Italy, and on his return to England, decorated a church in Droitwich with mosaics, and made stone- and wood-carvings for it and other churches. He was closely associated with St. Dominic's Press, Ditchling, illustrating some of its publications with wood engravings; he illustrated other books of a religious nature, and books of comic verse, with pen and ink drawings. He taught and painted in West Africa for five years, and in 1942 was awarded a Civil List pension for services to art.
Books illustrated include: *Old Rhymes with New Tunes* (Longman, 1912); R. Benson: *A Child's Rule of Life* (1912), *Old Testament Rhymes* (1913); G. Boas: *Domestic Ditties* (1919), *Traffic and Theatre Rhymes* (1925); *More Old Rhymes with New Tunes* (Longman, 1925); E.H. Moore: *Fifteen Roses; Being Our Lady's Rosary in Verse* (Oxford: Blackwell, 1926); *Still More Rhymes with New Tunes* (Longman, 1927); G.M. Sierra: *Holy Night* (1928).
Books written and illustrated include: *A Little Rosary* (1930).
Contrib: *Golden Hind; Joy Street; Merry-Go-Round.*
Bibl: ICB; Peppin.

PITTS, J. Martin **fl. 1983-**
Pitts teaches art full time but works also as an illustrator, dividing his time between educational books and small edition, finely printed books which are a vehicle for his linocuts. His *Twenty-Four Nudes* was selected for the British Book Production exhibition at the Foyle's Gallery and the Frankfurt Book Fair, 1986.
Books illustrated include (all published by Old Stile Press): G. Buchanan: *The Ballad of Judas Iscariot* (1983); P. Mullen: *The Holy Bomb* (1983); G. Crabbe: *Peter Grimes, from "The Borough"* (1985).
Books written and illustrated include: *Twenty-Four Nudes* (Old Stile Press, 1985); *Gymnopaediae* (Old Stile Press, 1989).

POLLOCK, Ian **b.1950**
In the mould of Ralph Steadman* and Gerald Scarfe*, Pollock is a savage satirist. He has contributed to a number of magazines, notably the Sunday colour supplements; illustrated book covers (for example, Stafen Heym's *The Wandering Jew* for Pan Books); and designed posters. His poster for the Royal Shakespeare Company's *King Lear* drew his work to the attention of the publisher doing a comic strip version of Shakespeare. His *King Lear* took about one year to complete.
Books illustrated include: W. Shakespeare: *King Lear* (Oval Project, 198?).
Contrib: *Esquire; Men Only; New Society; Penthouse; Radio Times; Sunday Times Magazine.*
Bibl: Ian Pollock: "Fooling with Shakespeare", *Illustrators* (1982): 14-16.

"PONT"
See LAIDLER, Gavin Graham

POOLE, Monica Mary **b.1921**
Born on 20 May 1921 in Canterbury, Poole was educated at Abbotsford School, Broadstairs, and studied art at the Thanet School of Art (1938-39), where Geoffrey Wales* introduced her to wood engraving. WW2 forced her into war work in Bedford; but in 1949 she became a student in the book production course at the Central School of Arts and Crafts (1949-50) under John Farleigh*, persuaded by Farleigh's *The Graven Image* and his illustrations for *The Man Who Died* by D.H. Lawrence.
Poole is primarily a print maker, but having trained as an illustrator she first looked to publishers for commissions. The first was to illustrate a book on Kent, for which she produced thirty-seven wood engravings. Between 1949 and 1955, she worked on book jackets, including a series of designs for the four *Books of Wild Flowers* published by Chambers in 1953. While doing this work for publishers, she was also producing prints for exhibitions and has continued to develop her engravings in this way. She has not entirely given up illustrating books, however, and recently produced engravings for *Winter Wind* by Elizabeth Jennings (1979). In 1985, her book on *The Wood Engravings of John Farleigh* was published by Gresham Books.
Poole was elected ARE (1967); RE (1975); SWE; and became a member of the Art Workers' Guild in 1970.

COLOUR Plate 123. Jacynth PARSONS *Songs of Innocence* by William Blake (Medici Society 1927)

Colour Plate 124. Jan PIENKOWSKI *Christmas* (William Heinemann 1984)

Colour Plate 125.
John PIPER
The Traveller by
Walter de la Mare
(Faber & Faber 1946)

Colour Plate 126.
G. Spencer PRYSE
"Gathering Cocoa
Pods" Poster for the
Empire Marketing
Board, 1928 (From the
Public Record Office
CO 956/5)

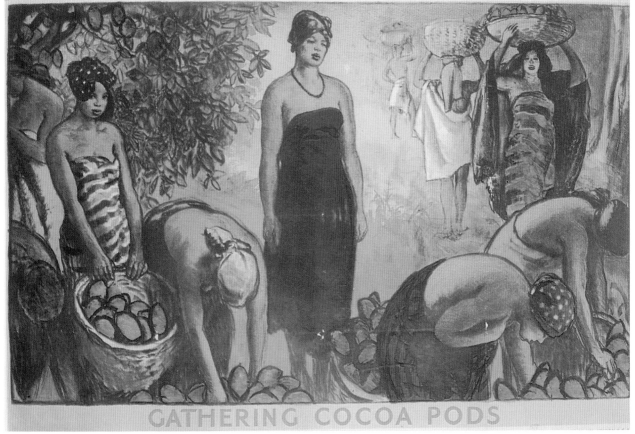

GATHERING COCOA PODS

Monica POOLE Wood engraving: "Dead trees — Sheppey"

Books illustrated include: R. Turnor: *Kent* (Elek, 1950); *Open Air Anthology* (Collins, 1952); E. Jennings: *Winter Wind* (Gruffyground Press, 1979).

Published: *The Wood Engravings of John Farleigh* (Gresham Books, 1985).

Contrib: *Saturday Book 31, 1971*.

Exhib: Studio One Gallery, Oxford (1981); Brighton Public Library (1982); Bluecoat Gallery, Liverpool (1987); RA; RE; SWE; Int. Exhibition of Botanical Art, Pittsburgh (1972; 1979); Xylon 8, 9 (1979; 1983).

Collns: V & A; Ashmolean; Fitzwilliam; Hunt Botanical Institute, Pittsburgh; V & A.

Bibl: Patricia Jaffé: *Women Engravers* (Virago Press, 1988); George Mackley: *Monica Poole, Wood Engraver* (The Florin Press, 1984); Keith Spencer: "Monica Poole, R.E., Wood Engraver", *The Green Book*, 8 (Summer 1982): 22-24; Garrett 1 & 2; Peppin; *Shall We Join the Ladies?*; Waters; Who; IFA.

POTTER, (Helen) Beatrix **1864-1943**
See Houfe
Collns: Osborne Collection, Toronto.

Exhib: Tate (1987).

Bibl: Marcus Crouch: *Beatrix Potter* (Bodley Head, 1960); Margaret Lane: *The Tale of Beatrix Potter* (Warne, 1946); Lane: *The Writings of Beatrix Potter* (Warne, 1971); Leslie Linder: *The Journal of Beatrix Potter* (Warne, 1966); Linder: *A History of the Writings of Beatrix Potter* (Warne, 1971); Anne Carroll Moore: *The Art of Beatrix Potter* (Warne, 1955); Tate Gallery; Johnson FIDB; Peppin; Waters.

POTTER, Margaret **b.1916**
Born in Heathrow, Middlesex, Potter (née Whittington) studied at Ealing School of Art and the Chelsea Polytechnic. She worked variously at commercial art, cartooning and cookery demonstrations. For two years she lived in Khartoum, Sudan (1959-61). She collaborated with her husband Alexander Potter in writing and illustrating a few books on building and architecture, including several for the Puffin Picture Book series.

Books illustrated include: L.A. Dovey: *The Cotswold Village* (three parts, Puffin Cut-Out Books, 1; Penguin, 1947), *A Half-Timbered Village* (three parts, Puffin Cut-Out Books; Penguin, 1951).

Margaret POTTER *A History of the Countryside* (Puffin Picture Book; Penguin Books, 1943)

Books written and illustrated (all with Alexander Potter) include: *A History of the Countryside* (Puffin Picture Books 37; Penguin, 1944); *The Building of London* (Puffin Picture Books 42; Penguin, 1945); *Houses* (Murray, 1948); *Interiors* (Murray, 1957).
Bibl: Peppin.

POULTON, Tom L. **d.1963**
A painter and illustrator, Poulton was one of the few artists whom Francis Meynell invited to illustrate Nonesuch Press books. Poulton used the stencil method ("pochoir") to create his delightful, coloured headpieces for *A Plurality of Worlds* (1929). For the Nonesuch Press also he illustrated with pen drawings the second edition of *The Weekend Book* (1931) (the first edition was done by Albert Rutherston* and the third by Edward Bawden*). He did a series of maps for the Herodotus (1935), but the illustrations were engravings by V. Le Campion. As well as his work for books, from 1929 to 1932 he illustrated with fine-line drawings *Over the Points*, a quarterly journal distributed by the Southern Railway to first-class season ticket holders to explain the electrification of the railway;

and he contributed several scraperboard illustrations to the *Radio Times*.
Books illustrated include: B. de Fontenelle: *A Plurality of Words* (Nonesuch Press, 1929); Plutarch: *The Lives of the Noble Grecians and Romans* (five vols., Nonesuch Press, 1929-30); I. Walton: *The Compleat Angler* (with Charles Sigrist., Nonesuch Press, 1929); J. Boswell: *The Conversations of Dr. Johnson* (Knopf, 1930); *Kynoch Press Notebook* (Kynoch Press, 1930); *The Weekend Book* (Nonesuch Press, 1930); G.M. Boumphrey: *The Story of the Ship* (Black, 1933); Herodotus: *The History of Herodotus* (1935).
Contrib: *Over the Points; Radio Times*.
Bibl: C.W. Bacon: *Scraperboard Drawing* (Studio, 1951); John Dreyfus: *A History of the Nonesuch Press* (Nonesuch Press, 1981); Herbert Simon: *Song and Words: A History of the Curwen Press* (Allen & Unwin, 1973); Peppin.

PRIMROSE, Jean Logan **b.1910**
Born on 16 June 1910 in Glasgow, Primrose was born into a musical family (William Primrose, the well-known viola player, was her brother). She studied at Hammersmith School of Art and at the City and Guilds. A painter in oils and watercolour, she did portraits, and those she did of children came to the attention of writer Rumer Godden, who was looking for an illustrator for her children's books. All the books she illustrated were published by Macmillan, and all had a Godden connection, being either written or translated by her. The first book that Primrose illustrated, *Miss Happiness and Miss Flower*, was runner-up for the Greenaway Medal.
Books illustrated include (all published by Macmillan): R. Godden: *Miss Happiness and Miss Flower* (1961), *St. Jerome and the Lion* (1961); B. de Gasztold: *Prayers Told from the Ark* (1963); R. Godden: *Little Plum* (1963); *Home Is the Sailor* (1964); B. de Gasztold: *The Beasts' Choice* (1967).
Exhib: RA; RBA; RP; WIAC; Paris Salon.
Bibl: ICB3; Peppin; Waters.

PRINCE, Alison Mary **b.1933**
Born on 26 March 1931 in Beckenham, Kent, Prince was educated at Beckenham Grammar School and studied at the Slade (1948-52 under William Coldstream) and Goldsmiths' College School of Art (1954). She taught art for a while and then designed for BBC Television and drew for comics. A free-lance writer of novels for teenagers, she has illustrated a number of books with ink drawings and etching.

Tom POULTON "Three Wise Men": illustration from the *Radio Times* reprinted in *Scraperboard Drawing* by C.W. Bacon (Studio Publications, 1951)

Books illustrated include: *Let's Explore Mathematics*; M.K. Harris: *Jessica on Her Own* (1968); A. Coppard: *Sending Secrets* (1972); R. Parker: *Keeping Time* (1973); A. Coppard: *Don't Panic!* (1975), *Get Well Soon* (1978); J. Allen and M. Danby: *Hello to Ponies* (1979), *Hello to Riding* (1980).
Books written and illustrated include: *The House on the Common*; *The Red Alfa*; *One of the Family* (1980).
Bibl: Peppin; Who.

PROBYN, Peter b.c.1916
Intended for army service, Probyn went to the Imperial Service College, but chose instead to work in advertising. In 1932-33 he went to Highams, a middle-of-the-road agency, but contracted tuberculosis after eighteen months. He began his career as a cartoonist while convalescing in bed, and contributed to *London Opinion, Men Only* and other magazines. He resumed advertising work in the mid-1940s, and became known as one of the illustrators who could conceive humorous advertising campaigns. He produced posters, showcards and other material for many organizations such as BOAC and the brewers of Double Diamond. Probyn always thought of himself as a cartoonist, but found that advertising work was much more profitable.
Contrib: *Humorist; Lilliput; London Opinion; Men Only; Passing Show*.
Published: *The Complete Drawing Book* (Studio, 1970).
Bibl: *Images: The British Association of Illustrators Sixth Annual 1981-82* (Creative Handbook, 1981); Fougasse.

PROCKTOR, Patrick b.1936
Born on 12 March 1936 in Dublin, Procktor moved back to England to Esher before he was four years old. After his father died, Procktor and his brother were brought up by their grandparents, and went to a boarding school in Malvern for a short while and then to Southport, Lancashire. After the end of WW2 he went to Highgate School in north London, where he started to paint, and left when he was sixteen to work at a builder's merchant. After National Service in the Royal Navy (1954-56), Sir William Coldstream encouraged him to study painting and etching at the Slade (1958-62), where he met and became friends with Keith Vaughan* and David Hockney* (who later painted his portrait). He wrote occasionally for the *New Statesman* and *New Society*, and in 1963 exhibited paintings at the Redfern Gallery and began to teach at Camberwell School of Art under Robert Medley* and then at Maidstone. After many homosexual relationships, he was happily married to Kirsten Benson (1973) until her death in 1984, and had one son (Nicholas).
He has travelled widely in Europe, the US and India. After the weeks he spent in India in 1970, he worked on large oils and a suite of aquatints, published as the *India, Mother* suite.
Primarily a painter, Procktor has exhibited widely; produced several suites of aquatints for Alecto Editions; done set designs for the theatre, including *Saints' Day* at the Theatre Royal, Stratford, and *Twelfth Night* for the Royal Court Theatre; designed windows for the AIFDS Recreation Centre, St. Stephen's Hospital, Fulham (1988); and illustrated a few books with pen and ink drawings.
Books illustrated include: S.T. Coleridge: *The Rime of the Ancient Mariner* (Cambridge: Rampant Lions Press, 1976); P. Theroux: *Sailing Through China* (Salisbury: Michael Russell, 1983); A.E. Housman: *A Shropshire Lad* (Folio Society, 1986).
Books written and illustrated include: *One Window in Venice* (Alecto Editions, 1974); *A Chinese Journey* (Alecto Editions, 1980); *Self-Portrait* (Weidenfeld, 1991).

Contrib: *Black Swarf; London Magazine*.
Exhib: Redfern; Whitechapel.
Bibl: Patrick Kinmonth: *Patrick Procktor* (1985); Procktor: *Self-Portrait* (Weidenfeld, 1991); Who's Who.

PRYSE, Gerald Spencer 1881-1956
See Houfe
Pryse designed many war posters during WW1 (including some published by Frank Pick for the Underground Electric Railways, a precursor of London Transport), a well-known series of election posters for the Labour Party (1910-1927), and several for the Empire Marketing Board. For the EMB he did two sets of five posters on West African products, for which he was paid 1,000 guineas and 100 guineas for further travel expenses. He illustrated a few books, including a souvenir volume published to commemorate the British Empire Exhibition at Wembley in 1924. He was a superb lithographic artist, working directly on the stone, even during off-duty moments while serving as a dispatch rider for the Belgian Government during WW1. He died on 28 November 1956.
Books illustrated include: E. Nesbit: *Jesus in London* (Fifield, 1908); H. Fielding: *The History of Tom Jones* (BH, 1930).
Books written and illustrated include: *Four Days: An Account of a Journey in France . . . 1914* (BH, 1932).
Collns: IWM; Public Records Office; V & A.
Bibl: P. Bradshaw: *S. Pryse and His Work* (The Art of the Illustrator, 1918); Stephen Constantine: *Buy & Build: The Advertising Posters of the Empire Marketing Board* (HMSO, 1986); Joseph Darracott and Belinda Loftus: *First World War Posters* (Imperial War Museum, 1972); Peppin.
Colour Plate 126

PURVIS, Tom 1888-1957
Born on 12 June 1888 in Bristol, Purvis studied at Camberwell School of Art (under Sickert and Degas). After working for an advertising company for six years, he studied lithography, becoming a highly successful poster designer in the 1930s. He worked for LNER, Austin Reed and produced posters for both WW1 and WW2, but after WW2 he concentrated on painting portraits and religious pictures. He made forty-eight illustrations for Negley Farson's *Bomber's Moon* (1941).
Purvis was one of the first eleven people made RDI. He died on 27 August 1957.
Books illustrated include: N. Farson: *Bomber's Moon* (Gollancz, 1941).
Collns: IWM.
Bibl: J. Darracott and B. Loftus: *Second World War Posters* (2nd edition; IWM, 1981).

PYM, Roland b.1920
Born in Cheveley, Newmarket, Pym studied at the Slade. After leaving school he concentrated on mural painting and designing for the theatre. He has illustrated a few books for children in pen and ink or watercolour; and he has produced three "peepshows" in the form of toy theatres.
Books illustrated include: B.W. Guinness: *The Story of Johnny and Jemima* (Heinemann, 1936), *The Children in the Desert* (Heinemann, 1947), *The Story of Priscilla and the Prawn* (Heinemann, 1960), *Leo and Rosabelle* (Heinemann, 1961); C. Tower: *A Distant Fluting: Poems and Sonnets* (Weidenfeld, 1977).
Bibl: Peppin.

QUENNELL, Charles Henry Bourne **1872-1935**
QUENNELL, Marjorie **b.1883**
See Houfe
Marjorie Quennell (née Courtney) was born on 14 September 1883 in Bromley, Kent. A painter in oils and watercolour, mostly of architectural subjects, she exhibited at the RA and collaborated with her husband in writing and illustrating many books for Batsford. Two series of books, *A History of Everyday Things in England* (1918-33), and *Everyday Life* (1921-52), illustrated with simple, clear line drawings, helped several generations of children understand a little more about life in other places and in earlier times.
Bibl: Peppin.

QUICK, Hilda M. **fl.1930s-1960s**
A wood engraver whose subjects are usually birds or other matters relating to natural history, Quick illustrated the *Birds of the Scilly Isles* (1964) with line drawings.
Books illustrated include: W.H. Davies: *My Birds* (Cape, 1933), *My Garden* (Cape, 1933).
Books written and illustrated include: *Marsh and Shore: Bird Watching on the Cornish Coast* (Cape, 1948); *Birds of the Scilly Isles* (Truro: Parton, 1964).

QUICK, W.M.R. **fl.1920s**
After working as a trade engraver on the *Illustrated London News*, Quick illustrated a few books for the Nonesuch Press, using wood engravings to create an old-fashioned effect.
Books illustrated include: *Mother Goose* (Nonesuch Press, 1925); C. Perrault: *Histories or Tales of Past Times* (Nonesuch Press, 1925); P. Warlock: *Song of the Gardens* (Nonesuch Press, 1925); A. M'Kittrick: *Irene Iddesleigh* (Nonesuch Press, 1926).
Bibl: John Dreyfus: *A History of the Nonesuch Press* (Nonesuch Press, 1981).

C.H.B. QUENNELL and M. QUENNELL *Everyday Life in Roman Britain* (Batsford, 1924)

Arthur RANSOME *Winter Holiday* (Jonathan Cape, 1933)

RACKHAM, Arthur **1867-1939**
See Houfe

RAFFÉ, Walter George **b.1888**
Born in Bradford, Raffé studied at Leeds School of Art and the
RCA. He lived and worked in Lucknow and Calcutta, India, for
some years, and lectured at the City of London College. He wrote
on graphic design and on posters in particular, and illustrated a few
books with striking woodcuts.
Books illustrated include: C.J. Campbell: *The Children of Aries*
(Blackwell, 1925); L. Housman: *Turn Again Tales* (with others;
Blackwell, 1930).
Books written and illustrated include: *Poems in Black and White*
(Palmer, 1922); *Art and Labour* (Daniel, 1927).
Published: *Graphic Design* (with others, C & H, 1927); *Poster
Design* (C & H, 1929).
Bibl: Peppin; Who.

RANSOME, Arthur **1884-1967**
Born on 18 January 1884 in Leeds, Ransome was educated at a
preparatory school in Windermere, at Rugby School, and started to
study chemistry at Leeds University. He left university after a few
months and became an office boy for the publisher, Grant Richards,
and started to write books for children. He was an overseas corre-
spondent for the *Manchester Guardian*, but resigned to write
Swallows and Amazons (1930), the first of twelve books for chil-
dren, set in the Lake District where Ransome had spent his summer
holidays as a child. These books grew steadily in popularity, and
have remained popular to this day. Clifford Webb* illustrated the
second edition of *Swallows and Amazons* and *Swallowdale* (1931);
but from *Peter Duck* (1932) on, Ransome provided his own simple,
amateurish pen drawings which suit the stories so well, rather as
Hugh Lofting's* do for his "Doctor Dolittle" stories. He also wrote
books on sailing and fishing, two of his passions. He was made
CBE in 1953; and died on 3 June 1967.
Books written and illustrated include (all published by Cape):
Peter Duck (1932); *Winter Holiday* (1933); and seven more to *Picts
and Martyrs* (1943); *Great Northern?* (1947).
Bibl: R. B. Shelley: *Arthur Ransome* (Bodley Head, 1968); Doyle;
Carpenter; Peppin.

RAVEN-HILL, Leonard **1867-1942**
See Houfe

RAVERAT, Gwendolen Mary **1885-1957**
See Houfe
Born on 26 August 1885 at Newnham Grange, Cambridge, the
daughter of Sir George Darwin, Professor of Astronomy at
Cambridge University, and grand-daughter of Charles Darwin,
Raverat studied at the Slade (1908-11). With the help of Elinor
Monsell (see Darwin, Elinor May Monsell), who had married her
cousin, Bernard Darwin, she taught herself wood engraving in
1908-09. In 1910 she met Jacques Raverat, a fellow student at the
Slade, and married him in 1911. They were friends with Eric Gill*,

Gwen RAVERAT *Farmer's Glory* by A.G. Street (Faber & Faber, 1934)

one being *The Devil's Devices*, illustrated by Eric Gill*, the other being Frances Cornford's *Spring Morning*, illustrated by Raverat. She illustrated a number of books for children, including a new edition of *The Cambridge Book of Poetry for Children* in 1932, and Elizabeth Hart's *The Runaway* (1936). The house in this book, which plays an important part in the story, was modelled on Raverat's own house, the Old Rectory, at Harlton near Cambridge. She continued to illustrate books and magazines throughout her life, mostly with engravings, including colour engravings which she used for *The Bird Talisman* (1939). Her illustrations for the Penguin Illustrated Classics edition of Sterne's *Sentimental Journey* (1938) are ruined by the use of poor quality paper but, as Hodnett remarks, some of the engravings "are among the successes of their day." She also used pen drawings for a number of books: her autobiographical work, *Period Piece: A Cambridge Childhood*, published in 1952 after five years' work, contains pen drawings.

Books illustrated include (but see Newman, 1989†): F. Cornford: *Spring Morning* (Poetry Bookshop, 1915); K. Grahame: *The Cambridge Book of Poetry for Children* (new edition; CUP, 1932); E. Farjeon: *Over the Garden Wall* (Faber, 1933); Longus: *Les Amours de Daphnis et Chloë* (Ashendene Press, 1933); A.G. Street: *Farmer's Glory* (Faber, 1934); F. Cornford: *Mountains and Molehills* (CUP, 1934); N.C. James: *Cottage Angles* (Dent, 1935); R.P. Keigwin: *A New Version of the First Four Tales from Hans Andersen* (CUP, 1935); E.A.Hart: *The Runaway* (Macmillan, 1936); L. Sterne: *A Sentimental Journey* (Penguin Illustrated Classics, 1938); A. Uttley: *Mustard, Pepper and Salt* (Faber, 1938); H.A. Wedgwood: *The Bird Talisman* (Faber, 1939); V. Pye: *Red-Letter Holiday* (Faber, 1940); W. de la Mare: *Crossings* (Faber, 1942); C.M. Yonge: *Countess Kate* (Faber, 1948); L.O. Tingay: *The Bedside Barsetshire* (Faber, 1949); E. Howe: *The London Bookbinders 1780-1806* (Dropmore Press, 1950).

Books written and illustrated include: *Period Piece* (Faber, 1952).

Contrib: *Apple; London Mercury; Time & Tide; Woodcut.*

Exhib: NEAC; RE; SWE; Friday Club (at Alpine Club Gallery); Redfern Gallery (1927); St. George's Gallery (1928); Agnew (memorial exhib. 1959); Fitzwilliam (1977); University of Lancaster Library (1989).

Collns: Fitzwilliam.

Bibl: Thomas Balston: *Wood-Engraving in Modern English Books: The Catalogue of an Exhibition for the National Book League* (CUP, 1949); John G. Fletcher: "The Woodcuts of Gwendolen Raverat", *Print Collector's Quarterly* 18 (1931): 330-50; L.M. Newman & D. A. Steel: *Gwen and Jacques Raverat: Paintings and Wood-Engravings: Exhibition and Catalogue* (University of Lancaster Library, 1989); Reynolds Stone: *The Wood Engravings of Gwen Raverat*, 2nd edition (Swavesey, Cambridge: Silent Books, 1989); *Times* obit. 13 February 1957; Deane; Garrett 1 & 2; Hodnett; ICB; ICB2; Jaffé; Peppin; Waters.

See also illustration on page 15

RAVILIOUS, Eric William **1903-1942**

Born on 22 August 1903 in Acton, London, Ravilious was educated at the Eastbourne Grammar School, studied at Eastbourne School of Art (1920-22) and RCA (1922-25), under Sir William Rothenstein, Alec Buckels* and Paul Nash*). His fellow students at RCA were a remarkably talented group which included Edward Bawden*, Douglas Bliss*, Barnett Freedman*, Henry Moore* and Helen Binyon*. He began teaching part-time at Eastbourne School of Art in 1925, and in October was elected to the Society of Wood Engravers, having been proposed by Nash. After leaving RCA he devoted himself to wood engraving, of which he became a complete master, illustrating books and producing patterned paper for the Curwen Press. His first wood engraved illustrations were for Martin Armstrong's *Desert* (1926) and two books for the Golden Cockerel Press, and these were followed by many more. He turned later to lithography, and *High Street*, printed by the Curwen Press in 1939, is the prime example of his book work in this medium. Later, as a war artist, he produced a series of ten lithographs of submarines which "have all the features of Ravilious' refined and ordered art: clarity and precision, richness and variety in line and texture." (Pidgley, 1986.†)

In 1928 Ravilious began a collaboration with Edward Bawden* on

Stanley Spencer* and André Gide, travelled in France and to Italy with Gide in 1914. Gwen Raverat had her first exhibition with the NEAC in 1913, and in 1920 became a founder-member of the Society of Wood Engravers and an Associate of the Royal Society of Painter-Etchers & Engravers.

Meanwhile, Jacques Raverat, who had first had health problems in 1907, had his illness diagnosed in 1915 as multiple sclerosis. The Raverats had two daughters (in 1916 and 1919) and for health reasons they settled in Vence in the south of France. After the death of her husband in 1925, Raverat and her daughters returned to England. She continued to engrave, was elected Fellow of RE in 1934, and was reviewer and art critic for *Time and Tide* (1929-40). During WW2 she worked in a factory and then was a draughtsman for Naval Intelligence in Cambridge. In 1951 she had a stroke and had to give up engraving, though she continued to paint until her death on 11 February 1957.

Raverat played an important role in the revival of wood engraving in England, which Noel Rooke* had started in 1904 when he turned to wood engraving because of dissatisfaction with the reproduction of his drawings by photographic processes. Independently of Rooke she had started to engrave in 1908 and in 1915 two small books containing modern wood engravings as illustrations were published,

Eric RAVILIOUS *A Ballad upon a Wedding* by Sir John Suckling (Golden Cockerel Press, 1927)

murals at Morley College, and later painted murals in the Midland Railway Hotel, Morecambe. In 1930 he married Tirzah Garwood* and began teaching at RCA (1929-38) and Ruskin School of Art, Oxford. With the Bawdens, Eric and Tirzah moved into Brick House in Great Bardfield, Essex, and this was the beginning of a very fruitful time for both Ravilious and Bawden. Ravilious had his first one-artist show at Zwemmer's in 1933, and his second in 1936. Although he was a fine watercolour painter, he was first and fore-most a wood engraver. Apart from his illustrations for book publishers, he was closely connected with the Curwen Press, producing engraved vignettes and borders and much other work; and he did some fine commercial work for the Monotype Corporation, London Transport, the Southern Railway and the BBC. He also produced posters, wallpaper and furniture designs, and designs for china. In 1937, when Ravilious was producing lithographs for *High Street* and wood engravings for a Nonesuch Press edition of *The Natural History of Selborne*, Wedgwood made their first of several Ravilious pieces, a coronation mug for Edward VIII.

He was appointed an official war artist in 1940, and painted sub-marine subjects at Gosport and the cross-channel bombardment. He was sent to Scotland with the Fleet Air Arm and in 1942 disappeared while observing an air-sea rescue operation near Iceland.

Books illustrated include: M. Armstrong: *Desert* (Cape, 1926); Sir J. Suckling: *A Ballad upon a Wedding* (GCP, 1927); N. Breton: *The Twelve Moneths* (GCP, 1927); A. Smith: *The Atrocities of the Pirates* (GCP, 1929); *The Apocrypha* (with others; Cresset Press, 1929); H. Munro: *Elm Angel* (Faber, 1930); W. Shakespeare: *Twelfth Night* (GCP, 1932); *Consequences* (GCP, 1932); C. Marlowe: *The Famous Tragedy of the Rich Jew of Malta* (Golden House Press, 1933); M. Armstrong: *Fifty-Four Conceits* (Cresset Press, 1933); *Kynoch Press Notebook, 1933* (Birmingham: Kynoch Press, 1933); L.A.G. Strong: *The Hansom Cab and the Pigeons* (GCP, 1935); T. Hennell: *Poems* (OUP, 1936); *Country Walks* (London Transport Board, 1937); A. Heath: *The Country Life Cookery Book* (Country Life, 1937); J.M. Richards: *High Street* (Country Life, 1938); G. White: *The Natural History of Selborne* (two vols., Nonesuch Press, 1938).
Contrib: *Cornhill Magazine; Curwen Press Newsletter; National Council of Social Service Journal; Wisden; The Woodcut.*
Exhib: St. George's Gallery; Zwemmer; Arthur Tooth's Gallery; Eastbourne; Sheffield; Arts Council (1948); The Minories, Colchester (1972); Exeter University (1986).

Collns: Ashmolean; Bristol; Towner Gallery, Eastbourne; IWM; Manchester; Tate; Wedgwood Museum, Barlaston.
Bibl: *Eric Ravilious: A Memorial Exhibition of Water-Colours, Wood Engravings, Illustrations . . .* (Arts Council, 1948); Helen Binyon: *Eric Ravilious; Memoir of an Artist* (Lutterworth Press, 1983); Noel Carrington: "Eric Ravilious", *Graphis*, 16 (1946), pp.430-35; Freda Constable: *The England of Eric Ravilious* (Scolar Press, 1982); Robert Harling: *Notes on the Wood-Engravings of Eric Ravilious* (Faber, 1946); *Eric Ravilious 1903-1942* (Colchester: The Minories, 1972); Michael Pidgley: *Eric Ravilious: Wood Engravings [and] Lithographs* (Exeter University, 1986); *Ravilious and Wedgwood; The Complete Wedgwood Designs of Eric Ravilious* (Dalrymple Press, 1986); Oliver Simon: "The Printed and Published Wood Engravings of Eric Ravilious", *Signature*, 1, pp.30-41; DNB; Garrett 1 & 2; Gilmour; Harries; Peppin; Sandford; Waters.
Colour Plate 127

RAVILIOUS, Tirzah
See GARWOOD, Tirzah

RAWLINS, Janet **b.1931**
Born on 3 May 1931 in Horsforth, Leeds, Rawlins was educated at Great Moreton Hall, Cheshire, and studied at Leeds College of Art. An easel painter who has exhibited at the RA, she has also illustrated children's books by William Mayne and Jane Gardam.
Books illustrated include: W. Mayne: *While the Bells Ring* (Hamilton, 1979); J. Gardam: *Bridget and William* (MacRae, 1981), *The Hollow Land* (MacRae, 1981), *Horse* (MacRae, 1982).
Contrib: *Dalesman.*
Exhib: RA.
Bibl: Who.

Rachel RECKITT *Voices on the Green* edited by A.R.J. Wise and R. A. Smith (Michael Joseph, 1945)

Peter REDDICK *Under the Greenwood Tree* by Thomas Hardy (Folio Society, 1989)

RAYMOND, Charles **fl. 1955**

Raymond has had a varied career, including work as a textile designer, a botanical painter, and as an illustrator. He has designed book jackets, contributed to many magazines and illustrated a few books, including three for the Folio Society, using drawings and lithographs; and a series of books by Alex Comfort on sex.

Books illustrated include: F.S. Fitzgerald: *The Great Gatsby* (Folio Society, 1968); A. Comfort: *The Joy of Sex* (NY: Crown, 1972), *More Joy of Sex* (NY: Crown, 1974), *The Joy of Lesbian Sex* (NY: Crown, 1978); D.H. Lawrence: *The Rainbow* (Folio Society, 1981), *Women in Love* (Folio Society, 1982).

Contrib: *Esquire; Homes and Gardens; Men Only; Observer; Radio Times; Sunday Times; Woman; Women's Journal.*

Bibl: Folio 40; Peppin.

RAYNER, Mary **b.1933**

Born in Burma, Rayner (née Grigson) escaped to India when the Japanese invaded in 1942 during WW2. She reached England in 1945, and studied English at St. Andrew's University. She illustrates and writes books for children. Her line drawings and watercolour illustrations are "unpretentious and quietly humorous" (Peppin).

Books illustrated include: D. Ghose: *Harry* (1973); S. Nowell: *The White Rabbit* (Lutterworth, 1975); G. Gifford: *Because of Blunder* (Gollancz, 1977), *Cass the Brave* (1978); P. Sharma: *Dog Detective Ranjha* (1978); G. Gifford: *Silver's Day* (1980); D. King-Smith: *Daggie Dogfoot* (Gollancz, 1980); E. Tennant: *The Boggart* (Granada, 1980); D. King-Smith: *Magnus Powermouse* (Gollancz, 1982); J. Mark: *The Dead Letter Box* (Hamilton, 1982); A. Colbert: *Mr Weller's Long March* (Chatto, 1983); D. King-Smith: *The Sheep-Pig* (Gollancz, 1983); J.P. Walsh: *Lost and Found* (Deutsch, 1984).

Books written and illustrated include: *The Witch Finder* (Macmillan, 1975); *Mr and Mrs Pig's Evening Out* (Macmillan, 1976); *Garth Pig and the Icecream Lady* (Macmillan, 1977); *The Rain Cloud* (Macmillan, 1980); *Mrs Pig's Bulk Buy* (Macmillan, 1981); *Crocodarling* (Collins, 1985); *Mrs Pig Gets Cross* (Collins, 1986); *Reilly* (Gollancz, 1987).

Bibl: ICB4; Peppin.

RECKITT, Rachel **b.1908**

Born in St. Albans, Reckitt studied wood engraving at the Grosvenor School of Modern Art (1933-37, under Iain Macnab*), stone sculpture at Hammersmith School of Building Crafts (1945-50) and lithography at the Central School of Art and Design. She exhibited with the London Group in the 1930s. Since 1946 she has worked in West Somerset, constructed pub signs and tombstones, painted and made wood engravings, and has sculpted in stone and wood. After the late 1960s she turned to metal sculpture, studying wrought iron and welding privately, and has been a member of the British Artist Blacksmith Association since 1983. She illustrated several books with wood engravings. Elected SWE (1950).

Books illustrated include: A.R.J. Wise and R.A. Smith: *Voices on the Green* (Joseph, 1945); S.P. Myers: *London, South of the River* (Vision of England series; Elek, 1949); W. de la Mare: *English Country Short Stories* (Elek, 1949); M. Bosanquet: *People with Six Legs* (Faber, 1953); *Seven Psalms* (Wellingborough: Skelton's Press, 1981).

Exhib: LG; NEAC; NS; SWE.

Bibl: *Engraving Then and Now: The 50th Retrospective Exhibition of the Society of Wood Engravers.* (SWE, 1987?); Garrett 1 & 2; Peppin; *Shall We Join the Ladies?*; Waters.

REDDICK, Peter **b.1924**

Born in Ilford, Essex, Reddick was educated at the Royal Liberty School, Gidea Park. He studied at the South-East Essex Technical College (1941-42), Cardiff School of Art (1947-48), the Slade (1948-51) under Norman Janes* and John Buckland Wright*, and the London School of Printing and Graphic Arts (1959-60). He was a visiting tutor at the Regent Street Polytechnic (1951-56), and

taught at Kumasi University of Science and Technology, Ghana (1960-62), at the Glasgow School of Art (1963-67), and since that date has been Senior Lecturer in Illustration, Bristol Polytechnic. Between 1956 and 1963 he worked for some time as assistant to commercial designers.

As an illustrator, Reddick works mostly with wood engravings though he has used pen and ink drawings, notably for the Folio Society seven-volume edition of Trollope. Much of his work has been done for the Folio Society, and Reddick's wood engravings for its edition of Thomas Hardy's *Return of the Native* (1971) won second prize in the Francis Williams Book Illustration Award. Hodnett asserts that Reddick is a major illustrator of his period. "His success stems from the unusually conscientious effort he makes to clothe imaginary characters and places in the semblance of reality. He takes pains to particularize faces and make them interesting. Then he transforms the traditionalism of his approach by means of bravura wood engravings." (Hodnett.)

Other illustrations include portraits of the poets for six collections published by the Folio Society, from Donne in 1963 to Tennyson in 1975. In the 1960s, he did the cover designs for the Penguin edition of Daphne Du Maurier's novels; and he illustrated the first major book published by the revived Gregynog Press in 1980, Parry's *Cerddi*.

In addition to his book illustrations, Reddick was commissioned in 1982 by the National Museum of Wales to make a number of engravings and he has engraved a number of pictorial bookplates and labels. He has had a number of one-artist shows of his work, including one of work done as a Gregynog Arts Fellow, which toured through Wales during 1981-82. He was elected a member of SWE (1953), ARE (1970), RE (1973); ARWA.

Books illustrated include: J. Donne: *Poems of Love* (Folio Society, 1963); T.L. Peacock: *Crotchet Castle* (Folio Society, 1964); T. Hardy: *The Mayor of Casterbridge* (Folio Society, 1968); R. Browning: *Poems* (NY: Limited Editions Club, 1969); T. Hardy: *The Return of the Native* (Folio Society, 1971); L. Powys: *So Wild a Thing* (Ark Press, 1973); *Folklore, Myths and Legends* (Reader's Digest, 1973); A. Trollope: *The Warden* (Folio Society, 1976), *Barchester Towers* (Folio Society, 1977), *Doctor Thorne* (Folio Society, 1978), *Framley Parsonage* (Folio Society, 1979), *The Small House at Allington* (Folio Society, 1980), *The Last Chronicle of Barset* (Folio Society, 1980), *The Two Heroines of Plumplington* (Folio Society, 1981); *Cerddi Robert Williams Parry* (Gregynog Press, 1980); T. Hardy: *Far From the Madding Crowd* (Folio Society, 1986), *The Wessex Tales* (Folio Society, 1987); J. Hogg: *Domestic Manners and Private Life of Sir Walter Scott* (Folio Society, 1987); W. Shakespeare: *King Lear; Richard III* (Folio Society, 1988); T. Hardy: *Tess of the D'Urbervilles* (Folio Society, 1988), *The Woodlanders* (Folio Society, 1989), *The Trumpet Major* (Folio Society, 1990).

Contrib: *Illustration 63; Motif 7*.

Exhib: RE; SWE; Bristol 1980, 1982); Wrexham, etc. (1981-2).

Bibl: Peter Reddick: "Engraved on the Heart", *The Green Book*, 7 (Spring 1982): 4-5; Garrett 1 & 2; Hodnett; Jacques; Peppin; Who; IFA.

See also illustration on page 25

REES, Gladys Mary **b.1898**

Born on 5 June 1898 in London, Rees studied at Chelsea School of Art. A landscape painter in watercolour and oil, an etcher and poster designer, Rees also illustrated a few books, in colour and black and white. Elected ASWA (1927); SWA (1939).

Books illustrated include: E. Clark: *Stories To Tell and How to Tell Them* (ULP, 1917); J.A. Bentham: *The City of Wishes* (Cape, 1922); H.E. Chapman: *Barbara in Pixieland* (Cape, 1922); F. Claremont: *The Book of the Cat Jeremiah* (ULP, 1929); C. Chaundler: *The Children's Story Hour* (Museum Press, 1945); B. Lovett: *The Princess Who Got Out of Bed on the Wrong Side* (Museum Press,1945).

Books written and illustrated include: *Praise: A Book of Verse* (Sheldon Press, 1936); *Loosey and Lankey* (Museum Press, 1945); *ABC and All That* (Hale, 1948); *XYZ and After* (Hale, 1952).

Exhib: RA; RI; NEAC; SWA; WIAC.

Bibl: Peppin; Waters.

Victor REINGANUM *Straw in the Hair* compiled by Denys Kilham Roberts (John Lane, The Bodley Head, 1938)

REID-HENRY, David M. **1919-1977**

Born in Ceylon, where his father was employed in government service as an entomologist, Reid-Henry spent his first ten years there. His father was also a wildlife painter and taught his son about the natural history of the island. He returned to England to complete his education and attended Colchester Royal Grammar School and Mount Radford School in Exeter. He had no formal art training but after being conscripted into the Royal Tank Regiment in 1940, he was sent to the Royal Military College, Sandhurst, and while there spent much time with the artist G.E. Lodge* who lived nearby. While in the army he travelled through North Africa, India, Singapore and Ceylon; after the war he returned to London, married in 1949, had two daughters and lived in Woodford Green, Essex.

He was introduced to ornithologist J.D. Macdonald and his career was launched when he was invited to illustrate Macdonald's *The Birds of Sudan* (1955). Other illustrating commissions followed, and he also designed postage stamps for Mauritius and Botswana. His paintings were based on close observation and expert knowledge, though he made few field sketches. He worked mostly in oil, gouache and tempera, believing that these allowed him to put in all the detail he required.

From Rhodesia Reid-Henry acquired a female African crested eagle with which he lived and travelled in London. According to his father, this eagle became a dominating influence in his life, and certainly attracted a lot of attention. Reid-Henry was also interested in hawking and cricket, both of which distracted him from painting.

His marriage ended in divorce and in 1976 he married Louise West-water, a medical doctor and amateur botanist and ornithologist. He went to live in Rhodesia after this marriage but died shortly after in 1977.
Books illustrated include: F.O. Cave and J.D. Macdonald: *The Birds of Sudan* (1955); D.A. Bannerman: *Birds of Cyprus* (with Roland Green*, O & B, 1958), *Birds of the Atlantic Islands* (O & B, 1963).
Bibl: Hammond.

REINGANUM, Victor **b.1907**
Born in London, Reinganum was educated at Haberdashers School, Hampstead, and studied at Heatherley's Art School and the Académie Julian, Paris. While in Paris, he was one of only six students accepted by the distinguished painter, Léger. He returned to London in 1926 and began a free-lance career. He worked in advertising for such companies as Mond Nickel; contributed to several magazines, including *Radio Times*; and in 1932 he took over from Tom Poulton* the job of illustrating *Over the Points*, the journal of the Southern Railway, and did so until publication came to an end in September 1939. He illustrated *Straw in the Hair* (1938) with a number of funny and sometimes surrealistic ink drawings. He has exhibited many times, including a one-artist show at the Hamet Gallery (1972). He was elected MSIA.
Books illustrated include: E.C. Bentley: *More Biography* (with others; Methuen, 1929); D.K. Roberts: *Straw in the Hair* (BH, 1938); E.C. Bentley: *Clerihews Complete* (with Nicolas Bentley*, G.K. Chesterton*; Werner Laurie, 1951); Ovid: *Ars Amatoria* (Folio Society, 1965).
Contrib: *Night and Day; Over the Points; Radio Times*.
Exhib:Beaux Arts Gallery; Marlborough Gallery; Hamet Gallery; and throughout Britain and Europe.
Bibl: Herbert Simon: *Song and Words: A History of the Curwen Press* (Allen & Unwin, 1973); Driver; Folio 40; Usherwood.

RELF, Douglas **fl. 1935-1966**
A painter who illustrated several books with pen or brush and ink.
Books illustrated include: K. Fidler: *Tales of London* (Lutterworth, 1953); E. Leyland: *Indian Range* (Brockhampton, 1953); K. Fidler: *Tales of the Midlands* (Lutterworth, 1954); A.G. Allbury: *Bamboo and Bushido* (Hale, 1955); K. Fidler: *Tales of Scotland* (Lutterworth, 1956); J. Pudney: *Friday Adventure* (Evans, 1956); K. Fidler: *Tales of the Island* (Lutterworth, 1959); E. Kyle: *Girl with a Lantern* (Evans, 1961); R. Maddock: *The Last Horizon* (Nelson, 1961); J. Pudney: *Spring Adventure* (and three other vols., Evans, 1961-5); A. MacVicar: *The High Cliffs of Kersivay* (Harrap, 1964), *The Kersivay Kraken* (Harrap, 1966).
Bibl: Peppin.

RENTON, Michael **b.1934**
Born in Middlesex, Renton studied at Harrow School of Art (1949-50), and was then apprenticed as a commercial wood engraver to S. Slinger Ltd., one of the last commercial engravers, where he stayed until 1960 (apart from two years in the RAF on National Service). While working at Slinger's, he studied in the evenings at the City and Guilds Art School, Kennington (1954-56, 1959-62).
He has been basically a free-lance artist since 1960. While at art school, he had ideas of becoming an illustrator, and was encouraged by the examples of Eric Gill* and Reynolds Stone*, who combined an interest in lettering with engraving and illustration. In 1963 he moved to Rye, Sussex, where he works as an engraver, designer, craftsman in lettering, and an occasional painter. In the 1960s and 1970s, little opportunity for illustration came his way, but since wood engraving became more popular as a medium of illustration, Renton has illustrated several books. He nevertheless enjoys variety in his work, and has done inscriptional and other lettering, as well as book jackets, endpapers, and book plates. He has exhibited widely in the South East of England; was elected SWE (1984); Rye Society of Artists (1965); Guild of Sussex Craftsmen (1971); founder member of the Letter Exchange (1988).
Books illustrated include: M. Saville: *Portrait of Rye* (East Grinstead: Goulden, 1976); H.D. Thoreau: *Walden* (Folio Society, 1980); H. Thomas: *A Memory of W.H. Hudson* (Fleece Press, 1984); J. Keats: *La Belle Dame Sans Merci* (Cherub Press, 1986); A.

Michael RENTON *A Memory of W.H. Hudson* by Helen Thomas (Fleece Press, 1984) From the original engraving

Crocker: *Paper Mills of Tillingbourne* (Oxshott: Tabard Press, 1988); W. Shakespeare: *Sonnets; A Lover's Complaint* (with Jane Lydbury*; Folio Society, 1989).
Contrib: *Sussex Life*.
Exhib: RE; SWE; Rye Art Gallery (1970, 1980); Hope Mill, Goudhurst (1974); Southover Gallery, Lewes (1979); Chichester Cathedral (1987).
Bibl: Michael Renton: "An Engraver's Apprentice", *Matrix* 3 (1983): 126-36; Brett; Folio 40; IFA.

REYNOLDS, Frank **1876-1953**
See Houfe
Books illustrated include: W. Sapte: *By the Way Ballads* (1901); K. Howard: *The Smiths of Surbiton* (1908); J.N. Raphael: *Pictures of Paris and Some Parisians* (Black, 1908); C. Dickens: *The Adventures of Mr. Pickwick* (Hodder, 1910), *David Copperfield* (Hodder, 1911), *The Pickwick Papers* (Hodder, 1912), *The Old Curiosity Shop* (Hodder, 1913), *The Buchanan Portfolio of Characters from Dickens* (1925).
Bibl: A.E. Johnson: *Frank Reynolds* (Black, 1907); Bradshaw; ICB; Peppin; Price; Waters.

REYNOLDS, John Patrick **1909-1935**
An illustrator and cartoonist, the son of Frank Reynolds*, he died by his own hand on 25 December 1935.
Books illustrated include: H.J.C. Graham: *Adam's Apples* (Methuen, 1930); W.C. Sellar and R.J. Yeatman: *1066 and All That* (Methuen, 1930), *And Now All This* (Methuen, 1932); R.J. Yeatman: *Horse Nonsense* (Methuen, 1933); R.H. Heaton: *The Perfect Cruise* (Nicholson, 1935).
Bibl: Waters; Peppin.

REYNOLDS, Warwick **1880-1926**
See Houfe
Books illustrated include: C.G.D. Roberts: *Babes in the Wild*

Colour Plate 127. Eric RAVILIOUS
High Street by J.M. Richards
(Country Life 1938)

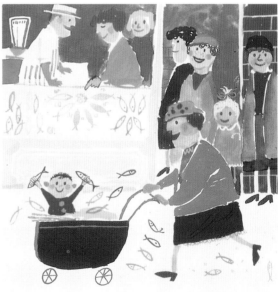

Colour Plate 129. Gerald ROSE *Old Winkle and the
Seagulls* by Elizabeth and Gerald Rose (Faber & Faber
1960)

Colour Plate 128. William Heath ROBINSON *Bill the
Minder* (Constable 1912)

Colour Plate 130. Victor ROSS
English Fashions
by John Mortimer
(Puffin Picture Book No. 76, 1947)

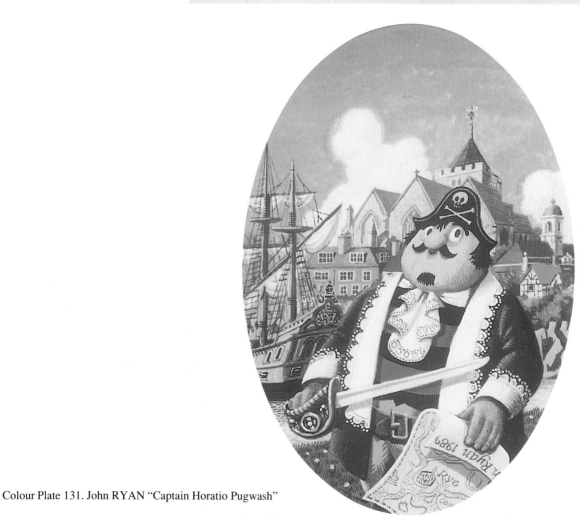

Colour Plate 131. John RYAN "Captain Horatio Pugwash"

(1912); F. Saint-Mars: *The Prowlers* (1913); H.M. Batten: *Habits and Characters of British Wild Animals* (Chambers, 1920), *Romances of the Wild* (1922); C. Ewald: *The Pond* (1922); J.M. Thomson: *Forest Dwellers* (1922), *Wild Kindred* (1922), *Wings and Pads* (1922); E. Glanville: *Claw and Fang* (1923); H.E. Barns: *Naju of the Nile* (1924); G. Casserly: *Dwellers in the Jungle* (1925); A. Hall: *The Cat, the Dog and the Dormouse* (Blackie, 1925); D.A. Mackenzie: *Old-Time Tales* (nd); J. A. Thomson: *The New Natural History* (nd).
Contrib: *Blackie's Children Annual; Blackie's Little Ones Annual; Bystander; Dreadnought; Gem; Golden Hind; Little Folks; London Magazine; Nash's Magazine; Passing Show; Pearson's Magazine; Pluck; Popular; Royal; Strand; Tatler; Wide World Magazine; Windsor Magazine.*
Exhib: RA; RSA; RSW; GI.
Bibl: Doyle BWI; Mackenzie; Peppin; Waters.

RIBBONS, Harold Ian **b.1924**
Born on 20 August 1924 in London, Ribbons studied at Beckenham School of Art and the RCA. After service in India and Burma during WW2, he travelled in Europe and taught at various art schools from 1952, and has been at St. Martin's School of Art since 1976. He has illustrated many books, using a variety of techniques, including pen, brush and spatter, and gouache for colour work. He is an illustrator rather than decorator, basing his work on careful research and recording the daily events of urban life. His illustrations to his own accounts of particular days in history are full of life and energy.
Books illustrated include: L. de Vilmorin: *Madame de . . .* (Collins, 1952); C.F. Smith: *Knave-Go-By* (OUP, 1951); L. Meynell: *Under the Hollies* (OUP, 1954); A. Pushkin: *An Amateur Peasant Girl* (Rodale Press, 1955); H.G. Wells: *The History of Mr Polly* (Folio Society, 1957); P. Power: *Kangaroo Country* (1961); R.L. Stevenson: *The Wrong Box* (1961); P. Farmer: *The Sea Gull* (Brockhampton, 1964); E. Goudge: *Linnets and Valerians* (Brockhampton, 1964); J.K. Jerome: *Three Men in a Boat* (Folio Society, 1964); F. Grice: *The Luckless Apple* (OUP, 1966); P. Turner: *Sea Peril* (OUP, 1966); R. Welch: *Bowman of Crecy* (OUP, 1966); R.L. Green: *Ten Tales of Detection* (1967); R. Weir: *High Courage* (1967); I. Southall: *The Fox Hole* (Methuen, 1967); E.M. Almedingen: *Fanny* (1970); F. Grice: *Young Tom Sawbones* (1972); R. Kipling: *Twenty-One Tales* (Folio Society, 1972); R. Leeson: *Beyond the Dragon Prow* (1973); A. Fournier: *Le Grand Meaulnes* (Folio Society, 1979); E.M. Forster: *A Passage to India* (Folio Society, 1983); R. Dana: *Two Years Before the Mast* (Folio Society, 1986).
Books written and illustrated include: *Monday 21 October 1805* (OUP, 1968); *Tuesday 4 August 1914* (OUP, 1970); *The Island* (1971); *The Battle of Gettysburg* (OUP, 1974); *Mr Mackenzie Painted Me* (OUP, 1975); *Waterloo, 1815* (Kestrel, 1982).
Contrib: *Harper's Bazaar; Radio Times.*
Bibl: Folio 40; ICB2; ICB3; Jacques; Peppin; Usherwood; Who.

RICE, Elizabeth Helen **b.1947**
Born on 4 April 1947 in Canterbury, Rice was educated at Ashford School, and studied at Exeter College of Art (1963-65), and worked at Arthur Sanderson and Sons (1965-70), studying wallpaper design. She has exhibited at a number of galleries, including the Society of Wild Life Artists, and illustrated a few books.
Books illustrated include: *Fieldguide to the Crop Plants of Europe* (Collins); *Reader's Digest Fieldguide to Butterflies; Gem Guide to Herbs* (Collins).
Exhib: SWLA; Mall Galleries; Medici Society.
Bibl: Who.

RICHARDS, Ceri Giraldus **1903-1971**
Born on 6 June 1903 in Dunvant, a small mining village near Swansea, Richards was educated at Gowerton Grammar School and, after two years as an apprentice to an electrical engineering firm, studied full-time at Swansea School of Art (1921-24). He won a scholarship to the RCA where he studied under Randolph Schwabe* (1924-27). He married artist and illustrator Frances Clayton (Frances Richards*) in 1929. He taught at Chelsea College of Art (1937-39), and taught graphic art at Cardiff School of Art

Ian RIBBONS *Linnets and Valerians* by Elizabeth Goudge (Brockhampton Press, 1964)

(1940-44). After his return to London in 1945 he taught at Chelsea Polytechnic (1947-57), the Slade (1955-58), and the RCA (1958-60).
Richards was primarily a painter, lithographer, and maker of reliefs, works often inspired by music and poetry. His first one-artist show was held in Swansea in 1930, and the first in London at the Leger Gallery (1942); he was a member of the Abstractions Group (1934), the Surrealists Group (1936) and the London Group (1937). Mellor† claims that Richards' paintings in the early 1940s brought a kind of post-surrealism and expressionism to British neo-romantic art whose masterpiece was Richards's "Cycle of Nature" (1944). During WW2 he made drawings of tin-plate workers in South Wales for the Ministry of Information; and in the 1950s he did cos-

tumes and scenery for the theatre. In the 1950s he also continued to produce lithographs and screen prints, often working at the Curwen Press; and among his paintings completed in this period are two church commissions. In 1964-65 he designed stained glass for Derby Cathedral, and had commissions for work at Liverpool Cathedral. In the 1960s also his paintings became more abstract.

His work as an illustrator began when he started work in 1927 for the London Press Association as a commercial artist and in 1929 illustrated *The Magic Horse* for Gollancz. He made his first lithograph as an illustration to Dylan Thomas' poem "The force that through the green fuse" for Tambimuttu's *Poetry London* in 1943. In 1953, done in twenty-four hours just a day before Thomas' death in New York, Richards made a series of forty ink drawings in a copy of the poet's *Collected Poems 1934-1952*. These were not published until 1980, in facsimile. His deep interest in Thomas' poetry is also reflected in Richards' *12 Lithographs for 6 Poems by Dylan Thomas* which he made at the Curwen Studio in 1965 and in the illustrations to *Under Milk Wood*, published in 1972 after his death. Bryan Robertson, in his introduction to the Tate Gallery Catalogue (1981), writes that poetry for Ceri Richards "was no mere pretext for superficial decoration but a living, imaginative world to be penetrated, felt and totally assimilated by the artist. Ceri sought always for the image *beyond* the words and never their illustration, however apt or sympathetic."

In 1960, the year of his major retrospective exhibition at the Whitechapel Gallery, Richards was awarded the CBE. He was a Trustee of the Tate Gallery (1958-65). He died on in London 9 November 1971 and in 1972 an exhibition, "Homage to Ceri Richards 1903-71" was held at the Fischer Fine Art Gallery, followed by another at the Tate in 1981, and in 1985 an exhibition of his work entitled "The Lyrical Vision" at the Gillian Jason Gallery in Camden Town.

Books illustrated include: *The Magic Horse from the Arabian Nights* (Gollancz, 1929); *Review of Reviews* (with others, Cape, 1930); B. Britten and I. Holst: *The Story of Music* (Rathbone Books, 1958); *The Oxford Illustrated Old Testament* (five vols., with others, OUP, 1968-9); D. Thomas: *Under Milk Wood* (Folio Society, 1971); R. Semesi: *Journey Towards the North* (1971); D. Thomas: *Ceri Richards: Drawings to Poems by Dylan Thomas* (Enitharmon Press, 1980).
Contrib: *Poetry London.*
Exhib: Glynn Vivian Art Gallery, Swansea (1930); Leger Gallery (1942); Whitechapel Gallery (1960); Fischer Fine Art Gallery (1972); Tate (1981); Gillian Jason Gallery (1985).
Collns: Glynn Vivian Art Gallery, Swansea; Tate; National Museum of Wales, Cardiff.
Bibl: Richard Burns: *Ceri Richards and Dylan Thomas: Keys to Transformation* (Enitharmon Press, 1981); D. Mellor: *A Paradise Lost: The Neo-Romantic Imagination in Britain 1935-55* (Humphries, 1987); Roberto Senesi: *Ceri Richards: The Graphic Works* (Milan: Cerastico, 1973); David Thompson: *Ceri Richards* (Methuen, 1963); *Ceri Richards* (Tate Gallery, 1981); DNB; Harries; Peppin; Rothenstein; Tate; Waters.

RICHARDS, Frances **1903-1985**
Born 1 August 1903 at Burslem, Stoke-on-Trent, the daughter of John Clayton, kiln fireman in a pottery, Richards studied at Burslem School of Art (1919-24) and worked as a pottery designer before winning a scholarship to RCA (1924-27). She married Ceri Richards* in 1929. A painter, illustrator and potter, she had her first one-artist show in 1945 at the Redfern Gallery and her work was included in the exhibition, "Artists of Fame and Promise, 1" at the Leicester Galleries in 1957. She illustrated *The Book of Revelation* (1931) for Faber with full- and two-page drawings coloured with crayon or chalk, printed at the Curwen Press. A number of her illustrated books of poetry have been published by the Enitharmon Press and she also did some unpublished illustrations for "Les Illuminations" by Rimbaud.
Books illustrated include: *Acts of the Apostles* (1930); *The Book of Revelation* (Faber, 1931); *The Oxford Illustrated Old Testament* (five vols., with others, OUP, 1968-9); *Juliet and Her Nurse* (1976); R. Burns: *Some Poems* (Enitharmon Press, 1977).
Books written and illustrated include (all published by Enitharmon Press): *Poems of Experience* (1981); *Some Poems with Drawings*

Ceri RICHARDS Illustration for "The force that drives through the green fuse" by Dylan Thomas in *Poetry London* no.11 (1947)

(1982); *Some Poems with Drawings in 1983*; *More Poems with Drawings 1983*; *More Poems with Drawings 1984* .
Contrib: *Sunday Times; Times.*
Exhib: Redfern; Leicester Gall.
Collns: Tate.
Bibl: Peppin; Tate; Waters.

RICHARDSON, Agnes **1885-1951**
Born in Wimbledon, Richardson studied at Lambeth School of Art. She illustrated books for children, annuals, and designed greeting cards, and at least three posters for London Transport (1912-22), all much in the same style as M.L. Attwell*.
Books illustrated include: E. Vredenburg: *Golden Locks and Pretty Frocks* (Tuck, 1914); L. Carroll: *Alice in Wonderland* (1920); C. Perrault: *Fairy Stories from the French* (1920); A.G. Herbertson: *The Cosy Corner Book* (Collins, 1923).
Books written and illustrated include: *The Dainty Series* (four vols., Geographia, 1924); *Chubby Chums* (Dean, 1932); *The Agnes Richardson Book* (Birn, 1936).
Contrib: *Agnes Richardson Annual.*
Bibl: Peppin.

RICKARBY, Joan **fl.1943-1950**
Illustrator of the rural scene in black and white.
Books illustrated include: R. Harman: *Countryside Mood* (Blandford Press, 1943); S.L. Bensusan: *My Woodland Friends* (Blandford Press, 1947), *Salt of the Marshes* (Routledge, 1949), *Right Forward Folks* (Routledge, 1949), *Late Harvest* (Routledge, 1950).
See illustration on page 370

Joan RICKARBY *My Woodland Friends* by S.L. Bensusan (Blandford Press, 1947)

RIDDELL, Chris **fl.1980-**
Born in South Africa, Riddell grew up in England. He was educated at Archbishop Tenison's Grammar School and studied illustration at Brighton Polytechnic. Since graduating, he has worked full-time as a free-lance illustrator (some of his early illustrations were done for computer adventure books published by Usborne) and has written and illustrated a number of picture books for young children. He lives in Brighton.
Books illustrated include: L. Howarth and C. Evans: *Fantasy Games* (Usborne, 1984); C. Oxlade and J. Tatchell: *The Mystery of Silver Mountain* (Usborne, 1984); T. Hughes: *Ffangs the Vampire and the Kiss of Truth* (Faber, 1986); M. Hoffman: *Beware, Princess!* (Heinemann, 1986); R. McCrum: *The Dream Boat Brontosaurus* (Hamilton, 1987); J. Williams: *The Magician's Cat* (Faber, 1987); *Tail Feathers from Mother Goose* (with others, Walker, 1988).
Books written and illustrated include: *Ben and the Bear* (Walker, 1986); *Humphrey and the Hippo* and three other titles (Grafton, 1986-7); *Mr Underbed* (Andersen Press, 1986); *Bird's New Shoes* (Andersen Press, 1987); *The Fibbs* (Walker, 1987); *The Trouble with Elephants* (Walker, 1988); *When the Walrus Comes* (Walker, 1989); *The Wish Factory* (Walker, 1990).
Bibl: Inf. from Walker Books.
Colour Plate 27

RIDDELL, William James **b.1909**
Born on 27 December 1909 in London, Riddell was educated at Harrow School and Cambridge University, and for periods at the universities of Bonn and Grenoble. He had no formal art training except for work done at Harrow School Art School. His career was very varied: he started in advertising and printing; did publicity work for De Haviland Aircraft and Selfridges; took up photography and took part in "big game" photographic expeditions to East Africa and the Belgian Congo (1938-39). During WW2 he became ADC to the High Commissioner of Palestine and Trans-Jordan; political officer in Syria; and organized a Middle East Mountain Warfare School in Lebanon (1941-43). He was awarded the MBE in 1944.
Riddell has travelled widely, including a journey down the Nile from its source to its mouth in 1939 and in 1948-9 a six-month flight with Nevil Shute from England to Australia in a single-engined "Proctor" monoplane, with two months in the Australian outback (which formed the basis for Shute's novel, *A Town Like Alice)*. He was also a notable skiier, being six times a member of the British Ski Team (1927-39); Vice-Captain of the British Olymic Ski Team (1936); President of the Ski Club of Great Britain (1969-74); President of the Kandahar Ski Club (1973-78).
He has written some twenty-seven books of various kinds — novels, satires, children's books, ski guides, and travel books — many of which are illustrated with his drawings or photographs. *Animal Lore and Disorder* is a flap-book, in which the reader can make up amusing and strange animals by turning over card flaps. He is also a painter, mostly of landscapes in the Bernese Oberland Alps, Switzerland, and views of London; and he has exhibited in a small way in the City of London. His present occupations include painting, writing ski articles and gardening. He is married, with one daughter.
Books written and illustrated include: *Animal Lore and Disorder* (Atrium, 1973).
Bibl: IFA.

RIDGEWELL, William Leigh **1881-1937**
Born on 8 September 1881 in Brighton, Ridgewell studied at Brighton School of Art. A cartoonist and book illustrator, he contributed to *Punch* in a variety of styles. He committed suicide on 7 November 1937.
Books written and illustrated include: *Line and Laughter* (1936).
Contrib: *Punch*.
Bibl: Price; Waters.

RIDLEY, Trevor **b.1942**
Born in York, Ridley worked as a teacher and in advertising before he turned free lance in 1972 as a painter, printmaker and illustrator. He has contributed to several magazines and illustrates children's books with ink drawings.
Books illustrated include (but see Peppin): K. Fidler: *Treasure of Ebba* (1968); F. Grice: *The Oak and the Ash* (1968); R. Manning-Sanders: *Stories from the English and Scottish Ballads* (1968); L. Garfield: *The Boy and the Monkey* (Heinemann, 1969), *The Captain's Watch* (1972); M. Hunter: *The Haunted Mountain* (1972); L. Garfield: *Lucifer Wilkins* (1973); M. Morpurgo: *Thatcher Jones* (Macmillan, 1975); J. Pelling: *Alfred at Athelney* (CUP, 1977), *The Emperor Napoleon* (CUP, 1978); V.E. Newbury: *History Hunter* (1979); H. Burton: *Five August Days* (1981); H. Walters: *School on the Moon* (Abelard, 1981).
Contrib: *Cruising World; Punch; Radio Times; Yachting Monthly; Yachting World*.
Bibl: Peppin.

RITCHIE, Trekkie
See PARSONS, Marjorie Tulip

RIVERS, Elizabeth Joyce **b.1903**
Born on 5 August 1903, Rivers studied at Goldsmiths' College School of Art (1921-24) under Edmund Sullivan (see Houfe), RA Schools (1925-30), and in Paris (1931-34). A painter, she illustrated books with wood engravings and pen drawings. Her *Stranger in Arran* (1946) contains many black and white drawings, and two are hand-coloured. She exhibited widely, and was elected SWA (1930); SWE.

Elizabeth RIVERS *The Man Who Invented Sin* by S. O'Faolain
(New York: Devin-Adair, 1948)

Books illustrated include: Theocritus: *The Second and Seventh Idylls* (BH, 1927); A. Tennyson: *The Day-Dream* (1928); F. Wolfe: *The Very Thing* (Sidgwick, 1928); W. de la Mare: *On the Edge* (Faber, 1930); F. O'Connor: *A Picture Book* (Dublin: Cuala Press, 1943); S. Dorman: *Valley of Graneon* (Davies, 1944); E.E. Mannin: *Connemara Journal* (Westhouse, 1947); P. Lynch: *The Mad O'Haras* (1948); S. O'Faorlain: *The Man Who Invented Sin* (NY: Devin-Adair, 1948); C.C. Rogers: *Our Cornwall* (1948); C. Smart: *Out of Bedlam* (Dolmen Press, 1956).
Books written and illustrated include: *This Man* (1939); *Stranger in Arran* (Dublin: Cuala Press, 1946); *Out of Bondage: Israel* (1957).
Bibl: Peppin; Waters.

ROBB, Brian 1913-1979
Born on 7 May 1913 in Scarborough, Yorkshire, Robb was educated at Malvern College and studied at Chelsea School of Art (1930-34) and the Slade (1935-36). He lectured at Chelsea School of Art, and was head of the Department of Illustration at the RCA (1963-78).
A painter in oils and watercolour, Robb was a member of the London Group (1954). He designed advertisements for Shell and contributed humorous drawings to *Punch*. As a book illustrator, he used mostly pen and ink, and his appreciation of the humour in the *12 Adventures of Baron Munchausen* comes out clearly in his drawings. Hodnett declares Robb to be "even more comfortable" illustrating *A Sentimental Journey* (1948) with amusing head- and tailpieces in the tradition of Cruikshank; but finds his vignettes and full-page illustrations for *Tristram Shandy* (1949) less successful. Ardizzone* is more positive, believing that in his *Tristram Shandy* Robb "has created [a world] which has a life of its own [but which] is a very close analogy or visual counterpart of the one created by the author, and interacts with it to their mutual advantage, making each more credible and therefore the more moving to the reader." (Ardizzone, 1950.†) Of his brush drawings made for *The Oxford Illustrated Old Testament* (1968-69), Robb wrote that "I have tried in my drawings to evoke lines of thought rather than to define them; to offer, but not to insist upon, the visual ideas the words brought to

mind: the half-conscious products, presumably, of intuitions, habits of thinking, and scraps from personal or collective experience." (*The Old Testament Drawings*, 1968.)
Books illustrated include: L. Andreyev: *Judas Iscariot* (Westhouse, 1947); Apuleius: *The Golden Asse* (Westhouse, 1947); R.E. Raspe: *12 Adventures of the Celebrated Baron Munchausen* (Lunn, 1947); T. De Quincey: *My Kingdom for a Cow* (1948); L. Sterne: *A Sentimental Journey* (Macdonald, 1948), *Tristram Shandy* (Macdonald, 1949); G. Barkas: *The Camouflage Story* (1952); H. Fielding: *Tom Jones* (Macdonald, 1953); *Fables of Aesop* (Penguin, 1954); *The Oxford Illustrated Old Testament* (five vols., with others, OUP, 1968-9); J.R. Evans: *The Adventures of Odd and Elsewhere* (1971), *The Secret of the Seven Bright Shiners* (1972), *Odd and the Great Bear* (1973), *Elsewhere and the gathering of the Clowns* (1974), *The Return of the Great Bear* (1975); E. Nesbit: *Fairy Stories* (1977).
Books written and illustrated include: *My Middle East Campaign* (Collins, 1944); *My Grandmother's Djin* (Deutsch, 1976); *The Last of the Centaurs* (1978).
Contrib: *Compleat Imbiber; Night and Day; Punch; Saturday Book 12.*
Exhib: LG.
Bibl: Edward Ardizzone: "Brian Robb", *Signature* 11 N.S. (1950): 37-45; *The Oxford Old Testament Drawings* (Royal Academy of Arts, 1968); Hodnett; Jacques; Peppin; Waters; Who.

The Baron relates his adventures

Brian ROBB *12 Adventures of the Celebrated Baron Munchausen* (Peter Lunn, 1947)

ROBERSON, Peter b.1907
Born in Oxford, Roberson studied at Oxford Art School, eventually specializing in lettering and illumination. He worked at the Clarendon Press after 1924, drawing maps most of the time but also designing jackets, title-pages and bindings. Landscape and architectural drawing became his main interests. He came to London in 1935 and worked as a commercial artist, including designing posters for London Transport, for whom he did at least thirty-four between 1951 and 1978. He has illustrated at least one book.
Books illustrated include: R.L. Stevenson: *Treasure Island* (Folio Society, 1963).
Bibl: Folio 40; Ryder.

ROBERTS, Doreen b.1922
Born in Walthamstow, North London, Roberts worked first as an office clerk, and then joined the Women's Land Army during WW2. After the war she studied at South-West Essex Technical College School of Art (1945-47), at the Slade (1947-50), and then trained to be a teacher at the University of London Institute of Education. She was Head of the Art Department at a girls' grammar school (1952-73) and since then has lectured in various guises. Since 1968 she has been a free-lance illustrator, painter and photographer. She illustrates children's books both in black and white and in full colour, using different media. Her favourite topics include ancient and medieval history; *The Story of Saul the King* (1966) was runner-up for the Kate Greenaway Medal. She won an award from the Worshipful Company of Goldsmiths which allowed her to travel to Canada and work with the National Film Board.
Books illustrated include: Moss: *The Story of Saul the King* (Constable, 1966); R.L. Green: *Stories of Ancient Greece* (1967); G. Avery: *The Hole in the Wall* (1968); A. Boucher: *The Sword of the Raven* (1969); W. Cawley: *Feast of the Serpent* (1969); E. Spence: *Jamberoo Road* (1969); H. Cresswell: *The Outlanders* (1970); M. Crouch: *Canterbury* (1970); M. Storey: *A Quarrel of Witches* (1970); B. Willard: *Priscilla Pentecost* (1970); M. Baker: *The Last Straw* (1971); S. Porter: *The Valley of Carreg-Wen* (1971); R.C. Scriven: *The Prospect of Whitby* (1971).
Books written and illustrated include: *Joe at the Fair* (OUP, 1972); *Joe's Day at the Market* (1973); *Harry By the Sea* (1974); *The Charley Car* (1975); *Jem in the Park* (1975); *The Other Side of the Day* (1976).
Published: *Teaching Art* (1978).
Bibl: ICB3; Peppin.

ROBERTS, Lunt fl. 1913-1964
Roberts illustrated children's books and contributed to a number of magazines and annuals. He was a member of the London Sketch Club, of which he was President in 1936.
Books illustrated include: J.N. More: *Dugout Doggerels from Palestine* (1922); M. England: *Warne's Happy Book for Girls* (Warne, 1938); T. Henley: *Let's Find Hidden Treasure* (1947); M. Saville: *The Riddle of the Painted Box* (1947), *Redshank's Warning* (1948), *Two Fair Plaits* (1948); A. MacVicar: *Stubby Sees It Through* (1950); M. Saville: *The Flying Fish Adventure* (1950) and three other titles; K. Fidler: *Pete, Pam and Jim* (1954); R.L. Stevenson: *Two Stories* (1964).
Contrib: *Cassell's Children's Annual; Daily Mail Annual; Humorist; Punch; Rocket*.
Bibl: Doyle BWI; Peppin.

ROBERTS, William Patrick 1895-1980
Born in Hackney, East London, on 5 June, 1895, Roberts was apprenticed to a firm of commercial artists when he was fourteen. He attended St. Martin's School of Art in the evenings and then won a scholarship to the Slade (1910-13). He travelled in France and Italy, and was influenced to some extent by the cubism of Picasso; and then he was briefly associated with Fry's Omega Workshops, and exhibited at NEAC. In 1914 he met Wyndham Lewis* and joined the Vorticists, signing the manifesto in the first issue of *Blast*, repudiating the Futurists; and in 1915 joined the London Group.
During WW1 he was first a gunner in the Royal Field Artillery and then an official war artist, and his experiences during the war appear to have produced in him a more humanist approach to art. From this time his concerns were with the "human condition" and his work depicted scenes of everyday life. His first one-artist show was at the Chenil Gallery in 1923; and in 1925 he started teaching at the Central School of Arts and Crafts, which he continued until 1960. Between 1927 and 1934 he was a member of the London Artists' Association. He lived in Oxford during WW2 and on his return to London exhibited at RA every year until his death. In 1956-58 he published *The Vortex Pamphlets*, after the 1956 Tate Gallery Vorticism exhibition. He believed that John Rothenstein and Michael Ayrton* amongst others had exaggerated the importance of Wyndham Lewis at the expense of himself and other artists.
His artistic output included a huge poster on "The History of the Omnibus" for London Transport in 1924, another in 1951 on "London Fairs", and illustrations for T.E. Lawrence's *Seven Pillars of Wisdom*. Published in a *de luxe* edition in 1926, it contained reproductions of drawings by Roberts and other artists.
He was elected ARA (1958); RA (1966); he died in London on 20 January 1980. A major retrospective exhibition was held at the Tate in 1965.
Books illustrated include: T.E. Lawrence: *Seven Pillars of Wisdom* (with others, 1926); R. Davies: *The Song of Songs* (Archer, 1927).
Books written and illustrated include (all published by Favil Press): *The Resurrection of Vorticism and the Apotheosis of Wyndham Lewis at the Tate* (1956); *Cometism and Vorticism* (1956); *A Press View at the Tate Gallery* (1956); *A Reply to My Biographer: Sir John Rothenstein* (1957).
Contrib: *Blast; New Coterie*.
Exhib: Chenil Galleries; Cooling Galleries; Lefevre Gallery; Redfern Gallery; Leicester Galleries; RA; Tate (retrospective, 1965); Michael Parkin (1976); NPG (1984); Albemarle Gallery (1989).
Collns: Tate; IWM; V & A.
Bibl: *William Roberts ARA: Retrospective Exhibition, Tate Gallery* (Arts Council, 1965); Compton; Harries; Rothenstein; Tate; Waters.

ROBERTSON, Walford Graham 1866-1948
See Houfe

ROBINSON, Charles 1870-1937
See Houfe

ROBINSON, Frederick Cayley 1862-1927
See Houfe
In addition to painting, Robinson designed murals, posters, and theatre sets, and illustrated a number of books. His stage designs for Maurice Maeterlinck's *The Blue Bird*, produced at the Haymarket Theatre in London in 1909, were much admired, and he illustrated the book of the same name in 1911, some of the illustrations being based on the theatre designs.
Books illustrated include: L.V. Hodgkin: *A Book of Quaker Saints* (Foulis, 1907); M. Maeterlinck: *The Blue Bird* (Methuen, 1911); *The Book of Genesis* (Riccardi Press, 1914); *The Little Flowers of St. Francis* (Foulis, 1915); P. Webling: *Saints and Their Stories* (Nisbet, 1922); G.K. Chesterton: *St. Francis of Assisi* (1926); R.W. Trine: *In Tune with the Infinite* (1926).
Contrib: *Venture*.
Bibl: M.A. Stevens: "Frederick Cayley Robinson", *Connoisseur* (September 1977); Johnson FIDB; Peppin; Waters.

ROBINSON, Gordon fl. 1905-1913
See Houfe
Books illustrated include: D. Defoe: *Robinson Crusoe* (1915); H.C. Andersen: *Fairy Tales* (1917); C. Dickens: *The Cricket on the Hearth* (1917); C. Kingsley: *The Water Babies* (1919).

ROBINSON, Sheila fl. 1951-1969
She contributed a full-page drawing of "The Corset Shop" to *Motif* 2 (1959) and a colour title page to at least two of the "About Britain" series published by Collins for the Festival of Britain Office in 1951. With Alistair Grant* she illustrated Jeremiah for *The Oxford Illustrated Old Testament* (1968-69) — she decided to use woodcuts, as she found the blackness of the ink suitable to portray Jeremiah's superhuman strength and persistence. "Reading Jeremiah for the first time, for me, was a landscape covered by a

Sheila ROBINSON *East Midlands and the Peak* (About Britain No.8; Collins, 1951)

louring black fog." (*The Oxford Old Testament Drawings*, 1968.)

Books illustrated include: W.G. Hoskins: *Chilterns to Black Country* (About Britain 5; Collins, 1951), *East Midland* (About Britain 8; Collins, 1951); *The Oxford Illustrated Old Testament* (five vols., with others, OUP, 1968-9).

Contrib: *Motif*.

Bibl: *The Oxford Old Testament Drawings* (Royal Academy of Arts, 1968).

ROBINSON, Thomas Heath **1869-1953**
See Houfe

Born on 19 June 1869 in Islington, north London, Thomas Heath was the eldest of six children (see William Heath Robinson). He attended school in Islington and then studied at the Islington School of Art. His first commission as an illustrator was for the *Pall Mall Magazine* (1893), and his first illustrated book was *Old World Japan* for George Allen (1895), which contains fourteen full-page drawings and twenty headpieces. He went on to illustrate many books for such publishers as Allen, Bliss Sands, Dent and Nister, and contributed to various magazines. Much of his work was done for historical subjects, sometimes in an art nouveau manner, and always well drawn, using both the colour plates and pen drawings. Robinson also painted in oils and made etchings.

He married in 1902, lived in Hampstead, and had four daughters. In 1906 they moved to Pinner, Middlesex, where they were joined by his brother William and his family. During WW1 and after, the demand for Thomas's illustrations seemed to dry up, and in 1920 the family had to move into lodgings, and then into a council house. Later he was commissioned to provide illustrations for books and children's annuals, and in 1926 they moved back to Pinner where they lived until his wife's death in 1940. He then moved to St. Ives in Cornwall and stayed there until his death in February 1953.

Books illustrated include (but see Beare, 1992†): F. Rinder: *Old World Japan* (Allen, 1895); E. Gaskell: *Cranford* (Bliss, Sands, 1896); C. Sylva: *Legends from River and Mountain* (Allen, 1896); W. Canton: *A Child's Book of Saints* (Dent, 1898); B. Minssen: *A Book of French Songs for the Young* (Dent, 1899); P. Creswick: *In Aelfred's Day* (Nister, 1900), *Under the Black Raven* (Nister, 1901); K.F. Boult: *Heroes of Norseland* (Temple Classics; Dent, 1903); E. Spenser: *Una and the Red Cross Knight* (Dent, 1905); C. Brontë: *Shirley* (Collins, 1909); A.F. Jackson: *The Tower of London* (Jack, 1910); J.R. Wyss: *The Swiss family Robinson* (OUP, 1913); L. Carroll: *Alice in Wonderland* (Colins, 1922); *The Story of the Bible* (Cassell, 1930); T. à Kempis: *Of the Imitation of Christ* (Hutchinson, 1935); H. Chesterman: *A Maid in Armour* (Warne, 1936).

Contrib: *Cassell's Family Magazine; Idler; Pall Mall Magazine; Quiver; Strand; Windmill*.

Exhib: Beetles/Royal Festival Hall (1992).

Bibl: Geoffrey Beare: "Thomas Heath Robinson" in *The Brothers Robinson: Catalogue* (Chris Beetles Ltd., 1992).

ROBINSON, William Heath **1872-1944**
See Houfe

Born in Hornsey on 31 May 1872, William Heath Robinson was one of six children of Thomas and Eliza Robinson (she was the daughter of a William Heath). His father Thomas was a wood engraver and illustrator, deriving his income mostly from his illustrations to the *Penny Illustrated Paper*; his grandfather, also a Thomas Robinson, began as a bookbinder and later became a wood engraver; his uncle Charles was an engraver for the *Illustrated London News*. It is small wonder that he and two of his brothers, Charles Robinson (see Houfe) and Thomas Heath Robinson* became illustrators. William was educated at the Islington High School and studied at Islington School of Art and briefly at the RA Schools.

After leaving school Robinson first tried, unsuccessfully, to make a living as a landscape painter before some of his drawings were accepted by Cassell's *Little Folks* magazine and *Good Words*. His first book illustrations were published in 1897 in *Danish Fairy Tales*, *The Giant Crab and Other Tales from India* and *Don Quixote*, but it was not until the publication of *Uncle Lubin* in 1902 and the start of his advertising work for commerce and industry in the same year that Robinson's financial position was assured. For his early books, Robinson worked in black and white, but his development as an artist reached true accomplishment during the first twenty years of the twentieth century when the lavishly-produced gift-book flourished, with its tipped-in colour plates and gilt, decorated binding. *Twelfth Night* was the first gift-book that Robinson illustrated (1908) and it had to compete with two immensely popular illustrators who produced books in the same year — Arthur Rackham's (see Houfe) *Midsummer Night's Dream* and Edmund Dulac's (see Houfe) *The Tempest*. Other gift-books which Robinson illustrated include *A Song of the English* (1909), *Bill the Minder* (1912), *Hans Andersen's Fairy Tales* (1914) and Perrault's *Old Time Stories* (1921).

Perhaps Robinson's best work was done for the 1913 *Andersen*, for *A Midsummer Night's Dream* and for two books for children which he wrote as well as illustrated — *The Adventures of Uncle Lubin* (1902) and *Bill the Minder* (1912). These stories are simple, funny, absurd and quite charming. The two-page openings of *Uncle Lubin* are designed as a whole, the text and the black and white pictures ideally complementing each other. Colour plates are used as well as black and white illustrations in *Bill the Minder*, and though these plates are among Robinson's best, they seem less a part of the book than the black and white illustrations which are treated in the simplest fashion, perfectly suiting the naïve tales. The *Hans Andersen*

William Heath ROBINSON "Science Jottings: Searching for Halley's Comet at Greenwich Observatory" published in *The Sketch* (17 November 1909) Pen, ink and monochrome watercolour with bodycolour. By permission of Chris Beetles Limited

is a total success, with exquisite, well-printed plates and black and white illustrations either absurdly humorous or endowed with decorative charm and gaiety.

Even before the publication of *Bill the Minder*, Robinson had begun drawing cartoons and depicting the sort of comic contraptions which we now call by his name. These drawings first appeared in magazines such as the *Sketch*, *Bystander*, *Pall Mall Magazine*, and the *London Magazine* — "Seeing London" and "How To Agricult" are typical of these and were in sections in the *London Magazine* in 1908. After the outbreak of WW1, most of his illustrations were of

this type and books of comic drawings appeared such as *Hunlikely* (1916) and *Railway Ribaldry* (1935). Robinson used this sort of drawing also to illustrate many advertising and publicity booklets. He began this long and fascinating relationship with commerce and industry in 1903 by agreeing to produce some drawings for the Lamson Paragon Supply Company, a company which supplied duplicate books, printed stationery and other printed material. He produced booklets for many other companies such as Moss Brothers (*Behind the Scenes at Moss Bros*), Connolly Bros., Curriers (*Heath Robinson on Leather*) and Ruston-Bucyrus (*The Gentle Art of*

Excavating). Robinson described the reason for the success of his comic drawings thus —"Whatever success these drawings may have had was not only due to the fantastic machinery and devices, the absurd situations, but to the style in which they were drawn. This was designed to imply that the artist had complete belief in what he was drawing. He was seeing no joke in the matter, in fact he was part of the joke." (Robinson: *My Line of Life*, 1938.†)

In addition to drawing for books and journals and for his commercial employers, Robinson appeared on radio and television; he produced scenery for the old Empire and Alhambra theatres which used to stand in Leicester Square; he painted murals for the Knickerbocker Bar and the children's room on the liner the *Empress of Britain*; and in 1934 he designed a "Heath Robinson" house for the "Daily Mail Ideal Homes Exhibition" in London. He worked right through to the end of his life, mixing the serious with the comic, and died in Highgate, London, on 13 September 1944.

Books illustrated include: H.C. Andersen: *Danish Fairy Tales and Legends* (Bliss, Sands, 1897); M. Cervantes: *Don Quixote* (Bliss, Sands, 1897); J. Bunyan: *The Pilgrim's Progress* (Bliss, Sands, 1897); W.H.D. Rouse: *The Giant Crab and Other Tales from India* (Nutt, 1897); *Fairy Tales from Hans Christian Andersen* (with Thomas and Charles Robinson, Dent, 1899); W. Crooke: *The Talking Thrush* (Dent, 1899); *The Poems of Edgar Allen Poe* (Bell, 1900); M. Cervantes: *Don Quixote* (Dent, 1902); C. Lamb: *Tales from Shakespeare* (Sands, 1902); F. Rabelais: *Gargantua and Pantagruel*, two vols. (Richards, 1904); R. Carse: *The Monarchs of Merry England* (Cooke, 1907), *More Monarchs of Merry England* (Fisher Unwin, 1908); W. Shakespeare: *Twelfth Night* (Hodder, 1908); *The Arabian Nights* (with Helen Stratton, Constable, 1908); R. Kipling: *Song of the English* (Hodder, 1909); R. Kipling: *The Dead King* (Hodder, 1910); *Hans Andersen's Fairy Tales* (Constable, 1913); W. Shakespeare: *A Midsummer Night's Dream* (Constable, 1914); C. Kingsley: *The Water-Babies* (Constable, 1915); W. de la Mare: *Peacock Pie* (Constable, 1916); C. Perrault: *Old Time Stories* (Constable, 1921); E. Smeaton: *Topsy-Turvy Tales* (Bodley Head, 1923); N. Hunter: *The Incredible Adventures of Professor Branestawm* (Bodley Head, 1933); *Heath Robinson's Book of Goblins* (Arnold, 1934); R.F. Patterson: *Mein Rant* (Blackie, 1940); L.M.C. Clopet: *Once Upon a Time* (Muller, 1944).

Books written and illustrated include: *The Adventures of Uncle Lubin* (Richards, 1902); *The Child's Arabian Nights* (Richards, 1903); *Bill the Minder* (Constable, 1912); *Some Frightful War Pictures* (Duckworth, 1915); *Hunlikely!* (Duckworth, 1916); *The Saintly Hun* (Duckworth, 1917); *Flypapers* (Duckworth, 1919); *Get On with It* (Robinson & Birch, 1920); *The Home Made Car* (Duckworth, 1921); *Quaint and Selected Pictures* (Robinson & Birch, 1922); *Peter Quip in Search of a Friend* (Partridge, 1922); *Humours of Golf* (Methuen, 1923); *Absurdities* (Hutchinson, 1934); *Railway Ribaldry* (GWR, 1935); (with K.R.G. Browne) *How To Live in a Flat* (Hutchinson, 1936), *How To Be a Perfect Husband* (Hutchinson, 1937), *How To Make a Garden Grow* (Hutchinson, 1938), *How To Be a Motorist* (Hutchinson, 1939); *Let's Laugh* (Hutchinson, 1939); (with C. Hunt) *How To Make the Best of Things* (Hutchinson, 1940), *How To Build a New World* (Hutchinson, 1941); *Heath Robinson At War* (Methuen, 1942); (with C. Hunt) *How To Run a Communal Home* (Hutchinson, 1943).

Contrib (but see Beare†): *Bystander; Good Housekeeping; Good Words; Grant Richards' Children's Annual; Graphic; Humorist; Little Folks; London Opinion; Nash's Magazine; Pearson's Magazine; Playbox Annual; Radio Times; Sketch; Strand*.
Collns: BM; V & A.
Exhib: FAS (1924, 1945); Medici Gallery (1972); Beetles (1987, 1992).
Bibl: G. Beare: *The Illustrations of W. Heath Robinson* (Werner Shaw, 1983); Beare: *The Brothers Robinson: Catalogue* (Beetles, 1992); Beare: *W. Heath Robinson: The Inventive Comic Genius of Our Age* (Chris Beetles Ltd., 1987); L. Day: *The Life and Art of W. Heath Robinson* (Joseph, 1947); J. Hamilton: *William Heath Robinson* (Pavilion, 1992); A.J. Horne: *The Art of William Heath Robinson* (University of Toronto Library, 1977); A.E. Johnson: *The Book of W. Heath Robinson* (Black, 1913); J. Lewis. *Heath Robinson: Artist and Comic Genius* (Constable, 1973); *The Penguin Heath Robinson* (Penguin, 1966); W. Heath Robinson: *My Line of*

Life (Blackie, 1938); Carpenter; DNB; Doyle BWI; Driver; ICB; Johnson FIDB; Peppin; Waters.
Colour Plate 128

ROFFEY, Maureen **b.1936**
Roffey studied at Hornsey College of Art and the RCA. She worked as a graphic designer in industry, but since 1971 has illustrated children's books for Bodley Head, some of which are written by her husband Bernard Lodge.
Books illustrated include: Halliwell: *Nursery Rhymes* (BH, 1972); B. Lodge: *Tinker, Tailor, Soldier, Sailor* (BH, 1976), *Rhyming Nell* (1979); J. Bennett: *Roger Was a Razor Fish* (1980), *Days Are Where We Live* (1980); B. Lodge: *Door to Door* (1980).
Books written and illustrated include: *Farming with Numbers* (BH, 1972); *A Bookload of Animals* (BH, 1973); (with B. Lodge) *The Grand Old Duke of York* (1975).
Bibl: ICB4; Peppin.

ROOKE, Noel **1881-1953**
See Houfe
Born on 30 December 1981 in Bedford Park, London (where he lived his whole life), Rooke was the son of Thomas Rooke, RWS, who had worked with Burne-Jones, Sydney Cockerell and Ruskin. He was educated at Lycée de Chartres and Godolphin Schools, and studied art at the Slade (1899-1903) and later at the Central School of Arts and Crafts under W.R. Lethaby and Edward Johnston. He was appointed teacher of book illustration at the Central School in 1905 and became Head of the School of Book Production in 1914.
In 1904 Rooke turned to wood engraving after he realized how badly his drawings were reproduced by the photographic process. He and Eric Gill* were both students of Edward Johnston, "who provided the immediate impetus to a revival of wood engraving which owed its initial inspiration to the designer-engravers Blake and Calvert rather than the facsimile illustration-engravers of the mid-Victorian period. The woodblock has always been used primarily for the illustration or decoration of books, and the twentieth-century revival of original wood engraving did not depart from that tradition." (Chamberlain, 1985.†) For thirty years Rooke taught wood engraving as a medium for the decoration of books. Among his pupils were Vivien Gribble*, Rachel Marshall (later Rachel Garnett*), Robert Gibbings*, John Farleigh*, Clare Leighton*, George Mackley*, and Lady Mabel Annesley*.
Rooke illustrated only a few books himself. He made some brilliant drawings of hands for Johnston's *Writing & Illuminating & Lettering* (1905), published by Hogg in the "Artistic Crafts" series, and he illustrated two others in that series. He illustrated Stevenson's *Travels with a Donkey* (1909) with watercolours, as he did his last book, the King Penguin on *Flowers of Marsh and Stream* (1946). His primary importance was as a teacher, an experimenter and one of the chief originators of the modern movement of wood engraving. Almost single-handedly, he reinstated the white line technique that Bewick and Blake had developed over one hundred years earlier. He was a founder member of the SWE in 1920 and in the same year was elected ARE. He gave a lecture to the Print Collectors' Club in 1925, later published as *Woodcuts and Wood Engravings* (1926), on the origin and character of the present school of engraving and cutting. In 1932 he married Celia Mary Fiennes*, herself a wood engraver. He died on 7 October 1953.
Books illustrated include: E. Johnston: *Writing & Illuminating & Lettering* (Hogg, 1905); D. Cockerell: *Bookbinding and the Care of Books* (Hogg); L. Hooper: *Hand-Loom Weaving* (Hogg); R.L. Stevenson: *Travels with a Donkey* (Chatto, 1909), *An Inland Voyage* (1913); R. Brooke: *The Old Vicarage, Grantchester* (Sidgwick, 1916); *The Nativity* (GCP, 1925); I.A. Williams: *Flowers of Marsh and Stream* (King Penguin, 1946).
Publ: *Woodcuts and Wood Engravings* (Print Collectors' Club, 1926).
Contrib: *Change; Impact; Open Window*.
Exhib: NEAC; RA; RE; NS; SWE.
Bibl: Eric Chamberlain: Introduction to *English Woodblock Illustration* (Cambridge: Fitzwilliam Museum, 1985); Justin Howes: "Noel Rooke: The Early Years", *Matrix 3* (1983): 118-25; *Times* obit.; Deane; Garrett; Hodnett; Peppin; Waters.
See illustration on page 14

ROSE, Sir Francis Cyril Stanley **1909-1979**

Born on 18 September 1909 at Moor Park, Farnham, Surrey, Rose was educated at a preparatory school in Eastbourne, before attending Beaumont College. He studied privately under Francis Picabia (1929-32). He served in the Royal Air Force during WW2 from 1940 to 1942 when he was invalided out.

He worked and lived in France for some years, becoming a member of a group of artists which included Gertrude Stein and Jean Cocteau. A landscape and portrait painter, stage designer, and textile designer, he exhibited widely, with a retrospective exhibition held in 1966 at the GLC London Gallery and the Royal Pavilion, Brighton. He designed textiles for the Cotton Board in the 1940s; acted as consultant to the Edinburgh Tapestry Company (1948-50); designed wallpaper; and produced the costumes and scenery for *Cupid and Psyche*, Sadler's Wells Ballet (1939), and *La Peri*, Monte Carlo Ballet (1946). He wrote a few books, and illustrated several, including two by his friend, Gertrude Stein.

He became 4th Baronet Rose in 1915; and died on 19 November 1979.

Books illustrated include: Byron: *Childe Harold's Pilgrimage* (1931); G. Stein: *The World Is Round* (1939), *Paris, France* (1940); Julian: *Common or Garden* (1946); E. Tollemache: *In the Light* (1948).

Books written and illustrated include: *Etoile de Mer* (1927); *The White Cow* (1945); *Your Home* (1945); *The Shadowy Pine Tree* (1946); *Drinking at Home* (1962).

Exhib: Redfern Gallery (1946); Gimpel Fils (1949, 1952); Moulton Gallery (1961); Upper Grosvenor Galleries (1967); retrospective London Gallery (1966).

Bibl: Sir Francis Rose: *Saying Life* (Cassell, 1962); Peppin; Waters; Who Was Who.

ROSE, Gerald Hembdon Seymour **b.1935**

Born on 27 July 1935 in Hong Kong, where he spent his childhood before returning to England, Rose studied at Lowestoft School of Art and the RA Schools (1955-59). He has taught at Blackpool College of Art, and at Maidstone College of Art since 1965. With his wife Elizabeth (née Pretty), who as a teacher was frustrated by the lack of reasonable picture books, he started writing and illustrating books for children: their first book was *How St. Francis Tamed the Wolf* (1958). Rose's apparently childlike drawings have a sophisticated sense of humour, and most are done in full colour, using gouache, crayon, coloured inks and coloured acetate film, though he has done a lot in black and white. He won the Kate Greenaway Award in 1960 for *Old Winkle and the Seagulls*, and the Premio Critici in Erba (Bologna 1979) for *Ahhh Said Stork*.

Books illustrated include: E. Rose: *How St. Francis Tamed the Wolf* (Faber, 1958), *Wuffles Goes to Town* (Faber, 1959), *Charlie on the Run* (Faber, 1961); C. Odell: *Mark and His Pictures* (Faber, 1962); E. Rose: *The Big River* (Faber, 1962); T. Hughes: *Nessie the Mannerless Monster* (Faber, 1964); I. Eberle: *Pete and the Mouse* (Abelard, 1964); P. Hughes: *The King Who Loved Candy* (1962); B. Ireson: *The Gingerbread Man* (Faber, 1963); E. Rose: *Good King Wenceslas* (Faber, 1964); L. Bourliaguet: *The Giant Who Drank from His Shoe* (1966); P. Hughes: *Baron Brandy's Boots* (1966); E. Rose: *The Sorcerer's Apprentice* (1966), *Tim's Giant Marrow* (Benn, 1966), *The Magic Suit* (Faber, 1966); L. Bourliaguet: *A Sword to Slice Through Mountains* (1967); L. Carroll: *Jabberwocky and Other Poems* (Faber, 1968); E. Lear: *The Dong with the Luminous Nose* (Faber, 1969); J. Kingston: *The Bird Who Saved the Jungle* (Faber, 1973); W. Horsbrugh: *The Bold Bad Bus* (BBC, 1973); L. Berg: *The Little Cat* (Penguin, 1974); E. Rose: *Mick Keeps a Secret* (1974), *Lucky Hans* (1976).

Books written and illustrated include: *Old Winkle and the Seagulls* (with E. Rose; Faber, 1960); *Punch and Judy Carry On* (with E. Rose; Faber, 1962); *St. George and the Fiery Dragon* (with E. Rose; Faber, 1963); *Alexander's Flycycle* (with E. Rose; Faber, 1967); *The Great Oak* (with E. Rose; Faber, 1970); *Ironhead* (1970); *Androcles and the Lion* (with E. Rose; Faber, 1971); *Trouble in the Ark* (1975); *Watch Out* (1977); *Ahhh Said the Stork* (1978); *The Tiger Skin Rug* (1979); *Polar Bear Takes a Holiday* (1980); *Rabbit Pie* (1980); *The Lion and the Mouse* (Methuen, 1988); *The Hare and the Tortoise* (Methuen, 1988); *The Raven and the Fox* (Methuen, 1988); *Wolf! Wolf!* (Methuen, 1988).

Bibl: CA; ICB3; Peppin.
Colour Plate 129

ROSOMAN, Leonard **b.1913**

Born on 27 October 1913 in Hampstead, London, Rosoman was educated at Deacons School, Peterborough, and studied at the King Edward VII School of Art, Durham University (1930-34), the RA Schools (1935-36) and the Central School of Arts and Crafts under Bernard Meninsky (1938-39). He has taught at Camberwell School of Art (1946-48 with John Minton*), Edinburgh College of Art (1948-56), Chelsea School of Art (1956-57), and RCA (1957-58). During WW2 he served in the Auxiliary Fire Service in London, illustrated books on firefighting (1943) and in 1944 was appointed an official war artist to the Admiralty. Since the war he has had many exhibitions, including several one-artist shows in London, the first at the St. George's Gallery (1946) and has exhibited in many cities throughout Britain, and in New York.

Rosoman illustrated one book before WW2, *My Friend Mr. Leakey* (1937), and taught life drawing at the Reimann School (1937-39). After the war he taught again and began contributing to magazines, including three superb portfolios for *Contact* in the 1940s, and illustrating books. He worked for the theatre, including the décor for ballets, and did murals for the Festival of Britain and in Edinburgh and elsewhere.

ARA (1960); RA (1969); OBE (1981).

Books illustrated include: J.B.S. Haldane: *My Friend Mr. Leakey* (Cresset Press, 1937); J. Avrach: Crooked Lane (Lunn, 1946); *Flower of Cities: A Book of London* (with others; Parrish, 1949); W. Mankowitz: *Make Me an Offer* (1952); C.L. Philippe: *Bubu of Montparnasse* (Weidenfeld, 1952); I. Serraillier: *Everest Climbed* (OUP, 1955); D. Suddaby: *The Moon of Snowshoes* (1956); A. Huxley: *Point Counterpoint* (Folio Society, 1958); R.L. Stevenson: *A Child's Garden of Verse* (BH, 1960); W. Collins: *The Woman in White* (NY: Limited Editions Club, 1964); *Oxford Illustrated Old Testament* (five vols., with others, OUP, 1968-9); L. Lee: *As I Walked Out One Midsummer Morning* (1969); A. Huxley: *Brave New World* (Folio Society, 1971).

Contrib: *Ballet; Contact; Far and Wide; Penguin New Writing; Radio Times*.

Exhib: FAS (1974); RA; St. George's Gallery; Leicester Galls; Leger Gallery.

Collns: IWM; NPG; Tate; V & A.

Bibl: Michael Middleton: "The Drawings of Leonard Rosoman", *Image* 3 (Winter 1950): 3-22; Amstutz 1; Driver; Folio 40; Jacques; Peppin; Ryder; Tate; Usherwood; Waters; Who.

Michael ROTHENSTEIN *The Country Child's Alphabet* by Eleanor Farjeon (Poetry Bookshop, 1924)

ROSS, Gunther Victor 1899-1963

Born Gunther Victor Russ in Berlin, he studied in Munich before coming to England in 1938. After WW2 he worked as a free-lance illustrator using a variety of techniques, including pen and ink and auto-lithography. He drew directly to the plate for *English Fashions*, the Puffin Picture Book, and the plates were then printed at the Baynard Press.

Books illustrated include: M. Black: *Two Explorers* (1947); J. Mortimer: *English Fashions* (Puffin Picture Books 76; Penguin, 1947); G.A. Sala: *Paris Herself Again* (1948); P. Pirbright: *Off the Beeton Track* (1949); C.G. Dobson: *A Century and a Quarter* (1951); J.T. Page: *Field Guide to British Deer* (1959).

Contrib: *Country Fair; Eagle; Lilliput; Strand.*

Bibl: Peppin; Who.

Colour Plate 130

ROSS, Tony b.1938

Born in London, Ross studied at Liverpool College of Art (1956-61). He worked in advertising before starting to teach at Manchester Polytechnic in 1965. An illustrator of children's books, he has done much of his work for the Andersen Press and Methuen. *Dr Monsoon Taggert's Amazing Finishing Academy* (1989) was short-listed for the Smarties Book Prize.

Books illustrated include: I. Grender: *Did I Ever Tell You?* (1977) and four others in series; P. Curtis: *Mr. Browser and the Brain Sharpeners* (1979) and three others in series; P. Gray and D. Mackay: *The Monkeys and the Moon* (1979), *The Monkeys and the Gardener* (1979); B. Stone: *The Charge of the Mouse Brigade* (1979); J. Russell: *The Magnet Book of Strange Tales* (1980); N. Lewis: *Hare and the Badger Go to the City* (1981); B. Stone: *The Tale of Admiral Mouse* (1981); J.K. Hooper: *Kaspar Klotz* (1982); E. Morcambe: *The Reluctant Vampire* (1982); J. Russell: *Book of Sinister Stories* (1982); A. Henri: *Rhinestone Rhino* (Methuen, 1989); A. Matthews: *Dr. Monsoon Taggert's Amazing Finishing Academy* (Methuen, 1989); J. Willis: *Dr Xargle's Book of Earth Hounds* (Andersen Press, 1989); H. Belloc: *The Bad Child's Book of Beasts* (Cape, 1991).

Books written and illustrated include: *Mr. Toffy* series (six titles, 1973); *Goldilocks and the Three Bears* (1976); *Hugo and the Oddsock* (Andersen Press, 1978); *The Enchanted Pig* (1982); *Hansel and Gretel* (Andersen Press, 1989); *I Want a Cat* (Andersen Press, 1989); *The Treasure of Cosy Cove* (Andersen Press, 1989).

Contrib: *Esquire; Punch; Time and Tide; Town.*

Bibl: Peppin.

ROTHENSTEIN, Michael b.1908

Born on 19 March 1908 in London, the younger son of Sir William Rothenstein, he studied at Chelsea Polytechnic, at the Central School of Arts and Crafts, and with Stanley Hayter in Paris (1949). He taught printmaking at Camberwell School of Art. His first commission was to illustrate Eleanor Farjeon's *The Country Child's Alphabet* in 1924 when he was only sixteen (see illustration on page 53). For this he produced twenty-six charming drawings and a colour cover. For his father's published portraits of *Men of the R.A.F.* (1942) he designed a simple but attractive book jacket in blues and black. His first one-artist show was held at the Mathiessen Gallery in 1938; his earliest prints were lithographs for an exhibition at the Redfern Gallery in 1948. He turned to copper plate etchings in Paris and became a leading printmaker in England, revolutionizing the use of wood and lino cuts. For an exhibition of his watercolours and hand-coloured woodcuts, held at the Royal Festival Hall, London, in 1989, Lynne Green wrote in the introduction to the catalogue, "Michael's reputation as an artist rests upon his achievement as a consummate printmaker who liberated the medium from traditional constraints of technique, scale and form."

He was elected ARA (1977); RA (1983); Hon. RE.

Books illustrated include: E. Farjeon: *The Country Child's Alphabet* (Poetry Bookshop, 1924); *Recording Britain* (four vols., OUP, 1946-9); R. Turnor: *Sussex* (Vision of England series; Elek, 1947).

Published: *Looking at Paintings* (Routledge, 1947); *Linocuts and Woodcuts: A Complete Printing Handbook* (Studio Vista, 1962); *Frontiers of Printmaking* (1966); *Relief Printing* (1970).

Kenneth ROWNTREE *Wessex* (About Britain No.2; Collins, 1951)

Contrib: *Motif (5, 10); Contact (11).*

Exhib: RA; RE; Mathiessen Gallery (1938); Redfern Gallery (1948); Bradford (retrospective 1972); ICA (retrospective 1974); Royal Festival Hall (1989).

Collns: BM; MOMA; Tate; V & A.

Bibl: *Michael Rothenstein: Paintings and Prints 1979-1989 [Exhibition at Royal Festival Hall]* (South Bank Centre, 1989); Waters; Who.

ROUNTREE, Harry 1878-1950

See Houfe

Books illustrated include (but see Peppin): S.H. Hamer: *Quackles, Junior* (Cassell, 1903), *Cheepy the Chicken* (Cassell, 1904); E. Nesbit: *Pug Peter* (1905); O. Morgan: *Mr Punch's Book of Birthdays* (1906); L. Carroll: *Alice's Adventures in Wonderland* (1908); A.D. Bright: *The Fortunate Princeling* (1909); B. Darwin: *The Golf Courses of the British Isles* (Duckworth, 1910); G. Davidson: *Tales from the Woods and Fields* (1911); B.S. Harvey: *The Magic Dragon* (1911); H.M. Batten: *Dramas of the Wild Folk* (1915); A.B. Paine: *The Arkansaw Bear* (1919); H. Fonhus: *The Trail of the Elk* (Cape, 1922); *Aesop's Fables* (Ward Lock, 1924); L. Carroll: *Through the Looking Glass* (Collins, 1928); A.J. Talbot: *The Pond Mermaid* (1929); H. Dearden: *A Wonderful Adventure* (Heinemann, 1929); L. Rountree: *Me and Jimmy* (Warne, 1929); O.

Bowen: *Beetles and Things* (Mathews & Marrot, 1931); L. Rountree: *Ronald, Rupert and Reg* (Warne, 1930), *Dicky Duck and Wonderful Walter* (Warne, 1931); E. Blyton: *The Children of Cherry Tree Farm* (1940); W. Humphries: *Wig and Wog* (Leicester: Ward & Wheeler, 1947).

Books written and illustrated include: *The Child's Book of Knowledge* (1903); *Rountree's Ridiculous Rabbits* (Stevenson, 1916), *Rabbit Rhymes* (Stevenson, 1917); *Birds, Beasts and Fishes* (Press Art School, 1929); *Jungle Tales* (Warne, 1934).

ROWNTREE, Kenneth b.1915

Born on 14 March 1915 in Scarborough, Yorkshire, Rowntree studied at the Ruskin School of Drawing, Oxford (1930-34 under Albert Rutherston*), and at the Slade (1934-35 under Randolph Schwabe*). A landscape painter, his first one-artist show was held at the Leicester Galleries in 1946. He taught painting at the RCA (1948-58), and was Professor of Fine Art at Durham University from 1959.

Rowntree illustrated a few books and produced some book jackets, including one for *The Village* by Marghanita Laski (Cresset Press, 1952). He contributed twenty-three paintings to the *Recording Britain* project, and produced coloured title pages for several volumes in the *About Britain* series, published for the Festival of Britain Office in 1951. Elected ARWS (1946).

Books illustrated include: *Recording Britain* (with others, four vols., OUP, 1946-9); A. Bott: *The Londoner's England* (with others; Avalon Press, 1947); G. Jones: *A Prospect of Wales* (King Penguin; Penguin Books, 1948); A. de Selincourt: *The Isle of Wight* (Vision of England series; Elek, 1948); R.H. Mottram: *Norfolk* (Vision of England series; Elek, 195?); G. Grigson: *Wessex* (About Britain No.2; Collins, 1951); S. Chaplin: *The Lakes to Tyneside* (About Britain No. 10; Collins, 1951); M. Laski: *The Village* (Cresset Press, 1952).

Bibl: Herbert Read: *Contemporary British Art* (Penguin Books, 1951; Waters.

RUSHTON, William b.1937

Born on 18 August 1937, Rushton was educated at Shrewsbury School, and was a contemporary there of Richard Ingrams. Rushton was a founder-editor of the satirical magazine *Private Eye* in 1961, and Ingrams was editor from 1963 to 1986. Rushton contributed many drawings to the magazine to illustrate articles, but later he did many "spot" cartoons (that is, funny drawings with or without captions.)

Rushton is an actor who made his stage début at the Marlowe Theatre in Canterbury in 1961 in *The Bed-Sitting Room*, written by Spike Milligan. He has appeared in other plays and in films, and became a television personality in the mid-1960s, when he appeared in the BBC satirical weekly programme, "That Was the Week That Was". He has written a number of books and illustrated them with cartoons and caricatures.

Books illustrated include: A. Waugh: *The Diaries of Auberon Waugh, 1976-1985* (Private Eye; Deutsch, 1985); D. Stewart and G. Campbell: *A Family at Law* (Fourmat Publishing, 1988).

Books written and illustrated include: *William Rushton's Dirty Book* (1964); *How To Play Football* (1968); *The Day of the Grocer* (1971); *The Geranium of Flut* (1975); *Superpig* (Macdonald, 1976); *Pigsticking; a Joy for Life* (Macdonald, 1977); *The Reluctant Euro* (1980); *The Filth Amendment* (1981); *W.G. Grace's Last Case* (Methuen, 1984); *Willie Rushton's Great Moments of History* (V & A, 1984); *The Alternative Gardener* (1986); *Marylebone Versus the Rest of the World* (1987).

Contrib: *Private Eye*.

Bibl: Richard Ingrams: *The Penguin Book of Private Eye Cartoons* (Penguin, 1983); Who's Who.

RUSS, Stephen 1919-1983

Russ was a designer of, and a writer and lecturer on, painted textiles, and at one time was an adviser on the subject to the United Nations. His work as an illustrator included much book jacket design for publishers such as Collins, Bodley Head and Penguin Books. His jacket for Fitter's book on *London's Birds* (Collins) shows the outlines of flying birds superimposed on a drawing of the west front of St. Paul's Cathedral. The success and popularity of his

William RUSHTON "Alarums at the Great Manhattan Gargantua Hotel" from *W.G. Grace's Last Case* (Methuen, 1984)

style is exemplified by the small group of covers he did for the Penguin Poets series, dating from the early 1960s. Some proofs and original designs are housed at the V & A.

Collns: V & A.

RUSSELL, Jim b.1933

Born in Walsall, Russell was educated at the Royal School, Wolverhampton, and studied at Birmingham College of Arts and Crafts (1951) before doing National Service in Singapore. He returned to art college and qualified as an art teacher, teaching for a year at a comprehensive school in Walsall. He became a free-lance artist, contributing to magazines and illustrating books, mostly for children. He draws in black and white with pen or brush, or in full colour.

Books illustrated include: W.H. Armstrong: *Sounder* (Puffin, 1973); P. Breinburg: *What Happened at Rita's Party* (1976); R. Leeson: *The Demon Bike Rider* (1976); M. Mahy: *David's Witch Doctor* (Watts, 1978); J. Mark: *Thunder and Lightning* (1976); J.P. Rutland: *Kites and Gliders* (1977); J. Webster: *Beauty and the Bus*

(Hart-Davis, 1978), *The Letter* (Hart-Davis, 1978), Missing (Hart-Davis, 1978), The Secret Wish (Hart-Davis, 1978), Copper (Hart-Davis, 1979), *The Man in the Mist* (Hart-Davis, 1979), *Poached Eggs* (Hart-Davis, 1979), *Pups!* (Hart-Davis, 1979); H. Morgan: *The Sketchbook Crime* (1980).
Contrib: *Radio Times*.
Bibl: Driver; ICB4; Peppin.

RUSSELL, Rachel fl.1920s
Illustrated Milton's *The English Sonnets* with wood engravings, the first book from the Swan Press in Chelsea.
Books illustrated include: J. Milton: *The English Sonnets* (Swan Press, 1926).

RUSSON, Mary Georgina b.1937
Born on 14 May 1937 in Birmingham, Russon first trained as a nurse, qualifying as an SRN. She did not like her job, however, and when she was twenty-three went to Birmingham College of Art (1960-63). She studied theatre design and then illustration and, after college, moved to London. Since 1965 she has illustrated books for children, mostly in pen and india ink, though she uses three-colour line drawings for book jackets.
Books illustrated include: L. Kendall: *The Mud Ponies* (1965); M. Lowe: *Tales of the Black and White Pig* (Faber, 1965); J. Macneill: *Tom's Tower* (1965); W. Mayne: *Pig in the Middle* (Hamilton, 1965); C.P. Thomson: *Boys from the Cafe* (1965); H. Treece: *The Bronze Sword* (1965); J. Macneill: *The Battle of St. George Without* (1966); W. Mayne: *Rooftops* (1966); J. Hope-Simpson: *Escape to the Castle* (1967); J. Tate: *Letters to Chris* (1967); M. Treadgold: *This Summer Last Summer* (1968); G. Trease: *The Runaway Serf* (1968); K. Fidler: *Mountain Rescue Dog* (1969); J. Macneill: *Goodbye Dove Square* (1969); B. Willard: *The Pocket Mouse* (1969); G. Lindsay: *The Dormice Who Didn't* (1980); M.J. Baker: *The Gift Horse* (1982).
Bibl: ICB3; Peppin.

RUTHERSTON, Albert Daniel 1881-1953
See Houfe
Born Albert Rothenstein (he changed his name to Rutherston in 1916) on 5 December 1881 in Bradford, younger brother of the painter Sir William Rothenstein, he was educated at Bradford Grammar School and studied at the Slade (1898-1902). He taught at Camberwell School of Art and at the Oxford School of Drawing, which was later taken over by the Ruskin School. He became Ruskin Master in 1929, a position he held for twenty years.
A painter in oils and watercolour, he first exhibited at NEAC in 1900, becoming a member in 1905. He worked with William Orpen, Spencer Gore and Walter Sickert, and in 1907 shared a studio from which the Camden Group sprang. He had his first one-artist exhibition in 1910 at the Carfax Gallery; he illustrated his first book in 1909; in 1911 he collaborated with Duncan Grant*, Macdonald Gill* and others in a mural for the dining room of the Borough Polytechnic in South London; and designed for the theatre and ballet (1912-14). He served in Palestine and Egypt in WW1 (1916-19) and after the war began to work for the Curwen Press, producing patterned paper and illustrating several books produced by the Press. He became a good friend of Claud Lovat Fraser*, introduced him to Oliver Simon of the Curwen Press, and collaborated with him on a poster for London Transport (1921). After Fraser's death that year, Rutherston and John Drinkwater produced a book devoted to their friend, appropriately and splendidly printed by the Curwen Press. In 1936, with Paul Nash*, Duncan Grant*, Vanessa Bell*, Graham Sutherland* and other artists, he founded the Pottery Group; and Rutherston experimented with painting on porcelain blanks. He was a strong supporter of the concept that there should be no distinction between "fine" and "commercial" artists, and in 1937 was registered as a qualified designer with the National Registry of Industrial Art Designers. He returned to oil painting after he met Patricia Koring, a young art student, who inspired him to paint several portraits of her. He was elected ARWS (1934); RWS (1942). He retired from the Ruskin School in 1949, and died in Switzerland on 14 July 1953.
Rutherston's typical book illustration is one drawn in a fine pen line, with cross-hatching to indicate shadows and transparent colour

Albert RUTHERSTON *A Box of Paints* by Geoffrey Smith (The Bookman's Journal, 1923)

washes added as highlights. He is best known as an illustrator for the Curwen Press, which included illustrations for a calendar produced for clients of the Press (1922); for a number of the booklets in the Ariel Poems series; and for *A Box of Paints*, a collection of poems by Geoffrey Scott (1923).
Books illustrated include (but see Max Rutherston, 1988†): P. Chase: *Peter Pan's Postbag* (Heinemann, 1909); G. Leblanc: *The Children's Bluebird* (Methuen, 1913); W. Shakespeare: *The Winter's Tale* (Heinemann, 1913); R. Firbank: *Inclinations* (Richards, 1916); L. Housman: *Angels and Ministers* (Cape, 1922); F.J.H. Darton: *The Good Fairy* (Wells Gardner, 1922); G. Scott: *A Box of Paints* (Bookman's Journal, 1923); W. Shakespeare: *The Tragedy of Cymbeline* (Benn, 1923); J. Drinkwater: *The Collected Poems* (Sidgwick, 1923); F. Bickley: *True Dialogues of the Dead* (Chapman, 1925); K. Colvile: *Mr. Marionette* (Chatto, 1925); E. Sitwell: *Poor Young People* (The Fleuron, 1925); K. Colvile: *Jason and the Princess* (Chatto, 1926); H. Wolfe: *Cursory Rhymes* (Benn, 1927); T. Hardy: *Yuletide in a Younger World* (Ariel Poems; Faber, 1927); T. Balston: *Sitwelliana* (Duckworth, 1928); E. Blunden: *Winter Nights* (Ariel Poems; Faber, 1928); R. Herrick: *Poetical Works* (Cresset Press, 1928); P. Quennell: *Inscription on a Fountainhead* (Ariel Poems; Faber, 1928); *The Weekend Book* (Nonesuch Press, 1928); A. Huxley: *Holy Face and Other Essays* (The Fleuron, 1929); *The Haggadah* Soncino Press, 1930); W. de la Mare: *To Lucy* (Ariel Poems; Faber, 1931); W. Shakespeare: *The Winter's Tale* (NY: Limited Editions Club, 1939).
Contrib: *Chapbook; Chatto & Windus Almanack (1926); Gypsy; Kynoch Press Diary (1933); New Broadside*.
Published: *Claud Lovat Fraser* (with John Drinkwater; Heinemann, 1923).
Exhib: NEAC; RWS; Carfax Gallery (1910/1913); Leicester Galls.

John RYAN "Captain Pugwash" strip from the *Radio Times* (23 June 1961)

(1921/1926/1934/1953); Stafford Gallery 1939); 180 New Bond Street (1988).
Collns: Tate; V & A; Ashmolean; Bryn Mawr College, Pa.
Bibl: R.M.Y. Gleadowe: *Albert Rutherston* (Benn, 1925); Max Rutherston: *Albert Rutherston* (180 New Bond Street [Gallery], 1988); Gilmour; Peppin; Tate; Waters.
Colour Plate 3

RYAN, John Gerald Christopher **b.1921**
Born on 4 March 1921 in Edinburgh, Ryan was educated at Ampleforth College, York (1930-43), and after army service during WW2 in Burma (1943-46), studied art at Regent Street Polytechnic, London (1946-48). He was Assistant Art Master at Harrow School (1948-54).
A free-lance illustrator of children's books and magazines since 1950, Ryan has been cartoonist for *Catholic Herald* since 1963. He has written and illustrated many books for children, and is probably best known for his strip-cartoon character, Captain Pugwash, which was first created in 1950 for *Eagle* magazine, and subsequently made many appearances on BBC TV as cartoon films and for eight years in *Radio Times*. Fourteen "Pugwash" titles have been published since 1956, by Bodley Head in hard back, and as Puffins by Penguin and by Collins in paperback. The Pugwash books have much humour and character delineation, with Pugwash himself a conceited but inept pirate, incapable of successful action except for the help of the boy hero.

Ryan claims to have been influenced by the work of Edward Ardizzone*, H.M. Bateman* and Ronald Searle*. He normally draws in black and white and then adds colour. He does his own book jackets and sleeves for video cassettes. The bulk of his original book illustration is held on permanent loan at the Centre for the Study of Cartoons in the University of Kent at Canterbury; and he has exhibited paintings at several galleries.
Books illustrated include: B.K. Wilson: *The Second Young Eve* (with Sylvia Stokeld*, Blackie, 1962).
Books written and illustrated include: *Captain Pugwash* (BH, 1956); *Pugwash Aloft* (BH, 1958); *Pugwash and the Ghost Ship* (BH, 1962), and eleven other titles in series; *The Story of Tiger-Pig* (1977); *Dodo's Delight* (Hamlyn, 1977); *Doodle's Homework* (Hamlyn, 1978); *Tiger-Pig at the Circus* (1978); *Crockle Saves the Ark* (1979); *Crockle Takes a Swim* (1980); *All Aboard* (twelve "Noah's Ark" stories; Hamlyn, 1980-3); *Crockle Adrift* (1981); *Crockle and the Kite* (1981); *The Floating Jungle* (1981); *Frisco & Fred* (Glasgow: Drew, 1985); *Frisco & Fred and the Space Monster* (Drew, 1986).
Contrib: *Catholic Herald; Eagle; Girl; Radio Times.*
Exhib: RA; Royal Pavilion, Brighton; Trafford Gallery; Ice House, Holland Park (1983); Royal Festival Hall (1984).
Collns: University of Kent at Canterbury.
Bibl: Driver; Peppin; Who; IFA.
Colour Plate 131

SAINSBURY, Hester b.1890?

Hester Sainsbury was the eldest of four children of Harrington and Maria (née Tuke) Sainsbury. There is no evidence that she received any formal art training, though she was involved with some artists in the Omega circle in the years 1915-18, and was one of the group which clustered around the painter, Nina Hamnett*. Sainsbury exhibited wood engravings at the SWE for the first time in 1921 and was a member from 1926 to 1932. In 1921 *Holy Women* was published, a small collection of Sainsbury's poems, illustrated by twelve of her woodcuts. This was the first book of the Favil Press, co-founded by her brother Philip Sainsbury in 1921 (he was later also the co-founder of the Cayme Press) and she illustrated three other publications for the Favil and Cayme presses. Her best work, however, was probably done for *Eastern Love* (1927-30), a twelve-volume work published by John Rodker, which contains forty-eight of her copper engravings. She also had two commissions from the Golden Cockerel Press, and in the late 1920s started an association with Haslewood Books, which became a relationship with Frederick Etchells, the Vorticist painter and publisher, who was co-founder of that press. She illustrated four books issued by Haslewood with her engravings, her last in 1930; her wood engravings for *Eve's Legend* (1928) are hand coloured, and Tucker† believes that these represent "the peak of Hester Sainsbury's work". She did at least one book jacket, for Henry Williamson's *Tarka the Otter* (Putnam's, 1927). In 1932 she became Etchells' second wife, and there is no record of her producing any engravings after that date.

Books illustrated include (but see Tucker†): E.P. Mathers: *Eastern Love* (twelve vols., Rodker, 1927); G. Savile: *The Lady's New-Years-Gift* (Cayme Press, 1927); J. Taylor: *A Dog of War* (Haslewood Books, 1927); *The Ladies' Pocket Book of Etiquette* (GCP, 1928); Lord Holland: *Eve's Legend* (Haslewood Books, 1928); P. Morand: *Earth Girdled* (Knopf, 1928); Ovid: *The Heroycall Epistles* (Cresset Press, 1928); H.C. Andersen: *Hans Andersen's Tales* (Haslewood Books, 1929); *Lucina Sine Concubitu*

(GCP, 1930); J. Taylor: *Tales from the Brothers Grimm* (Haslewood Books, 1930).
Books written and illustrated include: *Holy Women, and Other Poems* (Favil Press, 1921); *Meanderlane* (Cayme Press, 1925); *Noah's Ark* (Cayme Press, nd).
Contrib: *Woodcut*.
Bibl: Peter Tucker: "Hester Sainsbury: A Book-Illustrator of the 1920s", *Private Library*, 4S., v.5, no.1 (Autumn 1990); Peppin; Sandford.

SANDERSON, Ivan Terence b.1911

Born on 30 January 1911 in Edinburgh, Sanderson spent his early childhood in Scotland, then lived in England and France. He was educated at Eton and Cambridge University, graduating in 1931. He has travelled widely, first as a boy spending holidays on a relative's yacht, then going to East Asia on his own, getting specimens for the British Museum (Natural History). In 1932 he was leader of a scientific expedition to West Africa, and went to the West Indies in 1936 to study animal distribution. During WW2, he served in Naval Intelligence, and transferred to the Ministry of Information in New York in 1947. He became a permanent resident in the United States, started doing talks on radio and television, and founded a small private zoo in New Jersey. His books record his travels and his zoological work.
Books written and illustrated include: *Animal Treasure* (Macmillan, 1937); *Living Treasure* (Hamilton, 1941); *Caribbean Treasure* (Hamilton, 1942); *Inside Living Animals* (Pilot Press, 1947); *How To Know the American Mammals* (NY: New American Library, 1951); *Silver Mink* (Boston: Little, 1952); *Living Mammals of the World* (Hamilton, 1955).
Bibl: ICB.

SANDFORD, Lettice b.1902

Born Lettice Rate in St. Albans, she studied at the Byam Shaw and Vicat School of Art, Kensington, and then at the Chelsea Polytechnic (1926-29) under Robert Day and Graham Sutherland*. She was primarily an engraver and illustrated a number of books for the Boar's Head, Golden Hours, and Golden Cockerel Presses of which Christopher Sandford, whom she married in 1929, was director. She was much influenced by Blair Hughes-Stanton* whose *Comus* was published by the Gregynog Press in 1931, and his work tranformed her engravings for the Boar's Head. Though Hughes-Stanton might be the "prince" of the new movement, nevertheless "the sensuous line with which Lettice engraved the naked girls (which were to fill Christopher [Sandford]'s books over the next few years) traced more exactly the perfection of the feminine form than did Hughes-Stanton's often contorted eye, but his line remains her ideal." (Chambers, 1985†). The illustrations which she did after WW2 were mostly drawings and do not have the same clarity and sharpness of the engravings.
She was awarded a diploma at the 1937 International Exhibition of Art and Industry in Paris.
Books illustrated include: C. Sandford: *The Magic Forest* (Chiswick Press, 1931), *Clervis and Belamie* (Boar's Head Press,

Lettice SANDFORD *Dreams and Life* by G. de Nerval (Boar's Head Press, 1933)

1932); D.H. Booth: *Kleinias* (Boar's Head Press, 1932); E. Spenser: *Thalamos* (Boar's Head Press, 1932); M. Lyle: *The Virgin* (Boar's Head Press, 1932); E.M. Cox: *Sappho* (Boar's Head Press, 1932); G. de Nerval: *Dreams and Life* (First Editions Club/Boar's Head Press, 1933); B. Bingley: *Tales of the Turquoise* (Boar's Head Press, 1933); N. Morland and P. Barwell: *Salome Before the Head of St. John* (Boar's Head Press, 1933); C. Marlowe: *Hero and Leander* (Golden Hours Press, 1933); Apuleius: *Cupid and Psyches* (GCP, 1934); B. Bingley: *The Painted Cup* (Boar's Head Press, 1935); E. Lescasis: *The Golden Bed of Kydno*(GCP, 1935); *The Song of Songs* (1936); *The Golden Cockerel Greek Anthology*

(GCP, 1937); L. Cranmer-Byng: *Tomorrow's Star* (GCP, 1938); C. Whitfield: *Lady from Yesterday* (GCP, 1939); *Aucassin and Nicolette* (Folio Society, 1947); *Arabian Love Tales* (Folio Society, 1949); Sir T. Malory: *Lancelot and Guinevere* (Folio Society, 1953).

Books written and illustrated include: *Roo, Coo and Panessa* (Muller, 1938); *Coo My Doo* (Muller, 1943).
Publ: *Straw Work and Corn Dollies* (illus. by Philla Davis; Batsford, 1964).
Contrib: *ILN*.
Bibl: David Chambers: "Boar's Head & Golden Hours", *Private Library*, 3s., 8, no. 1 (Spring 1985), 2-33; Chambers: "Lettice Sandford's Engravings", *Matrix* 4 (1984): 89-92; Folio 40; Garrett 1 & 2; Peppin; Sandford.

SATORSKY, Cyril fl. 1960-1971
Hodnett declares Satorsky to be "the most impressive of the twenty-two illustrators of *The Oxford Illustrated Old Testament* (1968-9)... His designs have an intensity, a directness, and a symbolic richness that set them apart from the rest." His *Sir Gawain and the Green Knight* (1971), with the same bold techniques being used for the double-page spread of frontispiece and title page and the other illustrations, is equally successful.
Books illustrated include: M. Shamir: *Why Ziva Cried on the Feast of First Fruits* (Abelard, 1960); B. Cooke: *My Daddy and I* (Abelard, 1963); *The Oxford Illustrated Old Testament*, five vols., with others, OUP, 1968-9); *Sir Gawain and the Green Knight* (NY: Limited Editions Club, 1971).
Books written and illustrated include: *A Pride of Rabbis* (Baltimore: Aquarius, 1970).
Bibl: Hodnett.

SCARFE, Gerald b.1936
Born on 1 June 1936 in St. John's Wood, London, Scarfe's childhood was punctuated by long periods of illness from asthma. He attended St. Martin's School of Art (where he was a fellow student of Ralph Steadman*) and the London School of Printing. His first cartoons were accepted by the *Daily Sketch* in 1957 and around this time the *Evening Standard* was taking five or six a week; in 1960 *Punch* accepted its first from him, and he did several covers for that magazine.
It was in the new weekly satirical magazine, *Private Eye*, which started in 1962, that Scarfe found his ideal medium. Having developed into a caustic observer of life in England, he produced a series of harsh covers and many other illustrations for the paper, attacking all the public figures around him, such as David Frost, Lord Snowdon and Mick Jagger. His drawings show a Swiftian hatred for the human state, and his characters are represented as fat or skeletal, and often involved in some excretory function. In an unpublished article, the art critic John Berger wrote "Scarfe is that very rare thing, a natural satirical draughtsman. . . Gillray was one . . . The supreme examples are Goya and Daumier . . . what is essential to them is that they draw faithfully — and with pain — the ghosts that crowd in upon them." (Scarfe, 1986†).
The leading cartoonist on the *Sunday Times* for many years, Scarfe has acted as a graphic journalist during the Six-Day war in the Middle East, in Vietnam, and in India. He visited the US and did covers for *Time* magazine and travelled with Robert Kennedy for *Fortune*. Other commissions have been for posters and record sleeves; and the designs and costumes of theatrical productions, including "What the Butler Saw" (Oxford, 1978), "Who's a Lucky Boy" (Manchester, 1985), and "Orpheus in the Underworld" for the English National Opera (1985).
Books illustrated include: R. West: *Sketches from Vietnam* (Cape, 1968); J. Asher: *Jane Asher's Party Cakes* (Pelham, 1982); *Pink Floyd: The Wall* (Avon Books, 1982); B. Mooney: *Father Kissmass and Mother Claws* (Hamilton, 1985).
Books written and illustrated include: *Gerald Scarfe's People* (Owen, 1966); *Indecent Exposure* (p.p., 1973); *Expletive Deleted* (p.p., 1974); *Gerald Scarfe* (T & H, 1982); *Scarfe by Scarfe* (Hamilton, 1986); *Scarfe's Line of Attack* (Hamilton, 1988); *Scarfeland: A Lost World of Fabulous Beasts and Monsters* (Hamilton, 1989).
Contrib (but see Scarfe, 1986†): *Daily Mail; Economist; Esquire;*

Lettice SANDFORD *Song of Songs* (Golden Cockerel Press, 1936)

Books written and illustrated include: *Rome: Fragments in the Sun* (Hutchinson, 1950); *Venice: The Lion and the Peacock* (Hale, 1952).
Published: *Alphabets* (Batsford, 1954).
Contrib: *Far & Wide; Motif (4); Our Time; Radio Times; Saturday Book.*
Exhib: RA; RBA.
Collns: V & A; Tate; IWM; RIBA.
Bibl: Amstutz 2; Driver; Jacques; Peppin; Usherwood; Waters; Who.

SCHWABE, Randolph **1885-1948**
See Houfe
Born 9 May 1885 near Manchester, Schwabe was educately at Hemel Hempstead and studied at RCA (1899), the Slade (1900-05), and at the Académie Julian, Paris (1906). A draughtsman, watercolourist and etcher, Schwabe exhibited with NEAC from 1909 and was a member 1917; LG (1915); ARWS (1938); RWS (1942). He was an official war artist during WW1, the only artist commissioned to cover work on the land in Britain. After the war he taught at Camberwell, Westminster, RCA, and then became Slade Professor and Principal of the Slade in 1930, succeeding Henry Tonks. During WW2, recognized as a fine architectural draughtsman, he was commissioned to record war damage in Britain.
Schwabe illustrated a number of books in pen and ink, and his drawings are precise and meticulous. He was first employed in 1919

Fortune; New Scientist; Private Eye; Punch; Sunday Times; Time.
Exhib: Horse Shoe Wharf Club (1966); Grosvenor Gallery (1969); Royal Festival Hall (1983/4); Beetles (1988).
Bibl: Gerald Scarfe: *Scarfe by Scarfe* (Hamilton, 1986); Bateman; Feaver.

SCARFE, Laurence **b.1914**
Born on 4 February 1914 in Idle, near Bradford, Scarfe studied at RCA (1933-37) and then taught at Bromley School of Art (1937-39) and Central School of Arts and Crafts (1945-70). He worked as a free-lance artist, contributing to several magazines including *Radio Times*, designing for BBC, GPO and COI, and producing posters for the Curwen Press and London Transport. He was art editor and designer to the *Saturday Book* (and his illustrations are included in at least ten of them); and he wrote and illustrated his own travel books and books on the Italian Baroque. He won a prize for architecture as a student at the RCA and his book illustrations often contain buildings as the main or constituent feature and show his continued interest in the subject. He has lectured at Brighton Polytechnic.
Primarily a painter, muralist and designer, Scarfe has exhibited in London and the provinces, in US and Europe. He did murals for the Festival of Britain (1951) and for the S.S. *Orcades*, and ceramic designs for Wedgwood and other manufacturers. ARCA; FSIA; Member of the Society of Mural Painters.
Books illustrated include: N. Gubbins: *Dear Pig* (Dobson, 1948); *Three Ghosts* (Sampson Low, 1948).

Laurence SCARFE *Venice: The Lion and the Peacock* Robert Hale, 1952)

Randolph SCHWABE *A Summer's Fancy* by Edmund Blunden

by Cyril Beaumont, the writer, balletomane and publisher, to design wooden figures based on dancers in Diaghilev's ballet, and in the ten years 1921-31 decorated and illustrated several books issued by the Beaumont Press. He designed initial letters, title pages, full page illustrations and many smaller decorations. He died in Helensburgh, Dunbarton, 19 September 1948.

Books illustrated include: W. de la Mare: *Crossings* (Beaumont Press, 1921); C.W. Beaumont: *A Manual of the Theory and Practice of Classical Theatrical Dancing* (Beaumont, 1922); O. Wilde: *After Berneval: Letters of Oscar Wilde to Robert Ross* (Beaumont, 1922); E. Blunden: *To Nature* (Beaumont, 1923); A. Symons: *The Café Royal* (Beaumont, 1923); J. Clare: *Madrigals and Chronicles* (Beaumont, 1924); E. Blunden: *Masks of Time* (Beaumont, 1925); F.M. Kelly: *Historic Costume 1490-1790* (Batsford, 1925); *The Curwen Press Almanack* (The Fleuron, 1926); R. Lloyd: *The Actor* (Beaumont, 1926); C.W. Beaumont: *The First Score* (Beaumont, 1927); H. Williamson: *The Wet Flanders Plain* (Beaumont, 1929); C.W. Beaumont: *Theory and Practice of Allegro in Classical Ballet* (Beaumont, 1930); E. Blunden: *A Summer's Fancy* (Beaumont, 1930); F.M. Kelly: *A Short History of Costume and Armour 1066-1800* (Batsford, 1931); E. Blunden: *To Themis* (Beaumont, 1931); W.S. Maugham: *Of Human Bondage* (Heinemann, 1936); H.E. Bates: *The Tinkers of Elstow* (p.p., 1946).
Contrib: *Apple; Fanfare; Oxford Almanack.*
Exhib: NEAC; LG; RSA; RWS; Arts Council (memorial exhib., 1951).
Collns: Ashmolean; IWM; Tate; V & A.
Bibl: Cyril W. Beaumont: *The First Score: An Account of the Foundation and Development of the Beaumont Press (1927);* Robin Stemp: *"Artists in War and Peace: Randolph Schwabe", The Artist* (April 1989): 21-23; Eva White: *An Introduction to the Beaumont Press* (V & A, 1986); DNB; Harries; ICB; Peppin; Tate; Waters.

SCOTT, David Henry George b.1945
Born on 29 January 1945 in Edinburgh, Scott was educated at Eton and studied at the Byam Shaw School of Art (1963-66) and the RA Schools (1966-67). A landscape painter and illustrator, he has exhibited at the RA and elsewhere, and illustrated children's books for Walker and Methuen.
Exhib: RA; RBA; RP; Rutland Gallery.
Collns: Dublin.
Bibl: Who.

SCOTT, Sir Peter Markham 1909-1989
Born on 14 September 1909 in London, the son of Captain Robert Falcon Scott, the famous explorer who died in the Antarctic in 1912, and sculptress, Kathleen Bruce, Scott was educated at Oundle School and Trinity College, Cambridge, where he shifted his studies from natural sciences to art in his final year. He then did postgraduate studies in art at the State Academy School, Munich, and for two years at the RA Schools. His father had written to his mother from a tent in Antarctica, instructing her to "make the boy interested in Natural History." Drawing and animals were among his earliest enthusiasms and both were encouraged at Oundle School. At Cambridge he became a wildfowler and made pictures of his quarry, including some watercolours which were published in *Country Life* in August 1929. His first exhibition, also watercolours of wildfowl, was held at Bowes and Bowes in Cambridge. Scott soon abandoned hunting to become one of the world's most eminent conservationists.

After leaving art school, Scott had to earn a living from his paintings, and he was soon a commercial success. As Hammond writes, there was a "very strong emotional content [in] Peter Scott's pre-war painting. He was not scientifically or coldly recording on canvas the behaviour of wildfowl. He was rather recording experiences, no two of which were the same, except in that he was moved by seeing and hearing wildfowl." Each year from 1933 to 1939 Ackermann's Gallery in London held an exhibition of his work; and he also exhibited at the RA most years after 1933. During the 1930s Ackermann's sold thirty-one limited editions of Scott prints; one print published by the Medici Society sold more than 350,000 copies. This print, "Taking to Wing", was used as an illustration in Scott's first book, *Morning Flight* (1935). The illustrations show a variety of techniques from realistic bird portraiture to almost abstract paintings.

During WW2 Scott served in the Royal Naval Volunteer Reserve with distinction (being awarded the DSC in 1943), and appeared on a BBC television programme on artists and war. This was the first step in a successful broadcasting career which stretched over several decades. After the war he took up sailing again (he had won a bronze medal in the Olympics in 1936) and was President of the International Yacht Racing Union (1955-69); he also became an expert glider. He took part in many expeditions, including exploration of the Canadian arctic and led several ornithological expeditions to Iceland and the Galapagos and elsewhere. In 1946 he took a step of immense significance for national and international conservation by establishing the Severn Wildfowl Trust at Slimbridge. His involvement with wildlife conservation expanded, particularly the World Wildlife Fund which took up much of his time in the 1960s and 1970s, and he was knighted for his services to conservation in 1973. Despite his numerous other duties, he always managed to continue his painting, many works being reproduced as greeting cards, prints and in other commercial ways. He wrote eighteen books on natural history, and illustrated some twenty or so by other writers. His autobiography, *The Eye of the Wind*, was published in 1961.

His many awards include MBE (1942), DSC (1943), CBE (1953), Kt. (1973), CH (1987), FRS (1987). In February 1989 he was named "Conservationist of the Year" by the American *Wildlife Art News*; and was presented with the Conservation Medal of the National Zoological Park in Washington D.C. in May 1989. He died on 29 August 1989.

Books illustrated include: E.H. Young: *A Bird in the Bush* (Country Life, 1936); M. Bratby: *Grey Goose* (Bles, 1939), *Through the Air* (Country Life, 1941); J. Fisher: *A Thousand Geese* (Collins, 1953); I. Pitman: *And Clouds Flying* (Faber, 1947); J. Delacour: *The Waterfowl of the World* (four vols., Country Life, 1954); H. Boyd: *Wildfowl of the British Isles* (Country Life, 1957); P. Scott: *Animals in Africa* (1962); P. Gallico: *The Snow Goose* (Joseph, 1969); S. McCullagh: *Where the Wild Geese Fly* (Hart-Davis, 1981); M. Ogilvie: *The Wildfowl of Britain and Europe* (with N.W. Cusa; OUP, 1982).
Books written and illustrated include: *Morning Flight: A Book of Wildfowl* (Country Life, 1935); *Wild Chorus* (Country Life, 1938); *The Battle of the Narrow Seas* (Country Life, 1945); *A Coloured Key to the Wildfowl of the World* (Slimbridge: Wildfowl Trust, 1957; a black and white version first appeared in 1946); *The Eye of*

the Wind (Hodder, 1961); *Observations of Wildlife* (Oxford: Phaidon Press, 1980); *Travel Diaries of a Naturalist* (two vols., Collins, 1983-5).
Contrib: *Country Life*.
Exhib: Ackermann; RA.
Bibl: *New York Times:* 31 August 1989 (obit.); Peter Scott: *The Eye of the Wind* (Hodder, 1961); CA; Hammond; Waters; Who's Who.

SCOTT, William George **1913-1989**
Born on 15 February 1913 in Greenock, Scotland, Scott was brought up in Northern Ireland. He studied at Belfast College of Art (1928-31) and the RA Schools (1931-35). He was a painter of still lifes, landscapes and figures, and his first single-artist show was held at the Leger Gallery in 1942. After serving in the army during WW2 he illustrated, with lithographs, *Soldiers' Verse* (1945) in Muller's "New Directions" anthologies — other illustrators of this series included Michael Ayrton* and Edward Bawden*. He taught at Bath Academy (1946-56); became a member of the London Group (1949) and painted in St. Ives for a number of years. By the 1960s his work had become increasingly abstract, though he once described himself as belonging to the generation between the representational and non-representational phases of modern art. He continued his career as a painter, exhibiting at the Venice Biennale (1958) and the Sao Paulo Biennale (1961), where he won the inter-

Sue SCULLARD Proof of engraving for *Henry VI Part III* by William Shakespeare (Folio Society, 1988)

national critics' prize, and being honoured in several retrospective exhibitions. He was elected ARA (1977); RA (1984); and was awarded CBE. He will probably be best remembered for his still lifes of objects such as eggs, bottles, pots and pans laid out on a kitchen table. He died near Bath of Alzheimer's disease on 28 December 1989.
Books illustrated include: P. Dickinson: *Soldiers' Verse* (Muller, 1945).
Exhib: Tate; RA; LG; Leger Gallery; Leicester Galls; Hanover Gallery; retrospectives in Zurich (1959), Hanover (1960,61,62), Berne (1963), Belfast (1963).
Collns: Tate; MOMA.
Bibl: R. Atley: *William Scott: Art in Progress* (Methuen, 1963); *St. Ives 1939-64: Twenty Five Years of Painting, Sculpture and Pottery* (Tate Gallery, 1985); *William Scott: Paintings, Drawings and Gouaches* (Tate Gallery, 1972); Tate; Waters; Who.

SCOTT-MOORE, Elizabeth **b.1902**
Born on 7 October 1902 in Dartford, Kent, Scott-Moore (née Brier) was educated at Dartford County School for Girls and, while at school, attended Gravesend School of Art as a part-time student before she went on to Goldsmiths' College School of Art and the Central School of Arts and Crafts. After travel in France and Italy, she returned to England and established a studio in London at Lincoln's Inn Fields with two other artists. They were soon working for many London publishers, including Oxford University Press, Warne, Medici Society and Harrap. Scott-Moore has illustrated numerous children's books, but sadly reports that many of the originals were destroyed during the Blitz in WW2. She has exhibited widely, her latest one-artist show being held in Datchet, near Windsor, in April 1990. Some of her flower paintings have been reproduced as greetings cards by the Medici Society and other publishers. She was elected NEAC and RWS.
Exhib: RA; RWS; RP; NEAC.
Bibl: Who; IFA.

SCULLARD, Susan Diane **b.1958**
Born in Chatham, Kent, Scullard was educated at the Chatham Grammar School. From there she did a foundation course at Chelsea School of Art in 1976, studied for a BA in illustration at Camberwell School of Arts and Crafts (1977-80), and then did an MA in Graphic Design at the RCA (1980-83). She was taught to engrave at the RCA by Yvonne Skargon*. She became a free-lance illustrator in 1983, working as a book and commercial illustrator, using various media, including watercolour, and engraving on wood, lino and vinyl. Her work includes watercolour illustrations for three children's books she has written, and for topographical books for Robert Hale; and decoration of mugs, table mats and enamel boxes. Elected SWE.
Books illustrated include: W. Scott: *The Bride of Lammermoor* (Folio Society, 1985); R. Tomalin: *Little Nasty* (Faber, 1985); G. Chaucer: *The Canterbury Tales* (with others, Folio Society, 1986); W. Shakespeare: *Henry VI Parts 1, 2, and 3* (Folio Society, 1988).
Books written and illustrated include: *Miss Fanshawe and the Great Dragon Adventure* (Macmillan, 1986); *The Flyaway Pantaloons* (Macmillan, 1988); *The Great Round-the-World Balloon Race* (Macmillan, 1990).
Exhib: SWE.
Bibl: Brett; Folio 40; IFA.

SCULLY, William **fl. 1930-1940s**
A cartoonist for *Punch* in the late 1930s and 1940s, Scully has been regarded as a disciple of Peter Arno. Price writes that he "filled his space with exuberant and decorative lines and often with objects which, while unnecessary to the joke, gave pleasure by their appearance. His humour, even when topical, had often something oblique and eerie about it."
Contrib: *Punch*.
Bibl: Price.

SEABY, Allen William **1867-1953**
Born on 26 May 1867 in London, the son of a cabinet maker and carpenter, Seaby moved with his family to Godalming, Surrey, was educated at the Godalming Board School and became a pupil-

Edward SEAGO *The Rabbit Skin Cap* by George Baldry (Collins, 1939)

teacher there at the age of fourteen. He then attended the Borough Road Teacher Training College in Isleworth, and when qualified, took a teaching position in Reading where he spent the rest of his life. He studied at Reading School of Art, becoming a member of staff in 1899 under F. Morley Fletcher, who pioneered Japanese woodcut printing in Britain. Seaby became an expert printmaker, one of his prints being used on the cover of the *Studio* in 1927. His prints were exhibited in London, the US and Milan, where he won a gold medal in 1906. He became Head of the School at Reading in 1910 and, when the College became a university, became Professor of Fine Art (1920-33).

Seaby wrote and illustrated books on the techniques of art, and illustrated children's books and bird books. He used watercolour, pen and ink, linocuts and wood engravings for his work. After his retirement in 1933, he continued to make prints and to paint. His grandson, Robert Gillmor*, has recalled watching his grandfather making colour prints from his woodcuts. He died on 28 July 1953.

Books illustrated include: F.B.B. Kirkman: *British Birds* (twelve vols, Nelson, 1910-13); W.B. Thomas: *The English Year* (Jack, 1913); P. Cumming: *Doney* (Country Life, 1934); W.B. Thomas: *The Way of a Dog* (Joseph, 1948).

Books written and illustrated include: *Skewbald the New Forest Pony* (Black, 1923); *Art in the Life of Mankind* (four vols., Batsford, 1928-31); *Exmoor Lass* (Black, 1928); *The Birds of the Air* (Black, 1931); *Omrig and Nerla* (Harrap, 1934); *Dinah the Dartmoor Pony* (Black, 1935); *British Ponies* (Black,1936); *Sons of Skewbald* (Black, 1937); *Sheltie* (Black, 1939); *The White Buck* (Nelson, 1939); *The Ninth Legion* (Harrap, 1943); *Purkess the Charcoal Burner* (Harrap, 1946); *Alfred's Jewel* (Harrap, 1947); *Mona the Welsh Pony* (Black, 1948); *Pattern Without Pain* (Batsford, 1948);

Our Ponies (Puffin Picture Books #78, 1949); *Blondel the Minstrel* (Harrap, 1951).

Published: *Drawing for Art Students and Illustrators* (Batsford, 1921); *Colour Printing with Linoleum and Wood Blocks* (Dryad, 1925).

Bibl: Hammond; Peppin; Waters.

SEAGO, Edward Brian 1910-1974

Born on 31 March 1910 in Norwich, Seago suffered from a heart ailment (later diagnosed as paroxysmal tachycardia) throughout his life from early childhood, and his education at Norwich Grammar School and South Lodge Preparatory School in Lowestoft was broken by frequent attacks. His mother was an amateur painter in watercolours and he showed an interest in painting from an early age and, during his many periods of convalescence, busied himself with his paints and brushes while propped up in bed. By the time he was ten years old, Seago had returned home to continue his education at a day school and had decided that he was going to be a painter, and when he was thirteen he received private painting lessons from Bernard Priestman, a local Royal Academician.

Seago painted landscapes, horses, circus life and gypsies, and portraits, which included the war leaders during WW2. He was primarily a painter but some of these paintings were done for books. He painted scenery for several theatrical productions in the West End, his best work being perhaps for *The Brass Butterfly* (1958). He was "taken up" by members of the Royal Family, doing portraits of some of them including King George VI, and painted at Sandringham and on the Royal yacht "Britannia". He lived most of his life in Norfolk and had very strong affection for the land and people of East Anglia, but he travelled with circuses in Britain and

abroad 1928-33, and after WW2 spent much time in Morocco and Sardinia. He died in London of a brain tumour on 19 January 1974. He was elected RBA (1945), ARWS (1957); RWS (1959).

Books illustrated include: L.R. Haggard: *I Walked by Night* (Nicholson, 1935); J. Masefield: *The Country Scene* (Collins, 1937), *Tribute to Ballet* (Collins, 1938); G. Baldry: *The Rabbit Skin Cap* (Collins, 1939); J. Masefield: *A Generation Risen* (Collins, 1942); E.B. Wade: *There Is an Honour Likewise* (with John Kenney*; 1948).

Books written and illustrated include: *Circus Company* (Putnam, 1933); *Sons of Sawdust* (Putnam, 1934); *Caravan* (Collins, 1937); *Peace in War* (Collins, 1943); *High Endeavour* (Collins, 1944); *With the Allied Armies in Italy* (Collins, 1945); *A Canvas to Cover* (Collins, 1947); *Tideline* (Collins, 1948); *With Capricorn to Paris* (Collins, 1956).

Contrib: *Field; Punch*.

Exhib: RA; RWS; RP; RBA; ROI; RCamA; Arlington Gallery (1929); Sporting Gallery (1933-); Marlborough Fine Art (incl. memorial exhibition 1974); Colnaghi's (1945-); Richard Green's Gallery (1981); and many galleries in England, Europe and N. America.

Collns: IWM.

Bibl: Jean Goodman: *Edward Seago: the Other Side of the Canvas* (Collins, 1978); James W. Reid: *Edward Seago: the Landscape Art* (Sothebys' Publications, 1991); E.B. Seago: *A Canvas to Cover* (Collins, 1947); Seago: *A Review of the Years 1953-1964* (Collins, 1965); Horace Shipp: *Edward Seago: Painter in the English Tradition* (1952); Peppin; Titley; Waters.

SEARLE, Ronald William Fordham **b.1920**
Born in Cambridge, Searle studied at Cambridge School of Art (1936-39). He served in the Army during WW2, was captured by the Japanese and spent more than three years in a Japanese prisoner-of-war camp, some of which time was used to help build the Burma railway. A record of his captivity was published in 1946 as *Forty Drawings*.

His first cartoons appeared in the *Cambridge Daily News* and *Granta* (1935-39), but his career as a cartoonist and caricaturist really started after he settled in London after WW2, living at first just off Kensington Church Street, in the same house as Robert Colquhoun* and John Minton*. Searle was pictorial reporter for *Holiday* and *Life* and contributed cartoons to many magazines, including *Punch* (his first *Punch* cartoon was published on 20 March 1946) and *Lilliput*. Searle had already made a name for his fiendish schoolgirls at St. Trinian's (1941-53) when he was appointed as illustrator of the drama columns in *Punch* and he produced real caricatures for many years for this section of the journal. Later he did cartoons, including a most successful series called "The Rake's Progress", starting in February 1954, and he was encouraged to be "as decorative, fantastic and disquieting in *Punch* as he had hitherto been outside it." (Price.)

Searle has illustrated many books, and produced many books of his delightfully fanciful and decorative drawings of cats and other animals. Many of his drawings have been turned into postcards and greeting cards, and he has also done posters, book jackets, commemorative medals, and worked on a number of films, including *Those Magnificent Men in Their Flying Machines* (1965). The schoolgirls of St. Trinian's, first seen in 1941, were brought to life in a number of memorable films.

Searle is a painter, lithographer and etcher as well as an illustrator, and has had exhibitions of his work in many European countries and the US. Essentially a satirist, his sense of humour is sophisticated and sometimes cuts deeply.

Searle settled in Paris in 1961, but moved to a mountain village in the south of France in 1977. His recent work includes a set of commemorative medals for the French Mint, and illustrations to Peter Mayle's exceedingly popular books on Provence.

Books illustrated include (but see Davies, 1990†): R. Hastain: *White Coolie* (Hodder, 1947); P. Campbell: *A Long Drink of Cold Water* (Falcon Press, 1949), *Life in Thin Slices* (Falcon Press, 1951); K. Webb: *Paris Sketchbook* (Saturn Press, 1950); R. Braddon: *The Naked Island* (Laurie, 1952); W. Cowper: *John Gilpin* (King Penguin, 1952); K. Webb: *Looking at London* (News Chronicle, 1953); P. Campbell: *Patrick Campbell's Omnibus*

(Hulton Press, 1954); G. Willans: *Down with Skool!* (Parrish, 1953), *How To Be Topp* (Parrish, 1954), *Whizz for Atomms* (Parrish, 1956), *The Dog's Ear Book* (Parrish, 1958), *Back in the Jug Agane* (Parrish, 1959); C. Fry: *A Phoenix Too Frequent* (OUP, 1959); R. Graves: *The Anger of Achilles* (1959); K. Webb: *Refugees 1960: A Report in Words and Pictures* (Penguin, 1960); C. Dickens: *A Christmas Carol* (1961), *Great Expectations* (1962), *Oliver Twist* (1962); B. Richardson and A. Andrews: *Those Magnificent Men in Their Flying Machines* (Dobson, 1965); J. Davies and others: *Monte-Carlo or Bust* (Dobson, 1969); K. Dobbs: *The Great Fur Opera* (Dobson, 1970); G. Rainbird: *The Subtle Alchemist* (1973); I. Shaw: *Paris! Paris!* (Weidenfeld, 1977); R.E. Raspe: *The Adventures of Baron Munchausen* (Harrap, 1985), *Singular Travels, Campaigns and Adventures of Baron Munchausen* (Methuen, 1987).

Books written and illustrated include: *Forty Drawings* (CUP, 1946); *Le Nouveau Ballet Anglais* (Paris: Les Éditions Montbrun, 1947); *Hurrah for St. Trinian's!* (Macdonald, 1948); *The Female Approach* (Macdonald, 1949); *Back to the Slaughterhouse* (Macdonald, 1951); *Timothy Shy: The Terror of St. Trinian's* (with D.B. Wyndham, Parrish, 1952); *Souls in Torment* (Perpetua, 1953); *Médisances* (Paris: Éditions Delpire, 1953); *The Rake's Progress* (Perpetua, 1955); *Merry England* (Perpetua, 1956); *The Big City* (with A. Atkinson; Perpetua, 1958); *Russia for Beginners* (with A.

Ronald SEARLE "Well, actually, Miss Tonks, my soul *is* in torment": drawn for *Lilliput* (1951) Pen, ink and wash. By permission of Chris Beetles Limited

Atkinson; 1960); *Which Way Did He Go?* (Perpetua, 1961); *Escape from the Amazon* (with A. Atkinson; 1964); *From Frozen North to Filthy Lucre* (Heinemann, 1964); *Pardong M'sieur* (Paris: Éditions Denoël, 1965); *Searle's Cats* (Dobson, 1967); *The Rake's Progress* (Dobson, 1968); *The Square Egg* (Weidenfeld, 1968); *Take One Toad* (with D.B. Wyndham, Dobson, 1968); *Hello — Where Did All the People Go?* (Weidenfeld, 1969); *Filles de Hambourg* (Paris: Éditions Jean-Jacques Pauvert, 1969); *Homage à Toulouse Lautrec* (Paris: Éditions Empreinte, 1969); *Secret Sketchbook* (Weidenfeld, 1970); *The Addict* (Dobson, 1971); *Dick Deadeye* (Cape, 1975); *More Cats* (Dobson, 1975); *Searle's Zodiac* (Dobson, 1977); *The King of the Beasts* (Allen Lane, 1980); *The Big Fat Cat Book* (Macmillan, 1982); *The Illustrated Winespeak* (Souvenir Press, 1983); *Ronald Searle's Golden Oldies* (Pavilion, 1985); *Something in the Cellar* (Souvenir Press, 1986); *To the Kwai and Back: War Drawings 1939-1945* (Collins, 1986); *Ah Yes, I Remember It Well...Paris 1961-1975* (Joseph, 1987); *Slightly Foxed...But Still Desirable* (Souvenir Press, 1989).

Contrib: *Circus; Granta; Graphis; Holiday; Life; Lilliput; Punch;*

tion at Ghent University where he read philosophy and letters, and then art and archaeology. He wanted to be an artist and though was encouraged by many, receiving technical instruction later in life from Eric Gill*, Buckland Wright* and Eric Ravilious*, he was virtually self-taught. He produced coloured drawings for German magazines and then occasionally for the *Bystander* and *Sketch*; and in 1928 or 1929 was asked to illustrate a book from a Dutch publisher on life in the reclaimed areas of Holland.

He was Art Director of the well-established London advertising agency, C.R. Casson (1931-39) and then spent WW2 in Belgium. He returned to England in 1944 and went back to Belgium in 1948 as Professor of Wood-engraving at the Institut Supérieur des Beaux-Arts, and Professor of Graphic Design at the Institut Plantin des Hautes Etudes Typographiques, both in Antwerp.

Well known as an illustrator and engraver, Severin designed and engraved more than two hundred bookplates, many of which have erotic motifs. He also designed posters for many organizations in England, including London Transport and Imperial Airways, and carried out advertising campaigns for such companies as Shell,

Mark SEVERIN *Homeric Hymn to Aphrodite* (Golden Cockerel Press, 1948)

New Yorker; News Chronicle; Radio Times; Saturday Book; Sunday Express; [New York] Tribune.

Exhib: Batsford Gallery; Leicester Galleries; Grosvenor Gallery; Bibliothèque Nationale, Paris; Berlin-Dahlem Museum; and in many European countries and the US.

Collns: BM; V & A; IWM; Bibl. Nationale, Paris; Stadtmuseum, Munich.

Bibl: Russell Davies: *Ronald Searle: A Biography* (Sinclair-Stevenson, 1990); Alexander Duckers: *Graphis* no. 212 (1980/81): 570-75; *The Penguin Ronald Searle* (Penguin Books, 1960); Hans Pflug: "Ronald Searle", *Graphis* 14, no. 80 (1958): 470-81; *Ronald Searle* (Paris: Bibliothèque Nationale, 1973); *Searle in the Sixties* (Penguin Books, 1964); *Ronald Searle* (Deutsch, 1978); Amstutz; Driver; Feaver; ICB2; Peppin; Price; Usherwood; Who.

SEVERIN, Mark Fernand **1906-1987**

Born on 5 January 1906 in Brussel, Severin came to England and went to school in Oxford during WW1 before finishing his educa-

Whitbread and ICI. He designed pavilions at major exhibitions, such as the Brussels World Fair in 1935; and did work on postage stamps and greeting telegrams in both England and Belgium. Since the end of the war, Severin's illustrations were done almost entirely for English publishers. He started by illustrating four books of poems by Ian Serraillier for OUP, *Beowulf the Warrior* (1957) perhaps being the most successful. He worked also for the Golden Cockerel Press, and the second book he did for them, *Homeric Hymns to Aphrodite* (1948), is a magnificent, thin folio, printed in red and black and illustrated with thirteen wood engravings. He illustrated a few books with copper engravings and did sixteen engravings of nude women, sold originally as sets of prints and then issued by David Chambers in book form as *Mounts of Venus* (1978).

He was a member of the Royal Academy of Belgium; a commander of the Order of Leopold and of the Order of the Crown. There have been exhibitions of his work in England, Belgium, Italy, Spain, Shanghai and elsewhere.

Books illustrated include: H.G. Cannegieter: *Achter den Afsluitdijk* (Amsterdam: Van Kampen, 1929); L. Verhees: *De Heldentocht van de Alexis, Antwerpsche Bark* (Antwerp: De Sikkel, 1934); N.E. Fonteyne: *Hoe de Vlamingen te Laat Kwamen* (Antwerp: De Sikkel, 1937); P. Forgeron: *Als Ik Kan* (Brussels: Éditions des Artistes, 1941); K. van de Woestyne: *De Laethemsche Brieven over de Lente* (Antwerp: Standard Boekhandel, 1943); J. de Vinck: *Le Cantique de la Vie* (Brussels: Éditions Art et Technique, 1943); *The Four Gospels* (Brussels: W. Godenne, 1944); I. Serraillier: *Thomas and the Sparrow* (OUP, 1946); P. Miller: *Woman in Detail* (GCP, 1947); *The Homeric Hymn to Aphrodite* (GCP, 1948); T. Gautier: *Mademoiselle de Maupin* (Folio Society, 1948); F. Severin: *Poèmes* (Brussels: pp., 1951); I. Serraillier: *The Tale of the Monster Horse* (OUP, 1950), *The Ballad of Kon-Tiki and Other Verses* (OUP, 1952), *Beowulf the Warrior* (OUP, 1954); W. Browne: *Circe and Ulysses* (GCP, 1954); *Apollonius of Tyre* (GCP, 1956); *The Holy Bible* (NY: Hawthorne Books, 1958);I. Seikaku: *Five Japanese Love Stories* (Folio Society, 1958); J. Hanaghan: *Eve's Moods Unveiled* (Dublin: Runa Press, 1959); K. van de Woestijne: *Verhalen* (Amsterdam: Wereld-Bibliotheek-Vereniging, 1959); Count Potocki: *Meillerie* (Pinner: Cuckoo Hill Press, 1972).

Books written and illustrated include: *Making a Bookplate* (Studio, 1949); *Your Wood-Engraving* (Sylvan Press, 1955); (with A. Reid) *Engraved Bookplates, European Ex Libris 1950-70* (Pinner: Private Libraries Association, 1972); *Mounts of Venus* (Pinner: Cuckoo Hill Press, 1978).

Contrib: *Bystander; Sketch; Sport im Bild; Die Woche*.

Bibl: David Chambers: "Mark Severin's Book Illustrations", *Private Library*, (Autumn 1980): 99-115; Pola Gauguin: *Mark F. Severin* (Copenhagen: Areté, 1952); "Mark Severin: Illustrator", *Book Design & Production*, 3, no. 3 (1960): 18-23; Amstutz 2; Folio 40; ICB2; Peppin; Sandford.

SEWARD, Prudence Eaton b.1926

Born on 10 September 1926 in Kensington, London, Seward studied at Harrow School of Art (1945-46) and the RCA (1947-49). Having trained as an engraver, she spent two years in Rome as Rome Scholar in Engraving (1949-51). She was a free-lance illustrator (1951-75), and since 1975 she has worked mostly on paper conservation. Recently she has started printmaking again, producing lithographs and collographs. Her illustrations are mostly in pen and ink, but she does work in colour, including designs for book jackets. Elected ARWS; ARE (1949).

Books illustrated include: R. Parker: *The Three Pebbles* (Collins, 1954); R. Godden: *Candy Floss* (Macmillan, 1955); B. Carter: *Tricycle Tim* (Hamilton, 1957); B.E. Todd: *The Wizard and the Unicorn* (Hamilton, 1958); D. Ross: *The Dreadful Boy* (Hamilton, 1959); J. Hope-Simpson: *The Stranger in the Train* (Hamilton, 1960); W. Mayne: *The Man from the North Pole* (Hamilton, 1963), *On the Stepping Stones* (Hamilton, 1963); P.M. Warner: *The Paradise Summer* (Collins, 1963); U.M. Williams: *High Adventure* (Nelson, 1965); J.G. Robinson: *Charley* (Collins, 1969); E. Vipont: *The Pavilion* (OUP, 1969); E. Bell: *Tales from End Cottage* (Penguin, 1970), *More Tales from End Cottage* (Penguin, 1972); E. Roberts: *All about Simon and His Grandmother* (Methuen, 1973); J. Cunliffe: *The Farmer, the Rooks and the Cherry Tree* (Deutsch, 1974); L. Derwent: *Song of Sula* (Gollancz, 1976); M. Hynds: *The Golden Apple* (Blackie, 1976); D. Taylor: *Zoovet: The World of a Wildlife Vet* (Allen & Unwin, 1976); N. Tuft: *Scruff's New Home* (Macmillan, 1978).

Contrib: *Cricket; Radio Times*.

Exhib: RE; RA; RBA.

Bibl: Margery Fisher: *Who's Who in Children's Books* (Weidenfeld & Nicolson, 1975); ICB4; Peppin; Waters; Who; IFA.

SHACKLETON, Keith Hope b.1923

Born on 16 January 1923 in Weybridge, Surrey, Shackleton went to Australia with his family but returned to school at Oundle, a public school which counted Peter Scott* among its old boys. He served with the Royal Air Force during WW2 and had no serious art training, though he attended evening classes for a while. He specializes in painting seascapes with wildlife or boats, and has contributed illustrations to *Birds* and *Yachting World*. His illustrations for his

Prudence SEWARD *The Farmer, the Rooks and the Cherry Tree* by John Cunliffe (André Deutsch, 1974)

book, *Tidelines* (1951), show how much he was influenced by Scott's work.

Books illustrated include: T. Stokes: *A Sailor's Guide to Ocean Birds* (Adlard Coles, 1963); P. Scott: *My Favourite Stories of Wild Life* (Lutterworth, 1965).

Books written and illustrated include: *Tidelines* (Lutterworth, 1951); *Wake* (Lutterworth, 1954); *Wild Animals of Britain* (Nelson, 1960); *Ships in the Wilderness* (Dent, 1986); *Wildlife and Wilderness: An Artist's World* (Holloway Books, 1986).

Contrib: *Birds; Yachting World*.

Collns: RSMA; Maritime Museum, Greenwich.

Bibl: Hammond; Who.

SHEPARD, Ernest Howard 1879-1976
See Houfe

Shepard's name is, of course, inseparable from those creations of A.A. Milne and Kenneth Grahame — Pooh, Piglet, and Eeyore; and Toad, Badger and Rat. His pen and ink illustrations make the creatures visible and alive, and created permanent images. "Ernest Shepard is the only follower of Hugh Thomson who equalled him in lightness of spirit and mastery of that obdurate instrument, the pen. Apart from his ideal association with Milne and the classic drawings for *The Wind in the Willows*, he should be remembered for one of the few almost perfect English illustrated books — *Everybody's Pepys*." (Hodnett.) He died on 24 March 1976.

Books illustrated include (but see Knox, 1979†): H. Walpole: *Jeremy* (Macmillan, 1919); A.A. Milne: *When We Were Very Young* (Methuen, 1924), *Winnie-the-Pooh* (Methuen, 1926); *Everybody's Pepys* (Bell, 1926); G. Agnew: *Let's Pretend* (Methuen, 1927); E. Erleigh: *The Little One's Log* (Partridge, 1927); A.A. Milne: *Now We Are Six* (Methuen, 1927); E.V. Lucas: *Mr. Punch's County Songs* (Methuen, 1928); A.A. Milne: *The House At Pooh Corner* (Methuen, 1928); K. Grahame: *The Golden Age* (BH, 1928), *Dream Days* (BH, 1930); *Everybody's Boswell* (Bell, 1930); A.A. Milne: *When I Was Very Young* (Methuen, 1930); K. Grahame: *The Wind*

in the Willows (Methuen, 1931); J. Drinkwater: *Christmas Poems* (Sidgwick, 1931); J. Struther: *Sycamore Square* (Methuen, 1932); R. Jeffries: *Bevis* (Smith, 1932); *Everybody's Lamb* (Bell, 1933); L. Housman: *The Goblin Market* (Cape, 1933), *Victoria Regina* (Cape, 1934); W. Fortescue: *Perfume from Provence* (Blackwood, 1935); J. Struther: *The Modern Struwelpeter* (Methuen, 1936); L. Housman: *Gracious Majesty* (Cape, 1941); K. Grahame: *Bertie's Escapade* (NY: Lippincott, 1945); R. Pertwee: *The Islanders* (OUP, 1950); A.A. Milne: *Year In, Year Out* (Methuen, 1952); E. Farjeon: *The Silver Curlew* (OUP, 1953); M. Saville: *Susan, Bill and the Wolf-Dog* (Nelson, 1954), and five other titles; M.L. Molesworth: *The Cuckoo Clock* (Dent, 1954); E. Farjeon: *The Glass Slipper* (OUP, 1955); F. H. Burnett: *The Secret Garden* (Heinemann, 1956); S. Goulden: *Royal Reflections* (Methuen, 1956); T. Hughes: *Tom Brown's Schooldays* (Ginn, 1956); R.L. Green: *Old Greek Fairy Tales* (Bell, 1958); H. Andersen: *Fairy Tales* (OUP, 1961); E.V. Rieu: *The Flattered Flying Fish* (Methuen, 1962); K. Grahame: *The Wind in the Willows* (new edition, with coloured illustrations; Methuen, 1971).
Books written and illustrated include: *Ben and Brock* (Methuen, 1965); *Betsy and Joe* (Methuen, 1966).
Contrib: *Graphic; ILN; Nash's Magazine; Pear's Annual; Printer's Pie; Punch; Sketch.*
Collns: BM; IWM; V & A; University of Kent (political cartoons); University of Surrey (personal papers).
Bibl: Rawle Knox: *The Work of E. H. Shepard* (Methuen, 1979); E.H. Shepard: *Drawn from Life* (Methuen, 1961); E.H. Shepard. *Drawn from Memory* (Methuen, 1957); University of Kent: *Ernest H. Shepard: Exhibition of 100 Political Cartoons* (Centre for the Study of Cartoons and Caricature, 1974); Hodnett; Johnson FIDB; ICB; ICB2; ICB3; Peppin; Price; Waters.

SHEPARD, Mary Eleanor **b.1909**
Born on 25 December 1909, Shepard was the daughter of illustrator Ernest Shepard*. She was educated at St. Monica's, Tadworth, Surrey, and in France, and studied at the Slade (under Tonks and Randolph Schwabe*). Her first published drawings, for *Mary Poppins* (1934) were done at home; she subsequently illustrated other books in the series, and a few books for US publishers. In 1947 she married E.V. Knox, the Editor of *Punch*.
Books illustrated include: P.L. Travers: *Mary Poppins* (Howe, 1934), *Mary Poppins Comes Back* (Dickson & Thompson, 1935); A. Ransome: *Pigeon Post* (1937); R. Manning-Sanders: *Children by the Sea* (Collins, 1938); P.L. Travers: *Mary Poppins Opens the Door* (Davies, 1944), *Mary Poppins in the Park* (Davies, 1952), *Mary Poppins from A to Z* (Collins, 1963); A.A. Milne: *Prince Rabbit and the Princess Who Could Not Laugh* (NY: Dutton, 1966); P.L. Travers: *Mary Poppins in Cherry Tree Lane* (Collins, 1982).
Bibl: Doyle; ICB2; ICB3; Peppin.

SHEPHERD, James Affleck **1867-1946**
See Houfe

SHEPPARD, Raymond **1913-1958**
Born on 3 March 1913 in Muswell Hill, North London, Sheppard was educated at Christ's College, Finchley, and studied at the London School of Printing and Graphic Arts. He drew at the London Zoo and in the Natural History Museum, South Kensington; and, when he was twenty-one, became a free-lance artist, illustrating books on natural history, and other books with animals as the main subject. He taught for three years at the London School of Printing. During WW2 he was attached to the RAF Photographic Section. Elected FZS; SGA (1947); PS (1948); RI (1949). He died on 21 August 1958.
Books illustrated include: M. Edwin: *Round the Year Stories* (1942); J. Chipperfield: *Beyond the Timber Trail* (1951); J. Corbett: *The Man-Eaters of Kumaon* (OUP, 1952); E. Hemingway: *The Old Man and the Sea* (with C. Tunnicliffe*; 1952); *The Man-Eating Leopard of Rudraprayag* (OUP, 1954), *Tree Tops* (1955); L. Meynell: *Animal Doctor* (1956).
Books written and illustrated include: *How To Draw Birds* (Studio, 1940); *Drawing at the Zoo* (Studio, 1949); *More Birds To Draw* (Studio, 1956).
Contrib: *Lilliput*.

Exhib: RA; RI; RBA; RSA.
Bibl: *Lilliput* 166 (1951): 5; ICB2; Peppin; Waters.

SHERINGHAM, George **1884-1937**
See Houfe

SHERRIFFS, Robert Stewart **1906-1960**
Born in Edinburgh, Sherriffs was educated at Arbroath High School and studied at Edinburgh College of Art, initially specializing in heraldry. He contributed to several magazines, and his caricature of John Barrymore in the *Bystander* led to a series of illustrations of celebrities for the *Sketch*. He also contributed weekly drawings to the *Radio Times*. He was expected to replace Will Dyson* as the editorial cartoonist on the *Daily Herald*, but instead the position went to his friend, George Whitelaw*. After serving with the Tank Regiment in WW2, in 1948, he succeeded J.H. Dowd* as film caricaturist on *Punch* until his death. He illustrated a few books; and was also an accomplished cricketer.
Books illustrated include: C. Marlowe: *Tamburlaine the Great* (Hesperides Press, 1930); R. Arkell: *Playing the Game* (Jenkins, 1935); *The Rubaiyat of Omar Khayyam* (1947); C. Dickens: *Captain Boldheart* (1948), *Mrs. Orange* (1948).
Books written and illustrated include : *Salute If you Must* (Jenkins, 1945).
Contrib: *Bystander; Daily Herald; Punch; Radio Times; Sketch; Tatler.*
Exhib: Times Bookshop (1962); National Film Theatre (1975); National Theatre (1982).
Bibl: Driver; Feaver; Peppin; Price.

SHIELDS, Leonard **1876-1949**
First intending to be a chemist, Shields was educated at Sheffield University, but he soon decided to concentrate on art. His first work was published in the late 1890s, in comics like *Pluck* and *Marvel*, illustrating many stories for these papers and doing covers as well. He illustrated the "Billy Bunter" stories, first in the *Greyfriars Holiday Annual* (1923), and then in *Magnet* from 1926, sharing the illustrations with C.H. Chapman*. From about 1936, Shields concentrated on the cover illustrations while Chapman drew the illustrations inside. Some consider Shields the better illustrator, and his characters were more handsome and thus less to be caricatured than Chapman's. Others claim this for Chapman, who created the more traditional image of Bunter and his environment, and he was certainly more prolific. Shields worked right up to his death in Putney in January 1949, leaving a considerable fortune.
Contrib: *Answers; Family Journal; Film Fun; Holiday Annual; Magnet; Marvel; Puck; Schoolfriend.*
Bibl: Mary Cadogan: *Frank Richards: The Chap Behind the Chums* (Viking, 1988); Doyle BWI.

SHILLABEER, Mary Eleanor **b.1904**
Born on 30 August 1904 in Downton, near Salisbury, Shillabeer studied at the Central School of Arts and Crafts. In her final year as a student, she was commissioned by Dent to illustrate a series of readers for children. She first illustrated under her maiden name of Wright, but after she married in 1926, she took her husband's name for all her work. She was also an easel painter and a lithographer.
Books illustrated include: U.M. Williams: *Adventures of Puffin* (Harrap, 1939); B. Sleigh: *Patchwork Quilt* (Parrish, 1956); E. Kyle: *Run to Earth* (Nelson, 1957); M. Cockett: *Jasper Club* (Heinemann, 1959); R.L. Stevenson: *A Child's Garden of Verses* (Dent, 1960); L. Cooper: *Blackberry's Kitten* (Brockhampton, 1961); R.L. Green: *The Book of Verse for Children* (Dent, 1962); P. Lynch: *Holiday at Rosquin* (1964), *Mona of the Isle* (Dent, 1965).
Books written and illustrated include: *My Animal ABC* (OUP, 1938); *My Farmyard Counting Book* (OUP, 1940); *We Visit the Zoo* (Hutchinson, 1946); *At First* (Museum Press, 1947).
Bibl: ICB3; Peppin; Who.

SILAS, Ellis **b.1883**
Born in London, Silas studied privately. He worked as an official war artist for the Australian Government during WW1, and then spent some years living in Papua-New Guinea. A landscape and seascape painter, Silas also painted murals, designed posters and

greeting cards, and illustrated a few books.

Books illustrated include: H.F.B. Wheeler: *The Story of the British Navy* (Harrap, 1922); C. Kingsley: *Westward Ho!* (Harrap, 1927); P.F. Westerman: *One of the Many* (Blackie, 1945), *First Over* (Blackie, 1948), *Mystery of the Key* (Blackie, 1948), *Held to Ransom* (Blackie, 1951), *Working Their Passage* (Blackie, 1951), *Sabotage!* (Blackie, 1952).

Books written and ilustrated include: *Crusading at Anzac* (British & Australasian, 1916); *A Primitive Arcadia: Papua* (Fisher Unwin, 1926).

Contrib: *BOP; ILN; Little Folks.*

Bibl: Peppin; Waters.

SILCOCK, Sara Lesley b.1947

Born on 30 January 1947, Silcock spent her childhood in Leeds. She studied at Southampton College of Art and Hornsey College of Art, where she specialized in illustration. She became a free-lance artist on leaving college, and has concentrated on children's books and books about gardening and cooking. She also makes limited edition prints and etchings.

Books illustrated include: J. Piggott: *Myth and Moonshine* (Muller, 1973); *The Noel Streatfeild Christmas Holiday Book* (Dent, 1973); G. Treece: *A Voice in the Night* (Heinemann, 1973); J. Fitzgerald: *Me and My Little Brain* (1974); *The Noel Streatfeild Easter Holiday Book* (Dent, 1974); S. McGibbon: *Party Food* (Macdonald, 1975); G. Palmer and N. Lloyd: *Ghosts Go Haunting* (Odhams, 1975); G. Brandreth: *Here Comes Golly!* (Pelham, 1979), *Hey Diddle Diddle* (Carousel Books, 1979); P. McHoy: *Peter Seabrook's Book of the Garden* (with others, Cassell, 1979); A. Murfy: *Anyone Can Draw* (Fontana, 1981); J. Fitzpatrick: *In the Air* (and three other titles in series, Hamilton, 1984); E. Blyton: *Shuffle the Shoemaker* (Dragon, 1985); F. Everett and C. Garbera: *Making Clothes* (Usborne, 1985).

Books written and illustrated include: *Going to Hospital* (Macdonald, 1980); *The Three Little Pigs* (Macmillan, 1987).

Bibl: ICB4; Peppin; Who.

SILLINCE, William Augustus 1906-1974

Born on 16 November 1906 in Battersea, London, Sillince was educated at Osborne House, Romsey, and studied at the Regent Street Polytechnic and the Central School of Arts and Crafts (under W.P. Robins). After working in an advertising agency (1928-36), he became a free-lance artist, contributing to *Punch* and other magazines. Both Price and Fougasse refer to Sillince's draughting skills, and to his delight in innovation. He illustrated several books with cartoon-like drawings, often using a soft pencil on textured paper; and also painted watercolour landscapes which were widely exhibited. He taught part-time at Brighton College of Art (1949-52), and lectured in graphic design at Hull Regional College of Art (1952-71). He was elected RBA (1949); RWS; SGA. Died on 10 January 1974.

Books illustrated include: D.L. Sayers: *Even the Parrot* (Methuen, 1944); L. Berg: *The Story of the Little Car* (Epworth, 1955); H. Treece: *The Jet Beads* (Brockhampton, 1961).

Books written and illustrated include (all published by Collins): *We're All in It* (1941); *We're Still in It: More Pictures from Punch* (1942); *United Notions: More Pictures from Punch* (1943); *Combined Operations: More Pictures from Punch* (1944); *Minor Relaxations: Further Pictures from Punch* (1945).

Contrib: *Christmas Pie; Punch.*

Publ: *Comic Drawings* (Pitman, 1950).

Exhib: RA; RBA; RWS; RSA; NEAC; and overseas.

Bibl: *Times* obit., 17 January 1974; Fougasse; Peppin; Price; Waters.

SIME, Sidney Herbert 1867-1941
See Houfe

Books illustrated include: Lord Dunsany: *The Gods of Pegana* (Elkin Mathews, 1905), *Time and the Gods* (Heinemann, 1906), *The Sword of Welleran* (Allen, 1908), *A Dreamer's Tales* (Allen, 1910), *The Book of Wonder* (Heinemann, 1912), *Tales of Wonder* (Elkin Mathews, 1916). Frontispiece only for the following — A. Machen: *The House of Souls* (Grant Richards, 1906), *The Hill of Dreams* (Grant Richards, 1907); W.H. Hodgson: *The Ghost Pirates* (Paul,

1909); Lord Dunsany: *The Chronicles of Rodriguez* (Putnam, 1922), *The King of Elfland's Daughter* (Heinemann, 1924), *The Blessing of Pan* (Putnam, 1927), *My Talks with Dean Spanley* (Heinemann, 1936).

Books written and illustrated include: *Bogey Beasts* (music by J. Holbrooke; Goodwin and Tabb, 1923).

Bibl: George Locke: *From an Ultimate Dim Thule: A Review of the Early Works of Sidney H. Sime (1895-1905)* (Ferret Fantasy, 1973), and *The Land of Dreams: A Review of the Work . . . 1905-1916.* (Ferret Fantasy, 1975); Simon Heneage and Henry Ford. *Sidney Sime: Master of the Mysterious* (T&H, 1980); Johnson FIDB; Peppin; Waters.

SIMMONDS, Posy fl.1970-

Born in Berkshire, Simmonds studied painting in Paris and graphic design at the Central School of Art and design. Starting in 1977, she contributed a weekly satirical comic strip, "The Silent Three", to the *Guardian* (some of which have been collected in book form), and has done a wide range of free-lance illustration for books, magazines and newspapers.

Books illustrated include: K. Wright: *Cat Among the Pigeons* (Puffin Books, 1989).

Books written and illustrated include : *Mrs. Weber's Diary* (Cape, 1979).

Contrib: *Guardian; Observer; Sun; Sunday Times.*

SIMPSON, Charles Walter ["The Wag"] 1885-1971

Born on 8 May 1885 in Camberley, Surrey, Simpson studied at the Académie Julian, Paris. He was a painter of birds and animal, and, though best known as an artist who took horses as his most frequent subject, Paget described him in 1945 as "undoubtedly the best bird painter living. He alone, of all artists past and present, can make his birds appear out of their backgrounds as one approaches them or the light is increased as in nature. . . He is a great draughtsman and has done many first rate equestrian portraits." (Paget, 1945.†) He illustrated a number of books with watercolour paintings, pen and pencil drawings, and in one case, with woodcuts (*A Pastorale: A Word-Picture of Rural Life in Sussex*). He was elected RI (1914); ROI (1921).

Books illustrated include: C.E. Vulliamy: *Unknown Cornwall* (BH, 1925); M.F. McTaggart: *From Colonel to Subaltern* (Country Life, 1928); "Crascredo": *Hunting Lore* (Country Life, 1928), *Manners and Mannerism* (Country Life, 1929); J.L.M. Barratt: *Practical Jumping* (Country Life, 1930); S.G. Goldschmidt: *The Fellowship of the Horse* (Country Life, 1930); D.U. Ratcliffe: *The Gone Away: A Romance of the Dales in Three Acts* (BH, 1930); J. Thorburn: *Hildebrand* (Country Life, 1930); C.R. Simpson: *The History of the Lincolnshire Regiment* (1931); W.V. Faber: *Wit and Wisdom of the Shires* (Leicester: Backus, 1932); G. Paget and L. Irvine: *The Flying Parson and Dick Christian* (Backus, 1934); G. Paget: *The Autobiography of 'Sir' Bernard Montgomery* (British Technical and General Press, 1952).

Books written and illustrated include: *A Pastorale* (pp., 1922); *El Rodeo* (BH, 1924); *The Harboro' Country* (BH, 1927); *Leicestershire and Its Hunts* (BH, 1927); *Trencher and Kennel* (BH, 1927); *The Fields of Home* (Lewis, 1948).

Published: *Animal and Bird Painting* (Batsford, 1939).

Exhib: RA; RBA; RI; GI; Paris Salon.

Bibl: Guy Paget: *Sporting Pictures of England* (Collins, 1945); Peppin; Titley; Waters.

SIMPSON, Joseph W. 1879-1939
See Houfe

Books illustrated include: A. Keith: *Edinburgh Today* (1915); P. Kennedy: *Soldiers of Labour* (1917); J.B. Priestley: *Angel Pavement* (Heinemann, 1932).

SIMS, Graeme fl.1974-

A wildlife artist, who has had exhibited regularly in London since 1974, when he had his first one-artist show. He has had commissions from organizations such as RSPB, London Zoo, and the World Wildlife Fund. In 1984 he won the "Best Children's Book Illustrator" award for *Spiney the Hedgehog*.

Books written and illustrated include: *Rufus the Fox* (Warne,

Yvonne SKARGON *Gifts from Your Garden* by Celia Haddon
(Michael Joseph, 1985). Copyright © Celia Haddon

1983); *Spiney the Hedgehog* (Warne, 1983).
Published: *Painting and Drawing Animals* (Watson Guptill).
Bibl: Graeme Sims: "Painting Wildlife", *The Artist* (March 1988):
21-23.

SINDALL, Alfred J. fl. 1935-1948
Peppin declares Sindall "the most effective illustrator of the *Biggles*
books." Working in black and white, he illustrated some eleven of
W.E. Johns' books between 1935 and 1941, while Howard Leigh*
contributed coloured frontispieces. He illustrated a few other books,
and contributed to magazines and children's annuals.
Books illustrated include: E. Graham: *Six in a Family* (Nelson,
1935); W.E. Johns: *Biggles Flies East* (with Howard Leigh; and ten
other titles, OUP, 1935-41); G. Trease: *The Christmas Holiday
Mystery* (Black, 1937), *Mystery on the Moors* (Black, 1937).
Contrib: *Captain; Children's Wonder Book; Union Jack; Wide
World.*
Bibl: Peter B. Ellis and Piers Williams: *By Jove, Biggles!* (W.H.
Allen, 1981); Peppin.

SKARGON, Yvonne b.1931
Born at Dovercourt, Essex, Skargon studied at Colchester School of
Art (1947-50), where she was taught wood engraving by Blair-
Hughes Stanton* and John O'Connor*. She worked as typographer
and designer with various printers and publishers, including W.S.
Cowell, Lund Humphries and Longman; and in 1961 became a free-
lance artist, designing and illustrating books and book jackets,
mostly on botanical and culinary themes. She uses various media,
including wood engravings, watercolours and drawings. She also
taught wood engraving at the RCA for five years (1981-86). Elected
SWE.
Books illustrated include: R.St.B. Baker: *Kabongo* (Ronald,
1955); S. Macqueen: *Encyclopaedia of Flower Arranging* (Faber,
1967); O. Wijk: *Eat at Pleasure* (Constable, 1970); J. Grigson: *The
Mushroom Feast* (Joseph, 1975); S. Howarth: *Herbs with
Everything* (Pelham, 1976); J. Reekie: *No Need to Cook* (Pelham,
1977); J. Grigson: *Jane Grigson's Vegetable Book* (Joseph, 1978);
A. Frewin: *The Book of Days* (Collins, 1979); V. Paterson: *Eat Your
Way to Health* (Allen Lane, 1981); J. Grigson: *Jane Grigson's Fruit
Book* (Joseph, 1982); J. Beard: *Beard on Pasta* (Joseph, 1984); C.
Haddon: *Gifts from Your Garden* (Joseph, 1985); *The Importance of
Being Oscar* (Silent Books, 1988); H. Webb: *A Crown for Branwen*
(Gregynog Poets; Gregynog Press, 1988); *Engraved Gardens* (with
others; Silent Books, 1989); S. Johnson: *Lily and Hodge and Dr.
Johnson* (Silent Books, 1991).
Books written and illustrated include: *Conker Tree* (Black,
c.1975); *A Calendar of Herbs* (Scolar Press, 1978); *A Handful of
Flowers* (Black, 1980); *A Garland of Flowers* (Black, 1980).
Contrib: *Hortus; Wine & Food.*
Exhib: SWE.
Bibl: Brett; Jaffé; IFA.

SKINNER, Ivy Jacquier b.1890
Born on 27 January 1890 in Lyons, France, Ivy was the fifth of six
children of François Jacquier, who was disowned by his father for
marrying an English Protestant woman. Jacquier lived in England,
and the first four children were born there, but his father recalled
him to France and to the private bank which he owned. Though her
home was in Lyons, Skinner was educated in England, and studied
art in Dresden, Paris and Lyons. She married a Scottish army officer
on 7 May 1921 and bore a daughter in 1922. She exhibited at the
RA and in other galleries and she illustrated a few books, working
as "Jacquier". She produced illustrations for Maurois' *Ariel* in 1923,
but John Lane first rejected them as "too French", though in her
Diary she writes that she was paid £50 "for the copyright", and the
book was published in 1925; she exhibited the illustrations in
London in 1924. Her title-page decoration and five full-page illus-
trations for *The Seasons* were engraved in copper and hand-
coloured by stencil process at the Curwen Press, as were the illus-
trations for *Graziella*.
Books illustrated include: A. Maurois: *Ariel* (BH, 1925); J.
Thomson: *The Seasons* (Nonesuch Press, 1927); A. de Lamartine:
Graziella (Nonesuch Press, 1929).
Exhib: RA; RP; Redfern Gallery; Paris Salon.
Bibl: *The Diary of Ivy Jacquier 1907-1926* (Gollancz, 1960);
Waters.
Colour Plate 132

SLEIGH, Bernard Barnay 1872-1954
See Houfe
Books illustrated include: A.J. Gaskin: *A Book of Pictured Carols*
(Allen, 1893); A. Mark: *The Sea King's Daughter* (Birmingham:
Napier, 1895); R.K. Dent: *A Picture Map of Birmingham in the
Year 1730* (1924); *The Song of Songs as a Drama* (1937).
Books written and illustrated include: *Ancient Mappe of
Fairyland* (Sidgwick, 1918); *A Faerie Calendar* (Heath Cranton,
1920); *A Faerie Pageant* (pp., 1924); *Gates of Horn* (Dent, 1926).
Published: *Handbook of Elementary Design* (Pitman, 1930); *Wood
Engraving Since 1890* (Pitman, 1932).

SMEE, David Charles b.1937
Born on 24 December 1937 in Cambridge, Smee studied at
Cambridge School of Art. He worked as a signwriter in Cyprus
while doing his National Service (1956-58), and then worked in
various advertising agencies. After he won a Shell poster competi-
tion in 1964, he became a free-lance artist in Hertfordshire. He con-
tributed to *Punch*, and illustrated his first book in 1970. In 1973 he
moved to Devon and concentrated on "illustration and cider"
(ICB4). He is a great admirer of Mervyn Peake*.
Books illustrated include: P. Dickinson: *The Dancing Bear*
(Gollancz, 1972); *Chance, Luck and Destiny* (with Victor Ambrus*;
Gollancz, 1975), *The Blue Hawk* (Gollancz, 1976); G. Trease: *The

Seas of Morning (Puffin, 1976); J.P. Walsh: *The Walls of Athens* (Heinemann, 1977).
Contrib: *Punch*.
Bibl: ICB4; Peppin.

SMILBY
See SMITH, Francis W.

SMILEY, Lavinia **b.1919**
Born on 7 February 1919, Smiley is the grand-daughter of the first Viscount Cowdray. She grew up in a wealthy family in Sussex and was educated in England and France. She began writing and illustrating her humorous stories for her three children.
Books written and illustrated include: *Come Shopping* (Faber, 1955); *Hugh the Dragon Killer* (Faber, 1956); *Robin in Danger* (Faber, 1956); *Mr. Snodgrass's Holiday* (Faber, 1958); *Clive to the Rescue* (Tisbury: Compton Russell, 1975); *William and the Wolf* (Russell, 1975).
Bibl: L. Smiley: *A Nice Clean Plate: Recollections 1919-1931* (Salisbury: Michael Russell, 1981); ICB2; Peppin.

SMITH, Francis W. **b.1927**
Born in Rugby, Smith joined the Merchant Navy when he was sixteen, and then studied at Camberwell School of Art (under John Minton*). Known by the name "Smilby" as an artist, he has contributed cartoons to *Punch* and several US magazines. Price declares that "to some extent [Smilby] married the tradition of Crum [see Pettiward, Roger] with the new tradition of François and produced something, not only individual, but showing signs of potentiality for development, both in the idea and in the expression of it."
Contrib: *Esquire; New Yorker; Playboy; Punch*.
Bibl: Bateman; Fougasse; Price.

SMITH, John R. **fl.1980-**
Smith is an artist who has produced linocuts and illustrations by pen and ink for books printed by Jonathan Stephenson at the Rocket Press (now at Blewbury, near Didcot, Oxford).
Books illustrated include: J. de Bijl: *Salute to Celia Fiennes* (Oxford: Melmillo, 1983); R. Brough: *The Vacant Frame* (Rocket Press, 1983); J. Keble: *Assize Sermon on National Apostasy* (Rocket Press, 1983); *Bookish Quotations* (Rocket Press, 1985); J.H. Newman: *Tract One* (Rocket Press, 1985).
Bibl: John R. Smith: "Jonathan Stephenson & the Rocket Press", Private Library (Autumn 1985): 97-116.

SMITH, Lesley S.J. **b1951**
Born in London, Smith studied at Cambridge School of Art (1969-71) and St. Martin's School of Art (1971-74). She is a prolific illustrator of children's books in black and white and in colour.
Books illustrated include: P. Oldfield: *More About the Gumby Gang* (Blackie, 1979); T. Tully: *Little Ed* (Warne, 1979), *Ed at Large* (Warne, 1980); B. Ireson: *The Beaver Book of Funny Rhymes* (Beaver, 1980); P. Oldfield: *The Gumby Gang Strike Again* (Blackie, 1980); M.E. Allen: *Strangers in Wood Street* (Methuen, 1981); T. Tully: *Look Out — It's Little Ed* (Warne, 1981); L. Derwent: *Macpherson's Mystery Adventure* (Blackie, 1982); A. Rooke: *When Robert Went to Play Group* (and other titles, Hodder, 1984); J. Wilson: *The Killer Tadpole* (Hamilton, 1984); B. Ball: *Look Out, Duggy Dog* (Hamilton, 1985); K.M. Peyton: *Froggett's Revenge* (OUP, 1985); P. Oldfield: *The Gumby Gang Again* (Blackie, 1986); A. Rooke: *Front Page Dog* (Hodder, 1986); E. Walker: *The Adventures of the Gingerbread Man* (Hutchinson, 1986); B. Ball: *I'm Lost, Duggy Dog* (Hamilton, 1987).
Bibl: Peppin.

Richard Shirley SMITH *Messer Pietro Mio* (Libanus Press, 1985)

SMITH, May **b.1904**

Born in Manchester, Smith was educated at Manchester High School for Girls, and studied at Manchester Art School. She came to London in 1925 and became a free-lance artist, working for publishers and contributing to magazines, including *Radio Times* in the mid-1930s. She also illustrated a book of children's broadcast stories, and illustrated her own verse for several publications.

Books illustrated include: E. Farjeon: *Westwoods* (Blackwell, 1930); *The Man Who Caught the Wind*.
Contrib: *Radio Times*.
Bibl: Driver.

SMITH, Richard [Francis] Shirley **b.1935**

Born on 28 July 1935 in Hampstead, London, Smith was educated at Harrow School (1949-54) and studied at the Slade (1956-60) under Anthony Gross* and, after National Service in the Royal Artillery (1954-56), in Rome (1960-62). He lectured at St. Alban's and Watford Schools of Art (1963-66), was head of the art department at Marlborough School (1966-70), Extra-mural lecturer for London and Bristol universities (1963-70), and a part-time lecturer at Swindon School of Art (1974-83).

He has been much influenced by David Jones*, with whom he had a close association between 1956 and 1974, the year of Jones' death. He delights in the special qualities of wood engraving. "In his best work there is a marvellous tonal interplay and the areas of white too are managed with great subtlety, often giving a sculptured roundness to flesh (he is very good at women's bodies). . ." (Saunders, 1985.†) For his book illustrations, he uses pen and ink, pencil, and linocuts, though he is perhaps best known for his wood engravings. His visits to Italy have much influenced his art, and the settings of many of his illustrations and paintings are Italian or Italianate. A sense of decay is present in much of his work, implied when not explicit in the crumbling masonry and statuary.

In addition to his illustrative work, he is also a painter with a number of London one-artist shows to his credit, a muralist, and a designer and engraver of bookplates. He is a photographer and has completed a commission to produce a series of film-strips about St. Peter's, Rome, and Venetian villas. In a perceptive review of the film-strips, Simon Brett* in *The Times Educational Supplement* praised the photography for its "technical excellence and fastidious selection of detail", which as Brett implies, are hallmarks also of the wood engravings and pictures.

Books illustrated include: R. Bannister: *Prospect* (Hutchinson, 1962); F. Barlow: *The English Church 1000-1066* (Longman, 1963); W. Blunt: *Of Flowers and a Village* (Hamilton, 1963); S. Francis of Assisi: *The Writings* (Burns & Oates, 1963); E. Hamilton: *The Great Teresa* (Burns & Oates, 1963); G. Rawson: *Pandora's Last Voyage* (Longman, 1963); D. Bartrum: *The Gourmet's Garden* (Faber, 1964); A. Bell: *A Street in Suffolk* (Faber, 1964); E. Clarke: *The Darkening Green* (Faber, 1964); M. Mott: *Helmet and Wasps* (Deutsch, 1964); E.E. Reynolds: *The Trial of Thomas More* (Burns & Oates, 1964); M. Claridge: *Margaret Clitherow* (Burns & Oates, 1965); H. de Lubac: *The Faith of Teilhard de Chardin* (Burns & Oates, 1965); U.V. Williams: *Metamorphoses* (Duckworth, 1965); P.M. Young: *Handel* (and seven others in series, Benn, 1965-9); Addison and Steele: *Sir Roger de Coverly* (Folio Society, 1967); J. Finzi: *A Point of Departure* (Golden Head Press, 1967); R.H. Horne: *Memoirs of a London Doll* (Deutsch, 1967); *Garland* (Golden Head Press, 1968); J.C. Bretherton: *The Prince & the Puppeteer* (Compton Chamberlayne: Compton Press, 1969; P.B. Shelley: *Poems* (NY: Limited Editions Club, 1971); P. Stanhope: *Letters to His Son* (Folio Society, 1973); D. Burnett: *Hero & Leander* (OUP, 1975); T. Whistler: *The River Boy* OUP, 1976); J. Reeves: *The Closed Door* (Gruffyground Press, 1977); *Six Hampshire Epitaphs* (Gruffyground Press, 1977); J. Heath-Stubb: *Buzz Buzz* (Gruffyground Press, 1981); D. Burnett: *Vines* (Rocket Press, 1984); *Messer Pietro Mio* (Marlborough: Libanus Press, 1985).
Exhib: Mount Gallery, Hampstead (1963); Waterhouse Gallery (1971; 1973); Oxford Gallery (1976; 1978; 1980); International Ex Libris Centre, Brussels (with others, 1978); Katharine House Gallery, Marlborough (1982); Ashmolean (retrospective 1985); Aldeburgh Festival (1988).
Contrib: *Green Book; The Periodical (OUP); Wine and Food*

Richard Shirley SMITH *The Closed Door* by James Reeves (Gruffyground Press, 1977)

Magazine.
Collns: Ashmolean.
Bibl: *Richard Shirley Smith: Fiftieth Birthday Retrospective Exhibition* (Oxford: Ashmolean Museum, 1985); Brian North Lee: "Bookplate Designs by Richard Shirley Smith", *Private Library* 2nd s., 10, no. 2 (Summer 1977): 84-93; Linda Saunders: "The Painter as Wood Engraver: Richard Shirley Smith in His Studio", *Green Book* 2, no. 1 (Autumn 1985): 4-8; *Richard Shirley Smith: A Selection of Wood Engravings, 1960-77.* (Cuckoo Hill Press, 1983); Folio 40; Garrett 1 & 2; Peppin; IFA.
See also illustration on page 393

SMYTHE, Reg **b.1917**

Born in Hartlepool, Smythe (whose real name is Smyth) left Galleys Field School when he was fourteen to become a butcher's boy for two years. In 1936, after being unemployed like his father, he joined the regular army and served in the infantry during WW2. After the war he worked for the Post Office, and did some posters as an amateur, before trying his hand at cartoons. After contributing odd cartoons on a fairly regular basis to the *Daily Mirror*, he started the strip cartoon, "Andy Capp". This was a great success, and has since been syndicated throughout North America; and he has published several collections of his "Andy Capp" cartoons. His success in the US was a mystery for Smythe, as Andy, a "typical" man from north-east England, in his ubiquitous flat cap, would seem to be too much of a strong regional English character to be properly appreci-

ated by Americans. According to Bateman in 1966, Smythe was the wealthiest cartoonist in Britain, earning probably over £25,000 a year at that time.

Books written and illustrated include: *Smythe's Speedway World* (Fairfax, 1952); *The Andy Capp Book* (Daily Mirror, 1958); *Andy Capp's Spring Tonic* (DM, 1959); *The Andy Capp Collection* (DM, 1960); *The Best of Andy Capp* (DM, 1960); *The Andy Capp Spring Collection* (DM, 1960); *Laugh With Andy Capp* (DM, 1961); *The World of Andy Capp* (DM, 1961); *Andy Capp Picks His Favourites* (DM, 1963); *Andy Capp and Florrie* (DM, 1964); *All the Best from Andy Capp* (DM, 1965); *Andy Capp* (DM, 1966).

Contrib: *Daily Mirror*.

Collns: University of Kent.

Bibl: Bateman.

"SNAFFLES"
See PAYNE, Charles Johnson

SOLOMONS, Estella Frances 1882-1968
Born in Dublin, Solomons was educated there and in Hanover, where she learned to speak German fluently. She studied at Alexandra College in Dublin and at the Metropolitan School of Art, Dublin, the Royal Hibernian Academy Schools, and the Chelsea School of Art. A portrait and landscape painter and etcher, she exhibited in Ireland and Paris. A fervent supporter of the Irish republican movement, she painted many portraits of notable Irish men and women. She also illustrated a few books, using etchings for Kelleher's *The Glamour of Dublin*, and for Padraic Colum's *The Road Round Ireland*. She was married to the poet, James Starkey, who wrote under the name of Seumas O'Sullivan.

Books illustrated include: *Mud and Purple* (1918); P. Colum: *The Road Round Ireland* (1926); D.L. Kelleher: *The Glamour of Dublin* (3rd ed; Dublin: Talbot Press, 1928).

Bibl: Hilary Pyle: "A Biographical Sketch of the Artist" in Solomons: *Portraits of Patriots* (Dublin: Figgis, 1966); Waters.

SOPER, Eileen Alice 1905-1990
Born on 26 March 1905 in Enfield, Middlesex, three years later Soper moved to Harmer Green, near Welwyn, Hertfordshire, into the house her father had built, and lived there for the rest of her life. She was educated at home, and had no formal art training although she studied under her father, George Soper*, an engraver, etcher and illustrator. After producing etchings as a teenager (two were accepted by the Royal Academy when she was fifteen years old), she exhibited widely, her preferred subjects being animals and children. When her father died, she and her sister looked after the wildlife sanctuary he had created. She wrote and illustrated several books on the animals she found there, including *When Badgers Wake* (1955) and *Muntjac* (1969), a study of the small Asian deer which colonized their "garden". Later in her career, she started contributing illustrations to magazines and illustrated many books for children, including some thirty-five by Enid Blyton. A founder-member of SWLA, she was elected RMS in 1972. She died in March 1990, leaving the estate to the care of the Chris Beetles Gallery.

Books illustrated include (but see Peppin): U.M. Willams: *A Castle for John-Peter* (Harrap, 1941); E. Blyton: *Merry Story Book* (Hodder, 1943), *Five Run Away Together* (Hodder, 1944), and about thirty-three other titles; E. Gould: *Country Days* (Blackie, 1944, *Farm Holidays* (Blackie, 1944), *Happy Days on the Farm* (Blackie, 1944); M. Kent: *The Children's Nature Series* (with others, Harrap, 1944-); L. Carroll: *Alice in Wonderland* (1947); *The Song of Lambert* (1955); M. Knight: *How to Observe Wild Mammals* (Routledge, 1957); P. Drabble: *No Badgers in My Wood* (Joseph, 1979).

Books written and illustrated include: *Happy Rabbit* (Macmillan, 1947); *Dormouse Awake* (Macmillan, 1948); *Song on the Wind* (Museum Press, 1948); *Sail Away Shrew* (Macmillan, 1949); *When Badgers Wake* (Routledge, 1955); *Wild Encounters* (Routledge, 1957); *Wanderers of the Field* (Routledge, 1959); *Wild Favours* (Hutchinson, 1963); *Muntjac* (Longman, 1969).

Contrib: *Christian Science Monitor; Country Life; Countryman; Sunday Times; Wildlife*.

Exhib: RA; RMS; SWLA; Wildlife Gallery, Lavenham (1991).

Collns: BM; Blackpool; AGO, Toronto.

Bibl: Duff Hart Davies: *Wildings* (1990); *The Illustrators: Catalogue* (Chris Beetles Ltd., 1991); ICB; ICB2; Waters; Who; Peppin.

SOPER, George 1870-1942
See Houfe
Born in London, Soper was educated in Ramsgate, and had no early formal art training, though for a brief time he studied etching under Sir Frank Short. He became a watercolourist, etcher and engraver, and he exhibited widely. Like his daughter, Eileen Soper*, he took his subject matter mostly from nature and from life on the farm. He illustrated a few books, though most were done before 1915; and he illustrated many adventure stories in the *Captain* and other magazines. His magazine work included illustrations for John Buchan's "The Black General" which appeared in the *Captain* in 1910, and which was later republished as *Prester John*. He worked extensively as a printmaker in the 1920s and was elected ARE (1918); RE (1920). He was also a keen botanist and conservationist, creating a garden of rare plants at his home in Hertfordshire, later tended with love by his daughter, Eileen.

Books illustrated include: C. Kingsley: *The Water Babies* (Headley, 1908); C. Lamb: *Tales from Shakespeare* (Headley, 1909); C. Kingsley: *The Heroes* (Headley, 1910); L. Carroll: *Alice in Wonderland* (Headley, 1911); N. Hawthorne: *Tanglewood Tales* (Headley, 1912); G. Williams: *The Arabian Nights* (Headley, 1913); D. Defoe: *Robinson Crusoe* (Cassell, 1914); *Grimm's Fairy Tales* (1916); M. England: *Warne's Happy Book for Girls* (with others, Warne, 1935); G. Williams: *Little Gardens* (Warne, 1938); R. Farrar: *Among the Hills* (nd).

Contrib: *BOP; Cassell's Magazine; Captain; Chums; Country Life; Graphic; ILN; Strand; Young England*.

Exhib: RA; RE; RI; RHA; RSA; RBA; NEAC; FAS; Glasgow; Liverpool; Wildlife Gallery, Lavenham (1990).

Bibl: Paul Heiney: *George Soper's Horses* (1990); Doyle BWI; Peppin; Waters.

SORRELL, Alan 1904-1974
Born on 11 February 1904 in Tooting, Sorrell was brought up in Southend, Essex, and studied at Southend Municipal School of Art (1919). He worked as a commercial designer in London and then attended RCA (1924-28). After winning the Prix de Rome in 1928, he spent two years in Rome, returning in 1931. He taught drawing at the RCA; painted murals for Southend Public Library (1933-36). In 1936 he recorded the archaeological excavations of the Roman forum in Leicester, and these were published with drawings of reconstructions, in *Illustrated London News* in 1937. He was invited by Dr. Mortimer Wheeler to do similar reconstructions for Maiden Castle in Dorset, and these too were published in *ILN*. More work of this kind was done 1937-40, and during WW2 he was a camouflage officer. After the war he taught drawing again at RCA until 1948, and then worked largely on archaeological reconstructions in Britain and abroad for publishers and the Ministry of Works. He has the ability to invest his reconstructions with activity and drama — his illustrations for Jessup's *Age by Age* (1967) are among his best work in this genre. He was elected RWS (1941).

Books illustrated include: R. Jessup: *Age by Age* (Joseph, 1967); J.R.C. Hamilton: *Saxon England* (Lutterworth, 1968); B. Green: *Prehistoric Britain* (Lutterworth, 1968); *Holy Bible* (Collins, 1970); A.R. Birley: *Imperial Rome* (Lutterworth, 1970); M.S. Drower: *Nubia: A Drowning Land* (Longman, 1970).

Books written and illustrated include: *Living History* (Batsford, 1965); *Roman London* (Batsford, 1969); *British Castles* (Batsford, 1973).

Contrib: *ILN*.

Exhib: RA; RWS; NEAC.

Bibl: *Landscape in Britain 1850-1950* (Arts Council, 1983); Waters.

SOUTHALL, Joseph
See Houfe

SOWERBY, [Amy] Millicent 1878-1967
See Houfe
Born in Northumberland, the daughter of John Sowerby, a land-

scape and flower painter, Millicent Sowerby became a figure painter and illustrator. She illustrated many books for children, collaborating with her sister Githa. She also contributed to a number of magazines, and designed postcards. Beetles† asserts that the graphic style and flat colours of her early works "was later replaced by a loose and more painterly handling which was less conducive to reproduction".

Books illustrated include: G. Sowerby: *The Wise Book* (Dent, 1906); L. Carroll: *Alice in Wonderland* (Chatto, 1907); G. Sowerby: *The Bumbletoes* (Chatto, 1907), *Yesterday's Children* (Chatto, 1908); R.L. Stevenson: *A Child's Garden of Verses* (Macmillan, 1908); Grimm: *Fairy Tales* (1909); G. Sowerby: *The Happy Book* (Hodder, 1909) and ten other books; *Little Plays for Little People* (Hodder, 1910); R. Fyleman: *The Sunny Book* (OUP, 1918); N. Joan: *The Glad Book* (OUP, 1921), *The Darling Book* (OUP, 1922), *The Joyous Book* (OUP, 1923).

Contrib: *ILN; Pall Mall; Tatler; Windsor.*

Exhib: RI.

Bibl: *The Illustrators: Catalogue* (Chris Beetles Ltd., 1991); ICB; Peppin; Waters.

SPARE, Austin Osman **1886-1956**
See Houfe
Books illustrated include: E.R. Wheeler: *Behind the Veil* (Nutt, 1906); C.J. Darling: *On the Oxford Circuit* (Smith Elder, 1909); J. Bertram and F. Russell: *The Starlit Mire* (BH, 1915); J.C. Squire: *Twelve Poems* (Morland Press, 1916); V.S. Wainwright: *Poems and Masks* (St. Peter Port: Toucan Press, 1968).
Books written and illustrated include: *Earth Inferno* (Cooperative Printing Society, 1905); *A Book of Satyrs* (BH, 1909); *The Book of Pleasure* (Cooperative Printing Society, 1913); *The Focus of Life: The Mutterings of Aaos* (Morland Press, 1920).
Contrib: *Apple; Form; Golden Hind.*

SPENCE, Geraldine **b.1931**
Born in Esher, Surrey, Spence studied at Wimbledon School of Art (1948-52), and then at RCA (1953-56 under Edward Bawden* and John Nash*). While at the RCA she experimented with typography and design at the Lion and Unicorn Press. After she left college she became a free-lance artist, working mostly on illustrations for children's books and for book jackets; and illustrations for several school pamphlets for the BBC and school books for Hodder.
Books illustrated include: W. Mayne: *The Blue Boat* (OUP, 1957); P. Berna: *Threshold of the Stars* (BH, 1958); N. Chauncy: *Devil's Hill* (OUP, 1958); J. Reeves: *Mulbridge Manor* (Heinemann, 1958); B. Roland: *The Forbidden Bridge* (BH, 1961); E. Spence: *The Green Laurel* (OUP, 1963); N. Streatfeild: *Lisa Goes to Russia* (Collins, 1963); A. Hewitt: *The Bull Beneath the Walnut Trees* (1966); J. McNeill: *The Nest Spotters* (1972); N. Hunter: *The Frantic Phantom* (BH, 1973); E. Spence: *The Nothing Place* (OUP, 1973); L. Hinds: *Crockery* (Watts, 1976); B. Taylor: *First English* (Hodder, 1981); D. Phillips: *So Was!: Guided Composition Practice in German* (Hodder, 1982).
Contrib: *Economist; Radio Times.*
Bibl: ICB3; ICB4; Peppin; Ryder; Usherwood.

SPENCER, Gilbert **1892-1979**
Born in Cookham on 4 August 1892, the youngest of twelve children (including Stanley Spencer*, one of the finest twentieth century British painters), Gilbert Spencer was educated at home by his sister Annie before he attended the Ruskin School in Maidenhead (1909-11). He then studied various subjects, including woodcarving, at Camberwell School of Arts and Crafts and the Slade (1913-15) before enlisting in the RAMC, serving in Salonika and Egypt (1915-19). After the war he returned to the Slade, became a member of NEAC, and continued to paint, having his first one-man exhibition at the Goupil Gallery in 1923. He was appointed to the staff of the RCA in 1930 and was Professor of Painting 1932-48. He painted murals, including the "Legend of Balliol" for Balliol College, Oxford (1934-36). During WW2 he was an official war artist (1940-43), and after the war became Head of the Department of Painting, Glasgow School of Art (1948-50) and at Camberwell (1950-57). Elected NEAC (1919); ARWS (1943); RWS (1949); ARA (1950); RA (1959). He died in January 1979.

Austin O. SPARE "Farewell to synthesis": pen drawing from *Golden Hind* vol.1 no.3 (April 1923)

Spencer was mainly a painter of the countryside (he took particular pleasure in farm crafts) and muralist but he illustrated a number of books, mostly in pen and ink. His illustrations for Eiluned Lewis' *In Country Places* (1951) have something of the humour and apparent simplicity of Bawden*. He wrote a book on his brother, *Stanley Spencer* (1961).
Books illustrated include: T.F. Powys: *Fables* (Chatto, 1929), *Kindness in a Corner* (Chatto, 1930); W.B. Yeats: *Three Things* (Ariel Poem; Faber, 1929); *The Ten Commandments* (Mill House Press, 1934); E. Lewis: *In Country Places* (Country Life, 1951); A. Huxley; H.G. Wells.
Books written and illustrated include: *Stanley Spencer* (Gollancz, 1961).
Exhib: Goupil Gallery; Leicester Gall; Reading Art Gallery (retrospective 1964); FAS (retrospective 1974).
Collns: Tate.
Bibl: *John Bull's Home Guard: Exhibition Catalogue* (AIA, 1944); *Daily Telegraph* obit. 16 January 1979; Gilbert Spencer: *Memoirs of a Painter* (Chatto, 1974); *Gilbert Spencer* (The Fleuron, 1926); Harries; Peppin; Rothenstein; Tate; Waters.

SPENCER, Stanley **1891-1959**
Born on 30 June 1891 at Cookham, Berkshire, Spencer studied art at the Slade (1908-12), where his contemporaries included Paul

Nash*, William Roberts* and Mark Gertler. During WW1 he served first in the RAMC and later fought in the trenches with the Royal Berkshire Regiment. When he returned to England, he started the work which was to make him one of the greatest of twentieth century English painters. Between 1927 and 1932 he worked on the decorations for the Sandham Memorial Chapel, Burghclere, based on his memories of the war in Macedonia. He was a member of NEAC (1919-27), and was elected to the Royal Academy in 1932 but resigned in 1934 after his painting, "St. Francis and the Birds," was rejected. The War Artists' Advisory Committee commissioned him to paint pictures of shipyards during WW2. He rejoined the RA in 1950 and was elected Academician. In the same year he was created CBE and he was knighted in 1958. He died in Taplow on 14 December 1959.

Spencer illustrated only one book, *A Chatto & Windus Almanack for 1927*, for which Charles Prentice of Chatto & Windus commissioned him to produce twenty-five pen and ink drawings of pastoral and domestic themes. He began work on the drawings in March 1926, shortly after the completion of "The Resurrection, Cookham." Spencer interpreted the changing seasons with scenes from his childhood, life with his friends in London and his marriage to Hilda Carline. The drawings are almost lyrical in their evocation of a quiet domestic existence, and there is no hint of the exaggerated sexual emphasis which appears in the paintings of the late 1930s. The book was published in two versions — 3,000 at 1s. bound in paper covers, and 250 in an *edition de luxe*, all printed at the Curwen Press. Two copies are held at the Tate Gallery, annotated in Spencer's hand. Several of the drawings have been squared up for later development, and a number did appear as a basis for later paintings.

Books illustrated include: *A Chatto & Windus Almanack for 1927* (Chatto, 1927).

Exhib: 1st one-man show, Goupil Gallery, 1927; Venice Biennale, 1932 and 1938; Tate. Retrospective exhibitions — Temple Newsam, Leeds, 1946; Tate Gallery, 1955; RA, 1980.

Colln: Tate; IWM; Stanley Spencer Gallery, Cookham; Fitzwilliam; Leeds.

Bibl: Duncan Robinson: *Stanley Spencer: Visions from a Berkshire Village* (Oxford: Phaidon Press, 1979); *Stanley Spencer RA* (Royal Academy, 1980); Gilbert Spencer: *Stanley Spencer* (Gollancz, 1961); Introduction to the 1983 edition of *A Chatto & Windus Almanack for 1927* (Chatto & Windus, 1983); Harries; Rothenstein; Waters.

SPURRIER, Steven **1878-1961**
See Houfe
Born on 13 July 1878 in London, Spurrier was apprenticed to a silversmith when he was seventeen, and studied at Heatherley's in the evenings. He became a landscape and figure painter, exhibiting at the RA from 1913. He was elected RBA (1933); ARA (1943); RA (1952). He died in London on 12 March 1961.

He worked as an illustrator for the *Illustrated London News* for many years, and contributed to many other magazines, using line and wash. He illustrated a number of books, producing some richly colourful watercolour plates for *The Country Wife* (1934), and for *Nicholas Nickleby* (1940), to which he added some sixty-five small black and white drawings for the chapter headings. He also drew the maps for Arthur Ransome's books and wrote several books on illustration.

Books illustrated include: G.M. Fenn: *Trapped by Malays* (Chambers, 1907); W. Wycherley: *The Country Wife* (Hutchinson, 1934); H. Spring: *Sampson's Circus* (Faber, 1936); N. Streatfeild: *The Circus Is Coming* (Dent, 1938); C. Dickens: *Nicholas Nickleby* (NY: Heritage, 1940); K. Barne: *We'll Meet in England* (Hamilton, 1942); R. Lynd: *Life's Little Oddities* (Dent, 1941); K. Barne: *Three and a Pigeon* (Hamilton, 1944); *The Modern Gift Book for Children* (1948); W. Shakespeare: *The Sonnets* (Southend: Lewis, 1950); E. Goudge: *The Valley of Song* (ULP, 1951).

Contrib: *Black and White; Good Housekeeping; Harper's Bazaar; ILN; Madam; Nash's Magazine; Radio Times; Strand*.

Published: *Illustration: Its Practice in Wash and Line* (Pitman, 1933).

Exhib: RA; RBA; RI; ROI; NS; PS.

Collns: RA; V & A.

Bibl: Driver; Hodnett; Peppin; Waters.

STAMPA, George Loraine **1875-1951**
See Houfe
Books illustrated include: B. Atkey: *Easy Money* (Grant Richards, 1908); E.V. Lucas: *Specially Selected* (Methuen, 1920), *Urbanities* (Methuen, 1921); S.L. Cummins: *Plays for Children* (three vols., Methuen, 1922); B.M. Hastings: *Memoirs of a Child* (Philpot, 1926); R. Kipling: *Supplication of a Black Aberdeen* (1927), *Thy Servant a Dog* (Macmillan, 1930); J. Walker: *My Dog and Yours* (Ward Lock, 1929), *That Dog of Mine* (Ward Lock, 1930); R. Kipling: *Collected Dog Stories* (1934).

Books written and illustrated include: *Loud Laughter* (Cassell, 1907); *Ragamuffins* (1916); *Humours of the Street* (Methuen, 1921); *In Praise of Dogs* (Muller, 1948).

STANDON, Edward Cyril **b.1929**
Born on 31 May 1929 in London, Standon studied at St. Martin's School of Art. He paints animals and illustrates books for children, many written by his wife, Anna Standon. His picture books started because he used to draw animals for his son's amusement, and he turned this into a successful career. He also draws and designs graphics for children's television programmes, including his own programme, "Issi Noho". His illustrations are done in black and white, and occasionally in colour.

Books illustrated include: A. Standon: *The Singing Rhinoceros* (Constable, 1963), *A Flower for Ambrose* (Constable, 1964), *The Hippo Had Hiccups* (Constable, 1964), *Three Little Cats* (Constable, 1964), *The Tin Can Tortoise* (Constable, 1965), *Little Duck Lost* (Constable, 1965); L. Berg: *How John Caught the Sea Horse* (Penguin, 1966), *The Penguin Who Couldn't Paddle* (Penguin, 1966); A. Standon: *Bridie the Bantam* (Constable, 1967); K. Chatfield: *Issi Pandemonium* (Heinemann, 1975), *Issi's Magic Tonic* (Heinemann, 1976).

Books written and illustrated include: *The Porridge Pot and the Big Turnip* (Macmillan, 1970).

Bibl: ICB3; ICB4; Peppin.

STANDRING, Heather **b.1928**
Born in Olveston, Gloucestershire, Standring studied at the Central School of Arts and Crafts under Bernard Meninsky, intending to go into fashion drawing. She free lanced in this area and in general illustration for two years after graduation, and then travelled abroad, returning to London in 1954. She designed a number of book jackets, including those for Mordecai Richler's *A Choice of Enemies* (Deutsch, 1957) and Lapolla's *Mushroom Cookery* (Deutsch) where she made skilful use of mechanical tints to suggest the texture of the vegetables.

Bibl: Ryder.

STANLEY, Diana **b.1909**
Born on 18 February 1909 in London, Stanley was educated at Cheltenham Ladies College, and studied art at the Regent Street Polytechnic and the Byam Shaw School of Drawing and Painting (1929-34). She painted murals while still a student, and then worked as an engineering draughtsman in London. She taught at Byam Shaw (1934-38, 1946-48), but gave up teaching to write *Anatomy for Artists* (1951). She suffered an injury to her right arm during an air raid, and had to draw with her left hand for a while; she exhibited works done in that way after WW2 at the Batsford Gallery. Her injury made it impossible for her to produce etchings or engravings, and she concentrated on painting. As an illustrator, she is best known for her pen drawings for *The Borrowers*.

Books illustrated include: R. Henrey: *Matilda and the Chickens* (Dent, 1950); M. Norton: *The Borrowers* (Dent, 1952); L. Carroll: *Alice in Wonderland* (1954); M. Norton: *The Borrowers Afield* (Dent, 1955), *The Borrowers Afloat* (Dent, 1959), *The Borrowers Aloft* (Dent, 1961); M. Cockett: *Bridges* (O & B, 1963), *Ash Dry, Ash Green* (1966); M. Norton: *Poor Stainless* (Dent, 1971).

Published: *Anatomy for Artists* (Faber, 1951).

Exhib: RA; LG; Batsford Gallery (1945).

Bibl: Doyle; ICB2; Peppin; Waters.

STARKE, Leslie H. **b.1907?**
A Scottish artist who first planned to be a lawyer, Starke went to London from Fife in about 1932. He contributed cartoons to

Leslie STARKE "The JP" from *Poetic Justice* by J.P.C. (Stevens, 1947)

Lilliput, including at least two colour covers for the magazine, and did posters for the Ministry of Food during WW2. An all-round comic artist, he started working for *Punch* in the 1940s, and with Anton* and [J. W.] Taylor "represented the first generation of crazy humorists at their best." (Price.)

Books illustrated include: J.P.C.: *Poetic Justice* (Stevens, 1947).

Books written and illustrated include: *Starke and Unashamed* (Reinhardt, 1953); *Starke Staring* (Reinhardt, 1955); *Starke Parade* (Reinhardt, 1958).

Contrib: *Lilliput; Punch*.

Bibl: *Lilliput*, June 1950; Fougasse; Price.

STEAD, Leslie Leonard 1899-1966

One of the most prolific illustrators of the adventure stories for boys written by W.E. Johns*, Stead used both black and white, and full colour. Most of the illustrations use wash, and are reproduced in half-tone. He illustrated almost all of Johns' books after 1942 when Howard Leigh*, Johns' long-time friend and illustrator of his books, had died.

Books illustrated include: W.E. Johns: More than ninety books about Biggles, Gimlet and Worrals, published by Hodder or Brockhampton, 1942-65.

Bibl: Peter B. Ellis and Piers Williams: *By Jove, Biggles!* (W.H. Allen, 1981); Peppin.

STEADMAN, Ralph Idris b.1936

Born on 15 May 1936 in Wallasey, Cheshire, Steadman was educated at Abergele Grammar School in North Wales. He was first apprenticed to De Havilland Aircraft Company, but soon left to join an advertising agency. He began a correspondence course in art which he continued during National Service, after which he started working on the northern group of Kemsley Newspapers and studied art in evening classes at East Ham Technical College (1959-66) and London College of Printing and Graphic Arts (1961-65).

He became a free-lance artist, and began to work for a number of magazines, including *Punch* and *Private Eye*. Much influenced by the work of George Grosz and Saul Steinberg, most of his caricatures and his other drawings are strongly satirical. He has become one of Britain's leading cartoonists and illustrators, with an international reputation. He was voted "Illustrator of the Year" by American Institute of Graphic Art in 1977. He is a savage critic of many aspects of our civilization, and like Gerald Scarfe's*, Steadman's work is harsh and bitter, and delights in showing the stupidity and cupidity of his targets, and the cruelty of men. His illustrations of some of the less savoury aspects of life offend some readers while others find them amusing and honest. Some frequent victims of Steadman's scorn have been Freud, dogs and America.

Steadman has illustrated many books, including those that he has written. His illustrations for *Alice in Wonderland* (1967) won the Francis Williams Book Illustration Award in 1973, and *I, Leonardo* (1983) won the W.H. Smith Illustration Award in 1987; and he was awarded the Italian Critica in Erba Prize at the Bologna Children's Books Fair, 1987, for *That's My Dad*. He uses mostly pen and ink, with added colour, often red for blood, or full colour. His illustrations for children's books are much gentler.

Books illustrated include: R. Carrickford: *This Is Television* (Muller, 1958); *Private Eye's Romantic England* (Weidenfeld and Nicolson, 1963); F. Dickens: *Fly Away Peter* (Dobson, 1964); M. Damjan: *The Big Squirrel and the Little Rhinoceros* (NY: Norton, 1965); *The Penguin Private Eye* (Penguin, 1965); D. Ashford: *Love and Marriage* (Hart-Davis, 1965), *Where Love Lies Deepest* (Hart-Davis, 1966); *Book of Boobs* (Private Eye, 1966); T. Ali: *The Thoughts of Chairman Harold* (Gnome Press, 1967); L. Carroll: *Alice in Wonderland* (Dobson, 1967); M. Damjan: *The Little Prince and the Tiger Cat* (NY: McGraw-Hill, 1968), *The False Flamingoes* (Dobson, 1968); *Private Eyewash* (Macdonald, 1968); R. Ingrams: *The Tale of Driver Grope* (Dobson, 1969); M. Damjan: *Two Cats in America* (Longman, 1970); T. Palmer: *Born Under a Bad Sign* (Kimber, 1970); H.S. Thompson: *Fear and Loathing in Las Vegas* (NY: Random House, 1971); L. Carroll: *Alice Through the Looking Glass* (McGibbon & Kee, 1972); J. Deverson: *Night Edge* (Bettiscombe Press, 1972); T. Hughes: *In the Little Girl's Angel Gazem* (Steam Press, 1972); E. Lucie-Smith: *Two Poems of Night* (Turret Books, 1972), *The Rabbit* (Turret Books, 1973); H.S. Thompson: *Fear and Loathing on the Campaign Trail* (Straight Arrow, 1973); J. Letts: *A Little Treasury of Limericks Fair and Foul* (Deutsch, 1973); K. Baumann: *Dozy and Hawkeye* (Hutchinson, 1974); R. Heller: *The Common Millionaire* (Weidenfeld & Nicolson, 1974); *Steam Press Portfolios Nos. 1-3* (Steam Press, 1974-6); L. Carroll: *The Hunting of the Snark* (Dempsey/Studio Vista, 1975); F. O'Brien: *The Poor Mouth* (Hart-Davis, 1975); D. Sidjanski: *Cherrywood Cannon* (Paddington Press, 1978); B. Stone: *Emergency Mouse* (Andersen Press, 1978); T. Hughes: *The Threshold* (Steam Press, 1979); B. Stone: *Inspector Mouse* (Andersen Press, 1980); E. Lucie-Smith: *A Note on Mice* (Turret Books, 1981); A. Mitchell: *For Beauty Douglas: Collected Poems* (Allison & Busby, 1982); B. Stone: *Quasimodo Mouse* (Andersen Press, 1984); R.L. Stevenson: *Treasure Island* (Harrap, 1985); L. Carroll: *The Complete Alice; and, The Hunting of the Snark* (Cape, 1986).

Books written and illustrated include: *Ralph Steadman's Jelly Book* (Dobson, 1967); *The Little Red Computer* (Dobson, 1968); *The Yellow Flowers* (Dobson, 1968); *Still Life with Raspberries* (Rapp & Whiting, 1969); *Dogsbodies* (Abelard-Schuman, 1970); *The Bumper to Bumper Book for Children* (Abelard-Schuman, 1972); *America* (NY: Straight Arrow, 1974); *The Bridge* (Collins, 1974); *Flowers for the Moon* (Zurich: Nord Sud Verlag, 1974); *Sigmund Freud* (Paddington Press, 1979); *The Curse of Lono* (with H.S. Thompson, Pan/Picador, 1981); *No Good Dogs* (Putnams, 1982); *I, Leonardo* (Cape, 1983); *Between the Eyes* (Cape, 1984); *That's My Dad* (Andersen Press, 1986); *The Scar Strangled Banner* (Harrap, 1987); *The Big I Am* (Cape, 1988); *No Room To Swing a*

Cat (Andersen Press, 1989).

Contrib: *Ambit; Aquarius; Daily Sketch; Daily Telegraph; Observer; New Society; New Statesman; New York Times; Penthouse; Playboy; Private Eye; Punch; Rolling Stone; Saturday Night; Scanlans; Sunday Chronicle; Time Out; Times; Weekend Magazine (Canada).*

Exhib: Bath Gallery; National Theatre (retrospective 1977); Royal Festival Hall.

Bibl: P. Hogarth: *The Artist As Reporter* (Fraser, 1986); Stanley Mason: "I, Leonardo", *Graphis* 40 No. 230 (March/April, 1984): 22-29; Bateman; Driver; Feaver; Peppin; IFA.

Colour Plate 133

STEBBING, Hilary **fl. 1940s**
Stebbing wrote and illustrated a number of books for young children for the Transatlantic Arts and for Puffin. Her bright colours and style recall the work of Lewitt* and Him*. Stebbing's illustrations were done by autolithography, and printed by such companies as Curwen and Cowell. Eyre declares *Maggie the Streamlined Taxi* to be "one of the most amusing wartime picture books."

Books written and illustrated include: *Maggie the Streamlined Taxi* (Transatlantic Arts, 1943); *Pantomime Stories* (Puffin Picture Book 30; Penguin, 1943); *The Animals Went in Two by Two* (Transatlantic Arts, 1944); *Monty's New House* (Transatlantic Arts, 1944); *The Silly Rabbits* (Transatlantic Arts, 1944); *Extinct Animals* (Puffin Picture Book 55; Penguin, 1946); *Monty's New Car*; *Freddie and Ernest* (Transatlantic Arts, 1946); *Living Animals* (Cassell, 1954).

Bibl: Eyre; Whalley.

STERN, Simon **b.1943**
Born on 12 September 1943 in London, Stern studied graphic design at the London College of Printing, but left before completing the course in order to take a job in publishing. In 1969 he became a free-lance illustrator and writer of books for children, using simple, cartoon-like line drawings with bright colour washes.

Books illustrated include: I. Serraillier: *The Ballad of St. Simeon* (1970), *The Bishop and the Devil* (1971); D. Sampson: *Grump and the Hairy Mammoth* (Methuen, 1971); B. Earnshaw: *Dragonfall 5 and the Royal Beast* (Methuen, 1972), *Dragonfall 5 and the Space Cowboys* (Methuen, 1972) and two other titles; E. Ibbotson: *The Great Ghost Rescue* (Macmillan, 1975); S. Caveney: *Inside Mum* (Sidgwick, 1976), *Little Zip's Dressing-Up Book* (and three other titles in series, Pelham, 1977-80); D. Coates: *Jacko and Delilah* (Methuen, 1978); D. Sampson: *Grump and That Mammoth Again!* (Methuen, 1981); S. Caveney: *Fred Feels Fed Up* (Pelham, 1982) and three other titles; S. Arengo: *The Cave Kids* (Glasgow, 1983) and four other titles.

Books written and illustrated include: *The Life and Fables of Aesop* (1970); *Astonishing Adventures of Captain Ketchup* series (Methuen, 1972-6); *The Hobyahs* (Methuen, 1977); *Mrs. Vinegar* (Methuen, 1979); *Vasily and the Dragon* (Pelham, 1982); *The Adventures of Half Chick* (Methuen, 1983).

Bibl: CA; ICB4; Peppin.

STEWART, Charles William **b.1915**
Born on 18 November 1915 in Ilo-Ilo in the Philippines (where his father was a merchant), Stewart was sent home at the age of three and was brought up in Scotland and, after 1923, in Sussex. After

Charles STEWART *Uncle Silas* by Sheridan Le Fanu (Folio Society, 1988)

preparatory school in Surrey, he was educated at Radley College (1928-32), and studied at the Byam Shaw School (1932-38), where he was taught by Ernest Jackson. While at the Byam Shaw, he started going to ballet classes in the evening, and in 1936 was engaged as a member of the corps de ballet at the Royal Opera House, Covent Garden. He danced for two seasons and designed some costumes for male dancers, but gave up ballet to concentrate on his art studies. After working as an ARP stretcher bearer in London during WW2 (1940-46), he taught drawing and illustration at the Byam Shaw (1950-58). He returned to the family estate in Dumfries, Scotland, in 1960, and inherited the family property at New Abbey in 1962.

Stewart has illustrated many books with pen and ink drawings, sometimes with added watercolour washes. Since contemporary illustrators which influenced his work include Rex Whistler* and Joan Hassall*, it is not surprising that he is particularly interested in "period" illustrations, enjoying the research required for work such as the illustrations to Thackeray's *Pendennis*, which was done for the Limited Editions Club of New York. He has also designed many book jackets for various publishers, including Eyre & Spottiswoode, The Falcon Press, OUP, Bodley Head, Constable and Faber.

After 1975 the pressures of running the estate made it too difficult to keep to publishers' deadlines, and he has concentrated on painting landscapes and flowers in watercolour, and on forming a collection of antique costumes (which was started to model his illustrations and which he has now presented, with "Shambellie", the fami-

ly house, to the Royal Scottish Museum). In 1988, the Folio Society published an edition of Sheridan Le Fanu's *Uncle Silas*, illustrated with drawings done by Stewart some forty years earlier for the Bodley Head, but which had been shelved since then (see also illustration on page 16). This was followed by watercolour illustrations for T.H. White's *Mistress Masham's Repose* (1989).

Books illustrated include: R. Fyleman: *Hob and Bob* (Hollis, 1944); C.H. Warren: *A Boy in Kent* (Hollis, 1944); B.L. Picard: *The Faun and the Woodcutter's Daughter* (OUP, 1951); J. Brooke: *The Flower in Season* (BH, 1952); E. Crozier: *Noah Gives Thanks* (Duckworth, 1952); W. Beckford: *Vathek* (BH, 1953); J. Forbes-Robertson: *Chowry* (MacGibbon & Kee, 1953); B.L. Picard: *The Lady of the Linden Tree* (OUP, 1954); B. Russell: *Nightmares* (BH, 1954); *The Rubaiyat of Omar Khayyam* (Rodale Press, 1955); C. Furse: *The Visiting Moon* (Faber, 1956); P. Crowle: *Come to the Ballet* (Faber, 1957); H. Read: *This Way Delight* (Faber, 1957); J. Ruskin: *The King of the Golden River* (Ward, 1958); B.K. Wilson: *Path-Through-The-Woods* (Constable, 1958); B.L. Picard: *The Story of Rama and Sita* (Harrap, 1960); W.M. Thackeray: *Pendennis* (NY: Limited Editions Club, 1961); A. Ransome: *The Soldier and Death* (Ward, 1962); N.S. Gray: *Grimbold's Other World* (Faber, 1963), *Mainly in Moonlight* (Faber, 1965); M. Storey: *Timothy and the Two Witches* (1966), *The Dragon's Sister* (Faber, 1967); B.L. Picard: *The Story of the Pandavas* (Dobson, 1968); N.S. Gray: *The Edge of Evening* (Faber, 1976); S. Le Fanu: *Uncle Silas* (Folio Society, 1988); T.H. White: *Mistress Masham's Repose* (Folio Society, 1989).

Contrib: *Britannia & Eve; Leader; Lilliput; Radio Times*.

Exhib: Scott Hay Gallery, Dumfriesshire (1975); Broughton Gallery (with John O'Connor*, 1986).

Bibl: Charles W. Stewart: *Holy Greed: The Forming of a Collection* (Royal Scottish Museum, 1981?); Peppin; Who; IFA.

STOBBS, William b.1914

Born on 27 June 1914 in South Shields, County Durham, Stobbs studied at King Edward VII School of Art, and then read history of art at Durham University. He became Head of Design at the London School of Printing (1950-58), and then was Principal of Maidstone College of Art.

He has been a most prolific illustrator of children's books since the early 1950s, and has written and illustrated more than twenty of his own. He has produced black and white drawings for historical stories, and coloured illustrations for picture books for young children and collections of folk and fairy tales. For his illustrations to Chekhov's *Kashtanka* and Ruth Manning-Sanders' *A Bundle of Ballads* he won the Kate Greenaway Medal in 1959, while Ronald Welch's *Knight Crusader* won the Carnegie Medal in 1955. Whalley writes that the "strength and earthy vigour of his figure drawing [are] always backed by careful research into details and an underlying sensitivity to his theme", and Peppin believes that his work paved the way to the "new" picture books of John Burningham*. In 1981-82 he produced a few picture books in which the illustrations had a kind of linen textured background. Fortunately he returned to his earlier style of more solid, brighter colours. Stobbs is married to illustrator Joanna Stubbs*.

Books illustrated include (but see Peppin): N. Cavanagh: *Night Cargoes* (Lunn, 1946), *Sister to the Mermaid* (Lunn, 1946); R. Syme: *That Must Be Julian* (Lunn, 1947); D.W. MacArthur: *Traders North* (Collins, 1951); D. Suddaby: *The Death of Metal* (OUP, 1952); R. Syme: *Cortez* (Hodder, 1952); R. Welch: *Knight Crusader* (OUP, 1954), *Captain of the Dragoons* (OUP, 1956); R. Syme: *The Forest Fighters* (Hodder, 1958), *River of No Return* (Hodder, 1958); A. Chekhov: *Kashtanka* (OUP, 1959); R. Manning-Sanders: *A Bundle of Ballads* (OUP, 1959); W. Mayne: *Summer Visitors* (OUP, 1959); D. Suddaby: *Fresh News from Sherwood* (BH, 1959); I. Serraillier: *The Ivory Horn* (OUP, 1960); R. **Sutcliff**: *Houses and History* (Batsford, 1960); M. Polland: *Beorn the Proud* (Constable, 1961); H. Treece: *The Golden One* (BH, 1961); A. Hewitt: *The Little White Hen* (BH, 1962); I. Serraillier: *The Clashing Rocks* (OUP, 1963); E. Blishen: *Miscellany One* (with others; OUP, 1964); M. Polland: *Queen without Crown* (Constable, 1965); A. Williams-Ellis: *Round the World Fairy Tales* (Warne, 1966); Grimm: *Rumpelstiltskin* (BH, 1970); J. Jacobs: *The Magpie's Nest* (BH, 1970); R. Manning-Sanders: *Gianni and the Ogre*

William STOBBS *Knight Crusader* by Ronald Welch (Oxford University Press, 1954)

Reynolds STONE *Two Stories: Come and Dine; Tadnol* by T.F. Powys (Hastings: R.A. Brimmell, 1967)

(Methuen, 1970); E. Poston: *The Baby's Song Book* (BH, 1972); Perrault: *Little Red Riding Hood* (BH, 1972); J. Jacobs: *Old Mother Wiggle-Woggle* (BH, 1975); J. Cunliffe: *Mr. Gosling and the Great Art Robbery* (Deutsch, 1979); M. Crouch: *The Ivory City* (Pelham, 1980), *Rainbow Warrior's Bride* (Pelham, 1981); R. Kipling: *The Cat That Walked by Himself* (Macmillan, 1982); R. Bonne: *I Knew an Old Lady* (OUP, 1987).

Books written and illustrated include: *Lilybelle* (Lunn, 1946); *The Story of the Three Bears* (BH, 1964); *The Story of the Three Little Pigs* (BH, 1965); *Jack and the Beanstalk* (Constable, 1965); *Life in England* (1970); *The Crock of Gold* (BH, 1971); *Johnny-Cake* (BH, 1972); *Dilly Dally* (Pelham, 1974); *The Derby Ram* (BH, 1975); *A Car Called Beetle* (BH, 1976); *Town Mouse, Country Mouse* (Pelham, 1976); *A Gaping Wide-Mouthed Waddling Frog* (Pelham, 1977); *The Hare and the Frogs* (BH, 1978); *Chanticleer: Chaucer's Story* (BH, 1979); *The Grape That Ran Away* (BH, 1980); *One Sun, Two Eyes, and a Million Stars* (with Joanna Stubbs*; OUP, 1981); *This Little Piggy* (BH, 1981); *Animal Pictures* (BH, 1981); *Round and Round the Garden* (BH, 1982); *The House That Jack Built* (OUP, 1983); *Motor Museums of Europe* (Barker, 1983); *Guide to the Cheeses of France* (Apple, 1984); *Gregory's Dog* (OUP, 1984); *Gregory's Garden* OUP, 1984); *The Little Red Hen* (OUP, 1985); *Old Macdonald Had a Farm* (OUP, 1985); *A Frog He Would A-Wooing Go* (OUP, 1987).
Contrib: *Girl Annual*.
Bibl: Doyle; ICB2; ICB3; ICB4; Peppin; Ryder; Whalley.
Colour Plate 134

STOKELD, Sylvia b.1931
Books illustrated include: B.K. Wilson: *The Second Young Eve*

(with John Ryan*; Blackie, 1962); L. Millar: *Introducing Oxford: A Guide* (pp., 1974); J. Milton: *The Temptation, from Paradise Regained* (Hanborough Parrot, 1988).
Books written and illustrated include: *Some Dolls* (Inky Parrot Press, 1982)

STONE, Alan Reynolds 1909-1979
Born on 13 March 1909 in Eton, where his father was housemaster at Eton College (his grandfather was also a housemaster), Stone was educated at a preparatory school in Dorset before entering Eton himself (1921-27). He went on to Magdalene College, Cambridge, to read history and, after taking his degree in 1930, studied printing at the Cambridge University Press. He began to engrave during this period, met Eric Gill* by chance, and spent two weeks at Pigotts where he met David Jones* and René Hague. In 1932 he started work with a printer in Taunton, Somerset, and continued his own engraving, being further inspired by the engravers of the 1850s and 1860s. He received commissions for a number of engraving jobs, including his first royal bookplate (for Elizabeth of York) in 1934, *A Butler's Recipe Book* for CUP in 1935, and Royal Arms for the coronation of King George VI in 1937. He resigned from his job in 1934 to become a full-time, free-lance engraver and in 1939 he taught himself to cut letters in stone. He also painted in water-colour.
In 1938 Stone married Janet Woods, by whom he had two sons and two daughters (Phillida Gili*, an illustrator of children's books, is one daughter). During WW2 he served with the RAF in photo interpretation, and after the war his career blossomed, as did his reputation. The highlights of his output include the Royal Arms on the masthead of *The Times* (1951); postage stamps in 1946, 1958, 1960 and 1963; banknotes for the Bank of England (1963-64); a

Colour Plate 132. Ivy SKINNER ("JACQUIER") *Graziella* by Alphonse de Lamartine (The Nonesuch Press 1929)

Colour Plate 133. Ralph STEADMAN Original drawing from *I Leonardo* (Jonathan Cape 1983)

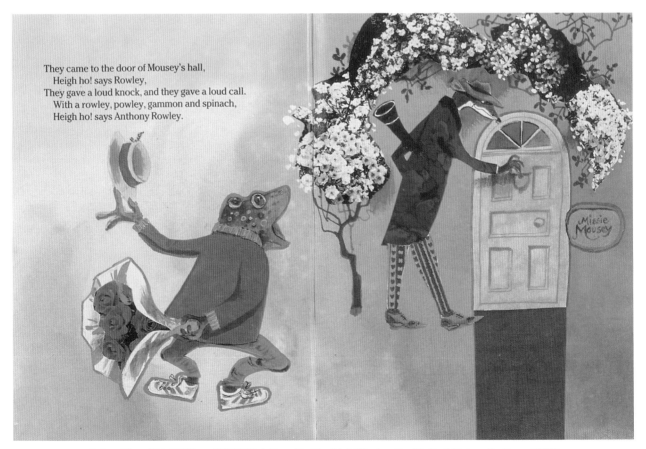

They came to the door of Mousey's hall,
 Heigh ho! says Rowley,
They gave a loud knock, and they gave a loud call.
 With a rowley, powley, gammon and spinach,
 Heigh ho! says Anthony Rowley.

Colour Plate 134. William STOBBS *A Frog He Would A-Wooing Go* (Oxford University Press 1987)

Colour Plate 135.
Betty SWANWICK
"The Scare-crow"
Original drawing in water-
colour with pencil
By permission of
Chris Beetles Limited

memorial stone for Winston Churchill in Westminster Abbey (1965); a typeface called "Minerva" (1954); devices for various publishers; and a large number of exquisitely executed book plates and book labels. His skill in cutting lettering for these small engravings has been unsurpassed. In addition, he illustrated a number of books with engravings, usually small blocks showing rural scenes. His admiration for Thomas Bewick and Gwen Raverat* can be seen in much of his work.

He was elected a member of the Art Workers Guild (1940); SWE (1948); RDI (1956); CBE (1953). He died in Dorchester on 23 June 1979.

Books illustrated include: P. James: *A Butler's Recipe Book* (CUP, 1935); W. Shakespeare: *Shakespeare Anthology* (Nonesuch Press, 1935); A. de Guevara: *The Praise and Happinesse of the Countrie-Life* (Gregynog Press, 1938); J.E. Masters: *Old English Wines & Cordials* (Bristol: High House Press, 1938); *Rousseau's Confessions* (Nonesuch Press, 1938); A.C. Swinburne: *Lucretia Borgia* (GCP, 1942); *Breviarum Romanum* (Burns, Oates, 1946); L. Paul: *The Living Hedge* (Faber, 1946); F. Reid: *Apostate* (Faber, 1947); A. Bell: *The Open Air* (Faber, 1949); E. Waugh: *The Holy Places* (Queen Anne Press, 1952); S.T. Warner: *Boxwood* (Monotype Corporation, 1957); E. Linklater: *The Sociable Plover* (Hart-Davis, 1957); R. Hodgson: *The Skylark* (Hart-Davis, 1958); H. Melville: *Omoo* (NY: Limited Editions Club, 1961); E.B. Browning: *Sonnets from the Portuguese* (Folio Society, 1962); S.T. Warner: *Lolly Willowes and Mr Fortune's Maggot* (Viking Press, 1966); T.F. Powys: *Two Stories* (Hastings: Brimmel, 1967); K. Clark: *The Other Side of the Alde* (Warren Editions, 1968); *Saint Thomas Aquinas* (NY: Limited Editions Club, 1971); K. Clark: *Moments of Vision* (Murray, 1973); A. Tennyson: *Poems* (NY: Limited Editions Club, 1974); F. Stark: *A Peak in Darien* (Murray, 1976); I. Murdoch: *A Year of Birds* (Compton Press, 1978); W.H. Hudson: *A Shepherd's Life* (Compton Press, 1978; Chatto, 1984).

Contrib: *London Mercury.*

Exhib: Agnews Gallery; New Grafton Gallery; Dorset County Museum (1981); V & A (1982).

Collns: V & A.

Bibl: John Carter: "The Woodcut Calligraphy of Reynolds Stone", *Signature* 2 (March 1936): 21-28; Myfanwy Piper: *Reynolds Stone* (Art & Technics, 1951); *Reynolds Stone: Engravings* (John Murray, 1977); *Times* 19 November 1979; *Reynolds Stone 1909-1979: An Exhibition . . .* (V & A, 1982); Garrett 1, 2; Peppin.

Colour Plate 18

STONEY, T.

Stoney produced wood engravings for Farjeon's *Dark World of Animals*, showing simple white outlines against solid black backgrounds, quite similar to some of Eric Daglish's* work.

Books illustrated include: E. Farjeon: *Dark World of Animals* (Sylvan Press, 1945).

STRICKLAND, Helen **fl. 1920-1930s**

Strickland studied at Westminster School of Art. A painter and illustrator, she made use of the pochoir stencil method of colouring illustrations by hand.

Books illustrated include: M. Strickland: *Shadow Birds* (1930).

Books written and illustrated include: *The Bargerys* (nd.)

Exhib: RA; NEAC.

Bibl: Peppin; Waters.

STRUBE, Sidney "George" **1891-1956**
See Houfe

Born at Bishopsgate in East London, Strube was christened Sidney but became universally known as "George" because of his custom of calling everyone by that name. He first worked as a draughtsman for a furniture company, before joining a small advertising agency. He studied figure drawing at John Hassall's Art School and started producing cartoons, first for the *Conservative and Unionist* and other papers. In 1912, he started working for the *Daily Express*, and his cartoons became extremely popular, being syndicated worldwide; he retired from the *Express* in 1948. Strube's cartoons display a fairly tolerant humour, being funny rather than severe and satirical. He seemed to have an ability of presenting popular thought on political subjects, but he entertained while pointing a political

Ann STRUGNELL "Prince Rabbit" from *The Faber Book of Modern Fairy Tales* edited by Sara and Stephen Corrin (Faber & Faber, 1981)

moral. His greatest creation was the "Little Man", the insignificant observer of what is going on around him.

Contrib: *Bystander; Conservative and Unionist; Daily Express; Evening Times; Everybody's; Throne and Country.*

Collns: University of Kent.

Bibl: *Beaverbrook's England 1940-1965: An Exhibition of Cartoon Originals . . .* (Centre for the Study of Cartoons and Caricature, University of Kent, 1981); H.R. Westwood: *Modern Caricaturists* (Lovat Dickson, 1932); Bradshaw.

STRUGNELL, Ann **fl. 1973-**

For *The Faber Book of Modern Fairy Tales*, Strugnell produced fifteen pen drawings and a full colour book jacket.

Books illustrated include: H. Cresswell: *The Bongleweed* (Faber, 1973); R. Godden: *Mr. McFadden's Hallowe'en* (Macmillan,

1975); A. Uttley: *Fairy Tales* (Faber, 1975); V. Havilland: *North American Legends* (NY: Philomel Books, 1979); M.W. Brown: *Once Upon a Time in a Pigpen* (Hutchinson, 1981; first pub. US 1977); S. Corrin: *The Faber Book of Modern Fairy Tales* (Faber, 1981).

Books written and illustrated by Strugnell include: *The Stories Julian Tells* (Gollancz, 1982); *More Stories Julian Tells* (Gollancz, 1986).

STUBBS, Joanna **b.1940**
Born on 20 April 1940 in London, Stubbs spent much of her childhood travelling abroad, and then studied at St. Martin's School of Art and Maidstone College of Art. She illustrates books for children in black and white and in colour. She writes her own stories for children, though normally the ideas for the illustrations come before the text. Elaine Moss in *The Times Literary Supplement* (29 September 1978) wrote of Stubbs' *Happy Bears Day* "Stubbs is a careful writer; her colour paintings are boldly bearish; the pencil work on alternate openings also has strength." Stubbs is married to illustrator William Stobbs*.
Books illustrated include: G. Kaye: *Koto and the Lagoon* (Deutsch, 1967); N. Mitchison: *The Family at Ditlabeng* (Collins, 1968); E. Figes: *Scribble Sam* (Deutsch, 1971); R. Brown: *The Million Pound Mouse* (Abelard, 1975); P. Appiah: *Why the Hyena Does Not Care for Fish* (Deutsch, 1977); M. Donaldson: *The Moon's on Fire* (Deutsch, 1980); Althea: *Going into Hospital* (Dinosaur, 1981); H. East: *Sara by the Seashore* (Macdonald, 1981); J.P. Walsh: *The Green Book* (Macmillan, 1981); A. Jungmann: *My Garden* (Purnell, 1982); S. Baker: *Eyes* (Macdonald, 1984), *Huff Puff Blow* (Macdonald, 1984); M. Dickinson: *Jilly You Look Terrible* (Deutsch, 1985), *Jilly Takes Over* (Deutsch, 1987).
Books written and illustrated include: *The Tree House* (Deutsch, 1974); *Weather Witch* (Deutsch, 1975); *Hannah* (Deutsch, 1976); *Happy Bears Day* (Deutsch, 1978); *UFO* (Deutsch, 1980); *With Cat's Eyes You'll Never Be Scared of the Dark* (Deutsch, 1983).
Bibl: ICB4; Peppin.

STUBLEY, Trevor Hugh **b.1932**
Born on 27 March 1932 in Leeds, Stubley was educated at Roundhay School, Leeds (1943-49), and studied at Leeds College of Art (1949-51) and Edinburgh College of Art (1951-53). He travelled through Europe on a scholarship for a year, and then did his National Service in Cyprus (1955-57). He did part-time teaching for a year (1957-58) and then lectured in painting and drawing at Huddersfield School of Art (1958-60), before becoming a free-lance artist in 1960.
A landscape and portrait painter, he has exhibited widely, and has had many significant commissions, including fifty portraits for *Yorkshire Life*, and H.M. The Queen, commissioned by the Institution of Electrical Engineers in 1986. His first book illustrations were published in 1960, and in the next twenty years, he illustrated over four hundred children's books. He uses a variety of techniques, including pen and ink, spatter, watercolour, gouache and pastel. He wrote in 1976 "I am an illustrator by adoption and not by instinct. I am here because I refuse to teach, because I insist on using my skills in the real world." (Stubley, 1976.†) His monochrome illustrations to White's *A Book of Merlyn* (1978), particularly his drawings of Merlin and Arthur, are imaginative and powerful, and yet humorous.
Stubley married Valerie Churm in 1963, and they have four sons. They live near Holmfirth in the Pennines, where he has his studios and his own gallery. Elected RP (1974); SIAD (1976, resigned 1985); ARBA (1986).
Books illustrated include (but see Peppin): M. Cockett: *Roads and Travelling* (Blackwell, 1964); W. Mayne: *The Yellow Airplane* (Hamilton, 1968); J. Seed: *The Voice of the Great Elephant* (Hamilton, 1968); J. Webster: *City Adventure* (Ginn, 1970); W. Mayne: *The Incline* (Hamilton, 1972); M. Hardcastle: *Free Kick* (Methuen, 1974); M. Mahy: *Clancy's Cabin* (1974); R. Parker: *The Fire Curse* (1974); *Mother Goose Abroad* (Hamilton, 1974); A. Ashton: *Saints and Changelings* (Blackie, 1975); G. Boshell: *Capt Cobwebb and the Chinese Unicorn* (Macdonald, 1975); D. Cate: *Flying Free* (Hamilton, 1975); N. Fisk: *The Witches of Wimmering* (Pelham, 1976); A. Chambers: *Funny Folk* (Heinemann, 1976); R.

Parker: *Flood* (Benn, 1976); D. Huddy: *No Ladder for Tom Bates* (Benn, 1978), *Gatecrashers* (Benn, 1978); T.H. White: *The Book of Merlyn* (Univ. of Texas Press, 1978); M. Cockett: *The Drowning Valley* (Hodder, 1978); D. Huddy: *Blow Up!* (Benn, 1978); *Portrait of Jesus* (OUP, 1979); E. Beresford: *The Four of Us* (Hutchinson, 1981); C. Cooper: *The Black Horn* (Hodder, 1981); S. McNeill: *Whizz-Kid* (Hamilton, 1982); B. Ashley: *A Bit of Give and Take* (Hamilton, 1984); J. Escott: *Radio Alert* (Hamilton, 1984); A. Ruffell: *The Black-Sand Miners* (Hamilton, 1985); C. Cooper: *The Kings of the Mountain* (Hodder, 1986); J. Pinto: *The School Library Disasters* (Hamilton, 1986); E. Renier: *The Night of the Storm* (Hamilton, 1986).
Contrib: *Yorkshire Life*.
Exhib: RA; RSA; RP; Bologna Children's Book Fair (1975); Bratislava Illustration Biennale (1976); Yorkshire Television Touring Exhibition; University of Leeds (retrospective 1986).
Collns: NPG; Leeds; University of Leeds.
Bibl: Trevor Stubley: "Illustrating Children's Books", *Growing Point* (November 1976); ICB4; Peppin; Who; IFA.

STUDDY, George Ernest **1878-1948**
See Houfe
Born in Devonport, Devon on 23 June 1878, Studdy was educated at Dulwich College, and studied art at evening classes at Heatherley's, followed by a term at Calderon's School of Animal Painting. He first worked in an engineering firm and then as a stockbroker's clerk before he became an illustrator. He contributed drawings, par-

Trevor STUBLEY *The Book of Merlyn* by T.H. White (University of Texas Press, 1977)

ticularly of children, to *Punch* and other magazines, and illustrated children's books. He created a puppy called "Bonzo" for the *Sketch* (first appeared on 8 November 1922) and this animal appeared in his books and was the creative urge for the *Bonzo Annual*. "Bonzo" became a craze in the 1920s, was reproduced in many forms, from postcards to clocks to car mascots, and featured in early animated films which Studdy directed. He was a member of the London Sketch Club, and was President in 1921-22. He died from lung cancer on 25 July 1948.

Books illustrated include: H.T. Sheringham: *Fishing* (1914).

Books written and illustrated include: *Uncle's Animal Book* (Warne, 1923); *The Bonzo Book* (Partridge, 1925); *The New Bonzo Book* (Partridge, 1927); *The Bonzooloo Book* (Partridge, 1929); *Bonzo and Us* (Partridge, 1931); *Bonzo Colouring Book* (Dean, 1934); *Jeek* (Hamilton, 1940).

Contrib: *Big Budget Boys Weekly; Bonzo Laughter Annual; Comic Cuts; Graphic; Little Folks; London Magazine; Punch; Sketch; Windsor.*

Bibl:*The Illustrators: Catalogue* (Chris Beetles Ltd., 1991); Doyle BWI; Peppin.

SULLIVAN, Edmund Joseph **1869-1933**
See Houfe

SUTHERLAND, Graham Vivian **1903-1980**
Born on 24 August 1903 in London, Sutherland was educated at a preparatory school in Sutton, Surrey, and at Epsom College. He abandoned an apprenticeship as a railway engineer to study art at Goldsmiths' College School of Art (1920-25), where he specialized in engraving. He held his first exhibition of drawings and engravings at the XXI Gallery in 1925 and was elected RE in 1926. He taught engraving and then illustration at Chelsea School of Art from 1926 to 1940. After experimenting with oils, he became a painter in the 1930s, and took part in the International Surrealist Exhibition in London in 1936. During WW2 he was an official war artist, and painted scenes of bomb devastation in Britain and of work in the mines and factories. After the war he concentrated on landscapes and portraits, which include well-known oils of Somerset Maugham and Winston Churchill (though the latter was disliked so much that it was destroyed). In 1952 he was commissioned to design a tapestry for the newly-built Coventry Cathedral. The cartoons for the tapestry became the souce material for his first *Bestiary*, which consisted of twenty-six colour lithographs (published by Marlborough Fine Art in 1968), and continued in the second *Bestiary* (1979), based on poems by Apollinaire.

A major British artist, Sutherland has also illustrated a few other books, his first being an Ariel Poem in 1931. His illustrations for *Henry VI, Part One* (1940) include six full-page lithographs in black and white, except for the frontispiece which has a red rose in it. Other graphic work includes at least seven posters for London Transport (1933-36).

Sutherland was elected ARE (1925); RE (1926); LG (1936); and was awarded OM (1960). He died in London on 17 February 1980.

Books illustrated include: V. Sackville-West: *An Invitation to Cast Out Care* (Ariel Poem; Faber, 1931); W. Shakespeare: *Henry VI Part One* (NY: Limited Editions Club, 1940); D. Gascoyne: *Poems*

1937-42 (Poetry London, 1943); S. Maugham: *Cakes and Ale* (Heinemann, 1954); G. Apollinaire: *Le Bestiaire* (Marlborough Fine Art, 1979).

Contrib: Horizon V/28; Poetry London; Signature.

Exhib: LG; NEAC; RE; Tate (1953, 1982); XXI Gallery; ICA (1951); Venice Biennale.

Collns: Tate; IWM; Graham Sutherland Gallery, Picton Castle, Haverfordwest.

Bibl: Ronald Alley: *Graham Sutherland* (Tate Gallery, 1982); Douglas Cooper: *The Work of Graham Sutherland* (Lund Humphries, 1961); Rigby Graham: *Romantic Book Illustration in England 1943-55* (Private Libraries Association, 1965); Edward Sackville-West: *Graham Sutherland* (Penguin Modern Painters; Penguin, 1943); Malcolm Yorke: *The Spirit of Place: Nine Neo-Romantic Artists and Their Times* (Constable, 1988); Compton; Harries; Peppin; Rothenstein; Tate; Waters.

SWANWICK, Ada Elizabeth Edith ("Betty") **1915-1989**
Born on 22 May 1915 at Forest Hill in south London, the daughter of a marine artist, Swanwick was educated at Prendergast School, Lewisham, and studied at Goldsmiths' College School of Art, the RCA (under Clive Gardiner* and Edward Bawden*), and the Central School of Arts and Crafts. She later taught at Goldsmiths' College (1948-69), the RA Schools, and the RCA.

Described by herself as "part of the small tradition of English painting that is a bit eccentric, a little odd and a little visionary" (Murphy, 1989†), and elsewhere as a "watercolourist of mystical symbolism enriched with a strange beauty" (Beetles, 1989†), Swanwick considered her late narrative pictures as her best work. She also designed posters for London Transport and advertisements for companies such as Shell-Mex; produced greeting cards and book jackets; painted murals for the Festival of Britain (1951) and Guy's Hospital (1955); illustrated a number of books for various publishers; and wrote and illustrated children's books. Her *The Cross Purposes* is subtitled "A Coloured Novelette", and is vividly illustrated with twenty-seven tinted line drawings; and John Betjeman described *Beauty and the Burglar* (1958) as "strange, startling, funny, with a weird beauty." (Beetles, 1991†.) She was elected ARA (1972); RA (1979); RWS (1976); and she died in Tunbridge Wells on 22 May 1989.

Books illustrated include: R. Duncan: *Jan's Journal* (Campion, 1949); U. Hounhane: *Little Pig Finnigan* (1958); B. Schofield: *The Urban Dweller's Country Almanac* (Cassell, 1978).

Books written and illustrated include: *The Cross Purposes* (Editions Poetry, 1945); *Lord Olly's Bay* (1946); *Ella's Birthday* (1946); *Hoodwinked* (Barker, 1957); *Beauty and the Burglar* (Barker, 1958); *Guide to Character* (1970).

Contrib: *Country Fair; Strand.*

Exhib: RA; RWS.

Bibl: *The Illustrators: Catalogue* (Chris Beetles Ltd., 1989; 1991); Brian Murphy: *The Art of Betty Swanwick* (Oxford Polytechnic, 1989); *Watercolours, Drawings and Paintings from the Studio of the Late Betty Swanwick* (an auction catalogue; Bonhams, 1990); Jacques; Peppin; Who.

Colour Plate 135

TALBOT KELLY, Chloe Elizabeth
See KELLY, Chloe Elizabeth Talbot

TALBOT KELLY, Richard Barrett
See KELLY, Richard Barrett Talbot

TANNER, Robin **1904-1988**
Born on 17 April 1904 in Bristol, Tanner was educated at Chippenham Grammar School, and went to London to study primary education at Goldsmiths' College (1922-24). He taught for a time in Greenwich, and in 1924 studied etching under Stanley Anderson and drawing under Clive Gardiner* at evening classes at Goldsmiths' College School of Art, with Graham Sutherland* as a fellow student.

An exhibition at the V & A in 1926 of the work of Samuel Palmer ensured Tanner's lasting addiction to his work and to etching. He returned to Wiltshire in 1928, intending to etch full time, but marriage in 1931 to Heather Spackman made him earn his living by teaching. During the 1930s and up to the end of WW2 Tanner did etch on a part-time basis and made drawings of plants to illustrate catalogues of the Royal Nurseries at Merriott in Somerset, but teaching filled his life from 1946 until 1964, when he retired as HM Inspector of Schools. He started etching again, producing "The Meadow Stile" in 1970, his first etching in twenty-four years. Another concern of the Tanners over many years was the establishment of the Crafts Study Centre in Bath at the Holburne of Menstrie Museum, under the aegis of the University of Bath.

Tanner's etchings, made as separate prints and for use as book illustration, are in the great romantic tradition of Calvert and Palmer. *Wiltshire Village*, written by Heather Tanner and illustrated by Robin Tanner, was published in 1939 with fifty-six pen drawings and six etchings. The Friends of the Bristol Art Gallery published Tanner's *The Etcher's Craft* in 1980 in which he discusses and describes his life and work. *Elegy Written in a Country Churchyard* was published in 1981, with an etched frontispiece and ten line

drawings. Elected ARE (1936); RE (1973); RWA. Tanner died in May 1988.

Books illustrated include: H. Tanner: *Wiltshire Village* (Collins, 1939; reissued by Robin Garton, 1979; Impact Books, 1987); G. Grigson: *Flowers of the Meadow* (King Penguin; Penguin, 1950); T. Gray: *Elegy Written in a Country Churchyard* (Garton, 1981); H. Tanner: *Woodland Plants* (Garton, 1981), *A Country Alphabet* (Blackheath: Old Stile Press, 1984), *A Country Book of Days* (Blackheath: Old Style Press, 1987?).

Books written and illustrated include: *The Etcher's Craft* (Friends of the Bristol Art Gallery, 1980).

Published: *Children's Work in Block Printing* (Dryad Press, 1936); *Lettering for Children* (Dryad Press, 1937).

Contrib: *Nash's* (1931).

Exhib: RA; Garton Gallery (retrospective 1977); Malmesbury (1980); Devizes Museum (1987?); Holburne Museum, Bath (commem. 1989); Bristol/Ashmolean (1980-81).

Collns: Ashmolean; Holburne Museum, Bath; Bristol.

Bibl: Michael Blaker: "Robin Tanner, R.E.", *Journal RE* no.6 (1984): 16-17; *Robin Tanner* (Bristol Museum and Art Gallery, 1981); Ian Jeffrey: *The British Landscape 1920-1950* (T & H, 1984); Barley Roscoe: "Et in Arcadia ego; Robin Tanner — master etcher", *The Green Book* 1, no.3 (Summer 1980): 12-13; Robin Tanner: *Double Harness: An Autobiography by Robin Tanner — Teacher and Etcher* (Impact Books, 1987); Waters.

See illustration on page 408

TARRANT, Margaret Winifred **1888-1959**
Born in Battersea, the daughter of Percy Tarrant*, Margaret Tarrant was educated at Clapham High School (1898-1905), where she won several awards for drawing. In 1905 she started to train as an art teacher but, uncertain of her teaching abilities, she became a full-time watercolour painter and illustrator of mostly children's books. Her first commission was for illustrations for Charles Kingsley's *The Water Babies* (1908), and she followed this with many other books, including some twenty for Harrap between 1915 and 1929. Her art studies at Heatherley's School of Art (1918, 1921, 1923) took place after she was already established as an illustrator. Later in her life, in about 1935 when she had moved to Surrey, she took another course at Guildford School of Art, where she met and made friends with fellow artist, Molly Brett (see Brett, Mary Elizabeth).

Tarrant had produced a series of paintings for postcards, published by C.W. Faulkner in 1909; but her work in this area really started when in 1920 she began working regularly for the Medici Society, producing many prints, books, booklets, greeting cards and calendars, illustrated by her romantic pictures of children, fairies and animals. She also produced many religious paintings which the Medici Society reproduced as prints; in 1936 the Society sent her to Palestine to collect material for her work, and extracts from her diary of that trip were published in 1988. In the 1930s and 1940s, she continued to produce watercolours of children and painted a wildflower series. Her delicately coloured and rather sentimental watercolours and pen and ink drawings have remained extremely popular to this day; a "Margaret Tarrant Diary" is still being pro-

Robin TANNER *Wiltshire Village* by Heather Tanner (Collins, 1939)

duced each year. She died on 28 July 1959 at her home in Peaslake, Surrey.

Books illustrated include (but see Peppin): C. Kingsley: *The Water-Babies* (Dent, 1908); G.A.B. Dewar: *The Book of Seasons* (1910); R. Browning: *The Pied Piper of Hamelin* (1912); M.A. Bigham: *Merry Animal Tales* (1913); M.St. J. Adcock: *The Littlest One* (1914); S. Wilman: *Games for Playtime and Parties* (1914); F. Cole: *A Picture Birthday Book for Boys and Girls* (1915); L. Carroll: *Alice's Adventures in Wonderland* (1916); M.St.J. Webb: *Knock Three Times* (1917); H. Golding: *Verses for Children* (1918); K. Howard: *The Little God* (1918); R. Rudolph: *The Tookey and Alice Mary Tales* (1919); F.E. Crompton: *The Gentle Heritage* (1920); N.M. Hayes: *The Book of Games* (with N.K. Brisley; 1920); M.St.J. Webb: *The Forest Fairies* (Medici Society, 1925), *The House Fairies* (Medici Society, 1925) and at least ten other titles to 1929; E. Farjeon: *An Alphabet of Magic* (1928); H. Goldin: *Our Animal Friends* (1930); M. Gann: *Dreamland Fairies* (1936); *Flowers of the Countryside* (with others; 1943).

Books written and illustrated include: *Autumn Gleanings from the Poets* (1910); *Our Day* (1923); *The Margaret Tarrant Birthday Book* (1932); *Joan in Flowerland* (1935); *The Margaret Tarrant Nursery Rhyme Book* (1944); *The Margaret Tarrant Story Book* (nd).

Exhib: RA; Walker; Royal Society of Artists, Birmingham.
Contrib: *Little Folks; Wonder Annual.*
Bibl: John Gurney: *Margaret Tarrant and Her Pictures* (Medici Society, 1988); *Margaret W. Tarrant 1888-1959: A Centenary Tribute* (Medici Society, 1988); *Times* obit. (7 August 1959); Johnson; Peppin; Waters.
Colour Plate 136

TARRANT, Percy **fl. 1880-1930**
See Houfe
Books illustrated include: M.L. Molesworth: *Greying Towers* (1898); M. Baldwin: *The Girls of St. Gabriel's* (Chambers, 1905); E.T. Meade: *Turquoise and Ruby* (1906); A. le Feuvre: *A Bit of Rough Road* (1908); E.T. Meade: *The Princess of the Revels* (1909), *Pretty-Girl and the Others* (Chambers, 1910), *Three Girls from School* (1913), *The Girls of Abinger Close* (1913); E. Lynn: *Comrades Ever!* (Chambers, 1921); E. Oxenham: *The Captain of*

the Fifth (1922); W. Scott: *Quentin Durward* (1923); E. Brontë: *Wuthering Heights* (1924); L.M. Alcott: *Little Women* (1926); E. Oxenham: *The Crisis in Camp Keema* (1928).

TAWSE, Sybil **fl. 1900-1940**
Tawse studied at Lambeth School of Art and at the RCA. She painted portraits, illustrated books in line and colour, and designed posters. Her colour illustrations to *Elia* and *Cranford* are accurate in the historical settings she portrays and the characters seem to be individuals rather than stereotypes. She owes much to Hugh Thomson (see Houfe) and the Brocks*, but her watercolours are the work of a fine artist.
Books illustrated include: C. Lamb: *The Essays of Elia* (C & H, 1910); M.M. Butt: *The Fairchild Family* (1913); M. Gaskell: *Cranford* (Black, 1914); W.J. Clover: *Tales from the Poets* (Black, 1915); C. Kingsley: *The Heroes* (1915); A. Dumas: *The Count of Monte Cristo* (Black, 1920); F. Marryat: *Mr Midshipman Easy* (1921); L.A. Harker: *Miss Esperance and Mr Wycherly* (Murray, 1926); L.M. Montgomery: *Anne of Green Gables* (1933).
Bibl: Hodnett; Peppin; Who.

TEALBY, Norman **fl. 1927-1931**
Tealby illustrated a few books, including Martin Armstrong's translation of De Alarcon's *The Three Cornered Hat* (1927), for which he produced some strong black and white illustrations and stylized colour plates in rather flat colours.
Books illustrated include: P.A.De Alarcon: *The Three Cornered Hat* (Howe, 1927); Voltaire: *Candide* (BH, 1928); E. Farjeon: *The Tale of Tom Tiddler* (1929); H. Fielding: *Joseph Andrews* (1929); L. Tolstoi: *Ivan the Fool and Other Tales* (1931).
Bibl: ICB; Peppin.

TEGETMEIER, Denis **b.1896**
Born in London, Tegetmeier served in WW1 and, with an ex-service grant, studied at the Central School of Arts and Crafts. He had come to know Eric Gill* at Ditchling where he helped with a war memorial, but never joined the community. While Gill was living in Wales, Tegetmeier lived in London, doing occasional work for Gill, and offering space in his house in St. John's Wood to anyone who visited from Capel-y-ffin. He married Gill's daughter Petra in January 1930.
Tegetmeier was an etcher, engraver and pen draughtsman. Speight† refers to his "remarkable gift for delicately mordant caricature" with which he illustrated a number of books, including two Fielding books for the Golden Cockerel Press, and Gill's *Seven Deadly Virtues* (1933). Hodnett declares his etchings for Fielding and Sterne books put him among "the most workmanlike of modern English interpretive illustrators." He also engraved the drawings which Gill made during the last weeks of his life to illustrate *Glue and Lacquer* (1941).
Books illustrated include: J. Taylor: *The Mysteriousness of Marriage* (Walterson, 1928); C.B. Cochrane: *Review of Revues* (Cape, 1930); H. Fielding: *A Journey from This World to the Next* (GCP, 1930); W. Langland: *The Vision of William Concerning Piers the Plowman* (Cassell, 1930); H. Fielding: *The Life of Mr. Jonathan Wild the Great* (GCP, 1932); E. Gill: *The Seven Deadly Virtues* (Lovat Dickson, 1933), *Money and Morals* (Faber, 1934); K. Matthews: *A Moral Tale* (Fanfare Press, 1935); L. Sterne: *A Sentimental Journey* (NY: Limited Editions Club, 1936); P. Beaujon: *Peace Under Earth* (1938); E. Gill: *Unholy Trinity* (Dent, 1938), *Sacred and Secular* (Hague & Gill, 1940).
Exhib: Studio One, Oxford (1977).
Bibl: Robert Speight: *The Life of Eric Gill* (Methuen, 1966); Malcolm Yorke: *Eric Gill: Man of Flesh and Spirit* (Constable, 1981); Hodnett; Peppin.

TEMPEST, Margaret Mary 1892-1982
Born in Ipswich, Tempest studied at Ipswich School of Art, Westminster School of Art, and the Royal Drawing Society; she was co-founder and honorary secretary of the Chelsea Illustrators Club (1919-39). She was a prolific illustrator of children's books and wrote some twenty of her own stories. During the 1920s and 1930s she produced several series of nursery friezes and postcards for the Medici Society, featuring rabbits, squirrels and teddy bears.

In the 1940s and 1950s she wrote and illustrated books with religious themes, as well as a number of books in her "Pinkie Mouse" and "Curley Cobbler" series. She illustrated almost thirty books written by Alison Uttley, with whom she had a long and difficult relationship, disagreeing about the responsibility for illustrations which did not satisfy the writer, and ultimately disputing about who was the primary begetter of the Little Grey Rabbit character.
Her delicate watercolour illustrations have charm but need more colour to be completely effective. Her style has been obviously influenced by that of Beatrix Potter*.
Tempest married Sir Grimwood Mears in 1951; she died in Ipswich on 23 July 1982.
Books illustrated include: P. Sage: *Katinka's Travels to the Himalayas* (1926); A. Uttley: *The Squirrel, the Hare and the Little Grey Rabbit* (Heinemann, 1929); R. Fyleman: *The Doll's House* (1930); A. Uttley: *How Little Grey Rabbit Got Back Her Tail* (Heinemann, 1930), *The Great Adventure of Hare* (Heinemann, 1931), *The Story of Fuzzypeg the Hedgehog* (Heinemann, 1932), *Squirrel Goes Skating* (Collins, 1934) and twenty-three other titles published by Collins to 1967.
Books written and illustrated include: *My Little Grey Rabbit Painting Book* (1939); *Pinkie Mouse and the Balloons* (1944) and four other titles; *A Belief for Children* (1945); *An ABC for You and Me* (Medici Society, 1948); *Curley Cobbler and the Fairy Shoe* (1948) and three other titles; *A Sunday Book for Children* (1954); *Stories from the Old Testament* (1955); *The Little Lamb of Bethlehem* (1957).
Bibl: Denis Judd: *Alison Uttley: The Life of a Country Child (1884-1976)* (Joseph, 1986); *Times* obit. 28 July 1982; Peppin; Waters; Whalley.

Norman TEALBY *The Three Cornered Hat* by P.A. de Alarcon (Gerald Howe, 1927)

Norman THELWELL "To ensure against penalties for a knockdown" from *Angels on Horseback* (Methuen & Co. Ltd., 1957)

TENISON, Nell Marion **1867-1953**
See Houfe
Born in London, Tenison studied at Cope's School of Painting, in Paris at Académie Colarossi, and under Whistler. She married Cyrus Cuneo in 1903 and they had a son, Terence Cuneo*, who also became an artist.
Books illustrated include: D. Alcock: *The Spanish Brothers* (Nelson, 1903); A. Lucas: *The City and the Castle* (Nelson, 1905); A. Brazil: *A Terrible Tomboy* (Hodder, 1915).
Contrib: *Black and White*.
Bibl: Peppin; Waters.

TENNANT, C. Dudley **fl. 1898-1918**
See Houfe
A painter who specialized in marine and sporting subjects, Tennant worked in Liverpool in the late 1890s, and in Surrey early in the twentieth century. He illustrated a few books, his illustrations mostly reproduced in poor half-tones, and contributed to *Punch* and several other magazines. His son Dudley was born in Hanley, Staffordshire, on 21 November 1897, and became a portrait and landscape painter.
Books illustrated include: L.L.D. Black: *Old Mother Hubbard* (Duckworth, 1910); E.W. Wheeler: *Poems of Passion and Pleasure*

Norman THELWELL "The mill wheel" from *A Millstone Round My Neck* (Eyre Methuen Ltd., 1981)

(Gay & Hancock, 1912); G. Barnett: *V.C.s of the Air* (Burrow, 1918).
Contrib: *Graphic; Punch; Royal; Windsor*.
Exhib: RA; LG.
Bibl: Peppin; Waters.

TENNANT, Stephen James Napier **1906-1987**
Tennant was born into a world of luxury and privilege, for his mother's family was an old one with aristocratic forebears, while his father was first Baron Glenconner, whose fortunes and title were based on the wealth of a great industrialist father. His mother made him wear dresses until he was eight, and treated him much as a girl. His father died in 1920, leaving Stephen a large sum of money and two properties, including Dryburgh Abbey in Berwickshire. As he grew up, he showed talent as an artist, exhibiting as early as 1921 when he was fourteen, painted throughout his life and illustrated a few books. He lived in London and was part of the wealthy artistic circles which included Cecil Beaton*, Rex Whistler*, Siegfried Sassoon (with whom he had an extended homosexual relationship) and the Sitwells.
Tennant suffered from tuberculosis as a young man, and this must have helped to emphasize his fine features and air of decadence. He was an aristocratic, wealthy, flamboyant English eccentric and aesthete, who knew "everybody"; a poet and a painter, though not particularly successful in either activity. He died on 28 February 1987. After his death, the contents of his house, Wilford Manor in Wiltshire, were sold at a newsmaking two-day country house sale by Sotheby's, and the house itself was sold for £1.5 million.
Books illustrated include: E. Olivier: *The Mildred Book* (Shaftesbury: High House Press, 1926); *The Treasure Ship* (with others, Partridge, 1926); P. Grey: *The White Wallet* (Dent, 1928); S. Sassoon: *To My Mother* (Ariel Poems; Faber, 1928), *In Sicily* (Ariel Poems; Faber, 1930), *To the Red Rose* (Ariel Poems; Faber, 1931).
Books written and illustrated include: *The Vein in the Marble* (Allen, 1925); *Leaves from a Missionary's Notebook* (Secker, 1929); *My Brother Aquarius* (Nash Publications, 1961).
Exhib: Dorien Leigh (1921); Redfern (1953); Anthony d'Offay (1976); Parkin (1985/1987).
Bibl: Philip Hoare: *Serious Pleasures: The Life of Stephen Tennant* (Hamilton, 1990).

TERRY, Herbert Stanley **b.1890**
See Houfe

THEAKER, Harry George **1873-1954**
Born in Wolstanton, Staffordshire, Theaker studied at Burslem School of Art, the RCA and in Italy. A landscape painter, potter, artist in glass and an illustrator, he became Head of the School of Art at the Regent Street Polytechnic (1931-38). He was a member of the Art Workers' Guild and he exhibited in London. His illustrations for children's books are usually not memorable, but the colour plates he produced for Grimm's *Fairy Tales* (1920) are imaginative in design and striking in colour. He was elected ARBA (1919); RBA (1920).
Books illustrated include: R.H. Barham: *The Ingoldsby Legends* (Macmillan, 1911); *Children's Stories from the Arabian Nights* (Tuck, 1914); N. Kato: *Children's Stories from Japanese Fairy Tales* (Tuck, 1918); M.D. Belgrave and H. Hart: *Children's Stories from Old British Legends* (Tuck, 1920); Grimm: *Fairy Tales* (Ward Lock, 1920); C. Kingsley: *The Water Babies* (Ward Lock, 1922); B. Oram: *Once Upon a Time* (Ward Lock, 1923); B. Winder: *Stories of King Arthur* (Ward Lock, 1925); E.C.H. Vivian: *Robin Hood* (Ward Lock, 1927); J. Swift: *Gulliver's Travels* (Ward Lock, 1928); M. de Cervantes: *The Adventures of Don Quixote* (Ward Lock, 1929).
Contrib: *Holly Leaves*.
Exhib: RA; RBA; RI.
Bibl: Peppin; Waters; Who.

THELWELL, Norman **b.1923**
Born on 3 May 1923 at Tranmere, Birkenhead, Cheshire, Thelwell was educated at Rock Ferry High School, Birkenhead, but left when he was sixteen to work in an office. During WW2 he served in the army in India, returning in November 1946, and studied at Liverpool College of Art (1947-50). He taught at Wolverhampton

College of Art (1950-55).
Thelwell's first cartoon was published in *London Opinion* during the war, and in 1952 he began contributing regularly to *Punch*. Over the next twenty-five years, he made over 1,500 drawings for the magazine, including sixty front covers. In 1955 he became a freelance artist, working mostly as a book and magazine illustrator, though he continued to paint landscapes. The largest part of his work has been devoted to humorous drawings of rural pursuits, particularly to the struggles of small girls to ride difficult ponies. The first book of humorous drawings he did was *Angels on Horseback*, published by Methuen in 1957, which launched a whole series of about twenty very successful titles, all of which were issued both in hardback and paperback editions.
Thelwell has illustrated a few books by other writers and produced a number of book jackets and paperback covers, including the paperback covers for the Pan editions of Herriott's novels. He produced a calendar of inn signs for Guinness and his work is reproduced in many forms, such as greeting cards, tee shirts and china.
Books illustrated include: M.J. Baker: *Away Went Galloper* (Brockhampton, 1962); C. Ramsden: *Racing Without Tears* (1964); C. Willock: *Rod, Pole or Perch* (1978).
Books written and illustrated include: *Angels on Horseback* (Methuen, 1957); *Thelwell Country* (Methuen, 1959); *Thelwell in Orbit* (Methuen, 1961); *A Leg at Each Corner* (Methuen, 1962), and at least fifteen other books of humorous drawings; *A Plank Bridge By a Pool* (Methuen, 1978); *A Millstone Round My Neck* (Eyre Methuen, 1981); *Wrestling with a Pencil* (Methuen, 1986).
Contrib: *Everybody's Weekly; London Opinion; Men Only; News Chronicle; News Review; Punch; Sunday Despatch; Sunday Express*.
Exhib: Beetles (1989, 1990).
Bibl: *Thelwell* (Chris Beetles Ltd., 1989); Norman Thelwell: *A Plank Bridge by a Pool* (Methuen, 1978); Thelwell: *Wrestling with a Pencil* (Methuen, 1986); Peppin; Price; Who.

THEMERSON, Franciszka **1907-1989?**
Born in Warsaw, Themerson (née Weinles) studied painting at the Academy of Art in Warsaw, and during the 1930s illustrated a number of books for children. She and her husband produced five experimental films in Poland between 1930 and 1937, and after they came to London in 1940 worked in the Film Unit of the Polish Ministry of Information, producing two abstract documentaries on the destruction of art work in Poland.
Her first published illustrations in England were done for *The Lion Who Ate Tomatoes* (1945), and then she produced a series of picture books for Harrap, illustrated with her "abstract", expressionist drawings. In 1948 she and her husband founded their own press, the Gaberbocchus Press, and published a series of books illustrated by Franciszka Themerson's unconventional art. Most of her illustrations were drawn directly on to the plate, and were then printed by lithography. She also produced theatrical sets and costumes.
Books illustrated include: *The Lion Who Ate Tomatoes* (Sylvan Press, 1945); *The Gingerbread Man* (Harrap, 1947); *Mother Goose* (Harrap, 1947); *My First Nursery Book* (Harrap, 1947); *The Three Bears* (Harrap, 1947); *Three Little Pigs* (Harrap, 1947); *Who Killed Cock Robin?* (Harrap, 1947); Aesop: *The Fox and the Eagle* (1949); S. Themerson: *Bayamus* (1949); A. Jarry: *Ubu Roi* (1950); B. Russell: *The Good Citizen's Alphabet* (1953; new edition Hanborough Parrot, 1989); S. Themerson: *Mr Rouse Builds His House* (1950), *The Adventures of Peddy Bottom* (1951), *Wooff Wooff, or Who Killed Richard Wagner?* (1951), *Professor Mmaa's Lecture* (1953); H. Lang and K. Tynan: *The Quest of Corbett* (1960); B. Russell: *History of the World in Epitome* (1962); S. Themerson: *St Francis and the Wolf of Gubbio* (1972).
Books written and illustrated include: *Forty Drawings for Friends* (1943); *The Way It Walks* (1956); *Traces of Living* (Gaberbocchus Press, 1959).
Contrib: *Poetry London*.
Exhib: Gallery One; Drian Gallery (1975); Whitechapel (1975); Warsaw (1977).
Collns: V & A; Arts Council; Polish National Museum.
Bibl: Charles Rosner: "Franciszka Themerson", *Graphis* 18 (1947): 118-23; Peppin; Who.
See illustration on page 412

Franciska THEMERSON Illustrations for *Bayamus* by Stefan Themerson in *Poetry London* no.16 (September 1949)

THOMAS, Bert **1883-1966**
See Houfe

Thomas was staff cartoonist on *London Opinion* for many years and became known nationally after producing a sketch to advertise a tobacco fund for soldiers. "'Arf a Mo, Kaiser" (1914) showed a grinning Cockney soldier, lighting his pipe, addressing the Kaiser; it raised over £250,000 and became the national symbol of the British spirit during WW1. He designed posters during both wars, one of his best known being the one he did in March 1942 — "Is Your Journey Really Necessary?" — in an attempt to reduce civilian rail travel. He worked in many media, but mostly used brush and ink on Whatman paper, producing his characteristic broken, chalk-like line. Thomas was a member of the London Sketch Club and a close friend of William Heath Robinson*. He died on 6 September 1966.

Books illustrated include: W. Williams: *One Hundred War Cartoons from London Opinion* (with others, London Opinion, 1919); W.W. Jacobs: *Sea Whispers* (Hodder, 1926); T.R. Arkell: *Meet These People* (Jenkins, 1928); *500 of the Best Cockney War*

Stories (Evening News, 1930); C.Graves and H.C. Longhurst: *Candid Caddies* (Duckworth, 1935); H. Simpson: *Nazty Nursery Rhymes* (Dakers, 1940); A. Reubens: *Podgy the Pup* (Pocket Editions, 1945).

Books written and illustrated include: *In Red and Black* (Methuen, 1928); *Cartoons and Characters* (Press Art School, 1936); *Fun at the Seaside* (P.M. Productions, 1944); *Fun on the Farm* (P.M. Productions, 1944); *A Mixed Bag* (Allen, 1945); *Fun in the Country* (Amex, 1946); *Fun in Town* (Amex, 1946); *Playtime* (Amex, 1947); *Railways by Day* (Amex, 1947); *Railways by Night* (Amex, 1947); *Toyland* (Amex, 1947); *A Trip on a Barge* (Pictorial Art, 1947).

Contrib: *Ally Sloper; Evening News; Fun; Graphic; Humorist; London Opinion; Pick-Me-Up; Punch; Radio Times; Sketch.*

Collns: IWM.

Bibl: Bradshaw; Driver; Peppin.

THOMPSON, Beryl Antonia
See "ANTON"

THOMPSON, Ralph **fl. 1949-**

Born in Thorner, Yorkshire, of farmer stock, Thompson lived in the country all his life, except while at college. He studied at Leeds College of Art and the RCA, and became a lithographer and illustrator. His subject matter is usually natural history in some form or other; he illustrated many of the "animal" books by Gerald Durrell with pen and ink drawings. He was elected FZS.

Books illustrated include: Pratten: *Winkie* (OUP, 1949); G. Durrell: *New Noah* (Collins, 1955) and several other titles by Durrell.

Bibl: Who.

THORBURN, Archibald **1860-1935**
See Houfe

Thorburn was one of the most popular British wildlife artists of this century, and for some forty years from the late 1890s he illustrated many books. His bird paintings, first used in Lilford's *Coloured Figures* (1885-94), were used to illustrate several other books, right up to the *Observer's Book of British Birds*, first published in 1937.

Books illustrated include: J.E. Harting: *Sketches of Bird Life* (Allen, 1883); Lord Lilford: *Coloured Figures of the Birds of the British Islands* (seven vols., Porter, 1885-94); A. Grimble: *Highland Sport* (C & H, 1894); W.H. Hudson: *British Birds* (1895); A. Grimble: *The Deer Forests of Scotland* (Kegan Paul, 1896); H.A. Macpherson: *The Hare* (Longmans, 1896), *Red Deer* (Longmans, 1896); H.E. Stewart: *The Birds of Our Country* (1897); J.E. Harting: *The Rabbit* (Longmans, 1898); H. Peek: *The Poetry of Sport* (1898); Gathorne-Hardy: *Autumns in Argyleshire with Dog and Gun* (1900); W. Swaysland: *Familiar Wild Birds* (with others, Longmans, 1901); A. Grimble: *Deer-Stalking and Deer Forests of Scotland* (Kegan Paul, 1901), *The Salmon Rivers of Scotland* (Kegan Paul, 1902), *Shooting and Salmon Fishing and Highland Sport* (Kegan Paul, 1902); S.C. Buxton: *Fishing and Shooting* (1902); Lord Lilford: *Lord Lilford on Birds* (Hutchinson, 1903); J.G. Millais: *The Mammals of Great Britain and Ireland* (with others, three vols., Longmans, 1904-06); T.F. Dale: *The Fox* (1906); G.A.B. Dewar: *Life and Sport in Hampshire* (1908); J.G. Millais: *The Natural History of British Game Birds* (with J.G. Millais, Longmans, 1909), *British Diving Ducks* (Longmans, 1913); P. Mackie and A.S. Walker: *The Keeper's Book* (with others, Foulis, 1929); G.F. Archer and E.M. Goodman: *The Birds of British Somaliland and the Gulf of Aden* (four vols., Gurney & Jackson/O & B, 1937); E.C. Keith: *A Countryman's Creed* (Country Life, 1938).

Books written and illustrated include: *The Pheasant* (1895); *British Birds* (four vols., Longmans, 1915-18); *A Naturalist's Sketchbook* (Longmans, 1919); *British Mammals* (two vols., Longmans, 1920); *Game Birds and Wild Fowl of Great Britain and Ireland* (Longmans, 1923).

Bibl: Southeby's: *Works by Archibald Thorburn* (Southeby's, 1993); Hammond; Peppin; Titley.

Colour Plate 137

THORNYCROFT, Rosalind **b.1891**

Born on 2 September 1891 in Frimley Green, Surrey, Thornycroft

was born into an artistic family, for her father, grandfather and grandmother were all sculptors. She was educated at King Alfred's School, and the London School of Economics. She studied art at the Slade and the Académie Julian in Paris, and then married A.E. Popham, who was Keeper of Prints and Drawings in the British Museum. While her three children were growing up, she lived in Florence and other parts of Italy. She returned to England and illustrated several books by her relatives, Eleanor and Herbert Farjeon. She also produced hand-printed textiles with her daughter.

Books illustrated include: E. Farjeon: *Nuts and May* (Collins, 1926), *Italian Peepshow and Other Tales* (1926); E. Farjeon and H. Farjeon: *Kings and Queens* (Gollancz, 1932), *Heroes and Heroines* (Gollancz, 1933).

Bibl: ICB; Peppin.

THORPE, James H. **1876-1949**
See Houfe

TICKNER, John **b.1913**
Tickner wrote and illustrated with humorous drawings a number of books devoted to horses and other rural pursuits. He was also illustrator and cartoonist of *Horse & Hound*, and there was an exhibition of his work at the Old Mayor's Parlour Gallery, Hereford.

Books written and illustrated by Tickner include (all published by Putnam except where noted): *Tickner's Light Horse* (1956); *Tickner's Dog Licence* (1957); *Tickner's Show Piece* (1958); *Tickner's Horse Encyclopaedia* (1960); *To Hounds with John Tickner* (1962); *Tickner's Rough Shooting* (1964); *Tickner's Pub* (1965); *Tickner's Ponies* (1966); *Tickner's Rural Guide* (1967);

Hans TISDALL *Songs and Lyrics* edited by F.S. Boas (The Cresset Press, 1945)

Tickner's Dog House (1968); *Tickner's Hunting Field* (1970); *Tickner's Terriers* (Standfast Press, 1977).

Contrib: *Horse & Hound*.
Bibl: Titley.

TIDY, Bill **b.1932**
Born in Frinton, Tranmere, Lancashire, Tidy was educated at a primary school in Liverpool, and at St. Margaret's, Anfield. He had no formal art training, but from an early age he was constantly drawing. He worked for an advertising agency before becoming a free-lance artist in 1957 and contributing to many magazines including *Picturegoer*, *Punch* and *Private Eye*.

He has created several cartoon strips, such as "The Cloggies" in *Private Eye* and "The Fosdyke Saga" for the *Daily Mirror*. Several books of his cartoons have been published and Tidy has illustrated books by other writers with his humorous drawings. Tidy has been described by Richard Ingram as "a devout Northerner living in Southport, Tidy has the characteristic of many cartoonists in that he looks a bit like one of his drawings." (*Private Eye Cartoons*, 1983†.) His work usually represents members of the "working class" and their attitudes and interests.

Books illustrated include: K. Whitehorn: *How To Survive in Hospital* (Eyre Methuen, 1972).

Books written and illustrated include: *The Cloggies* (1969); *The Cloggies Are Back* (1969); *Tidy's World* (1969); *Tidy Again* (1970); *The Fosdyke Series 1-10* (1971-81).

Contrib: *Camra; Daily Mirror; Datalink; Everybody's; General Practitioner; John Bull; New Scientist; Picturegoer; Private Eye; Punch*.

Bibl: *The Penguin Book of Private Eye Cartoons* (Penguin, 1983); Driver.

TILL, Peter **b.1945**
Born in Manchester, Till read English at Cambridge (1964-67), and started selling drawings to *Oz* magazine in 1969. He has combined two careers, one as a free-lance artist and the other on the stage. He joined "Flies Review" in 1970, and then the Comedy Factory in 1979 for six months, performing monologues; in the same year he formed a band, The Rumba Brothers, which made a record in 1980. Meanwhile he began to get commissions for illustrations in 1973, and has contributed to several magazines and newspapers.

Contrib: *New York Magazine; New York Times; Oz Magazine; Radio Times; Sunday Times; Times*.

Bibl: Driver.

TIMLIN, William M. **1893-1943**
Born in Ashington, Northumberland, Timlin was educated in England but emigrated to South Africa before 1915 and studied art there. He did illustrations in pen and ink and watercolour, and exhibited regularly in South Africa, where he practised as an architect. He wrote stories, composed music, illustrated periodicals, produced watercolour fantasies, painted in oil, and produced etchings. His book, *The Ship That Sailed to Mars*, was published in 1923 and the film rights were purchased in the US, where Timlin was popular during his lifetime. It has been asserted that the illustrations to this book put him in the top ten of fantasy illustrators with Rackham, Dulac, Goble* and Nielsen. He died in Kimberley, South Africa.

Books illustrated include: H.A. Chilvers: *Out of the Crucible* (Cassell, 1929).

Books written and illustrated include: *The Ship That Sailed to Mars* (Harrap, 1923); *South Africa: A Series of Pencil Sketches* (Black, 1927).

TISDALL, Hans **b.1910**
Born in Munich, Germany, as Hans Aufseeser, Tisdall studied at the Munich Academy of Fine Art before coming to London in 1930. He lectured at the Central School of Arts and Crafts and elsewhere, and painted murals and designed textiles. In the 1940s and 1950s he designed a range of book jackets for Jonathan Cape, using lively and distinctive lettering, often on a black background, and occasionally a simple but bold pictorial design. Best known for these jackets which made Cape's books easily and quickly identifiable, Tisdall also illustrated or decorated a few books.

Books illustrated include: O. Hill: *Balbus: A Picture Book of*

Colour Plate 136.
Margaret TARRANT
"Three beautiful little white girls
floating down the torrent"
Original watercolour with body
colour Illustrated *The Water
Babies* by Charles Kingsley
(J.M. Dent 1908). By permission
of Chris Beetles Limited

Colour Plate 137.
Archibald THORBURN
*Game Birds and Wild Fowl of
Great Britain and Ireland*
(Longmans, Green 1923)

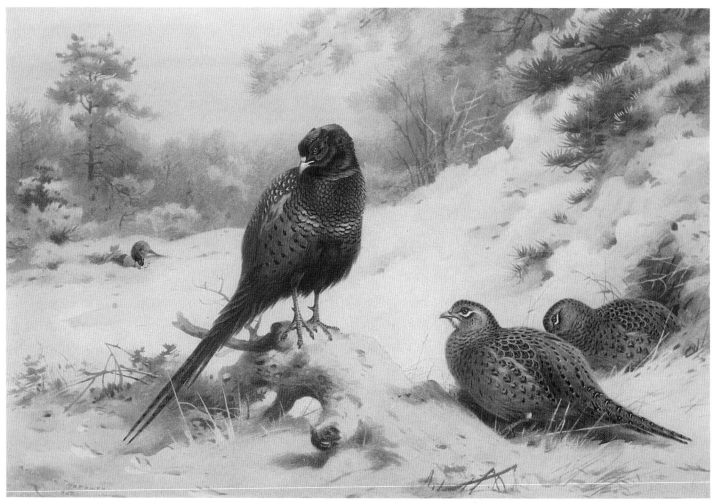

Colour Plate 138. Justin TODD *Wind in the Willows* by Kenneth Grahame (Victor Gollancz 1988)

Colour Plate 139. *The Clothes We Wear* written and illustrated by Jack TOWNEND (Puffin Picture Book No. 64, 1947)

Feliks TOPOLSKI *Geneva* by George Bernard Shaw
(Constable, 1939)

Building (Pleiades Books, 1944); F.S. Boas: *Songs and Lyrics from the English Playbooks* (Cresset Press, 1945); O. Hill: *Wheels* (1946); *Goosie Gander Plays His Part* (Muller, 1946); E. Linklater: *Position at Noon* (Cape, 1958).
Contrib: *Harvest*.
Bibl: Charles Rosner: *The Art of the Book Jacket* (V & A, 1949); Peppin; Waters; Who.
Colour Plate 10

TODD, [Michael] Justin **b.1932**
Born in New Malden, Surrey, Todd was educated at Raynes Park Grammar School and studied art at Wimbledon Art School and the RCA (1955-58), where one of his tutors was Edward Bawden* (he assisted Bawden with the murals at Morley College). He started to teach illustration as a part-time lecturer at Brighton Polytechnic in 1964.
His first published illustrations were for a series of social histories for Longmans. He designed other things, such as scarves for Liberty and postage stamps; but in 1967 he started working on book jackets for Blond and since then jackets and paperback covers have taken most of his time. He has worked for several publishers including

Penguin Books (for Alan Aldridge*), Granada and Fontana, designing for many books of horror or the supernatural. His illustrations are in full colour and are detailed and highly finished paintings.
Books illustrated include: H.G. Scarfe: *As We Were* (twenty-four parts, Longmans, 1962-67); J. Verne: *Round the World in Eighty Days* (Chatto, 1966); D. Taylor: *Pompeii and Vesuvius* (1967); D. Smith and D. Newton: *Wonders of the World* (1969); D. & J. Parker: *The Compleat Astrologer* (1971); A. Carter: *Moonshadow* (Gollancz, 1982); L. Carroll: *Alice's Adventures in Wonderland* (Gollancz, 1984); K. Grahame: *The Wind in the Willows* (Gollancz, 1988); *The Twelve Days of Christmas* (Gollancz, 1989).
Bibl: Mike Dempsey: *The Magical Paintings of Justin Todd* (Fontana, 1978); Peppin.
Colour Plate 138

TOPOLSKI, Feliks **1907-1989**
Born on 14 August 1907 in Warsaw, Topolski studied at the Warsaw Academy of Fine Art (1927-32). He came to London in 1935 (he became a naturalized British subject in 1947) and then spent some time in Paris, where he made about 200 drawings for *Paris Scenes and Secrets*. A prospectus was printed in 1939, but the drawings were lost in the confusion of the invasion of Poland, only to emerge "miraculously . . . after the War, bought by a German scholar in a ruined Berlin street from a Russian soldier, and published in book form a few years ago." (Topolski, 1984.†) He intended to return to Poland, but was caught up in events, stayed in England and became an official war artist to the Polish Forces (1940-45).
He had been a political caricaturist in Poland, and he brought these talents to the work he did in England. During the Blitz and the Battle of Britain, he became a tireless recorder of bombed street scenes in London, and then in 1941 travelled to Russia as a member of a Polish Diplomatic Mission. On his return, he published his illustrated account, expressing the horror of the war with Germany with magnificent economy in line and wash.
Topolski has illustrated many books, and his best work is done as a reporter. In 1953-54, he issued *Topolski's Chronicle*, a fortnightly record of events, printed on brown "wrapping" paper, with the 18th and 19th century broadsheets as his model. His apparently sketchy ink drawings are full of movement and life, and express the emotions that he feels as well as being factual. He is also a painter and a muralist, doing some large-scale paintings for the Festival of Britain in 1951 and many murals between 1952 and 1965. He has also designed costumes and sets for the theatre and television. In the '60s, he painted many portraits, including a series of twenty of English writers for the University of Texas; and in 1969 he produced a film for CBS television, *Topolski's Moscow*, and another (with his son, Daniel) in 1982 on his travels in South America, for the BBC. In 1988, he published *Fourteen Letters*, an erratic autobiography, filled with anecdotes and sketches. In 1974 the Jagiellonian University of Cracow awarded him an honorary doctorate; and he was given the Gold Medal by the International Fine Arts Council.
Books illustrated include: G.B. Shaw: *Geneva* (Constable, 1939), *In Good King Charles' Golden Days* (Constable, 1939); *Pygmalion* (Penguin Books, 1941); M.S. Collis: *Lord of the Three Worlds* (1947); H. Acton: *Prince Isadore* (Methuen, 1950); H. Burnett: *Face to Face* (1964); R. Whalen: *A City Destroying Itself* (1964); D.C.C. O'Brien: *The United Nations Sacred Drama* (1968); L. Tolstoy: *War and Peace* (two vols., Folio Society, 1971); *Poems from Bangla Desh* (Poetry London, 1971); J. Elsom: *Post-War British Theatre Criticism* (1980).
Books written and illustrated include: *The London Spectacle* (BH, 1935); *Britain in Peace and War* (1941); *Russia in War* (Methuen, 1942); *Portrait of G.B.S.* (E & S, 1946); *Three Continents 1944-45* (Methuen, 1946); *Confessions of a Congress Delegate* (London Gallery, 1949); *88 Pictures* (Methuen, 1951); *Sketches of Gandhi* (1954); *Holy China* (1958); *Topolski's Legal London* (1961); *Shem, Ham & Japeth Inc.* (Hutchinson, 1971); *Paris Lost* (Hutchinson, 1973); *Topolski's Buckingham Palace Panoramas* (1981); *Fourteen Letters* (Faber, 1988).
Contrib: *Fortune; ILN; News Chronicle; Night and Day; Picture Post; Punch; Tatler; Topolski's Chronicle; Vogue*.
Collns:*BM; IWM; Tate; V & A*.

Stuart TRESILIAN *Animal Stories* by Rudyard Kipling (Macmillan, 1932)

Bibl: Paul Arthur: "Topolski's Chronicle", *Graphis* 12, no. 64 (1956): 170-73; Oliver Beckett: "Magic Under the Arches: Felix Topolski's Memoirs of the 20th Century", *The Artist* (January 1987): 16-18; C.F.O. Clarke: "Feliks Topolski: War and Peace As Seen by Topolski", *Graphis*, 15 (1946), pp. 346-55; Paul Hogarth: *The Artist As Reporter* (Fraser, 1986); Feliks Topolski: "Not a Refugee", *Art and Artists* (April 1984): 14-5; Topolski: *Fourteen Letters* (Faber, 1988); Harries; ICB2; Peppin; Tate; Who; Who's Who.

TOURTEL, Mary **1897-1940**
The creator of the famous "Rupert Bear" newspaper picture strip for children, Tourtel drew the little bear for the *Daily Express* from 1921 to 1935, when her failing eyesight forced her to hand over to A.E. Bestall*. "Rupert Bear", written by Tourtel's husband, H.B. Tourtel, who was sub-editor of the paper, was devised originally to rival the "Teddy Tail" strip produced by Charles Folkard (see Houfe) for the *Daily Mirror* from 1915. The strip was reprinted in book form from the beginning, with *The Adventures of the Little Lost Bear* published by Nelson in 1921; and *Rupert Annuals*, illustrated by Tourtel and later illustrators, continue to appear. The daily strip and the main character became so popular that a Rupert League was established in 1930, and thousands of children throughout the world joined.
Books written and illustrated include: *The Adventures of the Little Lost Bear* (Nelson, 1921); *The Little Bear and the Fairy Child* (1922); *Rupert and the Enchanted Princess* (Sampson Low) and many other titles.
Contrib: *Daily Express; Girl's Realm; Rupert Annuals*.
Bibl: Carpenter; Doyle; Peppin; Whalley.

TOWNEND, Jack **b.1918**
Books written and illustrated include: *Jenny the Jeep* (Faber, 1944); *Ben* (Faber, 1945); *The Clothes We Wear* (Puffin Picture Book; Penguin, 1947).
Colour Plate 139

Colour Plate 140. Walter TRIER *Lilliput* cover, November 1948

Colour Plate 141. C. F. TUNNICLIFFE *Both Sides of the Road* by Sidney Rogerson (Collins 1949)

Colour Plate 142. Edward WADSWORTH "Imperial War Museum" Poster for London Transport, 1936 (Courtesy of the London Transport Museum)

Colour Plate 143. Michael WARREN Original painting for *Shorelines* (Hodder & Stoughton 1984)

TOZER, Katharine **fl. 1935-1947**
An illustrator and writer of children's books, Tozer wrote a series
about Mumfie, a stuffed toy elephant, which she illustrated with
strong black and white decorative drawings. Flat colours were
sometimes added.
Books illustrated include: E. Farjeon: *Paladins in Spain* (Nelson,
1937).
Books written and illustrated include: *The Wanderings of Mumfie*
(Murray, 1935); *Here Comes Mumfie* (Murray, 1936); *Mumfie the
Admiral* (Murray, 1937), and six other titles in series; *Noah: The
Story of Another Ark* (Murray, 1940); *The Adventures of Alfie*
(Murray, 1941).
Bibl: Peppin.

TOZER, Mary Christine **b.1947**
Born in London, Tozer studied at Reigate College of Art (1963-65).
After working variously as a technical illustrator and with textiles,
she began to write and illustrate picture books. All of these stories
for young children, illustrated in strong colours and filled with
details in the style of twentieth century Russian artists, have been
published by World's Work.
Books illustrated include: H.C. Andersen: *The Nightingale and
Other Tales* (World's Work, 1982).
Books written and illustrated include (all published by World's
Work): *Sing a Song of Sixpence* (1976); *The Tale of Old Mother
Hubbard* (1977); *The King's Beard* (1978); *Peter Pipkin and His
Very Best Boots* (1979); *The Grannies Three Have a Most Curious
Adventure* (1980); *Queen Yesno* (1981); *Isabella Bella Rides Again*
(1983); *The Wizard and the Wand* (1984).
Bibl: Peppin.

TRESILIAN, Cecil Stuart **b.1891**
Born on 12 July 1891 in Bristol, Tresilian studied at the Regent
Street Polytechnic School of Art and at the RCA. During WW1 he
served with the London Territorial Rangers, was wounded three
times and taken prisoner. On his return to England he taught at the
Polytechnic and resumed his work as an illustrator. His illustrations
are often in full colour, and were done mostly for children's books.
He was a member of the Art Workers Guild (Master 1960); and of
the Society of Graphic Artists (President 1962-65).
Books illustrated include: R. Kipling: *Animal Stories* (Macmillan,
1932), *All the Mowgli Stories* (Macmillan, 1937); M. Treadgold: *We
Couldn't Leave Dinah* (Cape, 1941); M.E. Atkinson: *Challenge to
Adventure* (1942), *The Monster of Widgeon Weir* (1943), *The Nest
of the Scarecrow* (1944), *Problem Party* (1945); E. Blyton: *The
Castle of Adventure* (Macmillan, 1946), *The Sea of Adventure*
(Macmillan, 1948), *The Mountain of Adventure* (Macmillan, 1949);
E. Dillon: *Midsummer Magic* (Macmillan, 1950); E. Blyton: *The
Circus of Adventure* (Macmillan, 1952), *The River of Adventure*
(Macmillan, 1955); R. Kipling: *Kim* (1958); V. Fuchs: *Antarctic
Adventure* (1959); J. Chipperfield: *Petrus, Dog of Hill Country*
(1960), *The Grey Dog from Galtymore* (1961); M. Gaunt: *Brim's
Boat* (Cape, 1965); I. Serraillier: *The Cave of Death* (1965); M.
Gaunt: *Brim Sails Out* (Cape, 1966).
Contrib: *Christmas Pie*.
Bibl: ICB; ICB2; ICB3; Peppin.

TREVELYAN, Julian **1910-1988**
Born on 20 February 1910 in Dorking, Surrey, Trevelyan was edu-
cated at Trinity College, Cambridge, and studied under S.W. Hayter
at his Atelier 17 in Paris (1930-34). After travelling widely in
Europe, he returned to settle in London. He became a member of
the English Surrealist Group in 1936, and had his first one-artist
exhibition at the Lefevre Gallery in 1937. During WW2 he served
as camouflage officer in the Royal Engineers (1940-43), and spent
some time in Africa and Palestine. He was a member of the London
Group from 1948, taught at Chelsea School of Art (1949-60), and
taught etching and later became Head of the Etching Department at
the Royal College of Art (1955-63).
Primarily a painter and etcher, Trevelyan illustrated at least one
book.
Books illustrated include: K. Raine: *A Place a State* (Enitharmon
Press, 1974).
Published: *Etching: Modern Methods of Intaglio Printmaking*

(Studio Books, 1963).
Exhib: Lefevre Gallery.
Colln: Tate.
Bibl: Julian Trevelyan: *Indigo Days: An Autobiography* (Mac-
Gibbon & Kee, 1957); Tate.

TREVELYAN, Pauline **b.1905**
Born on 9 October 1905 in Morpeth, Northumberland, Trevelyan
spent her childhood there and in London and Somerset. She was
educated at co-educational Quaker schools in England and Germany,
studied at the RCA and then took a diploma in agriculture at
Reading University. She was preparing to run her father's estate in
Northumberland when she met and married John Dower, a town
planner and architect. They lived in London before returning to
Northumberland. She was particularly interested in history as a sub-
ject matter for her illustrations.
Books illustrated include: *Lilliburlero* (OUP, 1933).
Bibl: ICB.

TRIER, Walter **1890-1951**
Born in Prague, Trier studied at the Munich Academy of Art. He
moved to Berlin, contributing to several magazines, including
Simplicissimus, and worked in advertising, designed sets and cos-
tumes for ballets and musicals. He illustrated a number of children's
books in Germany, notably the "Emil and the Detectives" series of
stories by Erich Kaestner which were published both there and in
England. He went to England in 1936, continued to illustrate books
and contributed many illustrations to *Lilliput*, including more than
eighty covers in colour. Feaver writes that "the deceptive naïvety of
his line carried a barbed humour." He died in Collingwood, Ontario,
Canada, in 1951.
Books illustrated include: E. Kaestner: *Annaluise and Anton*
(Cape, 1932), *The 35th of May* (Cape, 1933), *Eleven Merry Pranks
of Till the Jester* (Enoch, 1939); K. Barlay: *The Story of Frisky*
(Sylvan Press, 1945); D. S. Smith: *Jolly Families* (Studley Press,
1946); D. Morgan: *My Sex Right or Wrong* (Methuen, 1947); E.
Kaestner: *Emil* (Cape, 1949), *Lottie and Lisa* (Cape, 1950), *A
Salzburg Comedy* (Weidenfeld, 1950), *The Animals Conference*
(Collins, 1955).
Books written and illustrated include: *Toys* (Fisher Unwin,
1923); *The Jolly Picnic* (with C. Nelson; 1944); *10 Little Negroes*
(Sylvan Press, 1944); *8192 Quite Crazy People* (Atrium Press,
1949); *Dandy in the Circus* (Nicholson, 1950); *8192 Crazy
Costumes in One Book* (Atrium Press, 1950).
Contrib: *Lilliput; Simplicissimus; Die Zeitung*.
Collns: AGO.
Bibl: Feaver; ICB; ICB2; Peppin.
Colour Plate 140

TRIMBY, Elisabeth **b.1948**
Works as Elisa Trimby. Born on 30 June 1948 in Reigate, Surrey,
Trimby spent her childhood in villages in south and south-west
England. She studied at Brighton College of Art; taught life draw-
ing at Thames Polytechnic (1973-77), and then taught at Southend
College of Art (1975-76). For a time she worked as an art therapist
with geriatric patients at St. Thomas's Hospital, London. In 1971
she became a free-lance artist, illustrating books and doing commer-
cial work, including design work for the Folio Society. She uses
various techniques, including pen and ink, watercolour, lithographs,
and wood engraving; but whatever method is used, she believes it
important to work closely with the printer, to make sure that the
reproduction of her art work is as accurate as possible.
Books illustrated include: J.M. Barrie: *Peter Pan* (Puffin, 1967); J.
Wyatt: *The Shining Levels* (Bles, 1973); F. Satow: *Yan* (Lion,
1975); R. Marris: *The Cornerstone* (Heinemann, 1976); A.
Lawrence: *Mr Robertson's Hundred Pounds* (Kestrel, 1976); A.C.
Doyle: *The Lost World* (with Tim Stephens, Folio Society, 1977);
C.C. Moore: *The Night Before Christmas* (Benn, 1977); R. Craft:
The King's Collection (Collins, 1978); M. Curran: *The Country
Ones* (Chatto, 1978); I. Turgenev: *Love and Death* (Folio Society,
1982); W. Boase: *Toyland* (Walker, 1984); C. Kingsley: *The Water
Babies* (Puffin, 1984); R. Billington: *The First Easter* (Constable,
1987).
Books written and illustrated include: *Mr Plum's Paradise*

C.F. TUNNICLIFFE *Plowmen's Clocks* by Alison Uttley
(Faber & Faber, 1952)

(Faber, 1976); *Mr Plum's Oasis* (Faber, 1981); *The Christmas Story*
(Faber, 1983).
Bibl: Folio 40; ICB4; Peppin.

"TROG"
See FAWKES, Wally

TROUGHTON, Joanna Margaret b.1947
Born on 9 September 1947 in London, Troughton studied at
Hornsey College of Art. After leaving college, she has combined
the role of a free-lance illustrator of books and for television with
that of a part-time teacher at Harrow and Barnet Schools of Art. Her
main interests are in mythology and fairy stories, and she produces
her picture books around these. *How the Birds Changed Their
Feathers* (1976) was runner-up for the Kate Greenaway Medal in
1976.
Books illustrated include (but see Peppin): K. Crossley-Holland:
The Sea-Stranger (Heinemann, 1973); G. Trease: *Days to
Remember* (Heinemann, 1973); K. Crossley-Holland: *The Fire-
Brother* (Heinemann, 1974), *The Earth-Father* (Heinemann, 1976);
E. Kyle: *The Key of the Castle* (Heinemann, 1976); S. McCullagh:

The Kingdom Under the Sea (Hulton, 1976); J. Reeves: *Quest and
Conquest* (Blackie, 1976); R. Blythe: *Fabulous Beasts* (with Fiona
French*; Macdonald, 1977); J.D. Lincoln: *The Fair-Skinned
Stranger* (CUP, 1977), *Montezuma* (CUP, 1977); W. Body: *Clay
Horses* (Longman, 1979); M. Pollard: *My World* (Macdonald,
1979); J. Taylor: *Ganpat's Long Ride* (Longman, 1979); A.
Sproule: *Warriors* (1980); G. Robinson: *Raven the Trickster*
(Chatto, 1981); R. Pellock: *Yam Festival* (CUP, 1982).
Books written and illustrated include: *The Little Mohee* (1971);
Sir Gawain and the Loathly Damsel (1972); *Spotted Horse* (1972);
Why Flies Buzz (1974); *The Story of Rama and Sita* (1975); *How
the Birds Changed Their Feathers* (Blackie, 1976); *What Made
Tiddalik Laugh* (Blackie, 1977); *How the Rabbit Stole the Fire*
(Blackie, 1979); *Tortoise's Dream* (Blackie, 1980); *The Magic Mill*
(Blackie, 1981); *The Wizard Punchkin* (Blackie, 1982); *Blue-Jay
and Robin* (Blackie, 1983); *Mouse-Deer's Market* (Blackie, 1984).
Bibl: ICB4; Peppin.

TULLOCH, Maurice 1894-1974
An artist who concerned himself almost exclusively with horses and
rural pursuits, Tulloch has illustrated several books with his paint-
ings and drawings.
Books illustrated include: G.S. Hurst: *The P.V.H. (Peshawar Vale
Hunt)* (with C.J. Payne*; Gale & Polden, 1934); M. Stephens:
Novice's Luck; Or, Some Sporting Sprints (1936); R.S.
Summerhays: *From Saddle and Fireside* (Country Life, 1936); C.R.
Acton: *Stories of the Saddle* (1938); L. Dawson: *Hunting without
Tears* (1938); B. de Lisle: *Tournament Polo* (1938); R.P. Gallway:
Letters to a Young Shooter (1939); J.K. Stanford: *Last Chukker*
(Faber, 1951); R.S. Summerhays: *It's a Good Life with Horses*
(Country Life, 1951); J.K. Stanford: *No Sportsman At All* (Faber,
1952); H.S. Tegner: *The Buck of Lordenshaw: The Story of a Roe
Deer* (Batchworth Press, 1953); S.A. Walker: *In Praise of Horses*
(with others, 1953); C.A. Harris: *No Place for Ponies* (Blackie,
1954), *We Started a Riding Club* (Blackie, 1954); D.A. Young:
Ponies in Secret (1955).
Exhib: Tryon Gallery; Memorial Hall, Newmarket (1964).
Bibl: Titley.

TUNNICLIFFE, Charles Frederick 1901-1979
Born on 1 December 1901 in Langley, near Macclesfield, Cheshire,
Tunnicliffe grew up on a farm and was educated at the local village
school, St. James's School, Sutton. He studied art briefly at
Macclesfield School of Art (1915) before moving to Manchester
School of Art. In 1921 he won a scholarship to the RCA (1921-25),
where he met Malcolm Salaman, who was well known and respect-
ed in the art world, and began to supply him with etched plates for
publishers that Salaman knew. Salaman was instrumental in arrang-
ing the first publication of a portfolio of Tunnicliffe's etchings. He
had shared lodgings with several engravers, including Eric
Ravilious*, but in later life he had few recollections of his contem-
poraries.
After a part-time teaching job, he left London and moved back to
Macclesfield. He became a free-lance artist, doing commercial
graphic work for firms involved in farming, painting, making prints,
contributing to magazines and illustrating many books. His particu-
lar subject matter was usually birds, animals and other rural topics,
and he often used wood engraving as his medium. It was with the
illustrations for Henry Williamson's *Tarka the Otter* (1932) that
Tunnicliffe began his career as a book illustrator with such distinc-
tion. He first proposed aquatints as the method of illustration, but
this was rejected and twenty-four full page wood engravings and
some tailpieces were used. Despite the fact that Tunnicliffe did not
like Williamson, the artist did many other books with Williamson,
including an edition of *Salar the Salmon* for Faber in 1936 which
contained sixteen full-page, exquisite watercolours as well as scrap-
erboard illustrations. Later in his career, when the pressure of com-
missions was great, he more frequently turned to scraperboard for
illustrations. He did six books for Williamson, three for H.E. Bates,
five for R.M. Lockley, six for N.F. Ellison and eighteen for Alison
Uttley, all of which were generously illustrated with fine examples
of his work. He also collaborated on two books with Sidney
Rogerson: *Our Bird Book* (1947) which provided the artist the first
opportunity to use full-colour illustrations on a large size page; and

Robert TURNER *Bed and Sometimes Breakfast* by Philip Owens (Sylvan Press, 1944)

Highway (Putnam, 1937); F.F. Darling: *The Seasons and the Farmer* (CUP, 1940); H.E. Bates: *The Seasons and the Gardener* (CUP, 1940); D.H. Chapman: *The Seasons and the Woodman* (CUP, 1941); F.F. Darling: *The Seasons and the Fisherman* (CUP, 1941); E.L.G. Watson: *Nature Abounding* (Faber, 1941); HE. Bates: *In the Heart of the Country* (Country Life, 1942); N. Farson: *Going Fishing* (Country Life, 1942); H.E. Bates: *O More Than Happy Countryman* (Country Life, 1943); M. O'Hara: *My Friend Flicka* (Eyre, 1943); A. Uttley: *Country Hoard* (Faber, 1943); E.L.G. Watson: *Walking with Fancy* (Country Life, 1943); C.S. Bayne: *Exploring England* (Collins, 1944), *The Call of Birds* (Collins, 1944); D.H. Chapman: *Farmer Jim* (Harrap, 1944); F.F. Darling: *The Care of Farm Animals* (OUP, 1944); R.T. Gould: *Communications Old and New* (R.A. Publishing, nd.); R. Church: *Green Tide* (Country Life, 1945); A. Uttley: *The Country Child* (Faber, 1945); R.I. Pocock: *The Wonders of Nature* (Odhams Press, nd.); N. Ellison: *Wandering with Nomad* (ULP, 1946); A. Uttley: *Country Things* (Faber, 1946); C.H. Warren: *Happy Countryman* (Eyre, 1946); N. Ellison: *Out of Doors with Nomad* (ULP, 1947); T. Horsley: *Fishing and Flying* (Eyre, 1947), *The Long Flight* (Country Life, 1947); R.M. Lockley: *Letters from Skokholm* (Dent, 1947); C. Porteous: *Farmer's Creed* (Harrap, 1947); W.F.R. Reynolds *Angling Conclusions* (Faber, 1947); S. Rogerson: *Our Bird Book* (Collins, 1947); E.L.G. Watson: *The Leaves Return* (Country Life, 1947); N. Ellison: *Over the Hills with Nomad* (ULP, 1948); R.M. Lockley: *The Cinnamon Bird* (Staples Press, 1948); A. Uttley: *Carts and Candlesticks* (Faber, 1948), *The Farm on the Hill* (Faber, 1949); N. Ellison: *Roving with Nomad* (ULP, 1949); R. Jefferies: *Wild Life in a Southern County* (Lutterworth, 1949); S. Rogerson: *Both Sides of the Road* (Collins, 1949); B. Vesey-Fitzgerald: *Rivermouth* (Eyre, 1949); E.L.G. Watson: *Profitable Wonders* (Country Life, 1949); N. Ellison: *Adventuring with Nomad* (ULP, 1950), *Northwards with Nomad* (ULP, 1951); C.D. Dimsdale: *Come out of Doors* (Hutchinson, 1951); A. Uttley: *Ambush of Young Days* (Faber, 1951); M. Edwards: *Punchbowl Midnight* (Collins, 1951); A. Uttley: *Plowmen's Clocks* (Faber, 1952); E. Hemingway: *The Old Man and the Sea* (Reprint Society, 1953); J.C.W. Houghton: *Rural Studies, Book 4* (Dent, 1953); A. Uttley: *Here's a New Day* (Faber, 1956), *A Year in the Country* (Faber, 1957), *The Swans Fly Over* (Faber, 1959), *Something for Nothing* (Faber, 1960); J. W. Day: *British Birds of the Wild Places* (Blandford Press, 1961); A.J. Huxley: *Wild Flowers of the Countryside* (Blandford Press, 1962); A. Uttley: *Wild Honey* (Faber, 1962), *Cuckoo in June* (Faber, 1964); I. Niall: *The Way of the Countryman* (Country Life, 1965); A. Cadman: *Dawn, Dusk and Deer* (Country Life, 1966); H.L. Edlin: *New Forest* (HMSO, 1966); A. Uttley: *A Peck of Gold* (Faber, 1966); G.E. Evans: *The Horse in the Furrow* (Faber, 1967); I. Niall: *A Galloway Childhood*

Both Sides of the Road (1949) which includes twenty-three colour plates and sixty black and white illustrations.

Tunnicliffe was a prolific printmaker, and his skills as an etcher were recognized by the public early in his career. He first exhibited at the Royal Academy in 1934, and he continued to show at the summer exhibition until 1978. He made many watercolours and wood engravings of birds and animals, and was particularly admired for his measured drawings and sketchbooks of birds, of which the RA mounted a major exhibition in 1974. He was elected ARE (1929); RE (1934); ARA (1944); RA (1954); he was made a Vice-President of SWLA (1968); and he won many awards during his life, including the Gold Medal of the R.S.P.B. (1975) and the O.B.E. (1978). He died on 7 February 1979.

Books illustrated include: H. Williamson: *Tarka the Otter* (Putnam, 1932), *The Lone Swallows* (Putnam, 1933), *The Old Stag* (Putnam, 1933), *The Star Born* (Faber, 1933); K. Higson: *The Dull House* (Putnam, 1934); R.P. Russ: *Beasts Royal* (Putnam, 1934); H. Williams: *Tales from Ebony* (Putnam, 1934); H. Williamson: *The Peregrine's Saga* (Putnam, 1934), *Salar the Salmon* (Faber, 1935); R.L. Haig-Brown: *Pool and Rapid* (Cape, 1936); M. Priestley: *A Book of Birds* (Gollancz, 1937); K. Williamson: *The Sky's Their*

Krystyna TURSKA *A Year and a Day* by William Mayne (Hamish Hamilton, 1976)

(Heinemann, 1967), *A Fowler's World* (Heinemann, 1968); A. Uttley: *The Button Box* (Faber, 1968), *A Ten O'Clock Scholar* (Faber, 1970), *Secret Places* (Faber, 1972); R.M. Lockley: *Orielton* (Deutsch, 1977); I. Niall: *To Speed the Plough* (Heinemann, 1977); L. Bennett: *R.S.P.B. Book of British Birds* (Hamlyn, 1978); N.W. Brocklehurst: *Up with the Country Lark* (Stockwell, 1978).

Books written and illustrated include: *My Country Book* (Studio, 1942); *Bird Portraiture* (Studio, 1945); *Mereside Chronicle* (Country Life, 1948); *Birds of the Estuary* (Puffin Picture Books, 1952); *Shorelands Summer Diary* (Collins, 1952); *Wild Birds in Britain* (Happy House, 1974); *A Sketchbook of Birds* (Gollancz, 1979).

Published: *How To Draw Farm Animals* (Studio, 1947).

Contrib: *Country Life; Radio Times; Saturday Book 9, 10, 11*.

Exhib: RA; Manchester Academy; Preston Harris Gallery, Johannesburg.

Bibl: Ian Niall: *Portrait of a Country Artist: Charles Tunnicliffe R.A., 1901-1979* (Gollancz, 1980); Ian Niall: *Tunnicliffe's Countryside* (Holloway Books, 1983); DNB; Driver; Hammond; ICB2; Peppin.

Colour Plate 141

TURNER, Robert **fl.1944-1946**
Turner illustrated at least two books for the Sylvan Press with spidery line drawings.

Books illustrated include: P. Owens: *Bed and Sometimes Breakfast* (Sylvan Press, 1944); Gogol: *The Government Inspector* (Sylvan Press, 1946).

TURSKA, Krystyna Zofia **b.1933**
Born on 28 August 1933 in Poland, Turska spent her childhood there until WW2, and in 1940 she was arrested with her family and taken to a concentration camp in Russia. She escaped to Persia and finally reached England in 1948. She studied at the Hammersmith School of Art, and became an illustrator and writer of children's books. Her *Pegasus* was commended for the Kate Greenaway Medal in 1970, and she won it with *The Woodcutter's Duck* (1972).

Books illustrated include: W. Mayne: *The Hamish Hamilton Book of Heroes* (Hamilton, 1967); J. Reeves: *The Trojan Horse* (1968); A. Garner: *Hamish Hamilton Book of Goblins* (Hamilton, 1969); R.L. Green: *The Hamish Hamilton Book of Dragons* (Hamilton, 1970); G. Trease: *A Masque for the Queen* (1970); G. Avery: *Ellen's Birthday* (Hamilton, 1971), *Red Letter Days* (1971), *Ellen and the Queen* (Hamilton, 1971); J. Reeves: *The Path of Gold* (Hamilton, 1972); *Author's Choice* (Puffin, 1973); J. MacNeill: *A Snow-Clean Pinny* (1973); B. Willard: *Happy Families* (Macmillan, 1974); K. Killip: *Saint Bridget's Night* (Hamilton, 1975); H. Arundel: *The High House* (Hamilton, 1976); G. Avery: *Freddie's Feet* (Hamilton, 1976); J. Riordan: *Tales from Central Russia* (Kestrel, 1976); W. Mayne: *A Year and a Day* (Hamilton, 1976); H. Cooper: *Great Grandmother's Goose* (Hamilton, 1978); M. Heritage: *The Happy Little King* (Kaye, 1979); W. Mayne: *The Mouse and the Egg* (MacRae, 1980); R. Nye: *The Bird of the Golden Land* (Hamilton, 1980); R. Wood: *The Palace of the Moon* (Deutsch, 1981); L.M. Jenning: *The Prince and the Firebird* (Hodder, 1982), *Coppeli* (Hodder, 1985), *Crispin and the Dancing Mouse* (Hodder, 1986).

Books written and illustrated include: *Pegasus* (Hamilton, 1970); *Tamara and the Sea Witch* (Hamilton, 1971); *The Woodcutter's Duck* (Hamilton, 1972); *The Magician of Cracow* (Hamilton, 1975).

Bibl: ICB4; Peppin.

TUTE, George William **b.1933**
Born on 23 March 1933 in Hull, Yorkshire, and educated at Baines Grammar School, Poulton, Lancashire, Tute studied art at the Blackpool School of Art (1949-53) and at the Royal Academy Schools under Sir Henry Rushbury (1953-58). He taught graphics on a part-time basis at York School of Art (1960-62) and was appointed to the Department of Graphic Design at Bristol Polytechnic in 1962, where he was principal lecturer (1962-87). Tute started out as a painter, but while doing his National Service in the Royal Air Force in London he met Gertrude Hermes* (whose work he still admires) at the Central School of Arts and Crafts and taught himself wood engraving. He has illustrated a number of

George TUTE *Under the Hawthorn* by Sybil Marshall (J.M. Dent, 1981)

books with wood engravings including two books on folklore and mythology. He says that he enjoyed illustrating the humour and psychological stringency of the old saws in Sybil Marshall's *Under the Hawthorn* (1981). He has recently been working on illustrations for the Folio Society's edition of *The Monk*, for which he was "trying to add something, rather than literally interpret verbal descriptions." (Saunders, 1983.†) Tute has also done some advertising work including a large engraving for the Glenmorangie Distillery.

Tute was elected ARE (1965); ARWA; and was first chairman of the resurrected SWE (1984).

Books illustrated include: *Folklore, Myths and Legends of Britain* (Reader's Digest, 1973); *World Cookery* (Mitchell Beazley, 1974); W. Boase: *The Folklore of Hampshire and the Isle of Wight* (Batsford, 1976); E. Lewis: *The Old Home* (Gwasg Gregynog, 1981); S. Marshall: *Under the Hawthorn* (Dent, 1981); M. Lewis: *The Monk* (Folio Society, 1984); W. Shakespeare: *Henry IV Part 1 and Part 2* (Folio Society, 1988); D. Hart-Davis: *Country Matters* (Weidenfeld, 1989).

Books written and illustrated include: *Guide to the Art of Wood-Engraving* (Fleece Press, 1987).

Exhib: RE; RWA; SWE; Bristol (retrospective, 1986).

Bibl: Linda Saunders: "George Tute, RE, RWA, wood engraver", *The Green Book*, 9 (Winter 1983): 7-8; Brett; Garrett 1 & 2; Who.

Hermes and Hughes-Stanton seceded from the Society of Wood Engravers in 1925 and founded the English Wood Engraving Society. He wrote a number of books on art, including *Art for Heaven's Sake* (1934) and three books on West African art (1947-49).

His own published illustrations appeared mainly in the late 1920s, and are mostly wood engravings. *Animalia* (1926) is a collection of verse and woodcuts; *The Siamese Cat* (1928), which contains seventy woodcuts, is a novel which must be read at a symbolic level. The cat's intuition symbolizes a belief which is beyond knowledge, but the hero is nevertheless in a constant state of enquiry. Reviews of the book were not favourable, for most seemed to see it merely as an exercise in surrealism. As Neve writes "Its philosophy is not only more familiar [now] but immeasurably more popular." (Neve, 1974.†)

He died on 9 October 1975.

Books illustrated include: J.B. Cabell: *Music from behind the Moon* (NY: Day, 1926); P. Russell: *Red Tiger: Adventures in Yucatan and Mexico* (NY: Brentano, 1929); *The Apocrypha* (with others; Cresset Press, 1929); Hsiao Ch'ien: *The Dragon Beards Versus the Blueprints* (Pilot Press, 1944).

Books written and illustrated include: *Animalia* (NY: Payson and Clarke, 1926); *The Siamese Cat* (NY: Brentano, 1927); *Art for Heaven's Sake* (Faber, 1934).

Contrib: *The Island; Vanity Fair; Woodcut*.

Exhib: Chenil Gallery; St. George's Gallery; Leicester; Zwemmer; Kaplan Gallery; Agnew's; Archer Gallery; The Minories, Colchester (retrospective, 1969).

Collns: IWM; Tate.

Bibl: *Leon Underwood: Wood Engravings* (Fleece Press, 1988); Christopher Neve: *Leon Underwood* (T & H, 1974); *Times* obit. 11 October 1975; Garrett 1 & 2; Hodnett; ICB; Peppin; Tate; Waters.

UNWIN, Nora Spicer　　　　　　　　　　**1907-1982**
Born on 22 February 1907 in Tolworth, Surrey, one of five children of George and Eleanor Unwin, and one of twin daughters, Unwin was educated at Surbiton High School, and studied at Leon Underwood*'s studio (1923-25, where Blair Hughes-Stanton* and Gertrude Hermes* were fellow students), the Kingston School of Art (1925-27), and at the RCA (1927-31). Her family had been connected with printing and publishing for several generations, so it seemed natural that she become an illustrator as well as a painter and wood engraver. At the age of eighteen, her first commission for a black and white drawing for the dust jacket for a children's book by Edith Nesbit, came from her great-uncle, T. Fisher Unwin, the publisher. She was also engraving prints and from 1930 entered the annual exhibitions of the SWE, and her prints began to gain recognition and win awards. During her lifetime she made more than 200 wood engravings, many of which were used for bookplates or for book illustration.

After her first commission, she made wood engravings in 1933 for several books published by Allen & Unwin and T. Fisher Unwin and illustrated the Allen & Unwin Christmas catalogue with cartoon-like pen sketches. Commissions from other publishers

ULLYETT, Roy　　　　　　　　　　　　**b.1914**
Ullyett started drawing cartoons while working for a colour-printing firm in Essex. He became a sports caricaturist on the *Star* in 1933; after serving in the RAF during WW2, he returned to that paper, and also contributed to the *Sunday Pictorial*, using the sobriquet "Berryman"; and in 1953, he joined the *Daily Express*.

Books illustrated include: T.H. Cotton: *Henry Cotton Says . . .* (Country Life, 1962); *"I'm the Greatest!" : The Wit and Humour of Muhammad Ali* (with Jon — see Jones, John Philpin, Frewin, 1975); J. Greaves: *Stop the Game: I Want to Get On!* (Harrap, 1983).

Books written and illustrated include: *Roy Ullyett's Sports Cartoon Annual* (Daily Express, 1956-); *Cue for a Laugh* (D & C, 1984).

Contrib: *Daily Express; Southend Times; Star; Sunday Pictorial*.
Bibl: Feaver.

UNDERWOOD, [George Claude] Leon　　　　　**1890-1975**
Born in London on 25 December, 1890, Underwood studied at Regent Street Polytechnic Art School (1907-10), RCA (1910-13) and, after service in the R.E. Camouflage Section during WW1, at the Slade (1919-20). He travelled extensively throughout his life, from a visit to Holland in 1911 to another to West Africa in 1945. He opened his own school of drawing in 1921, the highly influential Brook Green School in Hammersmith and, after travels in 1925-28 to Italy, US, Canada, and Mexico, re-opened the school in 1931. In the same year he founded the magazine *The Island*, to which Henry Moore* and C.R.W. Nevinson* contributed. He served in the Camouflage Section of Civil Defence during WW2.

Underwood made a seminal contribution to the development of British sculpture, stressing the value of primitive art. He was also important as a teacher, wood engraver and painter. He instructed many students in wood engraving, including Gertrude Hermes*, Nora Unwin*, Blair Hughes-Stanton* and Mary Groom*, and with

followed, and by the late 1930s her reputation as an illustrator was fairly well established. As an illustrator, she worked primarily in black and white (wood engravings, pen or brush drawings) and in two colours, and many of her subjects were connected to natural history and the countryside. Several of her engravings show the influence of Agnes Miller Parker*, one of a large number of women of Nora's generation who became successful engravers. In 1937 she met an American writer, Elizabeth Yates, who was living in London with her husband, William McGreal, and designed a book jacket for her. Yates then recommended Unwin to Heffer, who was publishing another of her books (*Gathered Grace*, a collection of poems by George MacDonald), and Unwin was commissioned to produce six full-page engravings and one half-page. This book was published in 1938 and the collaboration led to a solid partnership between the two young women.

During WW2 Unwin cared for children who were removed to the relative safety of the country. She continued engraving and illustrating, and with Gwendy Caroe wrote a book for children, *Lucy and the Little Red Horse* (1943). She emigrated to the United States in 1946 at the invitation of Yates, and settled in New England. Unwin and Yates remained close friends and collaborators throughout Unwin's life — they worked together on twenty-six books. Wood engraving was a less familiar medium in the United States than in Britain, so her work was in demand, as were her skills as a teacher, and for many years she taught at the Sharon Arts Center, Sharon, New Hampshire, and in various other schools and centres in New England. She was a prolific illustrator, and produced many fine wood engravings for about one hundred books, some of the finest engravings being the twenty-five she did for John Kieran's *Footnotes on Nature* (1947). She also wrote and illustrated at least fourteen books for children.

Elected ARCA (1932); ARE (1933); RE (1946); Academician, National Academy of Design, NY (1953); SWE (1963). She died on 5 January 1982.

Books illustrated include (but see McGoldrick†): C. Elton: *Exploring the Animal World* (Allen & Unwin, 1933); B. Nichols: *How Does Your Garden Grow?* (Allen & Unwin, 1935); G. MacDonald: *Gathered Grace* (Heffer, 1938); E. Yates: *Hans and Frieda in the Swiss Mountains* (Nelson, 1939), *Under the Little Fir* (NY: Coward-McCann, 1941), *Mountain Born* (1943);E. Blyton: *Rainy Day Stories* (1944); D.U. Ratcliffe: *Rosemary Isle* (Nelson, 1944); E. Tregarthen: *The Doll Who Came Alive* (Faber, 1944); E. Blyton: *Round the Clock Stories* (1945); H.S. Bennett: *First Alphabet and Jingle Book* (National Magazine, 1946); *Bible: Joseph* (NY: Knopf, 1946); E. Blyton: *Rambles with Uncle Nat* (1947); J. Kieran: *Footnotes on Nature* (NY: Doubleday, 1947); B. Kyle: *Lost Karin* (Davies, 1947); F. Burnett: *The Secret Garden* (Lippincott, 1949); *Bible: The Christmas Story* (NY: Knopf, 1949); J.M. Barrie: *Peter Pan* (Scribner, 1950); E. Yates: *Amos Fortune, Free Man* (NY: Aladdin, 1950), *Children of the Bible* (NY: Aladdin, 1950); G. MacDonald: *The Princess and the Goblin* (Macmillan, 1951); C. de Banke: *Tabby Magic* (Hutchinson, 1959), *More Tabby Magic* (Hutchinson, 1961); E. Yates: *The Next Fine Day* (NY: Day, 1962; Dent, 1964); *Carolina and the Indian Doll* (Methuen, 1965).

Books written and illustrated include: *Round the Year* (Chatto, 1939); *My Own Picture Prayer Book* (SCM, 1946); *Lucy and the Little Red Horse* (Moring, 1943); *Doughnuts for Lin* (NY: Aladdin, 1950); *Proud Pumpkin* (NY: Aladdin, 1953); *Jack and Jill Books* (eight vols., Glasgow: House of Grant, 1955-6); *Poquito, the Little Mexican Duck* (Hutchinson, 1961); *Joyful the Morning* (NY: McKay, 1963); *The Way of the Shepherd* (World's Work, 1964); *Two Too Many* (Hutchinson, 1965); *Sinbad the Cygnet* (NY: Day, 1970); *The Chickadees Come and Other Poems* (Hudson, Ohio: Partridge Press, 1977).

Exhib (but see McGoldrick†): Sharon Arts Center; Print Club of Albany, New York; Boston Atheneum; SWE; RE; RA.

Collns: Ashmolean; BM; Boston Public Library; Sharon Arts Center; V & A.

Bibl: Linda Clark McGoldrick: *Nora S. Unwin: Artist and Wood Engraver* (Dublin, NH: Bauhan, 1990); *Times* obit. 18 January 1982; Garrett 1 & 2; ICB; ICB2; ICB3; ICB4; Peppin; *Shall We Join the Ladies?*; Waters.

Norah UNWIN *Footnotes on Nature* by J. Kieran (New York: Doubleday, 1947)

VALPY, Judith **b.1940**
Born in Malaysia, Valpy studied at the Regent Street Polytechnic (1959-62) and the Central School of Arts and Crafts (1962-64). She is a free-lance illustrator, using mostly wood engraving or pen drawings for her illustrations.
Books illustrated include: J. Edmundson: *Pan Book of Health* (Pan, 1963), *Pan Book of Party Games* (Pan, 1963); E. Beresford: *Awkward Magic* (Hart-Davis, 1964), *Travelling Magic* (Hart-Davis, 1965); D. Ross: *Letters from Foxy* (Macmillan, 1966); K. Crossley-Holland: *Running to Paradise* (1967).
Bibl: Peppin.

VAN ABBÉ, Salomon **1883-1955**
Born on 31 July 1883 in Amsterdam, Van Abbé came to England when he was five years old and studied in London at Kennington, Bolt Court, and the Central School of Arts and Crafts. He was a painter and etcher of portraits and genre work. He travelled extensively in Europe, and exhibited often at the Royal Academy and the Royal Hibernian Academy. He was elected ARE (1923); RBA (1933); and was a member of the London Sketch Club, becoming President (1939-40). He illustrated several books, usually with line drawings.
Books illustrated include: J. Galsworthy: *Loyalties* (Duckworth, 1930); W.R.G. Kent: *My Lord Mayor* (Jenkins, 1947); L. Alcott: *Little Women* (Dent, 1948); *The Modern Gift Book for Children* (Odhams, 1948).
Contrib: *ILN; Sporting & Dramatic News; Strand.*
Exhib: RA; RHA; RWA; Paris Salon.
Bibl: David Cuppleditch: *The London Sketch Club* (Dilke Press, 1978); Peppin; Waters.

VAN NIEKERK, Sarah Compton **b.1934**
Born on 16 January 1934 in London, Van Niekerk was educated at Bedales School and studied at the Central School of Arts and Crafts (1951-54) under Gertrude Hermes*, and the Slade(1954-55) under William Coldstream, Anthony Gross* and Lynton Lamb*. She became a member of SWE (1974); RE (1976); Art Workers Guild (1977); Printmakers Council (1981). She took over from Hermes the teaching of wood engraving at the RA Schools (1976-86), and since 1978 has taught wood engraving at the City and Guilds Art School. She has exhibited at the RA (1971-86) and at numerous other galleries.
A wood engraver, linocutter and printmaker, Van Niekerk was much influenced by Gertrude Hermes, who taught her engraving and zoological drawing. She has illustrated a few books; recently has worked on the Folio Society's editions of Ann Radcliffe's gothic novels and has been one of the illustrators for the Folio Shakespeare. She "loves the solid black, contracting large black areas with boldly cut-away white. The resulting intensity is alleviated by playful use of texture and exuberant line. She uses black and white line equally . . . however, all that is 'plain sailing' after the 'painful decision' required by the design. This she transfers to the block very simply, so as not to inhibit the tools' spontaneous exploration of the wood. As for content, 'My big step forward was when I realised there were people in the world. I never wanted to draw people, but do more now.' Books are about people, and an illustrator must accept this." (Saunders, 1987.†)
Van Niekerk has designed at least one book jacket (for *Poison on the Land* by Wentworth Day, E & S, 1958); and has collaborated with Simon Brett* and Harry Brockway* in illustrating the Reader's Digest edition of *The Bible*, now apparently abandoned.
Books illustrated include: B. Jefferies: *Half Angel* (Dent, 1959); M. Cunliffe: *America in the Making* (Folio Society, 1976), *The Divided Loyalist* (Folio Society, 1978); F. Kilvert: *The Curate of Clyro* (Newtown: Gwasg Gregynog, 1983); G. Vickers: *Woods and Tenses* (pp., 1983); G. Chaucer: *The Canterbury Tales* (with other artists, Folio Society, 1986); A. Radcliffe: *The Complete Works* (six vols., Folio Society, 1987); G. Jones: *The Meaning of Fuchsias* (Gregynog Press, 1988); W. Shakespeare: *Romeo and Juliet; Cymbeline* (Folio Society, 1988).
Exhib: RA; SWE; one-man shows include Nottingham (1976), Newbury (1979), Courtyard Gallery, Cheltenham (1988); also in USA, Australia and Czechoslovakia.
Collns: Ashmolean; Fitwilliam; V & A; National Museum of Wales; National Library of Wales.
Bibl: Linda Saunders: "A Third Hand: Sarah Van Niekerk, Wood-Engraver", *The Green Book* 2, no.6 (1987): 60-64; Jaffé; Brett; Garrett 1 & 2; Who; IFA.
See also illustration on page 23

VARLEY, Susan **fl. 1983-**
Varley won the Mother Goose Award for 1985 as "the most exciting newcomer to British picture book illustration" with *Badger's Parting Gifts*.
Books illustrated include (all published by Andersen Press): R.

Sarah Van NIEKERK *The Meaning of Fuchsias* by Glyn Jones (Gwasg Gregynog, 1988)

Taylor: *The Dewin* (1983); L. Baum: *After Dark* (1984); K. Crossley-Holland: *The Fox and the Cat* (1985); N. Hinton: *Run to Beaver Towers* (1986); U.M. Williams: *Grandma and the Ghowlies* (1986); J. Willis: *The Monster Bed* (1986).
Books written and illustrated include: *Badger's Parting Gifts* (Andersen Press, 1984).

VAUGHAN, Keith **1912-1977**
Born on 23 August 1912 at Selsey Bill in Sussex, Vaughan moved with his family to London soon after his birth. He was educated at Christ's Hospital, near Horsham, and had no formal art training because of the necessity to earn a living, his father having left the family in 1922 and died in 1935. He joined the advertising section of Unilever, but resigned in 1939 to try painting full time. When WW2 started, he claimed exemption as a conscientious objector, but had to serve in the Pioneer Corps (1940-46). During this period he was able to paint and make sketches, some of which were published by John Lehmann in *Penguin New Writing*. Twelve were purchased by the War Artists' Advisory Committee and displayed at the National Gallery's exhibition of War Art alongside those of such artists as Graham Sutherland*, Henry Moore* and John Piper*, whom he admired greatly. After his "demobilization" in 1946, he shared a house and studio with John Minton* for a few years, and taught illustration at Camberwell School of Art (1946-48) and at the Central School of Arts and Crafts (1948-57); and

from 1954 he was a visiting teacher at the Slade. He was commissioned by Lehmann to produce lithographs for a new edition of Rimbaud's "Une Saison en Enfer", with a parallel English translation. Published in *A Season in Hell* in 1949, the lithographs are dark and macabre, as suits the intensity of the writing. In 1946 he was put in charge of design and production of books published by John Lehmann (he was followed in this role by Val Biro*), and he also did many book jackets for Lehmann, including those for the *New Writing and Daylight* series.
One of the group of neo-romantic painters, Vaughan had his first one-artist exhibition of drawings at the Lefevre Gallery in 1942, where he also held his first exhibition of oil paintings (1946). He was one of a group of young painters, including Michael Ayrton*, Minton*, John Craxton*, who met regularly in the early 1940s at the studio of Robert Colquhoun* and Robert MacBryde in Camden Hill. He was a member of the London Group (1952-54). A full-scale retrospective exhibition was shown at the Whitechapel Art Gallery in 1962; he was made CBE in 1965.
Vaughan was troubled all his life by insecurities about his art and his sexuality, and he was deeply pessimistic about the human race. In the late 1960s, he steadily withdrew into inertia and loneliness. After suffering from severe kidney disease and terminal cancer, he committed suicide on 4 November 1977 by taking an overdose of drugs.
Books illustrated include: P.H. Newby: *The Spirit of Jem* (Lehmann, 1947); M. Twain: *Tom Sawyer* (Elek, (1947); J. Lehmann: *Orpheus 1* (Lehmann, 1948); *Flower of Cities: A Book of London* (with others, Parrish, 1949); A. Rimbaud: *A Season in Hell* (Lehmann, 1949).
Contrib: *Circus; Future; Leader; Opera; Penguin New Writing.*
Exhib: Lefevre Gallery; Whitechapel (1962); Matthiessen Gallery (1962).
Collns: Tate; Christchurch Museum, NZ; AGO.
Bibl: Bernard Denvir: "Young British Painters", *Graphis*, 16 (1946), pp. 494-501; D. Thompson: *Keith Vaughan: Retrospective Exhibition* (Whitechapel Art Gallery, 1962); *Times* obit. 8 November 1977; Keith Vaughan: *Journals and Drawings 1939-1965* (Ross, 1966); Vaughan: *Journals 1939-1977* (Murray, 1989); Malcolm Yorke: *The Spirit of Place: Nine Neo-Romantic Artists and Their Times* (Viking, 1988); Harries; Tate; Waters; Who.
See illustration on page 428

VERNEY, Sir John **b.1913**
Born on 30 September 1913 in London, Verney is the son of Sir Ralph Verney (1st Baronet, Speaker's Secretary 1921-55). He was educated at Eton College and Christchurch College, Oxford, and then trained to be an architect for two years before he decided to concentrate on painting and illustration. During WW2 he served in the army for six years, and his service included time with the SAS Regiment in Palestine and Syria (he was twice mentioned in despatches and was awarded the Military Cross and the Legion d'Honneur).
After the war he started his career of writing and making humorous drawings and serious paintings. He exhibited with the London Group and elsewhere in London. He contributed more than 100 covers and many feature articles to *Collins Magazine* (later the *Elizabethan*), and became its editor for 1961-62. His book illustrations are usually black and white line drawings, though he has used lithography, silk screen and copper engraving; his book jackets are often in two or three colours. He has written and illustrated a number of books for children, which are about family life as affected by events in the adult world. Verney married Lucinda Musgrave in 1939 and succeeded to the title as 2nd Baronet in 1959.
Books illustrated include: Homer: *The Odyssey* (Warne, 1947); G. Avery: *The Warden's Niece* (Collins, 1957); G. Lincoln: *No Moaning of the Bar* (Bles, 1957); A. Buckeridge: *Our Friend Jennings* (Collins, 1958); G. Avery: *James without Thomas* (Collins, 1959); J. Pudney: *The Trampoline* (1959); G. Avery: *The Elephant War* (Collins, 1960), *To Tame a Sister* (Collins, 1961), *The Greatest Gresham* (Collins, 1962); G. Brennand: *Walton's Delight* (Penguin, 1961); G. Avery: *The Peacock House* (Collins, 1963), *The Italian Spring* (Collins, 1964); R.G. Robinson: *My Uncle's Strange Voyages* (Deutsch, 1964); G. Avery: *Unforgettable Journeys* (Gollancz, 1965); A. Buckeridge: *Jennings Goes to School*

Keith VAUGHAN *Flower of Cities: A Book of London* (Max Parrish, 1949)

(Penguin, 1965); C.I. Bermant: *Diary of an Old Man* (C & H, 1966); W.J.W. Blunt: *Omar* (C & H, 1966); S. Chitty: *My Life and Horses* (Hodder, 1966); G. Avery: *School Remembered* (Gollancz, 1967); A. Buckeridge: *Our Friend Jennings* (Penguin, 1967); S. Chitty and A. Parry: *The Puffin Book of Horses* (Penguin, 1975); H. Massey: *Travels with Lionel* (1988).
Books written and illustrated include: *Verney Abroad* (Collins, 1954); *Look at Houses* (Hamilton, 1959); *Friday's Tunnel* (Collins, 1959); *February's Road* (Collins, 1961); *ISMO* (Collins, 1964); *The Mad King of Chichiboo* (Collins, 1964); *Seven Sunflower Seeds* (Collins, 1968).
Contrib: *Collins Magazine*.
Exhib: LG; Leicester Galls; New Grafton; Redfern; RBA; Zwemmer.
Bibl: ICB3; Peppin; Who's Who; IFA.

VICKY
See Weisz, Victor

"VICTORIA"
See DAVIDSON, Ulla R.B.

VOAKE, Charlotte fl. 1983-
An illustrator of children's books, Voake uses both colour and black and white. The illustrations to Philippa Pearce's *The Way to Sattin Shore* (1983) consist of small black and white sketches; her two-page spread in *Tail Feathers From Mother Goose* (1988) are in delicate colours.
Books illustrated include: I. Chichester: *Mr Teago and the Magic Slippers* (Kestrel, 1983); P. Pearce: *The Way to Sattin Shore* (Kestrel, 1983); I. Chichester: *The Witch Child* (Kestrel, 1984); D. Lloyd: *Duck* (Walker, 1984); E. Tennant: *The Ghost Child* (Heinemann, 1984); *Over the Moon: A Book of Nursery Rhymes* (Walker, 1985); *Tail Feathers from Mother Goose* (with others, Walker, 1988).

VOIGHT, Hans Henning 1887-1969
See Houfe

WADSWORTH, Edward Alexander 1889-1949

Born on 29 October 1889 in Cleckheaton, Yorkshire, Wadsworth was educated at Fettes College, Edinburgh, then studied engineering in Munich. There he also was a part-time art student at the Knirr School of Art in 1906, before returning to England to study at Bradford School of Art (1907) and at the Slade (1910-12). A painter and wood engraver, he exhibited at Roger Fry's Second Post-Impressionist Exhibition at the Grafton Galleries in 1912, and at a Futurist exhibition in 1913. He met Wyndham Lewis* in 1914, became a founder member of the London Group (1914), and joined the Vorticists. During WW1, after serving with RNVR as an intelligence officer (1914-17), he was employed on camouflage work. As a painter he started to change his style, moving away from the Vorticists, in 1919 ceasing to be a member of LG, and in 1921 became a member of NEAC. He had several one-man shows, including one entitled "The Black Country" at the Leicester Galleries in 1920; exhibited with Group X in the same year; returned to a more realistic style in the 1930s; and in 1944 was elected ARA. He died in London on 21 June 1949.

Wadsworth made many woodcuts and wood engravings; contributed illustrations to *Blast* and other magazines; and illustrated a few books in various media. His drawings for *The Black Country* (1920) were heavy and bold, while the copper engravings he made for *Sailing Ships and Barges* (1926) are beautifully balanced between the austere and the decorative. This latter book, with the plates hand-coloured by a colourist at the Curwen Press, was one of the finest to come from the Press.

Books illustrated include: B. Windeler: *Sailing-Ships and Barges of the Western Mediterranean and Adriatic Seas* (Etchells, 1926).

Books written and illustrated include: *The Black Country* (Ovid Press, 1920); *Antwerp* (1933).

Contrib: *Apple; Blast; Form.*

Exhib: NEAC; RA; SWE; Adelphi Gallery (1919); Leicester Galls (1920); Tooth (1929, 1938); Tate (memorial exhib. 1951); Colnaghi

(retrospective 1974); Bradford Art Gallery/Camden Arts Centre (retrospective 1989-90).

Collns: BM; Tate.

Bibl: Mark Glazebrook: *Edward Wadsworth 1889-1949: Paintings, Drawings and Prints* (Colnaghi, 1974); Peter Tucker: "Three Artists at Haslewood Books", *Matrix* 11 (Winter 1991): 102-9; Barbara Wadsworth: *Edward Wadsworth: A Painter's Life* (Salisbury: Russell, 1989); DNB; Garrett 1 &2; Peppin; Rothenstein; Tate; Waters.

Colour Plate 142

WAIN, Louis 1860-1939

See Houfe

Books illustrated include (but see Dale, 1968†): Kari: *Madame Tabby's Establishment* (Macmillan, 1886); F.W. Pattenden: *Our Farm* (Clarke, 1888); R. Leander: *Dreams of French Firesides* (Black, 1890); C. Morley: *Peter, a Cat O'One Tail* (1892); M.A. Owen: *Old Rabbit the Voodoo and Other Sorcerers* (Fisher Unwin, 1893); C. Birmingham: *Jingles, Jokes and Funny Folks* (Nister, 1898); C.J. Cornish: *The Living Animals of the World* (1901); G.C. Bingham: *All Sorts of Comical Cats* (Nister, 1902), *Fun and Frolic* (Nister, 1902), *Kittenland* (1903), *Ping-Pong Calendar for 1903* (1903), *Funny Favourites* (Nister, 1904); W.L. Alden: *Cat Tales* (Digby, Long, 1905); M. I. Hurrell: *The Adventures of Friskers and His Friends* (Culley, 1907); C.Y. Stephenson: *"Mephistopheles"* (1907); G.C. Bingham: *Full of Fun* (1908); M. Byron: *Cats' Cradle* (Blackie, 1908); M.C. Gillington: *Cat's Cradle* (1908); J. Hannon: *The Kings and the Cats* (1908); A.W. Riddler: *Holidays in Animal Land* (Clarke, 1909), *The Merry Animal Picture Book* (Clarke, 1910); S.C. Woodhouse: *Two Cats at Large* (Routledge, 1911); J. Pope: *The Cat Scouts* (Blackie, 1912); E. Nesbit: *Our New Story Book* (1913); A.W. Riddler: *Animal Happyland* (Clarke, 1913); E. Vredenburg: *"Tinker, Tailor"* (Tuck, 1914); *Wonder Book of Animals* (Warne, 1914); M. Crommelin: *Little Soldiers* (Hutchinson, 1916); S.C. Woodhouse: *Cinderella and Other Fairy Tales* (Gale & Polden, 1917); *Little Red Riding Hood and Other Tales* (Gale & Polden, 1917); "Kittycat": *The Story of Tabbykin Town* (Faulkner, 1920); C.M. Rutley: *Valentine's Rocker Books* (1920-1).

Books written and illustrated include (but see Dale, 1968†): *Mrs. Lovemouse's Letters* (Nelson, 1896); *Puppy Dog's Tales* (Nelson, 1896); *Pussies and Puppies* (Partridge, 1899); *The Dandy Lion* (with G.C. Bingham, Nister, 1900), *Fun and Frolic* (with G.C. Bingham, Nister, 1902); *Nursery Book* (Clarke, 1902); *Baby's Picture Book* (Clarke, 1903); *Big Dogs, Little Dogs, Cats and Kittens* (Tuck, 1903); *Kitten Book* (Treherne, 1903); *In Animal Land* (Partridge, 1904); *Animal Show* (Clarke, 1905); *Claws and Paws* (Nister, 1905); *A Cat Alphabet* (Blackie, 1914); *Daddy Cat* (Blackie, 1915); *Pussy Land* (1920); *Children's Book* (Hutchinson, 1923); *Animal Book* (Collins, 1928).

Contrib: *Boy's Own Paper; The Captain; English Illustrated Magazine; Father Tuck's Annual; Gentlewoman; ILN; Judy; Little Folks; Lloyds Weekly News; Louis Wain's Annual; Louis Wain's Summer Book; Moonshine; New York American; Pall Mall Budget;*

Colour Plate 144. Rex WHISTLER "The Tate Gallery" Poster for London Transport, 1928 (Courtesy of the London Transport Museum)

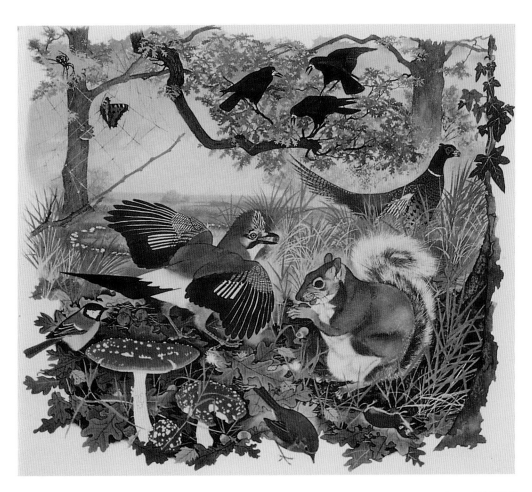

Colour Plate 145. Maurice WILSON
Shell Nature Studies: Birds and Beasts
(Phoenix House 1956)

Colour Plate 146. Alice B. WOODWARD
The Story of the Mikado by Sir W.S.
Gilbert (Daniel O'Connor 1921)

Brian WALKER Illustration for "The Thatcher's Craft" by Norman Goodland in *The Book of Leisure* edited by John Pudney (Odhams Press, 1957)

Pearson's Weekly; Playbox Annual; Sketch; Sporting & Dramatic News; Stock Keeper; Windsor Magazine.
Exhib: V & A (1972); Beetles (1983, 1989).
Collns: V & A.
Bibl: Rodney Dale: *Louis Wain: The Man Who Drew Cats* (Kimber, 1968); Michael Parkin: *Louis Wain's Cats* (T & H, 1983); Brian Reade: *Louis Wain: Exhibition Catalogue* (V & A, 1972); DNB; Peppin; Waters.

WAINWRIGHT, Albert **fl. 1922-1946**
Little is known about this artist, who decorated a few books in line between 1922 and 1946, mostly for the Swan Press in Leeds, who printed their books in very limited editions.
Books illustrated include: *Seven* (Leeds: Swan Press, 1922); A. Swinburne: *Cleopatra* (Swan Press, 1924); A. Vickridge: *The Forsaken Princess* (Swan Press, 1924), *The Mountain of Glass* (Allen & Unwin, 1924); S. Matthewson: *Orchard Idyll* (Swan Press, 1927), *Poems* (Swan Press, 1927); Theocritus: *Hylas* (High House Press, 1929); S. Matthewson: *Christmas Poems* (Comyns, 1946).
Books written and illustrated include: *Café Noir* (Swan Press, 1926).
Bibl: Peppin.

WAINWRIGHT, Francis **b.1940**
Born in Yorkshire on 24 April 1940, Wainwright studied at Burslem School of Art and then served in the Household Cavalry

from 1957 to 1960. He spent sixteen years in Italy, continuing his art studies there, and working on church restoration and designing scenery for operas. He has received numerous art awards, including the prestigious Le Muse Prize in Florence.
He returned to England in 1976, and his work has included illustrations for children's books, including the stories which his wife writes. The first two of these were published by Methuen and are based on the escapades of Freddie, a mouse in the Royal Mouseguards. He translated and illustrated *Pinocchio* (1986), depicting scenes from the area where Collodi spent his childhood, and is working on a life story of Collodi for television.
Books illustrated include: C. Collodi: *The Adventures of Pinocchio* (Methuen, 1986); S. Wainwright: *Freddie and the Bank of England Mystery* (Methuen, 1985); *A Magical Menagerie* (Methuen, 1988).
Bibl: *The Illustrators: Catalogue* (Chris Beetles Ltd., 1987-1991).

WALES, Geoffrey **b.1912**
Born on 26 May 1912 in Margate, Wales was educated at Chatham House School, Ramsgate, and studied at Thanet School of Art (1929-33), and the RCA (1933-37, under Malcolm Osborne, Robert Austin*, John Nash*, Eric Ravilious* and Edward Bawden*). He taught at art schools in the Canterbury area from 1937 to 1953, except for the years when he was serving with the RAF during WW2 (1940-46), and in Norwich (1953-77). A wood engraver and illustrator of a few books, he is particularly interested in landscape, including coastal subjects, and describes his engravings as metaphors rather than representations. He has also worked in

collage and watercolour, and has exhibited widely. He was elected SWE (1946); ARE (1948); and RE (1961).
Books illustrated include: T. Besterman: *The Pilgrim Fathers* (GCP, 1939); *The Kynoch Diary* (Kynoch Press, 1950); G. Rawson: *Nelson's Letters* (GCP, 1953); J. Hampden: *Sir Francis Drake's Raid on the Treasure Trains* (Folio Society, 1954).
Exhib: RE; SWE.
Bibl: *Engraving Then and Now* (SWE, 1987?); Garrett 1 & 2; Peppin; Waters; Who.

WALKER, Brian fl. 1957-
The illustrations seen have been finely drawn in pen and ink, and deal with rural topics.
Books illustrated include: J. Pudney: *The Book of Leisure* (with others, Odhams Press, 1957); *The Countryman Anthology* (Barker, 1962); G.H.N. Haines: *How To Be a Motorist and Stay Happy* (Muller, 1967); H. Phelps: *Just Across the Fields* (Joseph, 1976).
Contrib: *The Countryman*.

WALLACE, Donald Ian Mackenzie b.1933
Born on 14 December 1933 in Great Yarmouth, Wallace was educated at Loretto School (1947-51), and Clare College, Cambridge (1954-57). He worked in the food and drink industry from 1957 to 1979, becoming Managing Director of the Herring Division, Associated Fisheries Ltd. In 1980 he founded the Wallace Partnership, writing and illustrating books on birds, and in 1981 began working as Charity Accounts Director of Fine Art Development PLC. He had no formal art training, but has become a successful wildlife artist and illustrator, and was a founder member of the SWLA. He cites Archibald Thorburn*, Eric Ennion* and Bruno Lilefors as artists who influenced his work.
Books written and illustrated include: *Discover Birds* (Whizzard Press/Deutsch, 1979); *Birdwatching in the Seventies* (Macmillan, 1981); *Birds by Character* (Macmillan, 1990).
Contrib: *Birdlife; Birdwatching; British Birds*.
Exhib: SWLA.
Bibl: Who; IFA.

WALLACE, Harold Frank 1881-1962
Primarily a painter of country pursuits, the first of Wallace's autobiographical works, *Happier Years* (1944), is, however, illustrated by the author with pencil drawings.
Books illustrated include: H.B.C. Pollard: *The Gun Room Guide* (with P. Rickman, Eyre, 1930); E. Helme: *Seek There: A Story of Braemar* (Eyre, 1933).
Books written and illustrated include: *Stalks Abroad* (Longmans, 1908); *Big Game of Central and Western China* (Murray, 1913); *Hunting and Stalking the Deer* (with Lionel Edwards*; Eyre, 1927); *A Highland Gathering* (Eyre, 1932); *Big Game* (Eyre, 1934); *A Stuart Sketch Book, 1542-1746* (with Lionel Edwards; Eyre, 1934); *Happier Years* (Eyre, 1944); *Hunting Winds* (Eyre, 1949); *Please Ring the Bell* (Eyre, 1952).
Contrib: *Field*.
Bibl: Titley.

WALLER, Pickford 1873-1927
See Houfe

WALTERS, Edward Henry Seymour 1899-1977
Educated privately and, after a brief period in the Royal Navy during WW1, at Lincoln College, Oxford, Walters studied at the St. John's Wood School of Art (1923-), where he learned wood engraving, printing and painting. He studied typography at the Central School of Art and Design under J.H. Mason (1924-7), and began to concentrate on printing, partly due to the influence of Hilary Pepler (of the St. Dominic's Press) and Eric Gill*. He set up his own printing shop in 1929 at Primrose Hill, and designed and cut many of the illustrations to the books he printed. Between 1929 and 1939, Walters printed more than twelve books, mostly in short runs of 250 or so copies.
In 1941 Walters was appointed master at Marlborough College, where he took charge of the Marlborough College Press. From there he moved to Bromsgrove School and the Bromsgrove School Press, and in the 1960s was involved in the Carmelite Fathers' St.

Albert's Press at Aylesford, Kent. Walters retired to Cornwall in the late 1950s and died on 7 October 1977.
Books illustrated include (but see Sewell, 1982†): W.S. Landor: *Two Imaginary Conversations: Aesop and Rhodope* (pp., 1930); *Five Poems* (pp., 1930); *A Reprint of Six Poems* (pp., 1931); R. Coates: *Several Occasions* (pp., 1932); H.B. Walters: *The English Antiquaries* (pp., 1934); St.J. Fisher: *Sermon Against Luther* (Ditchling: St. Dominic's Press, 1935); *Hugh of Lincoln and Other Ballads* (pp., 1937); T. More: *Of Pilgrimage* (Aylesford: St. Albert's Press, 1956); E. Farjeon: *Elizabeth Myers* (Aylesford: St. Albert's Press, 1957).
Books written and illustrated include :*Silva Civica* (pp., 1934).
Bibl: Brocard Sewell: "Edward Walters, Printer and Engraver", *Matrix* 1 (1981): 35-43; Sewell: "A Check-List of Books . . . Printed by Edward Walters . . .", *Matrix* 2 (1982): 103-11; John Randle: "The Tale of Six Blocks", *Matrix* 1 (1981): 44 + 4p.

WALTON, Cecile 1891-1956
Born on 22 March 1891 in Glasgow, Walton studied in London, Edinburgh and Paris. An eminent painter of the Glasgow School, and a sculptor, she exhibited at the RA, RSA and RWS, and illustrated a few books in black and white and full colour. For a time in the 1930s she was an "aunt" in Scottish Children's Hour. She was married twice, her second husband being the artist Eric Robertson. She died in April 1956.
Books illustrated include: H.C. Andersen: *Fairy Tales* (Jack, 1911); A.J. Glinski: *Fairy Tales* (BH, 1920); A. Priestman: *Child Verses and Poems* (Stockwell, 1926); D.A. Ratcliffe: *Nightlights* (BH, 1929).
Books written and illustrated include: (with E. Robertson) *The Children's Theatre Book* (Black, 1949).
Exhib: RA; RWS.
Bibl: *Times* obit. 26 April 1956; ICB; Peppin.

WANKLYN, Joan fl. 1949-
Wanklyn is mostly an equestrian artist, who has illustrated a number of books, including books for children, and contributed to magazines. In addition to those publications listed, she has also illustrated a number issued by Pony Club.
Books illustrated include: M. Edwards: *Spirit of Punchbowl Farm* (Collins, 1952), *Punchbowl Harvest* (Collins, 1954); E.H. Parsons: *The Twins in the New Forest* (Hutchinson, 1955), *Quest for a Pony* (Hutchinson, 1956); M. Edwards: *The Wanderer* (Collins, 1957); J.A. Talbot-Ponsonby: *The Horseman's Bedside Book* (Batsford, 1957); E.H. Parsons: *Family in the Saddle* (Hutchinson, 1958); C. Blacker: *The Story of Workboy* (Collins, 1960); G. Spooner: *Pony Trekking* (Museum Press, 1961).
Books written and illustrated include: *Bobtail Shawn* (Warne, 1949); *Brown Shadow the Otter* (Warne, 1949); *Chequers; or, Kitty Alone* (Warne, 1949); *Flip: The Story of an Otter* (Warne, 1951); *Guns at the Wood: A Record of St. John's Wood Barracks* (pp. 1972); *Badminton from Below* (Midland Bank Horse Trials Handbook, 1981).
Contrib: *Field; Horse & Hound; Light Horse; Pony Club Annual; Pony Magazine; L'Année Hippique*.
Exhib: Leighton House (1982).
Bibl: Titley.

WARD, Bryan b.1925
Born in Leicester, Ward studied for a year at Leicester College of Art, and then worked briefly for a film company in Berkshire. He served in the army during WW2 (1943-47); since then he has worked as an illustrator, teacher, and graphic artist. He produced some children's books when he was just sixteen, but is best known for his colour illustrations for the "Ant and Bee" series of books for children by Angela Banner.
Books illustrated include: H.E. Todd: *Bobby Brewster and the Winkers' Club* (Ward, 1949); A. Banner: *Ant and Bee* (Ward, 1951), *More Ant and Bee* (Ward, 1956) and at least five more titles to *Ant and Bee and the Kind Dog* (Ward, 1963).
Books written and illustrated include: *The Leaping Match* (Ward, 1940); *Elfin Mount* (1941); *Sindibad's First Voyage* (Ward, 1942); *George the Snail Bee* (Spectrum, 1975).
Bibl: Peppin.

WARD, John Stanton b.1917

Born on 10 October 1917 in Hereford, Ward was educated at St. Owens School, Hereford, and studied at Hereford School of Art and at the RCA (1936-39 under Gilbert Spencer*). After serving in the Royal Engineers for seven years during WW2, he returned to RCA to finish his studies (1946-47). He was under contract to *Vogue* (1948-52) to produce fashion drawings and sketches of interiors. He is a painter who has concentrated on portraits and architectural drawings, and he has a great interest in antiques and the illustrations of the 1860s. He has illustrated some books and his illustrations appear to be quite spontaneous sketches, drawn in pen and ink. He is quoted in Jacques as saying "The decorative illustrator has done great harm to the job . . . An illustration should be a diagram that makes a point." A trustee of the RA, he was elected NEAC (1950); RWS (1952); RPS (1953); ARA (1956); RA (1965). Created CBE (1985).

Books illustrated include: C. Beaton-Jones: *The Adventures of So-Hi* (Barrie, 1952); L. Lee: *Poetry for Pleasure* (1958); *Cider with Rosie* (Hogarth Press, 1959); R. Church: *The Little Kingdom* (Hutchinson, 1964); T.F. Powys: *Rosie Plum* (Chatto, 1966); R. Church: *The White Doe* (Heinemann, 1968); H.E. Bates: *An Autobiography* (three vols., Joseph, 1969-72); H. Bosco: *The Adventures of Pascalet* (OUP, 1976); J. Grenfell: *George, Don't Do That* (Macmillan, 1977), *Stately as a Galleon* (Macmillan, 1978); K.M. Briggs: *Nine Lives* (Routledge, 1980).

Contrib: *Vogue*.

Exhib: RA; Agnews Gallery; Maas Gallery.

Collns: NPG; RA.

Bibl: Jacques; Peppin; Waters; Who; Who's Who.

WARNER, Peter b.1939

Born on 1 March 1939 in London, Warner studied at Wimbledon School of Art and the RA Schools. After finishing his studies, he began to illustrate as well as paint, his main subject being animals. He has had many pets, including cats, a Great Dane, and a white goat. He works in a variety of media, including coloured ink and watercolour. He has also written and designed texts for technical material such as series on ships and musical instruments for the magazine, *Pictorial Education*.

Books illustrated include: S.C. George: *The Happy Fisherman* (Hamilton, 1965); J. Hope-Simpson: *The Edge of the World* (Hamilton, 1965); R.E. Jackson: *The Witch of Castle Kerry* (Chatto, 1965); W. Mayne: *No More School* (Hamilton, 1965); N. Streatfeild: *Let's Go Coaching* (Hamilton, 1965); H. Sturton: *Zomo the Rabbit* (Hamilton, 1966); R.E. Jackson: *Aunt Eleanor* (Chatto, 1969); C. Metcalfe: *Cats* (Hamlyn, 1969); H. Loxton: *Guide to the Cats of the World* (Elsevier Phaidon, 1976); J. Firmin: *Sea Birds* (Macmillan, 1978); M. Wright and S. Walters: *The Book of the Cat* (Pan, 1980).

Bibl: ICB3; Peppin.

WARNER, Priscilla Mary b.1905

Born on 2 March 1905 in London, Warner was educated at Loughton High School, Essex, and studied at the RCA. She grew up with a love of gardens, the country and animals. She started teaching in high schools, but had to give up teaching because of ill health. She had illustrated two anthologies (*Welcome Christmas* and *High Days and Holidays*) while in her first school position, and then became a free-lance illustrator, writer and designer of children's books and books on embroidery. She returned later to teach at training colleges for teachers.

Books illustrated include: *Welcome Christmas*; *High Days and Holidays*.

Books written and illustrated include: *Biddy Christmas* (Blackwell, 1948); *Embroidery Mary* (Harrap, 1948); *Picture Come True* (Blackwell, 1951); *Tessie Growing Up* (Blackwell, 1952); *Tessie's Caravan* (Blackwell, 1953); *Mr. and Mrs. Cherry* (Harrap, 1954).

Published: *Pictures and Patchwork* (Dryad Press, 1950).

Bibl: ICB2; Peppin.

WARREN, Michael b.1938

Born on 26 October 1938, Warren was educated at Wolverhampton Grammar School and studied at Wolverhampton College of Art

Denys WATKINS-PITCHFORD "The March Hare" from *The Shooting Man's Bedside Book* (Eyre & Spottiswoode, 1948)

(1954-58), specializing in illustration. He started painting full-time in 1972, and has developed his art in conjunction with active bird-watching. His early works often contained highly decorative backgrounds to the bird subject, but this gave way to a greater realism, though a strong element of design remains. The artist has an eye for ornithological detail but his illustrations are more than purely documentary, often depicting birds in lively or humorous situations. He paints with acrylics on rag board.

He regularly illustrates the covers of *Birds*, the journal of the Royal Society for the Protection of Birds; and he has done at least two book jackets. In 1980 he designed a set of four postage stamps for the GPO, featuring water birds, and he has been commissioned to design a set for the Marshall Islands. He wrote and illustrated his first book in 1984, *Shorelines*, which contains striking and original pictures. He was elected SWLA in 1971.

Books written and illustrated include: *Shorelines: Birds at the Water's Edge* (Hodder, 1984).

Contrib: *Birds; British Birds.*

Collns: Wallsworth Hall, Glos.

Exhib: Barbican (1984); Moorland Gallery (1972, 1974, 1977, 1979); Tryon Gallery; Luxembourg; New York; ROM; Wildlife Gallery, Toronto.

Bibl: Hammond; Who; IFA.

Colour Plate 143

WATKINS, Dudley Dexter 1907-1969

Born in Manchester, Watkins studied at Nottingham School of Art and then worked for magazine publisher D.C. Thomson of Dundee

as an illustrator and cartoonist. He created many strip cartoon characters for comics and newspapers, such as "Desperate Dan" in 1937 for *Dandy*, the first weekly comic published by Thomson, "Lord Snooty and His Pals" for the first issue of *Beano* in 1938, and "Oor Wullie" (1936) in the Scottish *Sunday Post*. These cartoons lasted for many years and some were reprinted in annual collections. Watkins also illustrated a few versions of the classics of English literature for Thomson.

Books illustrated include (all published by Thomson): R.L. Stevenson: *Kidnapped* (1948); C. Dickens: *Oliver Twist* (1949); R.L. Stevenson: *Treasure Island* (1950); D. Defoe: *Robinson Crusoe* (1952).

Books written and illustrated include: *The Broons* (Thomson, 1947, 1949, 1951); *Oor Wullie* (Thomson, 1950-); *The Abominable Slowman* (Paxton, 1960).

Contrib: *Beano; Dandy; Sunday Post; Topper.*
Bibl: Horn; Peppin.

WATKINS-PITCHFORD, Denys James 1905-1990
Born on 25 July 1905, in Lamport, Northamptonshire, Watkins-Pitchford was one of twin boys, the sons of a country parson. He studied at the Northampton School of Art (where he won a travelling scholarship to Paris), and the RCA (1926-29 under Sir William Rothenstein). For fifteen years, he was art master at Rugby School, taking over from R.B. Talbot Kelly*. He then retired to be a full-time writer and illustrator. He painted landscapes in both watercolour and oils, but is best known as an author and illustrator, concentrating on books about nature and the English countryside. He wrote for children and adults, and in 1942 won the Carnegie Medal for *The Little Grey Men*. He also broadcast on country matters.

Watkins-Pitchford illustrated under his own name but wrote his books under the pseudonym "B.B" (a size of shot used by field sportsmen. An enthusiastic sportsman himself, he bought his own gun when still only a boy.) He illustrated his own works and those of others, notably Rolt's classic about canal boats, *Narrow Boat*. His pen and ink drawings are charming, though he also has made extensive use of scraperboard technique and colour. Peppin writes that the white-line scraperboard drawings for *The Little Grey Men* are "perfunctory and insubstantial (perhaps reflecting wartime difficulties) in comparison with the more varied texture and tonal counterpoint of scraperboard illustrations in earlier and later books." It did, however, win the Carnegie Medal as the outstanding children's book of the year. A great admirer of Arthur Rackham, one can see the influence of his work in some of Watkins-Pitchford's illustrations. He was elected FRSA; MBE (1989); died in Oxford on 8 September 1990.

Books illustrated include: H. Prichard: *Sport in Wildest Britain* (1936); R.G. Walmsley: *Winged Company* (1940); G.H. Warren: *England Is a Village* (1940); E. Barfield: *The Southern English* (Eyre, 1942); L.T.C. Rolt: *Narrow Boat* (1944); A.G. Street: *Landmarks: Reminiscences* (1947); B. Vesey-Fitzgerald: *It's My Delight* (1947); A. Applin: *Philandering Angler* (1948); J.B. Drought: *A Sportsman Looks at Eire* (1949); G.D. Adams: *Red Vagabond* (1951); M. Carey: *Fairy Tales of Long Ago* (Dent, 1952); W. Mayne: *The Long Night* (1958); A. Richards: *Vix, the Story of a Fox Cub* (1960); A. Lang: *Prince Prigio* (1961); F. Browne: *Granny's Wonderful Chair* (1966).

Books written and illustrated include: *The Sportsman's Bedside Book* (Eyre, 1937); *The Idle Countryman* (1938); *Wild Lone: A Story of the Pytchley Fox* (Eyre, 1938); *Sky Gipsy* (1938); *Manka, the White Goose* (Eyre); *The Countryman's Bedside Book* (Eyre, 1941); *The Little Grey Men* (Eyre, 1942); *Brendon Chase* (Methuen, 1944); *Confessions of a Carp Fisher* (1944); *The Fisherman's Bedside Book* (Eyre, 1945); *Down the Bright Stream* (Eyre, 1948); *Meeting Hill* (Hollis, 1948); *The Shooting Man's Bedside Book* (Eyre, 1948); *A Stream in Your Garden* (1948); *Tide's Ending* (Hollis, 1950); *The Wind in the Wood* (Hollis, 1952); *Dark Estuary* (Hollis, 1953); *The Forest of Boland Light Railway* (Eyre, 1955); *The Autumn Road to the Isles* (Kaye, 1959); *Bill Badger's Winter Cruise* (1959); *The Wizard of Boland* (1959); *Lepus, the Brown Hare* (1962); *The Summer Road to Wales* (1964); *Lord of the Forest* (1975); *A Child Alone: The Memoirs of BB* (Joseph, 1978); *Ramblings of a Sportsman-Naturalist* (1979).

Contrib: *Shooting Times.*
Bibl: *Guardian* obit. 13 September 1990; *Independent* obit. 15 September 1990; Carpenter; ICB2; Peppin; Titley; Waters.

WATSON, A.H. fl. 1924-1959
Watson was a prolific illustrator of children's books. She had a delicate touch in her line drawings, and many of her colour illustrations are lively and attractive. She was the first illustrator of the "Professor Branestawm" character, with drawings made for *Merry-Go-Round* magazine.

Books illustrated include: C. Mackenzie: *Santa Claus in Summer* (Constable, 1924); R. Fyleman: *The Adventure Club* (Blackwell, 1925); C. Asquith: *Everything Easy* (Jarrolds, 1926), *The Treasure Ship* (with others, Partridge, 1926); W. de la Mare: *Told Again* (1927); M.St.J. Webb: *The Littlest One: His Book* (Harrap, 1927); H. Asquith: *Pillicock Hill* (OUP, 1928); M.B. Lodge: *A Fairy To Stay* (OUP, 1928); E. Boumphrey: *The Hoojibahs* (OUP, 1929); C. Mackenzie: *The Adventures of Two Chairs* (Blackwell, 1929); D. Mariford: *The Dragon Who Would Be Good* (Brentano, 1929); C. Asquith: *The Children's Cargo* (with others, 1930); L. Housman: *Turn Again Tales* (with others, 1930); M.B. Lodge: *The Wishing Wood* (OUP, 1930); M.St.J. Webb: *John and Me and the Dickery Dog* (1930); C. Asquith: *The Silver Ship* (Putnam, 1932); C. Brahms: *Curiouser and Curiouser* (1932); C. Mackenzie: *The Dining-Room Battle* (Blackwell, 1933), *The Enchanted Blanket* (Blackwell, 1930), *The Stairs That Kept on Going Down* (Blackwell, 1937); L. Carroll: *Alice's Adventures in Wonderland* (1939); A.A. Milne: *A Gallery of Children* (Harrap, 1939); "Mrs. H. Strang": *Our Old Fairy Stories* (1939); P. Gann: *Martyn Merryfeather* (Warne, 1942); R.L. Stevenson: *A Child's Garden of Verse* (1946); E. Boumphrey: *Hoojibahs and Humans* (Lutterworth, 1949); K. Fidler: *The Brydons Go Camping* (and two other titles, Lutterworth, 1948-49), *The White-Starred Hare* (Lutterworth, 1951); E. Kyle: *The Reiver's Road* (Nelson, 1953); M. Gervaise: *Fireworks at Farthingale* (Nelson, 1954), *The Farthingale Fete* (Nelson, 1955), *The Farthingale Feud* (Nelson, 1957); C. Collodi: *The Adventures of Pinocchio* (1958).

Books written and illustrated include: *Nursery Rhymes* (1958).
Contrib: *Joy Street: Merry-Go-Round; Wonder Book.*
Bibl: Peppin.

WATSON, Clixby b.1906
Watson studied at St. Martin's School of Art and then worked abroad before returning to paint English people and landscapes. The need to earn a living turned him towards cartooning. He also contributed to *Radio Times* regularly from 1932 producing a number of covers for that magazine in 1939.

Contrib: *Radio Times.*
Bibl: Driver.

WATSON, Donald b.1918
Born at Cranleigh, Surrey, in 1932 Watson moved with his family to Edinburgh. At school, at Oxford University (where he read modern history) and while serving in the army in India and Burma (1940-46), he painted and drew birds. After WW2 he became a professional bird artist, travelling throughout Britain and holding many one-artist exhibitions. His first commission to illustrate a book was *The Oxford Book of Birds* (1946), and since then he has illustrated other books and magazines. He has travelled a lot outside Britain also, though he remains primarily an artist of the Scottish countryside.

Books illustrated include: *The Oxford Book of British Birds* (OUP, 1946); B. Campbell: *The Oxford Book of Birds* (OUP, 1964); A. MacNeillie: *But Hibou Was Special* (Country Life, 1964); *Birds of Moor and Mountain* (Scottish Academic Press, 1972); D. Nethersole-Thompson: *Pine Crossbills* (Poyser, 1975), *Greenshanks* (Poyser, 1979); D. Ratcliffe: *The Peregrine Falcon* (Poyser, 1980); D. Bannerman: *Birds of the Balearics* (Croom Helm, 1983).

Books written and illustrated include: *The Hen Harrier* (Poyser, 1977).
Exhib: Rowland Ward Gallery (1950).
Bibl: Hammond.

WATSON-WILLIAMS, M.
See KETTELWELL, John

WATTS, Arthur George 1883-1935
See Houfe

Books illustrated include: A.R. Thorndike and R. Arkell: *The Tragedy of Mr. Punch* (Duckworth, 1923); E. Knox: *Poems of Impudence* (Fisher Unwin, 1926); G.B. Hartford: *Commander, R.N.* (Arrowsmith, 1927); *A Little Pilgrim's Peeps at Parnassus* (1927); E.M. Delafield: *Diary of a Provincial Lady* (Macmillan, 1930), *The Provincial Lady Goes Further* (Macmillan, 1932).
Contrib: *Bystander; Humorist; Life; London Magazine; London Opinion; Nash's Magazine; Punch; Radio Times; Sketch*.
Bibl: Driver; Peppin; Waters.

WATTS, Bernadette b.1942
Born on 13 May 1942 in Northampton, Watts studied at Maidstone College of Art. She illustrates books for children in line and in gouache or watercolour, using a naïve style. She is quoted in ICB4 as writing that "her views on art and illustration are nostalgic and old-fashioned." Using the sobriquet "Bernadette", some of her books were first published in Switzerland.
Books illustrated include: J. Reeves: *One's None* (1968); R. Ainsworth: *Look, Do and Listen* (1969); R. Ehrhardt: *Kikeri* (Macdonald, 1970); Mendoza: *Christmas Tree Alphabet Book* (Collins, 1971); Grimm: *Rapunzel* (Dobson, 1975); A. Scholey: *Sallinka and the Golden Bird* (Evans, 1978); Grimm: *Cinderella* (Dent, 1979); P. Crompton: *Aesop's Fables* (Dent, 1980); M. Rogers: *Green Is Beautiful* (Andersen Press, 1977); G.M. Scheidl: *Chibby the Little Fish* (Dent, 1980); H.C. Andersen: *The Little Match Girl* (Abelard, 1983); Grimm: *Snow White* (Abelard, 1983), *The Sleeping Beauty* (Abelard, 1984); G.M. Scheidl: *George's Garden* (Abelard, 1985); L. Tolstoy: *Shoemaker Martin* (North-South Books, 1986); J. Curle: *The Four Good Friends* (North-South, 1987).
Books written and illustrated include: *David's Waiting Day* (Aardvark, 1975); *The Little Flute Player* (Abelard, 1975); *The Christmas Story* (Abelard, 1982); *Goldilocks and the Three Bears* (Abelard, 1984); *St. Francis and the Proud Crow* (Andersen, 1987).
Bibl: ICB4; Peppin.

WATTS, Marjorie-Ann fl. 1955-
Born in London, Watts is the daughter of Arthur Watts*. She studied at the Chelsea School of Art under Edward Ardizzone*, Brian Robb*, and Harold Jones*. A painter, etcher and lithographer, she has illustrated a number of children's books, as well as writing some herself. She uses mostly pen line drawings for her illustrations, but occasionally uses colour.
Books illustrated include: C. Storr: *Clever Polly and the Stupid Wolf* (Faber, 1955), *Polly the Giant's Bride* (Faber, 1956), *The Adventures of Polly and the Wolf* (Faber, 1957), *Marianne Dreams* (Faber, 1958); M. Baker: *The Magic Sea Shell* (1959); C. Storr: *Marianne and Mark* (Faber, 1960).
Books written and illustrated include: *Tea Shop by the Water* (Harrap, 1960); *Mulroy's Magic* (Faber, 1971); *The Dragon Clock* (D & C, 1974); *Crocodile Medicine* (Deutsch, 1977); *Crocodile Plaster* (Deutsch, 1978); *The Mill House Cat* (Beaver, 1978); *Zebra Goes to School* (Deutsch, 1981); *Tall Stories for Mr Tidyman* (Deutsch, 1983).
Bibl: Peppin.

WEBB, Archibald Bertram b.1887
Born in Ashford, Kent, Webb studied at St. Martin's School of Art. He spent some time in Western Australia, teaching, painting and making prints: he exhibited watercolours and coloured woodcut prints at the Fine Arts Society in 1934. He illustrated a few books, including several boys' adventure stories by W.H.G. Kingston, contributed to many magazines, and designed posters, including at least one for the Empire Marketing Board.
Books illustrated include: C. Kingsley: *Westward Ho!* (Cassell, 1910); W.G. Kingston: *Roger Willoughby* (Hodder, 1910), *Paddy Finn* (Hodder, 1910), *The Three Lieutenants* (Hodder, 1910), *The Rural Crusoes* (1911), *The Three Admirals* (Hodder, 1912), *The Missing Ship* (1913), *John Deane* (Milford, 1921); R.L. Stevenson:

New Arabian Nights (1926); R.M. Ballantyne: *Deep Down* (1937); F. Marryat: *Masterman Ready* (Nister, nd); H. Strang: *One of Rupert's Horse* (nd), *Roger the Scout* (nd); C.M. Yonge: *The Little Duke* (nd).
Contrib: *Captain; Chums; Herbert Strang's Annuals; Little Folks; Sunday at Home*.
Exhib: FAS (1934).
Bibl: Stephen Constantine. *Buy & Build: The Advertising Posters of the Empire Marketing Board*. (HMSO, 1986); Peppin.

WEBB, Clifford Cyril 1895-1972
Born on 14 February 1895 in London, Webb was educated at Chigwell Grammar School. He was apprenticed to a lithographer until the outbreak of WW1, during which he fought in France and Mesopotamia and served in India. After the war, he studied art at Westminster School of Art (1919-22 under Walter Bayes). He taught drawing at Birmingham School of Art (1923-26), at Westminster (1934-39) and at St. Martin's School of Art (1945-65). He painted watercolour landscapes based more on draughtsmanship than on colour washes, and produced many large lithographed colour prints between 1930 and 1960. A founder-member of the Society of Wood Engravers, he is better known for his wood engravings, which are strongly cut. Some of his engravings exhibit a tendency to the abstract, which is mostly the natural outcome of

Clifford WEBB *Ana the Runner* by Patrick Miller (Golden Cockerel Press, 1937)

simplification necessitated by the demands of the medium of lino or wood. He was a prominent figure in the group of engravers who brought about the revival of wood engraving in the 1920s, and benefited from the encouragement of Robert Gibbings* and the Golden Cockerel Press. He became a prolific book illustrator, using the techniques of scraperboard and watercolour, as well engraving. Webb was very good at slightly exotic subjects and portraying the characteristic qualities of birds and animals. He illustrated eight books for the Golden Cockerel Press (1937-54), including H.G. Wells' *The Country of the Blind* (1939). Hodnett regards the frontispiece to this book as one of the finest wood engravings made during this period, and considers the artist to be a genuine illustrator, rather than "just" a printmaker. Garrett remarks that "there are no bad Webb engravings." (Garrett 1).

Webb illustrated a number of books for children, in the first place for his own children. The earliest books were done with scraperboard, but later ones like *Animals from Everywhere* are a mixture of poster colours, chalk and splatter work.

He was elected SWE (1935); RBA (1936); ARE (1938); RE (1948). He died on 29 July 1972.

Books illustrated include: A. Ransome: *Swallows and Amazons* (Cape, 1931), *Swallowdale* (Cape, 1931); E. Monckton: *For the Moon* (1932), *The Gates Family* (Warne, 1934); M. Woodward: *A Key to the Countryside* (1935); M. Dixey: *Words, Beasts and Fishes* (Faber, 1936); P. Miller: *Ana the Runner* (GCP, 1937); E.B. Vesey: *The Hill Fox* (1937); V.G. Calderon: *The White Llama* (GCP, 1938); G. Murray: *The Gentle Art of Walking* (Blackie, 1939); H.G. Wells: *The Country of the Blind* (GCP, 1939); *Gesta Francorum: The First Crusade* (GCP, 1945); M. Alleyne: *The Pig Who Was Too Thin* (1946); R. Wightman: *Moss Green Days* (Westhouse, 1947), *Days on the Farm* (Westhouse, 1947?); I. Bannet: *The Amazons* (GCP, 1948); *Julius Caesar's Commentaries* (GCP, 1951); S. de Chair: *The Story of a Lifetime* (GCP, 1954); E. Walters: *The Serpent's Presence* (GCP, 1954); E. Monckton: *The Boy and the Mountain* (Warne, 1961).

Books written and illustrated include: *The Story of Noah* (Ward, 1931); *Butterwick Farm* (Warne, 1933); *A Jungle Picnic* (Warne, 1934); *The North Pole Before Lunch* (Warne, 1936); *Animals from Everywhere* (Warne, 1938); *Magic Island* (Warne, 1956); *More Animals from Everywhere* (Warne, 1959); *The Friendly Place* (Warne, 1962); *Strange Creatures* (Warne, 1963); *The Thirteenth Pig* (Warne, 1965); *A Visit to the Zoo*.

Exhib: LG; NEAC; RA; RBA; RE; SWE; Blond (1980).

Collns: BM; V & A.

Bibl: Roderick Cave: "Cockerels and Amazons: Letters of Christopher Sandford to Clifford Webb, 1946-1947", *Private Library* 4th S., 1, 1 (Spring 1988): 27-42; *Engraving Then and Now: The Retrospective 50th Exhibition of SWE* (SWE, 198?); *Times* obit. 12 August 1972; Chambers; Garrett 1 & 2; Hodnett; ICB; ICB2; ICB3; Peppin; Sandford; Waters.

Clifford WEBB *Julius Caesar's Commentaries* (Golden Cockerel Press, 1951)

WEBSTER, Tom **1886-1962**
See Houfe

Born in Bilston, Staffordshire, on 17 July 1886, Webster started working as a youth in the booking office of a Birmingham railway station. With no formal art training, he began contributing drawings to illustrate the sports pages on the *Birmingham Sports Argus*. He moved to London in 1912 and became political cartoonist on the new socialist paper, the *Daily Citizen*, but in 1913 returned to sport as his subject, and began to develop the sporting strip cartoon. Service in the Royal Fusiliers in France during WW1 interrupted his career, until he was invalided home in 1917. After the war and several years of real hardship, in 1919 he became sports cartoonist on the *Daily Mail*. He resigned from the *Mail* in 1940, but in 1944 returned to cartooning with the *Sunday Empire News* for a few years, and then worked for the *News Chronicle* until 1956. He died on 21 June 1962.

Within months of starting with the *Daily Mail* his work became extremely popular, and for twenty years he was at the peak of his career. DNB reports that in 1924 he was the most highly-paid cartoonist in the world. He published twenty collections of his cartoons in his *Tom Webster's Annual*, and these had an enormous following. Apart from his sports cartoons, Webster drew caricatures; was one of the artists commissioned to decorate the *Queen*

Mary in 1936, painting fourteen large panels of sportsmen for the ship's gymnasium; appeared on many radio programmes; made his first TV appearance in 1934.

Books written and illustrated include: *Tom Webster's Annual* (20 issues; Daily Mail).

Contrib: *Birmingham Sports Argus*; *Daily Citizen*; *Daily Mail*; *Evening News*; *News Chronicle*; *Sunday Despatch*; *Sunday Empire News*.

Exhib: University of Kent (1986).

Collns: University of Kent.

Bibl: Pat Adams: *Tom Webster — Sports Cartoonist: Centenary Exhibition* (Centre for the Study of Cartoons and Caricatures, University of Kent, 1986); Bradshaw; DNB; Feaver.

WEGNER, Fritz **b.1924**

Born on 15 September 1924 in Vienna where he spent his childhood, Wegner came to England in 1938. He won a scholarship to the St. Martin's School of Art (where he later was a visiting lecturer in graphic design), and was later apprenticed to a designer. During WW2 he worked on the land and after the war became a free-lance illustrator. He has designed book jackets and covers, contributed to magazines, designed postage stamps, and illustrated books. For his book illustrations he uses a variety of media but prefers pen and ink to produce finely drawn, often quietly humorous illustrations. His two-page spread in *Tail Feathers from Mother Goose* (1988) contains small, funny coloured pen drawings

with a hand-written text. *The Wicked Tricks of Till Owlyglass* (1989) was short-listed for an "Emil" award.

Books illustrated include: Swinnerton: *Cats and Rosemary* (Hamilton, 1950); Sisson: *The Impractical Sweep* (Macmillan, 1956); S.P. Johnson: *The Hamish Hamilton Book of Princesses* (Hamilton, 1963); J von Grimmelshausen: *Mother Courage* (Folio Society, 1965); J. Jacobs: *Jack the Giant Killer* (BH, 1970); L. Garfield: *The Strange Affair of Adelaide Harris* (Longman, 1971); A. Maurois: *Fattypuffs and Thinifers* (BH, 1971); E. Colwell: *The Bad Boys* (Penguin, 1972); J. Barber: *The Voyage of Jim* (Chatto, 1973); Grimm: *Snow White and the Seven Dwarves* (BH, 1973); *Tail Feathers from Mother Goose* (with others, Walker, 1988); A. Ahlberg: *Heard It in the Playground* (Kestrel, 1989); M. Rosen: *The Wicked Tricks of Till Owlyglass* (Walker, 1989).
Contrib: *Cricket; Everywoman; Farmer's Weekly; Radio Times.*
Bibl: Folio 40; ICB2; ICB4; Jacques; Peppin; Usherwood; Who.

WEIGHT, Carel Victor Morlais **b.1908**
Born on 10 September, 1908, in Paddington, London, of a lower-middle class family, Weight was brought up by a poor couple, who became virtually his foster-parents, living in the shabby and derelict areas of Chelsea and Fulham. They lavished much affection on him, but the contrast between their poverty and the relative luxury of his real home, where he spent weekends, was crucial to his upbringing and the development of his art — the decaying gentility of South London streets features in many of his paintings. He was educated at Sherbrook Road Board School and Sloane Secondary School, Chelsea, and after beginning to train as a singer studied for three years at Hammersmith College of Art (1928-30) and then part-time for three years at Goldsmiths' College (1931-33). He taught at Beckenham School of Art (1932-42) and RCA (1947-73), and is now a Professor Emeritus. After service in the army during WW2, Weight was an official war artist (1945-46), documenting war devastation in Italy, Greece and Austria.
Weight has illustrated at least two books, but he is "first and foremost an imaginative painter, a dreamer of visions: his pictures are often bizarre and haunted, frequently allegorical, sometimes witty but always profound in the subtlety of their illusions. . . He believes in the ultimate loneliness and isolation of man, in the insoluble problem of communication." (Levy, 1986.†) He first exhibited at the RA in 1931 — over the past fifty years the artist has shown over 200 paintings at the annual summer RA exhibitions. His first one-artist show was at the Cooling Galleries in 1934. Most of his early work was lost when his studio was destroyed during the Blitz in WW2. A retrospective exhibition of Weight's work was shown at RA in 1982. He was elected RBA (1934); RWA (1954); LG (1950); ARA (1955); RA (1965); and created CBE (1962).
Books illustrated include: *The Oxford Illustrated Old Testament* (five vols., with others; OUP, 1968-9); A.P. Hartley: *The Go-Between* (Folio Society, 1985).
Exhib: RA; Cooling Galleries (1934); Leicester Galls; Zwemmer Gallery (1965); Bernard Jacobson Gall (1988); retrospectives at Reading 1970, RCA 1973, RA 1982.
Colln: Tate; Liverpool; V & A; IWM.
Bibl: Peter Crookston: "Getting the Measure of Carel Weight", *Sunday Times Colour Supplement* (4 June 1989): 48-53; Mervyn Levy: *Carel Weight* (Weidenfeld and Nicolson, 1986); David Mills: "Carel Weight: The Real Setting of the Imagination", *The Artist's and Illustrator's Magazine* no. 15 (December 1987): 10-13; *Carel Weight: A Retrospective Exhibition* (RA, 1982); Linda Saunders: "Carel Weight, RA, CBE", *The Green Book* 2, no.3 (1986): 6-13; Harries; Tate; Waters; Who.

WEISSENBORN, Hellmuth **1898-1982**
Born on 29 December 1898 in Leipzig, Weissenborn fought in the trenches during WW1, and then studied in Leipzig at the university and the Academy of Graphic Art. He was a lecturer at the Academy (1926-38) before fleeing Germany for England at the beginning of WW2. After a short period of internment, he became a part-time lecturer at Ravensbourne College of Art (1941-70), married Lesley Macdonald, and with her took over the Acorn Press in 1946. Weissenborn, who had started wood engraving in earnest in 1940, illustrated many of the Acorn Press books, which were finely-

Hellmuth WEISSENBORN *Autumn Fields* by Michael Home (Methuen, 1944)

printed, illustrated books, produced in limited editions. Though the Weissenborns were responsible for the publishing plans of the Acorn Press, details of the designs and the actual printing was generally carried out by others. For example, Jonathan Stephenson of the Rocket Press was responsible for both *A Posy of Wildflowers* and Shakespeare's *Sonnets*; and the Whittington Press at Andoversford in Gloucestershire set and printed many others.
Weissenborn produced illustrations for many publishers, using linocuts, etchings, pastel and pen drawings as well as engravings. He experimented with engraving on perspex and vinyl, and also made many monoprints of birds, insects and flowers in this way. There were many one-artist shows of his work in Britain, Germany and the US. He was awarded the Grand Cross of the Order of Merit from the Federal Republic of Germany in 1979. He died in London on 2 September 1982.
Books illustrated include: J. Lied: *Return to Happiness* (1941); M. Home: *Autumn Fields* (Methuen, 1944); V.B. Carter: *Billy the Bumblebee* (1946), *A Posy of Wildflowers* (Wingate, 1946; reissued with wood engravings printed from the block — Acorn Press, 1983); M. Home: *Spring Sowing* (Methuen, 1946); S. Read: *The Poetical Ark* (1947); N.R. Smith: *Miss Bendix* (Hollis & Carter, 1947); R. Friedlenthal: *Goethe Chronicle* (1949); H. White: *The Singing Stream* (1950); H. Heine: *Doktor Faust* (1952); Lucian: *The True History of Lucius or the Ass* (1958); Grimmelshausen: *Simplicissimus* (1964); H.K. Adam: *German Cookery* (1967); A. Marston: *London: Some Aspects* (1968); R.C. Kenedy: *Grotesques* (1975); E. Thomas: *The Diary of Edward Thomas* (Whittington Press, 1977); J. Forget: *Vingt Poèmes* (1978); D'A. Kaye: *Masked and Unmasked* (1978), *Columbus* (1978); H. Swann: *Eleven Poems* (1978); G.E. Lessing: *Fables in English and German* (1979); F. Weissenborn: *Roads, Rails and Bridges* (Acorn Press, 1979); R. Kenedy: *Cretan Picture Postcards* (1981); E. Thomas: *The Chessplayer* (Whittington Press, 1981); *Aesop's Fables* (1982); W. Shakespeare: *Sonnets* (Acorn Press, 1982); J.E. Mikellatos: *Towns* (Acorn Press, 1985); *Anthology of Love* (Acorn Press, 1985).
Books written and illustrated include: *Simplex Simplicissimus* (Calder, 1964); *Picture Alphabet* (1975); *Ruins* (1977); *Fantasy* (1978); *Signs of the Zodiac* (Whittington Press, 1978); *Proverbs*

from All Nations (Acorn Press, 1979); *ABC of Names, Old and New* (Acorn Press, 1979);
Collns: IWM; V & A.
Bibl: Tom Colverson and Dennis Hall: *A Catalogue of Fine Press Printers in the British Isles* (Oxford: Inky Parrot Press, 1986); *Hellmuth Weissenborn: Engraver* (Whittington Press, 1983); *Times* obit., 11 September 1982; Peppin.

WEISZ, Victor "VICKY" **1913-1966**
Born on 25 April 1913 in Berlin of Hungarian Jewish parents, Weisz attended the Berlin School of Art, but had to leave when his father died in 1928 in order to earn a living. He started cartooning for a Berlin paper when he was fourteen, and his first anti-Hitler cartoon was done in 1928 when he was fifteen. He came to England in 1935, and was introduced to Sir Gerald Barry, editor of the *News Chronicle*, who made it his concern to see that "Vicky" (which was the sobriquet Weisz used as a cartoonist) learnt about British humour. After doing "spot" cartoons for several magazines, and "Vicky by Vicky" cartoons strips for the *Sunday Chronicle*, he joined the *News Chronicle* in 1941, but left for the *Daily Mirror*, and in 1958 joined the *Evening Standard*. Though best known as a newspaper cartoonist, Vicky also contributed cartoons and other drawings to many magazines, and illustrated a number of books.
Vicky, who often appeared in his own cartoons as a bespectacled and round-headed gnome, was an acerbic political cartoonist, a social moralist who attempted to avenge the failings of his political opponents. His most famous creation was "Supermac" (Harold Macmillan), introduced in the *Evening Standard* in 1958. Inspired by Stephen Potter's book, *Supermanship* (1958), Vicky's caricature backfired somewhat, for many people found Supermac's exploits more endearing than a source of ridicule. He believed that the point of his cartoons should be self-evident, and often included no words to explain it, though occasionally a quotation from Lewis Carroll or Shakespeare would supplement his drawing. In the brief catalogue to the National Portrait Gallery exhibition of his work (1987), he is described as "a humanitarian and a life-long socialist, though never a party member, [who] had a horror of social injustice, directing his contempt particularly at the abusers of power. He was an anxious man, with an acute political conscience, who believed that he was only as good as his latest cartoon." Depressed and suffering from insomnia, he committed suicide on 22 February 1966.
Books illustrated include (but see Davies and Ottway, 1987†): G.W.L. Day: *Outrageous Rhapsodies* (Jenkins, 1938); W. Douglas-Home: *Home Truths* (BH, 1939); G.W.L. Day: *We Are Not Amused* (Cresset Press, 1940); P. Noble: *Profiles and Personalities* (Brownlee, 1946); "Sagittarius": *Let Cowards Flinch* (Turnstile Press, 1947); G.W.L. Day: *Sigh No More Ladies* (Jenkins, 1948); "Sagittarius": *Up the Poll! The Sap's Guide to the General Election* (Turnstile Press, 1950); M. Schulman: *How To Be a Celebrity* (Reinhardt, 1950); I. Mackay: *The Real Mackay* (News Chronicle, 1953); M. Foot and M. Jones: *Guilty Men, 1957* (Gollancz, 1957); E. Hughes: *Pilgrim's Progress in Russia* (Housman's, 1959); A. Hilton: *This England* (Turnstile Press, 1960 and 1965).
Books written and illustrated include: *Drawn by Vicky* (Walding Press, 1944); *Aftermath: Cartoons by Vicky* (Alliance Press, 1946); *The Editor Regrets: Unpublished Cartoons by Vicky* (Wingate, 1947); *Stabs in the Back* (Reinhardt, 1952); *Meet the Russians* (Reinhardt, 1953); *New Statesman Profiles* (Phoenix House, 1957); *Vicky's World* (Secker, 1959); *Vicky Must Go!* (Beaverbrook Newspapers, 1960); *Twists* (Beaverbrook Newspapers, 1962); *Home and Abroad* (Beaverbrook Newspapers, 1964).
Contrib: *Daily Mail; Daily Mirror; Evening Standard; Lilliput; Men Only; New Statesman; News Chronicle; Sunday Chronicle; Time and Tide.*
Exhib: NPG (1987); University of Kent.
Collns: University of Kent.
Bibl: *Beaverbrook's England 1940-1965: An Exhibition of Cartoon Originals . . .* (Centre for the Study of Cartoons and Caricature, University of Kent, 1981); Russell Davies and Liz Ottway: *Vicky* (Secker, 1987); *Times* obit. 24 February 1966, 28 February 1966; Bateman; DNB; Feaver.

WELCH, Maurice Denton **1915-1948**
Born on 29 March 1915 of English parents in Shanghai, Welch was

educated in England, and started to study art at Goldsmiths' College in 1933. He was knocked off his bicycle in June 1935 when he was twenty and suffered a severe spinal injury, which brought him pain and illness for the rest of his short life. He died on 30 December 1948.
Despite his injuries, Welch started on a career as a writer, his first article being published in *Horizon* in 1942. He achieved considerable popularity and critical acclaim for his many short stories and the autobiographical novels. One collection of short stories, *Brave and Cruel* (1949) and two novels, *Maiden Voyage* (1943) and *In Youth Is Pleasure* (1945), were published during his lifetime. He illustrated the jackets for each book and provided pen drawings to illustrate the novels. The books published posthumously were illustrated with drawings found among his papers. He also managed to paint. In the introduction to his *Journals*, Michael De-la-Noy suggests that, but for his injuries and the brevity of his life, Welch "as an illustrator . . . might well have reached the top flight, and as an artist he progressed steadily from ineffectual student work to

Victor WEISZ ("VICKY") *Let Cowards Flinch* by "Sagittarius" (Turnstile Press, 1947)

439

paintings of outstanding originality and often startling beauty." (De-la-Noy, 1984.†)

Books illustrated include: D.L. Toye: *Contemporary Cookery* (with John Minton*, Condé Nast, 1947).

Books written and illustrated by Welch include: *Maiden Voyage* (Routledge, 1943); *In Youth Is Pleasure* (Routledge, 1945); *Brave and Cruel* (Hamilton, 1949); *A Voice Through a Cloud* (Lehmann, 1950); *A Last Sheaf* (Lehmann, 1951); *I Left My Grandfather's House* (Lion & Unicorn Press, 1958); *Dumb Instrument* (Enitharmon Press, 1976).

Contrib: *Penguin New Writing; Words.*

Bibl: Michael De-la-Noy: *The Journals of Denton Welch* (Allison & Busby, 1984); Peppin.

WELLS, Margaret fl.1932-
Wells studied at Glasgow School of Art (-1932), and at the Brook Green School in London, under Leon Underwood* (1932-36).

Books illustrated include: *Margaret Wells: A Selection of Her Wood Engravings* (Wakefield: Fleece Press, 1985).

WEST, Colin fl. 1976-
West writes and illustrates his own books, illustrates those of others, and has written at least two books illustrated by other artists. His two pages in *Tail Feathers from Mother Goose* (1988) show his typical style of illustration, including his humorous, cartoon-like characters.

Books illustrated include: P. Cleaver: *The Sparrow Book of Animal Records* (Sparrow, 1982); J. Ball: *Plays for Laughs* (Puffin, 1983); M. Cohen: *Cohen's Cornucopia* (Hardy, 1983); T. Baker: *The Boy Who Forgot To Grow Down* (Arrow, 1984); H. Castor: *Fat Puss and Friends* (Kestrel, 1984); P. Eldin: *The Wolly Jumper Joke Book* (Sparrow, 1984); J. Eldridge: *The Wobbly Jelly Joke Book* (Sparrow, 1984); *Tail Feathers from Mother Goose* (with others, Walker, 1988).

Books written and illustrated include: *Out of the Blue from Nowhere* (Dobson, 1976); *Back to Front and Back Again* (Dobson, 1980); *Winslow and His Bathtub* (Dobson, 1980); *Not To Be Taken Seriously* (Hutchinson, 1982); *Land of Utter Nonsense* (Hutchinson, 1983); *It's Funny When You Look at It* (Hutchinson, 1984); *A Step in the Wrong Direction* (Hutchinson, 1984); *Have You Seen the Crocodile?* (Walker, 1986); *Pardon? Said the Giraffe* (Walker, 1986).

WHATLEY, Julia b.1955?
Julia Whatley was born in Northamptonshire. She studied fine arts at Winchester Art School and Goldsmiths' College, London. She has illustrated book jackets and paperback covers, including the Penguin editions of Gerald Durrell's "animal" books, as well as illustrated books.

Books illustrated include: A. Wyndham and P. Gamble: *The Country Weekend* (Exeter: Webb & Bower, 1980).

WHEELER, Dorothy Muriel 1891-1966
See Houfe
Wheeler studied at Blackheath School of Art. A watercolour painter, in the 1920s she produced figure studies in the style of Kate Greenaway's later work, and during the 1940s and 1950s became one of the main illustrators of Enid Blyton's books for children.

Books illustrated include: *English Nursery Rhymes* (Black, 1916); A. Macdonald: *Through the Green Door* (Blackwell, 1923); E. Blyton: *The Little Tree House* (Newnes, 1940), *Six O'Clock Tales* (Methuen, 1942), and at least fifteen other titles.

Books written and illustrated include: *The Three Little Pigs* (Juvenile Productions, 1955).

Contrib: *Merry-Go-Round; Strand.*

Exhib: RA; SWA.

Bibl: Peppin; Waters.

WHEELHOUSE, Mary V. fl. 1895-1947
See Houfe
Born in Yorkshire, Wheelhouse studied at the Académie Delecture in Paris. According to Houfe, she probably also studied at Scarborough School of Art in 1895, and lived in Chelsea from 1900. She was a painter and illustrator of children's books,

producing some charming colour plates for the gift books of the early twentieth century, as well as some simple but effective black and white drawings. She won a *Bookman* competition for her illustrations to a friend's fairy story (*The Adventures of Merrywink* by Christina Wyte), and then had many commissions from Bell. She was a regular illustrator of Julia Ewing's books in the Queen's Treasures series from Bell. According to Peppin, Wheelhouse later moved to Cambridge where she ran a small shop.

Books illustrated include: C. Wyte: *The Adventures of Merrywinkle* (1906); M. Baldwin: *Holy House and Ridges Row* (Chambers, 1908); J.H. Ewing: *Flat Iron for a Farthing* (Bell, 1908), *Six to Sixteen* (Bell, 1908); E. Gaskell: *Cousin Phillis*] Bell, 1908); G. Sand: *Maîtres Sonneurs* (Bell, 1908);] J.C. von Schmidt: *Easter Eggs* (Bell, 1908); L.M. Alcott: *Little Women* (Bell, 1909); J.H. Ewing: *Jan of the Windmill* (Bell, 1909), *Mrs. Overtheway's Remembrances* (Bell, 1909); E. Gaskell: *Cranford* (Bell, 1909); G. Eliot: *Silas Marner* (Bell, 1910); J.H. Ewing: *We and the World* (Bell, 1910); E. Gaskell: *Sylvia's Lovers* (Bell, 1910); E.V. Lucas: *The Slowcoach* (Wells, Gardner, 1910); L.M. Alcott: *Good Wives* (Bell, 1911); C. Brontë: *Jane Eyre* (Bell, 1911); J.H. Ewing: *A Great Emergency* (Bell, 1911); E. Gaskell: *Wives and Daughters* (Herbert, 1912); F.M. Peard: *Mother Molly* (Bell, 1914); M.E. Phillips: *Tommy Tregennis* (Constable, 1914); J.H. Ewing: *Mary's Meadow* (SPCK, 1915); A. Steedman: *The Story of Florence Nightingale* (Jack, 1915); M.L. Molesworth: *Carrots* (Bell, 1920).

Bibl: Felmingham; ICB; Peppin.

WHEELWRIGHT, Rowland 1870-1955
Born on 10 September 1870 at Ipswich, Queensland, Australia, Wheelwright came to England and studied at Herkomer's School of Art at Bushey in Hertfordshire. A painter of classical and historical studies, he exhibited widely. He also illustrated a few books in both black and white and in full colour. He was elected RBA (1906); and he died on 20 May 1955.

Books illustrated include: W. Killingworth: *Matsya* (Wells Gardner, 1905); A. Dumas: *The Three Musketeers* (Harrap, 1920), *Twenty Years After* (Harrap, 1923); H. Fielding: *The History of Tom Jones* (Harrap, 1925); C. Dickens: *A Tale of Two Cities* (1926); L. Sterne: *Tristram Shandy* (1926); W. Scott: *The Talisman* (Harrap, 1929); C. Dickens: *The Old Curiosity Shop* (1930); R.D. Blackmore: *Lorna Doone* (with William Sewell, Harrap, 1931); E. Price: *The Adventures of King Arthur* (with others, 1931); M.N. Roberts: *Young Masters of Music* (Harrap, 1932).

Exhib: RA; RBA; RI; ROI; Paris Salon.

Bibl: Peppin; Waters; Who.

WHELPTON, Barbara Fanny b.1910
Born on 4 February in London, Whelpton (née Crocker) was educated at Putney High School and studied at the Slade (1927-30), and in France and Italy. She was a painter, lithographer and illustrator of architectural subjects, who exhibited quite widely. She also translated from French several books of history and travel. In 1970-71 she wrote four books of travel and description for the publisher, Johnson — *Painters' Paris* (1970), *Painters' Provence* (1970), *Painters' Florence* (1971), and *Painters' Venice* (1971).

Books illustrated include: G.S. Emmerson: *Scotland Through Her Country Dances* (Johnson, 1967).

Books written and illustrated include: *Book of Dublin* (Rockliff, 1948); *A Window on Greece* (Heinemann, 1954); *Paris Triumphant* (Burke, 1962); *London Majestic* (Burke, 1963); *Myths and Legends* (Burke, 1963); *Rome Resplendent* (Burke, 1963); *Unknown Ireland* (Johnson, 1966); *Unknown Austria* (three vols., Johnson, 1966-69).

Exhib: RA; RI; RBA.

Bibl: Waters; Who.

WHISTLER, Reginald John ("Rex") 1905-1944
Born on 24 June 1905 in Eltham, Kent, Whistler was educated at Haileybury School (1919-22), and studied at the RA Schools for one term under Charles Sims, before moving to the Slade (1922-26) and then to Rome. He became a distinguished artist in mural painting and in book illustration, two quite separate genres. Most of his murals are in private homes, such as the romantic seaside townscape which decorates the walls of Lord Anglesey's huge dining room at Plas Newydd, but one is in the public domain, the

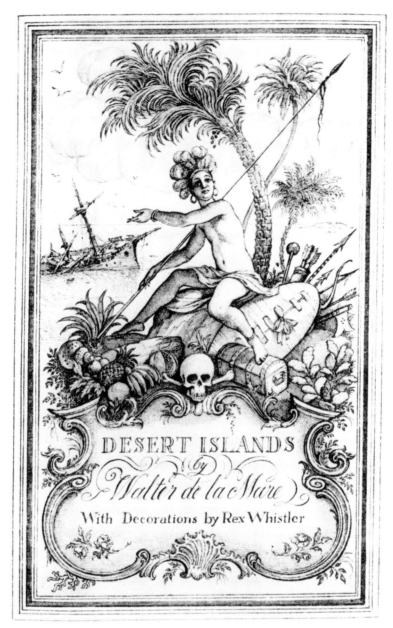

Rex WHISTLER *Desert Islands* by Walter de la Mare (Faber & Faber, 1930)

mural he painted in 1926-27 for the Restaurant at the Tate Gallery. He also designed posters (including one for London Transport which shows a scene in the Tate Restaurant, with his own mural there acting as the background!), painted portraits, and did stage designs, including sets for ballets and operas, and comic designs for C.B. Cochran's revues in the West End of London.

He illustrated many books, mostly in a style evocative of the eighteenth century, with the illustrations surrounded by ornate, baroque borders. Of these *Gulliver's Travels* (1930), published in a two-volume limited edition, is perhaps the best; in this book his illustrations at first look like etchings, but in fact they are pen drawings reproduced by photogravure, printed in the faded sepia of old engravings and then hand coloured. "This playful essay in 18th century pastiche is, like much English fine book-making of the 1920s and 1930s, aesthetically backward-looking. Whistler's drawings are matched by a text printed in a revival of John Baskerville's 18th century types." (BM exhibit, 1984.) Other important book illustrations were done for a Hans Andersen (1935), for de la Mare's *The Lord Fish* (1933), and for A.E.W. Mason's *Konigsmark*, though this latter was not published until 1952, after Whistler's death.

In addition to his illustrations, Whistler designed many book jackets, including one for *The Discovery of Poetry* by Hugh Lyon (Arnold, 1937), with its pillars and Roman arch recalling the Italian architectural folios of the eighteenth century. In a more light-hearted vein, he also produced a number for the "garden" books by

Beverley Nichols; after Whistler's death, William McLaren* took over and produced jackets with a similar "feel".

Whistler was one of the most gifted figures of the years between the wars. He was quite at home in the *haut monde* scene in London, but he was also a frequent visitor at large country houses. His friends included many of the well-known literary and artistic people of the time, such as Lord David Cecil, Lady Ottoline Morrell, Cecil Beaton, Siegfried Sassoon, and Tallulah Bankhead. He was only thirty-nine and still developing as an artist when he was killed in action on 18 July 1944 during WW2, while serving with the Welsh Guards in Normandy.

Books illustrated include (but see L. Whistler 1960†): F. Swettenham: *Arabella in Africa* (BH, 1925); *Mildred* (High House Press, 1926); *The New Forget-Me-Not* (Cobden Sanderson, 1929); L. Whistler: *Children of Hertha* (Oxford: Holywell Press, 1929); J. Swift: *Gulliver's Travels* (two vols., Cresset Press, 1930); W. de la Mare: *Desert Islands* (Faber, 1930); *The New Keepsake* (Cobden Sanderson, 1931); P. and M. Bloomfield: *The Traveller's Companion* (Bell, 1931); E. Godley: *Green Outside* (Chatto, 1931); E. James: *The Next Volume* (Janus Press, 1932); L. Whistler: *Armed October* (Cobden Sanderson, 1932); B. Nichols: *Down the Garden Path* (Cape, 1932); W. de la Mare: *The Lord Fish* (Faber, 1933); B. Nichols: *A Thatched Roof* (Cape, 1933), *A Village in a Valley* (Cape, 1934); C. Wright: *Silver Collar Boy* (Dent, 1934); H.C. Andersen: *Fairy Tales* (Cobden Sanderson, 1935); L. Whistler: *The Emperor Heart* (Heinemann, 1936); J. Agate: *Kingdoms for Horses* (Gollancz, 1936); S. Harcourt-Smith: *The Last of Uptake* (Batsford, 1942); E. Olivier: *Night Thoughts of a Country Landlady* (Batsford, 1943); A.E.W. Mason: *The Konigsmark Drawings* (Richards Press, 1952).
Contrib: *Masque; Radio Times.*
Exhib: Arts Council Memorial exhibition at V & A (1960).
Collns: Tate.
Bibl: Edith Olivier: "Rex Whistler's Book Illustrations and Decorations", *Typography* 8 (Summer 1939): 30-41; Laurence Whistler: *Rex Whistler 1905-1944: His Life and Drawings* (Art and Technics, 1948); L. Whistler and Ronald Fuller: *The Work of Rex Whistler* (Batsford, 1960); L. Whistler: *The Laughter and the Urn: The Life of Rex Whistler* (Weidenfeld, 1985); DNB; Driver; Parkin; Peppin; Tate; Waters.
Colour Plate 144

WHISTLER, Teresa **b.1927**
Born on 23 April 1927 in London, Whistler (née Furse) was educated at Lady Margaret Hall, Oxford. The most memorable part of her childhood was spent on farms in Devon and Wiltshire, and she used the memories as the basis of her book, *River Boy* (1955). In 1950 she married Laurence Whistler, poet and glass-engraver, brother of artist Rex Whistler*. Laurence Whistler's first wife had died six years earlier — she was Jill Furse, Teresa's sister.
Books written and illustrated include: *River Boy* (Hart-Davis, 1955).
Bibl: Who.

WHITE, Ethelbert **1891-1972**
Born on 26 February 1891 in Isleworth, Middlesex, White was educated at St. George's College, Weybridge, and studied art at St. John's Wood School of Art (1911-12). He married Elizabeth Crofton-Dodwell when he was nineteen, and with her travelled to Belgium and Italy. These travels continued through their lives, and they spent much time touring England in a caravan, and collecting folk songs in France and Spain.

He worked as a landscape painter, poster artist, wood engraver and illustrator. He exhibited widely, his first one-artist show being held at the Carfax Gallery in 1921, and his last fifty years later at the Leicester Galleries in 1971. In 1917-18, he was introduced to Cyril Beaumont by Sir Osbert Sitwell as a possible decorator of the books Beaumont was publishing, and White was commissioned to make drawings for Herbert Read's *Eclogues*, despite the fact that the writer wanted Wyndham Lewis*, and Beaumont first suggested both John Nash* and C.R.W. Nevinson*. He worked for the Beaumont Press as a designer, engraver and book decorator for several years. He was a self-taught wood engraver, and it was this

Ethelbert WHITE *The Story of My Heart* by Richard Jefferies (Gerald Duckworth, 1922)

medium which he used for most of his book illustrations. He was a pioneer in the revival in the 1920s of the use of wood engravings for book illustrations. *The Story of My Heart*, published by Duckworth in 1923, was one of the earliest books from a commercial press to use modern, white-line wood engravings, though the twelve designs appear like bold woodcuts. Even Hodnett finds these "memorable in twentieth-century illustration" and "a 1923 manifesto for autographic wood-engraving". White was appointed art editor of the short-lived Penguin Illustrated Classics series in 1938, each of the books being illustrated with wood engravings. The poor quality of the paper used was largely responsible for the failure of the series.

White was elected LG (1919); NEAC (1921); SWE (1921) but he resigned in 1925 to join the newly formed but short-lived English Wood Engraving Society — he was re-elected SWE in 1935; ARWS (1933); RWS (1939). He died in March 1972.

Books illustrated include: C.W. Beaumont: *Impressions of the Russian Ballet* (v. 4, 6, 7; Beaumont Press, 1919); H. Read: *Eclogues* (Beaumont Press, 1919); W.W. Gibson: *Home* (Beaumont Press, 1920); R.M.B. Nichols: *The Smile of the Sphinx* (Beaumont Press, 1920); O. Wilde: *After Reading: Letters of Oscar Wilde to Robert Ross* (Beaumont Press, 1921); C. Goldoni: *The Good-Humoured Ladies* (Beaumont Press, 1922); R. Jeffries: *The Story of My Heart* (Duckworth, 1923); E. Spenser: *The Wedding Songs of Edmund Spenser* (GCP, 1923); D. Thoreau: *Walden* (Penguin Illustrated Classics, 1938); *Recording Britain* (with others, four vols., OUP, 1946-9).

Contrib: *Apple*.

Exhib: LG; NEAC; RWS; SWE; Carfax Gallery (1921); Leicester Galls. (1971).

Bibl: Thomas Balston: "The Wood-Engravings of Ethelbert White", *Image* 3 (Winter 1949-50): 49-60; Cyril W. Beaumont: *The First Score* (Beaumont Press, 1927); Hilary Chapman: *The Wood Engravings of Ethelbert White* (Fleece Press, 1987); Eva White: *An Introduction to the Beaumont Press* (V & A, 1986); Deane; Garrett 1 & 2; Hodnett; Parkin; Peppin; Tate; Waters.

WHITE, Gwendolen Beatrice b.1903
Born in Exeter, White studied at Bournemouth School of Art and at the RCA. A landscape painter and muralist, she designed and illustrated books, including a King Penguin, *A Book of Toys* (1946), for which she designed the cover and made coloured illustrations, and even drew the text in block capitals. She was particularly interested in dolls and other toys, and wrote and illustrated several books on the subject.

Books illustrated include: R. Power: *Ten Minute Tales* (1943); E. Blyton: *Tales of Green Hedges* (1946).

Books written and illustrated include: *A Picture Book of Ancient and Modern Dolls* (Black, 1928); *The Toys' Adventures at the Zoo* (1929); *Ladybird, Ladybird* (1938); *A Book of Toys* (King Penguin 26; Penguin, 1946); *Eight Little Frogs* (1947); *A Book of Dolls* (1956); *Dolls of the World* (1962); *Antique Toys and Their Background* (1971).

Exhib: RA.

Bibl: Peppin; Waters.

WHITELAW, George 1887-1957
See Houfe
Whitelaw was born in Kirkintilloch, Dumbartonshire, and educated at Lenzic Academy and Glasgow High School. He studied under Maurice Greiffenhagen (see Houfe) at the Glasgow School of Art and, while still a student, at the age of seventeen became a staff artist on the *Glasgow Evening News*, drawing cartoons, caricatures and sketches illustrating news items. After service in the Tanks Corps during WW1 he moved to London, where his work was accepted by *London Opinion* and he became cartoonist for *Passing Show*. After a variety of work, including humorous and theatrical sketches for *Punch*, he succeeded Will Dyson* as cartoonist on the *Daily Herald* in 1938.

Contrib: *Bystander; Christmas Pie; Daily Herald; Glasgow Evening News; London Opinion; Passing Show; Punch*.

Exhib: Glasgow; Liverpool.

Bibl: Bradshaw; Feaver.

WHITTAM, Geoffrey b.1916
Born on 16 December 1916 near Southampton, Whittam was educated at Taunton School, Southampton, and studied at Southampton School of Art. He served in the Royal Navy for six years during WW2 and, on his release, worked in advertising in London and studied at the Central School of Arts and Crafts (1946-49). His first commission was for illustrations to the *Radio Times* which led to his becoming a free-lance artist. He is an illustrator of children's books, in the traditional style, using mostly ink drawings, though he does use gouache for full-colour work. He has designed book jackets, contributed to magazines (including comic strips), and written and illustrated a number of small educational books on different peoples and countries.

Books illustrated include (but see Peppin): R. Church: *The Cave* (1950); M. Edwards: *The White Riders* (Collins, 1950), *Black Hunting Whip* (Collins, 1950), *Cargo of Horses* (Collins, 1951); L.E. Cheesman: *Sealskins for Silk* (Methuen, 1952); M. Edwards: *Hidden in a Dream* (Collins, 1952), *Storm Ahead* (Collins, 1953); A. Catherall: *Ten Fathoms Deep* (Dent, 1954); C.S. Forester: *The Hornblower Stories* (Cadet Edition; Joseph, 1954); K. Fidler: *The Droving Lad* (Lutterworth, 1955); M.M. Reid: *All Because of Danks* (1955); E. Brontë: *Wuthering Heights* (1956); A. Catherall: *Forgotten Submarine* (Dent, 1956), *Land Under the White Rose* (Dent, 1956); F. Knight: *Family on the Tide* (Macmillan, 1956); G. Trease: *Word to Caesar* (1956); A. Catherall: *Java Sea Duel* (1957); M. Edwards: Operation Seabird (Collins, 1957), *The Cownappers* (Collins, 1958); K. Fidler: *Escape in Darkness* (Lutterworth, 1961); M.M. Reid: *Storm on Kildoney* (1961); A. Catherall: *Island of Forgotten Men* (Dent, 1968), *The Unwilling Smuggler* (1971); A. Adrian: *He Wore a Red Jersey* (Stockwell, 1975); J.M. Berrisford: *Skipper and Son* (Hodder, 1975), *Jackie and the Pony Thieves* (Hodder, 1978), *Jackie and the Pony Rivals* (Hodder, 1981), *Change Ponies, Jackie!* (Hodder, 1983).

Books written and illustrated include: *The Whale Hunters* (Bell, 1954); *Fur Hunting and Fur Farming* (OUP, 1957); *Lumbering in Canada* (OUP, 1957); *Farming on the Canadian Prairies* (OUP, 1959); *The Zambezi* (OUP, 1961); *The Rhine* (OUP, 1962); *Canals and Waterways* (1968).

Contrib: *Mandy; Radio Times; Victor*.

Bibl: ICB2; Peppin.

WHITTLESEA, Michael b.1938
Born on 6 June 1938 in London, Whittlesea studied at Harrow School of Art. He is a watercolour painter and illustrator. He was elected RWS (1985).

Exhib: NEAC; RWS; World of Newspapers Exhibition (1982).

Bibl: Who.

WHYDALE, Ernest Herbert 1886-1952
Born on 12 April 1886 in Elland, Yorkshire, Whydale studied at Westminster School of Art and the Central School of Arts and Crafts. A landscape painter, etcher and illustrator, he was elected RE in 1920.

Books illustrated include: E. Farjeon: *The Old Nun's Stocking Basket* (ULP, 1931); M. Gervaise: *A Pony of Your Own* (Lutterworth, 1950), *Ponies and Holidays* (Lutterworth, 1950), *Ponies in Clover* (Lutterworth, 1952).

Exhib: RA; RE; SGA.

Bibl: Mackenzie; Waters.

WIGFULL, W. Edward fl. 1890-1939
An artist who contributed to many magazines, Wigfull was one of Percy F. Westerman's chief illustrators. His work is reproduced mostly in half-tone, and is quite undistinguished.

Books illustrated include: P.F. Westerman: *The Sea-Girt Fortress* (Blackie, 1914), *The Thick of the Fray at Zeebruge* (Blackie, 1919), and nine other titles to *Standish Loses His Man* (Blackie, 1939); J.F.C. Westerman: *Peter Garner's Luck* (Ward Lock, 1934).

Contrib: *English Illustrated Magazine; Girl's Realm; Idler; Oxford Annual; Quartier Latin*.

Bibl: Peppin.

WIGGLESWORTH, Katherine **b.1901**
Born in India, where her father was Director of the Pasteur Institute, Wigglesworth (née Semple) studied at the Slade (1921-23). She worked briefly for an agency before designing materials for Liberty's in London and making drawings for their advertisements. With small black and white or coloured drawings of young animals, she illustrated books by Alison Uttley for some twenty-five years, including the "Little Brown Mouse" and the "Little Red Fox" series, published by Heinemann, and taking over the "Little Grey Rabbit" series from Margaret Tempest*. Uttley's stories were well served by her illustrators, and have proved to have a long-lasting appeal — some of the "Grey Rabbit" books were reprinted in 1980 with new illustrations by Faith Jaques*. Wigglesworth was a friend of Uttley, and they had a much better relationship than Tempest did with Uttley, who generally found her illustrators unsatisfactory. (*Who* provides quite different and apparently inaccurate information about Wigglesworth.)
Books illustrated include: A. Uttley: *The Little Brown Mouse series* thirteen vols., Heinemann, 1950-57), *The Little Red Fox series* (four vols., Heinemann, 1956-62), *The Little Grey Rabbit series* (1970-75); E. Smith: *Emily* (1959).
Bibl: Denis Judd: *Alison Uttley: The Life of a Country Child (1884-1976)* (Joseph, 1986); Peppin; Whalley; Who.

WIJNGAARD, Juan **fl. 1980s-**
Wijngaard works mostly in colour, though he uses a style to suit each story. The illustrations for *Janni's Stork* (1982) set the scene in early Holland very realistically, while those for *The Nativity* (1989) look like "old master" paintings. He won the Mother Goose Award for *Green Finger House*.
Books illustrated include: S. Teale: *Giants* (with others, Pan, 1980); R. Harris: *Green Finger House* (Eel Pie, 1981); S. Hastings: *Sir Gawain and the Green Knight* (Walker, 1981); R. Harris: *Janni's Stork* (Blackie, 1982); D. Lee: *Jelly Belly* (Toronto: Macmillan, 1983); S. Hastings: *Sir Gawain and the Loathly Lady* (Walker, 1985); *Tail Feathers from Mother Goose* (with others, Walker, 1988); *The Nativity* (Walker, 1989).
Books written and illustrated include: *In Summer When I Go To Bed* (Benn, 1981).

WILBRAHAM, Diana **b.1912**
Wilbraham studied for a short time at the Central School of Arts and Crafts under Bernard Adeney. Her early commissions included line illustrations and the cover paper for *Canteens at Work* (1941), printed by OUP for the Empire Tea Bureau. As a designer for the Bureau, she met Herbert Simon of the Curwen Press (which printed some of its publications), and subsequently produced several pattern papers for the Press, based on woodcut designs.
Books illustrated include: C.G. Gardiner: *Canteens at Work* (ETB, 1941).
Bibl: David McKitterick: *A New Specimen Book of Curwen Pattern Papers* (Whittington Press, 1987).

WILD, Jocelyn **b.1941**
Born in Mysore, India, Wild (née Van Ingen) studied Spanish at King's College, London. Using pen and ink and colour, she is an illustrator of children's books written by her husband.
Books illustrated include: R. Wild: *The Tiger Tree* (Heinemann, 1976), *The Bears' ABC Book* (Heinemann, 1977), *The Bears' Counting Book* (Heinemann, 1978), *Spot's Dogs and the Alley Cats* (Heinemann, 1979), *Spot's Dogs and the Kidnappers* (Heinemann, 1981); *Lady Agrippa's Unshuttable Caboodlebox* (Pavilion, 1984).
Contrib: *Cricket; The Egg; Pomme d'Api.*
Bibl: Peppin.

WILDE, Gerald William Clifford **1905-1986**
Born on 2 October 1905 in Clapham, Wilde was educated at Ion House School and Streatham Grammar School. He studied at Chelsea School of Art (1926-35 under Graham Sutherland* and Henry Moore* with whom he became a life-long friend; his fellow students included Brian Robb*). An abstract expressionist painter whom John Berger described as "a man, far removed from his neighbours by his unhappy imagination and violent compulsions, desperately striving to break down the barrier to describe and tell the reasons, as he sees them, for his being." (Berger, 1955.†) He exhibited widely, his first one-artist show being held at the Hanover Gallery in 1948. He produced a number of book jackets, including a lithograph for Elizabeth Smart's *By Grand Central Station I Sat Down and Wept* (Editions Poetry, 1945); and three lithographs were included in *Poetry London 10* (1944), inspired by T.S. Eliot's "Rhapsody on a Windy Night". He died on 2 October 1986.
Contrib: *Ark; International Textiles; Poetry London.*
Exhib: Hanover Gallery (1948); ICA (1955); Arts Council (1977); October Gallery (1979; 1981; 1984; 1988).
Collns: Tate.
Bibl: John Berger: "Review", *New Statesman* (24 September 1955); Chili Hawes: *Gerald Wilde 1905-1986* (Synergetic Press, 1988); David Mellor: *A Paradise Lost: The Neo-Romantic Imagination in Britain 1935-55* (Barbican Art Gallery; Lund Humphries, 1987); Tate; Waters.

WILDSMITH, Brian Lawrence **b.1930**
Born on 22 January 1930 in Penistone, Yorkshire, Wildsmith spent his childhood in Yorkshire. Having decided to be an artist when he was sixteen, he studied at Barnsley School of Art (1946-49) and at the Slade (1949-52). After teaching mathematics while doing his National Service (1952-54), he taught art full-time at Selhurst Grammar School (1955-57). He became a free-lance artist in 1957, concentrating on illustrating books for children and painting large-scale abstracts. His potential was recognized by Mabel George, the Children's Book Editor for OUP, and it was from her that he got his first commissions for both black and white, and full colour illustrations, which played a large part in the development of his career. His work as a line draughtsman was done between the years 1957 and 1964; but he is best known for the bright, full-coloured paintings in gouache which he does for his own picture books, often using double-page spreads.
Wildsmith was one of a small number of artists who established new conventions for the picture book, artists who include Victor Ambrus*, John Burningham* and Charles Keeping*. Tessa Chester writes that two artists (Keeping and Wildsmith) emerged at the end of the decade of the 1950s "who heralded the changing face of English children's book illustration in the '60s. . . The revolution in children's book illustration came about in the field of the picture book. . . This explosion . . . centred around the publication in 1962 of Brian Wildsmith's *ABC*, which glowed in colours brighter than ever seen before." (Whalley, 1988.) Wildsmith is quoted as saying that he tries "to reconcile the beauties of form and colour in pure painting with the problems of illustrating a given text. By attracting the child to the stories in picture form, consciously or unconsciously (it doesn't matter which), the shapes and colours seep into the child's artistic digestive system, and he is aroused and stimulated by them." (Wildsmith, 1965.†) He won the Kate Greenaway Medal in 1963 for his *ABC*, and was on the commended list several times, including in 1967 for his *Birds* and in 1971 for *The Owl and the Woodpecker*.
Books illustrated include (but see Martin, 1989†): K. Rudge: *The Baron's Sword High Sang the Sword* (OUP, 1959); R. Tomalin: *The Daffodil Bird* (Faber, 1959); E. Blishen: *The Oxford Book of Poetry for Children* (OUP, 1960); N. Chauncy: *Tangara* (OUP, 1960); R.L. Green: *The Saga of Agard* (BH, 1960); F. Grice: *The Bonnie Pit Laddie* (OUP, 1960); P. Berna: *The Knights of King Midas* (BH, 1961); M. Polland: *A Town Across the Water* (Constable, 1961); *Tales from the Arabian Nights* (OUP, 1961); R.J. MacGregor: *The Warrior's Treasure* (Dolphin Books, 1962); G. Marton: *The Boy and His Friend the Blizzard* (Cape, 1962); I. Serraillier: *Happily Ever After* (OUP, 1963); G. Trease: *Follow My Black Plume* (Macmillan, 1963); K. Crossley-Holland: *Havelock the Dane* (Macmillan, 1964); J. de la Fontaine: *The North Wind and the Sun* (OUP, 1964); G. Trease: *A Thousand for Sicily* (Macmillan, 1964); J. de la Fontaine: *The Rich Man and the Shoemaker* (OUP, 1965); R.L. Stevenson: *A Child's Garden of Verses* (OUP, 1966); P. Turner: *The Bible Story* (OUP, 1968); *The Oxford Illustrated Old Testament* (five vols., with others, OUP, 1968-9); J. de la Fontaine: *The Miller, the Boy and the Donkey* (OUP, 1969); M. Maeterlinck: *The Blue Bird* (OUP, 1976).
Books written and illustrated include (but see Martin, 1989†): (all published by OUP): *ABC* (1962); *Mother Goose* (1964); *123*

Garth WILLIAMS *The Turret* by Margery Sharp (Collins, 1964)

(1965); *Birds* (1967); *Wild Animals* (1967); *Fishes* (1968); *Circus* (1970); *Puzzles* (1970); *The Owl and the Woodpecker* (1972); *The Twelve Days of Christmas* (1972); *Python's Party* (1974); *What the Moon Saw* (1978); *Hunter and His Dog* (1979); *Animal Games* (1980); *Seasons* (1980); *Professor Noah's Spaceship* (1980); *Bears' Adventure* (1981); *The Trunk* (1982); *The Island* (1983); *Daisy* (1984); *My Dream* (1986); *If I Were You* (1987); *Carousel* (1988).
Bibl: Douglas Martin: *The Telling Line: Essays on Fifteen Contemporary Book Illustrators* (Julia MacRae Books, 1989); Brian Wildsmith: "Antic Disposition", *Library Journal* (15 November 1965): 5035-38; Carpenter; ICB3; ICB4; Jacques; Peppin; Ryder; Whalley.
Colour Plate 28

WILES, Frank E. **fl. 1899-1934**
See Houfe
He also illustrated adventure stories for boys and school stories for girls.

Books illustrated include: A. Brazil: *A Fourth Form Friendship* (Blackie, 1912) and three other titles; P.F. Westerman: *The Quest of the "Golden Hope"* (Blackie, 1912).

WILKINSON, Barry Thomas **b.1923**
Born on 29 April 1923 in Dewsbury, Yorkshire, Wilkinson studied at Dewsbury School of Art. He served in the RAF during WW2 and on his release returned to the RCA (1947-49), where he earned a diploma in design.. He worked in a stained glass studio, taught graphic design at Wimbledon School of Art for a few years, did animation designs for a film studio, and in 1961 became a free-lance artist. He works as a book illustrator, and does illustrations for television and work for commercial art studios. He has written and illustrated some picture books for young children, and succeeded Peggy Fortnum* as the illustrator of Michael Bond's "Paddington" stories. He uses mostly watercolour for his book illustrations.
Books illustrated include: W. MacKellar: *Davie's Wee Dog* (1965); J. Jacobs: *Lazy Jack* (BH, 1968); *The Story of Jonah* (BH,

1968); N. Lewis: *The Story of Aladdin* (BH, 1970); D. Mackay: *Sally Go Round the Sun* (1970); N. Mitchison: *Sun and Moon* (Nelson, 1970); W. Scott: *Kenilworth* (1970); C. Dickens: *A Tale of Two Cities* (1973); R.L. Stevenson: *Kidnapped* (1973); M. Cockett: *As Big As the Ark* (1974); U.M. Williams: *The Line* (1974); M. Darke: *What Can I Do?* (1975); F. Sen: *My Family* (1975); M. Bond: *Paddington at the Station* (1976) and at least four other titles in series; S. Haigh: *Watch for the Champion* (1980); R. Silcock: *Albert John Out Hunting* (1980); S. Marshall: *Seafarer's Quest to Colchis* (1981); R. Silcock: *Albert John in Disgrace* (Kestrel, 1981).
Books written and illustrated include: *The Diverting Adventures of Tom Thumb* (BH, 1967); *Puss in Boots* (1968); *What Can You Do with a Dithery-Doo?* (1971); *Jonathan Just* (1971).
Contrib: *Honey; New Society; Punch; Radio Times; TV Times.*
Bibl: ICB4; Peppin.

WILKINSON, Gilbert **fl.1912-1940**
Born in Liverpool, Wilkinson studied at Liverpool Art School, and after the family moved to London, at Bolt Court and the Camberwell School of Art, under A.S. Hartrick (see Houfe). He served a seven year apprenticeship to a firm of colour printers, and began to draw regularly for the *London Opinion* before serving in the army during WW1. After demobilization he drew the coloured covers for *Passing Show* for twenty years, and began contributing to a number of US journals. He turned down an offer to become a staff artist on *Life* and at the beginning of WW2 became cartoonist for the *Daily Herald*.
Contrib: *Christmas Pie; Cosmopolitan; Daily Herald; Good Housekeeping; Judge; Life; London Opinion; Passing Show; Strand.*
Bibl: Bradshaw.

WILKINSON, Norman L. **1878-1971**
See Houfe
There is some confusion between the works of this artist and of Norman Wilkinson of Four Oaks*.The British Library Catalogue designates the former as a "marine artist" and the latter as "designer and artist". Peppin points out the confusion in Houfe but appears to make matters worse by allocating some wrong titles to each artist.
Books illustrated include: H.L. Swinburne: *The Royal Navy* (Black, 1907); J. Baikie: *Peeps at the Royal Navy* (Black, 1913); Sir Hl. Newbolt: *The Book of the Blue Sea* (Longmans, 1914), *Tales of the Great War* (Longmans, 1916), *Submarine and Anti-Submarine* (Longmans, 1918).
Published: *Water Colour Sketching Out-of-Doors* (Seeley Service, 1953); *A Brush with Life* (Seeley Service, 1969).
Bibl: Frances Spalding: *20th Century Painters and Sculptors* (Antique Collectors' Club, 1990); Peppin; Waters.

WILKINSON of FOUR OAKS, Norman **1882-1934**
Wilkinson studied at Birmingham School of Art and in Paris, and became a painter and stage designer. As a book illustrator he took the suffix "of Four Oaks" to distinguish himself from the marine artist, Norman L. Wilkinson. He lived in Chiswick, and died on 14 February 1934.
Books illustrated include: W. Shakespeare: *Love's Labour Lost* (Chatto, 1908); R.L.Stevenson: *Virginibus Puerisque* (Chatto, 1910); G. de Lorris: *Romaunt of the Rose* (with Keith Henderson*, 1911); A.B. Austin: *An Angler's Anthology* (Country Life, 1913); J.W. Hills: *A Summer on the Test* (Allan, 1928); P.R. Chalmers: *A Fisherman's Angles* (Country Life, 1931).
Bibl: Peppin; Waters.

WILLIAMS, Garth Montgomery **b.1912**
Born on 16 April 1912 in New York, Williams was raised in the US and Canada, and taken to England when he was ten to go to school. He studied art at Westminster School of Art (1929-31) and the RCA (1931-35). He then painted murals and won the British Prix de Rome for sculpture in 1936, and taught at Luton School of Art (1935-36). He travelled in Europe for two years (1936-38), and on his return to England was appointed art editor of a proposed magazine for women, and made a number of portrait busts. During WW2 he first worked in civil defence in England, but returned to the US in 1941 to work in a factory on war work. In the 1940s he

began working for the *New Yorker*, and started illustrating books for children. He moved to Mexico in 1966, where he lived until 1976, doing little illustrative work. He travelled in Europe and the US before returning to live in Mexico. Many of his books were first published in the US.
Books illustrated include: E.B. White: *Stuart Little* (1945); Brown: *Wait Till the Moon Is Full* (1948); Williams: *The Adventures of Benjamin Pink* (1951), *The Rabbit's Wedding*; E.B. White: *Charlotte's Web* (1952); Lindquist: *Golden Name Day* (1955); Brown: *Three Little Animals* (1956); M. Sharp: *The Rescuers* (Collins, 1959), *Miss Bianca* (Collins); R. Hoban: *Bedtime for Frances* (Faber, 1963); M. Sharp: *The Turret* (Collins, 1964), *Miss Bianca in the Salt Mines* (Heinemann, 1966).
Bibl: ICB; ICB2; ICB3; ICB4.
See illustration on page 445

WILLIAMS, Graham Richard **b.1940**
Born on 21 February 1940 in Bromley, Kent, Williams was educated at Beckenham Grammar School and studied at Becken-

Graham WILLIAMS "Abstract 3" from *Comfort Me with Apples* (Florin Press, 1984)

ham College of Art. He worked in commercial art studios and then for advertising agencies, before establishing his own Florin Press to produce finely printed and illustrated books, including *Monica Poole: Wood Engraver* (1984), to which Williams contributed an introduction and a note on printing the engravings (this was expanded for an article in *Matrix 5*, 1985). His own engravings illustrate many of the Florin Press books; his work is now almost exclusively abstract. He is Director of the Folio Society, the Folio Press, and Folio Fine Art. He has exhibited in many group shows, including the Royal Academy Summer shows and the annual exhibitions of the Society of Wood Engravers.
Books illustrated include: *Character of John Bull* (Florin Press, 1979); *Seein' Things* (Florin Press, 1979); *Tarragon Magic* (Florin Press, 1979); *A Valediction Forbidding Mourning* (Florin Press,

1981); *Kentish Kitchen* (with Monica Poole* and George Mackley*, Mental Health Foundation, Kent County Committee, 1981); *Pudding's Lion* (Florin Press, 1983); *Comfort Me with Apples* (Florin Press, 1984).
Contrib: *Folio Magazine*.
Exhib: Alex Gerard Fine Art (one-artist show, 1985); RA; SWE.
Bibl: IFA.

WILLIAMS, Hubert John b.1905
Born in May 1905 in Beckenham, Kent, Williams was educated at Beckenham County High School, and studied at the RA Schools, St. Martin's School of Art, and the Central School of Arts and Crafts. A painter and etcher, he exhibited widely and illustrated a few books.
Books illustrated include: *The President's Hat; Underwater Naturalist; Britain Under the Romans*.
Exhib: NEAC; RA; RI; ROA; RP; RSA; SGA; one-artist shows at Old Silk Mill, Blockley, Gloucester.
Collns: IWM; Museum of London; Eastbourne; Southampton.
Bibl: Waters; Who.

WILLIAMS, Jenny b.1939
Born on 22 March 1939 in London, Williams studied art at Wimbledon School of Art and trained to be a teacher at the University of London Institute of Education. She married a graphic designer and they became free-lance commercial artists, doing advertising work, book jackets and fashion drawings. She writes and illustrates her own children's books, as well as illustrating many by other writers, using pen and ink with watercolour washes. For the first book she illustrated, *The Silver Wood* (1966), she alternated pages of black and white with pages of colour.
Books illustrated include: D. Kirby: *The Silver Wood* (Constable, 1966); M. Mahy: *A Lion in the Meadow* (Dent, 1969), *The Boy with Two Shadows* (Dent, 1971); M. Patten: *The Play and Cook Book* (Collins, 1973); M. Mahy: *The Witch in the Cherry Tree* (Dent, 1974); H. Young: *Wide Awake Jake* (1974); D. Edwards: *A Wet Monday* (Methuen, 1975), *The Read-Me-Another Story Book* (Methuen, 1976); D. Grant: *Favourite Fairy Tales* (Collins, 1976); M. and C. Shapp: *Let's Find Out About Babies* (Watts, 1977); S. Parsons: *My First Reading and Writing Book* (Longman, 1979).
Books written and illustrated include: *On Holiday* (1975); *First Fairy Story Book* (and three others; Collins, 1977-9); *Alphabet Adventures* (Collins, 1978); *The Poor Man's Kingdom; The Snake Prince* (and three other titles in series, Collins, 1980).
Bibl: ICB3; Peppin.

WILLIAMS, Kit fl. 1979-
Williams is a self-taught painter, who began to paint while serving in the Royal Navy. One of his paintings was chosen to be exhibited in the John Moores Exhibition in 1972, and he had one-artist shows at the Portal Gallery in 1973, 1975, 1977 and 1979. In 1979 he published his first book, *Masquerade*, a picture book with clues to a puzzle which readers were invited to solve embedded in the highly-worked paintings. It was an immense popular success, and was followed by other similar books including *The Bee on the Comb*, which showed meticulously painted illustrations within decorative marquetry frames. Alistair Fowler in the *Times Literary Supplement* declared the book to be "one of the most attractive puzzles ever devised". Williams produces a great variety of art objects, including paintings in wooden marquetry frames, moveable and highly-decorated globes, and orrerys.
Books written and illustrated by Williams include: *Masquerade* (Cape, 1979); *Quest for the Golden Hare* (Cape, 1983); *The Bee on the Comb* (Cape, 1985); *Out of One Eye* (Cape, 1986).
Bibl: Williams: *Out of One Eye* (Cape, 1986).

WILLIAMS, Morris Meredith b.1881
See Houfe
Books illustrated include: E.W. Grierson: *The Scottish Fairy Book* (Fisher Unwin, 1910); A. MacDonnell: *The Italian Fairy Book* (Unwin, 1911); W. Platt: *Stories of the Scottish Border* (1911); E.M. Wilmot-Buxton: *The Story of the Crusades* (1911); *The Boy's Froissart* (1912); E. Hull: *The Northmen in Britain* (1913); R.L. Mackie: *The Story of King Robert the Bruce* (1913); T.B. Franklin:

Tactics and the Landscape (1914); E.M. Wilmot- Buxton: *Anselm* (1915), *A Book of English Martyrs* (1915); E.M. Tappan: *Heroes of the Middle Ages* (Harrap, 1918).
Contrib: *Blackie's Children's Annual; Punch*.

WILLIAMS, Richard James 1876-1964
See Houfe
Born on 16 March 1876 in Hereford, Williams studied art in Hereford, Cardiff, Birmingham and London. A painter and book illustrator of numerous children's books, he was Headmaster of Worcester School of Arts and Crafts. He was elected ARCamA (1919); RCamA (1936).
Exhib: RCamA; RI.
Bibl: Waters.

WILLIAMS, Ursula Moray b.1911
Born on 19 April 1911 in Petersfield, Hampshire, Williams was educated privately at home, before attending finishing school in France (1927-28). She studied at Winchester School of Art (1928-29); and in 1931, started writing and illustrating books for children. Since then, she has produced more than seventy books, illustrating almost half herself, and co-illustrating at least two with her twin

Althea WILLOUGHBY *Review of Revues* edited by C.B. Cochrane (Jonathan Cape, 1930)

sister, Barbara Moray Williams. She married Peter John in 1935 — he died in 1974.

Books written and illustrated include (but see CA): *Jean-Pierre* (Black, 1931); *For Brownies: Stories and Games* (Harrap, 1932); *Grandfather* (Allen & Unwin, 1933); *Autumn Sweepers* (Black, 1933); *More for Brownies* (Harrap, 1934); *Kelpie, the Gipsies' Pony* (with B.M. Williams, Harrap, 1934); *Anders and Marta* (Harrap, 1935); *Sandy-on-the-Shore* (Harrap, 1936); *The Twins and Their Ponies* (Harrap, 1936); *Elaine of La Signe* (with B.M. Williams, Harrap, 1937); *Castle for John Peter* (Harrap, 1941); *Gobbolino, the Witch's Cat* (Harrap, 1942); *The Three Toymakers* (Harrap, 1946); *The Binklebys on the Farm* (Harrap, 1953); *Grumpa* (Brockhampton, 1955); *The Golden Horse with a Silver Tail* (Hamilton, 1957); *The Moonball* (Hamilton, 1958); *O For a Mouseless House* (Chatto, 1964).
Bibl: CA; Peppin.

WILLIAMSON, Irene G. **fl. 1932-1965**
Known mostly for her pen and ink illustrations to Gwynedd Rae's "Mary Plain" stories about a bear which Peppin characterizes as the forerunner of Michael Bond's "Paddington Bear".
Books illustrated include: B.G. Williamson: *The Dragon Farm* (1932), *The Polar Piggy* (1932); G. Rae: *Mary Plain in Town* (1935) and twelve other titles in series.
Books written and illustrated include: *The Adventures of Griselda* (1938).
Bibl: Peppin.

WILLOUGHBY, Althea **fl. 1920s-1930s**
Willoughby was a wood engraver and a book illustrator and decorator. She worked for the Curwen Press, producing vignettes and other decorative pieces, and designing at least one patterned paper (which was used on the covers of *The Woodcut* no. 3. She illustrated a few books, including several of the "Ariel Poems" for Faber (printed by the Curwen Press), and produced some prints. Some of her engraved illustrations lack contrast between black and white because of her use of cross-hatching.
Books illustrated include: J. Stephens: *The Outcast* (Ariel Poem #22; Faber, 1929); *The Glades of Glenbella* (Ingpen & Grant, nd); C.B. Cochrane: *Review of Revues* (with others, Cape, 1930); D.H. Lawrence: *The Triumph of the Machine* (Ariel Poem #28; Faber, 1930); C. Morley: *Rudolph and Amina* (1931); H. Newbolt: *A Child Is Born* (1931).
Contrib: *Woodcut* 4.
Exhib: SWE.
Bibl: David McKitterick: *A New Specimen Book of Curwen Pattern Papers* (Whittington Press, 1987); *The New Woodcut* (Studio, 1930); Peppin.
See illustration on page 447

WILLOUGHBY, Véra **1870-1939**
See Houfe
Born in Hungary, Willoughby studied at the Slade. A watercolour painter, costume and poster designer, in the 1920s and 1930s she illustrated and decorated a number of books, for which she received immediate recognition. Houfe writes that "her work is inspired by 18th century decoration, transformed by incipient art deco into pretty but stiff fantasies. Some of her pencil work . . . is pleasantly cubist in feeling." Period illustration, beneath the hands of a mediocre artist, can be boring or silly. Willoughby "is able to suggest a complete social background with the aid of a few carefully chosen objects skilfully placed to obtain their maximum effect. Her figures wear the clothes of their year and country, but they live beneath them and are not merely lay-figures exhibiting scraps of information culled from well-known works of reference." (Laver, 1929.†)
Books illustrated include: *Memoirs of a Lady of Quality* (Davies, 1925); G. Farquhar: *The Recruiting Officer* (1926); *Horace: Carminum Libri IV* (Davies, 1926); L. Sterne: *A Sentimental Journey* (Davies, 1927); *Four Gospels* (1927); *Sappho Revocata* (1928); J. Austen: *Pride and Prejudice* (1929); Catullus: *The Poems* (Piazza Press, 1929); J.M. Edmonds: *Some Greek Poems* (1929); L. Frank: *Carl and Anna and Breath* (1931); E.E. Fisk: *Lovely Laughter* (Cassell, 1932); W. Shakespeare: *Henry V* (NY: Limited

Véra WILLOUGHBY *Catulli Carmina* (Piazza Press, 1929)

Editions Club, 1939); B. Disraeli: *Popanilla, and Other Tales* (nd).
Books written and illustrated include: *A Vision of Greece* (1925).
Contrib: *Bystander*.
Exhib: RI; RP; Liverpool.
Collns: V & A.
Bibl: James Laver: *Véra Willoughby: An Appreciation* (J. & E. Bumpus, 1929); Peppin.

WILLSON, Richard David **b.1939**
Educated at Epsom College, Willson studied architecture at Kingston College of Art. However he was disturbed by high-rise projects, and started to draw cartoons for the *Ecologist* attacking them. He produced book illustrations and portraits, and did caricatures for *Punch* and the *Observer*. He maintains a considerable interest in the environment and the Third World, working on United Nations and Oxfam projects.
Contrib: *Ecologist*; *Observer*; *Punch*.
Bibl: Feaver.

WILSON, Maurice **b.1914**
Born on 15 March 1914 in London, Wilson studied at the Hastings School of Art (under Philip Cole) and the RA Schools (under Malcolm Osborne and Robert Austin*). He taught at the Bromley College of Art. He is an exceptionally talented animal artist, occasionally painting seascapes and portraits. He uses watercolour, oils and acrylic for his colour work, and pen or brush with ink for the black and white illustrations. Some of his illustrations are reminiscent of Rowland Hilder*, for example, the work he did for the "Shell Nature Studies" series. *Zoo Animals* (Puffin Picture Book, 1948), has been described as one of the most beautifully

illustrated books of the century. He was elected RI; and was Vice-President of SWLA.

Books illustrated include: E.G. Boulenger: *Zoo Animals* (Puffin Picture Book; Penguin, 1948); J.M. Fisher: *Birds and Beasts* (With Rowland Hilder*; Shell Nature Studies series; Phoenix House, 1956); R. Carrington: *A Guide to Earth History* (1958); D. Stephen: *The Red Stranger* (Lutterworth, 1958); J. Reeves: *Fables from Aesop* (Blackie, 1961); M. Fisher: *A World of Animals* (1962); D. Tovey: *Donkey Work* (1962); H. Griffiths: *Patar* (1970); J. Cunliffe: *Our Sam* (1980).

Books written and illustrated include: *Just Monkeys* (Country Life, 1937); *Dogs* (Puffin Picture Books 56; Penguin, 1946); *Coastal Craft* (Carrington, 1947); *Animals We Know* (Nelson, 1959).

Published: *Animals* (Studio, 1964); *Drawing Animals* (Studio, 1964); *Birds* (Studio, 1965).

Contrib: *Radio Times*.

Exhib: RA; RI; ROI; RSMA; SWLA.

Bibl: Jacques; Peppin; Usherwood; Who.

Colour Plate 145

WILSON, Mervyn **1905-1959**

Wilson studied at RA Schools. After showing a light-hearted drawing to the Art Editor of the *Radio Times* in 1929, he became a humorous artist despite himself and drew regularly for the magazine thereafter. He contributed also to *Punch*. The style of his drawing and the feeling in his work is at times somewhat like that of Edward Ardizzone*.

Contrib: *Junior*; *Punch*; *Radio Times*.

Bibl: Driver.

WILSON, Oscar **1867-1930**
See Houfe

WINNINGTON, Richard **1905-1953**

Born in Edmonton, North London, Winnington was unemployed as a young man during the Depression, and made a little money by making quick sketches in pubs. Later, as a salesman, he had a comic strip accepted by the *Daily Express* in 1936, and then joined the *News Chronicle* as a staff artist. He was film critic on that paper from 1943 until his death in 1953, and produced sketchy drawings to go with his columns. He also produced a cinema column for the *Daily Worker*, as "John Ross", from 1943 to 1948.

Contrib: *Daily Express*; *News Chronicle*.

Bibl: Feaver.

WOLFE, Edward **1897-1982**

Born on 29 May 1897 in Johannesburg, South Africa, Wolfe came to England to study at the Slade (1916-18). A landscape, figure, and flower painter, he exhibited with the London Group from 1918, and had his first one-artist show at the Mayor Gallery in 1925. He travelled in South Africa (1919-21, 1956-58), France (1922), USA and Mexico (1934-37), and elsewhere in Europe and North Africa. He illustrated at least two books. Elected LG (1923); 7 & 5 Society (1926); ARA (1967); RA (1972).

Books illustrated include: M. Joyce: *Peregrine Pieram* (1936); J. Garratt: *The Dancing Beggar* (1946).

Exhib: RA; LG; 7 & 5 Society; Mayor Gallery (1925; 1938).

Collns: Tate.

Bibl: Peppin; Tate; Waters.

WOLPE, Berthold Ludwig **1905-1989**

Born on 29 October 1905 in Offenbach, near Frankfurt, Wolpe became an apprentice with a firm of metalworkers instead of entering a university. There he acquired a basic training in metal and this, combined with his love of calligraphy and lettering, led to an interest in type design. He studied at the Offenbach Kungst-gewerbeschule (1924-28 under Rudolf Koch); and taught at the Frankfurt and Offenbach School of Art (1929-33), during which time he designed his Hyperion type. He left Germany in 1935 to live in England, first working at the Fanfare Press where he designed typefaces and ornaments (and also did the layout of many book jackets for Gollancz). He joined Faber in 1941, where he remained until his retirement in 1975.

Wolpe was one of the great graphic designers of the 20th century, one of those distinguished continental book designers and typographers whose work transformed the appearance of English books. The typefaces he designed included Albertus, Pegasus, Tempest, Sachenswald, and Decorata. At Faber he designed many books, but he is better known for the more than 1,500 book jackets he designed, many with his distinctive freely drawn lettering. He also illustrated a number of books, mostly with small drawn decorations in the form of vignettes, and head and tail pieces; designed a large number of crests and other devices; worked in metal, tapestry, jewellery and coins; and was an author, editor, and teacher. He won many awards during his life, including RDI (1959); received an honorary doctorate from RCA (1968); was Lyell Reader in Bibliography at Oxford University (1981-82); elected to the Double Crown Club (1938); OBE (1983). He died on 5 July 1989.

Books illustrated include: S. Zweig: *Der Begrabene Leuchter* (Vienna: Reichner, 1937; and other editions with additional illustrations in NY, 1937, and Milan, 1937); *Magna Carta and Other Charters of English Liberties* (Guyon House Press, 1938); K.M. Moir: *Some Adventures of a Cornet of Horse in the Crimean War* (Sette of Odd Volumes, 1938); W. de la Mare: *Collected Poems* (Faber, 1942), *Collected Rhymes and Verses* (Faber, 1944); F. Le Mesurier: *Sauces French and English* (Faber, 1947); N. Heaton: *Traditional Recipes of the British Isles* (Faber, 1951).

Bibl: *Berthold Wolpe: A Retrospective Survey* (V & A, and Faber, 1980); *The Bookseller* (21 July 1989); N. Gray: "Berthold Wolpe", *Signature* 15 (1940); R. Guyatt: "Berthold Wolpe", *Motif* 5 (1960); Amstutz 2; Peppin.

WOOD, Clarence Lawson **1878-1957**
See Houfe

During the 1930s Wood introduced a character in his humorous illustrations for the *Sketch* — "Gran'pop", an artful ape — which appeared every week for a number of years. These were also very popular in the US, and Wood prepared at least four animated cartoons for production in Hollywood. His humorous drawings also appeared in many other magazines, including *Printer's Pie* and *Winter Pie*. He was a member of the London Sketch Club. Later in his life, he lived in Kent much as a recluse, and died on 26 October 1957.

Books illustrated include: J. Finnemore: *The Red Men of the Dusk* (1899); J.C. Kernahan: *The Bow-Wow Book* (1912); R. Waylett: *A Basket of Plums* (with others, Gale & Polden, 1916), *A Box of Crackers* (with others, Gale & Polden, 1916); *Jolly Rhymes* (with others, Nelson, 1926); *The Old Nursery Rhymes* (1933).

Books written and illustrated include: *The "Mr" Books* (Warne, 1916); *Splinters: Drawings* (Duckworth, 1916); *The "Mrs" Books* (Warne, 1920); *Rummy Tales* (Warne, 1920); *The Noo-Zoo Tales* (Warne, 1922); *Colour Book Series* (Partridge, 1925-); *The Scot "Scotched"* (Newnes, 1927); *Fun Fair* (Arundel Prints, 1931); *Bedtime Picture Book* (Birn, 1943); *Gran'pop's Book of Fun* (Birn, 1943); *Meddlesome Monkeys* (1946); *Mischief Makers* (Birn, 1946); *Popular Gran'pop* (Birn, 1946).

Contrib: *Bystander*; *Graphic*; *ILN*; *London Opinion*; *Pearson's Magazine*; *Printer's Pie*; *Royal Magazine*; *Sketch*; *Winter's Pie*.

WOOD, Elsie Anna **fl. 1921-1950**

Peppin lists a number of books illustrated by Wood in black and white and colour, including school stories by Elsie Oxenham and Bible stories. She also wrote and illustrated a number of her own books.

Books illustrated include: E. Nesbit: *Our New Story Book* (with Louis Wain*, 1913); W.H.T. Gairdner: *Joseph and His Brothers* (1921); D.S. Forester: *Fumiko's Happy New Year* (1922); E. Oxenham: *The Abbey Girls Go Back to School* (Collins, 1923), *The New Abbey Girls* (Collins, 1923), *The Abbey Girls Again* (Collins, 1924); M. Entwhistle: *Musa, Son of Egypt* (1927); M.J. Chalmers: *Bible Books for Small People* (1932); *SPCK Giant Picture Books* (with N.K. Brisley*, 1950).

Books written and illustrated include: *Ayo and Her Brother* (Highway Press, 1927), *The Elsie Anna Wood Scripture Picture Books* (SPCK, 1929-31), *Gospel Picture Books* (SPCK, 1938).

Contrib: *Girls' Realm*.

Bibl: Peppin.

WOOD, Leslie **b.1920**

Born on 26 February 1920, Wood was educated at Stockport Grammar School, and studied at Manchester College of Art. He lectured at Epsom School of Art and Bristol Polytechnic. A freelance artist since 1946, he produced his first illustrations for Diana Ross' "Little Red Engine" stories, taking over from the Lewitt-Him* partnership. These illustrations are lively, double-page lithographs in full colour; elsewhere he also used wood engravings (for example, in *The Adventures of Baron Munchausen*, 1948) and other media.

Books illustrated include: E.M. Hatt: *Callers at Our House* (1945); D. Ross: *The Story of the Little Red Engine* (and eleven other titles, Faber, 1945-71), *Whoo, Whoo the Wind Blew* (Faber, 1946); E.M. Hatt: *The Cat with a Guinea To Spend* (1947); R.E. Raspe: *Baron Munchausen* (Cresset Press, 1948); J. Morris: *Delilah* (1964); H. Cresswell: *Jumbo Back to Nature* (1965), *Jumbo Afloat* (1966); W. Mayne: *Dormouse Tales* (five vols., 1966); M. Baker: *Hi-Jinks Joins the Bears* (1968); H. Cresswell: *Jumbo and the Big Dog* (1968); M. Bond: *Thursday Ahoy* (1969); A. Ridge and M. Bouhuys: *Melodia* (1969); M. Baker: *Teabag and the Bears* (1970); L. Berg: *The Little Red Car Has a Day Out* (1970); M. Bond: *Thursday in Paris* (1971); M. Baker: *Boots and the Ginger Bears* (1972); G. Kaye: *The Rotten Old Car* (1973); J. Tate: *Little Sister Bee* (1973).

Books written and illustrated include: (with D. Ross) *I Love My Love with an A* (1972); (with Roy Burden) *The Big Red Bus* (nine titles, 1978-81); *Six Silly Cyclists* (1979).

Bibl: Eyre; ICB2; Peppin.

WOOD, M.
See "EMMWOOD", John

WOOD, Owen **b.1929**

Born in Whetstone, North London, Wood was educated in London and studied at Camberwell School of Arts and Crafts (1945-47). He worked as a free-lance painter and illustrator before accepting a part-time teaching post in the Graphic Design Department, Cambridge College of Art (1960-64). In the summer of 1966, he began an extensive tour in Europe, visiting publishers, and since then he has worked entirely as a free-lance artist. His commissions have included designing new banknotes for the Clydesdale Bank of Scotland, painting a series of twelve large canvases for the London Stock Exchange and designing posters, greeting cards and book jackets.

He has illustrated at least three covers for *Radio Times* and contributed illustrations to many other magazines. *The Owl and the Pussy-Cat* (1978) was the first full-colour book he illustrated.

Books illustrated include: E. Lear: *The Owl and the Pussy-Cat & Other Nonesense* (Deutsch, 1978); *Jumblies* (Orbis, 1986).

Contrib: *Bride and Home; Club International; Economist; Esquire; Harpers Bazaar; Homes and Gardens; Radio Times.*

Bibl: Driver.

WOOD, Starr **1870-1944**
See Houfe

Books illustrated include: H. Simpson: *Women en Casserole* (1936); H.I. MacCourt: *Women as Pets* (1938).

Books written and illustrated include: *Cocktail Time* (1896); *Dances You Have Never Seen* (1921); *P.T.O. A Collection of 94 Humorous Drawings* (1934).

WOODLEY, Christine Anne **b.1949**

Born on 19 February 1949 in Northampton, Woodley was educated at St. Andrew's School, Bedford, and studied at Northampton School of Art (1967-69). She is an artist in pen and ink and watercolour, and has illustrated a few books.

Books illustrated include: *All About Squirrels and Moles and Things* (National Trust); *The Art of Yeast Cooking*.

Bibl: Who.

WOODROFFE, Patrick **b.1940**

Born in Halifax, Yorkshire, Woodroffe studied French and German at Leeds University, and then combined teaching and painting until 1972, when he became a full-time free-lance painter and had his

first exhibition. In 1976 his first book for children was published in Australia (*Micky's New Home*) and he had his second exhibition, at the Mel Calman Workshop Gallery. Other publishing enterprises include *The Pentateuch*, a fantasy book sold with two L.P. records. His illustrations are extremely detailed, finely-worked paintings and photographs of mixed media art. As well as writing and illustrating his own books, Woodroffe has produced many book jackets and paperback covers, featuring mostly fantasy and science fiction themes, including several for novels by Michael Moorcock, and record sleeves. His illustrations are much concerned with violence and humour, mysticism and sexuality, particularly the eroticism of young girls.

Books written and illustrated include: *Micky's New Home* (Cowbridge, NSW: Brown, 1976); *Mythopoeikon* (Dragon's World, 1976); *The Adventures of Tinker the Hole-Eating Duck* (Dragon's World, 1979); *The Pentateuch of the Cosmogony* (Dragon's World/EMI, 1979); *Hallelujah Anyway* (Dragon's World, 1984); *A Closer Look* (NY: Harmony Books, 1986).

Exhib: Covent Garden Gallery (1972); Calman's Workshop Gallery (1976).

Bibl: Patrick Woodroffe: *Mythopoeikon* (Limpsfield: Dragon's World, 1976); Woodroffe: *A Closer Look* (NY: Harmony Books, 1986).

WOODROFFE, Paul Vincent **1875-1954**
See Houfe

Born in Madras, India on 25 January 1875, Woodroffe returned to England with his family after the death of his father in 1882. He was educated at Stonyhurst College, Lancashire, and although he passed the entrance examination to the Royal Military Academy, he went instead to the Slade (1893-96).

His first illustrated book — the illustrations were quite imitative of Walter Crane's — was published in 1895, *Ye Booke of Nursery Rhymes*, with music by Joseph Moorat, who had married Woodroffe's sister in 1893. Moorat's music was the inspiration for much of Woodroffe's work as an illustrator. He contributed to *The Quarto* and met Laurence Housman* and Clemence Housman* who had a considerable influence on his style. He designed many bindings for a number of publishers. Taylor writes that "Once removed from the direct Housman influence he drifted into other artistic activities; his designs for *The Princess and Other Poems* (Dent, 1904) are very ordinary, and his later book-illustrations are quite uninteresting." (Taylor, 1966.†)

Later in the 1890s Woodroffe became a pupil of Christopher Whall, the leading Arts and Crafts stained glass designer, and in 1902 was elected a member of the Art Workers' Guild. He established a stained glass workshop in the Cotswolds in 1904, with a staff of about eight apprentices and assistants. Woodroffe had a number of commissions for glass in Britain but the most important came from the US in 1909, when he was asked to design and make fifteen windows for the Lady Chapel of St. Patrick's Cathedral in New York (which were not completed until 1934). Woodroffe served in the Ministry of Munitions during WW1, but continued his artistic work at the same time. After the war he worked on war memorial windows, painted landscapes, and decorated a number of books for the Shakespeare Head Press which was run by his friend Bernard Newdigate. In 1939 he moved to Dorset; his last recorded work is for a small window done in 1945. He died at Eastbourne on 7 May 1954.

Exhib: NEA; RA; Fine Arts Society (1910); RHA; RMS; Glasgow; Camden Society.

Books illustrated include: J.S. Moorat: *Ye Booke of Nursery Rhymes* (Bell, 1895), *The Second Book of Nursery Rhymes* (Allen, 1896); R. Herrick: *A Country Garland of Ten Songs* (Allen, 1897); W. Shakespeare: *Songs from the Plays of Shakespeare* (Dent, 1898); *The Little Flowers of Saint Francis of Assisi* (Art & Book, 1899); *The Little Flowers of Saint Benet* (Kegan Paul, 1901); L. Housman: *Of Aucassin and Nicolette* (Murray, 1902); A. Tennyson: *The Princess and Other Poems* (Dent, 1904); J. Moorat: *Humpty Dumpty and Other Songs* (De La More Press, 1905); C.M. Steedman: *The Child's Life of Jesus* (Jack, 1906); A. Steedman: *Nursery Tales* (Jack, 1906); J. Moorat: *Thirty Old-Time Nursery Songs* (Jack, 1907); S.T. Coleridge: *The Ancient Mariner* (Jack, 1907); L. Dalkeith: *Stories from Roman History* (Jack, 1907); E.

Christopher WORMELL *A Blackbird Singing* by R.S. Thomas (Gwasg Gregynog, 1989)

Lemon: *Stories from Greek History* (Jack, 1907); W. Shakespeare: *The Tempest* (Chapman & Hall, 1908); D.G. Rossetti: *The Blessed Damozel* (Foulis, 1910); M. Lemon: *The Enchanted Doll* (Jack, 1915); C. Lamb: *Dream Children and the Child Angel* (De La More Press, 1925); *Froissart's Cronycles* (eight vols., Stratford: Shakespeare Head Press, 1927-28); G. Cavendish: *The Life and Death of Thomas Wolsey* (Richards Press, 1930).
Contrib: *Dome; Illustrated London News; Pageant; Parade; Quarto; Venture.*
Colln: V & A.
Bibl: John Russell Taylor: *The Art Nouveau Book in Britain* (Methuen, 1966); Peter D. Cormack: *Paul Woodroffe 1875-1954* (Waltham Forest: William Morris Gallery, 1982); ICB; Johnson FIDB; Peppin.

WOODWARD, Alice Bolingbroke **fl.1885-1920**
See Houfe
Colour Plate 146

WORMELL, Christopher **b.1955**
Born on 1 September 1955 in Gainsborough, Lincolnshire, Wormell had no art training, but started wood engraving in 1982, and most of his illustrations are done using that medium. His first commission was a book jacket for Faber, and he has done many others for that company and for Penguin, Cape and other publishers. The largest proportion of his work is done for advertising, but he has illustrated several books, including food and wine books, and private press poetry.
Books illustrated include: R.P. Warren: *The Collected Work of Robert Penn Warren* (Franklin Library, 1984); H. Williamson: *The Story of a Norfolk Farm* (Holloway, 1986); H. Falkus: *The Sea*

Trout (Gollancz, 1987); *English Country Traditions* (V & A, 1988); R.S. Thomas: *A Blackbird Singing* (Gwasg Gregynog, 1989); I. Niall: *Trout from the Hills* (Witherby, 1991), *English Country Traditions* (1992?).
Contrib: *Country Homes; Country Life; Financial Times; Guardian; Observer; Radio Times; Sunday Times.*
Exhib: SWE; Spellmans Bookshop, York (one-artist show, 1985).
Bibl: *Images* 11; IFA.

WORSDELL, Guy **1908-1978**
Born in York, Worsdell studied at the Central School of Arts and Crafts (1930-33), where he learned how to engrave from Noel Rooke* and John Farleigh*. He had further instruction from R.J. Beedham, illustrated a few books with engravings, and was elected a member of the Society of Wood Engravers in 1971. As a painter and printmaker, his subjects were usually landscapes and railway subjects.
Books illustrated include: L. Paul: *Heron Lake* (Batchworth, 1948), *Exile and Other Poems* (Caravel Press, 1951); Rondel: *Poems from the French* (Caravel Press, 1951); A.G. Keown: *Collected Poems* (Caravel Press, 1952).
Bibl: Garrett 2; Peppin.

WORSLEY, John **b.1919**
Born on 16 February 1919 in Liverpool, Worsley studied at Goldsmiths' College School of Art (1934-37). He served in the Royal Navy during WW2, and was taken prisoner in Yugoslavia in 1943. During his years in prison camp, he acted as an official war artist (1943-46), recording in great detail life in various camps. He also was regularly employed as a forger of identity photographs; and helped in an escape by constructing a dummy of an officer, which was later commemorated in a film, "Albert, RN".
After the war, he was a free-lance portrait painter and illustrator of children's books. He drew strip cartoons for *Eagle*; made engravings for the Dropmore Press; and designed television programmes.
Books illustrated include: J. Fernald: *Destroyer from America* (1942); G. Morgan: *Only Ghosts Can Live* (1945); R. Harling: *The Steep Atlantick Stream* (1946), *Amateur Sailor* (1947); T. Cubbin: *The Wreck of the Serica* (1950); J. Pudney: *The Book of Leisure* (with others, Odhams, 1957); M. Hastings: *Sydney the Sparrow* (1971), *Mary Celeste* (1972); J. Carruthers: *Robinson Crusoe* (Purnell, 1975), *Treasure Island* (Purnell, 1975), *The Three Musketeers* (Purnell, 1976), *Tom Sawyer* (Purnell, 1977), *Lorna Doone* (Purnell, 1979); K. Grahame: *The Wind in the Willows* (1983).
Contrib: *Eagle; Girl.*
Exhib: NEAC; RA; RP; SMA.
Bibl: Harries; Peppin; Waters.

WRAGG, Arthur **b.1903**
Born on 3 January 1903 near Manchester, Wragg started his studies at Sheffield School of Art in 1916, but moved to London in 1923. He contributed to many magazines, and illustrated several books by other writers. He is best known for the powerful, strongly contrasting black and white drawings he made for books published by Selwyn and Blount. His social, political and spiritual concerns for the poor in Britain, their living and working conditions in the 1930s, and the threat of war, are starkly realised in these intensely-felt illustrations. A deeply religious man, Wragg seems to have been tortured by what he perceived as the inequities of life and by the underlying brutality of civilisation.
Books illustrated include: R.M. Freeman: *Samuel Pepys Looks at Life* (Hutchinson,1931); W. Holt: *I Was a Prisoner* (John Miles, 1935); E. Székely: *Cosmos, Man and Society* (Daniel, 1936); W. Greenwood: *The Cleft Stick* (Selwyn & Blount, 1937); *The Lord's Prayer in Black and White* (Cape, 1946); E. Gaskell: *Cranford* (Temple, 1947); D. Defoe: *Moll Flanders* (Temple, 1948); W.E. Purcell: *These Thy Gods* (Longmans, 1949); G. Flaubert: *Bibliomania* (Rodale Press, 1954); T. de Molina: *Three Husbands Hoaxed* (Rodale Press, 1955).
Books written and illustrated include: *The Psalms for Modern Life* (Selwyn & Blount, 1933); *Jesus Wept* (Selwyn & Blount, 1935); *Seven Words* (Heinemann,1939); *Thy Kingdom Come* (Selwyn & Blount, 1939); *Alice Through the Paper-Mill* (with

others, Birmingham: Foyle, 1940); *The Song of Songs* (Selwyn & Blount, 1952).
Contrib: *Nash's Magazine; Sunday Magazine; Woman's Journal; Woman's Pictorial.*
Bibl: Peppin; Waters.

WRIGHT, Alan **1864-1959?**
See Houfe
Born on 30 September 1864, Wright spent his early childhood in Somerset near Chard, but then moved with his family to south Hampstead, London. He studied at St. John's Wood School of Art, and in 1889 had an oil painting accepted by the RA. He had many commissions for the illustration and decoration of children's books, and Walter Crane included two of his head-pieces in his influential *The Decorative Illustration of Books Old and New* (Bell, 1896). Wright contributed illustrations to *Parade* and in 1897 replaced Harry Furniss* as the illustrator of G.E. Farrow's "Wallypug" books and other popular titles.

He shared rooms in London with Gleeson White, who in turn introduced him to Frederick Rolfe, Baron Corvo, and in 1898 Wright illustrated a Corvo story in *Wide World Magazine*. An all-out personal attack on Corvo started in the press, and perhaps because some of the hostility was directed towards his illustrator, there began a general change in Wright's spirits and fortunes. His commissions continued to evaporate, until in 1911 he met Anne Anderson*, herself an artist; they were married in 1912. She illustrated over a hundred books for children, and Wright collaborated in some of the work, but generally dedicated himself to providing her with an environment conducive to her work. He did continue to illustrate books himself, working right into his eighties, and occasionally earned good money, as he did in the 1930s when he was producing hunting and coaching scenes for calendars and greeting cards. Wright's most important work was produced around the turn of the century, but he did many fine illustrations throughout his life.

Books illustrated include: F.H. Low: *Queen Victoria's Dolls* (Newnes, 1894); J.M. Cobban: *The Tyrants of Kool-Sim* (Henry, 1897); M.E. Mann: *There Was Once a Prince* (Henry 1897), *When Arnold Comes Home* (Henry, 1897); G.E. Farrow: *The Wallypug in London* (Pearson, 1897), *Adventures in Wallypug Land* (Pearson, 1897), *The Little Panjandrum's Dodo* (Skeffington, 1899), *The Mandarin's Kite* (Skeffington, 1900), *Baker Minor and the Dragon* (Pearson, 1902), *The New Panjandrum* (Pearson, 1902), *In Search of the Wallypug* (Pearson, 1903), *Professor Philanderpan* (Pearson 1904), *The Wallypug in Fogland* (Pearson, 1904), *The Wallypug Birthday Book* (Routledge, 1904), *The Wallypug on the Moon* (Pearson, 1905); W.S.W. Anson: *The Christmas Book of Carols and Songs* (with others, Routledge, 1905); W. Irving: *Rural Life in England* (with others, Routledge, 1906); A. Corkran: *The Life of Queen Victoria* (Jack, 1910); W. Irving: *Rip Van Winkle* (Nelson, 1921); M. Lemon: *The Enchanted Doll* (Nelson, 1921).

Books written and illustrated include: *Busy-Bunny Book* (with Anne Anderson, Nelson, 1916); *Two Bold Sportsmen* (with Anderson, Nelson, 1918); *The Naughty Neddy Book* (with Anderson; Nelson, nd); *Bingo and Babs* (Blackie, 1919); *The Tale of the Trail of a Snail* (Jarrolds, 1919); *Mrs. Bunnykins' Busy Day* (Jarrolds, 1919); *Mrs. Bunnykins Builds an Igloo* (OUP, 1920); *Mr. Poodle's Half-Holiday* (Hodder, 1920); *Mr. Barker Bow* (Hodder, 1920); *The Violet Book for Children* (with Anderson, OUP, 1920?); *Tony Twiddler, His Tale* (Jarrolds, 1924); *The Wonderful Tale of the Trail of a Snail* (Jarrolds, 1924); *The Story of a Saucy Squirrel* (Jarrolds, 1924); *The Cuddly Kitty* (with Anderson; Nelson, 1926); *The Podgy Puppy* (with Anderson; Nelson, 1927); *The Book of Baby Birds* (with C. Englefield*; 1936); *Little Teddy Bear* (Collins, 1939).

Contrib: *Blackie's Children's Annual; Dome; Girl's Own Paper; Idler; Pall Mall; Parade; Pip, Squeak and Wilfred Annual; Strand; Sunday Pictorial; Wide World Magazine; Windmill.*
Exhib: RA; NEAC; RBA; ROI; Liverpool.
Bibl: Maleen Matthews: "An Illustrator of the 'Nineties", *Book Collector* 28, No. 4 (1979): 530-44; Felmingham; Peppin.

Arthur WRAGG *"Jesus Wept"* (Selwyn & Blount, 1935)

WRIGHT, George **1860-1942**
A painter in oils of hunting and coaching scenes, he exhibited at the RA from 1892, and he illustrated a few books.
Books illustrated include: T.C. Hinkle: *Wild Horse Silver* (1934), *Pinto the Mustang* (1935), King: *The Story of a Dog* (1936).
Exhib: RA.
Bibl: Titley; Waters.

WYSARD, Anthony **b.1907**
Born in Pangbourne-on-Thames, Wysard was educated at Harrow, and after a brief and unhappy period as an accountant started doing caricatures in line and wash for various journals. From 1928 to 1938, when he was commissioned in the Queen's Westminsters, his drawings appeared in the *Sphere*, *Tatler*, and other magazines and newspapers; and he had a one-artist show at the Walker Galleries in 1936. While working on Fleet Street he joined Alexander Korda as Advertising Manager in his film studios at Denham and after WW2 he returned to that work, before becoming associate editor of *Harper's Bazaar*. He then established his own advertising agency.
Contrib: *Bystander; Daily Dispatch; Daily Express; Harper's Bazaar; Sphere; Sunday Express; Tatler.*
Exhib: Walker Galleries.
Bibl: Feaver; Parkin.

YEATS, Jack Butler **1871-1957**
See Houfe
Books illustrated include: E. Rhys: *The Great Cockney Tragedy* (1891); W.B. Yeats: *Irish Fairy Tales* (1892); W.B. Yeats: *A London Garland* (1895); G.W. Russell: *New Songs* (1904); J. Masefield: *A Mainsail Haul* (1905); J.M. Synge: *The Aran Islands* (Maunsel, 1907); N. Borthwick: *Ceachda Beoga Gaeluingi* (three vols., Dublin: Irish Books, 1911); J.M. Synge: *In Wicklow, West Kerry and Connemara* (1911); S. Mitchell: *Frankincense and Myrrh* (Cuala Press, 1912); G.A. Birmingham: *Irishmen All* (1913); W.B. Yeats: *Reveries over Childhood and Youth* (Cuala Press, 1915); P. Colum: *A Boy in Erinn* (Dent, 1916); A.St.J. Gogarty: *The Ship and Other Poems* (1918); S. O'Kelly: *Ranns and Ballads* (Dublin:

Candle Press, 1918), *The Weaver's Grave* (Dublin: Talbot Press, 1922); P. Colum: *The Big Tree of Bunlahy* (Macmillan, 1933); P. Lynch: *The Turfcutter's Donkey* (Dent, 1934); G.C. Duggan: *The Stage Irishman* (Talbot Press, 1937); M. Cregan: *Sean-Eoin* (1938); W.B. Yeats: *On the Boiler* (Dublin: Cuala Press, 1939); T. Bodkin: *My Uncle Frank* (1940); W.B. Yeats: *Outriders* (1943).
Books written and illustrated include: *James Flaunty of the Terror of the Western Seas* (1901); *The Scourge of the Gulph* (Elkin Mathews, 1903); *The Treasure of the Garden* (Elkin Mathews, 1903); *The Bosun and the Bob-Tailed Comet* (Elkin Mathews, 1904); *The Little Fleet* (Elkin Mathews, 1909); *Life in the West of Ireland* (Maunsell, 1912); *Sligo* (Wishart, 1930); *Three Plays* (Cape, 1933); *Sailing, Sailing Swiftly* (Putnam, 1933); *The Charmed Life* (Routledge, 1938); *Ah Well* (Routledge, 1942); *And To You Also* (Routledge, 1944); *The Careless Flower* (Pilot Press, 1947); *In Sand* (Dublin: Dolmen Press, 1964).

YOUNGS, Betty **b.1934**
Born on 1 October 1934 in North Staffordshire, Youngs trained as a pharmaceutical chemist and was subsequently chief pharmacist in a hospital. She married Edward Youngs in 1958; lived near Cambridge 1958-77, and then moved to Hertfordshire. She has written and illustrated a few books for children, mostly concerned with animals.
Books written and illustrated include: *Farm Animals* (BH, 1976); *Humpty Dumpty and Other First Rhymes* (BH, 1977); *One Panda: An Animal Counting Book* (BH, 1980); *Pink Pigs in Mud: A Colour Book* (BH, 1982); *Pink Pigs in Mud* (BH, 1987).
Bibl: Who.

ZINKEISEN, Anna Katrina **1901-1976**
Born on 28 August 1901 in Kilcreggan, Scotland, the sister of the theatrical designer, Doris Zinkeisen*, she studied at the RA Schools. She painted society portraits and flowers, and exhibited widely, including at the Royal Academy; she also painted murals. During WW2 she painted hospital scenes and air-raid casualties. She designed posters for London Transport (1933-34), made sculptures, illustrated several books and designed some book jackets. She was married to a Col. G.R.N. Heseltine, and lived in Woodbridge, Suffolk. She was made RDI in 1940.
Books illustrated include: A.P. Herbert: *She-Shanties* (Fisher Unwin, 1926), *Plain Jane* (Fisher Unwin, 1927); C. Brahms: *The

Moon on My Left (Gollancz, 1930); B.H. Buergel: *Oolo-Boola's Wonder Book* (Bell, 1932); M. Sharp: *The Nymph and the Nobleman* (Barker, 1932); G. Quaglino: *The Complete Hostess* (Hamilton, 1935); H. Farjeon: *Nine Sharp and Earlier* (Dent, 1938); N. Streatfeild: *Party Frock* (Collins, 1946); C.H. Abrahall: *Prelude* (OUP, 1947); J. Phoenice: *A Rainbow of Paths* (Oriel Press, 1965).
Exhib: RA; FAS.
Bibl: Peppin; Waters.

ZINKEISEN, Doris **1898-1991**
Born on 31 July 1898 in Kilcreggan, Scotland, Zinkeisen was privately educated at home with her sister Anna Zinkeisen* and studied at the RA Schools. Doris became a portrait, figure and equestrian painter (being an equestrian champion herself) and with her sister also painted murals, including those for the "Queen" liners. She designed costumes and sets for the theatre, including for revues by Charles Cochrane and Noel Coward, and during WW2 she did stage work for the Old Vic Theatre. Later she was the official war artist for the St. John Ambulance Brigade, and drew the scenes of horror she found at the Belsen concentration camp. She also worked on two films, designed posters for London Transport, wrote a book on stage designing and illustrated at least one book, *The High Toby*, a play by J.B. Priestley, for which she did the scenery and characters for the "Puffin Cut-out Book" series. She was elected ROI (1928); died 3 January 1991.
Books illustrated include: J.B. Priestley: *The High Toby* (Puffin Cut-out Books, 1948).
Published: *Designing for the Stage* (Studio, 1938).
Collns: IWM.
Exhib: RA; RBA; ROI; FAS; Paris Salon.
Bibl: *Guardian* obit. 8 January 1991; Waters.

ABBREVIATIONS USED IN ENTRIES

GENERAL ABBREVIATIONS

AGO: Art Gallery of Ontario, Toronto
AIA: Academy of Irish Art *or* Artists International Association
ARA: Associate of Royal Academy
ARCA: Associate of the Royal College of Art
ARE: Associate, Royal Society of Painter-Etchers and Engravers
ARIBA: Associate, Royal Institute of British Architects
ARMS: Associate of the Royal Society of Miniature Painters
ARWA: Associate of the Royal West of England Academy
ARWS: Associate of Royal Society of Painters in Watercolour
Ashmolean: Ashmolean Museum, Oxford
Beetles: Chris Beetles Ltd. (Gallery)
Bibl: Bibliography
BM: British Museum
BM(NH): British Museum (Natural History)
BOA: Boys Own Annual
BOP: Boys Own Paper
Bristol: Bristol City Museum and Art Gallery
BWS: British Watercolour Society
CBE: Commander of the Order of the British Empire
CH: Companion of Honour
COI: Central Office of Information
Collns: Examples of the artist's work may be found at the places listed
Contrib: Contributed illustrations to the periodicals listed
DBE: Dame Commander of the Order of the British Empire
DCL: Doctor of Civil Law
Derby: Derby Art Gallery
Exhib: Exhibited at the places listed
FAS: Fine Art Society, London
FCSD: Fellow, Chartered Society of Designers
FRCA: Fellow, Royal College of Art
FRE: Fellow, Royal Society of Painter-Etchers and Engravers
FRIBA: Fellow, Royal Institute of British Architects
FRSA: Fellow of the Royal Society of Arts
FRSL: Fellow of the Royal Society of Literature
FSIA: Fellow, Society of Industrial Artists and Designers
FZS: Fellow of the Zoological Society
GI: Royal Glasgow Institute of Fine Arts
GPO: General Post Office
ICA: Institute of Contemporary Arts
ILN: *Illustrated London News*
IS: International Society of Sculptors, Painters and Gravers
IWM: Imperial War Museum
KCVO: Knight Commander of the Royal Victorian Order
Kt: Knight
LC: Library of Congress, Washington
Leicester Gall: Leicester Galleries, London
Liverpool: Walker Art Gallery, Liverpool
LG: London Group
LLD: Doctor of Laws
LNER: London and North Eastern Railway
MA: Master of Arts
MBE: Member of the Order of the British Empire
Manchester: City Art Gallery, Manchester
MOMA: Museum of Modern Art, New York
MSIA: Member, Society of Industrial Artists and Designers
NBL: National Book League
nd: no date

NDD: National Diploma in Design
NEAC: New English Art Club
np: not paged
NPG: National Portrait Gallery
NS: National Society of Painters, Sculptors and Engravers
OBE: Officer of the Order of the British Empire
Osborne Collection: Osborne Collection of Early Children's Books, Toronto Public Library, Toronto
pp: privately published
pseud: pseudonym
PS: Pastel Society
PRA: President of the Royal Academy
PRE: President, Royal Society of Painter-Etchers and Engravers
PRWS: President of the Royal Watercolour Society
Published: Wrote but did not illustrate the books listed
RA: Royal Academy
RAMC: Royal Army Medical Corps
RBA: Royal Society of British Artists
RBC: Royal British Colonial Society of Artists
RCA: Royal College of Art
RCamA: Royal Cambrian Academy
RCM: Royal College of Music
RDI: Royal Designer for Industry
RE: [Member of the] Royal Society of Painter-Etchers and Engravers
repr: reprinted
RGI: Royal Glasgow Institute
RHA: Royal Hibernian Academy
RI: Royal Institute of Painters in Watercolour
RIBA: Royal Institute of British Architects
RMS: Royal Society of Miniature Painters
ROI: Royal Institute of Oil Painters
ROM: Royal Ontario Museum, Toronto
RP: Royal Society of Portrait Painters
RSA: Royal Scottish Academy
RSW: Member of the Royal Scottish Society of Painters in Water-Colours
RUA: Royal Ulster Academy
RWEA: Royal West of England Academy
RWS: Member of the Royal Watercolour Society
SGA: Member, Society of Graphic Artists
SIA: Society of Industrial Artists and Designers
SMP: Society of Mural Painters
SSA: Society of Scottish Artists
SWA: Society of Women Artists
SWE: Member of the Society of Wood Engravers
SWLA: Society of Wildlife Artists
Tate: Tate Gallery, London
TLS: Times Literary Supplement
Tooth: Arthur Tooth Gallery, London
UA: United Artists
UWS: Ulster Water-colour Society
Whitworth: Whitworth Art Gallery, University of Manchester
WIAC: Women's International Art Club
WW1: World War 1
WW2: World War 2
V & A: Victoria & Albert Museum, London

BIBLIOGRAPHICAL ABBREVIATIONS

Alderson. Brian Alderson: *Looking at Picture Books 1973* (London: National Book League, 1973).

Amstutz 1. Walter Amstutz: *Who's Who in Graphic Art* (Zurich: Amstutz & Herdeg Graphis Press, 1962).

Amstutz 2. Walter Amstutz: *Who's Who in Graphic Art, Vol.2* (Zurich: Astutz & Herdeg Graphis Press, 1982).

Balston. Thomas Balston: English Wood-Engraving 1900-1950 (London: Art & Technics, 1951).Bateman. Michael Bateman: *Funny Way to Earn a Living* (London: Leslie Frewin, 1966).

Bellamy. B.E. Bellamy: *Private Presses & Publishing in England Since 1945* (London: Bingley, 1980).

Blount. Margaret Blount: *Animal Land; the Creatures of Children's Fiction* (London: Hutchinson, 1974).

Bradshaw. Percy V. Bradshaw: *They Make Us Smile* (London: Chapman & Hall, 1942).

Brett. Simon Brett: *Engravers: A Handbook for the Nineties* (Swavesey: Silent Books, 1987).

CA. *Contemporary Authors* (Detroit: Gale Research, 1962-) .

Carpenter. Humphrey Carpenter and Mari Prichard: *The Oxford Companion to Children's Literature* (Oxford University Press, 1984).

Cave. Roderick Cave: *The Private Press* (London: Faber, 1971).

Chambers. David Chambers and Christopher Sandford: *Cock-a-Hoop . . . A Bibliography of the Golden Cockerel Press, September 1949 - December 1961* (Pinner: Private Libraries Association, 1976).

Compton. Susan Compton: *British Art in the Twentieth Century; the Modern Movement* (London: Royal Academy of Art, 1986).

Deane. Yvonne Deane and Joanna Selborne: *British Wood Engraving of the 20's and 30's* (Portsmouth City Museum and Art Gallery, 1983).

DNB. *Dictionary of National Biography.*

Doyle. Brian Doyle: *The Who's Who of Children's Literature* (London: Hugh Evelyn, 1968)

Doyle BWI. Brian Doyle: *Who's Who of Boys' Writers and Illustrators* (pp., 1964).

Driver. David Driver: *The Art of the "Radio Times" : The First Sixty Years* (London: BBC, 1981).

Eyre. Frank Eyre: *British Children's Books in the Twentieth Century* (London: Longman, 1971).

Feaver. William Feaver: *Masters of Caricature* (London: Weidenfeld & Nicolson, 1981).

Felmingham. Michael Felmingham: *The Illustrated Gift Book 1880-1930* (Aldershot: Scolar Press, 1988).

Folio 40. *Folio 40: A Checklist of the Publications of the Folio Society, 1947-1987* (London: The Folio Society, 1987).

Fougasse. Fougasse: *The Good-Tempered Pencil* (London: Max Reinhardt, 1956).

Garrett. Albert Garrett: *A History of British Wood Engraving* (Tunbridge Wells: Midas Books, 1978).

Garrett 2. Albert Garrett: *British Wood Engraving of the 20th Century: A Personal View* (London: Scolar Press, 1980).

Gifford. Denis Gifford: *The International Book of Comics* (London: Hamlyn, 1984).

Gilmour. Pat Gilmour: *Artists at Curwen.* (Tate Gallery, 1977).

Harries. Meirion and Susie Harries: *The War Artists; British Official War Art of the Twentieth Century* (London: Michael Joseph, 1983).

Hammond. Nicholas Hammond: *Twentieth Century Wildlife Artists* (NY: Overlook Press, 1986).

Hodnett. Edward Hodnett: *Five Centuries of English Book Illustration* (Aldershot: Scolar Press, 1988).

Horn. Maurice Horn: *The World Encyclopedia of Comics* (London: New English Library, 1976).

Houfe. Simon Houfe: *The Dictionary of British Book Illustrators and Caricaturists 1800-1914,* 2nd edition (Woodbridge: Antique Collectors' Club, 1981).

ICB. Bertha E. Mahoney and others: *Illustrators of Children's Books 1744-1945* (Boston: Horn Book, 1947; with three supplements 1958, 1968 and 1978).

IFA: Information supplied by artist.

Jacques. Robin Jacques: *Illustrators at Work.* (London: Studio Books, 1963).

Jaffé. Patricia Jaffé: *Women Engravers* (London: Virago Press, 1988).

Johnson. J. Johnson and A. Greutzner: *The Dictionary of British Artists 1880-1940.* (Woodbridge: Antique Collectors' Club, 1976).

Johnson FIDB. Diana L. Johnson: *Fantastic Illustration and Design in Britain, 1850-1930* (Providence, RI:Museum of Art, Rhode Island School of Design, 1979).

Journal RE. *Journal of the Royal Society of Painter-Etchers and Engravers.*

Klemin. Diana Klemin: *The Illustrated Book; Its Art and Craft.* New York: (Potter, 1970).

Lewis. John Lewis: *A Handbook of Type and Illustration* (London: Faber, 1956).

Lewis and Brinkley. John Lewis and John Brinkley: *Graphic Design.* (London: Routledge, 1954).

Mackenzie. Ian Mackenzie: *British Prints: Dictionary and Price Guide* (Woodbridge: Antique Collectors' Club, 1987).

Morgan. Ann Lee Morgan: *Contemporary Designer.* (London: Macmillan, 1984).

Parkin. *The Artist as Illustrator, 1924-1984* (London: Michael Parkin Fine Art, 1984).

Parry-Cooke. Charlotte Parry-Cooke: *Contemporary British Artists* (London: Bergstrom+Boyle, 1979).

Peppin. Brigid Peppin and Lucy Micklethwait: *Dictionary of British Book Illustrators: The Twentieth Century* (London: John Murray, 1983).

Price. R.G.G. Price: *A History of Punch* (London: Collins, 1957).

Ross. Alan Ross: *Colours of War: War Art 1939-45* (London: Cape, 1983).

Rothenstein. John Rothenstein: *Modern English Painters* (three vols., 2nd edition, New York: St. Martin's Press, 1976).

Ryder. John Ryder: *Artists of a Certain Line* (London: Bodley Head, 1960).

Sandford. Christopher Sandford: *Bibliography of the Golden Cockerel Press, 1921-1949* (Folkestone: Dawson, 1975; a reprint of *Chanticleer; Pertelote;* and *Cockalorum* in one volume).

Shall We Join the Ladies? (Oxford: Studio One Gallery, 1979).

Tate. Mary Chamot and others: *Tate Gallery Catalogues: The Modern British Paintings, Drawings and Sculpture,* two vols. (London: Oldbourne Press, 1964).

Text and Image: English Woodblock Illustration, Thomas Bewick to Eric Gill (Cambridge: Fitzwilliam Museum, 1985).

Titley. Norah M. Titley: *A Bibliography of British Sporting Artists* (British Sporting Art Trust, 1984).

Usherwood. R.D.Usherwood: *Drawing for the "Radio Times"* (London: Bodley Head, 1961).

Waters. Grant M. Waters: *Dictionary of British Artists Working 1900-1950* (Eastbourne: Eastbourne Fine Arts, 1975. 2 vols.)

Whalley. Joyce Irene Whalley and Tessa Rose Chester: *A History of Children's Book Illustrators* (London: Murray, 1988).

Who. *Who's Who in Art.* 22nd edition (Havant, Hants: Art Trade Press, 1986 and earlier editions).

PUBLISHERS' ABBREVIATIONS

A & R: Angus & Robertson
Abelard: Abelard-Schumann
Barker: Arthur Barker
BH: John Lane, The Bodley Head; and Bodley Head
Brockhampton: Brockhampton Press
Burns: Burns, Oates
C & H: Chapman & Hall
Chatto: Chatto & Windus
CUP: Cambridge University Press
D&C: David & Charles
Davies: Peter Davies
Deutsch: André Deutsch
Epworth: Epworth Press
Etchells: Etchells & MacDonald
Eyre: Eyre & Spottiswoode
Faber: Faber & Faber
GCP: Golden Cockerel Press
Hamilton: Hamish Hamilton
Hart-Davis: Rupert Hart-Davis

Hollis: Hollis & Carter
ICBP: Cambridge: International Council for Bird Preservation
Kaye: Kaye & Ward
Lutterworth: Lutterworth Press
McGibbon: McGibbon & Kee
Nicholson: Nicholson & Watson
O & B: Oliver & Boyd
OUP: Oxford University Press
Penguin: Penguin Books
RTS: Religious Tract Society
SCM: Student Christian Movement
SPCK: Society for the Propagation of Christian Knowledge
Secker: Secker & Warburg
Sidgwick: Sidgwick & Jackson
T & H: Thames & Hudson
ULP: University of London Press
Weidenfeld: Weidenfeld & Nicolson